INFORMATION
U.S.A.

INFORMATION U.S.A.

Matthew Lesko
Founder, Washington Researchers

Research Director: Eudice Daly

The Viking Press • New York
Penguin Books

Penguin Books Ltd, Harmondsworth,
Middlesex, England
Penguin Books, 40 West 23rd Street,
New York, New York 10010, U.S.A.
Penguin Books Australia Ltd, Ringwood,
Victoria, Australia
Penguin Books Canada Limited, 2801 John Street,
Markham, Ontario, Canada L3R 1B4
Penguin Books (N.Z.) Ltd, 182–190 Wairau Road,
Auckland 10, New Zealand

First published in 1983
in simultaneous hardcover and paperback editions
by The Viking Press and Penguin Books,
40 West 23rd Street, New York, New York 10010
This paperback edition reprinted 1983 (twice)

Published simultaneously in Canada

LIBRARY OF CONGRESS CATALOGING IN PUBLICATION DATA
Main entry under title:
Information U.S.A.
 Includes index.
 1. Information services—United States—Handbooks, manuals, etc. I. Lesko, Matthew. II. Daly,
Eudice. III. Washington Researchers. IV. Title: Information U.S.A.
Z674.5.U5I53 1983 020'.973 82-11080
ISBN 0-670-39823-3 (hardcover)
ISBN 0 14 046.564 2 (paperback)

Charts by Mary Smith

Printed in the United States of America by
R. R. Donnelley & Sons Company, Crawfordsville, Indiana
Set in Times Roman

This book is dedicated to all federal bureaucrats,
the true possessors of institutional knowledge
in our federal government.

Acknowledgments

I'd like to thank the thousands of federal workers who shared their time to insure the accuracy and completeness of the manuscript. Thanks as well to Eudice Daly, whose research and writing skills, along with her special dedication and friendship, made the project a joy. And my special gratitude to my agent, Rafe Sagalyn, whose patience, support, and clear vision of the future are truly responsible for making Information U.S.A. *happen.*

Contents

Sampler Section
PAGE 1

Departments
PAGE 97

Agencies, Boards, Commissions, Committees, and Government Corporations
PAGE 527

Executive Branch
PAGE 839

Judicial Branch
PAGE 847

Legislative Branch
PAGE 853

Quasi-Official Agencies
PAGE 901

Index
PAGE 923

Introduction

It is not an exaggeration to say that information is the life-blood of modern American society. In business we rely on data to plan our agendas. Every day in our personal lives we make decisions—in buying and selling, entertainment, travel, education, and so many other areas—based largely on information that is available to us. What we do is shaped by what we learn from information sources—television, books, films, radio, newspapers, newsletters, magazines, and so on. Access to information, then, is a necessary tool for living.

By far the most comprehensive, yet the most unexplored, source of information in the United States is our federal government. Washington, DC, it can unequivocally be said, is the information capital of the world. We call the 2,880,000 employees of the government "bureaucrats." But "bureaucrats" is really a misnomer. Some 710,000 of these government workers are really information specialists. As taxpayers we pay their salaries and fund their research. As information consumers, we are entitled to a return on our investment.

These specialists work in every cubbyhole of the government bureaucracy, from cabinet-level agencies to independent government commissions, from the Department of Agriculture to the Library of Congress to the Small Business Administration. This book pinpoints the information sources and specialists in our government: who they are, what they do, how they can help *you*.

I was certainly not the first person to recognize the phenomenal information resources that are available in Washington. I simply discovered a way to run a business that exploits their expertise. In 1975 I founded Washington Researchers, a company designed to bridge the gap between the information source and the information user. In four years, Washington Researchers grew from an undercapitalized company with a staff of one—me—to a million-dollar enterprise with a staff of 35 workers.

As so often happens in a fledgling enterprise, my first client was a friend. His problem was this: could I, within 24 hours, describe the basic supply and demand for Maine potatoes? How I supplied the information he wanted illustrates perfectly how you can put government specialists to work for you.

My client represented a syndicate of commodity investors who invested millions of dollars in Maine potatoes. When he called me, these potatoes were selling at double their normal price; he wanted to know why. I knew absolutely nothing about potatoes, but I thought I knew where to find this out. We decided that I would be paid for my service only if I found the information within a day.

I immediately called the general office at the Department of Agriculture and asked to speak to an expert on potatoes. The operator referred me to a Mr. Charlie Porter. I wondered whether he was the department functionary for handling crank calls or if he really could help me. The operator assured me Porter was an agriculture economist specializing in potatoes. I called the number given and, to my surprise, he answered his telephone. I began by saying I was a struggling entrepreneur who knew nothing about potatoes and needed his help to answer a client's request. Charlie graciously gave me much of the information I needed, adding that he would be happy to talk at greater length either on the phone or in person at his office. I decided to go see him.

For two and one half hours the next morning, Charlie explained in intimate detail the supply and demand for Maine potatoes. He showed me computer printouts that explained why their price had doubled in recent weeks. For any subject that came up during our conversation, Charlie had immediate access to a reference source.

He had rows of books covering all aspects of the potato market. A strip of ticker tape that showed the daily price of potatoes from all over the country lay across his desk. Here in this office, I thought, was everything you would ever want to know about potatoes. My problem, it turned out, was not in getting *enough* information, but *too much*! Once Charlie started talking, it was hard to stop him. I sensed that Charlie Porter had spent his lifetime studying the supply and demand for the potato and *finally* someone with a genuine need sought his expertise.

Charlie then pointed me across the hall in the direction of a potato statistician whose sole responsibility was to produce a monthly report showing potato production and consumption in the United States. In the statistician's office, I learned all the various categories of potatoes that were tallied. I was surprised to learn that even the number of potato chips produced each month was counted.

My client couldn't have been more satisfied. And I realized that I was on to something big—and profitable.

The Art of Obtaining Information from Bureaucrats

ONCE YOU find your Charlie Porter you must make your information request carefully. Remember that the expert you find is probably a mid-level bureaucrat who has spent most of his career studying a narrow subject area. Moreover, his work goes largely unnoticed by top management. Bureaucrats are under no obligation to share their expertise with you: They receive the same paycheck no matter how useful they are to you. The success you have in rallying them to your cause will determine how fully your problem is solved.

Following are ten techniques developed by Washington Researchers to help insure a rewarding relationship with federal bureaucracy:

1. *Introduce yourself cheerfully.* The way you open the conversation will set the tone for the entire interview. Your greeting and initial comments should be cordial and cheery. They should give the feeling that yours is not going to be just another anonymous telephone call, but a pleasant interlude in your source's day.

2. *Be open.* You should be as candid as possible with your source since you are asking the same of him. If you are evasive or deceitful in explaining your needs or motives, your source will be reluctant to provide you with information. If there are certain facts you cannot reveal because of client confidentiality, for example, explain why. Most people will understand.

3. *Be optimistic.* Throughout your entire conversation, you should exude a sense of confidence. If you call a source and say, for example, "You don't have any information that can help me, do you?" it makes it easy for your source to say, "You're right. I can't help you." A positive attitude will encourage your sources to stretch their minds to see the various ways they can be of assistance.

4. *Be humble and courteous.* You can be optimistic and still be humble. Remember the old adage that you can catch more flies with honey than you can with vinegar. People in general, and experts in particular, love to tell others what they know, as long as their positions of authority are not questioned or threatened.

5. *Be concise.* State your problem in the simplest possible manner. If you bore your source with a long-winded request, your chances for a thorough response are diminished.

6. *Don't be a "gimme."* A "gimme" is someone who says "give me this" or "give me that," and has no consideration for the other person's feelings.

7. *Be complimentary.* This goes hand in hand with being humble. A well-placed compliment about your source's expertise or insight into a particular topic will serve you well. In searching for information in the government, you are apt to talk to people who are colleagues of your source. It would be reassuring to your source to know he is respected by his peers.

8. *Talk about other things.* Do not spend the entire time talking about the information

you need. If you can, discuss briefly a few irrelevant topics, such as the weather, the Washington Redskins, or this year's pennant race. The more social you are, the more likely it is that your source will respond favorably.

9. *Return the favor.* You might share with your source some bits of information, or even gossip, you have learned from other sources. However, be certain not to betray anyone's trust of your client or another source. If you do not have any information to share at the moment, it would still be a good idea to call back when you are further along in your research.

10. *Send thank-you notes.* A short note, typed or handwritten, will help insure that your source will be just as cooperative in the future.

How to Use *Information U.S.A.*

BEFORE you use the directory portion of this book, review the "Sampler" section. This section will give you a feeling for both the breadth and depth of the information presented in the directory portion.

There are essentially two ways to use the directory section. If you know exactly what you're looking for, the first—and quickest—way is to choose key words (e.g., earthworms, franchising, heart disease) that characterize your area of interest and turn to the subject index at the back of the book. This will refer you directly to those agencies where your information can be found. Alternatively, you can turn to a department or an agency whose name makes it sound as if it might be of value to you. For example, to research solar energy, look under U.S. Department of Energy; for business loans, look under the Small Business Administration. The description of each agency's "mission" will give you a good idea how useful that agency will be. Be sure to glance at the subject headings of the information sources listed. Although these might not be topics that directly meet your needs, there may be a related subject area listed.

As you begin to use government resources regularly, you'll be constantly surprised by the extent of the information sources. As I discovered in my meeting with Charlie Porter at the Department of Agriculture, my happy dilemma was not in finding enough information, but finding almost too much!

Some of the services you request will be available for free; some, such as booklets, directories, newsletters, etc., at a minimal cost. Keep the following in mind when you ask for such items:

If you do not know what to ask for specifically, describe your problem and ask how you can be helped, or request a listing of products or services that are available. Then request that your source send you the items you can use that are available.

Be sure to state that you authorize any costs that may be incurred on your behalf, up to a maximum amount.

For any items above your maximum amount, ask for descriptions and prices.

Include your name, address, and telephone number in all correspondence.

The Objectives and Limitations of *Information U.S.A.*

THE FEDERAL GOVERNMENT spends more than $700 billion a year. Much of that money goes toward accumulating expertise and information; *Information U.S.A.* is an attempt to catalog these resources. However, because of the herculean dimensions of this objective and because of the changing nature of the information, it is virtually impossible for this book to be thoroughly complete and up-to-date. What it *will* do is:

Expand your mind to see that somewhere in the federal government there is a free source of information on almost any topic you can think of.

Save you time in locating where in the federal government your needed source is located.

Help you realize that, large as this book is, it is still only the tip of the iceberg. If you cannot

find the exact source you need in the book, with a little more effort you can probably find the expert you need.

The reader should be warned that, like any directory, this book is out of date as soon as it is printed. Some of the addresses and telephone numbers may have changed by the time you use them. Do not be discouraged. Just knowing that an office or expert exists is the most important part of getting the information you need. It is not overly difficult to track down the correct address or phone number. If you get stuck in your search here are some tips:

Call the government operator at 202-655-4000 for the correct address or phone number.

Contact your local Federal Information Center, listed in the telephone book under "U.S. Government."

Contact the local office of your Congressman or Senator.

Each of these sources can help you locate what you need from the federal government.

SAMPLER SECTION

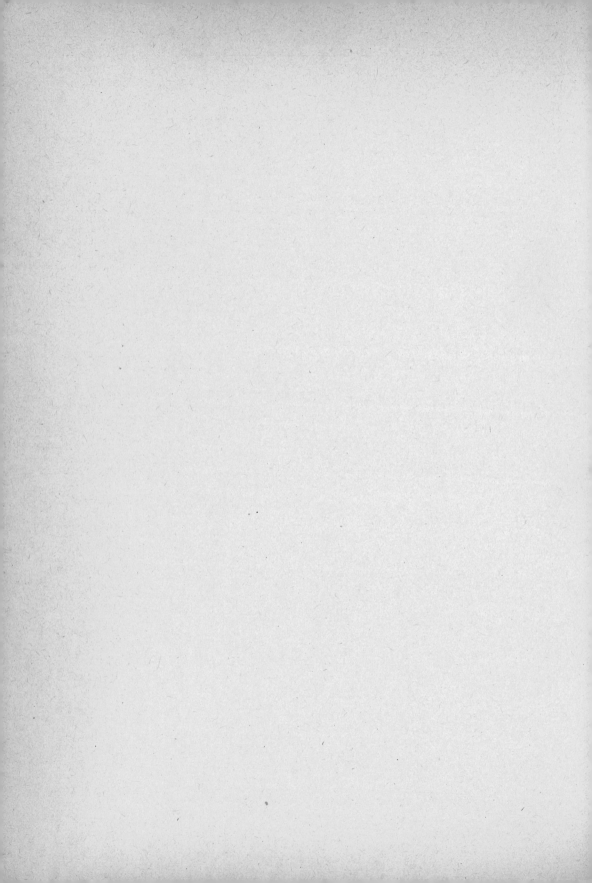

The Best of Government Freebies

The following is a selection of some of the best free merchandise, services, and publications available from the federal government.

Adopt-A-Horse

In order to control the population of wild horses and burros grazing on public land, the U.S. Department of the Interior offers these animals for adoption to qualified applicants. For further information and adoption applications contact: Adopt-A-Horse, P.O. Box 25047, Denver, CO 80225, or your nearest Bureau of Land Management.

Best and Worst Food Buys for Coming Months

A free subscription to the National Consumer Buying Alert will keep you informed on which foods will be cheaper or more expensive in coming months. This monthly publication also provides general consumer tips, such as how to deal with a wet basement, how to insulate your home or how to reduce gas consumption. Write for a free copy from Consumer Information Center, Pueblo, CO 81009.

Boating Help

The following publications are available to those interested in boating activities:

Visual Distress Signals
New Lighting Requirements
The ABC's of Waterskis
Trailer Boating, A Primer

Boat owners can also receive a courtesy marine examination of their boat's safety-related equipment covering all federal and state requirements plus additional standards recommended by the Coast Guard Auxiliary. Contact: Boating Information Branch, Office of Boating Safety, Coast Guard, Department of Transportation, 2100 2nd St. S.W., Room 4213, Washington, DC 20593/ 202-426-1080.

Business Loans for Children and Teenagers

The U.S. Department of Agriculture lends up to $30,000 to youths from ten to 21 years of age. The loans can be used to support both farm and non-farm ventures, such as small crop farming, livestock farming, roadside stands and custom work. They are normally made in conjunction with youth groups and require parental consent. Contact: Production Loan Division, Farmers Home Administration, Department of Agriculture, Washington, DC 20250/202-447-2288.

Captioned Films

A free catalog listing educational and entertainment films for the deaf is available from: Captioned Films for the Deaf, Education for the Handicapped, 814 Thayer Ave., Silver Spring, MD 20910/301-587-5940.

Celebrate A Special Day By Flying Your Flag Over the Capitol

This may not be free, but for the money it's priceless. For the cost of a flag ($5.50 to $16.00) your congressman can have the Architect for the Capitol fly your personal stars and stripes over the Capitol Building on the day you specify. This makes an unusual birthday gift because you then receive the flag and a certificate noting the date the flag was flown and for whom. Be sure to state the day to be flown and the name of the recipient. Contact the local office of your congressman or write Capitol, Washington, DC 20515/202-224-3121.

Christmas Trees

Free Christmas trees are available to nonprofit organizations. Commercial organizations and individuals can obtain trees at fair market value, and for $1.00 you can cut your own tree. The trees are located on federal land in ten western states. Contact your local office of the Bureau of Land Management, the Forest Service, or: Division of Forestry, Bureau of Land Management, Department of the Interior, Room 5620, Washington, DC 20240/202-343-3229; for a list of district offices: 202-343-5717.

College Money Hotline

Many middle- and higher-income college students are not aware that they may be eligible for government programs offering free money or low-interest loans for financing their education. Experts are available to show you how to take advantage of a variety of student grant and loan programs offered by the government. Contact: Basic Grants, Department of Education, P.O. Box 84, Washington, DC 20044/toll-free 800-638-6700/800-492-6602 in Maryland.

Consumer Publications

The Consumer Information Center is the major distributor of free consumer-oriented publications issued by the federal government. Available free publications include:

AUTOMOBILES
Common Sense in Buying a New Car (503H)
Common Sense in Buying a Used Car (504H)

Consumer Problems with Auto Repair (505H)
How to Deal with Motor Vehicle Emergencies (506H)

CHILDREN
Helping Children Make Career Plans (518H)
When Your Child Starts School (505K)
Stay Well Card (506K)
Plain Talk About Learning Disabilities (512H)
Plain Talk About Raising Children (522H)

FOOD
The Confusing World of Health Foods (543H)
Consumer's Guide to Food Labels (588H)
Nutrition and Your Health (656H)
Some Facts and Myths About Vitamins (550H)
Microwave Oven Radiation (553H)

HEALTH
Breast Self-Examination (590H)
Clearing the Air: A Guide to Quitting Smoking (572H)
Contraception: Comparing the Options (573H)
How to Donate the Body or Its Organs (577H)
Plain Talk About Feelings of Guilt (576H)
Plain Talk About Stress (631K)
Genetic Counseling (642K)
Generic Drugs: How Good Are They? (587H)
Low-Calorie Protein Diets (542H)
The Common Cold: Relief but No Cure (593H)

HOUSING
Can I Really Get Free or Cheap Public Land? (599H)
Having Problems Paying Your Mortgage? (600H)
Home Buyer's Vocabulary (601H)
Homeowner's Glossary of Building Terms (603H)
Move In ... With a Graduated Payment Mortgage (604H)
Wise Home Buying (609H)
Wise Rental Practices (655H)
Questions and Answers on Condominiums (605H)

For copies of any of the above publications or for a free catalog, contact: Consumer Information Center, Pueblo, CO 81009. Be sure to specify publication number.

Credit Protection Laws
Find out how you can profit from the new credit laws by obtaining a free copy of the *Consumer Handbook of Credit Protection Laws* from: Board of Governors of the Federal Reserve System, 20th St. and Constitution Ave. N.W., Washington, DC 20551/202-452-3245.

Discard or Keep Family Records?
A free booklet tells you what family/household records are worth keeping as well as how to keep them. Contact: Consumer Information Center, General Services Administration, 18th and F Sts. N.W., Washington, DC 20405/202-566-1794.

Education Publications
For a free directory of publications produced by the Department of Education contact: Office of Public Affairs, Department of Education, 400 Maryland Ave. S.E., Room 1059, Washington, DC 20202/202-245-8707.

Educational Grants Information Clearinghouse
Information and expertise is available for those who wish to submit grant proposals on education research. Contact: Clearinghouse for National Institute of Education, Department of Education, 1200 19th St. N.W., Room 804, Washington, DC 20208/202-254-5600.

Educational Programs That Work
Teachers and developers of programs that are deemed educationally significant are sponsored to go into the field to lend their expertise in repeating their programs. A free directory, called *Educational Programs That Work*, describes these programs. Contact: Division of Educational Replication, Office of Evaluation and Dissemination, Department of Education, 1832 M St. N.W., Room 802, Washington, DC 20030/202-653-7000.

Energy-Related Invention Assistance
Inventors can find technical assistance from the National Bureau of Standards. A staff of trained specialists evaluate thousands of energy-related inventions and make recommendations to the Department of Energy for grant money. Contact: Office of Energy-Related Inventions, National Bureau of Standards, Department of Commerce, Building 225 A46, Washington, DC 20234/301-921-3694.

Family Economics
A staff of experts research such topics as the economic aspects of family living, family resources, economic problems of families, the relationship of family budget items to each other, the use of food, clothing and textiles and the efficient management of money and time. Free publications are also available. Contact: Family Economics Research Group, ARF/NER, 6505 Belcrest Rd., Federal Building, Room 442A, Hyattsville, MD 20782/301-436-8461.

Films
National Aeronautics and Space Administration Motion Pictures, Office of Public Affairs, Washington, DC 20546/202-755-3500. Air and space films are available on such topics as earth-sun relationships, research on the atmosphere, and weather. A free catalog is available.

Consumer Product Safety Commission

Northeastern Regional Office, 6 World Trade Center, Vesey St., 6th Floor, New York, NY 10048/212-264-1134. Films are available on safety-related topics in such areas as outdoor power equipment, playground equipment, poison prevention packaging, and toys. A free catalog is available.

Bureau of Mines

Motion Pictures, 4800 Forbes Ave., Pittsburgh, PA 15213/412-621-4500. Films are available describing many of the country's natural resources. A free catalog is available.

For additional information concerning free films from the federal government contact: National Audiovisual Center, Information Branch, National Archives and Record Service, 8700 Edgeworth Dr., Capitol Heights, MD 20409/ 301-763-1896.

Firewood

Free firewood is available from the 187 million acres of land managed by the U.S. Forest Service. A local forest ranger will identify the fallen and dead wood which can be cut and/or carried away. Contact your local Forest Service office or ask for a free fact sheet and map showing Forest Service land from the Forest Service, Department of Agriculture, P.O. Box 2417, Washington, DC 20013/202-447-3957.

Food and Drug Consumer News

This free quarterly publication lists public hearings, promotes participation in Food and Drug Administration (FDA) hearings, describes the FDA decision-making process, announces consumer exchange meetings on national and district levels, and lists locations of FDA consumer offices. Contact: Office of Consumer Affairs, Food and Drug Administration, Department of Health and Human Services, 5600 Fishers La., Rockville, MD 20857/301-443-3170.

Food and Drug Consumer Training Courses

Free one-day seminars are held throughout the country by the Food and Drug Administration (FDA) showing how to use the FDA and be an active consumer. An example of the topics covered is how to petition the FDA to improve or change its regulation of a certain product or company. For a schedule of courses contact: National Consumer Awareness and Access Project, Office of Consumer Affairs, FDA, Department of Health and Human Services, 5600 Fishers La., Room 1685, Rockville, MD 20857/301-443-5006.

Gold Mining

Copies of *How To Mine and Prospect for Placer Gold* are available from: Office of Public Information, Bureau of Mines, Department of the Interior, 2401 E St. N.W., Room 1035, Washington, DC 20241/202-634-1004.

Government Surplus Property

The federal government regularly sells such surplus items as automobiles, furniture, and typewriters. Office equipment is sold on alternate Thursdays, vehicles on alternate Wednesdays. No catalog available. For buying information contact: Surplus Sales Center, Washington Navy Yard, 4th and W Sts. S.E., Washington, DC 20406/202-472-2190.

In addition to the General Services Administration, the U.S. Department of Defense also sells surplus property. Much of their property is in the form of heavy equipment such as jeeps, firearms, armored combat vehicles, aircraft, ships, explosives, and machinery. Contact: SIS Bidders Control Office, P.O. Box 1370, Battle Creek, MI 40916/616-962-6511, ext. 6736.

Government Will Stock Your Pond

As a result of some old soil conservation policies, ponds can be stocked free with bass and bluegills. Depending upon which state is involved, the U.S. Department of the Interior or the state government will provide the fish. To find out if you qualify, contact your local game warden or the local county agent from the Department of Agriculture.

Hearing Aid Facts

A free book entitled *Facts About Hearing and Hearing Aids* is available to consumers from: Consumer Communications, FDA, Department of Health and Human Services, 5600 Fishers La., Rockville, MD 20857/301-443-3170.

Help For The Homemaker

The U.S. Department of Agriculture publishes hundreds of free books to aid the farmer, suburbanite, homemaker and consumer. The most popular publications include:

Your Money's Worth in Foods
Nutrition Food at Work for You
Family Fare—A Guide to Good Nutrition
Food is More Than Just Something You Eat
Home Canning of Fruits and Vegetables
Food Guide For Older Folks
Food and Your Weight
Home Freezing of Fruits and Vegetables
Nutritive Value of Foods
Growing Vegetables in the Home Garden

For copies of any of the above publications or for a free catalog listing available publications contact: Publications Division, Office of Governmental and Public Affairs, Department of Agriculture, 14th St. and Independence Ave. S.W., Washington, DC 20450/202-447-2791.

Help for Older Americans
The following publications are available free:

You, the Law and Retirement
Guidelines for a Telephone Reassurance Service
To Find the Way to Opportunities and Services for Older Americans
Planning for Retirement: Information Sources
Energy Fact Sheet—Some Suggestions for Older Americans: Saving Energy in the Home
Sources of Information and Descriptions of Crime Prevention Programs for the Elderly

Contact: National Clearinghouse on Aging, Administration on Aging, Department of Health and Human Services, 330 Independence Ave. S.W., Room 4146, Washington, DC 20201/202-245-2158.

How To Strike It Rich In The Government Oil and Gas Lottery
Individuals can participate in public lotteries which offer the rights to extract oil and gas from federally owned land. For an application and further information contact: Bureau of Land Management, Department of Interior, 18th and C St. N.W., Room 3560, Washington, DC 20240/202-343-7753.

Infant Care
A free publication from the U.S. Department of Health and Human Services describes how to develop the skills necessary to care for a baby so that he or she can grow into a healthy, able child and adult. Copies are available from: LSDS, Department 76, Washington, DC 20401.

Jobs In Demand
If you are changing careers, beginning a career or moving to another area of the country, "Occupations in Demand" is a monthly publication that describes the demand for specific types of jobs in specific areas of the country. Available for $18 a year from the Government Printing Office, Superintendent of Documents, Washington, DC 20402/202-275-2091. For a sample copy and general information, contact: Employment and Training Administration, Department of Labor, 601 D St. N.W., Room 10225, Washington, DC 20213/202-376-6730.

Manure—All You Want
Many of the U.S. Department of Agriculture's Extension Service offices offer free manure to gardeners. There are Extension Service programs operating in 3,000 counties located in 50 states and the territories. For help in locating your nearest Extension Service office, contact: Administration Office, Department of Agriculture, Extension Service, Room 340-A, Washington, DC 20250/202-447-3377.

Mariners Weather Magazine
This quarterly magazine, for those who have a marine-based interest, costs $8 a year or $3 for a single copy. It covers weather in the Atlantic and Pacific for the previous two months and other related topics. To subscribe or order a single copy, contact: Government Printing Office, Superintendent of Documents, Washington, DC 20402/202-275-2091. For information contact: Marine Weather Log, National Oceanographic Data Center, NOAA, Department of Commerce, Washington, DC 20235/202-634-7394.

Mining and Prospecting on Public Land
Anyone can prospect on public lands. Some lands can be bought or leased through the U.S. Department of the Interior. Anyone interested in leasing or buying lands for prospecting or mining purposes must submit a plan to the Forest Service. Contact: Minerals and Geology Staff, Forest Service, Department of Agriculture, P.O. Box 2417, Washington, DC 20013/703-235-8010.

Missing Persons
The Social Security Administration can help you contact a lost loved one, an old friend or other missing person. Write a letter to your missing person and send it with as much personal information as possible, e.g., date of birth and last place of residence, to the Social Security Administration. If they can locate the person in their files, they will forward your letter. They will not, however, give you the current address. For further assistance, call information for the number of your Social Security Administration office or send your letter along with pertinent information to Social Security Administration, Public Inquiries, Department of Health and Human Services, 6501 Security Blvd., Baltimore, MD 20235.

Money For College Students
A free booklet is available describing federal financial aid programs for college students. Information on each program includes how much money you can get, how to apply, when to apply, how you will be paid and eligibility. Contact: Publications Branch, Office of Public Affairs,

Department of Education, 400 Maryland Ave. S.W., Room 2097, Washington, DC 20202/202-245-8564.

Money-Saving Directory of Drugs

A directory entitled *Approved Prescription Drug List With Therapeutic Equivalent Evaluation* shows how to substitute one drug for another, often at a substantial savings. Available from: Division of Drug Information Resources, FDA, Department of Health and Human Services, 5600 Fishers La., Room 8304, Rockville, MD 20857/301-443-3204.

Nutritional Information

A series of publications is available describing the nutritional value of the following food groups: dairy and eggs; spices and herbs; baby foods; fats and oils; poultry; soups, sauces and grains; sausages and luncheon meats; pork products; breakfast cereals by brand name; nuts and seeds; fruits; vegetables; legumes; fish and shellfish; beef; cereal grain products; beverages; candies and confections; and mixed dishes (TV dinners, pizza, etc.). For detailed information on the content of these publications contact: Nutrient Data Research Group, SEA, Federal Building, Room 313, 6505 Belcrest Rd., Hyattsville, MD 20782/301-436-8491. The publications are available for sale at the Government Printing Office, Superintendent of Documents, Washington, DC 20402/202-783-3238.

Organic Farming and Gardening

A free bibliography on this subject containing over two hundred citations is available from the National Agricultural Library, 10301 Baltimore Blvd., Beltsville, MD 20705/301-344-3704.

Pesticide Directory for Plants

A free directory, *Agricultural Handbook #571*, describes Environmental Protection Agency-cleared pesticides and their safe application on plant life. Contact: Publications, Science and Education Administration, Department of Agriculture, South Building, Washington, DC 20250/202-447-4111.

Physical Fitness and Sports

The President's Council on Physical Fitness and Sports will supply information and expertise for those who wish to establish physical fitness programs. Available free publications include:

Aqua Dynamics: Physical Conditioning Through Water Exercise
Exercise and Weight Control
An Introduction to Physical Fitness

Physical Education—A Performance Checklist
An Introduction to Physical Fitness
The Physically Underdeveloped Child
Youth Physical Fitness ($2.50)

Contact: President's Council on Physical Fitness and Sports, Department of Health and Human Services, 400 6th St. S.W., Room 3030, Washington, DC 20201/202-755-7478.

Pick Your Own Fruits and Vegetables

Many farmers allow consumers to pick products directly from their fields at substantial savings. For a directory of farms which offer these direct marketing programs contact your state department of agriculture or a state extension service. For help in locating your local office contact: Administrative Office, Department of Agriculture, Extension Service, Room 340-A, Washington, DC 20250/202-447-3377.

Posters

The following agencies and departments provide free posters of high graphic quality:

Department of Energy

Technical Information Center, P.O. Box 62, Oak Ridge, TN/615-576-1301.

Six energy tips in cartoon format
Photograph of the sun overlooking country landscape to promote solar and renewable energy
Two energy conservation posters showing children enjoying their natural environment

Federal Voting Assistance Program

Department of Defense, Pentagon Room 1B457, Washington, DC 20301/202-694-4928.

"Vote!" posters with an eagle and Brunhilda Stick-ups to encourage voting

National Clearinghouse on Aging

Administration on Aging, Office of Human Development Services, Department of Health and Human Services, 330 Independence Ave. S.W., Room 4247, Washington, DC 20201/202-245-0827.

Handsome photographs, changing yearly, celebrating Older American Month

Environmental Protection Agency

Office of Public Awareness, 401 M St. N.W., Gallery 2, Washington, DC 20460/202-755-0717.

A simple drawing of a bird in soft colors to encourage environmental protection

Sick Plants or Animals

Free technical assistance is available to aid in diagnosing and curing diseases of plants or animals. Services range from telephone consultations and free literature to analyzing your pet's stool or your plant's leaves or soil. For help in locating your local County Cooperative Extension Service office contact: Executive Officer, Department of Agriculture, SEA, Room 33A, Administration Building, Washington, DC 20250/202-447-3304.

Sport Fishing

A good deal of information and expertise is available describing the sport potential of various bodies of water. Publications describe the types and amounts of fish found in specific areas. Contact: Recreation Fisheries, National Marine Fisheries Service, NOAA, Department of Commerce, Room 430, Washington, DC 20235/202-254-5536.

Stains and Spots

Help is available for consumers who want to know how to remove stains from all types of fabric. For a free booklet and information, contact: Textile and Clothing Labs., Department of Agriculture, SEA, 1303 W. Cumberland, Knoxville, TN 37916/615-974-5249.

Stamp Collecting Guide

Anyone interested in philately, the collecting and study of stamps, can receive a free booklet called *Introduction to Stamp Collecting* from: Stamp Division, Postal Service, 475 L'Enfant Plaza West S.W., Washington, DC 20260/202-245-4956.

Statistical Training

Over fifty courses are given around the country each year to state and local employees. However, anyone may be admitted to the courses on a space-available basis. Courses are given at both elementary and advanced levels. Contact: Cooperative Health Statistics System, National Center for Health Statistics, Office of Health Policy, Research and Statistics, PHS, Department of Health and Human Services, 3700 East-West Highway, Hyattsville, MD 20782/301-436-7047.

Tax Tips For the Elderly

The U.S. Senate has prepared a free booklet which can serve as a checklist for itemizing deductions. The checklist attempts to protect older Americans from overpaying their federal income tax. Ask for a copy of *Protecting Older Americans Against Overpayment of Income Taxes* from Special Committee on Aging, Senate, Dirksen Office Building, Room 6233, Washington, DC 20510/202-224-5364.

Toys and Other Free Stuff for Children

The following free items are of special interest to children:

COLORING BOOKS

A coloring book called *Otto Otter for Safe Water* is available from: Office of Public Affairs, Water and Power Resources Service, Department of the Interior, Room, 7042, Washington, DC 20240/202-343-4643.

A coloring booklet and noise quiz is available from: Office of Noise Abatement and Control, Environmental Protection Agency, ANR 471, Washington, DC 20460/703-557-7634.

Coloring books showing the nutritional value of foods are available from: Public Information, Food and Nutrition Service, 500 12th St. S.W. #764, Washington, DC 20250/202-447-8077.

TOYS

Litter bags, coloring books, song sheets, photographs, posters, bike stickers, and wallet cards are available from: Woodsy Owl, Forest Service, Department of Agriculture, Room 3248, South Building, P. O. Box 2417, Washington, DC 20013/202-447-7013.

Badges, stickers and other children's toys are available by contacting Smokey Bear Headquarters, Washington, DC 20252/202-235-8160.

Buttons, decals, posters and children's educational materials, all related to ecology, are available from: Office of Public Awareness, Environmental Protection Agency, 401 M St. S.W., Washington, DC 20460/202-755-0717.

METRIC HEIGHT CHART

Children can measure their growth in meters by using the Metric Height Chart.

Contact: Publications Section, Community Affairs and Education Branch, National Aeronautics and Space Administration, 400 Maryland Ave. S.W., Room 5104, Washington, DC 20546/202-755-3350.

ENERGY ACTIVITIES

A wide range of educational materials are available to teachers and children at all levels. Most of the materials are aimed at illustrating certain principles and problems related to various forms of energy and to their development, use and conservation. A free catalog of available materials can be obtained from: Technical Information Center, Department of Energy, P.O. Box 62, Oak Ridge, TN 37830/615-576-1183.

Travel and Recreation

The following items are of special interest to

those seeking assistance with travel and recreational activities:

National Forests and Grasslands

Travel planning aids and information are available to those wishing to visit one of the country's 154 national forests and 19 national grasslands. Contact: Office of Information, Forest Service, Department of Agriculture, Room 3238, South Building, Washington, DC 20250/202-447-3957.

National Park Directory and Guide

A directory describing the nation's 300 national parks is available for $3.24 from: Government Printing Office, Superintendent of Documents, Washington, DC 20402/202-275-2051.

Camping Guides

For general information on and a listing of addresses of camping facilities in the country's 154 national forests and 19 national grasslands, contact: Office of Information, Forest Service, Department of Agriculture, Room 3238 South Building, Washington, DC 20250/202-447-3957.

Resort Guides

Free resort guides are available for various areas of the United States. They contain seasonal information on weather and recreational opportunities. Elements of interest for each season are stressed, along with a table of activities best suited for each season. Contact: Resort Guides, National Oceanographic Data Center, EDIS/ NOAA, Department of Commerce, Room 400, Washington, DC 20235/202-634-7394.

Ghost Towns and Old Mine Passages

Information on ghosts towns and abandoned mines is available. Contact: Office of Public Information, Bureau of Mines, Department of the Interior, Room 1035, Columbia Plaza, Washington, DC 20241/202-634-1004.

Happy Trails

There are 452 recreational, scenic and historical trails within the National Park System, the National Forest System and State Park Systems. Trail guides and other information are available from: Division of Natural Resource System Planning, HCRS, Department of the Interior, 440 G St. N.W., Room 203, Washington, DC 20243/ 202-272-3566.

Wildlife Refuges

A descriptive listing of more than 400 federally run wildlife refuges is available. The descriptions include location, types of recreation available, size of refuge and its primary species.

Contact: Division of National Wildlife Refuges, Fish and Wildlife Service, Department of the Interior, Room 2024, Washington, DC 20240/202-343-4305.

Passport to Parks for Older Americans

Persons over 62 years of age can receive a free Golden Age Passport which acts as a lifetime entrance permit to those parks, monuments and recreation areas administered by the federal government. It also provides for a 50 percent discount on federal use fees charged for facilities and services such as camping, boat launching, and parking. Apply in person for passports at most federally operated recreation areas, National Park Service regional offices or at Information Office, Department of the Interior, 18th and C Sts. N.W., Room 1013, Washington, DC 20240/ 202-343-4747.

Wild Rivers

For maps and other information describing the National Wild and Scenic River System contact: Rivers and Trails Division, National Park Service, Department of the Interior, 440 G St. N.W., Room 203, Washington, DC 20243/202-272-3566.

Historical Site Brochures

Illustrated brochures are available describing individual sites of historic and cultural value which have made significant contributions to American history. Contact: Office of Public Affairs, Water and Power Resources Service, Department of the Interior, Room 7642, Washington, DC 20240/202-343-4662.

Handicapped Visitors Guide to Parks

Access National Parks describes the facilities available at more than 300 national parks and how they meet the needs of the handicapped. It can serve as a great guide book for both the handicapped and the non-handicapped. Contact: Office of Public Affairs, National Park Service, Department of the Interior, Room 1013, Washington, DC 20240/202-343-4747.

Travel Tips

The following free publications offer helpful tips for those who travel:

Your Trip Abroad—Travel Tips for Senior Citizens. Available from: Public Affairs, Bureau of Consular Affairs, Department of State, Room 6811, Washington, DC 20520/202-632-1489.

Fly-Rights: A Guide to Air Travel in the United States. Available from Publications, Civil Aeronautics Board, Universal North Building, 1825 Connecticut

Ave N.W., Washington, DC 20428/202-673-5432.

Travelers' Tips on Bringing Food, Plant and Animal Products into the United States. Available from Information Division, Animal and Plant Health Inspection Service, Department of Agriculture, Room 638, Federal Building, 6505 Bellcrest Road, Hyattsville, MD 20782/301-436-8645.

Customs Hints for Returning United States Residents—Know Before You Go. Available from Public Information Division, Customs Service, Department of the Treasury, 1301 Constitution Ave. N.W., Washington, DC 20229/202-566-5286.

Recreation Area Maps:

The following organizations offer free maps identifying and describing various recreational opportunities in the United States:

Office of Public Affairs, Water and Power Resources Service, Department of the Interior, Room 7642, Washington, DC 20240/202-343-4662.

Office of the Chief of Engineers, Public Affairs Office, HQDA (DAEN-CWO-R), 20 Massachusetts Ave. N.W., Washington, DC 20314/202-272-0247.

Wine and Cheese Making at Home

The U.S. Department of Agriculture has accumulated documentation and expertise to assist in making wine and cheese at home. For a review on these topics, ask for the wine and cheese Agri-Topics Reports from USDA-SEA-TIS National Agriculture Library, 10301 Baltimore Blvd., Beltsville, MD 20705/301-344-3744. For more detailed expertise on wine, contact Fruit Laboratory, Agricultural Research Service, Department of Agriculture, Room 111, Building 004, BARC-West, Beltsville, MD 20705/301-344-3572. For expertise in cheese contact: Dairy Laboratory, Department of Agriculture, AR-NER, Eastern Regional Research Center, 600 East Mermaid Lane, Philadelphia, PA 19118/215-247-5800, ext. 285.

Consumer Complaints

The following government offices offer help to consumers with specific problems. If an office does not specifically address your problem, but its subject area is similar, contact the office anyway; these offices can usually direct you to other sources of information and help.

If you cannot find an appropriate office listed below, the following organization can tell you if an office exists that can help you: Office of Consumer Affairs, Department of Health and Human Services, 621 Reporters Building, Washington, DC 20201/202-755-8820.

The following information was selected from the *Consumer's Resource Handbook,* which lists

hundreds of offices helpful to consumers. Single copies of this publication are available for free by writing: Consumer Information Center, Dept. 532G, Pueblo, CO 81009.

Advertising

The Federal Trade Commission (FTC) is responsible for preventing the use of unfair, false, or deceptive advertisements for consumer products. This includes television, radio and print ads. Although the FTC does not investigate individual complaints, it can and will act when it receives a large number of specific advertising complaints involving substantial consumer harm. Contact: Office of the Secretary, Federal Trade Commission, Washington, DC 20580/202-523-3598.

Alcohol

The Bureau of Alcohol, Tobacco and Firearms monitors the content, labeling and advertising of alcoholic beverages. The Bureau works to eliminate illegal traffic and trade in alcoholic beverages and sets and monitors collection of taxes due for the sale of these beverages. The Bureau also issues permits to engage in the production of alcohol for industrial purposes, such as gasohol. Contact: Chief, Trade and Consumer Affairs Division, Bureau of Alcohol, Tobacco and Firearms, Department of the Treasury, Washington, DC 20226/202-566-7581.

Animals/Pets
Food and Drug Administration (FDA)

Insures that veterinary preparations, drugs and devices are safe and effective and also insures that animal and pet food is safe and properly labeled. Contact: Bureau of Veterinary Medicine, Department of Health and Human Services, 5600 Fishers Lane, Rockville, MD 20857/301-443-5363.

Animal and Plant Health Inspection Service (APHIS) of the Department of Agriculture

Protects and improves animal and plant health by administering federal laws and regulations dealing with animal and plant health and quarantine, humane treatment of animals and the eradication of pests and diseases. APHIS also administers laws concerning the humane handling of livestock and poultry in interstate commerce, and governing the transportation, sale and handling of dogs, cats, and circus and zoo animals intended for use in laboratory research or for exhibition. Contact: Information Division, Animal and Plant Health Inspection Service, Department of Agriculture, Washington, DC 20250/202-447-3977.

Antitrust

The Federal Trade Commission (FTC) and the Antitrust Division of the Department of Justice work to preserve the healthy competition of business in our free enterprise system. These offices share responsbility for enforcement of the antitrust laws. Antitrust violations include price fixing, monopoly, price discrimination and any other anticompetitive practices. Contact: Assistant Director for Evaluation, Bureau of Competition, Federal Trade Commission, Washington, DC 20580/202-523-3404, or Assistant Attorney General, Antitrust Division, Department of Justice, Washington, DC 20530/202-633-3543.

Appliances
Federal Trade Commission (FTC)

Enforces rules that requires refrigerators, refrigerator-freezers, freezers, dishwashers, water heaters, room air conditioners, central air conditioners, clothes washers and furnaces be sold with labels giving consumers the estimated annual energy costs or energy efficiency ratings for each appliance. The label must give: (1) a description of model; (2) the estimated energy cost for air conditioners and heat pumps, or energy efficiency ratings for other appliances; (3) the range of energy costs or efficiency ratings for comparable models; and (4) other useful information that will enable consumers to estimate costs more precisely. The FTC also enforces the Magnuson-Moss Warranty Act which requires that warranties on appliances costing more than $15 be available to consumers for review before purchase, and that the terms of the full and limited warranties be spelled out in clear, easy-to-read language. Contact: Office of the Secretary, Federal Trade Commission, Washington, DC 20580/ 202-523-3600.

Consumer Product Safety Commission (CPSC)

Protects consumers against the manufacture and sale of hazardous appliances. CPSC can ban or order a recall of products found to be dangerous to the public. For information and fact sheets, contact: Office of Communications, Consumer Product Safety Commission, Washington, DC 20207/toll-free 800-638-8326 (national hotline); 800-492-8363 in Maryland; 800-638-8333 in Puerto Rico, Virgin Islands, Alaska, and Hawaii.

Bureau of Radiological Health of the Food and Drug Administration (FDA)

Protects consumers against unnecessary exposure to radiation from electronic products including lasers, television sets, X-rays and sunlamps. Contact: Director, Technical Information Staff (HFX-25), Bureau of Radiological Health, Food and Drug Administration, Department of Health and Human Services, 5600 Fishers Lane, Rockville, MD 20857/301-443-3434.

Banking and Credit
Federally chartered commercial banks

These are called national banks and have the word "National" or "N.A." in their titles. These banks are supervised by the Office of the Comptroller of the Currency within the Department of the Treasury, which examines banks periodically to assure the soundness of their operation and management and their compliance with laws, rules and regulations. The Office of the Comptroller of the Currency can assist with problems or questions consumers have with a credit card issued through a national bank. This office is interested in learning of any problems consumers may have with any aspect of a national bank's practices. Contact: Director, Consumer Credit, Community and Fair Lending Examinations Division, Comptroller of the Currency, Department of the Treasury, Washington, DC 20219/202-447-1600.

State-chartered banks

These can belong to the Federal Reserve System (FRS), which serves as the nation's central bank. Its main responsibilities are to regulate the flow of money and credit and to perform supervisory services and functions for the public, the U.S. Treasury and commercial banks. State banks that are members of the FRS must comply with both federal and state rules and regulations. Contact: Director, Division of Consumer Affairs, Board of Governors of the Federal Reserve System, Washington, DC 20551/202-452-3946.

Insured state banks

Those that do not hold membership in the Federal Reserve System are subject to supervision by the Federal Deposit Insurance Corporation (FDIC). The FDIC protects bank customers and helps maintain confidence in the banking system by insuring bank deposits up to $100,000. Contact: Director, Office of Consumer Affairs, Federal Deposit Insurance Corporation, Washington, DC 20429/202-389-4767.

Savings and loan associations

Regulated by the Federal Home Loan Bank Board (FHLBB), which protects savers against losses on their deposits through the Federal Savings and Loan Insurance Corporation. Contact: Director, Consumer Division, Office of Community Investment, Federal Home Loan Bank Board, Washington, DC 20552/202-377-6237.

National Credit Union Administration

Supervises and examines federal credit unions throughout the country. It can insure accounts in federal or state-chartered credit unions that request and qualify for such coverage. Contact: Director, Division of Consumer Affairs, Office of Examination and Insurance, National Credit Union Administration, Washington, DC 20546/ 202-357-1050.

Clothing and Fabrics
Federal Trade Commission (FTC)—Care Labels

Enforces the rule that requires garment manufacturers to attach care labels to their products explaining to the consumer how the garment should be cleaned. Fabric manufacturers must provide care labels with their yard goods so that consumers buying fabric can attach the labels to the finished garments. Under the law, care labels must be provided for all textile and wearing apparel except hats, gloves and shoes, and material for draperies, curtains, slipcovers, upholstered furniture, carpets and rugs. Leather, suede, fur, plastic, and most vinyl fabrics or, garments are excluded from this rule.

Federal Trade Commission—Content Labels

Requires content labels to be attached to wool, textile, and down products to protect producers and consumers against misbranding and false advertising. Under these rules, the label must be printed in legible, unabbreviated English; be attached to an easy-to-locate place; and must state the composition of the product. The name or code number of the firm responsible for the accuracy of the label must be on the label or on one close to it. If the manufacturer chooses to use a code number, it must be registered with the FTC; anyone may write or call the FTC and learn the identity of the holder of a registered identification number. Contact: Federal Trade Commission, 1100 Wilshire Blvd., Los Angeles, CA/ 213-824-7575.

Consumer Product Safety Commission (CPSC)

Protects consumers against unreasonable risks from consumer products, including clothing and fabrics. The CPSC enforces the Flammable Fabrics Act, which sets flammability standards for carpets, rugs, mattresses, children's sleepwear, and general wearing apparel. The CPSC also ensures that clothes will not be cancer-causing or in any other way harmful to health. Contact: Director, Office of Communications, Consumer Product Safety Commission, Washington, DC 20207/ toll-free 800-638-8362/800-492-8363 in Maryland/800-638-8333 in Puerto Rico, Virgin Islands, Alaska, Hawaii.

Communications

The Federal Communications Commission (FCC) is the agency charged with regulating radio, television, wire, cable and satellite communications. FCC rules require that radio and television stations be responsive to the needs of consumers in the communities they serve; that their broadcasts present both sides of a controversial issue; and that misleading advertisments are not aired. The FCC does not regulate program content. The FCC regulates and licenses other two-way radio services for marine and aviation safety, and police and fire, business radio and CB service. Telephone companies operating entirely in one state are under the jurisdiction of the state public utility commissions. For information contact: Chief, Consumer Assistance Office, Federal Communications Commission, Washington, DC 20554/202-632-7000.

Cosmetics

The Food and Drug Administration (FDA) insures that cosmetics are safe and pure. The FDA also requires that cosmetics be truthfully and informatively packaged and labeled, and that cosmetic ingredients be listed on each package. If you have an unusual reaction from a cosmetic that you believe is mislabeled, unsanitary, or harmful, report it to the FDA. Contact: Director, Consumer Communications, Food and Drug Administration, Department of Health and Human Services, 5600 Fishers Lane, Rockville, MD 20857/301-443-3170.

Door-to-Door Sales

The Federal Trade Commission (FTC) requires a "cooling off" period for door-to-door sales. The salesperson must (1) inform consumers of their right to cancel the contract; (2) give consumers two copies of the cancellation form, and (3) give consumers a dated receipt or contract that shows the name and address of the seller. Should a consumer decide to cancel the purchase, he or she must sign and date one copy of the form and mail it to the address given for cancellation any time before midnight of the third business day after the contract date. Contact: Office of the Secretary, Federal Trade Commission, Washington, DC 20580/202-523-3598.

Drugs
Foods and Drug Administration (FDA)

Ensures that drugs on the market are properly labeled, safe and effective for their intended uses. The FDA determines whether a drug can be sold over the counter or should be obtainable only with a doctor's prescription. The FDA also regulates advertising of prescription drugs. Injuries

and adverse reactions from drugs should be reported to the prescribing doctor and to the FDA, which will investigate and take corrective action when necessary. Contact: Director, Professional and Consumer Relations, Food and Drug Administration, Department of Health and Human Services, 5600 Fishers Lane, Rockville, MD 20857/301-443-1016.

Drug Enforcement Administration (DEA), Department of Justice

Enforces laws and regulations which apply to legally produced controlled substances (narcotics, amphetamines and barbiturates) handled by registered importers, manufacturers, distributors, pharmacists and doctors. Contact: Director, Office of Compliance and Regulatory Affairs, Drug Enforcement Administration, Department of Justice, Washington, DC 20537/202-633-1216.

Education
Office of Civil Rights, Department of Education

Enforces Title IX of the Education Amendments, which prohibit sex discrimination in federally funded educational activities. Contact: Director, Office of Civil Rights, Department of Education, 400 Maryland Ave. S.W., Washington, DC 20202. Elementary/Secondary Division: 202-245-0284. Postsecondary Division: 202-245-0843.

Family Educational Rights and Privacy Act

Enforced by the Department of Education, this Act requires educational institutions that receive federal funds to allow students over 18 or parents of minors to see their own educational records. The Act also limits disclosure of these records to others. The Department of Education has the power to deny federal funds to any institution in violation of this Act. Contact: Director, Family Educational Rights and Privacy Act Office, Department of Education, Room 4511 Switzer Building, 330 C St. S.W., Washington, DC 20202/202-245-0233.

Energy
Office of Consumer Affairs, Department of Energy (DOE)

Acts as a liaison between consumers, special groups and organizations, and policymakers within DOE. It encourages consumer participation in DOE processes and represents consumers in DOE policy and decision-making. Contact: Director, Office of Consumer Affairs, Department of Energy, Washington, DC 20585/202-252-5141.

Economic Regulatory Administration (ERA)

Regulates the oil industry, administers the Public Utility Reform Policy Act, and carries out many of the Department of Energy's energy standby programs. ERA operates a toll-free hotline to receive consumer complaints on gasoline and heating oil supplies and prices. Contact: Administrator, Economic Regulatory Administration, 2000 M St. N.W., Washington, DC 20461/toll-free 800-424-9246/202-653-3437 in DC.

Nuclear Regulatory Commission (NRC)

Ensures that the civilian uses of nuclear materials and facilities are consistent with the public health and safety, environmental quality, national security, and the antitrust laws. Contact: Office of Public Affairs, Nuclear Regulatory Commission, Washington, DC 20555/202-492-7715.

Environment

The Environmental Protection Agency (EPA) is charged by Congress to protect the nation's land, air, and water systems. Under the mandate of national environmental laws, the Agency's programs focus on air, noise, radiation, water quality, drinking water, solid waste, hazardous waste, toxic substances, and pesticides. The Agency's goal is to achieve a compatible balance between human activities and the natural systems which support life.

The EPA tests automobiles to make sure they meet federal emission standards and compiles information about the gas mileage consumers can expect from their automobiles. Copies of a booklet on these gas mileage figures can be obtained at no charge.

Many people are concerned about the quality of their drinking water and are drinking bottled instead of tap water. The EPA provides information showing that not all bottled water is free from pollutants. The EPA also conducts studies on the effectiveness of home water purifiers and can provide information on study results.

The EPA provides information about proper pesticide storage and disposal; it certifies the safety of all pesticides used in the United States and has information about proper home pesticide use. The EPA also answers questions about chemicals and their dangers.

Asbestos was used in construction of some schools. When this asbestos or its protective covering deteriorates, dangerous particles are released into the air. The EPA has information about a program to identify these schools and help communities remedy this problem.

For any of the above information contact: Public Information Center, PM-211A, Environmen-

tal Protection Agency, Washington, DC 20460/
202-755-0707.

Food
Food and Drug Administration (FDA)

Insures that all foods and food additives (other
than meat and poultry or those containing meat
and poultry) are safe, pure and wholesome, and
honestly and informatively packaged and labeled.
If you find unsanitary, contaminated, or misla-
beled foods, Contact: Director, Consumer Com-
munications, Food and Drug Administration,
Department of Health and Human Services, 5600
Fishers Lane, Rockville, MD 20857/301-443-
3170.

Food Safety and Quality Service, Department of Agriculture

Insures that meat and poultry, and products
made from them, are safe, wholesome and truth-
fully labeled. They also provide voluntary grad-
ing services and develop grade standards for
meat, poultry, eggs, dairy products and fresh or
processed fruits and vegetables. In addition, egg
products are inspected for freshness and quality.
They investigate individual complaints concern-
ing the freshness and quality of egg products and
the grading of dairy products, eggs, poultry or
meat. Contact: Commodity Service, Food Safety
and Quality Service, Department of Agriculture,
Washington, DC 20250/202-447-5231.

The National Marine Fisheries Service
(NMFS) runs a voluntary inspection and grading
program for fish and fish products. In addition,
NMFS develops standards for quality, condi-
tions, quantity, grade and packaging for fish and
fishery plants and products. The NMFS has a
consumer education program on the voluntary
fishery inspection service and information on nu-
tritional value, preparation and availability of
fishery products. Contact: Inspection, National
Marine Fisheries Service, Department of Com-
merce, Washington, DC 20235/202-634-7458.

Housing
Fair Housing and Equal Opportunity Office, Department of Housing and Urban Development (HUD)

Administers the Civil Rights Act of 1968,
which prohibits discrimination in housing, em-
ployment and business opportunities. In particu-
lar, HUD enforces regulations that no one can be
denied housing because of race, color, religion,
sex, age or national origin. Discriminatory prac-
tices include steering (being directed to buy or
rent in a particular neighborhood or building),
red-lining (being denied a mortgage for a home in
a location boycotted by lending institutions), or

discriminating in sales (being rejected as the buy-
er of a home for other than financial reasons).
Contact: Fair Housing and Equal Opportunity,
Department of Housing and Urban Develop-
ment, Washington, DC 20410/toll-free 800-424-
8590/202-426-3500 in DC.

Real Estate Settlement Procedures Act (RESPA)

Also administered by HUD, this requires that
homebuyers get an estimate of settlement costs in
advance. For information see "Settlement
Costs—Information and Complaints" in this sec-
tion.

Interstate Land Sales

The Department of Housing and Urban Devel-
opment also administers and enforces disclosure
and registration requirements for developers sell-
ing land through any means of interstate com-
merce, including the mails. Under the law,
developers having subdivisions containing 50 lots
or more must: (1) file a statement of record with
the Office of Interstate Land Sales listing infor-
mation about the ownership of the land, the state
of its title, its physical nature, the availability of
roads and utilities, and other matters; (2) furnish
each purchaser with a printed property report at
least 72 hours before signing an agreement for
purchase or lease; and (3) not use fraud or mis-
representation in the sale or promotion of the
land. Contact: Director, Office of Interstate Land
Sales, Department of Housing and Urban Devel-
opment, Washington, DC 20410/202-755-6713.

Investments and Business Opportunities
Commodity Futures Trading Commission (CFTC)

Regulates trading in commodity futures and
certain other transactions such as options, lever-
age and deferred deliveries that call for future de-
livery of a commodity. The agency's mission
includes preventing market manipulation and
protecting consumers who buy and sell contracts.
Consumer services include a reparations proce-
dure through which customers can make claims
against brokers and salespeople. Contact: Office
of the Secretary, Federal Trade Commission,
Washington, DC 20580/202-523-3600.

Securities and Exchange Commission (SEC)

The securities laws administered by the SEC
protect investors by preventing fraud in the buy-
ing and selling of securities. Corporations under
the SEC's jurisdiction must disclose financial in-
formation in their prospectuses, proxy statements
and periodic reports filed with the commission,
so investors can make informed investment deci-
sions and vote their shares. The SEC's Office of

Consumer Affairs receives and processes complaints and inquiries from individual investors and the public. Contact: Office of Consumer Securities and Exchange Commission, Securities and Exchange Commission, 500 N. Capitol St. W., Washington, DC 20549/202-523-3952.

Mail
Inspection Service
Headed by the Chief Postal Inspector, this is the law enforcement and audit arm of the Postal Service that performs security, investigative, law enforcement and audit functions. It is responsible for enforcement of approximately 85 federal statutes relating to the Postal Service. Mail fraud, false mail-order advertising, and unsatisfactory mail-order transactions all come under their jurisdiction. Examples include chain letters, work-at-home schemes, pyramid sales promotions, misused credit cards, coupon redemption, false billing and franchising schemes. Contact: Chief Postal Inspector, Postal Service, Room 3509, Washington, DC 20206/202-245-5445.

Federal Trade Commission (FTC)—Mail Orders
Has a rule requiring mail order purchases be shipped within the time stated in the company's printed or broadcast offer. If no time is stated, shipment must be within 30 days after the company receives the order, unless the buyer is contacted and consents to a delay. Contact: Federal Trade Commission, Office of the Secretary, Washington, DC 20580/202-523-3600.

Motor Vehicles
National Highway Traffic Safety Administration (NHTSA)
Works to reduce highway deaths, injuries and property losses by writing and enforcing federal vehicle safety standards for vehicles and vehicle equipment, such as tires. NHTSA investigates reports of safety-related defects and substantial equipment failures and enforces laws requiring recall and remedy. NHTSA is also responsible for investigating violations of a law that prohibits anyone, including the vehicle owner, turning back or disconnecting the odometer of an automobile, unless performing repairs. Contact: Administrator, National Highway Traffic Safety Administration, Department of Transportation, Washington, DC 20590/toll-free 800-424-9393/202-426-0123 in DC.

Department of Justice
Enforces jurisdiction over the federal law requiring the disclosure of new automobile information. The following information must be included on the windshield or side window of the vehicle: make, model, indentification number, assembly point, name and location of dealer to whom the vehicle was delivered, method of transportation, total suggested retail price for accessories, and transportation charges. Contact: Consumer Affairs Section, Antitrust Division, Department of Justice, Washington, DC 20530/202-724-6711.

For more specific aid, see "Free Help and Infomation for Buying and Maintaining an Automobile," in this section.

Moving and Movers
The Interstate Commerce Commission (ICC) regulates interstate movers of household goods. To evaluate a mover before using its services, the commission requires that, on request, consumers be given copies of carrier performance reports. In addition, movers are required to provide each consumer with an ICC booklet explaining the consumer's rights and obligations on signing papers, estimates, weighing of shipments, payment for the move, and filing claims. Contact: Director, Consumer Assistance Office, Interstate Commerce Commission, Washington, DC 20423/202-275-0860.

Pensions
Pension Benefit Guarantee Corporation (PBGC)
Guarantees basic retirement benefits to participants in private pension plans. PBGC has booklets for consumers explaining the guarantee program and publications on program guidelines for plan administrators. It also offers a pamphlet for consumers who are considering Individual Retirement Accounts (IRA). Contact: Pension Benefit Guaranty Corporation, 2020 K St. N.W., Washington, DC 20006/202-254-4817.

Employee Retirement Income Security Act (ERISA)
The Department of Labor's Labor-Management Services Administration (LMSA) and the Internal Revenue Service (IRS) administer the Employee Retirement Income Security Act (ERISA). ERISA requires managers of pension and welfare plans to manage and invest plan funds prudently and to make sure there is enough money in the plan to pay benefits. If employers elect to set up a pension plan, their employees must be eligible to participate and be entitled to benefits without having to meet unreasonable age or service requirements. Contact: Director, Office of Communications and Public Service Assistance, Pension and Welfare Benefit Plans, Labor-Management Services Administration, Department of Labor, Washington, DC 20210/202-523-8764.

Product Safety

The Consumer Product Safety Commission (CPSC) protects consumers against unreasonable risks from consumer products used in and around the home, schools and recreation areas, and assists consumers in evaluating product safety. The CPSC develops uniform safety standards for consumer products, promotes research, and investigates product-related deaths, injuries and illnesses. It has the authority to ban hazardous products, set mandatory safety standards and seek court action to have products declared hazardous. Contact: Director, Office of Communications, Consumer Product Safety Commision, Washington, DC 20207/800-638-8362 Continental U.S. except Maryland/800-492-8363 in Maryland/800-638-8333 in Puerto Rico, Virgin Islands, Alaska, Hawaii.

Transportation

Civil Aeronautics Board (CAB)

Regulates airline fares and routes as well as basic passenger rights and airline responsibilities. The CAB's Bureau of Consumer Protection handles complaints against airlines and investigates suspected violations of the board's regulations. Contact: Bureau of Consumer Protection, Civil Aeronautics Board, Washington, DC 20428/202-673-6047.

Federal Aviation Administration (FAA)

Establishes and enforces safety standards for air carriers, air taxi operators and other private and commercial aviation enterprises. FAA safety regulations apply to nearly every facet of air travel, ranging from the aircraft and its crew and mechanics to the nation's airways, airports and air traffic control systems. The FAA enforces airport security measures, including passenger screening, to prevent hijacking and threats to safe and secure travel. Contact: Public Information Center, Federal Aviation Administration, APA—430, Department of Transportation, Washington, DC 20591/202-426-8058.

Interstate Commerce Commission (ICC)

Ensures that interstate bus lines give the public fair and reasonable rates and services. Discrimination, preferential treatment or prejudicial actions by interstate buses are illegal and should be reported to the ICC. Contact: Director, Office of Consumer Affairs, Interstate Commerce Commission, Washington, DC 20423/202-275-0860.

Coast Guard, Department of Transportation

Enforces federal laws on the high seas and navigable waters of the United States. It develops regulations on commercial vessel safety, recreational boating safety, port safety and security, and marine pollution. Contact: Office of Boating, Public and Consumer, Coast Guard (G-B/42), Department of Transportation, Washington, DC 20993/202-426-1084.

Federal Maritime Commission (FMC)

An independent agency responsible for the regulation of U.S. ocean commerce. Among other duties, the FMC ensures that steamship companies have the required insurance to cover passengers for personal injury or death, and informally assists and counsels passengers who have complaints about companies or service. The commission also assists consumers with problems involving goods transported by ship and advises consumers on appropriate actions. Contact: Office of Consumer Affairs, Federal Maritime Commission, Washington, DC 20573/202-523-5800.

Government Benefits

Almost everyone in the United States is entitled to some government benefits. Listed below are the major programs and the offices which can help you investigate your eligibility.

Government Employee Retirement Benefits

Annuities Services Division, Retired Employees Service Section, Office of Personnel Management, 1900 E. St. N.W., Room 4H23, Washington, DC 20415/202-632-7457.

Medicaid

Director, Inquiries Staff, Health Care Financing Administration, Department of Health and Human Services, 6325 Security Blvd., Room 1P4, Baltimore, MD 21207/301-594-9032, or contact your local Welfare Office.

Medicare

Bureau of Program Policy, Health Care Financing Administration, Department of Health and Human Services, 6325 Security Blvd., Room 1P4, Baltimore, MD 21234/301-594-9032, or see Social Security Administration in your local telephone book.

Social Security

Office of Public Inquiries, Social Security Administration, Department of Health and Human Services, 6401 Security Blvd., Room 4100 Annex

Building, Baltimore, MD 21235/301-594-7700, or see Social Security Administration in your local telephone book.

Veterans' Benefits

Department of Veterans' Benefits, Veterans Administration, 810 Vermont Ave. N.W., Washington, DC 20420/202-389-2044. The Veterans Administration maintains toll-free numbers in most states. Call 800-555-1212 for a number near you.

For additional assistance on obtaining any government benefit contact the local office of your congressman or senator.

Finding Your Roots

The following offices offer assistance to those trying to find information on their family background. Most of the available assistance is free.

National Archives and Records Service

Central Reference Division, Washington, DC 20408/202-523-3218. This division contains ship passenger records from 1820, military records from the Revolutionary War, and census forms from 1790 to 1900.

Library of Congress

Local History and Genealogy Section, General Reading Room, Washington, DC 20540/202-287-5537. This section contains a number of "finding aids" and indexes arranged by family names and geographic location.

Free Help and Information for Buying and Maintaining an Automobile

Next to buying a home, purchasing a car is probably the most important financial investment you will make. The skyrocketing cost of gasoline has made consumers more aware of the importance of this investment. The free services and publications described below will assist you in purchasing and maintaining a safe and economical automobile.

Auto Safety Hotline

This hotline can help in following ways:

Take your complaint about a safety problem concerning an automobile and investigate the problem with the manufacturer.
Provide you with on-the-spot information on safety recalls that might affect your car.
Refer you to staff experts in the agency for questions about federal safety standards and regulations.

Contact: Auto Safety Hotline, Department of Transportation, National Highway Traffic Safety Administration, Washington, DC 20590/toll-free 800-424-9393/202-426-0123 in DC.

The Best Consumer's Guide to Car Buying

The Car Book is beautifully presented and provides in-depth research on all models of new cars. The information on different models includes maintenance costs, performance in crash tests, fuel efficiency, and insurance breaks. The book also includes tips on buying used cars and getting assistance if you have a car problem. Free from the National Highway Traffic Safety Administration, General Services Division (NAD-42), 400 7th St. S.W., Washington, DC 20590.

Child Restraint Systems

Detailed information on purchasing the proper child restraint system for your atuomobile can be found in the publications *The Early Rider* and *Early Rider Fact Book*. Both are free from the National Highway Transportation Safety Administration, Public Affairs, DOT, 400 7th St. S.W., Room 5232, Washington, DC 20590/202-426-9550.

Odometer Tampering

Federal law prohibits tampering with a vehicle's odometer (the instrument, often called a speedometer, that measures the distance traveled by a vehicle). No one, including the vehicle owner, is permitted to turn back or disconnect the odometer, unless performing repairs. When a broken odometer cannot be adjusted to reflect the true mileage, the odometer must be set at zero and a sticker indicating the true mileage before service and the date of service must be attached to the left door frame. Federal law also requires disclosure of the vehicle mileage upon transfer of ownership. Automobile purchasers who suspect tampering should contact: Administrator, National Highway Traffic Safety Administration, Department of Transportation, Washington, DC 20590/202-426-0670, or, Consumer Affairs Section, Antitrust Division, Department of Justice, Washington, DC 20530/202-724-6786, or local or state law enforcement authorities.

Crash Protection

The following publications are free from the National Highway Traffic Safety Administration, General Services Division, (NAD-42), 400 7th St. S.W., Washington, DC 20590/202-426-9550:

Automobile Occupant Crash Protection
Free Life-Saving Information: Automobile Passive Restraint Systems and What They Mean to You
Safety Belts: A Step Closer to Automatic Crash Survival
Safety Belts—How Many of These Fairy Tales Have You Told?
Safety Belt Message
Encouraging Employees to Use Safety Belts

Police Radar

The National Bureau of Standards is conducting tests in order to measure the reliability and performance of police radar systems. For further information on these tests, including details on devices that affect the reliability of radar systems, contact: National Bureau of Standards, Public Information Division, Department of Commerce, Washington, DC 20234/301-921-3181.

How to Buy A New or Used Car

The following publications are free from the Consumer Information Center, Pueblo, CO 81009:

Common Sense in Buying A New Car: How to compare prices, dealer services, and warranties; how to inspect and test drive; and how to avoid new car problems.
Common Sense in Buying A Used Car: How to inspect before you buy; and how to understand the odometer law and used-car warranties.

Warranties

Information and expertise are available to help you understand your rights under automobile manufacturers and repair services' warranties and guarantees. The following publications are available from the Bureau of Consumer Protection, Office of Consumer Education, Federal Trade Commission, Washington, DC 20580:

Auto Service Contracts (Fact Sheet)
Warranties: There Ought To Be A Law
Magnuson-Moss Warranty Act—Private Consumer Remedies Fact Sheet: Explains how the law provides for attorney's fees to aid consumers in bringing suit for failure to honor warranties.
Warranties: Making Business Sense Out of Warranty Law

Tips on Saving Gas

The following publications are free from the TIC Request Services, Technical Information Center, Department of Energy, P.O. Box 62, Oak Ridge, TN 37830/615-576-1305:

Gas Mileage Guide: Annual information on EPA miles per gallon estimates for vehicles and a chart for calculating annual fuel costs for all new model cars.
How To Save Gasoline and Money: Basic money- and gas-saving tips, including choosing your next car, driving more effectively, planning your trips and caring for your car.
Starting a Driver-Owned and-Operated Vanpool: Tips on ways to start, operate, and finance a vanpool in your neighborhood.
Gasoline More Miles Per Gallon: Shows methods of selecting gas, maintaining your car, improving performance, and lowering costs. The booklet also contains information on the workings of a car engine. Free from the Consumer Information Center, Pueblo, Colorado 81009.

Ridesharing Hotline and Information Center

The National Ridesharing Information Center (NRIC) provides free information, experts, speakers, newsletters, conferences, and other events to aid individuals and organizations in organizing carpools, vanpools, and other ridesharing programs. Contact: NRIC, Federal Highway Administration, Room 4432, Washington, DC 20590/toll-free 800-424-9184/202-426-2943 in DC.

Tires—Safety and Saving Money

Study Says $50 K-Mart Tire Better Than $90 Michelin. The Department of Transportation has rated over 2,500 tires on aspects of wear and safety, The results of the study, called the *Uniform Tire Quality Grading List*, is made available to the public through credit unions, public libraries, recreation associations, and consumer information offices. Free booklets explaining the grading system are available from the National Highway Traffic Safety Administration, 400 7th St. S.W., Washington, DC 20590/202-426-0874 or 202-426-2768.

Consumer Tire Guide
Uniform Tire Quality Grading Standard
Tire Chains
The Hazards of Mixing Tires Types
Studded Tires
Three Rules for Maximum Tire Life
Tires: A Comparison of Tire Reserve Load for New Passenger Cars

Facts on Auto Emission Standards and Warranties

The Environmental Protection Agency (EPA) establishes and monitors pollution requirements in automobiles and offers the following free publications to aid the public in complying with the laws:

What You Should Know About Your Auto Emissions Warranty
Buying A Car Overseas? Beware
Mechanics . . . A New Law Affects You

Contact: Public Inquiries Center, EPA, Washington, DC 20460/202-755-0707.

Brakes

The following publications are free from the National Highway Traffic Safety Administration, General Services Division, 400 7th St. S.W., Washington, DC 20590:

Brakes: A comparison of Braking Performance for New Passenger Cars and Motorcycles
Safety Tips on the Purchase and Use of Hydraulic Brake Fluids
Passenger Car Brakes
Brake Fluids

Miscellaneous

The following publications are free from the National Highway Traffic Safety Administration, General Services Division, 400 7th St. S.W., Washington, DC 20590/202-426-0874.

Travel and Camper Trailer Safety
Consumer Protection Under the New Anti-Tampering Odometer Law
55: Judge for Yourself
Motorhome and Pickup Camper Safety
Standards, Federal Motor Vehicle Safety Standards
How to Deal With Motor Vehicle Emergencies
Safe Driving in Winter

Free Help, Information, and Financing for Buying, Renting, or Remodeling an Apartment, Condominium, or House

The biggest purchase most of us make in our lifetime is our home. With inflation having a devastating effect on both the cost of housing and the cost of money to purchase a home, we can use all the help we can get. The following free services, publications and government subsidies may prove to be just the assistance you've been waiting for to help make your dream house come true.

Money for Buying a House

The U.S. Department of Housing and Urban Development will insure a home loan for up to $90,000. A number of additional programs offer financial assistance to home buyers including:

Mortgage Insurance for One- to Four-Family Homes
Homeownership Assistance for Low- and Moderate-Income Families
Mortgage Insurance for Housing in Declining Neighborhoods
Mortgage Insurance for Special Credit Risks

Mortgage Insurance for Housing in Military Impacted Areas
Mortgage Insurance for Servicemen

For information on these programs contact your local Department of Housing and Urban Development office or Program Information Center, Department of Housing and Urban Development, 451 7th St. S.W., Room 1104, Washington DC 20410/202-755-6420.

If you live in the country you may be eligible to receive financial assistance from the U.S. Department of Agriculture. Some of its housing and loan guarantees are for amounts in excess of $100,000. Its programs include:

Rural Housing Site Loans
Low- to Moderate-Income Housing Loans
Above-Moderate-Income Housing Loans
Economic Emergency Loans
Recreation Facility Loans
Farm Ownership Loans

For additional information on these programs contact your local Department of Agriculture Office, or Farmers Home Administration, Department of Agriculture, 14th & Independence Ave. S.W., Room 4121 South, Washington, DC 20250/202-447-4323.

Veterans can receive special loans and loan guarantees that have no maximum limit. For further information contact your local Veterans Administration Office or Veterans Administration, Central Office, Washington, DC 20420/202-389-2356.

Money for Buying a Cooperative or Condominium

Special loan guarantees for up to $67,500 are available to those who wish to purchase cooperatives or condominiums. For further information on these programs contact your local Department of Housing and Urban Development office or Program Information Center, Department of Housing and Urban Development, 451 7th St. S.W., Room 1104, Washington, DC 20410/202-755-6420.

The following publications are also available free, from this office:

Questions About Condominiums—What To Ask Before You Buy
Let's Consider Cooperatives

Money for Remodeling and Improving Your Home

Guaranteed loans of up to $90,000 are available to homeowners for remodeling and rehabili-

tation. The following publications are free as long as supplies last:

Fixing Up Your Home—And How To Finance It
HUD's Role In Home Improvement
Fact Sheet—Home Improvement Loan Insurance
Fact Sheet—Rehabilitation Home Section 203(k)
Fact Sheet—Property Rehabilitation Loans

Contact your local Department of Housing and Urban Development office, or Program Information Center, Department of Housing and Urban Development, 451 7th St. S.W., Room 1104, Washington, DC 20410/202-755-6420.

Those living in small towns should investigate programs in the Department of Agriculture and the Veterans Administration. Their offices are listed under "Money for Buying a House" in this section.

Home Buying Publications

The following publications are free, as long as supplies last, and can provide you with essential information to assit you in buying a home:

Home Buyer's Vocabulary
Homeowner's Glossary of Building Terms
Protecting Your Housing Investment
Wise Home Buying
Wise Rental Practices
How To Buy Your Home Wisely
Should You Rent or Buy A Home?
Your Housing Rights—Live Where You Want To Live
Home Mortgage Insurance
Home Buying Members of the Armed Services

Contact: Program Information Center, Department of Housing and Urban Development, 451 7th St. S.W., Room 1104, Washington, DC 20410/202-755-6420.

Home Repair and Remodeling Publications

The following publications are free, as long as supplies last, from: Department of Agriculture, Office of Governmental and Public Affairs, Publications Division, Washington, DC 20250/202-447-2791.

Painting Inside and Out
Plumbing for the Home and Farmstead
Simple Plumbing Repairs
Roofing Farm Buildings
Home Heating—Systems, Fuels, and Controls
Wood Siding, Installing, Finishing, and Maintaining
Wood Decay in Houses—How to Prevent and Control It
Home Construction—How to Reduce Costs
Renovate an Old House?

Settlement Costs— Information and Complaints

In order to protect you from unnecessary or exorbitant settlement or closing costs the Real Estate Settlement Procedures Act requires that you receive some advance notice of what your settlement costs are going to be, plus an itemized account of the total costs. At the time you apply for a loan, the lender is required to furnish you with "good faith" estimates for each of the settlement charges likely to be incurred, as well as a free copy of *A Guide To Settlement Costs*. For further information, free booklets, or to register a complaint contract: Real Estate Practices Division, Office of Voluntary Associations and Consumer Protection, Department of Housing and Urban Development, 741 7th St. S.W., Room 9266, Washington, DC 20410/202-426-0070.

Buying a Mobile Home

If you cannot obtain a conventional loan the government will insure your loan for up to $27,000 for the purchase of a mobile home. For information contact your local Department of Housing and Urban Development office, or the Office of Title I Insured Loans, Department of Housing and Urban Development, 451 7th St. S.W., Room 9160, Washington, DC 20410/202-755-6880.

Veterans can receive assistance for mobile home financing assistance with no financial limitations. Contact your local Veterans Administration office or Veterans Administration, Central Office, Washington, DC 20420/202-389-2356.

If you believe that your mobile home does not meet government safety standards and you are unable to obtain satisfaction from the manufacturer or local authorities contact: Office of Mobile Home Construction and Safety Standards, Department of Housing and Urban Development, 451 7th St. S.W., Room 3248, Washington, DC 20410/202-755-6584.

Land Buying—Information and Complaints

Developers offering 50 or more unimproved lots are required to offer you a property report describing in detail the facts about the land you are thinking of buying. This report must also be filed with the U.S. Department of Housing and Urban Development. The government will also investigate complaints from those who feel that they have been cheated in their purchase of land. For further information or to file a complaint contact: Interstate Land Sales Registration, Office of Neighborhoods, Voluntary Associations and Consumer Protection, Department of Housing and Urban Development, 451 7th St. S.W., Room 4108, Washington, DC 20410/202-755-

5860. A free booklet, *Before Buying Land . . . Get the Facts* is also available from this office.

Renters, the Elderly, and the Handicapped

Special subsidies as well as loans and loan guarantees are available to renters, the elderly and the handicapped. For further information contact the Departments of Agriculture, and Housing and Urban Development as well as the Veterans Administration offices listed under "Money for Buying A House."

Counseling for Tenants and Homeowners

Some 600 approved agencies offer free counseling services with respect to property maintenance, household budget, debt management, and other housing matters. Prospective home buyers, homeowners and tenants under government assisted, owned or insured housing programs are eligible for counseling. Contact your local Department of Housing and Urban Development office for further information or Housing Counseling Programs, Office of Consumer Affairs, Office of Neighborhoods, Voluntary Associations and Consumer Protection, Department of Housing and Urban Development, 451 7th St. S.W., Room 4146, Washington, DC 20410/202-755-7812.

Homesteading

Under the Urban Homesteading program, the U.S. Department of Housing and Urban Development turns over to cities and towns single-family homes that the government has insured and for one reason or another, the people who owned them let run down and left without paying back the loan. Rather than let these homes stand empty, the government turns these houses over to local communities, which in turn sell them to lower-income families for just a small amount of money (usually only one dollar). To find out whether your community is participating in the program and whether you qualify, contact your local government officials at the Department of Housing and Urban Development office nearest to you, or Urban Homesteading Division, Office of Urban Rehabilitation, Community Planning and Development, Department of Housing and Urban Development, 451 7th St. S.W., Room 7162, Washington, DC 20410/202-755-5970.

Avoid Lead Poisoning

Houses built before 1960 may contain lead-based paint, which if picked up and swallowed by children can cause brain damage, mental retardation, behavior problems, blindness or even death. A law now requires that these hazards be identified and eliminated in all building rehabilitated or refurbished with Department of Housing and Urban Development funds. Many communities have local ordinances barring the sale and use of lead-based paint for housing. If you suspect your children have been exposed, or your house presents a lead hazard, contact your local Department of Housing and Urban Development office, or Lead-Based Paint Poisoning Prevention, Office of Public Housing, Technical Support Division, Department of Housing and Urban Development, 451 7th St. S.W., Room 628, Washington, DC 20410/202-755-4956. A free booklet, *Watch Out For Lead-Based Paint Poison* is also available from this office.

Your Neighborhood

There are a large number of federal programs available under which communities can receive government assistance to upgrade the quality of homes in a given neighborhood. For example, in order to improve the appearance of homes in a low-income area in Indianapolis, a community group worked through the city government to receive a Community Development Block Grant in order to subsidize home improvements for both poor and higher-income homeowners. A 400-page free publication, *People Power: What Communities Are Doing to Counter Inflation*, describes available programs and provides countless stories showing how individuals have used these programs to improve housing conditions in their neighborhoods. Available from: Consumer Information Center, Pueblo, CO 81009.

Saving Energy In Your Home

The following publications are free, as long as supplies last, from: Department of Energy, Technical Information Center, P.O. Box #62, Oak Ridge, TN 37830/615-576-1305:

Conserve Hot Water—Residential Hot Water Conservation Tips
Consumers Resource Handbook—General Publication on Wide-Ranging Conservation Materials and Actions
How to Improve the Efficiency of Your Oil-Fired Furnace
How to Keep Warm and Cut Your Fuel Bill
How to Understand Your Utility Bill
Infrared—An Energy Tool—Infrared Photography System That Pinpoints Heat Loss
Insulation
Model Code For Energy Conservation in New Building Construction
Tips For Energy Savers
Winter Survival

The following publications are free, as long as supplies last, from Energy, Department of Agriculture, Washington, DC 20250:

How to Determine Your Insulation Needs
Save Heating and Cooling Dollars with Weatherstripping and Caulking
How to Save Money with Storm Doors and Windows
What to Look for in Selecting Insulation
How to Install Insulation for Ceilings
How to Install Insulation for Walls
How to Install Insulation for the Floor and Basement
Solving Moisture Problems with Vapor Barriers and Ventilation
Weatherize Your Mobile Home to Keep Costs Down, Comfort Up
Tips on Financing Home Weatherization
Keeping Home Heating and Cooling Equipment in Top Shape
Landscaping to Cut Fuel Costs
Home Management Tips to Cut Heating Costs
Firewood for Your Fireplace, Selection, Purchase, Use

The following organization offers energy hotlines, free publications and other information services on how to save energy in the home: Conservation and Renewable Energy Inquiry and Referral Service, P.O. Box 8907, Silver Spring, MD 20907/800-523-2929/800-462-4963 in Pennsylvania.

Tax Considerations for Homeowners

The following publications are free from the Internal Revenue Service:

Condominiums and Cooperative Apartments, Tax Information on
Energy Tax Credits for Individuals
Homeowners, Tax Information for
Moving Expenses
Rental Property
Sales and Other Disposition of Assets
Selling or Buying Your Home, Tax Information on

For any additional tax information or copies of the above publications call 800-555-1212 and ask for the toll-free Internal Revenue Service number.

Help With Your Health

The federal govenrment spends billions of dollars studying the latest techniques and developments for every conceivable illness and ailment. Information on the results of this research as well as technical assistance on your specific health problem are available for the asking. The following information centers are available to provide you with information and assitance for their areas of interest. If you do not see a subject area which meets your needs contact: National Health Information Clearinghouse, P. O. Box 1133,

Washington, DC 20013/toll-free 800-336-4797. In Virginia call collect 703-522-2590.

See also Department of Health and Human Services section.

Aging

National Clearinghouse on Aging, 330 Independence Ave. S.W., Room 4146, Washington, DC 20201/202-245-0669. Provides access to information and referral services that assist the older American in obtaining services. Distributes Administration on Aging publications.

Alcohol

National Clearinghouse for Alcohol Information (NCALI), P. O. Box 2345, Rockville, MD 20852/301-468-2600. Gathers and disseminates current knowledge on alcohol-related subjects.

Arthritis

Arthritis Information Clearinghouse, P. O. Box 34427, Bethesda, MD 20034/301-881-9411. Identifies materials concerned with arthritis and related musculo-skeletal diseases and serves as an information exchange for individuals and organizations involved in public, professional, and patient education. Refers personal requests from patients to the Arthritis Foundation.

Cancer

Cancer Information Clearinghouse, National Cancer Institute, 805 15th St N.W., Room 500, Washington, DC 20005/202-842-7673. Collects and disseminates information on public, patient, and professional cancer education materials to organizations and health care professionals.

Office of Cancer Communications (OCC), Public Inquiries Section, 9000 Rockville Pike, Building 31, Room 10A18, Bethesda, MD 20205/301-496-5583. Answers requests for cancer information from patients and the general public.

Child Abuse

Clearinghouse on Child Abuse and Neglect Information, P. O. Box 1182, Washington, DC 20013/202-245-2840. Collects, processes, and disseminates information on child abuse and neglect.

Consumer Information

Consumer Information Center, Pueblo, CO 81009/303-544-5277, ext. 370. Distributes consumer publications on topics such as children, food and nutrition, health, exercise and weight control. The *Consumer Information Catalog* is available free from the Center and must be used to identify publications being requested.

Diabetes

National Diabetes Information Clearinghouse, 805 15th St. N.W., Suite 500, Washington, DC 20005/202-842-7630. Collects and disseminates information on patient education materials and coordinates the development of materials and programs for diabetes education.

Digestive Diseases

National Digestive Diseases Education and Information Clearinghouse, 1555 Wilson Blvd., Suite 600, Rosslyn, VA 22209/703-496-9707. Provides information on digestive diseases to health professionals and consumers.

Drug Abuse

National Clearinghouse for Drug Abuse Information, P. O. Box 416, Kensington, MD 20795/301-443-6500. Collects and disseminates information on drug abuse. Produces informational materials on drugs, and drug abuse and prevention.

Family Planning

National Clearinghouse for Family Planning Information, P. O. Box 2225, Rockville, MD 20852/301-881-9400. Collects family planning materials, makes referrals to other information centers, and distributes and produces materials. Primary audience is federally funded family planning clinics.

Food and Drugs

Food and Drug Administration (FDA), Office for Consumer Communications, 5600 Fishers Lane, Room 15B-32 (HFE-88), Rockville, MD 20857/301-443-3170. Answers consumer inquiries for the FDA and serves as a clearinghouse for its consumer publications.

Food and Nutrition

Food and Nutrition Information Center, National Agricultural Library Building, Room 304, Beltsville, MD 20705/301-344-3719. Serves the information needs of persons interested in human nutrition, food service management, and food technology. Acquires and lends books, journal articles, and audiovisual materials dealing with these areas of concern.

Genetic Diseases

National Clearinghouse for Human Genetic Diseases, 805 15th St., Suite 500, P. O. Box 28612, Washington, DC 20005/202-842-7617. Provides information on human genetics and genetic diseases for both patients and health care workers and reviews existing curricular materials on genetic education.

The Handicapped

Clearinghouse on the Handicapped, 330 C Street S.W., Washington, DC 20202/202-245-0080. Responds to inquiries from handicapped individuals and serves as a resource to organizations that supply information to, and about, handicapped individuals.

Health Education

Bureau of Health Education (BHE), 1300 Clifton Road, Building 14, Atlanta, GA 30333/404-329-3235. Provides leadership and program direction for the prevention of disease, disability, premature death, and unnecessary health problems through health education. Inquiries on health education can be directed to BHE.

Health Indexes

Clearinghouse on Health Indexes, National Center for Health Statistics, Division of Analysis, 3700 East-West Highway, Hyattsville, MD 20782/301-436-7035. Provides informational assistance in the development of health measures to health researchers, administrators, and planners.

Health Information

National Health Information Clearinghouse, P. O. Box 1133, Washington, DC 20013/toll-free 800-336-4797/703-522-2590 in Virginia. Helps the public locate health information through identification of health information resources and an inquiry and referral system. Health questions are referred to appropriate health resources that, in turn, respond directly to inquirers.

Health Planning

National Health Planning Information Center, 3700 East-West Highway, Room 6-50, Hyattsville, MD 20782/301-436-6736. Provides information for use in analysis of issues and problems related to health planning and resource development. Information services are limited to health systems agencies and state health planning and development agencies.

Health Standards

National Health Standards and Quality Information Clearinghouse, 11301 Rockville Pike, Kensington, MD 20795/301-881-9400. Collects materials concerning standards for health care and health facilities, qualifications of health professionals, and evaluation and certification of health care providers serving federal beneficiaries. While free to federal agency personnel, searches are billed at cost to other inquirers.

High Blood Pressure

High Blood Pressure Information Center, 1501

Wilson Blvd., Arlington, VA 22209/703-558-4880. Provides information on the detection, diagnosis, and management of high blood pressure to consumers and health professionals.

Injuries

National Injury Information Clearinghouse, 5401 Westbard Ave., Room 625, Washington, DC 20207/301-492-6424. Collects and disseminates injury data and information relating to the causes and prevention of death, injury, and illness associated with consumer products. Requests of a general nature are referred to the Consumer Product Safety Commission's Communications Office.

Mental Health

National Clearinghouse for Mental Health Information, Public Inquiries Section, 5600 Fishers Lane, Room 11A-21, Rockville, MD 20857/301-443-4513. Acquires and abstracts the world's mental health literature, answers inquiries from the public, and provides computer searches for the scientific and academic communities.

Occupational Safety

Information Retrieval Analysis Section, National Institute for Occupational Safety, Cincinnati, OH 45226/513-684-8328. Provides technical information support for National Institute for Occupational Safety and Health research programs and supplies information to others on request.

Physical Fitness

President's Council on Physical Fitness and Sports, 400 6th St. S.W., Room 3030, Washington, DC 20201/202-755-7478. Conducts a public service advertising program and cooperates with governmental and private groups in promoting the development of physical fitness leadership, facilities, and programs. Produces informational materials on exercise, school physical education programs, sports, and physical fitness for youth, adults, and the elderly.

Poison Control

Division of Poison Control, Federal Drug Administration, 5600 Fishers Lane, Room 1345 (HDF 240), Rockville, MD 20857/301-443-6260. Works with the national network of 600 poison control centers to reduce the incidence and severity of acute poisoning. Directs toxic emergency calls to a local poison control center.

Product Safety

Consumer Product Safety Commission, Washington, DC 20207/toll-free 800-638-8326/800-492-8363 in Maryland/800-638-8333 in Alaska, Hawaii, Virgin Islands and Puerto Rico. Evaluates the safety of products sold to the public. Provides printed materials on different aspects of consumer product safety on request. Does not answer questions from consumers on drugs, prescriptions, warranties, advertising, repairs, or maintenance.

Project Share

Project Share, P. O. Box 2309, Rockville, MD 20852/301-251-5170. Provides reference and referral services designed to improve the management of human services by emphasizing the integration of those services at the delivery level.

Rape Information

National Rape Information Clearinghouse, 5600 Fishers Lane, Room 15-99, Rockville, MD 20857/301-443-1910. Maintains a listing of rape prevention and treatment resources to help people locate services available in their community and to facilitate networking among those working in the field of sexual assault. Has very little information for inquiries from the general public and prefers to refer them to local resources.

Rehabilitation Information

National Rehabilitation Information Center, Catholic University of America, 4407 8th St. N.E., Washington, DC 20017/202-635-5822. Supplies publications and audiovisual materials on rehabilitation, and assists in locating answers to questions such as dates, places, names, addresses, or statistics. The collections include materials relevant to the rehabilitation of all disability groups.

Smoking

Office on Smoking and Health, Technical Information Center, Park Building, Room 158, 5600 Fishers Lane, Rockville, MD 20857/301-443-1575. Offers bibliographic and reference service to researchers and others, and publishes and distributes a number of titles in the field of smoking.

Sudden Infant Death Syndrome (SIDS)

Sudden Infant Death Syndrome Clearinghouse, 1555 Wilson Blvd., Suite 600, Rosslyn, VA 22209/703-522-0870. Provides information on SIDS to health professionals and consumers.

Surgical Opinion

National Second Surgical Opinion Program, 330 Indepencence Ave. S.W., Washington, DC 20201/202-245-7897/toll-free 800-638-6833/800-492-6603 in Maryland. Provides information for

people who are faced with the possibility of non-emergency surgery. Sponsors the toll-free number to assist the public in locating a surgeon or other specialist.

Education and Reading Information Centers (ERIC)

Within their particular areas of interest, the following information clearinghouses will assist teachers, students, and parents of students in identifying and providing information on: available programs; available grants, loans, and other government benefits; literature, experts, audiovisuals, and teaching aids. Here are three examples of the ways in which these clearinghouses can be used:

1. If you have a child with a reading problem, contact the Reading and Communications Skills Information Clearinghouse and learn the latest techniques in solving that problem.
2. If you live in a rural area, contact the Rural Education Information Clearinghouse to identify potential programs and available funding.
3. If you wish to study or teach science, mathematics or environmental education, contact the Clearinghouse on Science, Mathematics, and Environmental Education and investigate the potential opportunities.

Adult Career Vocational Information
ERIC Clearinghouse on Adult Career and Vocational Education, Ohio State University, 1960 Kenny Rd., Columbus, OH 43210/614-486-3655.

Bilingual Education Information
National Clearinghouse for Bilingual Education, Department of Education, 1300 Wilson Blvd., B2-11, Rosslyn, VA 22209/toll-free 800-336-4560/703-522-0710 in Virginia.

Consumer Education
Consumer Education Resource Network, Department of Education, 1555 Wilson Blvd., Suite #600, Arlington, VA 22209/toll-free 800-336-0223/703-522-4616 in Virginia.

Counseling and Personal Services Information
ERIC Clearinghouse on Counseling and Personal Services, University of Michigan, School of Education Building, Room 2108, Ann Arbor, MI 48109/313-764-9492.

Early Childhood Education Information
ERIC Clearinghouse on Elementary and Early Childhood Education, University of Illinois, 805 W. Pennsylvania Ave., Urbana, IL 61801/217-333-1386.

Energy Education Information
Energy and Education Action Center, Department of Education, Reporters Building, 300 7th St. S.W., Room 514, Washington, DC 20202/202-472-7777.

Handicap Information
Clearinghouse on the Handicapped, Office of Handicapped Individuals, Department of Health and Human Services, Room 3119, Switzer Building, 400 Maryland Ave. S.W., Washington, DC 20202/202-245-0080.

Higher Education Information
ERIC Clearinghouse on Higher Education, One Dupont Circle, Suite #630, Washington, DC 20036/202-296-2597.

Junior College Information
ERIC Clearinghouse for Junior Colleges, Powell Library, Room 96, 405 Hilgard Ave., Los Angeles, CA 90024/213-825-3931.

Library Resources Information
ERIC Clearinghouse on Information Resources, Syracuse University, School of Education, Area of Instructional Technology, 130 Huntington Hall, Syracuse, NY 13210/315-423-3640.

Reading and Communication Skills Information
ERIC Clearinghouse on Reading and Communication Skills, National Council of Teachers of English, 1111 Kenyon Road, Urbana, IL 61801/217-328-3870.

Rural Education
Rural Education and Small School ERIC Clearinghouse, New Mexico State University, Box 3AP, Las Cruces, New Mexico 88003/505-646-2623.

Science, Mathematics and Environmental Education
Clearinghouse for Science, Mathematics, and Environmental Education, Ohio State University, 1200 Chambers Road, 3rd Floor, Columbus, OH 43212/614-422-6717.

Social Science Information
ERIC Clearinghouse for Social Studies, University of Colorado, Social Science Education, 855 Broadway, Boulder, CO 80302/303-492-8434.

Tests, Measurement and Evaluation Information
ERIC Clearinghouse on Tests, Measurements,

and Evaluation, Educational Testing Service, Princeton, NJ 08540/609-921-9000, ext. 5181.

Urban Education Information
ERIC Clearinghouse on Urban Education, Box 40, Teachers College, Columbia University, 525 W. 120th St., New York, NY 10027/212-678-3437.

Free Help and Expertise on Having a Baby and Raising a Child

The federal government spends billions of dollars trying to determine the healthiest way to raise children. As taxpayers we can tap into this resource and have access to the latest in research developments and techniques. The list below represents only a small fraction of the publications and experts available to make pregnancy and child raising a healthier and happier experience. For additional references you can contact either the Health Information Clearinghouse or your local County Cooperative Extension Service for assistance. These organizations are described in this section.

All services described are free. Single copies of the publications mentioned are also free. However, if certain titles are out of print, the office described below may direct you to another office which may charge a fee for the publication.

The Cost of Raising a Child
The following table represents the average annual cost of raising an urban child in the Northeast United States at a moderate standard of living. The prices are in 1980 dollars.

Estimates are also available for different regions, standards of living, and cost factors. Contact: Department of Agriculture, Science and Education Administration, Family Economics

Research Group. Federal Building, Room 338, Hyattsville, MD 20782/301-436-8461.

Help Before Having A Baby
The following publications and services provide assistance during pregnancy:

Prenatal Care (OHDS 73-30017)—this bestseller gives the expectant mother advice on caring for herself during pregnancy. It also describes the needs of a newborn baby. Free from Department of Health and Human Services, Office of Human Development Services, LSDS, Department 76, Washington, DC 20401.

So You're Going To Be A New Father? (OHDS 78-30028)—offers counsel and suggestions to prospective fathers on what to expect during a woman's pregnancy, on things to do and not do, and on how to support and comfort her through this phase in their lives. Free from Department of Health and Human Services, Office of Human Development Services, LSDS, Department 76, Washington, DC 20401.

Alcohol and Pregnancy—the following publications discuss the effects of alcohol on pregnancies: *Should I Drink?, Think First of Your Unborn Child* (also available in Spanish), *Preventing Fetal Alcohol Effects.* They are free from National Clearinghouse for Alcohol Information, P. O. Box 2345, Rockville, MD 20852/301-468-2600.

Drugs and Pregnancy—these publications contain practical information and research results on the effects of drugs on pregnancies: *Drug Dependence in Pregnancy, Research Issues #5, Drugs and Pregnancy.* They are free from National Clearinghouse for Drug Abuse Information, P. O. Box 416, Kensington, MD 20795/301-443-6500.

Smoking and Pregnancy—free publications, including *Pregnancy and Infant Health*, and information assistance are avilable from: Office of Smoking and Health, Department of Health and Human Services, 5600 Fishers Lane, Room 1-58, Rockville, MD

Age of Child (years)	Total	Food at Home	Clothing	Housing	Medical Care	Education
Under 1	$3,360	$567	$121	$1,504	$198	$ 0
1	3,490	697	121	1,504	198	0
2–3	3,400	675	212	1,369	198	0
4–5	3,601	763	212	1,369	198	0
6	3,836	763	288	1,347	198	101
7–9	3,988	915	288	1,347	198	101
10–11	4,184	1,111	288	1,347	198	101
12	4,452	1,111	424	1,392	198	101
13–15	4,583	1,242	424	1,392	198	101
16–17	4,929	1,373	531	1,414	198	101
TOTAL	$73,079	$17,453	$5,576	$24,962	$3,564	$1,212

20857/301-443-1575. Ask for literature on smoking and pregnancy.

Caffeine and Pregnancy—results of a recent FDA study linking caffeine to birth defects in animals are available. Basic facts about caffeine, its known effects on health, and a list of foods and drugs containing caffeine can also be obtained. Free from Consumer Information Center, Pueblo, CO 81009.

X-Rays and Pregnancy—shows what special precautions to take if you must have an x-ray during pregnancy. Free from Consumer Information Center, Pueblo, CO 81009.

Down's Syndrome and Pregnancy After 35—*Facts About Down's Syndrome for Women Over 35* explains the increased chances of bearing a child with mongolism for women over 35 years of age. Free from Office of Research Reporting, National Institute of Child Health and Human Development, Building 31, Room 2A-32, National Institutes of Health and Human Development, 9000 Rockville Pike, Bethesda, MD 20205/301-496-5133.

Premature Birth—*Little Babies: Born Too Soon—Born Too Small* shows expectant mothers how to take precautions against premature birth and low birth weight in full-term infants. Free from Office of Research Reporting, National Institute of Child Health and Human Development, Building 31, Room 2A-32, National Institutes of Health, 9000 Rockville Pike, Bethesda, Md 20205/301-496-5133.

Pregnancy Information Hotline—this national hotline provides telephone information on such topics as adoption and abortion. The staff counsel pregnant women and make referrals to selected medical clinics. They also maintain a resource file. Call toll-free 800-356-5761/800-362-5721 in Wisconsin.

General Child Raising

Infant Care (OHDS 79-30015)—this popular booklet covers the basics of caring for an infant (e.g., feeding, clothing, bathing, health care). It is written for parents who want to make sure their baby has a good start in life.

Your Child from 1 to 6 (OHDS 78-30026)—describes the growth of children from 1 to 6 years of age. Emphasizes the child's emotional needs and his or her relationship to other members of the family.

Your Child from 6 to 12 (OHDS 76-30040)—brings together the opinions of many specialists on how parents can help their children mature into healthy, well-adjusted, and socially responsible people.

These publications are free from Department of Health and Human Services, Office of Human Development Services, LSDS, Department 76, Washington, DC 20401.

Childhood Diseases and Other Health Problems

A Parent's Guide to Childhood Immunization—describes measles, polio, rubella (German measles), mumps, diphtheria, pertussis (whooping cough), and tetanus. Shows how vaccinations should be given and includes record-keeping forms. Free from Consumer Information Center, Pueblo, CO 81009.

A Tale of Shots and Drops For Parents of Young Children (OHDS 79-31128)—provides information regarding the need for immunization against childhood diseases. Free from Department of Health and Human Services, Office of Human Development Services, LSDS, Department 76, Washington, DC 20401.

When Your Child Goes to the Hospital (OHDS 79-30092)—a guide to help parents and other family members prepare the child for a stay in the hospital. Free from Department of Health and Human Services, Office of Human Development Services, LSDS, Department 76, Washington, DC 20401.

Books That Help Children Deal With a Hospital Experience (HSA 78-5224)—explains how parents can use books in preparing a child for the physical and emotional experiences of hospitalization. Contains an annotated list of books for children about hospitals and illness. Free from National Clearinghouse for Human Genetics, 805 15th St. N.W., Washington, DC 20005/202-842-7617.

Young Children and Accidents in the Home (OHDS 79-30034)—describes the major causes of children's accidents in the home. Includes a checklist by age group of accident causing situations and how to avoid them, and a tear-out sheet with first aid information. Free from Department of Health and Human Services, Office of Human Development Services, Department 76, Washington, DC 20401

Lead Poisoning in Children (HSA 78-5142)—discusses problems of lead paint poisoning and emphasizes essential steps in preventing death or permanent harm. Free from Program Services, Bureau of Community Health Services, 5600 Fishers Lane, Room 708, Rockville, MD 20857/301-443-1080.

Facts About Sudden Infant Death Syndrome (Crib Death) (HSA 81-5259)—provides basic facts, answers most-frequently-asked questions, discusses problems of grief, and refers to sources of help and information. Free from Program Services, Bureau of Community Health Services, 5600 Fishers Lane, Rockville, MD 20857/301-443-1080.

Obesity in Childhood—free from Office of Research Reporting, National Institute of Child Health and Human Development, Building 31, Room 2A-32, National Institutes of Health, 9000 Rockville Pike, Bethesda, MD 20205/301-496-5133.

Child Abuse—free publications and information assistance are available from the Clearinghouse on Child Abuse and Neglect Information, P. O. Box 1182, Washington, DC 20013/202-755-0587.

Child Mental Health—the following publications are free from National Clearinghouse for Mental Health Information, Room 11A-21, 5600 Fishers Lane, Rockville, MD 20857/301-443-4513.

Caring about Kids: Dyslexia (ADM 80-616)

Caring about Kids: Stimulating Baby's Senses (ADM 77-481)

Caring About Kids: Talking to Children About Death
(ADM 8-838)
Child's Emotions: How Physical Illness Can Affect
Them (ADM-78-497)
Helping Children Face Crises (OM 3048)
Plain Talk About Children with Learning Disabilities
(ADM 79-825)
Plain Talk About Dealing with the Angry Child
(ADM 79-781)
Plain Talk About Feelings of Guilt (ADM 78-580)
Plain Talk About Raising Children (ADM 79-875)
Plain Talk About When Your Child Starts School
(ADM 80-1021)
A Handicapped Child In Your Home (OHDS 73-
30029)—discusses the problems, hardships, and re-
wards that parents will experience in caring for a
handicapped child at home. Free from Department
of Health and Human Services, Office of Human De-
velopment, LSDS, Department 76, Washington, DC
20401.

Food and Nutrition
Breast Feeding (HSA 80-5109)—provides information
to help mothers make decisions about breast feeding.
It also includes "how-to" techniques. Free from Pro-
gram Services Branch, Bureau of Community Health
Services, 5600 Fishers Lane, Rockville, MD 20857/
301-443-1080.
Recommendations for Feeding Normal Infants (HSA
79-5108)—contains information about breast feeding,
infant formula, other foods, and fluoride before and
after six months of age. Free from Program Services
Branch, Bureau of Community Health Services, 5600
Fishers Lane, Rockville, MD 20857/301-443-1080.
Nutrition—copies of the following publications are free
from Publications Requests and Distribution, Infor-
mation Staff, Science and Education Administration,
Department of Agriculture, Washington, DC 20250.
Nutrition: Food at Work For You (GS-1)
Family Fare: A Guide to Good Nutrition (G-1)
Family Food Budgeting—For Good Meals and Good
Nutrition (G-94)
Keeping Food Safe to Eat: A Guide for Homemakers
(G-162)
Your Money's Worth in Foods (G-183)
Food Is More Than Just Something to Eat (G-216)
Food (G-228)
Nutrition and Your Health: Dietary Guidlines for
Americans (G-233)

Day Care and Babysitters
A Parents Guide To Day Care (OHDS 80-30254)—this
guide provides parents with information on how to
select proper in-home care, family day care, or a cen-
ter-based care facility. Free from Department of
Health and Human Services, Office of Human Devel-
opment Services, LSDS, Department 76, Washing-
ton, DC 20401.
A Pocket Guide to Babysitting (OHDS 79-30045)—this
handy guide describes the responsibilities of babysit-
ting and also includes practical information needed

by babysitters. It is a useful document for both the
parent and the babysitter. Free from Department of
Health and Human Services, LSDS, Department 76,
Washington, DC 20401.
The Super Sitter—this booklet outlines responsibilities
of the babysitter. Free from Office of Communica-
tion, Consumer Product Safety Commission, Wash-
ington, DC 20207/toll-free 800-638-8326/800-492-
8363 in Maryland.

Child Physical Fitness
Children and Youth in Action: Physical Fitness in Sports
(OHDS 80-30182)—discusses the importance of
physical activity from birth to 18 years of age. Free
from Department of Health and Human Services,
Office of Human Development Service, LSDS, De-
partment 76, Washington, DC 20401.
Youth Physical Fitness—describes physical fitness pro-
grams for children from 4 to 18 years of age. Free
from President's Council on Physical Fitness and
Sports, Department of Health and Human Services,
400 6th St. S.W., Room 3030, Washington, DC
20201/202-755-8801.

Buying Toys and Children's Furniture
Hotline—before you purchase any toy or furni-
ture for your child, you can call the Consumer
Product Safety Commission's toll-free number
and find out if there have been any complaints
about the product you wish to buy, or if it has
been recalled by the manufacturer. The following
free publications are also available:

Crib Safety—Keep Them on the Safe Side
Toys—A Fact Sheet
Playground Equipment Guide
A Toy and Sports Equipment Safety Guide

Contact: Office of Communication, Consumer
Product Safety Commission, Washington, DC
20207/toll-free 800-638-8326/800-492-8363 in
Maryland/800-638-8333 in Puerto Rico, Virgin
Islands, Alaska, and Hawaii

Child Entrepreneurs
The U.S. Department of Agriculture lends up
to $30,000 to youths between 10 and 21 years of
age. The loans can be used to support both farm
and non-farm ventures such as small crop grow-
ing, livestock farming, roadside stands or custom
work. The loans are normally made in conjunc-
tion with youth groups and require parental con-
sent. Contact: Production Loan Division,
Farmers Home Administration, Department of
Agriculture, Washington, DC 20250/202-447-
2288.

Free for Kids
Two coloring books, *Play Happy, Play Safely*

and *Think Toy Safety*, are available from Office of Communication, Consumer Product Safety Commission, Washington, DC 20207/toll-free 800-638-8326/800-492-8363 in Maryland.

Toys: Fun in the Making. This free publication offers ideas for making children's toys and games from throw-away materials found in the home. Simple and fun to make, the toys and games encourage and help children learn and practice specific skills, such as the ability to recognize colors, shapes, and sizes of objects; coordinate hand and eye movements; count; and remember to use words to express themselves. Free from Department of Health and Human Services, Office of Human Development, LSDS, Department 76, Washington, DC 20401. See also "Toys and Other Free Stuff for Children," in this section.

Local Family Experts Offer Free Advice

Over 3,000 county Cooperative Extension Service offices throughout the country offer the services of home economists and family-life specialists, free for the asking. These experts provide information and assistance on almost any area of family living. To identify your local family life specialist, call information and ask for the Cooperative Extension Service for your county. If you cannot locate your local office, contact: Executive Officer, Department of Agriculture, SEA/Extension, Room 332A, Administration Building, Washington, DC 20250/202-447-3304.

Hotline to Health Questions

The Health Information Clearinghouse maintains a staff of information specialists who can locate a source of information for any health related problem that may be encountered while bringing up children. The staff's services are free. Contact: National Information Clearinghouse, P.O. Box 1133, Washington, DC 20013/toll-free 800-336-4797/in Virginia call collect 703-522-2590.

Information on Companies

The federal government is regulating and investigating more and more companies, both privately and publicly held. The result of this increased governmental activity has been additional disclosure information, nearly all of which is available to the public. Listed below are the major federal agencies that keep public information on companies. The information held at each federal office varies from agency to agency; however, most of the offices maintain financial or other information that most researchers would consider sensitive. The list is arranged by type of company or industry covered. The "Other Infor-

mation Sources" category lists those agencies that only occasionally collect information on companies in a variety of industries.

Airlines, Air Freight Commuter Carriers, and Air Taxis/Bureau of Domestic Aviation, Special Authorities, Civil Aeronautics Board, 1825 Connecticut Ave. N.W., Washington DC 20428/202-637-5858.

Airports/Air Traffic Service Division, National Flight Data Center, Federal Aviation Administration, 800 Independence Ave. S.W., Washington, DC 20591/202-426-3666.

Bank Holding Companies and State Members of the Federal Reserve System/Freedom of Information, Board of Governors of the Federal Reserve System, 20th St. and Constitution Ave. N.W., Room B1122, Washington, DC 20551/202-452-3684.

Banks, National/Communications Division, Comptroller of the Currency, 490 L'Enfant Plaza East S.W., Washington, DC 20219/202-447-1800.

Barge and Vessel Operators/Financial Analysis, Federal Maritime Commission, 1100 L St. N.W., Washington, DC 20573/202-523-5876.

Cable Television System Operators/Cable TV Bureau, Federal Communications Commission, 2025 M St. N.W., Washington, DC 20554/202-632-9797.

Colleges, Universities, Vocational Schools, and Public Schools/National Center for Educational Statistics, 6525 Belcrest Rd., Presidential Building, Room 1001, Hyattsville, MD/Mailing Address: 400 Maryland Ave. S.W., Washington, DC 20202/301-436-7900.

Commodity Trading Advisors, Commodity Pool Operators, and Futures Commission Merchants/Commodity Futures Trading Commission, 2033 K St. N.W., Washington, DC 20581/202-254-8360.

Consumer Products/Corrective Actions Division, Consumer Product Safety Commission, 5401 Westbard Ave., Bethesda, MD/Mailing Address: 5401 Westbard Ave., Washington, DC 20207/202-492-6608.

Electric and Gas Utilities and Gas Pipeline Companies/Federal Energy Regulatory Commission, Department of Energy, 825 North Capitol St. N.E., Washington, DC 20426/202-357-8370.

Exporting Companies/American International Traders Register, World Traders Data Reports Section, Department of Commerce, Washington, DC 20230/202-377-4203.

Federal Land Bank Associations and Production Credit Association/Farm Credit

Administration, 490 L'Enfant Plaza S.W., Washington, DC 20578/202-755-2170.

Foreign Corporations/World Traders Data Reports, Department of Commerce, Washington, DC 20230/202-377-4203.

Hospitals and Nursing Homes/National Center for Health Statistics, 3700 East-West Highway, Hyattsville, MD 20782/301-436-8500.

Land Developers/Office of Interstate Land Sales Registration, Department of Housing and Urgan Development, 451 7th St. S.W., Room 4130, Washington, DC 20411/202-755-7077.

Mining Companies/Mine Safety and Health Administration, Department of Labor, 4015 Wilson Blvd., Arlington, VA 22203/703-235-1452.

Nonprofit Institutions/Internal Revenue Service, Freedom of Information Reading Room, 1111 Constitution Ave. N.W., Washington, DC 20224/202-566-3770.

Nuclear Plants/Nuclear Regulatory Commission, 1717 H St. N.W., Washington, DC 20555/301-492-7715.

Pension Plans/Division of Inquiries and Technical Assistance, Office of Pension and Welfare Benefits Programs, Department of Labor, 200 Constitution Ave. N.W., Washington, DC 20216/202-523-8776.

Pharmaceutical, Cosmetic, and Food Firms/ Associate Commissioner for Compliance, Food and Drug Administration, 5600 Fishers Lane, Rockville, MD 20857/301-443-1594.

Pesticide and Chemical Manufacturers/ Environmental Protection Agency, Office of Pesticides and Toxic Substances, 401 M St. S.W., Washington, DC 20460/202-382-2902.

Public Companies/Securities and Exchange Commission, 1100 L. St. N.W., Room 6101, Washington DC 20549/202-523-5360.

Radio and Television Stations/Broadcast Bureau, Federal Communications Commission, 2025 M St. N.W., Washington, D.C. 20554/202-632-7136.

Railroads, Trucking Companies, Bus Lines, Freight Forwarders, Water Carriers, Oil Pipelines, Transportation Brokers, and Express Agencies/Interstate Commerce Commission, 12th St. and Constitution Ave. N.W., Washington, DC 20423/202-275-7331.

Savings and Loan Associations/Federal Home Loan Bank Board, 1700 G St. N.W., Washington, DC 20552/202-377-6000.

Telephone Companies, Overseas Telegraph Companies, Microwave Companies, Public Land, and Mobile Services/Common Carrier Bureau, Federal Communications

Commission, 1919 M St. N.W., Washington, D.C. 20554/202-632-6910.

Other Information Sources

Central Records Unit, International Trade Administration, Department of Commerce, 14th St. and Constitution Ave. N.W., Washington, DC 20230/ 202-377-4679.

Patent Office Search Room, Patent Office, Department of Commerce, 2021 Jefferson Davis Hwy., Building 3, Crystal Plaza, Arlington, VA 22202/703-557-2276.

Public Reference Division, Federal Trade Commission, 6th St. and Pennsylvania Ave. N.W., Room 130, Washington, DC 20580/202-523-3598.

Reference Room, International Trade Commission, 701 E St. N.W., Room 154, Washington, DC 20436/202-523-0430.

State governments—check state government offices for more information on companies.

Market Studies for Free

Each year the U.S. government invests millions of dollars in conducting market studies on subjects ranging from citizens' band radios to nuclear waste. But because the government spends very little to announce its reports, very few people are aware of them.

Such studies can prove invaluable to any business searching for new markets or investigating opportunities in existing markets. Over the years, I have used these little-known reports to satisfy client's information requests. I once was asked by a client to define the total size of the market for golf carts in the United States along with the approximate sales volume of the major manufacturers. I reviewed all the typical sources and interviewed all of the major manufacturers and turned up very little information. However, we finally found all the information we needed at the U.S. Customs Service of the Department of the Treasury. Customs had investigated a Polish golf cart manufacturer for a possible violation of the Anti-Dumping Act. The investigation involved a number of public hearings that included testimony from major manufacturers. This testimony was printed, and it gave our researchers all that was necessary to piece together a substantial market study on the industry.

Although all of these studies are available to anyone for free or for every little cost, they are costing you, as a taxpayer, a lot more than you think. We all pay large amounts of taxes to finance the production of these reports, yet few of

us get our money's worth. The government does not inform us of their availability and therefore we do not know where to go or what to get.

Described below are eight organizations that regularly publish market studies and topical reports. All but two of these offices can be contacted directly for free listings of reports or topics covered. Armed with such lists, you can request specific reports or documentation related to a topic. For copies of committee hearings available from the U.S. Senate or House of Representatives, you can contact your congressional representative's office and request a listing of committees of both the House and Senate. Then contact each committee separately and request lists of their hearings. If the committee will not produce a listing, ask your representative's office for further assistance. Committees should be contacted directly for further information on obtaining documentation and reports.

Copies of Congressional Research Service reports can only be obtained through the office of your member of Congress. Request a copy of the Congressional Research Service's annual index of reports, and with that you can then request copies of specific reports through your congressional representative's office.

Market studies and other topical reports are available from the following government offices:

International Trade Commission

Part of the function of this agency is to study the volume of imports in comparison to domestic production and consumption. As a result, it produces close to 100 market studies each year on topics such as:

Ice Hockey Sticks
Leather Wearing Apparel
Nonrubber Footwear
Unalloyed Unwrought Zinc
Motorcycles
Clothespins

Reports are free, but a listing of available reports costs 10¢ per page. Contact: Office of the Secretary, International Trade Commission, Washington, DC 20436/202-523-0471.

Department of the Commerce, International Trade Administration

Investigates a few dozen industries each year for possible violations of the Anti-Dumping Act. Such industries have included:

Offset Printing Paper

Household Incandescent Lamps
45 RPM Adapters
Carbon Steel Plates

A free listing of industries investigated is available and copies of documents on file can be made for 10¢ per page after the first 50 pages. Contact: Central Records Unit, International Trade Administration, Department of Commerce, 14th St. & Constitution Ave. N.W., Room 2802, Washington, DC 20230/202-377-1248.

Senate and House of Representatives Committee Hearings

There is hardly a topic that has not been covered by a congressional committee hearing. If a hearing has been held on a topic, it is very likely that the top experts have presented their viewpoints and all major information sources on the topic have been identified. Some 2,000 hearings are held annually on such topics as:

Administration's Comprehensive Program for the Steel Industry
Alcohol Fuels
Technology and the Cost of Health Care
Passive Solar Energy Programs and Plans
Capital Formation Problems Confronting Small Business
Nuclear Waste Management
Amateur Sports
Effects of the Baby Boom
U.S. Coal Production
Problems in the Sale of Travel Insurance at Airport Locations

To find out if a subject you are interested in has been researched by a congressional committee, call the House Bill Status Office: 202-225-8646.

You may also find it useful to consult the *Congressional Information Service Index*, which covers all publications (including hearing transcripts) of Congress. It can be found at most libraries, or can be purchased from: Congressional Information Service, 1701 Wisconsin Ave., Washington, DC 20014/301-654-1550.

Once identified, hearing transcripts are generally available for free from the committee directly, or for a small charge from: Superintendent of Documents, Government Printing Office, Washington, DC 20402/202-783-3238.

Central Intelligence Agency (CIA)

Each year, the CIA declassifies 50 to 100 reports, which are then available to the public. Topics include:

International Energy Statistics
Soviet Chemical Equipment Purchases from the West
Relating Climate Change to its Effects

A price listing of reports released from 1972 to the present is available free from: Photoduplication Service, Library of Congress, Washington, DC 20540/202-287-5650.

General Accounting Office

This office conducts special audits, surveys and reviews at the request of the U.S. Congress. It produces as many as 600 reports each year on such topics as:

Foreign Ownership of U.S. Farmland—Much Concern, Little Data
Fossil Energy Research, Development and Demonstration: Opportunities for Change
Timber Harvest Levels for National Forests—How Good Are They?
Deep Ocean Mining—Actions Needed to Make it Happen
What Causes Food Prices to Rise? What Can Be Done About It?
U.S. Statistics on International Technology Transfer—Need for Additional Measures
Computer Topography Scanning: Opportunity for Coordinated Federal Planning Before Substantial Acquisitions
Why Are New House Prices So High, How Are They Influenced by Government Regulations, and Can Prices Be Reduced?

Single copies of reports are available for free and additional copies can be obtained for $1 each. For a free annual index to available reports contact: General Accounting Office, Distribution Section, 441 G St. N.W., Room 1518, Washington, DC 20548/202-275-6241.

Congressional Research Service

This division of the Library of Congress services the legislative branch of the government exclusively with a wide variety of research and expertise. It generates more than 1,000 reports each year on such topics as:

A Legal Overview of the Antitrust Aspects of Mergers
The Future of American Agriculture
Future Higher Education Enrollments: An Analysis of Enrollment Projections
Incentives and Disincentives for U.S. Exporters
Taxes in 2000: A Projection of the Major Taxes Paid Directly by the Median Income Family for the Remainder of the 20th Century

Copies of these reports can be obtained through your congressional representative's office. A free annual index can be requested and specific reports from this can be obtained at no charge. You can contact your representative by writing, in care of his or her name, to: Senate, Washington, DC 20510, or, House of Representatives, Washington, DC 20515. You can also contact your representative through the Capitol Hill switchboard at 202-224-3121.

Federal Trade Commission (FTC)

Along with the Department of Justice, the FTC also investigates possible antitrust violations. Industries under investigation include:

Debt Collection
Auto Insurance
Rustproofing Industry Warranty Practices

For a listing of industries investigated and procedures for obtaining documents at 10¢ per page contact: Public Reference Division, Federal Trade Commission, 6th & Pennsylvania Ave. N.W., Room 130, Washington, DC 20580/202-523-3598.

Department of Justice

The antitrust division of this department investigates a number of industries every year. The industries investigated include:

Dairy Products
Corrugated Containers
Armored Car and Related Services
Adult Motion Pictures
Lumber Products

For a listing of industries investigated and procedures for obtaining documents at 10¢ per page contact: Legal Procedure Unit, Department of Justice, 10th & Constitution Ave. N.W., Room 7416, Washington, DC 20530/202-633-2481.

In addition to the offices described above, there are two government organizations that actively promote their publications. These organizations should be contacted to see how they might be helpful. Contact: Superintendent of Documents, Government Printing Office, Washington, DC 20402/202-783-3238, and, National Technical Information Service, 5285 Port Royal Road, Springfield, VA 22161/703-487-4650.

Also contact those Federal agencies that you think are involved with your subject area.

Information on International Markets

Washington literally is loaded with information and expertise for those who wish to do business overseas. The following describes some of the major services and publications offered (see also Departments of Commerce, State and Agriculture).

1. The *World Traders Data Report* provides a profile on an individual foreign firm for $15.00. Contact the Department of Commerce, Washington, DC 20230/202-377-4203.

2. Names and addresses of foreign firms are available by standard industrial classification code for $10.00, plus 6 cents per name. Request these from the Department of Commerce, International Trade Administration, Office of Export Marketing Assistance, Room 1312 FTI, Washington, DC 20230/202-377-5455.

3. Foreign sales leads generated from inquiries at Embassies can be obtained for 25 cents per name. Contact the Department of Commerce, Trade Opportunities Program, Room 2014, Washington, DC 20230/202-377-2665.

4. Official trade statistics concerning most countries are kept at the World Trade Reference Room, Room 2314, Department of Commerce, Washington, DC 20230/202-377-4855.

5. Airgrams about proposed and future construction sent in by embassy officials operating in foreign countries are available at the Export Reference Room, Room 1326, Department of Commerce, International Trade Administration, Washington, DC 20230/202-377-2107.

6. The New Product Information Service (NPIS) offers a free export promotion service that will: (a) publicize the availability of your new product to foreign markets, and (b) test foreign market interest in your new product. Contract Ms. Constance White, Export Communication Section, Room 3056, Department of Commerce, Washington, DC 20230/202-377-5131.

7. For $25 per day you can lease an office from the U.S. government in ten major foreign cities. The office includes free telephones for local calls, audio-visual equipment, and a list of key business prospects. Secretarial and interpreter services are also available at the company's expense. Contact: International Trade Administration, Office of Export Promotion, Department of Commerce, Washington, DC 20230/202-377-4231.

8. *Global Market Surveys* identify the highest export potential markets overseas. Contact: Department of Commerce, Market Research Division, Room 1204, Washington, DC 20230/202-377-3363.

9. *Foreign Market Reports* offer information on markets for specific products in foreign countries. Contact: Department of Commerce, International Trade Administration, Office of Export Marketing Assistance, Washington, DC 20230/202-377-5455.

10. Current import and export statistics for the United States are kept at Department of Commerce, Room 2314, Washington, DC 20230/202-377-2185.

11. Country specialists are located in several government departments and agencies. Each specialist has the responsibility for following a particular aspect (or aspects) of specific foreign countries. The specialists offer years of experience in answering information requests and possess knowledge far wider in scope than their assignments require. Because of their comprehensive understanding of the countries they study, these experts are invaluable sources of information for the researcher. The services they provide are free of charge and are available by mail or telephone.

Office of Export Promotion

Department of Commerce, Room 4015B, Washington, DC 20230/202-377-4231. Specialist in overseas markets and trade practices.

Department of State

2201 C St. N.W., Washington, DC 20520/202-632-6575. Country desk officers monitor the political, economic, and cultural affairs of specific countries.

Department of Energy

Office of International Affairs, 1000 Independence Ave. S.W., Washington, DC 20585/202-252-5918. Experts in energy resources of foreign countries.

Department of Interior

Bureau of Mines, Foreign Data Branch, 2401 E St. N.W., Washington, DC 20241/202-632-8970. Experts in mineral resources of foreign countries.

Department of Agriculture

Economics and Statistics Service, International Economic Division, 500 12th St. S.W., Washington, DC 20250/202-447-8219. Experts in foreign agriculture.

Agency for International Development
320 21st St. N.W., Washington, DC 20523/202-632-8628. Experts in U.S. economic assistance to certain foreign countries.

International Communication Agency
1776 Pennsylvania Ave. N.W., Washington, DC 20547/202-724-9843. Experts who provide information programs for specific foreign countries.

The following additional offices will prove helpful as information sources in their respective suject areas:

Economics
International Economics, Bureau of Economic Analysis, Department of Commerce, Washington, DC 20230/202-523-0695.

Productivity and Technology Statistics
Bureau of Labor Statistics, Department of Labor, 441 G St. N.W., Washington, DC 20212/202-523-9294.

Environment
International Environmental Referral Center, 401 M St. S.W., Washington, DC 20460/202-755-1836.

Investments and Other Monetary Matters
Office of Assistant Secretary for International Affairs, Department of the Treasury, Washington, DC 20220/202-566-5363.

Life In Europe
European Community Information Service, 2100 M St. N.W., Suite 707, Washington, DC 20037/202-862-9500.

Population
International Population Division, Bureau of Census, Department of Commerce, Washington, DC 20233/202-763-2870, and Population Reference Bureau, Inc., 1337 Connecticut Ave N.W., Washington, DC 20036/202-785-4664.

Country Development
Inter-American Development Bank, 808 17th St. N.W., Washington, DC 20577/202-634-8000, and International Monetary Fund, 700 19th St. N.W., Washington, DC 20531/202-477-7000, and World Bank, 1818 H St. N.W., Washington, DC 20433/202-477-5728.

Information on Technology
The following are the major sources that can assist you in locating information on current and future technology:

Department of Commerce
National Technical Information Service, 5285 Port Royal Rd., Springfield, VA 22161/703-487-4650, and Office of Technology Assessment and Forecasting, Patent and Trademark Office, Crystal Plaza, Room 2C-33, Washington, DC 20231/703-557-3050.

Executive Office of the President
Federal Coordinating Council on Science, Engineering and Technology, Old Executive Office Building, Room 356, Washington, DC 20500/202-456-7116, and Office of Science and Technology Policy, New Executive Office Building, Room 3025, 17th St. and Pennsylvania Ave. N.W., Washington, DC 20500/202-395-4692.

The George Washington University
Innovation Information Center, Program Policy Studies, Washington, DC 20052/202-676-7380.

National Aeronautics and Space Administration
Technology Transfer Division, NASA Headquarters, Code ET-6, 600 Independence Ave. S.W., Washington, DC 20546/202-755-2220. Connected with this NASA office are:

Aerospace Research Application Center
University of Indiana, Administration Building IUPUI, 1201 E. 38th St., Indianapolis, IN 46205/317-264-4644/Mailing address: P. O. Box 647, Indianapolis, IN 46223.

NASA Industrial Applications Center
University of Pittsburgh, 710 LIS Building, Pittsburgh, PA 15260/412-624-5211.

New England Research Application Center
University of Connecticut, Mansfield Professional Park, Route 44A, Storrs, CT 06268/203-486-4533.

North Carolina Science and Technology Research Center
P. O. Box 12235, Research Triangle Park, NC 27709/919-549-0671.

State Technology Applications Center
College of Engineering, University of Florida,

500 Weil Hall, Gainesville, FL 32611/904-392-6626.

Technology Application Center
University of New Mexico, 2500 Central Ave. S.E., Albuquerque, NM 87131/505-277-3622.

State Technology Applications Program
College of Business and Economics, University of Kentucky, 109 Kinkead Hall, Lexington, KY 40506/606-258-4632.

Western Research Application Center
University of Southern California, Denny Research Building, University Park, Los Angeles, CA 90007/213-741-6132.

National Science Foundation

Division of Policy Research and Analysis, 1800 G St. N.W., Washington, DC 20550/202-357-9689.

Congress

Office of Technology Assessment, Washington, DC 20510/202-224-8996, and, House of Representatives, Committee on Science and Technology, 2321 Rayburn House Office Building, Washington, DC 20515/202-225-6371.

Another valuable source of information on technology is the Federal Laboratory Consortium for Technology Transfer, an informal group of more than 180 of the largest federal government laboratories and high-technology agencies. This consortium's purpose is to maximize the usefulness of these laboratories' research and development activities by making the results available to both the government and private industry.

Consortium representatives will direct you to laboratories or individual researchers in your area of interest. The consortium can provide information on government patents originating in these laboratories. By acquiring these patents, private firms can manufacture and sell a product commercially without incurring high research and development costs. In addition, industry can benefit from the consortium's expertise by supplying goods and services to federal laboratories.

Listed below are the names and addresses of the consortium's chairman and vice chairman, the executive director, the two Washington, DC representatives, six regional coordinators, and the technical specialty coordinator. To locate the representative nearest you, contact the coordinator for your region.

Federal Laboratory Consortium Chairman
Dr. Eugene Stark, Los Alamos Scientific Laboratory, Los Alamos, NM 87545/505-667-4061.

Federal Laboratory Consortium Vice Chairman
Michael D'Angelo, Coast Guard Research and Development Center, Avery Point, Groton, CT 06340/203-445-8501.

Federal Laboratory Consortium Executive Director
George Linsteadt, Naval Weapons Center, China Lake, CA 93555/714-939-2305.

Washington, DC
Charles F. Miller/Dr. James Atkinson, Federal Laboratory Program Managers, National Science Foundation, 1800 G St. N.W., Washington, DC 20550/202-357-7560.

Northeast Region
R. V. Giangrande, Transportation Systems Center, Kendall Square, Cambridge, MA 02142/617-494-2486.

Mid-Atlantic Region
Jerome Bortman, Naval Air Development Center, Warminster, PA 18974/215-441-3100.

Southeast Region
Robert E. Brandon, Air Force Engineering and Services Center. Tyndall Air Force Base, FL 32403/904-283-6309.

Midwest Region
James G. Johnson, Air Force Avionics Laboratory, Wright Patterson Air Force Base, OH 45433/513-255-5804.

Mid-Continent Region
Dr. Eugene Stark, Los Alamos Scientific Laboratory, Los Alamos, NM 87545/505-667-4061.

Far West Region
Gerald Richards, Lawrence Livermore Laboratory, Livermore, CA 94550/415-422-6416.

Technical Specialty Coordinator
Clifford E. Lanham, Harry Diamond Laboratory, 2800 Powder Mill Rd., Adelphi, MD 20783/301-394-2296.

If you are interested in the range of services offered, you may wish to obtain the consortium's *Resource Directory*. This publication, updated annually, lists representatives in the six regions of the country and details the subject fields and activities of each member laboratory in sections arranged according to application area, laboratory

name, and technology transfer expertise. To obtain copies of the book (or photocopies of relevant sections—supplies are limited), contact the nearest consortium representative.

Government Money Programs

Available government money programs are described under each department and agency. They are listed under the following three headings: Direct Payments; Loans and Loan Guarantees; and Grants.

If you are looking for further information on government programs, you may find one or more of the following sources helpful.

Catalog of Federal Domestic Assistance

This 1,000-page document is the most complete source of information on government programs. It is published once a year with updates by the Office of Management and Budget. Subscriptions are available for $20.00 from: Superintendent of Documents, Government Printing Office, Washington, DC 20402/202-783-3238.

Federal Assistance Programs Retrieval System (FAPRS)

This is a computerized information system containing much of the same information in the *Catalog of Federal Domestic Assistance*. It is designed to identify quickly specific federal assistance programs for which applicants are eligible. It can be accessed through computer terminals in many government regional offices and in university libraries. The price of a search varies with the request. For an access point near you contact: FAPRS, Rural Development Service, Department of Agriculture, Washington, DC 20250/ 202-382-8348.

Federal Information Centers

There are 38 such centers throughout the country and their job is to personally assist the public in finding information within the federal government. For a center near you, check the white pages of your telephone book under U.S. Government or contact: Coordinator, Federal Information Center, 7th and D Sts. S.W., Washington, DC 20024/202-755-8660.

Your Congressman's Office

This is a good place to turn to when all else fails. Remember, your Congressman works for you in Washington. He or she can be reached by contacting the local district office or: c/o Capitol, Washington, DC 20515/202-224-3121.

Further details on how and where to obtain government money is described in my book, *Getting Yours: The Complete Guide to Government Money* (Penguin, 1982).

Capitol Hill—How to Use It Like a Washington Lawyer

Capitol Hill, or Congress, the legislative branch of the government, is just beginning to be used as a source of information. Very few people have been aware of this treasure trove of unpublished data. Over the years, the Congress has probably held investigations on any topic you can think of, with experts providing their opinions. The documentation for a given committee or subcommittee hearing provides an unmatched reference source for anyone researching current events or other topics.

The information available from Capitol Hill can be used to serve two ends: to monitor legislation, and to investigate a specific topic. Here is a brief outline on how to use this information to achieve both these purposes.

Monitoring Legislation

The best source for determining if there is any specific legislation pending in a given area is the Bill Status Office, Capitol, Washington, DC 20515/202-225-1772. By searching a computerized data base, this office can provide you with the answers to such questions as:

Have any bills been introduced covering a given topic?
What is the status of a given bill?
Who sponsored the bill?
On what date was it introduced?
What committee and subcommittees have held hearings on a given bill?
What other bills are related?

You must provide a key word for the subject searched. It is most likely that the legislation you are interested in is pending before a given committee or subcommittee. Armed with the name of the committee provided by the Bill Status Office, you can contact those on it directly in care of: Senate, Capitol, Washington, DC 20510/202-224-3121, or, House of Representatives, Capitol, Washington, DC 20515/202-224-3121.

Once you have reached the committee in question and are able to talk with the staff person covering your bill, you are now in a position to obtain the following information:

A copy of the bill
A copy of any hearings held on the bill
A description of where the bill will go once it leaves the committee

An analysis of the likelihood of the bill moving out of the committee

An estimate of the time involved for the bill to move out of the committee

If your bill is scheduled for action on the floor of the House or Senate, you can monitor its activity by the hour by listening to the recorded messages heard on Cloakroom numbers. It's like being on the floor of Congress yourself. The numbers are:

House of Representatives Cloakroom
 Republican/202-225-7430.
 Democrat/202-225-7400.
Senate Cloakroom
 Republican/202-224-8601.
 Democrat/202-224-8541.

Investigating Topics
See "Senate and House of Representatives Committee Hearings."

Help, Information, and Gifts from Your Congressman

The federal government is the world's largest storehouse of little-known sources of information, expertise and benefits, yet most people ignore the most important key to this treasure chest—their congressman. A call to the local office of your congressman or senator can often save you from the many pitfalls that keep people from taking advantage of government resources, e.g., they don't know what's available, they don't know where to look, or they get tired of fighting the bureaucracy and give up.

Each district office is staffed with a team of case workers who help constituents get what they need from Washington. Although the quantity and the quality of the service will vary from office to office, it is still worth your effort to investigate how this key can work for you. Remember it is only a local call. To find the district office of your congressman, call your local information operator. If you do not know the name of your congressman, call your local newspaper. Congressmen can also be reached c/o Capitol, Washington, DC 20215/202-224-3121.

The following is a listing of services and benefits offered by most congressmen and senators. Some of the books and souvenirs mentioned are limited in supply and are available on a first-come-first-served basis.

Celebrate a Special Day By Flying Your Flag Over the Capitol
For the price of a flag ($5.50 to $16.00) your congressman can have the Architect of the Capitol fly your personal Stars and Stripes over the Capitol Building on the day you specify. This makes an unusual birthday gift because you receive the flag and a certificate noting the date the flag was flown and in whose honor.

VIP Tours
If you are planning to visit Washington, your congressman can arrange special VIP tours for you at the White House, the Federal Bureau of Investigation, the Department of State and other agencies. It means that you will not have to wait in lines, which can be very long during the tourist season.

Government Benefits
Your congressman can be very effective in insuring that you receive the government benefits to which you are entitled. He or she can help with such matters as:

A late Social Security check
A Social Security check for the wrong amount
Identifying disability, unemployment, or veteran benefits

Getting the Bureaucracy to Move
If you have applied for a government loan, sent in an unsolicited proposal for government business or requested information from a regulatory agency, and you have waited an unreasonable amount of time for a response, your representative can help. His or her office can call the agency on your behalf and get them to move. Remember, that although you, a taxpayer, ultimately pay the salaries of all bureaucrats, it is your congressman that actually pulls the purse strings.

Reports On Current Events
The Congressional Research Service publishes and records on cassette hundreds of major issue briefs to keep members of Congress informed on important and current topics. These reports, written in laymen's language, provide an historical perspective in order to increase the understanding of issues. They are updated daily to include latest developments. Members of Congress have computer access to these reports and hard copies are available at no cost through their offices. Call your representative and ask for a listing of Congressional Research Service Current Issue Briefs. It will provide you with a shopping list from which you can then order reports that interest you.

Bills and Laws

For school projects or specific areas of interest, your congressman can send you copies of bills, committee hearings, committee reports, and recently enacted public laws.

Maps and Brochures

Most Congressmen have an abundant supply of free pamphlets and tourist information about resorts and national parks in their home state.

Calendars

Each congressional office has a large stock of free hanging wall calendars, containing beautiful photographs of Washington scenes.

The Capitol: A Pictorial History of the Capitol and the Congress

This free 200-page paperback is full of photographs of the mosaic corridors, the House and Senate Chambers, past member of Congress and many of today's key legislators.

Reports on High School and Intercollegiate Debate Topics

A free report, prepared by the Library of Congress, contains a compilation of pertinent excerpts, bibliographical references and other materials related to the subject selected by the National University Exension Service Association as the national high school debate topic, and the subject selected annually by the American Speech Association as the national college debate topic.

How Our Laws Are Made

This free handbook provides a nontechnical outline of the background and the multiple steps of the legislative process from the origin of a bill through to its publication as a federal statute.

Our American Government: What Is It? How Does It Function? 150 Questions and Answers

This free booklet describes the Legislative, Executive and Judicial branches of government and the relationships among them, and includes such information as the salary of a cabinet member, whether political parties offer legislative guidance to their individual Members of Congress, and the difference between opinions and decisions of the Supreme Court.

The Declaration of Independence and the Constitution of the United States

This free pamphlet also includes amendments and proposed amendments to the Constitution not yet ratified by the States.

How to Find a Free Expert and Free Information on Anything

Washington is the largest source of free information and expertise in the world and most of it goes to waste. The federal government supports over 500,000 subject experts and spends billions of dollars a year on specialized studies, of which few people take advantage. For any problem that you may face either professionally or personally, there is likely to be a free expert on the federal payroll who has spent years studying the very same subject. These specialists can save you countless hours in research and many dollars in consulting fees.

Examples of Problem-Solving

The organizations described below are to serve as starting points for finding a free expert or report that can solve your problem. If they cannot solve your problem directly, normally they can lead you to the proper information source. Here are a few examples of how these Washington sources can be tapped to answer specific questions:

What will be the supply and demand for lawyers for the next 10 years? See: #22 (National Center for Education Statistics) and #24 (Bureau of Labor Statistics)

What are the opportunities and outlook for the franchising business? See: #9 (Bureau of Industrial Economics)

Are Maine potatoes a good investment in the commodities market? See: #1 (National Agricultural Library) and #2 (U.S. Department of Agriculture)

What are the salaries of computer programmers in the Great Lakes region? See: #24 (Bureau of Labor Statistics)

What is the latest technology in preventing acid rain? See: #6 (Center for Environmental Services), #13 (National Referral Center), and #15 (Library of Congress)

Is there any current legislation which will affect the salaries of teachers? See: #17 (Bill Status Office)

What is the best design for building a solar heating unit? See: #1 (National Agricultural Library) and #2 (Department of Agriculture)

What is the best way to finance a home? See #8 (Department of Housing and Urban Development)

What are the latest developments in the treatment of backaches? See: #12 (Department of Health and Human Services)

Write or Call: Bureaucrats Have To Be Nice— It's The Law

You must be persistent in your search for information. Whether you write or telephone, remember the sources described above may not lead you to the appropriate expert on the first try.

Normally it takes a number of referrals before you find that one government employee who is devoting his or her time studying the very subject you are interested in.

Once you find the specialist, most likely you won't have trouble getting information. In fact, expect to be deluged with information. You will probably discover that this expert who has been concentrating on a particular field for years often does not get an opportunity to share his or her expertise.

Also bear in mind that the recently enacted Civil Service Reform Law makes it mandatory for bureaucrats to be polite to anyone outside the government. If they are impolite, you can report them to their supervisor and this can lead to their dismissal.

Information Starting Points

The following are the best starting places in the federal government for finding information on any question.

Agricultural Reference Help

National Agriculture Library, Department of Agriculture, 10301 Baltimore Blvd., Beltsville, MD 20705/301-344-3756. Provides published material and research services on botany, zoology, chemistry, veterinary medicine, forestry, plant pathology, livestock, poultry, entomology, and general agriculture.

Agriculture Information Clearinghouse

Information Office, Office of Public Affairs, Department of Agriculture, Room 230-E, Washington, DC 20250/202-447-4026. A staff of research specialists are available to provide specific answers or point you to an expert who can help on most any agriculture-related subject.

Free Advice for Business

Library, Department of Commerce, 14th and Constitution Ave. N.W., Washington, DC 20230/202-377-5511. Provides reference services on commerce and business.

Energy Technical Expertise

Department of Energy, Technical Information Center, P. O. Box 62, Oak Ridge, TN 37830/615-576-1308. Provides research and other information services on all energy-related topics.

Energy Information Clearinghouse

Energy Information Center, Department of Energy, 1F048 Forrestal Building, 1000 Independence Ave. N.W., Washington, DC 20585/202-252-8800. Provides general reference services on all aspects of energy.

Environmental Science Information Center

NOAA, 11400 Rockville Pike, Rockville Building, Rockville, MD 20852/301-443-8137. Provides information services on matters relating to the environment.

Federal Information Center—Government Assistance

General Services Administration, 7th and D Sts. S.W., Room 5716, Washington, DC 20405/202-755-8660. Will find you an expert in the government to assist you on almost any topic.

Building, Buying or Developing a Home

Program Information Center, Department of Housing and Urban Development, 451 7th St. S.W., Washington, DC 20410/202-755-6420. Will identify a program which provides information on all aspects of housing.

Bureau of Industrial Economics

Department of Commerce, Room 4845, Washington, DC 20230/202-377-1405. More than 100 industry analysts can supply you with or guide you to information about companies and industries.

Association Information Central

American Society of Association Executives, 1575 I St. N.W., Washington, DC 20005/202-626-2747. Will identify an association that has information on your subject.

Help on Health

National Health Information Clearinghouse, P.O. Box 1133, Washington, DC 20013/toll-free 800-336-4797/703-522-2590 in Virginia. Provides information referral and reference services on health-related topics.

Health and Welfare Information

Information, Department of Health and Human Services, 200 Independence Ave. S.W., Room 118F, Washington, DC 20201/202-245-6296. Will direct you to an office in Health and Human Services that can satisfy your needs.

National Referral Center

Library of Congress, Washington, DC 20540/202-287-5670. Will locate an organization that specializes in providing free information in your area of interest.

Performing Arts Information

Performing Arts Library, John F. Kennedy Center, Washington, DC 20566/202-287-6245. Offers reference services on any subject dealing with the performing arts.

Technical Research for Free or a Fee

Science and Technology Division, Reference Section, Library of Congress, Washington, DC 20540/202-287-5639. Offers both free and fee-based reference and bibliographic services.

Solar Heating and Cooling Information

Conservation and Renewable Energy Inquiry and Referral Service, P. O. Box 1607, Rockville, MD 20850/toll-free 800-523-2929/800-462-4983 in Pennsylvania/800-523-4700/in Alaska and Hawaii. Will provide research, publications and other information services on solar energy.

Current Legislation Information

Bill Status Office, Capitol, House Annex #2, Room 2650, Washington, DC 20515/202-225-1772. Can determine if there is any specific legislation pending on a particular topic.

Statistics

The following are the major statistical generators in the federal government. If an office does not contain statistics on your subject area the topical expert within the office may know of sources that would.

Agriculture and Food Statistics

Director, Estimates Division and Economics and Statistics Service, Department of Agriculture, 14th and Independence Ave. S.W., Washington, DC 20250/202-447-2122.

Economic and Demographic Statistics

Customer Services, Bureau of the Census, Data User Service Division, Washington, DC 20233/301-899-7600.

Crime Statistics

Uniform Crime Reporting Section, FBI, Department of Justice, 9th and Pennsylvania Ave. N.W., Room 6212, Washington, DC 20525/202-324-5038.

National, Regional and International Economics

Bureau of Economic Analysis, Department of Commerce, Tower Building, Washington, DC 20230/202-523-0777.

Education Statistics

National Center for Education Statistics, Department of Education, Presidential Building, 400 Maryland Ave. S.W., Washington, DC 20202/301-436-7900.

Health Statistics

National Center for Health Statistics, Department of Health and Human Services, 3700 East-West Highway, Room 1-53, Hyattsville, MD 20782/301-436-8500.

Statistics on Employment, Prices, Living Conditions, Productivity, and Occupational Safety and Health

Bureau of Labor Statistics, Department of Labor, 441 G St. N.W., Washington, DC 20212. For information: 202-523-1913/publications:202-523-1221/recording: 202-523-9685.

Import and Export Statistics

Foreign Trade Reference Room, Department of Commerce, Room 20314, Washington, DC 20230/202-377-2185.

World Import and Export Statistics

World Trade Statistics, Department of Commerce, Room 2036, Washington, DC 20230/202-377-4855.

Federal Document Rooms

In addition to the vast amounts of published information available in Washington, there is also an abundance of information in unpublished formats. Major sources of this unpublished information are public document rooms. These special rooms within federal departments and agencies can give you access to unique documents with very limited circulation. For example, you can obtain financial information on elected officials from the Federal Elections Commission or tax returns of nonprofit organizations from the Internal Revenue Service.

The following listing covers the main reference rooms open to the public. If you cannot visit in person, make arrangements with the document room on how you can obtain copies of the documents you need.

Agency for International Development

Development Information Center

Agency for International Development, Department of State Building, Room 1656, Washington, DC 20523/202-632-9345. Included here are documents covering AID projects overseas, such as contractors' reports, feasibility studies, studies on aspects of foreign aid programs, final reports from AID contractors who have completed work overseas, research done by universities for AID, and AID presentations to Congress for budgetary purposes. (Copying: available at no charge.)

Civil Aeronautics Board

Bureau of Domestic Aviation

Special Authorities Division, Civil Aeronautics Board, 1825 Connecticut Ave. N.W., Washington, DC 20428/202-673-5088. The bureau collects information about charter tours, including charter and depository agreements, advertisements and contracts, and insurance data for air taxis and air freight.

Also available are files of registrations for air taxis, scheduled commuter airlines, and charter planes. They show the carriers' names, addresses, types of aircraft operated, services performed, and descriptions of insurance carried. Each registration covers a period of two years; however, proposed rule changes will require carriers to file only an initial registration. (Copying: 15¢ per page.)

Financial and Traffic Data Section

Civil Aeronautics Board, Room 613, 1825 Connecticut Ave. N.W., Washington, DC, Financial Section: 202-673-5926/Traffic Data Section: 202-673-5924/Mailing Address: B-46C, 1825 Connecticut Ave. N.W., Washington, DC 20428. CAB handbooks and statistical reports cover all traffic data and financial statistics concerning U.S. airlines, U.S. airport activity, and international statistics for U.S. carriers. The section maintains monthly traffic reports, quarterly financial reports showing freight loss and damage, and denied boarding reports on all carriers, including foreign ones. (Copying: 15¢ per page.)

Public Reference Room

Civil Aeronautics Board, Room 710, 1825 Connecticut Ave. N.W., Washington, DC/202-673-5313/Mailing Address: CAB Public Reference Room, B-27, 1825 Connecticut Ave. N.W., Washington, DC 20428. The Public Reference Room contains all board orders and reports. It also has financial, statistical and performance reports filed by the carriers—commercial airlines, supplementals, foreign airlines and commuter airlines. This office also keeps some Freedom of Information materials, board meeting records, financial data on cargo carriers, and traffic schedules. The Reference Room can obtain other reports from specific CAB offices for public inspection. A few of these publications are free from the publications office. If you don't know where to look within the Civil Aeronautics Board, start here—the staff will refer you to other board offices. (Copying: 15¢ per page. Bring your own supply of change.)

Civil Rights Commission

Clearinghouse Library

Civil Rights Commission, 1121 Vermont Ave. N.W., Room 709, Washington, DC 20452/202-254-6636. The Clearinghouse Library contains the Commission's findings covering racial discrimination, minority and women's civil rights and legal reference material; and all books and documents published by the Commission relating to its statutes, regulations, and goals. (Copying: available at no charge.)

Commerce Department

Export Information Reference Room

International Trade Administration, Department of Commerce, Room 1326, 14th St. and Constitution Ave. N.W., Washington, DC 20230/202-377-2997. This room has several cabinets of reports, filed by country, which provide information on proposed and approved major projects, particularly overseas construction projects. Notices of overseas construction starts are received by early warning cables from Commerce officials posted abroad. Airgrams are kept on file for three months.

The room also maintains files of press releases on loan approvals, monthly reports of projects under consideration for loans from the World Bank, the Inter-American Development Bank and the Asian Development Bank. (Copying: 15¢ per page in the Commerce Department Library. Bring your own supply of change.)

Minority Business Development Agency (MBDA)

Information Clearinghouse, Department of Commerce, Room 5714, 14th St. and Constitution Ave. N.W., Washington, DC 20230/202-377-2414. This room contains a collection of MBDA publications and publications from other agencies relating to minority business enterprise. (Copying: not available)

Patent Office Search Room

Patent Office, Department of Commerce, 2021 Jefferson Davis Highway, Arlington, VA/703-557-2276/Mailing Address: Washington, DC 20231. In the search room are patents dating back to 1790, arranged numerically and in classified order. The patents are also arranged by classes and subclasses of subject matter. (Copying: 15¢ per page.)

Freedom of Information Records Inspection Facility

International Trade Administration, Depart-

ment of Commerce, Room 3102, 14th St. and Constitution Ave. N.W., Washington, DC 20230/202-377-3031. The documents which may be reviewed in this room include: boycott reporting forms for public inspection, charging letters and news releases involving boycott violations, boycott comments on proposed regulations, administrative staff manuals, instructions to the staff that affect the public, comments concerning countervailing and anti-dumping duties, etc. (Copying: 7¢ per page; 25¢ per microfilm copy.)

Public Information Office
Bureau of the Census, Department of Commerce, Federal Office Building #3, Room 2089, Suitland, MD 20233/301-763-4040. The Public Information Office assists researchers working with historical statistics. The office's collection contains mainly census material published by the Census Bureau itself, but there are some statistical materials published by other U.S. government agencies. Coverage includes financial, growth and production information about numerous industries (including transportation, agriculture and construction), plus the number of employees in each industry and other statistical data. If researchers let the office know in advance what materials they need to see, the office tries to have these ready for them to use. The office can supply most current census materials, either free or priced, and tries to obtain copies of old documents researchers wish to inspect. (Copying: limited copying facilites available at Census Bureau Library.)

Trademark Search Room
Patent and Trademark Office, Department of Commerce, Building #2, 2011 Jefferson Davis Highway, Arlington, VA 22202/703-557-3281. This room contains trademark registrations dating back to 1881. The registrations are arranged numerically and alphabetically by the complete name. (Copying: 15¢ per page; tokens must be purchased in the lobby of Building #4, 2031 Jefferson Davis Highway.)

U.S. Foreign Trade Reference Room
Department of Commerce, Room 2314, 14th St. and Constitution Ave. N.W., Washington, DC 20230/202-377-2185. The room contains the most current trade statistics available. It offers a large collection of published and unpublished reports concerning U.S. foreign trade—including import and export data by country and commodity, with quantities and dollar value of exports and imports—prepared mostly by the Bureau of the Census. (Copying: 15¢ per page; microfilm and microfiche—10¢ per copy.)

World Trade Reference Room
Department of Commerce, Room 2314, 14th St. and Constitution Ave. N.W., Washington, DC 20230/202-377-4855. Official trade statistics for most countries of the world are kept here. There are publications about importing and exporting, and market share reports which list the leading exporting countries for specific commodities and the countries to which they export. (Copying: 15¢ per page.)

Commodity Futures Trading Commission

Office of Public Information
Commodity Futures Trading Commission, 2033 K St. N.W., Washington, DC 20581/202-254-8630. This office has control over documents available to the public. These include copies of hearings and appeals, listings of registered agents, futures commission merchants and brokerage firms, registration applications and financial statements with principals and addresses. (Copying: 10¢ per page.)

Consumer Product Safety Commission

Public Reference Room
Consumer Product Safety Commission, 8th Floor, 1111 18th St. N.W., Washington, DC 20207/202-634-7700. The room contains all commission decisions, court cases, and dockets; petitions; comments on proposed regulations and rules; background study reports (these have been sanitized to protect manufacturers); transcriptions and minutes of commission meetings; the weekly public calendar; and other documents regarding work the commission does. There are about 18 open shelves of material. (Copying: the first 250 pages are free; 10¢ per page thereafter.)

Education Department

National Center for Education Statistics
Department of Education, 6525 Belcrest Rd., Presidential Building, Room 1001, Hyattsville, MD 20782/301-436-7900/Mailing Address: 400 Maryland Ave. S.W., Washington, DC 20202. The center compiles education statistics and analyses; provides financial data on educational institutions; and makes available numerous publications, most of which must be purchased. (Copying: not available.)

Energy Department

Economic Regulatory Administration
Public Document Room, Office of Public In-

formation, Department of Energy, 2000 M St. N.W., Washington, DC 20585/202-633-9451. This office contains copies of all Economic Regulatory Administration rules and orders and hearing transcripts. (Copying: 10¢ per page.)

Federal Energy Regulatory Commission

Office of Congressional and Public Affairs, Department of Energy, 825 North Capitol St. N.E., Washington, DC 20426. The office contains copies of annual and monthly reports filed by public utilities, natural gas producers, and interstate oil pipeline companies. These reports cover a wide range of topics from financial information to energy consumption. This room also has copies of special reports produced by the staff of the Federal Energy Regulatory Commission and FERC decisions and rules. (Copying: 10¢ per page.)

Environmental Protection Agency

Public Information Reference Unit

Environmental Protection Agency, 401 M St. S.W. (PM 213), Washington, DC 20460/202-755-2808. This is a reading room for review and inspection of unpublished materials. Many documents are comments in response to EPA-proposed legislation placed in the Federal Register. Other materials are EPA comments on environmental impact statements; Federal regulations and proposed rules; EPA guidelines, etc. A few published materials are here, but no handouts. (Copying: 10¢ per page after first 25 pages, which are free. Copying must be done by 4:15 P.M., and only checks are accepted—no cash.)

Equal Employment Opportunity Commission

Library

Equal Employment Opportunity Commission, 2401 E St. N.W., Washington, DC 20506/202-634-6990. In addition to legal and social science reference materials, the library makes available comments on proposed guidelines, transcripts of commission decisions, annual reports, and budgets. (Copying: 15¢ per page.)

Office of the Executive Secretariat

Equal Employment Opportunity Commission, 2401 E St. N.W., Room 4096, Washington, DC 20506/202-634-6750. This office maintains the minutes of all open commission meetings and commission votes; materials are available by appointment. (Copying: 15¢ per page.)

Farm Credit Administration

Public Affairs Division

Farm Credit Administration, 490 L'Enfant Plaza S.W., 4th Floor, Washington, DC 20578/202-755-2170. This office makes available a number of documents, including copies of regulations and clarifications and in-house reports and publications about the cooperative farm credit system. Special reports by the Farm Credit Administration include such topics as credit and economic outlook, interest rates, surveys, loan profiles, and statistics. Administration and personnel handbooks are also available for inspection. (Copying: 10¢ per page.)

Federal Communications Commission

Economic Studies Branch

Common Carrier Bureau, Federal Communications Commission, 1919 M St. N.W., Room 530, Washington, DC 20554/202-632-7084. This room contains copies of annual reports filed by over 1,200 common carriers in the United States. It also has monthly balance sheets of telephone and telegraph companies, as well as quarterly and annual statistical reports compiled by the office itself. (Copying: 10¢ per page if you make the copies yourself. If they must be mailed, contact: Downtown Copy Center, 1919 M St. N.W., Room 239, Washington, DC 20554/202-833-9765. This firm charges 9¢ per page, plus $10 per hour for research and retrieval.)

Domestic Radio Branch

Common Carrier Bureau, Federal Communications Commission, 1229 20th St. N.W., Room 340, Washington, DC 20554/202-632-6430. This room contains documentation on all point-to-point microwave companies. This includes applications for licenses, annual reports, and applications for new construction facilities. (Copying: 10¢ per page.)

Mobile Services Division

Common Carrier Bureau, Federal Communications Commission, 1919 M St. N.W., Room 632, Washington, DC 20554/202-632-6400. This room contains station files on licensing and all new construction for common carriers. (Copying: 10¢ per page if you make the copies yourself. If they must be mailed, contact Downtown Copy Center, 1919 M St. N.W., Room 239, Washington, DC 20554/202-833-9765. This firm charges 9¢ per page, plus $10 per hour for research and retrieval.)

Public Reference Room

Federal Communications Commission, 1919 M St. N.W., Room 239, Washington, DC 20554/ 202-632-7566. This room contains complete documentation on all hearings and cases handled by the Federal Communications Commission. An index is available for identifying specific cases or areas covered. (Copying: 10¢ per page.)

Reference Room—Broadcast Bureau

Federal Communications Commission, 1919 M St. N.W., Room 239, Washington, DC 20554/ 202-632-7569. This is a special section within the main reference room which handles documentation on all broadcast matters before it reaches the hearing stage. This room also contains copies of applications and annual reports filed by radio and television stations. (Copying: 10¢ per page.)

Reference Room—Cable Television Bureau

Federal Communications Commission, 2025 M St. N.W., Room 6218, Washington, DC 20554/202-632-7076. This room contains documentation on cable television companies, including annual reports and applications for licenses. History cards recording all action taken are also available for each company. (Copying: 10¢ per page.)

Tariff Review Branch

Common Carrier Bureau, Federal Communications Commission, 1919 M St. N.W., Room 514, Washington, DC 20554/202-632-5550. This reference room provides storage for copies of tariffs filed by more than 1,200 common carriers in the United States. (Copying: 10¢ per page.)

Federal Election Commission

Public Records Office

Federal Election Commission, 1325 K St. N.W., Washington, DC 20463/202-523-4181. This room contains all campaign finance reports for House, Senate and Presidential candiates since 1972. If you cannot visit Washington, you can call the commission's information office at toll-free 800-424-9530 to obtain guidance on holdings or copies of the information you need. (Copying: 5¢ per page: 10¢ per page for copies from microfilm.)

Federal Deposit Insurance Corporation

Information Office, Federal Deposit Insurance Corporation (FDIC), 550 17th St. N.W., Room 6061-B, Washington, DC 20429/202-389-4221. Popular FDIC materials, available gratis at the Information Office, are: *Your Insured Deposit*

and the FDIC annual report. All published FDIC statistical materials may be reviewed in the FDIC Library. Some publications are free; others are not. (Copying: available only at the FDIC Library, Room 4074; 10¢ each page.)

Federal Home Loan Bank Board

Docket Section

Federal Home Loan Bank Board, 1700 G St. N.W., Washington, DC 20552/202-377-6262. This room contains documentation related to savings and loan institutions and savings banks, including annual financial reports, applications for new facilities and copies of any correspondence between the bank board and the institution. (Copying: 10¢ per page.)

Information Disclosure Section

Federal Home Loan Bank Board, 1700 G St. N.W., Washington, DC 20252/202-377-6138. This section contains deposit figures, balance sheet income and expense data for branches and home offices of federally insured savings institutions. (Copying: 30¢ per page, plus $2.00 for search and handling.)

Federal Maritime Commission

Office of the Secretary

Federal Maritime Commission, 1100 L St. N.W., Room 11101, Washington, DC 20573/ 202-523-5725. The office has self-policing reports, records of how carriers handled requests and complaints, and tariffs and agreements, including comments and justifications. If you don't know which office under the Commission has the information you need, this is the place to start— you will be referred to the appropriate division. (Copying: no charge.)

Docket Room

Federal Maritime Commission, 1100 L St. N.W., Washington, DC 20573/202-523-5761. Contains documentation on all commission proceedings covering complaints, rule making, and investigations. (Copying: 5¢ per page; there is an additional $5 per hour service for copying performed by docket room staff.)

Compliance Records Center

Federal Maritime Commission, 1100 L St. N.W., Room 10223, Washington, DC 20573/ 202-523-5829. This room contains documentation on all domestic tariffs for water or water and land for common carriers and others engaged in the foreign and domestic offshore commerce of the United States. (Copying: 30¢ per page.)

Federal Reserve System

Freedom of Information

Board of Governors of the Federal Reserve System, 20th St. and Constitution Ave. N.W., Room B-1122, Washington, DC 20551/202-452-3684. This room contains copies of all proposals made by the Board of Governors along with copies of all public comments on these proposals. The room also has available registration statements and annual reports of all bank holding companies and banks that are state members of the Federal Reserve System. (Copying: 10¢ per page after the first 20 pages.)

Federal Trade Commission

Public Reference Division

Federal Trade Commission, 6th St. and Pennsylvania Ave. N.W., Room 130, Washington, DC 20580/202-523-3598. Records in this collection are FTC-originated complaints: docket sheets outlining proceedings of a case; FTC economic reports; copies of the Flammability Act and other requirements of manufacturers. Other FTC publications available are of a consumer protection nature. Documentation for all FTC investigations is maintained here. (Copying: 90% of all publications are free. For unpublished materials, a copying charge of 12¢ per page begins at the 80th page, retroactive to the first page.)

Health and Human Services Department

Freedom of Information Office

Food and Drug Administration, Freedom of Information Staff, HF-35, Department of Health and Human Services, 5600 Fishers Lane, Room 12A08, Rockville, MD 20857/301-443-6310. This division has information about food and drugs, including contents, usage, and records of investigations. It also has copies of requests for information, replies to these requests, and some FDA manuals (others are available from National Technical Information Service, 5285 Port Royal Road, Springfield, VA 22161/703 557-4650). Other materials available include establishment inspection reports, the Inspectors' Operations Manual, commissioners' reports, the FDA Directory, and the *Index to Evaluations*, published in the *Federal Register*. (Copying: 10¢ per page after the first 50 pages, plus postage.)

Dockets Management Branch

Food and Drug Administration, Department of Health and Human Services, 5600 Fishers Lane, Room 4-62, Rockville, MD 20857/301-443-1753. This office holds food and drug contents and labeling information, hearing records, dockets, comments on proposed rules and regulations, and FDA administrative files and manuals. (Copying: 10¢ per page after the first 50 pages, plus postage.)

National Center for Health Statistics

Department of Health and Human Services, 3700 East-West Highway, Room 157, Center Building, Hyattsville, MD 20782/301-436-8500. The center compiles health statistics from surveys and studies about health. It operates a clearinghouse on health indexes that publishes the quarterly "Bibliography on Health Indexes," a free publication. (Copying: available at no charge.)

National Clearinghouse for Alcohol Information

National Institute on Alcohol Abuse & Alcoholism, Department of Health and Human Services, 1776 Plaza South, 1776 E. Jefferson St., Rockville, MD 20852/301-468-2600/Mailing Address: P. O. Box 2345, Rockville, MD 20852. Contains over 50,000 items, including published and unpublished documents on the topic of alcoholism. (Copying: limited copying due to contract restrictions.)

Office of Family Planning

Bureau of Community Health Services, Department of Health and Human Services, 5600 Fishers Lane, Room 715, Rockville, MD 20857/301-443-2430. Materials include pamphlets on family planning, staff research on population, the *Five-Year Plan for Family Planning Services and Population Research* (an annual report to Congress), and some unpublished documents. The office's own documents are not for public distribution; most others are free. (Copying: not available.)

Office of Regulation Management

Health Care Financing Administration, Department of Health and Human Services, 200 Independence Ave. S.W., Room 309-G, Washington, DC 20201/202-245-7890. Contains a vast amount of regulatory documents covering Medicare, Medicaid, and Professional Standards Review Organizations (PSROs). (Copying: 10¢ per page.)

Housing and Urban Development Department

Public Reference Room

Office of Interstate Land Sales, Department of Housing and Urban Development, 451 7th St.

S.W., Room 4130, Washington, DC 20410/202-755-6464. This room contains filings for all developers of 50 or more lots, including articles of incorporation and registration; claims of exemptions; orders of exemptions (applicable to fewer than 300 lots); exemption advisory opinions (partial statements of the HUD Office of Legal Counsel), including those regarding condominiums; inquiries; and free brochures aimed at assisting property buyers. (Copying: 10¢ per page; a property report, complete with description of a property, costs $2.50.)

Interior Department
Public Information Office
Bureau of Indian Affairs, Department of Interior, 19th and E Sts. N.W., Room 4627, Washington, DC 20240/202-343-7445. This office has a number of pamphlets about various aspects of Indian life including religion, language, and population and labor statistics: (Copying: not available. Single copies are available free of charge.)

Interstate Commerce Commission
Docket File Reading Room
Interstate Commerce Commission, Constitution Ave. and 12th St. N.W., Room 1221, Washington, DC 20423/202-275-7285. The collection includes about 150,000 dockets: records of complaints, protest and cases against railroads, trucking companies and other carriers. (Copying 10¢ per page.)

Tariff Examining Branch
Public Tariff File Room, Interstate Commerce Commission, 12th St. and Constitution Ave. N.W., Room 436, Washington, DC 20423. The collection consists mainly of bound volumes of thousands of tariffs. There are about 350,000 tariffs (approximately one million pages) issued a year. A cancellation program eliminates outdated tariffs. (Copying: 10¢ per page.)

Public Reference Room
Interstate Commerce Commission, Constitution Ave. and 12th St. N.W., Room 6124, Washington, DC 20423/202-275-7343. This room contains bound volumes and vertical files of annual (and some quarterly) reports of transportation companies—motor carriers, railway companies, and freight forwarders—regulated by the ICC. The collection also includes reports of rate bureau organizations regulated by the ICC and stockholder reports on some carriers. (Copying: 10¢ per page.)

Labor Department
Public Disclosure Branch
Office of Pension and Employee Benefits, Department of Labor, 200 Constitution Ave. N.W., Room N4677, Washington, DC 20216/202-523-8773. This office maintains annual reports and other disclosure documents filed under the Employee Retirement Income Security Act of 1974. Reports mandated by the Welfare Pension Plans Disclosure Act of 1959 are kept at the Federal Records Center, 4205 Suitland Rd., Suitland, MD 20490/301-763-7010.

National Aeronautics and Space Administration
Information Center
National Aeronautics and Space Administration, 600 Independence Ave. S.W., Room 126, Washington, DC 20546/202-755-2320. The Center contains copies of handbooks and scientific and technical documents produced by NASA staff for the various NASA Projects. There are also copies of special reports covering new inventions from NASA. (Copying: 10¢ per page.)

National Foundation on the Arts and the Humanities
Library
National Foundation on the Arts and the Humanities, 2401 E. St. N.W., Room 1250, Washington, DC 20506/202-634-7640. In addition to its collection of published materials, this room also contains copies of over 150 special reports sponsored by the foundation on such topics as art administration, fund raising, and economic impact studies. (Copying: Available at no charge for 20 copies or less.)

National Labor Relations Board
Division of Information
National Labor Relations Board, 1717 Pennsylvania Ave. N.W., Room 710, Washington, DC 20570/202-632-4950. The Division contains decisions, orders and other documentation relating to cases involving unfair labor practices at commercial businesses, private hospitals, some law offices and other firms. This room also contains copies of quarterly reports produced by the board. Records are kept for approximately one year, then bound and sold through the Government Printing Office. (Copying: 10¢ per page at Freedom of Information Office, Room 1100.)

National Mediation Board

National Mediation Board
Department of Research, 1425 K St. N.W., Suite 910, Washington, DC 20005/202-523-5995. The board maintains collective bargaining records and hearing documentation for airlines and railroads, and five volumes of determinations by the board. A staff person is available to help with specific requests. (Copying: 15¢ per page, unless you are making fewer than 33 copies.)

National Science Foundation

Directorate for Engineering and Applied Science
National Science Foundation, 1800 G St. N.W., Room 1110, Washington, DC 20550/202-357-7484. The Directorate for Engineering and Applied Science handles published materials from NTIS, GPO, and some private publishers resulting from research performed under NSF grants and contracts. Extra copies of documents are frequently available on request. The directorate supports research in several areas, including earthquake hazard mitigation, chemical threats, alternative biological sources of materials, managing risks to community water, intergovernmental science and research and development incentives, and various public policy issues. The materials are maintained in the reference section of the NSF library, Room 1242/202-347-7811. (Copying: available at no charge in the NSF Library, Room 1242.)

National Transportation Safety Board

National Transportation Safety Board
Public Inquiry Section, Room 808-G, 800 Independence Ave. S.W., Washington, DC 20594/202-472-6600. Aviation accident information makes up the bulk of the section's collection, but it also includes reports concerning railroad, highway, pipeline, and marine safety. Included are investigators' complete reports on accidents, preliminary reports, probable cause, and transcripts of any hearings. (Copying: 20¢ per page.)

Nuclear Regulatory Commission

Public Document Room
Nuclear Regulatory Commission, 1717 H St. N.W., Washington, DC/202-634-3273/Mailing Address: Nuclear Regulatory Commission, Washington DC 20555. This room holds approximately 900,000 documents, including technical licensing information on nuclear materials, reactor operator licenses, publications of the advisory committee on reactor safeguards, and transcripts of rule-making hearings. Free press releases also available. (Copying: 5¢ per page for paper copies; 22¢ per page for paper copies of microfiche; 24¢ per microfiche copy.)

Occupational Safety and Health Administration

Occupational Safety and Health Administration
Dockets Office, 200 Constitution Ave. N.W., Rooms S-6212, Washington, DC 20210/202-523-7894. This room contains all the comments and transcripts from the private sector on OSHA proposals for new laws governing occupational safety. (Copying: 10¢ per page.)

Occupational Safety and Health Review Commission

Occupational Safety and Health Review Commission
Public Information, Room 701, 1825 K St. N.W., Washington, DC 20006/202-634-7943. This adjudicatory body has information on its procedures, as well as specific case transcripts, briefs, and decisions concerning any company which has employees and is engaged in interstate commerce. (Copying: commission decisions are usually free. However, there is a 10¢ per page charge for all briefs and transcripts.)

Panama Canal Commission

Panama Canal Commission
425 13th St. N.W., Suite 312, Washington, DC 20004/202-724-0104. The annual report of this organization is a large source of information. It includes: statistics on vessels and cargo, financial statement, and Canal Zone specifics (health, sanitation, schooling, etc.). Also available are consultant studies dealing with the capacity of the Canal and economic impacts. (Copying: not available.)

Pension Benefit Guaranty Corporation

Disclosure Room
Pension Benefit Guaranty Corporation, 2020 K St. N.W., Washington, DC 20006/202-254-5827. This room contains copies of the following items: Pension Benefit Guaranty Corporation Trusteeship Plans, opinion letters, opinion manuals, pertinent litigation for review, termination case data sheets, case log terminating plans updated quarterly, and a computer listing of termi-

nation cases. In addition, on microfilm there are annual reports filed by pension plans. (Copying: 10¢ per page.)

Postal Rate Commission

Postal Rate Commission, Dockets Section, 2000 L St. N.W. Suite 500, Washington, DC 20268/202-254-3800. This section contains notices, motions, rulings, transcripts of hearings, and mail classifications, all dealing with postal rate levels. (Copying: 15¢ per page on documents filed by outside organizations. All material published by the commission is free.)

Railroad Retirement Service

Railroad Retirement Service, 425 13th St. N.W., Room 444, Washington, DC 20004/202-724-0121. The service's annual report covers amounts paid out, numbers on rolls, and the benefits history of the board. Material pertaining to railroad unemployment and retirement benefits (general, not individual information) is also for public use. (Copying: no charge.)

Securities and Exchange Commission

Public Reference Section, Securities and Exchange Commission, 1100 L St. N.W., Room 6101, Washington, DC/202-523-5360/Mailing Address: 500 N. Capital St., Washington, DC 20549. The collection of documents includes annual reports (ten thousand), and quarterly reports (one hundred) of registered companies, as well as current company reports (eight thousand) of significant matters. Also available are registration statements relative to sales of shares and ownership reports concerning personal ownership of 10 percent or more of company stock. (Copying: 10¢ per page.)

Small Business Administration

Small Business Administration, Public Communications, 1441 L St. N.W., Washington, DC 20416/202-653-6365. This office contains a list of free management assistance publications and a list of booklets for sale about starting businesses. (Copying: not available).

Transportation Department

Public Inquiry Center—Federal Aviation Administration

Department of Transportation, 800 Independence Ave. S.W., Room 907, E., APA 430, Washington, DC 20591/202-426-8058. The center offers publications describing careers in aviation fields. It acts as a referral service to offices that handle statistical and research and development publications. Some of the statistical books list the number of air miles flown, number of aviation personnel and other figures about airports and aircraft. (Copying: 25¢ for the first page; 5¢ for each additional page, plus a $2 search fee.)

Office of Airports Programs-Federal Aviation Administration

Department of Transportation, 800 Independence Ave. S.W., Room 600 E., Washington, DC 20591/202-426-3050. The office has copies of the following publications: *General Standards* (i.e., for runways, lighting, etc.), safety standards specifications, *Design Guides, Federal Grant and Aid Programs,* and *Advisory Circulars.* The *Advisory Circulars* and most of the other publications are free. (Copying: 25¢ for the first page; 5¢ for each additional page.)

Public Affairs Office—National Transportation Safety Board

Department of Transportation, 800 Independence Ave. S.W., Room 810-D, Washington, DC 20594/202-472-6600. This is a central depository of reports about accidents—most involving aircraft, but some pertaining to railroad, marine, and pipeline accidents. (Copying: 25¢ per page.)

Technical Reference Branch—National Highway Traffic Safety Administration

Department of Transportation, 400 7th St. S.W., Room 5108, Washington, DC 20590/202-426-2768. The Technical Reference Branch collection includes more than 80,000 items pertaining to: highway safety literature (journal articles, monographs, technical reports and other NHTSA publications, results of contract research, and inhouse publications); reports other than r&d, such as standards enforcement test reports (formerly compliance test reports) issued monthly; certificate information requests; defects investigations; Motor Vehicle Safety Defect Recall Campaigns; Multidisciplinary accident investigation case reports; audio-visual materials; engineering specifications; dockets (public records of rulemaking activities for motor vehicle and highway safety standards); and general reference materials. The branch also makes available *A Guide to Reference Services in the National Highway Traffic Safety Administration.* (Copying: 25¢ for the first page, 5¢ for each additional page. Microfiche copies cost 15¢ per sheet.)

Office of Vehicle Safety Compliance Enforcement

National Highway Traffic Safety Administration, 400 7th St. S.W., Room 6111, Washington, DC 20590/202-426-2820. This office maintains files of ongoing investigations. Documents are filed by number assigned to the case in the standards enforcement test report (formerly compliance test report). Materials in reports identify which vehicles or vehicle parts have failed Transportation Department tests. (Copying: 25¢ for the first page; 5¢ for each additional page.)

Treasury Department

Communications Division—Comptroller of the Currency

Department of the Treasury, 490 L'Enfant Plaza East S.W., Washington, DC 20219/202-447-1800. The office contains financial reports by national banks showing conditions and income; some 300 trust reports and shareholder information about banks with 500 or more shareholders: Make a Freedom of Information Act request for materials. (Copying: 10¢ per page.)

Freedom of Information Reading Room— Customs Service

Department of the Treasury, 1301 Constitution Ave. N.W., Room 2325, Washington, DC 20229/202-566-8681. This room contains two microfilm files; one is a key word index to customs rulings, the other microfilm copies of rulings. (Copying: 10¢ per page.)

Legal Publications Department—Customs Service

Department of the Treasury, 1301 Constitution Ave. N.W., Washington, DC 20229/202-566-8237. Here you can find documents on the legal rulings of the Customs Service. (Copying: 10¢ per page.)

Legal Reference Department—Customs Service

Department of the Treasury, 1301 Constitution Ave. N.W., Washington, DC 20229/202-566-5095. This room contains the regulations and rulings of the U.S. Customs Service. It publishes the *Listing of Decisions and Rulings* in the Customs Bulletins; microfiche of these rulings are also available. (Copying: 10¢ per page.)

Public Information Department—Customs Service

Department of the Treasury, 1301 Constitution Ave. N.W., Room 6303, Washington, DC/ 202-566-8195 or 8196. Mailing Address: P. O. Box 7118, Washington, DC 20044. This is a public information center for the U.S. Customs Service. It contains pamphlets, publications, brochures, manuals and bulletins on all component activities (i.e., duties, tariffs, regulations, fines, rulings, etc.) of the U.S. Customs Service. (Copying: no charge.)

Freedom of Information Reading Room— Internal Revenue Service

Department of the Treasury, 1111 Constitution Ave. N.W., Washington, DC 20224/202-566-3770. Materials available to the public include: the *IRS Manual*, information concerning tax-exempt organizations, plans approved under the Employee Retirement Income Security Act of 1974, the commissioner's annual report, chief counsel's orders, revenue rulings and revenue procedures, and Treasury decisions, including statistics concerning the income of corporations, estates, and individuals. Individuals outside Washington, DC, may obtain IRS information from public information officers at IRS district offices. (Copying: 10¢ per page.)

International Trade Commission

Office of the Secretary, International Trade Commission, 701 E St. N.W., Room 160, Washington, DC 20436/202-523-0161. Publications in this collection date back to January 1961 and relate to the commission's investigation of cases in which U.S. industries sought "import relief." Industries investigated include nonrubber footwear, zippers, mushrooms, stainless steel, wrapper tobacco, nuts, bolts, and screws. Case documentation is available. (Copying: 10¢ per page, however most materials are free.)

Federal Government Libraries

Federal government libraries often have unique holdings in their fields, including photographs and hard-to-find archival material. They are therefore excellent sources of information for researchers. However, some are open to the public by appointment only; it is wise to call before scheduling your visit.

Many libraries also offer telephone reference services; the telephone number given in this listing is the reference number unless otherwise noted.

Federal libraries rarely lend materials outside the confines of the government. If you find that you need to borrow materials, you should arrange it through interlibrary loan. Contact your

company, university, or public library for assistance in this area.

The following is a list of major federal government libraries, with a few private libraries included whose collections are of special interest.

ACTION Library/Room 407, 806 Connecticut Ave. N.W., Washington, DC 20525/202-254-3307.

Agriculture Department National Agricultural Library/10301 Baltimore Blvd., Beltsville, MD 20705/301-344-3756.

Armed Forces Institute of Pathology Ash Library/Walter Reed Army Medical Center, Washington, DC 20306/202-576-2983.

Armed Forces Radiobiology Research Institute Library/Building 42, National Naval Medical Center, Bethesda, MD 20014/301-295-0428.

Arms Control and Disarmament Agency/Room 805, 1700 North Lynn St., Rosslyn, VA 22209. Mailing: Room 5672, State Department Building, Washington, DC 20451/703-235-9550.

Army Department Library/Room 1A518, The Pentagon, Washington, DC 20310/202-695-5346.

Army Mobility Equipment Research and Development Command Technical Library/Building 315, Fort Belvoir, VA 22060/703-664-5179.

Army Office of the Chief of Engineers Library/20 Massachusetts Ave. N.W., Room 3119, Washington, DC 20314/202-272-0455.

Bar Association of the District of Columbia Library/Room 3518, District Court Building, Washington, DC 20001/202-426-7087.

Civil Aeronautics Board Library/1825 Connecticut Ave. N.W., Room 912, Washington, DC 20428/202-673-5101.

Civil Rights Commission Library/Room 709, 1121 Vermont Ave. N.W., Washington, DC 20425/202-254-6636.

Commerce Department Library/Room 7046, 14th St. and Constitution Ave. N.W., Washington, DC 20230/202-377-5511.

Commerce Department Law Library/Room 1894, Main Commerce Bldg., 14th St. and Constitution Ave. N.W., Washington, DC 20230/202-377-5517.

Commerce Department Bureau of the Census Library/Room 2451, Federal Building 3, Suitland, MD. Mailing: Washington, DC 20233/301-763-5042.

Commerce Department National Bureau of Standards Library/Room E01, Administration Building, Quince Orchard Rd. and Rte. 270, Gaithersburg, MD. Mailing: Washington, DC 20234/301-921-3451.

Commerce Department National Bureau of Standards, Standards Information Service/Room A166, Building 225, Quince Orchard Rd. and Rte. 270, Gaithersburg, MD. Mailing: Washington, DC 20234/301-921-2587.

Commerce Department National Oceanic and Atmospheric Administration Library and Information Services Division/OA/D82, 6009 Executive Blvd., Rockville, MD 20852/301-443-8287.

Commerce Department National Oceanic and Atmospheric Administration Page Branch Library/Georgetown Information Center, 3300 Whitehaven St. N.W., Room 193, Washington, DC 20235/202-634-7346.

Commerce Department National Telecommunications and Information Administration Library/Room 755, 1800 G St. N.W., Washington, DC 20504/202-377-1860.

Commerce Department, Patent and Trademark Office Scientific Library/2021 Jefferson Davis Highway, Crystal Plaza Building 3, Arlington, VA 22202/703-557-2955.

Commodity Futures Trading Commission Library/2033 K St. N.W., Washington DC 20581/202-254-5901.

Consumer Product Safety Commission Library/5401 Westbard Ave., Bethesda, MD. Mailing: Washington, DC 20207/301-492-6456.

Congressional Budget Office Library/House Office Building Annex #2, 2nd and D Sts. S.W., Room 471, Washington, DC 20515/202-225-4525.

Defense Department Command and Control Technical Center Technical Library/Room BF679, The Pentagon, Washington, DC 20301/202-697-6469.

Defense Department Audiovisual Agency Still Picture Depository/Building 168, Naval District Washington, Washington, DC 20374/202-433-2168.

Defense Department Communications Agency Technical Library/Navy Department Service Center, Building 12, Arlington, VA 22204. Mailing: Headquarters DCA, Code 312, Washington, DC 20305/202-692-2468.

Defense Department Technical Information Center Technical Library/Cameron Station, Building #5, Alexandria, VA 22314/703-274-6833.

District of Columbia Government Martin Luther King, Jr. Memorial Library/901 G St. N.W., Washington, DC 20001/202-727-1126.

Education Department National Institute of Education Educational Research Library/ 1832 M St. N.W., 6th Floor, Washington, DC 20208/202-254-5060.

Education Department Division of Library Programs/Room 3124 ROB-3, 7th and D Sts. S.W., Washington, DC 20202/202-245-9687.

Education Department Office of Libraries and Learning Technologies/State and Public Library Services Branch, Room 3319B, ROB-3, 7th and D Sts. S.W., Washington, DC 20202/202-472-5150.

Energy Department Library/Route 270, Germantown, MD. Mailing: Room G-042, Washington, DC 20545/301-353-4166.

Energy Department Federal Energy Regulatory Commission Branch Library/825 N. Capital St. N.E., Room 8502, Washington, DC 20545/202-357-5479.

Energy Department Technical Library/ Forrestal Bldg., Room GA13A, 1000 Independence Ave. S.W., Washington, DC 20585/202-252-9534.

Environmental Protection Agency Headquarters Library/Room 2404, PM 213, 401 M St. S.W., Washington, DC 20460/202-755-0308.

Environmental Protection Agency Information Resources and Services Branch/Room 2904, PM 213, 401 M St. S.W., Washington, DC 20460/202-755-0353.

Equal Employment Opportunity Commission Library/2401 E St. N.W., Washington, DC 20506/202-634-6990.

Executive Office of the President Information Center/Room G102, New Executive Office Building, 726 Jackson Pl. N.W., Washington, DC 20503/202-395-3654.

Export-Import Bank of the U.S. Library/Room 1373, 811 Vermont Ave. N.W., Washington DC 20571/202-566-8320.

Farm Credit Administration Reference Library/ 490 L'Enfant Plaza, S.W., Washington, DC 20578/202-755-2170.

Federal Communications Commission Library/ Room 639, 1919 M St. N.W., Washington, DC 20554/202-632-7100.

Federal Deposit Insurance Corporation Library/Room 4074, 550 17th St. N.W., Washington, DC 20429/202-389-4314.

Federal Home Loan Bank Board Library/1700 G St. N.W., Washington, DC 20552/202-377-6269.

Federal Judicial Center Information Service/ 1520 H St. N.W., Washington, DC 20005/ 202-633-6365.

Federal Maritime Commission Library/1100 L St. N.W., Washington, DC 20573/202-523-5762.

Federal Reserve System Board of Governors Research Library/Federal Reserve Building, Room BC-241, Washington, DC 20551/202-452-3332.

Federal Trade Commission Library/6th St. and Pennsylvania Ave. N.W., Washington, DC 20580/202-523-3871.

Gallaudet College/Edward Miner Gallaudet Library, 7th St. and Florida Ave. N.E., Washington, DC 20002/202-651-5566.

General Accounting Office Technical Information Sources and Services Branch/ Room 6428, 441 G St. N.W., Washington, DC 20548/202-275-5180.

General Services Administration Library/Room 1033, GSA Building, 18th and F Sts. N.W., Washington, DC 20405/202-566-0212.

General Services Administration National Archives/8th St. and Pennsylvania Ave. N.W., Washington, DC 20408/202-523-3049.

General Services Administration National Archives and Records Service/Office of Presidential Libraries, Room 104, 8th St. and Pennsylvania Ave. N.W., Washington, DC 20408/202-523-3212.

General Services Administration National Archives and Records Service/Dwight D. Eisenhower Library, S.E. 4th St., Abilene, KS 67410/913-263-4751.

General Services Administration National Archives and Records Service/Herbert Hoover Presidential Library, Parkside Drive, P. O. Box 488, West Branch, IA 52358/319-643-5301.

General Services Administration National Archives and Records Service/Lyndon Baines Johnson Library, 2313 Red River St., Austin, TX 78705/512-397-5137.

General Services Administration National Archives and Records Service/John F. Kennedy Library, Columbia Point, Boston, MA 02125/617-929-4534.

General Services Administration National Archives and Records Service/Franklin D. Roosevelt Library, Albany Post Rd., Hyde Park, NY 12538/914-229-8114.

General Services Administration National Archives and Records Service/Harry S. Truman Library and Museum, Highway 24 and Delaware St., Independence, MO 64050/ 816-833-1400.

General Services Administration National Archives and Records/Stock Film Library/ 1411 South Fern St., Arlington, VA 22202/ 703-557-1114.

General Services Administration National Audiovisual Center/ATTN: Reference Section/Washington, DC 20409/301-763-1896

Government Printing Office Library Division/
5236 Eisenhower Ave., Alexandria, VA/
Mailing: Washington, DC 20401/703-557-
2145

Government Printing Office Library and
Statutory Distribution Service/5236
Eisenhower Ave., Alexandria, VA. Mailing:
Washington, DC 20401/703-557-2145.

Health and Human Services Department
Library/Room 1436, 330 Independence Ave.
S.W., Washington, DC 20201/202-245-6791.

Health and Human Services Department Center
for Disease Control Library/1600 Clifton,
Rd. N.E., Building 1, Room 4105, Atlanta,
GA 30333/404-329-3396.

Health and Human Services Department Food
and Drug Administration Medical Library/
HFD-630, Room 11B40, 5600 Fishers Lane,
Rockville, MD 20857/301-443-3180.

Health and Human Services Department
National Institute of Mental Health/
Parklawn Building, Room 15C05, 5600
Fishers Lane, Rockville, MD 20857/301-443-
4506.

Health and Human Services Department
National Institutes of Health Library/Room
IL 25G, Building 10, 9000 Rockville Pike,
Bethesda, MD 20205/301-496-2447.

Health and Human Services Department
National Institutes of Health Division of
Computer Research and Technology Library/
Building 12A, Room 3018, 9000 Rockville
Pike, Bethesda, MD 20205/301-496-1658.

Health and Human Services Department
National Institute of Health National Library
of Medicine/8600 Rockville Pike, Bethesda,
MD 20209/301-496-6095.

Health and Human Services Department Public
Health Service Parklawn Health Library/
Parklawn Building, Room 1312, 5600 Fishers
Lane, Rockville, MD 20857/301-443-2673.

Health and Human Services Department Social
Security Administration Library/Washington,
DC Branch, 1875 Connecticut Ave. N.W.,
Room 320-0, Washington, DC 20009/202-
673-5532.

Housing and Urban Development Department
Library/Room 8141, 451 7th St. S.W.,
Washington, DC 20410/202-755-6370.

Interior Department Bureau of Mines Library/
Avondale Research Center, 4900 LaSalle Rd.,
Avondale, MD 20782/301-436-7552.

Interior Department Geological Survey
Library/950 National Center, 12201 Sunrise
Valley Dr., Reston, VA 22092/703-860-6671.

Interior Department Geological Survey
National Cartographic Information Center/

507 National Center, 12201 Sunrise Valley
Dr., Reston, VA 22092/703-860-6045.

Interior Department Natural Resources Library
(Main Library), Main Interior Building, 18th
and C Sts. N.W., Washington, DC 20240-
202-343-5815.

Interior Department Natural Resources Library
Law Branch, PIR-L, Room 7100W, Main
Interior Building, 18th and C Sts. N.W.,
Washington, DC 20240/202-343-4571.

Interior Department U.S. Fish and Wildlife
Service Patuxent Wildlife Research Center
Library/Laurel, MD 20811/301-776-4880,
ext. 235.

International Communication Agency (formerly
Information Agency) Library/Room 1005,
1750 Pennsylvania Ave. N.W., Washington,
DC 20547/202-724-9126.

International Communication Agency Film
Library and Shipping Branch/601 D St.
N.W., Room L-0308, Washington, DC
20547/202-376-7817.

International Communication Agency Voice of
America Library/North Building, Room
G510, Washington, DC 20547/202-755-4649.

International Development Cooperation Agency
Information Center/Room 1656, 320 First St.
N.W., Washington, DC 20523/202-632-9345.
Mailing: Washington, DC 20523/703-235-
1000.

International Trade Commission, Main
Library/Room 301, 701 E St. N.W.,
Washington, DC 20436/202-523-0013.

International Trade Commission Law Library/
701 E St. N.W., Washington, DC 20436/202-
523-0333.

Interstate Commerce Commission Library/
Room 3392, 12th St. and Constitution Ave.
N.W., Washington, DC 20423/202-275-7327
or 7328.

Justice Department Main Library/Room 5400,
10th St. and Constitution Ave. N.W.,
Washingtonm DC 20530/202-633-3148.

Justice Department National Institute of Justice
Library/Room 438, 4340 East-West
Highway, Bethesda, MD. Mailing: 633
Indiana Ave. N.W., Washington, DC 20531/
301-724-5884.

Labor Department Library/200 Constitution
Ave. N.W., Washington, DC 20210/202-523-
6988.

Labor Department Law Library/Room N2439,
200 Constitution Ave. N.W., Washington,
DC 20210/202-523-7991.

Library of Congress/10 First St. S.E.,
Washington, DC 20540/202-287-5000.

National Aeronautics and Space Administration

Goddard Space Flight Center Library/Code 252, Greenbelt, MD 20771/301-344-7218.

National Aeronautics and Space Administration Law Library, Code GL-2, Room 7022, 400 Maryland Ave. S.W., Washington, DC 20546/202-755-3896.

National Archives and Records Service/Gerald R. Ford Library/1000 Real Ave., Ann Arbor, MI 48109/313-668-2218.

National Archives and Records Service/Carter Presidential Materials Project/77 Forsyth St. S.W., Atlanta, GA 30203/404-221-3942.

National Capital Planning Commission/1325 G St. N.W., Room 1018, Washington, DC 20576/202-724-0174.

National Endowment for the Arts Library/Room 1250, 2401 E St. N.W., Washington, DC 20506/202-634-7640.

National Endowment for the Humanities Library/Room 326, 806 15th St. N.W., Washington, DC 20506/202-724-0360.

National Labor Relations Board Library/Room 900, 1717 Pennsylvania Ave. N.W., Washington, DC 20570/202-254-9055.

National Science Foundation Library/Room 1242, 1800 G St. N.W., Washington, DC 20550/202-357-7811.

Navy Department Library/Building 220, Washington Navy Yard, 11th & M Sts. S.E., Washington, DC 20374/202-433-4131.

Navy Department Center for Naval Analyses Library/2000 North Beauregard St., Alexandria, VA 22311/703-998-3578.

Navy Department Naval Historical Center Operational Archives Branch/Building 210, Washington Navy Yard, 9th & M Sts. S.E., Washington, DC 20374/202-433-3171.

Navy Department Naval Medical Research Institute Information Services Branch/National Naval Medical Center, Bethesda, MD 20014/201-295-2186.

Navy Department Naval Sea Systems Command Technical Library/National Center #3, Room 1S15, Arlington, VA. Mailing: Washington, DC 20362/703-692-3305.

Navy Department Office of Naval Research Library/Room 633, Ballston Tower #1, 800 North Quincy St., Arlington, VA 22217/703-696-4415.

Nuclear Regulatory Commission/7920 Norfolk Ave., Bethesda, MD. Mailing: Washington, DC 20555/301-492-7748.

Office of Personnel Management Library/Room 5L45, 1900 E St. N.W., Washington, DC 20415/202-632-4432. Reference: 202-632-7640.

Office of Technology Assessment Information Center/Congress, Washington, DC 20510/202-226-2160.

Organization of American States Columbus Memorial Library/17th St. and Constitution Ave. N.W., Washington, DC 20006/202-789-6040.

Overseas Private Investment Corporation Library/7th Floor, 1129 20th St. N.W., Washington, DC 20527/202-652-2863.

Pension Benefit Guaranty Corporation Libary/Suite 7200, 2020 K St. N.W., Washington, DC 20006/202-254-4889.

Securities and Exchange Commission Library/Room 150, 500 N. Capital St., Washington, DC 20549/202-272-2618.

Small Business Administration Law Library/Room 714, 1441 L St. N.W., Washington, DC 20416/202-653-6556.

Small Business Administration Reference Library/1441 L. St. N.W., Washington, DC 20416/202-653-6914.

State Department Library/Room 3239, 22nd and C Sts. N.W., Washington, DC 20520/202-632-0372 or 0486.

State Department Foreign Service Institute Library/Room 300, State Annex 3, 1400 Key Boulevard, Rosslyn, VA 22209/703-235-8717.

Supreme Court Library (Information on Records and Briefs only)/1 First St. N.E., Washington, DC 20543/202-252-3184.

Tax Court of the U.S. Library/400 2nd St. N.W., Washington, DC 20217/202-376-2707.

Transportation Department Library Services Division/Room 2200, 400 7th St. S.W., Washington, DC 20590/202-426-1792.

Transportation Department National Highway Traffic Safety Administration Technical Reference Division, 400 7th St. S.W., Room 5108, Washington, DC 20590/202-426-2768.

Treasury Department Library/Room 5030, 15th St. and Pennsylvania Ave. N.W., Washington, DC 20220/202-566-2777.

Treasury Department Customs Service Library/1301 Constitution Ave. N.W., Room 3340, Washington, DC 20229/202-566-5642.

Treasury Department Internal Revenue Service Library/1111 Constitution Ave. N.W., Room 4324, CC:A:LIB, Washington, DC 20224/202-566-6342.

Veterans Administration Central Office Library/Room 976, Administration Building, 810 Vermont Ave. N.W., Washington, DC 20420/202-389-3085.

See also Library of Congress section.

The Freedom of Information Act

The Freedom of Information Act of 1966 is a key to much of the information held by the federal agencies. Under the law, any identifiable records of the administrative agencies in the executive branch of the federal government must be released upon request, unless they fall into one or more of nine exemption categories.

There is nothing difficult about using the Fredom of Information Act. It requires only that you identify the records you desire and write a letter of request. You do not have to state why you want the material.

Cost of Service

The act allows agencies to charge for the services, but the fees cannot be greater than the actual cost of searching for and copying documents. Search fees are roughly $5 per hour, and the average coping cost is 10 cents per page. Some agencies do not charge at all if the total cost is slight.

There are four possible ways to save money when you make a Freedom of Information Act request:

1. If you are indigent, you can ask that the fees be waived.
2. Request a fee waiver if release of the information would benefit the general public.
3. Ask to examine the documents at the agency, rather than purchase them
4. When writing your request letter, set a dollar amount ceiling on costs.

Your Rights under
Freedom of Information Act

The law provides that you must get some response from the agency within 10 working days. This does not mean you will receive the requested information that quickly. To speed the release process, it is wise to write "Freedom of Information Act Request" on the bottom left-hand corner of the envelope in which you send your letter and at the top of the letter itself. (See sample letters in this section.)

If your request is denied, the agency must notify you, giving you reasons for denial, the names and addresses of those reponsible for denial and advice about how to appeal.

It is your right to appeal a denial, and appeals often are successful. A Washington Researchers' study of agency reports for 1977 showed that 16 percent of the appeal letters written resulted in full release of the information and 33 percent resulted in partial release. This means that you have nearly a 50 percent chance of obtaining some information, even after your initial request has been denied.

Most agencies require appeals to be filed within 30 days; the agency is required to repond within 20 days of the appeal. Further, if your appeal is denied, you have access to the courts.

Problems for the Information-Seeker

The Freedom of Information Act is not perfect. Administration of the law is handled differently from agency to agency. In almost all agencies, the determination of what meets exemptions is left largely to the discretion of administrators.

Problems for the information-seeker, as well as the bureaucrat, have arisen from the act.

For some offices, utilization of the act has resulted in overkill, and you may be required to submit a formal request for documents you might otherwise have been able to obtain more easily.

Government personnel sometimes become less helpful if you approach the subject by threatening Freedom of Information Act action—it's best to ask for the material informally first.

Often the biggest problem is that you must know what it is you are after. You have to be able "reasonably" to identify what you need.

A Washington Researchers survey asked members of the Washington press corps to evaluate the effect the Freedom of Information Act has had on their ability to collect information. These are the results:

45 percent—said the act helped slightly.
36 percent—said it had no significant effect.
11 percent—said the act helped greatly.
7 percent—said the act hindered them greatly.

Another problem involves time. It can take two weeks, a month, or more to receive the material you request under the act, depending upon whether you need to appeal.

Request Letters

REMEMBER: Under the Freedom of Information Act, your letter of request becomes a public record. For this reason, many companies that don't want their names associated with requests hire attorneys or specialized firms to write the letters. Your company's attorney can write a request letter on his or her stationery or your local bar association lawyer referral service can help you find a qualified lawyer if you prefer one outside your organization.

To find an attorney in the Washington, DC, area, where the Freedom of Information offices are located, contact: Lawyer Referral Service,

Bar Association of Washington, DC, 1819 H St. N.W., Suite 300, Washington, DC 20036/202-223-1484.

Private firms that will write request letters include Washington Researchers and FOI Services, Inc. The addresses for Washington Researchers and FOI Services, Inc., are: Washington Researchers, 918 16th St. N.W., Washington DC 20006/202-833-2230, and, FOI Services, Inc., 12315 Wilkins Ave., Rockville, MD 20852/301-881-0410.

If you would like to look at request letters to get an idea of what is available under the act, contact the Freedom of Information office for the agency you are interested in. This is perhaps the best way to identify what a department or agency can provide. The letters, sometimes kept in loose-leaf binders in reading rooms, are unique shopping lists for researchers.

Exemptions

The act covers only the federal executive branch (not state or local governments); Presidential papers are not available under the act. The Freedom of Information Act does not apply to information kept by the federal legislative and judicial branches. This means that some vital sections of the government, such as Congress, the Library of Congress and the Government Printing Office, are exempt.

The nine categories of information exempt from the act are:

1. Classified documents concerning the national defense and foreign policy—government secrets and confidential material. If the document you request is classified, however, the agency is required to review it to determine whether it should remain classified.
2. Internal personnel rules and practices. Covered under this exemption are internal rules and practices that do not affect interests outside the agency.
3. Information exempt under other laws. This includes items such as income tax returns, which other laws prohibit releasing.
4. Confidential business information. This exemption provides that trade secrets and confidential commercial or financial data do not have to be released. Determing what does and does not fall under this exemption has been very controversial. One popular test has been the "competitive harm test," exempting material that could competitively harm the submitter if made public.
5. The confidential business information exemption also has spawned reverse-Freedom-of-Information-Act lawsuits, in which companies that submit information go to court to block agencies from releasing the data. Legislation clarifying this exemption is expected.
6. International communications, including inter- and

intra-agency memos. This does not cover factual information or communications about decisions that already have been made.
Personal, private information. Covered are personnel and medical files and other information which, if released, would constitute invasion of privacy.
7. Investigatory files. These files are records of investigations which, if released, would interfere with enforcement, deprive someone of a fair trial, constitute an invasion of privacy, expose a confidential source, expose investigative techniques, or endanger life or safety.
8. Information about financial institutions, such as Federal Reserve Board records of investigations of federal banks.
9. Information about wells, including some maps.

The act mandates that if only a portion of what you want falls under an exemption, the rest of what you have requested must be released.

Other Sources

If you need more information about the Freedom of Information Act, you can contact:

FOI Clearinghouse, 2000 P St. N.W., P. O. Box 19367, Washington, DC 20036/202-785-3704.
House Subcommittee on Government Information and Individual Rights, B349-C Rayburn House Office Building, Washington, DC 20515/202-225-3741.
Senate Subcommittee on Regulatory Reform and Procedure, 104, Russell Building, Washington, DC 20510/202-224-2951.
Congressional Research Service, Government and General Research Division, Library of Congress, 10 First St. S.E., Room 115A, Washington, DC 20540/202-287-5700.
Center for National Security Studies, 122 Maryland Ave. N.E., Washington, DC 20002/202-544-5380.

Publications include:

The Freedom of Information Act: What It Is and How To Use It—order through the FOI Clearinghouse (see address above). Single copies are free; 2 to 100 cost 10 cents each; for more than 100 the charge is 5 cents each.
Litigation Under the Amended Federal Freedom of Information Act—a lawyer's handbook to the act; this can be purchased for $20 prepaid from the Center for National Security Studies (see address above).
The Federal Register Index—a monthly index bound into quarterly cumulative volumes that list federal agencies' indexes to what is available through the Freedom of Information Act, how much it costs, and where it can be purchased or examined. Not all government agencies submit lists. The index can be ordered from the Government Printing Office for $8 per year (cite order symbol FRSU). Individual cu-

mulative volumes can be ordered for 75 cents each from: Federal Register, Washington, DC 20408/202-523-5240.

Freedom of Information Act Requests for Business Data and Reverse FOIA Lawsuits—by the House Committee on Government Operations; this can be ordered from the Government Printing Office for $2. Cite stock number 052-071-00571-4.

A Citizen's Guide On How To Use The Freedom of Information Act And The Privacy Act in Requesting Government Documents—by the House Committee on Government Operations; it can be ordered from the Government Printing Office for $3. Cite stock number 052-071-00540-4. Orders can be placed with the Government Printing Office by writing or calling: Superintendent of Documents, Government Printing Office, Washington DC 20402/202-783-3238.

The following sample Freedom of Information Act letters will show you exactly how to write request letters. The Freedom of Information Act Office list of names, addresses, and telephone numbers will tell you to whom you should address them.

Sample Freedom of Information Act Letter

FOIA Officer
Title
Name of Agency
Address of Agency
City, State Zip Code

Re: Freedom of Information Act Request

Dear :
Under the provisions of the Freedom of Information Act, 5 U.S.C. 552, I am requesting access to (identify the records as clearly and specifically as possible).

If there are any fees for searching for or copying the records I have requested, please inform me before you fill the request. (Or . . . please supply the records without informing if the fees do not exceed $____.)

(Optional) I am requesting this information (state the reason for your request only if you think it will assist you in obtaining the information).

(Optional) As you know, the act permits you to reduce or waive fees when the release of information is considered as "primarily benefitting the public." I believe that this request fits that category and therefore ask that you waive any fees.

If all or any part of this request is denied, please cite the specific exemption(s) that you think justifies your refusal to release the information and inform me of the appeal procedures available to me under the law.

I would appreciate your handling this request as quickly as possible and I look forward to hearing from you within 10 days, as the law stipulates.

Sincerely,

Signature
Name
Address
City, State Zip Code

Sample Letter of Appeal

Name of Agency Official
Title
Name of Agency
Address of Agency
City, State Zip Code

Re: Freedom of Information Act Appeal

Dear :
This is to appeal the denial of my request for information pursuant to the Freedom of Information Act, 5 U.S.C. 552.

On (date) , I received a letter from (individual's name) of your agency denying my request for access to (description of the information sought) . I am enclosing a copy of this denial along with a copy of my request. I trust that upon examination of these communications you will concede that the information I am seeking should be disclosed.

As provided for in the act, I will expect to receive a reply within 20 working days.

(Optional) If you decide not to release the requested information, I plan to take this matter to court.

Sincerely,

Signature
Name
Address
City, State Zip Code

The Privacy Act

Legislative Background

The underlying purpose of the Privacy Act is to give citizens more control over what information is collected about them by the federal government and how that information is used. The act accomplishes this in five basic ways. It requires agencies to report publicly the existence of all systems of records maintained on individuals. It requires that the information contained in these record systems be accurate, complete, rele-

vant, and up-to-date. It provides procedures whereby individuals can inspect and correct inaccuracies in almost all federal files about themselves. It specifies that information about an individual gathered for one purpose not be used for another without the individual's consent. And, finally, it requires agencies to keep an accurate accounting of the disclosure of records and, with certain exceptions, to make these disclosures available to the subject of the record. In addition, the bill provides sanctions to enforce these provisions.

How To Request Personal Records Information Available Under the Privacy Act

The Privacy Act applies only to personal records maintained by the executive branch of the federal government concerning individual citizens. It does not apply to records held by state and local governments or private organizations. The federal agencies covered by the act include executive departments and offices, military departments, government corporations, government-controlled corporations, and independent regulatory agencies. Subject to specified exceptions, files that are part of a system of records held by these agencies must be made available to the individual subject of the record upon request.* A system of records, as defined by the Privacy Act, is a group of records from which information is retrieved by reference to a name or other personal identifier such as a social security number.

The federal government is a vast storehouse of information concerning individual citizens. For example:

If you have worked for a federal agency or government contractor or have been a member of any branch of the armed services, the federal government has a file on you.

If you have participated in any federally financed project, some agency probably has a record of it.

If you have been arrested by local, state, or federal authorities and your fingerprints were taken, the FBI maintains a record of the arrest.†

*Unlike the FOIA—which applies to anyone making a request, including foreigners as well as American citizens—the Privacy Act applies only to American citizens and aliens lawfully admitted for permanent residence.

†If an individual is arrested more than once, he or she builds up a criminal history called a rap sheet. Rap sheets chronologically list all fingerprint submissions by local, state, and federal agencies. They also contain the charges lodged against the individual and what disposition is made of the case if the arresting agency supplies this information. You can get a copy of your rap sheet by forwarding to the Identification Division of the FBI in Washington, DC, a set of rolled-inked fingerprint impressions along with $5 in the form of a certified check or money order made out to the Treasury of the United States.

If you have applied for a government subsidy for farming purposes, the Department of Agriculture is likely to have this information.

If you have received veterans' benefits, such as mortgage or education loans, employment opportunities, or medical services, the Veterans Administration has a file on you.

If you have applied for or received a student loan or grant certified by the Government, the Department of Health and Human Services has recorded this information.

If you have applied for or been investigated for a security clearance for any reason, there is a good chance that the Department of Defense has a record of it.

If you have received Medicare or social security benefits, the Department of Health and Human Services has a file on you.

In addition, federal files on individuals include such items as:

Investigatory reports of the Federal Communications Commission concerning whether individuals holding citizens band and/or amateur radio licenses are violating operating rules.

Records of the Internal Revenue Service listing the names of individuals entitled to undeliverable refund checks.

Records compiled by the State Department regarding the conduct of American citizens in foreign countries.

This is just a fraction of the information held on individual citizens. In fact, if you have ever engaged in any activity that you think might be of interest to the federal government, there is a good chance that some federal agency has a file on you.

The only information that may be withheld under this act is that which falls within seven designated categories. These exemptions from disclosure are discussed under the section entitled "Reasons Why Access May Be Denied."

Locating Records

If you think that a particular agency maintains records concerning you, you should write to the head of that agency or to the Privacy Act Officer. Agencies are required to inform you, at your request, whether or not they have files on you.

If you want to make a more thorough search to determine what records other federal departments may have, you should consult the compilation of Privacy Act notices published annually by the *Federal Register*. This multi-volume work contains descriptions of all federal record systems: it describes the kinds of data covered by the systems and lists the categories of individuals to whom the information pertains. It also includes

the procedures that different agencies follow in helping individuals who request information about their records, and it specifies the agency official to whom you should write to find out whether you are the subject of a file.

The compilation is usually available in large reference, law, and university libraries. It can be purchased from the Superintendent of Documents, Government Printing Office, Washington, DC 20402. The cost per volume runs around $6 to $12. If you know which agencies you are interested in, the Superintendent of Documents can help you identify the particular volume or volumes which contain the information you want. However, this word of caution: at the present time, the compilation is poorly indexed and, as a consequence, difficult ot use. Therefore, you should examine the work before ordering it.

While it may be helpful to agency officials for you to specify a particular record system which you think contains information concerning you, it is not necessary to provide this information. If you have a general idea of the record you want, don't hesitate to write the agency which you think maintains it.

Making a Request

You can make a request in writing, by telephone, or in person. One advantage to writing is that it enables you to document the date and contents of the request and the agency's reply. This could be helpful in the event of future disputes. Be sure to keep copies of all correspondence concerning the request.

Your request should be addressed to the head of the agency which maintains the records you want or to the agency official specified in the compilation of Privacy Act notices. (See section on Locating Records.) In any event, be sure to write "Privacy Act Request" on the bottom left-hand corner of the envelope. Along with your name and permanent address, you should always give as much information as possible about the record you are seeking.* The more specific the inquiry, the faster you can expect a response. If you want access to a record concerning your application for a government loan, for example, you should give the date of the application, the place where the application was filed, the specific use to which the loan was put, and any relevant identifying numbers. Of course, if you have used the *Federal Register's* compilation of notices and indentified a particular record system which you think contains information on you, you should cite the system.

*If you were using a different name at the time the record was compiled, be sure to provide this information.

Most agencies require some proof of identity before they will release records. Therefore, when making your request, it would be a good idea to provide some identifying data such as a copy of an official document containing your complete name and address. Remember, too, to sign your request since a signature provides a form of identification. You might also want to consider having your signature notarized. If you are seeking access to a record which has something to do with a Government benefit, it could be helpful to give your social security number. Some agencies may request additional information such as a document containing your signature and/or photograph depending upon the nature and sensitivity of the material to be released.

Anyone who "knowingly and willfully" requests or receives access to a record about an individual "under false pretenses" is subject to criminal penalties. This means that a person can be prosecuted for deliberately attempting to obtain someone else's records.

Fees

Under the privacy Act, agencies are permitted to charge fees to cover the actual cost of copying records. However, they are not allowed to charge for the time spent in locating records or in preparing them for your inspection. Copying fees are about 10 cents a page for standard size copies of 8 × 11 inches and 8 × 14 inches.

As mentioned above, fees for locating files can be charged for requests processed under the Freedom of Information Act. Therefore, if you seek access to records under the Privacy Act which can be withheld under the act but are available under the FOIA, you could be charged searching fees. However the legislative histories of both the FOIA and the Privacy Act clearly indicate that Congress intended that access to records not be obstructed by costs. Consequently, if you feel that an agency's fees are beyond your means, you should ask for a reduction or waiver to the charges when making your request.

Sample Privacy Act Request Letter

Agency Head or Privacy Act Officer
Title
Agency
Address of Agency
City, State Zip Code

Re: Privacy Act Request

Dear :
Under the provisions of the Privacy Act of 1974, 5 U.S.C. 522a, I hereby request a copy of

(or: access to) (describe as accurately and specifically as possible the records you want, and provide all the relevant information you have concerning them).

If there are any fees for copying the records I am requesting, please inform me before you fill the request. (Or: . . . please supply the records without informing me if the fees do not exceed $____.)

If all or any part of this request is denied, please cite the specific exemption(s) which you think justifies your refusal to release the information. Also, please inform me of your agency's appeal procedure.

In order to expedite consideration of my request, I am enclosing a copy of (some document of identification).

Thank you for your prompt attention to this matter.

Sincerely,

Signature
Name
Address
City, State Zip Code

Requirements for Agency Responses

Unlike the Freedom of Information Act, which requires agencies to respond within 10 working days after receipt of a request, the Privacy Act imposes no time limits for agency responses. However, the guidelines for implementing the act's provisions recommended by the executive branch state that a request for records should be acknowledged within ten working days of its receipt. Moreover, the acknowledgment should indicate whether or not access will be granted and, if so, when and where. The records themselves should be produced within 30 working days. And, if this is not possible, the agency should tell you the reason and advise you when it is anticipated that access will be granted.

Most agencies will do their best to comply with these recommendations. Therefore, it is probably advisable to bear with some reasonable delay before taking further action.

Disclosure of Records

Agencies are required to release records to you in a form that is "comprehensible." This means that all computer codes and unintelligible notes must be translated into understandable language.

You can examine your records in person or have copies of them mailed to you, whichever you prefer. If you decide that you want to see the records at the agency and for some reason the agency is unable to provide for this, then you cannot be charged copying fees if the records are later mailed to you.

If you view the records in person, you are entitled to take someone along with you. If you do this, you will probably be asked to sign a statement authorizing the agency to disclose and discuss the record in the other person's presence.

Special rules apply to the release of medical records. In most cases, when you request to see your medical record, you will be permitted to view it directly. However, if it appears that the information contained in it could have an "adverse effect" on you, the agency may give it to someone of your choice, such as your family doctor, who would be willing to review its contents and discuss them with you.

Reasons Why Access May Be Denied

Under the Privacy Act, certain systems of records can be exempted from disclosure. Agencies are required to publish annually in the Federal Register the existence and characteristics of all record systems, including those which have been exempted from access. However, records declared exempt are not necessarily beyond your reach, since agencies do not always use the exemptions they have claimed. Therefore, don't hesitate to request any record you want. The burden is on the agency to justify withholding any information from you.

You should familiarize yourself with these exemptions before making a request so you will know in advance what kind of documents may not be available. It will also help you to understand the reasons agencies give for refusing to release information.

General Exemptions

The general exemptions apply only to the Central Intelligence Agency and criminal law enforcement agencies. The records held by these agencies can be exempt from more provisions of the act than those maintained by other agencies. However, even the systems of these agencies are subject to many of the act's basic provisions: (1) the existence and characteristics of all record systems must be publicly reported; (2) subject to specified exceptions, no personal records can be disclosed to other agencies or persons without prior consent of the individual to whom the record pertains; (3) all the disclosures must be accurately accounted for; (4) records which are disclosed must be accurate, relevant, up-to-date, and complete; and (5) no records describing how an individual exercises his First Amendment rights can be maintained unless such maintenance is authorized by statute or by the individ-

ual to whom it pertains or unless it is relevant to and within the scope of an authorized law enforcement activity.

General exemptions are referred to as (j)(1) and (j)(2) in accordance with their designations in the act.

Exemption (j)(1) Files maintained by the CIA—Exemption (j)(1) covers records "maintained by the Central Intelligence Agency." This exemption permits the heads of the Central Intelligence Agency to exclude certain systems of records within the agency from many of the act's requirements. The provisions from which the systems can be exempted are primarily those permitting individual access. Consequently, in most instances, you would probably not be allowed to inspect and correct records about yourself maintained by this agency. Congress permitted the exemption of these records from access because CIA files often contain highly sensitive information regarding national security. Nevertheless, you should always bear in mind that agencies are not required to invoke all the exemptions allowed them. Therefore, if you really want to see a record containing information about you that is maintained by this agency, go ahead and make your request.

Exemption (j)(2): Files maintained by Federal criminal law enforcement agencies—Exemption (j)(2) covers records "maintained by an agency or component thereof which performs as its principal function any activity pertaining to the enforcement of criminal laws, including police efforts to prevent, control, or reduce crime or to apprehend criminals, and the activities of prosecutors, courts, correctional, pardon, or parole authorities, and which consist of (A) information compiled for the purpose of identifying individual criminal offenders and alleged offenders and consisting only of identifying data and notations of arrests, the nature and disposition of criminal charges, information compiled for the purpose of a criminal investigation, including reports of informants and investigators; and is associated with an identifiable individual; or (B) reports identifiable to an individual compiled at any stage of the process of enforcement of the criminal laws from arrest or indictment through release from supervision."

This exemption would permit the heads of criminal law enforcement agencies such as the FBI, the Drug Enforcement Administration, and the Immigration and Naturalization Service to exclude certain systems of records from many of the act's requirements. As with the CIA, the allowed exemptions are primarily those permitting individual access. However, many agencies do not always use the exemptions available to them. Remember, too, the act explicitly states that records available under the FOIA must also be available under the Privacy Act. And under the FOIA, the CIA and FBI and other Federal agencies are required to release all nonexempt portions of their intelligence and investigatory files. Nevertheless, even though Congress intended that Privacy Act requests be coordinated with FOIA provisions, it is still a good idea to cite both these acts when seeking information of an intelligence or investigatory nature.

Specific Exemptions

There are seven specific exemptions which apply to all agencies. Under specified circumstances, agency heads are permitted to exclude certain record systems from the access and challenge provisions of the act. However, even exempted systems are subject to many of the act's requirements. In addition to the provisions listed under General Exemptions (which apply to all record systems), a record system that falls under any one of seven specific exemptions (listed below) is subject to the following requirements: (1) information that might be used to deny a person a right, benefit, or privilege must, whenever possible, be collected directly from the individual; (2) individuals asked to supply information must be informed of the authority for collecting it, the purposes to which it will be put, and whether or not the imparting of it is voluntary or mandatory; (3) individuals must be notified when records concerning them are disclosed in accordance with a compulsory legal process, such as a court subpoena; (4) agencies must notify persons or agencies of any corrections or disputes over the accuracy of the information; (5) and all records must be accurate, relevant, up-to-date, and complete.*

Record systems which fall within the seven exempt categories are also subject to the civil remedies provisions of the act. Therefore, if an agency denies you access to a record in an exempt record system or refuses to amend a record in accordance with your request, you can contest these actions in court. You can also bring suit against the agency if you are denied a right, benefit, or privilege as a result of records which have been improperly maintained. These remedies are not available under the general exemptions.

Specific exemptions are referred to as (k)(1), (k)(2), etc., in accordance with their designations in the act.

Exemption (k)(l): Classified documents concerning national defense and foreign policy—Exemption (k)(1) covers records "subject to the provisions of section 552(b)(1) of this title."

*This provision differs from the one pertaining to all record systems which requires that records which are disclosed be accurate, relevant, up-to-date, and complete. Record systems which are subject to the seven specific exemptions must at all times be accurate, relevant, up-to-date, and complete.

This refers to the first exemption of the Freedom of Information Act which exempts from disclosure records "(A) specifically authorized under criteria established by an Executive order to be kept secret in the interest of national defense or foreign policy and (B) are in fact properly classified pursuant to such Executive order." (For further discussion of the provision, see *Exemption 1: Classified documents concerning national defense and foreign policy* under the FOIA section of this guide.)

Exemption (k)(2): Investigatory material compiled for law enforcement purposes—Exemption (k)(2) pertains to "investigatory material compiled for law enforcement purposes, other than material within the scope of subsection (j)(2) of this section: *Provided, however,* that if any individual is denied any right, privilege, or benefit that he would otherwise be entitled by federal law, or for which he would otherwise be eligible, as a result of the maintenance of such material, such material shall be provided to such individual, except to the extent that the disclosure of such material would reveal the identity of a source who furnished information to the Government under an express promise that the identity of the source would be held in confidence, or, prior to the effective date of this section, under an implied promise that the identity of the source would be held in confidence."

This applies to investigatory materials compiled for law enforcement purpose by agencies whose principal function is other than criminal law enforcement. Included are such items as files maintained by the Internal Revenue Service concerning taxpayers who are delinquent in filing Federal tax returns, records compiled by the Customs Bureau on narcotic suspects, investigatory reports of the Federal Deposit Insurance Corporation regarding banking irregularities, and files maintained by the Securities and Exchange Commission on individuals who are being investigated by the agency.

Such files cannot be withheld from you, however, if they are used to deny you a benefit, right, or privilege to which you are entitled by law unless their disclosure would reveal the identity of a confidential source. You should always bear in mind that Congress intended that information avilable under either the FOIA or the Privacy Act be disclosed. Moreover, since the FOIA requires agencies to release all nonexempt portions of a file, some of the information exempted under this provision might be obtainable under the FOIA. In any event, as mentioned above, when seeking information of an investigatory nature, it is a good idea to request it under both acts.

Exemption (k)(3): Secret Service Intelligence files—Exemption (k)(3) covers records "maintained in connection with providing protective services to the President of the United States or other individuals pursuant to section 3056 of title 18."

This exemption pertains to files held by the Secret Service that are necessary to insure the safety of the President and other individuals under Secret Service protection.

Exemption (k)(4): Files used solely for statistical purposes—Exemption (k)(4) applies to records "required by statute to be maintained and used solely as statistical records."

This includes such items as Internal Revenue Service files regarding the income of selected individuals used in computing national income averages, and records of births, and deaths maintained by the Department of Health and Human Services for compiling vital statistics.

Exemption (k)(5): Investigatory material used in making decisions concerning Federal employment, military service, Federal contracts, and security clearances—Exemption (k)(5) related to "investigatory material compiled solely for the purpose of determining suitability, eligibility or qualifications for federal civilian employment, military service, federal contracts, or access to classified information, but only to the extent that the disclosure of such material would reveal the identity of a source who furnished information to the Government under an express promise that the identity of the source would be held in confidence, or, prior to the effective date of this section, under an implied promise that the identity of the source would be held in confidence."

This exemption applies only to investigatory records which would reveal the identity of a confidential source. Since it is not customary for agencies to grant pledges of confidentiality in collecting information concerning employment, Federal contracts, and security clearances, in most instances these records would be available.

Exemption (k)(6): Testing or examination material used solely for employment purposes—Exemption (k)(6) covers "testing or examination material used solely to determine individual qualifications for appointment or promotion in the Federal service, the disclosure of which would compromise the objectivity or fairness of the testing or examination process."

This provision permits agencies to withhold information concerning the testing process that would give an individual an unfair competitive advantage. It applies solely to information that

would reveal test questions and answers or testing procedures.

Exemption (k)(7): Evaluation material used in making decisions regarding promotions in the armed services— Exemption (k)(7) pertains to "evaluation material used to determine potential for promotion in the armed services, but only to the extent that the disclosure of such material would reveal the identity of the source who furnished information to the Government under an express promise that the identity of the source would be held in confidence, or, prior to the effective date of this section, under an implied promise that the identity of the source would be held in confidence."

This exemption is used solely by the armed services. Moreover, due to the nature of the military promotion process where numerous individuals compete for the same job, it is often necessary to grant pledges of confidentiality in collecting information so that those questioned about potential candidates will feel free to be candid in their assessments. Therefore, efficiency reports and other matrials used in making decisions about military promotions may be difficult to get. But always remember, when seeking information of an investigatory nature it is a good idea to request it under both the Privacy Act and the FOIA.

Appeal Procedure for Denial of Access

Unlike the FOIA, the Privacy Act provides no standard procedure for appealing refusals to release information. However, many agencies have their own regulations governing this. If your request is denied, the agency should advise you of its appeal procedure and tell you to whom to address your appeal. If this information is not provided, you should send your letter to the head of the agency. Include a copy of the rejection letter along with a copy of your original request and state your reason for wanting access, if you think it will help.

If an agency withholds all or any part of your record, it must tell you which Privacy Act exemption it is claiming as a justification. It should also advise you why it believes the record can be withheld under the Freedom of Information Act since Congress intended that information sought under either the Privacy Act or the FOIA be released unless it could be withheld under both acts. Therefore, in making your appeal, it would be a good idea to cite both the FOIA and the Privacy Act. Moreover, if you are able to do so, it might also help you to explain why you think the exemptions used to refuse you access are unjustified.

Sample Letter of Appeal

Agency Head or Appeal Officer
Title
Agency
Agency Address
City, State Zip Code

Re: Privacy Act Appeal

Dear :
On (date) , I received a letter from (individual's name) of your agency denying my request for access to (description of the information sought) . Enclosed is a copy of this denial along with a copy of my original request. By this letter, I am appealing the denial.

Since Congress intended that information sought under the Privacy Act of 1974, 5 U.S.C. 552a, be released unless it could be withheld under both this Act and the Freedom of Information Act, FOIA, 5 U.S.C. 552, I hereby request that you also refer to the FOIA in consideration of this appeal.

(Optional) I am seeking access to these records (state the reasons for your request if you think it will assist you in obtaining the information and give any arguments you have to justify its release).

Thank you for your prompt attention to this matter.

Sincerely,

Signature
Name
Address
City, State Zip Code

Amending Your Records

The Privacy Act requires agencies to keep all personal records on individuals accurate, complete, up-to-date, and relevant. Therefore, if, after seeing your record, you wish to correct, delete, or add information to it, you should write to the agency official who released the information to you, giving the reasons for the desired changes as well as any documentary evidence you might have to justify the changes. Some agencies may allow you to request these corrections in person or by telephone.

Sample Letter for Request to Amend Records

Agency Head or Privacy Officer
Title
Agency
Agency Address
City, State Zip Code

Re: Privacy Act Request to Amend Records

Dear :
By letter dated_____, I requested access to (use same descriptions as in request letter).

In viewing the information forwarded to me, I found that it was (inaccurate) (incomplete) (outdated) (not relevant to the purpose of your agency).

Therefore, pursuant to the Privacy Act of 1974, 5 U.S.C. 552a, I hereby request that you amend my record in the following manner: (describe errors, new information, irrelevance, etc.).

In accordance with the Act, I look forward to an acknowledgment of this request within 10 working days of its receipt.

Thank you for your assistance in this matter.

Sincerely,

Signature
Name
Address
City, State Zip Code

Appeal Procedure for Agency Refusal to Amend Records

If an agency refuses to amend your records, it must advise you of the reasons for the refusal as well as the appeal procedures available to you within the agency. It must also tell you to whom to address your appeal. Amendment appeals are usually handled by agency heads or by a senior official appointed by the agency head.

Your appeal letter should include a copy of your original request along with a copy of the agency's denial. You should also include any additional information you might have to substantiate your claims regarding the disputed material.

A decision on your appeal must be rendered within 30 working days from the date of its receipt. In unusual circumstances, such as the need to obtain information from retired records or another agency, an additional 30 days may be granted.

If the agency denies your appeal and continues to refuse to make the changes you request, you have the right to file a brief statement giving your reasons for disputing the record. This statement of disagreement then becomes part of the record and must be forwarded to all past and future recipients of your file. However, as previously noted, unless the agency has kept some record of disclosures prior to September 27, 1975, it might not be possible to notify all past recipients. The agency is also permitted to place in your file a short explanation of its refusal to change the record. This, too, becomes a part of your permanent file and is forwarded along with your statement of disagreement. If your appeal is denied or if the agency fails to act upon it within the specified time, you can take your case to court.

Sample Letter for Appealing Agency's Refusal to Amend Records

Agency Head or Designated Official
Title
Agency
Agency Address
City, State Zip Code

Re: Privacy Act Appeal

Dear :
By letter dated _____ to (official to whom you addressed your amendment request), I requested that information held by your agency concerning me be amended. This request was denied, and I am hereby appealing that denial. For your information, I am enclosing a copy of my request letter along with a copy of Mr. (Ms.) _____'s reply. (If you have any additional relevant information, send it, too.)

I trust that upon consideration of my reasons for seeking the desired changes, you will grant my request to amend the disputed material. However, in the event you refuse this request, please advise me of the agency procedures for filing a statement of disagreement.

(Optional) I plan to initiate legal action if my appeal is denied.

Thank you for your prompt attention to this matter.

Sincerely,

Signature
Name
Address
City, State Zip Code

Taking Your Case to Court

Under the Privacy Act, you can sue an agency for refusing to release your records, for denial of your appeal to amend a record, and for failure to act upon your appeal within the designated time. You can also sue if you are adversely affected by

the agency's failure to comply with any provisions of the Act. For example, if you are denied a job promotion due to inaccurate, incomplete, outdated, or irrelevant information in your file, you can contest this action in court.

While the Freedom of Information Act requires individuals to use agency appeal procedures before seeking judicial review, the Privacy Act permits individuals to appeal denials of access directly to the courts (although most agencies have their own appeal procedures and you should use them when available). On the other hand, you are required by the Act to use administrative appeal procedures in contesting agency refusals to amend your records.

Judicial rulings favorable to you could result in the release or amendment of the records in question. In addition, you can obtain money damages if it is proven that you have been adversely affected as a result of the agency's intentional and willful disregard of the Act's provisions. You might also be awarded court costs and attorney fees.

The Act provides criminal penalties for the knowing and willful disclosure of personal records to those not entitled to receive them, for the knowing and willful failure to publish the existence and characteristics of all record systems, and for the knowing and willful attempt to gain access to an individual's records under false pretenses.

If and when you do decide to go to court, you can file suit in the Federal district court where you reside or do business or where the agency records are situated. Or you can take the case to the U.S. District Court in the District of Columbia. Under the Privacy Act, you are also required to bring suit within two years from the date of the violation you are challenging. However, in cases where the agency has materially or willfully misrepresented information, the statute of limitations runs two years from the date you discover the misrepresentation. As with lawsuits brought under the FOIA, the burden is on the agency to justify its refusal to release or amend records.

The same advice applies here as with suits filed under the FOIA: if you go to court, you should consult a lawyer. If you cannot afford private counsel, contact your local legal aid society.

Other Rights Provided Under the Privacy Act

One of the most important provisions of the Privacy Act is the one that requires agencies to obtain an individual's written permission prior to disclosing to other persons or agencies information concerning him or her, unless such disclosures are specifically authorized under the Act. Information can be disclosed without an individual's consent under the following circumstances:

to employees and officers of the agency maintaining the records who have a need for the information in order to perform their duties; if the information is required to be disclosed under the FOIA; for "routine uses," i.e., uses which are compatible with the purpose for which the information was collected;* to the Census Bureau; to the National Archives; to a law enforcement agency upon the written request of the agency head; to individuals acting on behalf of the health or safety of the subject of the record; to Congress; to the General Accounting Office; or pursuant to court order. In all other circumstances, however, the individual who is the subject of the record must give his or her written consent before an agency can divulge information concerning him or her to others.

Under the Act, you are also entitled to know to whom information about you has been sent. Agencies must keep an accurate accounting of all disclosures made to other agencies or persons except those required under the FOIA. Moreover, this information must be maintained for at least five years or until the record disclosed is destroyed, whichever is longer. With the exception of disclosures requested by law enforcement agencies, a list of all recipients of information concerning you must be made available upon request. Therefore, if you are interested in knowing who has received records about you, you should write to the Privacy Act officer or the head of the agency that maintains the records and request that an accounting of disclosures be sent to you.

Finally, the Privacy Act places a moratorium upon any new uses of your social security number by federal, state, and local government agencies after January 1, 1975.† No agency may deny you a right, benefit, or privilege to which you are entitled by law because of your refusal to disclose your number unless the disclosure is specifically authorized by the statute or regulation adopted before January 1, 1975, or by a later act of Congress. Moreover, in requesting your social security number, agencies are required to tell you whether the disclosure is mandatory or voluntary, under what law or regulation the request is authorized, and what uses will be made of the number. You should bear in mind, however, that this provision applies only to government agencies. It does not apply to the private sector; requests made directly to you for your social security number by private organizations are not prohibited by law.

*All federal agencies must publish annually in the Federal Register the "routine uses" of the information they maintain.

†This is the only provision in the Privacy Act that applies to state and local as well as federal agencies.

Federal Information Centers

The General Services Administration has established a number of Federal Information Centers across the country to serve as a single source for citizens to turn to for information from the government. The types of information provided include:

How to protect one's rights to a game one has invented so that no one else can copy it.
Which office is responsible for setting time zones and daylight savings time.
Assistance available for prospective home buyers.

For information and help on your questions about the federal government, use the following list to call the nearest Federal Information Center:

Alabama
Birmingham/205-322-8591. Toll-free tieline to Atlanta, GA.
Mobile/205-438-1421. Toll-free tieline to New Orleans, LA.

Alaska
Anchorage/907-271-3650. Federal Building and U.S. Courthouse, 701 C St., 99513.

Arizona
Phoenix/602-261-3313. Federal Building, 230 N. First Ave., 85025.
Tucson/602-622-1511. Toll-free tieline to Phoenix.

Arkansas
Little Rock/501-378-6177. Toll-free tieline to Memphis, TN.

California
Los Angeles/213-688-3800. Federal Building, 300 N. Los Angeles St., 90012.
Sacramento/916-440-3344. Federal Building and U.S. Courthouse, 650 Capital Mall, 95814.
San Diego/714-293-6030. Federal Building, 880 Front St., Room 1S11, 92188.
San Francisco/415-556-6600. Federal Building and U.S. Courthouse, 450 Golden Gate Ave., P.O. Box 36082, 94102
San Jose/408-275-7422. Toll-free tieline to San Francisco.
Santa Ana/714-836-2386. Toll-free tieline to Los Angeles.

Colorado
Colorado Springs/303-471-9491. Toll-free tieline to Denver.
Denver/303-837-3602. Federal Building, 1961 Stout St., 80294.
Pueblo/303-544-9523. Toll-free tieline to Denver.

Connecticut
Hartford/203-527-2617. Toll-free tieline to New York City.
New Haven/203-624-4720. Toll-free tieline to New York City.

District of Columbia
Washington/202-755-8660. 7th and D Sts. S.W., Room 5716, 20407.

Florida
Fort Lauderdale/305-522-8531. Toll-free tieline to Miami.
Jacksonville/904-354-4756. Toll-free tieline to St. Petersburg.
Miami/305-350-4155. Federal Building, 51 S.W. 1st Ave., 33130.
Orlando/305-422-1800. Toll-free tieline to St. Petersburg.
St. Petersburg/813-893-3495. William C. Cramer Federal Building, 144 1st Ave. S., 33701.
Tampa/813-229-7911. Toll-free tieline to St. Petersburg.
West Palm Beach/305-833-7566. Toll-free tieline to Miami.
Northern Florida—Sarasota, Manatee, Polk, Osceola, Orange, Seminole, and Volusia counties and north/800-432-6668. Toll-free tieline to St. Petersburg.
Southern Florida—Charlotte, De Soto, Hardee, Highlands, Okeechobee, Indian River, and Broward counties and south/800-432-6668. Toll-free tieline to Miami.

Georgia
Atlanta/404-221-6891. Federal Building and U.S. Courthouse, 75 Spring St. S.W., 30303.

Hawaii
Honolulu/808-546-8620. Federal Building, 300 Ala Moana Blvd., P.O. Box 50091, 96850.

Illinois
Chicago/312-353-4242. Everett McKinley Dirksen Building, 219 S. Dearborn St., Room 250, 60604.

Indiana
Gary–Hammond/219-883-4110. Toll-free tieline to Indianapolis.
Indianapolis/317-269-7373. Federal Building, 575 N. Pennsylvania, 46204.

Iowa
Des Moines/515-284-4448. Federal Building, 210 Walnut St., 50309.
Other Iowa locations: 800-532-1556/toll-free tieline to Des Moines.

Kansas
Topeka/913-295-2866. Federal Building and U.S. Courthouse, 444 S.E. Quincy, 66684.

Other Kansas locations: toll-free tieline to Topeka/800-432-2934.

Kentucky
Louisville/502-582-6261. Federal Building, 600 Federal Place, 40202.

Louisiana
New Orleans/504-589-6696. U.S. Postal Service Building, 701 Loyola Ave., Room 1210, 70113.

Maryland
Baltimore/301-962-4980. Federal Building, 31 Hopkins Plaza, 21201.

Massachusetts
Boston/617-223-7121. J.F.K. Federal Building, Cambridge St., Room E-130, 02203.

Michigan
Detroit/313-226-7016. McNamara Federal Building, 477 Michigan Ave., Room 103, 48226.
Grand Rapids/616-451-2628. Toll-free tieline to Detroit.

Minnesota
Minneapolis/612-725-2073. Federal Building and U.S. Courthouse, 110 S. 4th St., 55401.

Missouri
Kansas City/816-374-2466. Federal Building, 601 E. 12th St., 64106.
St. Louis/314-425-4106. Federal Building, 1520 Market St., 63103
Other Missouri locations within area code 314: 800-392-7711/toll-free tieline to St. Louis.
Other Missouri locations within area codes 816 and 417: 800-892-5808/toll-free tieline to Kansas City.

Nebraska
Omaha/402-221-3353. U.S. Post Office and Courthouse, 215 N. 17th St., 68102.
Other Nebraska locations: 800-642-8383/toll-free tieline to Omaha.

New Jersey
Newark/201-645-3600. Federal Building, 970 Broad St., 07102.
Paterson–Passaic/201-523-0717. Toll-free tieline to Newark.
Trenton/609-396-4400. Toll-free tieline to Newark.

New Mexico
Albuquerque/505-766-3091. Federal Building and U.S. Courthouse, 500 Gold Ave. S.W., 87102.
Santa Fe/505-983-7743. Toll-free tieline to Albuquerque.

New York
Albany/518-463-4421. Toll-free tieline to New York City.

Buffalo/716-846-4010. Federal Building, 111 W. Huron, 14202.
New York/212-264-4464. Federal Building, 26 Federal Plaza, Room 1-114, 10278.
Rochester/716-546-5075. Toll-free tieline to Buffalo.
Syracuse/315-476-8534. Toll-free tieline to Buffalo.

North Carolina
Charlotte/704-376-3609. Toll-free tieline to Atlanta, GA.

Ohio
Akron/216-375-5638. Toll-free tieline to Cleveland.
Cincinnati/513-684-2801. Federal Building, 550 Main St., 45202.
Cleveland/216-522-4040. Federal Building, 1240 E. 9th St., 44199.
Columbus/614-221-1014. Toll-free tieline to Cincinnati.
Dayton/513-223-7377. Toll-free tieline to Cincinnati.
Toledo/419-241-3223. Toll-free tieline to Cleveland.

Oklahoma
Oklahoma City/405-231-4868. U.S. Post Office and Courthouse, 201 N.W. 3rd St., 73102.
Tulsa/918-584-4193. Toll-free tieline to Oklahoma City.

Oregon
Portland/503-221-2222. Federal Building 1220 S.W. 3rd Ave., Room 109, 97204.

Pennsylvania
Allentown–Bethlehem/215-821-7785. Toll-free tieline to Philadelphia.
Philadelphia/215-597-7042. Federal Building, 600 Arch St., 19106.
Pittsburgh/412-644-3456. Federal Building, 1000 Liberty Ave., 15222.
Scranton/717-346-7081. Toll-free tieline to Philadelphia.

Rhode Island
Providence/401-331-5565. Toll-free tieline to Boston, MA.

Tennessee
Chattanooga/615-265-8231. Toll-free tieline to Memphis.
Memphis/901-521-3285. Clifford Davis Federal Building, 167 N. Main St., 38103.
Nashville/615-242-5056. Toll-free tieline to Memphis.

Texas
Austin/512-472-5495. Toll-free tieline to Houston.
Dallas/214-767-8585. Toll-free tieline to Fort Worth.
Fort Worth/817-334-3624. Lanham Federal Building, 819 Taylor St., 76102.
Houston/713-226-5711. Federal Building and U.S. Courthouse, 515 Rusk Ave., 77208.

San Antonio/512-224-4471. Toll-free tieline to Houston.

Utah
Ogden/801-399-1347. Toll-free tieline to Salt Lake City.
Salt Lake City/801-524-5353. Federal Building, 125 S. State St., Room 1205, 84138.

Virginia
Newport News/804-244-0480. Toll-free tieline to Norfolk.
Norfolk/804-441-3101. Federal Building, 200 Granby Mall, Room 120, 23510.
Richmond/804-643-4928. Toll-free tieline to Norfolk.
Roanoke/703-982-8591. Toll-free tieline to Norfolk.

Washington
Seattle/206-442-0570. Federal Building, 915 2nd Ave., 98174.
Tacoma/206-383-5230. Toll-free tieline to Seattle.

Wisconsin
Milwaukee/414-271-2273. Toll-free tieline to Chicago, IL.

Government Publications

There are three main distributors of government publications: the Government Printing Office, the Consumer Information Center and the National Technical Information Services. Below is a brief description of each of these organizations along with a sampling of their best-selling titles.

It should be noted that these organizations only represent about fifty percent of what is published by the federal government. The remaining publications are available directly from the departments or agencies. You should also be aware that many of the titles that are sold by these organizations are also available at no cost, and with much faster service, directly from the publishing department or agency.

Government Printing Office

Superintendent of Documents, Washington, D.C. 20402/202-783-3238. Sells through mail orders and government bookstores more than 25,000 different publications that originated in various government agencies. (For more complete information see description listed under "Legislative Branch.")

BEST-SELLERS
Infant Care (017-091-00228-2—$2.25)
Prenatal Care (017-091-00187-1—$2.25)
Your Child From 1 to 6 (017-091-00219-3—$2.00)

Your Child From 6 to 12 (017-091-00070-1—$2.50)
Rescue Breathing (wallet-size card) (017-001-00145-7—$5.00 for 100)
Metric Conversion (wallet-size card) (003-003-01068-5—$6.50 for 100)
United States Postage Stamps (039-000-00224-8—$8.00)
Federal Benefits for Veterans and Dependents (051-000-00156-7—$4.25)
U.S. Government Manual (022-003-01075-1—$11.00)

Consumer Information Center

Pueblo, Colorado 81009. Established to encourage federal agencies to develop and release useful consumer information and to increase public awareness of this information

BEST-SELLERS FOR FREE
Some Facts and Myths About Vitamins (552J)
Occupations in Demand (533J)
Can I Really Get Free or Cheap Public Land? (591J)
Consumer's Resource Handbook (619J)
Being Your Own Boss (539J)
Arthritis (577J)
Nutrition and Your Health (548J)
Tips for Energy Savers (601J)
How To Deal with Motor Vehicle Emergencies (506J)
Salt (550J)

BEST-SELLERS FOR SALE
Backyard Mechanic—Volume I (101J—$1.60), *Volume II* (102J—$1.60)
Matching Personal and Job Characteristics (125J—$1.25)
Removing Stains from Fabrics (184J—$1.20)
Starting and Managing a Small Business of Your Own (129J—$3.50)
The Job Outlook in Brief (124J—$1.50)
Fats in Food and Diet (130J—$1.00)
Selecting and Financing a Home (159J—$1.50)
Federal Benefits for Veterans and Dependents (181J—$2.00)
Exercise and Weight Control (144J—$1.25)
Canker Sores and Fever Blisters (147J—$1.00)

National Technical Information Service (NTIS)

Department of Commerce, 5285 Port Royal Rd., Springfield, VA 22161/703-487-4600. The central source for the public sale of U.S. and foreign government-sponsored research, development and engineering reports and other analyses prepared by national and local government agencies, their contractors or grantees, or by Special Technology Groups. For more complete information see description listed under U.S. Department of Commerce.

BEST-SELLERS

The Directory of Computer Software and Related Technical Reports (PB80-11-0232—$40.00)

Evaluation of Surface Mining Blasting Procedures (PB80-148653—$15.00)

Passive Solar Design Handbook, Volume 1 (DOE/CS-0127/1—$27.00)

Passive Solar Design Handbook, Volume 2 (DOE/CS-1027/1—$31.50)

Samplers and Sampling Procedures for Hazardous Waste Streams (PB80-135353—$10.50)

The Soviet Economy in 1978–1979 and Prospects for 1980 (PB80-928112—$9.50)

Siting Handbook for Small Wind Energy Conversion Systems (PNL-2521—$12.00)

An Inexpensive Economical Solar Heating System for Homes (N76-27671—$9.00)

Electromagnetic Compatibility Standard for Medical Devices (PB80-180284—$9.00)

A Private Pension Forecasting Model (PB80-169667—$19.50)

Hotlines

The following toll-free numbers handle complaints or provide information to the public.

ACTION

Information on the Peace Corps: 800-424-8580. DC: 202-254-6886.

Agriculture, Department of

Fraud, waste and abuse hotline for whistleblowers: 800-424-9121. DC: 202-472-1388.
 Farmers' News: 900-976-0404.

Commodity Futures Trading Commission

Information on commodity brokers: 800-424-9838. DC: 202-254-8630.

Consumer Product Safety Commission

Product recall information, complaints, and fact sheets: 800-638-8326. Maryland: 800-492-8363. Alaska and Hawaii: 800-638-8333.

Defense, Department of

To collect information from those who participated in nuclear weapons tests in Nevada or Marshall Islands from 1945 to 1962, and from anyone who went into Japan three months after the nuclear bombs were dropped: 800-336-3068. DC: 202-274-9161. Alaska and Hawaii: 800-422-9213.

Retired Army Pay: 800-428-2290. Indiana: 317-542-3911 (call collect).
 Army recruiting: 800-431-4422. New York: 800-423-2244.
 Marine Corps recruiting: 800-423-2600. California: 800-252-0241.
 Navy recruiting: 800-841-8000. Georgia: 800-342-5855.

Education, Department of

DC: 202-472-2729. Consumer education resource network: 800-336-0223. Virginia: 703-522-4616 (call collect).
 Information clearinghouse on bilingual education: 800-522-4560. Virginia: 703-522-0710 (call collect).
 Information on financial aid for college education: 800-638-6700. Maryland: 800-492-6602.

Energy, Department of

News: 800-424-9128. DC: 202 252-9500.
 News in Spanish: 800-424-9129 (Mon., Wed., Fri. only)
 Complaints on gasoline and heating oil supplies and prices: 202-633-8755.
 Information on energy conservation: 800-424-9040. DC: 202-252-5568.
 Renewable energy: 800-523-2929. Pennsylvania: 800-462-4983. Alaska and Hawaii: 800-523-4700.

Environmental Protection Agency

Information on dangerous chemicals 800-424-9065: DC: 202-554-1404

Emergency Management Agency, Federal

Flood insurance information: 800-683-6620. DC: 202-472-2381 or 897-5900. Puerto Rico, Alaska, Virgin Islands, Hawaii: 800-638-6831. Maryland: 301-652-2631 (call collect).
 Crime insurance information: 800-638-8780. Maryland and DC: 202-652-2637.

Export/Import Bank

Small Business Advisory Hotline Service: 800-424-5201 or 800-424-5202. DC: 202-566-8860.

Federal Deposit Insurance Corporation

Banking complaints and information: 800-424-5488. DC: 202-389-4797.

Federal Election Commission

Information on political fund raising laws: 800-424-9530. DC: 202-523-4068.

General Accounting Office

Fraud, waste and abuse hotline for whistle-blowers: 800-424-5454. DC: 202-633-6987.

General Services Administration

Sexual harassment of GSA Employees: 800-424-5210: DC: 202-566-1780.

Fraud, waste and abuse hotline for whistle-blowers: 800-424-5210: DC: 202-566-1780.

Health and Human Services, Department of

Second opinion on non-emergency surgery: 800-638-6833. Maryland: 800-492-6603.

Cancer information: 800-638-6694. Maryland: 800-492-1444.

Medical scholarships from Health Services Corps: 800-638-0824. Maryland: 301-436-6453.

VD hotline: 800-227-8922. California: 800-982-5883.

Advice for children and parents of runaways: 800-621-4000. Illinois: 800-972-6004.

Assistance for Indochinese refugees: 800-424-0212. DC: 202-245-0061.

Assistance on legal problems facing refugees and their sponsors: 800-334-0074. North Carolina: 919-682-0315 (call collect).

Information vocations and on teaching English to Indochinese refugees: 800-424-3750. Washington, DC: 202-298-9292.

If denied treatment at a health care facility because you are on Medicare or Medicaid: 800-638-0742. Maryland: 800-492-0359.

Housing discrimination complaints: 800-424-8590: DC: 202-426-3500.

News: 800-424-8530. DC: 202-755-7395.

Interior, Department of

Abandoned mine land reclamation program: DC: 202-343-7931.

Interstate Commerce Commission

Complaints on moving household goods: DC: 202-275-0860.

Library of Congress

Information on programs and books for the blind and physically handicapped: 800-221-4792: DC: 202-727-2142.

Small Business Administration

Business publications: 800-433-7212. Texas: 800-792-9801.

Transportation, Department of

News: DC: 202-426-8058.

Complaints and information on auto safety: 800-424-9393. DC: 202-426-0123.

Coast Guard recruiting: 800-424-8883. DC: 202-426-7914.

To report oil spills: 800-424-8802. DC: 202-426-2675.

Treasury, Department of

Report thefts, losses or discoveries of explosive materials: DC: 202-566-7777.

Recorded Messages

The following recorded messages will give you information today that you are likely to read in the newspaper tomorrow.

Agriculture, Department of/Consumers' spot news/202-488-1110/Farmers' newsline (outside DC)/900-976-0404 (costs 50¢)/National grain market summary/202-447-8233/Features and highlights/202-488-8358.

Botanic Garden, U.S./Upcoming activities/202-225-7099.

Commerce, Department of/Economic News/202-393-4100/News highlights/202-393-1847/Weekend preview/202-393-4102.

Economic News Highlights/Joint Economic Committee of the Congress/202-224-3081.

Education, Department of/News/202-472-2729.

Energy, Department of/News/800-424-9128/202-252-9500/News in Spanish/ 800-424-9129.

Federal Communications Commission/News/202-632-0002.

Federal Energy Regulatory Commission/Actions/202-357/8555.

Federal Register/News on government policy: Washington, DC/202-523-5022/Chicago, IL/312-663-0884/Los Angeles, CA/213-688-6694.

Federal Trade Commission/Meetings/202-523-3806/News/202-523-3540.

Government Jobs/Federal Job Information Center/202-737-9616/Agriculture,

Department of/202-447-2108/Energy, Department of/202-252-4333/Environmental Protection Agency/202-755-5055/General Accounting Office/202-275-6361/Government Printing Office/202-275-2183/Housing and Urban Development, Department of/202-755-3203/Interior, Department of/202-343-2154/Justice, Department of/202-633-3121/National Institutes of Health/301-496-1209/National Oceanic and Atmospheric Administration/301-443-8274/Smithsonian Institution/202-357-1452/State, Department of/202-632-0580.

House of Representatives, U.S./Floor activity, Democrat/202-225-7400/Floor activity, Republican/202-225-7430/Democratic legislative program/202-225-1600/Republican legislative program/202-225-2020.

Housing and Urban Development, Department of/News/800-424-8530/202-755-7395.

Interior, Department of/News/202-343-3020.

Labor, Department of/Press release information/202-523-6899.

National Capital Parks/Washington, DC Area Activities/202-426-6975.

President's Daily Schedule/News/202-456-2343.

Senate/Floor activity, Democrat/202-224-8541/Floor activity, Republican/202-224-8601.

Smithsonian Institution/Dial-A-Museum/202-357-2020/Dial-A-Phenomenon/202-357-2000.

Transportation, Department of/News/800-484-8807/202-426-1921.

Treasury, Department of/A lesson in government securities/202-287-4091/Auction results and auction dates for government securities/202-287-4100.

Time Within Milli-seconds/Naval Observatory Master Clock/202-254-4950.

White House/News outside Washington, DC/800-424-9090.

Regional Offices

If you are not located in Washington, DC, and you are looking for information from a particular department or agency, start by contacting your nearest regional office. This can save you a lot of time and money in correspondence and telephone calls. A regional office may very often have the information you need or know exactly where to get it in Washington, DC. However, beware: The regional office may tell you that the information you need is *not* available. Don't necessarily stop your search. Try looking in Washington, DC for yourself. It is impossible for people in the field to be aware of everything that is available in Washington. (The people in Washington often don't even know.)

Following are the names, addresses and telephone numbers of all the government's major regional offices.

Department of Agriculture

Agricultural Marketing Service, Fruit and Vegetable Division, Regulatory Branch

Chicago, IL 60607: 610 Canal St./312-353-6220.

Fort Worth, TX 76102: Federal Building, 819 Taylor St./817-334-2624.

Los Angeles, CA 90013: 417 S. Hill St./213-798-3194.

New York, NY 10007: Federal Building, 26 Federal Plaza/212-264-1118.

Washington, DC 20250: 14th & Independence Ave. S.W./202-447-4180.

Agricultural Marketing Service, Information Division

Chicago, IL 60605: 536 S. Clark St./312-353-3631.

Dallas, TX 75242: 1100 Commerce St./214-729-0044.

New York, NY 10278: 26 Federal Plaza/212-264-1145.

Atlanta, GA 30309: 1718 Peachtree St. N.W./404-257-4154.

San Francisco, CA 94111: 630 Sansome St./415-556-6464.

Agricultural Marketing Service, Livestock, Poultry, Grain and Seed Division, Livestock Market News Areas

Eastern: 14th and Independence Ave. S.W., Washington, DC 20250/202-447-6231.

Western: Livestock Exchange Building, Omaha NB 68107/402-731-2014.

Nationwide (meat only): 14th St. and Independence Ave. S.W., Washington, DC 20250/202-447-6231.

Agricultural Marketing Service, Livestock, Poultry, Grain and Seed Division, Seed Regulatory Branch Laboratories

Montgomery, AL 36104: 474 S. Court St./205-832-7268.

Sacramento, CA 95808: Federal Building, P.O. Box 1641/916-449-3134.

Minneapolis, MN 55401: Federal Office Building/612-725-2923.

North Brunswick, NJ 08902: 825 Georges Rd./201-846-4500 ext. 288.

Agricultural Marketing Service, Packers and Stockyards Division

Bedford, VA 24523: Turnpike Rd., Box 101E/703-982-4330.

Atlanta, GA 30309: 1720 Peachtree St. N.W./404-881-4845.

Denver, CO 80216: 208 Livestock Exchange Building/303-837-3312.

Fort Worth, TX 76102: 819 Taylor St./817-334-3286.

Indianapolis, IN 46227: 537 Turtle Creek South Dr./317-269-6424.

Kansas City, MO 64102: 828 Livestock Exchange Building/816-374-2368.

Lawndale, CA 90261: 15000 Aviation Blvd./213-536-6687.

Memphis, TN 38103: 167 N. Main St./901-521-3414.

North Brunswick, NJ 08902: 525 Milltown Rd./201-246-0060.

Omaha, NB 68107: 909 Livestock Exchange Building/402-221-3391.

Portland, OR 97223: 9370 S.W. Greenburg Rd./503-221-2687.

South Saint Paul, MN 55075: 203 Post Office Building/612-451-6897.

Springfield, IL 62704: 975 Durkin Dr./217-525-4353.

Agricultural Marketing Service, Tobacco Division

Raleigh, NC 27611: 1306 Annapolis, Dr/919-755-4552.

Lexington, KY 40504: 333 Waller Ave., Suite 401-407/606-233-2613.

Washington, DC 20250: 300 12th St. S.W., Room 501/202-447-2567.

Agricultural Marketing Service, Warehouse Division

Atlanta, GA 20209: 1718 Peachtree St. N.W., Room 202/404-257-4924.

Indianapolis, IN 46224: 5610 Crawfordsville Rd./317-331-6396.

Minneapolis, MN 55415: 400 S. 4th St./612-725-2825.

Omaha, NB 68102: 106 S. 1st St., Room 810/402-864-4684.

Yuba City, CA 95991: 256 Cariage Sq./916-674-7660

Memphis, TN 38103: 167 N. Main St./901-534-3838.

Temple, TX 76501: 101 S. Main St./817-736-1281.

Agricultural Stabilization and Conservation Service

Northeast: Room 3720-S, P.O. Box 2415, Washington, DC 20013/202-447-4746.

Southeast: Room 3715-S, P.O. Box 2415, Washington, DC 20013/202-447-3593.

Midwest: Room 3709-S, P.O. Box 2415, Washington, DC 20013/202-447-3953.

Northwest: Room 3714-S, P.O. Box 2415, Washington, DC 20013/202-447-6941.

Southwest: Room 3721-S, P.O. Box 2415, Washington DC 20013/202-447-7889.

Animal and Plant Health Inspection Service, Plant Protection and Quarantine

Moorestown, NJ 08057: 505 S. Lenola Rd./609-235-9120.

Gulfport, MS 39501: P.O. Box 989/601-499-2603.

Alameda, CA 94501: 620 Central Ave./415-273-6041.

Brownsville, TX 78521: 2100 Boca Chica Blvd./512-542-7231.

Animal and Plant Health Inspection Service, Veterinary Services

South Central: 221 Lancaster Ave., Fort Worth, TX 76102/817-870-5566.

Northern: GSA Depot Building 12, Scotia, NY 12302/518-370-5026.

Southeastern: 700 Twiggs St., Rm. 821, Tampa, FL 33601/813-228-2952.

North Central: 240 W. 26th Ave., Rm. 237, Denver, CO 80211/303-837-3481.

Western: 245 E. Liberty St., Rm. 300, Reno, NV 89501/702-784-5801.

Federal Crop Insurance Corporation, Field Underwriting Offices

Billings, MT 59102: 2401 Grande Ave./406-657-6447.

Harrisburg, PA 17109: 75 S. Houcks Rd., Suite 320, 717-782-4807.

Jackson, MS 39201: 656 N. State St., Room 301/601-969-4771.

Oklahoma City, OK 73102: 200 N.W. 5th St./405-231-5057.

Raleigh, NC 27601: 300 Fayetteville St./919-755-4040.

St. Paul, MN 55101: 180 E. Kellogg Blvd., Room 827/612-725-5804.

Spokane, WA 99206: N. 112 University Rd., Suite 200/509-456-2147.

Springfield, IL 62701: 524 S. 2nd St., Suite 675/217-525-4186.

Topeka, KS 66603: 444 S.E. Quincy St., Room 310/913-295-2570.

Valdosta, GA 31601: 401 N. Patterson St., Room 239/912-242-3044.

Federal Crop Insurance Corporation, Regional Offices

Billings, MT 59102: 2401 Grand Ave./406-657-6196.

Bismarck, ND 58501: 220 E. Rosser Ave., Room 234/701-255-4011.

College Station, TX 77840: USDA Building/713-846-8821.

Columbia, MO 65201: 700 E. Cherry Rd., Room 201/314-442-2271.

Columbia, SC 29201: 1835 Assembly St./803-765-5766.

Des Moines, IA 50309: 210 Walnut St./515-284-4316.

Harrisburg, PA 17109: 75 S. Houcks Rd., Suite 320/717-782-4803.

Huron, SD 57350: 200 4th St. S.W./605-352-8651.

Indianapolis, IN 46224: 5610 Crawfordsville Rd., Suite 1501/317-269-6527.

Jackson, MS 39201: 100 W. Capitol St./601-969-4328.

Lincoln, NB 68508: 100 Centennial Mall, Room 443/402-471-5531.

Manhattan, KS 66502: 2601 Anderson Ave./913-537-4980.

Nashville, TN 37203: U.S. Courthouse, Room 508/615-251-5591.

Raleigh, NC 27611: 310 New Bern Building, Room 610/919-755-4470.

St. Paul, MN 55101: 316 Robert St., Room 222/612-725-5871.

Spokane, WA 99201: W. 920 Riverside Ave., Room 369/509-456/3763.

Springfield, IL 62701: 600 E. Monroe St., Room 134/217-525-4281.

Federal Grain Inspection Service

Atlanta, GA 30309: 1720 Peachtree St., Suite 338/404-881-7910.

Chicago, IL 60607: 433 W. Van Buren St., Room 929/312-353-2744.

Kansas City, MO 64105: Midland Building, 12th Floor, 1221 Baltimore Ave./816-842-9160.

Rockwell, TX 75087: 2313 Ridge Rd., Suite 105/214-226-7061.

Seattle, WA 98134: Federal Center S. Building 1201, Room 1103, 4735 E. Marginal Way S./206-764-3825.

Food and Nutrition Service

Burlington, MA 01803: 33 North Ave N./617-272-4272.

Robbinsville, NJ 08691: 1 Vahlsing Center/609-259-3041.

Chicago, IL 60605: 536 S. Clark St./312-353-6664.

Atlanta, GA 30309: 1100 Spring St. N.W./404-881-4131.

Dallas, TX 75242: 1100 Commerce St./214-749-0222.

San Francisco, CA 94108: 550 Kearny St./415-556-4950.

Denver, CO 80211: 2420 W. 26th Ave./303-837-5339.

Food Safety and Quality Service, Fruit and Vegetable Division, Fresh Products Standardization and Inspection Branch

Washington, DC 20250: 14th St. & Independence Ave. S.W./202-447-5870.

Chicago, IL 60607: 610 S. Canal St./312-353-6225.

San Francisco, CA 94111: 630 Sansome St./415-556-3845.

Falls Church, VA 22041: 5205 Leesburgh Pike/703-557-2550.

Food Safety and Quality Service, Fruit and Vegetable Division, Processed Products Standardization and Inspection

Washington, DC 20250: 14th St. & Independence Ave. S.W./202-447-4693.

Chicago, IL 60607: 610 S. Canal St./312-353-6217.

Winter Haven, FL 33880: 98 3rd St. S.W./813-294-4218.

San Jose, CA 95113: 111 W. St. John St., Suite 416/408-275-7253.

Food Safety and Quality Service, Meat and Poultry Inspection

Des Moines, IA 50316: 607 E. 2nd St./515-284-4042.

Atlanta, GA 30309: 1718 Peachtree St. N.W./404-881-3911.

Alameda, CA 94501: 620 Central Ave./415-273-7402.

Philadelphia, PA 19102: 1421 Cherry St./215-597-4217.

Dallas, TX 75201: 1100 Commerce St./214-749-3747.

Food Safety and Quality Service, Meat Quality Division

Amarillo, TX 79120: 101 Manhattan St./806-372-7361.

Atlanta, GA 30309: 1718 Peachtree St. N.W./404-881-4158.

Bell, CA 90201: 4747 Eastern Ave./213-265-0536.

Chicago, IL 60609: 4101 S. Halsted St./312-353-5751.

Denver, CO 80216: 206 Livestock Exchange Building/303-837-4088.

Kansas City, MO 64106: 811 Grand Ave./816-842-3808.

Martinez, CA 94553: P. O. Building, 815 Court St./415-229-2800.

Omaha, NB 68107: 723 Livestock Exchange Building/402-731-2014.

Princeton, NJ 98549: 1101 State Rd., Building E/609-921-3305.

Sioux City, IA 51107: 225 Livestock Exchange Building/712-252-3287.

South St. Paul, MN 55075: 236 N. Concorde St./612-451-6877.

Food Safety and Quality Service, Poultry and Dairy Quality Division, Dairy Inspection

San Francisco, CA 94111: 630 Sansome St./415-556-5585.

Chicago, IL 60607: 610 S. Canal St./312-353-6680.

Minneapolis, MN 55401: 110 S. 4th St./612-725-2246.

Syracuse, NY 13260: 100 S. Clinton St./315-423-5325.

Food Safety and Quality Service, Poultry and Dairy Quality Division, Poultry Grading

Gastonia, NC 28052: 469 Hospital Dr./704-867-3871.

Little Rock AK 72215: #1 Natural Resources Dr./501-378-5955.

Des Moines, IA 50309: 210 Walnut St./515-284-4581.

Modesto, CA 95355: World Plaza Building, 1508 Coffee Rd./209-946-6484.

Forest Service, Forest and Range Experiment Stations

Broomall, PA 19008: 370 Reed Rd./215-461-3008.

Asheville, NC 28802: Post Office Building, P. O. Box 2570/704-258-2850.

St. Paul, MN 55108: 1992 Folwell Ave./612-642-0249.

New Orleans, LA 70113: 701 Loyola Ave./504-589-6787.

Madison, WI 53705: N. Walnut St./608-264-5600.

Fort Collins, CO 80521: 240 W. Prospect St./303-221-4390.

Ogden, UT 84401: 507 25th St./801-626-3361.

Portland, OR 97208: 809 N.E. 6th Ave./503-231-2052.

Berkeley, CA 94701: 1960 Addison St./415-486-3291.

Forest Service, National Forest System

Missoula, MT 59807: Federal Building/406-329-3011.

Lakewood, CO 80225: 11177 W. 8th Ave./303-234-3711.

Albuquerque, NM 87102: 517 Gold Ave. S.W./505-766-2401.

Ogden, UT 84401: 324 25th St./801-626-3011.

Milwaukee, WI 53203: 633 W. Wisconsin Ave./414-291-3693.

Atlanta, GA 30367: 1720 Peachtree Rd. N.W./404-881-4177.

Portland, OR 97208: 319 S.W. Pine St./503-221-3625.

San Francisco, CA 94111: 630 Sansome St./415-556-4310.

Juneau, AK 99802: Federal Office Building/907-586-7263.

Forest Service, State and Private Forestry

Missoula, MT 59801: Federal Building/406-329-3011.

Lakewood, CO 80225/11177 W. 8th Ave./303-234-3711.

Albuquerque, NM 87102: 517 Gold Ave. S.W./505-766-2401.

Ogden, UT 84401: 324 25th St./801-626-3011.

Broomall, PA 19008: 370 Reed Rd./215-461-3124.

San Francisco, CA 94111: 630 Sansome St./415-556-4310.

Portland, OR 97208: 319 S.W. Pine St./503-221-3625.

Juneau, AK 99801: Federal Office Building/907-586-7263.

Atlanta, GA 30309: 1720 Peachtree Rd. N.W./404-881-7930.

Broomall, PA 19008: 370 Reed Rd./215-461-3124.

Office of the General Counsel

Atlanta, GA 30309: 1371 Peachtree St. N.E./404-257-4161.

Chicago, IL 60606: 230 S. Dearborn St./312-353-5640.

Denver, CO 80202: 817 17th St./303-837-4031.

Harrisburg, PA 17108: 228 Walnut St./717-782-3713.

Little Rock, AR 72201: 700 W. Capitol St./501-378-5246.

Milwaukee, WI 52303: 633 W. Wisconsin Ave./414-291-3774.

Portland, OR 97204: 1220 S.W. 3rd Ave./503-221-3115.

San Francisco, CA 94111: 2 Embarcadero Center, #860/415-556-4532.

Kansas City, MO 64141: 9435 Holmes St./816-926-7710.

Temple, TX 76501: 101 S. Main St., Suite 351/817-773-1711.

Office of the Inspector General, Audit Operations

Hyattsville, MD 20782: Federal Center Building, Room 422/301-436-8763.

Atlanta, GA 30309: 1447 Peachtree St. N.E., Room 900/404-881-3675.

Chicago, IL 60606: 1 N. Wacker Dr., Room 800/ 312-353-1352.

Temple, TX 76501: 101 S. Main St., Room 324/ 817-774-1311.

Kansas City, MO 64141: 9435 Holmes St., P. O. Box 293/816-926-7657.

San Francisco, CA 94111: 555 Battery St., Room 522/415-556-4244.

Office of the Inspector General, Investigation Operations

New York, NY 10278: 26 Federal Plaza, Room 1707/212-264-8400.

Hyattsville, MD 20782: Federal Center Building, Room 4324/301-436-8850.

Atlanta, GA 30309: 1447 Peachtree St. N.E., Room 901/404-881-4377.

Chicago, IL 60606: 1 N. Wacker Dr., Room 800/ 312-353-1358.

Temple, TX 76501: 101 S. Main St., Room 311/ 817-774-1351.

Kansas City, MO 64141: 9435 Holmes St., Room 210, P. O. Box 293/816-926-7606.

San Francisco, CA 94111: 555 Battery St., Room 552/415-556-4245.

Rural Electrification Administration

Electric Areas: 14th and Independence Ave. S.W., South Building, Room 2815, Washington, DC 20250/202-447-2960.

Telephone Areas: 14th and Independence Ave. S.W., South Building, Room 3308, Washington, DC 20250/202-447-4731.

Science and Education Administration, Agricultural Research

Beltsville, MD 20705: Agricultural Research Center W./301-344-3418.

Peoria, IL 21615: 2000 W. Pioneer Pkwy./309-671-7176.

New Orleans, LA 70153: P. O. Box 53326/504-589-6753.

Oakland, CA 94612: 1333 Broadway, Suite 400/ 415-273-4191.

Soil Conservation Service, Technical Service Centers

Lincoln, NB 68508: Federal Building, U.S. Court House, Room 393/402-471-5346.

Portland, OR 97209: 511 N.W. Broadway/503-423-2824.

Broomall, PA 19008: 1974 Sproul Rd./215-596-5783.

Fort Worth, TX 76115: Fort Worth Federal Center, P. O. Box 6567/817-334-5456.

Department of Commerce

Secretarial Representatives

Region I: 441 Stuart St., 7th Floor, Boston, MA 02116/617-223-0695.

Region II: Federal Building, Room 3722, 26 Federal Plaza, New York, NY 10007/212-264-5647.

Region III: Wm. J. Green Federal Building, Room 10414, 600 Arch St., Philadelphia, PA 19106/215-597-7527.

Region IV: 1365 Peachtree St., Suite 300, Atlanta, GA 30309/404-881-3165.

Region V: CNA Building, Room 1402, 55 E. Jackson Blvd., Chicago, IL 60604/312-353-4609.

Region VI: Federal Building, Room 9C40, 1100 Commerce St., Dallas, TX 75242/214-767-8097.

Region VII: Federal Building, Room 1844, 601 E. 12th St., Kansas City, MO 64106/816-374-3961.

Region VIII: Title Building, Room 515, 909 17th St., Denver, CO 80202/303-837-4285.

Region IX: Federal Building, P. O. Box 36135, 450 Golden Gate Ave., San Francisco, CA 94102/415-556-5145.

Region X: Federal Building, Room 3206, 915 2d Ave., Seattle, WA 98174/206-442-5780.

Bureau of the Census

Boston, MA 02116: 441 Stuart St./617-223-2327.

New York, NY 10007: 26 Federal Plaza/212-264-3860.

Philadelphia, PA 19106: 600 Arch St./215-597-4920.

Detroit, MI 48226: 231 W. Lafayette Blvd./313-226-7742.

Chicago, IL 60604: 55 E. Jackson Blvd./312-353-6251.

Kansas City, KS 66101: 4th & State Sts./816-374-4601.

Seattle, WA 98109: 1700 Westlake Ave. N./206-442-7800.

Charlotte, NC 28202: 230 S. Tryon St./ 704-371-6142.

Atlanta, GA 30309: 1365 Peachtree St., N.E./ 404/881-2271.

Dallas, TX 75242: 1100 Commerce St./214-767-0638.

Denver, CO 80225: 575 Union Blvd./303-234-3924.

Los Angeles, CA 90049: 11777 San Vincente Blvd./213-824-7317.

Economic Development Administration

Philadelphia, PA 19106: 105 N. 7th St., Room 600/215-597-4603.

Chicago, IL 60604: 175 W. Jackson Blvd., Suite A-1630/312-353-7706.

Denver, CO 80202: 909 17th St./303-837-4714.

Atlanta, GA 30309: 1365 Peachtree St., N.E./ 404-881-7401.

Austin, TX 78701: 221 W. 6th St./512-397-5461.

Seattle, WA 98109: 1700 Westlake Ave. N./206-442-0596.

Maritime Administration

New York, NY 10007: 26 Federal Plaza/212-264-1300.

New Orleans, LA 70130: 2 Canal St./504-589-6556.

San Francisco, CA 94102: 450 Golden Gate Ave./415-556-3816.

Kings Point, NY 11024: U.S. Merchant Marine Academy/516-482-8200.

Cleveland, OH 44114: 666 Euclid Ave./216-522-7617.

Minority Business Development Agency

Atlanta, GA 30309: 1371 Peachtree St. N.E./ 404-881-4091.

Chicago, IL 60603: 55 E. Monroe St./312-353-8375.

Dallas, TX 75242: 1100 Commerce St./214-767-8001.

New York, NY 10007: 26 Federal Plaza/212-264-3262.

San Francisco, CA 94102: 450 Golden Gate Ave./415-556-6733.

Washington, DC 20036: 1730 K St., N.W./202-634-7898.

National Oceanic and Atmospheric Administration, National Marine Fisheries Service

Juneau, AL 99802: P. O. Box 1668/907-586-7221.

Seattle, WA 98109: 1700 Westlake Ave. N./206-442-7575.

St. Petersburg, FL 33702: 9450 Koger Blvd./813-893-3141.

Gloucester, MA 01930: 14 Elm St./617-281-3600.

Terminal Island, CA 90731: 300 S. Ferry St./ 213-548-2575.

National Oceanic and Atmospheric Administration, National Weather Service

New York, NY 10112: 30 Rockefeller Plaza/212-399-5561.

Fort Worth, TX 76102: 819 Taylor St./ 817-334-2668.

Kansas City, MO 64106: 601 E. 12th St./816-374-5464.

Salt Lake City, UT 84147: 125 S. State St./801-525-5122.

Anchorage, AK 99501: 632 6th Ave./907-271-5136.

Honolulu, HI 96850: 300 Ala Moana Blvd./808-546-5680.

Department of Education

Interim Regional Coordinators

Region I: Office of Educational Programs, John F. Kennedy Federal Building, Room 2403, Boston, MA 02203/617-223-7500.

Region II: Office of Student Financial Assistance, 26 Federal Plaza, Room 3954, New York, NY 10007/264-4045.

Region III: Office of Student Financial Assistance, 3535 Market St., Philadelphia, PA 19104/215-596-1018.

Region IV: Office of Rehabilitation Services, 101 Marietta Tower Building, Atlanta, GA 30323/ 404-242-2352.

Region V: Office of Rehabilitation Services, 300 S. Wacker Dr., 15th Floor, Chicago, IL 60606/312-886-5360.

Region VI: Office of Educational Programs, 1200 Main Tower Building, Dallas, TX 75202/214-729-3626.

Region VII: Office of Educational Programs, Eleven Oak Building, 325 E. 11th St., Kansas City, MO 64106/816-758-2276.

Region VIII: Office of Rehabilitation Services, U.S. Customs House, 721 19th St., Room 195, Denver, CO 80294/303-327-2442.

Region IX: Office of Educational Programs, 50 United Nations Plaza, San Francisco, CA 94102/415-556-4920.

Region X: Office of Educational Programs, 1321 2d Ave., Room 509 M/S 1509, Seattle, WA 98101/206-399-0460.

Office for Civil Rights

Region I: 140 Federal St., 14th Floor, Boston, MA 02110/617-223-4248.

Region II: 26 Federal Plaza, 33d Floor, New York, NY 10007/212-264-5180.

Region III: Gateway Building, 3535 Market St., P. O. Box 13716, Philadelphia, PA 19101/215-596-6787.

Region IV: 101 Marietta St., 27th Floor, Atlanta, GA 30323/404-242-2954.

Region V: 300 S. Wacker Dr., Chicago, IL 60606/312-353-2520.

Region VI: 1200 Main Tower Building, Room 1930, Dallas, TX 75202/214-729-3951.

Region VII: Twelve Grand Building, 7th Floor,

1150 Grand Ave., Kansas City, MO 64106/816-758-2223.

Region VIII: Federal Office Building, Room 1185, 1961 Stout St., Denver, CO 80294/303-327-5695.

Region IX: 1275 Market St., 14th Floor, San Francisco, CA 94103/415-556-8586.

Region X: 1321 2d Ave., M/S 723, Seattle, WA 98101/206-399-1922.

Office of the Inspector General

Region I: Audit Agency, Bulfinch Building, 7th Floor, 15 New Chardon St., Boston, MA 02114/617-223-1408.

Region II: Audit Agency, Federal Building, Room 3906, 26 Federal Plaza, New York, NY 10007/212-264-8442.

Region III: Audit Agency, 3535 Market St., Room 6100, P. O. Box 13716, Philadelphia, PA 19101/215-596-0262.

Region IV: Division of Compliance, P. O. Box 874, Atlanta, GA 30301/404-242-2087.

Region V: Audit Agency, 300 S. Wacker Dr., Room 3536, Chicago, ILL 60606/312-353-2621.

Region VI: Division of Compliance, One Main Place, P. O. Box 50687, Dallas, TX 75250/214-729-5315.

Region VII: Division of Compliance, P. O. Box 15248, Kansas City, MO 64106/816-758-6473.

Region VIII: Office of Investigations, Drawer 3546, Federal Office Building, Room 1334, 1961 Stout St., Denver, CO 80294/303-327-5621.

Region IX: Office of Investigations, 100 Van Ness St., 12th Floor, San Francisco, CA 94102/415-556-7747.

Region X: Audit Agency, Arcade Plaza Building, Room 604, 1321 2d Ave., Seattle, WA 98101/206-399-0452.

Office of Student Financial Assistance

Region I: Bulfinch Building, 7th Floor, 15 New Chardon St., Boston, MA 02114/617-223-7205.

Region II: 26 Federal Plaza, New York, NY 10007/212-264-4045.

Region III: P. O. Box 13716, 3535 Market St., Philadelphia, PA 19101/215-596-1018.

Region IV: 101 Marietta Tower, 3d Floor, Atlanta, GA 30323/404-242-5008.

Region V: 300 S. Wacker Dr., Chicago, IL 60606/312-353-8102.

Region VI: 1200 Main Tower Building, Dallas, TX 75202/214-729-4359.

Region VII: 324 E. 11th St., 19th Floor, Kansas City, MO 64106/816-758-5875.

Region VIII: 11037 Federal Office Building, 19th & Stout Sts., Denver, CO 80294/303-327-4128.

Region IX: 50 United Nations Pl., San Francisco, CA 94102/415-556-8382.

Region X: Arcade Building, M/S 1508, 1321 2d Ave., Seattle, WA 98101/206-399-0434.

Regional Directors For Educational Programs

Region I: John F. Kennedy Federal Building, Room 2403, Boston, MA 02203/617-223-7500.

Region II: 26 Federal Plaza, Room 3954, New York, NY 10278/212-264-4370.

Region III: 3535 Market St., Room 16400, Philadelphia, PA 19108/215-596-1001.

Region IV: 101 Marietta Tower Building, Room 2221, Atlanta, GA 30323/404-242-2063.

Region V: 300 S. Wacker Dr., Room 3214, Chicago, IL 60606/312-353-5215.

Region VI: 1200 Main Tower Building, Room 1460, Dallas, TX 75202/214-729-3626.

Region VII: Eleven Oak Building, 9th Floor, 324 E. 11th St., Kansas City, MO 64106/816-758-2276.

Region VIII: Federal Regional Office Building, Room 380, 1961 Stout St., Denver, CO 80202/303-327-3544.

Region IX: 50 United Nations Pl., Room 205, San Francisco, CA 94102/415-556-4920.

Region X: Arcade Plaza Building, Room 509 M/S 1509, 1321 2d Ave., Seattle, WA 98101/206-399-0460.

Rehabilitation Services Administration

Region I: John F. Kennedy Federal Building, Room E-400, Government Center, Boston, MA 02203/617-223-6820.

Region II: 26 Federal Plaza, Room 4106, New York, NY 10007/212-264-4016.

Region III: 3535 Market St., P. O. Box 13716, Philadelphia, PA 19101/215-596-0327.

Region IV: 101 Marietta St. N.W., Suite 903, Atlanta, GA 30323/404-242-2352.

Region V: 300 S. Wacker Dr., 31st Floor, Chicago, IL 60606/312-886-5372.

Region VI: 1200 Main Tower Building, Room 2040, Dallas, TX 75202/214-729-2961.

Region VII: 324 E. 11th St., Kansas City, MO 64106/816-758-2381.

Region VIII: U.S. Customs House, Room 195, 721 19th St., Denver, CO 80202/303-327-2442.

Region IX: Federal Office Building, 50 United Nations Plaza, San Francisco, CA 94102/415-556-7333.

Region X: Arcade Building, M/S 533, 1321 2d Ave., Seattle, WA 98101/206-399-5331.

Department of Energy

Regional Offices

Region I: 150 Causeway St., Room 700, Boston, MA 02114/617-223-3701.

Region II: 26 Federal Plaza, Room 3206, New York, NY 10007/212-264-4780.

Region III: 1421 Cherry St., Philadelphia, PA 19102/215-597-3890.

Region IV: 1655 Peachtree St. N.E., Atlanta, GA 30309/404-881-2837.

Region V: 175 W. Jackson Blvd., Room A-333, Chicago, IL 60604/312-353-8420.

Region VI: P. O. Box 35228, Dallas, TX 75235/ 214-767-7741.

Region VII: 325 E. 11th St., Kansas City, MO 64106/816-374-2061.

Region VIII: P. O. Box 26247, Belmar Branch, Lakewood, CO 80226/303-234-2420.

Region IX: 333 Market St., San Francisco, CA 94105/415-556-7216.

Region X: 1992 Federal Building, 915 2d Ave., Seattle, WA 98174/206-442-7285.

Federal Energy Regulatory Commission

Atlanta, GA 30308: 730 Peachtree St./404-257-4134.

Chicago, IL 60604: 230 S. Dearborn St./312-353-6171.

Fort Worth, TX 76102: 819 Taylor St./817-334-2631.

New York, NY 10278: 26 Federal Pl./212-264-3687.

San Francisco, CA 94111: 333 Market St./415-556-3581.

Power Administrations

Alaska: P. O. Box 50, Juneau, AK 99802/907-586-7405.

Southeastern: Samuel Elbert Building, Elberton, GA 30635/404-283-3261.

Southwestern: P. O. Drawer 1619, Tulsa, OK 74101/918-581-7474.

Bonneville: P. O. Box 3621, Portland, OR 97208/503-234-3361.

Western Area: P. O. Box 3402, Golden, CO 80401/303-234-7500.

Department of Health and Human Services

Health Care Financing Administration

Region I: John F. Kennedy Federal Building, Room 1309, Boston, MA 02203/617-223-6871.

Region II: 26 Federal Plaza, Room 3811, New York, NY 10218/212-264-4488.

Region III: P. O. Box 7760, Philadelphia, PA 19101/215-596-1351.

Region IV: 101 Marietta Tower, Suite 701, Atlanta, GA 30323/404-221-2329.

Region V: 175 W. Jackson Blvd., 8th Floor, Room A 835, Chicago, IL 60604/312-353-8057.

Region VI: 1200 Main Tower, Suite 2400, Dallas, TX 75202/214-767-6427.

Region VII: 601 E. 12th St., Room 235, Kansas City, MO 64106/816-374-5233.

Region VIII: 1961 Stout St., Room 626, Denver, CO 80294/303-837-2111.

Region IX: 100 Van Ness Ave., 14th Floor, San Francisco, CA 94102/415-556-0254.

Region X: Arcade Plaza Building, 1321 2d Ave., Seattle, WA 98101/206-442-0425.

Office of Child Support Enforcement

Region I: 150 Causeway St., Room 1300, Boston, MA 02114/617-223-1138.

Region II: 26 Federal Plaza, Room 4016, New York, NY 10278/212-264-4021.

Region III: 3535 Market St., P. O. Box 8409, Philadelphia, PA 19101/215-596-1396.

Region IV: 101 Marietta Tower, Suite 1801, Atlanta, GA 30323/404-221-2180.

Region V: 300 S. Wacker Dr., Chicago, IL 60606/312-353-5415.

Region VI: 1100 Commerce St., Room 8A20, Dallas, TX 75242/214-767-3749.

Region VII: 601 E. 12th St., Room 1759, Kansas City, MO 64106/816-374-3584.

Region VIII: Federal Office Building, 19th & Stout Sts., Denver, CO 80202/303-837-5661.

Region IX: 100 Van Ness Ave., 9th Floor, San Francisco, CA 94102/415-556-5176.

Region X: Arcade Plaza Building, 1321 2d Ave., Seattle, WA 98101/206-442-0943.

Office of Human Development Services

Region I: John F. Kennedy Federal Building, Boston, MA 02203/617-223-3236.

Region II: 26 Federal Plaza, Room 4149, New York, NY 10278/212-264-1487.

Region III: 3535 Market St., P. O. Box 13716, Philadelphia, PA 19101/215-596-0351.

Region IV: 101 Marietta Tower, Suite 903, Atlanta, GA 30323/404-221-2398.

Region V: 300 S. Wacker Dr., Chicago, IL 60606/312-353-8322.

Region VI: 1200 Main Tower, Dallas, TX 75201/214-767-4540.

Region VII: 601 E. 12th St., Kansas City, MO 64106/816-374-3981.

Region VIII: 1961 Stout St., Room 7420, Denver, CO 80202/303-837-2622.

Region IX: 50 United Nations Pl., San Francisco, CA 94102/415-556-4027.

Region X: Arcade Plaza Building, 1321 2d Ave., Seattle, WA 98101/206-442-2430.

Principal Regional Officials

Region I: John F. Kennedy Federal Building, Boston, MA 02203/617-223-6831.

Region II: 26 Federal Plaza, New York, NY 10278/212-264-4600.

Region III: 3535 Market St., Phiadelphia, PA 19101/215-596-6492.

Region IV: 101 Marietta Tower, Atlanta, GA 30323/404-221-2442.

Region V: 300 S. Wacker Dr., Chicago, IL 60606/312-353-5160.

Region VI: 1200 Main Tower, Dallas, TX 75202/214-767-3301.

Region VII: 601 E. 12th St., Kansas City, MO 64106/816-374-2821.

Region VIII: 1961 Stout St., Denver, CO 80202/303-837-3373.

Region IX: 50 United Nations Pl., San Francisco, CA 94102/415-556-6746.

Region X: Arcade Plaza Building, 1321 2d Ave., Seattle, WA 98101/206-442-1290.

Public Health Service

Region I: John F. Kennedy Federal Building, Boston, MA 02203/617-223-6827.

Region II: 26 Federal Plaza, New York, NY 10278/212-264-2560.

Region III: P. O. Box 13716, Philadelphia, PA 19101/215-596-6637.

Region IV: 101 Marietta Tower, Suite 1007, Atlanta, GA 30323/404-221-2316.

Region V: 300 S. Wacker Dr., Chicago, IL 60606/312-353-1385.

Region VI: 1200 Main Tower, Dallas, TX 75202/214-767-3879.

Region VII: 601 E. 12th St., Kansas City, MO 64106/816-374-3291.

Region VIII: 19th & Stout Sts., Denver, CO 80294/303-837-4461.

Region IX: 50 United Nations Pl., San Francisco, CA 94102/415-556-5810.

Region X: Arcade Plaza Building, 1321 2d Ave., Seattle, WA 98101/206-442-0430.

Social Security Administration

Region I: John F. Kennedy Federal Building, Room E-319, Boston, MA 02203/617-223-5275.

Region II: 26 Federal Plaza, Room 4000, New York, NY 10278/212-264-4036.

Region III: 3535 Market St., Philadelphia, PA 19101/215-596-6975.

Region IV: 101 Marietta Tower, Suite 401, Atlanta, GA 30323/404-221-2400.

Region V: 300 S. Wacker Dr., 16th Floor, Chicago, IL 60606/312-353-9801.

Region VI: Federal Office Building, Room 14B1, Dallas, TX 75242/214-767-9401.

Region VII: Federal Office Building, Room 505, 911 Walnut St., Kansas City, MO 64106/816-374-5246.

Region VIII: Rio Grande Building, Suite 402, 1531 Stout St., Denver, CO 80202/303-837-5616.

Region IX: 100 Van Ness Ave., 24th Floor, San Francisco, CA 94102/415-556-0644.

Region X: Federal Building, 915 2d Ave., Room 1852, Seattle, WA 98174/206-442-1322.

Regional Commissioners

Region I: John F. Kennedy Federal Building, Room 1100, Boston, MA 02203/617-223-6810.

Region II: 26 Federal Plaza, Room 4008, New York, NY 10278/212-264-3915.

Region III: P. O. Box 8788, Philadelphia, PA 19101/215-596-6941.

Region IV: 101 Marietta Tower, Suite 2001, Atlanta, GA 30323/404-221-2475.

Region V: 300 S. Wacker Dr., 27th Floor, Chicago, IL 60606/312-353-4247.

Region VI: 1200 Main Tower, Room 2535, Dallas, TX 75202/214-767-4210.

Region VII: 601 E. 12th St., Room 436, Kansas City, MO 64106/816-374-3701.

Region VIII: 1961 Stout St., 8th Floor, Denver, CO 80294/303-837-2388.

Region IX: 100 Van Ness Ave., San Francisco, CA 94102/415-556-4910.

Region X: Arcade Plaza Building, 1321 2d Ave., Seattle, WA 98101/206-399-0417.

Health Services Administration, Indian Health Service

Anchorage, AK 99510: P. O. Box 7-741/907-279-6661.

Aberdeen, SD 57401: 115 4th Ave., S.E./605-225-7581.

Albuquerque, NM 87101: 500 Gold Ave., S.W./505-766-2151.

Billings, MT 59103: P. O. Box 2143/406-657-6403.

Oaklahoma City, OK 73102: Old Post Office & Court House Building/305-231-4796.

Phoenix, AZ 85104: 801 East Indian School/602-261-3143.

Portland, OR 97205: 1220 S.W. 3d Ave./503-221-2020.

Window Rock, AZ 86515: P. O. Box G/602-871-5811.

Bemidji, MN 56601 (USET Program Office) P. O. Box 768/218-751-1210.

Tucson, AZ 85734 (R. & D.): 203 Federal Build-

ing/602-792-6604.

Nashville, TN 37217 (USET Program Office): Oaks Tower Building, Suite 204/615-749-5104.

Sacramento, CA 95825 (USET Program Office): 2800 Cottage Way/916-468-4837.

Department of Housing and Urban Development

Regional Offices

Region I: John F. Kennedy Federal Building, Boston, MA 02203/617-223-4066.

Region II: 26 Federal Plaza, New York, NY 10007/212-264-8068.

Region III: 6th & Walnut Sts., Philadelphia, PA 19106/215-597-2560.

Region IV: Richard B. Russell Federal Building, 75 Spring St. S.W., Atlanta, GA 30303/404-221-5136.

Region V: 300 S. Wacker Dr., Chicago, IL 60606/312-353-5680.

Region VI: 221 W. Lancaster Ave., P. O. Box 2905, Ft. Worth, TX 76113/817-870-5401.

Region VII: Professional Building, 1103 Grand Ave., Kansas City, MO 64106/816-374-2661.

Region VIII: 1405 Curtis St., Denver, CO 80202/303-837-4513.

Region IX: 450 Golden Gate Ave., San Francisco, CA 94102/415-556-4752.

Region X: Arcade Plaza Building, 1321 2d Ave., Seattle, WA 98101/206-442-5414.

Department of the Interior

Office of Youth Programs

Region I: 8 McKinley Sq., Boston, MA 02109/617-223-1627.

Region II: 6 World Trade Center, Suite 612, New York, NY 10048/212-446-5612.

Region III: 2d & Chestnut Sts., Philadelphia, PA 19106/215-597-0684.

Region IV: 75 Spring St. S.W., Atlanta, GA 30303/414-221-2751.

Region V: 175 W. Jackson Blvd., Chicago, IL 60604/312-353-1008.

Region VI: 1100 Commerce St., Dallas, TX 75242/214-767-0981.

Region VII: 601 E. 12th St., Kansas City, MO 64106/816-374-5072.

Region VIII: 44 Union Blvd., Lakewood, CO 80228/303-234-6092.

Region IX: 450 Golden Gate Ave., San Francisco, CA 94102/415-556-8977.

Region X: 601 4th & Pike Building, Seattle, WA 98101/206-442-1170.

Bureau of Indian Affairs

Aberdeen, SD 57401: 115 4th Ave. S.E./605-225-0250.

Albuquerque, NM 87108: 5301 Central Ave. N.E./505-766-3170.

Anadarko, OK 73005: P. O. Box 368/405-247-6673.

Billings, MT 59101: 316 N. 26th St./406-657-6315.

Juneau, AK 99802: P. O. Box 3-8000/907-586-7177.

Minneapolis, MN 55402: 15 S. 5th St./612-725-2904.

Muskogee, OK 74401: Federal Bldg./918-687-2295.

Window Rock, AZ 86515: Navajo Area Office/602-871-4368.

Phoenix, AZ 85011: P. O. Box 7007/602-261-4101.

Portland, OR 97208: P. O. Box 3785/503-231-6702.

Sacramento, CA 95825: 2800 Cottage Way/916-484-4682.

Washington, DC 20240: 18th & C Sts. N.W./703-235-2571.

Bureau of Land Management

Regional Representatives

I–V, Alexandria, VA 22304: 850 S. Pickett St./703-235-2833.

VI, Santa Fe, NM 87501: P. O. Box 1449, S. Federal Pl/505-988-6219.

VII–VIII, Denver, CO 80225: Denver Federal Center, Building 50/303-234-2329.

IX, Sacramento, CA 95825: Federal Office Building/916-484-4676.

X, Portland, OR 97208: 729 N.E. Oregon St./503-231-6251.

State Offices

Anchorage, AK 99513: 701 C St., P. O. Box 13/907-271-5076.

Phoenix, AZ 85073: 2400 Valley Bank Center/602-261-3873.

Sacramento, CA 95825: Federal Office Building, 2800 Cottage Way/916-484-4676.

Denver, CO 80202: 1600 Broadway/303-837-4325.

Boise, ID 83724: Federal Building/208-384-1401.

Billings, MT 59107: Granite Tower Building, 222 N. 32d St./406-657-6462.

Reno, NV 89509: Federal Building/702-784-5451.

Santa Fe, NM 87501: U.S. Post Office & Federal Building/505-988-6217.

Portland, OR 97208: 729 N.E. Oregon St./503-231-6251.

Salt Lake City, UT 84111: 136 E. South Temple St/801-524-5311.

Cheyenne, WY 82001: 2515 Warren Ave/307-778-2220.

Outer Continental Shelf Offices
Anchorage, AK 99510: 800 A St./907-276-2955.
Los Angeles, CA 90012: 300 N. Los Angeles St./213-688-7234.
New Orleans, LA 70130: Hale Boggs Federal Building, 500 Camp St./504-589-6541.
New York, NY 10048: 26 Federal Plaza/212-264-2960.

Geological Survey
Reston, VA 22092: 12201 Sunrise Valley Dr./703-860-7414.
Denver, CO 80225: Denver Federal Center, P. O. Box 25046/303-234-4630.
Menlo Park, CA 94025: 345 Middlefield Rd./415-323-8111, etc. 2711.

Heritage Conservation and Recreation Service
Philadelphia, PA 19106: 600 Arch St./215-597-7989.
Atlanta, GA 30303: 75 Spring St./404-221-4405.
Ann Arbor, MI 48107: Federal Building/313-668-2023.
Denver, CO 80225: Denver Federal Center/303-234-6462.
Albuquerque, NM 87110: 5000 Marble Ave. N.E./505-766-3515.
Seattle, WA 98174: 915 2d Ave./206-442-4706.
San Francisco, CA 94102: 450 Golden Gate Ave./415-277-1666.
Anchorage, AK 99503: 1011 E. Tudor Rd./907-265-5345.

National Park Service
North Atlantic: 15 State St., Boston, MA 02109/617-223-3769.
Mid-Atlantic: 143 S. 3d St., Philadelphia, PA 19106/215-597-7013.
Southeast: 75 Spring St. N.W., Atlanta, GA 30303/404-242-5185.
Midwest: 1709 Jackson St., Omaha, NB 68102/402-864-3431.
Rocky Mountain: 655 Parfet St., Denver, CO 80225/303-234-2500.
Southwest: P. O. Box 728, Santa Fe, NM 87501/505-476-3388.
Western: 450 Golden Gate Ave., San Francisco, CA 94102/415-556-4196.
Alaska: 540 W. 5th Ave., Anchorage, AK 99501/907-276-8166.
Pacific Northwest: 601 4th & Pike Building, Seattle, WA 98101/206-399-5565.
National Captial: 1100 Ohio Dr. S.W., Washington, DC 20242/202-426-6612.

Office of Environmental Project Review
Boston, MA 02109: 15 State St./617-223-5517.
Atlanta, GA 30303: 75 Spring St. S.W./404-242-4524.
Chicago, IL 60604: 175 Jackson Blvd./312-353-6612.
Albuquerque, NM 87103: 5301 Central Ave. N.E./505-474-3565.
San Francisco, CA 94102: 450 Golden Gate Ave./415-556-8200.
Denver, CO 80225: Denver Federal Center/303-234-2071.
Portland, OR 97232: 500 N.E. Multnomah St./503-429-6157.
Anchorage, AL 99510: 1675 C St./907-271-5011.

Office of the Inspector General
Arlington, VA 22217: BT No. 1 800 N. Quincy, Room 401/703-235-1513.
Lakewood, CO 80228: 134 Union Blvd., Suite 510/303-234-2131.
Sacramento, CA 95825: 2800 Cottage Way, Room W2400/916-484-4874.

Office of the Solicitor
Anchorage, AL 99501: 510 L St., Suite 408/907-271-4131.
Denver, CO 80225: Denver Federal Center, P. O. Box 25007/303-234-3175.
Atlanta, GA 30303: 148 International Blvd. N.E., Suite 405/404-221-4447.
Newton Corner, MA 02158: 1 Gateway Center, Suite 306/617-829-9258.
Portland, OR 97208: 500 N.E. Multnomah St., Suite 607/503-234-4201.
Sacramento, CA 95825: 2800 Cottage Way/916-484-4331.
Salt Lake City, UT 84111: 125 S. State St., Suite 6201/801-524-5677.
Tulsa, OK 74101: P. O. Box 3156/918-265-7501.

Office of Surface Mining Reclamation and Enforcement
Region I: 950 Kamawha Blvd. E, Charleston, WV 25301/304-342-8125.
Region II: 530 Gay St., Knoxville, TN 37902/615-637-8060.
Region III: 46 E. Ohio St., Indianapolis, IN 46204/317-269-2600.
Region IV: 818 Grand Ave., Kansas City, MO 64106/816-374-2193.
Region V: 1020 15th St., Denver, CO 80202/303-837-5511.

Fish and Wildlife Service
Portland, OR 97232: 500 N.E. Multnomah St./503-231-6118.

Albuquerque, NM 87103: 500 Gold Ave. S.W./ 505-373-2321.

Twin Cities, MN 55111: Federal Building/612-725-3500.

Atlanta, GA 30347: 17 Executive Park Dr. N.E./ 404-881-4671.

Newton Corner, MA 02158: 1 Gateway Center, Suite 700/617-829-9200.

Denver, CO 80225: Denver Federal Center, P. O. Box 25486/303-234-2209.

Anchorage, AK 99507: 1011 E. Tudor Rd./907-276-3800.

Water and Power Resources Service
Boise, ID 83724: 550 W. Fort St./208-384-1908.

Sacramento, CA 95825: 2800 Cottage Way/916-484-4571.

Boulder City, NV 89005: Nevada Hwy, & Park St./702-293-7411.

Salt Lake City, UT 84147: 125 S. State St./801-524-5592.

Amarillo, TX 79101: 317 E. 3d St./806-376-2401.

Billings, MT 59103: 316 N. 26th St./406-657-6214.

Denver, CO 80225: Denver Federal Center, Building 20/303-234-4441.

Department of Justice

Community Relations Service
Region I: 100 Summer St., Boston, MA 02110. 617-223-5170.

Region II: 26 Federal Plaza, New York, NY 10278/212-264-0700.

Region III: 2d & Chestnut Sts., Philadelphia, PA 19106/215-597-2344.

Region IV: 75 Piedmont Ave. N.E., Atlanta, GA 30303/404-221-6883.

Region V: 175 W. Jackson Blvd., Chicago, IL 60604/312-353-4391.

Region VI: 1100 Commerce St., Dallas, TX 75242/214-767-0824.

Region VII: 911 Walnut St., Kansas City, MO 64106/816-374-2022.

Region VIII: 1531 Stout St., Denver, CO 80202/ 303-837-2973.

Region IX: 1275 Market St., San Francisco, CA 94103/415-556-2485.

Region X: Federal Office Building, 915 2d Ave., Seattle, WA 98104/206-442-4465.

Antitrust Division
Atlanta, GA 30309: 1776 Peachtree St. N.W./ 404-881-3828.

Chicago, IL 60604: 2634 Everett M. Dirksen Building, 219 S. Dearborn St./312-353-7530.

Cleveland, OH 44199: 995 Celebrezze Federal Building, 1240 E. 9th St./216-522-4070.

Dallas, TX 75242: Earle Cabell Federal Building, Room 8Cb, 1100 Commerce St./214-767-8051.

Los Angeles, CA 90012: Federal Building, Room 3101, 300 N. Los Angeles St./213-688-2500.

New York, NY 10007: 26 Federal Plaza, Room 3630, 212/264-0390.

Philadelphia, PA 19106: 11400 U.S. Courthouse, Independence Mall West, 601 Market St./215-597-7405.

San Francisco, CA 94102: 450 Golden Gate Ave., P. O. Box 36046/415-556-6300.

Bureau of Prisons
Northeast: Scott Plaza II, Industrial Highway, Philadelphia, PA 19113/215-596-1871.

Southeast: 523 McDonough Blvd. S.E., Atlanta, GA 30315/404-221-3531.

North Central: 8800 N.W. 112th St., Kansas City, MO 64153/816-243-5680.

South Central: 1607 Main St., Suite 700, Dallas, TX 75201/214-767-0012.

Western: 330 Primrose Rd., Burlingame, CA 94010/415-347-0721.

Civil Division
California: 450 Golden Gate Ave., P. O. Box 36028, San Francisco, CA 94102/415-556-3146.

New York: 26 Federal Plaza, Suite 36-100, New York, NY 10007/212-264-0480.

Drug Enforcement Administration
Northeast: 555 W. 57th St., New York, NY 10019/212-662-5001.

Southeast: 8400 N.W. 53d St., Miami, FL 33166/ 305-820-4800.

North Central: 219 S. Dearborn St., Chicago, IL 60604/312-353-1419.

South Central: 1880 Regal Row, Dallas, TX 75235/214-729-7106.

Western: 350 S. Figueroa St., Los Angeles, CA 90071/213-798-4825.

Executive Office for United States Trustees
Maine, Massachusetts, New Hampshire and Rhode Island: 87 Kirby St., Boston, MA 02109/617-223-4754.

Southern New York: Federal Building, Room 306, 26 Federal Plaza, New York, NY 10007/ 212-264-2858.

Delaware & New Jersey: 1180 Raymond Building, Room 2549, Newark, NJ 07102/201-645-2617.

District of Columbia & Eastern Virginia: 421 King St., Room 410, Alexandria, VA 22314/ 703-557-0746.

Northern Alabama: Frank Nelson Building, Suite 831, 2d Ave. & 20th St., Birmingham, AL 35203/205-254-0047.

Northern Texas: U.S. Courthouse, Room 9C60, 1100 Commerce St., Dallas, TX 75242/214-767-8697.

Northern Illinois: 175 W. Jackson St., Room A1303, Chicago, IL 60604/312-353-4400.

Minnesota, North Dakota, South Dakota: U.S. Courthouse, Room 454, 110 S. 4th St., Minneapolis, MN 55401/612-725-6191.

Central California: U.S. Courthouse, Room 514, 312 N. Spring St., Los Angeles, CA 90012/213-688-6811.

Colorado & Kansas: Columbine Building, Room 202, 1845 Sherman St., Denver, CO 80203/303-837-5188.

Immigration and Naturalization Service

Burlington, VT 05401: Federal Building/802-862-6501.

St. Paul, MN 55111: Federal Building, Fort Snelling/612-725-4450.

Dallas, TX 75270: 1201 Elm St., Room 2300/214-767-0514.

San Pedro, CA 90731: Terminal Island/213-548-2357.

Office of Justice Assistance, Research, and Statistics

Atlanta, GA 30323: 101 Marietta St., Suite 2322/404-221-5928.

Denver, CO 80201: P. O. Box 3119/303-837-2501.

Sacramento, CA 95812: P. O. Box 3010/916-440-2131.

Chicago, IL 60604: 175 W. Jackson Blvd., Suite A-1335/312-353-1203.

Washington, DC 20531: East/West Towers, Room 262, 633 Indiana Ave. N.W./301-492-9010.

Tax Division

Texas: 5B31 Federal Office Building, 1100 Commerce St., Dallas, TX 75242/214-749-1251.

Parole Commission

Northeast: Scott Plaza II, 6th Floor, Industrial Hwy., Philadelphia, PA 19113/215-596-1868.

South Central: 555 Griffin Sq., 8th Floor, Dallas, TX 75202/214-767-0024.

Western: Crocker Financial Center Building, 330 Primrose Rd., Burlingame, CA 94010/415-347-4737.

Southeast: 715 McDonough Blvd. S.E., Atlanta, GA 30315/404-221-5175.

North Central: Air World Center, 10920 Ambassador Dr., Suite 220, Kansas City, MO 64153/816-891-1395.

Department of Labor

Employment Standards Administration

Region I: John F. Kennedy Federal Building, Boston, MA 02203/617-223-4305.

Region II: 1515 Broadway, New York, NY 10036/212-944-3351.

Region III: 3535 Market St., Philadelphia, PA 19104/215-596-1185.

Region IV: 1371 Peachtree St. N.E., Atlanta, GA 30367/404-881-2818.

Region V: 230 S. Dearborn St., Chicago, IL 60604/312-353-7280.

Region VI: 555 Griffin Square Building, Dallas, TX 75202/214-767-6894.

Region VII: 911 Walnut St., Kansas City, MO 64106/816-374-5381.

Region VIII: 1961 Stout St., Denver, CO 80294/303-837-5903.

Region IX: 450 Golden Gate Ave., San Francisco, CA 94102/415-556-1318.

Region X: 909 1st Ave./Seattle, WA 98174/206-442-1536.

Office of Federal Contract Compliance Programs

Region I: John F. Kennedy Federal Building, Boston, MA 02203/617-223-4232.

Region II: 1515 Broadway, New York, NY 10036/212-944-3403.

Region III: 3535 Market St., Philadelphia, PA 19104/215-596-6168.

Region IV: 1371 Peachtree St. N.E., Atlanta, GA 30367/404-881-4211.

Region V: 230 S. Dearborn St., Chicago, IL 60604/312-353-0335.

Region VI: 555 Griffin Square Building, Dallas, TX 75202/214-767-4771.

Region VII: 911 Walnut St., Kansas City, MO 64106/816-374-5384.

Region VIII: 1961 Stout St., Denver, CO 80294/303-837-5011.

Region IX: 450 Golden Gate Ave., San Francisco, CA 94102/415-556-6060.

Region X: 909 1st Ave., Seattle, WA 98104/206-442-4508.

Wage and Hour Division

Region I: John F. Kennedy Federal Building, Boston, MA 02203/617-223-0995.

Region II: 1515 Broadway, New York, NY 10036/212-944-3348.

Region III: 3535 Market St., Philadelphia, PA 19104/215-596-1193.

Region IV: 1371 Peachtree St. N.E., Atlanta, GA

30367/404-881-4801.
1931 9th Ave., S., Birmingham, AL 35256/205-254-1301.
Region V: 230 S. Dearborn St., Chicago, IL 60604/312-353-8845.
Region VI: 555 Griffin Square Building, Dallas, TX 75202/214-767-6891.
Region VII: 911 Walnut St., Kansas City, MO 64106/816-374-5386.
Region VIII: 1961 Stout St., Federal Office Building, Denver, CO 80294/303-837-4613.
Region IX: 450 Golden Gate Ave., San Francisco, CA 94102/415-556-3592.
Region X: 99 1st Ave., Seattle, WA 98174/206-442-2805.

Employment and Training Administration
Region I: John K. Kennedy Federal Building, Boston, MA 02203/617-223-6440.
Region II: 1515 Broadway, New York, NY 10036/212-399-5445.
Region III: P. O. Box 8796, Philadelphia, PA 19101/215-596-6336.
Region IV: 1371 Peachtree St. N.E., Atlanta, GA 30309/404-257-4411.
Region V: 230 S. Dearborn St., Chicago, IL 60604/312-353-0313.
Region VI: 555 Griffin Square Building, Dallas, TX 75202/214-749-2721.
Region VII: 911 Walnut St., Kansas City, MO 64106/816-374-3796.
Region VIII: Federal Building, 1961 Stout St., Denver, CO 80294/303-837-4477.
Region IX: 450 Golden Gate Ave., San Francisco, CA 94102/415-556-7414.
Region X: Federal Office Building, 909 1st Ave., Seattle, WA 98174/206-442-7700.

Occupational Safety and Health Administration
Region I: 16-18 North St., 1 Dock Sq., Boston, MA 02109/617-223-6710.
Region II: 1515 Broadway, New York, NY 10036/212-944-3426.
Region III: 3535 Market St., Philadelphia, PA 19104/215-596-1201.
Region IV: 1371 Peachtree St. N.E., Atlanta, GA 30367/404-881-3573.
Region V: 230 S. Dearborn St., Chicago, IL 60604/312-353-2220.
Region VI: 555 Griffin Square Building, Dallas, TX 75202/214-767-4731.
Region VII: 911 Walnut St., Kansas City, MO 64106/816-374-5861.
Region VIII: 1961 Stout St., Denver, CO 80294/303-837-3883.
Region IX: 450 Golden Gate Ave., San Francisco, CA 94102/415-556-0586.

Region X: 909 1st Ave., Seattle, WA 98174/206-442-5930.

Office of Assistant Secretary for Administration and Management
Region I: John F. Kennedy Federal Building, Boston, MA 02203/617-223-4394.
Region II: 1515 Broadway, New York, NY 10036/212-399-5357.
Region III: 3535 Market St., Philadelphia, PA 19104/215-596-6560.
Region IV: 1371 Peachtree St. N.E., Atlanta, GA 30309/404-881-3898.
Region V: 230 S. Dearborn St., Chicago, IL 60604/312-353-8373.
Region VI: 555 Griffin Square Building, Dallas, TX 75202/214-767-6801.
Region VII: 911 Walnut St., Kansas City, MO 64106/816-374-3891.
Region VIII: 1961 Stout St., Denver, CO 80294/303-837-2218.
Region IX: 450 Golden Gate Ave., San Francisco, CA 94102/415-556-5417.
Region X: 909 1st Ave., Seattle, WA 98174/206-442-0100.

Regional Representatives
Region I: John F. Kennedy Federal Building, Boston, MA 02203/617-223-4220.
Region II: 1515 Broadway, New York, NY 10036/212-399-6738.
Region III: 3535 Market St., Philadelphia, PA 19104/215-596-1116.
Region IV: 1371 Peachtree St., N.E., Atlanta, GA 30309/404-881-4366.
Region V: 230 S. Dearborn St., Chicago, IL 60604/312-353-4703.
Region VI: 555 Griffin Square Building, Dallas, TX 75202/214-749-6807.
Region VII: 911 Walnut St., Kansas City, MO 64106/816-374-6371.
Region VIII: 1961 Stout St., Denver, CO 80294/303-837-5610.
Region IX: 450 Golden Gate Ave., San Francisco, CA 94102/415-556-4025.
Region X: 909 1st Ave., Seattle, WA 98174/206-442-7060.

Women's Bureau
Region I: John F. Kennedy Building, Boston, MA 02203/617-223-4036.
Region II: 1515 Broadway, New York, NY 10036/212-399-2935.
Region III: 3535 Market St., Philadelphia, PA 19104/215-596-1183.
Region IV: 1371 Peachtree St. N.E., Atlanta, GA 30309/404-881-4461.

Region V: 230 S. Dearborn St., Chicago, IL 60604/312-353-6985.

Region VI: 555 Griffin Square Building, Dallas, TX 75202/214-767-6985.

Region VII: 911 Walnut St., Kansas City, MO 64106/816-374-6108.

Region VIII: 1961 Stout St., Denver, CO 80294/303-837-4138.

Region IX: 450 Golden Gate Ave., San Francisco, CA 94102/415-556-2377.

Region X: 909 1st Ave., Seattle, WA 98174/206-442-1534.

Bureau of Labor Statistics

Boston, MA 02203: 1603 Federal Office Building/617-223-6727.

New York, NY 10036: 1515 Broadway/212-622-3117.

Philadelphia, PA 19104: 3535 Market St./215-596-1151.

Atlanta, GA 30309: 1371 Peachtree St. N.E./404-257-2161.

Chicago, ILL 60604: 230 S. Dearborn St./312-353-7226.

Dallas, TX 75202: 555 Griffin Square Building/214-729-6953.

Kansas City, MO 64106: 911 Walnut St./816-758-2378.

San Francisco, CA 94102: 450 Golden Gate Ave./415-556-3178.

Employment Standards Administration
Office of Workers' Compensation Programs,
Division of Federal Employees' Compensation

Boston, MA 02203: John F. Kennedy Federal Building/617-223-6755.

New York, NY 10036: 1515 Broadway/212-944-3376.

Philadelphia, PA 19104: 3535 Market St./215-596-1180.

Jacksonville, FL 32202: 400 W. Bay St./904-971-3426.

New Orleans, LA 70130: Federal Office Building, 500 Camp St./504-589-3963.

Cleveland, OH 44199: 1240 E. 9th St./216-522-3803.

Chicago, IL, 60604: 230 S. Dearborn St./312-886-5883.

Kansas City, MO 64106: 911 Walnut St./816-374-2723.

Denver, CO 80202: 1961 Stout St./303-837-5402.

San Francisco, CA 94102: 450 Golden Gate Ave./415-556-6183.

Seattle, WA 98174: 909 1st Ave./206-442-5521.

Honolulu, HI 96813: 300 Ala Moana Blvd./808-546-8336.

Washington, DC 20211: 666 11th St. N.W./202-724-0702.

Atlanta, GA 30309: 1371 Peachtree St. N.W./404-881-7566.

Dallas, TX 75202: 555 Griffin Square Building, Young & Griffin Sts./214-767-4712.

Office of Workers' Compensation Programs,
Division of Longshore and Harbor Workers'
Compensation

Boston, MA 02203: John F. Kennedy Federal Building/617-223-6755.

New York, NY 10036: 1515 Broadway/212-944-3376.

Philadelphia, PA 19104: 3535 Market St./215-596-1180.

Baltimore, MD 21201: Federal Building/301-962-3677.

Norfolk, VA 23510: 200 Granby Mall/804-441-3071.

Jacksonville, FL 32201: 311 W. Monroe St./904-791-2881.

New Orleans, LA 70130: Hale Boggs Federal Building, 500 Camp St./504-589-3963.

Houston, TX 77004: 2320 La Branch St./713-226-5801.

Chicago, IL 60604: 230 S. Dearborn St./312-886-5883.

Kansas City, MO 64106: 911 Walnut St./816-374-2723.

Denver, CO 80202: 1961 Stout St./303-837-5402.

San Francisco, CA 94102: 450 Golden Gate Ave./415-556-5757.

Seattle, WA 98174: 909 1st Ave./206-442-5521.

Honolulu, HI 96813: 300 Ala Moana Blvd., Room 5108/808-546-8336.

Washington, DC 20211: 1111 20th St. N.W./202-254-3472.

Long Beach, CA 90731/300 S. Ferry St./213-548-2687.

Labor-Management Services Administration

Atlanta, GA 30309: 1371 Peachtree St. N.E./404-257-4237.

Chicago, IL 60604: 230 S. Dearborn St./312-353-0133.

Kansas City, MO 64106: 911 Walnut St./816-758-5131.

New York, NY 10036: 1515 Broadway, Room 3515/212-662-3408.

Philadelphia, PA 19104: 3535 Market St., Room 14120/215-596-1134.

San Francisco, CA 94102: Federal Office Building, Room 9061, 450 Golden Gate Ave./415-556-5915.

Mine Safety and Health Administration
Coal Mine Safety and Health Districts

Wilkes-Barre, PA 18701: 20 N. Pennsylvania Ave./717-826-6321.

Pittsburgh, PA 15213: 4800 Forbes Ave./412-621-4500.

Morgantown, WV 26505: P. O. Box 886/304-599-7277.

Mount Hope, WV 25880: P. O. Box 112/304-877-6405.

Norton, VA 24273: P. O. Box 560/703-679-0230.

Pikeville, KY 41501: 219 High St./606-437-9616.

Barbourville, KY 40906: P. O. Box 572/606-546-5123.

Vincennes, IN 47591: 501 Busseron St./812-882-7617.

Denver, CO 80225: P. O. Box 25367/303-234-2293.

Madisonville, KY 42431: P. O. Box 473/502-821-4180.

Health and Safety Training Centers

Pittsburgh, PA 15220: 4 Parkway Center/412-621-4500.

Beckley, WV 25801: Drawer J/304-255-0451.

Norton, VA 24273: P. O. Building, Federal St./703-679-4430.

Birmingham, AL 35209: 228 W. Valley Ave./205-254-1513.

Vincennes, IN 47591: 2602 N. 6th St., Suite C/812-882-6307.

Dallas, TX 75221: P. O. Box 1020/214-749-1306.

Denver, CO 80225: P. O. Box 25367/303-234-2800.

Phoenix, AZ 85004: 522 N. Central Ave., Room 243/602-261-4905.

Albany, OR 97321: P. O. Box 70/503-967-5821.

Lexington, KY 40504: 340 Legion Dr., Suite 28/606-253-2820.

Metal and Nonmetal Mine Safety and Health Districts

Pittsburgh, PA 15213: 4800 Forbes Ave./412-621-4500.

Birmingham, AL 35209: 228 W. Valley Ave./205-254-1507.

Duluth, MN 55802: 228 Federal Building/218-727-6692.

Dallas, TX 75242: 1100 Commerce St./214-749-1241.

Denver, CO 80225: P. O. Box 25367/303-234-3421.

Alameda, CA 94501: 620 Central Ave., Building 7/415-273-7457.

Office of the Solicitor

Boston, MA 02203: John F. Kennedy Federal Building/617-223-6701.

New York, NY 10036: 1515 Broadway/212-662-5564.

Philadelphia, PA 19104: 3535 Market St./215-596-1126.

Atlanta, GA 30309: 1371 Peachtree St. N.E./404-257-4811.

Chicago, IL 60604: 230 S. Dearborn St./312-353-7256.

Kansas City, MO 64106: 911 Walnut St./816-374-6441.

Dallas, TX 75202: 555 Griffin Square Building/214-749-3482.

San Francisco, CA 94102: 450 Golden Gate Ave./415-556-4042.

Department of Transportation

National Highway Traffic Safety Administration

Region I: 55 Broadway, Cambridge, MA 02142/617-494-2680.

Region II: 222 Mamaroneck Ave., White Plains, NY 10605/914-761-4250, ext. 312.

Region III: 793 Elkridge Landing Rd., Linthicum, MD 21090/301-796-5117.

Region IV: 1720 Peachtree Rd., N.W., Atlanta, GA 30309/404-881-4537.

Region V: 1010 Dixie Hwy., Suite 214, Chicago Heights, IL 60411/312-756-1950.

Region VI: 819 Taylor St., Fort Worth, TX 76102/817-334-3653.

Region VII: P. O. Box 19515, Kansas City, MO 64141/816-926-7887.

Region VIII: 555 Zang St., 1st Floor, Denver, CO 80228/303-234-3253.

Region IX: 2 Embarcadero Center, Suite 610, San Francisco, CA 94111/415-556-6415.

Region X: 915 2d Ave., Seattle, WA 98174/206-442-5935.

Regional Representatives of the Secretary

Regions I,II, and III: 434 Walnut St., Suite 1000, Philadelphia, PA 19106/215-579-9430.

Region IV: 1720 Peachtree Rd. N.W., Suite 515, Atlanta, GA 30309/404-881-3738.

Region V: 300 S. Wacker Dr., Room 700, Chicago, IL 60606/312-353-4000.

Region VI: 7A29 Federal Building, 819 Taylor St., Fort Worth, TX 76102/817-334-2725.

Regions VII and VIII: 601 E. 12th St., Room 634, Kansas City, MO 64106/816-374-5801.

Regions IX and X: 2 Embarcadero Center, Suite 610, San Francisco, CA 94111/415-556-5961.

Urban Mass Transportation Administration

Region I: c/o Transportation Systems Center, Kendall Sq., 55 Broadway, Cambridge, MA 02142/617-494-2055.

Region II: 26 Federal Plaza, Suite 14-130, New York, NY 10007/212-264-8162.

Region III: 434 Walnut St., Suite 1010, Philadelphia, PA 19106/215-597-8098.

Region IV: 1720 Peachtree Rd. N.W., Suite 400, Atlanta, GA 30309/404-881-3948.

Region V: 300 S. Wacker Dr., Suite 1720, Chicago, IL 60606/312-353-2789.

Region VI: 819 Taylor St., Suite 9A32, Fort Worth, TX 76102/817-334-3787.

Region VII: 6301 Rockhill Rd., Suite 100, Kansas City, MO 64131/816-926-5053.

Region VIII: 1050 17th St., Suite 1822, Denver, CO 80265/303-837-3242.

Region IX: 2 Embarcadero Center, Suite 620, San Francisco, CA 94111/415-556-2884.

Region X: 915 2d Ave., Suite 3142, Seattle, WA 98174/206-442-4210.

Federal Aviation Administration

New England: 12 New England Executive Park, Burlington, MA 01803/617-273-7244.

Eastern: Federal Building, JFK International Airport, Jamaica, NY 11430/212-995-3333.

Southern: P. O. Box 20636, Atlanta, GA 30320/404-763-7222.

Great Lakes: 2300 E. Devon Ave., Des Plains, IL 60018/312-694-4500.

Central: 601 E. 12th St., Kansas City, MO 64106/816-374-5626.

Southwest: P. O. Box 1689, Fort Worth, TX 76101/817-624-4911.

Rocky Mountain: 10455 E. 25th Ave., Aurora, CO 80010/303-340-5001.

Western: Worldway Postal Center, P. O. Box 92007, Los Angeles, CA 90009/213-536-6427.

Northwest: FAA Building, 9010 E. Marginal Way, South King County International Airport, Seattle, WA 98108/206-767-2780.

Alaskan: P. O. Box 14, Anchorage, AK 99513/907-271-5645.

Pacific-Asia: P. O. Box 4009, Honolulu, HI 96813/808-955-0401.

Federal Highway Administration

Albany, NY 12207: Clinton Ave. & N. Pearl St./518-472-6476.

Baltimore, MD 21201: 31 Hopkins Plaza/301-962-2361.

Atlanta, GA 30309: 1720 Peachtree Rd. N.W./404-881-4078.

Homewood, IL 60430: 18209 Dixie Hwy./312-790-6300.

Fort Worth, TX 76102: 819 Taylor St./817-334-3221.

Kansas City, MO 64131: 6301 Rockhill Rd./816-926-7565.

Denver, CO 80225: Denver Federal Center, P. O. Box 25246/303-234-4051.

San Francisco, CA 94111: 2 Embarcadero Center/415-556-3951.

Portland, OR 97204: 222 S.W. Morrison St./503-221-2052.

Arlington, VA 22201: 1000 N. Glebe Rd./703-557-9070.

Federal Railroad Administration

Region I: 150 Causeway St., Room 1307, Boston, MA 02114/617-223-2775.

Region II: Independence Building, Room 1020, 434 Walnut St., Philadelphia, PA 19106/215-597-0750.

Region III: North Tower, Suite 440A, 1720 Peachtree Rd. N.W., Atlanta, GA 30309/404-881-2751.

Region IV: 536 S. Clark St., Room 210, Chicago,IL 60605/312-353-6203.

Region V: Federal Office Building, Room 11A23, 819 Taylor St., Fort. Worth, TX 76102/817-334-3601.

Region VI: Federal Office Building, Room 1807, 911 Walnut St., Kansas City, MO 64106/816-374-2497.

Region VII: 2 Embarcadero Center, Suite 630, San Francisco, CA 94111/415-556-6411.

Region VIII: 124 U.S. Federal Court House, W. 920 Riverside Ave., Spokane, WA 99201/509-456-2246.

Federal Assistance

Region I: 434 Walnut St., Philadelphia, PA 19106/215-597-3617.

Region II: 434 Walnut St., Philadelphia, PA 19106/215-597-3617.

Region III: North Tower, Suite 440A, 1720 Peachtree Rd. N.W., Atlanta, GA 30309/404-881-2718.

Region IV: 536 S. Clark St., Room 210, Chicago, IL 60605/312-353-8026.

Region V: Federal Office Building, Room 11A23, 819 Taylor St., Ft. Worth, TX 76102, 817-334-3817

Region VI: Federal Office Building, Room 11A23, 819 Taylor St., Ft. Worth, TX 76102/817-334-3817.

Region VII: 2 Embarcadero Center, Suite 630, San Francisco, CA 94111/415-556-2924.

Region VIII: 2 Embarcadero Center, Suite 630, San Francisco, CA 94111/415-556-2924.

Materials Transporatation Bureau, Research and Special Programs Administration

Eastern: 400 7th St. S.W., Washington, DC 20590/202-755-9435.

Southern: 1568 Willingham Dr., Atlanta, GA 30337/404-763-7861.

Central: 911 Walnut St., Kansas City, MO 64106/816-374-2654.

Southwest: 6622 Hornwood Dr., Houston, TX

77074/713-226-5476.
Western: 831 Mitten Rd., Burlingame, CA 94010/415-876-9085.

Coast Guard
Atlantic: Governors Island, New York, NY 10004/212-264-8743.
Pacific: 630 Sansome St., San Francisco, CA 94126/415-556-5326.
District 1: 150 Causeway St., Boston, MA 02114/617-223-3603.
District 2: 1520 Market St., St. Louis, MO 63103/314-425-4601.
District 3: Governors Island, New York, NY 10004/212-246-8743.
District 5: 431 Crawford St., Portsmouth, VA 23705/804-393-9611.
District 7: 1018 Federal Building, 51 S.W. 1st Ave., Miami, FL 33130/305-350-5654.
District 8: 500 Camp St., New Orleans, LA 70130/504-589-6298.
District 9: 1240 E. 9th St., Cleveland, OH 44199/216-522-3930.
District 11: 400 Oceangate Blvd., Long Beach, CA 90882/213-590-2311.
District 12: 630 Sansome St., San Francisco, CA 94126/415-556-3860.
District 13: 915 2d Ave., Seattle, WA 98174/206-442-5078.
District 14: 300 Ala Moana Blvd., Honolulu, HI 96813/808-546-5531.
District 17: P. O. Box 3-5000, Juneau, AK 99801/907-586-2680.

ACTION
Regional Offices
Region I: John W. McCormack Building, Room 1420, Boston, MA 02109/617-223-4501.
Region II: 26 Federal Plaza, 16th Floor, New York, NY 10007/212-264-5710.
Region III: U.S. Customs House, 2nd and Chestnut, Room 108, Philadelphia, PA 19106/215-597-9972.
Region IV: 101 Marietta St. N.W., Room 2524, Atlanta, GA 30303/404-242-2859.
Region V: 1 N. Wacker Dr., 3d Floor, Chicago, IL 60606/312-353-5107.
Region VI: Old Main Post Office, P. O. Box 370, Dallas, TX 75221/214-729-9494.
Region VII: II Gateway Center, Suite 330, 4th St. & State Ave., Kansas City, KS 66101/816-374-4486.
Region VIII: 1845 Sherman St., Room 201, Denver, CO 80202/303-837-2671.
Region IX: 211 Main St., Room 533, San Francisco, CA 94105/415-556-1736.

Region X: 1111 3rd Avenue Building, Suite 330, Seattle, WA 98101/206-442-1558.

Office of Recruitment and Communications
Field Service Centers
New York (serves Regions I & II and Eastern Pennsylvania and Delaware): 26 Federal Plaza, New York, NY 10007/212-264-1780.
Atlanta (serves Regions IV, VI and Maryland, West Virginia and Virginia): 101 Marietta St. N.W., Atlanta, GA 30303/404-242-2517.
Chicago (serves Regions V and VII): 1 N. Wacker Dr., Chicago, IL 60606/312-353-3585.
Dallas (serves Regions VI and VIII): 400 N. Ervay St., Dallas, TX 75201/214-729-5447.
San Francisco (serves Regions VIII, IX, and X): 211 Main St., San Francisco, CA 94105/415-556-1724.

Community Services Administration
Regional Offices
Region I: John F. Kennedy Federal Building, Boston, MA 02203/617-223-4080.
Region II: 26 Federal Plaza, New York, NY 10007/212-264-1900.
Region III: P. O. Box 160, 9th & Market Sts., Philadelphia, PA 19105/215-597-6102.
Region IV: 101 Marietta St. N.W., Atlanta, GA 30308 /404-221-2717.
Region V: 300 S. Wacker Dr., Chicago, IL 60606/312-353-5562.
Region VI: 1200 Main St., Dallas, TX 75202/214-767-6125.
Region VII: 911 Walnut St., Kansas City, MO 64106/816-374-3761.
Region VIII: Tremont Center Building, 333 W. Colfax Ave., Denver, CO 80204/303-327-4767.
Region IX: P. O. Box 36008, 450 Golden Gate Ave., San Francisco, CA 94102/415-556-5400.
Region X: Arcade Plaza Building, 1321 2d Ave., Seattle, WA 98108/206-442-4910.

Environmental Protection Agency
Regional Offices
Region I: John F. Kennedy Federal Building, Boston, MA 02203/617-223-7210.
Region II: 26 Federal Plaza, New York, NY 10007/212-264-2525.
Region III: 6th & Walnut Sts., Philadelphia, PA 19106/215-597-9814.
Region IV: 345 Courtland St N.E., Atlanta, GA 30308/404-881-4727.
Region V: 230 S. Dearborn St., Chicago, IL 60604/312-353-2000.
Region VI: First International Building, 1201

Elm St., Dallas, TX 75270/214-767-2600.
Region VII: 324 E. 11th St., Kansas City, MO 64106/816-374-5493.
Region VIII: 1860 Lincoln St., Denver, CO 80203/303-837-3895.
Region IX: 215 Fremont St., San Francisco, CA 94105/415-556-2320.
Region X: 1200 6th Ave., Seattle, WA 98101/206-442-1220.

Office of Personnel Management
Regional Offices
Region I: John W. McCormack Post Office & Courthouse, Boston, MA 02109/617-223-2539.
Region II: 26 Federal Plaza, New York, NY 10007/212-264-0440.
Region III: 600 Arch St., Philadelphia, PA 19106/215-597-4543.
Region IV: 75 Spring St. S.W., Atlanta, GA 30303/404-242-3459.
Region V: Federal Office Building, 29th Floor, 230 S. Dearborn St., Chicago, IL 60604/312-353-2901.
Region VI: 1100 Commerce St., Dallas, TX 75242/214-729-8227.
Region VII: 1256 Federal Building, 1520 Market St., St. Louis, MO 63103/314-279-4262.
Region VIII: Denver Federal Center, Denver, CO 80225/303-234-2023.
Region IX: 525 Market St., San Francisco, CA 94105/415-556-0581.
Region X: 915 2d Ave., Seattle, WA 98174, 206-399-7536.

Small Business Administration
Regional Offices
Region I: 60 Batterymarch, 10th Floor, Boston, MA 02110/617-223-3204.
Region II: 26 Federal Plaza, New York, NY 10007/212-264-7772.
Region III: 1 Bala Cynwyd Plaza, Bala Cynwyd, PA 19004/215-596-5984.
Region IV: 1375 Peachtree St. N.E., Atlanta, GA 30309/404-881-4999.
Region V: 219 S. Dearborn St., Chicago, IL 60604/312-353-0355.
Region VI: 1720 Regal Row, Dallas, TX 75235/214-767-7643.
Region VII: 911 Walnut St., Kansas City, MO 64106/816-374-5288.
Region VIII: 1405 Curtis St., Denver, CO 80202/303-837-5763.
Region IX: 450 Golden Gate Ave., San Francisco, CA 94102/415-556-7487.

Region X: 710 2d Ave., Seattle, WA 98104/206-442-5676.

Air Force
Air Force Regional Civil Engineers
Interagency/Intergovernmental Coordination for Environmental Planning
Eastern (Standard Federal Regions I-IV): 526 Title Building, Atlanta, GA 30303/404-221-6776.
Central (Standard Federal Regions V-VIII): 1114 Commerce St., Dallas, TX 75242/214-767-2514.
Western (Standard Federal Regions IX and X): 630 Sansome St., San Francisco, CA 94111/415-556-6439.

Department of the Treasury
Bureau of Alcohol, Tobacco and Firearms
Office of Criminal Enforcement
Atlanta, GA 30301: P. O. Box 2994/404-455-2635.
Chicago, IL 60604: 230 S. Dearborn St., 15th Floor/312-353-7147.
New York, NY 10048: 6 World Trade Center, Room 620/212-264-1850.
San Francisco, CA 94105: 525 Market St., 34th Floor/415-556-9484.
Birmingham, AL 35203: 2121 8th Ave. N., Room 1025/205-254-1205.
Charlotte, NC 28202: 222 S. Church St./704-371-6125.
Decatur, GA 30030: 1 W. Court Sq., Suite 265/404-221-6526.
Jackson, MS 39201: 100 W. Capitol St./601-969-4200.
Miami, FL 33166: 5205 N.W. 84th Ave., Suite 108/305-350-4368.
Nashville, TN 37215: 4004 Hillsboro Rd./615-251-5412.
New Orleans, LA 70130: Hale Boggs Federal Building, Room 330/504-589-2048.
Cincinnati, OH 45201: P. O. Box 1759/512-684-3756.
Cleveland, OH 44114: 55 Erieview Plaza, Suite 500/216-522-3080.
Detroit, MI 48226: 371 Federal Building/313-226-7300.
Kansas City, MO 64106: 1150 Grand Ave., Room 200/816-374-3886.
Louisville, KY 40202: 600 Federal Place/502-582-5211.
Oak Brook, IL 60521: 2115 Butterfield Rd./312-620-7824.
St. Louis, MO 63101: 1114 Market St./314-425-5560.

St. Paul, MN 55101: 316 N. Roberts St./612-725-7092.

Boston, MA 02114: P. O. Box 9115, JFK Post Office/617-223-3817.

Falls Church, VA 22046: 701 W. Broad St./703-557-1766.

Hartford, CT 06103: 135 High St./203-244-3642.

New York, NY 10008: P. O. Box 3482, Church St. Station/212-264-4658.

Philadelphia, PA 19106: U.S. Customs House, Room 504, 2d & Chestnut Sts./215-597-7266.

Richmond, VA 23240: P. O. Box 10068/804-771-2871.

Union, NJ 07083: P. O. 327/201-645-6300.

Dallas, TX 75242: 1114 Commerce St., Rm. 718/214-767-2250.

Houston, TX 77205: P. O. Box 60927/713-226-5405.

Los Angeles, CA 90012: P. O. Box 1991, Main Office/213-688-4812.

Oklahoma City, OK 73102: Federal Bldg., 200 N.W. 5th St./405-231-4877.

Phoenix, AR 85004: 522 N. Central Ave., Room 221/602-261-4328.

San Francisco, CA 94105: 525 Market St., Room 2540/415-556-6769.

Seattle, WA 98174: 915 2d Ave., Room 806/206-442-4485.

Office of Regulatory Enforcement

Cincinnati, OH 45202: 550 Main St./513-684-3331.

Philadelphia, PA 19102: 2 Penn Center Plaza/215-597-2217.

Chicago, IL 60604: 230 S. Dearborn St./312-353-3778.

New York, NY 10048: 6 World Trade Center/212-264-2328.

Atlanta, GA 30340: 3835 N.E. Expressway/404-455-2631.

Dallas, TX 75242: 1114 Commerce St./214-767-2260.

San Francisco, CA 94105: 525 Market St./415-556-2021.

Comptroller of the Currency

District 1: 470 Atlantic Ave., Boston, MA 02110/617-223-2274.

District 2: 1211 Avenue of the Americas, Suite 4250, New York, NY 10036/212-944-3495.

District 4: 1 Erieview Plaza, Cleveland, OH 44114/216-522-7141.

District 5: F & M Center, Richmond, VA 23277/804-643-3517.

District 6: 229 Peachtree St. N.E., Atlanta, GA 30303/404-221-4926.

District 7: Sears Tower, Chicago, IL 60606/312-353-0300.

District 8: 165 Madison Ave., Memphis, TN 38103/901-521-3376.

District 9: 800 Marquette Ave., Minneapolis, MN 55402/612-725-2684.

District 10: 911 Main St., Kansas City, MO 64105/816-374-6431.

District 11: 1201 Elm St., Dallas, TX 75270/214-767-4400.

District 12: 1405 Curtis St., Denver, CO 80202/303-837-4883.

District 13: 707 S.W. Washington St., Portland, OR 97205/503-221-3091.

District 14: 1 Market Plaza, San Francisco, CA 94105/415-556-4307.

Internal Revenue Service
Regional Commissioners

Cincinnati, OH 45202: 550 Main St./513-684-3613.

Philadelphia, PA 19102: 2 Penn Center Plaza/215-597-2040.

Chicago, IL 60606: 1 N. Wacker Dr./313-886-5600.

New York, NY 10007: 90 Church St./212-264-7061.

Atlanta, GA 30303: 275 Peachtree St. N.E./404-221-6048.

Dallas, TX 75251: 7839 Churchill Way/214-767-5855.

San Francisco, CA 94105: 525 Market St./415-556-4021.

Customs Service
Regional Commissioners

Boston, MA 02110: 100 Summer St., Suite 1819/617-223-7506.

New York, NY 10048: 6 World Trade Center, Room 716/212-466-4444.

Baltimore, MD 21202: 40 S. Gay St./301-962-3288.

Miami, FL 33131: 99 S.E. 5th St./305-350-5952.

New Orleans, LA 70112: 423 Canal St./504-589-6324.

Houston, TX 77002: 500 Dallas St./713-226-4893.

Los Angeles, CA 90053: 300 N. Los Angeles St./213-688-5900.

San Francisco, CA 94105: 211 Main St./415-556-3500.

Chicago, IL 60603: 55 E. Monroe St./312-353-4733.

Savings Bonds Division

New York, NY 10278: 26 Federal Plaza/212-264-7398.

Philadelphia, PA 19106: 2d & Chestnut Sts./215-597-3715.

New Orleans, LA 70113: 701 Loyola Ave./504-682-6105.

Chicago, IL 60604: 230 S. Dearborn St./312-353-6753.

St. Louis, MO 63101: 210 N. Tucker Blvd./314-279-5851.

Commodity Futures Trading Commission

Regional Offices

Eastern: 1 World Trade Center, Suite 4747, New York, NY 10048/212-466-2071.

Central: 233 S. Wacker Dr., Suite 4600, Chicago, IL 60606/312-353-6642.

Southwestern: 4901 Main St., Room 208, Kansas City, MO 64112/816-374-2994.

Western: 2 Embarcadero Center, Suite 1660, San Francisco, CA 94111/415-556-7503.

Consumer Product Safety Commission

Area Offices

Atlanta, GA 30308: 800 Peachtree St., N.E., Suite 210/404-881-2231.

Boston, MA 02110: 100 Summer St./617-223-5576.

New York, NY 10048: 6 World Trade Center/212-264-1125.

Chicago, IL 60604: 230 S. Dearborn St./312-353-8260.

Cleveland, OH 44114: 1404 E. 9th St./216-522-3886.

Dallas, TX 75242: 1100 Commerce St./214-767-0841.

Kansas City, MO 64105: 1221 Baltimore Ave./816-374-2034.

Los Angeles, CA 90010: 3660 Wilshire Blvd./213-688-7272.

St. Paul, MN 55101: Metro Square, 7th & Robert Sts./612-725-7781.

Philadelphia, PA 19106: 400 Market St./215-597-9105.

San Francisco, CA 94111: 555 Battery St./415-556-1816.

Seattle, WA 98174: 915 2d Ave./206-442-5276.

Equal Employment Opportunity Commission

Atlanta, GA 30303: 75 Piedmont Ave. N.E./404-221-4566.

Baltimore, MD 21211: 711 W. 40th St./301-962-3932.

Birmingham, AL 35203: 2121 8th Ave. N./205-254-1166.

Charlotte, N.C. 28204: 1301 E. Morehead St./704-371-6137.

Chicago, IL 60605: 536 S. Clark St./312-353-2713.

Cleveland, OH 44114: 1365 Ontario St./216-522-7425.

Dallas, TX 75201: 1900 Pacific Ave./214-767-4607.

Denver, CO 80202: 1531 Stout St./303-837-2771.

Detroit, MI 48226: 660 Woodward Ave./313-226-7636.

Houston, TX 77004: 2320 La Branch St./713-226-5511

Indianapolis, IN 46204: 46 E. Ohio St./317-269-7212.

Los Angeles, CA 90010: 3255 Wilshire Blvd./213-798-3400.

Memphis, TN 38104: 1407 Union Ave./901-521-2617.

Miami, FL 33131: 300 Biscayne Blvd. Way/305-350-4491.

Milwaukee, WI 53202: 342 N. Water St./414-291-1111.

New Orleans, LA 70130: 600 South St./504-589-3842.

New York, NY 10007: 90 Church St./212-264-7161.

Philadelphia, PA 19106: 127 N. 4th St./215-597-7784.

Phoenix, AZ 85073: 201 N. Central Ave./602-261-3882.

St. Louis, MO 63103: 625 N. Euclid St./314-425-5571.

San Francisco, CA 94102: 1390 Market St./415-556-0260.

Seattle, WA 98104: 710 2d Ave./206-442-0976.

Farm Credit Administration

Office of Examination

Columbia, SC 29204: 3710 Landmark Dr./803-765-5603.

St. Louis, MO 63141: 12101 Woodcrest Exectutive Dr./314-263-7101.

Bloomington, MN 55420: 2850 Metro Dr./612-854-3703.

Federal Deposit Insurance Corporation

Area Offices

Atlanta, GA 30043: 233 Peachtree St. NE./404-221-6631.

Boston, MA 02109: 60 State St./617-223-6420.

Chicago, IL 60606: 233 S. Wacker Dr./312-353-2600.

Columbus, OH 43215: 1 Nationwide Plaza/614-469-7301.

Dallas, TX 75201: 350 N. St. Paul St./214-767-5501.

Kansas City, MO 64108: 2345 Grand Ave./816-374-2851.

Madison, WI 53703: 1 S. Pinckney St./608-264-5226.

Memphis, TN 38103: 1 Commerce Sq./901-521-3872.

Minneapolis, MN 55402: 730 2d Ave. S./612-725-6241.

New York, NY 10154: 345 Park Ave./212-826-4762.

Omaha, NB 68102: 1700 Farnam St./402-221-3311.

Philadelphia, PA 19103: 5 Penn Center Plaza/215-597-2295.

Richmond, VA 23219: 707 E. Main St./804-771-2395.

San Francisco, CA. 94104: 44 Montgomery St./415-556-2736.

Federal Home Loan Bank Board

Area Offices

Boston, MA 02110: 1 Federal St./617-223-3206.

New York, NY 10048: 1 World Trade Center, 103rd Floor/212-264-1477.

Pittsburgh, PA 15222: 11 Stanwix St., Room 300, Gateway Center/412-644-2666.

Atlanta, GA. 30303: 260 Peachtree St. N.W./404-525-5778.

Cincinnati, OH 45202: 2700 DuBois Tower, 511 Walnut St./513-684-2855.

Indianapolis, IN 46204: 115 W. Washington St., Suite 1290/317-269-6559.

Chicago, IL 60601: 111 E. Wacker Dr., Room 700/312-353-8045.

Des Moines, IA 50309: 907 Walnut St., Room 501/515-284-4310.

Little Rock, AR 72201: 1350 Tower Bldg./501-378-5374.

Topeka, KS 66603: No. 3 Townsite Plaza, 120 E. 6th St./913-295-2615.

San Francisco, CA 94108: 600 California St., Room 310/415-556-1910.

Seattle, WA 98101: 600 Stewart St., Suite 610/206-442-7584.

Federal Labor Relations Authority

Regional Offices

Region I: 441 Stuart St., 9th Floor, Boston, MA 02116/617-223-0920.

Region II: 26 Federal Plaza, Room 241, New York, NY 10007/212-264-4934.

Region III: 1133 15th St., N.W., Suite 300, Washington, DC 20005/202-653-8452.

Region IV: 1776 Peachtree St. N.W., Suite 501, North Wing, Atlanta, GA 30309/404-881-2324.

Region V: 175 W. Jackson St., Suite 1359-A, Chicago, IL 60604/312-353-6306.

Region VI: Old Post Office Building, Room 450, Bryan & Ervay Sts., Dallas, TX 75221/214-767-4996.

Region VII: City Center Square, Suite 680, 1100 Main St., Kansas City, MO 64105/816-374-2199.

Region VIII: 350 S. Figueroa St., 10th Floor, Los Angeles, CA 90071/213-688-3805.

Region IX: 450 Golden Gate Ave., Room 11408, P. O. Box 36015, San Francisco, CA 94102/415-556-8105.

Federal Maritime Commission

Regional Offices

Atlantic: 6 World Trade Center, Suite 614, New York, NY 10048/212-264-1430.

Gulf: P. O. Box 30550, New Orleans, LA 70190/504-682-6662.

Pacific: 525 Market St., San Francisco, CA 94105/415-556-5272.

Great Lakes: 610 S. Canal St., Chicago, IL 60607/312-353-0282.

Puerto Rico: P. O. Box 3168, Carlos Chardon St. Hato Rey, PR 00917/809-753-4198.

Federal Mediation and Conciliation Service

Area Offices

New York, NY 10278: 26 Federal Plaza/212-264-1000.

Philadelphia, PA 19106: 4th & Chestnut Sts./215-597-7680.

Atlanta, GA 30309: 1422 W. Peachtree St. N.W./404-881-2473.

Cleveland, OH 44114: 815 Superior Ave. N.E./216-522-4800.

Chicago, IL 60604: 175 W. Jackson Blvd./312-353-7350.

St. Louis, MO 63141: 12140 Woodcrest Executive Dr./314-425-3291.

San Francisco, CA 94133: 50 Francisco St./415-556-4670.

Seattle, WA 98121: 2615 4th Ave./206-442-5800.

Federal Reserve System

Area Offices

Boston, MA 02106: 600 Atlantic Ave./617-973-3000.

New York, NY 10045: 33 Liberty St./212-791-5000.

Philadelphia, PA 19105: 100 N. 6th St./215-574-6000.

Cleveland, OH 44101: 1455 E. 6th St./216-579-2000.

Richmond, VA 23261: 701 E. Byrd St./804-643-1250.

Atlanta, GA 30303: 104 Marietta St. N.W./404-586-8500.

Chicago, IL 60690: 230 S. La Salle St./312-322-5322.

St. Louis, MO 63166: 411 Locust St./314-444-8444.

Minneapolis, MN 55480: 250 Marquette Ave./612-340-2345.

Kansas City, MO 64198: 925 Grand Ave./816-881-2000.

Dallas, TX 75222: 400 S. Akard St./214-651-6111.

San Francisco, CA 94120: 400 Sansome St./415-544-2000.

Federal Trade Commission
Area Offices
Atlanta, GA 30367: 1718 Peachtree St. N.W., Suite 1000/404-881-4836.

Boston, MA 02114: 150 Causeway St./617-223-6621.

Chicago, IL 60603: 55 E. Monroe St./312-353-4423.

Cleveland, OH 44114: 118 Saint Clair Ave., Suite 500/216-522-4207.

Dallas, TX 75201: 2001 Bryan St./214-767-0032.

Denver, CO 80202: 1405 Curtis St., Suite 2900/303-837-2271.

Los Angeles, CA 90024: 11000 Wilshire Blvd./213-824-7575.

New York, NY 10278: 26 Federal Plaza, Room 2237/212-264-1207.

San Francisco, CA 94102: 450 Golden Gate Ave./415-556-1270.

Seattle, WA 98174: 915 2d Ave./206-442-4655.

General Services Administration
Regional Offices
National Capital: 7th & D Sts. S.W., Washington DC 20407/202-472-1100.

Region I: John W. McCormack Post Office & Courthouse, Boston, MA 02109/617-223-2601.

Region II: 26 Federal Plaza, New York, NY 10278/212-264-2600.

Region III: 9th & Market Sts., Philadelphia, PA 19107/215-597-1237.

Region IV: 75 Spring St. S.W., Atlanta, GA 30303/404-221-3200.

Region V: 230 S. Dearborn St., Chicago, IL 60604/312-353-5395.

Region VI: 1500 E. Bannister Rd., Kansas City, MO 64131/816-926-7201.

Region VII: 819 Taylor St., Fort Worth, TX 76102/817-334-2321.

Region VIII: Denver Federal Center, Denver, CO 80225/303-234-4171.

Region IX: 525 Market St., San Francisco, CA 94105/415-556-3221.

Region X: GSA Center, Auburn, WA 98002/206-833-6500.

Interstate Commerce Commission
Area Offices
Boston, MA 02114: 150 Causeway St./617-223-2372.

Philadelphia, PA 19106: 101 N. 7th St./215-597-4449.

Atlanta, GA 30309: 1776 Peachtree St. N.W./404-881-4371.

Chicago, IL 60604: Everett McKinley Dirksen Building/312-353-6124.

Fort Worth, TX 76102: 411 W. 7th St./817-334-3101.

San Francisco, CA 94105: 211 Main St./415-556-5515.

Merit Systems Protection Board
Field Offices
Atlanta, GA 30309: 1776 Peachtree St. N.E./404-881-3631.

Boston, MA 02110: 100 Summer St., Room 1736/617-223-2556.

Chicago, IL 60604: 230 S. Dearborn St./312-353-2923.

Dallas, TX 75242: 1100 Commerce St./214-767-0555.

Denver, CO 80225: Denver Federal Center, Box 25025/303-234-3725.

Falls Church, VA 22041: 5203 Leesburg Pike, Room 1109/703-756-6250.

New York, NY 10007: 26 Federal Plaza/212-264-9372.

Philadelphia, PA 19106: U.S. Customhouse, Room 501/215-597-4446.

St. Louis, MO 63103: 1520 Market St., Room 1740/314-425-4295.

San Francisco, CA 94105: 525 Market St./415-556-0316.

Seattle, WA 98174: 915 2d Ave., Room 1840/206-442-0394.

National Credit Union Administration
Regional Offices
Region I: 441 Stuart St., Boston, MA 02116/617-223-6807.

Region II: 301 N. 2nd St., Harrisburg, PA 17101/717-782-4595.

Region III: 1365 Peachtree St. N.E., Atlanta, GA 30309/404-881-3127.

Region IV: 234 N. Summit St., Toledo, OH 43604/419-259-7511.

Region V: 515 Congress Ave., Suite 1400, Austin, TX 78701/512-397-5131.

Region VI: 2 Embarcadero Center, San Francisco, CA 94111/415-556-6277.

National Labor Relations Board
District Offices

District 1: Boston, MA 02110: 99 High St./617-223-3300.

District 2: New York, NY 10007: 26 Federal Plaza/212-264-0300.

District 3: Buffalo, NY 14202: 111 W. Huron St./716-846-4931.

District 4: Philadelphia, PA 19106: 600 Arch St./215-597-7601.

District 5: Baltimore, MD 21201: 101 W. Lombard St./301-962-2822.

District 6: Pittsburgh, PA 15219: 601 Grant St./412-644-2977.

District 7: Detroit, MI 48226: 477 Michigan Ave./313-226-3200.

District 8: Cleveland, OH 44199: 1240 E. 9th St./216-522-3715.

District 9: Cincinnati, OH 45202: 550 Main St./513-684-3686.

District 10: Atlanta, GA 30303: 101 Marietta St. N.W./404-221-2896.

District 11: Winston-Salem, NC 27101: 251 N. Main St./919-761-3201.

District 12: Tampa, FL 33602: 500 Zack St./813-228-2641.

District 13: Chicago, IL 60604: 219 S. Dearborn St./312-353-7570.

District 14: St. Louis, MO 63101: 210 N. 12th Blvd./314-425-4167.

District 15: New Orleans, LA 70113: 1001 Howard Ave./504-589-6361.

District 16: Fort Worth, TX 76102: 819 Taylor St./817-334-2921.

District 17: Kansas City, KS 66101: 4th St. & State Ave./816-374-4518.

District 18: Minneapolis, MN 55401: 110 S. 4th St./612-725-2611.

District 19: Seattle, WA 98174: 915 2d Ave./206-442-4532.

District 20: San Francisco, CA 94102: 450 Golden Gate Ave./415-556-3197.

District 21: Los Angeles, CA 90014: 606 S. Olive St./213-688-5200.

District 22: Newark, NJ 07102: 970 Broad St./201-645-2100.

District 23: Houston, TX 77002: 500 Dallas Ave./713-226-4296.

District 24: Hata Rey, PR 00918: Carlos E. Chardon Ave./809-753-4347.

District 25: Indianapolis, IN 46204: 575 N. Pennsylvania St./317-269-7430.

District 26: Memphis, TN 38104: 1407 Union Ave./901-521-2725.

District 27: Denver, CO 80202: 721 19th St./303-837-3555.

District 28: Phoenix, AZ 85067: 3030 N. Central Ave./602-241-2350.

District 29: Brooklyn, NY 11241: 16 Court St./212-330-7713.

District 30: Milwaukee, WI 53203: 744 N. 4th St./414-291-3861.

District 31: Los Angeles, CA 90024: 11000 Wilshire Blvd./213-824-7352.

District 32: Oakland, CA 94604: 2201 Broadway/415-273-7200.

District 33: Peoria, IL 61602: 411 Hamilton Ave./309-671-7080.

National Transportation Safety Board
Administrative Law Judge Circuits

Aurora, CO 80010: 10255 E. 25th Ave., Suite 8/303-837-4492.

Washington, DC 20594: 800 Independence Ave. S.W./202-472-6060.

Los Angeles, CA 90261: Federal Building, 15000 Aviation Blvd., P. O. Box 6117, Lawndale, CA 90261/213-966-6045.

Aviation Field Office

Jamaica, NY 11430: Federal Building, John F. Kennedy International Airport/212-995-3716.

Atlanta, GA 30309: 1720 Peachtree St. N.W./404-881-7385.

Miami Springs, FL 33166: 4471 N.W. 36th St./305-526-2940.

Des Plaines, IL 60018: 2300 E. Devon Ave./312-827-8858.

Kansas City, MO 64106: 601 E. 12th St./816-374-3576.

Los Angeles, CA 90261: Federal Building, 15000 Aviation Blvd., P. O. Box 6117/213-995-6041.

Anchorage, AK 99513: 701 C St., Room C-145, Box 11/907-271-5001.

Aurora, CO 80010: 10255 E. 25th Ave./303-837-4492.

Fort Worth, TX 76102: 819 Taylor St./817-334-2616.

Seattle, WA 98188: 19415 Pacific Hwy. S./206-764-3782.

Highway Field Offices

New York, NY 11430: Federal Building, John F. Kennedy International Airport, Jamaica, NY 11430/212-995-3716.

Atlanta, GA 30309: 1720 Peachtree St. N.W., Suite 921/404-881-7385.

Kansas City, MO 64106: 601 E. 12th St./816-374-3576.

Los Angeles, CA 90261: Federal Building, 15000 Aviation Blvd., P. O. Box 6117, Lawndale, CA 90261/213-536-6041.

Pipeline Field Offices

Washington, DC 20594: 800 Independence Ave. S.W./202-472-5973.

Fort Worth, TX 76102: 819 Taylor St./817-334-2616.

Railroad Field Offices

Jamaica, NY 11430: Federal Building, John F. Kennedy International Airport/212-995-3716.

Washington, DC 20594: 800 Independence Ave. S.W./202-472-6091.

Atlanta, GA 30309: 1720 Peachtree St. N.W., Suite 921/404-881-7385.

Des Plaines, IL 60018: 2300 E. Devon Ave./312-827-8858.

Kansas City, MO 64106: 601 E. 12th St./816-374-3576.

Los Angeles, CA 90261: Federal Building, 15000 Aviation Blvd., P.O. Box 6117, Lawndale, CA 90261/213-995-6041.

Aurora, CO 80010: 10255 E. 25th Ave./303-837-4492.

Fort Worth, TX 76102: 819 Taylor St./817-334-2616.

Seattle, WA 98188: 19415 Pacific Hwy. S./206-764-3782.

Nuclear Regulatory Commission

Area Offices

King of Prussia, PA 19406: 631 Park Ave./215-337-5000.

Atlanta, GA 30303: 101 Marietta St., Suite 3100/404-221-4503.

Glen Ellyn, IL 60137: 799 Roosevelt Rd./312-932-2500.

Arlington, TX 76012: 611 Ryan Plaza Dr., Suite 1000/817-465-8100.

Walnut Creek, CA 94596: 1990 N. California Blvd., Suite 202/415-943-3700.

Occupational Safety and Health Review Commission

Area Offices

Boston, MA 02109: John W. McCormack Post Office and Courthouse/617-223-3757.

New York, NY 10036: 1515 Broadway/212-944-3455.

Hyattsville, MD 20782: 6525 Belcrest Rd./301-436-8870.

Atlanta, GA 30309: 1365 Peachtree St./404-881-4086.

Chicago, IL 60603: 55 E. Monroe St./312-353-2564.

Dallas, TX 75242: 1100 Commerce St./214-767-5271.

St. Louis, MO 63101: 1114 Market St./314-425-5071.

Denver, CO 80265: 1050 17th St./303-837-2281.

Burlingame, CA 94010: 1818 Gilbreth Rd./415-876-9292.

Railroad Retirement Board

Area Offices

Atlanta, GA 30303: 101 Marietta St. N.W., Suite 2304/404-221-2690.

New York, NY 10278: Federal Building, Room 3415, 26 Federal Plaza/212-264-8495.

Cleveland, OH 44199: Anthony J. Celebrezze Federal Building/216-522-4043.

Kansas City, MO 64106: Federal Building, Room 257, 601 E. 12th St./816-374-3278.

San Francisco, CA 94102: Federal Building, Room 7419, 450 Golden Gate Ave., Box 36043/415-556-2584.

Securities and Exchange Commission

Area Offices

Atlanta, GA 30367: 1371 Peachtree St. N.E./404-257-2524.

Boston, MA 02214: 150 Causeway St./617-223-2721.

Chicago, IL 60604: 219 S. Dearborn St./312-353-9338.

Denver, CO 80202: 410 17th St./303-327-2071.

Fort Worth, TX 76102: 411 W. 7th St./817-334-3821.

Los Angeles, CA 90024: 10960 Wilshire Blvd./213-984-0211.

New York, NY 10007: 26 Federal Plaza/212-264-1636.

Seattle, WA 98174: 915 2d Ave./206-399-7990.

Arlington, VA 22203: 4015 Wilson Blvd./703-557-8200.

Army

Corps of Engineers (Civil Works)
Division Offices

Lower Mississippi Valley: P. O. Box 80, Vicksburg, MS 39180/601-634-5750.

Missouri River: P. O. Box 103, Downtown Station, Omaha, NB 68101/402-221-3207.

New England: 424 Trapelo Rd., Waltham, MA 02154/617-894-2400, Ext. 200.

North Atlantic: 90 Church St., New York, NY 10007/212-264-7101.

North Central: 536 S. Clark St., Chicago, IL 60605/312-353-6310.

North Pacific: P. O. Box 2870, Portland, OR 97208/503-221-3700.

Ohio River: P. O. Box 1159, Cincinnati, OH 45201/513-684-3002.

Pacific Ocean: Building 230, Fort Shafter, HI 96858/808-438-1500.

South Atlantic: 510 Title Building, 30 Pryor St. S.W., Atlanta GA 30303/404-221-6711.

South Pacific: 630 Sansome St., Room 1216, San Francisco, CA 94111/415-556-0914.

Southwestern: 1114 Commerce St., Dallas, TX 75242/214-767-2500.

Memphis: 668 Clifford Davis Federal Building, Memphis, TN 38103/901-521-3221.

New Orleans: P. O. Box 60267, New Orleans, LA 70160/504-838-1200.

St. Louis: 210 N. 12th St., St. Louis, MO 63101/314-263-5660.

Vicksburg: P. O. Box 60, Vicksburg, MS 39180/601-634-5010.

Kansas City: 700 Federal Building, Kansas City, MO 64106/816-374-3201.

Omaha: 6014 U.S. Post Office and Courthouse, 215 N. 17th St., Omaha, NB 68102/402-221-3900.

Baltimore: P. O. Box 1715, Baltimore, MD 21203/301-962-4545.

New York: 26 Federal Plaza, New York, NY 10007/212-264-0100.

Norfolk: 803 Front St., Norfolk, VA 23510/804-441-3601.

Philadelphia: U.S. Custom House, 2d & Chestnut Sts., Philadelphia, PA 19106/215-597-4848.

Buffalo: 1776 Niagara St., Buffalo, NY 14207/716-876-5454.

Chicago: 219 S. Dearborn St., Chicago, IL 60604/312-353-6400.

Detroit: P. O. Box 1027, Detroit, MI 48231/313-226-6762.

Rock Island: Clock Tower Building, Rock Island, IL 61201/309-788-6361.

St. Paul: 1135 U.S. Post Office and Custom House, St. Paul, MN 55101/612-725-7501.

Alaska: P. O. Box 7002, Anchorage, AK 99510/907-752-5233 or 279-1132 (FTS).

Portland: P. O. Box 2946, Portland, OR 97208/503-221-6000.

Seattle: P. O. Box C-3755, Seattle, WA 98124/206-764-3690.

Walla Walla: Building 602, City-County Airport, Walla Walla, WA 99362/509-525-5500.

Huntington: P. O. Box 2127, Huntington, W. VA 25721/304-529-5253.

Louisville: P. O. Box 59, Louisville, KY 40201/502-582-5601.

Nashville: P. O. Box 1070, Nashville, TN 37202, 615-251-5626.

Pittsburgh: Federal Building, 1000 Liberty Ave., Pittsburgh, PA 15222/412-644-6800.

Charleston: P. O. Box 919, Charleston, SC 29402/803-724-4229.

Jacksonville: P. O. Box 4970, Jacksonville, FL 32232/904-791-2241.

Mobile: P. O. Box 2288, Mobile, AL 36628/205-690-2511.

Savannah: P. O. Box 889, Savannah, GA 31402/912-944-5224.

Wilmington: P. O. Box 1890, Wilmington, NC 28402/919-343-4624, ext. 466.

Los Angeles: P. O. Box 2711, Los Angeles, CA 90053/213-688-5300.

Sacramento: 650 Capitol Mall, Sacramento, CA 95814/916-440-2232.

San Francisco: 211 Main St., San Francisco, CA 94105/415-556-3660.

Albuquerque: P. O. Box 1580, Albuquerque, NM 87103/505-766-2732.

Fort Worth: P. O. Box 17300, Fort Worth, TX 76102/817-334-2300.

Galveston: P. O. Box 1229, Galveston, TX 77553/713-763-1211.

Little Rock: P. O. Box 867, Little Rock, AR 72203/501-378-5531.

Tulsa: P. O. Box 61, Tulsa, OK 74102/918-581-7311.

Veterans Administration

Department of Medicine and Surgery

Northeastern: 810 Vermont Ave. N.W., Washington, DC 20420/202-389-2734.

Mid-Atlantic: 810 Vermont Ave. N.W., Washington, DC 20420/202-389-3571.

Southeastern: 810 Vermont Ave. N.W., Washington, DC 20420/202-389-2765.

Great Lakes: 810 Vermont Ave. N.W., Washington, DC 20420/202-389-3754.

Mid-Western: 810 Vermont Ave. N.W., Washington, DC 20420/202-389-2173.

Western: 810 Vermont Ave. N.W., Washington, DC 20420/202-389-5062.

District 1: 150 S. Huntington Ave., Boston, MA 02130/617-232-9500.

District 2: 3495 Bailey Ave., Buffalo, NY 14215/716-834-9200.

District 3: Castle Point, NY 12511/914-831-2000.

District 4: Coatesville, PA 19320/215-384-7711.

District 5: University Dr. C, Pittsburgh, PA 15240/412-683-3000.

District 6: 50 Irving St. N.W., Washington, DC 20422/202-483-6666.

District 7: 1201 Broad Rock Rd., Richmond, VA 23249/804-231-9011.

District 8: Asheville, NC 28805/704-298-7911.

District 9: 1670 Clairmont Rd., Atlanta, GA 30033/404-321-6111.

District 10: 700 S. 19th St., Birmingham, AL 35233/205-933-8101.

District 11: Lexington, KY 40507/606-233-4511.

District 12: Archer Rd., Gainesville, FL 32602/ 904-376-1611.

District 13: Brecksville, OH 44141/216-791-3800.

District 14: 2215 Fuller Rd., Ann Arbor, MI 48105/313-769-7100.

District 15: 1481 W. 10th St., Indianapolis, IN 46202/317-635-7401.

District 16: 2500 Overlook Terrace, Madison, WI. 53705/608-256-1910.

District 17: VA Medical Center, Hines, IL 60141/312-343-7200.

District 18: 54th St. & 48th Ave. S., Minneapolis, MN 55417/612-725-6767.

District 19: 300 Roosevelt Rd., Little Rock, AR 72206/501-372-8361.

District 20: Temple, TX 76501/817-778-4811.

District 21: St. Louis, MO 63125/314-487-0400.

District 22: Leavenworth, KS 66048/913-682-2000.

District 23: Omaha, NB 68105/402-346-8800.

District 24: 2121 North Ave., Grand Junction, CO 81501/303-242-0731.

District 25: Prescott, AZ 86313/602-445-4860.

District 26: 5901 E. 7th St., Long Beach, CA 90822/213-498-1313.

District 27: 4150 Clement St., San Francisco, CA 94121/415-221-4810.

District 28: Seattle, WA 98108/206-762-1010.

Department of Memorial Affairs
Area Offices

Atlanta, GA 30308: 730 Peachtree St. N.E./404-881-2121.

Philadelphia, PA 19106: 600 Arch St./215-922-5421.

San Francisco, CA 94105: 211 Main St./415-556-1903.

Department of Veterans Benefits
Field Directors

Eastern Region: Room 316 (201A), 810 Vermont Ave. N.W., Washington, DC 20420/202-389-5284.

Central Region: Room 324 (201B), 810 Vermont Ave. N.W., Washington, DC 20420/202-389-5341.

Western Region: Room 332 (201C), 810 Vermont Ave., N.W., Washington, DC 20420/202-389-5335

DEPARTMENTS

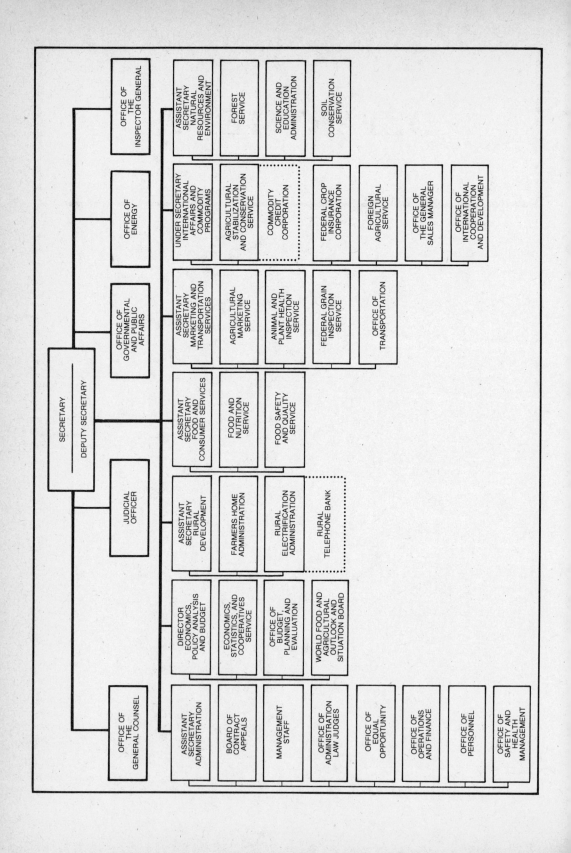

Department of Agriculture (USDA)

14th St. and Independence Ave. S.W.,

Washington, DC 20250/202-655-4000

ESTABLISHED: May 15, 1862
BUDGET (1980 est.): $20,543,731,000
EMPLOYEES: 120,000

MISSION: Improve and maintain farm income. Develop and expand markets abroad for agricultural products. Help curb and cure poverty, hunger and malnutrition. Enhance the environment and maintain production capacity by helping landowners protect the soil, water, forests and other natural resources. Aid in carrying out national growth policies with rural development, credit and conservation programs. Provide safeguards and assure standards of quality in the daily food supply by providing inspection and grading services.

Major Divisions and Offices

Natural Resources and Environment

USDA, Room 242-W, Washington, DC 20250/
202-447-7173.
Budget: $3,025,143,000
Employees: 65,746

1. Science and Education Administration (SEA)

USDA, Room 217-W, Washington, DC 20250/
202-447-5923.
Budget: $797,751,000
Employees: 10,000
Mission: Support, coordinate and plan food and agriculture research, extension and teaching efforts at local and national levels. Identify high priority national objectives in the food and agricultural sciences. Support world food and agriculture needs. Improve cooperation between food and agricultural sciences and communicate results to farmers, processors, handlers, consumers and other users. Support and promote information systems and libraries in the food and agricultural sciences.

2. Forest Service

USDA, Room 3008 South Building, Washington, DC 20250/202-447-6661.
Budget: $1,680,389,000

Employees: 39,481
Mission: Promote and achieve a pattern of natural resource use that will best meet the needs of people. Protect and improve the quality of air, water, soil, and natural beauty. Protect and improve the quality of the open space environment in urban and community areas. Generate forestry opportunities to accelerate rural community growth. Encourage optimum forest landownership patterns. Improve the welfare of underprivileged members of society. Involve the public in forestry policy and program formulation. Encourage the development of forestry throughout the world. Expand public understanding of environmental conservation.

3. Soil Conservation Service

USDA, Room 5105 South Building, Washington, DC 20250/202-447-4525.
Budget: $547,003,000
Employees: 16,265
Mission: Develop and carry out a national soil and water conservation program in cooperation with landowners and operators and other land users and developers, with community planning agencies and regional resource groups, and with other government agencies. Assist in agricultural pollution control, environmental improvement, and rural community development.

International Affairs and Commodity Programs

USDA, Room 212-A, Washington, DC 20250/
202-447-3111.
Budget: $3,472,068,000
Employees: 5,803

1. Agricultural Stabilization and Conservation Service

USDA, Room 3085 South Building, Washington,
DC 20250/202-447-3467.
Budget: $345,986,000
Employees: 3,094
Mission: Administer commodity stabilization
programs through loans, purchases and pay-
ments. Keep production of commodities desig-
nated by law in line with demand with crop land
set aside, acreage allotments, normal crop acre-
age and marketing quotas. Provide emergency as-
sistance to farmers.

2. Commodity Credit Corporation

USDA, Room 210-A, Washington, DC 20250/
202-447-3111.
Budget: $3,051,589
Employees: 1,172
Mission: Stabilize and protect farm income and
prices. Assist in maintaining balanced and ade-
quate supplies of agricultural commodities and
their products. Facilitate the orderly distribution
of commodities.

3. Federal Crop Insurance Corporation

USDA, Room 4096 South Building, Washington,
DC 20250/202-447-6795.
Budget: $12,000,000
Employees: 1,663
Mission: Promote the general welfare of the farm
community by providing crop insurance against
loss from unavoidable causes, such as weather,
insects, and diseases.

4. Foreign Agricultural Service

USDA, Room 5071 South Building, Washington,
DC 20250/202-447-3935.
Budget: $54,929,000
Employees: 789
Mission: Maintain and expand export sales. Im-
prove access to foreign markets for U.S. farm
products through representations to foreign gov-
ernments and participation in formal trade nego-

tiations. Operate a global reporting and analysis
network covering world agricultural production,
trade, competition and policy situations affecting
U.S. agriculture.

5. Office of General Sales Manager

USDA, Room 4071 South Building, Washington,
DC 20250/202-447-5173.
Budget: $4,600,000
Employees: 110
Mission: Administer export programs that facili-
tate exports of commodities in the United States.

6. Office of International Cooperation and Development

USDA, Room 3049 South Building, Washington,
DC 20250/202-447-3157.
Budget: $2,964,000
Employees: 147
Mission: Coordinate, plan and direct the depart-
ment's efforts in international development and
technical cooperation in food and agriculture.
Coordinate international organization affairs and
scientific exchange programs.

Food and Consumer Services

USDA, Room 207-W, Washington, DC 20250/
202-447-7711.
Budget: $11,303,205,000
Employees: 16,116

1. Food and Nutrition Service

USDA, 500 12th St. S.W. #726, Washington,
DC 20250/202-447-8384.
Budget: $10,708,433,000
Employees: 2,604
Mission: Administer programs to make food as-
sistance available to people who need it.

2. Food Safety and Quality Service (FSIS)

USDA, Room 332-E, Washington, DC 20250/
202-447-7025.
Budget: $594,772,000
Employees: 13,512
Mission: Provide assurance to the consumer that
foods are safe, wholesome, and nutritious, that
they are of good quality, and that they are infor-
matively and honestly labeled. Provide assistance
to the marketing system through purchase of sur-
plus food commodities.

Marketing and Inspection Services

USDA, Room 242-E, Washington, DC 20250/
202-447-4256.
Budget: $296,676,000
Employees: 11,334

1. Agricultural Marketing Service (AMS)

USDA, Room 3071 South Building, Washington,
DC 20250/202-447-5115.
Budget: $52,328,000
Employees: 3,755
Mission: Assist producers and handlers of agricultural commodities by administering standardization, grading, voluntary and mandatory inspection, market news, marketing orders, and regulatory and related programs.

2. Animal and Plant Health Inspection Service (APHIS)

USDA, Room 312-E, Washington, DC 20250/
202-447-3668.
Budget: $220,976,000
Employees: 5,722
Mission: Conduct regulatory and control programs to protect and improve animal and plant health for the benefit of man and his environment. Administer laws and regulations pertaining to animal and plant health, guarantee humane treatment of animals, and control eradication of pests and diseases.

3. Federal Grain Inspection Service

USDA, Room 1628 South Building, Washington,
DC 20250/202-447-9170.
Budget: $23,372,000
Employees: 1,857
Mission: Establish official U.S. standards for grain and other assigned commodities and administration of a nationwide system of official inspection. Regulate the weighing of all grain coming into or going out of any export facility in the United States.

Rural Development

USDA, Room 5015 South Building, Washington,
DC 20250/202-447-3333.
Budget: $2,609,065,000
Employees: 14,632

1. Farmers Home Administration

USDA, Room 5014 South Building, Washington,
DC 20250/202-447-7967.

Budget: $2,583,086,000
Employees: 13,897
Mission: Provide credit for those in rural America who are unable to get credit from other sources at reasonable rates and terms.

2. Rural Electrification Administration

USDA, Room 4051, Washington, DC 20250/
202-447-5123.
Budget: $25,970,000
Employees: 735
Mission: Provide, through self-liquidating loans and technical assistance, adequate and dependable electric and telephone service to rural people under rates and conditions that permit full and productive use of these utility services.

Economics

USDA, Room 227-E, Washington, DC 20250/
202-447-4164.
Budget: $92,144,000
Employees: 2,525

1. Office of Budget Program Analysis

USDA, Room 112-A, Washington, DC 20250/
202-447-3323.
Budget: $3,196,000
Employees: 81
Mission: Prepare departmental budget estimates and legislative reports. Provide policy, program and budgetary analysis of USDA proposals.

2. World Agricultural Outlook Board

USDA, Room 3509 S, Washington, DC 20250/
202-447-6030.
Budget: $1,045,000
Employees: 18
Mission: Coordinate and review all commodity and aggregate agricultural and food data and analysis used to develop outlook and situation material prepared within the USDA.

3. Economic Research Service

USDA, 500 12th St. S.W. #448-B, Washington,
DC 20250/202-447-8104.
Budget: $87,903,000
Employees: 2,426
Mission: Collect and publish statistics related to food, agriculture, and rural resources and communities. Provide research and technical assistance on the financial, organizational, management, legal, social and economic aspects of agriculture-related cooperatives.

Data Experts

Agricultural Economists

Staff economists can supply information on a wide variety of agricultural subjects. They are knowledgeable on all aspects of the distribution chain from producer to end user. Each individual below can be reached by mail in care of the Economics, Statistics and Cooperatives Service, USDA, or directly by telephone.

Office of Crops, Dairy, Livestock and Poultry
Broilers/Kenneth Blase/202-447-4997
Catfish/Dwight Gadsby/202-447-2352
Cattle/Ron Gustafson/202-447-8636
Corn & Feed Grains/Bruce Wright/202-447-4997
Cold Storage/Jim Lawson/202-447-6351
Cotton/Mildred Jones/202-447-8776
Dairy Products/Clifford Carman/202-447-8636
Eggs/Alan Baker/202-447-4997
Floriculture/Steve Raleigh/202-447-8661
Hay/Bruce Wright/202-447-4997
Hogs/Leland Southard/202-447-8636
Milk/Clifford Carman/202-447-8636
Oilseeds/Leslie L. Herren/202-447-8444
Peanuts/Robert H. Miller/202-447-8444
Poultry/Alan Baker/202-447-4997
Potatoes/Jules Powess/202-447-7133
Seeds/Pat Miles/202-447-7687
Sheep/John Lange/202-447-6880
Slaughter/John Lange/202-447-6880
Soybeans/Leslie L. Herren/202-447-8444
Sugar/Robert Barry/202-447-7290
Turkeys/Alan Baker/202-447-4997
Vegetables/Jules Powell/202-447-7290
Wool/Sam Evans/202-447-8776
Other Crops/Floyd Rolf/202-447-2127

U.S. Trade and Foreign Agriculture
U.S. Exports and Imports/John Dunmore/202-447-9160

International
World/Richard Kennedy/202-447-8260
Trade policies/Charles Hanrahan/202-447-8981
Africa and Mid-East/Cheryl Christensen/202-447-8054
Asia/Carmen Nohre/202-447-8860
China/Charles Liu/202-447-8676
Eastern Europe/Anton Malish/202-447-8380
Latin America/Wade Gregory/202-447-8133
Soviet Union/Anton Malish/202-447-8380
Economic development and trade/Arthur Mackie/202-447-8289
International monetary and financial/Eileen Manfredi/202-447-8712

Office of Farm Finances
Agricultural Finances/Steve Gabriel/202-447-7340
Balance Sheet of Farming Sector/Carson Evans/202-447-5457
Farm Credit/Steve Gabriel/202-447-7340
Income/Steve Guebert/202-447-7577
Prices and Parity/LeRoy Rude/202-447-8489
Production Expenditures/David Kincannon/202-447-7577
Taxes/Ronald Durst/202-447-7383
Wages and Labor/Robert Coltrane/202-447-8621

Office of Farms and Land
Corporate Farming/Donn Reimund/202-447-8168
Farm Numbers/Paul Hurt/202-447-4830
Farm Real Estate/Ronald Jeremias/202-447-7340
Family Farms/Donn Reimund/202-447-8168
Land Ownership/Gene Wunderlich/202-447-9179
Land Policy/Robert Boxley/202-447-4859
Land Use Planning/William Anderson/202-447-8320

Office of Food
Food Assistance Research/Paul Nelson/202-447-6363
Food Consumption/Richard Prescott/202-447-8801
Food Prices/Ralph Parlett/202-447-6860
Food Substitutes/William Gallimore/202-447-4190

Office of Marketing
Agricultural Promotion and Advertising/Peter Henderson/202-447-6860
Consumer Surveys/Charles Handy/202-447-4190
Marketing Margins and Statistics/Dennis Dunham/202-447-8801
Price Spreads/Don Agnew/202-447-3055

Other Topics
Agricultural History/Wayne Rasmussen/202-447-8183
Cooperatives/Ralph Richardson (Statistics)/202-447-8906
Economic Projection/Leroy Quance/202-447-7681
Energy/Gary Reisner/202-447-7340
Environmental Quality/Velmar Davis/202-447-8240

Farm Machinery/Carl Vosloh/202-447-7340

Fibers/Sam Evans/202-447-8776

Health and Education/Bernal Green/202-447-8673

Housing/Carol Meeks/202-447-8717

Natural Resource Projections/John Day/202-447-8320

Output and Productivity/Charles Cobb/202-447-8342

Personal Incomes/Tom Carlin/202-447-8366

Pest Control/John Schaub/202-447-8151

Pesticides/Theodore Eichers/202-447-7340

Commodity Programs and Policies/Jim Johnson/202-447-6620

Roadside Marketing/Harold Linstrom/202-447-6860

Rural Development/Kenneth Deavers/202-447-8225

State and Local Government Programs/J. Norman Reid/202-447-8874

Transportation/William Gallimore/202-447-8487

Water Policy/Richard Magleby/202-447-2667

Weather/Bill Blackson/202-447-3843

Office of Situation Reports

Cotton and Wool Situation/Mildred Jones/202-447-8776

Dairy Situation/Clifford Carman/202-447-8636

Fats and Oils Situation/George Kromer/202-447-8444

Feed Situation/Bruce Wright/202-447-4997

Fertilizer Situation/Paul Andrilenas/202-447-7340

Fruit Situation/Ben Huang/202-447-7290

Livestock and Meat Situation/Joseph Arata/202-447-8972

Poultry and Egg Situation/Allen Baker/202-447-8636

Rice Situation/Allen Schienbein/202-447-8776

Sugar and Sweetener Situation/Robert Barry/202-447-7290

Tobacco Situation/Robert Miller/202-447-8776

Vegetable Situation/Jules Powell/202-447-7290

Wheat Situation (rye included)/Allen Schienbein/202-447-8776

World Agricultural Situation/Richard Kennedy/202-447-8260

Major Sources of Information

Agricultural Research and Technical Expertise

A large staff administers a basic, applied and developmental research program in areas which include pesticides, radiological safety, crop production, plant genetics and breeding, plant introduction and narcotics, plant physiology, crop protection, pest and insect control, plant pathology and nematology, weed science, uses of farm products, processing animal products, soil fertility and plant nutrition, aerospace technology, and livestock and veterinary sciences. For expertise on a specific topic, contact: Agricultural Research Service, USDA, Room 302-A, Administration Building, Washington, DC 20250/202-447-3656.

Agricultural Statistics

Contact specific economists identified under "Statistics Reporting Service" in this section, Room 5829-S, USDA, Washington, DC 20250/202-447-4021.

Animal Diseases

See "Livestock and Veterinary Sciences."

Animal Products Production

Research is conducted on improving efficiency through plant layout, work methods, equipment design, etc. for livestock markets, commercial feedlots, meatpacking plants, boning plants, poultry plants, egg-packing plants, cheese making, and ice cream plants. Contact: Animal Products Group, Research and Development, AMS, Room 117, Building 307, BARC-East, Beltsville, MD 20705/301-344-2800.

Aquaculture

Professional expertise and services are available to those interested in controlled cultivation and harvesting of aquatic animals and plants. Contact: Aquaculture Department, SNE, Office of the Secretary, 434 W. Administration, Washington, DC 20250/202-447-7157.

Bees and Beekeeping

Production and price statistics are available. See "Agricultural Statistics" in this section. Technical expertise and advice are available from Bee Breeding and Stock Center, Rte. 3, Box 82B, Ben Hur Rd., Baton Rouge, Louisiana 70808/504-766-6064.

Best and Worst Food Buys

A monthly bulletin called *Food Marketing Alert* is available free to volume buyers and communication media. It lists current food prices for all commodities and states whether the food is plentiful, adequate or in short supply. Contact: Food Marketing Alert, Agricultural Marketing

Service, USDA, Room 2624, Washington, DC 20250/202-447-2399.

Consumers can subscribe to *National Consumer Buying Alert.* This publication contains the same information published in *Food Marketing Alert* along with other tips for saving money on energy, housing and health care. This monthly publication is available free by writing: Esther Peterson, Consumer Information Center, Pueblo, CO 81009.

Bibliographies

The National Agricultural Library has free bibliographies available on a wide variety of subjects. Contact the library and request a listing of their Quick Bibliography Series. See "Library."

Brides Information Package

A free package, entitled "Packet for the Bride," is available to new homemakers. The packet consists of an assortment of home and garden bulletins relating to budgeting, consumer tips, cooking, etc. Packets are available from your congressman or by contacting: Office of Governmental Public Affairs, USDA, Room 508A, Washington, DC 20250/202-447-7487.

Bull Sperm

For those interested in buying or selling bull semen, information is available from your local county extension agent (see "Extension Service" in this section) or from Animal Science Institute, Agricultural Research Center, 217 B-200 BARC-E., Beltsville, MD 20705/301-344-3431.

Children and Teenager Loans

Loans are available to children from 10 to 21 years old for projects such as small crop growing, livestock farming, roadside stands, and custom work. See "Best of Government Freebies."

College Courses

The USDA Graduate School offers college courses on nonagricultural subjects and at reasonable prices. The school does not grant degrees; some lectures are available on film, videotape and in manuscript form. Contact: Information Office, USDA Graduate School, Capital Gallery Building, 600 Maryland Ave. S.W., Room 129, Washington, DC 20024/202-447-4419.

Coloring Books

Free coloring books show nutritional value of foods. Books are in English and Spanish. Contact: Public Information, Food and Nutrition Service, S-51 12th St. S.E., #764, Washington, DC 20250/202-447-8138.

Compost and Sludge

For technical assistance on the production and use of compost and sludge, contact: Biological Waste Management and Organic Resources Labs, Building 007, Room 124 BARC-W., Beltsville, MD 20705/301-344-3163.

Computerized Data Bases

Crop and livestock production and demand data and forecasts can be obtained through private timesharing services. Contact: Secretary of the Crop Reporting Board, Room 5809, USDA, Washington, DC 20250/202-447-2130.

USDA's AGRICOLA data base, consisting of indexes to general agriculture, food and nutrition, and agricultural economics information is available for *free* from the National Agricultural Library. See "Library."

Conferences

A free four-day conference is held each fall in Washington, DC covering agricultural supplies, demand for farm products, food prices, pesticides, land use, and family characteristics. Contact: Economics, Statistics and Cooperatives Service.

Conservation

There is a wide range of loan and grant programs which support agricultural conservation. See "Grants," and "Loans and Loan Guarantees" in this section.

Consumer Complaints

If you have a complaint concerning a problem with any meat or poultry product, action can be taken by contacting: FSIS, Meatbone Hazard Control Center, Epidemiology Branch, USDA, BARC-E., Building 322, Beltsville, MD 20705/301-344-2003.

Daily Commodity Prices

With the help of AT&T, USDA offers a wire service of daily market quotations on agricultural products. Contact: AMS, Communications and Operations Branch, USDA, Room 0092, S Building, Washington, DC 20250/202-447-7047.

Direct Payments

The programs described below are those that provide financial assistance directly to individuals, private firms and other private institutions to encourage or subsidize a particular activity.

Beekeeper Indemnity Payments

Objectives: To indemnify beekeepers who through no fault of their own have suffered losses of honey bees as a result of utilization of econom-

ic poisons near or adjacent to the property on which the bee hives were located.

Eligibility: A beekeeper who established that he suffered a loss of bees; that the loss of bees was the result of the use of pesticides near or adjacent to his apiary and occurred without his fault; that if he used pesticides, his use of pesticides in no way contributed to the loss of his bees; that if he had advance notice that pesticides were going to be used near his apiary, he took reasonable steps to protect his bees. All bee losses must be inspected by a trained ASCS inspector shortly after the loss occurred.

Range of Financial Assistance: $7.50 to $125,000.

Contact: Emergency Operations and Livestock Programs Division, Agricultural Stabilization and Conservation Service, Department of Agriculture, P.O. Box 2415, Washington, DC 20013/202-447-7997.

Commodity Purchases (Price Supports)

Objectives: To improve and stabilize farm income, to assist in bringing about a better balance between supply and demand of the commodities, and to assist farmers in the orderly marketing of their crops.

Eligibility: An owner, landlord, tenant, or sharecropper on a farm that has history of producing the eligible commodities, and meets program requirements as announced by the Secretary.

Range of Financial Assistance: Not specified.

Contact: Cotton, Grain and Rice Price Support Group, Agricultural Stabilization and Conservation Service, Department of Agriculture, P.O. Box 2415, Washington, DC 20013/202-447-3391.

Cotton Production Stabilization

Objectives: To attract the cotton production that is needed to meet domestic and foreign demand for fiber, to protect income for farmers, and to assure adequate supplies at fair and reasonable prices.

Eligibility: An owner, landlord, tenant, or sharecropper on a farm.

Range of Financial Assistance: $3 to $45,000.

Contact: Cotton, Grain and Rice Price Support Group, Agricultural Stabilization and Conservation Service, P.O. Box 2415, Department of Agriculture, Washington, DC 20013/202-447-7633.

Dairy Indemnity

Objectives: To indemnify dairy farmers and manufacturers of dairy products who are directed to remove their milk, milk cows or dairy products from commercial markets because of contamination by residues of pesticides resulting from no misaction on the part of the dairy farmer or the manufacturer of the dairy product. Dairy farmers can also be indemnified because of contamination by chemicals or toxic substances, nuclear radiation or fallout.

Eligibility: Dairy farmers.

Range of Financial Assistance: $348 to $29,075.

Contact: Emergency Operations and Livestock Programs Division, Agricultural Stabilization and Conservation Service, Department of Agriculture, P.O. Box 2415, Washington, DC 20013/202-447-7997.

Emergency Feed Program

Objectives: To assist in the preservation and maintenance of livestock in any area of the United States where, because of flood, drought, fire, hurricane, earthquake, storm, or other natural disaster, it is determined that an emergency exists.

Eligibility: The applicant must meet all of the following conditions as determined by the county ASCS committee: (1) the person must have suffered a substantial loss (40 percent below normal) in the livestock feed normally produced on the person's farm for such person's livestock because of a disaster; (2) the person does not have sufficient feed for such livestock for the estimated period of the emergency; and (3) the person is required to make feed purchases during the period of the emergency in quantities larger than such person would normally make.

Range of Financial Assistance: $3 to $100,000.

Contact: Emergency Operation and Livestock Programs Division, Agricultural Stabilization and Conservation Service, Department of Agriculture, P.O. Box 2415, Washington, DC 20013/202-447-7997.

Feed Grain Production Stabilization

Objectives: To attract the production needed to meet domestic and foreign demand, to protect income for farmers, and to assure adequate supplies at fair and reasonable prices.

Eligibility: An owner, landlord, tenant, or sharecropper on a farm where the commodity is planted.

Range of Financial Assistance: $3 to $45,000.

Contact: Cotton, Grain and Rice Support Group, Agricultural Stabilization and Conservation Service, Department of Agriculture, P.O. Box 2415, Washington, DC 20013/202-447-7633.

Food Stamps

Objectives: To improve diets of low-income households by supplementing their food purchas-

ing ability. Households receive a free coupon allotment which varies according to household size and which is reduced by 30 percent of net income. The coupons may be used in participating retail stores to buy any food for human consumption and garden seeds and plants to produce food for personal consumption of eligible households.

Eligibility: The state or U.S. territory agency responsible for federally aided public assistance programs submits requests for the program to USDA's Food and Nutrition Service on behalf of local political subdivisions.

Range of Financial Assistance: Average approximately $31.00 per month per person.

Contact: Deputy Administrator, Family Nutrition Programs, Food and Nutrition Service, Department of Agriculture, Washington, DC 20250/202-447-8982.

Grain Reserve Program

Objectives: To insulate sufficient quantities of grain from the market to increase price to farmers. To improve and stabilize farm income and to assist farmers in the orderly marketing of their crops.

Eligibility: All producers or approved cooperatives having a Commodity Credit Corporation loan on wheat, rice, corn, barley, oats or sorghum from an authorized crop year who provide storage through loan maturity.

Range of Financial Assistance: $25 to $50,000.

Contact: Cotton, Grain and Rice Support Group, Agricultural Stabilization and Conservation Service, Department of Agriculture, P.O. Box 2415, Washington, DC 20013/202-447-7973.

Great Plains Conservation

Objectives: To conserve and develop the Great Plains soil and water resources by providing technical and financial assistance to farmers, ranchers, and others in planning and implementing conservation practices.

Eligibility: Applicant must have control of the land for the period of the contract running from a minimum of three years to a maximum of ten years.

Range of Financial Assistance: Up to $25,000.

Contact: Chief, Soil Conservation Service, Department of Agriculture, P.O. Box 2890, Washington, DC 20013/202-447-4531.

National Wool Act Payments

Objectives: To encourage increased domestic production of wool at prices fair to both producers and consumers in a way that has the least adverse effect on domestic and foreign trade and to encourage producers to improve the quality and marketing of their wool and mohair.

Eligibility: Any person who owns sheep or

lambs for 30 days or more and sells shorn wool or unshorn lambs during the marketing year. Any person who owns angora goats for 30 days or more and sells mohair produced from them.

Range of Financial Assistance: $5 to $179,000.

Contact: Emergency Operations and Livestock Programs Division, Agricultural Stabilization and Conservation Service, Department of Agriculture, P.O. Box 2415, Washington, DC 20013/202-447-5621.

Rural Abandoned Mine Program

Objectives: To protect people and the environment from the adverse effects of past coal mining practices and to promote the development of soil and water resources of unreclaimed mined lands.

Eligibility: Persons, groups or units of government who own or control the surface or water rights of abandoned coal land or lands and water affected by coal mining practices before August 3, 1977.

Range of Financial Assistance: $5,000 to $196,000.

Contact: Soil Conservation Service, Director, State and Local Operations Division, P.O. Box 2890, Washington, DC 20013/202-447-7145.

Rural Rental Assistance Payments

Objectives: To reduce the rents paid by low-income families occupying eligible Rural Rental Housing (RRH), Rural Cooperative Housing (RCH), and Farm Labor Housing (LH) projects financed by the Farmers Home Administration.

Eligibility: The applicant must be the owner or plan to become the owner of an eligible FHA RRH, RH, or LH project operating on a limited profit or nonprofit basis.

Range of Financial Assistance: Not specified.

Contact: Administrator, Farmers Home Administration, Department of Agriculture, Washington, DC 20250/202-447-7967.

Wheat Production Stabilization

Objectives: To attract the production that is needed to meet domestic and foreign demand for food, to protect income for farmers, and to assure adequate supplies at fair and reasonable prices.

Eligibility: An owner, landlord, tenant or sharecropper on a farm where the commodity is planted.

Range of Financial Assistance: $3 to $45,000.

Contact: Cotton, Grain and Rice Support Group, Agricultural Stabilization and Conservation Service, Department of Agriculture, P.O. Box 2415, Washington, DC 20013/202-447-7633.

Electric Utility Systems

The USDA lends money to approximately 1,000 rural electric companies and maintains a

staff which is knowledgeable on both operations and equipment. Contact: Assistant Administrator—Electric, Rural Electrification Administration, USDA, Room 4056, S Building, Washington, DC 20250/202-447-6237.

Emergency Assistance
There are a number of loan, grant, and direct payment programs available to those who need help in an emergency situation. See "Grants," "Direct Payments," and "Loans and Loan Guarantees" in this section.

Emergency Food
The USDA supplies surplus food to relief agencies. Contact: Commodity Credit Corporation, ASCS, USDA, Room 5714, S Building, Washington, DC 20250/202-447-4786.

Excess Food
The Commodity Credit Corporation also buys, stores and disposes of commodities such as dry milk, wheat, rice and corn, which are acquired through price-support programs. The commodities are sent either overseas as donations or distributed to domestic food programs. Contact: Utilization Branch, Commodity Operations Division, Commodity Credit Corporation, ASCS Room 5970 S Building, USDA, Washington, DC 20250/202-447-3995. Also see "Food For Peace," "Loans," "Grants," and "Direct Payments" in this section.

Exporting
A wide variety of assistance is available to exporters of food, livestock and other agricultural products. Information and services available include the following:

Reports on foreign agricultural production, trade and consumption for 200 farm commodities.
A weekly bulletin, called *Export Briefs*, which notes commodity items wanted by foreign purchasers.
Test marketing of new products.
Marketing research.
Contribution to export promotion costs for new products.
Financing for customers.
Contact: Foreign Agricultural Service, USDA, 14th St. and Independence Ave. S.W., Washington, DC 20250/202-447-3448.

Extension Service
The USDA operates an extension program in 3,000 counties located in 50 states and the territories. The program provides education and information to communities on agriculture, family education, food and nutrition, community and rural development, natural resources and 4-H

youth clubs. Information ranges from how to operate a better farm, create a better home, or build a better community to diseases of pets, plants and lawns, and is provided in person, by telephone, and by mail. For help in finding your local county agent, contact: Executive Officer, USDA/Extension, Room 332A Administration Building, Washington, DC 20250/202-447-3304.

Family Economics
A staff of experts researches such topics as the economic aspects of family living, family resources, economic problems of families, the relationship of family budget items to each other, the use of food, clothing and textiles, and the efficient management of money and time. Free publications are also available. Contact: Family Economics Research Group, ARS, 6505 Belcrest Rd., Federal Building, Room 338, Hyattsville, MD 20782/301-436-8461.

Farmer Cooperatives
There are approximately 7,500 cooperatives in this country that primarily exist to aid in the purchasing of supplies or the marketing of products. Contact: Agricultural Cooperative Service, USDA, 500 12th St. S.W., Room 550, Washington, DC 20250/202-447-8906.

Films
Motion pictures on a variety of agricultural subjects are available for loan through various State Extension Service film libraries. Contact: Video and Film Center, Office of Governmental and Public Affairs, USDA, Room 1618, S Building, Washington, DC 20250/202-447-6072.

Firewood
Free firewood is available from public lands by contacting your nearest forest ranger or Forest Service, USDA, P.O. Box 2417, Washington, DC 20013/202-447-4211.

Food Assistance
A number of programs are available, which include food stamps; breakfast and lunch in schools; food service for preschool children; meals for needy school-age children; foods for needy expectant mothers, new mothers, and infants and young children at home; donated foods for nonprofit summer camps and charitable institutions. See "Free Food for Non-Profit Institutions," "Grants," "Direct Payments," and "Loans and Loan Guarantees" in this section.

Food Consumption Research
Nationwide surveys are conducted every ten years identifying the quantity, type and value of food consumed in U.S. households. The most re-

cent survey was conducted in 1977–78. Contact: Food Consumption Research Group, Consumer Nutrition Center, HNIS, USDA, Federal Building, Room 337, Hyattsville, MD 20782/301-436-8484.

Food Distribution Research
Studies
Studies are available on a wide variety of markets covering all aspects of the distribution process—wholesaling, packaging, transportation, etc. For a list of studies available, contact: Marketing Research and Development Division, USDA, AMS, Room 130, Building 307, BARC-E., Beltsville, MD 20705/301-344-2805.

Food For Peace
By working with groups like CARE and UNICEF this program helps needy people abroad with food and other agricultural commodities. Contact: Foreign Agricultural Service, Export Credit, USDA, Room 4531 South Building, Washington, DC 20250/202-447-7763.

Food Stamps
See "Direct Payments" in this section.

Food Studies and Food Economics
Studies and expertise on such topics as the convenience food market, food purchases away from home, the fast food industry, the relationship between consumer attitudes about nutrition and actual food expenditures, and the economic effects of food safety regulations are available from Food Economics, National Economic Analysis Division, ESCS/USDA, 500 12th St. S.W., #260, Washington, DC 20250/202-447-8707.

Foreign Agriculture
For supply and demand information of agricultural products in other countries contact: Agricultural Economists and Information Division, Foreign Agricultural Service, USDA, 5074 South Building, Washington, DC 20250/202-447-3448.

Foreign Exchange Students
Students from developing countries can obtain assistance in identifying where to train in agriculture in the United States and in other countries. Contact: Office of International Cooperation, International Training Division, USDA, Room 3529 South Building, Washington, DC 20250/202-447-3287.

Foreign Investment in the U.S.
Research is conducted identifying the amount of U.S. land owned by foreign interests. Contact: Land Branch, ESCS/USDA, 500 12th St. S.W., #420, Washington, DC 20250/202-447-2628.

Forest Fire Reports
For information on major forest fires (over 100 acres) anywhere in the country, contact: Aviation and Fire Management, Current Forest Fire Situation, 340 COM-W-BG, Washington, DC 20013/703-235-8220.

Forest Products Utilization
Technical assistance is available to wood processors and harvesters of wood products in cooperation with private consultants and state agencies. Contact: Cooperative Forestry, Forest Service, USDA, Room 1227, Washington, DC 20250/202-447-9095.

Forest Ranger Jobs
For information on becoming a forest ranger, contact: Forest Service, Recruitment, P.O. Box 2417, Washington, DC 20013/703-235-2044.

Forestry Research and Technical Expertise
Basic research is conducted by a large staff of professionals on topics which include forest insects and diseases, forest fire and atmosphere sciences, forest resource economics, timber management, watershed and aquatic habitat, forest recreation, and related human environment, range and wildlife ecology, forest products and engineering research, wood chemistry and fiber products, and structural and forest system engineering. Contact: Deputy Research, Forest Service, USDA, Room 3007, South Building, Washington, DC 20250/202-447-6665.

Free Food for Non-Profit Institutions
Charitable and rehabilitation institutions are usually eligible to receive surplus commodities stored by USDA. The commodities available are dairy products, oil, grain, and peanuts. Contact: Food Distribution Program, Food and Nutrition Service, 500 12th St. S.W., #610, Washington, DC 20250/202-447-8019.

Free Manure
Many of the Extension Service offices offer free manure to gardeners. (See "Extension Service" in this section.) In the Washington, DC area it is available by the barrel or truckload from the University of Maryland, Department of Dairy Science, College Park, MD 20742/301-454-3935.

Freedom of Information Act
Each major division within the USDA has a Freedom of Information Act Office. For a list of these offices, contact: Office of Governmental and Public Affairs, USDA, Administration Building, Room 113, Washington, DC 20250/202-447-2791. See "Freedom of Information Act" section.

Gardening

See "Plants—Research and Reference" and "Extension Service" in this section.

Gasohol Loans

Anyone interested in producing gasohol can seek financial assistance under the Business and Industrial Guaranteed Loan Program. (See "Loans and Loan Guarantees" in this section.) For general policy information, contact: Office of Energy, USDA, Room 5175, South Building, Washington, DC 20250/202-447-6610.

Grading and Inspection

Meat, poultry, and eggs are the only products which are federally inspected on a mandatory basis. All other product grading is voluntary. Grading of meat, poultry, eggs, and dairy products and fresh and processed fruits and vegetables is provided on request for a fee. For further information and descriptions of grading categories, contact the appropriate office below:

Poultry Grading Branch, AMS Poultry Division, AMS (Food Safety and Quality Service), USDA, Room 3938, South Building, Washington, DC 20250/202-447-3272.

Dairy Standardization, Agricultural Marker Service Dairy Division, USDA, Room 2963, Washington, DC 20250/202-447-7473.

Standardization Branch, Meat Quality Division, FSQS/USDA, 300 12th St., M-2, Washington, DC 20250/202-447-2210.

Grading Branch—M-1; 202-447-2210.

Processed Products Branch, Food and Vegetable Division, AMS/USDA, Room 0717, South Building, Washington, DC 20250/202-447-4693.

Fresh Fruit and Vegetable Branch, Food and Vegetable Division, AMS/USDA, Room 2050, South Building, Washington, DC 20250/202-447-5870.

Grants

The programs described below are for sums of money which are given by the USDA to initiate and stimulate new or improved activities or to sustain ongoing services.

Agricultural Conservation Program

Objectives: Control of erosion and sedimentation; voluntary compliance with federal and state requirements to solve point and non-point source pollution; priorities in the National Environmental Policy Act; improvement of water quality; and assurance of a continued supply of necessary food and fiber for a strong and healthy people and economy. The program is directed toward the solution of critical soil, water, woodland and pollution abatement problems on farms and ranches.

Eligibility: Any person who, as owner, land-lord, tenant, or sharecropper on a farm or ranch, bears a part of the cost of an approved conservation practice.

Range of Financial Assistance: $3 to $10,000.

Contact: Conservation and Environmental Protection Division, Agricultural Stabilization and Conservation Service, USDA, P.O. Box 2415, Washington, DC 20013/202-447-6221.

Agricultural Research—Basic and Applied

Objectives: To make agricultural research discoveries; evaluate alternative ways of attaining goals; and provide scientific and technical information.

Eligibility: Nonprofit institutions of higher education or nonprofit organizations whose primary purpose is conducting scientific research.

Range of Financial Assistance: $12,000 to $67,700.

Contact: Acting Administrator for Agricultural Research Service, Science and Education Administration, USDA, Washington, DC 20250/202-447-3656.

Agricultural Research—Competitive Research Grants

Objectives: To promote research in food, agriculture, and related areas to further the programs of USDA through the award of research grants on a competitive basis.

Eligibility: State agricultural experiment stations, U.S. colleges and universities, other U.S. research institutions and organizations, federal agencies, private organizations or corporations, and individuals.

Range of Financial Assistance: $20,000 to $250,000.

Contact: Director, Competitive Grants Office, Science and Education Administration, Department of Agriculture, 1300 Wilson Blvd., Suite 103, Arlington, VA 22209/703-235-2628.

Agricultural Research— Special Research Grants

Objectives: To carry out research to facilitate or expand promising breakthroughs in areas of the food and agricultural sciences of importance to the nation; to facilitate or expand ongoing state-federal food and agricultural research programs.

Eligibility: Land grant colleges and universities and state agricultural experiment stations and all colleges and universities having demonstrable capacity in food and agricultural research.

Range of Financial Assistance: $38,420 to $162,000.

Contact: Acting Administrator of Cooperative Research Service, Science and Education, USDA, Washington, DC 20250/202-447-4423.

Area Development Assistance Planning Grants

Objectives: To contribute to the development of comprehensive planning for rural development, especially as such planning affects the unemployed, the underemployed, those with low family incomes, and minorities.

Eligibility: Organizations eligible for grants include units of general local government, substate district organizations, areawide comprehensive agencies, regional and local planning commissions, state governments, federally recognized Indian tribes or nations, and public, quasi-public, or private nonprofit organizations which may have authorization to prepare comprehensive plans for rural development.

Range of Financial Assistance: $3,750 to $50,000.

Contact: Office of Area Development Assistance, Farmers Home Administration, USDA, Room 5449, South Building, Washington, DC 20250/202-447-6557.

Assistance to States for Intrastate Meat and Poultry Inspection

Objectives: To supply federal assistance to states desiring to improve the quality of their meat and poultry inspection programs in order to assure the consumer an adequate, safe, supply of wholesale meat and poultry.

Eligibility: An appropriate state or U.S. territory agency administering state or territorial meat or poultry inspection programs under laws comparable to the Federal Meat and Poultry Products Inspection Acts.

Range of Financial Assistance: $106,568 to $3,145,000.

Contact: Executive Officer, Meat and Poultry Inspection Operations, Food Safety and Inspection Service, Department of Agriculture, Washington, DC 20250/202-447-5261.

Child Care Food Program

Objectives: To assist states, through grant-in-aid and other means, to initiate, maintain or expand nonprofit food service programs for children in nonresidential institutions providing child care.

Eligibility: The state and U.S. territory educational agency or other agency within the state and U.S. territory eligible to receive federal funds for disbursement; in states where that agency is not permitted to disburse funds to any institution, the institution may receive funds directly from USDA.

Range of Financial Assistance: Approximate average rate per meal is 43¢.

Contact: Director, Child Care and Summer Programs Division, Food and Nutrition Service, USDA, Washington, DC 20250/202-447-8211.

Commodity Supplemental Food Program

Objectives: To improve the health and nutrition of infants, preschool children, pregnant women, and nursing mothers through the donation of supplemental foods.

Eligibility: Agreements under this program are made between the USDA and state distributing agencies or with an Indian tribe, band or group recognized by the Department of the Interior.

Range of Financial Assistance: Not applicable.

Contact: Special Supplemental Food Unit, Food and Nutrition Service, Department of Agriculture, Washington, DC 20250/202-447-8193.

Cooperative Extension Service

Objectives: To provide educational programs based upon local needs in the fields of agricultural production and marketing, rural development, home economics, and youth development.

Eligibility: Grants are made to designated land-grant institutions and are administered by the director of the state extension service.

Range of Financial Assistance: $463,386 to $12,075,485.

Contact: Director, Science and Education Service, Department of Agriculture, Washington, DC 20250/202-447-5923.

Cooperative Forestry Assistance

Objectives: Assistance in the advancement of forest resources management in non-federal forest lands; encouragement of the production of timber; prevention and control of insects and diseases affecting trees and forests; prevention and control of rural fires; efficient utilization of wood and wood residues, including the recycling of wood fiber; improvement and maintenance of fish and wildlife habitat; and planning and conduct of urban forestry programs.

Eligibility: Forestry or equivalent agencies of states and territories.

Range of Financial Assistance: $40,000 to $5,000,000.

Contact: Deputy Chief, State and Private Forestry, Forest Service, USDA, P.O. Box 2417, Washington, DC 20013/202-447-3331.

Cooperative Forestry Research

Objectives: To encourage and assist the states in carrying on a program of forestry research at forestry schools, and to develop a trained pool of forest scientists capable of conducting needed forestry research.

Eligibility: State institutions certified as eligible by a state representative designated by the Governor.

Range of Financial Assistance: $24,923 to $342,588.

Contact: Acting Administrator for Coopera-

tive State Research Service, Science and Education Administration, USDA, Washington, DC 20250/202-447-4423.

Emergency Conservation Program

Objectives: To enable farmers to perform emergency conservation measures to control wind erosion on farm lands, or to rehabilitate farm lands damaged by wind, erosion, floods, hurricanes, or other natural disasters; and to carry out emergency water conservation or water-enhancing measures during periods of severe drought.

Eligibility: Any person who, as owner, landlord, tenant, or sharecropper on a farm or ranch, bears a part of the cost of an approved conservation practice in a disaster area.

Range of Financial Assistance: $400 to $10,000.

Contact: Conservation and Environmental Protection Division, Agricultural Stabilization and Conservation Service, USDA, P.O. Box 2415, Washington, DC 20013/202-447-6221.

Energy-Impacted Area Development Assistance Program

Objectives: To help areas affected by coal or uranium development activities by providing assistance for the growth management and housing planning and for developing and acquiring sites for housing and public facilities and services.

Eligibility: Local governments, councils of local governments, and state governments.

Range of Financial Assistance: $1,870 to $825,000.

Contact: Office of Area Development Assistance, Farmers Home Administration, Room 5449, South Building, Department of Agriculture, Washington, DC 20250/202-447-2573.

Equipment Assistance for School Food-Service Programs

Objectives: To provide states with cash grants to supply schools in low-income areas with equipment for storing, preparing, transporting, and serving food to children.

Eligibility: State and U.S. territory agencies and non-profit private schools drawing attendance from areas in which poor economic conditions exist, and demonstrating a need for equipment for the storage, preparation, transportation, and serving of food.

Range of Financial Assistance: Average assistance to schools without a food service program is approximately $15,739; with a food service program, $2,753.

Contact: Director, School Programs Division, Food and Nutrition Service, USDA, Washington, DC 20250/202-447-8130.

Farm Labor Housing

Objectives: Construction, repair, or purchase of housing for farm labor; acquiring the necessary land and making improvements for such housing; and developing related facilities including recreation areas, central cooking and dining facilities, small infirmaries, laundry facilities, fallout shelters, and other essential equipment and facilities. Funds may also be used to pay certain fees and interest incidental to the project.

Eligibility: States, political subdivisions of states, broad-based nonprofit organizations, and nonprofit corporations of farm workers may qualify.

Range of Financial Assistance: $22,750 to $1,760,000.

Contact: Administrator, Farmers Home Administration USDA, Washington, DC 20250/202-447-7967.

Federal-State Marketing Improvement Program

Objectives: To solve marketing problems at the state and local level through pilot marketing service projects conducted by states.

Eligibility: State departments of agriculture, or other appropriate state agencies.

Range of Financial Assistance: $7,200 to $69,000.

Contact: Director, Federal-State Marketing Improvement Program, Agricultural Marketing Service, USDA, Washington, DC 20250/202-447-2704.

Food Distribution

Objectives: To improve the diets of school children and needy persons in households, on Indian reservations not participating in the Food Stamp Program, and in charitable institutions; the elderly and other individuals in need of food assistance are also included. To increase the market for domestically produced foods acquired under surplus-removal or price-support operations.

Eligibility: Such state and federal agencies that are designated as distributing agencies by the Governor, legislature, or other authority may receive and distribute donated foods.

Range of Financial Assistance: Not applicable. Assistance in the form of grants of goods.

Contact: Food Distribution Division, Food and Nutrition Service, USDA, Washington, DC 20250/202-447-8371.

Forestry Incentives Program

Objectives: To increase the supply of timber primarily to meet demands for construction materials and to enhance other forest resources through a combination of public and private investments on the most productive sites by eligible

individuals or consolidated ownerships of efficient size and operation.

Eligibility: A private individual, group, association, corporation (except corporations whose stocks are publicly traded) or other legal entity that owns "non-industrial" private forest lands capable of producing industrial wood crops is eligible to apply for cost-sharing assistance. Cost-share agreements are limited to eligible ownerships of land of not more than 1,000 acres except by special approval.

Range of Financial Assistance: Up to $10,000 per year.

Contact: Conservation and Environmental Protection Division, Agricultural Stabilization and Conservation Service, USDA, P.O. Box 2415, Washington, DC 20013/202-447-6221.

Forestry Research

Objectives: To extend the research activities of the Forest Service by awarding grants primarily to nonprofit institutions of higher education, but also to other institutions and organizations engaged in scientific research.

Eligibility: Grants for basic or applied research may be made to state agricultural experiment stations, state and local governments, and nonprofit institutions or organizations.

Range of Financial Assistance: $2,000 to $100,000.

Contact: Deputy, Chief for Research, Forest Service, USDA, P.O. Box 2417, Washington, DC 20013/202-447-7075.

Higher Education—Land-Grant Colleges and Universities

Objectives: Grants to land-grant colleges and universities to support instructions in agriculture, mechanical arts, English, mathematics, science, and economics.

Eligibility: Each of the 50 states, the District of Columbia, Puerto Rico, the Virgin Islands, and Guam are eligible to receive grants for land-grant institutions of higher education.

Range of Financial Assistance: $151,031 to $479,252.

Contact: Assistant Director for Higher Education, Science and Education Administration, Department of Agriculture, Washington, DC 20250/202-447-6961.

Industrial Development Grants

Objectives: To facilitate the development of business, industry and related employment for improving the economy in rural communities.

Eligibility: Applicants eligible for grants are public bodies serving rural areas, such as states, counties, cities, townships and incorporated towns and villages, boroughs, authorities, districts, and Indian tribes on federal and state reservations that serve rural areas. For this program rural area is defined as all territory that is not within the outer boundary of any city having a population of 50,000 or more, according to the latest decennial census of the United States.

Range of Financial Assistance: $7,000 to $769,023.

Contact: Director, Community Facilities Loan Division, Farmers Home Administration, USDA, Washington, DC 20250/202-447-7667.

Nutrition Education and Training Program (NET Program)

Objectives: To encourage the effective dissemination of scientifically valid information to children participating in or eligible to participate in the school-lunch and related child-nutrition programs.

Eligibility: State and territorial education agencies.

Range of Financial Assistance: $75,000 to $2,297,000.

Contact: Nutrition and Technical Services Division, Food and Nutrition Service, USDA, Washington, DC 20250/202-447-9081.

Nutrition Education Experimental or Demonstration Projects

Objectives: To make cash grants to state educational agencies for the purpose of conducting experimental or demonstration projects to teach school children the nutritional value of foods and the relationship of nutrition to human health.

Eligibility: State educational agencies administering one or more child nutrition programs.

Range of Financial Assistance: Grants average approximately $82,000.

Contact: Director, Nutrition Technical Services Staff, Food and Nutrition Service, USDA, Washington, DC 20250/202-447-9081.

Payments to Agricultural Experiment Stations Under Hatch Act

Objectives: To support agricultural research at state agricultural experiment stations in order to promote efficient production, marketing, distribution, and utilization of farm products.

Eligibility: Agricultural experiment stations identified and declared eligible by their respective state legislatures.

Range of Financial Assistance: $363,405 to $3,974,545.

Contact: Acting Administrator for Cooperative State Research Service, Science and Education, USDA, Washington, DC 20250/202-447-4423.

Payments to 1890 Land-Grant Colleges and Tuskegee Institute

Objectives: To promote efficient production, marketing, distribution, and utilization of farm products.

Eligibility: Sixteen 1890 Land-Grant Colleges and Tuskegee Institute are eligible in the states of Alabama, Arkansas, Delaware, Florida, Georgia, Kentucky, Louisiana, Maryland, Mississippi, Missouri, North Carolina, Oklahoma, South Carolina, Tennessee, Texas, and Virginia.

Range of Financial Assistance: $355,956 to $1,454,348.

Contact: Acting Administrator for Cooperative State Research Service, Science and Education, USDA, Washington, DC 20250/202-447-4423.

Resource Appraisal and Program Development

Objectives: To insure that USDA soil and water conservation programs administered by the Secretary of Agriculture are responsive to the long-term needs of the nation and will further the conservation, protection and enhancement of the nation's soil, water and related resources.

Eligibility: Soil and water conservation agencies, local conservation districts and other appropriate state natural resources agencies.

Range of Financial Assistance: $13,000 to $122,000.

Contact: Deputy Chief for Planning and Evaluation, Soil Conservation Service, Department of Agriculture, P.O. Box 2890, Washington, DC 20013/202-447-7705.

Resource Conservation and Development

Objectives: To assist local people in initiating and carrying out long-range programs of resource conservation and development.

Eligibility: State and local governments and nonprofit organizations with authority to plan or carry out activities relating to resource use and development.

Range of Financial Assistance: $2,000 to $250,000.

Contact: State and Local Operations, Soil Conservation Service, Department of Agriculture, P.O. Box 2890, Washington, DC 20013/202-447-4554.

Rural Development Research

Objectives: To support rural development research at administratively responsible land-grant institutions and at other private and publicly supported colleges and universities including the Land-Grant Colleges of 1890.

Eligibility: Administration of each state research program shall be the responsibility of the state agricultural experiment station.

Range of Financial Assistance: $7,119 to $52,593.

Contact: Deputy Director for Cooperative Research, Science and Education Administration, Department of Agriculture, Washington, DC 20250/202-447-4423.

Rural Self-Help Housing Technical Assistance

Objectives: To provide financial support for programs of technical and supervisory assistance to aid needy low-income individuals and their families in mutual self-help efforts in rural areas.

Eligibility: State political subdivisions, public nonprofit corporations or private nonprofit corporations. Funds are available in open country and to communities with 10,000 population or less which are rural in character and to places of up to 20,000 population under certain conditions.

Range of Financial Assistance: $45,000 to $801,400.

Contact: Administrator, Farmers Home Administration, Department of Agriculture, Washington, DC 20250/202-447-7967.

School Breakfast Program

Objectives: To assist states in providing nutritious breakfasts for school children, through cash grants and food donations.

Eligibility: State and U.S. territory agencies or private schools which are exempt from income tax under the Internal Revenue Code.

Range of Financial Assistance: Average federal cash assistance is approximately 40¢ per meal.

Contact: Director, School Programs Division, Food and Nutrition Service, USDA, Washington, DC 20250/202-447-8130.

School Lunch Program

Objectives: To assist states in providing nutritious lunches for school children through cash grants and food donations.

Eligibility: State and agencies and private schools, residential child care centers, and settlement houses which are exempt from income tax under the Internal Revenue Code.

Range of Financial Assistance: Average federal assistance per meal is approximately 15¢ in cash and 13¢ in food. Special assistance to needy children averages 63¢ per meal.

Contact: Director, School Programs Division, Food and Nutrition Service, USDA, Washington, DC 20250/202-447-8130.

School Milk Program

Objectives: To encourage the consumption of fluid milk by children of high school grade and under through reimbursement to eligible schools and institutions which inaugurate or expand

milk-distribution services.

Eligibility: Any state agency or nonprofit private school or child care institution of high school grade or under may participate.

Range of Financial Assistance: Approximately 8¢ for each half pint of milk.

Contact: Director, School Programs Division, Food and Nutrition Service, USDA, Washington, DC 20250/202-447-8130.

Special Supplemental Food Program for Women, Infants and Children (WIC Program)

Objectives: To supply supplemental nutritious foods and nutrition education as an adjunct to good health care to participants identified to be at nutritional risks because of inadequate income and inadequate nutrition.

Eligibility: A local agency is eligible provided (1) it gives health services free or at reduced cost to residents of low-income areas; (2) serves a population of women, infants, and children at nutritional risk; (3) has the personnel, expertise, and equipment to perform measurements, tests and data collection specified for the WIC Program; (4) is able to maintain adequate medical records; and (5) is a public or private nonprofit health or welfare agency.

Range of Financial Assistance: Not specified.

Contact: Supplemental Food Programs Division, Food and Nutrition Service, USDA, Washington, DC 20250/202-447-8206.

State Administrative Expenses for Child Nutrition

Objectives: To provide each state educational agency with funds for use for its administrative expenses in supervising and giving technical assistance to the local school districts and institutions in their conduct of child nutrition programs.

Eligibility: State educational agencies responsible for conduct of child nutrition programs, including agencies in the U.S. Territories.

Range of Financial Assistance: $75,000 to $1,535,000.

Contact: Director, School Programs Division, Food and Nutrition Service, USDA, Washington, DC 20250/202-447-8130.

State Administrative Matching Grants for Food Stamp Program

Objectives: To provide financial aid to state and local governmental agencies for administrative costs incurred to operate the Food Stamp Program.

Eligibility: Welfare agencies of states and U.S. Territories.

Range of Financial Assistance: $142,000 to $37,165,000.

Contact: Food Stamp Division, Food and Nutrition Service, Family Nutrition Program, USDA, Washington, DC 20250/202-447-8982.

Summer Food Service Program for Children

Objectives: To assist states, through grants-in-aid and other means, to initiate, maintain and expand nonprofit food service programs for children in service institutions and camps during the summer months.

Eligibility: The state and U.S. Territory agency applies for and receives federal funds for disbursement, except that in states where that agency is not permitted to disburse funds to any service institution, the institution may receive funds directly from the USDA.

Range of Financial Assistance: Average reimbursement rate is approximately 90¢ per meal.

Contact: Director, Child Care and Summer Programs Division, Food and Nutrition Service, USDA, Washington, DC 20250/202-447-8211.

Technical and Supervisory Assistance Grants

Objectives: To assist low-income rural families in obtaining adequate housing to meet their needs and/or to provide the necessary guidance to promote their continued occupancy of already adequate housing. These objectives are to be accomplished through the establishment or support of housing delivery and counseling projects run by eligible applicants. This program is intended to make use of any available housing programs that provide the low-income rural resident access to adequate rental properties or home ownership.

Eligibility: State or political subdivisions, public nonprofit corporations (including Indian tribes or tribal corporations) authorized to receive and administer technical and supervisory assistance grants, or private nonprofit corporations with local representation from the area being served.

Range of Financial Assistance: Up to $100,000.

Contact: Multiple Family Special Authorities Division, Farmers Home Administration, USDA, Washington, DC 20250/202-382-1604.

Very Low-Income Housing Repair

Objectives: To give very low-income rural homeowners an opportunity to make essential minor repairs to their homes to make them safe and remove health hazards to the family or the community.

Eligibility: Applicant must own and occupy a home in a rural area, and be without sufficient income to qualify for a Low- To Moderate-Income Housing Loan to repair or improve his or her dwelling in order to make such dwelling safe and sanitary.

Range of Financial Assistance: $200 to $5,000.

Contact: Administrator, Farmers Home Administration, USDA, Washington, DC 20250/202-447-7967.

Water and Waste Disposal Systems for Rural Communities

Objectives: To provide basic human amenities, alleviate health hazards and promote the orderly growth of the rural areas of the nation by meeting the need for new and improved rural water and waste disposal facilities.

Eligibility: Municipalities, counties and other political subdivisions of a state, such as districts and authorities; associations, cooperatives and corporations operated on a not-for-profit basis; and federally recognized Indian tribes. Facilities should primarily serve rural residents and not include any area in any city or town having a population in excess of 10,000 inhabitants.

Range of Financial Assistance: $5,000 to $7,000,000.

Contact: Administrator, Farmers Home Administration, USDA, Washington, DC 20250/202-447-7967.

Water Bank Program

Objectives: To conserve surface waters; preserve and improve migratory waterfowl habitat and wildlife resources; and secure other environmental benefits.

Eligibility: Landowners and operators of specified types of wetlands in designated important nesting and breeding areas of migratory waterfowl.

Range of Financial Assistance: $4 to $55 per acre.

Contact: Conservation and environmental Protection Division, Agricultural Stabilization and Conservation Service, USDA, P.O. Box 2415, Washington, DC 20213/202-447-6221.

Watershed Protection and Flood Prevention

Objectives: To provide technical and financial assistance in planning and carrying out works of improvement to protect, develop, and utilize the land and water resources in small watersheds.

Eligibility: Any state agency, county or groups of counties, municipality, town or township, soil and water conservation district, flood prevention or flood control district, or any other nonprofit agency with authority under state law to carry out, maintain and operate watershed works of improvement may apply for assistance.

Range of Financial Assistance: $20,000 to $13,000,000.

Contact: Administrator, Soil Conservation Service, Department of Agriculture, P.O. Box 2890, Washington, DC 20013/202-447-4531.

Young Adult Conservation Corps—Grants to States

Objectives: To provide employment and other benefits to youth, who would otherwise not be currently productively employed, through service in useful conservation work and other projects of a public nature on federal and nonfederal public lands and waters.

Eligibility: State agencies, lower level governmental organizations, units of local government, and public agencies or organizations, and private, nonprofit agencies or organizations that have been in operation at least two years.

Range of Financial Assistance: $6,500 to $6,544,000.

Contact: Administrator, Staff Director, Human Resources Programs, Forest Service, USDA, P.O. Box 2417, Washington, DC 20013/202-382-1690.

Youth Conservation Corps—Grants to States

Objectives: To accomplish needed conservation on public lands; provide gainful employment for 15 through 18 year-old males and females from all social, economic, ethnic and racial classifications; and develop an understanding and appreciation in participating youths of the nation's natural environment and heritage.

Eligibility: State, county, municipal or other local government agencies administering nonfederal public lands and waters are eligible.

Range of Financial Assistance: $70,000 to $2,000,000.

Contact: Staff Director, Human Resources Programs, Forest Service, USDA, P.O. Box 2417, Washington, DC 20013/202-382-1690.

Human Nutrition

A large amount of research is conducted on such topics as human nutrient requirements, food composition, effects of fiber, sugar and fat, child nutrition, diet and aging, and food consumption. For help in identifying specific information and expertise, contact: Human Nutrition Center, Science and Education Administration, USDA, Room 330-A, Washington DC 20250/202-447-5121.

Hydroponics

Information and expertise on hydroponics, the process of growing crops without soil, is available from: Plants and Entomology, USDA, Environmental Research Laboratory, University of Arizona, Tuscon, AZ.

Insects and Pests

Technical assistance is available to aid in identifying and eliminating problems caused by insects and bugs. The USDA encourages that you

catch one of your problem insects and send it in for analysis. See "County Extension Service" in this section. Help is also available from: Animal and Plant Health Inspection Service, USDA, 1143 South Building, Washington, DC 20250/202-447-3977.

Insurance

The USDA runs a Crop Insurance Program whose objective is to improve the economic stability of agriculture through a sound system of crop insurance that provides all-risk insurance for individual farmers to ensure a basic income against droughts, freezes, insects, and other natural causes of disastrous crop losses.

Eligibility: Any owner or operator of farmland who has an insurable interest in a crop in a county where insurance is offered on that crop is eligible unless the land is not classified for insurance purposes.

Contact: Manager, Federal Crop Insurance Corporation, USDA, Washington, DC 20250/202-447-6795.

Land Grant Colleges

A system of state colleges and universities was established in 1890 from federal government grants of land and funds to each state to encourage practical education in agricultural and urban homemaking, and the mechanical arts. There are 88 land grant colleges. Contact: Information Staff, SEA/USDA, Room 433-A, Washington, DC 20250/202-447-6841.

Landscaping

Assistance is available to help those with problems related to landscaping. Help is available to individuals through the Extension Service (see "Extension Service" in this section). Those who need help with larger projects involving conservation can contact: Landscape Architect, Engineering Division, Soil Conservation Service, USDA, 6126 South Building, Washington, DC 20250/202-447-2520.

Library

The main USDA library provides published material and reference services on botany, zoology, chemistry, veterinary medicine, forestry, plant pathology, livestock, poultry, entomology, and general agriculture. Loans of monographs and reference works are available to the public through interlibrary loan. Contact: National Agricultural Library, 10301 Baltimore Blvd., Beltsville, MD 20705/301-344-3744. For additional information, see "Plants—Research and Reference" and "Research and Reference Service" in this section.

Livestock and Veterinary Sciences

A staff of specialists study such topics as domestic animal diseases, beef production, dairy production, foreign animal diseases, insects affecting man and animals, poultry production and diseases, production of sheep and fur-bearing animals, swine production, livestock facilities and rural housing. Contact: Livestock and Veterinary Sciences, SEA/AR, Beltsville Agricultural Research Center-West, Building 005, Chief's Office, Room 207, Beltsville, MD 20705/301-344-3924.

Loans and Loan Guarantees

The programs described below are those that offer financial assistance through the lending of federal monies for a specific period of time or programs in which the federal government makes an arrangement to indemnify a lender against part or all of any defaults by the borrower.

Above-Moderate-Income Housing Loans

Objectives: To assist above-moderate-income families in obtaining adequate but modest, decent, safe, and sanitary dwellings and related facilities for their own use in rural areas by guaranteeing sound rural housing loans when loans would not be made available without a guarantee.

Eligibility: Present or prospective owners of dwellings in rural areas.

Range of Financial Assistance: $1,000 to $50,000.

Contact: Administrator, Farmers Home Administration, Department of Agriculture, Washington, DC 20250/202-447-7967.

Business and Industrial Loans

Objectives: To assist public, private, or cooperative organizations organized for profit or nonprofit, Indian tribes or individuals in rural areas to obtain quality loans for the purpose of improving, developing or financing business, industry, and employment and improving the economic and environmental climate in rural communities, including pollution abatement and control, and the conservation, development, and utilization of water for aquaculture purposes.

Eligibility: An applicant may be a cooperative, corporation, partnership, trust or other legal entity organized and operated on a profit or nonprofit basis; an Indian tribe; a municipality, county, or other political subdivision of a state; or an individual in rural areas. Applicants must be located in areas other than cities having a population of more than 50,000 or immediately adjacent to urban areas with a population density of more than 100 persons per square mile.

Range of Financial Assistance: $11,000 to $33,000,000.

Contact: Administrator, Farmers Home Administration, Department of Agriculture, Washington, DC 20250/202-447-7967.

Commodity Loans (Price Supports)

Objectives: To improve and stabilize farm income; to assist in bringing about a better balance between supply and demand of the commodities, and to assist farmers in the orderly marketing of their crops.

Eligibility: An owner, landlord, tenant, or sharecropper on a farm that has history of producing the eligible commodities and meets program requirements as announced by the Secretary.

Range of Financial Assistance: $50 to $2,000,000.

Contact: Price Support and Loan Division, USDA-ASCS, P.O. Box 2415, Washington, DC 20013/202-447-3391.

Community Facilities Loans

Objectives: To construct, enlarge, extend, or otherwise improve community facilities providing essential services to rural residents.

Eligibility: State agencies; political and quasi-political subdivisions of states; and associations including corporations, Indian tribes on federal and state reservations and other federally recognized Indian tribes; and existing private corporations operated on a nonprofit basis, have or will have the legal authority necessary for constructing, operating, and maintaining the proposed facility or service and for obtaining, giving security for, and repaying the loan, and are unable to finance the proposed project from its own resources or through commercial credit at reasonable rates and terms. Assistance is authorized for eligible applicants in rural areas.

Range of Financial Assistance: $1,600 to $18,000,000.

Contact: Director, Community Facilities Division, Farmers Home Administration, Department of Agriculture, Washington, DC 20250/202-382-1490.

Economic Emergency Loans

Objectives: To make adequate financial assistance available in the form of loans insured or guaranteed for farmers, ranchers and aquaculture operators engaged in agricultural production, so that they may continue their normal farming or ranching operations during an economic emergency that has caused a lack of agricultural credit—for example a general tightening of agricultural credit or an unfavorable relationship

between production costs and prices received for agricultural commodities.

Eligibility: Individuals or cooperatives, corporations or partnerships primarily and directly engaged in agricultural production unable to obtain credit elsewhere in order to maintain a viable farm enterprise.

Range of Financial Assistance: Up to $400,000.

Contact: Administrator, Farmers Home Administration, Department of Agriculture, Washington, DC 20250/202-447-7967.

Emergency Livestock Loans

Objectives: To provide emergency loans to farmers and ranchers who are primarily and directly engaged in agricultural production and who have substantial livestock operations, in order that they may continue their normal farming or ranching operations.

Eligibility: Established farmers or ranchers (either owner-operator or tenant) primarily and directly engaged in agricultural production with substantial operations in beef cattle, dairy cattle, swine, sheep, goat, chicken, or turkey operations, including individuals, partnerships, and corporations, unable to obtain the credit needed without an FmHA guarantee.

Range of Financial Assistance: Up to $350,000.

Contact: Administrator, Farmers Home Administration, Department of Agriculture, Washington, DC 20250/202-447-7967.

Emergency Loans

Objectives: To assist farmers, ranchers and aquaculture operators with loans to cover losses resulting from a major and/or natural disaster, for annual farm operating expenses, and for other essential needs necessary to return the disaster victims' farming operation(s) to a financially sound basis.

Eligibility: Established farmers, ranchers, or aquaculture operators (either tenant or owner-operator), partnerships, cooperatives and corporations primarily engaged in farming that have suffered severe crop losses or property damage caused by a designated natural disaster, not compensated for fully by insurance or otherwise, and unable to obtain necessary credit from other sources.

Range of Financial Assistance: $500 to $6,400,000.

Contact: Administrator, Farmers Home Administration, Department of Agriculture, Washington, DC 20250/202-447-7967.

Farm Labor Housing Loans

Objectives: To provide decent, safe and sanitary low-rent housing and related facilities for

domestic farm laborers.

Eligibility: Loans are available to farmers and associations of farmers. States, political subdivisions of states, broad-based nonprofit organizations, and nonprofit corporations of farm workers may qualify for both loans and grants.

Range of Financial Assistance: $3,000 to $1,978,000.

Contact: Administrator, Farmers Home Administration, Department of Agriculture, Washington, DC 20250/202-447-7967.

Farm Operating Loans

Objectives: To enable operators of family farms (primarily limited-resource operators, new operators and low-income operators), through the extension of credit and supervisory assistance, to make efficient use of their land, labor, and other resources. Youth loans enable rural youths to establish and operate modest income-producing farm and nonfarm projects. Projects are educational and practical and provide the youth an opportunity to learn basic economic and credit principles.

Eligibility: Individual applicants must have farm experience or training and possess the character, industry and managerial ability to carry out the operation; be unable to obtain sufficient credit elsewhere at reasonable rates and terms; have the ability to repay the loan; and after the loan is closed, be an owner or tenant operating a family farm. Certain corporations, cooperatives and partnerships operating family-sized farms are now eligible for farm operating loans.

Range of Financial Assistance: Up to $200,000.

Contact: Director, Production Loan Division, Farmers Home Administration, USDA, Washington, DC 20250/202-447-2288.

Farm Ownership Loans

Objectives: To assist eligible farmers and ranchers, including cooperatives, partnerships and corporations, through the extension of credit and supervisory assistance, to become owner-operators of family farms, to make efficient use of the land, labor, and other resources, and to carry on sound and successful operations. Farm ownership loans are also available to eligible applicants with limited incomes and resources who are unable to pay the regular interest rate and have special problems such as undeveloped managerial ability.

Eligibility: An applicant must be unable to obtain adequate credit from other sources at reasonable terms; have the necessary experience, training, and managerial ability to operate a family farm or a nonfarm enterprise; and agree to refinance the balance due on the loan as soon as the borrower is able to obtain adequate credit at reasonable terms from another lender. Individual applicants must not have a combined farm ownership loan, soil and water loan, and recreation loan indebtedness to FmHA of no more than $200,000 for insured loans and $300,000 for guaranteed loans and a total indebtedness against the property securing the loan of more than the market value of the security.

Range of Financial Assistance: $16,000 to $200,000.

Contact: Administrator, Farmers Home Administration, Department of Agriculture, Washington, DC 20250/202-447-7967.

Grazing Association Loans

Objectives: Loans are made to associations of family farmers and ranchers to acquire and develop grazing land to provide seasonal grazing for livestock belonging to association members.

Eligibility: Nonprofit associations owned, operated, and managed by memberships consisting of neighboring farmers and ranchers, who need to increase their incomes, are eligible providing the association is unable to obtain needed credit elsewhere at reasonable rates and terms.

Range of Financial Assistance: $44,300 to $1,029,900.

Contact: Administrator, Farmers Home Administration, Department of Agriculture, Washington, DC 20250/202-447-7967.

Indian Tribes and Tribal Corporation Loans

Objectives: To enable tribes and tribal corporations to mortgage lands as security for loans from the Farmers Home Administration to buy additional land within the reservation.

Eligibility: Limited to any Indian tribe recognized by the Secretary of the Interior or tribal corporation established pursuant to the Indian Reorganization Act.

Range of Financial Assistance: $260,000 to $7,000,000.

Contact: Administrator, Farmers Home Administration, Department of Agriculture, Washington, DC 20250/202-447-7967.

Irrigation, Drainage, and Other Soil and Water Conservation Loans

Objectives: Loans are made to eligible applicants for irrigation, drainage, or other soil conservation measures.

Eligibility: Public or quasi-public bodies and nonprofit corporations serving residents of open country and rural towns and villages up to 10,000 population may receive assistance when they are unable to obtain needed funds from other sources at reasonable rates and terms; the pro-

posed improvements will primarily serve farmers and other rural residents.

Range of Financial Assistance: $32,000 to $612,000.

Contact: Administrator, Farmers Home Administration, Department of Agriculture, Washington, DC 20250/202-447-7967.

Low- to Moderate-Income Housing Loans

Objectives: To assist rural families to obtain decent, safe, and sanitary dwellings and related facilities.

Eligibility: Present or prospective owners of dwellings in rural areas. Interest credits may, under certain conditions, be granted to lower-income families that will reduce the effective interest rate paid to as low as one percent, depending on the size of the loan and the size and income of the applicant family.

Range of Financial Assistance: $1,000 to $50,000.

Contact: Administrator, Farmers Home Administration, Department of Agriculture, Washington, DC 20250/202-447-7967.

Recreation Facility Loans

Objectives: To assist eligible farm and ranch owners or tenants, including cooperatives, corporations or partnerships, through the extension of credit and supervisory assistance, to convert all or a portion of the farms they own or operate to income-producing outdoor recreational enterprises.

Eligibility: Applicants must be unable to obtain adequate credit from other sources at reasonable terms; be engaged in farming; have enough experience or training to be successful in the proposed recreational enterprise; and agree to refinance the balance due on the loan as soon as the borrower is able to obtain adequate credit at reasonable terms from another lender.

Range of Financial Assistance: $20,000 to $100,000.

Contact: Administrator, Farmers Home Administration, Department of Agriculture, Washington, DC 20250/202-447-7967.

Resource Conservation and Development Loans

Objectives: To provide loan assistance to local sponsoring agencies in authorized areas where an acceleration of a program of resource conservation, development, and utilization will increase economic opportunities for local people.

Eligibility: Public agencies and local nonprofit corporations in authorized Resource Conservation and Development Areas may be eligible for loan assistance.

Range of Financial Assistance: $2,400 to $250,000.

Contact: Director, Community Facilities Division, Farmers Home Administration, Department of Agriculture, Washington, DC 20250/202-382-1490.

Rural Electrification Loans and Loan Guarantees

Objectives: To assure that people in eligible rural areas have access to electric services comparable in reliability and quality to the rest of the nation.

Eligibility: Rural electric cooperatives, public utility districts, power companies, municipalities, and other qualified power suppliers, including those located in the U.S. Territories.

Range of Financial Assistance: $250,000 to $1,400,000,000.

Contact: Administrator, Rural Electrification Administration, Department of Agriculture, Washington, DC 20250/202-447-5123.

Rural Housing Site Loans

Objectives: To assist public or private nonprofit organizations interested in providing sites for housing to acquire and develop land in rural areas to be subdivided as building sites and sold on a nonprofit basis to families eligible for low- and moderate-income loans, cooperatives, and nonprofit rural rental housing applicants.

Eligibility: Private or public nonprofit organizations that will provide the developed sites to qualified borrowers on a nonprofit basis in open country and towns of 10,000 population or less and areas of up to 20,000 population under certain conditions.

Range of Financial Assistance: $45,000 to $571,000.

Contact: Administrator, Farmers Home Administration, Department of Agriculture, Washington, DC 20250/202-447-7967.

Rural Rental Housing Loans

Objectives: To provide economically designed and constructed rental and cooperative housing and related facilities suited for independent living for rural residents.

Eligibility: Applicants may be individuals, cooperatives, nonprofit organizations, state or local public agencies or nonprofit corporations, trusts, partnership, limited partnerships unable to finance the housing either with their own resources or with credit obtained from private sources.

Range of Financial Assistance: $27,000 to $750,000.

Contact: Administrator, Farmers Home Ad-

ministration, Department of Agriculture, Washington, DC 20250/202-447-7967.

Rural Telephone Bank Loans

Objectives: To provide supplemental financing to extend and improve telephone service in rural areas.

Eligibility: Borrowers, that have received a loan or loan commitment under Section 201 of Rural Electrification Act or that have been certified by the administrator as qualified to receive such a loan, are eligible to borrow from the Rural Telephone Bank. See "Rural Telephone Loans and Loan Guarantees" in this section.

Range of Financial Assistance: $250,000 to $20,000,000.

Contact: Governor, Rural Telephone Bank, Department of Agriculture, Washington, DC 20250/202-447-5123.

Rural Telephone Loans and Loan Guarantees

Objectives: To assure that people in eligible rural areas have access to telephone service comparable in reliability and quality to the rest of the nation.

Eligibility: Telephone companies or cooperatives, nonprofit associations, limited dividend associations, mutual associations or public bodies.

Range of Financial Assistance: $200,000 to $20,000,000.

Contact: Administrator, Rural Electrification Administration, Department of Agriculture, Washington, DC 20250/202-447-5123.

Soil and Water Loans

Objectives: To facilitate improvement, protection, and proper use of farmland by providing adequate financing and supervisory assistance for soil conservation, water development, conservation and use, forestation, drainage of farmland, establishment and improvement of permanent pasture, and development of pollution abatement and control facilities on farms.

Eligibility: Farming partnerships or cooperatives, domestic corporations, and individual farm owners or tenants.

Range of Financial Assistance: $3,300 to $100,000.

Contact: Administrator, Farmers Home Administration, Department of Agriculture, Washington, DC 20250/202-447-7967.

Storage Facilities and Equipment Loans

Objectives: To complement the commodity loan and grain reserve programs by providing adequate financing for needed on-farm storage facilities, drying equipment, and operating equipment, thereby affording farmers the oppor-

tunity for orderly marketing of their crops.

Eligibility: Any person who as owner, landlord, tenant, or sharecropper produces one or more of the applicable commodities.

Range of Financial Assistance: $200 to $50,000.

Contact: Price Support and Loan Division, Agricultural Stabilization and Conservation Service, Department of Agriculture, P.O. Box 2415, Washington, DC 20013/202-447-9221.

Very Low-Income Housing Repair Loans and Grants

Objectives: To give very low-income rural homeowners an opportunity to make essential minor repairs to their homes to make them safe and remove health hazards to the family or the community.

Eligibility: Applicants must own and occupy a home in a rural area; be without sufficient income to qualify for a Section 502 loan; and have sufficient income to repay the loan.

Range of Financial Assistance: $200 to $5,000.

Contact: Administrator, Farmers Home Administration, Department of Agriculture, Washington, DC 20250/202-447-7967.

Water and Waste Disposal Systems for Rural Communities

Objectives: To provide basic human amenities, alleviate health hazards and promote the orderly growth of the rural areas of the nation by meeting the need for new and improved rural water and waste disposal facilities.

Eligibility: Municipalities, counties, and other political subdivisions of a state, such as districts and authorities; associations, cooperatives, and corporations operated on a nonprofit basis; and Indian tribes on federal and state reservations and other federally recognized Indian tribes. Facilities should primarily serve rural residents.

Range of Financial Assistance: $50,000 to $53,000,000.

Contact: Administrator, Farmers Home Administration, Department of Agriculture, Room 5014, 14th and Independence Ave. S.W., Washington, DC 20250/202-447-7967.

Watershed Protection and Flood Prevention Loans

Objectives: To provide loan assistance to sponsoring local organizations in authorized watershed areas for share of cost for works of improvement.

Eligibility: Sponsoring local organizations, such as municipal corporation, soil and water conservation district, or other nonprofit organization in the approved watershed project, with

authority under state law to obtain, give security for and raise revenues to repay the loan and to operate and maintain the facilities to be financed with the loan.

Range of Financial Assistance: $4,000 to $5,450,000.

Contact: Director, Community Facilities Division, Farmers Home Administration, Department of Agriculture, 14th and Independence Ave. S.W., Washington, DC 20250/202-382-1490.

Market Studies

See "Agricultural Economists," "Computerized Data Bases," "Food Studies and Food Economics," "Library," "Regional Research Facilities," "Research," "Research and Reference Services," "Technology and Innovation."

Mining and Prospecting on Public Land

Anyone can prospect on public lands. Some lands can be bought or leased through the U.S. Department of Interior. Anyone interested in leasing or buying lands for prospecting or mining purposes must submit a plan to the Forest Service. Contact: Minerals and Geology Staff, Forest Service, USDA, P.O. Box 2417, Washington, DC 20013/703-235-8010.

News on Agriculture

For daily news announcements, recorded messages can be heard on the following topics:

Consumer Spot Newsline/202-488-1101
Economic Statistics and Cooperative Services (latest crop, livestock and farm economic information)/800-424-7964
National Grain Market Summary/202-447-8233
News Features/202-488-8358
News Stories/202-447-2545

Newsletters

Free newsletters aimed at producers and farmers that cover wheat, seed, livestock, oilseeds, cotton and general agricultural news are available from ESCS Information, Publications, South Building, Room 0054, USDA, Washington, DC 20250/202-447-7255.

Nutrition Information Center

This information clearinghouse on human nutrition and food service management answers a wide range of inquiries. Contact: Food and Nutrition Information and Education Resources Center, Room 304, National Agricultural Library Building, 10301 Baltimore Blvd., Beltsville, MD 20705/301-344-3719.

Nutrition Publications

A series of publications is available describing the nutritional value of the following food groups: Dairy and Eggs; Spices and Herbs; Baby Foods; Fats and Oils; Poultry; Soups, Sauces and Grains; Sausages and Luncheon Meats; Pork Products; Breakfast Cereals by Brand Name; Nuts and Seeds; Fruits; Vegetables; Legumes; Fish and Shellfish; Beef; Cereal Grain Products; Beverages; Candies and Confections; and Mixed Dishes (TV dinners, pizza, etc.). For detailed information on the content of these publications contact: Nutrient Data Research Group, SEA, Federal Building, Room 313, 6505 Belcrest Rd., Hyattsville, MD 20782/301-436-8491. The publications are available for sale at the Government Printing Office, Superintendent of Documents, Washington, DC 20402/202-783-3238.

Nutritional Labeling

The USDA is responsible for labeling requirements for meat and poultry only, and this is done on a voluntary basis. Contact: Nutritional Labeling, Meat and Poultry Standards and Labeling Division—Compliance Program, Room 204 Annex, 300 12th St. S.W., Washington, DC 20250/202-447-7620.

Organic Farming and Gardening

The National Agricultural Library has prepared a free bibliography on this subject containing over 200 citations. See "Library" in this section.

Patent Licensing Opportunities

Government patents resulting from agricultural research discoveries are available for licensing to U.S. companies and citizens. There is no charge for licensing agreements. For a description of the types of patents available, contact: Agreements and Patents Management, SEA-Administration Services Program, Federal Building, Room 524, 6505 Belcrest Rd., Hyattsville, MD 20782/301-436-8402.

Patents on Seeds

All unique seeds, with few exceptions, that are sexually reproduced can be patented. The patent provides owners exclusive rights to sell, reproduce, export and produce the seed; protection extends for 17 years. Contact: Plant Variety Protection Office, Livestock, Poultry and Grain Division/AMS, NAL Room 500, Beltsville, MD 20705/301-344-2518.

Pesticide Directory for Plants

A free directory, entitled *Agricultural Hand-*

book #554, describes Environmental Protection Agency-cleared pesticides and their safe application on plant life. Contact: Publications, Science and Education Administration, USDA, South Building, Washington, DC 20250/202-447-3776.

Pick Your Own Fruits and Vegetables

Many farmers allow consumers to pick products directly from their fields at substantial savings. For a directory of farms which offer these direct marketing programs, contact: the State Department of Agriculture or a state extension service. See "Extension Service" in this section. For statistical information on how many farms direct market what kinds of products, contact: Food Economics, Direct Marketing, 500 12th St. S.W., Room 260, Washington, DC 20250/202-447-8707.

Plant and Entomological Sciences

A group of specialists study such topics as Biological Control of Pests, Corn and Sorghum Production, Crop Mechanization and Pest Control Equipment, Crop Pollination, Bees and Honey, Insect Control, Forage Crop Production, Range Management, Plant Genetics and Breeding, Pest Control, Pest Management, Pesticide Usage and Impacts, Plant Introduction and Narcotics, Plant Pathology and Nematology, Weed Control, Small Grains Production, Sugar Crops Production, Vegetables and Ornamental Crops and Plant Physiology. Contact: Human Nutrition, Beltsville Agricultural Research Center-West, Building 005, Room 305, Beltsville, MD 20705/301-344-2446.

Plants—Research and Reference

For assistance on topics involving plants, contact: National Arboretum Library, 24th and R. Sts. N.E., Washington, DC 20002/202-472-9264.

Price Supports

This refers to interim financing by government enabling farmers to hold and sell their products at a profit when market prices rise and not at a depressed price when they need money. See "Loans and Loan Guarantees (Commodity Loans)" in this section.

Publications—Free and For a Fee

Most major offices within USDA publish informational books and pamphlets which are only available from their office. Contact your division of interest and request a free listing of available publications.

The USDA Publication Division publishes additional titles. A free book listing their publica-

tions is available by contacting: Office of Governmental and Public Affairs Publications Division, USDA, Room 114-A, Washington, DC 20250/202-447-2791. Most publications are available for free. Their most popular titles are:

Your Money's Worth In Foods
Nutrition Food At Work For You
Family Fare—A Guide to Good Nutrition
Food Is More Than Just Something To Eat
Home Canning of Fruits and Vegetables
Food Guide For Older Folks
Food and Your Weight
Home Freezing of Fruits and Vegetables
Nutritive Value of Foods
Growing Vegetables in the Home Garden

Quarantine—Plants and Animals

If you bring plants or animals into the country, they may be quarantined because of foreign pests. Contact: Plant Protection and Quarantine Program, APHIS, USDA, Room 1148, South Building, Washington, DC 20250/202-447-6190.

Ranches and Fish Farms

Many of the USDA programs are available to ranchers and aquaculture operators. Because program requirements are continually updated, ranchers and aquaculture operators will find it valuable to investigate any farm-related programs.

Regional Research Facilities

The Agricultural Research Division of the Science and Education Administration manages 4 regional research facilities, each of which conducts research suitable to its locale. The regional offices are listed below, along with a brief description of subject areas covered:

Northeast Regional Information Office, SEA/AR USDA, Room 251, Building 003, Beltsville Agricultural Research Center-West, Beltsville, MD 20701/301-344-3541 (animal health, plants, genetics).
North Central Regional Information Office, SEA/AR USDA, 2000 West Pioneer Parkway, Peoria, IL 61600/309-671-7166 (Crops of the north central region; grains).
Southern Regional Information Office, SEA/AR USDA, P.O. Box 53326, New Orleans, LA 70153/504-589-6708 (Southern-region focus on cotton and other southern crops).
Western Regional Information Office, SEA/AR USDA, 1333 Broadway, Suite 400, Oakland CA 94612/415-273-6052 (Fruit cropping, irrigation).

Each regional facility matches research needs

of the locale to the center. Cooperative work between facilities.

Regulatory Activities

Listed below are those organizations within USDA which are involved with regulating various business activities, with a description of those industries or situations which are regulated by the office. Regulatory activities generate large amounts of information on the companies and subjects they regulate; much of this information is available to the public. Regulatory activities can also be used by consumers. A regulatory office also can tell you your rights when dealing with a regulated company.

Agriculture Marketing Service

Information Division, USDA, Room 3086, South Building, Washington, DC 20250/202-447-6766.

Regulates the following segments of the agricultural industry: cotton, dairy products, fruits and vegetables, livestock, poultry, grains, seeds, tobacco, transportation and warehouses, and packers and stockyards.

Animal and Plant Health Inspection Service

Information Division, USDA, Room 1143, South Building, Washington, DC 20250/202-447-3977.

Administers programs which help control and eradicate diseases and pests that affect animals and plants. Also administers programs which concentrate on animal and plant health as well as quarantine.

Federal Grain Inspection Service

Administrator, USDA, Room 1628, South Building, Washington, DC 20250/202-447-9170

Establishes federal standards for grain and performs inspections to ensure compliance. Regulates the weighing of all grain for export.

Food Safety and Quality Service

Information Division, USDA, Room 327-E, Washington, DC 20250/202-447-7943.

Inspects all meats, poultry and egg products shipped interstate and abroad, and insures that labels on these products are truthful. Develops official grade standards for meat, poultry, eggs, dairy products and fresh and processed fruits and vegetables.

Foreign Agricultural Service

Information Services, USDA, Room 5918, South Building, Washington, DC 20250/202-447-7937.

Regulates the imports of beef, dairy products, and other commodities by administering quotas imposed by the President.

Forest Service

Director, Office of Information, USDA, 3244 South Building, Washington, DC 20250/202-447-3957.

Regulates the activities of commercial foresters working in national forests.

Other

In addition to the organizations mentioned above, any office which administers loans, grants, direct payments, or loan guarantees performs a regulatory function by insuring that the guidelines of the program are enforced. See "Loans and Loan Guarantees," "Grants," and "Direct Payments."

Research

The following six agencies conduct and administer research. Each can be contacted directly for a more detailed listing of topics covered along with documentation of findings.

Agricultural Research

Science and Education Administration, USDA, Room 432-A, Washington, DC 20250/202-447-2750.

Topics: Animal and plant production; use and improvement of soil water and air; processing, storage and distribution of farm products; food safety and consumer service; human nutrition.

Cooperative Research

Science and Education Administration, USDA, Room 322-A, Washington, DC 20250/202-447-4423.

Topics: Family and consumer services; natural resources; grants for research in agriculture, agriculture marketing, rural development and forestry.

Soil Conservation Service

Forest Service

Economic, Statistics and Cooperative Services

Agricultural Marketing Research

Agricultural Marketing Service, USDA, Room 0608, South Building, Washington, DC 20250/202-447-3075.

Topics: Feasibility studies to determine need for wholesale distribution facilities; provide technical and hiring assistance to implement project;

research alternative methods of handling, packaging and distributing food; electronic marketing systems; examine effects and benefits of marketing news on price reports for agricultural commodities and retail food prices; provide statistical analysis to AMS, federal grain inspection service, and transportation office; improve government regulations within AMS.

Research and Reference Services

Free services are available from the National Agricultural Library. A team of researchers is available to the public to answer questions and provide information on most any topic. Researchers will utilize resources both inside and outside of the library. See "Library" in this section.

Science and Education Newspaper

The Science and Education Administration publishes a free monthly newspaper entitled *SEA Newsmakers*. It is an ideal source for identifying new projects, research, technology, grants, etc. being worked on within the division. Contact: *SEA Newsmakers,* Information Staff, SEA, USDA, Washington, DC 20250/202-447-3776.

Sick Pets, House Plants, Gardens, Trees and Lawns

Free technical assistance is available to aid in diagnosing and curing diseases of plants and animals. Services range from telephone consultations and free literature to analyzing your pet's stools or your plant's leaves or soil. See "Extension Service" in this section.

Small and Disadvantaged Businesses

A special office has been established to help small and minority businesses obtain contracts from the USDA. Contact: Office of Small and Disadvantaged Business Utilization, USDA, Room 127W, Administration Building, Washington, DC 20250/202-447-7117.

Soil Conservation Technical Expertise

Technical expertise is available in such areas as geology, irrigation, drainage, landscape architecture, construction, sanitary and water quality and hydrology. Contact: Soil Conservation Service.

Soil, Water and Air Sciences

A group of specialists studies such topics as Environmental Quality, Erosion and Sedimentation, Soil Fertility and Plant Nutrition, Water-Use Efficiency and Tillage Practices, Water Management and Watershed Engineering Hydrology. Contact: Soil, Water and Air Sciences

Division, SEA/AR, Beltsville Agricultural Research Center-West, Building 005, Beltsville, MD 20705/301-344-2743.

Speakers

Experts will talk to groups for free on a wide variety of agricultural subjects. Contact: Office of Governmental and Public Affairs, USDA, Room 102-A, Administration, Washington, DC 20250/202-447-3805.

Stains and Spots

Help is available for consumers who wish to know how to remove stains from fabrics. Contact: Textile and Clothing Labs, USDA/SEA, 1303 W. Cumberland, Knoxville, TN 37916/615-974-5249.

Swimming and Boating in Secluded Spots

The USDA gives money to small landowners to help turn their property into recreation areas for the public. (See "Grants" in this section.) Most of these areas are in out-of-the-way places and are nice if you wish to avoid the crowds. For a map identifying these little-used areas, contact: Recreation Staff, Forest Service, USDA, P.O. Box 2417, Washington, DC 20013/202-447-2155.

Teaching Aids

A list of free teaching aids is available from USDA's Publication Division. See "Publications" in this section.

Technology and Innovation

Studies and expertise on such topics as the application of solar energy to farm production, new farm machinery technology, and the use of electronic automatic checkout systems in grocery stores are available from Technology and Innovation/National Economic Analysis Division, ERS/USDA, 500 12th St. S.W., Room 246, Washington, DC 20250/202-447-8168.

Telephone and Electricity in Rural Areas

The Rural Electrification Administration assists in providing telephone and electrical services to rural areas. See "Loans and Loan Guarantees" in this section.

Telephone Utility Systems

The USDA lends money to approximately 900 rural telephone companies and maintains a staff knowledgeable in both operations and equipment. Contact: Assistant Administrator—Telephone, Rural Electrification Administration, USDA, Room 4048, Washington, DC 20250/202-447-4305.

Toys, Free

Free litter bags, coloring sheets, song sheets, photographs, posters, bike stickers, and wallet cards are available from: Woodsy Owl, Forest Service, USDA, Room 3248, South Building, P.O. Box 2417, Washington, DC 20013/202-447-7013.

Free badges, stickers and other children's toys are available by contacting: Smokey Bear Headquarters, Washington, DC 20252/202-235-8040.

Transporting Plants Between States

Each state has separate rules and regulations for transporting plants across state boundaries. For information on a specific state's regulations, contact: Animal and Plant Health Inspection Service, Plant Protection and Quarantine, USDA, Room 1148, South Building, Washington, DC 20250/202-447-6190.

Travel and Recreation Information

Travel planning aid and information are available to those wishing to visit one of the country's 154 national forests and 19 national grasslands. Contact: Office of Information, Forest Service, USDA, Room 3244, South Building, Washington, DC 20250/202-447-3957.

Veterinary Services

A staff of specialists study communicable diseases and pests affecting livestock and poultry. Contact: Veterinary Services, Animal and Plant Health Inspection Service, USDA, Room 320-E, Washington, DC 20250/202-447-5193.

Visual Aids

A list of free posters, maps, charts, and other visual materials are available from USDA's Publication Division. See "Publications" in this section.

Weather Reports

A weekly publication summarizes weather conditions and their effect on crops for the previous week. Single copies are free. Annual sub-scriptions are $13.00. Contact: Weekly Weather and Crop Bulletin, USDA, Room 5844, South Building, Washington, DC 20250/202-447-7917.

Wilderness

The National Wilderness Preservation System consists of 19 million acres of roadless undeveloped lands which represent America's natural heritage. The land is open to the public but contains no commercial enterprises and motorized access is prohibited. Contact: Recreation, Forest Service, USDA, Box 2417, Washington, DC 20013/202-447-2422.

Wildlife and Birds

Bulk grain is available in emergency situations for wildlife and birds at the request of the U.S. Department of Interior. Contact: CCC/ASCS, USDA, 5714 South Building, Washington, DC 20250/202-447-4786.

Wine and Cheese Making at Home

The USDA has accumulated documentation and expertise to assist in making wine and cheese at home. For a literature review on these topics, ask for the wine and cheese Agri-Topics Reports from National Agriculture Library (see "Library" in this section).

For more detailed expertise on wine, contact Fruit Laboratory, Agricultural Research Service, USDA, Room 111, Building 004, BARC-West, Beltsville, MD 20705/301-344-3572. For expertise in cheese, contact: Dairy Laboratory, USDA, AR-NER, Eastern Regional Research Center, 600 East Mermaid Lane, Philadelphia, PA 19118/215-247-5800, ext. 285.

How Can USDA Help You?

A staff of research specialists is available to get you specific answers or point you to an expert who can help. If USDA does not have an answer to your question, they will also help in locating another agency who might. Contact: Information Office, Office of Public Affairs, USDA, Room 230-E, Washington, DC 20250/202-447-4894.

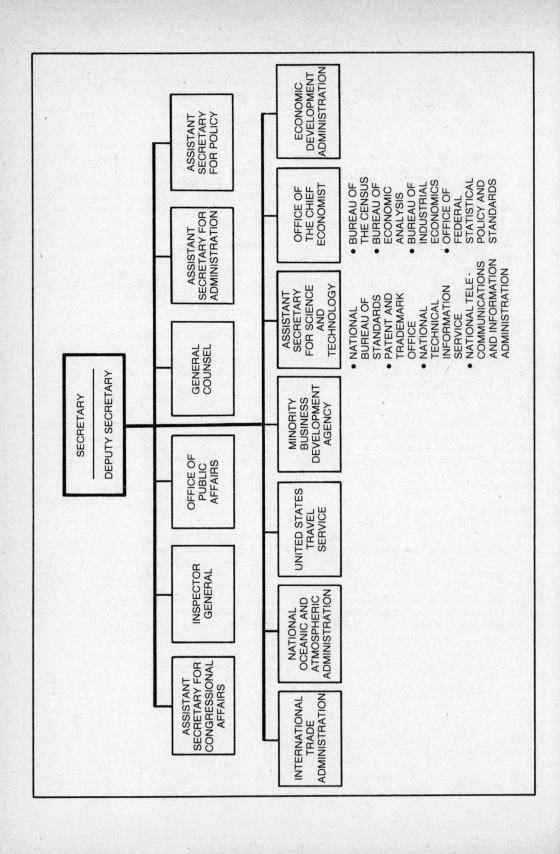

SECRETARY
—
DEPUTY SECRETARY

ASSISTANT SECRETARY FOR CONGRESSIONAL AFFAIRS

INSPECTOR GENERAL

OFFICE OF PUBLIC AFFAIRS

GENERAL COUNSEL

ASSISTANT SECRETARY FOR ADMINISTRATION

ASSISTANT SECRETARY FOR POLICY

INTERNATIONAL TRADE ADMINISTRATION

NATIONAL OCEANIC AND ATMOSPHERIC ADMINISTRATION

UNITED STATES TRAVEL SERVICE

MINORITY BUSINESS DEVELOPMENT AGENCY

ASSISTANT SECRETARY FOR SCIENCE AND TECHNOLOGY

OFFICE OF THE CHIEF ECONOMIST

ECONOMIC DEVELOPMENT ADMINISTRATION

- NATIONAL BUREAU OF STANDARDS
- PATENT AND TRADEMARK OFFICE
- NATIONAL TECHNICAL INFORMATION SERVICE
- NATIONAL TELE-COMMUNICATIONS AND INFORMATION ADMINISTRATION

- BUREAU OF THE CENSUS
- BUREAU OF ECONOMIC ANALYSIS
- BUREAU OF INDUSTRIAL ECONOMICS
- OFFICE OF FEDERAL STATISTICAL POLICY AND STANDARDS

Department of Commerce

14th St. between Constitution Ave. and E St. N.W.,

Washington, DC 20230/202-377-2000

ESTABLISHED: March 4, 1913
BUDGET (1980 estimate): $3,560,549,000
EMPLOYEES: 29,780

MISSION: Encourage, serve and promote economic development and techno-
logical advancement. Assist and inform domestic and international business and
government planners. Aid in speeding the development of economically under-
developed areas in this country, seek to improve understanding of the Earth's
physical environment and oceanic life. Promote travel to the United States by
residents of foreign countries. Assist in the growth of minority business. Seek to
prevent the loss of life and property from fire.

Major Divisions and Offices

International Trade Administration (ITA)

Department of Commerce, Room 3850, Wash-
ington, DC 20230/202-377-2867.
Budget: $93,512,000
Employees: 1,546
Mission: Foster international trade competitive-
ness of U.S. industry. Assist U.S. business in sell-
ing its goods in international markets by
providing counseling, marketing information ser-
vices and promotional assistance. Provide advice
and assistance on regulating exports. Coordinate
activities involving the research, analysis, and
formulation of international economic and com-
mercial programs and policies relating to trade,
finance, and investment.

National Oceanic and Atmospheric Administration (NOAA)

Department of Commerce, Room 5807, Wash-
ington, DC 20230/202-377-2985.
Budget: $832,390,000
Employees:12,680
Mission: Explore, map and chart the global
ocean and its living resources. Manage, use and
conserve those resources and describe, monitor
and predict conditions in the atmosphere, ocean,
sun and space environment. Issue warnings
against impending destructive natural events. De-
velop beneficial methods of environmental modi-
fication and assess its consequences.

United States Travel Service

Department of Commerce, Room 1524, Wash-
ington, DC 20230/202-377-3811.
Budget: $11,664,000
Employees: 75
Mission: Stimulate and facilitate travel to the
U.S. by residents of foreign countries. Promote
understanding and good will between the United
States and peoples of other countries. Generate
foreign exchange to increase U.S. export earn-
ings.

Minority Business Development Agency (MBDA)

Department of Commerce, Room 5053, Wash-
ington, DC 20230/202-377-2654.
Budget: $55,997,000
Employees: 247
Mission: Develop and coordinate a national pro-
gram for minority business enterprise. Promote
the mobilization of activities and resources of
public and private, state and local organizations
and institutions toward the growth of minority

business. Develop and disseminate information that will be helpful to persons or organizations throughout the nation in undertaking and successfully operating minority businesses. Provide financial assistance to public and private organizations for rendering technical and management assistance to minority businesses.

Assistant Secretary for Science and Technology

Department of Commerce, Room 3864, Washington, DC 20230/202-377-3111.
Budget: $204,131,000
Employees: 6,473

1. National Bureau of Standards (NBS)

Department of Commerce, Washington, DC 20234/301-921-1000.
Budget: $99,206,000
Employees: 3,477
Mission: Strengthen and advance the nation's science and technology and to facilitate their effective application for public benefit. Conduct research and provide a basis for the nation's physical measurement system, scientific and technological services for industry and government, technical basis for equity in trade, and technical services to promote public safety. Perform technical work at the National Measurement Laboratory, the National Engineering Laboratory, and the Institute for Computer Sciences and Technology.

2. Patent and Trademark Office

Department of Commerce, Washington, DC 20231/703-557-3158.
Budget: $103,425
Employees: 2,609
Mission: Examine patent and trademark applications. Issue patents and register trademarks. Sell printed copies of issued documents. Record and index documents transferring ownership. Maintain a scientific library and search files. Provide search rooms for the public to research their applications.

3. National Technical Information Service (NTIS)

Department of Commerce, 5285 Port Royal Rd., Springfield, Virginia 22161/703-557-4660.
Budget: $1,500,000
Employees: 397
Mission: To simplify and improve public access

to Department of Commerce publications and to data files and scientific and technical reports sponsored by federal agencies.

4. National Telecommunications and Information Administration

Department of Commerce, 1800 G Street N.W., Room 775, Washington, DC 20230/202-377-1840.
Budget: $38,316,000
Employees: 343
Mission: Formulate policies to support the development, growth and regulation of telecommunications information and related industries. Further the efficient development and use of telecommunications and information services. Provide telecommunications facilities grants to public service users.

Office of the Chief Economist

Department of Commerce, Room 4848, Washington, DC 20230/202-377-3523.

1. Bureau of the Census

Department of Commerce, Washington, DC 20230/202-377-3523.
Budget: $617,612,000
Employees: 4,300
Mission: To provide that a census of population is taken every ten years. To be a general purpose statistical agency which collects, tabulates, and publishes a wide variety of statistical data about the people and the economy of the nation. To have this data utilized by the Congress, by the executive branch, and by the public in the development and evaluation of economic and social programs.

2. Bureau of Economic Analysis (BEA)

Department of Commerce, Washington, DC 20230/202-523-0693.
Budget: $18,039,000
Employees: 491
Mission: To prepare, develop, and interpret the economic accounts of the United States. To provide a realistic, quantitative view of the production, distribution, and use of the nation's output.

3. Bureau of Industrial Economics

Department of Commerce, Room 4845, Washington, DC 20230/202-377-4024.
Budget: $5,353,000
Employees: 138

Mission: Provide business assistance and advice to the business community. Advise on development and implementation of domestic business programs. Implement policies and programs for business expansion, development and industrial recovery bringing together the Department of Commerce and other federal resources to assist in this effort.

4. Office of Federal Statistical Policy and Standards

2001 S St. N.W., Room 702, Washington, DC 20230.
Budget: $1,191,000
Mission: Conduct objective analysis of individual statistical programs in order to provide a basis for recommendations for improvement. Review all cooperative arrangements among statistical agencies including those of the Department of Commerce.

Economic Development Administration

Department of Commerce, Room 7800B, Washington, DC 20230/202-377-5081.
Budget: $933,556
Employees:911
Mission: Assist in the long-range economic development of areas with severe unemployment and low family income problems. Aid in developing public facilities and private enterprise to create new, permanent jobs through grants, loans and technical assistance. Provide financial and technical assistance for firms damaged by foreign imports.

Data Experts

Industry Experts

The Bureau of Industrial Economics maintains a staff of some 100 analysts who monitor specific industries. These analysts willingly share their information and industry contacts. They are a terrific resource for researchers beginning their investigation into any industry. If the list below does not present an industry which is of interest to you simply call the Director's office and ask for an expert who specializes in your topic. These experts can also be reached by mail, using the Director's address (Director, Bureau of Industrial Economics Department of Commerce, Room 2111, Washington, DC 20230/202-377-1405).

Science and Electronics

Medical, Surgical, and Dental Equipment and Supplies, Opthalmic Goods, Horological Instruments/W. Claude Bandy/202-566-5700.
Bearings, Ball and Roller/William Fletcher/202-566-7529.
Telephone Communications Services/William J. Sullivan/202-566-3387.
Broadcast Systems and Service/E. MacDonald Nyhen/202-566-3263.
Electronic Components and Accessories/Michael Kubiak/202-566-9757.
Computers, Business Equipment, Photographic Equipment/John E. McPhee/202-566-3266.
Science and Electronic Industries Data, Engineering and Scientific Instruments/Roland C. Kingsbury/202-566-7419.

Consumer Goods and Services Industries

Wholesale Trade, Hotels, Motels, Recreation Malton Evans/202-566-3537.
Insurance, Franchise Regulation in Legislation/Jacob H. Bennison/202-566-3412.
General Merchandise Retail Trade/Marvin J. Margulies/202-566-3385.
Retail Apparel and Accessory Stores/Marvin Margulies/202-566-3385.
Franchising/Andrew Kostecka/202-566-3400.
Advertising, Motion Pictures/Theodore A. Nelson/202-566-3328.
Banking, Consumer Credit, Finance/Wray Candilis/202-566-3435.
Footwear, Hides, Skins/Virginia Mannering/202-566-3153.
Leather, Tanning and Finishing/James E. Byron/202-566-3295.
Personal Leather Goods, Fur Skins, Luggage, Leather Apparel/James Pittard/202-566-3154.
Commercial Kitchen Appliances, Primary Batteries, Household Furniture and Appliances, Electric Lamps/John Harris/202-566-3147.
Mopeds, Bicycles, Motorcycles, Sporting Arms and Ammunition, Sporting Goods, Lawn and Garden Equipment, Brooms and Brushes, Wigs, Caskets/Vacant/202-377-3818.
Toys and Games, Jewelry Finding, Costume Jewelry, Silverware, Portable Lamps, Writing Instruments, Stamped Cookware, Flatglass, Novelties, Ceramics, Cutlery, Musical Instruments/John Harris/202-566-3147.

Retail Foods, Wholesale Groceries, Confectionery, Chocolate, Cocoa, Baking/Neil Kenny/202-566-3235.

Dairy Products and Tobacco, Sugar, Grain Mill Products, Fats, Oils/William Janis/202-566-3154.

Meat, Poultry/Donald Hodgen/202-566-3096.

Beverages/Neil Kenny/202-566-3235.

Forest Products, Packaging, and Printing Division

Forest Products/James McElroy/202-566-9440.

Plywood and Veneer/James McElroy/202-566-9440.

Lumber Products/Adair A. Mitchell/202-566-9440.

Poles, Piling, Wood Laminates, Wood Preserving, Logs, Timber Resources/David K. Henry/202-377-7606.

Paperboard Grades/Donald W. Butts/202-566-9440.

Pulp and Raw Materials, Newsprint/Howard A. Post/202-566-9440.

Converted Paper Products and Paper Packaging/Leonard Smith/202-566-9440.

Plastic Packaging/Richard Blassey/202-566-7788.

Commercial Printing/Charles Cook/202-566-6864.

Glass and Metal Containers/Richard Blassey/202-566-7788.

Newspapers/William S. Lofquist/202-566-6864.

Book Publishing, Book Printing, Miscellaneous Publishing/William S. Lofquist/202-566-6864.

Periodicals and Greeting Cards, Bookbinding/Rose Marie Bratland/202-566-6864.

Engineering and Water Resources, Wastewater Equipment/Vacant/202-377-4346.

Water Resources/Patrick L. McAuley/202-377-4346.

Water Resources, Wastewater Equipment/John Matticks/202-377-4346.

Construction and Building Products, Construction and Building Materials/Vacant/202-377-5255.

Housing Construction/Abraham Goldblatt/202-377-4271.

Building Materials and Products/Charles B. Pitcher/202-377-3601.

Construction Statistics, Construction Review, Building Materials Industries/Nathan Rubinstein/202-377-5289.

Steel Products and Insulation Materials/Franklin E. Williams/202-377-3602.

Transportation and Capital Equipment Division

Automotive Equipment/Charles R. Weaver/202-377-3296.

Alumininum and Miscellaneous Metals and Materials/Vacant/202-377-4437.

Aluminum and Magnesium/Marie Z. Harris/202-377-2196.

Precious Metals, Mercury, Titanium/James J. Manion/202-377-2692.

Miscellaneous Metals and Minerals, Industrial Diamonds/Neill F. Raab/202-377-2294.

Copper, Lead, Zinc/Robert Reiley/202-566-7732.

Materials/Vacant/202-377-4412.

Iron and Steel Economic Analysis, Steel Mill Products, Casting and Forgings/Ralph F. Thompson/202-566-3031.

Steel Industry, Raw Materials/William S. Kruppa/202-566-3031.

Textiles/James Bennett/202-377-4058.

Apparel/Laurie McKenna/202-377-4058.

Steel Mill Products/Ralph F. Thompson/202-566-3031.

Automotive Equipment/Robert Coleman/202-566-7425.

Truck and Bus Equipment/Eduardo Japson/202-566-7425.

Aerospace Equipment/Roland Kingsbury/202-566-7425.

Air Conditioning and Refrigeration, Residential Solar Applications/Earl Nettles/202-566-7559.

Ship and Boat Building and Repair/Ralph R. Nordlie/202-566-7408.

Railroad Equipment/Ralph R. Nordlie/202-566-7403.

Power Generating Boilers/David S. Climer/202-566-7455.

Textile and Printing Machinery/T. J. Jackson/202-566-7469.

Agricultural and Construction Machinery and Equipment, Materials Handling Equipment/John A. Lien/202-566-7519.

Mining and Oil Field Machinery, Fluid Power Equipment, Pumps and Compressors/Edward J. McDonald/202-566-7499.

General Components, Ball Bearings, Industrial Fasteners, Power Transmission Equipment/William E. Fletcher/202-377-3155.

Fans and Blowers, Pollution Control Equipment, Plastics and Rubber Machinery/Edward D. Abrahams/202-377-5593.

Electrical Equipment/Richard A. Whitley/202-377-3525.

Metalworking Machinery and Equipment,

Including Machine Tools/Robert J.
Hunsberger/202-566-7426.

Abrasives, Tool and Die, Industrial Heating
Equipment/Robert A. Ricciuti/202-377-2723.

Cutting Tools, Welding Equipment, Generators,
Rolling Mill Equipment/Paul Sacharov/202-
566-7459.

Food Processing and Packaging, Machinery and
Equipment/Irvin Axelrod/202-566-7563.

Machine Tools, Metal Cutting/Robert J.
Hunsberger/202-566-7426.

Machine Tools, Metal Forming/John A.
Mearman/202-566-7448.

Nuclear Power Plants, Turbine Generating
Equipment, Power Boilers, and Related
Equipment/David S. Cliemer/202-566-7455.

Basic Industries
Solid Waste/Diana B. Friedman/202-377-4437.

Refractories, and Steel Mill Products and
Statistics/Patrick J. Torrilo/202-566-3031.

Chemicals/Harry F. Pfann/202-377-5287.

Fertilizers/Frank P. Maxey/202-566-7047.

Organic Chemicals/Frederick S.
Magnusson/202-377-3464.

Rubber, Rubber Products/David H. Blank/202-
566-6982.

Plastics, Pigments, Paints/David G. Rosse/202-
566-6982.

Soaps, Detergents, Toilet Preparations/Leo
McIntyre/202-566-7047.

Inorganic Chemicals/Vacant/202-377-3174.

Pharmaceuticals and Miscellaneous
Chemicals/Leo R. McIntyre/202-566-7047.

Chemical Statistics/Vacant/202-377-2067.

Economists

A large staff of economists monitors various
aspects of the economy. These experts can supply
data and expertise for their specific areas of inter-
est. They can be contacted by telephone or by
writing to: Bureau of Economic Analysis, De-
partment of Commerce, Washington, DC 20230.
Be sure to include the expert's name and subject
area on all correspondence.

Division Chiefs
Balance of Payments/Christopher L. Bach/202-
523-0621.

Business Outlook/George R. Green/202-523-
0701.

Computer Systems and Services/Vincent C.
Finelli/202-523-0981.

Current Business Analysis/Carol S.
Carson/202-523-0707.

Environmental and Nonmarket Economics/

Charles Waite/202-523-0713.

Government/Joseph C. Wakefield/202-523-
0715.

Interindustry Economics/Paula C. Young/202-
523-0683.

International Investment/George R. Kruer/202-
523-0657.

Management Service Division/John M.
O'Brien/202-523-0884.

National Income and Wealth/Robert P.
Parker/202-523-0806.

Regional Economic Analysis/A. Ray
Grimes/202-523-0946.

Regional Economic Measurement/Edwin J.
Coleman/202-523-0901.

Statistical Indicators/Feliks Tamm/202-523-
0535.

National Economics
Antipollution Capital Spending/Gary L.
Rutledge/202-523-0687.

Auto Output/Robert T. Clucas/202-523-0836.

Business Cycle/Bob McCahill/202-523-0535.

Capital Consumption Allowance/Gerald
Silverstein/202-523-0809.

Capital Investment, Plant and Equipment
Expenditures/John T. Woodward/202-523-
0874.

National Income and Wealth Division,
Investment Branch/John Hinrichs/202-523-
0791.

Capital Stock/John C. Musgrave/202-523-0837.

Capacity Utilization, Manufacturing/John T.
Woodward/202-523-0874.

Composite Index of Economic Indicators/
Feliks Tamm/202-523-0535.

Construction/Jeffery W. Crawford/202-523-
0772.

Corporate Profits/Kenneth Petrick/202-523-
0888.

Debt, Public and Private/Jeanette M.
Honsa/202-523-0839.

Depreciation/Gerald S. Wentein/202-523-0809.

Disposable Personal Income/Mary Hook
202-523-0813.

Econometric Models/Albert A. Hirsch/202-
523-0729.

Economic Growth/Henry Townsend/202-523-
0508.

Economic Well-being/Janice Peskin/202-523-
0508.

Employee Compensation/Pauline M.
Cypert/202-523-0832.

Employee Benefit Plans/George M. Smith/202-
523-0810.

Environmental Studies/Frank W. Segel/202-
523-0519.

Farm Output/Shelby A. Herman/202-523-0828.
Forecasts and Projections/George R. Green/202-523-0701.

Government

Federal Grants-in-Aid/Deloris T. Tolson/202-523-0896.
Federal Price Measurement/Richard C. Ziemer/202-523-5027.
Federal Purchase of Goods and Services, Current Dollars/David T. Dobbs/202-523-0744.
Federal Purchase of Goods and Services, Constant Dollars/Robert T. Mangan/202-523-0522.
Federal Receipts and Expenditures/David T. Dobbs/202-523-0744.
Federal Transfers and Contributions/Kathleen M. Downs/202-523-0885.
State and Local Purchases of Goods and Services/David J. Levin/202-523-0725.
State and Local Receipts and Expenditures/ Donald L. Peters/202-523-0725.
Gross National Product, Current Estimates/Leo M. Bernstein/202-523-0824.
Gross National Product by Industry/Donald P. Eldridge/202-523-0808.
Gross Private Domestic Investment/John C. Hinrichs/202-523-0791.
Income Size Distribution/Jean K. Salter/202-523-0771.
Input-Output Analysis/Phlip M. Ritz/202-523-0683.
Business Services, Miscellaneous/Anne Probst/202-523-0587.
Capital Flows/Peter E. Coughlin/202-523-0761.
Capital Investment and Stocks/Vacant/202-523-0678.
Communications/Carolyn B. Knapp/202-523-0867.
Construction/Claiborne M. Ball/202-523-0764.
Employment and Employee Compensation/ Peter E. Coughlin/202-523-0761.
Finance, Insurance and Real Estate/Carolyn B. Knapp/202-523-0867.
Final Demand/Paula C. Young/202-523-0703.
Foreign Trade/Arlene K. Shapiro/202-523-0859.
Government/Roy A. Seaton, II/202-523-0857.
Manufacturing/Paula C. Young/202-523-0703.
Mining/Paula C. Young/202-523-0703.
Nonprofit Organizations/Carolyn B. Knapp/202-523-0867.
Retail Trade/George M. Swisko/202-523-5195.
Services/Carol B. Knapp/202-523-0867.
Summary Update Tables/Shirley F. Loftus/202-523-0877.
Transportation/Claiborne M. Ball/202-523-0764.

Utilities/Nancy W. Simon/202-523-0985.
Wholesale Trade/George M. Swisko/202-523-5195.
Input-Output Computer Tapes/Ray A. Seaton, II/202-523-0857.
Input—Output Research and Methodology/Peter Coughlin/202-523-0761.
Interest Income and Payments/Jeanette M. Honsa/202-523-0839.
Inventories/John C. Hinrichs/202-523-0791.
Manufacturing Capacity Utilization/John T. Woodward/202-523-0874.
National Income/Mary Hook/202-523-0813.
Personal Consumption Expenditures/James C. Byrnes/202-523-0819.
Personal Consumption Expenditures Autos/Robert T. Clucas/202-523-0836.
Personal Consumption Expenditures Other Goods/Paula Robinson/202-523-0829.
Personal Consumption Expenditures Services/Clinton P. McCully/202-523-0807.
Personal Income/Pauline M. Cypert/202-523-0832.
Plant and Equipment Expenditures/John T. Woodward/202-523-0874.
Pollution Abatement Capital Spending/Gary L. Rutledge/202-523-0687.
Pollutant Costs and Emissions/Frank W. Segel/202-523-0519.
Price Measures—Implicit Price Deflator, Fixed Weight Price Index, Chain Price Index/ Shelby A. Herman/202-523-0828.
Producers' Durable Equipment/Stephen P. Baldwin/202-523-0784.
Proprietor's Income/Kenneth Petrick/202-523-0888.
Rental Income/Pauline M. Cypert/202-523-0832.
Savings, Personal/Jeanette M. Honsa/202-523-0839.
Seasonal Adjustment Methods/Morton Somer/202-523-0525.
United Nations and O.E.C.D. System of National Accounts/Jeanette M. Honsa/202-523-0839.
Wealth Accounts/John A. Gorman/202-523-0803.

Regional Economics

BEA Economic Areas/Henry L. DeGraf/202-523-0528.
Economic Projections/Kenneth Johnson/202-523-0971.
Economic Situation, Current/Robert B. Bretzfelder/202-523-0948.
Employment, Counties, SMSAs, BEA Economic Areas, and States/Paul Levit/202-523-0966.

Ipact Analysis/Richard Gustely/202-523-0953.
Migration Patterns/Bruce Levine/202-523-0938.
Multipliers/Joe Cartwright/202-253-0594.
Personal Income, Counties, SMSA's BEA Economic Areas, and States/Paul Levit/202-253-0966.
Regional Economic Information System/David W. Cartwright/202-523-0966.
Residence Adjustment/Wallace K Bailey/202-523-0966.
Shift-Share Analysis/Bruce Levine/202-523-0938.
Work Force Data/Bruce Levine/202-523-0938.

International Economics
Balance of Payments, Current Developments/Christopher L. Bach/202-523-0621.
Capital Expenditures of Majority-Owned Foreign Affiliates of U.S. Companies/David Belli/202-523-0645.
Current Account Services/Anthony J. Dilullo/202-523-0625.
Foreign Direct Investment in the U.S./James L. Bomkamp/202-523-0559.
Government Grants & Capital Transactions/E. Seymour Kerber/202-523-0614.
International Direct Investment/George R. Kruer/202-523-0657.
International Travel/Etienne H. Miller/202-523-0609.
Merchandise Trade/Howard Murad/202-523-0668.
Multinational Corporations, Analysis of Activities/David Belli/202-523-0645.
Plant and Equipment Expenditures by Foreign Affiliates of U.S. Corporations/William K. Chung/202-523-0649.
Private Capital Transactions/Russell B. Scholl/202-523-0603.
Sales of Majority-Owned Foreign Affiliates of U.S. Companies/William K. Chung/202-523-0649.
Sources and Applications of Funds of Foreign Affiliates/David Belli-/202-523-0645.
U.S. Direct Investment Abroad, Benchmark Survey/John P. Bogumill/202-523-0637.
Quarterly and Annual Data and Analysis/Obie C. Whichard/202-523-0648.

Survey of Current Business
Editor/Carol S. Carson/202-523-0707.
Statistical Series/Kenneth A. Beckman/202-523-0769.
Business and Manufacturing Sales, Inventories, and Orders/Vacant/202-523-0769.
Chemicals and Allied Products/Rita M. Quick/202-523-0783.
Construction and Real Estate/Fred von Batchelder/202-523-0732.

Consumer and Wholesale Prices/Bernice A. Bowman/202-523-0788.
Electric Power and Gas/Bernice A. Bowman/202-523-0788.
Finance/Fred von Batchelder/202-523-0732.
Food and Kindred Products, Tobacco/Rita M. Quick/202-523-0783.
Foreign Trade of the United States/Bernice A. Bowman/202-523-0788.
General Business Indicators/Vacant/202-523-0769.
Industrial Production/Bernice A. Bowman/202-523-0788.
Labor Force, Employment, and Earnings/Duhurst Hood/202-523-0732.
Leather and Products/Fred von Batchelder/202-523-0732.
Lumber and Products/Bernice A. Bowman/202-523-0788.
Metals and Manufactures/Duhurst Hood/202-523-0732.
National Income and Product Accounts/Vacant/202-523-0769.
Personal Income, By Source/Vacant/202-523-0769.
Petroleum, Coal, and Products/Rita M. Quick/202-523-0783.
Prices Received and Paid by Farmers/Bernice A. Bowman/202-523-0788.
Pulp, Paper and Paper Products/Bernice A. Bowman/202-523-0788.
Rubber and Rubber Products/Vacant/202-523-0769.
Stone, Clay, and Glass Products/Rita M. Quick/202-523-0783.
Textile Products/Duhurst Hood/202-523-0732.
Transportation Communication/Duhurst Hood/202-523-0732.
Transportation Equipment/Duhurst Hood/202-523-0788.
U.S. Balance of International Payments/Bernice A. Bowman/202-523-0788.

Business Conditions Digest
Editor/Feliks Tamm/202-523-0535
Statistical Series/Betty F. Tunstall/202-523-0589.

Census Data Experts

The individuals listed below are able to tell you exactly what census data are available in their subject areas. They can also be helpful in identifying what information is available on their topics from other sources. They can be contacted directly by telephone or by writing to Bureau of the Census, U.S. Department of Commerce, Washington, DC 20233.

Directorial Staff

Director/Vincent P. Barabba/301-763-5190.

Deputy Director/Daniel B. Levine/301-763-5192.

Associate Director for Demographic Fields/George E. Hall/301-763-5167.

Associate Director for Economic Fields/Shirley Kallek/301-763-5274.

Associate Director for Statistical Standards and Methodology/Barbara A. Bailar/301-763-2562.

Associate Director for Administration/James D. Lincoln/301-763-7980.

Associate Director for Field Operations/Rex L. Pullin/301-763-7247.

Associate Director for Information Technology/W. Bruce Ramsay/301-763-5180.

Assistant Director for Computer Services/Howard Hamilton/301-763-2360.

Assistant Director for Demographic Censuses/Earle J. Gerson/301-763-7670.

Assistant Director for Economic and Agriculture Censuses/Richard B. Quanrud/301-763-7356.

Assistant Director for International Programs/Meyer Zitter/301-763-2350.

Congressional Liaison/Pennie Harvison/301-763-5360.

Data User Servicers Division/Staff/301-449-1600.

1980 Census Promotion Program/Staff/301-568-1200.

Public Information Office/Staff/301-568-1200.

Demographic Fields

Center for Demographic Studies/James Wetzel, Chief/201-763-5613.

Decennial Census Division/Vacant/301-763-7670.

Demographic Surveys Division/Marvin Thompson, Chief/301-763-2777.

Foreign Demographic Analysis Division/John Aird, Chief/202-376-7692.

Housing Division/Arthur F. Young, Chief/301-763-2863.

International Demographic Statistics Center/Samuel Baum, Chief/301-763-2870.

International Statistical Programs Center/Robert O. Bartram, Chief/301-763-2832.

Mid-Decade Census Staff/Marie G. Argana, Chief/301-763-7675.

Population Division/Meyer Zitter, Acting Chief/301-763-7646.

Statistical Methods Division/Charles D. Jones, Chief/301-763-2672.

Population and Housing Subjects

AGE AND SEX:

States (age only)/Edward Hanlon/301-763-5072.

United States/Louisa Miller/301-763-5184.

Aliens/Edward Fernandez/301-763-5219.

Annexation Population Counts/Joel Miller/301-763-7955.

Apportionment/Robert Speaker/301-763-7955.

Armed Forces/Louisa Miller/301-763-5184.

Births and Birth Expectations; Fertility Statistics/Maurice Moore/301-763-5303.

Census Tract Population/Robert Speaker/301-763-7955.

CITIZENSHIP:

Foreign Born Persons, Country of Birth; Foreign Stock Persons/Edward Fernandez/301-763-5219.

Means of Transportation; Place of Work/Philip Fulton/301-763-5226.

Consumer Expenditure Survey/Gail Hoff/301-763-2380.

Consumer Purchases and Ownership of Durables/Jack McNeil/301-763-5032.

CRIME SURVEYS:

Data Analysis and Publication/Adolfo Paez/301-763-1765.

Victimization, General Information/Robert N. Tinari/301-763-1735.

Current Population Survey/Gregory Russell/301-763-2773.

DECENNIAL CENSUS:

Content and Tabulations/Marie Argana/301-763-7325.

General Plans/Morris Gorinson/301-763-2748.

Minority Statistics Program/Clifton Jordan/301-763-5169.

National Services Program—Services for Minority Organizations/William L. Lucas/301-763-2050.

1980 Census Update (Newsletter)/Marlane Shaw/301-763-2740.

Disability/Jack McNeil/301-763-5032.

Education; School Enrollment/Rosalind Bruno/301-763-5050.

Employment; Unemployment; Labor Force/Thomas S. Scopp/301-763-2825.

Farm Population/Diana DeAre/301-763-7955.

Health Surveys/Robert Mangold/301-763-5508.

HOUSEHOLDS AND FAMILIES:

Size; Number; Marital Status/Arthur Norton/301-763-5487.

Quarterly Household Survey/John C. Cannon/301-763-2802.

HOUSING:

Annual Housing Survey/Edward Montfort/301-763-2881.

Components of Inventory Change Survey/Elmo Beach/301-763-1096.

Contract Block Program/Richard Knapp/301-763-2873.

Housing Information, Decennial Census/Bill Downs/301-763-2873.

Housing Vacancy Data/Margaret Harper/301-763-5840.

Residential Finance/Betty Kent/301-763-2866.

INCOME STATISTICS:

Current Surveys/Mary Henson/Ed Welniak/301-763-5050.

Decennial Statistics/George Patterson/Ruthy Sanders/301-763-5060.

Household/Robert Cleveland/301-763-5060.

Revenue Sharing/Dan Burkhead/301-763-5060.

Incorporated/Unincorporated Places/Robert Speaker/301-763-7955.

Industry and Occupation Statistics (See also Economic Fields)/John Priebe/301-763-5144.

Institutional Population/Arthur Norton/301-763-5487.

International Population/Samuel Baum/301-763-2870.

Language, Current; Mother Tongue/Edith McArthur/301-763-5050.

Local Review/Ann Liddle/301-763-2020.

Longitudinal Surveys/George Gray/301-763-2764.

Migration/Kristin Hansen/301-763-5255.

Mortality and/or Death/Ann Anderson/301-763-7946.

Neighborhood Statistics/Joanne Eitzen/301-763-1819.

Outlying Areas (Puerto Rico, etc.)/Jennifer Marks/301-763-5184.

POPULATION:

Decennial Census Count Complaints/Joel Miller/301-763-7955.

General Information; Census Data; Characteristics; Survey Data/Johanna Barten/301-763-5002.

POPULATION ESTIMATES:

Congressional Districts: SMSAs/Donald Starsinic/301-763-5072.

Counties; Federal-State Cooperative Program for Local Population Estimates/Fred Cavanaugh/301-763-7722.

Estimates Research/Richard Irwin/301-763-7883.

Local Areas; Revenue Sharing/Richard Engels/301-763-7892.

States/Edward Hanlon/301-763-5072.

United States (National)/Louisa Miller/301-763-5184.

POPULATION PROJECTIONS:

Federal-State Cooperative Program for

Population Projections/John Long/301-763-5300.

Household Projections/Robert Grymes/301-763-7950.

National/Gregory Spencer/301-763-5300.

State/Signe Wetrogan/301-763-5300.

Poverty Statistics; Low Income Areas/Arno Winard/301-763-5790.

PRISONER SURVEYS:

National Prisoner Statistics/Chester A. Bowie/301-763-1832.

Data Analysis and Publication/John Wallerstedt/301-763-1778.

RACE AND ETHNIC STATISTICS:/Nampeo McKenney/301-763-7890.

American Indian Population/Karen Crook/Edna Paisano/301-763-5910.

Asian Americans/Patricia Berman/301-763-2607.

Black Population/Dwight Johnson/301-763-7572.

Ethnic Populations/Edward Fernandez/301-763-5219.

Race/Patricia Berman/301-763-2607.

Spanish Population/Edward Fernandez/301-763-5219.

Religion/Edward Fernandez/301-763-5219.

Revenue Sharing (See also Economic Fields—Governments; Income Statistics)/Sharron Baucom/301-763-7964.

Sampling Methods/Charles Jones/301-763-2672.

Social Indicators/Denis Johnston/301-763-5145.

Social Research/Hal Wallach/301-763-1292.

Social Stratification/Rosalind Bruno/301-763-5050.

Special Censuses/George Hurn/301-763-5806.

Special Surveys/Linda R. Murphy/301-763-2767.

SMSAs: Area Definition and Total Population/Robert Speaker/301-763-7955.

SMSAs: New Criteria/Richard Forstall/301-763-5591.

Travel Surveys/Ron Dopkowski/301-763-1798.

Urban/Rural Residence/Diana DeAre/301-763-7955.

Veteran Status/Mark Littman/301-763-7962.

Voting and Registration/Jerry Jennings/301-763-7946.

Voting Rights/Gilbert Felton/301-763-5313.

Economic Fields

Agriculture Division/Vacant/301-763-5170.

Business Division/Tyler R. Sturdevant, Chief/301-763-7564.

Construction Statistics Division/Leonora M. Gross, Chief/301-763-7163.

Economic Census Staff/Richard B. Quanrud, Chief/301-763-7356.

Economic Surveys Division/Richard B. Quanrud, Acting Chief/301-763-7735.

Foreign Trade Division/Emanuel A. Lipscomb, Chief/301-763-5342.

Governments Division/Sherman Landau, Chief/301-763-7366.

Industry Division/Roger H. Bugenhagen, Chief/301-763-5850.

Economic Subjects

AGRICULTURE:

Crop Statistics/Donald Jahnke/301-763-1939.

Farm Economics/John Blackledge/301-763-5819.

General Information/Arnold Bollenbacher/301-763-5170.

Livestock Statistics/Thomas Monroe/301-763-1974.

Special Surveys/Kenneth Norell/301-763-5914.

CONSTRUCTION STATISTICS:

Census/Industries Surveys/Alan Blum/301-763-5435.

Special Trades; Contractors; General Contractor-Builder/Andrew Visnansky/301-763-7547.

Construction Authorized by Building Permits (C40 Series) and Residential Demolitions (C45 Series)/John Pettis/301-763-7244.

Current Programs/David Siskind/301-763-7165.

Expenditures on Residential Additions, Alterations, Maintenance and Repairs, and Replacements (C50 Series)/George Roff/301-763-5717.

Housing Starts (C20 Series); Housing Completions (C22 Series); and New Residential Construction in Selected SMSAs (C21 Series)/William Mittendorf/301-763-5731.

Price Indexes for New One-Family Homes Sold (C27 Series)/Steve Berman/301-763-7842.

Sales of New One-Family Homes Sold (C27 Series)/Steve Berman/301-763-7314.

Value of New Construction Put in Place (C30 Series)/Allan Meyer/301-763-5717.

County Business Patterns/James Aanestad/301-763-7642.

Employment/Unemployment Statistics/Thomas Scopp/301-763-2825.

Energy Related Statistics/Elmer S. Biles/301-763-7184.

Enterprise Statistics/John Dodds/301-763-7086.

Foreign Trade Information/Juanita Noone/301-763-5140.

GOVERNMENTS:

Criminal Justice Statistics/Diana Cull/301-763-2842.

Eastern States Government Sector/George Beaven/301-763-5017.

Employment/Alan Stevens/301-763-5086.

Finance/Vancil Kane/301-763-5847.

Governmental Organization and Special Projects/Muriel Miller/301-763-5308.

Revenue Sharing (See also Demographic Fields)/John Coleman/301-763-5272.

Taxation/John Behrens/301-763-2844.

Western States Government Sector/Ulvey Harris/301-763-5344.

Industry and Commodities Classification/Walter Neece/301-763-5449.

MANUFACTURES:

Census/Annual Survey of Manufactures/Arthur Horowitz/301-763-7666.

Durables/Dale Gordon/301-763-7304.

Nondurables/Michael Zampogna/301-763-2510.

Subject Reports (Concentration, Production Index, Water, etc.)/John Govoni/301-763-5872.

Current Programs/John Wikoff/301-763-7800.

Durables/Paul Berard/301-763-2518.

Environmental Surveys/Wayne McCaughey/301-763-5616.

Fuels/Electric Energy Consumed by Manufactures/John McNamee/301-763-5938.

Mondurables/Robert Nealon/301-763-5911.

Origin of Exports/John Govoni/301-763-5872.

Shipments, Inventories, and Orders/Ruth Runyan/301-763-2502.

Mineral Industries/John McNamee/301-763-5938.

Minority Businesses/Jerry McDonald/301-763-5182.

PUERTO RICO:

Census of Retail Trade, Wholesale Trade, and Selected Service Industries/Alvin Barten/301-763-5282.

RETAIL TRADE:

Annual Retail Trade Report; Advance Monthly Retail Sales; Monthly Retail Inventories Survey/Irving True/301-763-7660.

Census/Bobby Russell/301-763-7038.

Monthly Retail Trade Report: Accounts Receivable; and Monthly Department Store Sales/Conrad Alexander/301-763-7128.

SELECTED SERVICE INDUSTRIES:

Census/Dorothy Reynolds/301-763-7039.

Current Services Reports/Edward Gutbrod/301-763-7077.

TRANSPORTATION:

Commodity Transportation Survey; Truck Inventory and Use; Domestic Movement of Foreign Trade Data/Robert Torene/301-763-5430.

WHOLESALE TRADE:

Census/Faran Stoetzel/301-763-5281.

Current Wholesale Sales and Inventories; Green Coffee Survey; Canned Food Survey/Ronald Piencykoski/301-763-5294.

Geography and Statistical Research
Geography Division/Jacob Silver, Chief/301-763-5636.

Statistical Research Division/James L. O'Brien, Acting Chief/301-763-5350.

Boundaries and Annexations/Frances Barnett/301-763-5437.

Census Geography 1970/1980/Donald Hirschfeld/301-763-2668.

Computer Graphics and Computer Mapping/Frederick Broome/301-763-7442.

Congressional District Atlas/Robert Hamill/301-763-5437.

Earth Resources Satellite Technology: International/Robert Durland/301-763-5720.

United States/James Davis/301-763-5808.

Geographical Base File/Dual Independent Map Encoding (GBF/DIME) System/Robert La Macchia/301-763-7315.

Geographic Area Measurement and Centers of Population/Henry Tom/301-763-7856.

Geographic Statistical Areas/Alice Winterfeld/301-763-7290.

GE-50 Series Maps; Urban Atlas/Dan Jones/301-763-7818.

Land Area/Joel Miller/301-763-7955.

Revenue Sharing Geography/Frances Barnett/301-763-5437.

Survey Methodology Information System/Patricia Fuellhart/301-763-7600.

User Services
Administrative Services Division/Henry J. Husmann, Chief/301-763-5400.

Data User Services Division/Michael G. Garland, Chief/301-449-1620.

Field Division/Richard C. Burt, Chief/301-763-5000.

Age Search/Christine Stewart/301-449-1625.

Bureau of the Census Catalog/Ann King/301-449-1672.

Census Procedures, History of/Frederick Bohme/301-449-1625.

Census Use Research/Donald S. Luria/301-449-1618.

Clearinghouse for Census Data Services/Beverly South/301-449-5632.

College Curriculum Support Project/Les Solomon/301-449-1655.

Computer Tapes/Larry Carbaugh/301-449-1600.

Data User News (Monthly Newsletter)/Deborah Cohen/301-449-1606.

DATA USER TRAINING:

Registration/Dorothy Chin/301-449-1645.

Seminars, Workshops, Conferences/Deborah Barrett/301-449-1645.

Directory of Data Files/David McMillen/301-449-1667.

Exhibits/Douglas Moyer/301-449-1665.

Guides and Directories/Gary Young/301-449-1606.

Library/Betty Baxtresser/301-763-5040.

Circulation/Jim Thorne/301-763-1175.

Interlibrary Loan/Staff/301-763-1930.

Out of Print Publications and Microfiche/Maria Brown/301-763-5511.

Reference Service/Grace Waibel/301-763-5042.

Map Orders/Deloris Fentress/301-449-1600.

Microfilm/Paul Manka/301-449-1600.

Public Use Samples (Microdata)/Paul Zeisset/301-449-1653.

Reapportionment/Redistricting/Marshall Turner/301-449-1648.

Special Tabulations/Larry Carbaugh/301-449-1600.

State Data Center Program/Larry Carbaugh/301-449-1600.

Statistical Compendia/Glenn King/301-449-1650.

Publication Orders (Subscriber Services)/Daisy Williams/301-763-7472.

Summary Tape Processing Centers/Beverly South/301-449-5632.

User Software (CENSPAC, ADMATCH, etc.)/Larry Finnegan/301-449-1634.

User Assistance in Regional Offices
Atlanta, GA/Forest P. Cawley/404-881-2271/Wayne Wall/404-881-2274.

Boston, MA/Arthur G. Dukakis/617-223-2327/Judith Cohen/617-223-0668.

Charlotte, NC/Joseph R. Norwood/704-371-6142/Lawrence McNutt/704-371-6144.

Chicago, IL/Stanley D. Moore/312-353-6251/Stephen Laue/312-353-0980.

Dallas, TX/Percy R. Millard/214-767-0638/Valerie McFarland/214-767-0625.

Denver, CO/Leo C. Schilling/303-234-3924/Jerry O'Donnell/303-234-5825.

Detroit, MI/Robert G. McWilliam/313-226-7742/Timothy Jones/313-226-4675.

Kansas City, KS/Marvin L. Postma, Acting/816-374-4601/Kenneth Wright/816-374-4601.

Los Angeles, CA/C. Michael Long/213-824-7317/E. J. (Bud) Steinfeld/213-824-7291.

New York, NY/William Hill, Acting/212-264-3860/Jeffrey Hall/212-264-4730.

Philadelphia, PA/Porter S. Rickley/215-597-4920/David Lewis/215-597-8314.

Seattle, WA/John E. Tharaldson/206-442-7800/Larry Hartke/206-442-7080.

Country Experts

A large staff of experts is available to provide information on marketing and business practices for almost every country in the world. If you are trying to sell goods or services to a specific country, contact the country expert listed below by telephone or by writing to: Office of Country Marketing, International Trade Administration, Department of Commerce Room 3203, Washington, DC 20230. Be sure to include the expert's name and country name on all correspondence.

Afghanistan/Todd Burns/202-377-2051.
Albania/Karen Jurew/202-377-2645.
Algeria/Claude Clement/202-377-5737.
Angola/Philip Michelini/202-377-5148.
Argentina/Kenneth Hynes/202-377-4170.
Australia/Nancy Keely/202-377-3647.
Austria/V. Stanoyevitch/202-377-2841.
Bahamas/Fred Kayser/202-377-4302.
Bahrain/Robert Ruan/202-377-5200.
Bangladesh/George Pain/202-377-2471.
Barbados/Fred Kayser/202-377-2521.
Belgium/Caratina Alston/202-377-3337.
Belize (British Honduras)/Fred Kayser/202-377-4302.
Benin/Mary Inoussa/202-377-4389.
Bermuda/Fred Kayser/202-377-2521.
Bhutan/Todd Burns/202-377-2051.
Bolivia/Richard Muenzer/202-377-4302.
Botswana/Urath Gibson/202-377-3904.
Brazil/Larry Garges/202-377-5427.
Brunei/Ann Brosnan/202-377-3893.
Bulgaria/Karen Jurew/202-377-2645.
Burma/Todd Burns/202-377-2051.
Burundi/Philip Michelini/202-377-5148.
Cambodia/Ann Brosnan/202-377-3893.
Cameroon/Philip Michelini/202-377-5148.
Canada/Kenneth Fernandez/202-377-3459.
Cape Verde Islands/Mary Inoussa/202-377-4389.
Central African Republic/John Crown/202-377-4564.
Ceylon (Sri Lanka)/George Paine/202-377-2471.
Chad/John Crown/202-377-4564.
Chile/Bert Lindow/202-377-4303.
China, People's Republic of (Mainland)/David Laux/202-377-3583.
China, Republic of (Taiwan)/Betty Patrick/202-377-2648.
Colombia/Richard Muenzer/202-377-2521.
Comoros/John Crown/202-377-4564.

Congo (Brazzaville)/Philip Michelini/202-377-5148.
Costa Rica/Walter Bastain/202-377-3636.
Cyprus/Ann Corro/202-377-3945.
Czechoslovakia/Karen Jurew/202-377-2645.
Denmark/Russell Romer/202-377-2905.
D'Jibouti/Mary Manley/202-377-3865.
Dominican Republic/Fred Kayser/202-377-4302.
Ecuador/Bert Lindow/202-377-4303.
El Salvador/Walter Bastian/202-377-3636.
Equatorial Guinea/Philip Michelini/202-377-5148.
Egypt/Cheryl McQueen/202-377-4652.
Ethiopia/Mary Manley/202-377-3865.
European Economic Community (EEC)/Edward Mullelly/202-377-5381.
Fiji Islands/Joe Wilson/202-377-3647.
Finland/Russell Romer/202-377-2905.
France/Bill Crawford/202-377-3843.
French Guiana/Fred Kayser/202-377-2521.
French West Indies/Fred Kayser/202-377-2521.
Gabon/Philip Michelini/202-377-5148.
Gambia/Mary Inoussa/202-377-4389.
Germany (East)/Suzanne Porter/202-377-2645.
Germany (West)/V. Stanoyevitch/202-377-2841.
Ghana/Mary Inoussa/202-377-4389.
Greece/Ann Corro/202-377-3945.
Guatemala/Walter Bastian/202-377-3636.
Guinea/Mary Inoussa/202-377-4389.
Guinea-Bissau/Mary Inoussa/202-377-4389.
Guyana/Fred Kayser/202-377-2521.
Haiti/Fred Kayser/202-377-2521.
Honduras/Walter Bastian/202-377-3636.
Hong Kong/Carol Murray/202-377-4379.
Hungary/John Fogarasi/202-377-2645.
Iceland/Russell Romer/202-377-2905.
India/Jeffrey Johnson/202-377-2472.
Indonesia/Virginia Webbert/202-377-3875.
Iran/Donald Ryan/202-377-4652.
Iraq/Karl Reiner/202-377-5767.
Ireland/Paul Norloff/202-377-3422.
Israel/Kathleen Keim/202-377-4652.
Italy/Noel Negretti/202-377-3748.
Ivory Coast/Philip Michelini/202-377-5148.
Jamaica/Fred Kayser/202-377-2521.
Japan/Arthur Miyakawa/202-377-5085.
Jordan/Karl Reiner/202-377-5767.
Kenya/Mary Manley/202-377-3865.
Korea (South)/Carol Murray/202-377-4383.
Kuwait/Robert Ruan/202-377-5200.
Laos/Ann Brownan/202-377-3893.
Lebanon/Karl Reiner/202-377-5767.
Leeward Islands/Fred Kayser/202-377-4302.
Lesotho/Urath Gibson/202-377-3904.
Liberia/Mary Inoussa/202-377-4389.
Libya/Claude Clement/202-377-5737.

Luxembourg/Caratina Alston/202-377-3337.
Madagascar/John Crown/202-377-4564.
Malaysia/Ann Brosnan/202-377-2523.
Malawi/John Crown/202-337-4564.
Maldives/Jeffrey Johnson/202-377-2472.
Mali/John Crown/202-377-4564.
Malta/Boyce Fitzpatrick/202-377-3504.
Mauritania/Mary Inoussa/202-377-4389.
Mauritius/John Crown/202-377-4564.
Mexico/Fred Tower/202-377-2313.
Morocco/Claude Clement/202-377-5737.
Mozambique/John Crown/202-377-4564.
Namibia/Urath Gibson/202-377-3904.
Nepal/Todd Burns/202-377-2051.
Netherlands/Robert McLaughlin/202-377-3317.
Netherlands (Antilles)/Fred Kayser/202-377-2521.
New Zealand/Joseph Wilson/202-377-3647.
Nicaragua/Walter Bastian/202-377-3636.
Niger/John Crown/202-377-4654.
Nigeria/Reginald Biddle/202-377-4388.
Norway/James Devlin/202-377-4414.
Oman/Karl Reiner/202-377-5567.
Pacific Islands/Joseph Wilson/202-377-3647.
Pakistan/Todd Burns/202-377-2051.
Panama/Walter Bastian/202-377-3636.
Papua New Guinea/Joseph Wilson/202-377-3647.
Paraguay/Walter Hage/202-377-4170.
People's Democratic Republic (Yemen)/Robert Ruan/202-377-5200.
Peru/Bert Lindow/202-377-4303.
Philippines/George Paine/202-377-2471.
Poland/Delores Harrod/202-377-2645.
Portugal/Kenneth Nichols/202-377-4508.
Qatar/Robert Ruan/202-377-5200.
Rhodesia/Urath Gibson/202-377-3904.
Romania/Jay Burgess/202-377-2645.
Rwanda/Philip Michelini/202-377-5148.

Sao Tome and Principe/Philip Michelini/202-377-5148.
Saudi Arabia/Laron Jensen/202-377-5767.
Senegal/Mary Inoussa/202-377-4389.
Seychelles/John Crown/202-377-4564.
Sierra Leone/Mary Inoussa/202-377-4389.
Singapore/Lee Barnes/202-377-2523.
Somali/John Crown/202-377-4564.
South Africa/Urath Gibson/202-377-3904.
Spain/Kenneth Nichols/202-377-4508.
Sri Lanka/George Paine/202-377-2471.
Sudan/Mary Manley/202-377-3865.
Surinam/Fred Kayser/202-377-2521.
Swaziland/Urath Gibson/202-377-4927.
Sweden/James Devlin/202-377-4414.
Switzerland/Leo Kuus/202-377-4509.
Syria/Karl Reiner/202-377-5767.
Taiwan/Betty Patrick/202-377-4957.
Tanzania/Mary Manley/202-377-3865.
Thailand/Todd Burns/202-377-2051.
Togo/Mary Inoussa/202-377-4389.
Trinidad and Tobago/Fred Kayser/202-377-2521.
Tunisia/Claude Clement/202-377-5737.
Turkey/Ann Corro/202-377-3945.
Uganda/Mary Manley/202-377-3865.
United Arab Emirates (UAE)/Robert Ruan/202-377-5200.
United Kingdom/Paul Norloff/202-377-3422.
Upper Volta/John Crown/202-377-4564.
Uruguay/Walter Hage/202-377-4170.
USSR/Hertha Heiss/202-377-4505.
Venezuela/Thomas Jacka/202-377-4302.
Vietnam/Ann Brosnan/202-377-3893.
Windward Islands/Fred Kayser/202-377-2521.
Yemen Arab Republic/Robert Ruan/202-377-5200.
Yugoslavia/Leo Kuus/202-377-4509.
Zaire/Philip Michelini/202-377-5148.
Zambia/Mary Manley/202-377-3865.

Major Sources of Information

Abuses and Waste Hotline

A hotline has been established for those who wish to report to the U.S. Department of Commerce anything involving mismanagement, fraud, abuse or waste. Contact: Inspector General's Office, Department of Commerce, P. O. Box 612, Ben Franklin Station, Washington, DC 20044/202-724-3519, 800-424-5197.

Aeronomy Research

Information is available on the exotic chemis-

tries in the upper atmosphere, including studies on the destruction of ozone in the stratosphere. Contact: Public Affairs Office, National Oceanic and Atmosphere Administration (NOAA), Public Affairs Boulder (PAB), Department of Commerce, 3100 Marine St., Boulder, CO 80302/303-497-6286.

Air Quality and Atmospheric Research

Studies and expertise are available on subjects including short-term weather phenomena, long-

term climate fluctuations, basis atmospheric dynamics, applied weather forecasting technologies and atmospheric pollution. Contact: Public Affairs Office, NOAA, PAB, Department of Commerce, 3100 Marine St., Boulder, CO 80302/303-497-6286.

Appliance Labeling
The National Bureau of Standards (NBS) establishes methods and standards for measuring appliance efficiency so that labeling is uniform. Contact: Inquiry Service, NBS, Department of Commerce, Administration Building, Room A-617, Washington, DC 20234/301-921-2318.

Arab Boycott
For assistance and information on how to comply with the Arab Boycott laws contact: Antiboycott Compliance Staff, International Trade Administration (ITA), Department of Commerce, Room 3226, Washington, DC 20230/202-377-2004.

Building Technology
The National Bureau of Standards (NBS) is responsible in an advisory capacity for the usefulness, safety and economy of building through the development of improved technology and is responsible for its applications through improved building practices. It also provides research on construction safety; earthquake, soil collapse and high wind hazards in buildings; durability of construction materials; energy efficiency; and sensory environment. Contact: Center for Building Technology, NBS, Department of Commerce, BR Room B266, Washington, DC 20234/301-921-3106.

Business Assistance at the Local Level
The U.S. Department of Commerce maintains 43 District Offices throughout the United States. These offices provide a local contact for all Department of Commerce services. Most District Offices also maintain a business reference library which contain market research and business-related materials, foreign trade data, census reports, and "how to" guides on starting and managing a business. For a local office consult the white pages of your telephone book under U.S. Government. A list of District Offices is available from Commercial Service, ITA, Department of Commerce, Room 4800-B, Washington, DC 20230/202-377-3094.

Business Assistance Newsletter
ACCESS is a free monthly newsletter for minorities which deals with assistance available for minority business as well as available government contracts. Contact: Information Center, Minority Business Development Agency, Department of Commerce, Room 5713, 3-Access, Washington, DC 20230/202-377-1714.

Business Development
Aid is available in the form of loans, grants and technical assistance to help the economic development of the country. See "Economic Development" under "Grants and Loans and Loan Guarantees," in this section, or contact: Office of Public Affairs, Economic Development Administration, Department of Commerce, Room 7019, Washington, DC 20230/303-377-5113.

Business Economics—Publications and Data Bases
If you have an interest in macroeconomics you may be interested in one or more of the following publications produced by the Bureau of Economic Analysis.

Business Conditions Digest
About 300 economic time services are shown in charts covering more than 20 years. Measures the economic activity on national income and product accounts; prices, wages and productivity; labor force, employment and unemployment; government activities, U.S. international transactions, and multinational transactions. It also describes the leading, lagging and coincident economic indicators. (Monthly, $40.00)

Survey of Current Business
Provides an interpretation and analysis of the Gross National Product, balance of payments, consumer spending, plant and equipment spending, construction, inventory investment, government spending, foreign trade, price developments, labor markets, and financial flows. Lists some 2,500 statistical series. (Monthly, $20.00)

Handbook of Cyclical Indicators
Contains all of the economic time series shown in *Business Conditions Digest* as well as historical data, series descriptions, and measures of average variability. ($4.00)

Long-Term Economic Growth 1860-1970
Almost 1,200 annual time series, from both government and private sources, showing both the aggregator as well as the components based on geographic or industry breakdown. ($5.70)

Business Statistics
Presents historical data for approximately

2,500 series that appear in the statistical pages of the *Survey of Current Business.*

Detailed Input/Output Structure of the Economy 1972

The national input-output accounts are a source often overlooked by researchers. This work measures all the repercussions of changes in demand for industrial materials, broken down by standard industrial classification code. If utilities increase their use of coal, the accounts would show that, in addition to the increased output of coal, there will be an increased demand for related products such as explosives and steel products, which in turn will require more basic chemicals, more coal, more petroleum products, more plastics material and rubber, and more iron ore. There will be even further effects: For instance, the increased production of basic chemicals will require more chemical minerals, more steel, more nonferrous metals, and still more coal. With these accounts, one can show the market share for a selected product by end user. Input/output analysis also sheds light on regional implications of changes in the Gross National Product, employment requirements by industry, and cost price relationships. (Vol. I, $3.50, Vol. II, $7.50)

Above publications are available from Superintendent of Documents, Government Printing Office, Washington, DC 20402/202-783-3238. Much of the data referenced in the above publications are also available on computerized magnetic tape. Contact: Bureau of Economic Analysis, Budget Office, Department of Commerce, Room 908 Tower, Washington, DC 20230/202-523-0884.

Business Plans Surveys

The Bureau of Economic Analysis has done pioneer work in its surveys of business plans. The best known are the quarterly and annual surveys of business expenditures for plant and equipment. Contact: Business Outlook Division, Bureau of Economic Analysis, Department of Commerce Room 1205 Tower, Washington, DC 20230/202-523-0701.

Business Reference Service

The U.S. Department of Commerce Library has a free reference service that will answer quick questions about commerce and business. Services it will perform include consulting standard business reference books for company information and supplying foreign telephone numbers listed in its collection of overseas telephone books. Call or write Library, Department of Commerce, Washington, DC 20230/202-377-2161.

Business Site Selection Assistance

If you are looking for a new business location, the Economic Development Administration can help by accessing their Industrial Location Determinants computerized data base. This data base will identify those areas which best meet your criteria. There is a fee for the service. Contact: Industries Studies Division, Economic Development Administration, Department of Commerce, Room 6018, Washington, DC 20230/202-377-2145.

Calibration and Testing Services

The National Bureau of Standards (NBS) works with industry, individuals and government organizations in establishing measurement control and calibration programs. Contact: Office of Measurement Services, NBS, Department of Commerce Physics Building, Room B362, Washington, DC 20234/301-921-2805.

Census, 1985

Because of the ever-increasing demand for up-to-date statistics, the Bureau of the Census will start taking a mid-decade census in 1985. Contact: Data Users Service Division, Bureau of the Census, Department of Commerce, 1676 Federal Building 3 Washington, DC 20233/301-763-5820.

Census Data 1980

Researchers should remember that data from the decennial census will provide what is likely to be the most detailed information available on the demographics of the United States. It is also unique in that data is available for very small geographic areas called census tracts. These tracts represent an area the size of a few city blocks. The major publications generated from a decennial census include: four population reports for each state; two housing reports for each state; a summary of U.S. population; and a summary of U.S. housing. This information is also available in machine-readable (computer and micro) format. Contact: Decennial Census Division, Bureau of the Census, Department of Commerce, Room 3785-FB3, Washington, DC 20233/301-763-7670.

Census Data, Computerized

Much of the data collected by Census are available in machine-readable (computer and micro) format. For a complete description of available data order *The Directory of Data Files* for $11.00 from Subscriber Service Section, Data Users Service Division, Bureau of the Census, Department of Commerce, Room 1121 FB4, Washington, DC 20233/301-899-7600. For de-

tailed information on the type of computerized data available contact: Computer Programming Branch, Data User Services Division, Department of Commerce, FB3, Washington, DC 20233/301-899-7620.

Census Data Computer Software

A number of computer programs are available to those using Census computer tapes. The type of programs available include tabulations and cross-tabulations, mapping and address matching. Contact: Computer Programs, Data Users Service Division, Bureau of the Census, Department of Commerce, Room 3517 FB3, Washington, DC 20233/301-763-2398.

Census Data Guides and Indexes

There are a number of guides and indexes to Census publications. Contact: Guides and Indexes, Data User Services Division, Bureau of the Census, Department of Commerce, Washington, DC 20230/301-763-2400.

Census Data on Microformat

Much of Census information is also available on microfiche; some of the data available on microfiche are not available in printed reports. Contact: Subscriber Services, Bureau of the Census, Department of Commerce, Building 4, Room 1121, Washington, DC 20233/301-763-7472.

Census Data Processing Centers

If you would like special manipulation of Census computer data and do not have the proper facilities or expertise, there are a number of private organizations that will help you, for a fee. These Summary Tape Processing Centers provide services ranging from assistance in selecting the right statistical report to sophisticated computer tape processing. For a listing of Summary Tape Processing Centers contact: Data User Services Division, Bureau of the Census, Department of Commerce, FB3, Washington, DC 20233/301-899-7620.

Organizations which are part of a state government system (e.g., state planning agency, state library, or state university) can obtain the same services described above but at a substantially reduced fee (and sometimes for free) from a local State Data Center. Contact the office described above for listing of State Data Centers.

Census Data Seminars

Free seminars are available for librarians, government personnel and the general public. The seminars identify the types of statistical data available from Census and other Federal agencies as well as how to use these data. Contact: User Training Branch, Data User Service, Bureau of the Census, Department of Commerce, 1676 Federal Building 3, Washington, DC 20233/301-899-7645.

Census Data, Special

The Bureau of the Census will make special tabulations of their data upon request. There is a charge for any special tabulation and the sponsor will be given exclusive rights to the information generated for six months. After that time the tabulations go into the public domain. Contact: Data Users Services Division, Bureau of the Census, Department of Commerce, 1676 Federal Building 3, Washington, DC 20233/301-899-7620.

Census, Economic

Every five years (years ending in "2" and "7") a major effort is conducted to identify and classify the economic action within the United States. Subject areas covered include wholesale and retail trade, manufacturers, service industries, mineral industries, construction industries, transportation, enterprise statistics, minority-owned business enterprises and women-owned businesses. For a description of the type of data and reports available contact: Subscriber Services Section, Data Users Services Division, Bureau of the Census, Department of Commerce, Washington, DC 20233/301-899-7600.

Census Maps for Data and Art

Computer-generated maps are available for 65 major metropolitan areas. The maps, called "Urban Atlases," display selected census data characteristics such as population density, median family income and median housing value. Each atlas costs between $2.50 and $5.00 and is printed in brilliant colors. They make fine posters and wall decorations. Contact: Customer Service Branch, Data Users Services Division, Bureau of the Census, Department of Commerce, Washington, DC 20233/301-899-7620.

Census Microdata on Computer Tape

In addition to summary statistics (data already tabulated), microdata are also available from Census. Microdata are untabulated data of individual records. Microdata records do not provide residence identification at the small-area level because of confidentiality guidelines. Contact: Data Users Service Division, Bureau of the Census, Department of Commerce, Washington, DC 20233/301-899-7620.

Census Publications For Market Research

Listed below are a number of the more popular

Census publications subscribed to by market researchers. These publications can be ordered from Superintendent of Documents, Government Printing Office, Washington, DC 20402/202-783-3238. For further information contact: Subscriber Services, Bureau of the Census, Department of Commerce, Building 4, Room 1121, Washington, DC 20233/301-763-7472.

County and City Data Book ($18.65)
Annual Survey of Manufacturers ($13.00)
Current Retail Trade ($25.00 per year)
Monthly Wholesale and Trade ($10.00 per year)
Construction Review ($17.00 per year)
Containers and Packaging ($5.00 per year)
Copper ($5.00 per year)
Printing and Publishing ($5.00 per year)
Current Population Reports ($40.00 per year)
Measuring Markets—A Guide to the Use of Federal and State Statistical Data ($3.75)
Bureau of the Census Catalog ($14.40)
Bureau of the Census Guide to Programs and Publications: Subjects and Areas ($2.45)
Census Users Guide ($6.50)
Mini-Guide to Economic Census
Statistical Abstract of the U.S. ($10.00)
County Business Patterns ($6.00)

Climatic Information

The National Oceanic and Atmospheric Administration (NOAA) will provide, for a fee, climatological data in either hard-copy or machine-readable formats. Contact: National Climatic Center, Environmental Data Information Service, NOAA, Department of Commerce, Federal Building, Asheville, NC 28801/704-258-2850.

Climate Monitoring

Information is available estimating trends in climate change and the nature of climates to come. Contact: Public Affairs Office, NOAA, Public Affairs Boulder, Department of Commerce, 3100 Marine Street, Boulder, CO 80302/303-499-1000.

Coastal Zone Management

Information, expertise, and financial assistance are available on such topics as estuaries, marine sanctuaries, and the effects of offshore drilling. See "Coastal" under "Grants and Loans and Loan Guarantees," in this section or contact Coastal Zone Management, NOAA, Department of Commerce, Page Building 1, Room 324, Washington, DC 20235/202-634-4232.

Complaints from Business

Businesses that have problems or complaints for which government may be of some help can find assistance at the Office of Business Liaison. It has solved problems ranging from how to get a penguin into the country to finding sharecroppers to pick ripe produce quickly. Contact: Office of Business Liaison, Department of Commerce, Room 5898C, Washington, DC 20230/202-377-3176.

Coal Gasification

For technical expertise of the conversion of coal into liquid and gaseous fuels contact: Inquiry Service, National Bureau of Standards, Department of Commerce, Administration Building, Room A617, Washington, DC 20234/301-921-2318.

Commerce Publications Catalog

Each year the U.S. Department of Commerce publishes a catalog and index to publications published by the various offices within the Department. Copies are available for $3.25 from Superintendent of Documents, Government Printing Office, Washington, DC 20402/202-783-3238.

Communications and Information Policy

For national policy information on such topics as communications legislation, deregulation of common carrier networks, satellite usage for emergency medical networks and public television, and climatic effects on radio waves transmitted at extremely high frequencies contact: National Telecommunications, and Information Administration, Department of Commerce, Room 760, 1800 G Street N.W., Washington, DC 20504/202-377-1832.

Computer Crime

Technical expertise and published information are available to help organizations establish guidelines for preventing computer crime. Contact: Computer Security Standards Program, Technology, Department of Commerce, Room A265, National Bureau of Standards, Washington, DC 20234/301-921-3861.

Computerized Data File Directory

The National Technical Information Service (NTIS) publishes a directory of all known computerized files within the federal government. The cost of the directory is approximately $50.00. Contact: NTIS, 5285 Port Royal Road, Springfield, VA 22161/703-557-4650.

Consulting for Business, Free

The Trade Adjustment Assistance Program offers free business consulting services to those hurt by import competition. There are offices in ten

cities around the country that offer professional staff assistance and can also hire specialized consultants on an as-needed basis. Contact: Office of Technical Assistance, Economic Development Administration, Department of Commerce, Room 6224, Washington, DC 20230/202-377-4031.

Consumer Product Performance and Safety

Before you purchase a major consumer product help is available in determining the product's safety or energy performance. The National Bureau of Standards develops methods for measuring these qualities of consumer products. They are involved with such things as how to measure the energy consumption of a washing machine or the safety of a lawn mower, and methods for establishing standards for protective head gear like football helmets. *Consumers Report* and *Consumer Union* use their test methods. Contact: Center for Consumer Product Technology, National Bureau of Standards, Department of Commerce, Technology Building, Room B154, Washington, DC 20234/301-921-3751.

Corporate Social Performance

A special task force has been established to conduct research in measuring social performance of corporations, attempting to measure how a corporation affects its community, the consumer and their environment. The group is also studying what kind of management systems are necessary to establish social responsibility systems. Contact: Task Force on Corporate Social Performance, Department of Commerce, Room 5627, Washington, DC 20230/202-377-5953.

Crime in Business

The Department of Commerce has published a number of reports and reference works on the subject of crime in business. The subjects covered include crime in retailing, the cost of crime, crime in service industries and a bibliography on crime in business. Contact: Office of Service Industries, Bureau of Industrial Economics, Department of Commerce, Room 1104, Washington, DC 20230.

Current Business Topics, Free Reports

Throughout the year the Office of Business Liaison publishes a number of reports on topics of interest to the business community. Subjects have included foreign bribery and internal accounting controls, marketing industrial products on a low budget, and locating business statistics. For an individual report or for a complete list contact: Office of Business Liaison, Department of Commerce, Room 5898C, Washington, DC 20230/202-377-3176.

Data Evaluation Newsletter

An informal newsletter covering the evaluation of numerical data on physical and chemical properties is available for free. Contact: Office of Standard Reference Data, National Bureau of Standards, Department of Commerce, Physics Building A320, Washington, DC 20234/301-921-2228.

Disaster Research

Information is available on improving the designs of buildings to insure structural safety during disasters such as earthquakes. Contact: Inquiry Service, National Bureau of Standards, Department of Commerce, Administration Building, Room A617, Washington, DC 20234/301-921-2318.

District Offices

See "Business Assistance at the Local Level" in this section.

Economic Data in 24 Hours

The Bureau of Economic Analysis has established a service called NIPAGRAM (National Income and Product Accounts by Mailgram). Within 24 hours after release each month, you can receive a mailgram from Western Union showing the latest figures for the national income and product account. The service costs $120 per year for those in the contiguous United States and Hawaii and $145 for Alaska and Canada. For subscription information contact: NIPAGRAM, National Technical Information Service, Department of Commerce, 5285 Port Royal Rd., Springfield, VA 22161/703-557-4650.

Economic Indicators

The Bureau of Economic Analysis regularly releases current economic data which help business monitor economic activity. The more popular indexes released include: Plant and Equipment Expenditures, Personal Income and Outlays, Gross National Product, Composite Indexes of Leading, Coincident, and Lagging Indicators. For a list of release dates and further information on receiving the information quickly contact: Public Information, Bureau of Economic Analysis, Department of Commerce, Washington, DC 20230/202-523-0777.

Educational Materials

The following is a listing of free and inexpensive educational materials. Inquiries for more than one copy will be considered on an individual

basis. Classroom quantities are limited to not more than 25 copies per item, and no more than five items per request. Contact: National Ocean Survey (NOS), Physical Science Services Branch, NOAA, Department of Commerce, Rockville, MD 20852/301-443-8005.

American History

Facsimiles of Cartographic Treasures (maps for sale)
History of Copperplate Engraving (a look at 19th century engraving techniques)
A Capital Plan (first maps of Washington, DC)
Lost Maps of the American Coast (a review of the work of Dr. Johann G. Kohl)
Three Short Happy Months (the story of James Abbott McNeill Whistler, the artist)
Wilkes Expedition, 1838-1842, of the Pacific Northwest (exploits of Commander Charles Wilkes)
Hassler's Legacy—History of the National Ocean Survey (article)
Catalog of Early Nautical Charts
An American Philosopher (the life work of Charles Sanders Peirce)

General

NOS (National Ocean Survey) Products and Information (pamphlet)
Technology for Surveys and Charts (geodetic and photogrammetric services)
An Introduction to NOAA's National Ocean Survey
America's Islands (provides data on islands, interesting facts, photos and measurements)
Possible Sources of Shipwreck Information (list)
Summary of NOS Technical Publications and Charts (a complete list of all NOS publications)
NOAA Motion Picture Films (list)
Principal Rivers and Lakes of the World (includes a listing of rivers and lakes by depth, size, etc.)
The NOAA Story (all about the National Oceanic and Atmospheric Administration)
Data of the Great Lakes System
NOS Abstracts 2977 (Scientific papers presented by NOS authors)

Cartography

A Guide to Books on Maps & Mapping
Map Projections for Modern Charting (elementary school-level approach to projections)
Example of a Nautical Chart (for classroom use)
Navigate Safely (marine publications of NOS)
Aeronautical Chart Catalog
Obsolete Aeronautical Charts (limit one)
Nautical Chart Catalog, U.S. Coastal and Great Lakes Waters (four volumes)
Coastline of the United States (lengths in statute miles of each coastal state)
Maps and Charts—Catalog #5 (bathymetric maps and special-purpose charts)
Map of the United States Continental Shelf (page size)
Map Scales (and How They Differ)
World, U.S. & Historical Maps—April 1975

Geodetic Data

Geographic Center of Washington, DC
Geographic Center of the United States (conterminous)
Geographic Center of Hawaii
Geodetic Survey Mark Preservation (NGS 1974)

Oceanography

List of Institutions Offering Degrees In Oceanography
Our Restless Tides (pamphlet)
Tidal Currents (pamphlet)
Principal Ocean Currents of the World (page size map)
The Gulf Stream (pamphlet)
Oceanography in the National Ocean Survey (pamphlet)
Mapping Our New Sea Frontier (NOS Bathymetric Program)

Photogrammetry

Photogrammetry in the National Ocean Survey (pamphlet)
Aerial Photographs (reproductions for sale)

Requests for priced items must be addressed to the National Ocean Survey Distribution Division, C44, Riverdale, MD 20840, accompanied by your remittance made payable to the Department of Commerce.

1/Pamphlet of nautical chart symbols and abbreviations/85 cents
1210TR/A training chart for use in classroom work; ideal in navigational symbolization/85 cents
116-SC TR/A small-craft training chart for use in classroom work; ideal in navigational symbolization/85 cents
3042/Map of the world on an Azimuthal Equidistant Projection centered on New York City (four-color), size 35 × 42 inches/$2.70
3060/Outline map of the United States showing state boundaries, black & white, size 29 × 42 inches/$2.15
3060c/Large map of the United States portraying major cities, relief by gradient. Two sheets, assembled size 36½ × 46¾ inches/$3.20/set
3068/Outline map of the United States indicates major cities, shows conterminous United States, black and white, size 22 × 28 inches/$2.15
3069/Outline map of Alaska, portraying major cities, buff and water tint/$2.70
3084/Page-size map of the United States in outline form, size 9 × 13 inches/Free
3090/World map showing political boundaries and major cities, size 35 × 47 inches/$2.70
3093/Outline map for construction of a model of the world. When assembled produces a "Lambert Globe," nine inches in diameter/$1.00
Washington, DC 1791/L'Enfant Plan of the nation's capital, in color with descriptive text, size 30 × 48 inches/$2.15
Ellicott Map of Washington, DC 1792/Andrew Ellicot's map, which was adopted by Congress as the final plan for the Federal City, black & white, size 23 × 30 inches/$2.15

Special Interest Item

The National Ocean Survey has available tours of its Headquarters in Rockville, Maryland. Requests for information should be addressed to the Visitors Liaison Officer, National Ocean Survey, C513, Rockville, MD 20852.

Effects of Sunbursts on Communications

Solar forecasting is accomplished by space weather stations monitoring the conditions of the sun. They look for sunbursts that release energy and affect much of the earth's technology that operates in the ionosphere, such as satellite electronics, short-wave radios, and very-high-frequency waves used in air navigation. Contact: Public Affairs Office, NOAA, Public Affairs Boulder, Department of Commerce, 3100 Marine St., Boulder, CO 80302/303-499-1000.

Energy Conservation

The National Bureau of Standards (NBS) coordinates energy conservation programs for appliances, solar heating and cooling of residential and commercial buildings, and industry and community energy systems. Contact: Office of Energy Programs, National Bureau of Standards, Department of Commerce, Building 225, Room B120, Washington, DC 20234/301-921-3275.

Energy-Related Invention Assistance

Inventors can find technical help from the National Bureau of Standards. A staff of trained specialists evaluate thousands of energy related inventions and make recommendations to the Department of Energy for grant money. Contact: Office of Energy-Related Inventions, National Bureau of Standards, Department of Commerce, Building 225 A46, Washington, DC 20234/301-921-3694.

Energy Statistics

Three series of monthly reports on stocks and sales of fuel oils are issued jointly by the Bureau of the Census and the Department of Energy. They are: *Retail Sales and Inventories of Fuel Oil*; *Wholesale Fuel Oil Distributors Stocks and Sales*; and *Manufacturing Consumption and Stocks of Fuel Oil*. Contact: Chief, Business Division, Bureau of the Census, Department of Commerce, Washington, DC 20233/301-763-7564.

Environmental Information Center

Information and expertise are available on pollution, meteorology, biology, chemistry, oceanography, geology and solar-terrestrial information. Contact: Environmental Data and Information Service, NOAA, Department of Commerce, Page

Building 2, Room 290, Washington, DC 20235/202-634-7251.

Environmental Assessment

Environmental assessment services provided by the National Oceanic and Atmospheric Administration include data base studies and weekly assessments of potential effects of climatic fluctuations on national and global grain production, statistical oil spill trajectory risk model based on historical, meteorological, and oceanographic data, and environmental analysis and assessments to support efficient and effective planning, site selection, design, construction and operation of supertanker ports and offshore drilling rigs. Contact: Center for Environmental Assessment Services, NOAA, Department of Commerce, Room 290, Washington, DC 20234/202-634-7251.

Environmental Data Base Searches

The National Oceanic and Atmospheric Administration (NOAA) will perform searches on its environmental data base on a cost-recovery basis. The data files contain information on published literature, on-going research projects in the atmospheric sciences, marine and coastal studies, and a wide range of other subjects. A free guide to NOAA's computerized information retrieval services is also available. Contact: Environmental Science Information Center, User Services Branch, D822, NOAA, Department of Commerce Library and Information Services Division, 6009 Executive Blvd., Rockville, MD 20852/301-443-8330.

Environmental Data Information Service

This service operates a network of specialized service centers along with a computerized environmental data and information retrieval service. The services include managing environmental data and information; acquiring, processing, archiving, analyzing, and disseminating atmospheric marine, solar and solid earth data and information for use by commerce, industry and the scientific and engineering community and the general public as well as by the government; providing experiment design and data management support to large-scale environmental experiments; assessing the impact of environmental changes on food production, energy production and consumption, environmental quality and other economic systems; and assisting national decision makers in solving environment related problems. The centers included in the network are the National Climatic Center, National Oceanographic Data Center, National Geophysi-

cal and Solar Terrestrial Data Center, Environmental Science Information Center, and Center for Environmental Assessment Services. Contact: Environmental Data and Information Service, NOAA, Department of Commerce, Room 547, Page Building 2, Washington, DC 20235/202-634-7318.

Environmental Research

The type of environmental research conducted at the National Oceanic and Atmospheric Administration (NOAA) includes the effects of oil spills on seas and shorelines, and the impact of oil and gas development on the Alaskan shelf. Contact: Public Affairs Office, NOAA, Public Affairs Boulder, Department of Commerce, 3100 Marine Street, Boulder, CO 80302/303-499-1000.

Environmental Science Information Center

For information and expertise on the oceans, the atmosphere and related subjects contact: Environmental Science Information Center, NOAA, Department of Commerce, 11400 Rockville Pike Room 678, Rockville, MD 20852/301-443-8137. Information specialists are also available to handle requests concerning atmospheric, earth and oceanic sciences, energy, environment, pollution and natural resource management. Their resources include more than 80 computerized data bases. Contact: Environmental Science Information Center, NOAA, Department of Commerce, 6009 Executive Blvd., Rockville, MD 20852/301-443-8330.

Experimental Technology

The National Bureau of Standards stimulates industrial productivity by sponsoring contracts and research studies in experimental technology. They also provide policy information on industrial innovation and its relationship to U.S. productivity and the balance of trade. Contact: Experimental Technology Incentives Program, Center for Field Methods, National Bureau of Standards, Department of Commerce, Administration Building, Room A738, Washington, DC 20234/301-921-3185.

Expertise Available at NBS

The National Bureau of Standards (NBS) is the nation's central measurement standards laboratory. The staff of trained specialists who conduct this research is also available to provide information and expertise in their areas of interest. The general subject areas covered include the following: Nondestructive Evaluation; Environmental Measurements; Air and Water; Recycled Materials; Recycled Oil; Resource Recovery; Quantum Physics; Electrical Measurements and Standards; Temperature Measurements and Standards; Length and Mass Measurements and Standards; Time and Frequency; Atomic and Plasma Radiation; Nuclear Radiation; Radiation Physics; Radiometric Physics; Chemical Kinetics; Chemical Thermodynamics; Thermodynamics; Molecular Spectroscopy; Inorganic and Organic Chemistry; Gas and Particulate Science; Chemical Stability and Corrosion; Polymer Science; Metal Science; Ceramics; Glass and Solid State Science; Reactor Radiation; Computer Sciences and Technology; Computer Programming; Operations Research; Scientific Computing; Statistical Engineering; Applied Mathematics; Electronics and Electrical Engineering; Electron Devices; Electrosystems; Electromagnetic Technology; Mechanical Engineering; Mechanical Processes; Fluid Engineering; Thermal Processes; Industrial Engineering, Acoustical Engineering; Building Technology; Structures and Materials; Building Thermal and Service; Environmental Design; Building Economics; Fire Science; Fire Safety Engineering; Consumer Product Technology; Consumer Sciences; Product Performance; Product Safety and Energy Related Inventions. Contact: National Bureau of Standards, Department of Commerce, Washington, DC 20234/301-921-1000.

Exporting—Business Opportunities Abroad

The items listed below are all helpful to those U.S. firms which are currently doing business overseas or would like to do so.

Agent Distributor Service

For $25, U.S. Foreign Service posts will provide the names and addresses of three foreign firms who are interested in acting as agent or distributor for a company's product; service background information on the firms is also provided. Contact: Office of Export Marketing Assistance, ITA, Department of Commerce, Room 4009, Washington, DC 20230/202-377-5455.

Business America Magazine

This biweekly publication published by the Department of Commerce is an aid to those U.S. businesses who sell, or wish to sell, goods and services for export. For information on the magazine contact: *Business America*, Public Affairs, International Trade Administration, Department of Commerce, Room 3802, Washington, DC 20230/202-377-3251. Subscriptions are available for $41.00 per year from Superintendent of Documents, Government Printing Office, Washington, DC 20402/202-783-3238.

Catalog and Video Exhibitions

Companies that are unable to participate in a foreign trade show can have their catalogs or video presentations made available at overseas U.S. Business Information Offices. There is a fee for their service. Contact: Special Promotion Division, Bureau of Export Development, Department of Commerce, Room 4001, Washington, DC 20230/202-377-2525.

Cooperative Exhibits

Small, highly specialized exporters, whose markets are too narrow to warrant an individual show, can exhibit within U.S. pavilions at international fairs. Contact: Bureau of Export Development, ITA, Department of Commerce, Room 3203, Washington, DC 20230/202-377-5341.

Country Marketing Managers

A telephone directory of regional marketing managers is available for free. This directory lists government country specialists who are experts in export marketing. Contact: Office of Country Marketing, ITA, Department of Commerce, Room 3203, Washington, DC 20230/202-377-5341. (See also "Country Experts" in this section.)

Country Market Studies

Studies are available that provide broad discussions of long-range opportunities for U.S. businessmen in the following countries: Brazil, Iran, Japan, Indonesia, Venezuela and Nigeria. Contact: Market Research Division, Bureau of Export Development, ITA, Department of Commerce, Room 1204, Washington, DC 20230/202-377-3363.

Credit Reports on Foreign Companies

For $15 the World Traders Data Reports will provide financial and background information on any foreign company. Contact: Office of Export Marketing Assistance, ITA, Department of Commerce, Room 1315, Washington, DC 20230/202-377-5455.

Customs Privileges for Promotions

Carnet allows commercial and exhibition samples into a country into a country on a temporary basis without a duty payment. For advice contact: Foreign Business Practices Division, Office of International Finance and Investment, ITA, Department of Commerce, Washington, DC 20230/202-377-4471.

Domestic International Sales Corp (DISC)

The DISC program allows exporters to defer 50 percent of its export-related income in order to develop and increase exports. Contact: Foreign Business Practices Division, ITA, Department of Commerce, Room 4204, Washington, DC 20230/202-377-4471.

East-West Trade Assistance

A special office has been established to assist U.S. export firms to deal with the special problems which arise when doing business with Eastern European (Communist) countries. Contact: Trade Development Assistance Division: ITA, Department of Commerce, Room 4829, Washington, DC 20230/202-377-2835.

Exhibitions

Commercial exhibitions are sponsored abroad in those areas where there are no existing trade fairs but the market potential is promising. Contact: Export Awareness Division, Office of Export Marketing Assistance, ITA, Department of Commerce, Washington, DC 20230/202-377-3181.

Exhibitions at Government Facilities

Every year six to nine major product exhibitions are built around a product theme and are presented at overseas U.S. government trade centers. The U.S. Department of Commerce will provide exhibit space, design and construct the exhibit, market and promote the exhibit and advise exhibitors. Contact: Special Promotion Division, Office of Export Promotion, ITA, Department of Commerce, Room 2223, Washington, DC 20230/202-377-2223.

Export Counseling Services

Exporters may receive free personal counseling at any of the U.S. Department of Commerce field offices. These offices offer guidance in the way of in-depth counseling in every phase of international trade. They will also schedule appointments with offices of the International Trade Administration and other government agencies. Contact: Business Counseling and Trade Complaints Section, Office of Export Marketing Assistance, ITA, Department of Commerce, Room 1322, Washington, DC 20230/202-377-3107.

Export Financing Guide

A free booklet is available describing basic programs of international and U.S. government agencies that provide financing and insurance for U.S. exports and investments. Ask for *A Guide to Financing Exports* from International Finance Division, Bureau of International Economic Policy, ITA, Room 4424, Department of Commerce, 14th and Constitution N.W., Washington, DC 20230/202-377-3277.

Export Financing Hotline

On-the-spot information is available on sources of export financing, where to find export insurance, how to make maximum use of exporting, and overseas investment assistance programs. The hotline is a cooperative effort among the Department of Commerce, the Overseas Private Investment Corporation and the Export-Import Bank, 1000 Twin Parkway, Rockville, MD 20851/800-424-5201.

Export Mailing Lists

Lists are available on foreign companies by country and/or commodity classification. You can receive such lists as all the advertising agencies in Saudi Arabia or all shoe manufacturers in Brazil. There is a charge for the service. Contact: Export Contact List Branch, Office of Export Marketing Assistance, ITA, Department of Commerce, Room 1033, Washington, DC 20230/202-377-2988.

Export Marketing Package

For $350 the U.S. Department of Commerce will design an entire export package for a company including market research, market identification, sales strategy, and guidance on the basics of export documentation, finance and sales. The program is called TEMP (Tailored Export Marketing Plans). Contact: Office of Export Marketing Assistance, ITA, Department of Commerce, Room 4053, Washington, DC 20230/202-377-2960.

Export Reference Publications

Below is a descriptive listing of publications which will be useful in addition to the special publications described elsewhere.

A Business Guide to the Near East and North Africa ($2.20) Order from the Superintendent of Documents, Government Printing Office, Washington, DC 20402/202-783-3238

Business Service Checklist. Biweekly ($13 a year) Order from the Superintendent of Documents, Government Printing Office, Washington, DC 20402/202-783-3238.

A Guide To Financing Exports. (Free) Order from Office of Export Development, International Trade Administration, Department of Commerce, Washington, DC 20230/202-377-5261.

Foreign Economic Trends and Their Implications for the United States (Approximately 150 reports a year, $50 per year) Order from the Superintendent of Documents, Government Printing Office, Washington, DC 20402/202-783-3238.

Foreign Trade 4 (U.S. Exports). Monthly and cumulative ($80 per year) Order from the Superintendent of Documents, Government Printing Office, Washing-

ton, DC 20402/202-783-3238.

Ocean Freight Rate Guidelines (75 cents) Order from the Superintendent of Documents, Government Printing Office, Washington, DC 20402/202-783-3238.

International Economic Indicators (Annual subscription $12) Order from the Superintendent of Documents, Government Printing Office, Washington, DC 20402/202-783-3238.

How To Get the Most From Overseas Exhibitions (free) Order from Office of Export Development, International Trade Administration, Department of Commerce, Washington, DC 20230/202-377-5261.

The Export Management Company—Your Export Department (free) Order from Office of Export Development, International Trade Administration, Department of Commerce, Washington, DC 20230/202-377-5261.

Export Information Services for U.S. Business Firms (free) Order from Office of Export Development, International Trade Administration, Department of Commerce, Washington, DC 20230/202-377-5261 20230/202-377-5261.

Obtain Tax Deferral Through a Domestic International Sales Corporation (DISC) (free) Order from Office of Export Development, International Trade Administration, Department of Commerce, Washington, DC 20230/202-377-5261.

Foreign Business Practices ($1.70) Order from National Technical Information Service, Box 1553, Springfield, VA 22161/703-557-4650.

Exporters, List of

The American International Traders Register is a computerized file of 30,000 records by name, address and product classification code [Standard industrial codes (SIC)] of U.S. exporters and potential exporters. The list of addresses from the file can be bought for $350 in the following formats: computer printout, computer tape, labels or 5 × 8 inch cards. Contact: Trade Facilitation and Information Services Division, Office of Export Marketing Assistance ITA, Department of Commerce, Room 1315, Washington, DC 20230/202-377-4203.

Exporting Seminars

Export seminars are conducted periodically in cities across the country. Topics covered vary from one day introductory export overviews to multi-session, "how-to" programs. Contact: Office of Export Marketing Assistance (OEMA), ITA, Department of Commerce, Room 3056, Washington, DC 20230/202-377-5131.

Foreign Buyer Program

Individual foreign buyers may seek assistance in finding U.S. products or services. A project officer is assigned by the government who will act

as a contact of the foreign business executive. Contact: Exporter Liaison Division, OEMA, ITA, Department of Commerce, Room 2015 B, Washington, DC 20230/202-377-2256.

Foreign Country Desk Officers
See listing of "Country Experts" in this section.

Foreign Credit Ratings
If you need facts about the credit ratings of foreign firms a copy of "Sources of Credit Information in Foreign Countries" may help. Send $3 to TL (Trade List), International Trade Administration, Department of Commerce, Room 1033, Washington, DC 20230/202-377-2988.

Foreign Importers Lists
Lists of foreign importers who want to buy from the United States are available. These lists contain names and addresses of distributors, agents, retailers, manufacturers and potential end-users of American products or services in 130 countries. Lists are also available by industry classification. Information is available on hard copy or computer tapes. Contact: Export List Branch, Office of Export Marketing Assistance, ITA, Department of Commerce, Room 1033, Washington, DC 20230/202-377-2988.

Foreign Investment Services
The U.S. Department of Commerce will match foreign firms with U.S. firms for the purpose of joint ventures abroad. They will also match U.S. firms with foreign firms for the purpose of domestic joint ventures. Contact: Investment Advisory Staff, Office of Export Marketing Assistance, ITA, Department of Commerce, Room 4038, Washington, DC 20230/202-377-4545.

Foreign Market Airgrams
Airgrams are sent in from U.S. Department of Commerce foreign ports describing potential business opportunities for U.S. firms. Selections can be made by industry group. Each airgram is usually priced at $3.25. Contact: National Technical Information Service, Department of Commerce, 5285 Port Royal Rd., Springfield, VA 22161/703-557-4650.

Foreign Press and Radio Translations
Translations of radio news transmissions, newspaper editorials, and magazine articles are regrouped into eight areas of interest and sold through the National Technical Information Service (NTIS). The regions covered are China, Eastern Europe, USSR, Asia and the Pacific, Middle East and North Africa, Latin America,

Western Europe, and Sub-Sahara Africa. Contact: NTIS, Department of Commerce, 5258 Port Royal Rd., Springfield, VA 22161/703-557-4650.

Global Market Surveys
International market studies are available for 15 industries covering 20 countries. These studies cover past and future market size, names of local producers and technological trends. Both the buyers' and sellers' viewpoint are given. Contact: Market Research Division, Office of Export Planning and Evaluation, ITA, Department of Commerce, Room 1009, or MRD/214, Room 1204, Department of Commerce, Washington, DC 20230/202-377-2941.

Guide to Foreign Trade Statistics
This book describes all foreign trade reference tabulations and publications, showing formats, tables and charts. Free copies are available from Trade Information Section, Foreign Trade Division Bureau of the Census, Department of Commerce, Room 2179, Washington, DC 20233/301-763-5140.

Import/Export Statistics from Census
If you are unable to find published import/export statistics on a given product, it is possible that the Bureau of the Census can create the information for you from their vast amounts of raw data. There is a charge for this service. Contact: Trade Information and Cost Reports, Bureau of the Census, Department of Commerce, Room 2178, Washington, DC 20233/301-763-7700.

Industry-Organized Trade Missions
The U.S. Department of Commerce will advise and support industrial trade missions organized by groups such as trade associations, chambers of commerce, and state development agencies. Contact: Special Promotion Division, Office of Export Promotion, ITA, Department of Commerce, Room 6051, Washington, DC 20230/202-377-2223.

In-store Promotions
Consumer goods manufacturers can seek help in having their products promoted within foreign stores. Contact: Special Promotion Division, Bureau of Export Development, ITA, Department of Commerce, Room 4001, Washington, DC 20230/202-377-2525.

International Trade Fairs
Small and medium-sized businesses can obtain the following assistance in exhibiting at foreign trade fairs: facilities and space; shipping assistance; marketing and promotion; identification of

key buyers in specific areas. Contact: Special Promotion Division, Office of Export Marketing, Assistance (OEMA), ITA, Department of Commerce, Room 4001, Washington, DC 20230/202-377-2525.

Licensing of Products Overseas

If you are interested in obtaining licensing agreements to distribute U.S. products overseas, the following office can aid in identifying specific manufacturers who would be interested in such relationships: Foreign Business Practices Division, Office of International Finance and Investment, International Trade Administration, Department of Commerce, Room 4204, Washington, DC 20230/202-377-4471.

Local Export Councils

Each U.S. Department of Commerce field office has an Export Council comprising community businessmen along with a field officer, in order to foster export interest and expertise. They organize seminars and workshops and also work with schools and colleges to expand their curricula to include coursework on international trade. Contact: Commercial Service, ITA, Department of Commerce, Room 4800 B, Washington, DC 20230/202-377-5205.

Major Foreign Market Potential

The Office of Major Projects informs U.S. firms of specific large-scale overseas projects which have significant potential for U.S. exports. This office also provides government assistance necessary for successful participation by the American firms. Contact: Major Projects Division, Office of Export Marketing Assistance, International Trade Administration, Department of Commerce, Room 2314, Washington, DC 20230/202-377-2185.

Monthly Import/Export Statistics

For the latest in trade statistics contact: Foreign Trade Reference Room, Department of Commerce, Room 2314, Washington, DC 20230/202-377-4855.

Market Share Reports

Reports show the performance of U.S. goods in foreign markets for 88 countries and 1,100 commodities. Contact: Planning and Research, Trade Performance Division, Department of Commerce, Room 2324, Washington, DC 20230/202-377-5242.

New Product Information Service

Free promotion is available to small manufacturers for publicizing new U.S. products abroad.

The product information selected for this service is published in the bimonthly *Commercial News USA*, which is sent to 240 U.S. embassies and consulates. Contact: Office of Export Marketing Assistance, ITA, Department of Commerce, Room 4009, Washington, DC 20230/202-377-5783.

Overseas Business Travel Briefings

U.S. firms planning overseas business trips in search of a qualified business contact can get help in the way of in-depth briefings on markets and business practices as well as introductions to appropriate firms and individuals. Notification of travel must be made at least two weeks in advance. Contact: Office of Export Marketing Assistance, ITA, Department of Commerce, Room 4009, Washington, DC 20230/202-377-5131.

Overseas Business Reports

Reports are published, by country, one or two times per year, showing the economic and commercial profile of each country. Contact: Office of Country Marketing, Bureau of Export Development, ITA, Department of Commerce, Room 3203, Washington, DC 20230, 202-377-5341.

Overseas Export Promotion Calender

Each quarter a free 12-month schedule is published showing upcoming trade fair shows, catalog exhibitions, trade missions, etc. Contact: Export Awareness Division, Office of Export Marketing Assistance, ITA, Department of Commerce, Room 1033, Washington, DC 20230/202-377-3181.

Overseas Market Research

If you need customized market research performed in a foreign country, or a listing in a foreign country, a listing of 860 overseas *market research* organizations is available for $3.00 from Department of Commerce, International Trade Administration TFIC/ECL-33, Washington, DC 20230/202-377-2988.

Overseas Marketing Leads

The Trade Opportunities Program matches, through computers, U.S. suppliers with those overseas who are looking to purchase a specific product or service. The minimum cost is $62.50 for 50 sales leads. Contact: Office of Export Marketing Assistance, ITA, Department of Commerce, Room 3056, Washington, DC 20230/202-377-5131.

Target Industry Program

Industries which show the greatest potential for exporting are targeted for detailed marketing

research and promotional plans. Contact: Targeting Division, Office of Export Marketing Assistance, ITA, Department of Commerce, Room 7626, Washington, DC 20230/202-377-5657.

Technical Sales Seminars ·

For high-technology industries, the U.S. Department of Commerce will set up a special seminar to be given by approximately six U.S. company representatives. The seminars are followed by sales-oriented private appointments. Contact: Special Promotion Division, Bureau of Export Development, ITA, Department of Commerce, Room 4001, Washington, DC 20230/202-377-2525.

Temporary Office Space Overseas

For $25 per day the U.S. Department of Commerce will provide office space and services to businessmen as they travel abroad. Translation services and local market information are also available. Contact: Special Promotions Division, Bureau of Export Development, ITA, Department of Commerce, Room 4001, Washington, DC 20230/202-377-2525.

Trade Center Exhibitions

The U.S. Department of Commerce together with the U.S. Department of State operate a network of Trade Centers and East/West Trade Development Facilities. These centers act as commercial showrooms in major marketing centers where those is a high potential for sales of U.S. products. Contact: Special Promotion Division, Office of Export Promotion, ITA, Department of Commerce, Room 2223, Washington, DC 20230/202-377-2223.

Trade Missions

Small tours of U.S. businessmen offering a single product, make three or four stops overseas in order to evaluate market potential. The missions are prepared by the staff of the U.S. Department of Commerce and take up to two years of planning. Contact: Special Promotion Division, Office of Export Promotion, ITA, Department of Commerce, Room 6051, Washington, DC 20230/202-377-2223. ·

World Import/Export Statistics

For the latest information on any product imported to or exported from any foreign country, contact: Foreign Trade Reference Room, Department of Commerce, Room 2314, Washington, DC 20230/202-377-4855.

World Trade Information Service

The Worldwide Information and Trade System (WITS) Program is a computerized data base designed to provide information about U.S. suppliers, as well as trade leads, potential customers and market information on foreign countries. The system comprises three data bases containing business opportunities for exporters and importers, how-to-export information, and descriptions of export promotion activities worldwide. Foreign users can contact U.S. embassies for access to the system. Contact: Department of Commerce, Worldwide Information and Trade System Program, Room 7099C, 14th and Constitution Ave. N.W., Washington, DC 20230/202-377-5291.

Films

A number of offices within the Department of Commerce loan films to the public for free. Titles range from "WE," which presents the key findings of the 1970 census, to "Outdoor Fish Cookery" from the National Oceanic and Atmospheric Administration. For a free film catalog contact: Audio-Visual, Office of Public Affairs, Department of Commerce, Room 5056, Washington, DC 20230/202-377-5610.

Fire Prevention Protection and Research

The National Bureau of Standards (NBS) conducts research in fire prevention and information is given to such groups as the Consumer Product Safety Commission, HHS, Underwriters' Laboratory, and the Fire Administration. NBS works at preventing and reducing fire loss, fire detection, chemistry, and toxology. NBS has also developed a device that can test any installed smoke detector for sensitivity. Contact: Fire Protection Systems Research Center for Fire Research, NBS, Department of Commerce. Polyner Building A263, Washington, DC 20234/301-921-3387.

NBS also sets up methods and standards to test fire protection devices including crash helmets. Tips are available on fire safety and fire prevention. Contact: Inquiry Service, NBS, Department of Commerce, Administration Building, Room A617, Washington, DC 20234/301-921-2318.

For information on research covering all aspects of fire, ranging from the physics and chemistry of combustion to the psychological and motivational characteristics of arsonists, contact: The Center for Fire Research, NBS, Building 224, Room A247, Washington, DC 20234/301-921-3143.

Fish and Seafood Information Center

If you want to know such things as what is the difference between white and light tuna, why some frozen fish are graded "A" while others

have no grades, or if you would like to set up a consumer workshop on fish and seafood contact: Seafood Research Inspection and Consumer Services Division, National Marine Fisheries Service, NOAA, Department of Commerce, Room 384, Washington, DC 20235/202-634-7458.

Fisheries

The National Marine Fisheries office provides information on the development of commercial fisheries, along with seafood research and inspection. They also provide help for commercial fisherman and make available statistics on fish catches and provide assessment of fishery resources. Contact: Public Affairs, National Marine Fisheries Service, NOAA, Department of Commerce, Room 178, Washington, DC 20235/301-634-7281.

Fishing, Commercial

Technical expertise, research, information and financial assistance (see "Fishing" under "Loans") in this section are all available to commercial fisherman. A periodical, *Market News Service,* is published three times a week and is available for $35 per year. It covers such topics as pricing, production, landings, imports and exports, and cold storage holdings. Contact: Fisheries Development Division, National Marine Fisheries Service, NOAA, Department of Commerce, 3300 Whitehaven Street, Room 325, Washington, DC 20235/202-634-7451.

Fishery Products Grading and Inspection

Grading and inspection of fishery products are done on a voluntary basis. The types of inspection services available include plant sanitation; processing methods; lot inspection for weight, condition, etc.; and bacteriological, physical and chemical analysis. Contact: Seafood Research, Inspection and Consumer Services Division, National Marine Fisheries Service, NOAA, Department of Commerce, Room F/UD2, Washington, DC 20235/202-634-7458.

Fishing, Sport

A good deal of information and expertise is available describing the sport fishing potential of various coastal water. Publications describe the types and amounts of fish found in specific areas. Contact: Recreational Fisheries, National Marine Fisheries Service, NOAA, Department of Commerce, Room 430, Washington, DC 20235/202-254-5536.

Floods

For information on safety precautions for flash floods, community action for flash floods, or flood warning systems contact: Public Affairs—Weather, National Weather Service, Department of Commerce, 8060 13th Street, Room 421, Silver Spring, MD 20910/301-427-7622.

Foreign Investment Statistics

Statistics are kept on the amount of foreign direct investment in the U.S. as well as U.S. direct investment abroad. The kinds of information collected include balance-of-payment data, income and capital flows between U.S. parent companies and their foreign affiliates and between foreign companies and their U.S. affiliates, operating and financial statistics, and balance sheets and income statements of U.S. affiliates abroad and of affiliates of foreign companies in the United States contact: International Investment Division, Bureau of Economic Analysis, Department of Commerce, Room 617, 1401 K St. N.W., Washington, DC 20230/202-523-0645.

Franchising

Information and expertise are available from the Bureau of Industrial Economics on the franchising industry. Two publications, *Franchise Opportunity Handbook,* and *Franchising in the Economy,* present industry market data and pinpoint specific franchising opportunities. A 17-minute audiovisual slide presentation on "The World of Franchising" is available to interested groups. Contact: Bureau of Industrial Economics, Service Industries Division, Department of Commerce, Room 1001, Washington, DC 20230/202-377-2319.

Free-trade Zones

More than 100 free ports, free-trade zones or similar customs-privileged facilities are available to U.S. manufacturers or their distributors where they can receive large shipments of goods and reship smaller lots to customers overseas without paying a duty. Contact: Foreign Trade Zones Staff, Office of Import Administration, ITA, Department of Commerce, Room 2006, Washington, DC 20230/202-377-2862.

Freedom of Information Act

Each major office within the U.S. Department of Commerce handles Freedom of Information Act (FOIA) requests. If you are looking for the address of a specific FOIA office or wish to file a central office contact: Central Reference and Records Inspection Facility, Department of Commerce, Room 5319, Washington, DC 20230/202-377-4217. (See "The Freedom of Information Act.")

Geophysical and Solar-Terrestial Information

Information is available on solid earth and marine geophysics, ionospheric solar and other space environment data, and geomagnetic data. Contact: National Geophysical and Solar-Terrestrial Data Center, EDIS, NOAA, Department of Commerce, Boulder, CO 80303/303-499-1000.

Government Contract Announcements and Awards

The *Commerce Business Daily* lists almost all contracts from all government agencies that are open to bid by interested parties. This is an important publication for anyone who is interested in doing business with the federal government. Subscriptions are available for $105 annually from Government Printing Office, Superintendent of Documents, Washington, DC 20402/202-783-3238. For further information on content contact: Commercial Service, ITA, Department of Commerce, Room 4800 B, Washington, DC 20230/202-377-3094.

Government Inventions for Licensing

If you wish to identify new products and technology that have been invented by the Federal government and are available for licensing for $180 a year you can subscribe to a National Technical Information Service (NTIS) newsletter titled "Government Inventions for Licensing." Contact: NTIS, Department of Commerce, 5285 Port Royal Rd., Springfield, VA 22161/703-557-4600.

Grants

The programs described below are for sums of money that are given by the federal government to initiate and stimulate new or improved activities, or to sustain ongoing services.

Anadromous and Great Lakes Fisheries Conservation

Objectives: To cooperate with the states and other non-federal interests in the conservation, development, and enhancement of the nation's anadromous fish and the fish in the Great Lakes and Lake Champlain that ascend streams to spawn, and for the control of sea lampreys.

Eligibility: Any interested person or organization may propose a cooperative undertaking. However, all proposals must be coordinated with the state fishery agency having responsibility for the resource to be affected by the proposal.

Range of Financial Assistance: $2,950 to $127,609.

Contact: Chief, State Federal Division, National Marine Fisheries Service, Page Building 2, 3300 Whitehaven St. N.W., Washington, DC 20235/202-634-7454.

Coastal Energy Impact Program— Environmental Grants

Objectives: To help states and units of local governments prevent, reduce, or ameliorate unavoidable loss of valuable environmental or recreational resources resulting from coastal energy activity, while ensuring that the person responsible for these environmental or recreational losses pays for their full cost.

Eligibility: Any coastal state may apply for assistance.

Range of Financial Assistance: $3000 to $515,000.

Contact: Director, Coastal Energy Impact Program Office, Office of Coastal Zone Management, National Oceanic and Atmospheric Administration, Department of Commerce, 3300 Whitehaven St. N.W., Washington, DC 20235/202-254-8000.

Coastal Energy Impact Program—Formula Grants

Objectives: To provide financial assistance to coastal states to plan and construct public facilities and services and for the amelioration of environmental and recreational loss attributable to Outer Continental Shelf (OCS) energy development activities.

Eligibility: Any coastal state that has or has had adjacent OCS oil and gas leasing and development activities.

Range of Financial Assistance: Dependent upon state's allotment. In 1979, allotments ranged from $555,000 to $10,406,000.

Contact: Director, Coastal Energy Impact Program Office, Office of Coastal Zone Management, National Oceanic and Atmospheric Administration, Department of Commerce, 3300 Whitehaven St. N.W., Washington, DC 20235/202-254-8000.

Coastal Zone Management Program Development

Objective: To assist any coastal state in the development of a management program for the land and water resources of its coastal zone.

Eligibility: States in, or bordering on, the Atlantic, Pacific, or Arctic Ocean, the Gulf of Mexico, Long Island Sound, or one or more of the Great Lakes. The Governor will designate the state agency or entity that is to be the applicant.

Range of Financial Assistance: $131,000 to $1,000,000.

Contact: Director, Coastal Zone Management

Programs Office, Office of Coastal Zone Management, National Oceanic and Atmospheric Administration, Department of Commerce, 3300 Whitehaven St. N.W., Washington, DC 20235/202-634-4019.

Coastal Zone Management—Estuarine Sanctuaries

Objectives: To assist states in the acquisition, development and operation of estuarine sanctuaries for the purpose of creating natural field laboratories to gather data and make studies of the natural and human process occurring within the estuaries of the coastal zone.

Eligibility: Any coastal state. The Governor will designate the state agency or entity that is to be the applicant.

Range of Financial Assistance: $50,000 to $1,800,000.

Contact: Director, Sanctuary Programs Office, Office of Coastal Zone Management, National Oceanic and Atmospheric Administration, Department of Commerce, 3300 Whitehaven St. N.W., Washington, DC 20235/202-634-4236.

Commercial Fisheries Disaster Assistance

Objective: To provide resource disaster assistance.

Eligibility: The agency of a state government authorized under its laws to regulate commercial fisheries.

Range of Financial Assistance: $160,000 to $505,000.

Contact: Chief, State/Federal Division, National Marine Fisheries Services, Page Building 2, 3300 Whitehaven St. N.W., Washington, DC 20235/202-634-7454.

Commercial Fisheries Research and Development

Objectives: To promote state commercial fishery research and development.

Eligibility: The agency of a state government authorized under its laws to regulate commercial fisheries.

Range of Financial Assistance: $2,500 to $210,000.

Contact: Chief, State/Federal Division, National Marine Fisheries Service, 3300 Whitehaven St. N.W., Washington, DC 20235/202-634-7454.

Economic Development—District Operational Assistance

Objective: To assist Economic Development Districts in providing professional services (other than by grant) to their local governments.

Eligibility: Chief officers of governing bodies of Economic Development Districts designated by the Secretary of Commerce.

Range of Financial Assistance: $10,000 to $25,000

Contact: Director, Office of Development Organizations and Planning, Economic Development Administration, Department of Commerce, Washington, DC 20230/202-377-4062.

Economic Development—Public Works Impact Program

Objective: To provide immediate useful work to unemployed and underemployed persons in designated project areas.

Eligibility: State, cities, counties and other political subdivisions, Indian tribes, and private or public nonprofit organizations representing a redevelopment area or economic development center.

Range of Financial Assistance: Up to $600,000.

Contact: Director, Office of Public Investments, Economic Development Administration, Department of Commerce, Washington, DC 20230/202-377-5265.

Economic Development—State and Local Economic Development Planning

Objectives: To develop the capability of state and local governments to undertake comprehensive and coordinated economic development planning that leads to the formulation of development goals and specific strategies to achieve them, with particular emphasis on reducing unemployment and increasing incomes.

Eligibility: Eligible applicants are the governors of states and chief executives of cities and counties meeting Economic Development Administration (EDA) eligibility criteria.

Range of Financial Assistance: $50,000 to $300,000.

Contact: Chief, State and Urban Program Management Division, Office of Development Organizations and Planning, Economic Development Administration, Department of Commerce, Washington, DC 20230/202-377-4578.

Economic Development—Support for Planning Organizations

Objectives: To foster multi-county district and redevelopment area economic development planning and implementation and thereby promote the creation of full-time permanent jobs for the unemployed and the underemployed.

Eligibility: Areas designated as redevelopment areas or determined by the Secretary of Commerce to have substantial need for planning assis-

tance, groups of adjoining counties, labor market areas, and/or Indian reservations that include at least one area designated as a redevelopment area by the Secretary of Commerce, and one or more centers of growth not over 250,000 population.

Range of Financial Assistance: $25,000 to $150,000.

Contact: Chief, District Program Management Division, Office of Development Organizations and Planning, Economic Development Administration, Department of Commerce, Washington, DC 20230/202-377-4578.

Economic Development—
Technical Assistance

Objectives: To solve problems of economic growth in EDA-designated geographic areas and other areas of substantial need through administrative and demonstration project grants, feasibility studies, management and operational assistance, and other studies.

Eligibility: While there are no specific applicant eligibility requirements, most technical assistance applicants are private nonprofit groups of state, municipal or county governments located in economically depressed areas of the country. Technical assistance is also given to small private business firms; however, this technical assistance must be repaid to the government.

Range of Financial Assistance: $1,000 to $476,000.

Contact: Initial contact should be at the regional office, except for projects which are national in scope, in which case initial contact should be with headquarters office, Director, Office of Technical Assistance, Economic Development Administration, Department of Commerce, Washington, DC 20230/202-377-5111.

Economic Development—Grants for Public
Works and Development Facilities

Objectives: To assist in the construction of public facilities needed to initiate and encourage long-term economic growth in designated geographic areas where economic growth is lagging behind the rest of the nation.

Eligibility: States, cities, counties and other political subdivisions, Indian tribes, and private or public nonprofit organizations or associations representing a redevelopment area or a designated economic development center eligible to receive grants and loans.

Range of Financial Assistance: $5,000 to $7,138,000.

Contact: Director, Office of Public Investments, Economic Development Administration, Department of Commerce, Washington, DC 20230/202-377-5265.

Grants to States for Supplemental and Basic
Funding of Titles I, II, III, IV, IX Activities
(Economic Growth)

Objectives: To provide funds which will enable governors to assist in the construction of public facilities and other projects that meet the criteria of Titles I, II, III, IV and IX and are needed to initiate or enhance long-term economic growth in areas of their states where economic growth is lagging.

Eligibility: States, local subdivisions thereof, Indian tribes, and private or public nonprofit organizations or associations representing a designated redevelopment area or a designated economic development center are eligible to receive public works grants and loans. Corporations and associations organized for profit are eligible only for business development loans.

Range of Financial Assistance: $1,000 to $976,000.

Contact: Director, Office of Private Investment, Economic Development Administration, Department of Commerce, Washington, DC 20230/202-377-5067.

Matching Funds—Travel

Objective: To encourage foreign residents to visit the United States and to improve services for foreign visitors in this country.

Eligibility: States, counties, municipalities, cities, towns, townships, and private or public nonprofit organizations with IRS tax-exempt status.

Range of Financial Assistance: $2,500 to $10,000.

Contact: Director, Office of State-City Affairs, United States Travel Service, Department of Commerce, Washington, DC 20230/202-377-4003.

Minority Business Development—Management
and Technical Assistance

Objectives: To provide free management and technical assistance to economically and socially disadvantaged individuals who need assistance in starting and/or operating a business. Primary objectives of the assistance are to increase the gross receipts and decrease the failure rates of the client firms.

Eligibility: There are no restrictions on who may be funded under this program. This includes state and local governments, state colleges and universities, public, private, junior and community colleges, U.S. Trust Territories, Indian tribes, individuals, other nonprofit organizations and institutions, and profit-making firms.

Range of Financial Assistance: $10,000 to $3,000,000.

Contact: Deputy Director for Program Re-

sources, Office of Minority Business Enterprise, Department of Commerce, Washington, DC 20230/202-377-5997.

Public Telecommunications Facilities

Objectives: To assist, through matching grants, in the planning and construction of public telecommunications facilities in order to extend delivery of public telecommunications services to as many citizens as possible by the most efficient and economical means, including the use of broadcast and nonbroadcast technologies; increase public telecommunications services and facilities available to, operated by, and owned by minorities and women; and strengthen the capability of existing public television and radio stations to provide public telecommunications services to the public.

Eligibility: Public broadcast stations, noncommercial and public telecommunications entities, nonprofit foundations, corporations, institutions, or associations organized primarily for education or cultural purposes, and a state or local governmental agencies.

Range of Financial Assistance: $5,000 to $750,000.

Contact: Director Public Telecommunications Facilities Division/NTIA Room 198, 1325 G St. N.W., Washington, DC 20005/202-724-3307.

Sea Grant Support

Objectives: To support establishment of major university centers for marine research, education, training, and advisory services, and also individual efforts in these same areas. Limited funds are available for organized national projects and for international cooperative assistance relative to ocean and coastal resources.

Eligibility: Universities, colleges, junior colleges, technical schools, institutes, laboratories, any public or private corporation, partnership, or other association or entity; any state, political subdivision of a state or agency or officer thereof; any individual.

Range of Financial Assistance: $32,000 to $2,840,000.

Contact: Director, National Sea Grant College Program, National Oceanic and Atmospheric Administration, Department of Commerce, 6010 Executive Blvd., Rockville, MD 20852/301-443-8926.

Special Economic Development and Adjustment Assistance Program—Long-Term Economic Deterioration

Objective: To assist state and local areas in the development and implementation of strategies designed to arrest and reverse the problems associated with long-term economic deterioration.

Eligibility: Cities, counties, or other political subdivisions, consortiums of political subdivisions, public or private nonprofit organizations representing redevelopment areas designated under the Public Works and Economic Development Act of 1965, Economic Development Districts established under Title IV of the Act, and Indian tribes and states.

Range of Financial Assistance: $25,000 to $5,000,000.

Contact: Director, Office of Public Investments, Economic Development Administration, Department of Commerce, Washington, DC 20230/202-377-5265.

Special Economic Development and Adjustment Assistance Program—Sudden and Severe Economic Dislocation

Objectives: To help state and local areas meet special needs arising from actual or threatened unemployment resulting from sudden and severe economic dislocation.

Eligibility: A public or private nonprofit organization that has been determined to be the representative of a redevelopment area designated under Section 401 of the Public Works and Economic Development Act of 1965, as amended, Economic Development Districts established under Title IV of the Act or Indian tribes, a state, city or other political subdivision of a state, or a consortium of such political subdivisions.

Range of Financial Assistance: $25,000 to $5,000,000.

Contact: Deputy Assistant Secretary for Economic Development Operations, Department of Commerce, Washington DC 20230/202-377-3081, 202-377-2659.

State Marine Schools

Objective: To train Merchant Marine officers in state marine schools.

Eligibility: Individual states apply. Limited to one academy in any one state.

Range of Financial Assistance: Grant of $100,000 paid to each approved school provided state matches funds and admits eligible out-of-state students, plus an allowance of $1,200 per year, per student.

Contact: Director, Office of Maritime Labor and Training, Maritime Administration, Department of Commerce, Washington, DC 20230/202-377-3018.

Housing Survey, Annual

In addition to the decennial census of housing, other annual surveys are conducted. The results of these surveys are published in six reports: *Gen-*

eral Housing Characteristics ($6.00); *Indicators of Housing and Neighborhood Quality* ($5.50); *Financial Characteristics* ($6.00); *Recent Mover Households* ($4.75); *Urban and Rural Housing Characteristics* ($5.50); *Financial Characteristics Cross-Classified by Indicators of Housing and Neighborhood Quality* ($8.50). Copies of these publications are available from Government Printing Offices, Attn: Superintendent of Documents, Washington, DC 20402/202-783-3238. For detailed information on content contact: Housing Division, Bureau of the Census, Department of Commerce, FB3 Room 313, Washington, DC 20233/301-763-2881.

Industrial Mobilization
In case of national emergency defense contractors must follow rules and regulations. Contact: Office of Industrial Mobilization, International Trade Administration, Department of Commerce, Washington, DC 20230/202-377-4506.

Industrial Outlook, U.S.
This annual publication is produced by the Office of the Chief Economist. The book shows one- and five-year projections for the economic outlook of some 150 major industries in the United States. It is published each January and is available for $8.50 from Government Printing Office, Attn: Superintendent of Documents, Washington, DC 20402/202-783-3238.

Industry Technicians Can Use Government Facilities
The National Bureau of Standards (NBS) sponsors a Research Associate Program, which enables technical specialists from industry and professional organizations to work at their facilities under supervision of and consultation with NBS professionals. Contact: Research Associate Program, Industrial Liaison, National Bureau of Standards, Department of Commerce, Administration Building, Room A402, Washington, DC 20234/301-921-3591.

Inland Waterways
For a listing of available maps and literature describing the nation's inland waterway system contact: National Ocean Survey, Distribution Division, NOAA, Department of Commerce, Riverdale, MD 20840/301-436-6980.

International Service Industries
The Office of International Services attempts to identify and solve those problems that affect U.S. service industries (hotels, insurance, advertising and engineering firms, etc.) abroad. The problems identified may arise from either U.S. or foreign government policies such as taxes, export financing, antitrust or discrimination by a foreign government. This office also collects data on various problems that may be unique to service industries and tries to map ways to solve them. Contact: International Services Division, Office of International Finance and Investment, ITA, Department of Commerce, Room 2204, Washington, DC 20230/202-377-4581.

Invention, Evidence of Conception
For $10 inventors can officially record evidence of the date they conceived an invention. A "Disclosure Document" is filed, which will be kept in confidence by the Patent and Trademark Office. Contact: Commissions of Patents and Trademarks, Patent and Trademark Office, Department of Commerce, Washington, DC 20231/703-557-3225.

Invest in USA
A special program has been developed to provide information to foreign businesses on how, where, who can help, licensing, etc. involving investment in the U.S. "Invest in USA" seminars are held abroad to promote investment. Contact: Invest in USA Program, Investment Advisory Staff—Office of Export Marketing Assistance, ITA, Department of Commerce, Room 4036, Washington, DC 20230/202-377-4831.

Laser Information
Information and expertise are available on such topics as stablized lasers, measurement of laser frequencies and wave lengths, laser power measurements, and applications of lasers to lengths measurement. Contact: National Bureau of Standards, Technical Information and Publications Division, Department of Commerce, Administration Building, Room A617, Washington, DC 20234/301-921-2318.

Law Enforcement Equipment
The National Bureau of Standards has a special division which investigates such products as surveillance cameras, vapor generators, radar, breathohol detection and clothing worn by law enforcement officers. Contact: Law Enforcement Standards Laboratory, National Bureau of Standards, Department of Commerce, Physics Building, Room B157, Washington, DC 20234/301-921-3161.

Libraries
The libraries within the U.S. Department of Commerce offer a valuable source for information in their respective subject areas. The following is a listing of the major libraries:

Library, Department of Commerce, Washington, DC 20230/202-377-2161.

Atmospheric Sciences Library (NOAA), Department of Commerce, 8060 13th St., Silver Spring, MD 20910/301-427-7800.

Library and Information Services (NOAA), Department of Commerce, 6009 Executive Blvd., Rockville, MD 20852/301-443-8330.

National Bureau of Standards Library, Department of Commerce, Administration Building, Room E-106, Washington, DC 20234/301-921-3451.

Patent and Trademark Office Scientific Library, Department of Commerce, Building 3-4, Crystal Plaza, 2201 Jefferson Davis Highway, Arlington, VA 22202/703-557-2957.

Bureau of the Census Library, Department of Commerce, Federal Office Building No. 3, Room 2455, Washington, DC 20233/202-763-5042.

Bureau of Economic Analysis Reference Room, Department of Commerce, BE 16, 1401 K St. N.W., Washington, DC 20230/202-523-0595.

Technical Information Project, National Telecommunications and Information Administration, Department of Commerce, 1346 Connecticut Ave. N.W., Suite 217, Washington, DC 20036/202-466-2954.

Loans and Loan Guarantees

The programs described below are those that offer financial assistance through the lending of federal monies for a specific period of time or programs in which the federal government makes an arrangement to indemnify a lender against part or all of any defaults by the borrower.

Coastal Energy Impact Program—Loans and Guarantees

Objectives: To provide financial assistance for public facilities necessary to support increased populations stemming from new or expanded coastal energy activity.

Eligibility: Any coastal state may apply for funds for use on public facilities including, but not limited to, highways and secondary roads, parking, mass transit, docks, navigation aids, fire and police protection, water supply, waste collection and treatment (including drainage), schools and education, and hospitals and health care.

Range of Financial Assistance: $200,000 to $38,000,000.

Contact: Director, Coastal Energy Impact Program Office, Office of Coastal Zone Management, National Oceanic and Atmospheric Administration, Department of Commerce, 3300 Whitehaven St. N.W., Washington, DC 20235/202-254-8000.

Economic Development—Business Development Assistance

Objectives: To sustain industrial and commercial viability in designated areas by providing financial assistance to businesses that create or retain permanent jobs, and expand or establish plants in redevelopment areas for projects where financial assistance is not available from other sources.

Eligibility: Any individual, private or public corporation, or Indian tribe, provided that the project to be funded is in an area designated as eligible under the Act at the time the application is filed. Neither business development loans nor guarantees of any kind will be extended to applicants who: 1) have, within the previous three years, relocated any or all of their facilities to another city, or state; 2) contemplate relocating part or all of their existing facilities with a resultant loss of employment at such facilities; and 3) produce a product or service for which there is a sustained and prolonged excess of supply over demand.

Range of Financial Assistance: $260,000 to $5,200,000.

Contact: Office of Private Investment, Economic Development Administration, Department of Commerce, Washington, DC 20230/202-377-5081.

Fishermen—Reimbursement of Losses

Objectives: To provide for reimbursement of losses incurred as a result of the seizure of a U.S. commercial fishing vessel by a foreign country on the basis of rights or claims in territorial waters or on the high seas that are not recognized by the United States.

Eligibility: Must be a U.S. citizen and the owner or charterer of a fishing vessel documented as such by the United States.

Range of Financial Assistance: $1,000 to $109,000.

Contact: Chief, Financial Services Division, National Marine Fisheries Service, Department of Commerce, 3300 Whitehaven St. N.W., Washington, DC 20235/202-634-7496.

Fishing Vessel Obligation Guarantees

Objectives: To provide government guarantees of private loans to upgrade the U.S. fishing fleet.

Eligibility: Must have an obligee approved by the Secretary of Commerce as able to service the obligation properly; and an obligor approved as possessing the ability, experience, financial resources, and other qualifications necessary to the adequate operation and maintenance of the mortgaged property.

Range of Financial Assistance: $15,000 to $1,500,000.

Contact: Chief, Financial Services Division, National Marine Fisheries Service, Department

of Commerce, 3300 Whitehaven St. N.W., Washington, DC 20235, 202-634-7496.

Loans to States for Supplemental and Basic Funding of Titles I, II, III, IV and IX Activities

See "Grants" in this section.

Trade Adjustment Assistance

Objectives: To provide trade adjustment assistance to firms, business and industry associations and communities adversely affected by increased imports.

Eligibility: A firm must demonstrate that increased imports of articles like or directly competitive with those produced by the firm contributed importantly to declines in sales or production, and to separation or threat of separation of the firm's workers. A community must show an adverse economic impact from increased imports or from the transfer of a firm or a subdivision of a firm to a foreign country.

Range of Financial Assistance: Up to $3,000,000.

Contact: Director, Office of Private Investment, Economic Development Administration, Department of Commerce, N.W., Washington, DC 20230/202-377-5081.

Local Business Statistics

Every five years the Bureau of the Census publishes *County Business Patterns,* which shows statistics on business operations for every county in the United States. The data available include type of business, number of people employed, payroll size and type of industry. Copies of the publication are available from Superintendent of Documents, Government Printing Office, Washington, DC 20402/202-783-3238. For detailed information on content contact: County Business Patterns, Bureau of the Census, Department of Commerce, Room 3529-FB3, Washington, DC 20233/301-763-7642.

Life-Cycle Costing

The federal government uses a method of Life-Cycle Costing for determining the value of buildings and equipment. The National Bureau of Standards has published a free report which describes how to use this system. Request *Federal Life-Cycle Costing Manual* from Center for Building Technology, NBS, Department of Commerce, Building 226, Room 319, Washington, DC 20234/301-921-2330.

Local Business Assistance Centers for Minorities

The regional offices of the Minority Business Development Agency (MBDA) manage a network of 275 local business assistance centers. At one of these centers a minority owner can get assistance in preparing a business loan package, securing sales, or solving a particular management problem. Contact: Director MBDA, Department of Commerce, Room 5053, Washington, DC 20230/202-377-2654.

Mammals, Marine

Information is available from the National Oceanic and Atmospheric Administration (NOAA) on marine mammals and on rules and regulations for endangered species. They also issue permits to zoos and aquariums that want to house marine mammals. Contact: Office of Marine Mammals and Endangered Species, National Marine Fisheries Service, NOAA, Department of Commerce, Room 410B, Page Building 2, Washington, DC 20235/202-634-7461.

Marine Advisory Service

Through the sea-grant college system a national advisory service disseminates new knowledge from sea-grant researchers to the community and transmits community needs back to the researchers. Contact: National Sea-Grant College Program, NOAA, Department of Commerce, Room 622, 6010 Executive Blvd., Rockville, MD 20852/301-443-8886.

Mariners Weather Magazine

This bimonthly magazine is free to those who have a marine-related interest. It covers weather in the Atlantic and Pacific oceans for the last two months plus related articles. Contact: Marine Weather Log, National Oceanographic Data Center, NOAA, Department of Commerce, Washington, DC 20235/202-634-7394.

Market and Economic Conditions of States

Quarterly booklets are available on each of the 50 states and the District of Columbia that analyze economic indicators for each fiscal quarter and contain charts and tables that illustrate such items as consumer and industrial markets, changes in consumer prices, unemployment figures and estimates for future building activity. Contact: Regional Economic Analysis Division, Bureau of Economic Analysis, Department of Commerce, Room 1101, 14th and K Sts. N.W., Washington, DC 20230/202-523-0910.

Market Research Consulting Services

The professional staff at the Bureau of the Census are available on a cost basis to help organizations design and conduct surveys. Contact: Statistical Methods Division, Bureau of the Census, Department of Commerce, FB3, Room 3725, Washington, DC 20233/301-763-2672. See other "Census" listings in this section.

Meteorological Center

The National Meteorological Center is the primary information source for weather forecasting for the United States. They produce weather analysis charts and numerical forecasts, which are sent to both public and private weather offices. Contact: National Meterological Center, National Weather Service, NOAA, Department of Commerce, 5200 Auth Rd. #206, Camp Springs, MD 20033/301-763-8016.

Metric System

For assistance on the technical aspects of the metric system contact: Inquiry Service, National Bureau of Standards, Department of Commerce, Administration Building, Room A617, Washington, DC 20234/301-921-2318.

The National Bureau of Standards was heavily involved with metric conversion activities, but these activities have been moved outside of the Department of Commerce. Contact: Metric Board, 1815 North Lynn St. #600, Arlington, VA 22209/301-921-2318.

Merchant Marine Jobs

Persons 16 years old and over are eligible for jobs with the merchant marines. Applicants may or may not have experience at sea. Training is available at the U.S. Merchant Marine Academy and at State Marine Academies. For information on seafaring employment and training contact: Office of Maritime Labor and Training, Maritime Administration, Room 3069A, Department of Commerce, Washington, DC 20230/202-377-3018.

Minority Business Assistance

The Minority Business Development Agency provides management, marketing and technical assistance to new or developing minority businesses. They also help in obtaining procurement and construction contracts and in obtaining franchises. Contact: National Projects, Minority Business Development Agency, Department of Commerce, Room 5709, Washington, DC 20230/202-377-3163.

Minority Business Publications

The following publications are available free from Public Affairs Office, Minority Business Development Agency, Department of Commerce, Room 5713, Washington, DC 20230/202-377-3163.

Access Magazine
Directory of Minority Media
Franchise Opportunity Handbook
Directory of Marketing Assistance for Minority Business
National Directory of Minority Manufacturers

OMBE Funded Organizations Directory
Minority Ownership of Small Businesses (Thirty Case Studies)
Aquaculture, Fisheries, and Food Processing
Guide to Federal Assistance Programs for Minority Business Development Enterprises
Land and Minority Enterprise: The Crisis and the Opportunity
Federal Procurement and Contracting Training Manual for Minority Entrepreneurs
Report of the Task Force on Education and Training for Minority Business Enterprise
Try Us (National Minority Business Directory)
Women-Owned Businesses
Urban Business Profiles Series

Minority Business Purchasing

A special council composed of executives from over 1,000 major corporations, has been established to increase corporate purchases of supplies and services from minority firms. A free directory is also available describing the types of goods and services available from minority firms. Contact: National Minority Purchasing Council, Policy and Market Development, Minority Business and Development Agency, Department of Commerce, Room 5612, Washington, DC 20230/202-377-3936.

Minority Business Technology Clearinghouse

Through a series of nongovernment Technical Commercialization Centers, the clearinghouse identifies new products that might have long-term growth potential in the marketplace. Contact: Technology Clearinghouse for Minority Business, National Projects, Minority Business Development Agency, Department of Commerce, Room 5709, Washington, DC 20230/202-377-3163.

Minority Enterprise Small Business Investment Companies (MESBICs)

Private capitalized MESBICs, which invest in minority-owned ventures, receive three dollars of investment funds for every one dollar of private money invested. Contact: Capital Development, Minority Business Development Agency, Department of Commerce, Room 5098, Washington, DC 20230/202-377-5741.

Minority-Owned Financial Institutions

The Minority Business Development Agency encourages the organization of minority-owned financial institutions. They assist with management and technical information in the organizing and structuring of banks and savings and loan associations. They train in how to attract capital and depositors, and how to provide grants to banking associations. Contact: Capital Develop-

ment Branch, Minority Business Development Agency, Department of Commerce, Room 6887, Washington, DC 20230/202-377-3165.

Nautical Charts

Nautical charts, in various scales, cover the coastline of the United States, its territories and possessions, and the Great Lakes. There are six catalogs, which provide descriptions and ordering information: 1) Atlantic and Gulf coasts; 2) Pacific Coast including Hawaii, Guam and Samoa Islands; 3) Alaska, including Aleutian Islands; 4) Great Lakes and Adjacent Waterways; 5) Bathymetric Maps and Special Purpose Charts, and 6) Catalog of Aeronautical Charts and Related Publications. Also available are catalogs on early nautical charts, historical maps, and NOAA technical publications. Nautical Charts make ideal and inexpensive wall decorations. Contact: Physical Science Services Branch, National Ocean Survey, NOAA, Department of Commerce, Rockville, MD 20852/301-443-8005.

NOAA Corps

Scientists are recruited from colleges or from the armed services and are trained at the National Oceanic and Atmospheric Administration (NOAA), Officer Training Center in Kings Point, New York. The Corps officers work on and manage such projects as Marine Ecology Analyses, Solar Radiation, Geodesy, and Tide Monitoring, or fly research aircraft. Contact: Commission Personnel Division, NOAA Corps, Department of Commerce, Rockville, MD 20852/301-443-8616.

NTIS Data Base Searches

The National Technical Information Service (NTIS) can search its computerized data base of 680,000 reports on completed government research and analysis and provide a report which identifies all available reports for a specific topic. The fee varies and searches are available in both customized and published formats. Contact: NTIS, Department of Commerce, 5285 Port Royal Rd., Springfield, VA 22161/703-557-4650.

NTIS Index

The National Technical Information Service (NTIS) publishes an annual index to its publications. The index cost $375 for one year and provides a good starting place for determining if publications are available in your subject area. Many libraries throughout the world subscribe to this index. One can also consult NTIS's computerized data base which contains much of the same information. Contact: NTIS, Department of Commerce, 5285 Port Royal Rd., Springfield, VA 22161/703-557-4600.

Occupational Classification

More than 600 jobs are classified and described by the Office of Federal Statistical Policy and Standards. These standards are used by many organizations inside and outside the government. For more detailed information contact: Office of Federal Statistical Policy and Standards, Department of Commerce, 2001 S St. N.W., Room 300, Washington, DC 20230/202-673-7977. For a copy of *Standard Occupational Classification Manual* ($8.25) contact: Superintendent of Documents, Government Printing Office, Washington, DC 20402-202-783-3238.

Ocean Mining and Marine Pollutants

The Marine Ecosystem Analysis program explores the impact of marine pollutants on the New York-New Jersey Coast, Puget Sound and Alaska's Prince Williams Sound. They are also exploring the probable impact of deep ocean mining operations on the environment. Contact: Public Affairs Office, NOAA, Public Affairs Boulder, Department of Commerce, 30 Marine St., Boulder, CO 80302/303-499-1000.

Oceanographic Information

The National Oceanic and Atmospheric Administration contains the world's largest collection of oceanographic data. They collect information on all oceans, seas and estuaries from lundreds of domestic and foreign sources. Contact: National Oceanographic Data Center, Oceanographic Services Branch, NOAA, Department of Commerce, Washington, DC 20235/202-634-7500.

Packaging and Labeling Expertise

The National Bureau of Standards provides technical assistance to state enforcement agencies and other organizations in establishing proper packaging and labeling regulations. Contact: Office of Measurement Services, National Bureau of Standards, Department of Commerce, Physics Building, Room A363, Washington, DC 20234/301-921-3301.

Patent Academy

Training is available for patent examiners in patent practices and procedures. Government agencies can attend sessions for free; there is a charge for those in the private sector or in foreign agencies. Contact: Patent Academy, Patent and Trademark Office, Department of Commerce, Building 6, Room 1261, Crystal Plaza, Arlington, VA 22202/703-557-2086.

Patent Applications for Other Countries

Agreements have been made with 27 countries, including Japan, Australia, Russia, most of West-

ern Europe and Brazil, to allow a single patent application to be applied to all 27 countries. Contact: Patent and Trademark Office, Department of Commerce, Patent and Cooperative Treaty Building, Room 11D07, Washington, DC 20231/703-557-3070.

Patent Attorneys, List of

For a listing of patent attorneys contact: Office of the Solicitor, Patent and Trademark Office, Department of Commerce, Room 11C04CP3, Washington, DC 20231/703-557-3525.

Patent and Trademark Copies

Copies of the specifications and drawings of all patents are available for 50 cents each. Design patents are 20 cents each, Trademark copies are 20 cents each unless they contain data on renewal or cancellation, in which case they cost 60 cents. Contact: Customers Service Division, Patent and Trademark Office, Department of Commerce, Room 1627, Washington, DC 20231/202-377-5634.

Patent and Trademark Publications

Annual Indexes. Patents are indexed by patentees and by subject matter. Trademarks are indexed by registrant and by type of goods registered. Price varies from year to year.
General Information Concerning Patents ($1.80)
General Information Concerning Trademarks ($1.60)
Guide for Patent Draftsmen (65 cents)
Manual of Classification. Describes over 300 classes and 66,000 subclasses used in the subject classification of patents. ($60.00)
Manual of Patent Examining Procedure ($39). Used for detailed reference work on patents.
Patent Attorneys and Agents ($5.00). Registered to Practice before the Patent Office.
Patents and Inventions ($1.75). An information aid to inventors in deciding whether to apply for patents, in obtaining patent protection, and in promoting their inventions.
Patent Laws ($2.10)
Patent Official Gazette (Subscription $300.00). Issued every Tuesday, it contains copies of the drawings and an abstract of each patent granted, list of patents available for license or sale and general information.
Above publications are available from Superintendent of Documents, Government Printing Office, Washington, DC 20402/202-783-3238.

Patent Search, Where to Begin

Before beginning a patent search you may want to obtain a copy of *Guide to the Public Patent Search Facilities of the U.S. Patent and Trademark Office*. It explains all of the jargon used by the office as well as the types and locations of the available documents. It also tells how to conduct your own patent search. Contact:

Commissioner of Patents and Trademarks, Department of Commerce, Building 3, Room 1 A02, Washington, DC 20231/703-557-2276. If you wish to start immediately on your own search, the Patent Office will provide you with the necessary documentation and tell you the location of the nearest patent depository. Contact: Patent Search Division, Patent and Trademark Office, Department of Commerce, Washington, DC 20231/703-557-2219.

Patents and Trademarks
Weekly Listing

The *Official Gazette,* published every Tuesday, describes all new patents and includes drawings when available. Subscriptions are $200 Fourth Class and $300 First Class. Contact: Office of Publications, Patent and Trademark Office, Department of Commerce, Room 5C26, Washington, DC 20231/703-557-9738.

Patents, Foreign

For information on patents filed in other countries contact: Foreign Business Practices Division, Office of International Finance and Investments, ITA, Department of Commerce, Washington, DC 20230/202-377-4471.

Photographs

Photographs are available depicting the nation's foreign and domestic commerce. Contact: Office of Publications, Department of Commerce, Washington, DC 20230/202-377-2021.

Population Statistics

Statistics on the total U.S. population are available on a monthly basis. More detailed data are available annually. Contact: Population Division, Bureau of the Census, Department of Commerce, Building 3, Room 2030, Washington, DC 20233/301-763-5002.

Port Facility Technology

For information on developing and improving port facilities contact: Office of Port and Intermodal Development, Maritime Administration, Department of Commerce, Washington, DC 20230/202-377-2275.

Posters, Marine

The National Marine Fisheries Service publishes beautiful, scientifically accurate color posters. Available posters include Marine Fishes of the North Atlantic ($2.80), Marine Fishes of the North Pacific ($2.30), Marine Fishes of the California Current ($2.65), Mollusks and Crustaceans of the Coastal U.S. ($3.20), and Marine Mammals of the Western Hemisphere ($2.20). Order from Superintendent of Documents, Gov-

ernment Printing Office, Washington, DC 20402/202-783-3238.

Product Testing

The Office of Product Standards establishes policy on the development and evaluation of domestic and international standards. They also run a national voluntary laboratory accreditation program for testing products for a fee. Contact: Office of Products Standards, Department of Commerce, Room 3876, Washington, DC 20230/202-377-4148.

Productivity and Innovation

The Office of Science and Technology carries out research that often leads directly to innovation within industry. It analyzes how federal, state and local government programs can stimulate innovation. They also suggest ways in which the federal government can use subsidies and buying power to spark technological change. Contact: Experimental Technology Incentives Program, Office of Science and Technology, Department of Commerce, Room 3862, Washington, DC 20230/202-377-3111.

Radiation

The National Bureau of Standards works on radiation measurement standards for basic research in areas such as health care and energy applications. Contact: Inquiry Service, National Bureau of Standards, Department of Commerce, Administration Building, Room A617, Washington, DC 20234/301-921-2318.

Regional Economic Forecasts

A special division of the Bureau of Economic Analysis regularly publishes forecasts of the future economic conditions for a large number of regions within the country. Contact: Regional Economic Analysis Division, BEA, Department of Commerce, Tower, Room 308, Washington, DC 202/202-523-0946.

Research Journal

The National Bureau of Standards (NBS) publishes a bimonthly journal which contains papers in math engineering, physics, chemistry, computer science along with citations and abstracts to all NBS publications. Subscriptions to the *Journal of Research of the NBS* are available for $17.00 from Superintendent of Documents, Government Printing Office, Washington, DC 20402/202-783-3283.

Research Managers Magazine

Dimensions/NBS is published ten times per year by the National Bureau of Standards. It cov-

ers such topics as energy forecasting to predict fuel supplies, status reports on reference material on measuring auto emissions, and descriptions of grants, publications and conferences. Subscriptions are $11.00 per year from Superintendent of Documents, Government Printing Office, Washington, DC 20402/202-783-3238.

Resort Guides

Free resort guides are available for various areas of the United States. They contain seasonal breakdown of weather and recreational opportunities. They stress elements of interest for each season, along with table of activities best suited for each season. Contact: Resort Guides, National Oceanographic Data Center, EDIS/NOAA, Department of Commerce, Room 428 Page 1, Washington, DC 20235/202-634-7506.

Satellite Data

The National Climate Center makes satellite data available for studies related to climatology, coastal zone management, oceanography, and deep-water port planning. Contact: Satellite Data Services Branch, EDIS National Climatic Center, NOAA/EBIS/NCC, Satellite Data Service World Weather Building, Room 100, Washington, DC 20233/301-763-8111.

Satellite Information

Environmental satellites, which do such things as track the weather and predict hurricane paths, provide useful data for the agriculture, marine, transportation, and fishing industries. Information is also available from remote sensing satellites showing such land resources as the nation's agricultural inventory. Contact: Public Affairs, NOAA, Department of Commerce, 11400 Rockville Pike, Room 108, Rockville, MD 20852/301-443-8243.

Science and Technology Fellowship Programs

Members of upper management within the U.S. Department of Commerce can be assigned, for a period of ten months, to another bureau agency, house or senate committee. Contact: Office of Science and Technology, Department of Commerce, Room 3867, Washington, DC 20230/202-377-5065.

Sea-Grant Colleges

Sea- or water-related industries may find Sea-Grant Colleges to be an excellent resource for information and expertise on new products and processes. Federal grants are made to colleges to further the development of marine resources through research, education, and advisory services such as information transfer. Subject areas

include aquaculture, fisheries, coastal engineering, mineral projects, water recycling and seafood processing. For further information or for listing of Sea-Grant colleges contact: National Sea-Grant College Program, NOAA, Room 625, 60 Executive Blvd., Rockville, MD 20852/301-443-8923.

Shipping Research

Research and expertise is available on commercial ship operations and productivity. Subject areas include safety, efficiency, collision avoidance, navigation, communication, and ship design. Contact: National Maritime Research Center, Maritime Administration, Department of Commerce, U.S. Merchant Marine Academy, Kings Point, New York 11024/516-482-8200, ext. 313.

Small Business Tips

The following reports are available free: "How to Get Paid Promptly on Government Contracts"; "Marketing Industrial Products on a Low Budget"; "Small Business Investment Company Financing," and "Developing a Successful Loan Application Package." Contact a field office or Office of Business Liaison, Department of Commerce, Room 1510, Washington, DC 20230/202-377-3176.

Social Indicators

Every three years a chart book titled *Social Indicators* is published which provides statistical information about the population of the United States as a whole. It includes information on the changing composition of the family, health and nutrition, housing and the environment, transportation, public safety, education and training, unemployment, social security and welfare, income and productivity, social participation, and culture and leisure use of time. Contact: Center for Demographic Studies, Bureau of the Census, Department of Commerce, FB3, Room 3442, Washington, DC 20233/301-763-5145.

Solar Standards

The National Bureau of Standards (NBS) sets up test measurement methods and standards on solar heating and cooling devices. Contact: Inquiry Service, National Bureau of Standards, Department of Commerce, Administration Building, Room A617, Washington, DC 20234/301-921-2318.

Solve Your Identity Crisis

For $8.50 the Bureau of the Census will search its records of one or two censuses to prove one's identity, age, citizenship, or past occupation.

Transcripts often can be used in place of a missing birth certificate or to provide proof of occupation needed for collecting government assistance such as black lung benefits for miners. Contact: Census History Staff, Bureau of the Census, Department of Commerce, AFCU Building, Allentown Rd., Room 311, Suitland, MD 20233/301-899-7625.

Sources of Information on U.S. Firms

This small booklet is aimed at international traders and describes the major sources of information on U.S. companies. Contact: Export Liaison Division, OEMA, ITA, Department of Commerce, Room 2015B, Washington, DC 20230/202-377-2256.

Space Environment Research

Information and expertise is available on the space environment, the upper atmosphere, and the interactions of the sun and earth. Contact: Public Affairs Office, NOAA, Public Affairs Boulder, Department of Commerce, 30 Marine St., Boulder, CO 80302/303-499-1000.

Standard Reference Data System, National

The National Bureau of Standards (NBS) coordinates and disseminates critically evaluated reference data in the physical sciences. The NBS works with a number of evaluation centers, located in university, industrial and government laboratories, which compile and evaluate numerical data on physical and chemical properties retrieved from world scientific literature. Contact: Office of Standard Reference Data, NBS, Physics Building, Room A320, Washington, DC 20234/301-921-2228.

Standards Information Service

The National Bureau of Standards-Standards Information Service (NBS-SIS) maintains a reference collection of engineering and related standards, which includes more than 240,000 standards, specifications, test methods, codes, and recommended practices issued by U.S. technical, trade and professional societies, state and federal agencies, and foreign, national and international standardizing bodies. For information on specific standards contact: NBS-SIS, Technology Building 225, Room A-168, Washington, DC 20234/301-921-2587.

Statistical Abstract of the U.S.

This book comes out at the beginning of each year and is the most popular of Bureau of the Census publications. With more than 1,600 tables and charts it provides data on the social, economic and political organizations of the U.S. For or-

dering information see "Census Publications" in this section. For detailed information contact *Statistical Abstract*, Data User Services Division, Bureau of the Census, Department of Commerce, AFCUB, Room 426, Washington, DC 20233/301-899-7620.

Statistician's Magazine

Statisticians can keep current on federal statistical programs, reports and publications through the *Statistical Reporter* ($13.00). This monthly publication is produced by the Office of Federal Statistical Policy and Standards and is available from: Superintendent of Documents, Government Printing Office, Washington, DC 20402/ 202-783-3238.

Statistics, Federal

The Office of Federal Statistical Policy and Standards is responsible for setting statistical standards within the federal government and for recommending projects for data improvement. If you wish to know who collects what kind of data within the federal government, this is the place to start. Contact: Office of Federal Statistical Policy and Standards, Department of Commerce, Room 702, Washington, DC 20230/202-673-7959.

Status of Legislation Affecting Business

A few times a year the U.S. Department of Commerce publishes a "Situation Report," showing the current status of selected pieces of legislation that may be of interest to business executives. To be placed on the mailing list to receive free copies, contact: Office of Business Liaison, Department of Commerce, 14th and Constitution Ave. N.W., Room 1066, Washington, DC 20230/202-377-3176.

Storm Forecast Center

The Center prepares and releases messages of expected severe local storms including tornadoes. These messages, called *Tornado and Severe Thunderstorm Watches*, include information for public use and for aviation services. The Center also issues hourly advisories of significant aviation meteorological hazards. Contact: National Severe Storms Forecast Center, NOAA, Department of Commerce, 601 East 12th St., Room 1826, Kansas City, MO 64106/303-499-1000.

Surveillance Cameras

The National Bureau of Standards (NBS) has information available on how to select surveillance cameras for specific needs. It includes tips on storing processed film, improving photo quality, selection of film, and lens size. Contact: Law Enforcement Standards Laboratory, National Bureau of Standards, Department of Commerce, Physics Building, Room B157, Washington, DC 20234/301-921-3161.

Technical Advisory Board

The Commerce Technical Advisory Board serves as an advisory committee to the Secretary and the Assistant Secretary of Commerce on matters relating to science and technology. The Board, made up of academic and business representatives, reports on such topics as entrepreneurship, creating jobs and energy programs. Contact: Commerce Technical Advisory Board, Office of Science and Technology, Department of Commerce, Room 4872, Washington, DC 20230/202-377-5065.

Technical Assistance for Starting a Business

The Economic Development Administration offers grants, manpower consulting services, feasibility studies, marketing and management assistance, outreach programs to help with purchasing, training and production, and information on labor force and site location. See "Grant" and "Loans and Loan Guarantees" in this section. Those eligible include state and local governments, nonprofit institutions, hospitals, universities and profit-making businessess of all sizes. Contact: Office of Technical Assistance, Economic Development Administration, Department of Commerce, Room 7843, Washington, DC 20230/202-377-2812.

Technical Publications (NTIS)

The National Technical Information Service (NTIS) is the central source for obtaining copies of reports generated as a result of U.S. and foreign government sponsored research and development. Information on some 680,000 reports are available in hard copy, microfiche and computerized format. Special interest newsletters and other monitoring services are available for those who wish to keep current on a specific topic. A six volume annual index is also available. For a catalogue of available products and services contact: NTIS, Department of Commerce, 5285 Port Royal Rd., Springfield, VA 22161/703-557-4600.

The National Technical Information Service also publishes 33 newsletters that are designed to keep subscribers current on the latest technical reports available in specific areas. The areas covered include Behavior and Society, Civil Engineering, Energy, Library and Information Sciences, and Materials Sciences. Subscriptions average between $50 and $100 per year. For a descriptive listing of newsletters contact NTIS.

Technology Assessment with Patents

Both off-the-shelf and customized reports are available showing domestic and international patent activity. Reports can be produced by product category or by company and can cover both short or long periods of time. It provides excellent data for forecasting future technology. Contact: Office of Technology Assessment and Forecast, Patent and Trademark Office, Department of Commerce, Room 2C33, Washington, DC 20231/703-557-3050.

Telecommunication Sciences, Institute for

The Institute performs applied scientific and engineering research on the transmission of radio waves and on their effects of the environment, the interaction among these waves, and problems posed by telecommunications systems and standards. Contact: Institute of Telecommunication Sciences, Department of Commerce, Boulder, CO 80303/303-499-1000, ext. 3572.

Telecommunications Expertise for Public Service Groups

Institutions such as schools, hospitals, libraries, police and fire departments and government agencies at all levels can receive help in achieving their goals from the Office of Telecommunications Applications. This office will help public service groups identify their needs and show how these needs can be met through telecommunications. Contact: Office of Telecommunications Applications, National Telecommunications and Information Administration, Department of Commerce, 14th and Constitution Ave. N.W., Room 4078, Washington, DC 20230/202-724-3464.

Tourism Revenue

The U.S. Travel Service will work with state and local governments as well as private industry within the United States to help promote and assist travel from abroad. Contact: Marketing and Field Operations, Travel Service, U.S. Department of Commerce, Room 1859, Washington, DC 20230/202-377-4786.

Trace Foreign Economic Trends

The Office of International Economic Research, of the U.S. Department of Commerce, monthly produces comparative economic statistics for the United States, France, West Germany, Italy, Netherlands, United Kingdom, Japan and Canada. Subscriptions to "International Economic Indicators and Competitive Trends" are available for $12.65 (domestic mailing) and $15.85 (foreign mailing). Contact: Superintendent of Documents, Government Printing Office, Washington, DC 20402/202-783-3238.

Trademark

For information on trademarks one can request a free copy of *General Information Concerning Trademarks* from Trademark Director, Patent and Trademark Office, Department of Commerce, 2011 Crystal Plaza Building #2, Arlington, VA 22202/703-557-3268.

Trademark Search

There is only one office which has all the data necessary for searching a trademark. If you yourself cannot go to this Virginia office, they will recommend someone you can hire to do the searching for you. Contact: Trademark Search Room, Patent and Trademark Office, Department of Commerce, 2011 Crystal Plaza Building #2, Arlington, VA 22202/703-557-3268.

Travel Industry Market Research

The U.S. Travel Service publishes a number of studies describing the potential travel market in a number of countries. Contact: Marketing and Field Operations, Travel Service, Department of Commerce, Room 1859, Washington, DC 20230/202-377-4786.

Traveling to the United States

If you are in the travel business outside of the United States and you are interested in the United States as a travel destination, the U.S. Travel Service offers help. It has six offices abroad in Mexico City, Toronto, London, Paris, Tokyo and Frankfurt that deal with local tour operators, retail agents and journalists to promote U.S. travel. Those who are not near one of these six offices can contact Washington directly. Contact: Marketing and Field Operations, Travel Service, Department of Commerce, Room 1859, Washington, DC 20230/202-377-4786.

Weather

See "Meteorological Center" in this section.

Weather Forecast Messages

In most major cities the National Weather Service has recorded messages on everything from the weather at local recreation areas to two-day forecasts in 20 major cities in the United States. In the white pages of the phone book, look under U.S. Government, then Department of Commerce, then National Oceanic & Atmospheric Administration, *then* the National Weather Weather Service. The numbers for the Washington, DC area:

Aviation Forecast/202-347-4950
Marine Forecast/301-899-3210
MD-VA-DEL five-day forecast/301-899-3240
Ten Eastern Cities/301-899-3244
Ten Western Cities/301-899-3249
General Weather Information for Washington, DC
 area/202-936-1212

Weather Maps

The National Oceanic and Atmospheric Administration publishes a weekly series of daily weather maps. Annual subscriptions are available for $16.50 from Superintendent of Documents, Government Printing Office, Washington, DC 20402/202-783-3238.

The National Oceanic and Atmospheric Administration (NOAA) also has two services for transmitting weather graphics. NAFAX (National Facsimile Network) distributes to government and other users a comprehensive set of charts depicting analyses, prognoses and selected observed data. NAMFAX (National and Aviation Meterological Facsile Network) offers the same services as NAFAX but also includes international high-altitude aviation operations. Contact: National Weather Service Communications Division, W53, NOAA, Department of Commerce, 8060 13th St., Silver Spring, MD 20910/301-427-7737.

World Climate Data

The National Oceanic and Atmospheric Administration (NOAA) has world monthly surface climatological data for over 2,500 weather stations. Data for some stations go back to the mid-1700s. Contact: National Center for Atmospheric Research, NOAA, Department of Commerce, P. O. Box 3000, Boulder, CO 80303/303-494-5151.

How Can Department of Commerce Help You?

A staff of trained specialists is available to help the public with problems and information needs in the fields of business and economic development. This office is a great place to start in order to determine how the U.S. Department of Commerce can help you. They can also direct you to organizations outside of Commerce which may be helpful. Contact: Office of Business Liaison, Department of Commerce, 14th and Constitution Ave. N.W., Room 1066, Washington, DC 20230/202-377-3176.

Department of Defense

The Pentagon, Washington, DC 20301/202-697-5737

ESTABLISHED: September 18, 1947
BUDGET: $141,523,281,000
EMPLOYEES: 921,911*

MISSION: Provide the military forces needed to deter war and protect the security of our country. The major elements of these forces are the Army, Navy, Marine Corps and Air Force, consisting of about two million men and women on active duty, and two-and-one-half million members of the reserve components. Under the President, who is also Commander-in-Chief, the Secretary of Defense exercises direction, authority, and control over the Department of Defense.

Major Divisions and Offices

Department of the Army

Department of Defense, The Pentagon, Washington, DC 20310/202-697-8719.
Budget: $32,600,705,000
Employees: 297,936
Mission: Organize, train, and equip active duty and reserve forces for the preservation of peace, security and the defense of our nation; focus on land operations; administer programs aimed at protecting the environment, improving waterway navigation, flood and beach control, and water resource development; and support the National Civil Defense Program by providing military assistance to federal, state, and local government agencies, natural disaster relief assistance, and emergency medical air transportation services.

Department of the Air Force

Department of Defense, The Pentagon, Washington, DC 20330/202-695-4803.
Budget: $38,975,952,000
Employees: 226,320
Mission: Provides an Air Force that is capable, in conjunction with other armed forces, of preserving the peace and security of the United States.

*Employment estimate for Department of Defense does not include armed forces personnel.

Department of the Navy

Department of Defense, The Pentagon, Washington, DC 20350/202-697-5342.
Budget: $42,709,553,000
Employees: 276,723
Mission: Protects the United States by the effective prosecution of war at sea including with its Marine Corps component, the seizure of defense of advanced naval bases; supports as required the forces of all military departments of the United States; and maintains freedom of the seas.

1. United States Marine Corps

Commandant of the Marine Corps, Headquarters, United States Marine Corps, Washington, DC 20380/202-694-2500.
Budget: $3,046,301,000
Employees: 20,000
Mission: Provides Fleet Marine Forces of combined arms, together with supporting air components, for the seizure or defense of advanced naval bases and the conduct of land operations essential to the prosecution of a naval campaign; provides detachments and organizations for service on armed vessels of the Navy and provides security detachments for the protection of naval property at naval stations and bases; develops, in coordination with the other services, the tactics, techniques, and equipment for landing forces in

SECRETARY

DEPUTY SECRETARY

DEPARTMENT OF THE ARMY

DEPARTMENT OF THE AIR FORCE

DEPARTMENT OF THE NAVY
• UNITED STATES MARINE CORPS

ASSISTANT SECRETARY OF DEFENSE (MANPOWER, RESERVE AFFAIRS, AND LOGISTICS)
• DEFENSE LOGISTICS AGENCY

DEFENSE INVESTIGATIVE SERVICE

UNDER SECRETARY OF DEFENSE FOR RESEARCH AND ENGINEERING
• DEFENSE NUCLEAR AGENCY
• DEFENSE MAPPING AGENCY
• DEFENSE COMMUNICATIONS AGENCY
• DEFENSE ADVANCED RESEARCH PROJECTS AGENCY

DEFENSE INTELLIGENCE AGENCY

amphibious operations; prepares for wartime expansion; and performs such other duties as the President may direct.

Assistant Secretary of Defense (Manpower, Reserve Affairs and Logistics)

Department of Defense, The Pentagon Room 3E808, Washington, DC 20301/202-695-5254.
Budget: $1,300,000,000
Employees: 46,750

1. Defense Logistics Agency

Department of Defense, Room 3A150, Cameron Station, Alexandria, VA 22314/202-274-6115.
Budget: $1,256,000,000
Employees: 46,384
Mission: Provides effective economic support to the military services, other Defense components, federal civil agencies, foreign governments, and others as authorized, for assigned material commodities and items of supply, logistics services directly associated with the supply management function, contract administration services, and other support services as directed by the Secretary of Defense.

Defense Investigative Service

Department of Defense, Buzzard Point, 1900 Half St. S.W., Washington, DC 20324/202-693-1427.
Budget: $39,482,000
Employees: 1,540
Mission: Provides U.S. Department of Defense components, and other U.S. government activities, when authorized, with a single, centrally directed personnel security investigative service.

Under Secretary of Defense for Research and Engineering

Department of Defense, Washington, DC 20301/202-697-9111.
Budget: $1,034,500,000
Employees:

1. Defense Nuclear Agency

Department of Defense, Washington, DC 20305/202-325-7047.
Budget: $235,000,000
Employees: 625
Mission: Plans, coordinates, and supervises Defense efforts in nuclear weapons, including tests assessment, construction and management of simulation facilities, and field experiments.

2. Defense Mapping Agency

Department of Defense, U.S. Naval Observatory Building 56, Washington, DC 20305/202-254-4140.
Budget: $219,500,000
Employees: 7,997
Mission: Provides support to the Secreatry of Defense, the military departments, the Joint Chiefs of Staff, and other U.S. Department of Defense components, as appropriate, on matters concerning mapping, charting and geodesy.

3. Defense Communications Agency

Department of Defense, 8th St. and South Courthouse Rd., Arlington, VA 22204/202-692-0018.
Budget: $180,000,000
Employees: 1,592
Mission: Performs system engineering for the Defense Communication System (DCS) and ensures that the DCS is planned, improved, operated, maintained, and managed effectively, efficiently, and economically to meet the telecommunications requirements of the National Command Authorities, the Department of Defense and, as authorized and directed, other governmental agencies; provides system engineering and technical support to the National Military Command Systems and the Minimum Essential Emergency Communications Network; provides other engineering and technical support to the Worldwide Military Command and Control System; performs system architect functions for current and future Military Satellite Communication systems; provides analytical and automated data processing support to the Joint Chiefs of Staff, the Secretary of Defense and other Defense components; and procures leased communications circuits, services, facilities, and equipment for the U.S. Department of Defense, and other government agencies as directed.

4. Defense Advanced Research Projects Agency

Department of Defense, 1400 Wilson Blvd., Arlington, VA 22209/202-694-3007.
Budget: $400,000,000
Employees: 116
Mission: Manages high-risk, high-payoff basic research and applied technology programs in projects as may be designated by the Secretary of Defense; and selects and pursues revolutionary

technology developments that minimize the possibility of technological surprise and/or offer potential for major increases in national defense capability.

Defense Intelligence Agency
Department of Defense, The Pentagon, Washington, DC 20301/202-695-9977.
Budget: Not available
Employees: 2,502
Mission: Produces and disseminates defense intelligence to satisfy the intelligence requirements of the Secretary of Defense, the Joint Chiefs of Staff, and major components of the Department of Defense.

Major Sources of Information

Aberdeen Proving Ground
This facility provides research and development, production and post-production testing of components and complete items of weapons, systems, ammunition, and combat and support vehicles. Also tests numerous items of individual equipment in use Army-wide. The Proving Ground responds to written inquiries only. Contact: Commander, U.S. Army, Public Affairs Office (STEAP-10), Aberdeen Proving Ground, MD 21005.

Abuse and Fraud Reporting Hotline
For reporting alleged abuses and fraud in the Department of Defense, contact: Defense Hotline, The Pentagon, Washington, DC 20301/202-693-5080 or 800-424-9098.

Adjutant General
The Adjutant General is responsible for the development of Army policy and operational management of Army-wide administrative and community life support systems, including the Armed Forces Courier Service, the world-wide Army Publication System, Institute of Heraldry, all Army libraries, and casualty and memorial affairs. For information, contact: Department of the Army, The Adjutant General's Office, Department of Defense, The Pentagon, Room 2E532, Washington, DC 20310/202-695-0163.

Advanced Planning Briefings for Industry (APBIs)
These briefings are held periodically by the major subordinate commands of the Army Material Development and Readiness Command (DARCOM) to inform industry of the U.S. Army's requirements. These briefings are of interest to industrial executives, advance system planners, directors of development, engineering and production, and those concerned with the formulation of corporate long-range objectives. For information, contact: DARCOM Tri-Service Information Center, Department of the Army, Department of Defense, 5001 Eisenhower Ave., Alexandria, VA 22333/202-274-8948.

Aeronautical Research
Information is available on the procurement of exploratory and advanced research and development in the areas of air breathing; electric and advanced propulsion; fuels and lubricants; power generation: transmission and reception, including (above 15GC) molecular electronics, bionics, lasers, vehicle environment, photo materials and optronics, position and motion sensing devices, navigation, guidance, reconnaissance and avionics, and communications; flight dynamics, including structures; aerodynamics, aerothermodynamics, control displays and crew stations, aerodynamic accelerators and escape, alighting and orbital attachment; airframe and equipment bearing, and flight testing techniques; material sciences, including metals and ceramics, non-metallic materials, and manufacturing technology; subareas of life support, including aerospace medicine and human performance, environmental effects, techniques and equipment for well-being, protection and performance enhancement in subareas of biodynamic forces and energies, altitude thermals, toxic hazards, bionics, and human engineering and training. Basic research in selected areas of applied mathematics, organic and inorganic radiation and molecular chemistry, plasma, atomic, theoretical; nuclear and solid state physics, metallurgy and ceramics, heat transfer, energy conversion and fluid dynamics. For information, contact: Directorate of Research and Development Contracting (ASD-PMR), Aeronautical Systems Division, Air Force Systems Command, Department of the Air Force, Department of Defense, Wright-Patterson Air Force Base, OH 45433/513-255-2358.

Aeronautical Systems
This office develops and acquires aeronautical

systems, subsystems, their components and related government-furnished aerospace equipment (GFAE), including, but not limited to, aircraft engines, aircraft wheels and brakes, airborne communications systems, aircraft bombing and navigation systems, aircraft instruments, aeronautical reconnaissance systems, subsystems, special reconnaissance projects and interpretation facilities. Contact: Aeronautical Systems Division, Air Force Systems Command, Department of the Air Force, Department of Defense, Wright-Patterson Air Force Base, OH 45433/513-255-2014.

Aerospace Center—Defense Mapping Agency

This center provides mapping, charting and geodetic products and services to the U.S. Armed Forces and other government agencies. Its products and services include aeronautical charts, digital data, flight information, publications, space mission charts and a wide spectrum of technical data about the earth and its aerospace environments vital to navigation on a worldwide basis. DMAAC products are available to the public through: Distribution Division, Office of Aeronautical Charting and Cartography, National Ocean Survey, NOAA, Department of Commerce, Riverdale, MD 20840/310-436-6990. For general information, contact: Public Affairs Office, Defense Mapping Agency, Aerospace Center, Department of Defense, LOP, St. Louis AFS, MO 63118/314-268-4142.

Aerospace Medicine

Research and development is conducted in the life sciences, human factors, aerospace medicine, biosciences, biomedicine, behavioral sciences, space medicine, biotechnology, human engineering, human resources, aviation medicine, space biology and medical equipment. Contact: Aerospace Medical Division, Air Force Systems Command, Department of the Air Force, Department of Defense, Brooks Air Force Base, TX 78234/512-536-110.

Air Development Center

This Center acts as the principal Navy research, development, test, and evaluation center for Naval aircraft systems except aircraft-launched weapons systems. Contact: Naval Air Development Center, Department of the Navy, Department of Defense, Warminster, PA 18974/215-441-2456.

Air Force Art Collection

The actions and deeds of Air Force men and women are recorded in paintings which the Air Force puts on continual public display through traveling art shows. The collection includes paintings on World War I aerial combat and U.S. Army Air Force operations in England during World War II. Contact: Art and Museum Branch, Community Relations Division, Office of Public Affairs, Department of the Air Force, Department of Defense, The Pentagon, Room 4A120, Washington, DC 20330/202-697-6629.

Air Force Bands

For information on Air Force Bands, write to: Bands Branch, SAF-PACE, The Pentagon, Room 4A120, Washington, DC 20330/202-695-0019.

Air Force Casualties

For information on Air Force personnel missing in action or taken prisoner of war, contact: Casualty Assistance, Personnel HQ AFMPC, Randolph Air Force Base, TX 78150/512-652-3505.

Air Force History, Office of

This office manages the Air Force historical program. It publishes scholarly books, monographs and other studies, runs the Albert I. Simpson Historical Center (see listing in this section) and offers the Air Force History Fellowship Program. For a list of the publications and general information, contact: Office of Air Force History, Bolling Air Force Base, Building. 5681, Washington, DC 20332/202-767-5089.

Air Force Lithographs

For a listing of Air Force lithographs, mainly of aircraft, contact: DAVA-N-LGL, Norton Air Force Base, CA 92409/714-382-2394, or Government Printing Office, Washington, DC 20402/202-783-3238.

Air Force Motion Pictures

For information on motion picture film created or acquired by the Air Force and cleared for public distribution, contact: DAVA-N-LGL, Norton Air Force Base, CA 92409/714-382-2394. A film catalog, *Air Force Regulations 95-2, Vol. 2,* is available for $9.00 from the Government Printing Office, Superintendent of Documents, Washington, DC 20402/202-783-3238.

Air Force Museum

The Air Force Museum is the largest and oldest military aviation museum in the world. About 140 aircraft are on display including historical, experimental and presidential airplanes. Military uniforms, celebrities in uniform, and space exhib-

it are also shown. The research library at the museum has still photographs, books, drawings and other historical Air Force material. Contact: United States Air Force Museum, Department of Defense, Wright-Patterson Air Force Base, OH 45433/513-255-3284. For information on other Air Force museums, contact: Art and Museum Branch, Community Relations Division, Office of Public Affairs, Department of the Air Force, Department of Defense, The Pentagon, Room 4A120, Washington, DC 20330/202-697-6629.

Air Force Potential Contractor Program

This program provides state, county, and city government organizations the opportunity to obtain scientific and technical information needed to maintain their capabilities as developers and producers of military equipment. This program is specifically of military equipment. This program is specifically aimed at contractors who do not have an active U.S. Department of Defense contract but have a demonstrable capability to work for the U.S. Air Force. Contact: Contracting and Acquisition Policy, Research, Development and Acquisition, Department of the Air Force, Department of Defense, The Pentagon, Room 4B262, Washington, DC 20330/202-695-2128.

Air Force Report

This free annual report describes the Air Force programs. Contact: Office of Air Force Public Affairs, Department of Defense, The Pentagon, Room 4A120, Washington, DC 20330/202-697-2842.

Air Force Reserve

The Reserve trains and serves with active Air Force units. It also controls all active and reserve elements airlifting supplies to victims of hurricanes, tornadoes or other emergencies. Contact: Office of Air Force Reserve, Department of the Air Force, Department of Defense, The Pentagon, Room 5D323, Washington, DC 20330/202-697-1761.

Air Force Still Photographs

Some Air Force still photographs are available for duplication. For information, contact: DAVA Still Photo Depository (AF), Anacostia Naval Station, Building 168, NDW, Washington, DC 20374/202-433-2166.

Air Force Stock Footage

Stock footage of Air Force films is available from: DAVA-N-LGD, Morion Media Depository, Norton Air Force Base, CA 92409/714-382-2513.

Air Force Technical Publications

Technical publications are available from any one of the following offices:

Air Force Information for Industry Office, Air Force Wright Aeronautical Laboratories (AFWAL/TST), Wright-Patterson AFB, OH 45433/513-258-4259.

Air Force Information for Industry Office, 5001 Eisenhower Ave., Alexandria, VA 22333/202-274-9305

Air Force Information for Industry Office, 1030 East Green Street, Pasadena, CA 91106/213-792-3192

Air Force Force Logistics Needs

A compilation of those R&D programs that will result in a long-term improvement in operation and support costs. It contains proposed logistics-oriented research and development programs in ten major areas: systems design and development; acquisition; systems management; depot maintenance; field maintenance; supply; transportation; personnel; meteorology; and energy management.

Manufacturing Technology Planning Information

Estimates of long-range plans under consideration by the Manufacturing Technology Division of the Air Force Materials Laboratory. It provides manufacturing processes and techniques in advance of acquisition requirements.

Mission Element Need Statements (MENS)

Identifies a mission deficiency or technological opportunity within a mission area. A MENS is required for each new major system acquisition including system modifications which the U.S. Department of Defense component anticipates will cost in excess of $100 million in research, development, test and evaluation or $500 million in production.

Program Element Descriptive Summaries

Provide information on the Air Force research, development, testing and evaluation (RDT&E) program to congressional committees. They contain supporting data for budget estimates and summarize each program element within the Air Force RDT&E program.

Program Management Directive

The official Air Force management directive used to provide direction to the implementing and participating commands and to satisfy documentation requirements. It is used during the entire acquisition cycle to state requirements and request studies as well as to initiate, approve,

change, transition, modify or terminate programs.

R&D Planning Summaries

Prepared by all U.S. Department of Defense component organizations that direct, administer or perform RDT&E work. These documents contain summaries of planned R&D efforts at project and task levels in the following categories: research, exploratory development, advanced development, engineering development, operational system development, management and support. These summaries may be used to identify RDT&E programs in certain scientific or technical areas for a specific budget year.

Research Planning Guide

An annual that consists of research objectives categorized by seven technical areas. Each objective contains a short description of its scope, midterm requirements, the long-term requirements, and points of contact from which any additional technical information may be obtained.

Tactical Air Forces Integrated Information Systems (TAFIIS) Master Plan

Provides in a single-source document the framework for the development of tactical command and control systems. It is intended to bring the operational, developmental, industrial and financial aspects of command and control together in a common document.

Technical Objective Documents

Compilations of technical planning objectives within a specific technical area which describe the technical effort that may satisfy an existing or anticipated Air Force goal. These documents try to stimulate academic, scientific and industrial organizations to participate in Air Force R&D programs by providing them with scientific and technical objectives toward which they can direct their research efforts.

Technology Needs Documents

Identify research and technology barriers to future Air Force systems. They contain specific items of research and technology required for the orderly development of systems, subsystems or capabilities. Each document normally contains a description of the problem and its order of priority.

Vanguard Planning Summary

Summarizes the long-range plans of the Air Force Vanguard System.

Work Unit Information Summaries

Brief descriptions of research and technology efforts currently in progress within the Air Force.

Air Logistics Center

This office conducts, tests and evaluates aircraft weapons systems and their components. Contact: Naval Aviation Logistics Center, Patuxent River, MD 20670/301-863-3997.

Air National Guard

The Air National Guard assists the Air Force in its fighting capabilities with flying and specialized ground support. On a state level, the Guard also protects lives and property while preserving peace and public safety during disasters, civil disorders, and other emergencies. Contact: National Guard Bureau, Department of the Air Force, Department of Defense, The Pentagon, Room 2E394, Washington, DC 20310/202-697-2430.

Air Propulsion Test Center

This Center tests and evaluates air-breathing and gas-turbine propulsion systems, components, accessories, fuels, and lubricants. Contact: Naval Air Propulsion Test Center, Department of the Navy, Department of Defense, Trenton, NJ 08628/609-896-5600.

Air Research

Research and development is conducted in surveillance, electronic intelligence, communications, computer and data processing techniques, textual data processing, intelligence extraction from aerial reconnaissance, data presentation, high-power electromagnetic generators, receivers, transmission line components, microelectronics applications, reliability and maintainability, survivability, propagation, vulnerability reduction, electronic countermeasures, and electromagnetic weapons. Contact: Small Business Office (BC), Rome Air Development Center, Air Force Systems Command, Griffiss Air Force Base, NY 13411/315-330-4020.

Albert F. Simpson Historical Center

This is the principal repository for Air Force historical records. It holds the most extensive collection of documentary source material in the history of U.S. military action in the country. The Historical Reference Branch maintains the Center's document and microfilm collection and provides research services. Contact: Albert F. Simpson Historical Research Center, (AFSHRC/HD), Maxwell Air Force Base, AL 36112/205-293-5958.

American Forces Information Service

This Service provides information, through print and audiovisual products, to U.S. Depart-

ment of Defense personnel, including the Armed Forces abroad. It oversees the production of Defense newspapers and periodicals, and information and entertainment radio and television activities on Armed Forces Radio and Television. Contact: American Forces Information Service, 1735 N. Lynn Street, Arlington, VA 22209/202-696-5285.

American Forces Publications

Defense 82 is a monthly publication for $13 per year that provides official and professional information on matters related to Defense policies, programs and interests. On sale from the U.S. Government Printing Office, Superintendent of Documents, Washington, DC 20402/202-483-3238. For information on the publication, contact: American Forces Press Service, Armed Forces Information Service, Department of Defense, 1735 N. Lynn St., Arlington, VA 22209. 202-696-5268.

Amnesty and Deserter Policies

For information on amnesty programs, contact: Office of the Assistant Secretary of Defense, (MRA and L-MPFM, Legal Policy), The Pentagon, Washington, DC 20301/202-697-3387. For information on deserter programs, contact: Military Personnel Policy and Force Management, Manpower, Reserve Affairs and Logistics, Department of Defense, The Pentagon, Room 3C980, Washington, DC 20301/202-697-9283.

Annual Report

The U.S. Department of Defense Annual Report describes all Defense programs and provides numerous breakdowns of the Defense budget. Available for $9.00 from U.S. Government Printing Office, Superintendent of Documents, Washington, DC 20402/202-783-3238.

Aquatic Plant Control

Technical information is available to help control obnoxious aquatic plants in rivers, harbors, and allied waters. The program deals with weed infestations of major economic significance including such weeds as water hyacinth, alligatorweed elodea, watermilfoil, and others that constitute a known problem of economic importance in the area involved. Contact the nearest U.S. Army division or District Engineer or Director of Civil Works, Army Corps of Engineers, Department of the Army, Department of Defense, 20 Massachusetts Ave. N.W., Room 6223, Washington, DC 20314/202-272-0247.

Armament Research

For information on the procurement of research, development and test related to the evaluation of guns and other aircraft weapons, new explosives, non-nuclear munitions, bomb warheads, chemical-biological weapons, dispensers, target, and scorers, equipment and the application of equipment or new techniques for counterinsurgency operations, testing of Air Force tactics and techniques, test ranges for aircraft and missile systems testing and an electromagnetic test environment for ECM and ECCM, contact: armament Development and Test Center, Air Force Systems Command, Department of the Air Force, Department of Defense, Eglin Air Force Base, FLA 32542/904-882-2843.

Armed Forces Health Professions Scholarship Programs (H&E)

A total of 5,000 scholarships are available for award to eligible persons attending accredited educational institutions providing training in approved health professions. The Army, Navy and Air Force each processes applications for their own participants in the program. For general information, contact: Deputy Assistant Secretary of Defense (HPPS), Department of Defense, The Pentagon, Room 1b657, Washington, DC 20301/202-694-4705. A student may apply to one, two, or all three military departments. Contact: Commander, Army Medical Department, Personnel Support Agency, Department of the Army, AttN: SGPE-PD, 1900 Half St. S.W., Room 6319, Washington, DC 20314/202-693-6160. Or Commander, Navy Recruiting Command, 4015 Wilson Blvd., Room 200, Arlington, VA 22203/202-696-4181. Or United States Air Force (USAFRS/RSH) Recruiting Service, Medical Recruiting Division, Randolph Air Force Base, TX 78148/512-652-2490.

Arms Transfer Management Group

The Arms Transfer Management Group advises the Secretary of State, National Security Council, and the President in matters relating to conventional arms transfers. It provides recommendations in the following specific functional areas: provision of systematic and comprehensive policy oversight in the arms transfer field; review of security assistance plans and programs to ensure that they support overall U.S. policies; and preparation of annual program funding levels. Contact: Undersecretary of State for Security Assistance, Science, and Technology, Department of State, Washington, DC 20520/202-632-0004.

Army Armament Materiel Readiness Command (APRCOM)

This office is responsible for integrated materiel readiness management, including follow-on procurement, production, engineering in support of production, industrial management, product

assurance, maintenance value and logistics engineering, international logistics, and transportation and traffic management of various Army weapons systems. ARRCOM has responsibility of managing conventional ammunition for the U.S. Department of Defense, and also controls over four arsenals, 26 government owned contractor-operated army ammunition plants (AAP), and three government owned-and-operated AAP activities. Contact: Army Armament Material Readiness Command (ARRCOM), Rock Army Armament Materiel Readiness Command (ARRCOM), Rock Island, IL 61299/309-794-6001.

Army Armament Research and Development Command (ARRADCOM)

This office is responsible for the management of research, development, life-cycle engineering, product assurance, initial acquisition through transition to the U.S. Army Armament Materiel Readiness Command and surety of various nuclear and non-nuclear weapons and ammunition and special tools and test equipment which are a part of or used with assigned materiel. Contact: Army Armament Research and Development Command, Dover, NJ 07801/201-328-4021.

Army Artists

Photos of paintings by Army artists are available through the Defense Audio-visual Agency. For information on what is available, contact: Army Art Activity, Army Center of Military History, Department of the Army, 5001 Eisenhower Ave, Room G2W18, Alexandria, VA 22333/202-274-8290. For information on prices, contact: DAVA, Still Photo Depository Activity, The Pentagon, Room 518, Washington, DC 20310/202-697-2806.

Army Assets

The Department of the Army has a variety of assets available for participation in activities in the public domain. These assets are used to increase public understanding of the Army's role in national security and assist total Army recruiting and retention. A Public Affairs Office is available at most of the major Army installations throughout the United States to assist in determining the availability and propriety of participation. These assets include, but are not limited to, color guards, drill teams, parachute teams, demonstrations, installation tours, guest speakers, static displays (including weapons, vehicles and aircraft), marching units, bands and other musical units, and exhibits. Contact: Community Affairs Branch, Chief of Public Affairs, Department of the Army, Department of Defense, The Pentagon, Room 2E631, Washington, DC 20310/202-697-2707.

Army Aviation Research and Development Command

This office is responsible for research and development of new helicopter systems, support of qualification testing of turbine engines, development and evaluation of prototype hardware for fueling and defueling equipment for use in combat areas and solving of fuel contamination problems. Contact: Army Aviation Research and Development Command (AVRADCOM), Department of the Army, Department of Defense, St. Louis, MO 63166/314-263-3901.

Army Community Service Program

This is a community-oriented social service program designed to assist service members and their families. Some of the services include: information and referral, financial planning and assistance, relocation, handicapped dependents' assistance, child-support services and child advocacy programs to prevent child abuse and neglect. Contact: Community Services Division, Community Support Directorate, Office of the Adjutant General, Department of the Army, 2461 Eisenhower Ave. Room 1408, Alexandria, VA 22331/202-325-9390.

Army Computer Systems Selection and Acquisition Agency

This office performs automated data, processing equipment evaluation, provides Army-wide technical support in the selection, acquisition and installation of the equipment. Contact: Army Computer Systems Selection and Acquisition Agency, Department of the Army, 2461 Eisenhower Ave., Room 954, Alexandria, VA 22331/202-325-9490.

Army Corps of Engineers Civil Works Program

The Corps's civil works program provides a broad range of water resources development and management projects. It has constructed major dams, levees, harbors, waterways and locks throughout the United States. Contact: Civil Works, Army Corps of Engineers, Department of the Army, Department of Defense, 20 Massachusetts Ave. N.W., Room 7227, Washington, DC 20314/202-272-0099.

Army Corps of Engineers, Audio-Visual Materials and Exhibits

The Corps produces and makes available to the general public informational films on subjects that include navigation, flood control, hydroelectric power, recreation, emergency operations

management, environmental enhancement and boating safety. Requests for loan of these films should be sent to: Modern Talking Picture Service, Inc., 5000 Park St. N., St. Petersburg, FLA 33709/813-541-7571, or contact: Public Affairs, Army Crops of Engineers, Department of the Army, Department of Defense, 20 Massachusetts Ave. N.W., Room 8122C, HQDA (DAEN-PAV), Washington, DC 20314/202-272-0017.

Various exhibits and audiovisual presentations produced by the Corps are available for touring. For short, descriptive lists and information, contact the same address as above. 20 Massachusetts Ave. N.W., Room 8122C, HQDA (DAEN-PAV), Washington, DC 20314/202-272-0017.

Army Corps of Engineers, Military Research and Development

The military research and development conducted by the Corps of Engineers include binary munitions for engineer obstacles and demolitions; realistic battlefield environmental conditions that affect tactical operations and weapons systems; rapid repair and restoration of bomb-damaged runways; computer-aided architectural and engineering design system; and energy analysis system for estimating fuel consumption in buildings. Contact: Military Programs, Research and Development, Army Corps of Engineers, Department of the Army, Department of Defense, 20 Massachusetts Ave. N.W., Room 6208, Washington, DC 20314/202-272-0259.

Army Corps of Engineers, Permits

A Corps permit is required if you plan to locate a structure, excavate or discharge dredged or fill material in waters of the United States, or if you plan to transport dredged material for the purpose of dumping it into ocean waters. Contact District Engineer Offices for current information about nationwide and general permits, or Regulatory Functions Branch, Army Corps of Engineers, Department of the Army, Department of Defense, 20 Massachusetts Ave. N.W., Room 6235, Washington, DC 20314/202-272-0199.

Army Corps of Engineers, Publications

Free pamphlets and brochures on the Corps programs are available, including *The Genesis of the United States Army Corps of Engineers,* a sketch of events from 1775 to 1978. A list of Corps publications on a wide variety of subjects, including archaeology, bicycle trails, camping, canoeing, environment, erosion control, flood control, flood plain management, games for children, history, hunting guides, safety, waste-water treatment and water supply is also available. Contact: Public Affairs, Army Corps of Engi-

neers, Department of the Army, Department of Defense, 20 Massachusetts Ave. N.W., Room 8137, Washington, DC 20314/202-272-0011.

Army Corps of Engineers, Training Programs for Foreign Participants

The Corps conducts training programs in the U.S. in the field of water resource development and related activities such as river basin planning, flood protection, beach erosion control and shore protection, hydroelectric power generation, improvement of waterways for navigation and construction management. The training programs may be long-term, on-the-job training, short-term observation, academic study at a university or research institution and practical training with the Corps's activities or other Federal agencies. For program information, contact: Foreign Programs, Army Corps of Engineers, Department of the Army, Department of Defense, 20 Massachusetts Ave. N.W., Room 8236, Washington, DC 20314/202-272-0006.

Army Films

For Army films available to the public, contact: Audio-Visual, Public Affairs, Department of the Army, Department of Defense, The Pentagon, Room 2E641, Washington, DC 20310/202-695-3007.

Army Library

This is the U.S. Department of Defense Library funded by the Army. For information on its holdings, contact: Army Library, The Pentagon, Room 1A518, Washington, DC 20310/202-697-4301.

Army Materials and Mechanics Research Center

This center manages and directs portions of the U.S. Army Development and Readiness Command materials research program conducted within its own laboratories, including basic scientific research and research in metals and ceramics. It also coordinates the total materials research program of the U.S. Army Materiel Development and Readiness Command (DARCOM). Contact: Army Materials and Mechanics Research Center, Department of Defense, Watertown, MA 02172/617-923-5278.

Army Materiel Systems Analysis Activity

This office has the overall mission of providing a central technical capability for systems analysis within the Army Materiel Development and Readiness Command (DARCOM) and for continuing improvement in the total command-wide systems analysis activity. This includes the con-

duct of systems analysis studies, investigations, functions and activities; the evaluation of concepts and proposals on a DARCOM-wide base; and the advancement, improvement and dissemination of techniques and methods of systems analysis. Contact: Army Materiel Systems Analysis Activity, Department of Defense, Aberdeen Proving Ground, MD 21005/301-278-2432.

Army Parachute Team—The Golden Knights

The Golden Knights are the Army's official aerial demonstration team. As part of the Army's recruiting effort, they will participate in those civilian-sponsored events that meet with the Department's approval. Requests should be made at least 90 days prior to the event. Contact: Army Recruiting Support Center, Department of the Army, Department of Defense, Cameron Station, Building 6, Alexandria, VA 22314/202-274-6666.

Army Posture Statement

The Posture of the Army and the Department of the Army Budget Estimates Fiscal Year 1981 is a joint statement by the Secretary of the Army and the Chief of Staff of the Army. The statement has information on the status and direction of Army forces, the Army budget overview, and Army programs. It is available from: Community Relations Division, Public Affairs, Department of the Army, Department of Defense, The Pentagon, Room 2E631, Washington, DC 20310/202-697-5720.

Army Public Affairs

For information on Army programs, personnel and general data, contact: Media Relations Division, Office of Public Affairs, Department of the Army, Department of Defense, The Pentagon, Room 2E641, Washington, DC 20310/202-697-7589.

Army Publications

For information on Army publications, contact: Publications, Army Adjutant General Publications Center, Department of the Army, The Pentagon, Room 1B928, Washington, DC 20310/202-695-4739.

Army Recruiting

The U.S. Army Recruiting Command has a variety of recruiting-oriented traveling exhibits, including a mobile theater in an expandable van equipped for presenting multi-slide, multi-screen shows. Contact: Army Recruiting Support Center, Department of the Army, Department of Defense, Cameron Station, Building 6, Alexandria, VA 22314/202-274-5340.

Army Research and Development Projects

Personnel are available to provide technical consultation, guidance and information on current and long-range research and development projects. Among the planning documents available are:

R&D Planning Summaries—lists project title, objective and approach on project, arranged by subject.
DA Project Listing—contains five-year Development Plan. Classified.
U.S. Army Project Management List—provides command and program manager name, address and telephone number.
Descriptive Summaries of the U.S. Army Development, Test and Evaluation Program—provides a descriptive summary of each program element to be financed for the coming two years
Science and Technology Objective Guides (STOG)—the principal research, development, testing, and evaluation guidance document for science and technology.
Systematic Planning for the Integration of Defense Engineering and Research (Spider Chart)—relates the DARCOM-base technology program to Army Mission Areas and defines specific science and technology requirements.
Requirements Documents Listing—a monthly list of approved materiel actuaries.
Catalog of Approved Requirements Documents (CARDS)—lists operational capabilities objectives, currently approved materiel requirements, and materiel requirements deleted for the past 12 months.
Guide for Voluntary Unsolicited Proposals
U.S. Army Research Development and Planning Information

Office Location:

Army Technical Industrial Liaison Office (DRCLD-TILO), Hdq. DARCOM, 5001 Eisenhower Ave., Alexandria, VA 22333.

Army Reserve

The Army Reserve supports the Army contingency plans with units and people. It also conducts projects to improve the environment, work with youth groups and assist the elderly. For additional information on the Reserve's activities and services, contact: Chief, Army Reserve Headquarters, Department of the Army, DAAR-ZX, Washington, DC 20310/202-697-8619.

Army Speaker Programs

Speakers are provided for public audiences interested in presentations on Army matters. The speakers' bureau will arrange for senior Army officials or other appropriate persons to address meetings, conventions, etc. Contact: Speakers Branch, Community Relations Division, Office of the Chief of Public Affairs, Army, The Penta-

gon, Room 2E631, Washington, DC 20301/202-697-5720.

Arnold Engineering Development Center
This center has test laboratories in which atmospheric conditions, orbital, space flight and ballistic conditions can be simulated. Contact: Arnold Engineering Development Center, Air Force Systems Command, Department of the Air Force, Department of Defense, Arnold Air Force Station, TN 37389/615-455-2611, ext. 7843.

Automation and Communications
This office is responsible for all of the Army's Automated Telecommunication System. For information, contact: Assistant Deputy Chief of Staff for Operations and Plans (C4), Department of the Army, Washington, DC 20310/202-695-6604.

Aviation Research
Information is available on the research and development of new helicopter systems, support-of-qualification testing of turbine engines, improved Army aircraft support for extreme environments, prototype hardware for fueling and defueling equipment for use in combat areas and solutions to fuel contamination problems. Contact: Army Aviation Research and Development Command (AVRADCOM), Department of Defense, St. Louis, MO 63166/314-263-3901.

Avionics Center
This Center provides research and development on avionics and related equipment. Contact: Naval Avionics Center, Department of the Navy, Department of Defense, Indianapolis, IND 64218/317-359-8471.

Ballistic Missile Defense System Command
This office provides advanced research and development in the fields of radar, interceptors, optics, discrimination data processing, and other technical aspects of ballistic missile defense. Contact: Army Ballistic Missile Defense Systems Command, Department of Defense, P.O. Box 1500, Huntsville, AL 35807/205-895-5150.

Behavioral and Social Sciences
The U.S. Army Research Institute for Behavioral and Social Sciences conducts research for the military on educational and training methods and organizational effectiveness. It publishes reports and an index. Contact: Army Research Institute for the Behavioral and Social Sciences, Department of the Army, Department of Defense, 5001 Eisenhower Ave., Alexandria, VA 22333/202-274-8641.

Casualty Services
The Casualty Services Division is responsible for the Army casualty reporting and notification system worldwide. It also runs the survivor and next-of-kin assistance program. For information, contact: Casualty Services Division, Department of the Army, Hoffman Building, Room 920, Alexandria, VA 22331/202-325-7990. A casualty information number (202-325-7990) is available 24 hours a day, seven days a week.

Civil Engineering
This office is the principal Navy research, development, test and evaluation center for shore and sea-floor facilities and for support of Navy and Marine Corps construction forces. Contact: Naval Civil Engineering Laboratory, Naval Construction Battalion Center, Department of the Navy, Department of Defense, Port Hueneme, CA 93043/805-982-5336.

Civil Engineering Research
Research and development is conducted on civil engineering aspects systems hardware and techniques, including mobility shelters, environmental engineering, airbase survivability and vulnerability, and numerous other areas. Contact: Air Force Engineering Service Center, Air Force Engineering Service Center, Tyndall Air Force Base, Panama City, FLA 32403/904-283-6441.

Civil Works Research and Development
Civil works research and development programs conducted by the Army Corps of Engineers include effective solution or improvement of ice problems on waterways; reservoir water quality; wastewater management systems; coastal ecology; aquatic plant control and environmental impacts of developmental actions; and methods of assessing and designing for effects of earthquakes on dams, locks, floodwalls, and other hydraulic structures. Contact: Civil Works Program, Research and Development, Army Corps of Engineers, Department of the Army, Department of Defense, 20 Massachusetts Ave. N.W., Room 6208, Washington, DC 20314/202-272-0257.

Coastal Engineering Research Center
This office conducts research in the materials, utilities, energy, and structures of all buildings except those specifically designed for cold regions and systems-oriented research and development on the life-cycle requirements of military facilities and their management; integrates technological developments into construction; and develops procedures and technology to protect and enhance environmental quality during the course of

normal Army missions. Contact: Army Coastal Engineering Research Center, Office of the Chief of Engineers, Kingman Building, Fort Belvoir, VA 22060/202-325-7000.

Coastal Systems Center

This office performs research and development, tests and evaluation in support of naval missions and operations that take place primarily in the coastal (Continental Shelf) regions, including mine countermeasures, diving and salvage, coastal and inshore defense swimmer operations and amphibious operations. Contact: Naval Coastal Systems Center, Department of the Navy, Department of Defense, Panama City, FL 32407/904-234-4011.

Coastline Modification

The Army Corps of Engineers issues permits to those who want to modify coastline. Contact your district Engineer Office for permits and for information, or Regulatory Functions Branch, Army Corps of Engineers, Department of the Army, Department of Defense, 20 Massachusetts Ave. N.W., Room 6235, Washington, DC 20314/202-272-0200.

Cold Regions Research

Research is conducted on characteristics and events unique to cold regions, especially winter conditions including the design of facilities, structures and equipment and refining methods for building, traveling, living and working in cold environments. Contact: Army Cold Regions Research and Engineering Laboratory, Office of the Chief of Engineers, Department of Defense, P.O. Box 282, Hanover, NH 03755/603-643-3200, ext. 200.

Communications Command

This office is responsible for planning, engineering, installation, operation and maintenance of all assigned Army communications. Contact: Army Communications Command, Department of the Army, Department of Defense, Fort Huachuca, AZ 85613/602-538-2151.

Communications Research

Information is available on research, development and acquisition of communications tactical data and of command and control systems. Information is also available on research and development on the components and materials of electronic communications, such as integrated circuits, semiconductor devices, display devices, microwave and signal processing, power sources, wire and cable and test maintenance and diagnos-

tic equipment. Contact: Army Communications-Electronics Command (DRSELPCD), Department of Defense, Fort Monmouth, NJ 07703/201-532-1088.

Conscientious Objectors

For general information on conscientious objectors, including reclassification and discharge data, contact: Military Personnel and Force Management, Manpower Reserve Affairs and Logistics, Department of Defense, The Pentagon, Room 3C980, Washington, DC 20301/202-697-9525.

Construction Engineering

Research is conducted on coastal processes, waves, tides, currents, and coastal materials as they affect navigation, recreation, flood and storm protection, beach erosion control, and structures in the coastal zones. The ecological effects of the Corps's coastal zone activities are also studied. Contact: Army Construction Engineering Research Laboratory, Office of the Chief of Engineers, Department of Defense, P.O. Box 4005, Champaign, IL 61820/217-352-6511, ext. 400.

Consumer Programs

For information on Air Force consumer programs, which include disaster relief assistance, air shows, timber and timber product sales, use of public picnic areas, and water recreational facilities, contact: Community Relations Division, Office of Public Affairs, Department of the Air Force, Department of Defense, The Pentagon, Room 4A120, Washington, DC 20330/202-697-4008.

Contract Disputes

The Board of Appeals handles appeals of unusual difficulty, dispute or precedential significance regarding Defense contracts. Contact: Armed Service Board of Appeals, Department of Defense, 200 Stovall St., Alexandria, VA 22332/202-325-8000.

Correction of Air Force Records

The Air Force can take action to correct Air Force records in order to remove an error or to redress an injustice. For records information, contact: Air Force Board for the Correction of Military Records, Department of the Air Force, Department of Defense, The Pentagon, Room 5C868, Washington, DC 20330/202-697-6470.

Correction of Army Records

The Army can take action to correct Army re-

cords in order to remove an error or to redress an injustice. For information on the status of the application, contact: Army Board for Correction of Military Records, Department of the Army, Department of Defense, The Pentagon, Room 1E512, Washington, DC 20310/202-697-4254.

Correction of Naval Records
The Navy can take action to correct Naval or military records in order to remove an error or to redress an injustice. For information on the status of a case under consideration, contact: Status of Case Information, Board for Correction of Naval Records, Department of the Navy, Department of Defense, Columbia Pike and Arlington Ridge Rd., Room 2432, Arlington, VA 20370/202-694-1316.

Defense Advanced Research Projects Agency (DARPA)
DARPA supports research and technology development for multi-service applications and potential new defense missions. It pursues high-risk, high-payoff types of programs. Examples of these include research on continuous tracking of a Simulated Quiet Submarine; Aircraft Undersea Sound Experiment; Self-Initiated Antiaircraft Missile; Rapid Solidification Technology; Two-Color Focal Plane Array; Space Defense and Surveillance; and Cruise Missile Technologies. Contact: Defense Advanced Research Projects Agency, Department of Defense, 1400 Wilson Blvd., Arlington, VA 22209/202-694-3007.

Defense Audiovisual Material
For information on all U.S. Department of Defense audiovisual material, production, acquisition, operational, testing and evaluation, depository and distribution activities, contact: DAVA-N-LGLD, Norton Air Force Base, CA 92409/714-382-2394.

Defense Communication Publications
For an index to, and information on available publications from the Defense Communications Agency, contact: Publications, Defense Communications Agency, Department of Defense, 8th St. and S. Courthouse Rd., Arlington, VA 20305/202-692-6965.

Defense Contract Administration Service (DCAS)
This is a post-award service organization responsible for performing contract administration services, including production surveillance, quality assurance, industry security, financial services, disbursements and other post-award functions.

DCAS regions and management areas are located in the principal sectors of industrial concentration throughout the United States. For a listing of DCAS regional contacts and for further information, contact: Defense Logistics Agency, Deputy Director of Acquisition Management, Cameron Station, Alexandria, VA 22314/202-274-7091.

Defense Contract Audits
The Defense Contract Audit Agency performs all necessary contract audit functions for the U.S. Department of Defense. It provides accounting services to all Defense components responsible for procurement and contract administration. These services include evaluating the acceptability of costs claimed or proposed by contractors and reviewing the efficiency and economy of contractor operations. Contact: Defense Contract Audit Agency, Cameron Station, Building 4, Room 4A459, Alexandria, VA 22314/202-274-7328.

Defense Disposal Manual
This publication includes the policy and procedures for the disposing of Defense Department surplus property. Contact: Property Disposal Division, Defense Logistics Agency, Department of Defense, Cameron Station, Room 4C541, Washington, DC 20301/202-274-6765.

Defense Fuel
The Defense Fuel Supply Center publishes booklets describing the type, quantity and prices of petroleum fuel products purchased by the U.S. Department of Defense and other Federal agencies. Contact: Public Affairs, Defense Fuel Supply Center, Defense Logistics Agency, Cameron Station, Alexandria, VA 22314/202-274-6489.

Defense Intelligence Agency Publications
For a list of Defense Intelligence Agency unclassified publications, write to: Freedom of Information Services, Defense Intelligence Agency, Department of Defense, The Pentagon, RTS-2A, Washington, DC 20301/202-692-5766.

Defense Logistics Agency Films
For information on films available for public showing to present and potential contractors, contact: Headquarters, Defense Logistics Agency, Department of Defense, Cameron Station, Room 3C547, Alexandria, VA 22314/202-274-6075.

Defense Logistics Agency Introduction
This free publication describes the Agency's

operations, supply services, supply centers, defense depots, contract administration services and technical and logistics services. It tells how to do business with the Agency and lists major categories of material under the cognizance of each of the six supply centers. Contact: Public Affairs, Defense Logistics Agency, Department of Defense, Room 3A210, Cameron Station, Alexandria, VA 22314/202-274-6135.

Free publications from the Defense Logistics Agency include:

DLA Index to Forms
DLA Index to Publications
How To Do Business With the Defense Logistics Agency
An Identification of Commodities Purchased by the Defense Logistics Agency

Contact: DLA-XPD, Department of Defense, Cameron Station, Building 6, Door 26, Alexandria, VA 22314/202-274-6011.

Defense Management Journal
This quarterly publication is designed for the middle and senior management levels of the U.S. Department of Defense, industry and academia. It covers manpower, logistics, personnel, policy, research and development, and administration. Available for $9.00 per year from Superintendent of Documents, Government Printing Office, Washington, DC 20402/202-483-3238. For information, contact: *Defense Management Journal*, Defense Logistics Agency, Department of Defense, Cameron Station, Alexandria, VA 22314/703-325-0340.

Defense Mapping School
This school provides training to the military on mapping, geodesy, and charting. Subjects range from basic maps courses to geodetic surveying and terrain analysis. The school offers an apprenticeship program recognized by the U.S. Department of Labor. Contact: Defense Mapping School, Defense Mapping Agency, Department of Defense, Fort Belvoir, VA 22060/703-664-2383.

Defense Organizational and Functions Guidebook
This publication outlines the functions of the major components of the U.S. Department of Defense. Each functional statement cites the pertinent charter, which provides more detailed information on the authorities and responsibilities of each organization. An organizational chart is also available. Contact: Directorate for Organizational and Management Planning, De-

partment of Defense, The Pentagon, Room 3A326, Washington, DC 20301/202-697-9330.

Defense Research and Development
The U.S. Department of Defense Program for Research, Development and Acquisition is a statement by the Office of Defense Research and Engineering to the Congress in support of a budget request for defense research. It includes information on the major research and development areas, military equipment, international initiatives, strategic and tactical programs, and funding summaries. Contact: Public Affairs Information Office, Department of Defense, The Pentagon, Room 2E777, Washington, DC 20301/202-697-5737.

Defense Systems Management College
The College conducts advanced courses of study for military officers and civilian personnel in program management. It also disseminates information on new methods and practices in program management. The College publishes a bimonthly newsletter, *Program Manager*, and *The Defense Systems Management Review*, a quarterly publication. Both publications include articles and reports on policies, trends and events that affect program management and defense systems acquisition. Contact: Defense Systems Management College, Fort Belvoir, VA 22060/202-664-5082.

Department of the Navy Energy Fact Book
This book reviews the national and naval energy situation. It summarizes Navy energy research and development initiatives, and provides an in-depth description of the processes and developments related to the various energy sources. Available for $9.00 from Government Printing Office, Superintendent of Documents, Washington, DC 20402/202-783-3238.

Dependents Schools
These schools provide education from kindergarten through grade 12, to eligible minor dependents of military and civilian personnel of the U.S. Department of Defense stationed overseas. Contact: Department of Defense Dependents Schools, Department of Defense, 2461 Eisenhower Ave., Room 152, Alexandria, VA 22331/202-325-0188.

Descriptive Summaries
This is an annual summary of Air Force research and development programs presented annually to the Congress. The price varies each year. For information, contact: Management Pol-

icy Division, Research Development and Acquisition, Department of the Air Force, Department of Defense, The Pentagon, Room 4D314, Washington, DC 20330/202-697-6093.

Development and Readiness Command Publications

An Index of Army Development and Readiness Command (DARCOM) Administrative Publications is available from Publication Services, DARCOM Service Support Activity, Materiel Development and Readiness Command, Department of the Army, Department of Defense, 5001 Eisenhower Ave., Alexandria, VA 22333/202-274-9663.

Dictionary of American Naval Fighting Ships

This series presents brief histories, arranged alphabetically by name, of all ships commissioned in the U.S. Navy from 1775 to the present. Appendices include discussions and tabulated data on specific ship types, and other related subjects. For prices of individual volumes and to order, contact: Government Printing Office, Superintendent of Documents, Washington, DC 20402/202-783-3238.

Dictionary of Military and Associated Terms

This Dictionary is the U.S. Department of Defense bible for definitions of military terms. It also includes the NATO glossary. Available for $6.50 at the Superintendent of Documents, Government Printing Office, Washington, DC 20402/202-783-3238. For information, contact: Terminology Branch, Plans and Policy, Joint Chiefs of Staff, Department of Defense, Room 1D958, Washington, DC 20301/202-694-3081.

Directives and Instructions

For research and reference service on U.S. Department of Defense directives and instructions, and editorial service on all U.S. Department of Defense publications, contact: The Directives Division, Washington Headquarters Service, Department of Defense, The Pentagon, Room 2A286, Washington, DC 20301/202-697-4111. For free copies of the quarterly index, DoD Directives & DoD Instructions, contact: Naval Publications and Forms Center, Department of Defense, 5801 Tabor Ave., Philadelphia, PA 19120/215-697-3321.

Drug and Alcohol Abuse in the Military

The Office of Drug Abuse has identification, treatment and educational programs on drug and alcohol abuse. It also provides quarterly reports that include data on the number of people identified, rejected, discharged, tried and courtmartialed by the military. Contact: Office for Drug and Alcohol Abuse Prevention, Health Affairs, Department of Defense, The Pentagon, Room 3D171, Washington, DC 20301/202-695-6800.

DTIC (Defense Technical Information Center)

DTIC is the clearinghouse for the U.S. Department of Defense's collection of research and development in science and technology and covering subjects that range from aeronautics to zoology. The Center can answer three basic questions related to research, development, testing and evaluation: (1) What research is being planned? (2) What research is currently being performed? and (3) What results were realized by completed research?

There are four data bases at DTIC:

1. R&D Program Planning (R'DPP)—planned research at the project and task level.
2. R&O Work Unit Information System (WUIS) Data Base—a collection of technically oriented summaries describing research and technology projects currently in progress.
3. Technical Report (TR) Bibliographic Data Base—a collection of bibliographic citations of formally documented scientific and the technical results of Defense-sponsored R&D, testing and evaluation.
4. Independent Research and Development (IR&D) Data Base—describes the technical programs being performed by U.S. Department of Defense contractors as part of their independent research and development programs. This is considered proprietary information and is exempt from disclosure under the Freedom of Information Act.

DTIC services registered users only. For information on registration, see "DTIC—How Does a Potential User Become Eligible?" in this section.

DTIC Data Base Publications and Services

For information on any of the following, contact: Defense Technical Information Center (DTIC) Defense Logistics Agency, Department of Defense, Cameron Station, B St., Building 5, Alexandria, VA 22314/202-274-6871.

Technical Abstract Bulletin (TAB)—biweekly listing of all new classified and unclassified but limited scientific and technical reports received by DTIC.

Technical Abstract Bulletin Indexes—issued simultaneously with TAB to assist in identifying accessions of particular interest. Available in paper copy only, there are seven indexes: Corporate Author, Monitoring Agent, Subject, Title, Personal Author, Contract Number, Report Number, and Release Authority.

DTIC Digest—an unclassified publication consisting of four pages announcing plans, changes in services, new DTIC publications, and other developments in DTIC.

Automatic Document Distribution Programs—microfiche copies of newly accessioned reports selected according to a user's subject interest, published every two weeks.

Report (Demand) Bibliography—a tailor-made literature search on a particular subject conducted at the request of a user.

Current Awareness Bibliography Program—a customized, automated bibliography service based on the recurring subject needs of DTIC users.

Direct Response Bibiliography—a tailor-made response to a specific request.

Bibliography of Bibliographies—publicizes DTIC-scheduled bibliographies, also bibliographies received from military organizations and their educational and industrial contractors.

Technical Vocabulary

DTIC Retrieval and Indexing Terminology—used to index DTIC's scientific and technical literature.

Recurring Management Information System Reports—compiled monthly, quarterly, semiannually or annually from management information systems with formats designed by recipient organizations. They may be requested on a demand basis or with an automated receiving procedure.

Central Registry—a central file of user-authorized access to Defense scientific and technical information.

DTIC—How Does a Potential User Become Eligible?

DTIC provides a Joint Service Regulation called *Certification and Registration for Access to DoD Scientific and Technical Information.* This regulation assists organizations in determining their eligibility for services. It also outlines procedures for registration and includes an explanation of the various forms required to request services and other informational materials concerning programs, products and services offered by the Center. Contact: Defense Technical Information Center, Attn: DTIC-DDR-2, Cameron Station, Alexandria, VA 22314/202-274-6871.

DTIC Motion Picture

A 25-minute color film called *Your Partner in R&D* depicts DTIC operations, products and services. Film prints are available on a no-fee loan basis. Contact: Defense Technical Information Center (DTIC-V) Office of User Services, Cameron Station, Alexandria, VA 22314/202-274-6434.

DTIC Referral Data Base

This is a referral data base of information on specialized scientific and technical government-sponsored activities with the capability of serving the defense community. An unclassified directory is available from both DTIC and the National Technical Information Service. It includes information centers, specialized libraries, information exchanges and offices, data base depositories, laboratories, testing directories and similar research facilities. Each entry gives mission, subject areas, services and materials, publications issued, key personnel, access limitations, all updated and verified prior to publication of a new edition. Paper copy, $3.00; microfiche, $.95. Contact: DTIC, Defense Logistics Agency, Department of Defense, Cameron Station, B St., Building 5, Alexandria, VA 22314/202-274-6986.

DTIC Tours and Briefings

Visitors are welcomed to DTIC by a tour and briefing held the second Tuesday of every month at 9 A.M. Contact: Defense Technical Information Center (DTIC-V), Office of User Services, Cameron Station, Alexandria, VA 22314/202-272-6727.

Dugway Proving Ground

This facility conducts field and lab tests to evaluate chemical and radiological weapons and defense systems and materiel, as well as biological defense research. Contact: Dugway Proving Ground, Army Test and Evaluation Command (TECOM), Department of Defense, Dugway, UT 84022/801-522-2116.

Economic Adjustment

Economic adjustment programs are devised for alleviating the serious social and economic impact of major U.S. Department of Defense activities, such as base closures, establishment of new installations, conversion of in-house activities to contractual services, or cutbacks or expansion of activities. The Office of Economic Adjustment assists local communities, areas or states affected by U.S. Department of Defense actions. The following free publications are available:

Communities in Transition—Communities Response to Reduced Defense Activity
Acquiring Former Military Bases
Planning Civilian Reuse of Former Military Bases
Economic Recovery, Community Response to Defense Decisions to Close Bases.

Contact: Office of Economic Adjustment, Department of Defense, The Pentagon, Room 3E772, Washington, DC 20301/202-697-9155.

Electronics Research

For information on research and development

associated with communications, communications electronics, intelligence equipment, electronic warfare, aviation electronics, combat surveillance, target acquisition and night vision equipment, identification friend-or-foe systems, automatic data processing, radar (other than weapon use), meteorological and electronic radiological detection materiel, batteries and electric power generation equipment, contact: Army Electronics Research and Development Command (ERADCOM), Department of Defense, 2800 Powder Mill Rd., Adelphi, MD 20783/202-394-1076.

Electronic Systems Command

This office is responsible for the research and development, testing and evaluation for command, control, and communications of undersea and space surveillance; electronic warfare; navigational aids; electronic test equipment; and electronic materials, components and devices. For information contact: Naval Electronic Systems Command, Department of the Navy, Department of Defense, Washington, DC 20360/202-692-6413.

Electronics System Research

Research and development is conducted on command control systems and related equipment; systems for data collection, transmission and display; and the development of weapon command and executive control associated with Air Force aerospace operations. Contact: Electronics Systems Division, Air Force Systems Command, Department of the Air Force, Department of Defense, Hanscom Air Force Base, Bedford, MA 01731/617-861-4973.

Energy Conservation

This office maintains the Defense energy program, environmental and safety policy, and international civil emergency program; provides guidance to the military on the availability of petroleum; represents the U.S. Department of Defense on petroleum matters; conducts U.S. Department of Defense energy consumption studies; and provides information on energy conservation developments. Contact: Directorate for Energy Policy, Office of the Assistant Secretary of Defense, Manpower, Reserve Affairs and Logistics, The Pentagon, Washington, DC 20301/202-697-2500.

Engineer Museum

The U.S. Army Engineer Museum is open to the public. Its historical collection reflects the contributions of the Corps of Engineers. Contact: Army Engineer Museum, 16th St. and Belvoir Rd., Building 1000, Fort Belvoir, VA 22060/703-664-6104.

Equipping the Army of the Eighties

This is an annual statement to the Congress that describes the military hardware used by the Army. Available from: Research, Development and Acquisition, Department of the Army, Department of Defense, The Pentagon, 3E412, Washington, DC 20310/202-697-7975.

Explosive Ordnance Disposal

This office is responsible for research and development on the technology base for the consolidated U.S. Department of Defense explosive ordnance disposal (EOD) mission. It defines tool and technology requirements for the development program; it also conducts research and development on EOD tools and equipment for all the Armed Services. Contact: Naval Explosive Ordnance Disposal Technology Center, Department of the Navy, Department of Defense, Indian Head, MD 20640/301-743-4612.

Financing Foreign Military Sales

Foreign military sales financing is provided by the U.S. government in the form of either direct loans or guarantees of Federal Financing Bank loans to assist in the purchase by foreign governments of equipment and services through U.S. government channels or directly from contractors. Contact: Defense Security Assistance Agency, Department of Defense, The Pentagon, Room 4E841, Washington, DC 20301/202-695-3291.

Flight Test Center

The Center supports advanced development programs in four principal areas:

1. Flight testing and evaluation of all new aircraft planned for inventory production and aerospace research vehicles, including fixed wing, VTOL, STOL, lifting body, and other experimental manned flight vehicles.
2. Training experimental and aerospace research pilots.
3. Development, testing and evaluation of new parachutes (Personnel and Cargo), deceleration and retardation devices, and aerial delivery and recovery systems.
4. Development, testing, and evaluation of rocket propulsion systems, including static test of complete engines, and investigation and synthesis of new propellant formulations—liquid, solid, and hybrid.

Contact: Air Force Flight Test Center, Air Force Systems Command, Department of the Air Force, Department of Defense, Edwards Air Force Base, CA 93523/805-277-3510.

Flood Plain Management

The Army Corps of Engineers provides information, guidance, and technical assistance to nonfederal groups in developing regulations for flood plain use. The flood plain management services help communities understand the extent and magnitude of the flood hazards in their areas. Contact: Flood Plain Management, Civil Works, Army Corps of Engineers, Department of the Army, Department of Defense, 20 Massachusetts Ave. N.W., Room 7215, Washington, DC 20314/202-272-0169.

Foreign Area Studies Series

This is a series of books that deal with a particular foreign country, describing and analyzing its economic, military and political and social systems and institutions, and the ways they are shaped by cultural factors. Origins and traditions of the people and their social and national attitudes are featured. For a list of the books and prices, contact: the Government Printing Office, Superintendent of Documents, Washington, DC 20402/202-783-3238.

Foreign Military Affairs

For information on negotiating for U.S. military installations, properties, and personnel in foreign countries, contact: Foreign Military Rights Affairs, International Security Affairs, Department of Defense, The Pentagon, Room 4D830, Washington, DC 20301/202-695-6386.

Foreign Military Sales (FMS) Program

This program sells defense articles, and defense services to foreign governments. Contact: Defense Security Assistance Agency, Department of Defense, The Pentagon, Room 4E841, Washington, DC 20301/202-695-3291.

Foreign Military Sales and Military Assistance (FACTS)

This free annual publication includes information and statistics on the Foreign Military Sales (FMS), the Military Assistance (MAP), and the INternational Military Education and Training programs. Contact: Data Management Division, Defense Security Assistance Agency, Department of Defense, The Pentagon, Room 4B659, Washington, DC 20301/202-697-3574.

Foreign Programs of the Army Corps of Engineers

The Corps's experience and expertise in construction, management and planning is made available to foreign countries. Its projects have included the design and supervision of the construction of part of Afghanistan's highways; re-habilitation of the port of Inchon in Korea; and help in developing a public works program in the Congo. Its current major effort is building army installations, naval bases, and a military academy in five major training centers in Saudi Arabia. Other Corps services include: development of conceptual plans; comprehensive planning and studies; project planning, programming, and feasibility studies; engineering design and construction management; supervision of contract to ensure a quality end product; selection of qualified architect-engineers; advertising and awarding competitive construction contracts; training host nation personnel in the operation and maintenance of completed facilities on-site and in managing design and construction; training of friendly nations' specialists in the United States; consultation on the application of new technology; and assessment of environmental impacts. Contact: International Programs, Army Corps of Engineers, Department of the Army, Department of Defense, 20 Massachusetts Ave. N.W., Room 8236, Washington, DC 20314/202-272-0006.

Freedom of Information

For a list of Freedom of Information contacts within the Department of Defense and the three services, contact: Office of Public Affairs, Freedom of Information and Security Review, Department of Defense, The Pentagon, Room 2C757, Washington, DC 20301/202-697-1180. See also "Freedom of Information Act."

Grants

The programs described below are for sums of money given by the federal government to initiate and stimulate new or improved activities or to sustain on-going services.

Military Construction, Army National Guard

Objectives: To provide a combat-ready reserve force and facilities for training and administering the Army National Guard units.

Eligibility: The state National Guard unit must be federally recognized, and the state must provide real estate for armory projects.

Range of Financial Assistance: $1,000 to $3,500,000.

Contact: Chief, Army Installations Division, National Guard Bureau, Pentagon, Washington, DC 20310/202-697-1732.

Military History Grants

Objectives: Assist research in military history.

Eligibility: Educational institutions and scholars.

Range of Financial Assistance: Up to $500.

Contact: Historical Services, Army Military History Institute, Department of Defense, Carlisle Barracks, PA 17013/717-245-4113.

Help to Local Governments

For information on specialized or technical services provided by the U.S. Department of Defense to state and local governments, contact: DoD Washington Headquarters Services, Directorate for Information Operations and Reports, Manpower Management Information Division, The Pentagon, Room 1C535, Washington, DC 20301/202-695-6815.

Historical Budget Data Book

This annual free publication provides a concise array of historical budget data for fiscal year 1974 through the present, broken down by Navy program. Contact: Office of the Comptroller of the Navy, NCB322, Washington, DC 20350/202-697-7819.

Honorary Awards to Private Citizens and Organizations

The U.S. Department of Defense honors private citizens and organizations in recognition of significant achievements that have benefitted one or more Defense components or the U.S. Department of Defense as a whole. Among the awards presented are: U.S. Department of Defense Medal for Distinguished Public Service; Secretary of Defense Award for Outstanding Public Service; and the U.S. Department of Defense Meritorious Award. Contact: Civilian Personnel Policy, Manpower and Reserve Affairs, Department of Defense, The Pentagon, Room 3D265, Washington, DC 20301/202-697-5421.

Human Engineering

For information on life sciences regarding human factors capabilities and limitations, and human factors engineering applications in relation to Army materiel, contact: Army Human Engineering Laboratories, Department of Defense, Aberdeen Proving Ground, MD 21005/301-278-4648.

Hydroelectric Energy

The Army Corps of Engineers builds and operates hydroelectric power plants in connection with large multipurpose dams. The power is sold through the U.S. Department of Energy. The Corps continues to increase production from its existing dams by adding new units and by using pumped storage. *Hydropower: The Role of the U.S. Army Corps of Engineers* is a free pamphlet that describes hydroelectric projects and lists their locations and functions. Contact: Civil Works Program, Army Corps of Engineers, Department of the Army, Department of Defense, 20 Massachusetts Ave. N.W., Room 8137, Washington, DC 20314/202-272-0011.

Hydrographic/Topographic Center—Defense Mapping Agency (DMA—HTC)

This center provides mapping, charting and geodetic products and services to the military and navigators in general on the world oceans. It also gathers and processes vast amounts of information about the earth for precise navigation purposes. Contact: DMA Hydrographic/Topographic Center, Department of Defense, PAO, Washington, DC 20315/202-227-2006.

Independent Research and Development— TriService Industry Information Center

Contractors who want to recover the cost of their independent research and development must submit annually a technical plan describing their projects. For information and technical guidelines, contact: TriService Industry Information Center, Materiel Development and Readiness Command, Department of the Army, Department of Defense, 5001 Eisenhower Avenue, Room 8S58, Alexandria, VA 22333/202-274-8948.

Industrial Personnel Security Clearance

The Defense Industrial Security Program provides clearances for industrial facilities and industrial personnel. Inspections are conducted annually to assist contractors to establish and maintain information security systems adequate for the protection of classified information. The Defense Industrial Security Clearance Office determines the eligibility of contractor personnel for access to classified information belonging to the U.S. international treaty organizations and to foreign governments. Contact the regional offices or Defense Investigative Service, Director for Industrial Security, 1900 Half St. S.W., Washington, DC 20324/202-693-1264, or Defense Investigative Service, Defense Industrial Security Clearance Office (S0800), P. O. Box 2499, Columbus, OH 43216/614-236-2133.

Industrial Security Education

The Defense Industrial Security Institute presents courses of instruction, both resident and extension, on industrial security. Contact: Defense Investigative Service, Defense Industrial Security Institute, c/o Defense General Supply Center, Richmond, VA 23297/804-275-4891.

Institute of Heraldry

The Institute of Heraldry is responsible for the

design, sculpture, development and quality control of heraldic items. It is involved from the concept of design to introduction of items into the federal supply system. It is also concerned with the Department of the Army policy governing flags and other heraldic items (except those worn on uniforms). Heraldic items include decorations, medals, badges, all types of insignia, lapel devices, flags, streamers, and other items of symbolic nature that are worn or displayed. Contact: The Institute of Heraldry, Army, Department of Defense, Cameron Station, Building 15, Alexandria, VA 22314/202-274-6632.

InterAmerican Geodetic Survey (IAGS)

IAGS was founded to assist Latin American cartographic agencies in performing surveys and producing maps and charts. The training includes classes at the School and on the job covering areas such as geodesy, surveys, photogrammetry, cartography, lithography, photography and computer science. Contact: Inter-American Geodetic Survey Liaison Office, c/o DMA Hydrographic/Topographic Center, Department of Defense, Washington, DC 20315/202-227-2516.

International Exchange of Patents

For information on the International Interchange of Patent Rights and Technical Information, contact: Intellectual Property Division, Office of the Judge Advocate General, Department of the Army, Department of Defense, The Pentagon, Room 2D444, Washington, DC 20310/202-695-6822.

International Military Education and Training Program (IMET)

This program provides training to foreign personnel as a grant aid. Contact: Defense Security Assistance Agency, Department of Defense, The Pentagon, Room 4E837, Washington, DC 20301/202-695-7976.

Jefferson Proving Ground

This facility processes, assembles, and accepts testing of ammunition and ammunition components, and receives, stores, maintains and issues assigned industrial stocks, including calibrated components. Contact: Jefferson Proving Ground, Army Test and Evaluation Command (TECOM), Department of Defense, Madison, IN 47250/812-273-7211.

Joint Chiefs of Staff

The principal military advisors to the Secretary of Defense, the President and the National Security Council. The Joint Chiefs prepare plans and provisions for the strategic direction of the Armed Forces including the direction of operations conducted by commanders of unified and specified commands. Contact: Public Affairs, Joint Chiefs of Staff, Department of Defense, The Pentagon, Room 2E838, Washington, DC 20301/202-697-4272.

Joint Chiefs of Staff History

For information on Joint Chiefs of Staff history, contact: Historical Division, Joint Chiefs of Staff, Department of Defense, The Pentagon, Room 1A714, Washington, DC 20301/202-697-3088.

Licenses for Army Patents

The Army grants licenses under government-owned, Army-administered patents. For further information, contact: Intellectual Property Division, Office of the Judge Advocate General, Department of the Army, Department of Defense, The Pentagon, Room 2D444, Washington, DC 20310/202-695-6822.

Licenses for Navy Patents

The Navy grants licenses under government-owned, Navy-administered patents on a nonexclusive, revocable, royalty-free, nontransferable basis to any American citizen or business entity capable of introducing the invention into commercial use. Contact: Director, Navy Patent Program, Patent Counsel for the Navy, Office of Naval Research, Department of the Navy, Department of Defense, 800 North Quincy St., Arlington, VA 22217/202-696-4000.

Map of Military Installations in the United States

This map is available for $2.55 at the Defense Mapping Agency, Office of Distribution Services, Attn: DDCP, Washington, DC 20315/202-227-2534.

Maps and Charts— Defense Mapping Agency

A price list and general information on maps and charts produced by the Defense Mapping Agency is available from: Defense Mapping Agency, Office of Distribution Services, U.S. Department of Defense, Washington, DC 20315/202-227-2816.

Marine Corps Casualty and Missing in Action Information

For casualty and missing-in-action information

on Marine Corps personnel, contact: Casualty Section, Personnel Service Division, Marine Corps, Headquarters, Arlington Navy Annex, Building #4, Washington, DC 20380/202-694-1787.

Marine Corps Band

For information on the Marine Corps Band and their schedules, contact: Marine Band (Mar-Band) Affairs, Division of Public Affairs (PAB), Headquarters, Marine Corps, Washington, DC 20380/202-694-3502.

Marine Corps Community Relations

For information on Marine Corps community projects and activities, contact: Community Relations Branch, Marine Corps, Department of the Navy, Department of Defense, Room 1133, Washington, DC 20380/202-694-4080.

Marine Corps Information

For general information on Marine Corps programs, contact: Public Affairs Headquarters, Marine Corps, Department of Defense, Washington, DC 20380/202-694-4309.

Marine Corps Museum

The museum exhibits illustrate through the use of uniforms, weapons and other military equipage, graphics, contemporaneous art, and documents a chronological review of the Marine Corps' role in American history. Contact: The Marine Corps Museum, Marine Corps Historical Center, Washington Navy Yard, 9th and M Sts. S.E., Washington, DC 20374/202-433-3534. A number of additional study collections are located at the Museum's ordnance and technology storage and exhibit facility at Quantico. They include a definitive collection of automatic weapons, uniforms, historic flags and infantry weapons. These collections can be studied by appointment only: Marine Corps Museums Activities, Marine Corps Development and Education Command, Quantico, VA 22134/703-640-2606.

Marine Corps Posture, Plans and Programs Statement

This booklet describes Marine Corps programs, personnel and budget. For a copy, contact: Public Affairs Headquarters, Marine Corps, Department of Defense, Washington, DC 20380/202-694-4309.

Marine Corps Reserve

The Reserve provides units for rapid mobilization and deployment, reinforcing and augmenting active units, and providing air-ground forces of various strengths. In addition to mission-oriented training, specialized training in certain skills is provided through schools and colleges. Contact: Marine Corps Reserve Division, Marine Corps, Headquarters, Department of the Navy, Department of Defense, Navy Annex, Room 1114, Washington, DC 20380/202-694-1161.

Marine Corps Still Photo Archives

The Marine Corps holds about 600,000 still photos dating from December 1941 to the present. The Archives are open to the public. For information, contact: Marine Corps Still Library, Building 168, NDW, Washington, DC 20374/202-433-2168.

Medical Museum

This museum contains specimens representing practically all diseases that affect man, as well as an extensive collections of medical, surgical and diagnostic instruments and related medical items. Contact: Armed Forces Medical Musuem of the Armed Forces Institute of Pathology, Department of Defense, Walter Reed Army Medical Center, 6825-16th St. N.W., Building #54, Washington, DC 20306/202-576-2341. For recorded information, call: 202-576-2418.

Medical Research—Army

Research and development in medical sciences, supplies and equipment is conducted at: Army Medical Research and Development Command, Office of the Surgeon General, Army, Department of Defense, Fort Detrick, Frederick, MD 21701/301-663-2121.

Medical Research—Navy

This office is responsible for research and development, test and evaluation in diving medicine, submarine medicine, aviation medicine, bioeffects of electromagnetic radiation, human performance, fleet health care, infectious diseases, oral and dental health, and fleet occupational health. Contact: Naval Medical Research and Development Command, Department of the Navy, Department of Defense, Washington, DC 20370/202-694-1053.

Memorial Affairs

This division operates and maintains Arlington and Soldiers' Home National Cemetery and 28 post cemeteries. It also supervises the worldwide care and disposition of remains and effects of deceased Army personnel. Contact: Memorial Affairs Division, Casualty and Memorial Affairs Directorate, TAGO, 2461 Eisenhower Ave., Alexandria, VA 22331/202-325-7960.

Military Assistance Program

See "Foreign Military Sales Program" in this section.

Military Assistance Programs Logistics

This office implements all military assistance programs overseas. It also provides support analysis of the programs. Contact: Directorate of International Logistics and Support Analysis, Office of Assistant Secretary of Defense, Manpower Reserve Affairs and Logistics (PI), The Pentagon, Room 2B329, Washington, DC 20301/202-697-9740.

Military Audiovisual Material

A variety of audiovisual materials is available for sale or on loan through the National Audiovisual Center. The material covers a wide range of subjects that include air defense, air warfare, aviation history, flying exhibitions and competitions, marine strategy and tactics, guided missiles, marine ceremonies, national security, nuclear warfare and military training. *A Reference List of Audiovisual Materials Produced by the U.S. Government* is a free catalog available through the Reference Section, National Audiovisual Center, National Archives and Records Service, General Services Administration, Washington, DC 20409/301-763-1896.

Military Ceremonies

For information on military ceremonies and participation in public events, contact: OASD/PA-DCR, Programs Division, The Pentagon, Washington, DC 20301/202-697-6005.

Military Engineering Programs

The Corps of Engineers provides military engineering support to the Army and other defense agencies. It plans, designs and supervises the construction of housing for soldiers and their families, health, shopping and recreational facilities and factories for military equipment. The Corps maintains and operates a worldwide network of Army installations. Contact: Military Programs, Army Corps of Engineers, Department of the Army, Department of Defense, Pulaski Building, Room 3237, Washington, DC 20314/202-272-0379.

Military Exchange Services

Procurement of resale merchandise for post and base exchanges in the Continental United States (CONUS) is accomplished by five exhange regions. Each exchange region buys for approximately 25 installation exchanges in the region's general geographical area. To sell to exchanges a firm must, by appointment, offer its product to the buyers at any or all of these five regions, or contact: Army and Air Force, Exchange Service, P.O. Box 222305, Dallas, TX 75222/214-330-2011.

Military History Institute

The Institute collects, preserves, and provides to researchers source materials of American military history. It holds more than one million catalogued items relating to military history. Some of the books in the collection date from the 15th century and provide historical background on the American army. Original source material includes diaries, letters, photographs, art work and other records. The Institute provides research and reference assistance. It also publishes bibliographies of its holdings, a biannual anthology titled *Essays in Some Dimensions of Military History,* and collections of short, factual *Vignettes of Military History.* Contact: Army Military History Institute, Department of Defense, Carlisle Barracks, PA 17013/717-245-3611.

Military History on View

A list of Army, Navy, Marine Corps and Air Force museums located throughout the country is available from: Public Affairs, Department of Defense, The Pentagon, Room 2E800, Washington, DC 20301/202-697-5737.

Military History Publications

A free listing of publications is available from: Army Center of Military History, 20 Massachusetts Avenue, N.W., Room 4224, Washington, DC 20314/202-272-0295.

Military Manpower and Training Report

This report is submitted to Congress annually, and recommends the average student load for each category of training for each component of the armed forces for the next three fiscal years. Contact: Training and Education, Manpower, Reserve Affairs and Logistics, Department of Defense, The Pentagon, Room 3B930, Washington, DC 20301/202-695-6857.

Military Strength and Defense Contract Publications

For further information on any of the following publications or for a complete publication catalog, contact: Information Operations and Reports, Washington Headquarters Service, Department of Defense, The Pentagon, Room 1C535, Washington, DC 20301/202-695-6815.

Catalog of DIOR Reports—contains audited data pertaining to selected procurement, logistics, manpower, economics, financial management, property manage-

ment, and supply statistical reports (free).

Map Book—Major Military Military Installations (biannual, $8.50)

Working Capital Funds of the DoD (annual, $9.20)

Military Manpower Statistics (monthly, $6.00)

Worldwide Manpower Distribution by Geographic Areas (quarterly, $5.20)

To obtain copies of the following publications, contact: Public Correspondence, Public Affairs, Office of the Secretary of Defense, The Pentagon, Washington, DC 20301/202-697-5737.

Monthly Report of Military Strength—a press release that provides data on the previous two months and compares the present military strength to that of a year ago (free).

Active Military Duty by Country Worldwide—a quarterly press release that comes out 50 to 60 days after the end of the quarter (free).

100 Companies Receiving the Largest Dollar Volume of Military Prime Contract Awards (annual, $4.40)

Educational and Nonprofit Institutions Receiving Military Prime Contract Awards for Research, Development, Test and Evaluation (annual, $3.90)

Military Prime Contract Awards by State, City and Contractor (annual, $99.90)

Companies Participating in the DoD Subcontracting Programs (quarterly, $5.30)

Military Traffic Management Command (MTMC)

This office is responsible for operation of common user CONUS (Continental United States) military ocean terminals and for providing or procuring required terminal services for movement of cargo through other CONUS military or commercial ocean terminal facilities. MTMC is also responsible for the control and maintenance of the Defense Freight Railway Interchange Fleet. Contact: Headquarters, Military Traffic Management Command, 5611 Columbia Pike, Falls Church, VA 22041/202-756-1242.

Missile Research

For information on research and development on rockets, guided missiles, ballistic missiles, targets, air defense weapons systems, fire control coordination equipment, related special purpose and multisystem test equipment, missile launching and ground support equipment, meteorology, calibration equipment, and other associated equipment, contact: Army Missile Research and Development Command (MIRADCOM), Department of Defense, Redstone Arsenal, Huntsville, AL 35809/205-876-4759.

Missile Test Facility

This facility is resonsible for research and development, testing and evaluation programs on the flight testing of guided missiles, and supports endo- and exo-atmospheric research in the launching of rockets. Contact: Naval Ordnance Missile Test Facility, White Sands Missile Range, NM 88002/505-678-2101.

Missing in Action

For inquiries on military personnel listed as missing in action, see "National Archives."

Mobility Equipment Research

For information on research, development, engineering and first production buys on all varieties and aspects of mobile equipment, contact: Army Mobility Equipment Research and Development Command (MERADCOM), Department of Defense, Fort Belvoir, VA 22060/703-664-5251.

National Dam Inspection Program

This program authorizes the Corps of Engineers to inventory all dams in the United States and to inspect nonfederal, high-hazard dams. The Corps maintains a list and provides reports of those dams inspected. Contact: Engineering Division, Civil Works, Army Corps of Engineers, Department of the Army, Department of Defense, 20 Massachusetts Ave. N.W., Room 6131, Washington, DC 20314/202-272-0219. For information on the computer-based detailed inventory of the 63,000 dams over 25 feet high or which impound over 50 acre feet of water, contact: Water Resources Support Center, Engineering Division, Civil Works, Army Corps of Engineers, Department of the Army, Department of Defense, Kingman Building, Fort Belvoir, VA 22060/202-325-0670.

National Guard

The National Guard is the primary backup for the U.S. Army, providing it with infantry, armor, artillery, aviation, medical, engineering, communications and electronics support. When not on federal duty, the National Guard is under the control of the state governors to help protect life and property and to preserve peace, order and public safety in their states. Free publications of the National Guard include: *Annual Review, and Facts and Fiction About the National Guard.* Contact: Public Affairs, National Guard Bureau, Department of the Army, Department of Defense, The Pentagon, Room 2E258, Washington, DC 20310/202-695-0421.

NATO Programs

A table of key North American Treaty Organi-

zation (NATO) programs including a brief description of the goals, achievements and status of the programs and the countries involved, is included in the U.S. Department of Defense *Program for Research Development and Acquisition Annual Report.* For more NATO information, contact: NATO Affairs, Department of Defense, The Pentagon, Room 1E814, Washington, DC 20301/202-697-7202.

Nautical Charts

The *Catalog of Maps, Charts and Related Products* is a four-part catalog providing a comprehensive reference of all Defense Mapping Agency maps, charts and related products available to U.S. Department of Defense users: Part I, Aerospace Products; Part II, Hydrographic Products; Part III, Topographic Products; Part IV, World—Small- and Medium-Scale Maps. Contact: Defense Mapping Agency, Hydrographic/Topographic Center, Office of Distribution Services, Attn: DDCP, Washington, DC 20315/202-227-2495. Other available charts cover nine regions: 1) United States and Canada; 2) Central and South America and Antarctica; 3) Western Europe, Iceland, Greenland and the Arctic; 4) Scandinavia, Baltic and USSR; 5) Western Africa and the Mediterranean; 6) Indian Ocean; 7) Australia, Indonesia and New Zealand; 8) Oceana; 9) East Asia. (Nautical charts of the U.S., Hawaii, and Alaska are sold through the National Ocean Survey at the Department of Commerce.) Contact: Defense Mapping Agency, Office of Distribution Services, Attn: DDCP, Department of Defense, 6101 MacArthur Blvd., Warren Building, Washington, DC 20315/202-227-3048/3049.

Naval Air Engineering Center

This Center provides research and development, engineering testing and evaluation, system integration, limited production and fleet engineering support in launching recovery and landing aids for aircraft, and in ground support equipment for aircraft and airborne weapons system. It also supports the U.S. Department of Defense standardization and specification programs. Contact: Naval Air Engineering Center, Department of the Navy, Department of Defense, Lakehurst, NJ 08733/201-323-1110.

Naval Air Systems Command

This office is responsible for the design, development, testing and evaluation of naval airframes, aircraft engines, components, and fuels and lubricants; airborne versions of electronic equipment, pyrotechnics and minesweeping equipment; air-launched weapon systems and underwater sound systems; aircraft drone and target systems, catapults, arresting gear, visual landing aids, photographic equipment, meteorological equipment, ground handling equipment for aircraft, parachutes, flight clothing and survival equipment. Contact: Naval Air Systems Command, Department of the Navy, Department of Defense, Washington, DC 20361/202-692-8373.

Naval Facilities Engineering

Research and development is directed toward items of new or improved materials and equipment or engineering techniques pertaining to the technical planning, design, construction, operation, and maintenance of the shore facilities and related material and equipment. Contact: Naval Facilities Engineering Command, Department of the Navy, 200 Stovall St., Alexandria, VA 22332/202-325-8537.

Naval Historical Center

The Naval Historical Center preserves official Navy historical documents and published accounts of naval history. For information and a list of their publications, contact: Naval Historical Center, Department of the Navy, Washington Navy Yard, Washington, DC 20374/202-433-2210.

Naval Observatory

The primary purpose of the Naval Observatory is to provide accurate astronomical data essential for safe navigation at sea, in the air and in space. It is the only observatory in the United States at which fundamental positions of the sun, moon, planets and stars are continually determined. It is also the only observatory to determine time and is the source of all standard time used in the country. The Observatory library contains many rare and periodical sets on astronomy as well as the current literature. It also publishes astronomical and nautical papers. Contact: Naval Observatory, Department of the Navy, 34th and Massachusetts Ave. N.W., Washington, DC 20390/202-254-4567.

Naval Research

This office supports basic research and technology. Contract awards usually result from unsolicited proposals for research on naval vehicles and weapons technology; sensor and control technology; physical sciences; math and information sciences; biological sciences; psychological sciences; arctic and earth sciences; material sciences; ocean science and technology; and analysis

of the development and maintenance of future naval power. Contact: Office of Naval Research, Department of the Navy, Code 731, Department of Defense, 800 North Quincy St., Arlington, VA 22217/202-696-5031.

Naval Research Laboratory

The Naval Research Laboratory conducts scientific research and advanced technological development directed toward new and improved materials, equipment, techniques, systems and related operational procedures for the Navy. Major fields of interest are communications, countermeasures, device technology, directed energy devices, energy conversion, environmental effects, hydrodynamics, surveillance systems, undersea technology, navigation, sensor systems, sonar standards, weapons guidance and radiation technology. The *Fact Book* is an annual reference source of factual information about the Naval Research Lab, its personnel and its programs. The *Naval Research Laboratory Review,* an annual, describes programs and includes articles and reports on the research in progress. Contact: Technical Commanding Officer, Naval Research Laboratory, Code 2628, Washington, DC 20375/202-767-2949.

Naval Research Publications

Naval Research Logistics Quarterly—basic original research in mathematical and informational science available for $12.00 per year at the Superintendent of Documents, Government Printing Office, Washington, DC 20402/202-783-3238. For publication information, contact: Operational Research, Mathematical and Physical Sciences Directorate, Office of Naval Research, Department of the Navy, Department of Defense, 800 N. Quincy St., Room 607, Arlington, VA 22217/202-696-4314.

Naval Research Review Quarterly—reviews research in such areas as the physical sciences, mathematics, biology, psychology, metallurgy, oceanography and earth sciences. Available for $10.00 per year at the Superintendent of Documents, Government Printing Office, Washington, DC 20402/202-783-3238. For information, contact: Special Projects and Publications, Code 732, Office of Naval Research, Arlington, VA 22217/202-696-5031.

European Scientific Notes (free)—Office of Naval Research Branch Office, Department of the Navy, Department of Defense, Box 39, FPO, New York, NY 09510.

Tokyo Scientific Bulletin (free)—Office Services Branch, Office of Naval Research, Department of the Navy, Department of Defense, 800 N. Quincy St., Room 320, Arlington, VA 22217/202-696-4610.

Naval Reserve

The Reserve prepares for mobilization with equipment and programs that parallel the active Navy. Reservists participate in fleet exercises throughout the year. Contact: Naval Reserve Center, Department of the Navy, Department of Defense, Anacostia S.E., Room 351, Washington, DC 20374/202-433-2623.

Naval Still Picture Depository

Still pictures, taken daily, are available for a small charge. The photos on file range from ships, aircraft, marine crafts, to scenic views and people. Photographic records prior to 1958 are in the National Archives. Prints or reproductions of unclassified official photography may be purchased by the public. The Reference Library is open to the public by appointment only. Contact: Defense Audiovisual Agency, Building 168, Naval District Washington, Washington, DC 20374/202-433-2168.

Naval Stock Footage

Collections of official film photography covering the activities of the U.S. Navy since 1958 (anything prior to that year is kept in the National Archives) are maintained. For information on the collection and ordering, contact: DAVA-N-LGDR, Norton Air Force Base, CA 92409/714-382-2307.

Naval Weapons

This office provides research and development, testing and evaluation on air warfare and missile systems, including technological efforts in missile propulsion, warheads, fuses, avionics, fire control and missile guidance. It is also the lead laboratory on various total weapons system developments. Contact: Naval Weapons Center, Department of the Navy, Department of Defense, China Lake, CA 93555/714-939-3511.

Naval Weapons Support

This office provides research and development as well as support for ships and crafts equipment, shipboard weapons systems, and assigned expendable and nonexpendable ordnance items. Contact: Naval Weapons Support Center, Department of the Navy, Department of Defense, Crane, IN 47522/812-854-2511.

Navy Acquisition Research and Development Information Center (NARDIC)

This office makes Navy research and develop-

ment planning and requirements information available to current or potential U.S. Department of Defense contractors who are registered for access to U.S. Department of Defense information services. For a list of services and information, contact: Navy Acquisition, Research and Development Information Center (NARDIC), Naval Ocean Systems Center, 5001 Eisenhower Ave., Alexandria, VA 22333/202-274-9315, or 1630 East Green St., Pasadena, CA 91106/213-792-5182. For NARDIC representative, consult a free booklet, *NARDIC*, which describes the services and procedures and lists the contact offices.

Navy Band

There are several performing units of the U.S. Navy Band—Concert Band, Ceremonial Band, Sea Chanters, the Commodores jazz ensemble, Port Authority rock group, Country Current bluegrass unit, Commanders Trio, Classical Clarinet Quartet and Harp-Flute Duo. For information and requests for a Navy Band unit to appear at a civilian program outside Washington, DC, contact: United States Navy Band, Department of the Navy, Department of Defense, Washington, DC 20374/202-433-3676; inside Washington, DC, contact: Chief of Information, Department of the Navy, Department of Defense, The Pentagon, Washington, DC 20350/202-697-9344.

Navy Community Relations

For information on Navy programs for communities, contact: Community Relations, Office of Information, Department of the Navy, Department of Defense, The Pentagon, Room 2E335, Washington, DC 20350/202-695-6915.

Navy Exchange Services

There are two basic methods of doing business with Navy exchanges—directly with each exchange or through the Navy Resale System Office (NAVRESO). All exchange equipment is centrally procured or approved for local procurement by NAVRESO. Contact: Naval Resale Services Support Office, Department of the Navy, Department of Defense, Fort Wadsworth, Staten Island, NY 10305/212-965-5000.

Navy/Industry Cooperative Research and Development Program (NICRAD)

This program provides a mechanism for the interchange of technical information with civilian scientists and engineers and facilitates the transfer of technology. Through the NICRAD program both classified and nonclassified technical information on Navy requirements and Navy research and development is made available to participants. The services of the Navy acquisition Research and Development Information Center (NARDIC) and the Defense Technical Information Center (DTIC) are available to NICRAD participants. For information, contact: Office of Research, Development, Test and Evaluation, Chief of Naval Operations, Department of the Navy, Department of Defense, The Pentagon, Room 5D670, Washington, DC 20350/202-695-2053.

Navy Information

For general information on the Navy and Navy programs, contact: Public Information Division, Office of Information, Department of the Navy, Department of Defense, The Pentagon, Room 2E341, Washington, DC 20350/202-697-4627.

Navy Library

In addition to providing information on their own collection, this library can also provide a complete list of all other Navy libraries. Contact: Library, Department of the Navy, Department of Defense, Washington Navy Yard, 11th and M Sts. S.E., Building 220, Washington, DC 20374/202-433-4131.

Navy Memorial Museum

The exhibits in the museum focus on the fighting ships, aircraft and weapons of each evolving era and on the people who operated them. Contact: Navy Memorial Museum, Washington Naval Yard, Building 76, Washington, DC 20374/202-433-2651.

Navy Prisoner of War and Missing-in-Action Information

For information on Naval personnel either missing in action or prisoners of war, contact: Naval Military Personnel Command, Department of the Navy, Department of Defense, Navy Annex, Arlington, VA 20370/202-694-3197.

Navy Salvage Assistance

Salvage experts are available to handle spills of oils and hazardous chemicals resulting from vessel casualties. For a list of regional contacts and for general information, contact: Office of Chief of Naval Operations, Department of the Navy, Department of Defense, The Pentagon, Room 4E624, Washington, DC 20350/202-695-0231.

Navy Toll-Free Number

For information on Navy recruitment and Navy recruiting programs, contact: Navy Oppor-

tunity Information Center, P.O. Box 5000, Clifton, NJ 07012/1-800-327-NAVY, in Florida call 1-800-432-1884; call collect in Alaska, 272-9133; and in Hawaii call, 546-7540.

Nuclear

The Defense Nuclear Agency coordinates nuclear weapons stockpile planning, management and testing in conjunction with the Department of Energy, including nuclear readiness, inspection and safety programs. It develops, coordinates and maintains the National Nuclear Test Readiness Program jointly with the U.S. Department of Energy. It provides nuclear weapon stockpile information to the Joint Chiefs of Staff and nuclear warhead logistic information to authorized Defense organizations. Contact: Director, Defense Nuclear Agency, Washington, DC 20305/202-325-7095.

Nuclear Weapons Research

Testing and engineering on nuclear weapons systems equipment with specific focus on nuclear effects simulation; analysis of nuclear effects and the reaction of equipment to these effects; telemetry, instrumentation weapons/aircraft flight characteristics, high-speed camera techniques. This division of the Air Force is also concerned with testing and evaluation of systems, subsystems, and support equipment for nuclear safety, reliability, compatibility, survivability, and vulnerability and provides Air Force resources to support Atomic Energy Commission/DoD nuclear test operations or training exercises both in the United States and overseas. Kirtland Contracting Center, Air Force Systems Command, Department of the Air Force, Research and Development Contracts Division, Kirtland Air Force Base, NM 87117/505-844-4565.

Ocean Systems

The Naval Oceans Systems Center conducts research and development, testing and evaluation for command control communications, ocean surveillance, surface and air launched undersea weapons systems, and support technologies. Contact: Naval Ocean Systems Center, 271 Catalina Blvd., San Diego, CA 92152/714-225-7805.

Oceanographic Research

The Naval Oceanographic Office conducts research and development in oceangraphic, hydrographic, and geodetic equipment, techniques and systems. Contact: Naval Oceanographic Office, Department of the Navy, Department of Defense, NSTL Station, Bay St., Louis, MS 39522/601-688-4312.

Opportunities for Small and Disadvantaged Businesses

This pamphlet describes the Army Corps of Engineers' mission and provides information on Corps procurement, supplies and services. Small and disadvantaged business utilization specialists throughout the United States are also listed. (See listing in this section) For information, contact: DAEN-DB, Army Corps of Engineers, Department of the Army, Department of Defense, 20 Massachusetts Ave. N.W., Room 5112, Washington, DC 20314/202-272-0725.

Ordnance Research

The Naval Ordnance Station conducts research and development, testing and evaluation of ammunition pyrotechnics and solid propellants used in missiles, rockets and guns. Contact: Naval Explosive Ordnance Disposal Technology Center, Department of the Navy, Department of Defense, Indian Head, MD 20640/301-743-4530.

Outdoor Recreation at Army Corps Facilities

The U.S. Army Corps of Engineers administers an extension system of reservoirs, and camping is provided at many of these installations. For maps, directories and general information, contact: Public Affairs, Army Corps of Engineers, Department of the Army, Department of Defense, 20 Massachusetts Ave. N.W., Room 8122C, Washington, DC 20314/202-272-0017.

Outleasing Program

The Corps has an active outleasing program, especially in the area of industrial and port facilities. It leases supplies laid aside for agricultural and grazing, wildlife and recreational facilities, and it also leases real property for storage and other purposes. This office keeps records of both land that the Army leases out and the land it leases from others. Contact: Programs Division, Real Estate, Army Corps of Engineers, Department of the Army, Department of Defense, 20 Massachusetts Ave. N.W., Room 5217, Washington, DC 20314/202-272-0526.

Pacific Missile Test Center

The Center performs testing and evaluation, development support, follow-on engineering and provides logistics and training support for Naval weapons, weapons systems, and related devices; and provides major range, technical, and base support for fleet users and other U.S. Department of Defense and government agencies. Functions include those related to guided missiles, rockets, free-fall weapons, fire control and radar systems, drones and target drones, computers,

electronic warfare devices, countermeasures equipment, range services and instrumentation, test planning, simulations, and data collection. Contact: Pacific Missile Test Center, Code 0910, Point Mugu, CA 93042/805-982-8914.

Paternity and Adoption

For information on paternity claims and adoption proceedings involving members and former members of the Armed Forces, contact: Manpower, Reserve Affairs and Logistics, Department of Defense, The Pentagon, Room 3D823, Washington, DC 20301/202-697-5947.

Pentagon Building Tours

Tours are available Monday through Friday throughout the day. For information on specific times, contact: Directorate for Community Relations, Public Affairs, Department of Defense, The Pentagon, Room 1E776, Washington, DC 20301/202-695-1776.

Personnel Administration Research

Applied research is conducted in personnel administration and related behavioral sciences contributing to improved management and utilization of manpower. Contact: Naval Military Personnel Command, Department of the Navy, Washington, DC 20370/202-694-1271.

Procurement Policies and Programs

For information on the coordination of U.S. Department of Defense procurement policies and programs, contact: Assistant Deputy Under Secretary of Defense for Acquisition, Research and Engineering, Department of Defense, The Pentagon, Room 3E144, Washington, DC 20301/202-697-8177.

Procurement, Small Business

For information and guidance on federal government activities for small businesses, contact: Directorate for Small Business and Economic Utilization, Research and Engineering, Department of Defense, The Pentagon, Room 2A340, Washington, DC 20301/202-697-9383.

Qualitative Requirements Information (QRI) Program

This program is an information exchange between the Army and industry. When the Army has a requirement, a statement is sent to all QRI registrants giving background information, suggested approaches and objectives. Registrants to the QRI Program are listed in the Defense Documentation Center (DTIC) Dissemination Authority List and can request documents in their field of interest. Contact: DARCOM TriService Information Center, Department of the Army,

Department of Defense, 5001 Eisenhower Ave., Alexandria, VA 22333/202-274-8948.

Radioactive Material

For information on radiological assistance in the event of an accident involving radioactive material, contact: Assistant to the Secretary of Defense (Atomic Energy), Department of Defense, The Pentagon, Room 3E1074, Washington, DC 20530/202-697-5161.

Radiobiological Research Institute

The Institute publishes an annual report summarizing current work in progress in radiobiological research. Contact: Armed Forces Radiobiology Research Institute, Defense Nuclear Agency, Department of Defense, National Naval Medical Center, Building 42, Bethesda, MD 20814/202-295-1210.

Recreational Development and Land Use Management

The Office of Development and Land Use Management handles leases, licenses, outgrants and disposals; archeological, historical and cultural resource protection; visitors centers; lakeshore management; interagency agreements; and master plans for recreation areas. Contact: HQ, Army Corps of Engineers, (DAEN-CWO-R), Washington, DC 20314/202-272-0247.

Recreation Statistics

The Corps keeps records of the largest outdoor recreation attendances of any single U.S. agency. It manages 440 lakes and waterway projects—approximately 11 million acres of land and water. Data are available which show the number of developed recreation areas under management by the Corps, other federal agencies, states, local public agencies, and private concessionaires. The tables further divide areas into overnight use areas that have camping facilities and day-use areas offering picnic but no camping facilities. Attendance numbers and percentage of activity use is broken down into types of activity; e.g., picnicking, swimming, waterskiing, and fishing. Contact: Natural Resources Management Branch, Civil Works Operation, H.Q., Army Corps of Engineers, (DAEN-CWO-R), Washington, DC 20314/202-272-0247.

ROTC

Reserve Officers Training Corps (ROTC) is the single largest source of officers for the Armed Forces. It is used to provide a relatively constant input of officers for active duty. ROTC provides noncareer officers as well as career officers. The program is currently conducted at 341 colleges and universities in the United States. Contact:

Training and Education, Manpower, Reserve Affairs and Logistics, Department of Defense, The Pentagon, Room 3B930, Washington, DC 20301/202-695-2618.

Scientific Research
This office accepts unsolicited proposals in the natural sciences, which include aeromechanics and energies, electronic and solid state sciences, life sciences, mathematical and information sciences, physics and geophysics. Contact: Office of Scientific Research Opportunities, Directorate of Contracts (BC) Air Force, Department of the Air Force, Department of Defense, Bolling Air Force Base, Washington, DC 20332/202-767-4943.

Scientific Research Grants
The Army will consider requests for the support of basic research from educational institutions and nonprofit organizations. Proposals should be submitted to the Army activity having primary interest in the research to be undertaken, or to the Army Research Office, Department of Defense, P.O. Box 12211, Research Triangle Park, NC 27709/919-549-0641.

Sea Systems Command
This office is responsible for the research and development, procurement and logistical support and other material functions for all ships and craft, shipboard weapon systems and ordnance, air-launched mines and torpedoes, shipboard components such as propulsion (including nuclear) power-generated, sonar search radar, and auxiliary equipment. It also gives contracts and offers technical guidance and supervision of operations related to salvage of stranded and sunk ships and craft. Contact: Naval Sea Systems Command, Department of the Navy, Department of Defense, Washington, DC 20362/202-692-1574.

Selling to the Military
This publication provides businesses with essential information on selling to the military, and buying real and personal surplus property from the federal government. It includes the major buying offices and military exchange services, and details the major research and development programs. It also lists items purchased and includes copies of necessary forms. It is available for $4.00 from the Superintendent of Documents, Government Printing Office, Washington, DC 20402/202-783-3238. For information, contact the small business specialist at the nearest military purchasing activity.

Service Academies
The mission of all three service academies—

United States Military Academy, United States Naval Academy and United States Air Force Academy—is to meet a portion of the long-range requirement for career military officers. Their curricula are specifically designed to prepare their students for service as professional officers. The enrollment of each of the academies is established by law. For information, contact any of the service academies, or Training and Education, Manpower Reserve Affairs and Logistics, Department of Defense, The Pentagon, Room 3B930, Washington, DC 20301/202-695-2618.

Ship Engineering Center
This office is responsible for the research and development in materials, ship production, safety and damage control, new ship systems design, hull structures and fluid dynamics, electrical and mechanical and auxiliary systems, ship propulsion (non-nuclear) and control and electronic command surveillance systems. Contact: Naval Sea Systems Command, Department of the Navy, Washington, DC 20362/202-692-9728.

Ship Research
Research and development is conducted on naval vehicles, including systems development and analyses, fleet support and investigations into related fields of science and technology including hydromechanics, aeromechanics, structures, computer technology, machinery and materials. Contact: David W. Taylor Naval Ship Research and Development Center, Department of the Navy, Department of Defense, Bethesda, MD 20084/202-227-1417.

Ship Weapons
The Naval Ship Weapons Systems Engineering Station conducts research and development, testing, evaluation and engineering support services for programs for ships' guided weapons systems. Contact: Naval Ship Weapon Systems Engineering Station, Department of the Navy, Department of Defense, Port Hueneme, CA 93043/805-982-5356.

Ships Names and Sponsors
For background information on how ships' names and sponsors are chosen, for ship types and basic sources of names, contact: Ships Histories Branch, Naval Historical Center, Washington Navy Yard, Building 57, Washington, DC 20374/202-433-3643.

Small and Disadvantaged Business Utilization Specialists
This free booklet is designed to assist small, minority and labor surplus area businessmen. It lists main contract offices within the U.S. De-

partment of Defense and the Services, and it lists local contacts by state. Small Business Administration Field Office addresses are also included. Contact: Office of Small and Disadvantaged Business Utilization Policy, Office of the Secretary of Defense, The Pentagon, Room 2A340, Washington, DC 20301/202-697-1481. See also "Opportunities for Small and Disadvantaged Businesses" in this section.

Small Beach Erosion Control
The Corps of Engineers designs and constructs projects to control all beach and shore erosion to public shores. Contact the nearest district engineer or Civil Works, Army Corps of Engineers, Department of the Army, Department of Defense, 20 Massachusetts Ave. N.W., Room 7227, Washington, DC 20314/202-272-0099.

Soldiers' and Airmen's Home
The Home was established by an Act of Congress in 1851 for retired or discharged enlisted and warrant officer personnel, both men and women, of the Regular Army and Air Force who have served 20 years or more as warrant officers or enlisted personnel; or have a service-connected disability rendering them unable to earn a livelihood; or have a nonservice-connected disability rendering them unable to earn a livelihood and have served during periods of war. Free information pamphlets are available from: Secretary, Board of Commissioners, U.S. Soldiers' and Airmen's Home, Department of Defense, 3700 North Capitol St., Washington, DC 20317/202-722-3336.

Soldiers' Home National Cemetery
For historical and general information on the Soldiers' Home National Cemetery, contact: Information Liaison, Memorial Affairs Division, Department of the Army, 2461 Eisenhower Ave., Hoffman Building #1, Room 984, Alexandria, VA 22331/703-325-7960.

Space and Missile Research
Research and development is conducted in test range instrumentation involving radar, trajectory computers and recorders, tracking and target analysis, wire communications, radio communications, programming timing and firing systems, telemetry receiving, data storage, separation and presentation, optics and telemetry data reduction; develops, maintains, and operates the Test Range and provides support for the U.S. Department of Defense missile and space programs. Contact: ESMC/BC, Patrick Air Force Base, FLA 32925/305-494-2207.
For information on research and development

and product engineering in radar, telemetry, electro-optics, range instrumentation, ships, aircraft impact location, data handling, data reduction, communications range and mission control, range safety, weather timing and firing and frequency control and analysis, contact: Space and Missile Test Center, Air Force Systems Command, Department of the Air Force, Department of Defense, Vandenberg Air Force Base, Lompoc, CA 93437/805-866-3016.

Space and Missile System Organization
This office plans programs and manages the development and acquisition of missile and space systems and related equipment. Contact: Space Division, Air Force Systems Command, Worldway Postal Center, P.O. Box 92960, Los Angeles, CA 90009/213-643-2100.

Specifications and Standards
The Naval Publications and Forms Center (NPFC) is the U.S. Department of Defense's Single Stock Point (SSP) and Distribution Center for Unclassified Specifications and Standards used throughout the Department for military procurement. It indexes, determines requirements, procures, receives, distributes, warehouses, issues and controls the *Index of Specifications and Standards*. It stocks and distributes the following types of documents:

Military Specifications
Military Standards
Federal Specifications
Federal Standards
Qualified Products Lists
Industry Documents
Military Handbooks
Air Force-Navy Aeronautical Standards
Air Force-Navy Aeronautical Design Standards
Air Force-Navy Aeronautical Specifications
Air Force Specifications
Other Departmental Documents
Air Force-Navy Aeronautical Bulletins
Air Force Specification Bulletins

Contact: Naval Publications and Forms Center (NPEC43), Department of Defense, 5801 Tabor Ave., Philadelphia, PA 19120/215-697-3321.

Supply Systems Command
This office is responsible for research and development in supply systems management techniques, including mathematical and statistical analysis, materials handling, clothing, and textiles, transportation and logistics data processing systems. Contact: Naval Supply Systems Com-

mand, Department of the Navy, Washington, DC 20376/202-697-4561.

Surface Weapons Center

This office performs research and development, testing and evaluation in the field of exterior, interior and terminal ballistics, surface warfare systems, strategic systems and ordnance systems; also basic and applied research in physics, chemistry, aeroballistics and mathematics in areas that relate to weapons systems development and evaluation of both conventional and nuclear weapons. Contact: Naval Surface Weapons Center, Department of the Navy, Dahlgren, VA 22448/703-633-8391, or 202-394-1488.

Surplus Personal Property Sales

The U.S. Department of Defense sells its surplus and foreign excess property (excluding real property) to individuals, business concerns and other organizations of all sizes and classifications. There are two types of sales—national and local. Two free pamphlets—*How to Buy Surplus Personal Property from the Department of Defense* and *Classes of Surplus Personal Property Sold by the Department of Defense*—as well as a list of regional officers and property locations are available. For further information, contact: Department of Defense Bidders Control Office, Defense Property Disposal Service, Defense Logistics Agency, Department of Defense, Federal Center, Battle Creek, MI 49016/616-962-6511, ext. 6736.

The U.S. Department of Defense donates or lends surplus material to veterans' organizations, soldiers' museums, incorporated museums and incorporated municipalities. Contact the nearest military installation or Property Disposal Division, Defense Logistics Agency, Cameron Station, Room 46541, Alexandria, VA 22314/202-274-6765.

Tank Research

For information on research and development programs on combat, tactical and special purpose vehicles, including automotive subsystems and components, component programs involving engines, transmissions and suspensions, and electrical and miscellaneous vehicular components, contact: Army Tank Automotive Command (TACOM), Department of Defense, Warren, MI 48090/313-574-6307.

Technology Transfer

For information on the technology transfer policy, which includes the transfer of critical technologies to NATO and the tapping of technological resources of U.S. allies, contact: International Programs and Technology Research and Engineering, Department of Defense, The Pentagon, Room 3E1082, Washington, DC 20301/202-697-4172.

Textiles Research and Development

Research and development is conducted in the physical and biological sciences and engineering to meet military requirements in commodity areas of textiles, clothing, body armor, footwear, insecticides and fungicides, subsistence, containers, food service, equipment, tentage, equipage, and air delivery equipment. Contact: Army Natick Research and Development Command (NARADCOM), Department of Defense, Natick, MA 01760/617-633-4300.

Tools for Schools

Qualified nonprofit educational institutions and training schools may be loaned idle equipment from the Defense Industrial Reserve. Contact: Directorate of Technical and Logistics Services, Defense Logistics Agency, Cameron Station, Alexandria, VA 22314/202-274-6269.

Topographic Laboratories

Research and development is conducted in the topographic sciences, including mapping, point positioning and military geographic information; scientific and technical advisory services and provided to meet environmental design requirements of military materiel developers and to support the geographic intelligence and environmental resource inventory requirements of military and nonmilitary programs. Contact: Army Engineer Topographic Laboratories, Office of the Chief of Engineers, Department of Defense, Fort Belvoir, VA 22060/703-664-5448.

Topographic Maps—Defense Mapping Agency

Topographic maps present the horizontal and vertical positions of the features represented. The shape and elevation of the terrain are normally portrayed by contours and spot elevations. Contact: DMA Office of Distribution Services, Department of the Army, Department of Defense, Washington, DC 20315/202-227-2816.

Training Equipment

The Naval Training Equipment Center is responsible for the procurement of training aids and devices for the Army, Navy, Marine Corps and other government activities, including the following: research and development in simulation technology and techniques; studies in the fields of training psychology and human engineering; design and engineering development of training devices, weapons system trainers and

simulators; and technical data and related and ancillary support materials and services. Contact: Naval Training Equipment Center, Department of the Navy, Department of Defense, Orlando, FL 32813/305-646-5464.

Underwater Systems Center

This office plans and conducts programs of warfare and systems analysis, research, development, testing and evaluation and fleet support in underwater warfare systems and components, undersea surveillance systems, navigation, and related science and technology. Contact: Naval Underwater Systems Center, Department of the Navy, Department of Defense, Newport Laboratory, Newport, RI 02840/401-841-2067.

Unfunded Research and Development Studies

Qualified individuals and organizations may conduct studies and projects pertaining to Army research and development as part of its organization-funded, defense-oriented research and development programs. The Army will make its personnel available for consultation. Contact: DARCOM TRI-SERVICE Information Center, Department of the Army, Department of Defense, 5001 Eisenhower Ave., Alexandria, VA 22333/202-274-8948.

Uniform Relocation Assistance Act

The Act strives to alleviate the hardships imposed on landowners and tenants who are displaced by government projects. Under this Act, benefits to landowners are provided over and above the amount that is paid to them for their land, including payment of moving costs, optional payments to displaced farmers and businessmen, payment of subsidies to homeowners in the purchase of replacement homes, and payments to tenants for increased rental costs or down payment assistance in buying a home. Contact: Realty Services Division, Real Estate, Army Corps of Engineers, Department of the Army, Department of Defense, 20 Massachusetts Ave. N.W., Room 5132, Washington, DC 20314/202-272-0517.

Uniformed Services University of the Health Sciences

This school has been established to educate career-oriented health professionals for the military services and in the case of physicians, for the Public Health Service as well. The university currently incorporates a school of medicine and graduate and continuing education programs. Contact: Uniformed Services University of the Health Sciences, Department of Defense, 4301 Jones Bridge Rd., Room A1017, Bethesda, MD 20814/202-295-3030.

United States Air Force Academy

The Academy offers four years of college education leading to a bachelor of science degree. For further information, contact: Air Force Academy, USAFA, CO 80840/303-472-4040.

United States Army Field Band

The U.S. Army Field Band, the Army's official band, conducts two major tours each year. Components of the band are the Concert Band, Soldiers' Chorus and Jazz Ambassadors. Contact: Office of the Chief of Public Affairs, Department of the Army, Department of Defense, The Pentagon, Room 2E631, Washington, DC 20310/202-697-2707, or United States Army Field Band, Ft. George G. Meade, MD 20755/301-677-2615.

United States Military Academy

The Academy offers four years of college education leading to a bachelor of science degree. Cadets receive a monthly allowance plus tuition, medical care, and room and board. Graduates receive Regular Army commissions and must serve on active duty for at least five years after commissioning. Those interested in securing an appointment should write to their Senators or district Representative in Congress, or contact: Academy Director of Admissions and Registrar, United States Military Academy, West Point, NY 10996/914-938-4011.

United States Naval Academy

The Academy offers a four-year program of academic, military and professional instruction leading to a bachelor of science degree. Completion of the program normally leads to a commission in the United States Navy or the U.S. Merchant Marine. For information, contact: United States Naval Academy, Annapolis, MD 21402/301-267-6100.

Unsolicited Proposals

Industrial organizations, academic institutions, and individuals can participate in research and development programs through unsolicited proposals. These proposals should have no relation to specific solicitation and should contain new ideas. A free guide, *Guide for Voluntary Unsolicited Proposals*, is available from: Army Materiel Development and Readiness Command, Attn: DRCDE-LU, Department of Defense, 5001 Eisenhower Ave., Alexandria, VA 22333/202-274-8978.

Voting Assistance

A *Voting Assistance Guide*, posters and a revised Federal Post Card Application (FPCA) are available to support voting assistance programs enabling United States citizens overseas to regis-

ter to vote. The material is available free from U.S. embassies, consulates and U.S. military installations. *Voting Assistance Guide* ($7.00) and Federal Post Card Applications (100 for $5.50) are also available from the Government Printing Office, Superintendent of Documents, Washington, DC 20402/202-783-3238.

Water Supply and Management

The Corps is responsible for the balance between water supply and management to meet the demands from municipal, industrial and agricultural interests. For many communities the water that the Corps has reserved from its multipurpose reservoirs is the main water source. Contact: Civil Works, Directorate, Army Corps of Engineers, Washington, DC 20314/202-272-0099.

Waterways

Research and development is conducted in the fields of hydraulics, soil mechanics, concrete, engineering, geology, rock mechanics, pavements, expedient construction, nuclear and conventional weapons effects, protective structures, vehicle mobility, environmental relationships, aquatic weeds water quality, dredge material research and nuclear and chemical explosives excavation. Contact: Engineer Waterways Experiment Station, Office of the Chief of Engineers, Department of Defense, P.O. Box 631, Vicksburg, MS 39180/601-636-3111.

Weapons Research—Air Force

Research is conducted in the areas of weapons effects, kill mechanisms, radiation hazards, and delivery techniques. Development and evaluation programs for advanced nonconventional weapon and nuclear power systems integration, nuclear weapon components, training devices, suspension and release systems, ground handling equipment, nuclear safety studies and civil engineering research and weapons effects simulation devices and techniques are conducted. Contact: Air Force Weapons Laboratory, Air Force Systems Command, Department of the Air Force, Kirtland Air Force Base, NM 87117/505-844-2664.

White Sands Missile Range

This facility conducts testing and evaluation of Army missiles and rockets and operates the only U.S. land-based national range to support missile and other testing for the Army, Air Force, Navy and National Aeronautics and Space Administration. Contact: Public Affairs Office, White Sands Missile Range, NM 88002/505-678-1134.

Your Army—200 Years

This is a free illustrated pamphlet that describes the Army, its mission, its forces and its various commands. It provides information on the branches of the Army and the Insignia of Assignment, the units of the Army, types of divisions, and career opportunities. A description of Army weapons and equipment is also included. Contact: HDQA, Attn: SAPA-CR, Washington, DC 20310/202-697-5720.

Yuma Proving Ground

This facility conducts research and development, production and post-production testing of components and complete items of weapons, systems, ammunition and combat and support vehicles, desert environmental tests of some items, air drop and air delivery tests and participation in engineering and expanded service testing of combat and support items. Contact: Commander, Yuma Proving Ground, Yuma AZ 85365/602-328-2163.

How Can the Department of Defense Help You?

If you believe that the U.S. Department of Defense can help you and you cannot find a relevant office listed in this section, contact: Staff Assistant for Public Correspondence, Department of Defense, Office of the Assistant Secretary of Defense, Public Affairs, The Pentagon, Washington, DC 20301/202-697-5737.

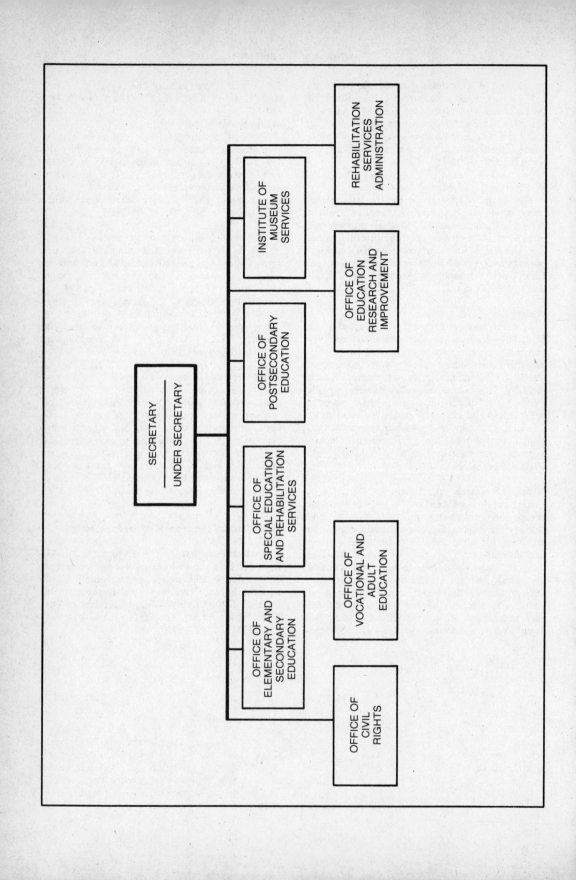

Department of Education

400 Maryland Ave. S.W., FOB 6, Room 4181,
Washington, DC 20202/202-426-6426

ESTABLISHED: May 5, 1980
BUDGET (1980 est.): $13,887,470,000
EMPLOYEES: 6,100
MISSION: To oversee the federal education effort as outlined by Congress.

Major Divisions and Offices

Office of Civil Rights

Department of Education (ED), 400 Maryland
Ave. S.W., Room 5000, Washington, DC
20202/202-245-7680.
Budget: $23,122,000
Employees: 1,201
Mission: Enforce programs that prohibit discrimination because of sex, race or handicap. Investigate and insure compliance with standards for public architectural, transportation and communication barriers, including public conveyances, confronting handicapped individuals.

Office of Elementary and Secondary Education

Department of Education, 400 Maryland Ave.
S.W., Room 2189, Washington, DC 20202/202-245-8720.
Budget: $5,200,206,000
Employees: 1,710
Mission: Administer grants to state education agencies and local school districts, programs of financial assistance for the elimination of racial segregation, and grants to states for development and construction of public libraries and for acquisition of library resources.

Office of Vocational and Adult Education

Department of Education, ROB #3, 7th and D
Sts. S.W., Room 5102, Washington, DC
20202/202-245-8166.
Budget: $889,035,000
Employees: 277
Mission: Administer programs of grants, contracts, and technical assistance for vocational and technical education, occupational education, metric education, adult education, consumer education, education professions development, and community schools.

Office of Special Education and Rehabilitation Services

Department of Education, 3006 Switzer Building, Washington, DC 20202/202-245-8492.
Budget: $1,447,244,000
Employees: 462
Mission: Assist states, colleges and universities, and other institutions and agencies in meeting the educational needs of the nation's handicapped children who require special services. Administer programs such as support of training for teachers and other professional personnel; grants for research; financial aid to help states initiate, expand, and improve their special education sources; and media services and captioned films for the deaf.

Office of Postsecondary Education

Department of Education, 400 Maryland Ave.
S.W., ROB3, Room 4082, Washington, DC
20202/202-245-8102.
Budget: $5,646,090,000
Employees: 1,849
Mission: Support and assist programs directed to higher education, and assist in the improvement and expansion of American educational resources for international studies and services. Administer programs in crucial academic subjects.

Office of Educational Research and Improvement

Department of Education, 400 Maryland Ave. S.W., FOB6, Room 3073C, Washington, DC 20202/202-472-5753.
Budget: $309,187,000
Employees: 92
Mission: Collect and disseminate statistics and other data related to education in the United States and in other nations. Support a wide variety of school improvement programs.

Institute of Museum Services

Department of Education, 330 C St. S.W., Room 4006, Washington, DC 20202/202-245-0413.
Budget: $10,922,000
Employees: 276
Mission: Assist museums in their educational role to better serve all age groups, in modernizing their methods and facilities, and in easing the financial burden on museums which is a result of their increasing use by the public.

Rehabilitation Services Administration

Department of Education, 330 C St. S.W., Switzer Building, Room 3006, Washington, DC 20201/202-472-3814.
Budget: $62,437,000
Employees: 20
Mission: Provide leadership in the planning, coordination and development of services for handicapped individuals and advocate on their behalf. Promote effective utilization of the wide range of services available to aid handicapped persons; serve as a catalyst to stimulate the development and expansion of these services, especially for those with severe disabilities; and work to establish a coordinated network of services for handicapped citizens.

Major Sources of Information

Abroad, Study and Teaching Opportunities
See *"International Education Information Clearinghouse"* in this section.

Adult Career and Vocational Information Clearinghouse
Information services are available on adult, career, and continuing education, and vocational and technical education contact: Educational Reference and Information Center (ERIC), Clearinghouse on Adult, Career and Vocational Education, Ohio State University, Center for Vocational Education, 1960 Kenny Rd., Columbus, OH 43210/614-486-3655, ext. 21.

Adult Education
See *"Occupational Education"* in this section.

American Education Magazine
Published monthly this magazine keeps educational professionals informed on new funding programs and the results of studies and reports sponsored by the Department of Education. Subscriptions are available for $13 per year from Editor, *American Education Magazine*, 400 Maryland Ave. S.W., Washington, DC 20202/202-245-8907.

Architectural and Transportation Barriers
Complaints about buildings that are inaccessible to handicapped people are handled by the Compliance Board. A free publication called *Access America* tells how and when to file a formal complaint. Contact: Architectural and Transportation Barriers Compliance Board, Department of Education, 330 C St. S.W., Room 1010, Washington, DC 20201/202-245-1591.

Arts and Humanities
For information on programs and funding available for arts and humanities education contact: Arts and Humanities, Department of Education, 400 Maryland Ave. S.W., Donohoe Building, Room 3728, Washington, DC 20202/202-245-8912.

Asian and Pacific Americans
A special office provides information to the Asian and Pacific community on grants and other projects that might be of special interest. Contact: Asian and Pacific American Concerns Staff, Department of Education, 400 Maryland Ave. S.W., Reporters Building, Room 3728, Washington, DC 20202/202-472-3730.

Bilingual Education Information Clearinghouse and Hotline
Along with a free monthly newsletter, *Forum*, the Clearinghouse offers data base searches, publications and other information services. Contact:

National Clearinghouse for Bilingual Education, Department of Education, 1300 Wilson Blvd. #B2-11, Rosslyn, VA 22209/800-336-4560 (VA: 703-522-0710).

Black Educational Programs
For information on the availability and need for educational programs covering black concerns contact: Black Concerns Unit, Department of Education, 300 7th St. S.W., Reporters Building, Room 513, Washington, DC 20202/202-245-7926.

Braille Books
See "Braille Books," under "Major Sources of Information," "U.S. Department of Health and Human Services."

Captioned Films
A free catalog listing educational and entertainment films for the deaf is available from: Captioned Films for the Deaf, Education for the Handicapped, 814 Thayer Ave., Silver Spring, MD 20910/301-585-4363.

Career Education
For information on effective career education techniques at elementary and secondary levels contact: Career Education, Department of Education, 400 Maryland Ave. S.W., Donohoe Building, Room 1725, Washington, DC 20202/202-245-2284.

Class of 1972
The U.S. Department of Education maintains a continual investigation into the education, job training and vocational histories of a nationally representative sample of 22,000 young people who were high school seniors in 1972. The data include: postsecondary education, early vocation and work experiences, social development information, and how all these factors are related to earlier achievement levels, aspirations, attitudes and intervening educational and occupational variables. For information on available publications and other output contact: National Longitudinal Study of the High School Class of 1972, Longitudinal Studies Branch, Division of Math-Level Education Statistics, National Center for Education Statistics, Department of Education, 6525 Belcrest Rd., Prince Georges Center, Presidential Building, Suite 408, Hyattsville, MD 20782/301-436-6688.

College and University Directory
A directory entitled *Educational Directory: Colleges and Universities 1981-82* is available of-fering pertinent data on all colleges and universities in the United States. The cost is $9.00. Contact: Government Printing Office, Superintendent of Documents, Washington, DC 20202/202-783-3238.

Community Colleges
For information and expertise concerning community college activities, including available programs and funding contact: Community College Unit, Bureau of Higher and Continuing Education, Department of Education, 7th and D Sts. S.W., Room 4913, Washington, DC 20202/202-472-3674.

Consumer Education Hotline and Clearinghouse
An information and referral service is available to those who are in the business of educating consumers. Its newsletter, *Concern*, is available for $25.00 per year for 11 issues. A free booklet is also available. Contact: Consumer Education Resource Network, Education Department, 1555 Wilson Blvd., Arlington, VA 22209/800-336-0223.

Continuing Education
The Bureau of Higher and Continuing Education supports strengthening of community service programs and the expansion of continuing education programs for adults and other nontraditional students; provides encouragement and assistance to women and minorities to prepare them for careers in academic and other fields in which they have traditionally been underrepresented and to increase the number of persons trained for public service; helps graduate students undertake advanced study in domestic mining and mineral fuel conservation; and helps disadvantaged students train for the legal profession. Contact: Bureau of Higher and Continuing Education, Department of Education, ED, 400 Maryland Ave. S.W., ROB3, Room 4060, Washington, DC 20202/202-245-2787.

Counseling and Personnel Services Information Clearinghouse
Information services are available on the training, practice and supervision of counselors at all education levels and in all settings; contact: Education Reference and Information Center (ERIC), Clearinghouse on Counseling and Personnel Services, University of Michigan, School of Education Building, Room 2108, Ann Arbor, MI 48109/313-764-9492.

Direct Payments
The programs described below are those that provide financial assistance directly to individ-

uals, private firms and other private institutions to encourage or subsidize a particular activity.

Handicapped Media Services and Captioned Films

Objectives: To maintain a free loan service of captioned films for the deaf and instructional media for the educational, cultural, and vocational enrichment of the handicapped; provide for acquisition and distribution of media materials and equipment; provide contracts and grants for research into the use of media; and train teachers, parents, and others in media utilization.

Eligibility: Public and private agencies, organizations, or groups may submit proposals and applications for projects to the Division of Media Services.

Range of Financial Assistance: $1,350 to $1,650,000.

Contact: Caption Films and Media Application Branch, Division of Educational Services, Office of Special Education and Rehabilitative Services, Department of Education, Washington, DC 20202/202-472-4640.

Higher Education—Veteran's Cost of Instruction Program

Objectives: To encourage colleges and universities to serve the special needs of Vietnam-era veterans.

Eligibility: Nationally or regionally accredited institutions of higher education. Proprietary institutions (i.e., organized for profit) and schools or departments of divinity are not eligible.

Range of Financial Assistance: $3,037 to $135,000.

Contact: Division of Training, Facilities and Veterans' Programs, Veterans' Cost-of-Instruction Program Branch, Department of Education, 7th and O St. S.W., ROB3, Room 3154, Washington, DC 20202/202-245-2806.

Higher Education Work-Study

Objectives: To promote the part-time employment of students, particularly those with great financial need, who require assistance to pursue courses of study at institutions of higher education.

Eligibility: Accredited (and certain other) institutions of higher education, including junior colleges and institutions that provide to high school graduates at least a 12-month course of training, leading to gainful employment in a recognized occupation. Accredited proprietary schools that provide at least a six-month course of training leading to gainful employment in a recognized occupation may be eligible. Area vocational schools

also may participate, but, of their students, only high school graduates are eligible.

Range of Financial Assistance: $176 to $8,286,574.

Contact: Policy Section, Campus-Based Branch, Division of Policy and Program Development, Office of Student Financial Assistance, Department of Education, Washington, DC 20202/202-245-9720.

National Direct Student Loans

Objectives: To establish loan funds at eligible higher education institutions to permit needy undergraduate and graduate students to complete their education.

Eligibility: Higher education institutions (public, other nonprofit, and proprietary) meeting eligibility requirements

Range of Financial Assistance: $187 to $4,738,389.

Contact: Campus-Based Branch, Division of Policy and Program Development, Office of Student Financial Assistance, Department of Education, Washington, DC 20202/202-245-9720.

Supplementary Educational Opportunity

Objectives: To enable students of exceptional financial need to pursue higher education by providing grant assistance for educational expenses.

Eligibility: Institutions of higher education.

Range of Financial Assistance: $200 to $1,500 per year.

Contact: Chief, Policy Section, Campus Based Branch, Division of Policy and Program Development, Office of Student Financial Assistance, Department of Education, Washington, DC 20202-3454/202-245-9720.

Disadvantaged Children

For information on programs available to expand and improve elementary and secondary school programs for educationally deprived children in low-income areas contact: Division of Education for the Disadvantaged, Department of Education, 400 Maryland Ave. S.W. ROB3, Room 3642, Washington, DC 20202/202-245-2722.

Early Childhood Education Information Clearinghouse

Information services are available on the physical, psychological, social, educational and cultural development of children from birth through the primary grades. Contact: Educational Reference and Information Center (ERIC), Clearinghouse on Educational Management, University of Oregon, Eugene, OR 79403/503-686-5043.

Education Research Newsletters

The National Institute of Education (NIE) publishes three free newsletters dealing with education research: *NIE Information, Funding Opportunities* and *Information on Unsolicited Proposals*. Contact: Office of Public Affairs, NIE, Department of Education, 1200 19th St. N.W., Room 717, Washington, DC 20208/202-254-7150.

Education Data Bases

For a free directory of computerized data bases related to education, contact: National Center for Educational Statistics, Department of Education, 400 Maryland Ave. S.W., Presidential Building, Room 1001, Washington, DC 20202/301-436-7900.

Educational Development

The National Institute of Education supports research and dissemination activities that will help individuals, regardless of race, sex, age, economic status, ethnic origin, or handicapped condition, realize their full potential through education. Contact: National Institute of Education, Department of Education, 1200 19th St. N.W., Room 722, Washington, DC 20208/202-254-5740.

Educational Programs That Work

Teachers and developers of programs that are deemed educationally significant are sponsored to go into the field to lend their expertise in repeating their programs. A directory called *Educational Programs That Work* describes these programs and is available for free. Contact: National Diffusion Network, Office of Educational Research and Improvement, Department of Education, 1832 M St. N.W., Room 802, Washington, DC 20201/202-653-7000.

Educational Resources Information Center (ERIC)

ERIC is a data base of literature on educational topics. Through ERIC, any person in education has easy access to reports of innovative programs, conference proceedings, bibliographies, outstanding professional papers, curriculum-related materials, and reports of the most significant efforts in educational research and development. The computerized data base can be accessed through any one of 500 facilities throughout the United States. A free directory of these facilities is available from ERIC; however, there is likely to be a charge for its services. Much of the information is also available in the following publications.

Resources in Education—a monthly abstract journal announcing recently completed research reports, descriptions of outstanding programs, and other documents of educational significance indexed by, subject, author, institutional source, and publication type. Available at $47.00 per year from Superintendent of Documents, Government Printing Office, Washington, DC 20402/202-783-3238.

Current Index to Journals in Education—a monthly guide to the periodical literature with coverage of more than 775 major educational and education-related publications. It includes a main entry section with annotations, and is indexed by subject, author, and journal title. Available at $115.00 per year from the ORYX Press, 2214 North Central Ave., Phoenix, AZ 85004/602-254-6156.

For further information on the Educational Reference and Information Center (ERIC), contact: ERIC, Dissemination and Improvement Of Practice (DIP)/Information Resources, Riviere Building, Room 705, Washington, DC 20208/202-254-7934.

Elementary and Secondary Education

For information on programs offering financial and technical assistance to meet special needs in elementary and secondary education contact: Bureau of Elementary and Secondary Education, Department of Education, 400 Maryland Ave. S.W., FOB6, Room 2189, Washington, DC 20020/202-245-8720.

Energy Education Information Clearinghouse

A special office has been established to serve as an information center and data distribution network for data on energy and conservation measures. The office also distributes educational materials and location experts in both government and the private sector who can provide information on a specific problem. Contact: Energy and Education Action Center, Department of Education, 400 Maryland Ave. S.W., Donohoe Building, Room 1651, Washington, DC 20202/202-472-7777.

Environmental Education

Although there are no funds for new programs in environmental education, information on other resources or existing programs is available from: Office of Environmental Education, Bureau of Elementary and Secondary Education, Department of Education, 400 Maryland Ave. S.W., Donohoe Building, Room 1100, Washington, DC 20202/202-245-9231.

Ethnic Heritage Studies

For information and expertise on programs and funding available for helping students become

aware of their own heritage contact: Ethnic Heritage Studies, Bureau of School Improvement Program, Department of Education, 400 Maryland Ave. S.W., Donohoe Building, Room 1133, Washington, DC 20202/202-245-2293. For additional information on this topic contact: Ethnic Heritage Studies Clearinghouse, Social Studies Education Consortium, 855 Broadway, Boulder, CO 80302/303-492-8154.

Films, Slides, Video and Other Audiovisual Matter

For a listing of audiovisual materials produced by the Education Department contact: Office of Public Affairs, Department of Education, 400 Maryland Ave. S.W., FOB6, Room 2097, Washington, DC 20202/202-245-8564.

Freedom of Information Act

The central office for making a Freedom of Information Act request is: FOI, Department of Education, 400 Maryland Ave. S.W., FOB6, Room 2089, Washington, DC 20202/202-245-8633. See "Freedom of Information Act."

Fulbright Scholarships

See "Grants" in this section.

Gifted and Talented Education

For information on federal government-sponsored programs for gifted and talented children contact: Office of Gifted and Talented Education, Department of Education, 400 6th St. S.W., Room 3835, Washington, DC 20202/202-245-2482.

Grants

The programs described below are for sums of money given by the federal government to initiate and stimulate new or improved activities, or to sustain ongoing services.

Adult Education Program for Adult Immigrants

Objectives: To provide adult education programs and educational support services for adult immigrants.

Eligibility: State educational agencies, local educational agencies and other public or private nonprofit agencies, organizations, or institutions.

Range of Financial Assistance: Not specified.

Contact: Director, Division of Adult Education, Bureau of Occupational and Adult Education, Department of Education, Washington, DC 20202/202-245-2278.

Adult Education—State-Administered Program

Objectives: To expand educational opportunities and to encourage the establishment of programs of adult education enabling all adults to acquire basic skills necessary to function in society, to enable those adults who desire to continue their education to at least the level of completion of secondary schools.

Eligibility: Designated state educational agencies.

Range of Financial Assistance: $170,089 to $6,648,292.

Contact: Division of Adult Education, Bureau of Occupational and Adult Education, Department of Education, Washington, DC 20202/202-245-2278.

Alcohol and Drug Abuse Education Program

Objectives: To develop, through training and technical assistance, local capability to solve problems in the area of alcohol and drug abuse prevention with applicability to other behavior problems such as truancy, vandalism, and disruptive behavior; to alleviate the alcohol and drug abuse crisis among youth by promoting awareness and understanding of the nature of the problem and developing and disseminating prevention and early intervention strategies.

Eligibility: Institutions of higher education; state education agencies; local educational agencies; public and private educational and community agencies, institutions, and organizations.

Range of Financial Assistance: Up to $10,000.

Contact: Alcohol and Drug Education Program, Bureau of Elementary and Secondary Education, Department of Education, 400 Maryland Ave. S.W., Donohoe Building, Room 1561, Washington, DC 20202/202-245-8272.

Basic Educational Opportunity Grant Program (BEOG)

Objectives: To assist in making available the benefits of postsecondary education to qualified students.

Eligibility: Undergraduate students attending eligible institutions of higher education, and enrolling at least on a half-time basis.

Range of Financial Assistance: $200 to $1,800.

Contact: Division of Policy and Program Development, Basic Grants Branch, Office of Student Financial Assistance, Department of Education, 400 Maryland Ave. S.W., Washington, DC 20202/202-472-4300.

Basic Skills Improvement

Objectives: To provide facilitative services and resources to educational institutions, governmental agencies, and private organizations to improve and expand their activities relating to reading, communication skills, both written and oral, and mathematical skills.

Eligibility: State educational agencies, local

agencies, public or private agencies, organizations or institutions, including institutions of higher education are eligible.

Range of Financial Assistance: Not specified.

Contact: Basic Skills Program Office, Department of Education, 400 Maryland Ave. S.W., Room 1167, Washington, DC 20202/202-245-8537.

Bilingual Education

Objectives: To develop and carry out elementary and secondary school programs, including activities at the preschool level, to meet the educational needs of children of limited English proficiency, and to demonstrate effective ways of providing such children instruction designed to enable them, while using their native language, to achieve competence in English.

Eligibility: State education agencies, local education agencies, and institutions of higher education including junior and community colleges, and private nonprofit organizations that apply jointly or after consultation with one or more local education agencies.

Range of Financial Assistance: $25,000 to $2,000,000.

Contact: Office of Bilingual Education, Department of Education, 400 Maryland Ave. S.W., Reporters Building, Room 422, Washington, DC 20202/202-447-9227.

Bilingual Vocational Instructional Materials, Methods, and Techniques

Objectives: To develop instructional materials and encourage research programs and demonstration projects to meet the shortage of such instructional materials available for bilingual vocational training programs.

Eligibility: State agencies, public and private educational institutions, appropriate nonprofit organizations, and private for-profit individuals and organizations.

Range of Financial Assistance: Average grant is $280,000.

Contact: Office of Bilingual Education, Department of Education, 400 Maryland Ave. S.W., Reporters Building, Room 422, Washington, DC 20202/202-447-9227.

Bilingual Vocational Instructor Training

Objectives: To provide training for instructions of bilingual vocational training programs.

Eligibility: States, public and private educational institutions, and private for-profit educational institutions.

Range of Financial Assistance: $127,903 to $370,403.

Contact: Office of Bilingual Education Branch,

Department of Education, 400 Maryland Ave. S.W., Reporters Building, Room 422, Washington, DC 20202/202-447-9227.

Bilingual Vocational Training

Objectives: To train individuals of limited English-speaking ability for gainful employment as semi-skilled or skilled workers or technicians or sub-professionals in recognized, new and emerging occupations.

Eligibility: Local educational agencies, appropriate state agencies, postsecondary education institutions, private nonprofit vocational training institutions, nonprofit organizations, and private for-profit agencies especially created to serve a group whose language normally used is other than English.

Range of Financial Assistance: $49,204 to $360,780.

Contact: Office of Bilingual Education Branch, Department of Education, 400 Maryland Ave. S.W., Reporters Building, Room 422, Washington, DC 20202/202-447-9227.

Capacity-Building for Statistical Activities in State Educational Agencies

Objectives: To provide grants to build the statistical capabilities of state educational agencies by facilitating improvements or automation in their statistical systems.

Eligibility: State educational agencies with primary statewide responsibility for elementary, secondary, postsecondary or vocational education.

Range of Financial Assistance: $30,400 to $58,000.

Contact: National Center for Educational Statistics, Department of Education, 400 Maryland Ave. S.W., Presidential Building, Room 205, Washington, DC 20202/202-245-8744.

Career Education

Objectives: To demonstrate the most effective methods and techniques in career education and to develop exemplary career education models.

Eligibility: State educational agencies, local educational agencies, institutions of higher education, and other nonprofit agencies and organizations.

Range of Financial Assistance: $999 to $396,065.

Contact: Office of Career Education, Department of Education, 400 Maryland Ave. S.W., Donohoe Building, Room 1725, Washington, DC 20202/202-245-2284.

Citizen Education for Cultural Understanding Program

Objectives: To provide assistance to projects that will increase the availability of information

about the cultures, actions, and policies of other nations to students in the United States so that they might make more informed judgments with respect to the international policies and actions of the United States.

Eligibility: Any public or private nonprofit agency or organization, including but not limited to institutions of higher education, state and local educational agencies, professional associations, educational consortia, and organizations of teachers.

Range of Financial Assistance: $25,000 to $100,000.

Contact: International Studies Branch, Office of International Education Programs, Department of Education, 7th and D Sts. S.W., ROB3, Room 3068, Washington, DC 20202/202-245-2794.

Career Education State Allotment Program

Objectives: To enable state and local education agencies to implement career education in elementary and secondary schools.

Eligibility: State educational agencies and Insular Area education agencies.

Range of Financial Assistance: $125,000 to $1,670,000.

Contact: Office of Career Education, Department of Education, 400 Maryland Ave. S.W., Room 1725, Washington, DC 20202/202-245-2284.

Civil Rights Technical Assistance and Training

Objectives: To provide direct and indirect technical assistance and training services to school districts to cope with educational problems occasioned by desegregation for race, sex, and national origin.

Eligibility: Any school board, state educational agency, institution of higher education, private nonprofit organization or public agency intended to help solve problems related to the desegregation by race, sex, and national origin of public elementary and secondary schools.

Range of Financial Assistance: $14,000 to $400,000.

Contact: Division of Technical Assistance, Bureau of Elementary and Secondary Education, Department of Education, 400 Maryland Ave. S.W., Room 2031, Washington, DC 20202/202-245-8840.

College Library Resources

Objectives: To assist and encourage institutions of higher education and other eligible institutions in the acquisition of library materials.

Eligibility: All institutions of higher education, institutions, organizations and all other public or private nonprofit agencies that meet maintenance-of-effort requirements for library purposes. State, local, and private nonprofit library organizations and agencies which on the basis of a formal written agreement with one or more institutions of higher education make available library and information services on a cooperative basis.

Range of Financial Assistance: Average grant is $3,906.

Contact: Library Education and Postsecondary Resources Branch, Division of Library and Learning Resources, Bureau of Elementary and Secondary Education, Department of Education, 400 Maryland Ave. S.W., Room 3622, Washington, DC 20202/202-245-9530.

Community Education

Objectives: To provide educational, recreational, cultural, and other related community services, through the establishment of the community education programs.

Eligibility: Local educational agencies and public and private nonprofit organizations that plan, establish, expand, or maintain community education programs; institutions of higher education for training grants.

Range of Financial Assistance: $7,800 to $81,800.

Contact: Director, Community Education Program, Division of Development and Dissemination, Department of Education, Washington, DC 20202/202-245-0691.

Consumers' Education

Objectives: To provide consumers' education to students and the general public.

Eligibility: Institutions of higher education, state and local educational agencies, and other public and private nonprofit agencies, organizations, and institutions (including libraries).

Range of Financial Assistance: $14,940 to $105,888.

Contact: Director, Office of Consumers' Education, Bureau of School of Improvement, Department of Education, 400 6th St. S.W., Room 1628, Washington, DC 20202/202-426-9303.

Domestic Mining and Mineral Fuel Conservation Fellowship Program

Objectives: To assist students of exceptional ability who demonstrate a financial need to undertake graduate study in domestic mining and minerals, and mineral fuel conservation.

Eligibility: Any accredited institution with a graduate/professional program leading to an advanced degree in mining and minerals, and mineral fuel conservation including oil, gas, coal, oil shale, and uranium.

Range of Financial Assistance: Not specified.

Contact: Headquarters Office, Bureau of Higher and Continuing Education, Division of Training and Facilities, Graduate Training Branch, Department of Education, 400 Maryland Ave. S.W., Room 3060, ROB3, Washington, DC 20202/202-245-2347.

Education for Gifted and Talented Children and Youth

Objectives: To support state and local planning, development, operation and improvement of programs and projects designed to meet the special educational needs of the gifted and talented at preschool, elementary and secondary levels.

Eligibility: Public or private agencies.

Range of Financial Assistance: $6,000 to $190,000.

Contact: Gifted and Talented Staff, Office of the Deputy Commissioner, Office of Special Education and Rehabilitative Services, Department of Education, 400 Maryland Ave. S.W., Donohoe Building, Washington, DC 20202/202-245-2482.

Education for the Use of the Metric System of Measurement

Objectives: To provide assistance to state and local educational agencies, institutions of higher education and public and private nonprofit organizations, groups and institutions in their efforts to teach students including teachers, parents and other adults to use the revised Metric System of Measurement.

Eligibility: State educational agencies, local educational agencies, colleges and universities, and public and private nonprofit organizations, groups, and institutions.

Range of Financial Assistance: $14,824 to $95,972.

Contact: Metric Education Program, Bureau of Occupational and Adult Education, Department of Education, 400 Maryland Ave. S.W., Washington, DC 20202/202-653-5920.

Education of Handicapped Children in State-Operated or Supported Schools

Objectives: To extend and improve comprehensive educational programs for handicapped children enrolled in state-operated or -supported schools.

Eligibility: State agencies and state-supported and state-operated schools for handicapped children. Local educational agencies may also participate on behalf of children who were formerly enrolled in state agencies.

Range of Financial Assistance: $250,347 to $17,810,136.

Contact: Division of Assistance to States, Office of Special Education and Rehabilitative Services, Department of Education, Washington, DC 20202/202-472-4825.

Education Television and Radio Programming

Objectives: To carry out the development, production, evaluation, dissemination, and utilization of innovative educational television and/or radio programs.

Eligibility: State and local governments, public and private agencies, profit and nonprofit organizations, associations, institutions, and individuals.

Range of Financial Assistance: Not specified.

Contact: Educational Technology Development Branch, Division of Educational Technology, Office of Libraries and Learning Resources, Bureau of Elementary and Secondary Education, Department of Education, 400 Maryland Ave. S.W., Room 3116, Washington, DC 20202/202-245-9228.

Educational Research and Development

Objectives: To improve education in the United States through concentrating the resources of the National Institute of Education on priority research and development needs.

Eligibility: Public and private, profit and nonprofit organizations, institutions, agencies, and individuals, including state educational agencies, local education agencies and international organizations or agencies.

Range of Financial Assistance: $1,500 to $3,000,000.

Contact: National Institute of Education, Department of Education, 1200 19th St. N.W., Washington, DC 20208/202-254-5750

Educationally Deprived Children in State Administered Institutions Serving Neglected or Delinquent Children

Objectives: To expand and improve educational programs to meet the special needs of institutionalized children for whom the state has an educational responsibility.

Eligibility: Departments of education in states.

Range of Financial Assistance: $2,062 to $2,771,434.

Contact: Director, Compensatory Education Programs, Office of Elementary and Secondary Education, Department of Education, 7th and D Sts. S.W., Washington, DC 20202/202-245-2722.

Educationally Deprived Children—Local Educational Agencies

Objectives: To expand and improve educational programs to meet the needs of educationally disadvantaged children in low-income areas wheth-

er enrolled in public or private elementary and secondary schools.

Eligibility: Departments of education in states; Bureau of Indian Affairs.

Range of Financial Assistance: $606,537 to $256,171,631.

Contact: Compensatory Education Programs, Office of Elementary and Secondary Education, Department of Education, Washington, DC 20202/202-245-2722.

Educationally Deprived Children—Migrants

Objectives: To expand and improve educational programs to meet the special needs of children of migratory agricultural workers or of migratory fishermen.

Eligibility: Departments of education in states.

Range of Financial Assistance: $36,818 to $46,836,071.

Contact: Migrant Education, Program Office, Office of Elementary and Secondary Education, Department of Education, 400 Maryland Ave. S.W., Washington, DC 20202/202-245-2222.

Educationally Deprived Children—Special Incentive Grants

Objectives: To provide an incentive for an increase in state compensatory education funding for elementary and secondary education.

Eligibility: Educational agencies of states with a compensatory education program.

Range of Financial Assistance: Not specified.

Contact: Compensatory Education Programs, Office of Elementary and Secondary Education, Department of Education, 7th and D Sts. S.W., Washington, DC 20202/202-245-2722.

Educationally Deprived Children—State Administration

Objectives: To improve and expand educational programs for disadvantaged children through financial assistance to state education agencies.

Eligibility: Departments of education in states.

Range of Financial Assistance: $50,000 to $4,173,310.

Contact: Director, Compensatory Education Program, Office of Elementary and Secondary Education, Department of Education, 7th and D Sts. S.W., Washington, DC 20202/202-245-2722.

Educational Opportunity Centers

Objectives: To provide and coordinate services for residents in areas with a major concentration of low-income people to facilitate their entry into postsecondary educational programs and to provide tutoring, counseling and other supportive services for enrolled postsecondary students from the target community.

Eligibility: Institutions of higher education, combinations of such institutions, public and private nonprofit agencies and organizations (including professional and scholarly organizations) and, in exceptional cases, secondary schools and secondary vocational schools.

Range of Financial Assistance: $100,000 to $300,000.

Contact: Director, Division of Student Services and Veterans Programs, Office of Postsecondary Education, Department of Education, 400 Maryland Ave. S.W., Washington, DC 20202/202-426-8960.

Elementary and Secondary School Education in the Arts

Objectives: To encourage and support programs that stress the essential role that the arts play in elementary and secondary education; to conduct programs in which the arts are an integral part of elementary and secondary school curricula; to develop performing arts for children and youth; and to identify, develop, and implement model projects or programs in all the arts for handicapped persons.

Eligibility: State or territorial educational agencies, local educational agencies, and nonprofit groups.

Range of Financial Assistance: $25,000 to $100,000.

Contact: Arts and Humanities Staff, Department of Education, 400 Maryland Ave. S.W., Donohoe Building, Room 3728, Washington, DC 20202/202-472-7793.

Emergency Adult Education Program for Indochina Refugees

Objectives: To provide emergency adult education programs and educational support services for Indochinese refugees.

Eligibility: State and local education agencies.

Range of Financial Assistance: Not specified.

Contact: Director, Division of Adult Education, Office of Vocational and Adult Education, Department of Education, Washington, DC 20202/202-245-2278.

Emergency School Aid Act—Basic Grants to Local Educational Agencies

Objectives: To assist the process of eliminating, reducing, or preventing minority group isolation and aiding school children in overcoming the ecucational disadvantages of minority group isolation.

Eligibility: Local educational agencies implementing: a court-ordered desegregation plan, a plan approved by the Office for Civil Rights under Title VI of the Civil Rights Act, or a plan,

without having been required to do so, for the elimination of minority group isolated schools.

Range of Financial Assistance: $279,674.

Contact: Division of Equal Educational Opportunity Program Operations, Bureau of Elementary and Secondary Education, Department of Education, 400 Maryland Ave., S.W., Room 2010, Washington, DC 20202/202-245-7965.

Emergency School Aid Act—Bilingual Education Projects

Objectives: To assist the process of reducing minority group isolation and aiding school children in overcoming the eucational disadvantages of minority group isolation by insuring the establishment of bilingual/bicultural programs.

Eligibility: Local educational agencies which have developed plans to meet the needs of minority group children who, because they are from an environment in which the dominant language is other than English, do not have equal educational opportunity.

Range of Financial Assistance: Average grant is $296,550.

Contact: Division of Equal Education Opportunity Program Operations, Bureau of Elementary and Secondary Education, Department of Education, 400 Maryland Ave. S.W., Room 2010, Washington, DC 20202/202-245-7965.

Emergency School Aid Act—Grants for the Arts

Objectives: To assist the process of reducing minority group isolation by providing through the arts opportunities for interracial and intercultural communication and understanding.

Eligibility: A public agency other than a local educational agency that is responsible for the administration of statewide public arts programs.

Range of Financial Assistance: Average grant is $100,000.

Contact: Division of Equal Educational Opportunity Program Operations, Bureau of Elementary and Secondary Education, Department of Education, 400 Maryland Ave. S.W., Room 2010, Washington, DC 20202/202-245-7965.

Emergency School Aid Act—Out-of-Cycle Grants

Objectives: To assist the process of reducing minority group isolation by meeting education needs that arise from the implementation of a qualifying plan adopted too late to serve as the basis for a basic grant.

Eligibility: Local educational agencies, state educational agencies and private nonprofit agencies and organizations are eligible.

Range of Financial Assistance: Average grant is $976,000.

Contact: Division of Equal Educational Op-

portunity Program Operations, Bureau of Elementary and Secondary Education, Department of Education, 400 Maryland Ave. S.W., Room 2010, Washington, DC 20202/202-245-7965.

Emergency School Aid Act—Planning Grants

Objectives: To assist the process of reducing minority group isolation by providing assistance to develop a qualifying plan.

Eligibility: Local education agencies.

Range of Financial Assistance: Average grant is $45,000.

Contact: Division of Equal Educational Opportunity Program Operations, Bureau of Elementary and Secondary Education, Department of Education, 400 Maryland Ave. S.W., Room 2010, Washington, DC 20202/202-245-7965.

Emergency School Aid Act—Preimplementation Assistance Grants

Objectives: To assist the process of reducing minority group isolation by providing help to an agency that has adopted but not yet implemented a required plan.

Eligibility: Local educational agencies, state educational agencies, other public agencies and private nonprofit organizations.

Range of Financial Assistance: Average grant is $78,766.

Contact: Division of Equal Educational Opportunity Program Operations, Bureau of Elementary and Secondary Education, Department of Education, 400 Maryland Ave. S.W., Room 2010, Washington, DC 20202/202-245-7965.

Emergency School Aid Act—Pilot Programs

Objectives: To assist the process of reducing minority group isolation, especially school children, by providing funds to be used by those who have or will adopt a plan to meet this objective.

Eligibility: Nonprofit private organizations which receive a request from an eligible local education agency to develop bilingual curricula designed to meet the special educational needs of minority group children who are from environments in which a dominant language is other than English.

Range of Financial Assistance: Average grant is $296,550.

Contact: Division of Equal Educational Opportunity Program Operations, Bureau of Elementary and Secondary Education, Department of Education, 400 Maryland Ave. S.W., Room 2010, Washington, DC 20202/202-245-7965.

Emergency School Aid Act—Special Discretionary Assistance Grants

Objectives: To assist the process of reducing

minority group isolation by providing funds to be used for special discretionary assistance to help meet unexpected educational needs arising from the implementation of a qualifying plan after the deadline for receipt of basic grant applications.

Eligibility: Local educational agencies, state educational agencies and private nonprofit agencies and organizations are eligible.

Range of Financial Assistance: Average grant is $256,000.

Contact: Division of Equal Educational Opportunity Program Operations, Bureau of Elementary and Secondary Education, Department of Education, 400 Maryland Ave. S.W., Room 2010, Washington, DC 20202/202-245-7965.

Emergency School Aid Act—Special Programs

Objectives: To assist the process of reducing minority group isolation, especially school children.

Eligibility: State and local educational agencies, other public agencies and organizations, and public and private nonprofit agencies, institution and organizations that will conduct activities, if assistance is made available are otherwise authorized by the Emergency School Aid Act and promise to make substantial progress toward achieving the purposes of the Emergency School Aid Act.

Range of Financial Assistance: Average grant is $478,845.

Contact: Division of Equal Educational Opportunity Programs Operations, Bureau of Elementary and Secondary Education, Department of Education, 400 Maryland Ave. S.W., Room 2010, Washington, D.C. 20202/202-245-7965.

Emergency School Aid Act—Special Programs and Projects (Nonprofit Organization)

Objectives: To assist the process of reducing minority group isolation by providing funds to be used by nonprofit organizations to conduct special programs that support local educational agencies' efforts to develop or implement a plan to meet special problems incident to desegregation, that encourage voluntary integration, or that aid school children in overcoming the educational disadvantages of minority group isolation.

Eligibility: Any public agency, institution, or organization (other than a local educational agency) and any nonprofit private agency, institution or organization whose application shows evidence that activities proposed are related to supporting local education agency's desegregation plan.

Range of Financial Assistance: Average grant is $85,000.

Contact: Division of Equal Educational Opportunity Program Operations, Bureau of Elementary and Secondary Education, U.S. Department of Education, 400 Maryland Ave. S.W., Room 2010, Washington, DC 20202/202-245-7965.

Emergency School Aid Act—State Agency Grants

Objectives: To meet the special needs incident to the elimination of minority group segregation and discrimination against students and faculty; and to encourage the voluntary elimination, reduction, or prevention of minority group isolation in public education.

Eligibility: State education agencies or other agencies responsible for the desegregation of public education.

Range of Financial Assistance: Average grant is $500,000.

Contact: Division of Equal Educational Opportunity Program Operations, Bureau of Elementary and Secondary Education, Department of Education, 400 Maryland Ave. S.W., Room 2010, Washington, DC 20202/202-245-7965.

Emergency School Aid Act—Television and Radio

Objectives: To assist the process of reducing minority group isolation by providing funds to be used for the development of television programming that presents multi-ethnic children's activities.

Eligibility: Public or private nonprofit agencies or organizations capable of developing educational television and radio programming to meet the purpose of the Act.

Range of Financial Assistance: $300,000 to $1,850,000.

Contact: Director, Division of Educational Technology, Office of Educational Research and Improvement, Department of Education, 400 Maryland Ave. S.W., ROB3, Room 3116, Washington, DC 20202/202-245-9225.

Emergency School Aid—Magnet Schools, University/Business Cooperation

Objectives: To assist the reduction of minority group isolation in elementary and secondary schools with substantial proportions of minority group students by providing funds to be used in connection with a school or education center that offers a special curriculum capable of attracting substantial numbers of students of different racial backgrounds.

Eligibility: Local educational agencies.

Range of Financial Assistance: Average grant is $382,421.

Contact: Division of Equal Educational Opportunity, Program Operations, Bureau of Elementary and Secondary Education, Department of Education, 400 Maryland Ave. S.W., Room 2010, Washington, DC 20202/202-245-7965.

Emergency School Aid—Neutral Site Planning

Objectives: To encourage the reduction of minority group isolation in elementary and secondary schools with substantial proportions of minority group students.

Eligibility: Local educational agencies which have implemented or will, if assistance is made available, adopt and implement a plan to reduce the isolation of minority group students in their schools.

Range of Financial Assistance: Average grant is $750,000.

Contact: Division of Equal Educational Opportunity, Program Operations, Bureau of Elementary and Secondary Education, Department of Education, 400 Maryland Ave. S.W., Room 2010, Washington, DC 20202/202-245-7965.

Environmental Education

Objectives: To improve public understanding of environmental issues as they relate to the quality of life.

Eligibility: Institutions of higher education, state or local educational agencies, and other public and nonprofit private agencies, organizations and institutions including libraries and museums. An applicant group or organization must have been organized and active for at least one year before making application for a grant.

Range of Financial Assistance: $7,000 to $150,000.

Contact: Office of Environmental Education, Bureau of Elementary and Secondary Education, Department of Education, 400 Maryland Ave. S.W., Donohoe Building, Room 1100, Washington, DC 20202/202-245-9231.

Ethnic Heritage Studies Program

Objectives: To recognize the contributions of ethnic groups to American society; to provide students opportunities to learn more about the nature of their own heritage and that of other groups; and to reduce social divisiveness by promoting awareness of ethnic and cultural diversity in the nation.

Eligibility: Public or nonprofit private educational agencies, institutions, or organizations, including such organizations as ethnic associations and educational institutions.

Range of Financial Assistance: $10 to $60,000.

Contact: Ethnic Heritage Studies Staff, Bureau

of School Improvement, Department of Education, Washington, DC 20202/202-245-3471.

Follow Through

Objectives: To sustain and augment in primary grades the gains that children from low-income families make in Headstart and other quality preschool programs. Follow Through provides special programs of instruction as well as health, nutrition, and other related services which will aid in the continued development of children to their full potential. Active participation of parents is stressed.

Eligibility: For discretionary project grants or contracts, only currently approved public and private institutions of higher education or other currently approved public or private educational or research agencies and organizations. For formula grants or contracts, state educational agencies and/or other appropriate agencies are eligible.

Range of Financial Assistance: $6,300 to $1,783,000.

Contact: Follow Through Division, Bureau of Elementary and Secondary Education, Department of Education, ROB3, Room 3124, 7th and D Sts. S.W., Washington, DC 20202/202-245-9846.

Foreign Language and Area Studies Research

Objectives: To improve foreign language and area studies training in the United States through support of research and studies, experimentation, and development of specialized instructional materials.

Eligibility: Institutions of higher education; qualified individual researchers; state educational agencies; public school systems; other educational and professional organizations.

Range of Financial Assistance: $2,500 to $100,000.

Contact: Centers and Research Section, Division of International Education, Department of Education, ROB3, 7th and D Sts. S.W., Washington, DC 20202/202-245-2761.

Fulbright-Hays Training Grants

Objectives: To provide opportunities for advanced graduate students to engage in full-time dissertation research abroad in modern foreign language and area studies. The program is designed to develop research knowledge and capability in world areas not widely included in American curriculums.

Eligibility: Candidate for a Dissertation Research Fellowship must be a citizen or national or permanent resident of the United States.

Fulbright-Hays Training Grants—Faculty Research Abroad

Objectives: To help universities and colleges strengthen their programs of international studies through selected opportunities for research and study abroad in foreign language and area studies; to enable key faculty members to keep current in their specialties; to facilitate the updating of curricula and to help improve teaching methods and materials.

Eligibility: Candidates for faculty research awards must be U.S. citizens or nationals, educators experienced in a foreign language and area studies, with whom institutions have long-term employment relationships; possess adequate skills in the language of the country or in a language germane to the project or region where project would be undertaken; present detailed description of proposed project significant and feasible for the area and time concerned; and present a statement from the employing institution describing how the project will contribute to institution's plans for developing programs in foreign language or area studies.

Range of Financial Assistance: $865 to $18,568.

Contact: Research Branch, Division of Advanced Training and Research, International Education Programs, Department of Education, 7th and D Sts. S.W., ROB3, Room 3907, Washington, DC 20202/202-245-2761.

Fulbright-Hays Training Grants—Foreign Curriculum Consultants

Objectives: To benefit American education at all levels by helping institutions bring specialists from other countries to the United States to assist in planning and developing local curriculums in foreign language and area studies.

Eligibility: State departments of education, local school systems, institutions of higher education accredited by a nationally recognized accrediting agency or association, selected nonprofit eudcational organizations, or a consortium of these institutions.

Range of Financial Assistance: $9,420 to $14,298.

Contact: Interstitutional Studies Branch, Division of International Services and Improvement, Department of Education, ROB3, Room 3916, Washington, DC 20202/202-245-2794.

Fulbright-Hays Training Grants—Group Projects Abroad

Objectives: To help education institutions improve their program in foreign language and area studies.

Eligibility: Universities, four-year colleges, community and junior colleges, state departments of education, nonprofit organizations, or consortiums of these institutions.

Range of Financial Assistance: $20,000 to $249,882.

Contact: International Studies Branch, Division of International Services and Improvement, Department of Education, 7th and D Streets, S.W., ROB3, Room 3916, Washington, DC 20202/202-245-2794.

Fund for the Improvement of Postsecondary Education

Objectives: To provide grants and contracts for innovative programs which increase the effectiveness of postsecondary education.

Eligibility: Postsecondary institutions, agencies and community organizations.

Range of Financial Assistance: $4,000 to $300,000.

Contact: Director, Fund for the Improvement of Postsecondary Education, Office of the Assistant Secretary for Education, Department of Education, 400 Maryland Ave. S.W., ROB3, Room 3110, Washington, DC 20202/202-245-8091.

Graduate and Professional Opportunities

Objectives: To strengthen and develop programs which would assist in providing graduate professional education to persons with varied backgrounds and experiences including members of minority groups that are underrepresented in colleges and universities and in academic and professional career fields; to provide fellowships to support full-time graduate and professional training of members of those minority groups and women.

Eligibility: Any accredited institution of higher education with a graduate or professional program leading to an advanced degree, other than a medical degree. For fellowship applicants, any individual accepted by an approved institution as a candidate for an advanced degree.

Range of Financial Assistance: $10,000 to $32,000.

Contact: Bureau of Continuing and Higher Education, Division of Training and Facilities, Graduate Training Branch, Department of Education, 7th and D Sts. S.W., Room 3060, Washington, DC 20202/202-245-2347.

Guidance, Counseling and Testing in Elementary/Secondary Schools

Objectives: To provide assistance to state educational agencies so that they may strengthen their leadership in the fields of guidance, counseling, and testing; and may provide assistance to local educational agencies regarding comprehen-

sive guidance, counseling, and testing programs in elementary and secondary schools.

Eligibility: State agencies.

Range of Financial Assistance: $5,000 to $1,620,000.

Contact: Bureau of Elementary and Secondary Education, Division of State Educational Assistance Programs, Department of Education, 400 Maryland Ave. S.W., ROB3, Room 3010, Washington, DC 20202/202-245-2592.

Handicapped Early Childhood Assistance

Objectives: To support experimental demonstration, outreach and state implementation of preschool and early childhood projects for handicapped children.

Eligibility: Public agencies and private nonprofit organizations.

Range of Financial Assistance: $50,000 to $150,000.

Contact: Program Development Branch, Handicapped Children's Early Education Assistance, Program Development Branch, Division of Innovation and Development, Department of Education, 400 Maryland Ave. S.W., Room 3133, Washington, DC 20202/202-245-9722.

Handicapped Innovative Programs—Deaf-Blind Centers

Objectives: To establish state and multistate centers to provide all deaf-blind children with comprehensive diagnostic and evaluative services, a program for their education, adjustment, and orientation, and effective consultative services for their parents, teachers, and others involved in their welfare.

Eligibility: Public or nonprofit agencies, organizations, or institutions.

Range of Financial Assistance: $600,000 to $1,600,000.

Contact: Centers and Services for Deaf-Blind Children, Office of Special Education and Rehabilitative Services, Division of Assistance to States, Department of Education, 400 Maryland Ave. S.W., Washington, DC 20202/202-472-4825.

Handicapped Innovative Programs—Programs for Severely Handicapped Children

Objectives: To improve and expand innovative educational/training services for severely handicapped children and youth, and improve the general acceptance of such people by the general public, professionals, and possible employers.

Eligibility: Public and nonprofit private agencies, organizations, or institutions including state departments of special education, intermediate or local educational agencies, institutions of higher learning, professional organizations and volunteer associations.

Range of Financial Assistance: $54,680 to $189,900.

Contact: Program Officer, Projects for Severely Handicapped Children and Youth, Special Needs Section, Office of Special Education and Rehabilitative Services, Department of Education, 400 Maryland Ave. S.W., Donohoe Building, Room 3135, Washington, DC 20202/202-472-2535.

Handicapped Media Services and Captioned Films

Objectives: To maintain a free loan service of captioned films for the deaf and instructional media for the educational, cultural, and vocational enrichment of the handicapped; to provide for acquisition and distribution of media materials and equipment, and to provide contracts and grants for research into the use of media, and train teachers, parents and others in media utilization.

Eligibility: Public and private agencies, organizations, or groups.

Range of Financial Assistance: $1,350 to $1,650,000.

Contact: Captioned Films and Media Application Branch, Division of Educational Programs, Office of Special Education and Rehabilitative Services, Department of Education, Washington, DC 20202/202-472-4640.

Handicapped Personnel Preparation

Objectives: To improve the quality and increase the supply of teachers, supervisors, administrators, researchers, teacher educators, speech correctionists, and other special personnel such as specialists in physical education and recreation, and paraprofessionals.

Eligibility: Institutions of higher education, state and local educational agencies, and other nonprofit public and private agencies.

Range of Financial Assistance: Grants range from $3,000 to $360,000; average grant is $45,000.

Contact: Division of Personnel Preparation, Office of Education, Office of Special Education and Rehabilitative Services, Department of Education, Room 4153, Washington, DC 20202/202-245-9886.

Handicapped Preschool and School Programs

Objectives: To provide grants to states to assist them in providing a free appropriate public education to all handicapped children.

Eligibility: State education agencies.

Range of Financial Assistance: $167,523 to $49,893,306.

Contact: Division of Assistance to States, Office of Special Education and Rehabilitative Services, Department of Education, 400 Maryland Ave. S.W., Washington, DC 20202/202-472-4865.

Handicapped Regional Resource Centers

Objectives: To establish regional resource centers which provide advice and technical services to educators for improving education of handicapped children.

Eligibility: Institutions of higher education, state education agencies, local education agencies, or combinations of such agencies or institutions.

Range of Financial Assistance: $100,000 to $800,000.

Contact: Learning Resources Branch, Division of Education Services, Office of Special Education and Rehabilitative Services, Department of Education, 400 Maryland Ave. S.W., Washington, DC 20202/202-472-4650.

Handicapped—Research and Demonstration

Objectives: To improve the education of handicapped children through research and development projects, and demonstrations model programs.

Eligibility: State or local educational agencies, public and private institutions of higher learning, and other public or private educational or research agencies and organizations.

Range of Financial Assistance: $4,000 to $500,000.

Contact: Research, Chief, Research Projects Branch, Division of Innovation and Development, Office of Special Education and Rehabilitative Services, Department of Education, 400 Maryland Ave. S.W., Room 3165, Washington, DC 20202/202-245-2275. See "National Institute of Handicapped Research," and "Rehabilitation" and "Vocational Rehabilitation" listings in this section.

Handicapped Teacher Recruitment and Information

Objectives: To disseminate information which can help parents, consumer organizations, professionals and others interested in special education in making decisions that affect the education and general well-being of handicapped children.

Eligibility: Public or nonprofit agencies, organizations, or institutions.

Range of Financial Assistance: $10,000 to $400,000.

Contact: Office of Special Education and Rehabilitative Services, Department of Education, 400 Maryland Ave. S.W., Washington, DC 20202/202-245-9661.

Health Education Assistance Loans

See "Health Education Assistance Loans," under "Grants;" "Major Sources of Information;" and "U.S. Department of Health and Human Services."

Higher Education Academic Facilities—State Administration

Objectives: To provide funds to the state commissions on higher education facilities for administering state plans.

Eligibility: All state commissions for higher education facilities approved by the Commissioner of Education.

Range of Financial Assistance: $500 to $36,000.

Contact: Acting Chief, College Facilities Branch, Office of Postsecondary Education, Room 4052, ROB3, 7th and D Sts. S.W., Washington, DC 20202/202-245-9868.

Higher Education—Cooperative Education

Objectives: To provide federal support for cooperative education programs. Cooperative education programs are those which alternate periods of academic study with periods of public or private employment related to the student's academic program or professional goals.

Eligibility: Accredited institutions of higher education, including junior colleges, four-year colleges and universities, and other public or private nonprofit agencies and organizations.

Range of Financial Assistance: $20,000 to $175,000.

Contact: Cooperative Education Branch, Division of Training and Facilities, Bureau of Higher and Continuing Education, Department of Education, Room 3053, Washington, DC 20202/202-245-2146.

Higher Education—Instructional Equipment

Objectives: To improve the quality of undergraduate instruction in institutions of higher education by providing financial assistance on a matching basis for the acquisition of instructional equipment, materials, and related minor remodeling.

Eligibility: All public or nonprofit institutions of higher education, including trade and vocational schools or combinations of such institutions are eligible. These institutions must offer not less than a one-year program of training to prepare students for gainful employment in a recognized occupation.

Range of Financial Assistance: $500 to $50,000.

Contact: Office of Libraries and Learning Technologies, Office of Educational Research and Improvement, Elementary and Secondary Education, Department of Education, 400 Maryland Ave. S.W., Washington, DC 20202/202-245-9601

Higher Education—Strengthening Developing Institutions

Objectives: To strengthen developing colleges in their academic, administrative, and student services programs so that they may participate adequately in the higher education community.

Eligibility: A college or institution of higher learning that qualifies as developing.

Range of Financial Assistance: $37,000 to $1,404,500.

Contact: Division of Institutional Development, Office of Postsecondary Education, Department of Education, Washington, DC 20202/202-245-2384.

Improvement in Local Educational Practice

Objectives: To provide assistance to local educational agencies so that they may provide assistance to local educational institutions to improve their educational practices.

Eligibility: Any state desiring to receive funds must establish a State Advisory Council and submit a state plan designating the state educational agency as the sole administrator of the plan.

Range of Financial Assistance: $840,537 to $17,817,526.

Contact: Office of Education, Bureau of Elementary and Secondary Education, Division of State Educational Assistance Programs, Department of Education, 400 Maryland Ave. S.W., ROB3, Room 3010, Washington, DC 20202/202-245-2592.

Incentive Grants for State Student Financial Assistance Training

Objectives: To make incentive grants to states to design, develop, and implement programs to increase the proficiency of state and institutional financial aid administrators in all aspects of student financial assistance.

Eligibility: States, the District of Columbia, and outlying areas may submit applications through the state agency administering student grants.

Range of Financial Assistance: Up to $30,000.

Contact: Division of Training and Dissemination, Office of Student Financial Assistance, Department of Education, P.O. Box 84, Washington, DC 20044/202-472-5080.

Indian Education—Adult Indian Education

Objectives: To plan, develop, and implement programs for Indian adults.

Eligibility: State and local educational agencies, and Indian tribes, institutions, and organizations.

Range of Financial Assistance: $20,600 to $195,000.

Contact: Office of Indian Education, Department of Education, 400 Maryland Ave. S.W., Room 2177, Washington, DC 20202/202-2673.

Indian Education—Fellowships for Indian Students

Objectives: To provide support which enables American Indian people to study for careers in medicine, law, engineering, natural resources, business administration, education and related fields.

Eligibility: An American Indian who is in attendance, or who has been accepted for admission, as a full-time student at an institution of higher education for study in a graduate or professional program leading to a degree in engineering, medicine, law, business, forestry, or a related field.

Range of Financial Assistance: $2,300 to $13,000.

Contact: Office of Indian Education, Department of Education, 400 Maryland Ave. S.W., Room 2177, Washington, DC 20202/202-245-2673.

Indian Education—Grants to Local Education Agencies

Objectives: To provide financial assistance to local educational agencies to develop and implement elementary and secondary school programs designed to meet the special educational and culturally related academic needs of Indian children.

Eligibility: Local educational agencies which have at least ten Indian children or in which Indians constitute at least 50 percent of the total enrollment.

Contact: Office of Indian Education, Department of Education, 400 Maryland Ave. S.W., Room 2161, Washington, DC 20202/202-245-9159.

Indian Education Grants to Nonlocal Education Agencies

Objectives: To provide financial assistance to nonlocal educational agencies to develop and implement elementary and secondary school programs designed to meet the special educational needs of Indian children. Nonlocal educational

agencies are schools on or near a reservation which are governed by a nonprofit institution or organization of an Indian tribe.

Eligibility: Nonlocal educational agencies meeting the eligibility factors; local educational agencies which have been local educational agencies for less than three years and meet the selection criteria may also apply.

Range of Financial Assistance: $50,000 to $160,000.

Contact: Office of Indian Education, Department of Education, 400 Maryland Ave. S.W., Room 2161, Washington, DC 20202/202-245-8298.

Indian Education—Special Programs and Projects

Objectives: To plan, develop, and implement programs and projects for the improvement of educational opportunities for Indian children.

Eligibility: State and local educational agencies, federally supported elementary and secondary schools for Indian children, tribal and other Indian community organizations, and institutions of higher education.

Range of Financial Assistance: $5,580 to $400,000.

Contact: Office of Indian Education, Department of Education, 400 Maryland Ave. S.W., Room 2161, Washington, DC 20202/202-245-8298.

Institute Museum Services

Objectives: To help ease the increasing operating costs borne by museums as a result of their increasing use by the public; to encourage and assist museums in their educational and conservation roles; and to assist museums in modernizing their facilities so that they may be better able to conserve our cultural, historical, and scientific heritage.

Eligibility: A museum located in the United States or its territories.

Range of Financial Assistance: $1,000 to $25,000.

Contact: Institute of Museum Services, Office of the Assistant Secretary for Education, Department of Education, 330 C St. S.W., Switzer Building, Room 4006, Washington, DC 20201/202-245-0413.

International Studies Centers and Foreign Language and Area Studies—Fellowships

Objectives: To promote instruction in modern foreign languages and area and international studies critical to national needs by supporting the establishment and operation of such programs at colleges and universities and fellowships for advanced study at higher education institutions.

Eligibility: Accredited higher education institutions offering comprehensive graduate language and area programs are eligibile to apply for award quotas.

Range of Financial Assistance: $4,125 to $175,000.

Contact: Division of International Education, Department of Education, Washington, DC 20202/202-245-9808.

International Studies, Graduate Program; International Studies and Foreign Language, Undergraduate Program

Objectives: To strengthen international and global dimensions in the general education curriculum of institutions of higher education by establishing international and global studies programs at the graduate and undergraduate levels.

Eligibility: Accredited American colleges and universities.

Range of Financial Assistance: $24,000 to $50,000.

Contact: International Studies Branch, Division of International Education, Department of Education, 7th and D Sts. S.W., ROB3, Room 3916, Washington, DC 20202/202-245-2794.

Law School Clinical Experience Program

Objectives: To establish and expand programs in law schools to provide clinical experience to students in the practice of law, with preference being given to programs providing such experience, to the extent practicable, in the preparation and trial of cases.

Eligibility: Accredited law schools.

Range of Financial Assistance: $22,000 to $56,000.

Contact: Graduate Training Branch, Bureau of Higher and Continuing Education, Department of Education, 7th and D Sts. S.W., ROB3, Room 3066, Washington, DC 20202/202-245-2347.

Libraries and Learning Resources

Objectives: To carry out a program of making grants to states for the acquisition of school library resources, textbooks, and other printed and published instructional materials for use by children and teachers in public and private elementary and secondary schools; for the acquisition of instructional equipment such as laboratory and other special equipment, including audiovisual materials; programs of testing, counseling and guidance services, projects and leadership activities.

Eligibility: State education agencies.

Range of Financial Assistance: $48,748 to $15,706,317.

Contact: Office of Libraries and Learning Technologies, Office of Educational Research and Improvement, Department of Education, 400 Maryland Ave. S.W., Washington, DC 20202/202-245-9687.

Library Research and Demonstration

Objectives: To award grants and contracts for research and/or demonstration projects in areas of specialized services intended to improve library and information science practices and principles.

Eligibility: All institutions of higher education and all other public or private agencies, institutions, and organizations of a nonprofit nature; contracts only to profit agencies and organizations.

Range of Financial Assistance: $1,800 to $320,000.

Contact: Division of Library Programs, Office of Libraries and Learning Technologies, Office of Educational Research and Improvement, Department of Education, 400 Maryland Ave. S.W., Washington, DC 20202/202-245-9687.

Library Services and Construction Act

Objectives: To assist in extending public library services to areas without service or with inadequate service, establishing and expanding state institutional library services and library services to the physically handicapped, and to the disadvantaged in urban and rural areas, and strengthening the metropolitan public libraries which serve as national or regional resource centers; and programs and projects which serve areas with high concentrations of persons of limited English-speaking ability.

Eligibility: State library extension agencies which have authority to administer federal funds, supervise public library service within a state, and together with participating libraries, have financial resources sufficient to match federal funds on a percentage basis according to per capita wealth.

Range of Financial Assistance: Not applicable.

Contact: State and Public Library Services Branch, Office of Libraries and Learning Technologies, Office of Educational Research and Improvement, Department of Education, 400 Maryland Ave. S.W., ROB3, Room 3124, Washington, DC 20202/202-472-5150.

Library Services—Interlibrary Cooperation

Objectives: To provide for the systematic and effective coordination of the resources of school, public, academic, and special libraries and special information centers for improved services of a supplementary nature to the special clientele served by each type of library center.

Eligibility: State library extension agencies which have authority to administer federal funds and supervise library service within a state.

Range of Financial Assistance: Not applicable.

Contact: State and Public Library Services Branch, Office of Libraries and Learning Technologies, Office of Educational Research and Improvement, Department of Education, 400 Maryland Ave. S.W., ROB3, Room 3124, Washington, DC 20202/202-452-5150.

Library Training Grants

Objectives: To assist institutions of higher education and library organizations and agencies in training persons in the principles and practices of librarianship and information science.

Eligibility: All institutions of higher education and all other nonprofit library organizations or agencies which have an established program of library education or are planning to begin such a program, or which have sufficient facilities and resources necessary to conduct a training program.

Range of Financial Assistance: $11,387 to $115,000.

Contact: Library Education Research and Resources Branch, Division of Library Programs Office of Libraries and Learning Technologies, Office of Educational Research and Improvement, Department of Education, 400 Maryland Ave. S.W., Room 3622, Washington, DC, 20202/202-245-9530.

National Diffusion Program

Objectives: To promote and accelerate the systematic, rapid dissemination and replication of educational practices, products, and programs which were developed in Office of Education, state and discretionary grant programs and whose effectiveness had been certified by the Joint Dissemination Review Panel.

Eligibility: Nonprofit public or private agencies, organizations, groups or individuals.

Range of Financial Assistance: $16,000 to $211,000.

Contact: Acting Director, National Diffusion Network, Office of Educational Research and Improvement, Department of Education, 1832 M St. N.W., Room 802, Washington, DC 20201/202-653-7000.

National Direct Student Loan Cancellations

Objectives: To reimburse institutions for their share of loans cancelled for National Defense Student Loan recipients who become teachers or

who perform active military service in the U.S. Armed Forces, and restore to the fund the full amounts of National Direct Student Loans cancelled for teaching service and for military service in specified areas of hostility.

Eligibility: Higher education institutions (public, other nonprofit, and proprietary) meeting the eligibility requirements and currently or previously participating in the National Direct (or Defense) Student Loan Program.

Range of Financial Assistance: $4 to $129,821.

Contact: Campus and State Grant Branch, Division of Program Operations, Bureau of Student Financial Assistance, Department of Education, 400 Maryland Ave. S.W., Room 4642, Washington, DC 20202/202-245-2320.

National Institute of Handicapped Research

Objectives: To support research and its utilization to improve the lives of people of all ages with physical and mental handicaps, especially the severely disabled.

Eligibility: State, public or private nonprofit agencies and organizations, including institutions of higher education are eligible.

Range of Financial Assistance: $10,000 to $1,500,000.

Contact: Grants Management Branch, National Institute of Handicapped Research, Department of Education, Room 3511, Washington, DC 20201/202-472-6551.

Public Service Education—Institutional Grants and Fellowships

Objectives: To provide up to 500 fellowships annually for graduate or professional study for college graduates intending to pursue a career in public service and to provide grants to institutions of higher education on the graduate level.

Eligibility: Any accredited institution of higher education with a graduate or professional program of public service education leading to an advanced degree, other than a medical degree.

Range of Financial Assistance: $17,800 to $18,454.

Contact: Bureau of Higher and Continuing Education, Division of Training and Facilities, Graduate Training Branch, Department of Education, ROB3, 7th and D Sts. S.W., Washington, DC 20202/202-245-2347.

Regional Education Programs for Deaf and Other Handicapped Persons

Objectives: To develop and operate specially designed or modified programs of vocational, technical, postsecondary, or adult education for deaf or other handicapped persons.

Eligibility: Institutions of higher education, including junior and community colleges, vocational and technical institutions, and other appropriate nonprofit educational agencies.

Range of Financial Assistance: $75,000 to $450,200.

Contact: Program Development Branch, Regional Education Programs, Division of Innovation and Development, Office of Special Education and Rehabilitative Services, Department of Education, 400 Maryland Ave. S.W., Room 3113, Washington, DC 20202/202-245-9722.

Rehabilitation Research and Demonstrations

Objectives: To discover, test, demonstrate, and promote utilization of information on new concepts and devices which will improve rehabilitation services to handicapped individuals.

Eligibility: Grants may be made to states and nonprofit organizations. Grants cannot be made directly to the individuals.

Range of Financial Assistance: $10,000 to $1,500,000.

Contact: National Institute of Handicapped Research, Rehabilitation Services Administration, Department of Education, Switzer Building, S.W., Room 3511, Washington, DC 20201/202-472-6551.

Rehabilitation Services and Facilities—Basic Support

Objectives: To provide vocational rehabilitation services to persons with mental and/or physical handicaps. Priority service is placed on needs of those persons with the most severe disabilities.

Eligibility: State agencies designated as the sole state agency to administer the vocational rehabilitation program.

Financial Assistance: $400,000 to $55,784,000.

Contact: Basic State Grant Branch, Division of Program Administration, Office of Program Operation, Rehabilitation Services Administration, Department of Education, Washington, DC 20201/202-472-9120.

Rehabilitation Services and Facilities—Special Projects

Objectives: To provide funds to state vocational rehabilitation agencies and public or nonprofit organizations for projects and demonstrations which hold promise of expanding and otherwise improving services for the mentally and physically handicapped over and above those provided by the Basic Support Program administered by states.

Eligibility: Projects with industry-employers and other organizations, and all other public or private nonprofit institutions or organizations.

Grants cannot be made directly to individuals.

Range of Financial Assistance: Not available.

Contact: Director, Division of Special Programs, Rehabilitation Services Administration, Office of Program Development, Department of Education, Washington, DC 20201, 202-245-0079.

Rehabilitation Training

Objectives: To support projects to increase the numbers of personnel trained in providing vocational rehabilitation services to handicapped individuals.

Eligibility: State vocational rehabilitation agencies, and other public or nonprofit agencies and organizations, including institutions of higher education.

Range of Financial Assistance: $5,000 to $200,000.

Contact: Division of Resource Development, Rehabilitation Services Administration, Department of Education, Washington, DC 20201/202-245-0076.

Right to Read—Elimination of Illiteracy

Objectives: To provide facilitating services and resources to stimulate educational institutions, governmental agencies, and private organizations to improve and expand their activities related to reading.

Eligibility: Any public or nonpublic school district officially recognized by the state department of public instruction; any state department of education in the United States or its possessions; any accredited college or university; or any community agency eligible to receive federal funds.

Range of Financial Assistance: $10,000 to $150,000.

Contact: National Right to Read Office, Department of Education, 400 Maryland Ave. S.W., Donohoe Building, Room 1167, Washington, DC 20202/202-245-8538.

School Assistance in Federally Affected Areas—Construction

Objectives: To provide assistance for the construction of urgently needed minimum school facilities in school districts that have had substantial increases in school membership as a result of new or increased federal activities, or where reconstruction of facilities is necessary because of natural disaster.

Eligibility: Local educational agencies which provide free public elementary or secondary education in federally impacted areas, or which provide technical, vocational, or other special education to children of elementary or secondary school age where school facilities are damaged as a result of a declared natural disaster.

Range of Financial Assistance: $2,000 to $3,000,000.

Contact: Division of Impact Aid, Bureau of Elementary and Secondary Education, Department of Education, 400 Maryland Ave. S.W., FOB6, Room 2113, Washington, DC 20202/202-245-8427.

State Postsecondary Education Commission Program—Intrastate Planning

Objectives: To provide comprehensive planning for postsecondary education on an intrastate basis.

Eligibility: State postsecondary education commissions

Range of Financial Assistance: $30,100 to $173,000.

Contact: Chief, College Facilities Branch, Office of Postsecondary Education, Department of Education, ROB3, Room 3717, 7th and D Sts. S.W., Washington, DC 20202/202-245-9868.

State Student Activities

Objectives: To make incentive grants to states to develop and expand assistance to eligible students in attendance at institutions of postsecondary education.

Eligibility: The agency responsible for administering each state's need-based, undergraduate scholarship/grant program.

Range of Financial Assistance: $1,613 to $12,000,000.

Contact: Chief, State Student Incentive Grant Program, Programs Branch, Bureau of Student Financial Assistance, Department of Education, Washington, DC 20202/202-472-4265.

Strengthening Research Library Resources

Objectives: To provide financial assistance to help major research libraries maintain and strengthen their collections; and to assist major research libraries in making their holdings available to individual researchers and scholars outside their primary clientele and to other libraries whose users have need for research materials.

Eligibility: Major research libraries, which may be public or private nonprofit institutions, including the resources of an institution of higher education, independent research libraries, and state or public libraries.

Range of Financial Assistance: $69,000 to $750,000.

Contact: Division of Library Programs, Department of Education, 400 Maryland Ave. S.W., Room 3124, Washington, DC 20202/202-245-9687.

Supplemental Educational Opportunity Grants (SEOG)

Objectives: To enable students of exceptional financial need to pursue higher education by providing grant assistance for educational expenses.

Eligibility: Institutions of higher education.

Range of Financial Assistance: $235 to $4,409,060.

Contact: Campus and State Grant Branch, Division of Policy and Program Development, Bureau of Student Financial Assistance, Department of Education, Room 4100, Washington, DC 20202/202-245-9717.

School Assistance in Federally Affected Areas— Maintenance and Operation

Objectives: To provide financial assistance to local educational agencies upon which financial burdens are placed due to federal activity where the tax base of a district is reduced through the federal acquisition of real property, or where there is sudden and substantial increase in school attendance as the result of federal activities. Also to provide major disaster assistance by replacing or repairing damaged or destroyed supplies, equipment or facilities.

Eligibility: Local educational agencies which provide free public elementary or secondary education may apply.

Range of Financial Assistance: $1,000 to $12,000,000.

Contact: Division of Impact Aid, Bureau of Elementary and Secondary Education, Department of Education, 400 Maryland Ave. S.W., ROB3, Room 2113, Washington, DC 20202/202-245-8427.

Special Services for Disadvantaged Students

Objectives: To assist low-income, educationally or culturally deprived, physically handicapped students and/or students with limited English-speaking ability who are enrolled or accepted for enrollment by institutions which are recipients of grants to initiate, continue, or resume postsecondary education.

Eligibility: Institutions of higher education or combinations of institutions of higher education or agencies created or designated by such combinations.

Range of Financial Assistance: $50,000 to $225,000.

Contact: Division of Student Services, Office of Postsecondary Education, Department of Education, 400 Maryland Ave. S.W., Washington, DC 20202/202-426-8960.

Strengthening State Educational Agency Management

Objectives: To strengthen the leadership re-

sources of state educational agencies and to assist in identifying and meeting the critical educational needs of the State.

Eligibility: State educational agencies.

Range of Financial Assistance: $400,000 to $4,000,000.

Contact: Bureau of Elementary and Secondary Education, Office of Educational Support, Department of Education, 400 Maryland Ave. S.W., FOB6, Room 2079, Washington, DC 20202/202-245-2592.

Talent Search

Objectives: To identify youths of financial or cultural need with exceptional potential for postsecondary educational training and assist them in obtaining admissions to postsecondary schools, with adequate financial aid.

Eligibility: Institutions of higher education, combinations of such institutions, public and private nonprofit agencies and organizations, including professional and scholarly associations, and, in exceptional cases, secondary schools and secondary vocational schools.

Range of Financial Assistance: $50,000 to $150,000.

Contact: Director, Division of Student Services, Office of Postsecondary Education, Department of Education, 400 Maryland Ave. S.W., Washington, DC 20202/202-245-8960.

Teacher Centers

Objectives: To assist local educational agencies and institutions of higher education in operating teacher centers designed to provide improved inservice training for teachers and to develop improved curricula for the schools.

Eligibility: Local educational agencies; public and private institutions of higher education.

Range of Financial Assistance: $5,000 to $250,000.

Contact: Division of Teacher Centers, Office of Elementary and Secondary Education, Department of Education, 400 Maryland Ave. S.W., FOB6, Room 2128, Washington, DC 20202/202-472-5940.

Teacher Corps—Operations and Training

Objectives: To strengthen the educational opportunities available to children in areas having concentrations of low-income families; to encourage colleges and universities to broaden their programs of teacher preparation; and to encourage institutions of higher education and local education agencies to improve programs of training and retraining for teachers, teacher aides, and other educational personnel.

Eligibility: Joint application from an accredited college or university with a state-approved de-

gree program and the capacity to deliver graduate level teacher training and retraining and a local educational agency if the percentage of pupils from low-income homes in the schools to be served does not fall below the national and the school district's poverty averages. Except under special arrangements for correctional projects agencies must be public school districts of state or U.S. territory educational agencies. Private schools can be served only through delegation of resources from a public school district.

Range of Financial Assistance: $150,000 to $300,000.

Contact: Associate Director, Operations Branch, Teacher Corps, Department of Education, Washington, DC 20202/202-653-8334.

Teacher Exchange

Objectives: To increase mutual understanding between the people of the United States and those in other countries by offering qualified American teachers opportunities to teach in elementary and secondary schools and in some instances in teacher training institutions, technical colleges, polytechnics or colleges of art abroad. With the cooperation of American schools, teachers from other countries may teach for an academic year in the United States under the same program. There are also opportunities for American teachers to participate in short-term seminars abroad.

Eligibility: Elementary and secondary school teachers, college instructors, and assistant professors. Applicants must have at least a bachelor's degree and must be U.S. citizens at time of application; have at least three years of successful full-time teaching experience to qualify for teaching position abroad; two years for summer seminars; and must be teaching currently in the subject field. Associate and full professors are eligible for seminars in Germany and teaching positions in the United Kingdom.

Range of Financial Assistance: Not applicable.

Contact: Teacher Exchange Section, International Exchange Branch, Division of International Education, Department of Education, 7th and D Sts. S.W., ROB3, Room 3068, Washington, DC 20202/202-245-2454.

Training for Special Programs—Staff and Leadership Personnel

Objectives: To provide training for staff and leadership personnel associated with projects funded under the Special Programs for Students from Disadvantaged Backgrounds.

Eligibility: Institutions of higher education, public agencies and nonprofit private organizations.

Range of Financial Assistance: Not specified.

Contact: Division of Student Services, Office of Postsecondary Education, Department of Education, 400 Maryland Ave. S.W., Washington, DC 20202/202-426-8960.

Upward Bound

Objectives: To generate the skill and motivation necessary for success in education beyond high school among young people from low-income families and with inadequate secondary school preparation.

Eligibility: Institutions of higher education, combinations of such institutions, public and private nonprofit agencies, and, in exceptional cases, secondary schools and secondary vocational schools.

Range of Financial Assistance: $50,000 to $230,000.

Contact: Division of Student Services, Office of Postsecondary Education, Department of Education, 400 Maryland Ave. S.W., Washington, DC 20202/202-426-8960.

Vocational Education—Basic Grants to States

Objectives: To assist states in improving planning and in conducting vocational programs for persons of all ages in all communities who desire and need education and training for employment.

Eligibility: State boards for vocational education.

Range of Financial Assistance: $143,130 to $35,964,514.

Contact: Director, Division of State Vocational Program Operations, Office of Vocational and Adult Education, Department of Education, ROB3, Room 5640, Washington, DC 20202/202-472-3440.

Vocational Education—Consumer and Homemaking

Objectives: To assist states in conducting programs in consumer and homemaking education. Emphasis is placed on programs located in economically depressed areas or areas of high rates of unemployment.

Eligibility: State boards for vocational education.

Range of Financial Assistance: $14,173 to $3,561,349.

Contact: Director, Division of State Vocational Program Operations, Office of Vocational and Adult Education, Department of Education, ROB3, Room 5640, Washington, DC 20202/202-472-3440.

Vocational Education—Contract Program for Indian Tribes and Indian Organizations

Objective: To make contracts with Indian tribal organizations to plan, conduct, and administer programs or portions of programs authorized

by and consistent with the Vocational Education Act.

Eligibility: Indian tribal organizations of Indian tribes

Range of Financial Assistance: $45,015 to $1,530,819.

Contact: Indian Vocational Education Program, Special Programs Staff, Office of Vocational and Adult Education. Department of Education, 7th and D Sts. S.W., ROB3, Room 5600, Washington, DC 20202/202-245-8190.

Vocational Education—Graduate Leadership Development Program

Objective: To assist in meeting the need of all states for qualified vocational education leadership personnel.

Eligibility: Institutions of higher education which offer a comprehensive program in vocational education in a school of graduate study in accordance with the published rules and regulations.

Range of Financial Assistance: $51,225 to $215,145.

Contact: Personnel Development Branch, Division of National Vocational Programs, Office of Vocational and Adult Education, Department of Education, ROB3, Room 5608, Washington, DC 20202/202-245-9793.

Vocational Education—Program Improvement and Supportive Service

Objective: To assist the states in improving their programs of vocational education and in providing supportive services for such programs.

Eligibility: State boards for vocational education.

Range of Financial Assistance: $35,782 to $8,991,128.

Contact: Division of National Vocational Programs, Office of Vocational and Adult Education, Department of Education, ROB3, Room 5018, Washington, DC 20202/202-245-2617.

Vocational Education—Program Improvement Projects

Objectives: To provide support for a National Center for Research in Vocational Education, projects for research, curriculum development, and demonstration in vocational education, and 51 Curriculum Coordination Centers.

Eligibility: Public organizations, institutions, and agencies; nonprofit and profit-making organizations, institutions, and agencies; individuals.

Range of Financial Assistance: $100,000 to $5,000,000.

Contact: Division of National Vocational Programs, Office of Vocational and Adult Educa-

tion, Department of Education, Washington, DC 20202/202-245-2617.

Vocational Education—Special Needs

Objectives: To provide special vocational education programs for persons who have academic or economic handicaps and who require special services and assistance in order to enable them to succeed.

Eligibility: State boards for vocational education.

Range of Financial Assistance: $6,925 to $1,737,498.

Contact: Division of National Vocational Programs, Office of Vocational and Adult Education, Department of Education, Washington, DC 20202/202-245-9634.

Vocational Education—State Advisory Councils

Objectives: To advise state boards for vocational education on the development and administration of state plans; evaluate vocational education programs, services, and activities and publish and distribute the results; and prepare and submit through the state boards to the Commissioner and the National Advisory Council an annual evaluation report.

Eligibility: State advisory council.

Range of Financial Assistance: $68,750 to $158,595.

Contact: Division of National Vocational Programs, Office of Vocational and Adult Education, Department of Education, Washington, DC 20202/202-245-2617.

Vocational Education—Teacher Certification Fellowship Program

Objectives: To provide adequate numbers of teachers and related classroom instructors in vocational education in order to take full advantage of already certified teachers who are unable to find employment in their fields of training. Assistance is also available to individuals employed in business, industry or agriculture who have skills and experiences in vocational fields by providing opportunities to such individuals to achieve certification in vocational fields. Awards will primarily be made in ares of shortage.

Eligibility: Individuals who have been certified within the last ten years and are unable to find employment in their field of certification, if those teachers have skills and experience in vocational fields for which they can be trained and be certified; and persons in industry, business and agriculture who have skills and experience in vocational fields for which there is need for vocational instructors, but who do not necessarily have baccalaureate degrees.

Range of Financial Assistance: $3,588 to $166,155.

Contact: Personnel Development Branch, Division of National Vocational Programs, Office of Vocational and Adult Education, Department of Education, ROB3, Room 5608, Washington, DC 20202/202-245-9793.

Vocational Rehabilitation

Information and expertise are available on vocational rehabilitation services and programs which assist handicapped individuals to prepare for and engage in gainful occupations. A directory of State Vocational Rehabilitation Agencies is available at no charge. Contact: Bureau of Vocational Rehabilitation Operations, Rehabilitation Services Administration, Department of Education, 330 C St. S.W., Room 3030, Washington, DC 20201/202-245-0212.

Vocational Rehabilitation Services for Social Security Disability Beneficiaries

Objectives: To provide necessary rehabilitation services to more disability beneficiaries to enable their return to gainful employment.

Eligibility: States operating under a State Plan approved under Section 110 of the Rehabilitation Act of 1973; if state agency has no amended State Plan, other public or private agencies, organizations, institutions or individuals may be designated by the Secretary.

Range of Financial Assistance: $25,000 to $9,204,340.

Contact: Division of Social Security Rehabilitation Programs, Rehabilitation Services Administration, Department of Health and Human Services, 330 C St. S.W., Room 3522, Washington, DC 20202/202-245-1338.

Vocational Rehabilitation Services for Supplemental Security Income Beneficiaries

Objectives: To provide necessary rehabilitation services to recipients of Supplemental Security Income (SSI) to enable them to attain or return to gainful employment.

Eligibility: Grants are made to states.

Range of Financial Assistance: $125,000 to $9,731,307.

Contact: Office of Program Operations, Rehabilitation Services Administration, Office of Human Development Services, Department of HHS, 330 Switzer Building, Washington, DC 20201/202-245-1338.

Women's Educational Equity

Objectives: To provide educational equity for women at levels of education through grants and contracts for research and development, evalua-

tion, dissemination, guidance and counseling, and support for the improvement and expansion of special and innovative programs.

Eligibility: State and local government, private nonprofit organizations and institutions, and individuals.

Range of Financial Assistance: $10,000 to $480,000.

Contact: Women's Program Staff Department of Education, 400 Maryland Ave. S.W., Donohoe Building, Room 1100, Washington, DC 20202/202-245-2181.

Grants Information Clearinghouse

Information and expertise are available for those who wish to submit grant proposals on education research. Contact: Clearinghouse for National Institute of Education, Department of Education, 1200 19th St N.W., Room 813, Washington, DC 20208/202-254-5600.

Guidance and Counseling

The Bureau of Elementary and Secondary Education strengthens and expands guidance, counseling and testing programs by developing position papers to strengthen leadership and supervision in their area, offering technical assistance, administering funding programs, providing background information for proposal writing, and presenting workshops and performing on-site visits. Contact: Guidance and Counseling Branch, Bureau of Elementary and Secondary Education, Department of Education, 7th and D Sts. S.W., Washington, DC 20202/202-472-1357.

Handicapped and Gifted Children Information Clearinghouse

Information services are available on the aurally, visually, mentally, and speech handicapped, the emotionally disturbed, learning disabled and the gifted children. Contact: ERIC Clearinghouse on Handicapped and Gifted Children, Council for Exceptional Children, 1920 Association Dr., Reston, VA 22091/703-620-3660.

Handicapped, Education of the

For information on programs and funding available for the education of the handicapped contact: Bureau of Education for the Handicapped, Department of Education, 400 6th St. S.W., Room 4030, Washington, DC 20202/202-245-9661.

Handicap Information Clearinghouse

The Clearinghouse offers the following: 1) information and referral services 2) monitoring information operations on a national, state and

local level, 3) technical assistance to information operations on request 4) information on federal funding programs and legislation, 5) a Directory of National Information Services on Handicapping Conditions and Related Services, 6) a Directory of Model Programs for Handicapped Children, and 7) a bimonthly newsletter describing programs for the handicapped. Contact: Clearinghouse on the Handicapped, Office for Handicapped Individuals, Department of Education, 330 C St. N.W., Switzer Building, Room 3106, Washington, DC 20201/202-245-1961.

Head Start
See "Head Start," under "Major Sources of Information," and "U.S. Department of Health and Human Services."

Higher Education Information Clearinghouse
Information services are available on various subjects relating to college and university students, conditions, programs and problems. Contact: Educational Reference and Information Center (ERIC) Clearinghouse on Higher Education, George Washington University, One Dupont Circle, #630, Washington, DC 20036/202-296-2597.

Higher Education Information System
A computerized data base contains information on all institutions of higher learning. Data include: earned degrees conferred; number, characteristics and salaries of employees; financial statistics; institutional characteristics and enrollment; physical facilities; and residence and migration of students and students enrolled for advanced degrees. Contact: National Center for Education Statistics, Department of Education, 400 Maryland Ave. S.W., Prince Georges Plaza, Room 215, Washington, DC 20202/301-436-7881.

Hispanic-American Program
The Hispanic Concerns Staff provides a focal point in the Department of Education for directing federal resources toward the education of children and adults of Hispanic-American Communities. This office provides information services and designs methods for informing Hispanic-Americans of ways to gain access to educational and employment opportunities. Contact: Hispanic Concerns Staff, Department of Education, 400 Maryland Ave. S.W., Reporters Building, Room 511, Washington, DC 20202/202-245-8467.

Indian Education
For information on programs and funding for Indian education contact: Office of Indian Education, Department of Education, 400 Maryland Ave. S.W., Room 2161, Washington, DC 20202/202-245-9159.

International Education
The Education Department promotes international education through international teacher exchange and other programs aimed at increasing mutual understanding between the United States and other countries. Contact: Division of International Education, Department of Education, 400 Maryland Ave. S.W., Room 3082, Washington, DC 20202/202-245-9758.

International Education Information Clearinghouse
Information services and publications are available on such topics as study and teaching opportunities, student exchange programs academic year abroad programs, educational tours for teachers and students overseas, and employment and programs of financial assistance to foreign students. Contact: Clearinghouse, Division of International Education, Department of Education, ROB3, Room 3912, Washington, DC 20202/202-245-7804.

Junior College Information Clearinghouse
Information services are available on the development, administration and evaluation of public and private community junior colleges. Contact: ERIC Clearinghouse for Junior Colleges, Powell Library, Room 96, 405 Hilgard Ave., Los Angeles, CA 90024/213-825-3931.

Languages and Linguistics Information Clearinghouse
Information services are available on languages and linguistics, including instructional methodology, psychology of language learning, teacher training and qualifications and commonly taught languages including English for those who speak other languages. Contact: ERIC Clearinghouse on Languages and Linguistics, Center for Applied Linguistics, 3520 Prospect St. N.W., Washington, DC 20007/202-298-9292.

Learning and Development
For information on current developments and programs covering topics such as mathematics learning, how people learn to think and reason, and why women shun mathematics and the sciences, contact: Programs on Learning and Development, National Institute of Education, Department of Education, 1200 19th St. N.W., Room 821K, Washington, DC 20208/202-254-6572.

Libraries

For information on programs and funding for library resources and library education contact: Library Education Research and Resources Branch, Office of Libaries and Learning Technologies, Department of Education, 400 Maryland Ave. S.W., Room 3622, Washington, DC 20202/202-245-9530.

For information on programs and funding available for improving libraries contact: Library Research and Demonstration Branch, Office of Libraries and Learning Technologies, Department of Education, 7th and D Sts. S.W., ROB3, Room 3319A, Washington, DC 20202/202-245-2994.

Library Resources Information Clearinghouse

Information services are available on the management, operation and use of libraries. Contact: ERIC Clearinghouse on Information Resources, Syracuse University, School of Education, Area of Instructional Technology, Syracuse, New York 13210/315-423-3640.

Loans and Loan Guarantees

The program described below is one which offers financial assistance through the lending of federal monies for a specific period of time or to indemnify a lender against part or all of any defaults by the borrower.

Higher Education Act Insured Loans

Objectives: To authorize low-interest deferred loans for educational expenses available from eligible lenders such as banks, credit unions, savings and loan associations, pension funds, insurance companies, and eligible institutions to vocational, undergraduate, and graduate students enrolled at eligible institutions. The loans are insured by a state or private nonprofit agency or the federal government.

Eligibility: Any U.S. citizen, national, or person in the United States for other than a temporary purpose, who is enrolled or accepted for enrollment on at least a half-time basis at a participating postsecondary school may apply. Only U.S. nationals may attend eligible foreign postsecondary schools.

Range of Financial Assistance: $2,500 to $15,000.

Contact: Guaranteed Student Loan Branch, Division of Policy and Program Development, Bureau of Student Financial Assistance, Department of Education, ROB3, Room 4310, Washington, DC 20202/202-245-9717.

Media Resources

Information and expertise are available on the acquisition of instructional materials and equipment for the use of children and teachers in public and private elementary schools. The following free publications are also available: *Aids to Media Selection for Students,* and *A List of Sources for Both Audio-Visual and Printed Material for Teachers and Libraries.* Contact: School Media Resource Branch, Office of Libraries and Learning Technologies, Office of Educational Research and Improvement, Department of Education, 400 Maryland Ave. S.W., Room 3125B, Washington, DC 20202/202-245-2488.

Metric Education

Information and expertise are available on metric education programs, in addition, a free metric poster. Contact: Metric Education Program, Office of Vocational and Adult Education, Department of Education, 400 Maryland Ave. S.W., Washington, DC 20202/202-426-7220.

Museums

For information on programs and funding available museums contact: Institute of Museum Services, Department of Education, 330 C St. N.W., Switzer Building, Room 4106, Washington, DC 20201/202-245-0413.

Occupational Education

The Bureau of Occupational and Adult Education maintains a vocational education data base, plans conferences on such topics as adult urban guidance centers, and produces papers and reports. Contact: Office of Vocational and Adult Education, Department of Education, 7th and D Sts. S.W., Room 3682, Washington, DC 20202/202-245-8166.

Publications on Education

For a free directory of publications produced by the Department of Education contact: Office of Public Affairs, Department of Education, 400 Maryland Ave. S.W., Room 2089, Washington, DC 20202/202-245-8564.

Reading and Communication Skills Information Clearinghouse

Information services are available on reading, English and communication skills from preschool through college. Contact: ERIC Clearinghouse on Reading and Communication Skills, National Council of Teachers of English, 1111 Kenyon Rd., Urbana, IL 61801/217-328-3870.

Reading and Language

For information on developments and programs in the development of language and literacy and how they are affected by cultural factors

contact: Program on Reading and Language, National Institute of Education, Department of Education, 1200 19th St. N.W., Room 722F, Washington, DC 20208/202-254-5766.

Refugees

A number of programs are available for providing educational services to Vietnamese, Cambodian and Laotian children. Contact: Indochinese Refugee Children Assistance, Office of Bilingual Education and Minority Language Affairs, Department of Education, 400 Maryland Ave. S.W., Reporters Building, Room 421, Washington, DC 20202/202-245-3081.

Right to Read

For information and expertise on improving reading and other basic skills contact: Basic Skills Office, Department of Education, 400 Maryland Ave. S.W., Room 1167, Washington, DC 20202/202-245-8537.

Rural Education Information Clearinghouse

Information services are available on the education of Indian Americans, Mexican Americans, Spanish Americans, migratory farm workers and other disadvantaged rural and small-school populations. Contact: ERIC Clearinghouse on Rural Education and Small Schools, New Mexico State University, Box 3AP, Las Cruces, NM 88003/505-646-2623.

Scholarships

See "Grants" and "Student Financial Assistance Hotline" in this section.

School Construction

For information and expertise on programs and funding available for school construction contact: School Construction Branch, Division of School Assistance in Federally Affected Areas, Department of Education, 400 Maryland Ave. S.W., Room 2069, Washington, DC 20202/202-245-8198.

Science, Mathematics and Environmental Education Clearinghouse

Information services are available on the development of curriculum and instructional materials for all levels of science, mathematics and environmental education. Contact: ERIC Clearinghouse for Science, Mathematics and Environmental Education, Ohio State University, 1200 Chambers Rd., 3rd Floor, Columbus, OH 43212/614-422-6717.

Social Science Information Clearinghouse

Information services are available on the development of educational programs at all levels of social studies and social science. Contact: ERIC Clearinghouse for Social Studies/Social Science Education, 855 Broadway, Boulder, CO 80302/303-492-8434.

Statistics, National Center for Education (NCES)

Statistics are available on such topics as enrollment, teachers and instructional staff, retention rates, finances, educational achievement, financial aid, adult and vocational education, international education and libraries and public television. Contact: Statistical Information Office, NCES, Department of Education, 400 Maryland Ave. S.W., Prince Georges Plaza, Washington, DC 20202/301-436-7900.

Statistical Publications on Education

For a free catalog describing available releases, reports, directories and other publications on educational statistics contact: Information Office, National Center for Education Statistics, Department of Education, 400 Maryland Ave. S.W., Prince Georges Plaza, Washington DC 20202/301-436-7900.

Student Financial Assistance Hotline

There are a number of federally funded loan and grant programs available to students for financing their education. (See "Grants and Loans and Loan Guarantees" in this section.) A hotline has been established to assist with basic information on available programs. Contact: Student Information, Department of Education, 7th and D Sts. S.W., Washington, DC 20202/800-638-6700, in Maryland: 800-492-6602.

Talent Search

The Bureau of Higher Education sponsors a number of programs that are aimed at helping students. They include:

Talent Search—counseling and funds to promising students to help them pursue postsecondary education.
Upward Bound—on-campus program for special training between junior and senior years
Special Services—tutorial support for those already in college; counseling is also included both on an individual and group basis
Educational Opportunity Centers—tutorial and counseling support based on community cooperation. (A directory of Centers is also available.)

Contact: Division of Student Services, Office of Postsecondary Education, Department of Education, 7th and D Sts. S.W., Washington, DC 20202/202-426-8960.

Teacher Corps

Assistance is available to improve the school environment in low-income areas. A directory is available describing current projects. Contact: Teacher Corps., Department of Education, 1832 M St. N.W., Washington, DC 20036/202-653-8370.

Teacher Education Information Clearinghouse

Information services are available on issues concerning school personnel at all levels from selection through preservice and in-service preparation and training to retirement. Contact: ERIC Clearinghouse on Teacher Education, American Association of Colleges for Teacher Education, One Dupont Circle, N.W., #616, Washington, DC 20036/202-293-2450.

Teacher Exchange

See "Grants" and "International Education" in this section.

Teacher Supply and Demand

Surveys are regularly conducted showing the employment and education status of recent college graduates as well as teacher demand and shortages. Contact: National Center for Educational Statistics, Department of Education, 400 Maryland Ave. S.W., Presidential Building, Room 205, Washington, DC 20202/301-436-7881.

Teaching and Learning

For information and expertise regarding the latest developments on the nature of good teaching or on how children and adults learn, contact: Program on Teaching and Learning, Department of Education, 1200 19th St. N.W., Room 820, Washington, DC 20208/202-254-6000.

Testing, Assessment and Evaluation

For information on developments and progams regarding the measurement of student achievement contact: Program on Testing, Assessment and Evaluation, National Institute of Education, Department of Education, 1200 19th St. N.W., Room 822, Washington, DC 20208/202-254-6271.

Tests, Measurement and Evaluation Information Clearinghouse

Information services are available on topics covering tests and other measurement devices; evaluation procedures and techniques; and application of tests, measurement or evaluation in educational projects or programs. Contact: ERIC Clearinghouse on Tests, Measurement and Evaluation, Educational Testing Service, Princeton, NJ 08540/609-921-9000, ext. 2176.

Urban Education Information Clearinghouse

Information services are available on topics relating to the relationship between urban life and schooling. Contact: ERIC Clearinghouse on Urban Education, Box 40, Teachers College, Columbia University, 525 West 120th St., New York, NY 10027/212-678-3437.

Vocational and Technical Education

For information on programs and funding for vocational and technical education for occupations that do not require college degrees, contact: Division of National Vocational Programs, Office of Vocational and Adult Education, Department of Education, 7th and D Sts. S.W., Room 5102, Washington, DC 20202/202-245-2617.

Women's Educational Programs

For information on the availability and need for educational programs covering women's concerns contact: Women's Educational Equity Act Program, Department of Education, 400 6th St. S.W., Donohoe Building, Room 1100, Washington, DC 20202/202-245-2182.

How Can the Education Department Help You?

If you believe that the Department of Education can help you and you are not sure where to start contact: Information Branch, Office of Public Affairs, Department of Education, 400 Maryland Ave. S.W., Room 2097, Washington, DC 20202/202-245-3192.

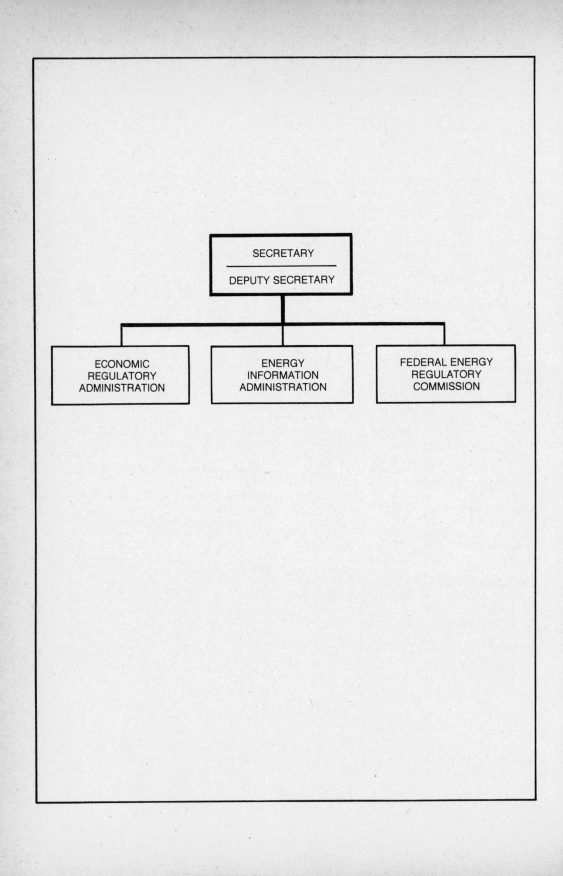

Department of Energy

1000 Independence Ave. S.W.,

Washington, DC 20585/202-252-5000

ESTABLISHED: August 4, 1977
BUDGET: $10,467,286,000
EMPLOYEES: 20,662

MISSION: To provide the framework for a comprehensive and balanced national energy plan through the coordination and administration of the energy functions of the federal government; to be responsible for the research, development and demonstration of energy technology, the marketing of federal power, energy conservation, the nuclear weapons program, regulation of energy production and use, pricing and allocation, and a central energy data collection and analysis program; to promote consumer interests; to encourage competition in the energy industry; and to protect the nation's environment and the health and safety of its citizens.

Major Divisions and Offices

Economic Regulation Administration

Department of Energy, 2000 M St. N.W., Washington, DC 20461/202-653-4055.
Budget: $152,879,000
Employees: 2,322
Mission: Administer the U.S. Department of Energy's regulatory programs, other than those assigned to the Federal Energy Regulatory Commission, including oil pricing, allocation, and import programs designed to ensure price stability and equitable supplies of crude oil, petroleum products, and natural gas liquids among a wide range of domestic users.

Energy Information Administration

Department of Energy, 12th St. and Pennsylvania Ave. N.W., Washington, DC 20461/202-634-5610.

Budget: $88,208,000
Employees: 815
Mission: Timely and accurate collection, processing, and publication of data on energy reserves, the financial status of energy-producing companies, production, demand, consumption and other areas.

Federal Energy Regulatory Commission (FERC)

Department of Energy, 825 North Capitol St. N.E., Washington, DC 20426/202-357-8380.
Budget: $69,622,000
Employees: 11,813
Mission: Sets rates and charges for the transportation and sale of natural gas, the transmission and sale of electricity and the licensing of hydroelectric power projects.

Data Experts

Energy Efficient Building Experts

The following experts are involved in research, development, and demonstration projects in energy conservation for retrofitting and new construction of both residential and commercial buildings. Each expert can be reached at: Energy

Efficient Building Program, Berkeley Laboratory, Building 90, Room 3026F, Berkeley, CA 94720.

Building Energy Analysis/Richard Curtis/415-486-5711.

Building Envelopes and Infiltration/Robert Sonderegger/415-486-6651.

Ventilation and Indoor Air Quality/Craig Hollowell/415-486-6593.

Windows and Use of Daylight/Steve Selkowitz/415-486-5064.

Lighting Systems/Sam Berman/415-486-5682.

Building Energy Performance Standards/Mark Levine/415-486-5238.

Building Energy Analysis Compilation/Art Rosenfeld/415-486-4834.

International Energy Experts

A staff of experts is available to provide information on most any aspect of the world supply and demand of energy. They can be called directly or reached by writing. For information on countries not listed below, or for information on other international topics, contact: International Affairs, Department of Energy, 1000 Independence Ave. S.W., Room MSF031, Washington, DC 20585. (Be sure to note name, country and room number when corresponding with experts.)

Africa/William Carter/202-252-6380
Algeria/Bernie Kritzer/202-252-6770
Angola/Carol Lee/202-252-6770
Antarctic and Arctic/John Dupper/202-252-6380
Asia/Thomas Cutler/202-252-6777
Asia/Steve Goldman/202-252-5755
Australia/Denise Dwyer/202-252-6777
Austria/Jeffrey Hartman/202-252-6380
Belgium/Patricia German/202-252-6380
Brazil/Bob Swandby/202-252-6770
Canada/Roseann Mazaka/202-252-6380
Canada/Bob Price/202-252-6770
Caribbean/Patricia German/202-252-6380
Denmark/Patricia German/202-252-6380
Eastern Europe/Steve Goldman/202-252-5755
Egypt/Bernie Kritzer/202-252-6770
Finland/Patricia German/202-252-6380
France/Patricia German/202-252-6380
Gabon/Carol Lee/202-252-6770
Germany/Jeffrey Hartman/202-252-6380
Greece/Denise Dwyer/202-252-6777
Iceland/Patricia German/202-252-6380
Indonesia/Steve Goldman/202-252-5755
Iran/Steve Goldman/202-252-5755
Iraq/Carol Lee/202-252-6770
Ireland/Roseann Mazaka/202-252-6380
Israel/Jack Schick/202-252-6777

Italy/Donald Albert/202-252-6771
Japan/Jeffrey Hartman/202-252-6380
Kuwait/Bernie Kritzer/202-252-6770
Latin America/Patricia German/202-252-6380
Libya/Bernie Kritzer/202-252-6770
Luxembourg/Patricia German/202-252-6380
Mexico/Kay McKeough/202-252-6770
Netherlands/Roseann Mazaka/202-252-6380
New Zealand/Denise Dwyer/202-252-6777
Nigeria/Carol Lee/202-252-6770
Norway/Roseann Mazaka/202-252-6380
Portugal/Roseann Mazaka/202-252-6380
Qatar/Carol Lee/202-252-6770
Saudi Arabia/Bernie Kritzer/202-252-6770
Spain/Roseann Mazaka/202-252-6380
Sweden/Roseann Mazaka/202-252-6380
Switzerland/Jeffrey Hartman/202-252-6380
Trinidad and Tobago/Bob Price/202-252-6770
Turkey/Denise Dwyer/202-252-6777
United Arab Emirates/Bernie Kritzer/202-252-6770
United Kingdom/Roseann Mazaka/202-252-6380
USSR/Steve Goldman/202-252-5755
Venezuela/Bob Swandby/202-252-6770

Energy Statistics at Census

The following are subject matter specialists for energy statistics within the Census Bureau. They can be contacted directly by telephone or by writing in care of Director, Bureau of the Census, Washington, DC 20233.

Agriculture/Frank Shelton/301-763-1081
Business/Carl Bostrom/301-763-2745
Construction/William Mittendorf/301-763-7165
Economic Surveys/Jerry McDonald/301-763-5182
Foreign Trade/Gerald Kotwas/301-763-5333
Government/Gerald T. Keffer/301-763-2844
Manufactures/John McNamee/301-763-5938
Mineral Industries/John McNamee/301-763-5938
Housing/William A. Downs/301-763-2873
Journey to Work/Philip N. Fulton/301-763-4255 or 763-5020
Transportation/Robert Torene/301-763-5430
Energy Coordinator/Elmer S. Biles/301-763-7184

Technology and Commercialization Experts

The following experts can provide information on the latest available technology and commercialization possibilities for their subject areas. They can be reached by writing: Department of

Energy, Washington, DC 20585. (Be sure to note name, topic and room number when corresponding with experts.)

Electric/Hybrid Vehicles/Kendall Wilson/202-252-9181
Cogeneration/Richard Cowles/202-252-9209
Wind Energy Systems/Ted Ankrum/202-252-9258
High Efficiency Motors/Albert Hayes/202-252-9207
Active Solar Systems/Roger Johnson/202-252-9208
Urban Waste/Charlotte Rines/202-252-9397
Low/Medium BTU Gasification/Russell Bardos/202-633-9195

Geothermal/Hydrothermal/Rudolph Black/202-633-8774
Industrial Atmospheric Fluidized Bed (AFB)/Howard Feibus/202-633-9272
High BTU Gasification/Phillip Gallo/202-633-9195
Low Head Hydro/Farwell Smith/202-633-8828
Coal Gasification/Richard Passman/202-633-8350
Shale Oil/Paul Petzrick/202-633-8660
Enhanced Oil Recovery/Lisle Reed/202-633-8395
Unconventional Development/Troyt York/202-633-8383

Major Sources of Information

Agriculture and Food Processing Industry—Conservation

For information on technological developments that conserve energy in agricultural production, irrigation, fertilizer production, food processing, food preservation, food preparation and distribution, farm power systems, and other areas, contact: Agriculture and Food Process Branch, Conservation Research and Development Division, Industrial Programs, Conservation and Solar Energy, Department of Energy, 1000 Independence Ave. S.W., MS 2H086, Washington, DC 20461/202-252-2075.

Alcohol Fuels

The Office of Alcohol Fuels provides information on the use of liquid fuels from biomass in vehicles; handles the market analysis, market testing, and research and development activities related to the production and use of alcohol fuels from renewable resources; implements the commercialization programs that are related to accelerating the production and use of alcohol fuels; consolidates information about federal alcohol fuels activities; and works with farmers, businessmen, and representatives of the financial, scientific, engineering, and educational communities to stimulate activities leading to wider production and use of alcohol fuels. To promote the development of alcohol fuel production, this office also works with the U.S. Departments of Agriculture, Commerce, and Housing and Urban Development on the White House Alcohol Fuels Task Force. Contact: Office of Alcohol Fuels, Department of Energy, 1000 Independence Ave. S.W., MS6A211, Washington, DC 20585/202-252-9487.

Alcohol Fuels Publications

The following publications are available free from the Office of Alcohol Fuels, Department of Energy, 1000 Independence Ave. S.W., MS GA211, Washington, DC 20585/202-252-9487:

Report on Gasohol (Energy Research Advisory Board)—recommendations on alcohol fuel, and research and development policy
Response to the Energy Research Advisory Board Paper

The following publications are available free from the Solar Energy Research Institute, Document Distribution Service, 1617 Cole Blvd., Golden, CO 80401/303-231-1158:

Alcohol Fuels Reading List
Facts About Gasohol—answers most common questions
Energy Consumer—state-by-state guide to alcohol fuels activity, including key state alcohol contacts, names and numbers of alcohol training programs and workshops, number of gasohol stations by state, and an alcohol fuel glossary

The following publication is available free from the Technical Information Center, Department of Energy, P. O. Box 62, Oak Ridge, TN 27830/615-576-1301:

Fuel from Farms: A Guide to Small-Scale Ethanol Production—information on benefits, market, uses, market assessments, production potential, financial requirements, and equipment selection; also information on basic ethanol production, feedstock, co-products plant design, analysis of financial requirements, summary of ethanol legislation, permit requirements, references, resources, bibliography, glossary and sources of public finance.

Alternative Fuels

This office answers questions about specifically administrative aspects of new solicitations under Public Law 96-126, which appropriates $2.208 billion to the U.S. Department of Energy to stimulate alternative fuel production in anticipation of the formation of the Energy Security Corporation. The Department will implement this program through feasibility study grants, cooperative agreements, loan guarantees, and price guarantees or purchase commitments. Contact: Industrial Planning Development, Resource Applications, Department of Energy, 12th St. and Pennsylvania Ave. N.W., Room 3500, Washington, DC 20461/202-633-8365.

Alternative Fuels Utilization

This office aims to reduce transportation dependence on petroleum fuels by encouraging development of such fuels as coal, biomass, alcohol, and hydrogen, and their applicability to new auto-engine systems. Contact: Alternative Fuels Utilization Branch, Automotive Technology Development Division, Transportation Programs, Conservation and Solar Energy, Department of Energy, 1000 Independence Ave. S.W., MS 5H063, Washington, DC 20585/202-252-8055.

Analysis, Long-Term

Information is available on long-term forecasts of energy supply and demand through evaluations of new technologies, substitute fuels, conservation and transportation alternatives. Contact: Long-Term Analysis Division, Office of Integrative Analysis, Office of Applies Analysis, Energy Information Administration, Department of Energy, 12th St. and Pennsylvania Ave. N.W., MS 4530, Washington, DC 20461/202-633-9805.

Analysis, Mid-Term

Information is available of mid-term forecasts of energy production, distribution, consumption and price, including projections of demand growth, resource depletion, and application of new technologies. Forecasts are made for the years 1985, 1990 and 1995. Contact: Mid-term Analysis Division, Office of Integrative Analysis, Office of Applied Analysis, Energy Information Administration, Department of Energy, 12th St. and Pennsylvania Ave. N.W., MS 4530, Washington, DC 20461/202-633-8505.

Analysis, Short-Term

Information is available on short-term projection of supply, consumption, stock levels, prices, and imports of energy. Research and analysis is conducted on petroleum, natural gas, coal, electric power, and other energy sources in order to interpret the domestic energy situation in each energy field and forecast future developments. Contact: Short-Term Analysis Division, Office of Integrative Analysis, Office of Applied Analysis, Energy Information Administration, Department of Energy, 12th St. and Pennsylvania Ave. N.W., MS 4530, Washington, DC 20461/202-633-9029.

Anthracite Coal

Information is available on the prospects for increased production and use of anthracite coal consistent with environmental needs. The U.S. Department of Energy is involved with underground mining, surface mining, and coal preparation. Contact: Coal Supply Division, Industrial and Utility Application and Operation, Resource Applications, Department of Energy, 12th St. and Pennsylvania Ave. N.W., MS 3344, Washington, DC 20461/202-633-9058.

Appliance Labeling

When you shop for a major appliance, look for the yellow and black "Energy Guide" labels which show the yearly energy cost of operating an appliance. The guide enables you to compare competing brands of models of appliances of similar size with similar features. Energy efficiency guides are required by law on major household appliances and on home furnaces. There are three types of Energy Guide labels: Energy Cost Labels, Energy Efficiency labels, and Generic labels. Contact: Consumer Products Efficiency Branch, Consumer Products Division, Buildings and Community Systems, Conservation and Solar Energy, Department of Energy, 1000 Independence Ave. S.W., MSGH065, Washington, DC 20585/202-252-9143.

Atmospheric Fluidized Bed (AFB)

Information is available on the commercialization of atmospheric fluidized bed combustion technology as well as direct coal combustion applications. The fluidized-bed process burns coal in a bed of limestone with the mixture suspended on an upward-blowing stream of air. Sulphur released from the burning coal is captured by the limestone before it can leave the boiler and pollute the air. Contact: Direct Combustion Applications and Industrial AFB, Office of Coal Resource Management, Industrial and Utility Applications and Operations, Resource Applications, Department of Energy, 12th St. and Pennsylvania Ave. N.W., MS 3344, Washington, DC 20461/202-633-9272.

Audiovisuals

For information on the availability of U.S. Department of Energy motion pictures and multi-

media presentations, contact: Audiovisual Branch, Office of Public Affairs, Department of Energy, 1000 Independence Ave. S.W., MS 1E218, Washington, DC 20585/202-252-5588.

Bartlesville Energy Technology Center

This U.S. Department of Energy-supported center is devoted primarily to research and engineering in petroleum and natural gas, including improvement and demonstration of technologies in exploration, production, refining and utilization. Petroleum production programs are involved with enhanced oil and gas recovery, heavy oil recovery, improved drilling methods, and determinations of residual oil. A data bank on crude oil production and marketed fuel properties is maintained, the Alternative Fuels Utilization Technical Data Bank. Research is also conducted on automotive octane and gasoline blends and automotive fuels from coal liquids. Contact: Bartlesville Energy Technology Center, P. O. Box 1398, Bartlesville, OK 74003/918-336-2400.

Basic Energy Sciences

Research and development is conducted to expend the fundamental knowledge base in science and engineering so that all energy technologies will have a strong scientific foundation for the future. Work is done in metallurgy, ceramics, solid state physics, natural chemistry, chemical science, engineering, mathematics, geoscience, and biological energy. Contact: Basic Energy Sciences, Energy Research, Department of Energy, Germantown, Room 5304, Washington, DC 20545/301-353-5565.

Biomass Systems

This office integrates the U.S. Department of Energy's efforts to promote the commercialization of biomass—organic material such as trees, crops, manure, seaweed and algae that captures and stores energy from the sun. It oversees research and development for converting biomass into energy-intensive products such as methanol (wood alcohol), ethanol (grain alcohol), hydrogen and petrochemical substitutes. Studies are conducted on the production of methane and other fuel sources from the anaerobic digestion of manure and other agricultural wastes. Contact: Biomass Systems Branch, Biomass Energy Systems Division, Conservation and Solar Energy, Department of Energy, 600 E St. N.W., MS 404, Washington, DC 20545/202-376-9739.

Building Codes and Conservation

New Building codes and standards are evaluated to assess their impact on energy conservation.

Contact: Building Codes and Standards Branch, Buildings Division, Buildings and Community Systems, Conservation and Solar Energy, Department of Energy, 1000 Independence Ave. S.W., MS GH068, Washington, DC 20585/202-252-9197.

Building Conservation Services

This office promotes the applications of energy-efficient systems in residential and commercial buildings; fosters the utilization in the marketplace of energy systems technologies and efficient operations practices that reduce energy usage in new and existing buildings; and provides incentives or eliminates disincentives to effective energy conservation in buildings. Contact: Building Conservation Services Division, Buildings and Community Systems, Conservation and Solar Energy, Department of Energy, 1000 Independence Ave. S.W., MS GH068, Washington, DC 20585/202-252-9161.

Citizen Participation

This office promotes public involvement in the development of policies, regulations, and administrative decisions established by the U.S. Department of Energy. Free publications include:

Citizen Participation Manual
Selected Department of Energy Publications
Active Communities Today
Organize Now for Energy

Contact: Citizen Participation Division, Office of Consumer Affairs, Department of Energy, 1000 Independence Ave. S.W., MS 7E054, Washington, DC 20585/202-252-5141.

Citizens' Assistance

The following pamphlets and publications on energy production, use and conservation are free to students, teachers, and other individuals:

Black Contributors to Science and Energy Technology
Citizens' Workshops on Energy and the Environment Handbook
How to Comply with the Emergency Building Temperature Restrictions
How to Keep Warm and Cut Your Fuel Bill
Making Energy Regulations: How to Get the Public Involved
National Energy Plan II
A New Start: The National Energy Act
Professional Energy Careers
Tips for Energy Savers
Winter Survival: A Consumer's Guide to Winter Preparedness
Careers in Energy Industries

Energy Information: What's Available and How to Obtain It
Energy from the Winds
Energy and You
Energy-Saving Checklist for Home Builders, Buyers, and Owners
Enhanced Recovery of Oil and Gas
Fuels from Biomass
Gas Mileage Guide for New Car Buyers
Geothermal Energy
Guide for the Submission of Unsolicited Proposals
How to Improve the Efficiency of Your Oil-Fired Furnace
How to Save Gasoline . . . and Money
How to Understand Your Utility Bill
Hydrogen Fuel
Insulate Your Water Heater and Save Fuel
Low-Cost/No-Cost Energy Savers
Magnetic Fusion
Solar Electricity from Photovoltaic Conversion
Solar Electricity from Thermal Conversion
Solar Energy
Solar Energy for Agriculture and Industry
Solar Energy for Heating and Cooling
Turbine Power for Highway Transportation
Vanpool
Waste-to-Energy Program: A Source of Energy for our Country
Where to Find Information About Solar Energy

Contact: Citizens Assistance Section, Technical Information Center, Department of Energy, P. O. Box 62, Oak Ridge, TN 37830/615-576-1308.

Citizens' Workshops

A citizens' workshop is a one-and-one-half-to-three-hour presentation which consists of a lecture presentation by experts on energy matters; audience participation in an electronic game dealing with the problems of meeting increasing demands for energy in the face of dwindling supplies of fuel sources; and roundtable discussions among technical experts and participants. A unique feature of the workshops is the "Energy-Environment Simulator," which enables participants to balance the effects of decisions they make regarding use of fuel resources and the demands for energy against the remaining resources and the potential effects of their use on the environment. They are held for community organizations, civic clubs, business and professional groups, local governments, museums, colleges and universities. Contact: Special Programs Division, Office of Public Affairs, Department of Energy, Washington, DC 20585/202-252-4670.

Classified Material

For information on the classification and declassification of restricted data and other energy-related national security information, contact: Classification Office, Defense Programs, Department of Energy, 1000 Independence Ave. S.W., Room A23200, Washington, DC 20585, 202-353-3521.

Coal and Electric Power Analysis

Studies are conducted on various aspects of coal and electric power, including analysis and forecasting of supply and demand balances of coal; exploration of new technologies to derive energy from coal; forecasts of electric power supply and consumption; utility prices and inter-fuel substitution, and detailed examination of existing and proposed legislation affecting coal and electric power production. Contact: Coal and Electric Power Analysis Division, Office of Energy Source Analysis, Office of Applied Analysis, Energy Information Administration, Department of Energy, 12th St. and Pennsylvania Ave. N.W., MS 4530, Washington, DC 20461/202-633-9274.

Coal and Electric Power Statistics

Statistics are collected, compiled, and evaluated on the coal and electric power industries, and reports and publications are issued pertaining to coal reserves, production, and distribution, coke and coal chemicals, electric retail rates, power disturbances, electricity production and rates, and fuel consumption and stocks at generating facilities. More than 200 statistical periodicals are published. Contact: Office of Coal and Electric Power Statistics, Energy Data Operation, Energy Information Administration, Department of Energy, 1000 Independence Ave. S.W., MS B6042, Washington, DC 20585/202-252-6860.

Coal Conversion Research

Many programs are concerned with the development of coal gasification technology. These include advanced techniques for producing high-BTU gas from eastern caking coals and improvement of two advanced gasifier concepts for high and medium BTU and others. Contact: Conversion Technology, Division of Coal Gasification, Office of Coal Processing, Fossil Energy, Department of Energy, Germantown, MS F305, Washington, DC 20545/301-353-3498.

Coal Licensing

The Coal Supply Division focuses on ensuring the improved planning, public participation, compatibility and integration of federal licensing and siting programs with state and local procedures. It also assesses the regulatory impacts on current and planned low-BTU coal gasification commercialization plants in an effort to minimize conflicts. Contact: Licensing and Siting Branch, Coal Supply Division, Industrial and Utility Ap-

plications and Operations, Resource Application, Department of Energy, 12th St. and Pennsylvania Ave. N.W., MS 3344, Washington, DC 20461/202-633-8600.

Coal Liquids

For information on commercial application of liquid coal and coal-derived liquid fuels, contact: Division of Coal Liquids, Office of Coal Resource Management, Resource Application, Department of Energy, 12th St. and Pennsylvania Ave. N.W., MS 3344, Washington, DC 20461/202-633-9102.

For information on the latest developments in coal liquifaction, including the technological aspects of coal liquids refining and indirect liquifaction, contact: Office of Coal Processing, Fossil Energy, Department of Energy, Germantown, MS E338, Washington, DC 20545/301-353-3482.

Coal Operators Assistance

The U.S. Department of Energy provides financial and other types of assistance to help small- and medium-sized producers to expand, develop or reopen underground low-sulphur coal mines and to build coal preparation plants. Contact: Coal Loan Guarantee Programs Branch, Coal Supply Division, Industrial and Utility Applications and Operations, Resource Applications, Department of Energy, 12th St. and Pennsylvania Ave. N.W., MS 3344, Washington, DC 20461/202-633-8200.

Coal Technology

Information is available on coal supply and demand, commercial application of new coal mining technology, and potential constraints to adequate and competitively priced coal supplies as well as strategies to overcome such constraints. Contact: Coal Production technology Logistics Branch, Coal Supply Division, Industrial and Utility Applications and Operations, Resource Applications, Department of Energy, 12th St. and Pennsylvania Ave. N.W., MS 3344, Washington, DC 20461/202-633-9073.

Coal Utilization Research

Research is conducted into the direct utilization of coal, i.e., use of coal which has not been changed into another form of fuel. The four main areas of interest are: combustion systems, advanced environmental control technology, heat engines and heat recovery, and fuel cells. Contact: Office of Coal Utilization Systems, Fossil Energy, Department of Energy, Germantown MS E178, Washington, DC 20545/301-353-2838.

Cogeneration

Research is conducted into cogeneration and related waste energy utilization systems. With cogeneration, industrial waste heat is utilized to generate electricity or provide heating. Contact: Waste Energy Utilization and Cogeneration Branch, Conservation Research and Development Division, Industrial Programs, Conservation and Solar Energy, Department of Energy, 1000 Independence Ave. S.W., MS 2H085, Washington, DC 20585/202-252-2084.

Comment on Energy Rules

Twice a year, the U.S. Department of Energy is required to publish an agenda of significant regulations it is currently developing or reviewing on such topics as the environment, conservation and solar, weatherization, equal opportunity, consumer affairs, oil regulation, utility systems, and other areas. These proposed rules are published for public comment. Contact: Office of Public Information, Economic Regulatory Administration, Department of Energy, 2000 M St. N.W., MS B110, Washington, DC 20461/202-653-4055.

Community Conservation

Studies are conducted on energy conservation at the community level in order to promote sound conservation practices in community planning and design. Contact: Community Systems Division, Buildings and Community Systems, Conservation and Solar Energy, Department of Energy, 1000 Independence Ave. S.W., MS 1F075, Washington, DC 20585/202-252-9389.

Community Energy Efficiency Hotline

This hotline provides information to state and local officials on energy demand reduction and community energy conservation. It also has information on Building Energy Performance Standards (BEPS) which provide a means for incorporating energy-efficient designs and technologies into commercial and residential buildings. Contact: Energy Hotline, Community Systems Division, Conservation and Solar Energy, Department of Energy, 1000 Independence Ave. S.W., MS 1H031, Washington, DC 20585/202-252-9398, 800-424-9040 (DC: 800-255-2855; Alaska, Hawaii and Puerto Rico: 800-424-9081); or contact: President's Clearinghouse for Community Energy Efficiency, 400 N. Capitol St. N.W., Suite 185, Washington, DC 20001.

Conservation and Renewable Resources

Analysis is conducted of federal initiatives in energy conservation with respect to the social, economic, environmental and energy impacts of policies. Contact: Conservation and Renewable Resources, Policy and Evaluation, Department of Energy, 1000 Independence Ave. S.W., MS

7E088, Washington, DC 20585/202-252-5493.

Conservation and Solar Energy

For information on programs in research, development and demonstration of advanced technologies and financial and technical assistance for conservation-related activities involving solar applications, contact: Conservation and Solar Energy, Department of Energy, 1000 Independence Ave. S.W., MS 6B025, Washington, DC 20585/202-252-9220.

Conservation at Home and Energy Audits

The Building Conservation Service seeks to reduce the energy consumption of single- to four-family residences by requiring the larger electric and gas utility companies to provide information to those customers on energy conservation and renewable resources. Utilities are required to offer energy audits and arrangements for installation and financing of energy-saving measures. Free publications include: *Rating Your Oil Home-Heating System* and *Upgrading Oil Home-Heating Systems.* Contact: Building Conservation Service Division, Office of Buildings and Community Systems, Conservation and Solar Energy, Department of Energy, 1000 Independence Ave. S.W., MS GH068, Washington, DC 20585/202-252-9161.

Conservation Hotline

Information is available on the U.S. Department of Energy's emergency energy conservation efforts, the Standby Federal Conservation Plan and the Emergency Building Temperature Restrictions. The publication *How to Comply With Emergency Building Temperature Restrictions* is available free. Contact: Office of Emergency Conservation Programs, State and Local Programs, Conservation and Solar Energy, Department of Energy, 1000 Independence Ave. S.W., MS GE004, Washington, DC 20585/800-424-9122 (DC: 202-252-4950; Alaska, Hawaii, Virgin Islands and Puerto Rico: 800-424-9088).

Consumer Affairs

This office is responsible for providing policy direction for and oversight of U.S. Department of Energy's consumer and education activities. Free publications include: *Energy Consumer* (a newsletter); *Energy Insider* (a newspaper); *Winter Survival: A Consumer's Guide*; and *Winter Preparedness.* Contact: Office of Consumer Affairs, Department of Energy, 1000 Independence Ave. S.W., MS 7E054, Washington, DC 20585/202-252-5373.

Consumer Product Technology

The commercialization of energy-efficient de-sign is encouraged in such products as heating furnaces, wood stoves, cooling and ventilation equipment and systems, lighting appliances, building controls, and materials and diagnostic equipment used to determine the efficiency of energy used in buildings. Contact: Technology and Consumer Products Branch, Consumer Products Division, Buildings and Community Systems, Conservation and Solar Energy, Department of Energy, 1000 Independence Ave. S.W., MS GH068, Washington, DC 20585/202-252-9130.

Consumption Data Bases

The *Residential Energy Consumption System* provides national estimates on vehicle miles traveled, fuel consumption, efficiency of residential vehicle fleets, and energy consumption, storage, and cost by fuel type and housing unit characteristics. The *Commercial and Industrial Energy Consumption System* provides data on age, size, and characteristics of nonresidential buildings by types and amount of energy used or stored in them and by the uses to which the energy is put. Contact: Consumption Data System, Program Development, Energy Information Administration, Department of Energy, 1726 M St. N.W., MS 260, Washington, DC 20461/202-634-5641.

Department of Energy Historian

The historical program includes preparing the official history of the U.S. Department of Energy and its predecessors, making archival decisions on the retention of historically important papers and documents and providing policy and analysis information within an historical context. Contact: Chief Historian, Office of the Secretary, Department of Energy, 1000 Independence Ave. S.W., Room MS 7E054, Washington, DC 20585/202-252-5235.

Direct Payments

The following program provides direct financial assistance to encourage or subsidize a particular activity:

Public Utility Regulatory Innovative Rates Support

Objectives: To provide financial assistance for planning and carrying out electric utility regulatory rate reform initiatives relating to innovative rate structures.

Eligibility: Awards will be made only to state utility regulatory commissions, nonregulated electric utilities, and the Tennessee Valley Authority.

Range of Financial Assistance: $100,000 to $250,000.

Contact: Office of Utility Systems, Economic Regulatory Administration, Department of Ener-

gy, 2000 M St. N.W., Washington, DC 20461/202-653-3920.

Driver Efficiency Program

This program offers an intensive instruction training course, regional seminars, workshops and educational materials, including:

To Help You Save Gas—a free publication that describes U.S. Department of Energy's programs and materials in driver awareness and efficiency.

Implementation Manual Handbook—a free publication that serves as a trainer's guide to developing and implementing driver efficiency programs for employees, students and the general public and as a reference book on driver efficiency materials and trainers around the country.

Running on Empty—a 27-minute film covering four basic conservation areas for drivers education: vehicle selection, driving skills, maintenance, and trip planning.

Hotline—answers questions and provides materials (toll-free 800-424-9043; DC: 202-252-2855).

Gas Saver's Kits—for employers.

Contact: Driver Efficiency Program, Transportation Programs, Office of Conservation and Solar Energy, Department of Energy, 1000 Independence Ave. S.W., MS 5H044, Washington, DC 20585/202-252-8003, or call Hotline listed above.

Economic Analysis

Econometric models are used to conduct macroeconomic analysis of energy markets with respect to finance, competition, regulation and the effects of government actions on energy supply, demand and price. Contact: Office of Economic Analysis, Office of Applied Analysis, Energy Information Administration, Department of Energy, 12th St. and Pennsylvania Ave. N.W., MS 4530, Washington, DC 20461/202-633-8737.

Economic Regulation

The Economic Regulatory Administration is responsible for the following areas:

Natural Gas—imports/exports and curtailment priorities; and natural gas liquids price and allocation regulations.

Petroleum—crude oil price and allocation regulations; crude oil and refined petroleum imports; licenses for importation of all finished and unfinished petroleum oils and fee-free licenses to refiners, petrochemical companies, and deep-water terminal operators; special investigation and compliance audits of oil companies; and non-Federal Energy Regulatory Commission (FERC) oil pipeline regulation.

Regulatory Programs—regulatory programs allocating petroleum products, crude oil, and liquid natural gas; development, management, and direction of Department of Energy's economic and regulatory programs

other than Federal Energy Regulatory Commission; pricing and allocation regulations; the monitoring of supply and price trends; the administration of programs for the conversion of oil- and gas-fired utilities to alternate fuels development; and implementation of standby and emergency regulations and programs.

Contact: Office of Public Information, Economic Regulatory Administration, Department of Energy, 2000 M St. N.W., MS B-110, Washington, DC 20461/202-653-4055.

Electric Energy Systems

The Electric Energy Systems Division investigates dispersed generation and storage systems, and resolves transmission corridor siting problems and electric network-related problems. It also tries to control large-scale complex systems. Contact: Electric Energy Systems Division, Resource Applications, Department of Energy, 12th St. and Pennsylvania Avenue, N.W., MS 3344, Washington, DC 20461/202-633-8627.

Electric Power Regulation

This office regulates the interstate aspects of the electric power industry and provides professional staff assistance and public policy evaluation on electric power matters. Contact: Electric Power Regulation, Federal Energy Regulatory Commission, Department of Energy, 400 1st St. N.W., Washington, DC 20545/202-376-9232.

Electric Vehicles

Electric and hybrid vehicles are promoted and research and development is encouraged to improve existing propulsion systems and batteries. Examples include the Near-Term Electric Vehicle designed and developed by General Electric and Chrysler. Contact: Electric and Hybrid Vehicle Systems, Transportation Programs, Conservation and Solar Energy, Department of Energy, 1000 Independence Ave. S.W. MS 5H063, Washington, DC 20585/202-252-8027.

Energy Budget and Annual Report

The Division of Budget and Administration prepares the U.S. Department of Energy's annual budget and *Annual Report*, which contains information on such items as foreign direct investment in U.S. energy sources and supplies, exports of energy resources by foreign companies, major recipients of funding by name, and future plans. Contact: Division of Budget and Administration, Policy and Evaluation, Department of Energy, 1000 Independence Ave. S.W., MS 7E088, Washington, DC 20585/202-252-4381.

Energy Conservation Audiovisuals

Energy Conservation audiovisual materials are

available on such topics as alternative energy sources, gas economy, and solid waste recycling. For a free catalog and information, contact: National Audiovisual Center, General Services Administration, Washington, DC 20409/301-763-1896.

Energy-Consuming Nations
Policies, strategies and options for bilateral, multilateral and regional energy relations, negotiations and developments with energy-consuming nations are studied at: Energy-Consuming Nations, International Energy Resources, International Affairs, Department of Energy, 1000 Independence Ave. S.W., MS 7F031, Washington, DC 20585/202-252-6777.

Energy Data Collection
The Office of Data Collection and Survey Operations provides statistics and general data services to the offices within the U.S. Department of Energy. It conducts telephone and mail surveys, such as measuring residential heating oil prices of refiners and large companies and on-site surveys of gasoline prices. Contact: Office of Data Collection and Survey Operations, Energy Data Operations, Energy Information Administration, Department of Energy, 12th St. and Pennsylvania Ave. N.W., MS 4311, Washington, DC 20585/202-252-6554.

Energy Education
The U.S. Department of Energy is concerned with the role of educational processes and institutions in the implementation of the National Energy Plan, and with developing a public understanding of and facility with energy-related subject matters. Free publications include *Guide for the Preparation of Proposals for Faculty Development Projects in Energy Education* and *Guide for the Preparation of Proposals for the Pre-Freshman Engineering Program for Women and Minorities*. Contact: Education Division, Office of Consumer Affairs, Department of Energy, 1000 Independence Ave. S.W., MS 7E054, Washington, DC 20585/202-252-6480.

Energy Emergency Handbook
This publication serves as a reference guide for individuals and offices with management responsibilities in energy emergencies. Available for $25.00 from: Superintendent of Documents, Government Printing Office, Washington, DC 20402/202-783-3238.

Energy Emergency Management Information System
This system provides energy information and

projections prior to and during energy emergencies. It combines a communication and information handling facility with fast access to information and the analysts who can interpret and analyze the available data. Contact: Energy Emergency Management Information System, Program Development, Energy Information Administration, Department of Energy, 1726 M St. N.W., MS 840, Washington, DC 20461/202-634-2079.

Energy and the Environment
The Office of Environment supports the energy program offices in identifying environmental health and safety issues; conducts comprehensive health and environmental effects research and development programs; and overviews U.S. Department of Energy's environmental performance to insure compliance with internal and external environmental health and safety requirements. Contact: Environment, Department of Energy, 1000 Independence Ave. S.W., MS 4G065, Washington, DC 20585/202-252-4700.

Energy Information Administration Annual Report
This three-volume report includes: *Volume I*—Energy Information Administration activities detailed by office and major publications from each office ($3.75); *Volume II*—Data ($7.00); *Volume III*—Forecasts ($8.00). For more information on content, contact: Office of Energy Information Services, Energy Information Administration, Department of Energy, 1726 M St. N.W., MS 240, Washington, DC 20461/202-634-5602.

Energy Information Center, National
This center serves as the central clearinghouse for providing energy information and assistance in support of federal agencies, state and local governments, the academic community, industrial and commercial organizations, and the general public. The Center is a comprehensive source of information about energy data and information, providing the following services: copies of publications issued by the Energy Information Administration; indices and catalogs of energy information products, systems, data bases, and models incorporated in the National Energy Information System; compilations of energy data; standard reference materials; an inquiry unit; expertise on energy sources and applications; and online search and retrieval access to both government and commercial data bases. Contact: National Energy Information Center, Energy Information Administration, Department of Energy, 1000 Independence Ave. S.W., MS 1F048, Washington, DC 20585/202-252-8800.

Energy Information, Office of

This office administers publications to support the functions of the Energy Information Administration's energy data and information programs. They work with ten Department of Energy Regional Energy Information Centers and maintain a public reading room which contains examples of their publications and data survey forms. Contact: Office of Energy Information Services, Energy Information Administration, Department of Energy, 1000 Independence Ave. S.W., MS E170, Washington, DC 20585/202-252-1088.

Energy Information Referral Directory

This quarterly publication is an excellent source for identifying U.S. Department of Energy information. This topical subject index describes offices within the Department, as well as regional energy information offices, state energy offices, and research and development field facilities. Available at $17.00 per year or $4.50 for a single issue from: Government Printing Office, Superintendent of Documents, Washington, DC 20402/202-783-3238.

Energy Information, Regional

Access to U.S. Department of Energy information and services are also available through any one of ten regional offices. Contact:

Department of Energy, Region I/150 Causeway St., Boston, MA 02114/617-223-0504.
Department of Energy, Region II/26 Federal Plaza, Room 3200, New York, NY 10007/212-264-0560.
Department of Energy, Region III/1421 Cherry St., 10th Floor, Philadelphia, PA 19102/215-597-3609.
Department of Energy, Region IV/1655 Peachtree St. N.E., Atlanta, GA 30309/404-881-2352.
Department of Energy, Region V/175 West Jackson Blvd., Room A-333, Chicago, IL 60604/312-353-8515.
Department of Energy, Region VI/P. O. Box 35228, 2626 West Mockingbird Lane, Dallas, TX 75235/214-767-7777.
Department of Energy, Region VII/Regional Representative's Office, 324 East 11th St., Kansas City, MO 64106/816-374-3481/FTS: 758-2481.
Department of Energy, Region VIII/Regional Representative's Office, P. O. Box 26247, Belmar Branch, 1075 S. Yukon St., Lakewood, CO 80226/303-234-2420/FTS: 234-2420.
Department of Energy, Region IX/Energy Resources Center, 333 Market St., 7th Floor, San Francisco, CA 94105/415-764-7035/FTS: 454-7035.
Department of Energy, Region X/Regional Energy Information Center, Room 1992, Federal Building, 915 Second Ave., Seattle, WA 98174/206-442-7285/FTS: 399-7285.

Energy Legislation

The Office of Legislative Affairs tracks daily actions by the U.S. Congress on major energy legislation and provides information on the current status of legislation. Contact: Research and Analysis Division, Legislative Affairs, Department of Energy, 1000 Independence Ave. S.W., MS 7E054, Washington, DC 20585/202-252-8687.

Energy Libraries

The following are the major libraries at the U.S. Department of Energy:

Library, Department of Energy, 1000 Independence Ave. S.W., Room GA138, Washington, DC 20585/202-252-9534. Administrative and regulatory matters, non-nuclear research and development, and alternative energy sources.
Library, Department of Energy, 825 N. Capitol St. N.W., Room 8502, Washington, DC 20426/202-233-4166. Regulatory matters concerning gas and electric utilities and oil and gas pipelines.
Library, Department of Energy, Room G043, Germantown, MD 20545/301-353-4166. Nuclear, environmental, fossil energies and safety research and development.

Energy Market Analyses

Analyses are conducted of international energy developments and forecasts of relevance to policy formulation mode. A free monthly publication, *International Energy Indicators*, includes information on: crude oil capacity of Iran, Saudi Arabia, OPEC, Non-OPEC free world, and United States; free world, U.S., Japan and Europe oil stock; petroleum consumption by industrial countries; USSR crude oil production; free world and U.S. nuclear generation capacity; world crude oil production by area; estimated proved world reserves of crude oil; world marketed production of natural gas, estimated proved world reserves of natural gas; U.S. trade in natural gas; U.S. trade in coal; U.S. imports of crude oil and products; summary of U.S. merchandise trades; energy/GNP ratios; and cost of Saudi crude oil in current and 1974 dollars. Contact: Marketing Analysis, Office of International Energy Analysis, International Affairs, Department of Energy, 1000 Independence Ave. S.W., MS GA257, Washington, DC 20585/202-252-5893.

Energy-Producing Nations

Policies, strategies and options for bilateral, multilateral and regional energy relations, negotiations and developments with energy-producing nations are studied at: Energy-Producing Nations, International Energy Resources, International Affairs, Department of Energy, 1000

Independence Ave. S.W., MS 7F031, Washington, DC 20585/202-252-5924.

Energy Regulation

For information on the implementation of new legislation covering crude oil, petroleum products, natural gas, or coal, contact: Office of Regulations, Economic Regulatory Administration, Department of Energy, 2000 M St. N.W., MS 7219, Washington, DC 20461/202-653-3166.

Energy Regulation Hotline

The documents hotline provides a recorded listing of all Federal Energy Regulatory Commission orders, notices, opinions, and news releases, issued at 10:00 A.M. and 3:00 P.M. daily. Contact: Public Inquiries Branch, Office of Congressional and Public Affairs, Federal Energy Regulatory Commission, Department of Energy, 825 N. Capitol St. N.W., MS 9200, Washington, DC 20426/202-357-8555.

Energy Regulatory Liaison

The Energy Liaison Center is the liaison with state and local governments on Economic Regulatory Administration programs. Contact: Energy Liaison Center, Economic Regulatory Administration, Department of Energy, 2000 M St. N.W., MS 4126, Washington, DC 20461/202-252-5155.

Energy-Related Inventions

Support is provided for energy-related inventions that involve energy conservation or alternative sources of energy. For information on the application process for receiving funds, contact: Inventions Support Office, Office of Inventions and Small-Scale Technology, Conservation and Solar Energy, Department of Energy, 1000 Independence Ave. S.W., MS 6G040, Washington, DC 20585/202-252-9104.

Energy-Related Laboratory Equipment Grants

Used energy-related equipment is donated to nonprofit educational institutions of higher learning for use in energy-oriented programs in the life, physical and environmental sciences and engineering. Contact: Director, University and Industry Programs Division, Office of Field Operations Management, Department of Energy, Washington, DC 20585/202-252-6833.

Energy Research

The Office of Energy Research provides advice on U.S. Department of Energy physical energy research programs, the Department's overall energy research and development programs, university-based education and training activities, and

grants and other forms of financial assistance. Their major programs include high-energy physics, basic energy sciences, university research support, nuclear physics, technical assessment projects and magnetic fusion energy. Contact: Office of Energy Research, Department of Energy, 1000 Independence Ave. S.W., MS 6E084, Washington, DC 20585/202-252-5430.

Energy Research Abstracts

This semimonthly publication includes a semi-annual and an annual index along with abstracts of all U.S. government-originated literature on energy-related research and development. It contains information on solar, wind, geothermal, fossil, nuclear, energy information, and storage conversion, as well as literature from foreign governments with which the U.S. Department of Energy has cooperative arrangements. Available for $184 per year from: Government Printing Office, Superintendent of Documents, Washington, DC 20402/202-783-3238.

Energy Research Laboratories

For a description of activities at the U.S. Department of Energy's multi-program nonweapons laboratories, contact: Field Operations Management, Energy Research, Department of Energy, 1000 Independence Ave. S.W., MS 3F032, Washington, DC 20585/202-252-5447.

Energy Reserves

The U.S. Department of Energy is responsible for managing three naval petroleum reserves and four oil shale reserves. Contact: Office of Naval Petroleum and Oil Shale Reserve, Resource Applications, Department of Energy, 12th St. and Pennsylvania Ave. N.W., MS 3344, Washington, DC 20461/202-633-8674.

Energy Resources on Federal Land

For information on the leasing of federal public domain lands for the extraction of energy resources of all types, including coal, gas, petroleum, oil shale, geothermal and uranium, contact: Office of Leasing Policy Development, Resource Applications, Department of Energy, 12th St. and Pennsylvania Ave. N.W., MS 3344, Washington, DC 20461/202-633-9326.

Energy Review, Monthly

This monthly publication is an inclusive and timely review of statistical trends and developments in energy. Any factor having a bearing on the U.S. energy situation is examined, such as current fuel prices at the various levels of sale; data on petroleum production by OPEC countries; and data on demand for petroleum produc-

tion in countries of the International Energy Agency. Available at $23.00 per year from: Government Printing Office, Superintendent of Documents, Washington, DC 20402/202-783-3238.

Energy-Saving Architecture and Engineering

The Buildings Division is responsible for information dissemination and outreach programs concerned with energy efficient buildings. It focuses on how systems, subsystems, and components of buildings function both independently and interactively; and develops and promotes research, which includes construction and operation methods and standards for application to new or existing residential and commercial buildings. Areas of application are illumination, ventilation, infiltration, insulation, heating, ventilating, and air-conditioning control systems, diagnostics, heat transfer, and energy analysis calculations. The Division operates demonstration projects to illustrate these principles. Contact: Architecture and Engineering System Branch, Buildings Division, Buildings and Community Systems, Conservation and Solar Energy, Department of Energy, 1000 Independence Ave. S.W., MS GH068, Washington, DC 20585/202-252-9177.

Energy Source Analysis

Research is conducted on the applied analyses of petroleum, natural gas, coal electric power, nuclear and other energy sources. Topics considered include resource availability, exploration, extraction and processing, transmission and distribution, costs and pricing, imports and exports, and the integration of short-term supply/demand balances. Contact: Office of Energy Source Analysis, Office of Applied Analysis, Energy Information Administration, Department of Energy, 12th St. and Pennsylvania Ave. N.W., MS 4530, Washington, DC 20461/202-633-8537.

Energy Statistics

The following are some of the major statistical publications published by the Energy Information Administration:

Quarterly Report to Congress: Energy Information ($8.00 per year)
Petroleum Market Shares: Report on Sales of Refined Petroleum Products (monthly, $14.00 per year)
Monthly Petroleum Statistics Report ($14.00 per year)
Petroleum Market Shares: Report on Sales of Retail Gasoline (monthly, $12.00 per year)
Monthly Petroleum Product Price Report (monthly, $12.00 per year)

Available from U.S. Government Printing Office, Superintendent of Documents, Washington, DC

20402/202-783-3238. For further information on statistics collected by the Energy Information Administration, contact: National Energy Information Services, Statistical Information, Energy Information Administration, Department of Energy, 1000 Independence Ave. S.W., MS E170, Washington, DC 20585/202-252-8800.

Energy Storage Systems

Research is conducted on solar and other intermittent energy systems so that they can provide continuous service. Areas of interest include conserving energy by storing industrial and utility waste heat for later use; improving the efficiency of electrochemical processes; and electrochemical, mechanical, thermal and chemical energy storage technologies to be used in solar systems, transportation, building heating and cooling, industry and utilities. Contact: Advanced Conservation Technologies, Conservation and Solar Energy, Department of Energy, 600 E St. N.W., Room 416, Washington, DC 20545/202-376-9284.

Energy Survey Hotline

A special hotline is available to help with filling out U.S. Department of Energy data survey forms, and to answer inquiries regarding the availability and procedures for all energy data survey forms. Contact: 800-424-9041; DC: 202-252-6626.

Energy Transportation

The Office of Energy Supply Transportation coordinates U.S. Department of Energy's activities and policy in all matters of energy transportation. For example, it provides policy papers on railroad reorganization and coal slurry pipeline legislation, and it completed the U.S. Department of Energy's study on the Northern Tier Pipeline. A primary mission of this office is the development of transportation methods for oil shale and synthetic fuels from coal. It helps manage programs for coal exports to Western Europe and coordinates with the U.S. Department of Transportation on the National Energy Transportation Study. Contact: Office of Energy Supply Transportation, Industrial Planning and Development, Resource Application, Department of Energy, 12th St. and Pennsylvania Ave. N.W., MS 3344, Washington, DC 20461/202-633-8959.

Energy Use Analysis

Research is conducted to produce models and forecasts of short-term and mid-term energy demand in the end-use sectors (residential, commercial, transportation, and industrial), in-

cluding regional and demographic breakdowns and analysis of market penetration, as well as the impact of conservation and new technologies. Contact: Energy Use Analysis Office, Office of Applied Analysis, Energy Information Administration, Department of Energy, 12th St. and Pennsylvania Ave. N.W., MS 4530, Washington, DC 20461/202-633-8510.

Energy Use in Buildings
A computer program is available that provides a detailed analysis of building energy consumption. The program can be used by people who have only limited experience with computers, and architects and engineers can apply it to design energy efficient buildings that have low life-cycle costs. Contact: Energy Efficient Building Program, Berkeley Laboratory, Building 90, Room 3026F, Berkeley, CA 94720/415-486-4834.

Enhanced Oil Recovery
For information on the commercialization of enhanced oil recovery technologies, contact: Enhanced Oil Recovery Division, Oil and Natural Gas, Resource Applications, Department of Energy, 12th St. and Pennsylvania Ave. N.W., MS 3344, Washington, DC 20461/202-633-8395.

Environmental Energy Liaison
The Office of Environmental Liaison coordinates the participation of Congress, state and local governments and public interest groups in the development of environmental energy programs. Contact: Environmental Liaison Division, Office of Program Coordination, Environment, Department of Energy, 1000 Independence Ave. S.W., MS 4G085, Washington, DC 20585/202-252-4620.

Environmental Impacts of Energy Technology
The Office of Environmental Control Technology is responsible for identifying and evaluating the equipment, methods and procedures necessary to minimize detrimental impacts from energy systems on the public and environment. It also compiles an annual inventory of U.S. Department of Energy environmental control technology-related projects. Contact: Environmental Control Technology, Environment, Department of Energy, Germantown MS 201, Washington, DC 20545/301-353-3016.

Environmental Policy
Information and analysis on environmental energy-related policy is available from: Office of Environment Systems Analysis, Policy and Eval-

uation, Department of Energy, 1000 Independence Ave. S.W., MS 7E088, Washington, DC 20585/202-252-6453.

Exhibits
The U.S. Department of Energy offers free traveling exhibits suitable for malls, shopping centers, conventions, fairs, science centers, museums, libraries, civic clubs, theme parks, and tourist attractions. The exhibits include:

The Energy Laboratories—these exhibits stress energy conservation, driving for dollars, energy tax credits and home insulation.
Energy—looks at the problems with various energy resources—coal, oil, natural gas, nuclear, water—and discusses other alternatives such as oil shale, geothermal energy, nuclear fusion, and energy storage systems.
The Savings Energy Show—how various energy systems can be used to save energy.
The American Energy Pie—looks at where our energy is being used, where it comes from and how we can use less.
Saving Energy in Your Home—demonstrates sources of heat loss in the home, economical uses of insulation, and energy-efficient thermostats.
Extraction of Oil and Gas—informs energy specialists in oil and gas production about the research and development programs for enhanced oil and gas recovery by the U.S. Department of Energy.
Coal Mining—provides information on U.S. Department of Energy's program to develop and test equipment and procedures that safely and economically mine coal by stripping and deep mining.

Contact: Traveling Programs Department, American Museum of Science and Energy, U.S. Department of Energy, P.O. Box 117, Oak Ridge, TN 37830/615-576-3215. Energy-related exhibits are also available from: Exhibits Branch, Office of Public Affairs, Department of Energy, 1000 Independence Ave. S.W., MS 1E218, Washington, DC 20585/202-252-6171.

Extension Service Program
This program is a federal/state partnership to give personalized information and technical assistance to small-scale energy users on energy conservation and the use of renewable and more abundant resources. States receive grants to work personally with families, owners of small companies, and local government officials to help them take practical steps to save energy. Examples of programs include self-help solar workshops; home builders workshops; clearinghouses; hospital energy management; family-business energy audits; hotel/motel energy audits. Available tech-

nical assistance includes source books; a computerized information retrieval system; technical materials (posters, pamphlets, media messages, training materials and technical reports); and seminars and workshops. Contact: Extension Service Program, State and Local Programs, Conservation and Solar Energy, Department of Energy, 1000 Independence Ave. S.W., MS 2H027, Washington, DC 20585/202-252-2346.

Federal Energy Management Program
This program oversees and monitors progress of federal agencies in the reduction of energy consumption in federal buildings and federal operations. Contact: Federal Energy Management Programs Branch, Federal Programs Division, Buildings and Community Systems, Conservation and Solar Energy, Department of Energy, 1000 Independence Ave. S.W., MS 1H054, Washington, DC 20585/202-252-9467.

Federal, State and International Energy Statistics
The Office of Interfuels, International and Emerging Energy Statistics provides information on federal and state energy usage, energy indicators and measures of consumption; develops and collects international statistics and coordinates Energy Information Administration data submissions to major international energy agencies; compiles nuclear energy data; designs and conducts special surveys on emerging fuels such as solar energy, wood, geothermal and conservation activities; and compiles financial statistics from natural gas pipeline companies and electric utilities. Contact: Office of Interfuels, International and Emerging Energy Statistics, Energy Data Operations, Energy Information Administration, Department of Energy, 12th St. and Pennsylvania Ave. N.W., MS 413, Washington, DC 20461/202-633-8500.

FEDEX—Federal Energy Data Index
This computerized data base provides a quick reference to statistical tabulations of all Energy Information Administration publications. It contains standard bibliographic information as well as descriptions of the data tables within the publications. The system is commercially available through: Bibliographic Retrieval Services, Inc., Corporation Park, Building 702, Scotia, NY 12302/508-374-5011. For general information on the publications included within the system, contact: Office of Energy Information Services, Energy Information Administration, Department of Energy, 1000 Independence Ave. S.W., MS E170, Washington, DC 20585/202-252-8800.

Films
Films are available on a loan basis. For a catalog, contact: Film Library, Technical Information Center, Department of Energy, P.O. Box 62, Oak Ridge, TN 37830/615-576-1285.

Financial Data on Energy Companies
Financial and operation performance data is collected on companies in energy-related industries. Companies are arranged by energy source, firm size, operation segment and geographic area. Contact: Financial Reporting System, Program Development, Energy Information Administration, Department of Energy, 12th St. and Pennsylvania Ave. N.W., MS 5302, Washington, DC 20461/202-633-8806.

Financing Energy Development
Research is conducted on the feasibility of financing energy development through 1990. Contact: Financial and Industry Studies Division, Office of Economic Analysis, Energy Information Administration, Department of Energy, 12th St. and Pennsylvania Ave. N.W., MS 4530, Washington, DC 20461/202-633-8729.

Forecasts and Analysis
The Applied Analysis Division carries out forecasts and analysis functions for the Energy Information Administration. The type of studies available include:

An Analysis of the Natural Gas Policy Act of 1978 and the Powerplant and Industrial Fuel Act of 1978
The Short-Term Costs of Petroleum Imports
The Possible Utility Fuel Use Implications of Alternative Legislative or Regulatory Reactions to the Three Mile Island Nuclear Power Station Accident
The Short-Term Forecasts of Energy Supply and Demand Balances
The Estimated Impacts of Gasoline Deregulation on Household Energy Consumption Expenditures
The Feasibility of Financing Energy Development Through 1990
An Assessment in Terms of World Oil Prices of the Iranian Petroleum Supply Disruption.

Contact: Applied Analysis, Energy Information Administration, Department of Energy, 12th St. and Pennsylvania Ave. N.W., MS 4530, Washington, DC 20461/202-633-8544.

Fossil Energy Research
Research is conducted on the capabilities to convert coal to liquid and gaseous fuels; the increase of domestic production of coal, oil and gas; and more efficient and more economically attractive use of fossil energy resources. Contact:

Fossil Energy, Office of Advanced Technology, Research and Technology, Department of Energy, Room C156, Germantown, Washington, DC 20545/301-353-2784.

Freedom of Information Act

For information on Freedom of Information and Privacy Act activities within the U.S. Department of Energy, contact: Office of Administrative Services, Department of Energy, 1000 Independence Ave. S.W., MS 5B138, Washington, DC 20585/202-252-5955. See also "Freedom of Information Act."

Fuel Conversion

Information is available on the Powerplants and Industrial Fuel Use Act of 1978, which prohibits utilities and industry from building and operating major new boiler facilities that would burn oil or natural gas unless the Economic Regulatory Administration grants an exemption. Responsibility also includes ordering the conversion of existing power plants and industrial boilers to coal or other alternate fuels. Contact: Office of Fuels Conversion, Economic Regulatory Administration, Department of Energy, 2000 M St. N.W., MS 3214, Washington, DC 20461/202-653-3649.

Fuel Regulation Hotline

The Economic Regulatory Administration answers inquiries about violations of various U.S. Department of Energy fuel price regulations, including gasoline and heating oil price gouging. The hotline staff has phone numbers of local community action groups for low-income people who need help with utility bills. They also act as a referral service for other energy information. Call: 800-424-9246 (DC: 202-653-3437).

Fusion

For information on the latest technology for safe, economical and environmentally acceptable use of fusion power for the generation of electricity and for the production of synfuels and heat, contact: Office of Fusion Energy, Energy Research, Department of Energy, Germantown, MS 6234, Washington, DC 20545/301-353-4941.

Gas Centrifuge Technology

For information on the latest developments and applications of gas centrifuge technology and on the construction of the Gas Centrifuge Enrichment Plant at Portsmouth, Ohio, contact: Gas Centrifuge Enrichment Division, Office of Uranium Resources and Enrichment, Industrial and Utility Applications and Operations, Resource Applications, Department of Energy, 12th

St. and Pennsylvania Ave. N.W., MS 6521, Washington, DC 20461/202-633-9492.

Gaseous Diffusion Plants

For information on the activities associated with the operation, construction and maintenance of the three existing gaseous diffusion plants operated by the U.S. Department of Energy, contact: Gaseous Diffusion Operations Division, Office of Uranium Resources and Enrichment, Industrial and Utilities Applications and Operations, Resource Applications, Department of Energy, 12th St. and Pennsylvania Ave. N.W., MS 6521, Washington, DC 20461/202-633-9385.

Gas Mileage Guide

This free booklet provides estimates on fuel economy by vehicle size in order to provide a basis for selecting the most fuel-efficient vehicle to meet basic needs; information on relative fuel economy, engines, transmissions, fuel systems, and body types including sizes of passenger compartments, and trunk and storage space; and information on factors affecting fuel economy such as temperature, wind, precipitation, road conditions and driving style. Contact: Fuel Economy Distribution, Technical Information Center, Department of Energy, P. O. Box 62, Oak Ridge, TN 37830/615-576-1301.

Gasohol and Alcohol Fuels Hotline

For information and research assistance and for the following free publications: *Facts About Gasohol* and *Fuel From Farms: A Guide to Small Scale Ethanol Production*, call 800-525-5555 (CO: 800-332-8339).

Gasohol Entitlement Payments

For information on regulatory incentives for gasohol producers including entitlement payments, contact: Entitlements Program Branch, Economic Regulatory Administration, Department of Energy, 2000 M St. N.W., Room 6212A, Washington, DC 20461/202-653-3873.

Gasohol Price Regulations

For information on proposed changed in allocation and pricing regulations on gasohol, contact: Office of Hearings and Appeals Task Force, Economic Regulatory Administration, Department of Energy, 2000 M St. N.W., Room 8014, Washington, DC 20461/202-653-3058.

Gasoline Rationing

Information is available on emergency gas rationing plans. The Winter Emergency Plan lays out various combinations of actions that federal

and state governments can take to meet different kinds of winter-related energy shortages. Contact: Gasoline Rationing Preimplementation Project Office, Department of Energy, 1111 20th St. N.W., Room 538A, Washington, DC 20461/202-653-4133.

Gas Resource Development

Information is available on the production and recovery of unconventional and conventional gas from all sources, including marginal wells, as well as the commercialization of all gas and unconventional gas resources. Contact: Resource Development and Operations, Office of Oil and Natural Gas, Resource Applications, Department of Energy, 12th St. and Pennsylvania Ave. N.W., MS 3344, Washington, DC 20461/202-633-8395.

Gas Turbines

Work is done in conjunction with the U.S. auto industry toward the development of gas turbine engines that receive 30 percent or better fuel economy by 1985 (as required by the U.S. Congress). Contact: Gas Turbine Branch, Motive Technology Development Division, Transportation Programs, Conservation and Solar Energy, Department of Energy, 1000 Independence Ave. S.W., MS 5H063, Washington, DC 20585/202-252-8064.

Geothermal Energy

For information on the resource assessment and technological development of hydrothermal energy including commercial activities related to geopressured resources and hot dry rock, contact: Division of Geothermal Energy, Resource Applications, Department of Energy, 12th St. and Pennsylvania Ave. N.W., MS 3344, Washington, DC 20461/202-633-8909.

Grants

The programs described below are for sums of money which are given by the federal government to initiate and stimulate new or improved activities or to sustain ongoing services.

Appropriate Energy Technology

Objectives: To encourage research and development of energy-related small-scale technologies.

Eligibility: Individuals, small businesses, local agencies, nonprofit organizations and institutions, and Indian tribes.

Range of Financial Assistance: $350 to $50,000.

Contact: Appropriate Energy Technology, Department of Energy, Washington, DC 20585/202-252-9104.

Basic Energy Sciences, High Energy/Nuclear Physics, Fusion Energy, and Program Analysis

Objectives: To provide financial support for fundamental research in the basic sciences and advanced technology concepts and assessments in fields related to energy.

Eligibility: Institutions of higher education.

Range of Financial Assistance: $10,000 to $1,000,000.

Contact: Program Information, Office of Energy Research, Department of Energy, Forrestal Building, MS 6E084, Washington, DC 20585/301-353-5544.

Energy Conservation for Institutional Buildings

Objectives: To provide grants to states and to public and private nonprofit schools, hospitals, units of local government, and public care institutions to identify and implement energy conservation maintenance and operating procedures, and, for schools and hospitals only, to acquire energy conservation measures to reduce consumption.

Eligibility: State energy agencies are eligible to apply for financial assistance to conduct energy audits of public and private nonprofit institutions—schools, hospitals, local government buildings, and public care institutions. Individual institutions are eligible for assistance to conduct technical assistance and energy conservation measures.

Range of Financial Assistance: $150,000 to $1,000,000.

Contact: Institutional Buildings Grants Programs, Office of State and Local Programs, CS, Department of Energy, Washington, DC 20585/202-252-2330.

Energy Extension Service

Objectives: To encourage individuals and small establishments to reduce energy consumption and convert to alternative energy sources; to assist in building a credible, nonduplicative, state-planned and operated energy outreach program responsive to local needs.

Eligibility: States and territories

Range of Financial Assistance: Average of $486,000.

Contact: Acting Director, Energy Extension Service, Department of Energy, Forrestal Building, 1000 Independence Ave. S.W., Washington, DC 20585/202-252-2300.

Energy-Related Inventions

Objectives: To encourage innovations in developing non-nuclear energy technology by providing assistance to individual inventors and small business research and development companies in

the development of promising energy-related inventions.

Eligibility: Small business, individual inventors, and entrepreneurs are especially invited to participate.

Contact: Inventions Support Division, Department of Energy, MS 6G040, Forrestal Building, 1000 Independence Ave. S.W., Washington, DC 20585/202-252-9104.

Grants for Offices of Consumer Services

Objectives: To assist in the establishment of state utility consumer offices to represent consumer interests in electric proceedings before utility regulatory commissions.

Eligibility: States, territories, the District of Columbia, Guam, and the Tennessee Valley Authority are eligible to submit a grant application.

Range of Financial Assistance: $40,000 to $244,000.

Contact: Office of Utility Systems, Economic Regulatory Administration, Department of Energy, 2000 M St. N.W., Room 4306, Washington, DC 20461/202-254-8266.

Pre-Freshman and Cooperative Education for Minorities and Women in Engineering

Objectives: To promote equitable participation of all Americans in energy-related careers—specifically, to increase the educational opportunities available to qualified minority group members and women in the field of engineering.

Eligibility: United States institutions of higher learning offering an engineering degree. Projects of a cooperative nature between engineering degree-granting and non-degree-granting institutions are allowable, but the proposal should be submitted by the degree-granting institution.

Range of Financial Assistance: Up to $25,000.

Contact: Education Division, Office of Consumer Affairs, Department of Energy, Forrestal Building, 1000 Independence Ave. S.W., Washington, DC 20585/202-252-6480.

Public Utility Regulatory Support

Objectives: To assist state utility regulatory commissions and nonregulated electric utlities carry out duties and responsibilities under Titles I and III, and Section 210 of the Public Utility Regulatory Program Act (PURPA).

Eligibility: State utility regulatory commissions that have rate-making authority over at least one PURPA-covered electric utility, and PURPA-covered nonregulated electric utilities.

Range of Financial Assistance: Up to $200,000.

Contact: Office of Utility Systems, Economic Regulatory Administration, Department of Energy, 2000 M St. N.W., Room 4306, Washington, DC 20461/202-353-3920.

Research and Development—Fission, Fossil, Solar, Geothermal, Electric and Storage Systems

Objectives: To assure the continued conduct of research and development in energy technology matters.

Eligibility: City, county and state governments; U.S. territories; private, profit, and nonprofit organizations and institutions; individuals; public, private, and state colleges and universities, junior and community colleges. Proposals may be submitted relating to the objectives of the energy technology research and development program.

Range of Financial Assistance: No limitations.

Contact: Fossil Energy, Department of Energy, C156, Washington, DC 20545/301-353-2784.

Research and Development in Energy Conservation

Objectives: To provide financial support for basic and applied research and development in the field of energy conservation.

Eligibility: Any person or organization may submit a proposal requesting U.S. Department of Energy support for the purpose of exploring an idea or carrying out an initial development which does not unnecessarily duplicate work already in progress or contemplated by the Department or is not already known about by the Department.

Range of Financial Assistance: Not available.

Contact: Office of Conservation and Solar Energy, Department of Energy, 20 Massachusetts Ave. N.W., Washington, DC 20585/202-376-4934.

State Energy Conservation

Objectives: To promote the conservation of energy and reduce the rate of growth of energy demand by authorizing the U.S. Department of Energy to establish procedures and guidelines for specific state energy conservation programs and to provide federal financial and technical assistance to states in support of such programs.

Eligibility: The Governor is first invited to submit a report assessing the feasibility of establishing a five percent per year goal in energy reduction, including a proposal to develop a state energy conservation plan; and then to submit a report to include a proposed state energy conservation plan and a detailed description of the requirements, including the estimated energy savings and estimated cost of such a plan.

Range of Financial Assistance: $163,000 to $2,380,200.

Contact: Office of State Energy Conservation Programs, Conservation and Solar Energy, Department of Energy, Forrestal Building, 1000 Independence Ave. S.W., Washington, DC 20585/202-252-2360.

Supplemental State Energy Conservation

Objectives: To promote further the conservation of energy and reduce the rate of growth of energy demand by authorizing U.S. Department of Energy to establish procedures and guidelines for supplemental state energy conservation plans and to provide federal financial and technical assistance to states in support of such programs.

Eligibility: States and territories

Range of Financial Assistance: $44,000 to $783,500.

Contact: Office of State Energy Conservation Programs, Conservation and Solar Energy, Department of Energy, Forrestal Building, 1000 Independence Ave. S.W., Washington, DC 20585/202-252-2360.

Teacher Development Projects in Energy

Objectives: To train college and university faculty, high school, junior high and elementary teachers in energy resource alternatives, conservation, environmental effects, and the social and political aspects of energy development.

Eligibility: Any U.S. college or university faculty, secondary school teacher or elementary teacher may apply to the host institution for selection as a participant.

Range of Financial Assistance: Up to $31,000.

Contact: Education Division, Office of Consumer Affairs, Department of Energy, Washington, DC 20585/202-252-6480.

University Coal Research

Objectives: To improve scientific and technical understanding of the fundamental processes involved in the conversion and utilization of coal; to furnish technical support for the ongoing and developing coal conversion process; to produce clean fuels in an environmentally acceptable manner; and to develop new approaches to the design of future coal conversion and utilization technologies.

Eligibility: Institutions of higher education.

Range of Financial Assistance: Not available.

Contact: Office of Advanced Research and Technology, Office of Fossil Energy, Department of Energy, Washington, DC 20585/301-353-2784.

University-Laboratory Cooperative Program

Objectives: To provide college and university science and engineering faculty and students with energy-related training and experience in areas of energy research at U.S. Department of Energy facilities.

Eligibility: Science, engineering, and technology faculty and students at U.S. institutions of higher education. U.S. citizenship required.

Range of Financial Assistance: Not available.

Contact: Director, University and Industry Division, Office of Energy Research, Department of Energy, Washington, DC 20585/202-252-6883.

Weatherization Assistance for Low-Income Persons

Objectives: To insulate the dwellings of low-income persons, particularly the elderly and handicapped, in order to conserve needed energy and to aid those persons least able to afford higher utility costs.

Eligibility: States, including the District of Columbia, and in certain instances, Native American tribal organizations. In the event a state does not apply, a unit of local government or community action agency within the state becomes eligible to apply.

Range of Financial Assistance: $433,900 to $18,442,000.

Contact: Weatherization Special Projects Office, Conservation and Solar Energy, Department of Energy, Forrestal Building, Washington, DC 20585/202-252-2204.

Health and Environment Research

Research is conducted into the health and environmental effects of energy technology development, including medical applications of nuclear technology. Investigations of the physical and chemical interactions of pollutants in the environment and in biological systems are conducted in an attempt to identify and characterize those pollutants to which humans may be exposed. The transportation of pollutants is also studied for possible disruptions to ecosystems. Biological studies are conducted on animals, organ tissues, cells and subcellular material to understand toxic action and to predict the effects on human health. Studies are made on the effects of weather and climate fluctuations on the nation's utilization of its energy resources in order to determine which types of energy use are most sensitive to climate fluctuations. Contact: Office of Health and Environment Research, Environment, Department of Energy, Germantown, MS E201, Washington, DC 20545/301-353-3153.

Health Effects of Energy Technology

Research is conducted on the health and environmental effects of all phases of the energy technologies under development, including biological energy conversion. Contact: Contracts Management and Special Projects Branch, Financial Services Division, Environment, Department of Energy, MS E201, Washington, DC 20545/301-353-3468.

Hearings and Appeals, Office of

This office deals with U.S. Department of En-

ergy issues that require adjudicatory, trial-type hearings and formal decisions. Individuals or firms adversely affected by a regulatory requirement may apply to this office for an exception from the regulations. Contact: Office of Hearings and Appeals, Department of Energy, 2000 M St. N.W., Room 8014, Washington, DC 20461/202-653-3144.

High BTU Coal Gasification

The Office of Coal Resource Management promotes commercial applications of high BTU gasification. It hopes to have two to three high-BTU gas plants operational by the mid-1980s. Contact: High BTU Coal Gasification, Coal Resource Management, Industrial and Utility Applications and Operations, Resource Applications, Department of Energy, 12th St. and Pennsylvania Ave. N.W., MS 3344, Washington, DC 20461/202-633-9176.

High Energy and Nuclear Physics

Information is available on research and development in high-energy physics (the study of the interaction between very-high-energy particle beams with other particles of matter) and nuclear physics. Contact: High Energy and Nuclear Physics Energy Research, Department of Energy, Germantown, Room G304, Washington, DC 20545/301-353-3713.

High Temperature Manufacturing Processes

For information on technological developments in high-temperature manufacturing processes of such materials as steel, aluminum, glass, cement, copper and lead, contact: High Temperature Manufacturing Processes Branch, Conservation Research and Development Division, Industrial Programs, Conservation and Solar Energy, Department of Energy, 1000 Independence Ave. S.W., MS 2H086, Washington, DC 20585/202-252-2080.

Hydroelectric Power

The Office of Hydroelectric Resource Development is responsible for research, development, demonstration, and commercialization of small-scale (15 megawatts or less) hydroelectric power systems of existing dams. The office is doing a feasibility study, in addition to a related licensing loan program for the development of existing dams, that looks at the economic, technical, and environmental aspects of redeveloping or upgrading existing small-scale dams, and has completed a national hydroelectric site inventory and survey of existing dams in the northwest. Contact: Hydroelectric Resource Development, Office of Renewable Resources, Resource Application,

Department of Energy, 12th St. and Pennsylvania Ave. N.W., MS 3344, Washington, DC 20461/202-633-8828.

Hydrogen Statistics

National estimates of hydrogen energy production and consumption are compiled by: Hydrogen Energy Statistics, Office of Oil and Gas Statistics, Energy Data Operations, Energy Information Administration, Department of Energy, 1000 Independence Ave. S.W., MS BE012, Washington, DC 20585/202-252-8381.

Impact of Energy Technology

The Office of Technology Impact analyzes proposed environmental policies, laws and regulations to determine the effect on energy development and use; assesses the potential impact on the environment of energy technologies being developed by the U.S. Department of Energy and the impact of national energy strategies at both the national and regional level; conducts an analysis of the environmental impacts of synthetic liquid fuels; and runs the National Coal Utilization Assessment and the Imperial Valley Geothermal Integrated Assessment. Contact: Office of Technology Impact, Environment, Department of Energy, 1000 Independence Ave. S.W., MS 4G065, Washington, DC 20585/202-252-2061.

Industrial Conservation Programs

Increased energy efficiency is promoted to U.S. industry. Programs include the identification and ranking of the major energy-consumptive manufacturing industries; workshops, trade shows, and seminars to further industrial energy conservation practices; and publications and films for selected audiences concerning industrial processes. Contact: Office of Industrial Programs, Conservation and Solar Energy, Department of Energy, 1000 Independence Ave. S.W., MS 2H085, Washington, DC 20585/202-252-2092.

Industrial Energy Conservation Legislation

For information on legislative options related to industrial energy conservation and the effectiveness of current programs, contact: New Legislation and Programs Analysis Branch, Conservation Technology Development and Monitoring Division, Industrial Programs, Conservation and Solar Energy, Department of Energy, 1000 Independence Ave. S.W., MS 2H086, Washington, DC 20585/202-252-2384.

Industrial Energy Consumption

Annual data identifying those manufacturing companies consuming at least one trillion BTUs

are collected to measure progress toward the industrial energy efficiency improvement targets as required by the Energy Policy and Conservation Act. The information lists the ten most energy-consumptive industries, which consume over 90 percent of the purchased energy used by U.S. manufacturers. Contact: Industrial Reporting Branch, Conservation Technology Development and Monitoring Division, Industrial Programs, Conservation and Solar Energy, Department of Energy, 1000 Independence Ave. S.W., MS 2H085, Washington, DC 20585/202-252-2371.

Industrial Waste Utilization

Research is conducted on technological developments in industrial waste utilization and in the use of alternative materials as either feedstock or as fuels. Funds are provided for marginally economical programs, which are evaluated as to whether they can become economical, and work is done in materials recycling, alternative material usage, and energy and feedstock production. Contact: Alternative Materials Utilization Branch, Office of Industrial Programs, Conservation Research and Development Division, Industrial Programs, Conservation and Solar Energy, Department of Energy, 1000 Independence Ave. S.W., MS 2H085, Washington, DC 20585/202-252-2366.

Information Systems Analysis

Energy Information Administration data and data systems are continually appraised for their adequacy and steps taken where necessary to fill in the gaps. Contact: National Energy Information System, Program Development, Energy Information Administration, Department of Energy, 12th St. and Pennsylvania Ave. N.W., MS 5302, Washington, DC 20461/202-633-9577.

Institutional Conservation Programs

These programs are designed to increase the level of energy conservation in schools, hospitals, buildings owned and operated by units of local government, and buildings that house public care institutions. Contact: Institutional Conservation Programs, State and Local Programs, Conservation and Solar Energy, Department of Energy, 1000 Independence Ave. S.W., MS 28027, Washington, DC 20585/202-252-2198.

International Analysis

Information is available on forecasts of international economic conditions and energy supply demand and prices under various assumptions regarding institutional arrangements and other international factors. Contact: International Energy Analysis Division, Office of Integrative Analysis, Office of Applied Analysis, Energy Information Administration, Department of Energy, 12th St. and Pennsylvania Ave. N.W., MS 4530, Washington, DC 20461/202-633-9723.

International Energy Technology Cooperation

The Office of Technical Cooperation negotiates, implements, coordinates and evaluates international energy technology cooperation. Contact: Technical Cooperation, International Nuclear and Technical Programs, International Affairs, Department of Energy, 1000 Independence Ave. S.W., Washington, DC 20585/202-252-6140.

International Statistics

For information on international energy statistics, contact: International Statistics Division, Energy Data Operations, Energy Information Administration, Department of Energy, 1000 Independence Ave. S.W., MS 2G020, Washington, DC 20585/202-252-5931.

International Visits

An international program controls unclassified visits and assignments of foreign nationals to the U.S. Department of Energy, recruits U.S. nationals for overseas assignments, and coordinates participation in energy-related international meetings. Contact: International Visits and Assignments, International Program Supports, International Affairs, Department of Energy, 1000 Independence Ave. S.W., MS 7F031, Washington, DC 20585/202-252-6121.

Loans and Loan Guarantees

The programs described below are those which offer financial assistance through the lending of federal monies for a specific period of time or programs in which the federal government makes an arrangement to indemnify a lender against part or all of any defaults by the borrower.

Coal Loan Guarantees

Objectives: To encourage and assist small- and medium-sized coal producers to increase production of underground low-sulfur coal and to enhance competition in the coal industry.

Eligibility: Any individual, partnership, corporation, association, joint venture, or any other entity can apply for a guaranteed loan. The applicant and its affiliates cannot have produced, in the previous calendar year, more than one million tons of coal, 300,000 barrels of oil, owned an oil refinery, or had gross revenue in excess of $50 million.

Range of Financial Assistance: Up to $30 million.

Contact: Office of Coal Loan Programs, Department of Energy, 1200 Pennsylvania Ave. N.W., Room 3515, Washington, DC 20461/202-633-8200.

Electric and Hybrid Vehicle Loan Guarantees

Objectives: To accelerate the development of electric and hybrid vehicles for introduction into the nation's transportation fleet by encouraging and assisting qualified borrowers, minimizing a lender's financial risk to encourage the flow of credit, and developing normal borrower-lender relationships.

Eligibility: Any individual, partnership, corporation, small business, or other legal entity having authority to enter into a loan agreement which has presented satisfactory evidence of an interest in electric or hybrid vehicles or components thereof in an acceptable manner. A borrower seeking a guaranty must be a citizen or national of the United States.

Range of Financial Assistance: Up to $3,000,000.

Contact: Chief, Demonstration and Incentives Branch, Electric and Hybrid Vehicles Division, Office of Transportation Programs, Department of Energy, Washington, DC 20585/202-252-8034.

Geothermal Loan Guarantees

Objectives: To accelerate the commercial development and utilization of geothermal energy by minimizing a lender's risk to assure the flow of credit for geothermal projects; enhancing competition; encouraging new entrants into the geothermal marketplace; developing normal borrower-lender relationships; and demonstrating the commercial viability of several projects.

Eligibility: Any private or public agency, institution, association, partnership, corporation or other legal entity that has presented satisfactory evidence of an interest in geothermal resources and is capable of completing the project in an environmentally acceptable manner.

Range of Financial Assistance: Up to $100 million.

Contact: Program Manager, Geothermal Loan Guaranty Program, Department of Energy, 1200 Pennsylvania Ave. N.W., Room 7112, Washington, DC 20461/202-633-8760.

Small Hydroelectric Power Project Feasibility Studies

Objectives: To encourage accelerated renovation and development of existing small hydro dam sites by loaning up to 90 percent of the cost of a feasibility study.

Eligibility: Any municipality, electric cooperative, industrial development agency, nonprofit organization, and individuals, partnerships, associations, and corporations.

Range of Financial Assistance: $30,000 to $50,000.

Contact: Hydroelectric Resource Development, Department of Energy, 12th St. and Pennsylvania Ave. N.W., Room 1422, Washington, DC 20461/202-633-8828.

Local Energy Conservation

Assistance is available to state and local governments to promote laws, ordinances, techniques and practices that promote the conservation of energy on a community-wide basis. Help is also available with site selection and neighborhood design for planning new communities and renovating old ones. Contact: Community Management Systems Branch, Community Systems Division, Buildings and Community Systems, Conservation and Solar Energy, Department of Energy, 1000 Independence Ave. S.W., MS 1H031, Washington, DC 20585/202-252-9395.

Low and Medium BTU Gas

The Coal Research Management Office promotes commercial applications of low- and medium-BTU gasification. The objective is to develop a timely program for the use of these gases resulting from coal gasification as alternatives to natural gas and fuel oil. Contact: Low and Medium BTU Gas, Coal Resources Management, Industrial and Utility Application and Operation, Resource Application, Department of Energy, 12th St. and Pennsylvania Ave. N.W., MS 3344, Washington, DC 20461/202-633-9195.

Low Temperature Manufacturing Processes

This office focuses on technological developments in specific industries requiring low-temperature manufacturing processes, such as textile and paper manufacturing, petroleum refining, and chemical and general manufacturing. Contact: Low Temperature Manufacturing Processes Branch, Conservation Research and Development Division, Industrial Programs, Conservation and Solar Energy, Department of Energy, 1000 Independence Ave. S.W., MS 2H086, Washington, DC 20585/202-252-2188.

Microeconomics of Energy

Analysis is conducted on the relationships between the energy sectors and the general economy in determining macroeconomic impacts associated with national energy forecasts. Contact: Macroeconomics Analysis Division, Office of Economic Analysis, Office of Applied Analy-

sis, Energy Information Administration, Department of Energy, 12th St. and Pennsylvania Ave. N.W., MS 4530, Washington, DC 20461/202-633-8693.

Magnetohydrodynamics
For information on the development and commercial applications of magnetohydrodynamics—the process of converting hot gases produced from burning coal directly into electricity, which is potentially more efficient than many other methods—contact, Magnetohydrodynamics, Fossil Energy, Department of Energy, Germantown, MS F338, Washington, DC 20545/301-353-5937.

Marketing of Energy Conservation
After the economic and technical feasibility of pilot programs have been demonstrated, both the hardware and software of the energy conservation technology is marketed to potential users, such as developers, city planners, utility executives, and other officials at the local level. Contact: Community Services Branch, Community Services Division, Buildings and Community System, Conservation and Solar Energy, Department of Energy, 1000 Independence Ave. S.W., MS 1F075, Washington, DC 20585/202-252-9393.

Metric Units and Symbols, Department of Energy Guide to Selected
This quick reference tool provides information on correct spelling, punctuation and capitalization of energy-related metric units, derived units and symbols. Free from: Interfuel Statistics Division, Office of Energy Data and Interpretation, Energy Information Administration, Department of Energy, 12th St. and Pennsylvania Ave. N.W., MS 4310, Washington, DC 20461/202-633-8500.

Mining and Mining Equipment
For information with latest developments in mining equipment and systems to improve productivity, contact: Office of Mining, Fossil Energy, Department of Energy, Germantown, MS D107, Washington, DC 20545/202-353-2737.

Minority Business Procurement
Information, advice, and assistance are available to minority business firms that wish to sell to the U.S. Department of Energy. Contact: Minority Business Division, Office of Small and Disadvantaged Business Utilization, Procurement and Contracts Management, Directorate, Department of Energy, 1000 Independence Ave. S.W., MS 1J009, Washington, DC 20585/202-252-8208.

Museum on Energy
The American Museum of Science and Energy is the largest exhibition on energy in the United States. It contains a variety of demonstrations and films, including harnessed atoms and pedal power exhibitions. Contact: Museum Division, Oak Ridge Associated Universities, Department of Energy, P. O. Box 117, Oak Ridge, TN 37830/615-576-3211.

MX Missile
Research is conducted in conjunction with the U.S. Department of Defense to develop a renewable energy system for the MX missile system. Contact: MX-RES Project, Conservation and Solar Energy, Department of Energy, 1000 Independence Ave. S.W., Room BH024, Washington, DC 20585/202-252-8742.

National Environmental Policy Act (NEPA)
The Office of Environmental Compliance and Overview provides technical assistance to all U.S. Department of Energy programs on matters pertaining to the NEPA; reviews and approves NEPA documents and reports prepared for the Department's activities; and determines whether Department programs, projects or regulations require Environmental Impact Statements or other environmental impact review. This is the focal point in the Department for reviewing environmental impact statements from other agencies. Contact: NEPA Affairs Division, Environmental Compliance and Overview, Environment, Department of Energy, 1000 Independence Ave. S.W., MS 4G064, Washington, DC 20585/202-252-4600.

Natural Gas Policy
Analysis is conducted on such policy issues as the importation of liquified natural gas, the domestic development of natural gas, and alternative regulatory policies to guide natural gas development and marketing. Contact: Office of Natural Gas Policy and Evaluation, Department of Energy, 1000 Independence Ave. S.W., MS 7E088, Washington, DC 20585/202-252-6423. For answers to questions about the provisions of the Natural Gas Policy Act, contact: General Counsel, Federal Energy Regulatory Commission, Department of Energy, Washington, DC 20585/800-424-5200 (DC: 202-357-8133.)

Natural Gas Regulation
The regulation of the import and export of natural gas controls pipeline imports from Canada and Mexico as well as the import of natural gas in a super-cooled liquid form commonly known as Liquified Natural Gas (LNG). Contact: Divi-

sion of Natural Gas, Office of Regulatory Policy, Economic Regulatory Administration, Department of Energy, 2000 M St. N.W., MS 7219, Washington, DC 20461/202-653-3286.

Nuclear Energy Analysis

Detailed analysis is performed on the demand, costs, and resource requirements of uranium fuel and nuclear electric power, along with nuclear supply and demand forecasts. Contact: Nuclear Energy Analysis Division, Office of Energy Source Analysis, Office of Applied Analysis, Energy Information Administration, Department of Energy, 12th St. and Pennsylvania Ave. N.W., MS 4530, Washington, DC 20461/202-633-8486.

Nuclear Energy Research

For information on research performed in nuclear energy, including nuclear waste management and administration of nuclear fission power generation and fuel technology, contact: Office of Resource Management Acquisition and Administration, Nuclear Energy, Department of Energy, MS B107, Washington, DC 20545/301-353-4354.

Nuclear Fuel Efficiency

Research is conducted to improve the efficiency of uranium fuel, reduce occupational exposure to radiation, improve plant productivity and improve reactor safety. Contact: Light Water Reactors, Nuclear Reactor Program, Nuclear Energy, Department of Energy, Germantown, MS B107, Washington, DC 20545/301-353-3375.

Nuclear Fuel Reprocessing

Information is available on fuel reprocessing technology research and development related to breeder systems. Contact: Nuclear Fuel Cycle Division, Nuclear Reactor Programs, Nuclear Energy, Department of Energy, Germantown, MS B17, Washington, DC 20545/301-353-4729.

Nuclear Nonproliferation

For information on U.S. nuclear nonproliferation, cooperation and export policies, contact: Nuclear Affairs, International Nuclear and Technical Programs, International Affairs, Department of Energy, 1000 Independence Ave. S.W., MS 7F031, Washington, DC 20585/202-252-6175.

Two major system evaluation programs have been established to examine the issue of nuclear proliferation:

1. Domestic Nonproliferation Alternative Systems Assessment Program—evaluates alternative nuclear systems.
2. International Nuclear Fuel Cycle Evaluation Pro-

gram—established to minimize nuclear weapons proliferation without jeopardizing energy supplies; provides a means for evaluating alternative proliferation-resistant nuclear energy systems and institutional arrangements that could be deployed worldwide.

Contact: Advanced Systems Evaluation, Nuclear Reactor Programs, Nuclear Energy, Department of Energy, Germantown, MS B107, Washington, DC 20545/301-353-5502.

Nuclear Reactor Research

The Reactor Research and Technology Division is responsible for U.S. programs and projects for liquid metal fast breeder reactors. It participates in the international nuclear fuel cycle evaluation and working groups, and assists U.S. government agencies and industry in studies and evaluations of breeder reactors. Contact: Reactor Research and Technology Division, Nuclear Reactor Programs, Nuclear Energy, Department of Energy, Germantown, MS B107, Washington, DC 20545/301-353-2915.

Nuclear Space Technology

Nuclear devices are developed for federal agencies for space-oriented scientific experiments in telemetry, navigation, communication and surveillance. Programs continue to analyze data from NASA's Viking, Pioneer 10, Pioneer 11, Voyager 1 and Voyager 2 spacecraft. Contact: Space and Terrestrial Systems Branch, Nuclear Reactor Programs, Nuclear Energy, Department of Energy, Germantown, MS B107, Washington, DC 20545/301-353-4117.

Nuclear Test Facility Safety

Safety evaluation of nuclear test facilities are conducted by: Assurance Standards and Operational Safety Branch, Division of Nuclear Power Development, Nuclear Energy Programs, Nuclear Energy, Department of Energy, Germantown, MS B107, Washington, DC 20545/301-353-4567.

Nuclear Waste

Information is available on the planning, development and execution of programs for civilian and defense nuclear waste processing and isolation, as well as for energy waste decontamination. Contact: Office of Nuclear Waste Management, Nuclear Energy, Department of Energy, Germantown, MS B107, Washington, DC 20545/301-353-5645.

The Transportation Technology Center is responsible for assuring a national capability to analyze and resolve problems associated with nuclear waste transportation and for assuring the availability of transportation systems for national

nuclear waste storage and disposal programs. The Center also maintains information on state legislation upgrading nuclear waste transportation, and hazardous material incident reports. The Center is the national focal point for nuclear waste transportation, integrating U.S. Department of Energy programs with those of other federal agencies and private industries. Contact: Transportation Technology Center, 4550 Sandice Laboratories, P.O. Box 5800, Albuquerque, NM 87185/505-544-5296.

Nuclear Weapons

The Office of Military Applications develops and directs programs in research, testing production, and reliability assessment of nuclear weapons. It also directs the U.S. Department of Energy program for the prevention of accidental and unauthorized nuclear detonation; maintains liaison with the U.S. Department of Defense on nuclear weapon matters; and administers international agreements for cooperation involving nuclear weapons. Contact: Division of Program Support, Office of Military Applications, Defense Programs, Department of Energy, Germantown, MS A362, Washington, DC 20545/302-353-3618.

Nuclear Weapons Data Indexing Program

All U.S. Department of Energy weapons development reports are cataloged, abstracted, and subject-indexed. A monthly abstract bulletin, *Abstracts of Weapons Data Reports*, is also available. A security clearance is required to receive classified information. Contact: Technical Information Center, Department of Energy, P. O. Box 62, Oak Ridge, TN 37830/615-676-1309.

Ocean Energy Systems

Information is available on ocean energy systems. One example is Ocean Thermal Energy Conservation (OTEC), which uses large floating platforms to capture the temperature difference in the ocean, driving turbines to generate electricity. Studies are also conducted on the feasibility of methods for generating electricity or energy-intensive products through wave energy, ocean currents and salinity gradients. Contact: Ocean System Division, Office of Solar Power Applicants, Conservation and Solar Energy, Department of Energy, 600 E St. N.W., Room 421, Washington, DC 20545/202-376-5889.

Offshore Drilling Technology

Information is available on selected projects concerned with offshore production of oil and gas on the outer continental shelf and with offshore instrumentation and drilling technology to increase reserves of oil and gas. Contact: Drilling and Offshore Technology, Oil, Gas and Shale Technology, Fossil Energy, Department of Energy, Germantown, MS D107, Washington, DC 20545/301-353-2727.

Oil and Gas Analysis

Detailed analysis is performed on oil and gas, including short-term supply and demand studies, forecasts of domestic supplies and imports of natural gas, crude oil and petroleum products, and the production, distribution and importation of synthetic oil and gas. Contact: Oil and Gas Analysis Division, Office of Energy Source Analysis, Energy Information Administration, Department of Energy, 12th St. and Pennsylvania Ave. N.W. MS 4530, Washington, DC 20461/202-633-8533.

Oil and Gas Information System

A specialized information system has been developed to collect data on proven reserves and production of crude oil, natural gas, and natural gas liquids. Interpretive reports are available on reserve ownership and operation. Contact: Oil and Gas Information System, Program Development, Energy Information Administration, Department of Energy, 12th St. and Pennsylvania Ave. N.W., MS 5302, Washington, DC 20461/202-633-9698.

Oil and Gas Statistics

Statistics are collected, interpreted and disseminated on all forms of petroleum and natural gas supply and demand. More than 200 periodicals, special publications, data bases and situation reports are published each year covering such topics as monthly petroleum statistics, petroleum market shares, sales of refined petroleum products, heating oil prices and margins, natural gas production and consumption, and underground storage and refinery capacity. Contact: Office of Oil and Gas Statistics, Energy Data Operations, Energy Information Administration, Department of Energy, 1000 Independence Ave. S.W., MS BE012, Washington, DC 20585/202-252-5214.

Oil, Gas, and Shale Programs

For information on underground gasification programs, i.e., turning coal into synthetic gas underground, contact: Office of Oil, Gas and Shale Technology, Fossil Energy, Department of Energy, Germantown, MS D107, Washington, DC 20545/301-353-2723. This office also develops strategies and plans for enhancing recovery in light oil, heavy oil, and tar sands as well as for upgrading and refining of petroleum drilling, offshore technology, and advanced energy research.

Oil Policy

Analysis is conducted on such topics as crude

oil decontrol, refinery policy, strategic petroleum reserves, and alternative demand restraint strategies. Contact: Office of Oil Policy, Oil and Gas Policy, Policy and Evaluation, Department of Energy, 1000 Independence Ave. S.W., MS 7ED88, Washington, DC 20585/202-252-5667.

Oil Shale Development

The Office of Shale Resource Application promotes the commercial development of oil shale as an energy source and evaluates alternative incentive mechanisms to accelerate adoption of oil shale technologies. Contact: Office of Shale Resource Applications, Resource Development and Operations, Resource Applications, Department of Energy, 12th St. and Pennsylvania Ave. N.W., MS 3344, Washington, DC 20461/202-633-8660.

Oil Shale Research

Basic and applied research and development is conducted on oil shale and oil shale reserves. The primary focus of the research is the "in situ" process, which extracts oil by heating shale underground rather than bringing it to the surface. Work is also done on processing shale on the surface. Contact: Office of Oil Shale, Oil, Gas and Shale Technology, Fossil Energy, Department of Energy, Germantown, MS G434, Washington, DC 20545/301-353-2707.

Passive Solar

Research and development is conducted to promote the use of passive and hybrid solar heating and cooling programs and buildings systems, including component development, building design and application development, systems modeling and design tool development, field testings of a variety of passive heating components and systems and data collection. Contact: Passive Division, Systems Development Division, Solar Applications, Conservation and Solar Energy, Department of Energy, 1000 Independence Ave. S.W., MS 5G033, Washington, DC 20585/202-252-8153.

Patents Available for Licensing

Nonexclusive, royalty-free, revocable licenses are granted by the U.S. Department of Energy upon request to responsible U.S. citizens and corporations on more than 4,000 Department-owned U.S. patents. Exclusive and limited exclusive licenses may also be granted. Similar licenses on more than 3,000 Department-owned foreign patents may be accorded to U.S. citizens and corporations, and to others under terms and conditions which depend upon particular facts. Contact: Assistant General Counsel for Patents, Department of Energy, Washington, DC 20585/202-353-4018.

Petroleum Allocation

For information on the Emergency Petroleum Allocation Act, which is meant to equalize the cost of crude oil to refiners regardless of whether they have access to domestically produced price-controlled oil or rely on imported oil, contact: Petroleum Allocation Regulations Division, Economic Regulatory Administration, Department of Energy, 2000 M St. N.W., MS 7219, Washington, DC 20461/202-653-3256.

Petroleum and Natural Gas Regulation

The Economic Regulatory Administration is responsible for importing and exporting petroleum and natural gas and for allocating crude oil and petroleum products. The allocation programs include motor gasoline, middle distillant stock buildup and entitlements for crude oil. Contact: Office of Petroleum Operations, Economic Regulatory Administration, Department of Energy, 2000 M St. N.W., MS 6128, Washington, DC 20461/202-653-3883.

Petroleum Regulation

For information on such topics as the regulation of the rates charged by oil pipelines for transporting oil in interstate commerce, or the establishment of oil pipeline valuations, contact: Public Information Division, Office of Congressional and Public Affairs, Federal Energy Regulatory Commission, Department of Energy, 825 N. Capitol St. N.E., MS 1000, Washington, DC 20426/202-357-8055.

Photovoltaic

This office manages the photovoltaic program, which includes research, and technological development to reduce manufacturing costs. Photovoltaic devices, or solar cells, convert light directly into electricity. The Solar Photovoltaic Energy Research and Development Act of 1978 provides for an accelerated program, including federal procurement of photovoltaic systems, in order to make photovoltaic technologies commercially competitive. Contact: Photovoltaic Division, Office of Solar Applications for Buildings, Conservation and Solar Energy, Department of Energy, 600 E St. N.W., MS 404, Washington, DC 20545/202-376-1957.

Pipeline and Producers Regulations

This office is responsible for oil pipeline rates, valuations, charges, operating rules, natural gas pipeline curtailments, certifications, mergers, acquisitions, rates, reserve evaluation, preparation and defense of environmental impact statements in administrative proceedings, etc. Contact: Pipeline and Producers Regulations, Federal Energy Regulatory Commission, Department of Energy,

825 N. Capitol St. N.W., Washington, DC 20426/202-357-8500.

Power Marketing

The U.S. Department of Energy sells power to utilities and industries and maintains extensive transmission lines in some areas of the United States. As part of the rate setting procedure, hearings are held where the public and customers of the power marketing administration are invited to comment. The five power marketing administrations are:

Alaska Power Administration/Juneau, AK 99801/907-586-7405

Bonneville Power Administration/Portland, OR 97208/503-234-3361

Southeastern Power Administration/Elberton, GA 30635/404-283-3261

Southwestern Power Administration/Tulsa, OK 74101/918-581-7474

Western Area Power Administration/Golden, CO 80401/303-231-1628

For additional information contact: Office of Power Marketing Coordination, Resources Applications, Department of Energy, 12th St. and Pennsylvania Ave. N.W., MS 3344, Washington, DC 20461/202-633-8338.

Price Enforcement—Oil Refineries

Audits are conducted on 35 of the largest U.S. refineries to determine their compliance with U.S. Department of Energy's pricing and allocation regulations. Contact: Office of Special Counsel for Compliance, Economic Regulatory Administration, Department of Energy, 2000 M St. N.W., MS 2140, Washington, DC 20461/202-633-8925.

Price Enforcement—Small Companies

Audits are conducted on the thousands of small firms engaged in some facet of the oil business to assure their compliance with the pricing regulations. Contact: Enforcement, Economic Regulatory Administration, Department of Energy, 2000 M St. N.W., MS 5204, Washington, DC 20461/202-653-3592.

Procurement Policy

Information is available on U.S. Department of Energy's procurement and contract policies, procedures, and other business matters. A booklet, *An Introduction to U.S. Department of Energy Procurement*, is free. Contact: Business Liaison Division, Office of Small and Disadvantaged Business Utilization, Procurement and Contracts Management Directorate, Department of Energy, MS 1J009, 1000 Independence Ave. S.W., Washington, DC 20585/202-252-9050.

Publications Directory, Energy Information Administration

This user's guide describes periodicals, one-time publications, a list of survey forms, and information available on microfiche file and computer tape. Copies are free from Office of Energy Information Services, Energy Information Administration, Department of Energy, 1000 Independence Ave. S.W., MS E170, Washington, DC 20461/202-252-8800.

Publications, Free

For copies of the following publications or for a complete listing of additional publications, contact: Publications Branch, Office of Public Affairs, Department of Energy, 1000 Independence Ave. S.W., MS 1E218, Washington, DC 20585/202-252-6250.

How To Understand Your Utility Bill
Energy-Saving Checklist for Home Builders, Buyers and Owners
U.S. Department of Energy Weekly Announcements
Careers in Energy Industries

See also "Citizens Assistance" in this section.

Public Reading/Document Rooms

Copies of U.S. Department of Energy Environmental Assessments and of Draft Environmental Impact Statements, along with comment letters and other material related to the environmental impact stations, may be seen in the Department's public reading room and in public document rooms at the following locations:

Public Reading Room/Department of Energy Headquarters, Room GA-152 Forrestal Building, 1000 Independence Ave. S.W., Washington, DC

Albuquerque Operations Office/Kirkland Air Force Base East, Albuquerque, NM

Chicago Operations Office/9800 South Cass Ave., Argonne, IL

Idaho Operations Office/550 Second St., Idaho Falls, ID

Nevada Operations Office/2753 South Highland Dr., Las Vegas, NV

Oak Ridge Operations Office/Federal Building, Oak Ridge, TN

Richland Operations Office/Federal Building, Richland, WA

San Francisco Operations Office/1333 Broadway, Oakland, CA

Savannah River Operations Office/Savannah Plant, Aiken, SC

In individual cases, as appropriate, copies of Environmental Assessments and Draft Environmental Impact States may also be seen at one or more of the following U.S. Department of Energy Technology Centers:

Bartlesville Energy Technology Center/Virginia and Cudahy Sts., Bartlesville, OK

Grand Forks Energy Technology Center/15 North 23rd St., Grand Forks, ND

Laramie Energy Technology Center/Corner of 9th and Lewis Sts., Laramie, WY

Morgantown Energy Technology Center/Collins Ferry Rd., Morgantown, WV

Pittsburgh Energy Technology Center/Cochran Mill Rd., Burceton, PA

Radiological Emergency Assistance

Assistance is available at the time of a radiological incident to evaluate the hazardous aspects of the situation, to counsel responsible officials at the incident scene, to bring hazardous conditions under control, and to supplement the radiological emergency capabilities of other government and private organizations involved. Assistance is also available to help federal, state, local, industrial and other organizations to develop their own plans and capabilities for dealing with radiological emergencies. Contact: Environmental Protection and Public Safety Branch, Operational and Environmental Safety Division, Department of Energy, Washington, DC 20585/301-353-4093.

Reactor Fuel Assistance for Universities

Nuclear materials, reactor fuel, and funds are available to colleges and universities to use in regulatory scheduled laboratory and lecture courses. Contact: Division of Engineering, Mathematical and Geo-Sciences, Office of Energy Research, Department of Energy, Washington, DC 20585/301-353-5822.

Reactors, High-Temperature Gas-Cooled

For information on advanced high-temperature reactors capable of direct cycle electricity production via a gas turbine and process heat production, contact: High-Temperature Gas Reactor Branch, Nuclear Reactor Programs, Nuclear Energy, Department of Energy, Germantown, MS B107, Washington, DC 20545/301-353-3692.

Recreation at Hydroelectric Projects

Many of the hydroelectric projects licensed by the U.S. Department of Energy provide various facilities for recreational activities such as swimming, boating, hiking, camping, picknicking, fishing and hunting. Some also offer historical sites, natural history museums, guided tours of powerhouses and other facilities for enjoyment of the public. A free booklet provides regional maps and information on available facilities. Contact: Public Inquiries Branch, Office of Congressional and Public Affairs, Federal Energy Regulatory Commission (FERC), Department of Energy,

825 N. Capitol St. N.E., Washington, DC 20426/202-357-8055.

Regional Libraries

U.S. Department of Energy and other energy-related publications are available at the following regional libraries:

Regional Energy Information Center/1655 Peachtree St. N.E., Atlanta, GA 30309/404-881-4463.

Regional Energy Information Center/175 West Jackson Blvd. (Room 1136), Chicago, IL 60604/312-353-5769

Regional Energy Information Center/2626 West Mockingbird Lane, Dallas, TX 75235/214-767-7736

Regional Energy Information Center/26 Federal Plaza, Room 3200, New York, NY 10007/212-264-4834

Regional Energy Information Center/111 Pine Street, 4th Floor, San Francisco, CA 94111/415-556-0305

Regional Energy Information Center/Room 1992 Federal Building, 915 Second Ave., Seattle, WA 98174/206-442-7285

Regional Energy/Environment Information Center Conservation Library, Denver Public Library, 1375 Broadway, Denver, CO 80203/303-837-5994

Regional Solar Energy Centers

Each of these centers provides many services, particularly those relating to the "ready-now" solar technologies: passive solar heating and cooling, solar hot water, industrial process heat, small wind energy systems, and wood combustion. The U.S. Department of Energy established the four regional centers to advance solar energy utilization. Each center employs professional and technical personnel in each state, as well as maintaining a network of companies and institutions involved in developing the solar market. Centers and their service areas are:

Western Solar Utilization Network (WESUN)/Pioneer Park Building, 715 Southwest Morrison, Portland, OR 97205/503-241-1222. Serves: Alaska, Arizona, California, Colorado, Hawaii, Idaho, Montana, Nevada, New Mexico, Oregon, Utah, Washington, Wyoming.

Southern Solar Energy Center (SSEC)/61 Perimeter Park, Atlanta, GA 30341/404-458-8765. Serves: Alabama, Arkansas, Delaware, District of Columbia, Florida, Georgia, Kentucky, Louisiana, Maryland, Mississippi, North Carolina, Oklahoma, Puerto Rico, South Carolina, Tennessee, Texas, Virginia, West Virginia, Virgin Islands.

Mid-American Solar Energy Complex (MASEC)/8140 26th Ave. South, Bloomington, MN 55420/612-853-0400. Serves: Illinois, Indiana, Iowa, Kansas, Michigan, Minnesota, Missouri, Nebraska, North Dakota, Ohio, South Dakota, Wisconsin.

Northeast Solar Energy Center (NSEC)/470 Atlantic

Ave., Boston, MA 02110/617-292-9250. Serves: Connecticut, Maine, Massachusetts, New Hampshire, New Jersey, New York, Pennsylvania, Rhode Island, Vermont

Regulated Industries Data

Data on regulated industries are verified, certified as acceptable, stored and processed. Contact: Regulatory Systems Development Division, Office of Energy Data Development, Energy Systems Support, Energy Information Administration, Department of Energy, 12th St. and Pennsylvania Ave. N.W., MS 4356, Washington, DC 20461/202-633-9302.

Regulatory Activities

Listed below are those organizations within the U.S. Department of Energy that are involved with regulating various activities. With each listing is a description of those industries or situations regulated by the office. Regulatory activities generate large amounts of information on the companies and subjects they regulate; much of this information is available to the public. A regulatory office can also tell you your rights when dealing with a regulated company.

Economic Regulatory Administration/See "Economic Regulation" in this section.

Federal Energy Regulatory Commission/Department of Energy, 825 N. Capitol St. N.W., MS 9200, Washington, DC 20426/202-357-8555. Sets rates and charges for the transportation and sale of natural gas and the transmission and sale of electricity and the licensing of hydroelectric power projects.

Office of Conservation and Solar Energy/Department of Energy, 1000 Independence Ave. S.W., Washington, DC 20585/202-252-9249. Establishes conservation standards in buildings and consumer products, and monitors energy conservation within industry.

Regulatory and Competitive Analysis

Analytical studies estimate the impact of gasoline deregulation on household energy consumption expenditures. Contact: Regulatory and Competitive Analysis Division, Office of Applied Analysis, Energy Information Administration, Department of Energy, 12th St. and Pennsylvania Ave. N.W., MS 4530, Washington, DC 20461/202-633-8720.

Regulatory Files

Files and records of the Federal Energy Regulatory Commission are available for public inspection or copying in FERC's Division of Public Information in Washington, DC. Photocopies of Commission records may be obtained through a private firm under FERC contract, requiring payment of a fee directly to the firm. Cost information and order forms are available from the Division of Public Information. The following is a summary of information available:

All filings submitted to the Commission comprising formal records, including applications, petitions and other pleadings requesting FERC action; responses, protests, motions, briefs, contracts, rate schedules, tariffs and related filings; FERC staff correspondence relating to any proceeding.

Transcripts of hearings, hearing exhibits, proposed testimony and exhibits filed with the Commission but not yet offered or received in evidence.

Administrative law judge's actions, orders and correspondence in connection with proceedings.

Commission orders, notices, opinions, decisions, letter-orders and approved Commission minutes.

Agendas and lists of actions taken at Commission meetings, which are open to the public.

Environmental impact statements prepared by FERC staff pursuant to the National Environmental Policy Act of 1969.

Agendas, minutes and draft papers relating to the National Power Survey, Natural Gas Policy Council and other FERC advisory committee meetings, all open to the public.

Accounting files and FERC audits of gas, electric and oil companies.

Legislative matters under consideration by Congress, after release by the Committee or Member of Congress involved.

Filings and records in court proceedings to which the Commission is a party and FERC correspondence with the courts.

News releases and announcements issued by FERC.

Subject index of Commission actions.

Contact: Public Reference Branch, Public Information Division, Office of Congressional and Public Affairs, Federal Energy Regulatory Commission, Department of Energy, 825 N. Capitol St. N.E., MS 1000, Washington, DC 20426/202-357-8118.

Regulatory Information

For general or specific information on any of the regulatory activities of the Federal Energy Regulatory Commission, contact: Office of Congressional and Public Affairs, Federal Energy Regulatory Commission, Department of Energy, 825 N. Capitol St. N.W., MS 9200, Washington, DC 20426/202-357-8370.

Regulatory Legislation on Energy

For information on legislation related to energy regulation, contact: Office of Legislation, Office of the General Counsel, Federal Energy Regulatory Commission, Department of Energy, 825 N. Capitol St. N.W., Washington, DC 20426/202-357-8318.

Renewable Resources

The Office of Renewable Resources oversees commercial activities related to the development of hydrothermal resources; analyzes market penetration in the field of geothermal resources, oversees federal and state incentive efforts in this area; oversees state planning for commercial development; conducts small-scale hydroelectric and geothermal research and development; and identifies legal, environmental, and institutional barriers to the development of renewable resources, and studies solutions. Contact: Office of Renewable Resources, Industrial and Utility Applications and Operations, Resource Applications, Department of Energy, 12th St. and Pennsylvania Ave. N.W., MS 3344, Washington, DC 20461/202-633-8774.

Research Contracts

A free publication, *The DOE Program Guide for Universities and Other Research Groups*, provides introductory information about U.S. Department of Energy programs, general procedures, energy research needs and potential opportunities. It also describes federal assistance and procurement policies and procedures. Contact: University and Industry Division, Office of Field Operations Management, Office of Energy Research, Department of Energy, 1000 Independence Ave. S.W., MS 3F032, Washington, DC 20585/202-252-5447.

Ridesharing and Vanpooling

For information, including free publications, on establishing ridesharing or vanpooling programs, contact: Transportation Programs, Office of Conservation and Solar Energy, Department of Energy, 1000 Independence Ave. S.W., MS 5H044, Washington, DC 20585/202-252-8012, or contact the Ridesharing Hotline: 800-424-9184 (DC: 202-426-2943).

School Conservation

The National Energy Conservation Act allows for 50 percent federal matching grants for detailed energy audits of schools and certain other public buildings and for the installation of conservation measures recommended in the audit. Contact: Institutional Building Grants Program, Office of Institutional Conservation Programs, Conservation and Solar Energy, Department of Energy, 1000 Independence Ave. S.W., MS 2H027, Washington, DC 20585/202-252-2343.

Small Business Conservation

Small businesses can obtain recommendations, based on an audit of their facility, on ways to retrofit their building to save money and energy.

Contact: Small Business Section, Community Service Branch, Community Systems Division, Buildings and Community Systems, Department of Energy, 1000 Independence Ave. S.W., MS 1F075, Washington, DC 20585/202-252-9416.

Small Business Liaison

The Office of Business and Small Business Programs establishes the U.S. Department of Energy outreach policy for small business. It provides the Department with information about the concerns of business and keeps business informed of Energy's objectives and policies. Contact: Business and Small Business Programs, Office of Educational Business and Labor Affairs, Office of Intergovernmental Affairs, Department of Energy, 1000 Independence Ave. S.W., MS 7E054, Washington, DC 20585/202-252-4634.

Small Business Procurement

A special office fosters U.S. Department of Energy procurement from small business. The staff provides advice and assistance to Energy buying offices and to the private sector. Contact: Small Business Division, Office of Small and Disadvantaged Business Utilization, Procurement and Contracts Management Directorate, Department of Energy, 1000 Independence Ave. S.W., MS 1J009, Washington, DC 20585/202-252-8203.

Small-Scale Technology

Small grants are provided to encourage individuals, groups, communities, and small businesses to develop energy-related concepts. Projects are to be small-scale, nonpolluting, environmentally safe, and decentralized. They should make the best use of available renewable energy sources and depend largely upon human labor. Awards of up to $10,000 are made for the development of an idea or concept in areas ranging from new concepts of energy sources to the new application of existing procedures or systems. Awards of up to $50,000 are made for the systematic and practical development of a concept into useful technology. Demonstration awards of up to $50,000 are made to test a technology under operating conditions showing that its commercial application is technically, economically, and environmentally feasible. Contact: Office of Small-Scale Technology, Conservation and Solar Energy, Department of Energy, 1000 Independence Ave. S.W., MS 6G040, Washington, DC 20585/202-252-9104.

Small Wind Energy Conservation Program

This office manages U.S. Department of Energy's small (less than 100 kilowatts) wind energy conservation systems program. It answers inqui-

ries about such systems; investigates tax incentives, zoning laws, utility interconnections and related aspects of establishing wind systems; and operates the Rocky Flats National Test Center for evaluating small wind systems. Contact: Small Wind Energy Conservation Program, Rocky Flats Area Office, Department of Energy, P. O. Box 928, Golden, CO 80401/303-441-1333.

Software Center, National Energy (NESC)

NESC is the software exchange and information center for the U.S. Department of Energy. It promotes the sharing of computer software among agency offices and contractors to eliminate duplication of effort and costs. NESC facilitates the transfer of computer applications and technology and arranges for acquiring nongovernment software for the U.S. Department of Energy. Contact: National Energy Software Center, Department of Energy, Argonne National Laboratory, 9700 S. Cass Ave. IL 60439/312-972-7250.

Solar Commercialization Demonstrations

For information on demonstration projects on solar commercialization in commercial and residential buildings, contact: Commercial Demonstration Program, Field and Test Applications Branch, Active Solar Division, Office of Solar Application for Buildings, Conservation and Solar Energy, Department of Energy, 1000 Independence Ave. S.W., MS 5G026, Washington, DC 20585/202-252-8168.

Solar Data

The National Solar Data Program provides instrumentation for selected commercial and residential solar demonstration sites. Data is acquired from these sites through a centralized solar data network. The data are analyzed, generating monthly and seasonal performance reports. The subjects covered in these reports include active hot water systems; active heating, cooling, and hot water systems; passive systems; hybrid heating and hot water systems. Some of the reports available include:

Availability of Solar Energy Reports from the National Solar Data Program—semiannual listing of all the reports.
User's Guide to the Monthly Performance Report of the National Solar Data Program
Monthly Performance Reports—documents information on the thermal performance system operation and general status of the solar energy system.
Solar Energy System Performance Evaluation—presents thermal performance data in a more comprehensive manner.

Environmental Data Reports
Solar Project Description Reports
Solar Project Cost Reports
Program Information Reports—deal with program issues such as project descriptions, project status reports and program plans and are published as needed.
Comparative Reports—compare thermal performance, cost, economics, or other aspects of several solar energy systems.
Reliability and Material Assessment Reports:
 Reliability—information needed by the solar industry to design, manufacture, install, and service devices that are unique to solar energy systems.
Materials Assessment—data on the performance of various materials under the operating conditions characteristic of solar heating and cooling systems.

Contact: National Solar Data Program, Field Applications Branch, Active Solar Division, Office of Solar Applications of Buildings, Conservation and Solar Energy, Department of Energy, 1000 Independence Ave. S.W., MS 5G033, Washington, DC 20585/202-252-8168.

Solar Education

The National Solar Energy Education Directory is a guide to programs, courses and curricula offered nationwide ($5.50) from: Superintendent of Documents, Government Printing Office, Washington, DC 20404/202-783-3238.

Solar Energy Hotline

This information and referral service responds to solar-related questions from both consumers and professionals, including on photovoltaic, wind, biomass, and solar thermal energy. Contact: Public Information, Solar Energy Research Institute, 1617 Cole Boulevard, Golden, CO 80401/800-525-5000 (Colorado: 800-332-8339).

Solar Energy Information Data Bank (SEIDB)

This data bank is a national solar energy information network that offers bibliographic and nonbibliographic data base searching capabilities on the following:

International Contacts Data Base (ICON)—Contains information on foreign individuals who are involved in international solar energy activities. These participants have been cited in professional journals or visited SERI since August 1978 and are associated with a wide range of organizations, including governmental energy departments, business and industry, universities and research institutes, and regional quasi-governmental organizations. Over 1,500 international contacts are maintained.

Legislation Data Base (LEG)—Contains information on renewable energy legislation that has been intro-

duced or acted upon in Congress or the state legislatures. The data base contains information on legislation introduced in federal and state legislative sessions. More than 1,000 pieces of legislation are maintained.

Insolation Data Base (INSOL)—contains typical mean daily temperatures and insolation values by month and annually for 248 National Weather Service (NWS) stations. Typical means reflect a 24-25 year period of meteorological and insolation measurements. The data base also carries heating and cooling degree-days (base 18.3°C), global K_T* (a cloudiness index), and mean daily maximum and minimum temperatures (°C). Unit conversion algorithms are available for converting from metric representations to, for example, temperature in °F, a base of 65°F for degree-days, and insolation in langleys. Insolation values represent total global radiation on a horizontal surface. These were based on corrected hourly measurements for 26 (SOLMET) stations, and derived values from the corrected values for 222 stations.

Manufacturers Data Base (MFG)—contains information on U.S. and foreign manufacturers that produce solar and solar-related equipment. Included in this data base are those businesses that manufacture solar systems, components, or materials. Products that convert, conserve, store, transfer, measure, or control solar energy in any one of the solar technologies qualify as solar equipment. Excluded are on-site fabricators and distributors as well as producers of prototypes. More than 1,800 U.S. manufacturers and 500 international firms have been identified.

Models Data Base (MODELS)—Contains descriptive information on models that pertain to the development and usage of energy technologies and applications. Models, codes, and programs contained in the data base range from those that can easily be calculated, to those that require extensive computer processing, such as monitoring the response of an OTEC platform to ocean waves. Models are included which have reached various stages of development, such as those that may or may not be available for public use, that are in the formative stage, fully developed, or no longer maintained. More than 150 models are maintained.

International Projects Data Base (INPRO)—contains information on solar energy programs being undertaken by countries outside the United States. Included are outstanding programs mentioned in the literature since August 1978 as representative of specific technological applications or programs of importance to the United States in its relationship with foreign countries. International solar activities that SERI has monitored for the past 18 months are part of INPRO. Actual installations resulting from these programs are stored in the Installation Sites (SITES) Data Base. More than 350 international projects are maintained.

Education Data Base (EDUC)—contains information on courses, programs, and organizations offering educational opportunities in solar-related technologies. Represented in this data base is a broad spectrum of U.S. institutions ranging from nonaccredited adult and community education programs offering short-term workshops and seminars to accredited post-secondary schools offering specialized curricula leading to a degree. More than 1,500 organizations, 200 programs and 2,000 courses have been identified.

For further information on accessing these data bases, contact: Solar Energy Information Data Bank, Information Systems Division, Solar Energy Research Institute, Department of Energy, 1617 Cole Blvd., Golden, CO 80401/303-231-1032.

Solar Equipment in Buildings

Research and development and testing of active heating and cooling systems is conducted for residential and commercial buildings. Systems and devices studied include solar collectors, solar-assisted heat pumps, Rankine driven air-cooling systems, absorption chillers, thermal storage systems, evacuated tube collectors, hybrid solar systems and district heating and cooling operations. Contact: Active Buildings Systems Branch, System Development Division, Office of Applications for Buildings, Conservation and Solar Energy, Department of Energy, 1000 Independence Ave. S.W., MS B025, Washington, DC 20585/202-252-8160.

Solar Heating and Cooling Hotline

This hotline provides general and detailed information on any aspect of solar heating and cooling for both the consumer and professional. Among the free publications available are *Home Mortgage Lending and Solar Energy*; *Solar Energy System Consumer Tips*; and *Tax Credit for Energy Investments*. Contact: National Solar Heating and Cooling Information Center, P. O. Box 1607, Rockville, MD 20850/800-523-2929 (PA: 800-462-4983; Alaska and Hawaii: 800-523-4700).

Solar Home Awards

For copies of drawings and descriptions of successful passive solar homes, order *The First Passive Solar Home Awards* ($5.50), from: Government Printing Office, Superintendent of Documents, Washington, DC 20402/202-783-3238.

Solar Index

This index is announced daily to the press as part of the weather service news stating what percentage of a standard solar water heating system for a family of four could have been heated by the

sun that day. Contact: Office of Solar Applications for Buildings, Conservation and Solar Energy, Department of Energy, 1000 Independence Ave. S.W., MS 5G044, Washington, DC 20585/202-252-8107.

Solar in Federal Buildings Program

This program promotes the use of solar energy in federal buildings by providing funds to federal agencies for the design and construction of solar applications in new and existing federal buildings. By expanding an important solar market sector, the program will help demonstrate the federal government's confidence and support of the solar industry. Contact: Solar in Federal Buildings Program, Field Applications Branch, Active Solar Division, Office of Solar Applications for Buildings, Conservation and Solar Energy, Department of Energy, 1000 Independence Ave. S.W., MS 5G033, Washington, DC 20585/202-252-8121.

Solar Information Center

Technical reference assistance, interlibrary loan, literature searches, and bibliography searches on solar-related subjects are available from: Solar Information Center, Solar Energy Research Institute, 1617 Cole Blvd., Golden, CO 80401/303-231-1415.

Solar Power Applications

Public utility companies are encouraged to convert or use solar power instead of electricity. Contact: Office of Solar Power Application, Conservation and Solar Energy, Department of Energy, 600 E St. N.W., Room 413, Washington, DC 20545/202-376-4424.

Solar Publications

The following is a listing of some of the more popular publications available from Document Distribution Services, Solar Energy Research Institute, 1617 Cole Blvd., Golden, CO 80401/303-231-1260.

Don't Get Burned with Solar Energy: A Consumer's Guide to Buying Solar (free)
What Every Community Should Do About Solar Access (free)
Municipal Bond Financing of Solar Energy Facilities (free)
Solar Energy Information Locator (free)
Solar Calendar—a listing of conferences, symposia, workshops and other formal meetings pertaining to the solar technologies. (monthly, free)
Making the Solar Loan: A Primer for Financial Institutions (free)
Solar Hot Water and Your Home (free)
Consumer Tips Fact Sheet (free)

List of Selected Solar Buildings Available for Viewing (free)
Analysis Methods for Solar Heating and Cooling Applications—aimed at architects to take the guesswork out of solar. (free)
What Your Community Can Do About Energy—Examples of what many communities are doing now about energy. (free)

Available from *Solar Law Reporter*, P. O. Box 5400, Denver, CO 80217:

Solar Law Reporter—Discusses important issues related to the legal institutions and rules surrounding the development of solar energy. (bimonthly, $12 per year).

Available from Superintendent of Documents, Government Printing Office, Washington, DC 20402/202-783-3238:

Reaching Up, Reaching Out: A Guide to Organizing Local Solar Events ($6.00)
Passive Design: It's A Natural ($1.50)

Solar Science Courses

Curricula in the solar sciences are developed for both the community college level and for grades kindergarten through 12. Training programs are also developed for installers of passive solar energy equipment. Contact: Office of Solar Application for Buildings, Conservation and Solar Energy, Department of Energy, 1000 Independence Ave. S.W., MS 5G044, Washington, DC 20585/202-252-8107.

Solar Systems Performance

Assistance is available for research and development technology transfer and commercialization of solar applications in order to reduce solar systems cost and improve performance. Contact: Systems Development Division, Solar Applications for Buildings, Conservation and Solar Energy, Department of Energy, 1000 Independence Ave. S.W., MS 5G088, Washington, DC 20585/202-252-8150.

Solar Technical Documents

For information on available technical reports and other documents produced by the Solar Energy Research Institute, contact: Document Distribution Service, Solar Energy Research Institute, 1617 Cole Blvd., Golden, CO 80401/303-231-1158.

Solar Thermal Energy Systems

This office is concerned with the development of highly concentrated minor configurations (in-

cludes solar power towers) to produce high-temperature heat for electric power generation and industrial use. It aims to demonstrate the technical, economic and environmental feasibility of large and small solar thermal applications. Contact: Division of Solar Thermal Energy Systems, Office of Solar Application for Industry, Conservation and Solar Energy, Department of Energy, 600 E St. N.W., MS 404, Washington, DC 20545/202-376-1934.

Solar-Thermal Power Market Development

This office coordinates demonstration and marketing activities to commercialize the use of solar thermal energy in industrial process heat applications. Contact: Market Development Branch, Division of Solar-Thermal Energy Systems, Office of Solar Applications for Industry, Conservation and Solar Energy, Department of Energy, 1000 Independence Ave. S.W., MS 5G026, Washington, DC 20585/202-252-8168.

Solar Workshops

For information on solar conferences and workshops, contact: Solar Energy Research Institute, 1617 Cole Blvd., Golden, CO 80401/303-231-1465.

Speakers and Conferences

If you are interested in obtaining a speaker for your meeting from the U.S. Department of Energy, or would like a listing of all U.S. Department of Energy meetings, contact: Conference Coordination, Speakers Bureau, Office of Public Affairs, Department of Energy, 1000 Independence Ave. S.W., MS 1E218, Washington, DC 20585/202-252-5644.

State and Local Government Assistance

For information on energy conservation programs available to state and local governments, contact: Grants Management and Technical Assistance, State and Local Programs, Conservation and Solar Energy, Department of Energy, 1000 Independence Ave. S.W., MS 2H027, Washington, DC 20585/202-252-2302.

State Conservation

Financial and technical assistance is available for implementing state-wide conservation programs. Contact: Office of Government Conservation, Conservation and Solar Energy, Department of Energy, 1000 Independence Ave. S.W., MS 6B025, Washington, DC 20585/202-252-2198.

Stirling Engine

A set of Stirling engines is being developed that will burn a variety of fuels such as synthetic fuels and alcohols. Work is also being performed on an engine that will utilize solar and thermal energy sources. These engines have great potential for high-efficiency, low-cost, low-noise and low-pollution emissions. Copies of the *Annual Report to Congress on the Automotive Technology Development Program* are available. Contact: Stirling Engine Branch, Automotive Technology Development Division, Transportation Programs, Conservation and Solar Energy, Department of Energy, 1000 Independence Ave., S.W., MS 5H063, Washington, DC 20585/202-252-8053.

Strategic Petroleum Reserve

For answers to specific questions on the Strategic Petroleum Reserve program, such as project implementation, site locations, construction and technical problems, contact: New Orleans Project Management Office, Strategic Petroleum Reserve, Resource Applications, Department of Energy, 900 Commerce Rd. E., New Orleans, LA 70123/504-838-0295.

Strategic Petroleum Reserve Management

The Department of Energy is responsible for the managing, planning, development and operation of a crude oil and petroleum products storage and distribution system. This includes the acquisition of crude oil or petroleum products for strategic and regional reserves. Contact: Management Division, Strategic Petroleum Reserve, Resource Applications, Department of Energy, 1726 M St. N.W., MS 440, Washington, DC 20461/202-634-5570.

Survey and Statistical Design

This office provides survey design and other statistical services for all energy data collection efforts in the U.S. Department of Energy and is responsible for management of the U.S. Department of Energy forms clearance process, including form design, reports, management and control. Contact: Survey and Statistical Design Division, Office of Energy Data and Standards and Statistical Design, Energy Systems Support, Energy Information Administration, Department of Energy, 12th St. and Pennsylvania Ave. N.W., MS 4146, Washington, DC 20461/202-633-9464.

Synfuels Corporation

For information on the development of the Synfuels Corporation, contact: Natural Resources, Office of Management and Budget, New Executive Office Building, Room 10225, Washington, DC 20503/202-395-5105.

Tax Incentives for Using Solar

The federal government and many states are offering tax incentives for adding solar improvements to your home. For free literature, contact: National Solar Heating and Cooling Information Center, P. O. Box 1607, Rockville, MD 20850/800-523-2929 (PA: 800-462-4983; AK and HI: 800-523-4700).

Teacher Training

For information on teacher training and curriculum development in energy education for kindergarten through twelfth grade, contact: Education Division, Office of Consumer Affairs, Department of Energy, 1000 Independence Ave. S.W., MS 7E054, Washington, DC 20585/202-252-6484.

Technical Energy Information

The Technical Information Center (TIC) provides research, publication, and other information services on energy-related topics. These services include:

Customer Service Branch—provides monthly meeting lists, announcements of translations received or published by TIC and consultations on request for building energy data bases; exchanges technical reports with foreign countries.

Energy Information Outreach Program—provides reports, pamphlets, brochures, posters, special packets, films, and technology transfer products to industry, educational institutions, consumers and the general public.

Energy Abstract Journals—include printed products and products from energy data base files which contain U.S. Department of Energy reports, other reports, monographs, theses, patents, journal articles and conference literature:

Energy Research Abstracts—a bimonthly that covers a full range of energy-related literature

Energy Abstracts for Policy Analysis—a monthly that covers all phases of energy analysis and development from the nontechnical and quasi-technical literature

Energy Updates—a monthly that announces new items added to the Energy Data Base files in a particular subject area, such as Solar Energy Update, Geothermal Energy Update, Fossil Energy Update, Energy Conservation Update, and Fusion Energy Update.

Bibliographies—provide customized on-line searches and special subsets of data available upon request.

Data Bases—include:
General and Practical Energy Information Data Base (GAP)—contains references to popular scientific and technical energy information of a practical nature, intended for the nontechnical, nonprofessional audience; energy information available as pamphlets, films, booklets, monographs, reports and journal articles; references to energy information available as mass media products; "how to" energy questions.

Energy Research in Progress Data Base (RIP)—contains records that characterize energy and energy-related research projects sponsored by U.S. Department of Energy, other federal agencies and private industry.

Technical Information Management System (TIMS)—designed to insure that the results of U.S. Department of Energy-funded research are available.

RECON—an on-line, interactive search service available to organizations whose mission and responsibilities require access to the U.S. Department of Energy Data Bases including Energy Data Base File, Energy Research in Progress Data Base File, General and Practical Energy Information Data Base File and 19 other computerized data bases.

Contact: Technical Information Center, Department of Energy, P. O. Box 62, Oak Ridge, TN 37830/615-576-1301.

Technology Implementation

This office focuses on transferring new technologies to the appropriate end-use market and encouraging implementation by the private sector. It provides technical assistance in implementation of new energy-conserving technologies and solicits proposals and selects cost-sharing contractors for demonstrations of selected supply and conservation technologies with commercialization in mind. Contact: Technology Implementation Branch, Conservation Technology Development and Monitoring Division, Industrial Programs, Conservation and Solar Energy, Department of Energy, 1000 Independence Ave. S.W., MS 2H086, Washington, DC 20585/202-253-2392.

Thermal Imaging Technology

Thermal imaging systems offer the potential for being a significant tool to determine the effectiveness of existing insulation on residential and commercial buildings and to pinpoint areas where existing weather stripping, caulking and insulation is insufficient. Thermal imaging can be processed through airborne and ground surveys. A report, *Status of Thermal Imaging Technology As Applied to Conservation*, describes the state of the art. Contact: Architectural and Engineering Systems Branch, Division of Building and Community Ststems, Conservation and Solar Applications, Department of Energy, 1000 Independence Ave. S.W., MS GH68, Washington, DC 20585/202-252-9187.

Transportation Systems Utilization

This office promotes energy conservation in the transportation sector and assesses the effects of alternative transportation energy conservation policies and programs. It operates a Fuel Economy Information program which provides the new car purchaser with comparative automobile fuel economy information. The Driver Energy Conservation Awareness program furnishes automobile fleets and the general motoring public with information on conserving fuel in their everyday driving operations. A free newsletter, *Fuel Economy News*, is aimed at the trucking industry to promote fuel-use efficiency of commercial vehicles. Contact: Transportation Systems Utilization Division, Transportation Programs, Conservation and Solar Energy, Department of Energy, 1000 Independence Ave. S.W., MS 5H063, Washington, DC 20585/202-252-8000.

Truck and Bus Fuel Economy

A voluntary program encourages motor carriers, manufacturers, suppliers, trade associations and labor unions to support and publicize voluntary fuel conservation efforts. The following publications are free: *Truckers' Guide to Fuel Savings*; *How To Save Truck Fuel*; and *Fuel Economy News*—a quarterly newsletter. Contact: Voluntary Truck and Bus Fuel Economy-Improvement Program, Transportation Programs, Conservation and Solar Energy, Department of Energy, 1000 Independence Ave. S.W., MS 54044, Washington, DC 20585/202-252-8003.

Unconventional Gas Recovery

Research and development is conducted in unconventional gas recovery, including gas from Western Tight sands, Eastern Devonian shales and methane from coal seams. Contact: Unconventional Gas Recovery, Office of Oil, Gas and Shale Recovery, Fossil Energy, Department of Energy, Germantown, MS D107, Washington, DC 20545/301-353-2723.

Unsolicited Proposals, Guide for the Submission of

This free pamphlet describes types of research supported, inventions wanted, and general guidelines and instructions on how to go about submitting unsolicited proposals; description of the various U.S. Department of Energy offices that consider these proposals is also included. Contact: Business Liaison Division, Office of Small and Disadvantaged Business Utilization, Procurement and Contracts Management Directorate, Department of Energy, 1000 Independence Ave. S.W., MS 1J009, Washington, DC 20585/202-252-9050.

For information on submitting unsolicited proposals on energy research, contact: Office of Energy Research, Department of Energy, MS G256, Washington, DC 20545/301-353-4154.

Uranium Enrichment

The U.S. Department of Energy directs and administers programs to assess U.S. uranium resources and provides uranium enrichment services to domestic and international customers. It also directs the operation of three existing gaseous diffusion plants, a gas centrifuge program and business activities associated with the marketing of enriched uranium. Contact: Uranium Resources and Enrichment Office, Resource Application, Department of Energy, 12th St. and Pennsylvania Ave. N.W., MS 6521, Washington, DC 20461/202-633-9500.

Uranium Industry Seminars

Two-day information sessions, led by U.S. Department of Energy staff members, are held once a year in order to disseminate up-to-date information on domestic uranium exploration and development, economics, production capability, estimated national uranium resources and requirements, and foreign uranium resources to representatives of the uranium mining and milling industry, the nuclear industry, financial institutions, universities, and government, to assist in planning for national energy requirements. Contact: Director, Office of Uranium Resource and Enrichment, Department of Energy, Washington, DC 20461, Attn: Division of Resource Assessment Operations, 202-633-8700.

Uranium Marketing

For information on the administration, contracting, marketing, planning and financial control activities in support of the uranium resources and enrichment program, contact: Business and Marketing Operations Division, Office of Uranium Resources and Enrichment, Industrial and Utility Applications and Operations, Resource Applications, Department of Energy, 12th St. and Pennsylvania Ave. N.W., MS 6521, Washington, DC 20461/202-633-8690.

Uranium Mills

The Resource Applications Office is responsible for clean-up at 25 inactive uranium mill processing sites in ten states and on the Navajo Reservation. After the clean-up is completed, the sites will be licensed by the Nuclear Regulatory Commission. These 25 sites are privately owned, but the uranium milled at the sites was sold to the Nuclear Regulatory Commission. Contact: Uranium Mill Tailings Remedial Action Project

Office, Resources Applications, Department of Energy, Albuquerque Operations, P. O. Box 5400, Albuquerque, NM 87115/505-844-2185.

Uranium Resource Assessment

This office directs the National Uranium Resource Evaluation (NURE) program in order to make increasingly reliable estimates of the nation's uranium resources, and to determine areas favorable to uranium deposits. It also collects data from the uranium industry on reserves in the western United States; prepares production capability limits based on NURE and reserve data in order to determine the requirements for uranium enrichment facilities; does research and development work on uranium measuring and exploration equipment; accumulates data on uranium tailings sites throughout the West; carries out activities relating to environmental effects of uranium mining and milling operations; and manages uranium leases on lands under U.S. Department of Energy control. Contact: Uranium Resource Assessment, Grand Junction Office, Department of Energy, 2597 B¾ Rd. (South Redlands), P. O. Box 2567, Grand Junction, CO 81502.

Uranium Resources

Information is available on programs to conserve uranium resources by developing a technology that will permit more economical enrichment of uranium for use as fuel in power reactors. The technology includes using laser and plasma techniques. Contact: Advanced Isotope Separation Technology, Nuclear Reactor Programs, Nuclear Energy, Department of Energy, Germantown, MS B107, Washington, DC 20545/301-353-4781.

Uranium Supply and Demand

The Resource Applications Office develops and implements plans to assess U.S. uranium resources; evaluates potential United States and foreign uranium supplies and market activity in light of projected demands; works to improve related technologies; collects data on uranium prices and procurements; and assesses all phases of uranium marketing—domestic sales, prices, imports, inventories, unfilled demand and uncommitted supply. Contact: Resource Assessment Operation Division, Office of Uranium Resources and Enrichment, Industrial and Utility Applications and Operations, Resource Applications, Department of Energy, 12th St. and Pennsylvania Ave. N.W., MS 6521, Washington, DC 20461/202-633-8700.

Utility Rate Reform

The National Energy Act is based on the principle that electric rates should encourage the conservation of energy and the efficient use of resources. The items under consideration for determining rates should be time-of-day pricing, seasonal rates, cost of service, interruptible rates, and prohibition of decreasing rates for large users. Contact: Public Information Division, Office of Congressional and Public Affairs, Federal Energy Regulatory Commission, Department of Energy, 825 N. Capitol St. N.E., MS 1000, Washington, DC 20426/202-357-8500.

Utility Rates and Systems

The Office of Utility Systems designs utility rates that encourage electric utilities to operate more efficiently with rates that are fair to consumers. The office promotes utility interconnections to improve reliability of bulk power supplies and can require interconnection in an emergency. It also provides technical and financial assistance to state regulatory agencies. Contact: Office of Utility Systems, Economic Regulatory Administration, Department of Energy, 2000 M St. N.W., MS 4002, Washington, DC 20461/202-653-3949.

Utility Regulation Intervention

The Regulatory Intervention Division intervenes in regulatory proceedings before the Federal Energy Regulatory Commission, other federal regulatory bodies and state utility commissions. The interventions are designed to urge the regulatory bodies to take actions consistent with national energy policy objectives such as the elimination of lower rates for large users of electricity. Contact: Regulatory Intervention Division, Utility Systems, Economic Regulatory Administration, Department of Energy, 2000 M St. N.W., MS 4000, Washington, DC 20461/202-653-3547.

Validation of Energy Information

All data produced by the Energy Information Administration are checked for clarity and accuracy. Procedures, techniques and methodologies are established to properly validate, collect and analyze the data. Contact: Office of Energy Information Validation, Energy Information Administration, Department of Energy, 12th St. and Pennsylvania Ave. N.W., MS 7413, Washington, DC 20461/202-633-8800.

Vehicle Performance

This office operates the following programs: prints and distributes gas mileage information for new cars; determines and analyzes the disparities between Environmental Protection Agency's data and this office's end-use auto mileage data; evaluates new concepts in transportation; trains

the public and government officials in aspects of fuel efficiency, driving techniques, maintenance, trip planning, and purchasing of new cars; and promotes fuel economy in the car and trucking industry. Contact: Vehicle Performance Branch, Transportation System Utilization Division, Transportation Programs, Conservation and Solar Energy, Department of Energy, 1000 Independence Ave. S.W., MS 5H063, Washington, DC 20585/202-252-8003.

Vehicle Systems, Non-Engine
Research is conducted on all the automotive systems that are not part of the engine itself. Areas of investigation include waste heat utilization, speed control accessories and other heat engine subsystems. Contact: Vehicle Systems Branch, Automotive Technology Development Division, Transportation Programs, Conservation and Solar Energy, Department of Energy, 1000 Independence Ave. S.W., MS 5H063, Washington, DC 20585/202-252-8059.

Waste Heat Recovery
For information on technological developments in waste heat recovery, combustion efficiency, advanced industrial cogeneration, waste materials on feedstocks and fuels, and effective reuse of recovered waste heat, contact: Waste Energy Utilization and Cogeneration Branch, Conservation Research and Development Division, Industrial Programs, Conservation and Solar Energy, Department of Energy, 1000 Independence Avenue, S.W., MS 2H085, Washington, DC 20585/202-252-2084.

Waste Utilization
This office is responsible for research and development on technologies for recovery of energy-intensive materials from waste, and converting it into energy and heating and cooling for businesses, residences and manufacturing. Contact: Waste Utilization, Community Technology Systems Branch, Community Systems Division, Buildings and Community Systems, Conservation and Solar Energy, Department of Energy, 1000 Independence Ave. S.W., MS 1F059, Washington, DC 20585/202-252-9397.

Weatherization Assistance
A national program has been developed to weatherize the homes of low-income persons, particularly the elderly and handicapped through the installation of energy-conserving measures in eligible homes and through the provision of training and technical assistance to states, localities, Indian tribes, and program beneficiaries. *Weath-*

erization Bulletin—WX is a free newsletter describing recent developments. Contact: Weatherization Assistance Programs, State and Local Programs, Conservation and Solar Energy, Department of Energy, 1000 Independence Ave.

Western Coal Monitoring System
The U.S. Department of Energy performs periodic surveys of all known operators of existing and planned large (200,000+ tons per year) coal mines in the western United States. The survey tracks progress and changes in production capacity, amounts of coal currently under contract and potential constraints to higher production. Contact: Western Coal Development Monitoring System, Coal Production Technology and Logistics Branch, Coal Survey Division, Resource Applications, Department of Energy, 12th St. and Pennsylvania Ave. N.W., MS 3344, Washington, DC 20461/202-633-9100.

Wind Energy Conversion
The Wind Energy Conversion program aims to spread the development and commercialization of reliable and cost-effective wind systems yielding significant quantities of energy. They publish a national wind resource atlas as well as the following:

Wind Energy Systems Program Summary—provides an overview of government-sponsored activities.
Wind Energy Information Directory—lists manufacturers, dealers, wind data, etc.

Contact: Wind Energy Division, Office of Solar Power Applications, Conservation and Solar Energy, Department of Energy, 600 E St. N.W., Room 413, Washington, DC 20545/202-376-4878.

Wind Energy Simulation
Analysis Methods of Wind Energy Applications is a free publication which reports on work done in developing wind energy simulation methods. It includes descriptions of 17 computer programs. Contact: Document Distribution Service, Solar Energy Research Institute, 1617 Cole Blvd., Golden, CO 80401/301-231-1158.

Wind Instrumentation
Research is conducted on wind instrumentation, wind-measuring machines (anemometers), and other devices for gauging wind characteristics. A free handbook is available describing small wind turbines. Contact: Wind Characteris-

tics Projects, Battelle Memorial Institute, Pacific Northwest Laboratory, P. O. Box 999, Battelle Blvd., Richland, WA 99352/509-942-4626.

Winds, Energy From The
This free pamphlet describes the history of wind energy, current U.S. Department of Energy programs, limits of wind energy, prospects of wind energy development and tax credit informa-tion. Contact: Solar Heating, P. O. Box 1607, Rockville, MD 20850/800-523-2929 (PA: 800-462-4983).

How Can the Department of Energy Help You?
To determine how the U.S. Department of Energy can help you, contact: Public Inquiries, Department of Energy, 1000 Independence Ave. S.W., Washington, DC 20585/202-252-5565.

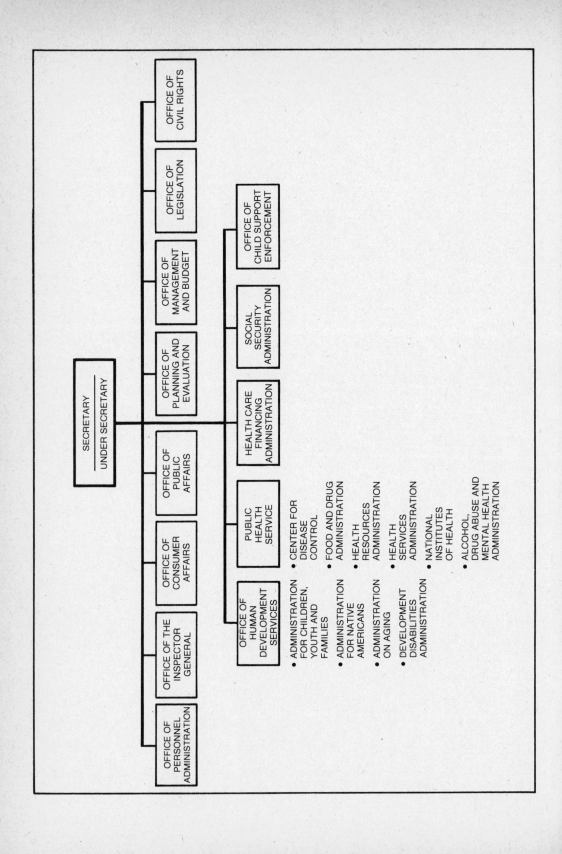

Department of Health and Human Services

200 Independence Ave. S.W., Washington, DC 20201/202-245-7000

ESTABLISHED: May 5, 1980
BUDGET (1980 est.): $195,411,000,000
EMPLOYEES: 140,900
MISSION: Serve as the federal executive branch most concerned with people and most involved with the nation's human concerns. Protect and advance the health of the American people.

Major Divisions and Offices

Office of Human Development Services (OHDS)

Department of Health and Human Services, 200 Independence Ave. S.W., Washington, DC 20201/202-245-7246.
Budget: $5,704,151,000
Employees: 1,740

1. Administration for Children, Youth and Families (ACYF)

Department of Health and Human Services, 400 6th St. S.W., Room 5030, Washington, DC 20201/202-755-7762.
Budget: $852,703,000
Employees: 403
Mission: Emphasize programs that maximize positive development of young children, especially those receiving out-of-home care during some portion of the day; administer programs that provide social services to children and their families and serve as an advocate for the needs of children and youth and facilitate the adoption or foster care placement of children with special needs.

2. Administration for Native Americans

Department of Health and Human Services, 330 Independence Ave. S.W., Room 5300, Washington, DC 20201/202-245-7776.
Budget: $33,800,000
Employees: 15
Mission: Provides a focus for special concerns of American Indians, Alaskan Natives, and Native Hawaiians; assist Native Americans in achieving the goal of economic and social self-sufficiency by providing direct and flexible funding to Indian tribes and other organizations through which Native Americans establish their own priorities as well as control and direct the institutions and programs which affect their lives.

3. Administration on Aging

Department of Health and Human Services, 330 Independence Ave. S.W., Room 4760, Washington, DC 20201/202-245-0724.
Budget: $652,220,000
Employees: 171
Mission: Identify the needs, concerns, and interests of older persons; and promote coordination of federal resources available to meet the needs of older persons.

Public Health Service (PHS)

Department of Health and Human Services, 200 Independence Ave. S.W., Room 716G, Washington, DC 20201/202-245-7694.
Budget: $8,169,970,000
Employees: 50,837

1. Center for Disease Control (CDC)

Department of Health and Human Services, 1600 Clifton Rd. N.E., Atlanta, GA 30333/404-329-3291.
Budget: $291,415,000
Employees: 4,051
Mission: Protect the public health of the nation by providing leadership and direction in the prevention and control of diseases and other

preventable conditions; administer national programs for the prevention and control of communicable and vectorborne diseases and other preventable conditions, including the control of childhood lead-based paint poisoning and urban rat control; insure safe and healthful working conditions for all working people.

2. Food and Drug Administration (FDA)

Department of Health and Human Services, 5600 Fishers Lane, HF-1, Rockville, MD 20857/301-443-2410.
Budget: $328,620,000
Employees: 7,889
Mission: Protect the health of the nation against impure and unsafe foods, drugs, and cosmetics; administer regulation of biological products; develop policy with regard to the safety, effectiveness, and labeling of all drugs for human use; develop standards on the composition, quality, nutrition, and safety of foods, food additives, colorings, and cosmetics; reduce human exposure to hazardous ionizing and nonionizing radiation; improve the safety and efficacy of medical devices and veterinary preparations and devices.

3. Health Resources Administration (HRA)

Department of Health and Human Services, 3700 East-West Hwy., Hyattsville, MD 20782/301-436-7200.
Budget: $633,335,000
Employees: 1,208
Mission: Identify health care resource problems and maintain or strengthen the distribution, supply utilization, quality and cost effectiveness of these resources to improve the health care system and individual health status.

4. Health Services Administration

Department of Health and Human Services, 5600 Fishers Lane, Rockville, MD 20857/301-443-2216.
Budget: $2,012,060,000
Employees: 19,838
Mission: Provide professional leadership in the delivery of health services; help communities find the best ways of meeting their health needs.

5. National Institutes of Health (NIH)

Department of Health and Human Services, 9000 Rockville Pike, Building 1, Room 124, Bethesda, MD 20205/301-496-2433.

Budget: $3,442,879,000
Employees: 11,424
Mission: Improve the health of the American people by coordinating and supporting biomedical research into the causes, prevention, and cure of diseases; support research training and the development of research resources; and make use of modern methods to communicate biomedical information. The following are major components: National Cancer Institute; National Heart, Lung, and Blood Institute; National Library of Medicine; National Institute of Arthritis, Metabolism, and Digestive Diseases; National Institute of Allergy and Infectious Diseases; National Institute of Child Health and Human Development; National Institute of Dental Research; National Institute of Environmental Health Sciences; National Institute of General Medical Sciences; National Institute of Neurological and Communicative Disorders and Stroke; National Eye Institute; and National Institute on Aging.

6. Alcohol, Drug Abuse and Mental Health Administration

Department of Health and Human Services, 5600 Fishers Lane, Room 6C15, Rockville, MD 20857, Attn: Mildred Lehman/301-443-4797.
Budget: $1,184,806,000
Employees: 4,254
Mission: Provide leadership in the Federal effort to reduce, and eliminate where possible, health problems caused by the abuse of alcohol and drugs, and improve the mental health of the people of the United States generally.

Health Care Financing Administration

Department of Health and Human Services, Humphrey Building, Room 314G, 200 Independence Ave. S.W., Washington, DC 20201/202-245-6726.
Budget: $22,611,606
Employees: 4,997
Mission: Provide oversight of the Medicare and Medicaid programs and related federal medical care quality control, including long-term care for the aged and the chronically ill and for nursing home affairs.

Social Security Administration

Department of Health and Human Services, 6401 Security Blvd., Baltimore, MD 21235/301-594-7700.
Budget: $15,930,503
Employees: 78,188
Mission: Administer national program of con-

tributory, social insurance whereby employees, employers, and the self-employed pay contributions which are pooled in special trust funds; provide research and recommendations oriented to the problems of poverty, insecurity, and health care for the aged, blind, and disabled.

Office of Child Support Enforcement

Department of Health and Human Services, 6110

Executive Blvd., Rockville, MD 20852/301-443-4442.
Budget: $67,000,000
Employees: 313
Mission: Provide leadership in the planning, development, management and coordination of programs that require states to enforce support obligations owed by absent parents to their children by locating absent parents, establishing paternity when necessary, and obtaining child support.

Data Experts

Disease Information and Developments

For most diseases, the Department of Health and Human Services maintains a staff that keeps current on the latest developments, the best doctors, and the best hospitals available for treating the disease. In many cases literature is available for both the professional and layman. If a disease strikes you or a loved one, it may not be wise to totally trust your local doctor; he or she cannot keep current on everything. Contact the relevant office listed below and ask for the latest facts and developments. This way you will know all the options available to you. If the disease you are interested in is not listed below, contact: Health Information Clearing House, P.O. Box 1133, Washington, D.C. 20013/800-336-4797. In Virginia, 703-522-2590.

Alcoholism
National Clearinghouse on Alcohol Information, Department of Health and Human Services, P.O. Box 2345, 5600 Fishers Lane, Rockville, MD 20852/301-468-2600.
Allergic Diseases
Research Reportive and Public Response, National Institute of Allergy and Infectious Diseases, NIH, Department of Health and Human Services, Building 31, Room 7A32, Bethesda, MD 20205/301-496-5717.
Anemia
Office of Information, National Heart, Lung and Blood Institute, NIH, Department of Health and Human Services, Building 31, Room 4A21, Bethesda, MD 20205/301-496-4236.
Ansomia
National Institute of Arthritis, Metabolism, and Digestive Diseases, NIH, Department of Health and Human Services, Building 31, Room 9A04, Bethesda, MD 20205/301-496-3583.

Arteriosclerosis
See "Anemia."
Arthritis
Arthritis Information Clearinghouse, Box 34427, Bethesda, MD 20817/301-881-9411.
Astigmatism
Office of Program Planning and Scientific Reporting, National Eye Institute, NIH, Department of Health and Human Services, Building 31, Room 6A32, Bethesda, MD 20205/301-496-5248.
Ataxia
Office of Science and Health Reports, National Institute of Neurological and Communicative Disorders and Stroke, NIH, Department of Health and Human Services, Building 31, Room 8A06, Bethesda, MD 20205/301-496-5751.
Birth Defects
Genetic Disease Services Branch, Office of Maternal and Child Health, Bureau of Community Health Services, Department of Health and Human Services, 5600 Fishers Lane, Room 749, Rockville, MD 20857/301-443-1080.
Black Lung Disease
Division of Respiratory Disease, Center for Disease Control, Department of Health and Human Services, 944 Chestnut Ridge Rd., Room 220, Morgantown, WV 26505/304-599-7474.
Bleeding Disorders
See "Anemia."
Blood Diseases
See "Ansomia." See also "Anemia."
Bone Diseases
See "Ansomia."
Brain Trauma
See "Ataxia."
Brain Tumor
See "Ataxia."
Bronchitis, Chronic
See "Anemia."
Cancer
Office of Cancer Communications, National Cancer In-

stitute, NIH, Department of Health and Human Services, Building 31, Room 10A18, Bethesda, MD 20014/301-496-5583, Hotline: toll-free 800-638-6694; 800-492-1444 in Maryland.

Cancer Genetics
See "Birth Defects."

Cardiomyopathus
See "Anemia."

Cataracts
See "Astigmatism."

Cerebral Palsy
See "Ataxia."

Cerebrovascular Disease
See "Anemia."

Chagas Disease
Center for Infectious Diseases, Center for Disease Control, Department of Health and Human Services, Building 4, Room 124, 1600 Clifton Rd. N.E., Atlanta, GA 30333/404-329-3423.

Child Health
Office of Research Reporting and Public Response, National Institute of Child Health and Human Development, NIH, Department of Health and Human Services, Building 31, Room 2A-32, Bethesda, MD 20205/301-496-5133.

Cirrhosis
See "Ansomia."

Clinical Immunology
See "Allergic Diseases."

Clotting Disorders
See "Anemia."

Common Cold
See "Allergic Diseases."

Communicative Disorders
Office of Deafness and Communicative Disorders, Rehabilitation Services Administration, Department of Health and Human Services, 330 C St. S.W., Room 3413, Washington, DC 20201/202-245-0591.
See also "Ataxia."

Cooley's Anemia
See "Birth Defects."

Corneal Disease
See "Astigmatism."

Coronary Artery Disease
See "Anemia."

Cystic Fibrosis
See "Birth Defects."
See also "Ansomia."

Deafness
See "Communicative Disorders.". See also "Ataxia."

Dental Disease
Scientific and Health Reports, National Institute of Dental Research, NIH, Department of Health and Human Services, Building 31, Room 2C34, Bethesda, MD 20205/301-496-4261.

Depression
National Clearinghouse for Mental Health Information, National Institute of Mental Health, Department of Health and Human Services, 5600 Fishers Lane, Room 11A33, Rockville, MD 20857/301-443-4517.

Diabetes
National Diabetic Information Clearinghouse, Department of Health and Human Services, 805 15th St. N.W., Room 500, Washington, DC 20005/202-842-7600.

Diabetic Retinopathy
See "Astigmatism."

Digestive Diseases
See "Ansomia."

Down's Syndrome
See "Birth Defects."

Drug Addiction
National Clearinghouse for Drug Abuse Information, Department of Health and Human Services, 5600 Fishers Lane, Room 10A53, Rockville, MD 20857/301-443-6500.

Drug Reactions
See "Allergic Diseases."

Eczema
See "Allergic Diseases."

Emphysema
See "Anemia."

Encephalitis
See "Chagas Disease."

Endocrine Diseases
See "Ansomia."

Epilepsy
See "Ataxia."

Eye Diseases
See "Cataracts."

Food Hypersensitivity
See "Allergic Diseases."

Genetic Diseases
National Clearinghouse for Human Genetic Diseases, Department of Health and Human Services, 805 15th St. N.W., Suite 500, Washington, DC 20005/202-842-7617.

Glaucoma
See "Astigmatism. See also "Cataracts."

Gonorrhea
See "Sexually Transmissible Diseases."

Hay Fever
See "Allergic Diseases."

Head Injuries
See "Ataxia."

Hearing Disorders
See "Ataxia."

Heart Disease
See "Anemia."

Heart Failure and Shock
See "Anemia."

Heart Infections
See "Anemia."

Hemophilia
See "Birth Defects."

Hepatitis
See "Allergic Diseases."

High Blood Pressure
High Blood Pressure Information Center, National Heart, Lung and Blood Institute, NIH, Department of Health and Human Services, 1501 Wilson Blvd.,

Suite 500, Arlington, VA 22209/703-558-4880.
Human Development Problems
See "Child Health."
Huntington's Disease
See "Ataxia."
Hyperopia (Farsightedness)
See "Astigmatism."
Hypertension
See "Anemia."
Hypoglycemia
See "Ansomia."
Hypokalemia
See "Anemia."
Influenza
See "Allergic Diseases."
Insect Sting Allergy
See "Allergic Diseases."
Kidney Diseases
See "Ansomia."
Lead Poisoning
Environmental Health Services, Center for Disease Control, Department of Health and Human Services, Room 511, Buckhead, 1600 Clifton Rd. N.E., Atlanta, GA 30333/404-262-6645.
Leprosy
U.S. Public Health Hospital, Carville, LA 70721/504-642-7771.
Lung Diseases
See "Anemia."
Macular Degeneration
See "Astigmatism."
Malaria
See "Chagas Disease."
Mania
See "Depression."
Mental Illness
See "Depression."
Mental Retardation
See "Child Health."
Metabolic Diseases
See "Ansomia."
Mononucleosis
See "Allergic Diseases."
Multiple Sclerosis
See "Ataxia."
Muscular Dystrophy
See "Ataxia."
Myasthenia Gravis
See "Ataxia."
Myopia (Nearsightedness)
See "Astigmatism."
Nervous System, Infectious Disorders
See "Ataxia."
Neural Trauma
See "Ataxia."
Neuropsychiatric Disorders
See "Depression."
Obesity
See "Ansomia."
Onchoceriasis
See "Chagas Disease."

Oral-Facial Disorders
See "Dental Disease."
Organ Transplantation
See "Allergic Diseases."
Osteoporosis
See "Ansomia."
Parasitic Diseases
See "Allergic Diseases."
Parkinson's Disease
See "Ataxia."
Pituitary Tumors
See "Ataxia."
Poisoning
National Clearinghouse for Poison Control Center, Bureau of Drugs, Food and Drug Administration, Department of Health and Human Services, 5600 Fishers Lane, Room 13-45, Rockville, MD 20857/301-443-6260.
Psoriasis
See "Ansomia."
Pulmonary Vascular Disease
See "Anemia."
Red Blood Cell Disorders
See "Anemia."
Reproductive Disorders
See "Child Health."
Respiratory Diseases
See "Black Lung Disease."
Respiratory Distress
See "Anemia."
Respiratory Failure
See "Anemia."
Retinal Degeneration
See "Cataracts."
Retinal Detachment
See "Astigmatism."
Retinitis Pigmentosa
See "Astigmatism."
Rheumatism
See "Arthritis."
Rheumatoid
See "Ansomia."
Serum Sickness
See "Allergic Diseases."
Sexually Transmissible Diseases
Veneral Disease Section, Center for Disease Control, Department of Health and Human Services, Atlanta, GA 30333/404-452-3343.
Sickle Cell Anemia
See "Anemia." See also "Birth Defects."
Skin Diseases
See "Ansomia."
Sleep Disturbances
See "Depression."
Speech Disorders
See "Ataxia."
Spinal Cord Injuries
See "Ataxia."
Spinal Cord Tumors
See "Ataxia."
Strabismus

See "Astigmatism."
Stroke
See "Anemia." See also "Ataxia."
Tay-Sachs Disease
See "Birth Defects."
Thyroid Diseases
See "Ansomia."
Tooth Decay
See "Dental Disease."
Trauma
See "Ataxia."

Tropical Diseases
See "Chagas Disease."
Tropical Parasitic Diseases
See "Chagas Disease."
Urologic Diseases
See "Ansomia."
Vasculitis
See "Allergic Diseases."
Venereal Diseases
See "Sexually Transmissible Diseases."
Viral Respiratory Infections
See "Allergic Diseases."

Major Sources of Information

Adolescent Pregnancy

For information on programs and funding available for adolescent health services, pregnancy prevention and care services, contact: Adolescent Pregnancy Programs, Public Health Service, Department of Health and Human Services, 200 Independence Ave. S.W., Room 725H, Washington, DC 20201/202-472-9093.

Adoption

See "Grants—Adoption Opportunities" and "Children's Bureau" in this section.

Aging Information Clearinghouse

The Clearinghouse provides a wide range of services, including collecting statistics on the aging population, custom computerized literature searches, document delivery, and referring users directly to appropriate information sources. Contact: National Clearinghouse on Aging, Administration on Aging, Office of Human Development Services, Department of Health and Human Services, Room 4255, Washington, DC 20201/202-245-0995.

Aging Magazine

This bi-monthly publication at $11 per year is geared to professionals in the field of aging and covers such topics as legislation, projects, book reviews, conferences and international news. Contact: *Aging Magazine,* Administration on Aging, Department of Health and Human Services, Room 4243, Washington, DC 20201/202-245-1190.

Alcohol Health Magazine

Alcohol Health and Research World is a quarterly magazine intended for professionals involved in treatment of, research into, and prevention of alcohol abuse and alcoholism. It covers developments in the alcohol abuse field,

such as new research findings, and prevention, treatment and training programs. Subscriptions are available for $8.50 per year from Superintendent of Documents, Government Printing Office, Washington, DC 20402/202-783-3238.

Alcohol Information Clearinghouse

The Clearinghouse will perform research on alcohol-related topics as well as provide free pamphlets, brochures, books, posters, and films. A newsletter called *NIAA Information and Feature Service* is also available at no charge. Contact: National Clearinghouse for Alcohol Information, National Institute on Alcohol Abuse, Department of Health and Human Services, 5600 Fishers Lane, Box 2345, Rockville, MD 20852/301-468-2600.

Alcoholism—Health Insurance Coverage

The National Institute on Alcohol Abuse and Alcoholism (NIAA) works with health agencies and insurance carriers to study the status of alcoholism insurance coverage; to identify barriers to improved coverage; and to develop model benefit provisions. Contact: Office of Policy Development, NIAA, Department of Health and Human Services, 5600 Fishers Lane, Parklawn Building, 14C03, Rockville, MD 20852/301-443-5208.

Alcoholism Treatment On the Job

Nonprofit organizations can receive funds to finance consultants to set up on-the-job programs to help employees deal with alcoholism. Others not eligible for funds can receive a list of consultants, as well as printed material to help set up a program. Contact: Division of Occupational Programs, National Institute on Alcohol Abuse and Alcoholism, Department of Health and Human Services, 5600 Fishers Lane, Room 11055, Parklawn Building, Rockville, MD 20857/301-443-1148.

Animals and Pets

The Food and Drug Administration (FDA) insures that veterinary preparations, drugs, and devices are safe and effective and that animal and pet food is safe and properly labeled. Contact: Bureau of Veterinary Medicine, Food and Drug Administration, Department of Health and Human Services, 5600 Fishers Lane, Room 7B39, Rockville, MD 20857/301-443-5363.

Arthritis Information Clearinghouse

The Clearinghouse provides information and referral services to both professionals and the general public. It contains a large collection of books and journals, as well as films, slide presentations, videotapes, cassettes, and other audiovisual materials, posters, exhibits and displays. A descriptive listing is available which identifies free bibliographies, catalogues, reference sheets and other guides. The *Arthritis Information Clearinghouse Bulletin* is published monthly and is free to interested parties. It identifies new information sources, audiovisual materials as well as published bibliographies and books. Contact: Arthritis Information Clearinghouse, P.O. Box 34427, Bethesda, MD 20817/301-881-9411.

Biologics

The Bureau of Biologics accumulates information and expertise on blood and blood products, coagulation, hepatitis, immunohematology, plasma derivatives, electron microscopy, pathology, cellular physiology, experimental biology, pathobiology, primatology, bacterial products, allergenic products, bacterial toxins, bacterial polysaccharides, biochemistry, mycobacterial and fungal antigens, and mycoplasma. Contact: Bureau of Biologics, Federal Drug Administration, Department of Health and Human Services, 8800 Rockville Pike, Building 29, Room 129, Bethesda, MD 20205/301-496-3556.

Braille Books

The American Printing House for the Blind is a private nonprofit organization and receives funding from the Department of Health and Human Services. It produces material in Braille, large type, talking books, cassettes, Braille music, and catalogs in Braille. Contact: American Printing House for the Blind, 1839 Frankfort Ave., Louisville, KY 40206/502-895-2405.

Breast Cancer

For information and expertise on the latest developments concerning breast cancer, contact: Breast Cancer Program Coordinating Branch, National Cancer Institute, NIH, Department of Health and Human Services, 7910 Woodmont Ave., Room 8C09, Bethesda, MD 20205/301-496-6718.

Cancer-Causing Products

To obtain a free listing of 250 trade name products which contain carcinogens (cancer-causing elements), contact: Clearinghouse for Occupational Safety and Health Information, NIOSH, Center for Disease Control, 4676 Columbia Pkwy., Cincinnati, Ohio 45226/513-684-8326.

Cancer Hotline

This hotline provides information about all aspects of cancer to the general public, cancer patients, and their families. Call: Cancer Information Service, toll-free 800-638-6694: toll-free 800-492-6600 in Maryland.

Cancer Information Clearinghouse

The clearinghouse assists organizations in the treatment and education of cancer patients. It will perform individually tailored searches of its own files as well as other data bases, and will make referrals to specific information sources. *Current Awareness Services* alerts cancer-concerned organizations to new publications, programs, services, data bases and audiovisual material. Contact: Cancer Information Clearinghouse, Office of Cancer Communications, National Cancer Institute, Building 31, Room 10A18, 9000 Rockville Pike, Bethesda, MD 20205/301-496-4070.

Cancer Information Offices

The National Cancer Institute has established a number of offices throughout the country that provide consultations with cancer experts; help in referring cases to cancer specialists; and information on services and resources available to patients, such as causes of cancer, methods for detecting cancer, medical facilities in local areas, financial aids, and emotional counseling services. For a list of Cancer Information Service Offices or further information, contact: Office of Cancer Communications, National Cancer Institute, NIH, Department of Health and Human Services, Building 31, Room 10A18, Bethesda, MD 20205/301-496-5583.

Cancer Journal

Those who wish to keep abreast of cancer topics, including research, new books, and conferences, can subscribe to *The Journal of the National Cancer Institute*. Subscriptions to this monthly publication are $75 per year, from: Superintendent of Documents, Government Printing Office, Washington, DC 20402/202-783-3238.

Cancer Literature

The following publications are available from National Technical Information Services, 5285 Port Royal Rd., Springfield, VA 22161/703-487-4650:

Cancergrams—More than 60 monthly current awareness publications containing abstracts of recently published articles in major areas of cancer research ($24).

Special Listings—Fifty annual compilations describing ongoing projects in major cancer research areas (prices vary).

Oncology Overviews—Specialized bibliographies containing abstracts of recent articles on cancer research topics of timely interest (prices vary.)

Compilation of Clinical Protocol Summaries—800 summaries of clinical protocols currently used for treating cancer ($16.25).

Directory of Cancer Research Information Resources—Describes technical information services and publications in the area of cancer. ($10.75).

Cancer Literature Searches

CANCERLINE is a computerized data base containing CANCERLIT (Cancer Literature), CANCERPROS (Cancer Research Projects), CLINPROT (Clinical Cancer Protocols). (See "Computerized Literature Searches on Health Sciences" in this section for more detailed descriptions.) Searches of this computerized data base are available for a charge from: National Cancer Institute, NIH, Department of Health and Human Services, 5333 Westward St., Room 10A18, Bethesda, MD 20205/301-496-7403.

Cancer Pamphlets

Twenty-five free pamphlets are available describing various types of cancer. Pamphlets include information on symptoms, diagnosis, treatment, and rehabilitation. A listing of other free publications which provide information to both cancer patients and professionals is also available. Contact: Office of Cancer Communications, National Cancer Institute, NIH, Department of Health and Human Services, Building 31, Room 10A18, Bethesda, MD 20205/301-496-5583, 800-638-6694 (in Maryland: 800-492-6600).

Cancer Speakers

Specialists will speak for free to both professional and lay groups on such cancer-related topics as environmental causes of cancer, cancer detection and diagnosis, immunology, treatment methods, diet and nutrition, the psychological impact of cancer and public and patient education. Contact: NCP Speakers Bureau, Office of Cancer Communications, National Cancer Institute, Department of Health and Human Services, Building 31, Room 10A18, Bethesda, MD 20014/301-496-6756.

Chief Nurse

The Office of Chief Nurse serves as an advisor to the Department of Health and Human Services on matters concerning nursing and long-term care. Contact: Office of Chief Nurse, Public Health Service, Department of Health and Human Services, 5600 Fishers Lane, Room 17B09, Rockville, MD 20857/301-443-6497.

Child Abuse and Neglect

Information and expertise are available on improving the prevention, identification and treatment of child abuse and neglect. The services available include data bases describing ongoing research programs, abstracts of public documents and excerpts of state child abuse laws; a listing of available publications, directories and audiovisual materials; and a list of Regional Child Abuse and Neglect Resource Centers. Contact: National Center on Child Abuse and Neglect, Administration for Children, Youth and Families, Department of Health and Human Services, P.O. Box 1182, Washington, DC 20013/202-245-2840.

Child Health and Human Development

Information and expertise are available on topics such as birth defects, developmental disabilities, Sudden Infant Death Syndrome, human reproduction, and fertility. Contact: National Institute of Child Health and Human Development, NIH, Department of Health and Human Services, 9000 Rockville Pike, Bethesda, MD 20203/301-496-5133.

Child Support Enforcement

See "Grants" in this section.

Children's Bureau

The Children's Bureau offers information on data sources and programs related to child welfare services, child abuse and neglect, and adoption. Contact: Children's Bureau, Administration for Children, Youth and Families, Office of Human Development Services, Department of Health and Human Services, P.O. Box 1182, Washington, DC 20013/202-755-7583.

Children, Youth and Families
Project Directory

An annual directory of research, demonstra-

tion and evaluative studies on children, youth and families is available from: Administration for Children, Youth, and Families, Department of Health and Human Services, 400 6th St. S.W., Washington, DC 20201/202-755-7762.

Civil Rights Complaints

You can file a formal complaint and have an investigation of a federally funded organization, if you feel your civil rights have been violated (discrimination because of sex, race, or handicap). The *Complaint Procedural Manual* is available free from: Publications, Office of Civil Rights, Department of Health and Human Services, 330 Independence Ave. S.W., North Building, Room 5411, Washington, DC 20201/202-472-7937. For further information, contact: Director, Office for Civil Rights, Department of Health and Human Services, 330 Independence Ave. S.W., North Building, Washington, DC 20201/202-245-6700.

Community Health Services

Community health services are designed to reach those people who are underserved and unserved by the nation's health services systems. For further information on publications, projects or available funding, contact: Bureau of Community Health Services, Health Services Administration, Public Health Service, Department of Health and Human Services, 5600 Fishers Lane, Room 7-05, Rockville, MD 20857/301-443-2320.

Contraception

For information on developments aimed at providing safe and effective methods for regulating fertility in both men and women, contact: Contraceptive Development Branch, Center for Population Research, National Institute of Child Health and Human Development, Department of Health and Human Services, 7910 Woodmont Ave., Room 7A-04, Bethesda, MD 20205/301-496-1661.

Day Care

Information and expertise are available on improving the quality and expanding the availability of day care centers. The following manuals are available for setting up a day care center:

General Information
Day Care Centers Serving Infants
Day Care Centers Serving Pre-Schoolers
Day Care Centers Serving School Age Children
Health Services—A Guide to Health Care Personnel and Project Directors
Day Care Centers Serving Children with Special Needs

Contact: Day Care Division, Administration for Children, Youth and Families, Department of Health and Human Services, P.O. Box 1182, Washington, DC 20013/202-755-7430.

Defective Drugs

A list is available from the Food and Drug Administration (FDA), identifying by product or by company name those drug products which have proved defective. Contact: Product Surveillance Branch, Bureau of Foods, Food and Drug Administration, Department of Health and Human Services, 5600 Fishers Lane, Room 9-45, Rockville, MD 20857/301-443-2263.

Dental Care and Research

The National Institute of Dental Research accumulates information and expertise on tooth decay, gum disease, soft tissue diseases and nutrition, tooth implants, control of oral pain, cranio-facial anomalies, cleft lip, cleft palate, and malocclusions. Up to 50 copies each of the following publications are available for free:

Good Teeth for You and Your Baby (English)
Good Teeth for You and Your Baby (Spanish)
RX for Sound Teeth
Malocclusion
Tetracycline Stained Teeth
Tooth Decay
Cleft Lip and Cleft Palate
Periodontal (Gum) Disease
Research Explores Canker Sores and Fever Blisters
Seal Out Dental Decay

Contact: Scientific and Health Reports, National Institute of Dental Research, NIH, Department of Health and Human Services, Building 31, Room 2C36, Bethesda, MD 20205/301-496-4261.

Developmental Disabilities

For information on mental retardation, autism, epilepsy, cerebral palsy, and other such developmental diseases which are manifested before the age of 22, contact: Administration of Developmental Disabilities, 3730 Health and Human Services Building, Washington, DC 20201/202-472-7210.

Diabetic Information Clearinghouse

The clearinghouse services the public by supplying references and citations as well as referrals to other information sources. Contact: National Diabetic Information Clearinghouse, 805 15th St. N.W., Room 500, Washington, DC 20005/202-638-7620.

Direct Payments

The programs described below are those that provide financial assistance directly to individuals, private firms and other private institutions to encourage or subsidize a particular activity.

Allied Health Traineeship Grants for Advanced Training

Objectives: To provide support for traineeship grants to public and nonprofit private colleges and universities which offer graduate programs to prepare allied health professionals as teachers, administrators, or supervisors.

Eligibility: Any accredited college or university located in a state that provides or is able to provide a graduate level allied health advanced training program.

Range of Financial Assistance: $2,627 to $146,678.

Contact: Grants Management Officer, Bureau of Health Manpower, HRA, PHS, Department of Health and Human Services, Center Building, Room 4-27, 3700 East-West Hwy., Hyattsville, MD 20782/301-436-6564.

Medicare—Hospital Insurance

Objectives: To provide hospital insurance protection for covered services to any person 65 or over and to certain disabled persons.

Eligibility: Persons 65 or over and certain disabled persons are eligible for hospital insurance protection. Nearly everyone who reached 65 before 1968 is eligible for hospital insurance, including people not eligible for cash social security benefits; a person who reached 65 in 1968 or after who is not eligible for such benefits needs some work credit to qualify for hospital insurance benefits. Hospital insurance is also available to persons, age 65 or over, not otherwise eligible through payment of a monthly premium; such coverage is voluntary. Persons under age 65 who have been entitled for at least 24 consecutive months to social security disability benefits or for 29 consecutive months to railroad retirement benefits based on disability, are eligible for hospital insurance benefits. Also, most people who have chronic kidney disease and require kidney dialysis or transplant are eligible.

Range of Financial Assistance: Benefits may be paid for most of the reasonable costs of covered inpatient hospital services and post-hospital extended care services incurred in a benefit period. For benefit periods beginning in the calendar year 1979, the beneficiary is responsible for $160 inpatient hospital deductible, a $40 per day coinsurance amount for the 61st through 90th day of inpatient hospital care during the 60 lifetime reserve days, and a $20 per day coinsurance amount after 20 days of care in a skilled nursing facility. Post-hospital home health services are paid in full for 100 visits per benefit period.

Contact: Local Social Security offices or Health Care Financing Administration, 330 Independence Ave. S.W., Washington, DC/301-594-9000.

Medicare—Supplementary Medical Insurance

Objectives: To provide medical insurance protection for covered services to persons 65 or over and certain disabled persons who elect this coverage.

Eligibility: All persons 65 and over and those under 65 who are eligible for hospital insurance benefits may voluntarily enroll for supplementary medical insurance. The enrollee pays a monthly premium which is currently $8.70. Some states pay the premium on behalf of qualifying individuals.

Range of Financial Assistance: The beneficiary is responsible for meeting an annual $60 deductible before benefits may begin. Thereafter, Medicare pays 80 percent of the reasonable charges for covered services. Medicare pays 100 percent of reasonable charges for services to hospital inpatients by doctors in the field of radiology or pathology and, after the $60 deductible, 100 percent of the costs for home health services covered under the Supplementary Medical Insurance program.

Contact: Local Social Security offices or Health Care Financing Administration, 330 Independence Ave. S.W., Washington, DC 20201/202-245-0923.

Refugee Assistance—Cuban Refugees

Objectives: To assist Cuban refugees with problems such as finding homes, training and job opportunities, and to help alleviate fiscal impact on state and local resources for welfare and medical assistance to needy eligible refugees and, in Dade County for public education.

Eligibility: The State of Florida, Dade County (Miami); state agencies administering public assistance programs are eligible for funds to provide welfare and medical assistance and service to needy eligible Cuban refugees.

Range of Financial Assistance: Not specified.

Contact: Office of Refugee Resettlement, Department of Health and Human Services, Switzer Building, Room 1332-E, 330 C St. S.W., Washington, DC 20201/202-245-0418.

Refugee Assistance—Indochinese Refugees

Objectives: To help refugees from Cambodia, Vietnam, and Laos resettle throughout the country by funding maintenance and medical assis-

tance and social services for needy refugees through state and local public assistance agencies; and to provide grants for special employment training and related projects.

Eligibility: For the public assistance aspects of the program, the state agency responsible for administration of the regular public assistance programs of the state, through agreement with the Social Security Administration, Department of Health and Human Services, is eligible to receive funds for providing cash and medical assistance and social services to needy eligible Indochinese refugees.

Range of Financial Assistance: Not specified.

Contact: Office of Refugee Resettlement, Department of Health and Human Services, Switzer Building, Room 1232-E, 330 C St. S.W., Washington, DC 20201/202-245-0418.

Social Security—Disability Insurance

Objectives: To replace part of the earnings lost because of a physical or mental impairment severe enough to prevent a person from working.

Eligibility: A disabled worker under age 65 is eligible for social security disability benefits if he or she has worked for a sufficient period of time under social security to be insured. The insured status requirements depend upon the age of the applicant and the date he or she became disabled. Dependents of disabled workers also are eligible for benefits: Unmarried children under age 18; children age 18 through 21 if unmarried and full-time students; unmarried disabled children of any age if disabled before age 22; wife at any age if child in her care is receiving benefits on worker's social security record; wife age 62 or over and husband age 62 or over except those receiving governmental pensions from noncovered employment on their own work record are subject to a pension offset; widows over age 50 who are unable to engage in gainful activity.

Range of Financial Assistance: Monthly cash benefits range from a minimum of $121.80 for a disabled worker to a mximum of $879.60 for a family receiving benefits.

Contact: Local Social Security offices or Social Security Administration, 6401 Security Blvd., Baltimore, MD 21235/301-594-2200.

Social Security—Retirement Insurance

Objectives: To replace part of the earnings lost because of retirement.

Eligibility: Retired workers age 62 and over who have worked the required number of years under social security are eligible for monthly benefits. If an eligible worker applies before age 65, the individual will receive permanently reduced benefits. Also certain dependents can re-

ceive benefits. They include a wife or husband 62 or over (except those receiving governmental pensions from noncovered employment on their own record are subject to a pension offset); a wife of any age with a dependent child in her care if the child is entitled to benefits based on the worker's record; unmarried children under 18 (22 if in school); unmarried disabled children if disabled before age 22; and divorced wives or husbands age 62 or over and married to the worker for at least 10 years, except that those receiving governmental pensions from noncovered employment on their own record are subject to a pension offset.

Range of Financial Assistance: Monthly cash benefits range from $107.80 for retired workers age 62, to $553.30 for retired workers of age 65, and from $182.70 to $880.70 for maximum family benefits.

Contact: Local Social Security offices or Social Security Administration, 6401 Security Blvd., Baltimore, MD 21235/301-594-2200.

Social Security—Special Benefits for Persons Aged 72 and Over

Objectives: To assure some regular income to certain persons age 72 and over who had little or no opportunity to earn social security protection during their working years.

Eligibility: Individuals who attained age 72 before 1968 need no work credits under social security to be eligible for special payments. Those who reached age 72 in 1968 or later need some work credits to be eligible. The amount of work credit needed increases gradually each year for people reaching age 72 after 1968, until it is the same as that required for social security retirement benefits. Special payments can also be made to an eligible wife age 72 or over.

Range of Financial Assistance: $92 per person, $139.10 per couple. (The payments are not made for any month for which the person receives a payment under the Supplemental Security Income program. The payments are reduced by the amount of most other governmental pensions, retirement, or annuities.)

Contact: Local Social Security offices or Social Security Administration, 6401 Security Blvd., Baltimore, MD 21235/301-594-2200.

Social Security—Survivors Insurance

Objectives: To replace part of earnings lost to dependents because of worker's death.

Eligibility: Benefits are payable only if the deceased was insured for survivors' insurance protection. Survivors eligible for monthly cash benefits are the following: widow, widower, surviving divorced wife, or surviving divorced hus-

band age 60 or over who was married to the deceased worker for at least ten years (except those receiving governmental pensions from non-covered employment on their own work record are subject to a pension offset); widow or widower age 50–59 and disabled; young (under age 60) widow, widower, or surviving divorced wife who has in her care a child under age 18 or over age 18 and disabled and entitled to benefits on the deceased worker's social security record; unmarried children under age 18 (22 if in school) or age 18 or over and disabled; and dependent parents age 62 and over.

Range of Financial Assistance: Monthly cash benefits range from a minimum of $134.10 for a sole survivor to a maximum of $966.70 for a family receiving benefits.

Contact: Local Social Security offices or Social Security Administration, 6401 Security Blvd., Baltimore, MD 21235/301-594-2200.

Special Benefits for Disabled Coal Miners

Objectives: To replace income lost to coal miners because they have become totally disabled due to pneumoconiosis (black lung disease), and replace income lost to widows of miners who were receiving black lung benefits when they died, totally disabled by this disease at the time of death, or who died because of this disease. Where no widow survives the miner, benefits are payable to a miner's children or, if none, to the miner's totally dependent parents or brothers and sisters in that order of priority. Benefits are also payable to children of a deceased widow who was entitled to black lung benefits at the time of her death.

Eligibility: In order to become entitled, the miner must have become "totally disabled" (as defined in the Act) from black lung disease. The applicant may be able to work in areas other than coal mines and still be eligible for benefits. Widows of coal miners whose deaths or total disability at the time of death resulted from black lung disease are also eligible for benefits as are other categories of beneficiaries.

Range of Financial Assistance: Benefits payable to miners or widows are increased when there are dependents in the family. Maximum benefit payable in 1979: $463.90.

Contact: Local Social Security offices or Social Security Administration, 6401 Security Blvd., Baltimore, MD 21235/301-594-2200.

Supplemental Security Income

Objectives: To provide supplemental income to persons aged 65 and over and to persons blind or disabled whose income and resources are below specified levels.

Eligibility: The eligibility of an individual who has attained age 65 or over or who is blind or disabled is determined on the basis of quarterly income and resources. In determining income, the first $60 of social security or other income would not be counted. An additional $195 of earned income, plus one-half of any quarterly earnings above $195, would also not be counted. If, after these exclusions, an individual's countable income, effective July 1978, is less than $568.20 per quarter ($852.30 for a couple, both of whom are categorized as above) and resources are less than $1,500 ($2,250 for a couple), the individual is eligible for payments. The value of household goods, personal effects, an automobile, and property needed for self-support are, if found reasonable, excluded in determining value of resources. Life insurance policies with face value of $1,500 or less and the value of a home are excluded in resource valuation.

Range of Financial Assistance: Monthly Federal cash payments range from $1 to $189.40 for a single person and $1 to $284.10 for a couple depending on other income and resources.

Contact: Local Social Security offices or Social Security Administration, 6401 Security Blvd., Baltimore, MD 21235/301-594-2200.

Disease Control Training

The Center for Disease Control (CDC) provides training in epidemiologic surveillance, laboratory procedures and public health. Courses are given at the CDC or by CDC personnel in various states and foreign locations. Contact: Center for Professional Development and Training, CDC, Department of Health and Human Services, 1600 Clifton Rd., N.E., Atlanta, GA 30333/404-262-6671.

Doctoral Dissertation Grants

Financial assistance is available to students whose dissertation covers specific topics. See "Grants" in this section.

Drug Abuse Information
Clearinghouse

The Clearinghouse will perform free research to answer questions relating to drug abuse. In addition to reference services it also provides drug abuse prevention materials, pamphlets and posters, treatment manuals for medical personnel, and many other publications. Interested persons can be placed on one of the following subject-area mailing lists: epidemiology; laws/policy documents; prevention/education; research papers/reports; and training and treatment. Contact National Clearinghouse on Drug Abuse Informa-

tion, National Institute on Drug Abuse, Department of Health and Human Services, 5600 Fishers Lane, Room 10A53, Rockville, MD 20857/301-443-6500.

The *National Directory of Drug Abuse Programs* is a compilation of 9,100 federal, state, local and privately funded agencies responsible for the administration or provision of alcoholism or drug abuse services throughout the U.S. Free copies of this directory, as well as more than 300 other free publications that provide information to parents, educators, students, community program workers, trainees, and prevention treatment program personnel are available at the address given above.

Drug Abuse Resource Center
The Center contains more than 7,500 books, magazines and journals, on drug abuse. It also provides a free audiovisual loan service through inter-library loan only on 300 educational films. Contact: National Institute on Drug Abuse Resource Center, Alcohol, Drug Abuse and Mental Health Administration, Department of Health and Human Services, 5600 Fishers Lane, Room 10A54, Rockville, MD 20857/301-443-6614.

Drugs—Money-Saving Directory
A directory entitled *Approved Prescription Drug List With Therapeutic Equivalent Evaluation* shows how to substitute one drug for another, often at a savings, and sells for $50. Contact: Government Printing Office, Attn: Superintendent of Documents, Washington, DC 20402/201-783-3238.

Drug Newsletter
This free newsletter is published approximately six times a year and is sent to doctors, hospital administrators, nurses, students and others interested in following drug-related activities at the Food and Drug Administration. Contact: *Drug Bulletin*, Food and Drug Administration, Department of Health and Human Services, HFI-22, 5600 Fishers Lane, Rockville, MD 20857/301-443-1016.

Drug Registration Directory
All registered drugs are given a unique identification number by the Food and Drug Administration, which is used in third-party reimbursement programs. The information, called the *National Drug Code Directory*, is available in hard copy for $32.00 or on magnetic tape, organized by trade name and indexed by company and ingredients. Contact: Government Printing Office, Attn: Superintendent of Documents,

Washington, DC 20402/202-783-3238.

Drugs—Research and Evaluation
The Bureau of Drugs accumulates information and expertise on new drug evaluation, biometrics, epidemiology, poison control, drug labeling, drug manufacturing, methadone monitoring, pharmaceutical research, drug biology, and drug chemistry. Contact: Advisory Opinions Branch, Bureau of Drugs, FDA, Department of Health and Human Services, HFD-35, 5600 Fishers Lane, Room 974, Rockville, MD 20857/301-443-1016; or contact Associate Commissioner, Consumer Affairs, Consumer Communications Staff, HFE 88, FDA, 5600 Fishers Lane, Rockville, MD 20857.

Education and Training
There are more than 44 programs offering financial assistance to support education and training in health-related careers. Programs range from nursing scholarships to financial distress grants. The listings offer many career opportunities; if a program of interest does not provide assistance directly to individuals, contact the grant-giving office for a listing of local organizations receiving funds. See "Grants" in this section.

Emergency Mental Health
For information and assistance in setting up supplementary counseling services where needed in disaster areas, contact: Disaster Assistance and Emergency Mental Health, National Institute of Mental Health, Department of Health and Human Services, 5600 Fishers Lane, Room 18-97, Rockville, MD 20857/301-443-4283.

Employee Industrial Hygiene Guides
Information is available describing health and safety rules to be followed by workers involved in such work as foundry operations, metal cleaning, printing, rendering, textile dying, and pesticide applications. Contact: Publications Dissemination, Department of Health and Human Services, 4676 Columbia Pkwy., Cincinnati, Ohio 45226/513-684-4287.

Energy and Health Facilities
Technical information and expertise are available on energy conservation and costs and how they relate to health facilities. Contact: Division of Energy Policy and Programs, Bureau of Health Facilities, HRA, Department of Health and Human Services, 3700 East-West Hwy., Room 5-50, Hyattsville, MD 20782/301-436-6845.

Environmental Health Sciences

Technical information and expertise are available concerning the effects of chemicals on the environment. Areas of interest include biometry; epidemiology; biochemical, animal and molecular genetics; toxicology; pharmacology; and pulmonary medicine. Contact: Public information, National Institute of Environmental Health Sciences, NIH, Department of Health and Human Services, P.O. Box 12233, Research Triangle Park, NC 27709/919-541-3345.

Epidemic Intelligence Service

This special medical intelligence organization tracks and investigates problems of acute diseases that may lead to epidemic situations. In addition to investigating such cases as the Three Mile Island Nuclear Power Plant accident and Legionnaires' Disease, it maintains surveillance programs in infectious diseases, chronic diseases, influenza, parasitic diseases, congenital malformations, and environmental hazards. Contact: Bureau of Epidemiology Program Office, Center for Disease Control, Department of Health and Human Services, Building 1, Room 5009, Atlanta, GA 30330/404-329-3661.

Family Planning Information Clearinghouse

Information, reference services and other expertise are available on such topics as family planning, birth control, infertility, sex education and related subjects. Other services available include patient and professional education material; books, pamphlets, manuals, films, cassette programs, and models; catalogues of family-planning publications and audiovisual materials; a free newsletter on health education for clinic staff members; and a free newsletter identifying new information services on family planning. Contact: National Clearinghouse for Family Planning Information, Department of Health and Human Services, P.O. Box 2225, Rockville, MD 20852/301-881-9400.

Food and Drug Company and Product Listings

Under the Freedom of Information Act, the Food and Drug Administration makes the following listings available: registered drug establishments; import product list (drugs); product ingredient list (drugs); medical device establishments; radiological health companies. There is a charge for these listings. Contact: Freedom of Information Office, FDA, Department of Health and Human Services, 5600 Fishers Lane, Room 12A16, Rockville, MD 20857/301-443-6310.

Food and Drug Consumer Update

This free quarterly publication lists public hearings, promotes participation in Food and Drug Administration hearings, describes the FDA decision-making process, announces consumer exchange meetings on a national and district level, and lists locations of FDA consumer offices. Contact: Office of Consumer Affairs, Food and Drug Administration (HFE-20), Department of Health and Human Services, 5600 Fishers Lane, Rockville, MD 20857/301-443-2932.

Food and Drug Consumer Publications

The Food and Drug Administration publishes more than 300 free publications covering such topics as vitamins, minerals, food labeling, drug regulation, cosmetics, and microwave ovens. You can simply state your food- or drug-related area of interest and relevant publications will be sent to you, or you can request a free catalogue. For current information on the latest topics of interest, subscribe to *The FDA Consumer* at $12 per year. Contact: Office of Public Affairs (HFI-20), Food and Drug Administration, Department of Health and Human Services, 5600 Fishers Lane, Rockville, MD 20857/301-443-3210.

Food and Drug Consumer Information

If you have a question concerning the use or safety of any food, drug, radiologic product, medical device or biologic product, the Food and Drug Administration will either find the answer for you or find you an expert who has the answer. These experts answer questions by mail or telephone. Contact: Office of Consumer Communications, Food and Drug Administration, Department of Health and Human Services, 5600 Fishers Lane, Room 15B32, Rockville, MD 20857/301-443-3170.

Food and Drug Consumer Training Courses and Speakers

Free one-day seminars are held throughout the country by the Food and Drug Administration on how to use the FDA and be an alert consumer. The topics covered include how to petition the FDA to improve or change its regulation of a certain product or company. For a schedule of courses, contact: National Consumer Awareness and Access Project, Office of Consumer Affairs, Food and Drug Administration, Department of Health and Human Services, 5600 Fishers Lane, Room 1685, Rockville, MD 20857/301-443-5006.

The Food and Drug Administration also has 55 experts stationed throughout the country who

are available to talk to your group on food, drugs, cosmetics, and biologic and medical devices. Topics include nutritional labeling, food additives, food fads, and saccharin. Contact: Office of Consumer Affairs, Food and Drug Administration, Department of Health and Human Services, 5600 Fishers Lane, Room 1382, Rockville, MD 20857/301-443-4166.

Food and Drug Photographs

The Food and Drug Administration maintains a photo file on food- and drug-related matters which is available for loan. Contact: Office of Public Affairs, Food and Drug Administration, HFI-20, 5600 Fishers Lane, Rockville, MD 20857/301-443-3220.

Food and Drugs—Reporting Problem Products

If you know of any foods, drugs, cosmetics, medical or veterinary products that you think are not properly labeled or packaged or that are harmful or unsanitary, you would perform a public service by reporting it to the Food and Drug Administration. Reports should be made as soon as possible, providing as many details as possible, in writing or by telephone to one of the FDA's 140 regional offices; or to Food and Drug Administration, Department of Health and Human Services, 5600 Fishers Lane (HFO-410), Room 1362, Rockville, MD 20857/301-443-1240. For an emergency call, there is a 24-hour answering service at 202-737-0448.

Food and Drug Small Business Help

The Food and Drug Administration offers special help to the small businesses it regulates. It will explain how the businesses are affected by the regulations and how to complete applications and other forms, describe what manufacturers must do in order to market a new product, and make on-site visits in order to understand special small business problems. Contact: Small Business Coordinator, Office of Consumer Affairs, Food and Drug Administration, Department of Health and Human Services, 5600 Fishers Lane, Room 1382, Rockville, MD 20857/301-443-4166.

Foods—Research and Evaluation

The Bureau of Foods accumulates information and expertise on food cosmetic microbiology, veterinary pathology, whole animal toxicology, dermal and ocular toxicology, animal resources, genetics toxicology, metabolism, food animal additives, food additives, coloring and cosmetics, contaminants and natural toxicants, packaging technology, food technology, chemical technology, coloring technology, and cosmetics technolo-

gy. Contact: FDA Press Office, Bureau of Foods, Food and Drug Administration, Department of Health and Human Services, 200 C St. S.W., Room 3807, Washington, DC 20204/202-245-1144.

Freedom of Information Act

Each major division within the Department of Health and Human Services has a freedom of Information Act office. For a list of these offices, contact: Office of the Secretary, FOIA, Department of Health and Human Services, 200 Independence Ave. S.W., Room 118F, Washington, DC 20201/202-472-7453. See also "Freedom of Information Act."

Genetic Disease Information Clearinghouse

The clearinghouse provides pamphlets, books, journals, posters, charts, brochures, audio cassettes, film strips, teaching kits, slide and tape lectures, as well as a free directory describing informational and clinical resources. Contact: National Clearinghouse for Human Genetic Diseases, Department of Health and Human Services, 805 15th St. N.W., Suite 500, Washington, DC 20005/202-842-7617.

Grants

The programs described below are for sums of money which are given by the federal government to initiate and stimulate new or improved activities or to sustain on-going services.

Adolescent Pregnancy Prevention and Services

Objectives: To establish networks of community-based health, education, and social services for adolescents at risk of unintended pregnancies, for pregnant adolescents, and for adolescent parents.

Eligibility: State and local governments; any nonprofit public or private organization.

Range of Financial Assistance: Not specified.

Contact: Office of Adolescent Pregnancy Programs, Public Health Service, Department of Health and Human Services, Room 725-H, 200 Independence Ave. S.W., Washington, DC 20201/202-472-9093.

Adoption Opportunities

Objectives: To provide financial support for demonstration projects to improve adoption practices; to gather information on adoptions, and to provide training and technical assistance to improve adoption services.

Eligibility: State or local governmental or nonprofit institutions of higher learning; state and local government or nonprofit organizations engaged in research on child welfare activities.

Range of Financial Assistance: $50,000 to $500,000.

Contact: Training and Technical Assistance Division, Children's Bureau, Administration for Children, Youth and Families, Department of Health and Human Services, P.O. Box 1182, Washington, DC 20013/202-755-7820.

Advanced Nurse Training Program

Objectives: To prepare registered nurses to teach in the various fields of nurse training and to serve in administrative or supervisory capacities, in nursing specialties, and as nurse clinicians.

Eligibility: Public and nonprofit private collegiate schools of nursing accredited by the appropriate accrediting body.

Range of Financial Assistance: $34,000 to $350,000.

Contact: Division of Nursing, Bureau of Health Manpower, Health Resources Administration, Public Health Service, Department of Health and Human Services, Center Building, 3700 East-West Highway, Hyattsville, MD 20782/301-436-6314.

Aging—Discretionary Projects and Programs

Objectives: To demonstrate new approaches, techniques and methods to improve or expand social services or nutrition services and otherwise promote the well-being of older individuals.

Eligibility: Any public or private nonprofit agency, institution, or organization engaged in activities related to serving the needs of older people or the field of aging. Grants are not available to individuals.

Range of Financial Assistance: $50,000 to $250,000.

Contact: Office of Research Demonstration and Evaluation, Administration on Aging, Office of Human Development Services, Department of Health and Human Services, Washington, DC 20201/202-472-7225.

Aging—Grants for State and Community Programs on Aging

Objectives: To provide assistance to state and area agencies for support of programs for older persons through statewide and area planning and provision of social services, including multipurpose senior centers.

Eligibility: All states and territories with approved state plans and state agencies on aging designated by the governors.

Range of Financial Assistance: $121,875 to $17,490,326.

Contact: Office of Program Operations, Administration on Aging, Office of Human Devel-

opment Services, Department of Health and Human Services, Washington, DC 20201/202-245-0011.

Aging—Multidisciplinary Centers of Gerontology

Objectives: To establish new, and support existing multidisciplinary centers of gerontology.

Eligibility: Any public or private nonprofit college or university, agency, organization, or institution. Grants may not be awarded to any profit-making organization or any individual.

Range of Financial Assistance: $50,000 to $200,000.

Contact: Office of Education and Training, Administration on Aging, Department of Health and Human Services, Washington, DC 20201/202-472-4226.

Aging—Nutrition Services

Objectives: To provide older Americans with low-cost nutritious meals, and with appropriate nutrition education services. Meals may be served in a congregate setting or delivered to the home.

Eligibility: All states with approved state plans.

Range of Financial Assistance: $618,750 to $21,998,812.

Contact: Office of Program Operations, Administration on Aging, Office of Human Development Services, Department of Health and Human Services, Washington, DC 20201/202-245-0011.

Aging—Research

Objectives: To support biomedical, social and behavioral research and research training directed toward greater understanding of the aging process and the needs and problems of the elderly.

Eligibility: Universities, colleges, medical, dental and nursing schools, schools of public health, laboratories, hospitals, state and local health departments, other public or private nonprofit institutions, and individuals.

Range of Financial Assistance: $5,000 to $479,966.

Contact: National Institute on Aging, National Institutes of Health, Department of Health and Human Services, Building 31, Room 5C11A, Bethesda, MD 20205/301-496-1752.

Aging—Research and Development

Objectives: To develop knowledge of the needs and conditions of older persons to provide policies, programs and services for improving their lives.

Eligibility: Any public or nonprofit agency, organization, or institution. Grants may not be awarded to any profit-making organization, nor to any individual.

Range of Financial Assistance: $35,000 to $400,000.

Contact: Division of Research and Evaluation, Office of Research Demonstration and Evaluation Resources, Administration on Aging, Department of Health and Human Services, Room 3280, Washington, DC 20201/202-472-7225.

Aging—Training

Objectives: To support activities that attract qualified persons to the field of aging, and train persons employed or preparing for employment in aging-related fields.

Eligibility: State agencies on aging, state or local educational agencies, institutions of higher education or other public or nonprofit private agencies, organizations or institutions.

Range of Financial Assistance: $15,000 to $528,000.

Contact: Office of Education and Training, Administration on Aging, Office of Human Development, Department of Health and Human Services, Room 4270, Washington, DC 20201/202-472-4226.

Alcohol Abuse and Alcoholism Prevention Demonstration

Objectives: To support exploratory studies related to the reduction of the occurrence of alcohol-related problems through means other than direct treatment or rehabilitation services.

Eligibility: Domestic public or private nonprofit organizations with appropriate expertise, including state, local and U.S. territorial governments.

Range of Financial Assistance: $4,256 to $224,608.

Contact: Division of Prevention, National Institute on Alcohol Abuse and Alcoholism, Alcohol, Drug Abuse, and Mental Health Administration, Public Health Service, Department of Health and Human Services, 5600 Fishers Lane, Room 14C20, Rockville, MD 20857/301-443-4733.

Alcohol Clinical or Service-Related Training Programs

Objectives: To provide specialized training of personnel who will staff community projects.

Eligibility: Public or private nonprofit institutions.

Range of Financial Assistance: $12,420 to $168,324.

Contact: Alcohol Services Division, National

Institute on Alcohol Abuse and Alcoholism, Public Health Service, Department of Health and Human Services, 5600 Fishers Lane, Rockville, MD 20857/Attn: Fran Cotter, 301-443-3885.

Alcohol Formula Grants

Objectives: To assist states to plan, establish, maintain, coordinate and evaluate effective prevention, treatment, and rehabilitation programs to deal with alcohol abuse and alcoholism.

Eligibility: The state agency designated by the governor to administer the state plan.

Range of Financial Assistance: $9,882 to $5,355,461.

Contact: Division of Resource Development, National Institute on Alcohol Abuse and Alcoholism, Alcohol, Drug Abuse and Mental Health Administration, PHS, Dept. of HHS, 5600 Fishers Lane, Rockville, MD 20852/301-443-2530

Alcohol National Research Service Awards for Research Training

Objectives: To provide support to individuals for predoctoral and postdoctoral research training in specified alcohol abuse-related areas.

Eligibility: Support is provided for predoctoral and postdoctoral academic and research training only, in health and health-related areas which are specified by the National Institute of Alcohol Abuse and Alcoholism and include research training in the various aspects of prevention, education and treatment.

Range of Financial Assistance: $6,900 to $108,827.

Contact: Research Division, National Institute on Alcohol Abuse and Alcoholism, Department of Health and Human Services, 5600 Fishers Lane, Rockville, MD 20857/Attn: Dr. Nino Salmoyraghi, 301-443-2784.

Alcohol Research Center Grants

Objectives: To provide long-term support for research efforts into the problems of alcohol use and alcoholism by coordinating the activities of investigators from biomedical, behavioral, and social science disciplines.

Eligibility: State and local governments, and any domestic public or nonprofit private institution.

Range of Financial Assistance: $269,431 to $497,668.

Contact: Division of Extramural Research, Director, National Institute on Alcohol Abuse and Alcoholism, Alcohol, Drug Abuse, and Mental Health Administration, Public Health Service, Department of Health and Human Services, 5600 Fishers Lane, Rockville, MD 20857/301-443-4223.

Alcohol Research Programs

Objectives: To develop approaches to the causes, diagnosis, treatment, control, and prevention of alcohol abuse and alcoholism through basic, clinical and applied research.

Eligibility: Investigators affiliated with public or nonprofit private agencies, including state, local or regional government agencies, universities, colleges, hospitals, academic or research institutions, and other organizations.

Range of Financial Assistance: $2,675 to $313,884.

Contact: Division of Extramural Research, Director, National Institute on Alcohol Abuse and Alcoholism, Alcohol, Drug Abuse, and Mental Health Administration Public Health Service, Department of Health and Human Services, 5600 Fishers Lane, Rockville, MD 20857/301-443-4223.

Alcohol Research Scientist Development and Research Scientist Awards

Objectives: To provide support for research relating to the problems of alcohol abuse and alcoholism prevention, treatment, and rehabilitation and to raise the level of competence and increase the number of individuals engaged in such research.

Eligibility: Appropriate research centers, medical schools, community mental health centers, and research institutes with alcoholism programs on behalf of deserving individuals.

Range of Financial Assistance: $28,893 to $42,288.

Contact: Division of Extramural Research, Director, National Institute on Alcohol Abuse and Alcoholism, Alcohol, Drug Abuse, and Mental Health Administration Public Health Service, Department of Health and Human Services, 5600 Fishers Lane, Rockville, MD 20857/301-443-4223.

Alcoholism Demonstration Evaluation

Objectives: To support exploratory studies regarding innovative or standard alcoholism projects.

Eligibility: Domestic public or private nonprofit organizations with appropriate expertise, including state, local and U.S. territorial governments.

Range of Financial Assistance: $45,896 to $50,000.

Contact: Division of Alcohol Services Program and Director, Division of Resource Development, National Institute on Alcohol Abuse and Alcoholism, Alcohol, Drug Abuse and Mental Health Administration, Public Health Service,

Department of Health and Human Services, 5600 Fishers Lane, Rockville, MD 20857/301-443-6317.

Alcoholism Treatment and Rehabilitation/Occupational Alcoholism Services Programs

Objectives: To provide quality alcohol abuse and alcoholism treatment services to persons in need of them, especially to develop and implement work-place project activity for employed people whose work is adversely affected by the abuse of alcohol.

Eligibility: Domestic public or private nonprofit organizations with appropriate expertise, including state, local and U.S. territorial governments.

Range of Financial Assistance: $3,553 to $835,795.

Contact: Director, Division of Occupational Programs, National Institute on Alcohol Abuse and Alcoholism, Alcohol, Drug Abuse, and Mental Health Administration, Public Health Service, Department of Health and Human Services, 5600 Fishers Lane, Rockville, MD 20857/301-443-6317.

Allied Health Professions Project Grants

Objectives: To establish or improve recruitment, training and retraining, and career advancement of allied health personnel.

Eligibility: Any public or nonprofit private entities capable of carrying out projects under this authority.

Range of Financial Assistance: $655 to $399,919.

Contact: Grants Management Officers, Bureau of Health Manpower, Health Resources Administration, Department of Health and Human Services, Center Building, Room 4-27, 3700 East-West Highway, Hyattsville, MD 20782/301-436-6564.

Allied Health Traineeship Grants for Advanced Training Institutes

Objectives: To provide support to public and nonprofit private entities that offer advanced training for allied health professions personnel to increase their preparedness for teaching, administrative, or supervisory positions.

Eligibility: Public or nonprofit private institutions, agencies, or organizations.

Range of Financial Assistance: $3,980 to $278,699.

Contact: Grants Management Officer, Bureau of Health Manpower, Health Resources Administration, Department of Health and Human Ser-

vices, Center Building, Room 4-27, 3700 East-West Highway, Hyattsville, MD 20782/301-436-6564.

Area Health Education Centers

Objectives: To improve the distribution, supply, quality, utilization and efficiency of health personnel to increase the regionalization of educational responsibilities of health professions schools.

Eligibility: Accredited public or nonprofit schools of medicine or of osteopathy.

Range of Financial Assistance: $132,329 to $2,037,312.

Contact: Director, Division of Medicine, Bureau of Health, Manpower, Public Health Service, Department of Health and Human Services, Center Building, Room 322, 3700 East-West Highway, Hyattsville, MD 20782/301-436-6418.

Arthritis, Bone and Skin Diseases Research

Objectives: To support basic laboratory research and extramural clinical investigations and to provide postdoctoral biomedical research training for individuals.

Eligibility: Research grants are available to individuals and public and nonprofit institutions, who propose to establish, expand, or improve research activities. Research contracts are available to public, commercial, and industrial hospitals, and nonprofit and educational institutions.

Range of Financial Assistance: $25,000 to $1,041,000.

Contact: Director for Extramural Program Activities, National Institute of Arthritis, Metabolism and Digestive Diseases, National Institute of Health, Department of Health and Human Services, Room 637, Westwood Building, Bethesda, MD 20014/301-496-7277.

Assistance Payments—Maintenance Assistance

Objectives: To set general standards for state administration and to provide the federal financial share to states for aid to families with dependent children, emergency assistance to families with children, assistance to repatriated U.S. nationals.

Eligibility: State and local welfare agencies, which must operate under Health and Human Services-approved state plans and must comply with all Federal regulations governing aid and assistance to needy families with dependent children.

Range of Financial Assistance: $1,177,000 to $921,000,000.

Contact: Office of Family Assistance, Social Security Administration, Department of Health and Human Services, 330 C St. S.W., Room B404, Washington, DC 20201/202-245-2000.

Assistance Payments—Research

Objectives: To demonstrate and research new public assistance concepts to reduce dependency and improve living conditions of recipients of public assistance.

Eligibility: Grants may be made to states and nonprofit organizations. Contracts may be executed with nonprofit or profit organizations.

Range of Financial Assistance: $10,000 to $300,000.

Contact: Research and Evaluation Statistics Studies Staff, Social Security Administration Department of Health and Human Services, 2100 2nd St. S.W., Room B724, Washington, DC 20009/202-245-2051.

Assistance Payments—State and Local Training

Objectives: To train personnel employed or preparing for employment in state or local agencies administering approved public assistance plans.

Eligibility: States, whose state program is part of its approved state plan and who provide its share of the costs.

Range of Financial Assistance: Up to $7,804,261.

Contact: Division of Grants Administration and Budget, Office of Family Assistance, Social Security Administration, Department of Health and Human Services, 2100 2nd St. S.W., Room 412, Washington, DC 20201/202-245-2086.

Biomedical Communications Research

Objectives: To develop new communications technology for the storage, retrieval, or transmittal of biomedical information, or to apply existing technology in innovative ways to support biomedical research, education or health care.

Eligibility: Applicant must be able to meet the requirements of technical expertise and financial responsibility specified in the Request for Proposals.

Range of Financial Assistance: $7,897 to $338,000.

Contact: Lister Hill National Center for Biomedical Communications, National Library of Medicine, Department of Health and Human Services, 8600 Rockville Pike, Bethesda, MD 20014/301-496-4441.

Biomedical Research Support and Development

Objectives: To strengthen, balance, and stabilize Public Health Service-supported biomedical and behavioral research.

Eligibility: Health professional schools, other academic institutions, non-federal hospitals, state and municipal health agencies, and other nonprofit, nonacademic research organizations engaged in health-related research.

Range of Financial Assistance: $14,198 to $200,416.

Contact: Biomedical Research Support Program, Division of Research Resources, NIH, Department of Health and Human Services, Room 5B32, Bethesda, MD 20205/301-496-6743.

Biotechnology Research

Objectives: To assist in developing and sustaining sophisticated research, and biomedical engineering resources.

Eligibility: Public or nonprofit private institutions of higher education, hospitals, and other private, nonprofit institutions with programs of biomedical research.

Range of Financial Assistance: $35,000 to $1,900,000.

Contact: Biotechnology Resources Branch, Division of Research Resources, NIH, Department of Health and Human Services, Building 31, Room 5B43, Bethesda, MD 20205/301-496-5411.

Blood Diseases and Resources Research

Objectives: To further the development of blood resources and coordinate national and regional activities of blood centers, and to promote research on blood diseases, including sickle cell disease, and develop new scientists for such research.

Eligibility: Any nonprofit organization engaged in biomedical research.

Range of Financial Assistance: $13,000 to $1,976,780.

Contact: Director, Division of Blood Diseases, National Heart, Lung, and Blood Institute, Department of Health and Human Services, Room 512 Bethesda, MD 20014/301-496-3533.

Cancer Biology Research

Objectives: To provide fundamental information on the cause and nature of cancer in humans in order to develop better methods of prevention, detection, diagnosis, and treatment of neoplastic diseases.

Eligibility: Universities, colleges, hospitals, public agencies or nonprofit research institutions.

Range of Financial Assistance: $5,000 to $1,339,394.

Contact: Chief, Grants Administration Branch, Division of Resources Centers and Community Activities, National Cancer Institute, De-partment of Health and Human Services, Room 8A18, Bethesda, MD 20205/301-496-7753.

Cancer Cause and Prevention Research

Objectives: Identification of those factors which cause cancer in humans and the development of mechanisms for preventing cancer.

Eligibility: Universities, colleges, hospitals, public agencies, or nonprofit research institutions.

Range of Financial Assistance: $11,005 to $2,500,126.

Contact: Grants Administration Branch, Division of Resources Centers and Community Activities, National Cancer Institute, Department of Health and Human Services, Room 8A18, Bethesda, MD 20205/301-496-7753.

Cancer Centers Support

Objectives: To assist in the development and maintenance of multidisciplinary cancer centers for laboratory and clinical research, as well as training and demonstration of the latest diagnostic and treatment techniques.

Eligibility: Universities, colleges, hospitals, public agencies, or nonprofit research institutions.

Range of Financial Assistance: $22,172 to $7,302,258.

Contact: Grants Administration Branch, Division of Resources Centers and Community Activities, National Cancer Institute, Department of Health and Human Services, 5333 Westbard Ave., Room 8A18, Bethesda, MD 20205/301-496-7753.

Cancer—Construction

Objectives: To provide new, and expand existing, cancer research facilities and to achieve a geographic distribution of cancer research facilities and centers.

Eligibility: Universities, colleges, hospitals, public agencies or nonprofit research institutions.

Range of Financial Assistance: $350,000 to $2,244,000.

Contact: Research Facilities Branch, Division of Resources Centers and Community Activities, National Cancer Institute, Department of Health and Human Services, Blair Building, Room 3A05, Silver Spring, MD 20910/301-496-8804.

Cancer Control

Objectives: To bridge the gap between research and application in the practice of medicine and public health so as to minimize illness and death from cancer.

Eligibility: Universities, colleges, hospitals,

public agencies, or nonprofit research institutions.

Range of Financial Assistance: $11,270 to $1,774,074.

Contact: Extramural Activities, Division of Cancer Control and Rehabilitation Grant Review Committee, National Cancer Institute, Department of Health and Human Services, Westwood Building, Room 806, Bethesda, MD 20205/301-496-7413.

Cancer Detection and Diagnosis Research
Objectives: To identify cancer in patients early and precisely enough so that the latest methods of treatment can be applied toward control of the disease.

Eligibility: Universities, colleges, hospitals, public agencies, or nonprofit research institutions.

Range of Financial Assistance: $20,000 to $504,922.

Contact: Grants Administration Branch, Division of Resources Centers and Community Activities, National Cancer Institute, Department of Health and Human Services, Room 8A18, Bethesda, MD 20205/301-496-7753.

Cancer Research Manpower
Objectives: To support nonprofit institutions in providing biomedical training opportunities for individuals interested in careers in basic and clinical research in important areas of the National Cancer Program.

Eligibility: Institutions able to provide the staff and facilities suitable for the proposed training.

Range of Financial Assistance: $10,000 to $369,278.

Contact: Chief, Research Manpower Branch, Division of Resources Centers and Community Activities, National Cancer Institute, Department of Health and Human Services, Bethesda, MD 20205/301-427-8898.

Cancer Treatment Research
Objectives: To develop the means to cure as many cancer patients as possible and to maintain maximum control of the cancerous process.

Eligibility: Universities, colleges, hospitals, public agencies, or nonprofit research institutions.

Range of Financial Assistance: $9,300 to $2,105,020.

Contact: Grants Administration Branch, Division of Resources Centers and Community Activities, National Cancer Institute, Department of Health and Human Services, Room 8A18, Bethesda, MD 20205/301-496-7753.

Caries Research
Objectives: To develop methods to eliminate dental caries as a major health problem.

Eligibility: Scientists at universities, hospitals, laboratories, and other public or private nonprofit institutions.

Range of Financial Assistance: $5,000 to $300,000.

Contact: Caries Research Grants and Contracts Branch, National Institute of Dental Research, NIH, Department of Health and Human Services, Room 522, Bethesda, MD 20014/301-496-7884.

Cataract Research
Objectives: To support research and training to identify the causes of this disorder and develop methods for its prevention and improved treatment.

Eligibility: Universities, colleges, hospitals, laboratories, federal institutions and other public or private nonprofit domestic institutions including state and local units of government.

Range of Financial Assistance: $10,000 to $300,000.

Contact: Director for Extramural and Collaborative Programs, National Eye Institute, NIH, Department of Health and Human Services, Building 31, Room 6A03, Bethesda, MD 20014/301-496-4903.

Cellular and Molecular Basis of Disease Research
Objectives: To support research on the structure and function of cells and their component parts, with the expectation that a greater understanding of these aspects will contribute to the ultimate control of human disease.

Eligibility: Public or private nonprofit universities, colleges, hospitals, laboratories, or other institutions, including state and local units of government, and individuals.

Range of Financial Assistance: $3,900 to $1,373,000.

Contact: Director, Cellular and Molecular Basis of Disease, National Institute of General Medical Sciences, NIH, Department of Health and Human Services, Bethesda, MD 20014/301-496-7021.

Centers for Independent Living
Objectives: To provide independent living services to severely handicapped individuals in order for them to function more independently in family and community settings, and secure and maintain appropriate employment.

Eligibility: State vocational rehabilitation agencies.

Range of Financial Assistance: Not specified.

Contact: Special Assistant for Independent Living Projects, Rehabilitation Services Administration, Department of Health and Human Services, 330 C St. S.W., Room 3214, Washington, DC 20201/202-245-0890.

Chemical/Biological Information-Handling Research

Objectives: To provide support for the development and evaluation of the PROPHET System, an advanced national computer resource in support of pharmacology/toxicology research, and to assist users of the system.

Eligibility: University and industrial research organizations, including engineering development organizations.

Range of Financial Assistance: $400,000 to $600,000.

Contact: Division of Research Resources, NIH, Department of Health and Human Services, Westwood Building, Room 5B03, Bethesda, MD/301-496-5605.

Child Abuse and Neglect Prevention and Treatment

Objectives: To assist state, local, and voluntary agencies and organizations in developing programs that will prevent, identify, and treat child abuse and neglect.

Eligibility: State or local governments or other nonprofit institutions of higher learning, and private nonprofit agencies or organizations engaged in related activities.

Range of Financial Assistance: $30,000 to $300,000.

Contact: National Center on Child Abuse and Neglect, Children's Bureau, Department of Health and Human Services, P. O. Box 1182, Washington, DC 20013/202-245-2840.

Child Support Enforcement

Objectives: To enforce the support obligations of absent parents to their children, locate absent parents, establish paternity, and obtain child support.

Eligibility: State child support agencies.

Range of Financial Assistance: $89,000 to $56,877,000.

Contact: Office of Child Support Enforcement, Department of Health and Human Services, 6110 Executive Blvd., Rockville, MD 20852/301-443-4442.

Child Welfare Research and Demonstration

Objectives: To provide financial support for re-

search demonstration projects in the area of child and family development and welfare.

Eligibility: Grants are available to state and local governments, other nonprofit institutions of higher learning, and nonprofit agencies or organizations engaged in research or child welfare activities. Contracts are available to public or private organizations.

Range of Financial Assistance: $10,000 to $500,000.

Contact: Grants Coordinator, Research and Evaluation Division, Administration for Children, Youth and Families, Office of Human Development Services, OS, Department of Health and Human Services, P. O. Box 1182, Washington, DC 20013/202-755-7740.

Child Welfare Service—State Grants

Objectives: To establish, extend, and strengthen services provided by state and local public welfare programs to prevent the neglect, abuse, exploitation or delinquency of children.

Eligibility: State agencies.

Range of Financial Assistance: $112,530 to $4,420,291.

Contact: Children's Bureau, Administration for Children, Youth and Families, office of Human Development Services, Department of Health and Human Services, P. O. Box 1182, Washington, DC 20013/202-755-7418.

Child Welfare Services Training Grants

Objectives: To develop and maintain an adequate supply of qualified and trained personnel for the field of services to children and their families, and to improve educational programs and resources for preparing personnel to work in this field.

Eligibility: Accredited institutions of higher learning.

Range of Financial Assistance: Up to $50,000.

Contact: Associate Chief, Children's Bureau, Department of Health and Human Services, P. O. Box 1182, Washington, DC 20013/202-755-7418.

Childhood Immunization Grants

Objective: To assist states and communities in establishing and maintaining immunization programs for the control of vaccine-preventable diseases of childhood.

Eligibility: States.

Range of Financial Assistance: $95,000 to $903,000.

Contact: Director, Center for Disease Control, PHS, Department of Health and Human Services, 1600 Clifton Rd., N.E. Atlanta, GA 30333/404-329-3291.

Childhood Lead-Based Paint Poisoning Prevention

Objectives: To stimulate communities in the development of comprehensive lead-based paint poisoning prevention programs, and to assist state agencies in establishing centralized laboratory facilities for analyzing biological and environmental lead specimens.

Eligibility: Public agencies of local government, private nonprofit organizations, and agencies of state government.

Range of Financial Assistance: $20,232 to $518,000.

Contact: Director, Center for Disease Control, PHS, Department of Health and Human Services, 1600 Clifton Rd. N.E., Atlanta, GA 30333/404-329-3291.

Clinical Research

Objectives: To create and sustain institutional resources in which clinical investigators can observe and study human disease.

Eligibility: Public or non profit medical schools, research hospitals, and other medical institutions capable of carrying out well-designed studies working with patients in any preclinical or clinical science.

Range of Financial Assistance: $184,186 to $1,460,074.

Contact: General Clinical Research Centers Program Branch, Division of Research Resources, National Institutes of Health, Department of Health and Human Services, Room 5B51 Bethesda, MD 20014/301-496-6595.

Coal Respiratory Impairment Treatment

Objectives: To develop in areas where there are significant numbers of active and inactive miners high quality patient-oriented systems of health care.

Eligibility: State and local government agencies; private nonprofit agencies.

Range of Financial Assistance: $30,000 to $150,000.

Contact: Director, Regional Commissions Health Programs, Health Services Administration, Bureau of Community Health Services, Department of Health and Human Services, 5600 Fishers Lane, Room 7A-55, Rockville, MD 20857/301-443-5033.

Communicative Disorders Research

Objectives: To support research and research training directed toward understanding the causes, prevention, diagnoses and treatment of communicative disorders.

Eligibility: Public or private nonprofit institutions.

Range of Financial Assistance: $3,674 to $886,325.

Contact: Extramural Activities Program, NIH, Department of Health and Human Services, Federal Building, Room 1004, Bethesda, MD 20205/301-496-9234.

Community Health Centers

Objectives: To support the development and operation of community health centers that provide primary supplemental, and environmental health services to medically underserved populations.

Eligibility: State and local governments, and public or nonprofit private agencies, institutions, or organizations.

Range of Financial Assistance: $25,000 to $4,000,000.

Contact: Associate Bureau Director for Community Health Centers, Bureau of Community Health Service, Department of Health and Human Services, 5600 Fishers Lane, Room 7A-55, Rockville, MD 20852/301-443-2260.

Community Mental Health Centers

Objectives: To provide comprehensive mental health services through a community mental health center through grant programs to support staffing, planning, initial operations, consultation and education services and conversion and to alleviate financial distress grants.

Eligibility: Public and nonprofit private community mental health centers, and other public or nonprofit private entities that provide mental health services.

Range of Financial Assistance: $13,506 to $1,633,741.

Contact: Division of Mental Health Service Programs, National Institute of Mental Health, Alcohol, Drug Abuse and Mental Health Administration, Department of Health and Human Services, 5600 Fishers Lane, Room 11C26, Rockville, MD 20857/301-443-3606.

Comprehensive Hemophilia Diagnostic and Treatment Centers

Objectives: To expand the nationwide availability of comprehensive ambulatory diagnostic and treatment centers for persons with hemophilia, particularly in areas where there are concentrations of hemophilia cases.

Eligibility: State and local governments, public and nonprofit entities.

Range of Financial Assistance: $50,000 to $300,000.

Contact: Associate Bureau Director for Maternal and Child Health, Bureau of Community Health Services, Health Services Administration,

Public Health Service, Department of Health and Human Services, 5600 Fishers Lane, Room 739, Rockville, MD 20857/301-443-2170.

Comprehensive Public Health Services—Formula Grants

Objectives: To assist state health authorities in meeting the cost of providing comprehensive public health services.

Eligibility: State health authorities.

Range of Financial Assistance: $127,000 to $3,918,000.

Contact: Center for Disease Control, Department of Health and Human Services, Building 1, Room 2050, 1600 Clifton Rd. N.E., Atlanta, GA 30333/404-329-3243.

Corneal Diseases Research

Objectives: To reduce the impact of this cause of visual disability through improved methods of treatment, prevention, and diagnosis;

Eligibility: Universities, colleges, hospitals, laboratories, federal institutions and other public or private nonprofit domestic institutions including state and local units of government.

Range of Financial Assistance: $6,000 to $300,000.

Contact: Grants Management Section, National Eye Institute, NIH, Department of Health and Human Services, Bethesda, MD 20014/301-496-5884.

Craniofacial Anomalies Research

Objectives: To acquire new knowledge for the prevention and treatment of malformations such as cleft lip/palate, acquired malformations from surgery or accident, and malocclusion of teeth and jaws.

Eligibility: Scientists at universities, hospitals, laboratories, and other public or private nonprofit institutions.

Range of Financial Assistance: $5,000 to $300,000.

Contact: Chief, Craniofacial Anomalies Program Branch, Extramural Programs, National Institute of Dental Research, NIH, Department of Health and Human Services, Westwood Building, Room 520, Bethesda, MD 20205/301-496-7807.

Crippled Children's Services

Objectives: To provide financial support to states to extend and improve medical and related services to crippled children and children suffering from conditions that lead to crippling, especially in rural areas and in areas suffering from severe economic distress, and for special projects of regional or national significance which may contribute to the advancement of services for crippled children.

Eligibility: State crippled children's agencies and institutions of higher learning.

Range of Financial Assistance: $2,000 to $2,800,000.

Contact: Associate Bureau Director MCH, Bureau of Community Health Services, Department of Health and Human Services, 5600 Fishers Lane, Room 7-39, Rockville, MD 20857/301-443-2170.

Dental Research Institutes

Objectives: To develop institutes or centers that focus on the problems of oral health.

Eligibility: Universities with established research strength or organized to focus on oral health problems.

Range of Financial Assistance: $1,000,000 to $1,500,000.

Contact: Extramural Programs, National Institute of Dental Research, Department of Health and Human Services, 5333 Westbard Ave., Room 503, Bethesda, MD 20205/301-496-7748.

Dental Team Practice

Objectives: To teach dental students how to function effectively as managers and organizers in multiple auxiliary dental health care delivery teams.

Eligibility: Public or nonprofit private schools of dentistry, or other public or nonprofit private entities.

Range of Financial Assistance: $83,498 to $312,810.

Contact: Professional Education Branch, Division of Dentistry, Bureau of Health Manpower, Health Resources Administration, Public Health Service, Department of Health and Human Services, Center Building, 3700 East-West Highway, Hyattsville, MD 20782/301-436-6510.

Developmental Disabilities—Basic Support and Advocacy Grants

Objectives: To assist states in the provision of comprehensive services for developmentally disabled persons.

Eligibility: Designated state agencies.

Range of Financial Assistance: $30,000 to $3,581,000.

Contact: Administration on Developmental Disabilities, Office of Human Development Services, Department of Health and Human Services Building, 330 Independence Ave. S.W., Room 3194c, Washington, DC 20201/202-472-7210.

Developmental Disabilities—Special Projects

Objectives: To provide support for projects to improve the quality of services to the developmentally disabled, and public awareness and informational programs.

Eligibility: States, political subdivisions of states, other public agencies, and nonprofit organizations.

Range of Financial Assistance: $25,000 to $561,700.

Contact: Administration on Developmental Disabilities, Office of Human Development, Department of Health and Human Services, 330 Independence Ave. S.W., Room 3194C, Washington, DC 20201/202-472-7210.

Developmental Disabilities—University-Affiliated Facilities

Objectives: To assist with the cost of administration and operation of facilities for providing interdisciplinary training for personnel concerned with developmental disabilities, demonstrations of exemplary services related to the developmentally disabled and of findings related to their provision.

Eligibility: Public or nonprofit facilities associated with a college or university.

Range of Financial Assistance: $92,100 to $348,200.

Contact: Administration on Developmental Disabilities, Office of Human Development Services, Department of Health and Human Services, 330 Independence Ave. S.W., Room 3194C, Washington, DC 20201/202-472-7210.

Diabetes, Endocrinology and Metabolism Research

Objectives: To support basic laboratory research and extramural clinical investigations and to provide postdoctoral biomedical research training for individuals interested in careers in health sciences and related fields.

Eligibility: Individuals and public and nonprofit institutions who propose to establish, expand, and improve research activities in health sciences and related fields.

Range of Financial Assistance: $25,000 to $1,448,191.

Contact: Director for Extramural Program Activities, National Institute of Arthritis, Metabolism, and Digestive Diseases, NIH, Department of Health and Human Services, Westwood Building, Room 637, Bethesda, MD 20014/301-496-7277.

Digestive Diseases and Nutrition Research

Objectives: To support basic laboratory re-

search and extramural clinical investigations and to provide postdoctoral biomedical research training for individuals interested in careers in health sciences and related fields.

Eligibility: Individuals and public and nonprofit institutions who propose to establish, expand and improve research activities in health sciences and related fields.

Range of Financial Assistance: $25,000 to $1,069,000.

Contact: Associate Director for Extramural Program Activities, National Institute of Arthritis, Metabolism, and Digestive Diseases, Department of Health and Human Services, Westwood Building, Room 637, Bethesda, MD 20014/301-496-7277.

Disease Control

Objectives: To support a disease control program designed to contribute to national protection against diseases or conditions of national significance which are amenable to reduction, including tuberculosis, rubella, measles, poliomyelitis, diphtheria, tetanus, pertussis, mumps, venereal disease, and other communicable diseases, and arthritis, diabetes, hypertension, pulmonary diseases, cardiovascular diseases, and RH disease.

Eligibility: States and public entities in consultation with state health authorities, and political subdivisions of a state.

Range of Financial Assistance: $17,043 to $2,461,000.

Contact: Director, Center for Disease Control, Public Health Service, Department of Health and Human Services, 1600 Clifton Rd. N.E., Atlanta, GA 30333/404-329-3291.

Drug Abuse Clinical or Service Training Programs

Objectives: To support training programs for treatment personnel to work with drug addicts or abusers and for programs for evaluation and development of teaching methods.

Eligibility: Public or private nonprofit institutions.

Range of Financial Assistance: $23,640 to $200,000.

Contact: Division of Prevention and Treatment Development, Alcohol, Drug Abuse and Mental Health Administration, National Institute on Drug Abuse, Department of Health and Human Services, 5600 Fishers Lane, Room 10A16, Rockville, MD 20857/301-443-6697.

Drug Abuse Community Service Programs

Objectives: To reach, treat, and rehabilitate

narcotic addicts, drug abusers, and drug dependent persons through a wide range of community-based services.

Eligibility: Public or private nonprofit organizations.

Range of Financial Assistance: $10,000 to $19,000,000.

Contact: Division of Community Assistance, Director, Alcohol, Drug Abuse and Mental Health Administration, National Institute on Drug Abuse, Department of Health and Human Services, 5600 Fishers Lane, Room 9-03, Rockville, MD 20857/301-443-6780.

Drug Abuse Demonstration Programs

Objectives: To cover the operational costs for surveys and field trials of programs for the treatment of narcotic addiction and drug abuse, and of programs for treatment and rehabilitation of narcotic addicts and drug abusers.

Eligibility: Public or private nonprofit agencies or organizations.

Range of Financial Assistance: $22,000 to $540,044.

Contact: Division of Prevention and Treatment Development, Alcohol, Drug Abuse and Mental Health Administration, National Institute on Drug Abuse, Public Health Service, Department of Health and Human Services, 5600 Fishers Lane, Room 10A16, Rockville, MD 20857/301-443-6697.

Drug Abuse Education Programs

Objectives: To collect, prepare and disseminate information dealing with the use and abuse of drugs and its prevention.

Eligibility: Public or private nonprofit organizations.

Range of Financial Assistance: $47,000 to $452,440.

Contact: Division of Prevention and Treatment Development, Director, Alcohol, Drug Abuse and Mental Health Administration, National Institute on Drug Abuse, Public Health Service, Department of Health and Human Services, 5600 Fishers Lane, Room 10A16, Rockville, MD 20857/301-443-6697.

Drug Abuse National Research Service Awards for Research Training

Objectives: To provide support to individuals for predoctoral and postdoctoral research training in specified drug related areas, and to enable nonprofit institutions to develop research training opportunities for such individuals.

Eligibility: Support is provided for predoctoral and postdoctoral academic and research training

only, in health and health related areas which are specified by the National Institute on Drug Abuse and include both basic and applied studies in all of the life sciences relevant to drug abuse, as well as research on behavioral, societal factors and the epidemiology of drug use and abuse and special training in experimental design and methodology.

Range of Financial Assistance: $3,900 to $99,400.

Contact: Division of Prevention and Treatment Development, Alcohol, Drug Abuse and Mental Health Administration, National Institute on Drug Abuse, Department of Health and Human Services, 5600 Fishers Lane, Room 10A16, Rockville, MD 20857/301-443-6697.

Drug Abuse Prevention Formula Grants

Objectives: To assist the states in projects for drug abuse prevention.

Eligibility: State agencies designated by the governing authority of the state as the sole agency for the preparation and administration or supervision of the state plan.

Range of Financial Assistance: $28,919 to $3,963,359.

Contact: Division of Community Assistance, Director, Alcohol, Drug Abuse and Mental Health Administration, National Institute on Drug Abuse, Public Health Service, Department of Health and Human Services, Room 9-03, 5600 Fishers Lane, Rockville, MD 20857/301-443-6780.

Drug Abuse Research Programs

Objectives: To develop new approaches to the control and prevention of narcotic addiction and drug abuse through basic, clinical, and applied research.

Eligibility: State, local or regional government agencies, universities, colleges, hospitals, academic or research institutions and other organizations.

Range of Financial Assistance: $7,450 to $556,884.

Contact: Division of Research, Alcohol, Drug Abuse and Mental Health Administration, National Institute on Drug Abuse, Public Health Service, Department of Health and Human Services, 5600 Fishers Lane, Room 936, Rockville, MD 20857/301-443-1887.

Drug Abuse Research Scientist Development and Research Scientist Awards

Objectives: To provide support for research relating to the problems of narcotic addiction and drug abuse and to raise the level of competence

and to increase the number of individuals engaged in such research.

Eligibility: Research Scientist Development and Research Scientist Awards are made on behalf of individuals to research centers, medical schools, community mental health centers and research institutes.

Range of Financial Assistance: $22,632 to $41,329.

Contact: Director, Division of Research, Alcohol, Drug Abuse and Mental Health Administration, National Institute on Drug Abuse, Public Health Service, Department of Health and Human Services, 5600 Fishers Lane, Room 936, Rockville, MD 20857/301-443-1887.

Emerency Medical Services

Objectives: To provide assistance for the development of comprehensive regional emergency medical services systems throughout the country.

Eligibility: States units of local government, public entites administering a compact or other regional arrangement or consortium, or other public and nonprofit private entities.

Range of Financial Assistance: $60,000 to $350,000.

Contact: Division of Emergency Medical Services, Department of Health and Human Services, 5600 Fishers Lane, Room 6-40, Rockville, MD 20857/301-443-5250.

Environmental Health Research and Manpower Development Resources

Objectives: To provide support for multidisciplinary research and training on environmental health problems in environmental health sciences centers and marine and freshwater biomedical centers.

Eligibility: University-based or nonprofit research institutions.

Range of Financial Assistance: $132,000 to $1,934,000.

Contact: Director for Extramural Programs, National Institute of Environmental Health Sciences, Department of Health and Human Services, P. O. Box 12233, Research Triangle Park, NC 27709/919-541-3350.

Expanded Function Dental Auxiliary Training Program

Objectives: To plan, develop and operate programs for the training of expanded function dental auxiliaries.

Eligibility: Public or nonprofit private schools of dentistry or other public or nonprofit private entities, such as junior and community colleges, with established dental auxiliary programs.

Range of Financial Assistance: $24,000 to $100,000.

Contact: Professional Education Branch, Division of Dentistry, Bureau of Health Manpower, Health Resources Administration, Department of Health and Human Services, 3700 East-West Highway, Federal Center Building No. 2, Room 116, Hyattsville, MD 20782/301-436-6514.

Faculty Development in Family Medicine

Objectives: To increase the supply of physician faculty available to teach in family medicine programs and to enhance the pedagogical skills of faculty currently teaching in family medicine.

Eligibility: Public or nonprofit private hospitals, accredited public or nonprofit schools of medicine or of osteopathy, or other public or private nonprofit entities.

Range of Financial Assistance: $33,994 to $294,968.

Contact: Director, Division of Medicine, Bureau of Health Manpower, Public Health Service, Department of Health and Human Services, Center Building, Room 322, 3700 East-West Highway, Hyattsville, MD 20782/301-436-6418.

Family Planning Projects

Objectives: To provide educational, medical and social services to enable individuals to determine freely the number and spacing of their children, to promote the health of mothers and children, and to help reduce maternal and infant mortality.

Eligibility: City, county, and state governments or nonprofit private entities.

Range of Financial Assistance: $20,000 to $1,000,000.

Contact: Associate Bureau Director for Family Planning Services, Health Services Administration, Department of Health and Human Services, 5600 Fishers Lane, Room 7-15, Rockville, MD 20857/301-443-2430.

Family Planning Services

Objectives: To provide job-specified training for personnel to improve the delivery of family planning services.

Eligibility: City, county, and state governments or nonprofit private entities.

Range of Financial Assistance: $15,000 to $600,000

Contact: Office for Family Planning, Health Services Administration, Bureau of Community Health Services, Office for Family Planning, Department of Health and Human Services, 5600 Fishers Lane, Rockville, MD 20857/301-443-2430.

Family Planning Services—Delivery Improvement Research Grants

Objectives: To provide techniques for service delivery improvement through demonstration projects, operational research, or technology development and technical assistance.

Eligibility: Public or private nonprofit entities.

Range of Financial Assistance: $15,000 to $200,000

Contact: Office for Family Planning, Health Services Administration, Bureau of Community Health Services, Department of Health and Human Services, 5600 Fishers Lane, Rockville, MD 20857/301-443-2430.

Fluoridation Grants

Objectives: To assist states and communities in promoting, implementing and maintaining fluoridated water systems on a national basis.

Eligibility: States, or political subdivisions of states and other public nonprofit institutions in consultation with state health authorities, or any other public agency that has been established to supply potable water for public consumption.

Range of Financial Assistance: $2,500 to $100,000

Contact: Director, Center for Disease Control, Public Health Service, Department of Health and Human Services, 1600 Clifton Rd. N.E., Atlanta, GA 30333/404-329-3291.

Food and Drug Administration Research

Objectives: To establish, expand, and improve research activities concerned with foods, food additives, shellfish sanitation, poison control, drug and cosmetic hazards, human and veterinary drugs, medical devices and diagnostic products, biologics, and radiation-emitting devices and materials.

Eligibility: Colleges, universities, nonprofit institutions and state and local governments.

Range of Financial Assistance: $5,000 to $125,000.

Contact: Chief, Grants Management Branch, HFA-520, Department of Health and Human Services, 5600 Fishers Lane, Room 12A27, Rockville, MD 20857/301-443-6170.

Fundamental Neurosciences Research

Objectives: To support specific research and training in the fundamental neurosciences to elucidate the mechanisms responsible for normal function of the human nervous system and to understand the nature of its diseases and disorders.

Eligibility: Public or private nonprofit institutions.

Range of Financial Assistance: $7,350 to $518,826.

Contact: Extramural Activities Program, NIH, Department of Health and Human Services, Federal Building, Room 1016, 7550 Wisconsin Ave., Bethesda, MD 20205/301-496-9234.

Genetic Diseases Testing and Counseling Services

Objectives: To establish and operate voluntary genetic testing and counseling programs primarily in conjunction with other existing health programs.

Eligibility: State and local governments, and public and nonprofit entities.

Range of Financial Assistance: $10,000 to $400,000.

Contact: Division of Clinical Services, Bureau of Community Health Services, Health Services Administration, Public Health Service, Department of Health and Human Services, 5600 Fishers Lane, Room 7-49, Rockville, MD 20857/301-443-1080.

Genetics Research

Objectives: To support basic research aimed at the prevention, treatment, and control of genetic diseases in humans, including those multifactorial illnesses with a strong hereditary component.

Eligibility: Public or private nonprofit universities, colleges, hospitals, laboratories, or other institutions, including state and local units of government, or individuals.

Range of Financial Assistance: $3,900 to $1,373,000.

Contact: Program Director (Genetics), National Institute of General Medical Sciences, Department of Health and Human Services, Westwood Building, Room 910, 5333 Westbard Ave., Bethesda, MD 20205/301-496-7087.

Glaucoma Research

Objectives: To support research and training to determine the cause of glaucoma, develop techniques for prevention and detection of the disease, and improve methods of treatment.

Eligibility: Universities, colleges, hospitals, laboratories, federal institutions and other public or private nonprofit domestic institutions, including state and local units of government.

Range of Financial Assistance: $10,000 to $300,000.

Contact: Director of Extramural and Collaborative Programs, National Eye Institute, Department of Health and Human Services, Building 31, Room 6A03, Bethesda, MD 20014/301-496-4903.

Graduate Programs in Health Administration

Objectives: To support accredited graduate educational programs in health administration, hospital administration, and health planning.

Eligibility: Accredited public or nonprofit private educational entities.

Range of Financial Assistance: Up to $135,000.

Contact: Grants Management Officer, Bureau of Health Professions, Health Resources Administration, Department of Health and Human Services, 3700 East-West Highway, Center Building, Room 4-27, Hyattsville, MD 20782/301-436-6564.

Graduate Training in Family Medicine

Objectives: To increase the number of physicians practicing family medicine.

Eligibility: Public and nonprofit private hospitals, accredited public nonprofit private schools of medicine or osteopathy, or nonprofit private health or educational entities.

Range of Financial Assistance: $11,016 to $1,109,574.

Contact: Director, Division of Medicine, Bureau of Health Professions, Health Resources Administration, Department of Health and Human Services, 3700 East-West Highway, Center Building, Room 322, Hyattsville, MD 20782/301-436-6418.

Head Start

Objectives: To provide comprehensive health, educational, nutritional, social and other services primarily to economically disadvantaged preschool children and their families, and to involve parents in activities with their children so that the children will attain social competence.

Eligibility: Local government or private nonprofit agencies.

Range of Financial Assistance: $60,000 to $15,000,000.

Contact: Administration for Children, Youth and Families/Head Start Bureau, Office of Human Development Services, Department of Health and Human Services, P. O. Box 1182, Washington, DC 20013/202-755-7790.

Health Career Opportunity Program

Objectives: To identify, recruit, and select individuals from disadvantaged backgrounds for education and training in a health profession. To facilitate their entry into such a school and to provide counseling or other services designed to assist them to complete successfully their training.

Eligibility: Public or nonprofit private health or educational entities.

Range of Financial Assistance: $7,060 to $550,000.

Contact: Grants Management Office, Bureau of Health Professions, Health Resources Administration, Department of Health and Human Services, 3700 East-West Highway, Center Building, Room 4-27, Hyattsville, MD 20782/301-436-6564.

Health Education Assistance Loans

Objectives: To authorize loans for educational expenses available from eligible lenders such as banks, credit unions, savings and loan associations, pension funds, insurance companies and eligible educational institutions. Loans are made to graduate students enrolled at eligible health professions institutions. The loans are insured by the federal government.

Eligibility: Generally, any U.S. citizen, national, or person in the United States for other than a temporary purpose, who is enrolled on a full-time basis at an eligible health professions school may apply.

Range of Financial Assistance: $7,500 to $37,500

Contact: Health Loan Branch, Division of Student Services, Department of Health and Human Services, P. O. Box 1837, 6525 Belcrest Rd., Hyattsville, MD 20782/301-436-5986.

Health Education—Risk Reduction

Objectives: To assist state and local health agencies to plan, coordinate and evaluate health education programs which emphasize personal behavior in reducing the health risks of preventable conditions and certain chronic diseases.

Eligibility: State and local official health departments.

Range of Financial Assistance: $15,000 to $150,000.

Contact: Director, Center for Health Promotion and Education, Center for Disease Control, Department of Health and Human Services, Building 14, Room 1, 1600 Clifton Rd. N.E., Atlanta, GA 30333/404-329-3111.

Health Financing Research Demonstrations and Experiments

Objectives: To discover, test, demonstrate, and promote utilization of health care financing concepts which will provide service to the beneficiary population.

Eligibility: States and nonprofit organizations.

Range of Financial Assistance: $25,000 to $6,000,000.

Contact: Research, Demonstration and Statistics, Health Care Financing Administration, De-

partment of Health and Human Services, 330 C St. S.W., Washington, DC 20201/202-472-7431.

Health Maintenance Organizations

Objectives: To stimulate the development and increase the number of various kinds of prepaid, comprehensive health maintenance organizations throughout the United States and support the expansion of federally qualified health maintenance organizations.

Eligibility: Public and private nonprofit organizations that plan to operate and expand a health maintenance organization.

Range of Financial Assistance: $75,000 to $1,600,000.

Contact: Office of Health Maintenance Organizations, Public Health Service, Department of Health and Human Services, 12420 Parklawn Drive, Rockville, MD 20857/301-443-2560.

Health Planning—Health Systems Agencies

Objectives: To provide for effective health resources planning at the area level to meet problems in health care delivery systems, maldistribution of health care facilities and manpower, and increasing cost of health care.

Eligibility: Private nonprofit corporation, single units of local government, or a regional planning bodies authorized to carry out health planning and resources development activities for its area.

Range of Financial Assistance: $175,000 to $3,763,330.

Contact: Director, Bureau of Health Planning, Health Resources Administration, Public Health Service, Department of Health and Human Services, 3700 East-West Highway, Center Building, · Room 622, Hyattsville, MD 20782/301-436-6850.

Health Professions—Capitation Grants

Objectives: To provide financial assistance to schools of medicine, osteopathy, dentistry, public health, veterinary medicine, optometry, pharmacy and podiatry for enrollment goals.

Eligibility: Public or nonprofit private accredited schools, or those that have reasonable assurance of accreditation.

Range of Financial Assistance: $38,306 to $1,960,011.

Contact: Bureau of Health Professions, Health Resources Administration, Department of Health and Human Services, 3700 East-West Highway, Center Building, Hyattsville, MD 20782/301-436-6564.

Health Professions—Financial Distress Grants

Objectives: To assist schools of medicine, oste-

opathy, dentistry, optometry, pharmacy, podiatry, public health and veterinary medicine which are in serious financial distress to meet costs of operation, or which have special financial need to meet accreditation requirements or carry out appropriate operational, managerial and financial reforms.

Eligibility: Public or nonprofit private accredited or those that have reasonable assurance of accreditation.

Range of Financial Assistance: $15,000 to $2,753,349.

Contact: Bureau of Health Professions, Health Resources Administration, Public Health Service, Department of Health and Human Services, 3700 East-West Highway, Center Building, Hyattsville, MD 20782/301-436-6564.

Health Professions—Preparatory Scholarship Program for Indians

Objectives: To make scholarship grants to Indians for the purpose of completing compensatory preprofessional education in order to qualify for enrollment or re-enrollment in a health professions school.

Eligibility: Individuals.

Range of Financial Assistance: $5,000 to $12,000.

Contact: Office of Grants and Contracts, Indian Health Service, Health Services Administration, Public Health Service, Department of Health and Human Services, 5600 Fishers Lane, Room 6A29, Rockville, MD 20857/301-443-5204.

Health Professions—Recruitment Program for Indians

Objectives: To identify Indians with a potential for education or training in the health professions and encourage and assist them to enroll in health or allied health professional schools.

Eligibility: Public or nonprofit health or educational entities or Indian tribes or tribal organizations.

Range of Financial Assistance: $26,000 to $180,000.

Contact: Office of Grants and Contracts, Indian Health Service, Health Services Administration, Public Health Service, Department of Health and Human Services, 5600 Fishers Lane, Room 6A29, Rockville, MD 20857/301-443-5204.

Health Professions—Scholarship Program for Indians

Objectives: To make scholarship grants to Indians and others for the purposes of completing health professional education. Upon completion

grantees are required to fulfill an obligated service payback requirement.

Eligibility: Individuals.

Range of Financial Assistance: $5,000 to $12,000.

Contact: Office of Grants and Contracts, Indian Health Service, Health Services Administration, Public Health Service, Department of Health and Human Services, 5600 Fishers Lane, Room 6A29, Rockville, MD 20857/301-443-5204.

Health Professions—Start-Up Assistance

Objectives: To assist new schools of medicine, osteopathy, dentistry, public health, veterinary medicine, optometry, pharmacy, and podiatry to accelerate start of instruction or increase size of entering class.

Eligibility: New public and nonprofit schools which have a reasonable assurance of accreditation.

Range of Financial Assistance: $180,000 to $583,990.

Contact: Bureau of Health Professions, Health Resources Administration, Public Health Service, Department of Health and Human Services, 3700 East-West Highway, Center Building, Hyattsville, MD 20782/301-436-6564.

Health Professions—Student Loans

Objectives: To increase educational opportunities for students in need of financial assistance to pursue a course of study in specified health professions by providing long-term, low-interest loans.

Eligibility: Accredited public or nonprofit schools of medicine, dentistry, osteopathy, optometry, podiatry, pharmacy, or veterinary medicine.

Range of Financial Assistance: $3,500 to $224,752.

Contact: Division of Student Services Training Support, Bureau of Health Personnel, Health Development and Services Administration, Public Health Service, Department of Health and Human Services, Center Building, 3700 East-West Highway, Hyattsville, MD 20782/301-436-6310.

Health Services Research and Development Grants

Objectives: To support research, development, demonstration and evaluation activities to develop new options for health services delivery policy, to test the assumptions on which current policies and delivery practices are based, and to develop the means for monitoring the performance of the health care system.

Eligibility: States, counties, cities, towns, political subdivisions, universities, hospitals, Native Americans and other public or nonprofit private agencies, institutions, or organizations and individuals.

Range of Financial Assistance: $3,000 to $5,000,000.

Contact: Director, National Center for Health Services Research, Office of Health Research, Statistic and Technology, Public Health Service, Department of Health and Human Services, 3700 East-West Highway, Center Building, Room 841, Hyattsville, MD 20782/301-436-6184.

Health Underserved Research and Demonstration Projects

Objectives: To provide grants with public and private entities which provide health services that demonstrate new and innovative methods for the provision of primary health dental services, or that conduct research on new or existing methods.

Eligibility: Entities that are health care providers and that have demonstrated financial viability.

Range of Financial Assistance: $20,000 to $433,000.

Contact: Office for Rural Health, Bureau of Community Health Services, Department of Health and Human Services, 5600 Fishers Lane, Room 7A55, Rockville, MD 20857/301-443-2220.

Heart and Vascular Diseases Research

Objectives: To foster research, prevention, and education and control activities related to heart and vascular diseases.

Eligibility: Nonprofit organizations engaged in biomedical research.

Range of Financial Assistance: $13,000 to $3,938,440.

Contact: Division of Heart and Vascular Diseases, National Heart, Lung and Blood Institute, Department of Health and Human Services, Federal Building, Room 420, 7550 Wisconsin Ave., Bethesda, MD 20205/301-496-5595.

Home Health Services and Training Grant Program

Objectives: To expand and develop home agencies and services as defined under the Medicare program, and to provide funds for the training of professional and paraprofessional personnel to provide home health services.

Eligibility: State and local government entities and any public or private nonprofit organizations.

Range of Financial Assistance: $10,000 to $200,000.

Contact: Home Health Services Program, Bureau of Community Health Services, Health Services Administration, Department of Health and Human Services, 5600 Fishers Lane, Room 7A-55, Rockville, MD 20857/301-443-2270.

Hospital-Affiliated Primary Care Centers

Objectives: To provide funds for the planning, development and operation of hospital-affiliated primary care centers.

Eligibility: Community hospitals.

Range of Financial Assistance: Up to $150,000.

Contact: Director, Home Health Services Program and Hospital-Affiliated Primary Care Centers, Department of Health and Human Services, 5600 Fishers Lane, Room 7A-55, Rockville, MD 20857/301-443-5033.

Hypertension Program

Objectives: To assist state health authorities in establishing and maintaining programs for screening, detection, diagnosis, prevention, referral for treatment of, and follow-up on compliance with treatment prescribed for hypertension.

Eligibility: State health authorities.

Range of Financial Assistance: $12,200 to $860,300.

Contact: Bureau of Community Health Services, Department of Health and Human Services, 5600 Fishers Lane, Room 7A-55, Rockville, MD 20857/301-443-5033.

Immunology, Allergic and Immunologic Diseases Research

Objectives: To assist public and private nonprofit institutions and individuals in establishing, expanding, and improving biomedical research and research training in allergic and immunologic diseases and related areas.

Eligibility: Universities, colleges, hospitals, laboratories, and other public or private nonprofit domestic institutions including state and local units of government.

Range of Financial Assistance: $6,000 to $1,878,000.

Contact: Grants Management and Operations Branch, National Institute of Allergy and Infectious Diseases, NIH, Department of Health and Human Services, Room 723, Bethesda, MD 20014/301-496-7075.

Indian Health Services—Health Management Development Program

Objectives: To improve the health of American Indians and Alaskan Natives by providing a full range of curative, preventive and rehabilitative health services, including public health nursing, maternal and child health care, dental and nutrition services, psychiatric care and health education and to increase the Indian communities' capacity to man and manage their own health programs.

Eligibility: Federally recognized tribes and tribal organizations.

Range of Financial Assistance: Up to $1,000,000.

Contact: Director, Indian Health Service, Department of Health and Human Services, 5600 Fishers Lane, Room 5A55, Rockville, MD 20857/301-443-1085.

Indian Health Services—Sanitation Management Development Program

Objectives: To alleviate unsanitary conditions, lack of safe water supplies and inadequate waste disposal facilities which contribute to infectious and gastroenteric diseases among Indians and Alaskan natives through environmental health activities, including construction of sanitation facilities for individual homes and communities.

Eligibility: Federally recognized tribes and tribal organizations.

Range of Financial Assistance: Up to $1,000,000.

Contact: Director, Indian Health Service, Department of Health and Human Services, 5600 Fishers Lane, Room 5A55, Rockville, MD 20857/301-443-1085.

Influenza Immunization Grants

Objectives: To assist states and communities in establishing and maintaining influenza immunization programs directed to persons in high-risk populations who are not at present receiving such services.

Eligibility: Any state, and political subdivisions of states and other public nonprofit institutions in consultation with state health authorities.

Range of Financial Assistance: $10,000 to $1,223,000.

Contact: Director, Center for Disease Control, Public Health Service, Department of Health and Human Services, 1600 Clifton Rd. N.E., Atlanta, GA 30333/404-329-3291.

Kidney Diseases, Urology and Hematology Research

Objectives: To support basic laboratory research and extramural clinical investigations and to provide postdoctoral biomedical research training for individuals interested in careers in health sciences and fields related to these programs.

Eligibility: Individuals and public and nonprofit institutions.

Range of Financial Assistance: $25,000 to $650,000.

Contact: Associate Director for Extramural Program Activities, National Institute of Arthritis, Metabolism and Digestive Diseases, NIH, Department of Health and Human Services, Westwood Building, Room 637, 5333 Westbard Ave., Bethesda, MD 20014/301-496-7277.

Laboratory Animal Sciences and Primate Research

Objectives: To provide animal resources with which the biomedical scientist can develop knowledge for prevention and control of disease in man through experimentation with animal models.

Eligibility: Public or nonprofit private institutions of higher education, hospitals, and other private, nonprofit institutions.

Range of Financial Assistance: $3,000 to $2,863,285.

Contact: Animal Resources Branch, Division of Research Resources, NIH, Department of Health and Human Services, Building 31, Room 5B59, Bethesda, MD 20205/301-496-5175.

Lung Diseases Research

Objectives: To use available knowledge and technology to solve specific disease problems of the lungs, to promote further studies on the structure and function of the lung, and to improve prevention and treatment of lung disease.

Eligibility: Nonprofit organizations engaged in biomedical research may apply for grant or contract support. Institutions or companies organized for profit may apply for contracts only. An individual may qualify for a research grant if he or she has adequate facilities in which to perform the research.

Range of Financial Assistance: $13,000 to $1,277,359.

Contact: Director, Division of Lung Diseases, National Heart, Lung, and Blood Institute, Department of Health and Human Services, Room 6A16, Bethesda, MD 20014/301-496-7208.

Maternal and Child Health Research

Objectives: To support research projects, which show promise of substantial contribution, relating to maternal and child health services or crippled children's services.

Eligibility: Public or other nonprofit institutions of higher learning, and public or other nonprofit agencies including state and local governments and organizations.

Range of Financial Assistance: $13,954 to $357,657.

Contact: Office for Maternal and Child

Health, Bureau of Community Health Service Administration, Department of Health and Human Services, 5600 Fishers Lane, Rockville, MD 20857/301-443-2190.

Maternal and Child Health Services

Objectives: To provide financial support to states to extend and improve services, especially in rural areas and in areas suffering from severe economic distress, for reducing infant mortality, improving the health of mothers and children, reducing the incidence of mental retardation and other handicapping conditions caused by complications associated with childbearing, and promoting the physical and dental health of children and youth of school or preschool age.

Eligibility: State health agencies and institutions of higher learning.

Range of Financial Assistance: $4,000 to $18,100,000.

Contact: Associate Bureau Director, Maternal and Child Health, Bureau of Community Health Services, Department of Health and Human Services, 5600 Fishers Lane, Room 7-39, Rockville, MD 20857/301-443-2170.

Maternal and Child Health Training

Objectives: To train personnel in the health care of mothers and children, particularly mentally retarded children and children with multiple handicaps.

Eligibility: Public and other nonprofit institutions of higher learning.

Range of Financial Assistance: $50,000 to $1,000,000.

Contact: Office for Maternal and Child Health, Health Services Administration, Department of Health and Human Services, 5600 Fishers Lane, Room 7-44, Rockville, MD 20857/301-443-2340.

Mechanisms of Environmental Diseases and Disorders

Objectives: To gain a thorough understanding of the mechanisms involved in disease processes and to prevent or reduce disease caused by environmental agents.

Eligibility: Universities, colleges, hospitals, state or local governments, or nonprofit research institutions.

Range of Financial Assistance: $15,000 to $390,000.

Contact: Research Grants and Research Career Development Awards: Associate Director for Extramural Programs, National Institute of Environmental Health Sciences, Department of Health and Human Services, P. O. Box 12233,

Research Triangle Park, NC 27709/919-541-3350.

Medical Assistance Program

Objectives: To provide financial assistance to states for payments of Medical Assistance on behalf of cash assistance recipients and, in certain states, on behalf of other individuals, who, except for income and resources, would be eligible for cash assistance.

Eligibility: State and local welfare agencies operating under an Health and Human Services-approved (Medicaid) state plan and complying with all federal regulations governing aid and medical assistance to the needy.

Range of Financial Assistance: $862,235 to $1,705,750.707.

Contact: Local Social Welfare office or Health Care Financing Administration, Department of Health and Human Services, 330 Independence Ave. S.W., Washington, DC 20201/202-245-0923.

Medical Facilities Construction

Objectives: To assist the states in the planning for and provision of medical facility modernization, new outpatient facilities, and new inpatient facilities in areas of recent rapid population growth.

Eligibility: State and local governments, U.S. territories, hospital districts or authorities, and private nonprofit organizations.

Range of Financial Assistance: $10,000 to $3,750,000.

Contact: Division of Health Facilities Financing, Compliance, and Conversion, Health Resources Administration, Public Health Service, Department of Health and Human Services, Hyattsville, MD 20782/301-436-6880.

Medical Facilities Construction— Project Grants

Objectives: To assist projects designed to prevent or eliminate safety hazards in publicly owned or operated medical facilities or to avoid noncompliance by such facilities with licensure or accreditation standards.

Eligibility: State and local governments, and public jurisdictions, authorities, corporations, or quasi-public coporations owning or operating a medical facility.

Range of Financial Assistance: $20,000 to $5,223,905.

Contact: Division of Facilities Financing, Bureau of Health Facilities, Financing, Compliance, and Conversion, Health Resource Administration, Public Health Service, Department of Health and Human Services, Hyattsville, MD 20782/301-436-6880.

Medical Library Assistance

Objectives: To improve health information services by providing funds to train professional library personnel, strengthen library resources, support biomedical publications, and conduct research in ways of improving information transfer. In addition, funds provide a network of regional medical libraries with the necessary resources and services to provide backup support for local medical libraries.

Eligibility: Public or private nonprofit institutions which maintain or plan to establish a collection or provide services to clientele in the health professions.

Range of Financial Assistance: $2,500 to $450,000.

Contact: Extramural Programs, National Library of Medicine, Department of Health and Human Services, Building 38A, Room 58N505, Bethesda, MD 20014/301-496-4671.

Mental Health—Children's Services

Objectives: To stimulate innovative approaches to children's mental health problems, emphasizing prevention and coordination of community services, and to expand training activities and broaden resources for children's mental health services.

Eligibility: Community mental health centers, and public or private nonprofit agencies.

Range of Financial Assistance: $26,355 to $691,481.

Contact: Division of Mental Health Service Program, National Institute of Mental Health, Department of Health and Human Services, 5600 Fishers Lane, Room 11C26, Rockville, MD 20857/301-443-3606.

Mental Health—Clinical or Service-Related Training Grants

Objectives: To maintain the existing capacity of training institutions to meet mental health manpower needs, while relating the types of personnel trained more closely to service priorities and manpower requirements.

Eligibility: Public or private nonprofit institutions and organizations, and state and local government agencies.

Range of Financial Assistance: $4968 to $346,536.

Contact: Director, Division of Manpower and Training Programs, National Institute of Mental Health, Department of Health and Human Services, 5600 Fishers Lane, Room 8-101, Rockville, MD 20857/301-443-4257.

Mental Health—Disaster Assistance and Emergency Mental Health

Objectives: To provide supplemental emergen-

cy mental health counseling to individuals affected by major disasters, including the training of volunteers to provide such counseling.

Eligibility: State, local or nonprofit agencies as recommended by the state governor and accepted by the Secretary.

Range of Financial Assistance: $7,000 to $462,000.

Contact: Mental Health Disaster Assistance Section, National Institute of Mental Health, Department of Health and Human Services, 5600 Fishers Lane, Room 1894, Rockville, MD 20857/301-443-4283.

Mental Health—
Hospital Improvement Grants

Objectives: To provide funds to state mental hospitals for projects which will improve the quality of care, treatment, and rehabilitation of patients, encourage transition to open institutions, and develop more cooperative relationships with community programs for mental health.

Eligibility: State hospitals for the mentally ill directly administered by the state agency responsible for mental hospitals, or installations not directly administered by the state agency but which are a part of the state's formal system for institutional care of the mentally ill.

Range of Financial Assistance: $43,730 to $100,000.

Contact: Director, Division of Mental Health Service Programs, National Institute of Mental Health, Department of Health and Human Services, 5600 Fishers Lane, Room 11C26, Rockville, MD 20857/301-443-3606.

Mental Health—Hospital Staff Development Grants

Objectives: To increase the effectiveness of staff in mental hospitals in providing effective services to patients and to help state hospitals achieve a more positive role as an integral part of community programs and to help communities benefit from such contributions toward comprehensive programs.

Eligibility: State hospitals for the mentally ill which are directly administered by the state agency responsible for mental hospitals, and installations not directly administered by the state agency, but which are a part of the state's formal system for institutional care of the mentally ill.

Range of Financial Assistance: $19,000 to $25,000.

Contact: Director, Division of Mental Health Service Programs, National Institute of Mental Health, Department of Health and Human Services, 5600 Fishers Lane, Room 11C26, Rockville, MD 20857/301-443-3606.

Mental Health—National Research Service Awards for Research Training

Objectives: To provide support to individuals for predoctoral and postdoctoral research training in specified mental health related areas, and to enable nonprofit institutions to develop research training opportunities for individuals interested in careers in a particular specified mental health related field.

Eligibility: Support is provided for predoctoral and postdoctoral academic and research training only, in health and health-related priority areas which are specified by the National Institute of Mental Health and includes child mental health, depression and suicide; schizophrenia; brain and behavior; psychoactive drugs, crime and delinquency; aging; minorities; program evaluation and mental health services management.

Range of Financial Assistance: $3,900 to $14,000.

Contact: National Institute of Mental Health, Division of Manpower and Training Programs, Department of Health and Human Services, 5600 Fishers Lane, Room 8-101, Rockville, MD 20857/301-443-4257.

Mental Health—Research Grants

Objectives: To develop new knowledge and approaches to the diagnosis, treatment, control and prevention of mental diseases in humans through basic, clinical, and applied research.

Eligibility: Investigators affiliated with public or nonprofit private agencies, including state, local, or regional government agencies, universities, colleges, hospitals, academic or research institutions, and other organizations.

Range of Financial Assistance: $1,434 to $388,917.

Contact: Director, Division of Extramural Research Programs, National Institute of Mental Health, Department of Health and Human Services, 5600 Fishers Lane, Room 10-105, Rockville, MD 20857/301-443-3563.

Mental Health—Research Scientist Development and Research Scientist Awards

Objectives: To provide support for research relating to the problems of mental illness and mental health and to raise the level of competence and to increase the number of individuals engaged in such research.

Eligibility: Research centers, medical schools, departments of psychiatry, psychiatric hospitals, community mental health centers, research institutes with mental health programs and behavioral sciences institutes with mental health research programs, on behalf of individuals.

Range of Financial Assistance: $15,000 to $39,852.

Contact: Division of Extramural Research Programs, National Institute of Mental Health, Department of Health and Human Services, 5600 Fishers Lane, Room 10-105, Rockville, MD 20857/301-443-3563.

Microbiology and Infectious Diseases Research

Objectives: To establish, expand, and improve biomedical research and research training in infectious diseases and related areas and to conduct developmental research, produce and test research materials, and provide research services programs in infectious diseases.

Eligibility: Universities, colleges, hospitals, laboratories and other public or private nonprofit domestic institutions, including state and local units of government.

Range of Financial Assistance: $4,000 to $451,000.

Contact: Grants Management and Operations Branch, National Institute of Allergy and Infectious Diseases, NIH, Department of Health and Human Services, Room 723, Bethesda, MD 20014/301-496-7075.

Migrant Health Grants

Objectives: To support the development and operation of migrant health centers and projects which provide primary ambulatory and in-patient, supplemental and environmental health services which are accessible to migrant and seasonal farm workers and their families.

Eligibility: Public or nonprofit private entities particularly community-based organizations which are representative of the populations to be served.

Range of Financial Assistance: $30,000 to $1,795,680.

Contact: Associate Bureau Director for Migrant Health, Bureau of Community Health Services, Department of Health and Human Services, 5600 Fishers Lane, Room 7A55, Rockville, MD 20857/301-443-1153.

Minority Access to Research Careers

Objectives: To assist minority institutions to train greater numbers of scientists and teachers in health related fields, increase the number of minority students who can compete successfully for entry into graduate programs in biomedical science fields.

Eligibility: Public or private nonprofit universities, colleges, hospitals, laboratories, or other institutions, including state or local units of government, or individuals.

Range of Financial Assistance: $3,900 to $200,000.

Contact: Program Director (MARC Program), National Institute of General Medical Sciences, NIH, Department of Health and Human Services, Room 9A18, Bethesda, MD 20014/301-496-9741.

Minority Biomedical Support

Objectives: To increase the numbers of ethnic minority faculty, students, and investigators engaged in biomedical research and to broaden the opportunities for participation in biomedical research of ethnic minority faculty, students and investigators.

Eligibility: Four-year colleges, universities, and health professional schools with over 50 percent minority enrollment, four-year institutions with significant but not necessarily over 50 percent minority enrollment, provided they have a history of encouragement and assistance to minorities; two-year colleges with 50 percent minority enrollment; and Indian tribal schools which have a recognized governing body and which perform substantial governmental functions.

Range of Financial Assistance: $100,000 to $300,000.

Contact: Minority Biomedical Support Program Branch, Division of Research Resources, NIH, Department of Health and Human Services, Bethesda, MD 20205/301-496-6743.

National Health Service Corps Scholarship Program

Objectives: To insure an adequate supply of physicians, dentists, and other health professionals for the National Health Service Corps for service in health manpower shortage areas in the United States.

Eligibility: Applicants must be accepted for or enrolled in an accredited educational institution, in a full-time course of study leading to a degree in medicine, osteopathy, dentistry, or other participating health professions; be eligible for, or hold, an appointment as a commissioned officer in the Regular or Reserve Corps of the Service or be eligible for selection for civil service employment; and submit application and signed contract to accept payment of a scholarship and to serve for the applicable period of obligated service in a health manpower shortage area.

Range of Financial Assistance: Average of $11,900.

Contact: National Health Service Corps Scholarship Program, Division of Student Services, Bureau of Health Personnel, Development and Services Administration, Public Health Service, Department of Health and Human Services, Center Building, 3700 East-West Highway, Hyattsville, MD 20782/301-436-6450.

Native American Programs

Objectives: To promote the goal of economic and social self-sufficiency for American Indians, Native Hawaiians, and Alaskan Natives.

Eligibility: Governing bodies of Indian tribes, Alaskan Native villages, and regional corporations and other public or private nonprofit agencies.

Range of Financial Assistance: $40,000 to $5,000,000.

Contact: Administration for Native Americans, Department of Health and Human Services, 330 Independence Ave. S.W., Room 5300, Washington, DC 20201/202-245-7776.

Neurological Disorders Research

Objectives: To support specific research and training directed toward understanding the causes, prevention, diagnoses and treatment of neurological disorders.

Eligibility: Public or private nonprofit institutions.

Range of Financial Assistance: $4,514 to $897,581.

Contact: Extramural Activities Program, NIH, Department of Health and Human Services, Room 1016, Bethesda, MD 20205/301-496-9234.

Nurse Practitioner Training Program and Nurse Practitioner Traineeships

Objectives: To educate registered nurses who will be qualified to provide primary health care.

Eligibility: State and local governments, public or nonprofit private schools or nursing, medicine, and public health, public or nonprofit private hospitals, and other public or nonprofit private entities.

Range of Financial Assistance: $3,900 to $332,297.

Contact: Division of Nursing, Bureau of Health Professions, Public Health Service, Department of Health and Human Services, 3700 East-West Highway, Center Building, Room 346 Hyattsville, MD 20782/301-436-6314.

Nurse Training Improvement—Special Projects

Objectives: To help schools of nursing and other institutions improve the quality and availability of nursing education through projects for specified purposes, such as opportunities for individuals from disadvantaged backgrounds.

Eligibility: Public and nonprofit private schools of nursing and other public or nonprofit private entities.

Range of Financial Assistance: $7,142 to $233,064.

Contact: Division of Nursing, Bureau of Health Professions, Health Resource Adminis-

tration, Public Health Service, Department of Health and Human Services, 3700 East-West Highway, Center Building, Room 346, Hyattsville, MD 20782/301-436-6314.

Nursing Capitation Grants

Objectives: To support the educational programs of nursing schools; applicants must insure that they will increase first-year enrollment of nursing students or carry out projects in two of four areas.

Eligibility: Public or other nonprofit school of nursing, accredited by the appropriate body or having reasonable assurance of accreditation.

Range of Financial Assistance: $1,039 to $413,967.

Contact: Division of Nursing, Bureau of Health Professions, Health Resources Administration, Public Health Service, Department of Health and Human Services, 3700 East-West Highway, Center Building, Room 346, Hyattsville, MD 20782/301-436-6314.

Nursing Research Project Grants

Objectives: To support basic and applied research activities in nursing education, practice, and administration.

Eligibility: Nonprofit organizations or institutions, government agencies, and occasionally individuals.

Range of Financial Assistance: $19,308 to $370,463.

Contact: Division of Nursing, Bureau of Health Professions, Health Resources Administration, Public Health Service, Department of Health and Human Services, 3700 East-West Highway, Center Building, Room 346, Hyattsville, MD 20782/301-436-6314.

Nursing Research Service Awards

Objectives: To prepare qualified professional nurses to conduct nursing research, collaborate in interdisciplinary research, and function as faculty in schools of nursing at graduate level.

Eligibility: Registered professional nurses with either a baccalaureate and/or a master's degree in nursing.

Range of Financial Assistance: $3,900 to $14,000.

Contact: Chief, Research Training Section, Division of Nursing, Department of Health and Human Services, 3700 East-West Highway, Center Building, Room 3-50, Hyattsville, MD 20782/301-436-6204.

Nursing Scholarships

Objectives: To enable students with exceptional financial need to pursue a course of study in

nursing by providing scholarship aid.

Eligibility: Accredited public schools of nursing, or nonprofit private schools of nursing located in a state eligible for grant awards.

Range of Financial Assistance: $256 to $54,329.

Contact: Student and Institutional Assistance Branch, Division of Student Services, Bureau of Health Manpower, Health Resources Administration, Public Health Service, Department of Health and Human Services, 3700 East-West Highway, Center Building, Room 9-50B, Hyattsville, MD 20782/301-436-6310.

Nursing Student Loans

Objectives: To assist students in need of financial assistance to pursue a course of study in professional nursing education by providing long-term low-interest loans.

Eligibility: Public and nonprofit private schools of nursing that prepare students for practice as registered nurses, and that meet accreditation requirements as defined in the Nurse Training Act of 1975.

Range of Financial Assistance: $920 to $135,046.

Contact: Student and Institutional Assistance Branch, Division of Student Services, Bureau of Health Manpower, Health Resources Administration, Public Health Service, Department of Health and Human Services, 3700 East-West Highway, Center Building, Room 9-50B, Hyattsville, MD 20782/301-436-6310.

Occupational Safety and Health Research Grants

Objectives: To understand the underlying characteristics of occupational safety and health problems and provide effective solutions in dealing with them.

Eligibility: Individuals, state or local governments, nonprofit organizations, state colleges or universities or public, private, junior or community colleges.

Range of Financial Assistance: $5,000 to $150,000.

Contact: Procurement and Grants Management Branch, OAMS Center for Disease Control, National Institute for Occupation Safety and Health, Department of Health and Human Services, 5600 Fishers Lane, Room 8-33, Rockville, MD 20857/301-443-3122.

Occupational Safety and Health Training Grants

Objectives: To develop specialized professional personnel with training in occupational medicine, nursing, industrial hygiene and safety.

Eligibility: State, local or private nonprofit institutions or agencies involved in training at technical, professional, or graduate level.

Range of Financial Assistance: $10,000 to $600,000.

Contact: Procurement and Grants Management Branch, OAMS, Center for Disease Control, National Institute for Occupational Safety and Health, Department of Health and Human Services, 5600 Fishers Lane, Rockville, MD 20857/301-443-3122.

Pain Control and Behavioral Studies

Objectives: To increase knowledge concerning the nature, etiology, pathophysiology, diagnosis and treatment of oral pain problems, and to achieve greater utilization of behavioral sciences knowledge in dental and oral problems.

Eligibility: Scientists at universities, hospitals, laboratories, and other public or private nonprofit institutions.

Range of Financial Assistance: $5,000 to $300,000.

Contact: Chief, Pain Control and Behavioral Studies Branch, Extramural Programs, National Institute of Dental Research, NIH, Department of Health and Human Services, Room 505, Bethesda, MD 20014/301-496-7491.

Periodontal Diseases Research

Objectives: To develop new knowledge which may lead to the prevention and eradication of periodontal diseases.

Eligibility: Scientists at universities, hospitals, laboratories, and other public or private nonprofit institutions.

Range of Financial Assistance: $5,000 to $300,000.

Contact: Grants and NRSA's, Extramural Programs, National Institute of Dental Research, NIH, Department of Health and Human Services, Room 408, Bethesda, MD 20014/301-496-7437.

Pharmacology-Toxicology Research

Objectives: To improve medical therapy through increased knowledge of the mechanisms of drug action, and of ways to increase efficacy and safety and diminish toxicity.

Eligibility: Public or private nonprofit universities, colleges, hospitals, laboratories, or other institutions, including state and local units of government, or individuals.

Range of Financial Assistance: $3,900 to $1,373,000.

Contact: Program Director (Pharmacology-Toxicology), National Institute of General Medical Sciences, NIH, Department of Health and

Human Services, Westwood Building, Room 919, Bethesda, MD 20014/301-496-7707.

Physiology and Biomedical Engineering

Objectives: To support basic research that applies concepts from mathematics, physics, and engineering to biological systems, uses engineering principles in the development of computers for patient monitoring, and is related to physiology, anesthesiology, trauma and burn studies, and related areas.

Eligibility: Public or private nonprofit universities, colleges, hospitals, laboratories, or other institutions, including states and local units of government, or individuals.

Range of Financial Assistance: $3,900 to $1,373,000.

Contact: Director (Physiology and Biomedical Engineering), National Institute of General Medical Sciences, NIH, Department of Health and Human Services, Westwood Building, Room 926, Bethesda, MD 20014/301-496-7891.

Population Research

Objectives: To seek solutions to the fundamental problems of the reproductive processes and develop and evaluate safer, more effective, and convenient contraceptives, and to understand how population dynamics affects the health and well-being of individuals and society.

Eligibility: Universities, colleges, medical, dental, and nursing schools, schools of public health, laboratories, hospitals, state and local health departments, other public or private nonprofit institutions, and individuals.

Range of Financial Assistance: $4,000 to $703,727.

Contact: Chief, Office of Grants and Contracts, National Institute of Child Health and Human Development, NIH, Department of Health and Human Services, Room 6A21, Bethesda, MD 20014/301-496-5001.

Prediction, Detection and Assessment of Environmentally Caused Diseases and Disorders

Objectives: To provide the scientific basis for effective forecasting technology, identification of sources, and understanding of the dynamics of transport and conversion of contaminants in environmentally induced health problems.

Eligibility: Universities, colleges, hospitals, state or local governments, or nonprofit research institutions.

Range of Financial Assistance: $7,000 to $580,000.

Contact: Associate Director for Extramural Programs, National Institute of Environmental Health Sciences, Department of Health and Human Services, P. O. Box 12233, Research Triangle Park, NC 27709/919-541-3350.

Predoctoral Training in Family Medicine

Objectives: To assist schools of medicine and osteopathy in meeting the costs of projects to plan, develop, and operate or participate in professional predoctoral training programs in the field of family medicine.

Eligibility: Accredited public or private nonprofit schools of medicine or of osteopathy.

Range of Financial Assistance: $34,560 to $324,387.

Contact: Director, Division of Medicine, Bureau of Health Manpower, Public Health Service, Department of Health and Human Services, 3700 East-West Highway, Center Building, Hyattsville, MD 20782/301-436-6418.

Professional Nurse Traineeships

Objectives: To prepare registered nurses as administrators, supervisors, teachers, nursing specialists, and nurse practitioners for positions in hospitals and related institutions, public health agencies, schools of nursing, and other roles requiring advanced training.

Eligibility: Institutions providing advanced nurse training.

Range of Financial Assistance: $4,800 to $611,774.

Contact: Division of Nursing, Bureau of Health Professions, Public Health Service, Department of Health and Human Services, 3700 East-West Highway, Center Building, Room 346, Hyattsville, MD 20782/301-436-6314.

Professional Standards Review Organizations

Objectives: To insure that health care services and medical items for which payment may be made in whole or in part conform to appropriate professional standards and are delivered in the most effective, efficient, and economical manner.

Eligibility: Voluntary, nonprofit groups of local physicians organized into Professional Standard Review Organizations meeting the requirements of the Social Security Act as amended, or other public nonprofit private groups the Secretary of Health and Human Services determines to be of sufficient professional competence and otherwise suitable.

Range of Financial Assistance: $175,000 to $1,200,000.

Contact: The Office of Professional Standards and Review Organization, Standards and Quality Bureau, Health Care Financing Administration, Department of Health and Human Services, 6325 Security Blvd., Dogwood East Building, Baltimore, MD 21207/301-594-9207.

Public Assistance Training Grants

Objectives: To provide training directly related to the provision of social services for staffs of designated state agencies, volunteers attached to the agency, and service delivery personnel of provider agencies as well as students preparing for employment in a designated state agency.

Eligibility: Designated state agencies.

Range of Financial Assistance: $13,000 to $11,461,000.

Contact: Division of Program Management, Office of Policy Development, Office of Human Development Services, Department of Health and Human Services, 330 C St. S.W., Washington, DC 20201/202-245-6233.

Public Health Special Project Grants

Objectives: To develop and strengthen graduate public health programs in biostatistics, epidemiology, health administration planning, or policy analysis, environmental and occupational health, and dietetics and nutrition.

Eligibility: Schools of public health accredited by the Council on Education for Public Health, or public or nonprofit educational institutions with related graduate programs.

Range of Financial Assistance: $1,173 to $165,802.

Contact: Grants Management Officer, Bureau of Health Professions, Center Building, Department of Health and Human Services, 3700 East-West Highway, Room 4-27, Hyattsville, MD 20782/301-436-6564.

Refugee Assistance—Soviet and Other Refugees

Objectives: To assist Soviet and other refugees (excluding Cuban and Indochinese refugees) to become self-supporting and independent members of American society, by providing grant funds to voluntary resettlement agencies currently resettling these refugees in the United States.

Eligibility: National voluntary resettlement agencies currently under contract to the U.S. Department of State to provide reception and initial placement services to the eligible recipient refugees.

Range of Financial Assistance: $60,000 to $15,000,000.

Contact: Office of Refugee Resettlement, Department of Health and Human Services, Switzer Building, 330 C St. N.W., Room 1332-E, Washington, DC 20201/202-245-0418.

Research for Mothers and Children

Objectives: To improve the health and well-being of mothers, children, and families, through study of the health problems of the period of life from conception through adolescence, centering on the major problems of pregnancy and infancy, developmental biology and nutrition, human learning and behavior, and mental retardation and developmental disabilities.

Eligibility: Universities, colleges, medical, dental and nursing schools, schools of public health, laboratories, hospitals, state and local health departments, other public or private nonprofit institutions, and individuals.

Range of Financial Assistance: $6,750 to $795,000.

Contact: Office of Grants and Contracts, National Institute of Child Health and Human Development, NIH, Department of Health and Human Services, Landow Building, Room 6A21, Bethesda, MD 20014/301-495-5001.

Residency Training in General Internal Medicine and/or General Pediatrics

Objectives: To promote the graduate education of physicians who plan to enter the practice of general internal medicine or general pediatrics.

Eligibility: Public or nonprofit private schools of medicine and osteopathy only for approved residency training programs or a new program with provisional approval.

Range of Financial Assistance: $22,252 to $382,094.

Contact: Division of Medicine, Bureau of Health Professions, Health Resources Administration, Public Health Service, Department of Health and Human Services, 3700 East-West Hwy, Center Building, Room 322, Hyattsville, MD 20782/301-436-6418.

Residency Training in the General Practice of Dentistry

Objectives: To plan, develop, and operate an approved residency program in the general practice of dentistry.

Eligibility: Public or private nonprofit schools of dentistry or accredited postgraduate dental training institutions.

Range of Financial Assistance: $20,000 to $250,000.

Contact: Professional Education Branch, Division of Dentistry, Bureau of Health Professions, Health Resources Administration, Public Health Service, Department of Health and Human Services, 3700 East-West Highway, Hyattsville, MD 20782/301-436-6510.

Restorative Materials Research

Objectives: To provide better dental care by fostering the development of improved materials and methods to restore lost oral tissues to normal form and function.

Eligibility: Scientists at universities, hospitals, laboratories, and other public or private nonprofit institutions.

Range of Financial Assistance: $5,000 to $300,000.

Contact: Extramural Programs, National Institute of Dental Research, NIH, Department of Health and Human Services, Bethesda, MD 20014/301-496-7492.

Retinal and Choroidal Diseases Research

Objectives: To support research and training to study retinal function and to advance understanding of how the retina is damaged by diseases and to develop methods of prevention, early detection, and treatment.

Eligibility: Universities, colleges, hospitals, laboratories, federal institutions and other public or private nonprofit domestic institutions, including state and local units of government.

Range of Financial Assistance: $10,000 to $300,000.

Contact: Director for Extramural and Collaborative Programs, National Eye Institute, NIH, Department of Health and Human Services, Building 31, Room 6A03, Bethesda, MD 20014/ 301-496-4903.

Risk Reduction

Objectives: To assist state and local health agencies to plan, coordinate and evaluate health education programs which emphasize personal choice behavior to reduce the health risks of preventable conditions and certain chronic diseases.

Eligibility: State health departments, local official health departments.

Range of Financial Assistance: $15,000 to $150,000

Contact: Director, Bureau of Health Education, Center for Disease Control, Department of Health and Human Services, Building 14, Room 1, Atlanta, GA 30333/404-329-3111.

Runaway Youth

Objectives: To develop local facilities to address the immediate needs of runaway youth.

Eligibility: State and local governments, localities or nonprofit private agencies, or coordinated networks of such agencies.

Range of Financial Assistance: $25,000 to $75,000.

Contact: Youth Development Bureau, Administration for Children, Youth and Families, Office of Human Development Services, Department of Health and Human Services, 400 6th. St. S.W., Washington, DC 20201/202-755-0590.

Scholarships for First-Year Students of Exceptional Financial Need

Objectives: To make funds available to authorized health professions schools to award scholarships to full-time, first-year health professions students of exceptional financial need.

Eligibility: Health professions schools fully accredited by a recognized accreditation body or have reasonable assurance of such accreditation.

Range of Financial Assistance: Average $10,000 a year.

Contact: Student and Institutional Assistance Branch, Division of Manpower Training Support, Bureau of Health Manpower, Health Resources Administration, Public Health Service, Department of Health and Human Services, 3700 East-West Hwy., Center Building, Room 9-50, Hyattsville, MD 20782/301-436-6310.

Sensory and Motor Disorders of Vision Research

Objectives: To support laboratory and clinical investigations of the optic nerve and the development and functions of those activities of the brain and the eye muscles which make vision possible, and for the development of rehabilitation techniques and vision substitution devices.

Eligibility: Universities, colleges, hospitals, laboratories, federal institutions and other public or private nonprofit domestic institutions including state and local units of government.

Range of Financial Assistance: $10,000 to $300,000.

Contact: Director for Extramural and Collaborative Programs, National Eye Institute, NIH, Department of Health and Human Services, Bethesda, MD 20014/301-496-4903.

Social Services for Low-Income and Public Assistance Recipients

Objectives: To enable states to provide social services to public assistance recipients and other low-income persons.

Eligibility: Designated state agencies.

Range of Financial Assistance: $56,000 to $290,733,000.

Contact: Office of Policy Development, Division of Research and Demonstration, Office of Human Development Services, Department of Health and Human Services, 330 C St. S.W., Room 723E2, Washington, DC 20201/202-245-6223.

Social Services Research and Demonstration

Objectives: To discover, test, demonstrate, and promote new social service concepts which will provide service to dependent and vulnerable populations such as the poor, the aged, children and youth.

Eligibility: States and nonprofit organizations.

Range of Financial Assistance: $50,000 to $175,000.

Contact: Division of Research, Demonstration, and Evaluation, Administration for Public Services, Department of Health and Human Ser-

vices, 330 C St. S.W., Room 732E2, Washington, DC 20201/202-245-6233.

Soft Tissue Stomatology and Nutrition Research

Objectives: To develop new knowledge which may lead to improved treatment and/or prevention of oral soft tissue diseases and conditions.

Eligibility: Scientists at universities, hospitals, laboratories, and other public or private nonprofit institutions.

Range of Financial Assistance: $5,000 to $300,000.

Contact: Extramural Programs, National Institute of Dental Research, NIH, Department of Health and Human Services, Westwood Building, Room 510, Bethesda, MD 20014/301-496-7807.

Special Alcoholism Projects to Implement the Uniform Act

Objectives: To assist states in their implementation of the provisions of the Uniform Alcoholism and Intoxication Treatment Act, which facilitates their efforts to approach alcohol abuse and alcoholism from a community care standpoint.

Eligibility: The state agency authorized by the state administers the grant program.

Range of Financial Assistance: $190,000 to $1,063,321.

Contact: State Planning Branch, Division of State and Community Assistance, National Institute on Alcohol Abuse and Alcoholism, Alcohol, Drug Abuse and Mental Health Administration, Public Health Service, Department of Health and Human Services, 5600 Fishers Lane, Room 11A05, Rockville, MD 20857/301-443-1273.

Special Grants for Former National Health Corps Members to Enter Private Practice

Objectives: To assist former National Health Service Corps members establish their own private practice in a health manpower shortage area.

Eligibility: Former National Health Service Corps members who have completed obligated service.

Range of Financial Assistance: $12,500 for one year or $25,000 for two years.

Contact: Director, Grants Management Office, Bureau of Community Health Services, Health Services Administration, Department of Health and Human Services Administration, 5600 Fishers Lane, Room 9A-16, Rockville, MD 20857/301-443-2226.

State Health Care Providers Survey Certification

Objectives: To provide financial assistance to any state which is able and willing to determine through its state health agency or other appropri-

ate state agency that providers of health care surveys are in compliance with statutory health and safety standards and conditions of participation in Medicare and Medicaid programs.

Eligibility: The designated state agency performing licensure activities within the state health departments.

Range of Financial Assistance: $14,000 to $3,833,700.

Contact: Office of State Certification, Health Standards and Quality Bureau, Health Care Financing Administration, Department of Health and Human Services, 1849 Gwynn Oak Ave., Dogwood East Building, Baltimore, MD 21207/301-597-2750.

State Health Planning and Development Agencies

Objectives: To provide support to the state health planning agencies conducting physical and mental health planning and development functions.

Range of Financial Assistance: $49,772 to $2,061,466.

Contact: Director, Bureau of Health Planning, Department of Health and Human Services, 3700 East-West Hwy., Center Building, Room 622, Hyattsville, MD 20782/301-436-6850.

State Medicaid Fraud Control Clinics

Objectives: To control fraud in the states' Medicaid program.

Eligibility: The single state agency which the Secretary certifies as meeting the requirements.

Range of Financial Assistance: $131,000 to $10,000,000.

Contact: Bureau of Quality Control, Health Care Financing Administration, Room 501 East, 6325 Security Blvd., Baltimore, MD 21235/301-594-5878.

Stroke, Nervous System Trauma Research

Objectives: To support specific research and research training directed toward understanding the causes, prevention, diagnosis and treatment of stroke and nervous system trauma.

Eligibility: Public or private nonprofit institutions.

Range of Financial Assistance: $2,460 to $995,373.

Contact: Extramural Activities Programs, NIH, Department of Health and Human Services, Bethesda, MD 20205/301-496-9234.

Sudden Infant Death Syndrome Information and Counseling Program

Objectives: To collect, analyze and furnish information relating to the cause of Sudden Infant

Death Syndrome (SIDS), to provide information and counseling to families affected by the Sudden Infant Death Syndrome, and to educate health professionals, emergency care providers and the general public.

Eligibility: Public or nonprofit private agencies, (including state and local governments), institutions or organizations.

Range of Financial Assistance: $37,000 to $181,000.

Contact: Associate Bureau Director, SIDS Program Office, Bureau of Community Health Services, Health Services Administration, Department of Health and Human Services, 5600 Fishers Lane, Room 7-36, Rockville, MD 20857/301-443-6600.

Traineeships for Students in Other Graduate Programs

Objectives: To support eligible students enrolled in accredited graduate degree programs in health administration, hospital administration, or health policy analysis and planning.

Eligibility: Accredited Public or nonprofit private educational entities (excluding Schools of Public Health) offering a graduate program in relevant areas.

Range of Financial Assistance: $11,800 to $305,910.

Contact: Grants Management Office, Bureau of Health Manpower, Department of Health and Human Services, 3700 East-West Highway, Center Building, Room 4-27, Hyattsville, MD 20782/301-436-6564.

Traineeship for Students in Schools of Public Health and Other Graduate Public Health Programs

Objectives: To support traineeships for students in graduate educational programs in schools of public health or other public or nonprofit educational entities (excluding programs eligible for support under program listed above).

Eligibility: Accredited schools of public health and other public or nonprofit educational entities which provide graduate or specialized training in public health.

Range of Financial Assistance: $6,036 to $608,533.

Contact: Bureau of Health Professions, Department of Health and Human Services, 3700 East-West Highway, Center Building, Room 541, Hyattsville, MD 20782/301-436-6800.

Training in Emergency Medical Services

Objectives: To meet the cost of training and to aid in the establishment, improvement or expansion of training programs in the techniques and methods of providing emergency medical services.

Eligibility: Public or nonprofit private accredited schools of medicine, dentistry, osteopathy or nursing; public or nonprofit private colleges or universities, or any other appropriate educational entity that is a public or nonprofit private organization.

Range of Financial Assistance: $14,800 to $342,658.

Contact: Director, Division of Medicine, Bureau of Health Manpower, Department of Health and Human Services, Hyattsville, MD 20782/301-436-6418.

Training of Physicians' Assistants

Objectives: To meet the cost of projects to plan, develop, operate or maintain programs for the training of physicians' assistants.

Eligibility: State and local government entities, or nonprofit private health or educational entities.

Range of Financial Assistance: $22,869 to $364,985.

Contact: Division of Medicine, Bureau of Health Professions, Health Resources Administration, Public Health Service, Department of Health and Human Services, 3700 East-West Hwy., Center Building, Hyattsville, MD 20782/301-436-6418.

Training United States Citizen Foreign Medical Students

Objectives: To train U.S. citizens who were students in foreign medical schools to meet the requirements for enrolling in schools of medicine or osteopathy in the States as full-time students with advanced standing and to provide assistance to those enrolled in schools of medicine with advanced standing, but whose level of competency in selected areas is not comparable to that of the U.S. trained counterparts.

Eligibility: Accredited public or private schools of medicine or osteopathy.

Range of Financial Assistance: $9,932 to $132,257.

Contact: Division of Medicine, Bureau of Health Professions, Health Resources Administration, Public Health Service, Department of Health and Human Services, 3700 East-West Hwy., Center Building, Hyattsville, MD 20782/301-436-6418.

Urban Rat Control

Objectives: To support comprehensive rat control activities in urban communities by improving the living environment to obviate rat proliferation and to promote the identification of local re-

sources during the project period to sustain the program's achievements.

Eligibility: State agencies, or after consultation with the appropriate state health authority, political subdivisions or instrumentalities of a state, and public and nonprofit agencies.

Range of Financial Assistance: $30,000 to $1,721,964.

Contact: Director, Center for Disease Control, Public Health Service, Department of Health and Human Services, 1600 Clifton Rd. N.E., Atlanta, GA 30333/404-329-3291.

Venereal Disease Control Grants

Objectives: To reduce morbidity and mortality by preventing cases and complications of venereal diseases.

Eligibility: States, and any political subdivisions of a state in consultation with the appropriate state health authority.

Range of Financial Assistance: $30,000 to $2,340,000

Contact: Director, Center for Disease Control, Public Health Service, Department of Health and Human Services, 1600 Clifton Rd. N.E., Atlanta, GA 30333/404-329-3291.

Venereal Disease Research, Demonstration, and Public Information and Education Grants

Objectives: To provide assistance to programs designed for the conducting of research, demonstrations, and public information and education for the prevention and control of venereal disease.

Eligibility: States, and other public or private nonprofit entities.

Range of Financial Assistance: $20,000 to $150,000

Contact: Director, Center for Disease Control, Public Health Service, Department of Health and Human Services, 1600 Clifton Rd. N.E., Atlanta, GA 30333/404-329-3291.

Work Incentive Program

Objectives: To move men, women, and out-of-school youth, age 16 or older, from dependency on grants to economic independence through meaningful, permanent, productive employment by providing appropriate employment training, job placement and other related services, supplemented by child care and other supportive social services when needed to enable a person to participate or secure employment.

Eligibility: States.

Range of Financial Assistance: Not specified.

Contact: Executive Director, National Coordination Committee, Work Incentive Program, Department of Health and Human Services, Room 5110, Washington, DC 20213/202-376-7030.

Youth Research and Development

Objectives: To support research, development, and evaluation efforts in the area of runaway youth and in broader youth development issues.

Eligibility: State or local governments or other nonprofit institutions of higher learning, and nonprofit agencies engaged in youth research.

Range of Financial Assistance: $15,000 to $400,000.

Contact: Youth Development Bureau, Administration for Children, Youth and Families, Office of Human Development Services, Department of Health and Human Services, Room 3853, Washington, DC 20201/202-755-0590.

Head Start

For information and expertise on Head Start programs, contact: Project Head Start, Department of Health and Human Services, P. O. Box 1152, Washington, DC 20013/202-755-7700.

Health Almanac

The National Institutes of Health (NIH) publishes a free almanac covering its activities. Topics covered include historical data on the Institute, biographical sketches of the Institute's research divisions, lists of NIH lectures, Nobel laureates, honors, exhibits, symposia, and major projects. Contact: Editorial Operations Branch, Division of Public Information, NIH, Department of Health and Human Services, Building 31, Room 2B03, Bethesda, MD 20205/301-496-4143.

Health Care Statistics and Publications

Both the Health Care Financing Administration (HCFA) and Social Security Administration collect data and analyze trends related to health and health care. For information on data and publications available, contact: Office of Public Affairs, HCFA, Department of Health and Human Services, 330 C St. S.W., Room 4236, Washington, DC 20201/202-245-8056, and Office of Research and Statistics, Social Security Administration, Department of Health and Human Services, 1875 Connecticut Ave. N.W., Washington, DC 20009/202-673-5602.

Health Care Technology

Information services on the latest technological developments for improving the safety, efficiency, effectiveness and cost effectiveness of health care are available from: National Center for Health Care Technology, Department of

Health and Human Services, 5600 Fishers Lane, Room 17A-29, Rockville, MD 20857/301-443-4990.

Health Education

The Bureau of Health Education provides professional services and consultative support in health education to organizations and individuals in both the public and private sectors. Its areas of interest include school health education, patient education, sex education, nutrition education for the elderly, and risk prevention, etc. Free publications include: *Focal Points,* a monthly newsletter, and *Current Awareness in Health Education.* Contact: Center for Health Promotion and Education, Center for Disease Control, Department of Health and Human Services, Building 14, Atlanta, GA 30333/404-329-3112.

Health Hazard Intelligence Reports

Current Intelligence Bulletins informs health professionals in government, industry, organized labor and universities about new health hazards or about new data on old hazards. These reports also capsulize background information about hazards and outline recommended action for controlling exposure. Some 32 bulletins are available free from: Criteria Development Branch, Division of Documentation and Technology Transfer, Department of Health and Human Services, 5600 Fishers Lane, Room 8-48, Rockville, MD 20857/301-443-3843.

Health Information Clearinghouse

The Clearinghouse serves as a public referral service for almost any question on health. Contact: National Health Information Clearinghouse, 1555 Wilson Blvd., Suite 600, Rosslyn, VA 22209/703-522-2590.

Health Insurance Guide

A *Guide to Health Insurance for People with Medicare* is available free from Office of Public Affairs, Health Care Financing Administration, Department of Health and Human Services, 330 C St. S.W., Room 5221, Washington, DC 20201/202-245-8056.

Health Maintenance Organizations (HMOs)

Those considering joining an HMO can obtain free pamphlets and other information to help in making their decision: Division of Program Promotion, Office of Health Maintenance Organizations, Department of Health and Human Services, 12420 Parklawn Dr., Rockville, MD 20857/301-443-2300. For information on programs and funding for Health Maintenance

Organizations (HMOs), contact: Office of Health Maintenance Organizations, Public Health Service, Department of Health and Human Services, 12420 Parklawn Dr., Room 3-10, Rockville, MD 20857/301-443-4106.

Health Research Information System

CRISP (Computer Retrieval of Information on Scientific Projects) provides up-to-date scientific information on research projects supported through various research grants and contracts from the Public Health Service. Contact: Research Documentation Section, Division of Research Grants, NIH, Department of Health and Human Services, 5333 Westbard Ave., Westwood Building, Room 148B, Bethesda, MD 20016/301-496-7543.

Health Service Corps

The National Health Service Corps provides health professionals to those areas designated as having critical shortages of such personnel. Contact: National Health Service Corps, Health Services Administration, 5600 Fishers Lane, Room R321, Rockville, MD 20857/301-443-4434.

Health Services Information

The National Center for Health Services Research is the main source of information and funding for general research on problems related to the quality and delivery of health service. The topics covered include long-term care, health care expenditures, health care for the disadvantaged, hospital cost and utilization, health care plans, ambulatory care and emergency medical services. Contact: National Center for Health Services Research, Office of Health Research, Statistics, and Technology, Public Health Service, Department of Health and Human Services, 3700 East-West Highway, Room 8-41, Hyattsville, MD 20782/301-436-6944.

Health Manpower

For information on the education, training and availability of doctors, dentists, nurses, veterinarians, pharmacists, optometrists, nurse practitioners, physician's attendants, dental assistants, dental technicians, allopathic and osteopathic physicians and podiatrists, contact: Office of Information, Bureau of Health Professions, Health Resources Administration, Department of Health and Human Services, 3700 East-West Hwy., Room 1044, Hyattsville, MD 20782/301-436-6448.

Health Planning Information Clearinghouse

Technical assistance and information is provid-

ed to state health planning and development agencies, state health coordinating councils, health systems agencies, and centers for health planning to help them develop health planning programs. Contact: National Health Planning Information Center, Bureau of Health Planning, Health Resources Administration, Department of Health and Human Services, 3700 East-West Hwy., Center Building, Room 6-50, Hyattsville, MD 20782/301-436-6716.

For a *free* catalogue of health planning publications, contact: Information Office, Bureau of Health Planning, Department of Health and Human Services, 3700 East-West Hwy., Center Building, Room 6-22, Hyattsville, MD 20782/301-436-6716.

Health Publications

A free catalogue of publications produced by the National Institutes of Health is available from: Public Information Division, NIH, Department of Health and Human Services, Room 305, Bethesda, MD 20205/301-496-4143.

Health Services Publications

A free directory is available describing those publications obtainable from the Health Services Administration, including those from the Bureau of Community Health Services, Bureau of Medical Services, Bureau of Quality Assurance, and the Indian Health Service. Contact: Office of Public Affairs, Health Services Administration, Department of Health and Human Services, 5600 Fishers Lane, Room 14A-55, Rockville, MD 20857/301-443-2086.

Health Standards Information Clearinghouse

The Clearinghouse collects information on topics such as: medical malpractice, necessity of surgery, peer review, and quality assessment of health care. Bibliographies, information services, publications, and referral services are also available. A free monthly publication, called *Information Bulletin* keeps subscribers current on news in health standards. Contact: National Health Standards and Quality Information Clearinghouse, 11301 Rockville Pike, Kensington, MD 20895/301-881-9400.

Health Statistics

The National Center for Health Statistics (NCHS) is the only federal agency established specifically to collect and disseminate data on health in the United States. The Center designs and maintains national data collection systems, conducts research in statistical and survey methodology, and cooperates with other agencies in the U.S. and in foreign countries in activities to increase the availability and usefulness of health data. Data are available in the form of published reports, computer tapes and specialized tabulations. Described below are those offices within the Center which perform the majority of the data collection activities:

Division of Health Interview Statistics, NCHS, Department of Health and Human Services, 3700 East-West Hwy., Room 2-44, FCB2, Hyattsville, MD 20782/301-436-7085. Conducts a continuing national household interview survey to obtain data on health and demographic factors related to illness, injuries, disability and costs and uses of medical services.

Division of Health Manpower and Facilities Statistics, NCHS, Department of Health and Human Services, 3700 East-West Hwy., Room 2-63, FCB2, Hyattsville, MD 20782/301-436-8522. Develops and maintains a national register for primary and allied health personnel, conducts health manpower surveys, establishes inventories of personnel in selected health occupations, and develops statistics on the characteristics of inpatient and outpatient health facilities.

Division of Health Care Statistics, NCHS, Department of Health and Human Services, 3700 East-West Hwy., Room 2-63, Hyattsville, MD 20782/301-436-8522. Compiles data on the utilization of health manpower and facilities providing long-term care, ambulatory care, hospital care, and family planning.
Division of Health Examination Statistics, NCHS, Department of Health and Human Services, 3700 East-West Hwy., Room 2-58, Hyattsville, MD 20782/301-436-7068. Collects data on nutritional status, health-related measurements, prevalence of chronic diseases and related health care needs, and on physical and intellectual growth and development patterns.

Division of Vital Statistics, NCHS, Department of Health and Human Services, 3700 East-West Hwy., Room 1-44, Hyattsville, MD 20782/301-436-8952. Collects data on births, deaths, fetal deaths, marriages, and divorces.

For a central source on health statistics, contact: National Center for Health Statistics, Scientific and Technical Information Branch, 3700 East-West Hwy., Room 1-57, Hyattsville, MD 20782/301-436-8500. See also "Health Care Statistics and Publications" in this section.

Health Statistics Publications

Statistical Notes for Health Planners is a series of free reports which provide information on methodology for using existing data available from federal programs. *Bibliography on Health Indexes,* available free, is published four times a year and identifies relevant articles, reports and conferences on the subject of health data. For

copies of these publications and further information on other available publications, see address directly above for the National Center for Health Statistics.

Healthy Volunteers

The National Institutes of Health operates a number of programs that require healthy persons to provide an index of normal body functions against which to measure the abnormal. These "Normal Volunteers" receive a per diem plus expenses and health services. Many of the volunteers work only during holidays or in their free time. Contact: Normal Volunteer Program, Clinical Center, NIH, Department of Health and Human Services, Building 10, Room 7D50, Bethesda, MD 20205/301-496-4763.

Hearing Aids

A free book entitled *Facts About Hearing and Hearing Aids* is available to consumers and other interested parties from: Office of Consumer Affairs, Food and Drug Administration, Department of Health and Human Services, 5600 Fishers Lane, Rockville, MD 20857/301-443-3170.

High Blood Pressure Information Center

The Center acts as a clearinghouse for high blood pressure information. It provides educational materials and technical assistance to those in both the private and public sector who wish to control high blood pressure, and maintains a speaker's roster and manages an exhibit program. A free newsletter, called *Information Memorandum*, is published eight times per year, announces new projects and the availability of educational materials. Contact: High Blood Pressure Information Center, National Heart, Lung and Blood Institute, NIH, Department of Health and Human Services, 1501 Wilson Blvd., Arlington, VA 22209/703-558-4880.

High Blood Pressure Screening Programs

If you are interested in establishing a high blood pressure screening program in your office or factory, the High Blood Pressure Information Center will send an expert to help with the program. See address directly above.

Illness and Injury Data Base

See "Occupational Safety and Health Information Clearinghouse" in this section.

Indian Health

Some 51 hospitals, 99 health centers and several hundred field health stations have been established to raise the health status of the American Indian and Alaskan Native. Contact: Indian Health Service, Office of Tribal Affairs, Health Services Administration, Department of Health and Human Services, 5600 Fishers Lane, Room 5A43, Rockville, MD 20857/301-443-1104.

Industrial Hygiene

The National Institute for Occupational Safety and Health (NIOSH) conducts research on eliminating on-the-job hazards to the health and safety of workers. Their activities include identifying hazards and determining methods to control them, recommending federal standards to limit hazards, providing training to help alleviate the critical shortage of occupational safety and health manpower, offering a series of courses, supporting education and resource centers at colleges and universities, providing long-term training to upgrade the knowledge and skills of professionals in the field, and making on-the-job investigations in response to requests of reported worker exposures. Contact: NIOSH, Center for Disease Control, Public Health Service, Department of Health and Human Services, 5600 Fishers Lane, Room 805, Rockville, MD 20857/301-443-1530.

Industry Health Studies

The National Institute for Occupational Safety and Health (NIOSH) conducts in-depth studies on health hazards in specific industries. Approximately 60 studies are being conducted at any one time; topics include causes of death at oil refineries and asbestos-related deaths. Contact: Division of Surveillance, Hazard Evaluation and Field Studies, NIOSH, Center for Disease Control, Public Health Service, Department of Health and Human Services, 4676 Columbia Pky, Cincinnati, OH 45226/513-684-2427.

Infant Care

A free book entitled *Infant Care,* is available from: Publications, Administration for Children, Youth and Families, Department of Health and Human Services, P. O. Box 1182, Washington, DC 20013/202-755-7724.

International Health Sciences Studies

The National Institutes of Health provides a forum for study, discussion and dialogue between international scholars and the American biomedical community. They provide access to the international community to their laboratories and libraries. Awards are presented for post-doctoral fellowships to foreign scientists. A free listing of publications on international health science is available upon request. Contact: John E. Fogarty, International Center for Advanced Study

in the Health Sciences, NIH, Department of Health and Human Services, Building 38a, Room 609, Bethesda, MD 20205/301-496-1415.

Library of Medicine

The National Library of Medicine is the world's largest research library in a single scientific and professional field. The Library collects materials exhaustively in some 40 biomedical areas and, to a lesser degree, in such related subjects as general chemistry, physics, zoology, botany, psychology, and instrumentation. The holdings include 1.5 million books, journals, technical reports, documents, theses, pamphlets, microfilms, and pictorial and audiovisual materials. More than 70 languages are represented in the collection. Those who are unable to visit the Library can access the information through:

Interlibrary loans—any library can request a copy of an article or document for you, or the Library of Medicine will send you a copy at no charge.

MEDLARS (Medical Literature Analysis and Retrieval System)—a computerized data base on medical literature, available in approximately 1,000 medical libraries throughout the country. The public can access this data base; however, there may be a small fee involved. Your local college or university or Veterans Administration Hospital is likely to have access to the system. See "Literature Searches on Health Science" below for a full description.

Contact: National Library of Medicine, NIH, Department of Health and Human Services, Rockville, MD 20209/301-496-6095.

Literature Searches on Health Sciences

The National Library of Medicine maintains a computerized data base called MEDLARS (Medical Literature Analysis and Retrieval System). The system contains some 4,500,000 references to journal articles and books in health sciences published after 1965. Access to the data base can be made through a number of centers around the country. The charge for a search varies among centers: Some absorb all or more of the costs; others levy a modest fee. The location of local centers can be obtained from the National Library of Medicine. The data bases available on the network include:

MEDLINE—600,000 references to biomedical journal articles published in the current and preceding years.

TOXLINE (Toxicology Information Online)—520,000 references from the last five years on published human and animal toxicity studies, effects of environmental chemicals and pollutants, and adverse drug reactions.

CHEMLINE (Chemical Dictionary Online)—760,000 names for chemical substances, representing 380,000 unique compounds.

RTECS (Registry of Toxic Effects of Chemical Substances)—toxicity data for 31,600 substances.

TDB (Toxicology Data Bank)—chemical, pharmacological, and toxicological information and data on approximately 2,500 substances.

SERLINE (Serials Online)—bibliographic information for about 30,000 serial publications.

AVLINE (Audiovisual Online)—citations to some 6,000 audiovisual teaching packages used in health sciences education at the college level and for the continuing education of practitioners.

Health Planning and Administration—100,000 references to literature on health planning, organization, financing, management, manpower, and related subjects.

HISTLINE (History of Medicine Online)—35,000 references to articles, monographs, symposia, and other publications dealing with the history of medicine and related sciences.

CANCERLIT (Cancer Literature)—140,000 references dealing with various aspects of cancer.

CANCERPRO (Cancer Research Projects)—20,000 descriptions of ongoing cancer research projects from the current and preceding two years.

CLINPROT (Clinical Cancer Protocols)—summaries of clinical investigations of new anticancer agents and treatment techniques.

BIOETHICSLINE—6,500 references to materials on bioethical topics such as euthanasia, human experimentation, and abortion.

EPILEPSYLINE—25,000 references and abstracts to articles on epilepsy.

Some of the special interest data bases mentioned above are also available through the relevant information clearinghouses described in this section. Contact: Office of Inquiries and Publications Management, National Library of Medicine, Department of Health and Human Services, 8600 Rockville Pike, Room M121, Bethesda, MD 20209/301-496-6308.

Loans and Loan Guarantees

The programs described below are those which offer financial assistance through the lending of federal monies for a specific period of time or program in which the federal government makes

an arrangement to indemnify a lender against part or all of any defaults by the borrower.

Health Maintenance Organizations

Objectives: To stimulate the development and increase the number of various models of prepaid, comprehensive health maintenance organizations (HMOs) throughout the United States and the expansion of federally qualified health maintenance organizations.

Eligibility: Public and private nonprofit organizations that plan to develop, operate and expand an HMO, and private organizations including profit-making organizations, that plan to develop or operate and expand an HMO in a medically underserved area.

Range of Financial Assistance: Up to $2,500,000.

Contact: Office of Health Maintenance Organizations, Public Health Service, Department of Health and Human Services, 12420 Parklawn Dr., Rockville, MD 20857/301-443-2560.

Medical Facilities Construction Loans and Loan Guarantees

Objectives: To assist the states in the planning for and provision of medical facility modernization, additional outpatient facilities, and additional inpatient facilities in areas of recent rapid population growth.

Eligibility: State and local governments and all entities having bonding authority are eligible for direct loans. Private nonprofit organizations are eligible for mortgage loan guarantees.

Range of Financial Assistance: $75,000 to $17,542,000.

Contact: Bureau of Health Facilities Financing, Compliance and Conversion, Health Resources Administration, Public Health Service, Department of Health and Human Services, Room 544, Hyattsville, MD 20782/301-436-6880.

Medicaid

The Medicaid program through grants to states provides medical services to the medically needy. See "Grants—Medical Assistance Program" in this section. For answers to questions on Medicaid, contact your local welfare office or Director, Inquiries Staff, Bureau of Program Policy, Health Care Financing Administration, Department of Health and Human Services, 6325 Security Blvd., East Lowrise Building, Room 1P4, Baltimore, MD 21207/301-594-9032.

Medicaid Statistics

Medicaid data are available describing such elements as the number of recipients by age, sex and race, the amount of payments by state, and the number of days recipients have been hospitalized. *Medicaid Statistics*, a free monthly publication, keeps subscribers current on latest developments. Contact: Medicaid Program Data Branch, Office of Research, Demonstration and Statistics, Health Care Finance Administration, Department of Health and Human Services, 6340 Security Blvd., Room 1-A-13, Baltimore, MD 21235/301-597-1411.

Medical Devices

The Bureau of Medical Devices accumulates information and expertise on surgical and rehabilitation devices; gastro/urology and general use devices; anesthesiology and neurology devices; clinical laboratory devices, cardiovascular devices, ophthalmic, ear, nose, throat and dental devices, ob/gyn and radiology devices. Contact: Device Experience Branch, Bureau of Medical Devices, Food and Drug Administration, Department of Health and Human Services, 8757 Georgia Ave., Room 1222C, Silver Spring, Md 20910/301-427-8100.

Medical Devices—Technical Assistance for Small Business

The Food and Drug Administration (FDA) offers free technical assistance to help small manufacturers comply with the new safety and performance requirements for medical devices. Resident experts provide assistance by handling inquiries over the telephone or by mail, presenting workshops and conferences, and by making on-site visits. A free newsletter called *Small Manufacturers Memo* describes new developments in device regulation. Contact: Office of Small Manufacturers Assistance, Bureau of Medical Devices, Food and Drug Administration, Department of Health and Human Services, HFK-60, 8757 Georgia Avenue, Room 1431, Silver Spring, MD 20910/301-427-7184.

Medical Malpractice

See "Health Standards Information Clearinghouse" in this section.

Medical Sciences

For information on the latest research and training being conducted in the medical sciences, including cellular and molecular basis diseases, genetics, pharmacologic sciences, physiology, and biomedical engineering, contact: Office of Research Reports, National Institute of General Medical Sciences, NIH, Department of Health and Human Services, 533 Westbard Ave., Westwood Building, Room 9A10, Bethesda, MD 20205/301-496-7301.

Medicare

Medicare is a health insurance program for almost everybody over 65 years old and for certain disabled people under 65. See "Direct Payments" in this section. For answers to questions on Medicare, see "Social Security Administration" in your telephone book. Individual assistance is also available from: Bureau of Program Policy, Health Care Financing Administration, Department of Health and Human Services, 6325 Security Blvd., Room 100, Baltimore, MD 21234/301-594-9324.

Mental Health Information
Clearinghouse

Free data base searches and other information sources are available including free copies of publications on the following topics: dyslexia, hyperactive children, psychopharmacology, suicide, depressive illness, mental health and the law, art therapy, guilt, stress and schizophrenia. Contact: National Clearinghouse for Mental Health Information, National Institute of Mental Health, Department of Health and Human Services, 5600 Fishers Lane, Room 11A33, Rockville, MD 20857/301-443-4517.

Mental Health, National Institute of

Information and expertise are available on a wide variety of topics concerned with mental health and the treatment of mental illnesses. Contact: Public Inquiries, National Institute of Mental Health, Alcohol, Drug Abuse and Mental Health Administration, Department of Health and Human Services, 5600 Fishers Lane, Room 11A21, Rockville, MD 20857/301-443-4515.

Mental Retardation

The President's Committee on Mental Retardation is a study, evaluation and planning office which coordinates mental retardation programs in agencies and organizations. It answers questions from the public, maintains data bases on trends, population and nature of programs, and publishes reports. Two directories are available upon request: *Directory of Services to the Handicapped,* which lists what agency is doing what for the mentally retarded; and *Directory of Funding Possibilities.* Contact: President's Committee on Mental Retardation, Department of Health and Human Services, Room 4025, Washington, DC 20201/202-245-7634.

Mine Health Standards

For information on mine health standards, including health hazards and worker exposure, contact: Mine Health Standards Branch, Division of Criteria Documentation and Standards Development, Department of Health and Human Services, 5600 Fishers Lane, Room 8A-46, Rockville, MD 20857/301-443-4614.

Minority Group Mental Health

For information and expertise related to the improvement of the quality of life for minority groups—American Indians, Alaskan Natives, Asian Americans, Pacific Islanders, Blacks and Hispanics, the elimination of racism and increasing the quantity and quality of minority mental health professionals, contact: Center for Minority Group Mental Health Programs, National Institute of Mental Health, Alcohol, Drug Abuse, and Mental Health Administration, Public Health Service, Department of Health and Human Services, 5600 Fishers Lane, Room 18C04, Rockville, MD 20857/301-443-3724.

Missing Persons

The Social Security Administration can help you contact a lost loved one, an old friend or other missing person. The procedure is to write a letter to your missing person and send it to the Social Security Administration, along with as much personal information as possible, e.g., date of birth and last place of residence. If it can locate the person in its files, it will forward your letter; it will not give you the current address. For further assistance, call information for the number of your local Social Security Administration office, or send your letter along with pertinent information to Social Security Administration, Public Inquiries, Department of Health and Human Services, 6501 Security Blvd., Baltimore, MD 21235.

Narcotic Addiction

See "Drug Abuse" in this section.

National Health Insurance

For information on the status of National Health Insurance in the White House and/or Congress, contact: Office of Planning and Evaluation, Department of Health and Human Services, 200 Independence Ave. S.W., Room 442, Washington, DC 20201/202-245-1870.

NIH Grant Information

For information on past and current grants and awards made by the National Institutes of Health (NIH), as well as information on policies and procedures for funding, contact: Office of Grants Inquiries, NIH, Department of Health and Human Services, 5333 Westbard Ave., Westwood Building, Room 449, Bethesda, MD 20205/301-496-7441.

Occupational Health Data by Industry and Chemical

The National Institute for Occupational Safety and Health (NIOSH) maintains a data base which analyzes environmental, medical, and demographic data on industrial employees. Special reports can be generated categorized by industry or chemical. Contact: Division of Surveillance Hazard Evaluation, NIOSH, Center for Disease Control, Department of Health and Human Services, 4676 Columbia Pkwy., Cincinnati, OH 45226/513-684-3616.

Occupational Safety and Health College Courses

The National Institute for Occupational Safety and Health (NIOSH) sponsors training courses for professionals independently or through colleges. For a list of available training programs, contact: Division of Training and Manpower Development, NIOSH, Center for Disease Control, Department of Health and Human Services, 4676 Columbia Pkwy., Cincinnati, OH 45226/513-684-8221.

Occupational Safety and Health Information Clearinghouse

The clearinghouse provides answers to both technical and nontechnical questions. In addition to maintaining a technical library and providing free copies of pamphlets and publications, it also maintains the following data bases:

National Occupational Hazard Survey—identifies those agents to which workers in various industries are commonly exposed; it also includes information on the companies in the industry and the protection equipment required.

NIOSH Technical Information Center—contains information on toxicology, analytical methods, engineering, chemical names, and syndromes.

A catalogue of publications is also available. Contact: Clearinghouse for Occupational Safety and Health Information, NIOSH, Center for Disease Control, 4676 Columbia Pkwy., Cincinnati, OH 45226/513-684-8326.

Physical Fitness Award

All schools and youth groups in the United States which have qualified physical education and/or physical fitness personnel can offer the Presidential Physical Fitness Award Program. Youths qualify by passing six test items—a sprint, an endurance run, an agility run, standing long jump, situps, and a test of arm and shoulder strength. Contact: President's Council on Physi-

cal Fitness and Sports, Department of Health and Human Services, 400 6th St. S.W., Washington, DC 20201/202-755-8801.

Physical Fitness Bibliography

Physical Fitness/Sports Medicine is the most comprehensive bibliographic service available on exercise physiology, sports injuries, physical conditioning, and the medical aspects of exercise. This quarterly publication is available for $8.50 per year from Superintendent of Documents, Government Printing Office, Washington, DC 20402/202-783-3238.

Physical Fitness and Health Promotion

For information and expertise relating to such topics as preventive medicine, health promotion, physical fitness and sports medicine, contact: Office of Health Information, Health Promotion, Physical Fitness and Sports Medicine, Public Health Service, Department of Health and Human Services, 200 Independence Ave. S.W., Room 721B, Washington, DC 20201/202-472-5660.

Physical Fitness and Sports Information

The President's Council on Physical Fitness and Sports will supply information and expertise for those who wish to establish physical fitness programs. Available free publications include *Run for Yourself—An Introduction to Running, Exercise and Weight Control, An Introduction to Physical Fitness, Physical Education—A Performance Checklist, The Physically Undeveloped Child,* and *Youth Physical Fitness.* Contact: President's Council on Physical Fitness and Sports, Department of Health and Human Services, 400 6th St. S.W., Washington, DC 20201/202-755-8801.

Poison Information Clearinghouse

Literature searches and expert referral services are available to the public, as are brochures, flyers, pamphlets, posters, films, slide talks and media aids on the subject of poison control. Poisoning case reports are collected by a product's category and trade name, and a directory of local poison control centers is available. Contact: National Clearinghouse for Poison Control Center, Bureau of Drugs, Food and Drug Administration, Department of Health and Human Services, 5600 Fishers Lane, Room 13-45, Rockville, MD 20857/301-443-6260.

Pregnancy

Current information and expertise are available on such topics as pregnancy, the birth process, intrauterine development and disorders of

infants, including low birth weight, prematurity, Sudden Infant Death Syndrome, and other problems that may originate before birth, at birth, or during early adaption to life outside the womb. Contact: Pregnancy and Perimatology Section, Clinical Nutrition and Early Development Branch, National Institute of Child Health and Human Development, Department of Health and Human Services, Landow Building, Room 7C09, 7910 Woodmont Ave., Bethesda, MD 20205/301-496-5575.

Public Health Hospitals and Clinics

For a listing of eight Public Health Service hospitals and 26 clinics, contact: Bureau of Medical Services, Health Services Administration, Department of Health and Human Services, 6525 Belcrest Rd., West Hyattsville, MD 20782/301-436-6261.

Radiation

Information and expertise are available on radiation and the effects of radiation exposure. Subject areas covered include medical x-rays, medical radiation therapy, lasers, microwave, ionizing radiation, nuclear medicine, radioactive materials, ultra-sound, ultraviolet light, TV radiation, and X-raying baggage. Contact: Bureau of Radiological Health, Food and Drug Administration, Department of Health and Human Services, HFX 25, 5600 Fishers Lane, Rockville, MD 20857/301-443-3434.

Rape Information Clearinghouse

Information services are available to assist in identifying projects, funding, publication and other specialized expertise on topics involving the prevention and control of rape. A free directory of rape crisis centers is also available. Contact: National Center for the Prevention and Control of Rape, National Institute of Mental Health, Department of Health and Human Services, 5600 Fishers Lane, Room 15-99, Rockville, MD 20857/301-443-1910.

Refugee Assistance

A number of grant and direct payment programs are aimed to assist Cuban, Indochinese, and Soviet refugees. See "Grants" and "Direct Payments" in this section.

Regulatory Activities

Listed below are those organizations within the Department of Health and Human Services which are involved with regulating various business activities. Regulatory activities generate large amounts of information on the companies and subjects they regulate, and much of the information is available to the public. A regulatory office also can tell you your rights when dealing with a regulated company.

Food and Drug Administration, Office of Public Affairs, Department of Health and Human Services, 5600 Fishers Lane, Rockville, MD 20852/302-443-1544. Administers programs which protect the public against impure and unsafe foods, drugs and cosmetics, and from the hazards of unsafe medical devices and electronic products which produce radiation exposure.

Office of Civil Rights, Public Affairs Division, Department of Health and Human Services, 300 Independence Ave. S.W., Washington, DC 20201/202-245-6671. Enforces the Civil Rights Act of 1964 which prohibits discrimination with regard to race, color, national origin, sex, age and physical or mental handicap in programs and activities receiving federal financial assistance.

Rehabilitation Magazine

Professionals working with the handicapped can keep current on new programs, innovations and other news in the field by subscribing to *American Rehabilitation*. Subscriptions to the bimonthly publication are available for $11.00 from Superintendent of Documents, Government Printing Office, Washington, DC 20402/202-783-3238.

Research Data

The Department of Health and Human Services commissions hundreds of studies every year which contain data and information of value to both the business community and the general public. To identify relevant studies, review the list of grant-giving offices. (See "Grants" in this section.) Then request a listing of recent studies from those offices which cover subjects which may be of interest to you—e.g., on alcoholism if you are a member of the beverage industry. Other sources provide a selected collection of commissioned studies. See "National Institutes of Health Grant Information," "Health Research Information System," and "Health Statistics," in this section.

Runaway Hotline

The National Runaway Hotline provides advice to both parents and runaways. The service is confidential and operates 24 hours a day. Call toll-free 800-621-4000: 800-972-6004 in Illinois.

Runaway Youths

For information and expertise on Runaway Youth Programs or for a directory of available programs, contact: Division of Runaway Youth

Programs, Administration for Children, Youth and Families, Department of Health and Human Services, P. O. Box 1182, Washington, DC 20013/202-755-0593.

Scholarship Hotline for Health Service Corps

Scholarships that pay all tuition and fees at medical, osteopathy or dental schools are available for those willing to serve at least two years in the National Health Corps. Contact: National Health Service Corps, Scholarship Program, Health Resources Administration, Department of Health and Human Services, 3700 East-West Hwy., Room G15, Hyattsville, MD 20782/toll-free 800-638-0824: call collect: 301-436-6453 in Alaska, Hawaii and Maryland.

Scholarships—Medical, Dental and Nursing

See "Grants" in this section.

Second Opinion Hotline

The Health Care Financing Administration operates a toll-free hotline referral system for supplying names of physicians who will give second opinions on nonemergency surgery. Contact: Health Care Financing Administration, Health Standards and Quality Bureau, Department of Health and Human Services, 330 C St. S.W., Room 5329, Washington, DC 20201/toll-free 800-638-6833: 800-492-6603 in Maryland.

Sickle Cell Directory

A free directory is available describing national, federal and local sickle cell disease programs, along with a listing of comprehensive sickle cell centers, screening and education clinics and national centers for family planning. Contact: Sickle Cell Disease Branch, Division of Blood Disease and Resources, National Heart, Lung and Blood Institute, NIH, Department of Health and Human Services, Federal Building, 7550 Wisconsin Ave., Room 504, Bethesda, MD 20015/301-496-6931.

Small Business Health and Safety Guides

More than 25 handbooks covering the most common violations of Occupational Safety and Health Administration (OSHA) standards in a particular type of business, as well as guidelines for preventing injuries and illnesses are free from: Publications Dissemination, Department of Health and Human Services, 4676 Columbia Pkwy., Cincinnati, OH 45226/513-684-4287.

Smoking and Health Information Center

The Office on Smoking and Health handles written and telephone inquiries on scientific and technical aspects of smoking and health. It will perform computerized literature searches on its specialized data base containing over 12,000 records. The following publications are available for free:

Smoking and Health Bulletin
Bibliography on Smoking and Health
Health Consequences of Smoking
Directory of On-Going Research in Smoking and Health
State Legislation on Smoking and Health

Contact: Technical Information Center, Office on Smoking and Health, 5600 Fishers Lane, Room 1-16, Rockville, MD 20857/301-443-1690.

Social Security

Social Security is the basic method of providing a continuing income when family earnings are reduced or stopped because of retirement, disability or death. Monthly benefits include retirement checks, disability checks, survivor checks, and Medicare (see "Direct Payments" in this section). The following pamphlets are available for free:

Your Social Security
Social Security Information for Young Families
Thinking About Retiring
If You Work After You Retire
Social Security Survivors Benefits
Applying for a Social Security Number
Check Your Social Security Record
If You Become Disabled
Social Security Benefits for People Disabled Before Age 22
A Brief Explanation of Medicare
How Medicare Helps During a Hospital Stay
Medicare Coverage in a Skilled Nursing Facility
Home Health Care Under Medicare
Social Security Income for the Aged, Blind and Disabled
A Guide to Supplemental Security Income
A Woman's Guide to Social Security
Social Security and Your Household Employee
If You're Self-Employed . . . Reporting Your Income for Social Security
Farmers . . . How to Report Your Income for Social Security
Social Security Checks for Students 18 to 22
The Advantages of Social Security, A Message for State and Local Government Employee Groups

Information services are also available to handle questions concerning Social Security benefits. Call information in your area for the number of your local Social Security office, or contact: Office of Public Inquiry, Social Security Administration, Department of Health and Human

Services, 6401 Security Blvd., Baltimore, MD 20235/301-594-7700.

Social Security Checks

If your Social Security check has been lost, stolen, or delayed, contact the nearest office listed in your telephone book under "Social Security Administration," or Social Security Administration, Department of Health and Human Services, 6401 Security Blvd., Baltimore, MD 21235/301-594-7700.

Social Security Health and Welfare Statistics

The Social Security Administration collects and publishes data on a wide variety of health and welfare topics, including health insurance, supplementary security income, social security and the economy, old age survivors and disability health insurance, Black Lung disability, public assistance, Medicare, GNP and social welfare expenditures, and estimates of the labor forces covered under social insurance. Contact: Office of Research and Statistics, Social Security Administration, Department of Health and Human Services, 1875 Connecticut Ave. N.W., Room 1121, Washington, DC 20009/202-673-5602.

Sports

See "Physical Fitness" in this section.

Sports Awards

Anyone over the age of 15 can earn the Presidential Sports Award, which consists of a personalized Presidential Certificate of Achievement, a Presidential Sports Award blazer patch, lapel pin, decal, and membership card. To receive the award you must meet the qualifying standards in one of 43 sports. For an application form, send a stamped self-addressed envelope to: Presidential Sports Award, P. O. Box 5214, FDR Post Office, New York, NY 10022.

Surgeon General

The Surgeon General serves the Department of Health and Human Services as principal advisor to the public on health matters such as smoking and health, diet and nutrition, environmental health hazards, and the importance of immunization and disease prevention. The Surgeon General also oversees the activities of the 6,000-member Public Health Service Commissioned Corps. Contact: Surgeon General, Public Health Service, Department of Health and Human Services, 200 Independence Ave. S.W., Room 7166, Washington, DC 20201/202-245-6467.

Surplus Property

Health and educational organizations can receive surplus federal property to aid in carrying out their programs. Contact: Division of Realty, Office of Real Property, Office of Facilities Engineering, Office of the Secretary, Department of Health and Human Services, Room 4733, Washington, DC 20201/202-472-4763.

Toxic Effects of Chemicals Registry

The *Registry of Toxic Effects of Chemical Substances* lists chemical information and known biological effects for about 22,000 chemicals currently found in the workplace. Contact: Technical publication Development Section, Department of Health and Human Services, 4676 Columbia Pkwy., Cincinnati, OH 45226/513-684-8317.

Toxicological Research

The National Center for Toxicological Research accumulates information and expertise, which includes carcinogenic research, mutagenic research, teratogenic research, molecular biology, and microbiology, and immunology. Contact: National Center for Toxicological Research, General Services, Food and Drug Administration, Department of Health and Human Services, Jefferson, AK 72079/501-541-4344.

Training Programs for Careers in Aging

The Department of Health and Human Services funds a number of institutions to provide educational programs for professional careers in aging. (See "Grants" in this section.) For a listing of institutions which offer training programs for careers in aging, contact: Office of Education and Training, Administration on Aging, Office of Human Development Services, Department of Health and Human Services, Room 4266, Washington, DC 20201/202-472-4226.

Treatment at Government Expense

The National Institutes of Health (NIH) selects a limited number of patients each month for study and therapy. If your illness is one under investigation at NIH, your doctor can refer you to the program. Travel and housing are supplied to patients. For information on illnesses under investigation or further assistance, contact: Office of the Director, The Clinical Center, Building 10, Room 1N212, NIH, Department of Health and Human Services, 9000 Rockville Pike, Bethesda, MD 20205/301-496-4891.

Veterinary Medicine

The Food and Drug Administration (FDA), as

part of its duties, works to assure the safety and efficiency of drugs, devices and feeds to animals. Contact: Bureau of Veterinary Medicine, Food and Drug Administration, Department of Health and Human Services, 5600 Fishers Lane, Room 7-57, Rockville, MD 20857/301-443-3450.

Visual Health

For information on programs and funding on topics related to the nation's visual health, contact: Office of Program Planning and Scientific Reporting, National Eye Institute, NIH, Department of Health and Human Services, Building 31-6A32, Bethesda, MD 20205/301-496-5248.

Work Environment Health Examinations

The National Institute on Occupational Safety and Health (NIOSH) will conduct on-site health hazard evaluations at the request of employers or employees. It will inspect the work environment and give medical exams when warranted. Contact: Division of Surveillance Hazard Evaluations and Field Studies, NIOSH, Department of Health and Human Services, 4676 Columbia Pkwy., Cincinnati, OH 45226/516-684-2427.

How Can the Department of Health and Human Services Help You?

If you believe that the Department of Health and Human Services can be of help to you and you cannot find a relevant office listed in this section, contact: Information, Department of Health and Human Services, 200 Independence Ave. S.W., Room 1187, Washington, DC 20201/202-245-6296.

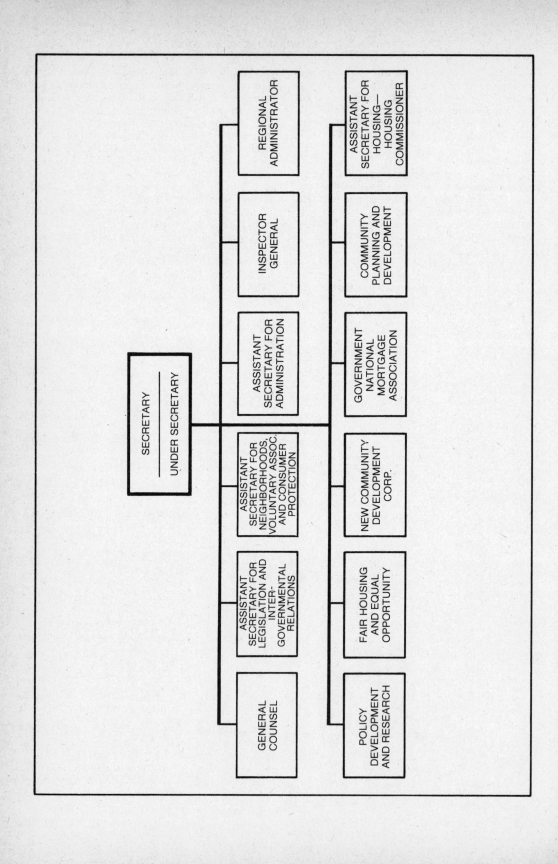

Department of Housing and Urban Development

451 7th St. S.W., Washington, DC 20410/202-755-5111

ESTABLISHED: September 9, 1965
BUDGET: $35,687,194,000
EMPLOYEES: 16,000
MISSION: Assist in the sound development of our communities. Administer mortgage insurance programs which help families become homeowners; a rental subsidy program for lower income families; and programs that aid neighborhood rehabilitation. Protect the home buyer in the market place and foster programs that stimulate and guide the housing industry to provide not only housing but a suitable living environment.

Major Divisions and Offices

Policy Development and Research

Department of Housing and Urban Development, 451 7th St. S.W., Room 8100, Washington, DC 20410/202-755-5600.
Budget: $49,650,000
Employees: 1544
Mission: Advise the secretary in policy, program evaluation, and research. Evaluate existing programs and policies and analyze potential programs and policies by employing the independent and objective research capabilities of its staff and its consultants.

Fair Housing and Equal Opportunity

Department of Housing and Urban Development, 451 7th St. S.W., Room 5100, Washington, DC 20410/202-755-7252.
Budget: $3,700,000
Employees: 777
Mission: Administer the fair housing program authorized by the Civil Rights Act of 1968. Advise the Secretary on all matters relating to civil rights and equal opportunity in housing and related facilities.

New Community Development Corp.

Department of Housing and Urban Development, 451 7th St. S.W., Room 7110, Washington, DC 20410/202-755-7920.
Budget: $37,618,000
Employees: 480

Mission: Assist in the development of well-planned, diversified, economically sound new communities including new-towns-in-town. Guarantee long-term debt for land acquisition and land development, or determine eligibility for assistance without debt guarantee.

Government National Mortgage Association

Department of Housing and Urban Development (HUD), 451 7th St. S.W., Room 6100, Washington, DC 20410/202-755-5926.
Budget: $1,828,759,000
Employees: 334
Mission: Provide special assistance in the financing of eligible types of federally underwritten mortgages.

Community Planning and Development

Department of Housing and Urban Development, 451 7th St. S.W., Room 7100, Washington, DC 20410/202-755-6270.
Budget: $4,752,500,000
Employees: 2711
Mission: Provide decent housing and a suitable living environment and expanding economic opportunities principally for persons of low and moderate income. Make direct grants to severely distressed cities and urban counties for local economic development projects designed to stimulate new, increased private investment. Assist

state and local governments with common or related planning development programs. Insure fair treatment of persons displaced by federally assisted projects. Implement policies and procedures for the protection and enhancement of environmental quality. Provide loans for rehabilitation of property. Provide assistance to the urban homesteading program.

Assistant Secretary For Housing

Housing Commissioner, Department of Housing and Urban Development, 451 7th St. S.W.,

Room 9100, Washington, DC 20410/202-755-6600.

Budget: $28,691,970,000

Employees: 5809

Mission: Direct housing programs and functions of the department including the production, financing, and management of housing, and the conservation and rehabilitation of the housing stock. Provide mortgage insurance. Provide advice and technical assistance to nonprofit sponsors of low- and moderate-income housing. Provide technical and financial assistance in planning, developing and managing housing for low-income families.

Major Sources of Information

Bibliographies, Housing

A number of specialized bibliographies on housing related topics are available from: Library Division, Department of Housing and Urban Development, 451 7th St. S.W., Room 8141, Washington, DC 20410/202-755-6370.

Block Grants

Block grants are provided to local governments to support a variety of programs benefiting lower and middle income people. Projects include: urban renewal; neighborhood development; housing rehabilitation; repairing streets, sidewalks, sewer lines and roads; and parks and recreational centers. See "Grants" or contact: Office of Block Grant Assistance, Office of Community Planning and Development, Department of Housing and Urban Development, 451 7th St. S.W., Room 7128, Washington, DC 20410/202-755-6587.

Bonds for Financing of Housing

State agencies are encouraged to get into bond financed tax-exempt programs for multifamily projects. For information and expertise on developing such programs contact: Office of State Agency and Bond Financed Programs, Office of Housing, Department of Housing and Urban Development, 451 7th St. S.W., Room 6138, Washington, DC 20410/202-462-7113.

Building a House

Homeowner's Glossary of Building Terms is available for free from Program Information, Department of Housing and Urban Development, 451 7th St. S.W., Room 1104, Washington, DC 20410/202-755-6420.

The following books are produced by Housing and Urban Development and are available from Superintendent of Documents, Government Printing Office, Washington, DC 20402/202-783-3238:

How to Build a House Using Self Help Housing Techniques ($1.40)
All Weather Home Building Manual ($4.75)
Solar Dwellings Design Concepts ($2.30)
Designing Kitchens for Safety ($.35)
Design Guide for Home Safety ($4.75)

See "Consumer Publications on Housing" in this section.

Building Technology

See "Consumer Information" in this section.

Buying a House

The following publications are available for free from: Program Information Center, Department of Housing and Urban Development, 451 7th St. S.W., Room 1104, Washington, DC 20401/202-755-6420.

Wise Home Buying (also available in Spanish)
Buying a Home? Don't Forget the Settlement Costs
Comparison of Condominiums and Cooperatives (also available in Spanish)
Home Buyer Vocabulary
Buying, Maintaining and Selling a Home
Real Estate Settlement Procedures Act—Special Information Booklet
Selling the Solar Home
Fact Sheet—Should You Rent or Buy a Home
Fact Sheet—Counseling for Tenants and Homeowners
Let's Consider Cooperatives
Home Mortgage Insurance

Protecting Your Housing Investment
Property Appraisals

The following book, produced by Housing and Urban Development, is available from Superintendent of Documents, Government Printing Office, Washington, DC 20402/202-783-3238.

Homebuyers Information Package: A Guidebook for Buying and Owning a Home ($5.50) Includes the following information: to buy or not to buy; search for a house; purchase contracts; financing the house; closing process; money management; maintaining your home; definitions.

See "Consumer Publications in Housing" in this section.

Citizen Participation

Many of the community development programs sponsored by HUD require citizen participation. A special office has been established to monitor citizen participation programs, help cities in gaining citizen participation, train citizens on their rights, and handle complaints. A helpful booklet entitled *Guidebook: Citizen Participation in the Community Development Block Grant Program,* is available free. Contact: Citizen Participation, Community Planning and Development, Department of Housing and Urban Development, 451 7th St. S.W., Room 7208, Washington, DC 20510/202-755-5564. For information on reports, studies or surveys on topics of community development contact: Intergovernmental Program, Analysis and Evaluation, Office of Evaluation, Office of Urban Rehabilitation and Community Reinvestment, Department of Housing and Urban Development, 451 7th St. S.W., Room 7144, Washington, DC 20410/202-755-6032.

Community Services

The Office of Consumer Affairs provides a variety of services to communities, such as linking beneficiaries of Housing and Urban Development programs with providors of social services, teaching energy conservation, making energy audits, and offering technical assistance for weatherization. Contact: Residents Service Section, Conventional Housing Branch, Project Management Division, Office of Public Housing, Department of Housing and Urban Development, 451 7th St. S.W., Room 4140, Washington, DC 20410/202-755-6460.

Consumer Complaints, Land Sales

See "Land Sales" in this section.

Consumer Complaints, Mobile Home

See "Mobile Home Safety and Construction" in this section.

Consumer Complaints—Settlement Costs

If you have a complaint concerning settlement costs on a real estate transaction, assistance is available from Real Estate Practices Division, Office of Voluntary Associations and Consumer Protection, Department of Housing and Urban Development, 451 7th St. S.W., Room 9266, Washington, DC 20410/202-426-0070.

Consumer Information

A wide variety of information is available to consumers on such topics as: home improvement; renting, buying or building a home; building technology; community development; economic development; housing finance; and housing management. Literature searches are available from a computerized data base, as well as copies of HUD sponsored studies and reports. Contact: Program Information Center, Department of Housing and Urban Development, 451 7th St. S.W., Room 1104, Washington, DC 20410/202-755-6420.

Consumer Publications on Housing

The following housing publications are available from Consumer Information Center, Pueblo, Colorado 81009:

Buying Lots From Developers 142H. $1.00. 28 pp. 1976. What to ask about a property and contract before you sign; information the developer must give you under law.

Can I Really Get Free or Cheap Public Land? 599H. Free. 12 pp. 1978. What public lands are still available for purchase or homesteading; how to go about obtaining them.

Designs For Low-cost Wood Homes. 143H. $1.30. 30 pp. 1978. Sketches and model floor plans; how to select economical, durable materials; order forms for working plans.

Drainage Around The Home. 144H. $.60. 6 pp. 1977. How to identify drainage problems caused by flooding, seasonal high water tables, or density of the soil.

Having Problems Paying Your Mortgage? 600H. Free. 5 pp. 1979. Steps to take if you are having trouble making your mortgage payments on time; where to go for help.

Home Buying Veteran. 602H. Free. 36 pp. 1977. Useful for non-veterans as well; choosing a neighborhood, a lot, a house; checklist for inspecting a house; financing.

Homeowner's Glossary of Building Terms. 603H. Free. 16 pp. 1977. Definitions of everything from acoustical tile to weep holes.

House Construction: How to Reduce Costs. 145H. $.80 16 pp. 1977. How to save in location, style, interior arrangements, and selection of materials and utilities.

Move in ... With A Graduate Payment Mortgage. 604H. Free. 2 pp. 1978. How this new program enables you to buy a home and make lower monthly payments during the first few years of your mortgage.

Questions And Answers On Condominiums. 605H. Free. 48 pp. 1979. What to ask before buying.

Remodeling A House—Will It Be Worthwhile? 606H. Free. 9 pp. 1978. What to consider when deciding whether a wood-frame house is worth remodeling.

Rent or Buy? 146H. $1.50. 32 pp. 1979. How to compare costs and returns of renting with owning a home; includes charts for estimating the monthly costs of each.

Selecting and Financing A Home. 147H. $1.25. 24 pp. 1979. Brief comparison of renting with buying; how to figure what you can afford; how to apply for a loan; what to look for in homeowner's insurance.

Selling Property: Brokers, Title, Closing, and Taxes. 607H. Free. 7 pp. 1978. Advantages and disadvantages of using a real estate broker; some costs of selling; tax implications.

When You Move—Dos and Don'ts. 608H. Free. 7 pp. 1974. Planning, what to expect during the move, and how to handle a loss or damage claim; tips for the do-it yourselfer.

Wise Home Buying. 609H. Free. 28 pp. 1978. Discusses choosing a real estate broker, locating a house, inspecting an old house, and financing the purchase of a home.

Wood-frame House Construction. 148H. $4.25. 223 pp. 1975. Comprehensive, illustrated handbook of detailed instructions and basic principles for building and insulating.

The Energy-wise Home Buyer. 150H. $2.00. 59 pp. 1979. Twelve energy features to look for in a home; detailed energy checklists; comprehensive charts and maps for figuring your energy needs and costs.

Fireplaces and Chimneys. 151H. $1.00. 23 pp. 1978. Selection of materials, construction, and maintenance.

Firewood for Your Fireplace. 152H. $.60. 7 pp. 1978. Burning characteristics of various woods, where and how to buy firewood, and tips on safe fireplace use.

Home Heating. 153H. $1.10. 24 pp. 1978. Installation, operation, maintenance, and costs of the most commonly used heating systems.

How To Improve The Efficiency of Your Oil-fired Furnace. 610H. Free. 12 pp. 1978. What you and the service technician should check; adjustments that will cut costs.

Insulate Your Water Heater and Save Fuel. 611H. Free. 3pp. 1978. How to insulate electric or gas water heaters to save fuel and money; other tips for saving on household hot water bills.

In the Bank or Up The Chimney? 173H. $1.70. 70 pp. 1977. Illustrated how-to instructions for weatherstripping, caulking, and installing storm windows and insulation in your home; how to choose a contractor; includes guide for choosing methods of energy conservation and estimating potential savings.

Tips for Energy Savers. 614H. Free. 46 pp. 1978. How to save energy and money on home heating, cooling, lighting, appliances, etc.; how much insulation you need; lists annual electricity use for appliances.

Where to Find Information About Solar Energy. 613H. Free. 32 pp. 1979. Where to write or call to learn how solar heating and cooling systems work; where to buy and how to select solar equipment; how to find professional help in designing a system; what financial aids and tax credits are available.

Controlling Household Pests. 154H. $1.50. 30 pp. 1977. Procedures and proper pesticides for controlling rats, cockroaches, termites, clothes moths, carpet beetles, etc.

Corrosion. 155H. $.80. 8 pp. 1978. Causes of common corrosion problems; how to prevent and remove rust, tarnish, and other corrosion from silver and other metals.

Family Work and Storage Areas Outside The Home. 614H. Free. 11 pp. 1978. How to use the space you have more efficiently; build different types of storage sheds; and get financing.

How To Prevent and Remove Mildew. 156H. $.90. 12 pp. 1978. What it is; how to prevent and remove it from different surfaces; and how to get rid of dampness and musty odors.

Imaginative Ways with Bathrooms. 615H. Free. 6 pp. 1974. Accessories, storage areas, and safety features to consider when planning a new or remodeling an old bathroom.

Painting—Inside and Out. 157H. $1.30. 32 pp. 1978. Directions for doing a top-quality paint job, including

surface preparation, paint selection, application, use of natural finishes; also lists references.

Protecting Your Housing Investment. 616H. Free. 32 pp. 1979. Maintenance of heating systems, plumbing, and building structure; treatment of special problems such as pest control and moisture.

Simple Home Repairs . . . Inside. 158H. $1.50. 23 pp. 1978. Guide to repairing and replacing faucets, electric plugs, screens, tiles, etc.

Direct Payments

The programs described below are those which provide financial assistance directly to individuals, private firms and other private institutions to encourage or subsidize a particular activity.

Interest Reduction—Homes for Lower-Income Families

Objectives: To make homeownership more readily available to lower-income families by providing interest reduction payments on a monthly basis to lenders on behalf of the lower-income families.

Eligibility: Families, handicapped persons or single persons 62 years old or older are eligible.

Range of Financial Assistance: Estimated average $414 per year in interest subsidy payments per unit for the original program and $1,337 per unit per year for the revised program.

Contact: Director, Single Family Development Division, Office of Single Family Housing, Department of Housing and Urban Development, Room 9270, Washington, DC 20410/202-755-6720.

Interest Reduction Payments—Rental and Cooperative Housing for Lower-Income Families

Objectives: To provide good quality rental and cooperative housing for persons of low and moderate income by providing interest reduction payments in order to lower their housing costs.

Eligibility: Eligible mortgagors include nonprofit, cooperative, builder-seller, investor-sponsor, and limited-distribution sponsors. Public bodies do not qualify as mortgagors under this program.

Range of Financial Assistance: The unit mortgage limits are as follows: efficiency, $16,860; one bedroom, $18,648; two bedrooms, $22,356; three bedrooms, $28,152; four or more bedrooms, $31,884.

Contact: Director, Multifamily Development Division, Office of Multifamily Housing Devel-

opment, Room 6116, Housing, Department of Housing and Urban Development, Washington, DC 20410/202-755-9280.

Lower-Income Housing Assistance

Objectives: To aid lower-income families in obtaining decent, safe and sanitary housing in private accommodations and to promote economically mixed existing, newly constructed, and substantially rehabilitated housing.

Eligibility: Any private owner, profit-motivated and nonprofit, cooperative, or an authorized public housing agency, any state, county, municipality or other governmental entity or public body, or agency or instrumentality thereof which is authorized to engage in or assist in the development or operation of housing for low-income families.

Range of Financial Assistance: Amount necessary to lease units and cover related management and maintenance and operating expenses including utilities, not to exceed Housing and Urban Development approved reasonable rents for constructed or existing comparable units, offering equivalent accommodations, utilities and services, for the housing area in which the units will be located.

Contact: Office of Public Housing and Indian Programs, Housing, Department of Housing and Urban Development, Room 6230, Washington, DC 20410/202-755-6522.

Mortgage Insurance—Rental Housing for the Elderly

Objectives: To provide good quality rental housing for the elderly.

Eligibility: Eligible mortgagors include investors, builder developers, public bodies, and nonprofit sponsors.

Range of Financial Assistance: The unit mortgage limits for non-elevator apartments are as follows: efficiency, $18,450; one bedroom, $20,625; two bedrooms, $24,630; three bedrooms, $29,640; four or more bedrooms, $34,846. Limits per family unit are somewhat higher for elevator apartments. In areas where cost levels so require, limits per family unit may be increased up to 50 percent.

Contact: Director, Multifamily Development Division, Office of Multifamily Housing Development, Housing, Department of Housing and Urban Development, Room 6116, Washington, DC 20410/202-755-9280.

Rent Supplements—Rental Housing for Lower-Income Families

Objectives: To make good quality rental hous-

ing available to low-income families at a cost they can afford.

Eligibility: Eligible sponsors include nonprofit, cooperative, builder-seller, investor-sponsor, and limited-distribution mortgagors.

Range of Financial Assistance: Not specified.

Contact: For Management Information: Director, Office of Multifamily Housing Management and Occupancy, Housing, Department of Housing and Urban Development, Room 6150, Washington, DC 20401/202-755-5866.

Discrimination Hotline

If you feel discriminated against in the rental, purchase or financing of housing HUD will investigate and aid in processing your complaint. Contact: Office of Fair Housing Enforcement and Compliance, Department of Housing and Urban Development, 451 7th St. S.W., Room 5206, Washington, DC 20410/toll-free 800-424-8590, 202-426-3500 in DC.

Elderly Housing

For information and expertise on special problems encountered by the elderly contact: Elderly Housing & Special Programs, Federal Housing Commissioner, Department of Housing and Urban Development, 451 7th St. S.W., Room 6214, Washington, DC 20410/202-755-5318 or Consumer Affairs and the Elderly, Office for Neighborhoods, Voluntary Associations and Consumer Protection, Department of Housing and Urban Development, 451 7th St. S.W., Washington, DC 20410/202-755-5318.

Energy Conservation Research

HUD, in cooperation with the Department of Energy and other agencies, encourages the development and use of new energy conservation designs, methods and standards for all types of existing and new residences including mobile homes. Contact: Division of Energy, Building Technology Division, Office of Research, Office of Policy Development and Research, Department of Housing and Urban Development, 451 7th St. S.W., Room 8158, Washington, DC 20410/202-755-6443.

Environmental Quality

Guidance and training in historic preservation and environmental quality are available to local communities from: Environmental Planning Division, Office of Environmental Quality, Community Planning and Development, Department of Housing and Urban Development, 451 7th St. S.W., Room 5128, Washington, DC 20410/202-755-6580.

Experimental Housing

See "Loans and Loan Guarantees (Mortgage Insurance)" in this section.

Fair Housing and Equal Opportunity

For information on expertise on the law which prohibits the discrimination in housing on the basis of race, color, religion, sex or national origin contact: Office of Fair Housing Enforcement and Compliance, Department of Housing and Urban Development, 451 7th St. S.W., Room 5206, Washington, DC 20410/202-755-5673. See also "Discrimination Hotline" in this section.

Federal Housing Administration (FHA)

The major program of the FHA is the basic home mortgage insurance program which covers 1 to 4 family units. FHA insures private financial institutions against any loss. There is really no FHA. Everything referred to as FHA really means HUD Insured Mortgage. See "Loans and Loan Guarantees" or contact: Office of Single Family Housing, Department of Housing and Urban Development, 451 7th St. S.W., Room 9264, Washington, DC 20410/202-426-7212.

Federal Housing Administration (FHA) Lenders

For information on financial institutions which supply FHA mortgages contact: Office of Mortgages Activities, Office of Housing, Department of Housing and Urban Development, 451 7th St. S.W., Room 9160, Washington, DC 20410/202-755-5740.

Films

The Department of Housing and Urban Development has 3 films which can be borrowed at no cost to the user. The films are: 1) *Citizen Involvement* (urban planning); 2) *Designing the Urban Environment;* 3) *A Matter of Independence* (use of mobile homes for handicapped). Contact: Filmedia, 9 E. 38th St., New York, NY 10016/212-686-9833.

Financial Institution Regulation and Alternative Housing Finance Mechanisms

Research is conducted to look into capital markets, savings and loan associations, credit unions, mortgage markets, and alternative mortgages to make home buying cheaper. Contact: Division of Housing Finance Analysis, Office of Economic Affairs, Policy Development and Research, Department of Housing and Urban Development, 451 7th St. S.W., Room 8218, Washington, DC 20410/202-755-5426.

Finance, Housing

The Financial Analysis Division conducts studies and maintains statistics relating to conditions in the mortgage market, municipal securities market, housing finance, taxation, current national housing productions, mortgage market trends, mortgage lending and commitment activity, survey of mortgage interest rates, and capital market forecasts. Contact: Financial Analysis Division, Office of Financial D Management, Office of Housing, Department of Housing and Urban Development, 451 7th St. S.W., Room 6186, Washington, DC 20410/202-426-4667.

Freedom of Information Act

For requests made under the Freedom of Information Act or for further information contact: Program Information Center, Department of Housing and Urban Development, 451 7th St. S.W., Room 1104, Washington, DC 20410/202-755-5640.

Funds to Attract Private Investment

Funds are available to cities to attract private investment in a project in a distressed neighborhood, industrial park or business district. See "Grants" (Urban Development Action Grants) or contact: Urban Development Action Grants, Office of Community Planning and Development, Department of Housing and Urban Development, 451 7th St. S.W., Room 7236, Washington, DC 20410/202-755-6193.

Government National Mortgage Association (GNMA)

The GNMA program offers government guaranteed securities to investors which are designed to attract non-traditional investors into the residential mortgage market. The minimum size of a security certificate is $25,000. The maturity is typically 30 years. Contact: Office of Corporate Planning, Government National Mortgage Association, Department of Housing and Urban Development, 451 7th St. S.W., Room 4272, Washington, DC 20410/202-426-1663.

Grants

The programs described below are for sums of money which are given by the federal government to initiate and stimulate new or improved activities or to sustain on-going services.

Community Development Block Grants/Entitlement Grants

Objectives: To develop viable urban communities, including decent housing and a suitable living environment, and expand economic opportunities, principally for persons of low and moderate income.

Eligibility: Cities in standard metropolitan statistical areas (SMSAs) with populations in excess of 50,000, and cities with populations of under 50,000 which are central cities in SMSAs.

Range of Financial Assistance: Not specified.

Contact: Community Planning and Development, Department of Housing and Urban Development, 451 7th St. S.W., Room 7082, Washington, DC 20410/202-755-6587.

Community Development Block Grants/Small Cities Programs

Objectives: To assist communities in providing decent housing and a suitable living environment for persons of low and moderate income.

Eligibility: All states, counties, and units of general local government, except metropolitan cities and urban counties, may apply for Small Cities Grants.

Range of Financial Assistance: $100,000 to $600,000

Contact: Assistant Secretary for Community Planning and Development, Department of Housing and Urban Development, 451 7th St. S.W., Room 7182, Washington, DC 20410/202-755-6587.

Comprehensive Planning Assistance

Objectives: To strengthen planning and decision making capabilities of chief executives of state, and local governments and areawide planning organizations, and thereby promote more effective use of the nation's physical, economic, and human resources.

Eligibility: States with planned assistance to local governments; states with state, interstate, metropolitan, district or regional activities; cities of 50,000 or more are not eligible.

Range of Financial Assistance: Not specified.

Contact: Director, Office of Community Planning and Program Coordination, Community Planning and Development, Department of Housing and Urban Development, 451 7th St. S.W., Washington, DC 20410/202-755-5649.

General Research and Technology

Objectives: To carry out applied research and demonstration projects of high priority and preselected by the department to serve the needs of housing and community development groups and to improve the operations of the Department's programs.

Eligibility: State and local governments, public and/or private profit and nonprofit organizations

which have authority and capacity to carry out projects.

Range of Financial Assistance: $150 to $1,500,000

Contact: Assistant Secretary for Policy Development and Research, Housing and Urban Development Publications Service Center, Department of Housing and Urban Development, 451 7th St. S.W., Room B258, Washington, DC 20410/1 202-755-7353.

Indian Community Development Block Grant Program

Objectives: To assist Indian Tribes and Alaskan Natives in the development of viable Indian communities principally for persons of low and moderate income.

Eligibility: Approved Indian Tribes.

Range of Financial Assistance: $43,000 to $1,714,532

Contact: Office of Policy Development, Department of Housing and Urban Development, 451 7th St. S.W., Room 7138, Washington, DC 20410/202-755-6092.

Low Income Housing—Assistance Program (Public Housing)

Objectives: To provide decent, safe and sanitary housing and related facilities for families of low income through an authorized Public Housing Agency (PHA).

Eligibility: Public Housing Agencies established by a local government in accordance with state law, authorized public agencies, or Indian tribal organizations are eligible.

Range of Financial Assistance: Average obligation per unit is $2,300.

Contact: Director, Office of Public Housing and Indian Programs, Housing, Department of Housing and Urban Development, Room 6230, Washington, DC 20410/202-755-6522.

Low Income Housing—Homeownership for Low-Income Families

Objectives: To provide low-income families with the opportunity of owning their own homes through local public housing agencies.

Eligibility: Public Housing Agencies established by a local government in accordance with state law, authorized public agencies, or Indian tribal organizations are eligible. The proposed program must be approved by the local governing body.

Range of Financial Assistance: Not specified.

Contact: Office of Public Housing and Indian Programs, Housing, Department of Housing and Urban Development, Washington, DC 20410/202-755-6522.

Public Housing—Modernization of Projects

Objectives: To provide annual contributions to modernize existing public housing projects to upgrade living conditions, correct physical deficiencies, and achieve operating efficiency and economy.

Eligibility: Public Housing Agencies (PHAs) operating PHA-owned low income public housing projects under an existing annual contributions contract.

Range of Financial Assistance: Not specified.

Contact: Office of Public Housing and Indian Programs, Assistant Secretary for Housing—Federal Housing Commissioner, Department of Housing and Urban Development, Washington, DC 20413/202-755-6522.

Urban Development Action Grants

Objective: To assist severely distressed cities and severely distressed urban counties in alleviating physical and economic deterioration through economic development and neighborhood revitalization.

Eligibility: Eligible applicants are distressed cities and distressed urban counties.

Range of Financial Assistance: $77,700 to $13,500,000

Contact: Office of Urban Development Action Grants, Community Planning and Development, Department of Housing and Urban Development, 451 7th St. S.W., Room 7132, Washington, DC 20410/202-472-3947.

Handicapped Housing Information Center

For information and expertise on how Housing and Urban Development programs can be used to help disabled individuals contact: Office of Independent Living, Intergovernmental Relations, Office of Housing, Office of Federal Housing Commissioner, Department of Housing and Urban Development, 451 7th St. S.W., Room 10184, Washington, DC 20410/202-755-5857.

Hispanic Programs

A special Housing and Urban Development office has been established to insure that all Housing and Urban Development programs take into account the needs of Hispanic consumers. It also insures that the Hispanic communities are aware of Housing and Urban Development programs. Contact: Hispanic Policy and Program Staff, Office of Intergovernmental Relations, Department of Housing and Urban Development, 451 7th St. S.W., Room 4208, Washington, DC 20410/202-755-6480.

Historic Preservation

See "Environmental Quality" in this section.

Home Improvement

The following publications are available free from: Program Information Center, Department of Housing and Urban Development, 451 7th St. S.W., Room 1104, Washington, DC 20410/202-755-6420.

Remodeling Your Basement and Attic
Protecting Your Home Against Theft
Protecting Your Home Against Weather Damage
Fixing Up Your Home—What You Can Do and How to Finance it
Dealer and Contractor Guide to Property Improvement Loans
Fact Sheet—Home Improvement Loan Insurances

See "Loans (Major Home Improvement)," and "Consumer Publications on Housing" in this section.

Homesteading

The urban Homesteading Program transfers government defaulted properties to a buyer-occupant for $1.00 through a lottery. The homesteader is obliged to rehabilitate the property within 18 months to meet minimum health and safety standards and to live there for at least 3 years. Also available is a listing of publications and audiovisual programs on homesteading. Contact: Urban Homesteading Division, Office of Urban Rehabilitation and Community Reinvestment, Community Planning and Development, Department of Housing and Urban Development, 451 7th St. S.W., Room 7160, Washington, DC 20410/202-755-5970.

Housing Assistance Research

Research is conducted on the effectiveness of various housing assistance programs. Contact: Division of Housing Assistance Research, Office of Research, Office of Policy Development and Research, Department of Housing and Urban Development, 451 7th St. S.W., Room 8138, Washington, DC 20410/202-755-5900.

Housing Counseling

Over 600 HUD approved counseling agencies are available throughout the United States to aid with such problems as mortgage defaults, financing and maintaining housing, how to conserve energy, how to budget money, and information on available HUD programs. Contact: Housing Counseling Programs, Office of Consumer Affairs, Office for Neighborhoods, Voluntary Associations and Consumer Protection, Department of Housing and Urban Development, 451 7th St. S.W., Room 4148, Washington, DC 20410/202-755-7802.

Housing Information and Research

The Department of Housing and Urban Development provides the following free information services: 1) Personalized literature searches from HUD User's computerized data base to answer specific questions; 2) *The Compendium*—a semi-annual annotated catalog of Housing and Urban Development sponsored research results ($4.00 for three documents); 3) *Recent Research Results* a free bimonthly bulletin announcing the latest research reports; 4) bibliographies, brochures, and announcements of important future research; and 5) document distribution service to supply copies of research results. Included in the topical areas covered are: building technology, community development, conserving communities, economic development and public finance, elderly and the handicapped, energy and utilities, environmental research, financial management, housing finance, housing management and housing programs. Contact: Housing and Urban Development User, P. O. Box 280, Germantown, MD 29767/301-251-5154.

Housing Management

Research is conducted on various aspects of housing management, e.g. special user housing, modernization needs, cost of retrofitting for the elderly and handicapped, and cost of retrofitting for energy conservation. Contact: Division of Housing Management and Special User Research, Office of Research, Office for Policy, Development and Research, Department of Housing and Urban Development, 451 7th St. S.W., Room 8156, Washington, DC 20410/202-755-5574.

Housing Market Studies

Local and national studies are conducted on various aspects of the housing market. Contact: Division of Economic Market Analysis, Offices of Economic Affairs, Policy Development and Research, Department of Housing and Urban Development, 451 7th St. S.W., Room 2251, Washington, DC 20410/202-755-7166.

HUD Periodical

The following periodical provides information on the latest Housing and Urban Development programs, projects, policies, and new directions, and answers pressing questions about housing and urban development: *HUD Newsletter* (weekly, $44.00/year). Available from: Superintendent of Documents, Government Printing Office, Washington, DC 20402/202-783-3238.

Indian Housing

For information and expertise concerning the

special housing needs for American Indians contact: Office of Indian Housing, Public Housing and Indian Programs, Office of Housing, Department of Housing and Urban Development, 451 7th St. S.W., Room 6254, Washington, DC 20410/202-755-5380.

Land Development Assistance

Up-front capital is available to cities for acquiring or rehabilitating property to stimulate industrial, commercial or residential land development. See "Loans (Rehabilitation)" or contact: Financial Management Division, Office of Block Grant Assistance, Office of Community Planning and Development, Department of Housing and Urban Development, 451 7th St. S.W., Room 7186, Washington, DC 20410/202-755-1871.

Land Sales

The Department of Housing and Urban Development protects consumers against fraudulent practices of land developers. Anyone with 100 lots or more must register with HUD. Consumers have the rights to obtain a copy of the disclosure registration documents from the developer or can view them in the HUD reading room. A free pamphlet, *Before Buying Land ... Get the Facts,* is available from HUD. Contact: Office of Interstate Land Sales Registration, Office of Neighborhoods, Voluntary Associations and Consumer Protection, Department of Housing and Urban Development, 451 7th St. S.W., Room 4116, Washington, DC 204/202-755-5989. Land Sales Documents and Reading Room: Office of Neighborhoods, Voluntary Associations, and Consumer Protection, Department of Housing and Urban Development, 451 7th St. S.W., Room 4130, Washington, DC 20410/202-755-7077.

Lead-Based Paint Poisoning Information Clearinghouse

A variety of information services are available on lead-based paint poisoning prevention from: Lead-Based Paint Poisoning Prevention, Office of Neighborhoods, Voluntary Associations and Consumer Protection, Department of Housing and Urban Development, 451 7th St. S.W., Room 6248, Washington, DC 20410/202-755-6640.

Loans and Loan Guarantees

The programs described below are those which offer financial assistance through the lending of federal monies for a specific period of time or programs in which the federal government makes an arrangement to indemnify a lender against part or all of any defaults by the borrower.

Graduated Payment Mortgage Program

Objectives: To facilitate early homeownership for households that expect their incomes to rise substantially. Program allows homeowners to make smaller monthly payments initially and to increase their size gradually over time.

Eligibility: All persons are eligible to apply.

Range of Financial Assistance: Up to $60,000

Contact: Director, Single Family Development Division, Office of Single Family Housing, Department of Housing and Urban Development, Room 9270, Washington, DC 20410/202-755-6720.

Housing for the Elderly or Handicapped

Objectives: To provide for rental or cooperative housing and related facilities (such as central dining) for the elderly or handicapped.

Eligibility: Private nonprofit corporations and consumer cooperatives. Public bodies and their instrumentalities are not eligible.

Range of Financial Assistance: Approximate average award is $3,300,000.

Contact: Multifamily Development Division, Office of Multifamily Housing Development, Housing, Department of Housing and Urban Development, Room 6110, Washington, DC 20410/202-755-6142.

Interest Reduction Payments—Rental and Cooperative Housing for Lower-Income Families

Objectives: To provide good quality rental and cooperative housing for persons of low and moderate income by providing interest reduction payments in order to lower their housing costs.

Eligibility: Eligible mortgagors include nonprofit, cooperative, builder-seller, investor-sponsor, and limited-distribution sponsors. Public bodies do not qualify as mortgagors under this program.

Range of Financial Assistance: The unit mortgage limits are as follows: efficiency, $16,860; one bedroom, $18,648; two bedrooms, $22,356; three bedrooms, $28,152; four or more bedrooms, $31,884.

Contact: Director, Multifamily Development Division, Office of Multifamily Housing Development, Housing, Department of Housing and Urban Development, Room 6116, Washington, DC 20410/202-755-9280.

Low-Income Housing—Assistance Program (Public Housing)

Objectives: To provide decent, safe and sani-

tary housing and related facilities for families of low income through an authorized Public Housing Agency.

Eligibility Requirements: Public Housing Agencies established by a local government in accordance with state law, authorized public agencies, or Indian tribal organizations are eligible.

Range of Financial Assistance: Average Obligation per unit is $2,300.

Contact: Director, Office of Public Housing and Indian Programs, Housing, Department of Housing and Urban Development, Room 6230, Washington, DC 20410/202-755-6522.

Low-Income Housing—Home Ownership for Low-Income Families

Objectives: To provide, through local public housing agencies, low-income families with the opportunity of owning their own homes.

Eligibility: Public Housing Agencies established by a local government in accordance with state law, authorized public agencies, or Indian tribal organizations are eligible. The proposed program must be approved by the local governing body.

Range of Financial Assistance: Not specified.

Contact: Office of Public Housing and Indian Programs, Housing, Department of Housing and Urban Development, Washington, DC 20410/202-755-6522.

Major Home Improvement Loan Insurance— Housing Outside Urban Renewal Areas

Objectives: To help families repair or improve existing residential structures outside urban renewal areas.

Eligibility: All families are eligible to apply.

Range of Financial Assistance: Up to $12,000.

Contact: Director, Single Family Development Division, Office of Single Family Housing, Department of Housing and Urban Development, Room 9270, Washington, DC 20410/202-755-6720.

Mobile Home Loan Insurance—Financing Purchase of Mobile Homes as Principal Residences of Borrowers

Objectives: To make possible reasonable financing of mobile home purchases.

Eligibility: All persons are eligible to apply.

Range of Financial Assistance: Maximum amount of loan is $16,000.

Contact: Director, Title I Insured and 312 Loan Servicing Division, Office of Single Family Housing, Department of Housing and Urban Development, Room 9160, Washington, DC 20410/202-755-6880.

Mortgage Insurance

Objectives: To help families undertake home ownership.

Eligibility: All families are eligible to apply.

Range of Financial Assistance: Maximum insurable loans for an occupant mortgagor are as follows: One family, $60,000; two or three family, $65,000; four family, $75,000.

Contact: Director, Single Family Development Division, Office of Single Family Housing, Department of Housing and Urban Development, Room 9270, Washington, DC 20410/202-755-6720.

Mortgage Insurance—Combination and Mobile Home Lot Loans

Objectives: To make possible reasonable financing of mobile home purchase and lot to place it in.

Eligibility: All persons are eligible to apply.

Range of Financial Assistance: $23,500 to $31,500

Contact: Director, Title I Insured and 312 Loan Serving Division, Office of Single Family Housing, Department of Housing and Urban Development, Room 9160, Washington, DC 20410/202-755-6880.

Mortgage Insurance—Construction or Rehabilitation of Condominium Projects

Objectives: To enable sponsors to develop condominium projects in which individual units will be sold to home buyers.

Eligibility: Eligible sponsors include investors, builders, developers, public bodies, and others who meet FHA requirements for mortgagors.

Range of Financial Assistance: Maximum insurable loans are as follows: efficiency, $19,500; one bedroom, $21,600; two bedrooms, $25,800; three bedrooms, $31,800; four or more bedrooms, $36,000. Unit mortgage.

Contact: Director, Multifamily Development Division, Office of Multifamily Housing Development, Housing, Department of Housing and Urban Development, Room 6116, Washington, DC 20410/202-755-9280.

Mortgage Insurance—Cooperative Financing

Objectives: To provide insured financing for the purchase of shares of stock in a cooperative project. Ownership of the shares carries the right to occupy a unit located within the cooperative project.

Eligibility: Owner occupant mortgagors are eligible.

Range of Financial Assistance: Up to $60,000

Contact: Director, Single Family Development

Division, Office of Single Family Housing, Department of Housing and Urban Development, Room 9270, Washington, DC 20410/202-755-6720.

Mortgage Insurance—Development of Sales Type Cooperative Projects

Objectives: To make it possible for housing cooperatives, ownership housing corporations or trusts to sponsor the development of new housing that will be sold to individual cooperative members.

Eligibility: Eligible mortgagors include nonprofit cooperative ownership housing corporations or trusts sponsors intending to sell individual units to cooperative members.

Range of Financial Assistance: Up to $60,000

Contact: Director, Multifamily Development Division, Office of Multifamily Housing Development, Housing, Department of Housing and Urban Development, Room 6116, Washington, DC 20410/202-755-9280.

Mortgage Insurance—Experimental Homes

Objectives: To help finance the development of homes that incorporate new or untried construction concepts designed to reduce housing costs, raise living standards, and improve neighborhood design by providing mortgage insurance.

Eligibility: Interested applicants able to prove that the property which is proposed is an acceptable risk for testing advanced housing design or experimental property standards are eligible.

Range of Financial Assistance: Average mortgage is $30,485.

Contact: Assistant Secretary for Policy Development and Research, Department of Housing and Urban Development, 451 7th St. S.W., Room 8100, Washington, DC 20410/202-755-5600.

Mortgage Insurance—Experimental Projects Other Than Housing

Objectives: To provide mortgage insurance to help finance the development of group medical facilities or subdivisions or new communities that incorporate new or untried construction concepts intended to reduce construction costs, raise living standards or improve neighborhood design.

Eligibility: Interested sponsors eligible under HUD/FHA's land development or group practice medical facilities program are eligible.

Range of Financial Assistance: Not applicable.

Contact: Assistant Secretary for Policy Development and Research, Department of Housing and Urban Development, 451 7th St. S.W., Room 8100, Washington, DC 20410/202-755-5600.

Mortgage Insurance—Experimental Rental Housing

Objectives: To provide mortgage insurance to help finance the development of multifamily housing that incorporates new or untried construction concepts designed to reduce housing costs; raise living standards; and improve neighborhood design.

Eligibility: Interested sponsors, able to prove the property which is proposed is an acceptable risk for testing advanced housing design or experimental property standards, are eligible.

Range of Financial Assistance: Average is $2,314,814 per project.

Contact: Assistant Secretary for Policy Development and Research, Department of Housing and Urban Development, 451 7th St. S.W., Room 8100, Washington, DC 20410/202-755-5600.

Mortgage Insurance for the Purchase or Refinancing of Existing Multifamily Housing Projects

Objectives: To provide mortgage insurance for the purchase or refinancing of existing multifamily housing projects whether conventionally financed or subject to federally insured mortgages at the time of application for mortgage insurance.

Eligibility: The mortgagors may be either private or public. Property must consist of not less than eight living units.

Range of Financial Assistance: Not specified.

Contact: Director, Office of Multifamily Housing Development, Multifamily Housing Development Division, Housing, Department of Housing and Urban Development, Room 6116, Washington, DC 20410/202-755-9280.

Mortgage Insurance—Group Practice Facilities

Objective: To help develop group practice facilities.

Eligibility: Private nonprofit sponsors 1) undertaking to provide comprehensive health care to members or subscribers on a group practice prepayment or fee-for-service basis, or 2) established for the purpose of improving the availability of health care in the community, which will make the group practice facility available to an eligible group.

Range of Financial Assistance: The maximum insurable mortgage would be equal to 90 percent of the estimated replacement cost of the facility, including major movable equipment.

Contact: Director, Multifamily Development Division, Office of Multifamily Housing Development, Housing, Department of Housing and Urban Development, Room 6116, Washington, DC 20110/202-755-9280.

Mortgage Insurance—Homes for Certified Veterans

Objectives: To help veterans undertake home ownership on a sound basis.

Eligibility: Any certified veteran.

Range of Financial Assistance: Up to $60,000

Contact: Director, Single Family Development Division, Office of Single Family Housing, Department of Housing and Urban Development, Room 9270, Washington, DC 20410/202-755-6720.

Mortgage Insurance—Housing in Older, Declining Areas

Objectives: To help families purchase or rehabilitate housing in older, declining urban areas.

Eligibility: All families are eligible to apply.

Range of Financial Assistance: Range varies. Average is $9,400.

Contact: Director, Single Family Development Division, Office of Single Family Housing, Department of Housing and Urban Development, Room 9270, Washington, DC 20410/202-755-6720.

Mortgage Insurance—Homes in Outlying Areas

Objectives: To help families purchase homes in outlying areas.

Eligibility: All families are eligible to apply.

Range of Financial Assistance: Up to $45,000.

Contact: Director, Single Family Development Division, Office of Single Family Housing, Department of Housing and Urban Development, Room 9270, Washington, DC 20410/202-755-6720.

Mortgage Insurance—Homes in Urban Renewal Areas

Objectives: To help families purchase or rehabilitate homes in urban renewal areas.

Eligibility: All families are eligible to apply.

Range of Financial Assistance: Maximum insurable loans for the occupant mortgagor are as follows: one-family, $60,000; two- or three-family, $65,000; four-family, $75,000, plus $7,700 for each family unit over four.

Contact: Director, Single Family Development Division, Office of Single Family Housing, Department of Housing and Urban Development, Room 9270, Washington, DC 20410/202-755-6720.

Mortgage Insurance—Investor Sponsored Cooperative Housing

Objectives: To provide good quality multifamily housing to be sold to nonprofit cooperatives ownership housing corporations or trusts.

Eligibility: Eligible mortgagors include investors, builders, developers, public bodies, and others who meet FHA requirements for mortgagors.

Mortgage Insurance—Homes for Disaster Victims

Objective: To help victims of a major disaster undertake homeownership on a sound basis.

Eligibility: Any family which is a victim of a major disaster as designated by the President is eligible to apply.

Range of Financial Assistance: Up to $14,400.

Contact: Director, Single Family Development Division, Office of Single Family Housing, Department of Housing and Urban Development, Room 9270, Washington, DC 20410/202-755-6720.

Mortgage Insurance—Homes for Low and Moderate Income Families

Objectives: To make home ownership more readily available to families displaced by urban renewal or other government actions as well as other low-income and moderate-income families.

Eligibility: All families are eligible to apply. Displaced families qualify for special terms. Certification of eligibility as a displaced family is made by the appropriate local government agency.

Range of Financial Assistance: Up to $42,000

Contact: Director, Single Family Development Division, Office of Single Family Housing, Department of Housing and Urban Development, Room 9270, Washington, DC 20410/202-755-6720.

Mortgage Insurance—Hospitals

Objectives: To make possible the financing of hospitals.

Eligibility: Eligible applicants are a proprietary facility, or facility of a private nonprofit corporation or association, licensed or regulated by the state, municipality, or other political subdivision.

Range of Financial Assistance: Not specified.

Contact: Director, Multifamily Development Division, Office of Multifamily Housing Development, Housing, Department of Housing and Urban Development, Room 6116, Washington, DC 20410/202-755-9280.

Range of Financial Assistance: The unit mortgage limits for non-elevator apartments are as follows: Efficiency, $19,500; one bedroom, $21,600; two bedrooms, $25,800; three bedrooms, $31,800; four or more bedrooms, $36,000. Limits per family unit are somewhat higher for elevator apartments. In areas where cost levels so require, limits per family unit may be increased up to 50 percent.

Contact: Director, Multifamily Development

Division, Office of Multifamily Housing Development, Housing, Department of Housing and Urban Development, Room 6116, Washington, DC 20410/202-755-9280.

Mortgage Insurance—Land Development and New Communities

Objectives: To assist the development of large subdivisions or new communities on a sound economic basis.

Eligibility: Prospective developers, subject to the approval of HUD, are eligible. Public bodies are not eligible.

Range of Financial Assistance: Not specified.

Contact: Director, Single Family Development Division, Office of Single Family Housing, Department of Housing and Urban Development, Room 9720, Washington, DC 20410/202-755-6720.

Mortgage Insurance—Management Type Cooperative Projects

Objectives: To make it possible for nonprofit cooperatives, ownership housing corporations or trust to acquire housing projects to be operated as management-type cooperatives.

Eligibility: Eligible mortgagors are nonprofit cooperatives, ownership housing corporations or trusts which may either sponsor projects directly, or purchase projects from investor-sponsors.

Range of Financial Assistance: The unit mortgage limits are as follows: Efficiency, $19,500; one bedroom, $21,600; two bedrooms, $25,800; three bedrooms, $31,800; four or more bedrooms, $36,000. Limits per family unit are somewhat higher for elevator apartments. In areas where cost levels so require, limits per family unit may be increased up to 50 percent.

Contact: Director, Multifamily Development Division, Office of Multifamily Housing Development, Housing, Department of Housing and Urban Development, Room 6116, Washington, DC 20410/202-755-9280.

Mortgage Insurance—Mobile Home Parks

Objectives: To make possible the financing of construction or rehabilitation of mobile home parks.

Eligibility: Eligible mortgagors include investors, builders, developers and others who meet FHA requirements for mortgagors.

Range of Financial Assistance: The maximum mortgage limit is $3,900 per space.

Contact: Director, Multifamily Development Division, Office of Multifamily Housing Development, Housing, Department of Housing and Urban Development, Room 6116, Washington, DC 20410/202-755-9280.

Mortgage Insurance—Nursing Homes and Intermediate Care Facilities

Objectives: To make possible financing for construction or rehabilitation of nursing homes and intermediate care facilities, and to provide loan insurance to install fire safety equipment.

Eligibility: Eligible mortgagors include investors, builders, developers, and private nonprofit corporations or associations licensed or regulated by the state for the accommodation of convalescents and persons requiring skilled nursing care or intermediate care.

Range of Financial Assistance: Not specified.

Contact: Director, Multifamily Development Division, Office of Multifamily Housing Development, Housing, Department of Housing and Urban Development, Room 6116, Washington, DC 20412/202-755-9280.

Mortgage Insurance—Purchase by Homeowners of Fee-Simple Title From Lessors

Objectives: To help homeowners obtain fee-simple title to the property which they hold under long-term leases and on which their homes are located.

Eligibility: All homeowners whose homes are located on property which is held under long-term ground leases are eligible to apply.

Range of Financial Assistance: Up to $10,000

Contact: Director, Single Family Development Division, Office of Single Family Housing, Department of Housing and Urban Development, Room 9270, Washington, DC 20410/202-755-6720.

Mortgage Insurance—Purchase of Sales-Type Cooperative Housing Units

Objectives: To provide available, good quality, new housing for purchase by individual members of a housing cooperative.

Eligibility: Eligible mortgagors include members of a nonprofit cooperative, ownership housing corporations or trusts which sponsor such housing.

Range of Financial Assistance: Up to $60,000

Contact: Director, Multifamily Development Division, Office of Multifamily Development, Housing, Department of Housing and Urban Development, Room 6116, Washington, DC 20410/202-755-8135.

Mortgage Insurance—Purchase of Units in Condominiums

Objectives: To enable families to purchase units in condominium projects.

Eligibility: All families are eligible to apply.

Range of Financial Assistance: Up to $60,000

Contact: Director, Single Family Development

Division, Office of Single Family Housing, Housing, Department of Housing and Urban Development, Room 9270, Washington, DC 20410/202-755-6720.

Mortgage Insurance—Rental Housing

Objectives: To provide good quality rental housing.

Eligibility: Eligible mortgagors include investors, builders, developers, and others who meet FHA requirements for mortgagors.

Range of Financial Assistance: The unit mortgage limits for non-elevator apartments are as follows: Efficiency $19,500; one bedroom, $21,600; two bedrooms, $25,800; three bedrooms, $31,800; four or more bedrooms, $36,000. Limits per family unit are somewhat higher for elevator apartments. In areas where costs levels so require, limits per family unit may be increased up to 50 percent.

Contact: Director, Multifamily Development Division, Office of Multifamily Housing Development, Housing, Department of Housing and Urban Development, Room 6116, Washington, DC 20410/202-755-9280.

Mortgage Insurance—Rental Housing for Low and Moderate Income Families, Market Interest Rate

Objectives: To provide good quality rental or cooperative housing within the price range of low- and moderate-income families.

Eligibility Requirements: Eligible sponsors include public, nonprofit, cooperative, builder-seller, investor-sponsor, and limited distribution mortgagors.

Range of Financial Assistance: The unit mortgage limits for non-elevator apartments are as follows: efficiency, $16,860; one bedroom, $18,648; two bedroom, $22,356; three bedroom, $28,152; four or more bedrooms, $31,884. Unit mortgage limits are somewhat higher for elevator apartments. In areas where cost levels so require, limits per family unit may be increased up to 50 percent.

Contact: Director, Multifamily Development Division, Office of Multifamily Housing Development, Housing, Department of Housing and Urban Development, Room 6116, Washington, DC 20410/202-755-9280.

Mortgage Insurance—Rental Housing for Moderate Income Families

Objectives: To provide good quality rental housing within the price range of low- and moderate-income families.

Eligibility: Profit motivated sponsors, limited distribution and nonprofit sponsors, and others

who meet FHA requirements for mortgagors.

Range of Financial Assistance: The unit mortgage limits for non-elevator apartments are as follows: Efficiency, $19,406; one bedroom, $22,028; two bedrooms, $26,625; three bedrooms, $33,420; four or more bedrooms, $37,870. Unit mortgage limits are somewhat higher for elevator apartments. In areas where cost levels so require, limits per family unit may be increased up to 50 percent.

Contact: Director, Multifamily Development Division, Office of Multifamily Housing Development, Department of Housing and Urban Development, Room 6116, Washington, DC 20410/202-755-9280.

Mortgage Insurance—Rental Housing for the Elderly

Objectives: To provide good quality rental housing for the elderly.

Eligibility: Eligible mortgagors include investors, builder developers, public bodies, and nonprofit sponsors.

Range of Financial Assistance: The unit mortgage limits for nonelevator apartments are as follows: Efficiency, $18,450; one bedroom, $20,625; two bedrooms, $24,630; three bedrooms, $29,640; four or more bedrooms, $34,846. Limits per family unit are somewhat higher for elevator apartments. In areas where cost levels so require, limits per family unit may be increased up to 50 percent.

Contact: Director, Multifamily Development Division, Office of Multifamily Housing Development, Housing, Department of Housing and Urban Development, Room 6116, Washington, DC 20410/202-755-9280.

Mortgage Insurance—Rental Housing in Urban Renewal Areas

Objectives: To provide good quality rental housing in urban renewal areas.

Eligibility: Eligible mortgagors include investors, builders, developers, public bodies, and others who are able to meet FHA requirements for mortgagors.

Range of Financial Assistance: Unit mortgage limits for non-elevator apartments are as follows: Efficiency, $19,500; one bedroom, $21,600; two bedrooms, $25,800; three bedrooms, $31,800; four or more bedrooms, $36,000. Limits per family unit are somewhat higher for elevator apartments. In areas where cost levels so require limits per family unit may be increased up to 50 percent.

Contact: Director, Multifamily Development Division, Office of Multifamily Housing Development, Housing, Department of Housing and

Urban Development, Room 6116, Washington, DC 20410/202-755-9280.

Mortgage Insurance—Special Credit Risks

Objective: To make homeownership possible for low-and-moderate-income families who cannot meet normal Housing and Urban Development requirements.

Eligibility: Only families who do not qualify for homeownership under regular HUD credit standards are eligible. Families qualifying for mortgage insurance under this program must have a gross monthly income that amounts to at least four times the families' required mortgage payment.

Range of Financial Assistance: Up to $18,000

Contact: Director, Single Family Development Division, Office of Single Family Housing, Department of Housing and Urban Development, Room 9270, Washington, DC 20410/202-755-6720.

New Communities—Loan Guarantees

Objective: To encourage the development of well-planned, diversified, and economically sound new communities, including major additions to existing communities.

Eligibility: Private new community developers and public land development agencies (including state, local, or regional public bodies) which are authorized to act as developers for new community development programs under state or local law.

Range of Financial Assistance: $7,500,000 to $50,000,000

Contact: General Manager, New Community Development Corporation, Department of Housing and Urban Development, 451 7th St. S.W., Room 7110, Washington, DC 20410/202-755-7920.

Nonprofit Housing Sponsor Loans—Planning Projects for Low- and Moderate-Income Families

Objective: To assist and stimulate prospective nonprofit sponsors of Section 202 housing to develop sound housing projects for the elderly or handicapped.

Eligibility: Nonprofit organizations as defined by Housing and Urban Development which will qualify as proposed mortgagor corporations.

Range of Financial Assistance: Up to $50,000

Contact: Director, Multifamily Development Division, Office of Multifamily Housing Development, Housing, Department of Housing and Urban Development, Room 6116, Washington, DC 20410/202-755-9281.

Property Improvement Loan Insurance for Improving All Existing Structures and Building of New Nonresidential Structures

Objective: To facilitate the financing of improvements to homes and other existing structures and the erection of new nonresidential structures.

Eligibility: Eligible borrowers include the owner of the property to be improved or a lessee having a lease extending at least 6 months beyond maturity of the loan.

Range of Financial Assistance: Up to $15,000 for a one-family dwelling

Contact: Director, Title I Insured and 312 Loan Servicing Division, Office of Single Family Housing, Department of Housing and Urban Development, Room 9160, Washington, DC 20410/202-755-6880.

Public Housing—Modernization of Projects

Objective: To provide annual contributions to modernize existing public housing projects to upgrade living conditions, correct physical deficiencies, and achieve operating efficiency and economy.

Eligibility: Public Housing Agencies (PHAs) operating PHA-owner low income public housing projects under an existing annual contributions contract (ACC).

Range of Financial Assistance: Not specified.

Contact: Office of Public Housing and Indian Programs, Assistant Secretary for Housing-Federal Housing Commissioner, Department of Housing and Urban Development, Washington, DC 20413/202-755-6522.

Rehabilitation Loans

Objective: To provide funds for rehabilitation of residential, commercial and other nonresidential properties.

Eligibility: Residential or nonresidential property owners, or owners and/or tenants of nonresidential property in neighborhood development, urban renewal, code enforcement areas, Community Development Block Grant areas and Section 810 Urban Homesteading Areas.

Range of Financial Assistance: Up to $200,000

Contact: Community Planning and Development, Office of Urban Rehabilitation and Community Reinvestment, Department of Housing and Urban Development, 451 7th St. S.W., Room 7162, Washington, DC 20410/202-755-5970.

Single—Family Home Mortgage Coinsurance

Objective: To help families undertake homeownership.

Eligibility: All persons are eligible to apply.

Range of Financial Assistance: Maximum insurable loans for an occupant mortgagor are as follows: one family, $60,000; two or three family, $65,000; four family, $75,000.

Contact: Director, Single Family Development Division, Office of Single Family Housing, Department of Housing and Urban Development, Room 9270, Washington, DC 20410/202-755-6720.

Supplemental Loan Insurance Multifamily Rental Housing

Objectives: To finance additions and improvements to any multifamily project, group practice facility, hospital nursing home insured by Housing and Urban Development or held by Housing and Urban Development. Major movable equipment for nursing homes, or group practice facilities or hospital may be covered by a mortgage under this program.

Eligibility: Owners of a multifamily project or facility subject to a mortgage insured by HUD/FHA or held by Housing and Urban Development are eligible.

Range of Financial Assistance: Not specified.

Contact: Director, Multifamily Development Division, Office of Multifamily Housing Development, Housing, Department of Housing and Urban Development, Room 6116, Washington, DC 20411/202-755-9280.

Mobile Homes

See "Loans and Loan Guarantees" in this section.

Mobile Home Safety and Construction

The Department of Housing and Urban Development sets and enforces mobile home construction and safety standards. In addition to providing information on this topic, it will also act on consumer complaints. Contact: State and Consumer Liaison, Investigation and Data Collection, Office of Mobile Home Standards, Department of Housing and Urban Development, 451 7th St. S.W., Room 3248, Washington, DC 20410/202-755-6584.

Modular Housing

For information and expertise on the construction of modular housing contact: Components and Structural Engineering Division, Office of Architecture and Engineering Standards, Office of Housing, Department of Housing and Urban Development, 451 7th St. S.W., Room 6172, Washington, DC 20410/202-755-5924.

Mortgage Help

If you are looking for help in obtaining a mortgage the following free publications are available from HUD:

HUD/FHA Assisted Program for Rental and Cooperative Housing for Lower Income Families
HUD/FHA Program for Home Mortgage Insurance
HUD/FHA Non-Assisted Program for Rental Housing for Moderate Income Families
HUD/FHA Non-Assisted Program for Condominium Housing
Mobile Home Financing thru HUD Graduated Payment Mortgage
Having Problems Paying Your Mortgage?

Contact: Program Information Center, Department of Housing and Urban Development; 451 7th St. S.W., Room 1104, Washington, DC 20410/202-755-6420.

Mortgage Rates

Information and expertise on national mortgage rates are available from: Mortgagee Monitoring Division, Office of Mortgagee Activities, Office of Housing, Department of Housing and Urban Development, 451 7th St. S.W., Room 9160, Washington, DC 20410/202-755-5740.

Neighborhood Reinvestment and Revitalization

See "Grants" ("Community Development Block Grants" and "Urban Development Action Grants").

New Communities and New Towns-in-Town

For information and expertise on the development of new communities in central cities, suburbs and rural areas contact: New Community Development Corp, Department of Housing and Urban Development, 451 7th St. S.W., Room 5282, Washington, DC 20410/202-755-6808.

New Products Meeting Property Standards

A free publication, *Material Releases,* identifies those new products which are not listed in *Minimum Property Standards* (see "Property Standards") but are acceptable. Contact: Material Acceptance Division, Office of Architecture and Engineering Standards, Department of Housing and Urban Development, 451 7th St. S.W., Room 6178, Washington, DC 20410/202-755-5929.

Noise and Indoor Air Pollution

Information and expertise are available on various aspects of environmental hazards, including noise, indoor air pollution and lead-based paint,

from Division of Environmental Hazard Research, Office of Research, Office of Policy Development and Research, Department of Housing and Urban Development, 451 7th St. S.W., Room 8214, Washington, DC 20410/202-755-7340.

Property for Sale—Multifamily

The Department of Housing and Urban Development–held multifamily properties are sold by sealed-bid auction throughout the country. Contact: Multifamily Sales Division, Office of Multifamily Financing and Preservation, Office of Housing, Department of Housing and Urban Development, 451 7th St. S.W., Room 6151, Washington, DC 20410/202-755-7220.

Property for Sale—Single Family

The Department of Housing and Urban Development held single-family properties are sold by sealed-bid auction throughout the country. Contact: Single Family Preservation and Sales, Office of Single Family Housing, Office of Housing, Department of Housing and Urban Development, 451 7th St. S.W., Room 9174, Washington, DC 20410/202-755-6880.

Property Standards

The Department of Housing and Urban Development publishes a 5-volume set of *Minimum Property Standards,* which give builders guidance on such items as safety, design, layout, types of windows, etc., to which they must conform if they want to be eligible for VA, and FHA loans. The volumes are: 1) *Single Family Dwelling,* $20; 2) *Multifamily Dwelling,* $19; 3) *Care Type Housing* (nursing homes), $18; 4) *Manual of Acceptable Practices* (with sketches of designs), $22; and 5) *Solar Heating and Domestic Hot Water Systems,* $12. The 5-volume set is available from Superintendent of Documents, Government Printing Office, Washington, DC 20402/202-783-3238 or contact: Office of Architecture and Engineering Standards, Department of Housing and Urban Development, 451 7th St. S.W., Room 6164, Washington DC 20410/202-755-5718.

Public Housing

Public housing is run locally by a Public Housing Agency. The Department of Housing and Urban Development pays for either the cost of building a new housing project or the cost of buying an existing building. HUD also provides technical and professional assistance in planning, developing and managing projects in construction and modernization. Contact: Technical Support Division, Office of Public Housing, Office of

Housing, Department of Housing and Urban Development, 451 7th St. S.W., Room 6248, Washington, DC 20410/202-755-4956.

Real Estate Practices

See "Settlement Costs" in this section.

Redlining

Redlining is a form of discrimination in which lending institutions boycott investing in certain areas of a city because of race, color, etc. See "Discrimination Hotline" in this section.

Regulatory Activities

Listed below are those organizations within the Department of Housing and Urban Development which are involved with regulating various business activities. With each listing is a description of those industries or situations which are regulated by the office. Regulatory activities generate large amounts of information on the companies and subjects they regulate. Much of the information is available to the public. Regulatory activities can also be used by consumers. A regulatory office can tell you your rights when dealing with a regulated company.

Interstate Land Sales Registration Office. Regulates land developers who sell the land through any means of interstate commerce, including the mails. Contact: Department of Housing and Urban Development, 451 7th St. S.W., Room 4108, Washington, DC 20410/202-755-5860.

Mobile Home Standards. Regulates mobile home construction and safety standards. Contact: Department of Housing and Urban Development, 451 7th St. S.W., Room 3240, Washington, DC 20410/202-755-6920.

Office of Fair Housing and Equal Opportunity. Administers the fair housing program authorized by the Civil Rights Act of 1968. Contact: Department of Housing and Urban Development, 451 7th St. S.W., Room 5208, Washington, DC 20410/202-755-5518.

Real Estate Practices. Regulates real estate settlement procedures used by lenders. Contact: Department of Housing and Urban Development, 451 7th St. S.W., Room 3234, Washington, DC 20410/202-755-6524.

Rental Rates

Fair market rents for various types of dwellings in over 450 market areas are published yearly. Contact: Technical Support Division, Office of Multifamily Housing Development, Office of Housing, Department of Housing and Urban Development, 451 7th St. S.W., Room 6133, Washington, DC 20410/202-755-8686.

Rent Subsidies, Multifamily

Those who are developing or rehabilitating multifamily housing can seek rent subsidies for low-income tenants. See "Direct Payments" in this section or contact: Rehabilitation Division, Office of Multifamily Housing Development, Office of Housing, Department of Housing and Urban Development, 451 7th St. S.W., Room 6132, Washington, DC 20410/202-755-6500.

Research Studies

See "Consumer Information" and "Consumer Publications on Housing" in this section.

Settlement Costs

Lending institutions which deal in FHA or VA loans are required to provide buyers with a special information booklet which describes the settlement and the roles of the realtor, seller and buyer. Copies of the booklet, *Buying a Home? Don't Forget the Settlement Costs,* are also available for free from Housing and Urban Development. Contact: Information Center, Department of Housing and Urban Development, 451 7th St. S.W., Room 1104, Washington, DC 20410/202-755-6420.

Small Cities Assistance

Special financial assistance is available to small cities for improving neighborhood facilities, health facilities, sewer systems, roads, parks, land acquisition, property and rehabilitation. See "Grants" ("Community Development Block Grants/Small Cities Program") or contact: Small Cities Division, Office of Block Grant Assistance, Office for Community Planning and Development, Department of Housing and Urban Development, 451 7th St. S.W., Room 7282, Washington, DC 20410/202-755-6322.

Solar Heating and Cooling Research

The Department of Housing and Urban Development is responsible for demonstrating the practical application of solar energy in residential heating and cooling systems. It supports residential demonstrations in which solar equipment is installed in both existing and new homes; develops performance criteria for solar equipment; develop markets to encourage the housing industry to use solar technology; and provides information on its demonstration and marketing development efforts. A listing of publications is available. Contact: Solar Heating and Cooling Research, Office of Policy Development and Research, Department of Housing and Urban Development, 451 7th St. S.W., Room 8162, Washington, DC 20410/202-755-6900.

Solar Information Hotline

The Department of Housing and Urban Development with the Department of Energy has established a National Solar Heating and Cooling Information Center to provide free information to both consumers and industry. They will perform literature searches on specific subjects, serve as a referral point for people needing detailed technical data from a number of sources, and distribute available publications. Contact: National Solar Heating and Cooling Center, P. O. Box 1607, Rockville, MD 20850/toll-free 800-523-2929; 800-462-4983 in Pennsylvania; 800-523-4700 in Alaska or Hawaii.

Statistics, Housing

Each year an *Annual Housing Survey* is conducted which samples some 80,000 housing units and 60 metropolitan areas and produces information on house inventory, house and neighborhood quality, characteristics of inhabitants, energy retrofitting, condominiums and cooperatives, and condominium conversion. The data from the survey are available in a variety of formats. In addition to the *Annual Housing Survey,* HUD also:

Analyzes non-financial resources for housing requirements (labor, land, etc.)
Projects housing needs for the next 2 decades
Projects housing inventory to the year 2000
Conducts special research on new usage for increasing housing quality
Assesses housing needs
Conducts research on reducing settlement costs and increasing efficiency

Contact: Division of Housing and Demographic Analysis, Office of Economic Affairs, Offices of Policy Development and Research, Department of Housing and Urban Development, 451 7th St. S.W., Room 8224, Washington, DC 20410/202-755-5590. Another source for housing statistics is the Statistical Operations Branch. In addition to general information and expertise the following publication is available for free: *HUD Statistical Yearbook*—annual tallies by state of Housing and Urban Development programs. Contact: Statistical Operations Branch, Data Management Division, Office of Organization and Management Information, Department of Housing and Urban Development, 451 7th St. S.W., Room 3186, Washington, DC 20410/202-755-5194.

Steering

Steering is a type of discrimination in which a person is directed to buy or rent in a particular neighborhood or facility in order to keep

him/her from buying in other areas. See "Discrimination Hotline."

Surplus Land

HUD sells or leases real property that is surplus to the Federal government's needs (e.g. a closed air force base). Property can range from unimproved land to housing projects. About 25 percent of the property must be used for low and moderate income housing. Contact: Office of Surplus Land and Housing, New Community Development Corporation, Office of Community Planning and Development, Department of Housing and Urban Development, 451 7th St. S.W., Room 5182, Washington, DC 20410/202-755-1862.

Tax Policy and Public Finance

Research is conducted on items involving city revenue; local tax policies; how well economic development is working; and local municipal pension funds (how well funded they are and their future state). Contact: Division of Economic Development and Public Finance, Office of Economic Affairs, Policy Development and Research, Department of Housing and Urban Development, 451 7th St. S.W., Room 8208, Washington, DC 20410/202-755-6164.

Urban Economic Development

See "Grants" ("Community Development Block Grants" and "Urban Development Action Grants").

Women's Housing Information Center

For information on the special needs and concerns of women in housing and the housing market contact: Women's Policy and Program Staff, Office of Intergovernmental Affairs, Department of Housing and Urban Development, 451 7th St. S.W., Room 4212, Washington, DC 20410/202-755-6480.

How Can the Department of Housing and Urban Development Help You?

To determine how the U.S. Department of Housing and Urban Development can help you first contact: Program Information Center, Department of Housing and Urban Development, 451 7th St. S.W., Room 1104, Washington, DC 20410/202-755-6420.

Department of the Interior

C St. between 18th and 19th Sts. N.W., Washington, DC 20240/202-343-7351

ESTABLISHED: March 3, 1949
BUDGET: $4,998,064,000
EMPLOYEES: 57,845

MISSION: Administration of over 500 million acres of federal land, and trust responsibilities for approximately 50 million acres of land, mostly Indian reservations; the conservation and development of mineral and water resources; the conservation, development, and utilization of fish and wildlife resources; the co-ordination of federal and state recreation programs; the preservation and administration of the nation's scenic and historic areas; the operation of Job Corps Conservation Centers, and Youth and Young Adult Conservation Corps camps, and coordination of other manpower and youth training programs; the reclamation of arid lands in the West through irrigation; and the management of hydro-electric power systems.

Major Divisions and Offices

Assistant Secretary for Energy and Minerals

Department of the Interior, Room 6654, Washington, DC 20240/202-343-2186.
Budget: $972,760,000
Employees: 13,233

1. Geological Survey

Department of the Interior, National Center, 12201 Sunrise Valley Dr., Reston, VA 22092/703-860-7444.
Budget: $626,673,000
Employees: 9,536
Mission: Perform surveys, investigations, and research covering topography, geology, and the mineral and water resources of the United States; classify land as to mineral character and water and power resources; enforce departmental regulations applicable to oil, gas, and other mining leases, permits, licenses, development contracts, and gas storage contracts; and publish and disseminate data relative to the foregoing activities.

2. Bureau of Mines

Department of the Interior, 2401 E St. N.W., Washington, DC 20241/202-634-1004.

Budget: $165,504,000
Employees: 2,672
Mission: Help ensure that the nation has adequate mineral supplies for security and other needs; conduct applied and basic research to develop the technology for the extraction, processing, use, and recycling of the nation's mineral resources at a reasonable cost without harm to the environment or the workers involved; administer some environmental repair programs specifically authorized by laws such as the Appalachian Regional Development Act; and collect, compile, analyze, and publish statistical and economic information on all phases of mineral resource development, including exploration, production, shipments, demand, stocks, prices, imports and exports.

3. Office of Surface Mining Reclamation and Enforcement

Department of the Interior, Washington, DC 20240/202-343-4953.
Budget: $180,583,000
Employees: 1,025
Mission: Create a nationwide program that protects society and the environment from the adverse effects of coal mining operations, while

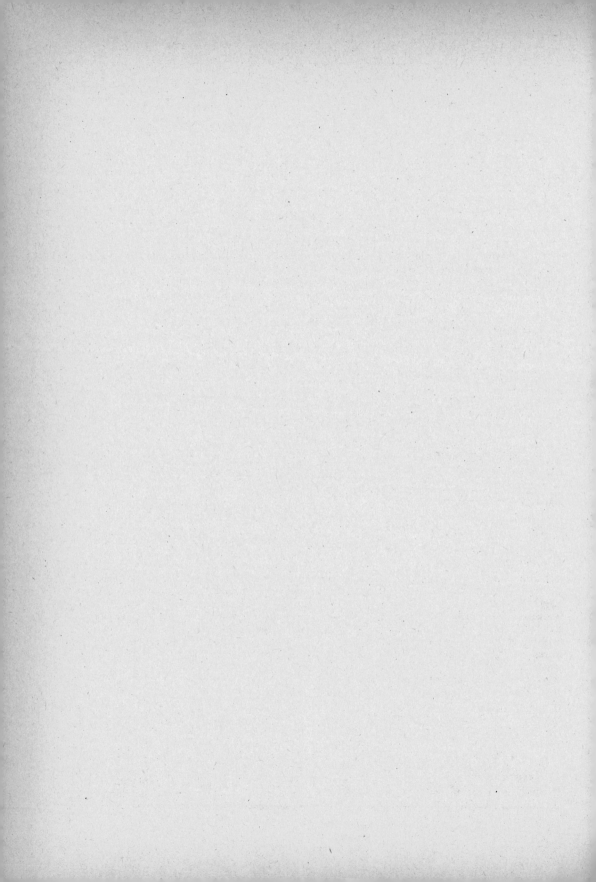

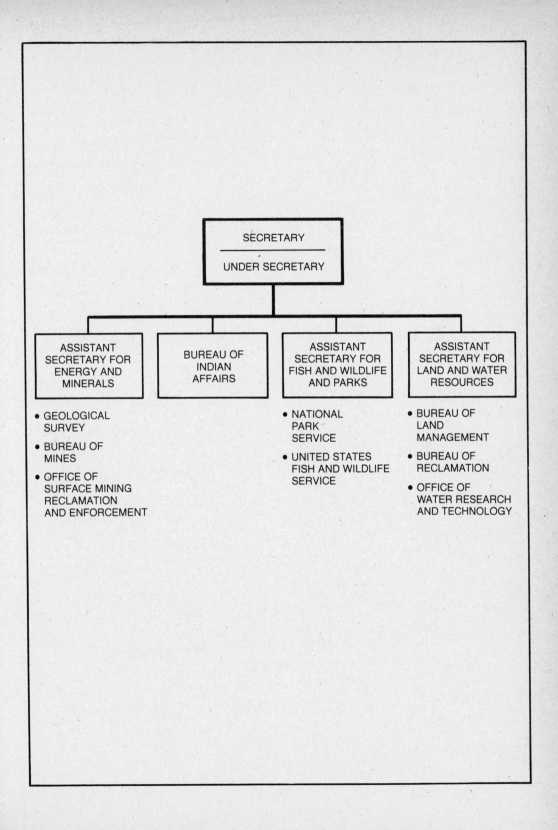

ensuring an adequate supply of coal to meet the Nation's energy needs; establish minimum standards for regulating the surface effects of coal mining; assist the States in developing and implementing regulatory programs; and promote the reclamation of previously mined areas.

Bureau of Indian Affairs

Department of the Interior, Washington, DC 20240/202-343-7445.
Budget: $801,895,000
Employees: 13,438
Mission: Encourage and train Indian and Alaskan Native people to manage their own affairs under the trust relationship to the federal government; facilitate with maximum involvement of Indian and Alaskan Native people, full development of their human and natural resource potentials; mobilize all public and private aids to the advancement of Indian and Alaskan Native people for use by them; and utilize the skills and capabilities of Indian and Alaskan Native people in the direction and management of programs for their benefit.

Assistant Secretary for Fish and Wildlife and Parks

Department of the Interior, Washington, DC 20240/202-343-4416.
Budget: $1,693,468,000
Employees: 15,782

1. National Park Service

Department of the Interior, Washington, DC 20240/202-343-7394.
Budget: $522,001,000
Employees: 9,702
Mission: Administer the properties under its jurisdiction for the enjoyment and education of our citizens; protect the natural environment of the areas; and assist states, local governments, and citizen groups in the development of park areas, the protection of the natural environment and the preservation of historic properties.

2. United States Fish and Wildlife Service

Department of the Interior, Washington, DC 20240/202-343-5634.
Budget: $436,534,000
Employees: 5,464
Mission: Responsible for wild birds, endangered species, certain marine mammals, inland sport fisheries, and specific fishery and wildlife resources; insure maximum opportunity for the American people to benefit from fish and wildlife resources as part of their natural environment; assist in the development of an environmental stewardship based on ecological principles, scientific knowledge of wildlife, and a sense of moral responsibility; guide the conservation, development, and management of the nation's fish and wildlife resources; and administer a national program which provides opportunities to the American public to understand, appreciate, and wisely use these resources.

Assistant Secretary for Land and Water Resources

Department of the Interior, Washington, DC 20243/202-343-2191.
Budget: $1,529,941,000
Employees: 13,724

1. Bureau of Land Management

Department of the Interior, Washington, DC 20240/202-343-4151.
Budget: $878,319
Employees: 6,214
Mission: Total management of 417 million acres of public lands; issue rights-of-way, in certain instances, for crossing federal lands under other agencies' jurisdiction; and survey the federal lands and establish and maintain public land records and records of mining claims.

2. Bureau of Reclamation

Department of the Interior, Washington, DC 20240/202-343-4662.
Budget: $620,841,000
Employees: 7,431
Mission: Assist States, local governments, and other federal agencies to stabilize and stimulate local and regional economies, enhance and protect the environment, and improve the quality of life through development of water, other renewable resources, and related land resources throughout the 17 contiguous Western States and Hawaii.

3. Office of Water Research and Technology

Department of the Interior, Washington, DC 20240/202-343-4607.
Budget: $30,781,000
Employees: 83
Mission: Develop new or improved technology and methods for solving or mitigating existing

and projected state, regional, and nationwide water resource problems; train water scientists and engineers through their on-the-job participation in research work; and accomplish water research coordination and research results information dissemination activities.

Data Experts

Foreign Minerals and Metals Experts

Foreign country mineral experts monitor all aspects of foreign mineral industries. Statistics are kept on current and anticipated mineral production. The role of mineral industries in foreign economies is studied along with the legislative and investment climates affecting these industries. These experts can be reached by telephone or by writing in care of: Branch of Foreign Data, Mineral and Materials Supply and Demand, Bureau of Mines, Department of the Interior, 2401 E St. N.W., Room W614, Washington, DC 20241/202-632-8970.

Afghanistan/P. Clarke/202-632-5065
Albania/W. Steblez/202-632-1276
Algeria/S. Ambrosio/202-632-5065
Angola/D. Morgan/202-632-5065
Antarctica/C. Wyche/202-632-5052
Argentina/P. Velasco/202-632-9352
Australia/C. Wyche/202-632-5052
Austria/G. Rabchevsky/202-632-5043
Bahamas/H. Ensminger/202-632-5060
Bahrein/P. Clarke/202-632-5065
Bangladesh/G. Kinney/202-634-1272
Barbados/H. Ensminger/202-632-5060
Belgium/G. Rabchevsky/202-632-5053
Belize/H. Ensminger/202-632-5060
Benin/G. Morgan/202-632-5065
Bermuda/H. Ensminger/202-632-5060
Bhutan/G. Kinney/202-634-1272
Bolivia/P. Velasco/202-632-9352
Botswana/K. Connor/202-632-5065
Br. Solomon Islands/C. Wyche/202-632-5052
Brazil/T. Lyday/202-632-5061
Brunei/J. Wu/202-634-1272
Bulgaria/T. Karpinsky/202-634-1276
Burma/G. Kinney/202-634-1272
Burundi/K. Connor/202-632-5065
Cambodia (Kampucheu)/G. Kinney/202-634-1272
Cameroon/S. Ambrosio/202-632-5065
Canada/H. Newman/202-632-5060
Cape Verde Islands/G. Morgan/202-632-5065
Central African Republic/S. Ambrosio/202-632-5065
Chad/S. Ambrosio/202-632-5065
Chile/P. Velasco/202-632-9352

China/E. Chin/202-634-1272
Christmas Island/J. Wu/202-634-1272
Columbia/D. Hyde/202-632-9352
Comoros/K. Connor/202-632-5065
Congo/S. Ambrosio/202-632-5065
Costa Rica/H. Ensminger/202-632-5060
Cuba/H. Ensminger/202-632-5060
Cyprus/T. Glover/202-632-5065
Czechoslovakia/T. Karpinsky/202-634-1276
Denmark/J. Huvos/202-632-5047
Djibouti (Afars & Issars)/K. Connor/202-632-5065
Dominican Republic/H. Ensminger/202-632-5060
Ecuador/T. Lyday/202-632-5061
Egypt/J. Lewis/202-632-5065
El Salvador/H. Ensminger/202-632-9352
Equatorial Guinea/S. Ambrosio/202-632-5065
Ethiopia/K. Connor/202-632-1272
Fiji/C. Wyche/202-634-1272
Finland/J. Huvos/202-632-5047
France/R. Sondermayer/202-632-5049
French Guiana/T. Lyday/202-632-5061
Gabon/B. Kornhauser/202-632-5065
Gambia/G. Morgan/202-632-5065
Germany, East/G. Rabchevsky/202-632-5053
Germany, West/G. Rabchevsky/202-632-5053
Ghana/B. Kornhauser/202-632-5065
Greece/W. Steblez/202-634-1276
Greenland/J. Huvos/202-632-5047
Grenada/D. Hyde/202-632-9352
Guadaloupe/H. Ensminger/202-632-5060
Guatemala/H. Ensminger/202-632-5060
Guinea/G. Morgan/202-632-5065
Guinea Bissau/G. Morgan/202-632-5065
Guyana/T. Lyday/202-632-5061
Haiti/H. Ensminger/202-632-5060
Honduras/H. Ensminger/202-632-5060
Hong Kong/E. Chin/202-634-1272
Hungary/W. Steblez/202-634-1276
Iceland/J. Huvos/202-632-5047
India/G. Kinney/202-634-1272
Indonesia/J. Wu/202-634-1272
Iran/J. Lewis/202-632-5065
Iraq/G. Morgan/202-632-5065
Ireland/T. Karpinsky/202-634-1276
Israel/S. Ambrosio/202-632-5065
Italy/R. Sondermayer/202-632-5049

Ivory Coast/G. Morgan/202-632-5065
Jamaica/H.Ensminger/202-632-5060
Japan/J. Wu/202-634-1272
Jordan/P. Clarke/202-632-5065
Kenya/T.Glover/202-632-5065
Kampuchea (Cambodia)/G. Kinney/202-634-1272
Kiribati/C. Wyche/202-634-1272
Korea, North/E. Chin/202-634-1272
Korea, South/E.Chin/202-634-1272
Kuwait/P. Clarke/202-632-5065
Kuwait (Neutral Zone)/P. Clarke/202-632-5065
Laos/G. Kinney/202-634-1272
Lebanon/P. Clarke/202-632-5065
Lesotho/K. Connor/202-632-5065
Liberia/B. Kornhauser/202-632-5065
Libya/J. Lewis/202-632-5065
Luxembourg/G. Rabchevsky/202-632-5053
Macao/J. Wu/202-634-1272
Madagascar (Malagasy Republic)/
 K. Connor/202-632-5065
Malawi/K. Connor/202-632-5065
Malaysia/J. Wu/202-634-1272
Mali/G. Morgan/202-632-5065
Malta/W. Steblez/202-632-5076
Martinique/H. Ensminger/202-632-5060
Mauritania/T. Glover/202-632-5065
Mauritius/K. Connor/202-632-5065
Mexico/D. Hyde/202-632-9352
Mongolia/J. Wu/202-634-1272
Morocco/G. Morgan/202-632-5065
Mozambique/T. Glover/202-632-5065
Namibia (South West Africa)/M. Ellis/202-632-5065
Nauru/C. Wyche/202-634-1272
Nepal/G. Kinney/202-634-1272
Netherlands/G. Rabchevsky/202-632-5053
Netherlands Antilles/H. Ensminger/202-632-5060
New Caledonia/C. Wyche/202-634-1272
New Hebrides/C. Wyche/202-634-1272
New Zealand/C. Wyche/202-634-1272
Nicaragua/H. Ensminger/202-632-5060
Niger/G. Morgan/202-632-5065
Nigeria/B. Kornhauser/202-632-5065
Norway/J. Huvos/202-632-5047
Ocean Islands/C. Wyche/202-632-5052
Ocean Minerals/C. Wyche/202-632-5052
Oman/P. Clarke/202-632-5065
Pakistan/S. Ambrosio/202-634-5065
Panama/H. Ensminger/202-632-5060
Papau New Guinea/C. Wyche/202-634-1272
Paraguay/T. Lyday/202-632-5061
Peru/D. Hyde/202-632-9352
Phillippine Islands/J. Wu/202-634-1272
Poland/T. Karpinsky/202-634-1276
Portugal/R. Sondermayer/202-632-5049
Qatar/P. Clarke/202-632-5065

Reunion/K. Connor/202-632-5065
Romania/W. Steblez/202-634-1276
Rwanda/K. Connor/202-632-5065
Sao Tome e Principe/S. Ambrosio/202-632-5065
Saudi Arabia/J. Lewis/202-632-5065
Senegal/G. Morgan/202-632-5065
Seychelles/K. Connor/202-632-5065
Sierra Leone/B. Kornhauser/202-632-5065
Singapore/E. Chin/202-634-1272
Somalia, Republic of/K. Connor/202-632-5065
South Africa, Republic of/M. Ellis/202-632-5065
South West Africa (Namibia)/E. Shekarchi/202-632-5065
Spain/R. Sondermayer/202-632-5049
Spanish Sahara/J. L. Jolly/202-632-5065
Sri Lanka/G. Kinney/202-634-1272
Sudan/K. Connor/202-632-5065
Surinam/T. Lyday/202-632-5061
Swaziland/K. Connor/202-632-5065
Sweden/J. Huvos/202-632-5047
Switzerland/R. Sondermayer/202-632-5049
Syria/P. Clarke/202-632-5065
Taiwan/E. Chin/202-634-1272
Tanzania/T. Glover/202-634-1272
Thailand/G. Kinney/202-634-1272
Togo/G. Morgan/202-632-5065
Trinidad and Tobago/H. Ensminger/202-632-5060
Tunisia/K. Connor/202-632-5065
Turkey/P. Clarke/202-632-5065
Uganda/K. Connor/202-632-5065
United Arab Emirates/J. Lewis/202-632-5065
United Kingdom/T. Karpinsky/202-634-1276
Upper Volta/G. Morgan/202-632-5065
Uruguay/T. Lyday/202-632-5061
U.S.S.R./P. Levine/202-632-5060
Venezuela/H. Ensminger/202-632-5060
Vietnam/G. Kinney/202-634-1272
Yemen (Aden)/P. Clarke/202-632-5065
Yemen (Sana)/P. Clarke/202-632-5065
Yugoslavia/R. Sondermayer/202-632-5049
Zaire/B. Kornhauser/202-632-5065
Zambia/T. Glover/202-632-5065
Zimbabwe Rhodesia/G. Morgan/202-632-5065

Minerals and Metals Experts

Commodity specialists collect, analyze, and disseminate information on the adequacy and availability of the mineral base for the national economy. Fluctuations of supply and demand of particular commodities are studied. These experts can be reached by telephone or writing in care of: Bureau of Mines, Department of the Interior, Washington, DC 20241.

Abrasive Materials/J. F. Smoak/202-634-1206
Aluminum/F. X. McCawley/202-634-1080
Antimony/P. Plunkert/202-634-1063
Argon/W. F. Stowasser/202-634-1190
Arsenic/J. R. Loebenstein/202-634-1056
Asbestos/R. A. Clifton/202-634-1206
Asphalt/W. Johnson/202-634-4770
Barite/D. Morse/202-634-1177
Bauxite/L. Baumgardner/202-634-1081
Beryllium/B. Petkof/202-634-1073
Bismuth/J. Carlin/202-634-1063
Boron/P. Lyday/202-634-1177
Bromine/P. Lyday/202-634-1177
Cadmium/P. Plunkert/202-634-1063
Calcium/L. Pelham/202-634-4770
Cement/S. Absalom/202-634-1184
Cesium/J. Rathjen/202-634-1083
Chromium/J. Papp/202-634-1028
Clays/S. G. Ampian/202-634-1180
Cobalt/W. S. Kirk/202-634-1028
Columbium/L. Cunningham/202-634-1024
Copper/W. Butterman/202-634-1071
Copper Scrap/L. Carrico/202-634-1082
Corundum/J. Smoak/202-634-1206
Diamond (Industrial)/J. Smoak/202-634-1206
Diatomite/A. C. Meisinger/202-634-1184
Explosives/C. Davis/202-634-1177
Feldspar/M. J. Potter/202-634-1180
Ferroalloys/R. Brown/202-634-1015
Fluorspar/D. Morse/202-634-1177
Fluorine/L. Pelham/202-634-4770
Gallium/B. Petkof/202-634-1073
Garnet/J. Smoak/202-634-1206
Gemstones/J. Pressler/202-634-1206
Germanium/R. Reese/202-634-1083
Gold/J. Lucas/202-634-1070
Graphite (Natural)/H. Taylor/202-634-1180
Greensand/J. Searls/202-634-1190
Gypsum/J. W. Pressler/202-634-1206
Hafnium/L. E. Lynd/202-634-1073
Helium/P. Tully/202-376-2604
Ilmenite/L. E. Lynd/202-634-1073
Indium/J. F. Carlin, Jr./202-634-1063
Iodine/P. Lyday/202-634-1177
Iron Ore/F. L. Klinger/202-634-1023
Iron and Steel/F.Schottman/202-634-1022
Iron and Steel Scrap/F. Cooper/202-634-1022
Kyanite and Related Minerals/M. J.
 Potter/202-634-1180
Lead/W. Woodbury/202-634-1083
Lime/J. W. Pressler/202-634-1206
Lithium/J. Ferrell/202-634-4770
Magnesium Compounds/B. Petkof/202-634-
 1073
Magnesium Metal/B. Petkof/202-634-1073

Manganese/T. Jones/202-634-7091
Mercury/L. Carrico/202-634-1082
Mica (Natural, Scrap and Flake)/
 W. Johnson/202-634-4770
Mica (Natural, Sheet)/A. B. Zlobik/202-634-
 1202
Molybdenum/J. O'Donnell/202-634-1025
Nickel/S. Sibley/202-634-1025
Nitrogen (Elemental, Fixed, and Natural
 Nitrates)/C. Davis/202-634-1190
Oxygen/W. F. Stowasser/202-634-1190
Peat/C. Davis/202-634-1190
Perlite (Crude)/A. C. Meisinger/202-634-1184
Phosphate Rock/W. Stowasser/202-634-1190
Platinum Group Metals/J. R. Loebenstein/202-
 634-1056
Potash/J. Searles/202-634-1190
Pumice and Volcanic Cinder/A. Meisinger/202-
 634-1184
Quartz Crystal/A. Meisinger/202-634-4770
Radium/W. S. Kirk/202-634-1085
Rare-Earth Metals/J. Hedrick/202-634-1082
Rhenium/I. Torres/202-634-1029
Rubidium/J. Rathjen/202-634-1083
Rutile/L. E. Lynd/202-634-1073
Salt/D. Kostick/202-634-1177
Sand and Gravel/V. V. Tepordei/202-634-1185
Scandium/C. M. Moore/202-634-1085
Selenium/J. R. Loebenstein/202-634-1056
Silicon/G. Murphy/202-634-1024
Silver/H. J. Drake/202-634-1054
Slag (Iron and Steel)/C. T. Collins/202-634-
 1024
Sodium Carbonate/D. S. Kostick/202-634-1177
Sodium Sulfate/D. S. Kostick/202-634-1177
Stone/M. Taylor/202-634-1180
Stone/H. Taylor/202-634-1180
Strontium/J. Farrell/202-634-4770
Talc & Pyrophyllite/R. A. Clifton/202-634-
 1206
Tantalum/L. Cunningham/202-634-1024
Tellurium/J. R. Loebenstein/202-634-1054
Thallium/P. Plunkert/202-634-1063
Thorium/J. B. Hedrick/202-634-1082
Tin/J. F. Carlin/202-634-1063
Titanium and Titanium Dioxide/L. E.
 Lynd/202-634-1073
Tungsten/P. T. Stafford/202-634-1029
Uranium (Depleted)/W. S. Kirk/202-634-1085
Vanadium/P. Kuck/202-634-1021
Vermiculite (Crude)/A. Meisinger/202-634-
 1184
Yttrium/J. Hendrick/202-634-1082
Zinc/V. A. Cammarota/202-634-1063
Zirconium/L. E. Lynd/202-634-1073

Major Sources of Information

Abandoned Mine Lands Reclamation

The Office of Surface Mining Reclamation and Enforcement is concerned with reclaiming those mines that are either abandoned or not adequately safeguarded against hazards to public health and safety. This office collects fees from every ton of coal mined in order to restore the land and rectify past mistakes. Contact: Abandoned Mine Lands, Office of Surface Mining Reclamation and Enforcement, Department of the Interior, 1951 Constitution Ave. N.W., Room 220, Washington, DC 20245/202-343-4012.

Aerial Photographs of the United States

Aerial photographs are available for most any large or small area of the United States, taken from heights ranging from a few thousand feet to over 60,000 feet. You can probably get a picture of your neighborhood. Contact: User Services, Earth Resources Observation System Data Center, Geological Survey, Department of the Interior, Sioux Falls, SD 57198/605-594-6511, ext. 111.

Animal Damage Control

Information and assistance are available to reduce damage caused by wildlife (birds and mammals) to livestock, crops, forests, wildlife resources; residential, business and industrial properties; and to reduce threats to human health and safety. Examples of damage include: pets killed by coyotes, pigeons living in the eaves of houses, and birds on airport runways. Contact: Division of Animal Damage Control, Fish and Wildlife Service, Department of the Interior, 1717 H St. N.W., Room 510, Washington, DC 20240/202-632-7463.

Antarctic Maps

The Geological Survey in cooperation with the National Science Foundation prepares and publishes topographic maps of selected areas of Antarctica needed to support the U.S. Antarctic Research Program (USARP) efforts. These maps are prepared from aerial photography by U.S. Navy Air Development Squadron Six (VXE-6) in accordance with USGS specifications. For a catalog of available maps, contact: Branch of Distribution, Geological Survey, Department of the Interior, 1200 South Eads St., Arlington, VA 22202/703-557-2781.

Aquarium, National

The National Aquarium is located in the basement of the Main Commerce Building, 14th St. and Constitution Ave., in Washington, DC, and contains a wide variety of fish from all parts of the country. Contact: Fish and Wildlife Service, Department of the Interior, Washington, DC 20240/202-377-2826.

Archeological and Historic Area Studies

See "National Park Service Information" in this section.

Archeological and Historical Publications

The results of National Park Service research on history and archeology are available to the public. Contact: Professional Publications, National Park Service, Department of the Interior, 1100 L St. N.W., Room 8220, Washington, DC 20005/202-357-0080.

Archeological Projects

For information on archeologic projects being conducted in the Western states, contact: Senior Service Archeologist, Office of Environmental Affairs, Department of the Interior, P.O. Box 25007, Denver Federal Center, Denver, CO 80225/303-234-4348.

Archeological Services

The Department of the Interior preserves historic and archeological data threatened by destruction because of federal construction projects or other federally-assisted activities. Contact: Interagency Archeological Services Division, Heritage Conservation and Recreation Service, Department of the Interior, 440 G St. N.W., Room 235, Washington, DC 20243/202-272-3750.

Art Catalog

The American Artist and Water Reclamation, an art catalog of the 65 paintings from the Water and Power Resources Service Art Collection, is available for $1.75. Contact: Manager, Public Documents Distribution Center, Government Printing Office, Pueblo, Colorado 81009/303-544-5277.

Atlas, National

The National Atlas of the U.S. will be a looseleaf collection of full-color maps and charts showing physical features such as landforms, geology, soil, vegetation, climate and environmental hazards such as landslides. Economic, social and cultural data are also presented. Sixty percent of the Atlas is digitized. Contact: Geographic Research, National Mapping Division,

Geological Survey, Department of the Interior, National Center, MS 512, Reston, VA 22092/703-860-6212.

Buffalo and Cattle

Certain nonprofit organizations can obtain free American buffalo or Texas longhorn cattle from government refuges. The government also auctions these animals to the public. Information and expertise are also available on the management of herds of range animals. Contact: Division of Refuge Management, Fish and Wildlife Service, Department of the Interior, Room 2340, Washington, DC 20240/202-343-4305.

Bureau of Land Management Needs You

In order to understand the ecological relationships in an area and to better consider the needs and wishes of the people throughout the Nation, the Bureau of Land Management encourages individuals to visit a local office and offer their ideas. For a complete listing of local offices, contact: Bureau of Land Management, Department of the Interior, 1129 20th St. N.W., Room 309, Washington, DC 20036/202-343-8205.

Cadastral Survey

The Division of Cadastral Surveys determines boundaries for ownership purposes for the federal government using the "Rectangular System." All original land titles except those in the 13 Colonial States are based on cadastral surveys. Records are in the form of drawings or maps and written descriptions of all land which is now or was once either a part of the public domain or land designated by Congress as within the jurisdiction of the cadastral survey. Contact: Division of Cadastral Survey, Bureau of Land Management, Department of the Interior, 1129 20th St. N.W., Room 309, Washington, DC 20036/202-653-8798.

Camping, Hunting, Fishing, Hiking, Etc.

See "Outdoor Activites," "Outdoor Recreation," and "Trails, National" in this section.

Camping Publications

The following publications are published by the Department of the Interior and are useful for campers:

Camping in the National Park System ($1.40)
Guide and Map, National Parks of the U.S. ($.70)
Visitor Accomodations, Facilities and Services Furnished by Concessioners in the National Park System ($2.75)
Index, National Park System and Related Areas ($3.25). Available from Superintendent of Documents, Government Printing Office, Washington, DC 20402/202-783-3238.

Campground Reservations. Free from: Department of the Interior, National Park Service, 18th and C Sts. N.W., Room 1013, Washington, DC 20240/202-343-7394.

The Complete Guide to America's National Parks ($5.80). Available from National Park Foundation, P.O. Box 57473, Washington, DC 20037/202-343-6578.

Christmas Trees

Free Christmas trees are available from public lands to nonprofit organizations. For the nominal fee of $1.00, an individual can cut his or her own tree. This program is mainly in the 10 western states. Contact: Division of Forestry, Bureau of Land Management, Department of the Interior, Room 5620, Washington, DC 20240/202-653-8864.

City and Land Planning Assistance

Technical help and information are available to city planners, officials and environmentalists from the Resource and Land Investigation Program. The program enables a planner to find the variety of information needed to solve a particular problem. Information ranges from topographic, geologic and hydrologic data to those on fish and wildlife, recreation, mining and rangeland. Activities include technical workshops that train coastal area planners or town officials to predict and prepare for the impact of energy exploitation in their area. Contact: Earth Resource Observation Systems, Land and Information Analysis, Geological Survey, Department of the Interior, The National Center, MS 730, Room 2A200, Reston, VA 22092/703-860-6717.

Cloud Seeding

For information and technical expertise on Project Skywater and other cloud seeding programs, contact: Office of Atmospheric Resources Management, Water and Power Resources Service, Department of the Interior, P.O. Box 25007, Denver Federal Center, Denver, CO 80225/303-234-2056.

Conservation on Public Lands

General information is available on: 1) classification of public lands as to their mineral character and their value for water power and water storage purposes; 2) evaluation of mineral tracts that are subject to competitive leasing; and 3) supervision and regulation of operations associated with the exploration, development and production of minerals on Federal, Indian and Outer Continental Shelf lands under lease, license and

prospecting permits, including the collection of royalties and certain rentals which result from these operations. Contact: Information, Conservation Division, Geological Survey, Department of the Interior, 600 National Center, Reston, VA 22092/703-860-7524.

Conservation Law Enforcement Training

Training assistance is available to state conservation officers in criminal law, and the principles, techniques and procedures of wildlife law enforcement. Contact: Chief, Division of Law Enforcement, Fish and Wildlife Service, Department of the Interior, Box 28006, Washington, DC 20005/202-343-9243.

Cultural Resources

Information is available on all National Park Service historic, cultural, archeological and architectural structures on historic sites and on artifacts considered worthy of preservation. Two computer files are available: 1) List of Classified Structures, and 2) Bibliography Inventory of Park Historical and Architectural Studies. Contact: Cultural Resources, National Park Service, Department of the Interior, MS 560, Washington, DC 20240/202-272-3750.

Data Base Directory

The U.S. Geological Survey publishes a comprehensive inventory of its machine-readable scientific and technical, spatial, and bibliographic data bases. Copies of *Scientific and Technical, Spatial, and Bibliographic Data Bases of the U.S. Geological Survey* can be obtained free of charge from: Branch of Distribution, Geological Survey, Department of the Interior, 1200 South Eads Street, Arlington, VA 22202/703-557-2781. For technical information regarding the data bases, contact: Office of Data Base Administration, Geological Survey, Department of the Interior, 115 National Center, Reston, VA 22022/703-860-6086.

Desalting Plants Study

A detailed, three-volume study by Burns and Roe for the Office of Water Research and Technology investigated brackish Water Membrane Desalting Plants. Copies are available for $60.00 (NTIS No. PB294-080) from: National Technical Information Service, Department of Commerce, Springfield, VA 22161/703-487-4600 (see, also, "Saline Water Conversion" in this section).

Direct Payments

The programs described below are those which provide financial assistance directly to individuals, private firms and other private institutions to encourage or subsidize a particular activity.

Indian Social Services—Child Welfare Assistance

Objectives: To provide foster home care and appropriate insitutional care for dependent, neglected, and handicapped Indian children residing on or near reservations, including those children living in jurisdictions under the BIA in Alaska and Oklahoma, when these services are not available from state or local public agencies.

Eligibility: Dependent, neglected, and handicapped Indian children whose families live on or near Indian reservations or in jurisdictions under the Bureau of Indian Affairs in Alaska and Oklahoma. Applications may be made by a parent or guardian or person having custody of the child.

Range of Financial Assistance: Not specified.

Contact: Office of Tribal Resources Development, Bureau of Indian Affairs, Department of the Interior, Room 4659, 18th and C Sts. N.W., Washington, DC 20245/202-343-7445.

Indian Social Services—General Assistance

Objectives: To provide assistance for living needs to needy Indians on or near reservations, including those Indians living in jurisdictions under the Bureau of Indian Affairs in Alaska and Oklahoma, when such assistance is not available from state or local public agencies.

Eligibility: Needy Indians living on or near Indian reservations or in jurisdictions under the Bureau of Indian Affairs in Alaska and Oklahoma.

Range of Financial Assistance: Not specified.

Contact: Division of Social Services, Office of Indian Services, Bureau of Indians Affairs, Department of the Interior, 18th and C Sts. N.W., Washington, DC 20245/703-235-2756.

Regulation of Surface Coal Mining and Surface Effects of Underground Coal Mining

Objectives: To protect society and the environment from the adverse effects of surface coal mining operations consistent with assuring the coal supply essential to the nation's energy requirements.

Eligibility: State governor designated agencies, small operators, coal mining operations. Eligibility for small operator assistance is determined by production of less than 100,000 tons of coal annually at all mining locations.

Range of Financial Assistance: $13,783 to $8,146,000.

Contact: State Grants and Small Operator Assistance, State and Federal Programs, Office of

Surface Mining Reclamation and Enforcement, Dept. of the Interior, Washington, DC 20240/202-343-5361.

Dredging and Filling

Wetlands and aquatic culture areas are monitored to avoid unnecessary environmental disruption when there is dumping and discharge. Contact: Permits and License Branch, Ecological Services, Fish and Wildlife Service, Department of the Interior, 1375 K St. N.W., Room 415, Washington, DC 20240/202-343-4545.

Duck Stamp Contest

The duck stamp contest is held annually from July 1 to October 15. An artist can present a rendition of any living species of North American migratory duck, goose, or swan. The stamps are sold for $7.50 at Post Offices and hunting refuges. The winner receives one sheet of stamps (worth $225) and owns the copyright of the painting, which can be of great value. Contact: Public Affairs, Audio Visual, Fish and Wildlife Service, Department of the Interior, Room 8070, Washington, DC 20240/202-343-5611.

Earthquake Hazards Reduction Program

This program aims to identify areas of high risk, to acquire the ability to predict the time and intensity of earthquakes and to control them through the gradual release of strain. Contact: Earthquake Hazards Reduction Program, Geological Survey, Department of the Interior, 345 Middlefield Rd., MS 77, Menlo Park, CA 94025/415-323-8111. Two periodicals are published by the program, *Earthquake Information Bulletin* ($7.00/year) and *Preliminary Determination of Epicenters* ($4.80/year) are available from: Superintendent of Documents, Government Printing Office, Washington, DC 20402/202-783-3238.

Earthquake Information Center

The National Earthquake Information Service computes and publishes epicenter locations for earthquakes worldwide, and provides general information pertaining to the geographic location, magnitude and intensity of current earthquakes. Contact: National Earthquake Information Service, Geological Survey, Department of the Interior, Box 25046, Federal Center, MS 967, Denver, CO 80225/303-234-3994.

Earth Resources Observation System (EROS) Data Center

This data center contains a collection of over 6 million images and photographs of the earth's surface features. The data are collected from NASA's Landsat imagery, aerial photography acquired by the Department of the Interior, from NASA research aircraft and from the Skylab, Apollo and Gemini spacecraft. The primary functions of the data center are data storage, reproduction and user assistance and training. Special tours are available to visitors. Contact: User Services, Earth Resources Observation System Data Center, Geological Survey, Department of the Interior, Sioux Falls, SD 57198/605-594-6511, ext. 111.

Earth Resources Observation System (EROS) Regional Center

In addition to the main data center in South Dakota, EROS maintains a number of regional offices which have access to the EROS data files. For a listing of regional *Applications Assistance Facilities,* contact: User Services, Earth Resources Observation System Data Center, Geological Survey, Department of the Interior, Sioux Falls, SD 57198/605-594-6511, ext. 111.

Earth Sciences Information

The Department of the Interior transforms and translates Geological Survey science information and reports into useful and understandable formats for planners and the general public. Contact: Earth Sciences Application Program, Information and Analysis, Geological Survey, Department of the Interior, National Center, Room 3D212, MS 720, Reston, VA 22092/703-860-6961.

Earth-Science Libraries

The following earth-science libraries contain collections on geology, paleontology, petrology, mineralogy, geochemistry, geophysics, ground and surface water, topography, cartography, mineral resources, physics, chemistry, zoology, earth satellites and remote sensing, geothermal energy, marine geology, land use, lunar geology, and the conservation of resources. Contact:

Library, Geological Survey, 2255 North Gemini Dr., Flagstaff, AZ 86001/602-779-3311, ext. 1386.

Library, Geological Survey, 345 Middlefield Rd., MS 55, Menlo Park, CA 94025/415-323-8111, ext. 2207.

Library, Geological Survey, Box 25046, Federal Center, Stop 914, Denver, CO 80225/303-234-4133.

Don Lee Kulow Memorial Library, EROS Data Center, Sioux Falls, SD 57198/605-594-6511.

Library, Geological Survey, 950 National Center, Room 4-A-100, 12201 Sunrise Valley Dr., Reston, Va 22092/703-860-6671.

Endangered and Rare Wildlife

For a listing, as well as additional information, on threatened, rare and endangered species, contact: Office of Endangered Species, Fish and Wildlife Service, Department of the Interior, 1000 Glebe Rd., Arlington, VA 22201/703-235-2771.

Endangered Plants

See "Wildlife Use of Federal Lands" in this section.

Energy Resources, Future

Estimates on the availability of future energy resources, like oil, gas, uranium, and oil shale are available from: Office of Energy Resources, Geologic Division, Geological Survey, Department of the Interior, National Center, Room 3A38A, Reston, VA 22092/703-860-6431.

Energy Resources in Alaska

Exploration programs are conducted to determine the likelihood and quantity of oil and gas deposits above the Arctic Circle. Contact: Office of National Petroleum Reserves in Alaska, Geological Survey, Department of the Interior, National Center, MS 151, Reston, VA 22092/703-860-6208.

Engineering

Information on environmental engineering and the construction of roads, buildings, recreational complexes, water control and related structures can be obtained from: Division of Engineering, Bureau of Land Management, Department of the Interior, 1129 20th St. N.W., Room 301, Washington, DC 20036/202-653-8811.

Environmental Affairs

The focal point for environmental impact information for the Water and Power Resources Service is: Office of Environmental Affairs, Water and Power Resources Service, Department of the Interior, Room 7622, Washington, DC 20240/202-343-4991.

Environmental Contaminant Evaluation

For information and expertise on pesticide-fish-wildlife ecology, contact: Environmental Contaminant Evaluation Program, Fish and Wildlife Service, Department of the Interior, Washington, DC 20240/202-343-4034.

Environmental Education

The National Park Service operates a general program for environmental information and education to users of the National Park Service. Visitors to the parks are informed on their surroundings and local elementary and secondary schools are supplied with outdoor classrooms. The programs include National Environmental Study Areas (NESA) and National Environmental Education Development Program (NEED). Contact: Division of Interpretation and Visitor Services, National Park Service, Department of the Interior, 1100 L St. N.W., Room 4135, Washington, DC 20240/202-523-5270.

Environmental Geology

Basic geological investigations are conducted to help solve engineering, land-use and mining problems which arise form unstable ground conditions and natural hazards. Information is also available on various aspects of engineering and structural geology, physical geography, paleontology, and stratigraphy. Contact: Office of Environmental Geology, Geologic Division, Geological Survey, Department of the Interior, National Center, MS 908, Reston, VA 22092/703-860-6411.

Environmental Impact Analysis

A special office provides a focal point on environmental matters for the Geological Survey. This office reviews environmental impact statements from other agencies, prepares environmental impact statements for Geological Survey actions, performs research related to environmental consequences (physical, social and economic), and maintains an oil spill model which predicts the probability of spills and their effects. Contact: Office of Environmental Affairs, Land Information Analysis, Geological Survey, Department of the Interior, National Center, MS 760, Reston, VA 22092/703-860-7455.

Environmental Mining

Information is available on strip mining, deep mining, and the reclamation of scarred public lands. Environmental mining research is conducted on better ways to handle overburdened extract minerals and coal; soil handling to prevent slides; the effects of mining on local hydrological systems; and the use of sewage, sludge and effluents in revegetation. Contact: Division of Minerals Environmental Technology, Bureau of Mines, Department of the Interior, 2401 E St. N.W., Room 1233, Washington, DC 20241/202-634-1233.

Environmental Research

Studies are conducted on environmental containment evaluation, endangered wildlife research and urban wildlife research at Environment and Research Division of Population, Ecology Research, Fish and Wildlife Service, Patuxent Wildlife Research Laboratories, Wildlife Research Laboratories, Wildlife Research Center, Laurel, MD 20811/301-776-4880.

Federal Surplus Land For Parks

Surplus federal land is sold at 80 percent of fair market value to states and local governments for parks and recreation use. Contact: Division of Federal Lands Planning, Heritage Conservation and Recreation Service, Department of the Interior, 440 G St. N.W., Room 236, Washington, DC 22201/202-343-4243.

Films

Films are available usually at no cost. Each of the following organizations will provide you with a free catalog:

Office of Public Affairs, Bureau of Land Management, Department of the Interior, 1129 20th St. N.W., Room 311, Washington, DC 20240/202-343-4151.

Office of Public Affairs, Bureau of Reclamation, Department of the Interior, Room 7642, Washington, DC 20240/202-343-4662.

Harpers Ferry Historical Association, P.O. Box 147, Harpers Ferry, WV 25425/304-535-6371, ext. 6330.

Branch of Visual Services, Geological Survey, Department of the Interior, 303 National Center, Room B-C-103, 12201 Sunrise Valley Dr., Reston, VA 22092/703-860-6171.

Films on Mining

Free films are available to acquaint the public with the mineral resources of the United States and to show the need and value of conservation in mineral production and utilization. Most of the films depict mining and metallurgical operations and related manufacturing processes. For a listing of films, contact: Motion Pictures, Bureau of Mines, Department of the Interior, 4800 Forbes Ave., Pittsburgh, PA 15213/412-621-4500.

Fire Management

The Bureau of Land Management is responsible for emergency preparedness and search and recovery coordination for fires on public land. Information is also available on fire prevention, fire suppression, air operations and fire training. Contact: Division of Fire Management, Bureau of Land Management, Department of the Interior, 18th and C Sts. N.W., Washington, DC 20240/202-343-7864.

Fish and Wildlife Cooperative Research

For information on the 26 fishery, 21 wildlife and three fish and Wildlife research units, contact: Office of Cooperative Research Units, Fish and Wildlife Service, Department of the Interior, Washington, DC 20240/202-653-8766.

Fish and Wildlife Education

The Office of Education and Interpretation offers environmental educational information to visitors of fish and wildlife refuges and hatcheries and work with other government agencies and universities on fish and wildlife matters. Contact: Office of Education and Interpretation, Fish and Wildlife Service, Department of the Interior, Washington, DC 20240/202-634-6333.

Fish and Wildlife Health Laboratory

This national laboratory develops methods of wildlife and bird disease prevention and control. Its research covers the effects of management practices and environmental changes on the incidence of fish and wildlife diseases. The laboratory compiles statistics on wildlife losses from disease and geographic and species distributions of specific diseases. Workshops and lectures are also available on the identification, prevention and control of wildlife diseases. Contact: National Fish and Wildlife Health Laboratory, Division of Wildlife Research, Fish and Wildlife Service, Department of the Interior, 1655 Linden Drive, University of Wisconsin, Madison, WI 53706/608-262-2671.

Fish and Wildlife Information

For information on hunting and fishing license sales statistics; federal aid to fish and wildlife restoration; fish and wildlife research; duck stamp data; migratory bird hunting regulations; recreation use of National Wildlife Refuges and National Fish Hatcheries; river-basin studies; rare and endangered wildlife; photographs, contact: Public Affairs Office, Fish and Wildlife Service, Department of the Interior, Room 3240, Interior Building, Washington, DC 20240/202-343-5634.

Fish and Wildlife Photographs

An extensive collection of black and white and color slides on fish and wildlife of America is available for education and information purposes. These photographs can be borrowed at no

charge. Contact: Public Affairs, Audio Visuals, Fish and Wildlife Service, Department of the Interior, Room 8070, Washington, DC 20240/202-343-5611.

Fish and Wildlife Protection

The Office of Biological Services studies the effects of land and energy development on fish and wildlife, and develops information on how these activities can coexist and compromise with fish and wildlife conservation. Contact: Office of Biological Services, Fish and Wildlife Service, Department of the Interior, Washington, DC 20240/202-343-4667.

Fish and Wildlife Publications

For a free listing of fish and wildlife publications, contact: Publications, Fish and Wildlife Service, Department of the Interior, 1717 H St. N.W., Room 621, Washington, DC 20240/202-653-8732.

Fish and Wildlife Reference Service

This reference service maintains a computerized index to reports and files covering fish and wildlife history and management techniques with emphasis on big game, upland game, waterfowl and freshwater sport fish, as well as surveys of species, habitat improvement studies, and recovery plans of endangered species. A free *Fish and Wildlife Reference Service Newsletter* identifies new reports. Literature searches are available upon request. Contact: Fish and Wildlife Reference Service, Fish and Wildlife Service, Department of the Interior, 3840 York St., Unit I, Denver, CO 80205/303-571-4656.

Fish Diseases

For information and expertise on fish virology, bacteriology, parasitology, and immunology as well as tissue culture and related areas including embryology, genetics, histology, and physiology, contact: National Fisheries Center Library, Division of Fishery Research, Fish and Wildlife Service, Department of the Interior, Leetown, Rt. 1, Box 17A, Kearneysville, WV 25430/304-725-8461.

Fisheries Academy

The Fisheries Academy provides fishery workers throughout the world with up-to-date training in fisheries management and husbandry. It also serves as a distribution point for information on technical training opportunities available from other sources. Contact: Fisheries Academy, National Fisheries Center, Fish and Wildlife Service, Department of the Interior, Rte. 3, Box 49, Kearneysville, WV 25430/304-725-8461.

Fishery Ecology

Through a network of one research center, 12 laboratories and 26 field stations, research is conducted on: 1) predicting the impact of land and water development decisions and actions on fish and their habitat; 2) determining the effects of man's impact on ecosystems and the resultant effect on fish populations and their habitat; 3) evaluating and identifying the vast array of chemicals and other environmental pollutants which affect fish and their habitat; 4) sea-lamprey control in the Great Lakes; 5) all phases of ecology of the Great Lakes; 6) improving existing methods for fish husbandry and management of federal reserves; and 7) pursuing the registration of chemicals used in fisheries work. Contact: Division of Fishery Ecology Research, Fish and Wildlife Service, Department of the Interior, 1717 H St. N.W., Room 501, Washington, DC 20240/202-653-8772.

Fishery Information

For a central source of technical information on the protection and enhancement of freshwater fishery resources, contact: Deputy Associate Director—Research, Fish and Wildlife Service, Department of the Interior, Washington, DC 20240/202-343-5715.

Fishery Research

The Division of Fishery Research studies population ecology and population dynamics, aquaculture and fish husbandry, effective contaminants, fish and wildlife disease and nutrition and fish genetics. Contact: Division of Fishery Research, Fish and Wildlife Service, Department of the Interior, 1717 H St. N.W., Washington, DC 20240/202-343-6521.

Fishery Research Laboratories

Research is conducted on the toxicology and analysis of chemical contaminants in fish and fish food organisms, water management practices regarding fishery resources, crude oil effluents and range management practices regarding salmonids, and sediments' effects on toxicity of herbicides to aquatic organisms. Contact: Columbia National Fishery Research Laboratory, Fish and Wildlife Service, Department of the Interior, Rte. 1, Columbia, MO 65201/314-442-2271, ext. 3201. Research is also conducted on the toxic effects, modes of action, residue dynamics and ecological impacts of chemicals used to manage fishery resources or to culture fishes, and the interrelationships between water chemistry variations, pollutants and contaminants, and biological strains and their effects on the activity of fishery chemicals. Contact: National Fishery

Research Laboratory-La Crosse, Fish and Wildlife Service, Department of the Interior, P.O. Box 818, La Crosse, WI 54601/608-783-6451.

Fish, Free

Trout and catfish are supplied free to stock new or reclaimed farm or ranch ponds. The fish are not available for ponds which are less than ¼ acre in size or are subject to any form of commercialization. This offer is good only once. Contact: Fish and Wildlife Service, Department of the Interior, 1717 H St. N.W., Room 637, Washington, DC 20240/202-343-5634.

Fish Genetics Laboratory

This laboratory genetically characterizes existing strains of rainbow trout and evaluates their suitability for various environment and management uses. It also defines and develops selection and breeding methods for improved maintenance and performance of rainbow trout. Contact: National Fishery Research Center, Division of Fishery Research, Fish and Wildlife, Department of the Interior, Rte. 3, Box 49, Kerneysville, WV 25430/304-725-8461.

Fish Hatcheries

The National Fish Hatcheries produces and distributes species of fish of the size, number, strain and quantity to meet resource requirements. The anadromous fishery program is primarily concerned with providing juvenile fishes to supplement natural reproduction to improve the quality, abundance and utilization of the fishery resources of coastal areas for recreational and commercial interests. The Great Lake Fishery is committed to producing lake trout and for stocking the Great Lakes. The Inland Fisheries produce and rear inland fish species for stocking federal, state and Indian waters in order to improve, restore and maintain recreational fishing. Contact: National Fish Hatcheries, Fish and Wildlife Service, Department of the Interior, 1717 H St. N.W., Room 633, Washington, DC 20240/202-343-6394.

Forestry

The Bureau of Land Management manages 4 million acres of commercial forest lands of which 3 million are subject to timber production. It determines which land should be commercially harvested consistent with environmental and other uses (watershed, wildlife, scenic or wilderness). Commercial harvesters bid on the rights at oral auctions and must conform to the regulations. The bureau also maintains past and current information on Bureau of Land Management timber harvest levels, and forest product sales.

Contact: Division of Forestry, Bureau of Land Management, Department of the Interior, Room 5620, Washington, DC 20240/202-653-8887.

Freedom of Information Act

Each major office within the Department of the Interior handles Freedom of Information Act (FOIA) requests. If you are looking for the address of a specific FOIA office or wish to file with the central office, contact: Freedom of Information Appeals Officer, Department of the Interior, Room 5417, Washington, DC 20240/202-343-6191.

Geochemical and Geophysical Research

Research is conducted on the distribution of elements in the earth's mantle and crust, and the processes leading to their concentration to form single bodies; testing and development of new concepts of rock formation; isotopes and their application to determining the ages of rock; the analysis of rocks, minerals and ores; study of the earth's crust by ground and aerial geophysical methods. Contact: Office of Geochemistry and Geophysics, Geologic Division, Geological Survey, Department of the Interior, National Center, Room 3A110, MS 906, Reston, VA 22092/703-860-6584.

Geographic Names Information Center

The geographic names staff maintains an active national research, coordinating and information center. It provides a single authority in the United States to which all problems and inquiries concerning domestic geographic names may be directed. Staff members furnish assistance to the U.S. Board on Geographic Names, an interdepartmental agency. It manages a names data repository, answers public inquiries, compiles name information and publishes books and lists on domestic names. It also coordinates the name usage between federal and state governments. Any person or organization, public or private, may make inquiries or request the U.S. Board on Geographic Names to render formal decisions on proposed new names, proposed name changes or names that are in conflict. Contact: Geographic Names Section, Geological Survey, Department of the Interior, 523 National Center, Reston, VA 22092/703-860-6262.

Geography Research

Research is conducted on land-use analysis which consists of an inventory of current land uses, monitoring of land-use changes, and explanations of present patterns and changes in land use that occur. Projects include demonstrating the value and use of remote-sensor data received

from high-altitude aircraft and satellite platforms, experiments in urban change detection, regional mapping and updating of land-use information, development of a two-level land-use classification system for use with remote-sensor data, and analysis of the effects of land-use patterns and changes on environmental quality. Contact: Office of Geographic Research, National Mapping Division, Geological Survey, Department of the Interior, National Center, Room 2D108, Reston, VA 22092/703-860-6344.

Geological Publications

The Geological Survey publishes a number of books and periodicals. One can receive a free monthly catalog called *New Publications of the Geological Survey*. Subscriptions can be obtained from Geological Survey, Department of the Interior, 329 National Center, Reston, VA 22092/703-860-6781. A host of free publications are available. The following are a few of the more popular titles:

Sources of Information, Products, and Services of the U.S. Geological Survey
John Wesley Powell's Exploration of the Colorado River
The Geology of Caves
Landforms of the United States
The Interior of the Earth
Volcanoes
Permafrost
Collecting Rocks
Suggestions for Prospecting
Why is the Ocean Salty?

For free copies of any of the above publications or for a complete listing of publications, contact: Geological Survey, Branch of Distribution, 1200 South Eads St., Arlington, VA 22202/703-557-2781.

Geological Survey, Regional Information Offices

The Geological Survey's 10 regional offices answer inquiries, recommend publications and refer requests for technical information. They sell limited quantities of maps and books over the counter and distribute circulars, nontechnical publications, catalogs and indexes free of charge. All offices, except those in Reston, VA, Washington, DC, and Menlo Park, CA, maintain small reference libraries. Most are depositories for open-file reports. The Anchorage, Los Angeles, and Spokane offices maintain Landsat reference files and viewers for satellite imagery. The 10 offices are listed below along with a description of their major holdings:

Public Inquiries Office, Geological Survey, 108 Skyline Building, 508 Second Ave., Anchorage, AK 99501/907-277-0577. Maps of and book reports on Alaska.

Public Inquiries Office, Geological Survey, 7638 Federal Building, 300 North Los Angeles St., Los Angeles, CA 90012/213-688-2850. Maps of and book reports on Alaska, Arizona, California, Hawaii, Nevada, Oregon, and Washington.

Public Inquiries Office, Building 3, Mail Stop 33, 345 Middlefield Rd., Menlo Park, CA 94025/415-323-8111, ext. 2817. Maps of and book reports on Alaska, Arizona, California, Hawaii, Idaho, Nevada, Oregon, and Washington.

Public Inquiries Office, Geological Survey, 504 Customhouse, 555 Battery St., San Francisco, CA 94111/415-556-5627. Maps of and book reports on Alaska, Arizona, California, Hawaii, Idaho, Nevada, Oregon and Washington.

Public Inquiries Office, Geological Survey, 169 Federal Building, 1961 Stout St., Denver, CO 80294/303-837-4169. Maps of and book reports on Alaska, Arizona, Colorado, Kansas, Montana, Nebraska, New Mexico, North Dakota, South Dakota, Utah, and Wyoming.

Public Inquiries Office, Geological Survey, 1028 General Services Administration Building, 19th and F Sts. N.W., Washington, DC 20244/202-343-8073. Maps of and book reports on all states.

Public Inquiries Office, Geological Survey, 1-C-45 Federal Building, 1100 Commerce St., Dallas, TX 75242/214-767-0198. Maps of and book reports on Arkansas, Louisiana, New Mexico, Oklahoma, and Texas.

Public Inquiries, Geological Survey, 8105 Federal Building, 125 South State St., Salt Lake City, UT 84138/801-524-5652. Maps of and book reports on Arizona, Colorado, Idaho, Montana, Nevada, New Mexico, Utah, and Wyoming.

Public Inquiries Office, Geological Survey, 302 National Center, Room 1-C-402, 12201 Sunrise Valley Dr., Reston, VA 22092. Maps of and book reports on all states.

Public Inquiries Office, Geological Survey, 678 U.S. Courthouse, West 920 Riverside Ave., Spokane, WA 99201/509-456-2524. Maps of and book reports on Alaska, Idaho, Montana, Oregon, and Washington.

Geological Survey

The main purpose of the U.S. Geological Survey is to provide: accurate maps that show the slope of land surface, the location of man-made features, and the present land use; information

about the composition and structure of rocks for prospecting, designing engineering and construction works, and identifying natural hazards such as earthquakes and landslides; data on surface and ground water for the development and conservation of water supplies, determination of water quality and reduction of damage from floods; knowledge of earth history and natural processes; appraisals of the nation's energy and mineral resources; classification of federal lands for minerals and waterpower; and supervision of oil, gas, and mineral lease operations on Indian and federal lands, including the Outer Continental Shelf. Contact: Information Office, Geological Survey, Department of the Interior, National Center, Reston, VA 22092/703-860-7444.

Geological Computerized Data and Software
Computer programs and data from the Geological Survey's nationwide earth science computer network are available from: User Services Section, Computer Center Division, Geological Survey, Department of the Interior, 804 National Center, Reston, VA 22092/703-860-7123.

Geologic Names
For information and expertise on names given to rocks and the arrangement of rocks in layers (stratigraphic nomenclature) contact: Geologic Names Committee, Geological Survey, Department of the Interior, 902 National Center, Room 3A214, Reston, VA 22092/703-860-6511.

Geology Exhibits
Free exhibit panels are available illustrating recent work in conservation, geology, topography and water resources. The exhibits can be obtained for professional meetings, technical conventions and similar gatherings. The panels or three-dimensional exhibits can be obtained with structural supports and lights for free-standing display. Contact one of the following offices:

Branch of Exhibits, Geological Survey, Mail Stop 4, 345 Middlefield Rd., Menlo Park, CA 94025/415-323-2389.

Branch of Exhibits, Geological Survey, Box 25046, Mail Stop 960, Federal Center, Denver, CO 80225/303-234-3566

Branch of Exhibits, Geological Survey, 301 National Center, 12201 Sunrise Valley Dr., Reston, VA 22092/703-860-6162

Geology, International
The Office of International Geology provides technical assistance and training to developing countries. The Office participates in scientific cooperation and exchange programs with counterpart agencies abroad. Subject areas include mineral resources, marine geology, hydrology, remote sensing, cartography, water resources, geochemistry and geophysics. Contact: Office of International Geology, Geologic Division, Geological Survey, Department of the Interior, National Center, MS 917, Reston, VA 22092/703-860-6418

Geology Questions
A special office handles public inquiries on geology topics such as earthquakes, energy, the geology of specific areas, and geologic maps and mapping. Packets of teaching aids are available for courses at the elementary, secondary and college levels. Contact: Geologic Inquiries Group, Geological Survey, Department of the Interior, 907 National Center, 12201 Sunrise Valley Dr., Reston, VA 22092/703-860-6517.

Geology Speakers
Speakers are available to talk on a wide variety of geological subjects. Contact: Information Office, Geological Survey, Department of the Interior, National Center, Room 7A110, MS 119, Reston, VA 22092/703-860-7444.

Geology, Unpublished Reports
The Open-File Service of the Geological Survey provides copies of unpublished preliminary reports and other unpublished documents. The monthly newsletter, *New Publications of the Geological Survey,* announces the availability of these reports. Contact: Open-File Service Section, Geological Survey, Department of the Interior, Box 25425, Federal Center, Denver, CO 80225/303-234-5888.

Geothermal Energy
For information and expertise on the use and effects of geothermal energy on fish and wildlife, contact: Ecological Services, Fish and Wildlife Service, Department of the Interior, 1375 K St. N.W., Suite 403, Washington, DC 20240/202-343-5656.

Gold Prospecting
A free book, *How To Mine and Prospect for Gold,* is available from: Publications Department, Bureau of Mines, Department of the Interior, 4900 La Salle Rd., Annandale, VA 20782/703-436-7912.

Grants
The programs described below are for sums of money which are given by the federal govern-

ment to initiate and stimulate new or improved activities, or to sustain ongoing services.

Abandoned Mine Land Reclamation Program

Objectives: To protect the public and correct the environmental damage caused by coal and noncoal mining practices that occurred before August 3, 1977.

Eligibility: State and Indian Reclamation Program (Project Grants): The program is restricted to states with eligible lands and coal mining operations within their borders that are paying coal reclamation fees into the Abandoned Mine Reclamation Fund. Federal Reclamation Program: Federal reclamation projects are conducted on a national basis through cooperative agreements with states, local governments, or other recipients, and by direct contracting.

Range of Financial Assistance: Not specified.

Contact: Office of Surface Mining, Division of Abandoned Mined Lands, Department of the Interior, 1951 Constitution Ave. N.W., Washington, DC 20245/202-343-4012.

Anadromous Fish Conservation

Objectives: To conserve, develop, and enhance the anadromous fish resources of the nation and the fish of the Great Lakes and Lake Champlain that ascend streams to spawn.

Eligibility: States and other non-federal interests are eligible. Non-federal interests are eligible if projects are coordinated with the state agency having jurisdiction over the resource. Nineteen inland states are ineligible. Non-federal interests include state, local, nonprofit and individual entities with professional fishery capabilities. Public and private colleges and Indian Tribes are included.

Range of Financial Assistance: $6,000 to $632,800.

Contact: Fish and Wildlife Service, Department of the Interior, Washington, DC 20240/202-343-5333.

Endangered Species Conservation

Objectives: To provide federal financial assistance to any state, through its respective state agency, which has entered into a Cooperative Agreement to assist in the development of programs for the conservation of endangered and threatened species.

Eligibility: Participation limited to state agencies that have entered into a Cooperative Agreement with the Secretary of the Interior.

Range of Financial Assistance: $10,600 to $1,630,000.

Contact: Fish and Wildlife Service, Depart-

ment of the Interior, Washington, DC 20240/202-235-2771.

Fish Restoration

Objectives: To support projects designed to restore and manage sport fish populations for the preservation and improvement of sport fishing and related uses of these fisheries resources.

Eligibility: Participation limited to state fish and wildlife agencies. State must have passed laws for the conservation of fish which include a prohibition against diversion of license fees paid by fishermen for purposes other than the administration of the State fish and wildlife agency. Also eligible are Puerto Rico, Guam, the Virgin Islands, and American Samoa.

Range of Financial Assistance: $280,000 to $1,400,000.

Contact: Fish and Wildlife Service, Department of the Interior, Washington, DC 20240/202-235-1526.

Grants for Mining and Mineral Resources and Research Institutes, Mineral Research Projects, Scholarships and Fellowships.

Objectives: Support research and training in mining and mineral resources problems related to the mission of the Department of the Interior; contribute to a comprehensive nationwide program of mining and mineral research having due regard for the protection and conservation of the environment; support specific mineral research and demonstration projects of industrywide application; assist the states in carrying on the work of competent and qualified mining and mineral resources research institutes; and provide scholarships, graduate fellowships and postdoctoral fellowships in mining, mineral resources and allied fields.

Eligibility: The state Governor's designated public college or institute pursuant to Title III of the Surface Mining Control and Reclamation Act of 1977. If a state does not have an eligible public college, then a private college or university may be eligible.

Range of Financial Assistance: Up to $270,000.

Contact: Office of Surface Mining Reclamation and Enforcement, Department of the Interior, South Building, 1900 Constitution Ave. N.W., Washington, DC 20240/202-343-4719.

Historic Preservation Grants-in-Aid

Objectives: Expand and maintain the National Register of Historic Places, the Nation's listing of districts, sites, buildings, structures, and objects significant in American history, architecture, archeology, and culture at the national, state and local levels; provide matching survey and plan-

ning grants-in-aid to identify, evaluate, and protect historic properties; provide matching acquisition and development grants-in-aid, to public and private parties for preservation of National Register-listed properties; provide matching grants-in-aid to the National Trust for Historic Preservation to preserve historic resources.

Eligibility: Eligible applicants are the National Trust for Historic Preservation and state and territories as defined in the National Historic Preservation Act operating programs administered by a State Historic Preservation Officer appointed by the Governor.

Range of Financial Assistance: $500 to $500,000.

Contact: Chief, Grants Administration, National Park Service, Department of the Interior, Washington, DC 20243/202-272-3703.

Indian Child Welfare Act—Title II Grants

Objectives: To promote the stability and security of Indian tribes and families by the establishment of minimum federal standards for the removal of Indian children from their families and the placement of such children in foster or adoptive homes and providing assistance to Indian tribes in the operation of child and family service programs.

Eligibility: The governing body of any tribe or tribes, or any Indian organization, including multi-service centers, may apply individually or as a consortium for a grant.

Range of Financial Assistance: $15,000 upward.

Contact: Division of Social Services, Office of Indian Services, Bureau of Indian Affairs, Department of the Interior, 1951 Constitution Ave. N.W., Washington, DC 20245/202-235-2756.

Indian Education—Colleges and Universities

Objectives: To encourage Indian students to continue their education and training beyond high school.

Eligibility: Must be one-fourth or more degree Indian, Eskimo, or Aleut blood, of a tribe being served by the Bureau, enrolled or accepted for enrollment in an accredited college, have financial need as determined by the institution's financial aid office.

Range of Financial Assistance: $200 to $7,000.

Contact: Office of Indian Education Programs, Department of the Interior, 18th and C Sts. N.W., Washington, DC 20245/202-343-2175.

Indian Employment Assistance

Objectives: To provide vocational training and employment opportunities for Indians.

Eligibility: The applicant must be a member of a recognized tribe, band, or group of Indians, whose residence is on or near an Indian reservation under the jurisdiction of the Bureau of Indian Affairs; and for vocational training grants, must have one-quarter degree or more of Indian blood.

Range of Financial Assistance: $800 to $5,500.

Contact: Office of Tribal Resources Development, Division of Job Placement and Training, Bureau of Indian Affairs, Department of the Interior, 18th and C Sts. N.W., Room 4659, Washington, DC 20245/202-235-8355.

Indian Housing Assistance

Objectives: To use the Indian Housing Improvement Program (HIP) and Bureau of Indian Affairs resources to substantially eliminate substandard Indian housing. This effort is combined with the Departments of Health and Human Services and Housing and Urban Development.

Eligibility: Indians in need of financial assistance who meet the eligibility criteria of the HIP regulations (25 CFR, Subchapter X, Part 261). For HUD, Indians who meet the income criteria and other rules and regulations of the legally established local Indian housing authorities.

Range of Financial Assistance: $2,500 to $55,000.

Contact: Division of Housing Assistance, Office of Indian Services, Department of the Interior, Bureau of Indian Affairs, 18th and C Sts. N.W., Washington, DC 20245/202-343-4876.

Marine Mammal Grant Program

Objectives: To provide financial assistance to states in development and implementation of programs for protection and management of marine mammals that inhabit a state's waters.

Eligibility: State must have established laws and regulations, approved by the Secretary of the Interior, for protection and management of marine mammals consistent with the purposes and policies of the Marine Mammals Protection Act.

Range of Financial Assistance: Not specified.

Contact: Office of Wildlife Assistance, Fish and Wildlife Service, Department of the Interior, Washington, DC 20240/202-632-2202.

National Water Research and Development Program

Objectives: To support needed research and development into any aspects of water-related problems deemed desirable in the national interest.

Eligibility: Educational institutions, private foundations or other institutions, federal, state and local governmental agencies, and private firms and individuals whose training, experience,

and qualifications are adequate for conducting water research or development projects.

Range of Financial Assistance: up to $150,000.

Contact: Office of Water Research and Technology, Department of the Interior, Washington, DC 20240/202-343-4607.

Outdoor Recreation—Acquisition, Development, and Planning

Objectives: Provide financial assistance to the states and their political subdivisions for the preparation of comprehensive statewide outdoor recreation plans and acquisition and development of outdoor recreation areas and facilities for the general public to meet current and future needs.

Eligibility: For planning grants, only the state agency formally designated by the Governor or state law as responsible for the preparation and maintenance of the Statewide Comprehensive Outdoor Recreation Plan is eligible to apply. For acquisition and development grants, the designated agency may apply for assistance for itself, or on behalf of other state agencies or political subdivisions such as cities, counties, and park districts. Additionally, Indian tribes which are organized to govern themselves and perform the function of a municipal government qualify for assistance under the program. Individuals and private organizations are not eligible.

Range of Financial Assistance: $150 to $5,450,000.

Contact: Chief, Division of State Programs, National Park Service, Department of the Interior, Washington, DC 20243/202-272-3660.

Self Determination Grants—Indian Tribal Governments

Objectives: To improve tribal governing capabilities; to prepare for contracting of Bureau programs; to enable tribes to provide direction to the Bureau, and to have input to other federal programs intended to serve Indian people.

Eligibility: Only governing bodies of federally recognized Indian tribes are eligible to apply for self-determination grants.

Range of Financial Assistance: Not specified.

Contact: Division Chief, Office of Indian Services, Division of Self-Determination Services, Department of the Interior, 18th and C Sts. N.W., Washington, DC 20240/202-343-2786.

Training and Technical Assistance—Indian Tribal Governments

Objectives: To aid Indian Tribes to exercise self-determination in accord with Public Law 93-638.

Eligibility: Governing body of any federally recognized Indian tribe.

Range of Financial Assistance: Not specified.

Contact: Division Chief, Office of Indian Services, Division of Self-Determination Services, Department of the Interior, 18th and C Sts. N.W., Washington, DC 20240/202-343-2786.

Water Research and Technology—Matching Funds to State Institutions

Objectives: To provide matching funds, on a dollar-for-dollar matching basis, to Water Resources Research and Technology Institutes located at a designated State university in each of the 50 states, Puerto Rico, the District of Columbia, Guam and the Virgin Islands, to train scientists and support work in various aspects of water research and development which could not otherwise be undertaken.

Eligibility: State Water Research and Technology Institutes as designated pursuant to Section 101a of Title I of the Water Research Act and Development Act of 1978. Other colleges and universities may participate in the program in cooperation with, and administered by, the appropriate State Water Resources Research Institute.

Range of Financial Assistance: $10,000 to $195,000.

Contact: Office of Water Research and Technology, Department of the Interior, Washington, DC 20240/202-343-4607.

Water Resources Research and Technology— Assistance to State Institutes

Objectives: To provide financial support to Water Research and Technology Institutes located at designated state universities in each of the 50 states, Puerto Rico, the District of Columbia, Guam, and the Virgin Islands, to work on one or more aspects of problem-oriented water resources research, disseminate information as to research results, and train scientists.

Eligibility: One State University Water Research and Development Institute in each state, Puerto Rico, the District of Columbia, Guam and the Virgin Islands is designated pursuant to Title I of the Water Research and Development Act of 1978. Other colleges and universities may participate in the program in cooperation with, and administered by, the designated state institute.

Range of Financial Assistance: Up to $110,000.

Contact: Office of Water Research and Technology, Department of the Interior, Washington, DC 20240/202-343-4607.

Wildlife Restoration

Objectives: To support projects to 1) restore or

manage wildlife populations and the provision of public use of these resources, or 2) provide facilities and services for conducting a hunter safety program.

Eligibility: Participation limited to state fish and wildlife agencies. States must have passed laws for the conservation of wildlife which include a prohibition against diversion of license fees paid by hunters for purposes other than the administration of the state fish and wildlife agency. Also eligible are Puerto Rico, Guam and the Virgin Islands. ·

Range of Financial Assistance: $501,440 to $3,998,480.

Contact: Fish and Wildlife Service, Department of the Interior, Washington, DC 20240/202-235-1526.

Grave Robbers

The Bureau of Land Management has an education program to keep the public from plundering and destroying ancient sites. It provides information, brochures, posters, etc. on the importance of drawings, pottery and ruins of the American Indians' ancient civilizations. Contact: Office of Public Affairs, Bureau of Land Management, Department of the Interior, Room 5625, Washington, DC 20240/202-343-5717.

Helium

Information is collected on all aspects of helium including production, sales, distribution, conservation uses, future demand and reserves from 1917 to the present. Contact: Division of Helium, Minerals Research, Bureau of Mines, Department of the Interior, Room 901, Columbia Plaza, 2401 E St. N.W., Washington, DC 20241/202-634-4734.

Heritage Conservation and Recreation Information

For general information on publications and services available, contact: Public Affairs, Heritage Conservation and Recreation Service, Department of the Interior, 440 G St. N.W., Room 216, Washington, DC 20243/202-343-5726.

Historic American Buildings Survey

A national archive of historic architecture is maintained and assistance is provided to public and private organizations to help document structures of historic and architectural merit. Documentation consists of the preparation of architecturally measured drawings, photographs, and written reports which are deposited in the Library of Congress where they are available for public use and reproduction. Contact: Historic American Buildings Survey/Historic American Engineering Records, National Park Service, Department of the Interior, 440 G St. N.W., Room 323, Washington, DC 20243/202-272-3527.

Historic Landmarks

The National Historic Landmarks Program studies, identifies, recognizes, and encourages the preservation of nationally significant historic properties which are tangible reminders of the American heritage. If you are interested in having your property designated a national historic landmark, contact the Program for details. If it is accepted, a bronze plaque and certificate are awarded in a presentation ceremony. This provides permanent identification of nationally significant properties. Contact: History Division, National Park Service, Department of the Interior, 400 G St. N.W., Room 116, Washington, DC 20243/202-523-0089.

Historic Landmarks Directory

A complete listing of all certified historic properties is contained in the *National Register of Historic Places* ($27.00 for 2-volume set). Available from: Superintendent of Documents, Government Printing Office, Washington, DC 20402/202-783-3238.

Historic Preservation, Advisory Council on

This independent agency is administered by the Department of the Interior. It advises the President and the Congress on historic preservation policy. It also reviews and comments to the Department of the Interior on the historic preservation program and protects historic places when they are threatened by a federal project. Contact: Advisory Council on Historic Preservation, 1522 K St. N.W., Room 430, Washington, DC 20005/202-254-3967.

Hunting, Fishing and Wildlife Statistics

The *National Survey of Hunting, Fishing and Wildlife Associated Recreation* includes information on hunting and fishing activities, statistics on wildlife observation, wildlife photography, recreational shooting, crabbing and clamming. Information is available on time and money expended on wildlife-related activit1es, characteristics of hunters and anglers, and types of fishing and hunting. Contact: Office of Fishery Assistance, Fish and Wildlife Service, Department of the Interior, 1717 H St. N.W., Room 554, Washington, DC 20240/202-632-5166.

Hunting Regulations

Each year migratory bird hunting regulations

are developed by: Office of Migratory Bird Management, Fish and Wildlife Service, Department of the Interior, 1717 H St. N.W., Room 555, Washington, DC 20006/202-254-3207.

Hydroelectric Power
The Department of the Interior operates 50 hydroelectric power plants, including Hoover Dam and Grand Coulee Dam, in the 17 Western States. For information on power matters and related environmental impact statements, contact: Hydroelectric Power, Bureau of Reclamation, Department of the Interior, Room 7429, Washington, DC 20240/202-343-4914.

Hydrology, International
An international collection of books, pamphlets and reports is available covering all aspects of hydrology. Topics include the hydrologic cycle, the assessment of water resources, evaluation of the influence of man's activities on water systems, and education and training in hydrology. Contact: Office of International Activities, Water Resources Division, Geological Survey, Department of the Interior, MS 740, Reston, VA 22092/703-860-6547.

Indian Arts and Crafts Development
A special program provides planning assistance, such as the development of innovative educational, production, promotion, and economic concepts related to Native culture. Complaints about imitation Native American arts and crafts that are misrepresented as geuine handicrafts are referred to appropriate federal or local authorities for action. The three museums operated by the Board serve Indians and the general public: the Sioux Indian Museum in Rapid City, South Dakota; the Museum of the Plains Indian in Browning, Montana; and the Southern Plains Indian Museum in Anadarko, Oklahoma. Contact: General Manager, Indian Arts and Crafts Board, Department of the Interior, Washington, DC 20240/202-343-2773.

Indian Business Assistance
Indian businesses and tribes can receive technical and financial assistance from the Department of the Interior. Contact: Indian Business Enterprise, Bureau of Indian Affairs, Department of the Interior, 1000 Glebe Rd., Room 129, Arlington, VA 22201/703-235-1650.

Indian Ceremonials and Celebrations
For a free calendar describing the location and dates of Indian ceremonials and celebrations of interest to visitors, contact: Information Office, Bureau of Indian Affairs, Department of the Interior, Room 4071, Washington, DC 20240/202-343-7445.

Indian Craft Shop
The Interior building contains an Indian craft shop which sells handicrafts of various tribes at commercial prices. Contact: Indian Craft Shop, Department of the Interior, 18th and C Sts. N.W., Room 1023, Washington, DC 20240/202-343-4056.

Indian Development
The Office of Indian Development is responsible for developing and managing programs designed to promote the welfare and development of individual Indians and Indian communities. Programs include: social services, housing, law enforcement, tribal governmental services, and self-determination services. Demographic and cultural data are also available. Contact: Office of Indian Services, Bureau of Indian Affairs, Department of the Interior, Room 4058, Washington, DC 20240/202-343-2111.

Indian Education
For statistical and other information relating to Indian education, contact: Office of Indian Education Programs, Bureau of Indian Affairs, Department of the Interior, Code 503, Washington, DC 20240/202-343-6364.

Indian Information
Information is available on Indians, their relationship to the federal government, specific reservations, or other items regarding their culture. A list of available publications is also available. Contact: Information Office, Bureau of Indian Affairs, Department of the Interior, Room 4061, Washington, DC 20240/202-343-7445.

Indian Library
A collection of information is available on topics of Indian interest that include: Indian education, Indians of North America, Indian laws and treaties, tribal government, Indian ceremonies and legends, Indian history, and Indian arts and crafts from 1870 to the present. Contact: National Indian Training Center, Professional Library, Bureau of Indian Affairs, Department of the Interior, P.O. Box 66, Brigham City, UT 84302/801-734-2071.

Indian Photographs
Photographs of Indian lands are available. Contact: Soil and Moisture Conservation Cartographic Section, Bureau of Indian Affairs, Department of the Interior, Brigham City, UT 84203/801-586-4500.

International Programs

The Office of International Programs acts as a liaison office for the Department of the Interior's international activities. Some of its activities include work with the U.S.-Saudi Arabia Joint Commission on Economic Cooperation on building the first national park in Saudi Arabia; looking for lowgrade iron ore; developing desalinization technology; and developing water resources. Contact: International Programs, Office of Territorial and International Affairs, Department of the Interior, Room 5125, Washington, DC 20240/202-343-3101.

Irrigation

For information or expertise on technical aspects of irrigation facilities, contact: Water Operations, Operations and Maintenance Policy Staff, Water and Power Resources Service, Department of the Interior, Room 7421, Washington, DC 20240/202-343-5471.

Job Corps Conservation Centers

Twelve job corps conservation centers throughout the country train disadvantaged youths between the ages of 16 and 22. This residential program provides both formal education and vocational training for 18 months to 2 years. Contact: Job Corps, Office of Youth Programs, Department of the Interior, Room 2071, Washington, DC 20240/202-343-4041.

Land Information Directory

Information Sources and Services Directory of the Department of the Interior describes sources of information within the Department of the Interior both in Washington, DC and in the field offices. It includes field office locations and their areas of expertise. Free copies are available from: EROS (Earth Resources Observation Systems), Geological Survey, Department of the Interior, National Center, Room 2A2001, MS 750, Reston, VA 22092/703-860-6717.

Land Management

Information is available on wildlife management on 473 million acres of public lands; camping, hunting, fishing, hiking, pack trips on public land, mostly in the West and Alaska; wildlife use of lands; forest and watershed practices aiding wildlife and recreation; adventure-seeking, outdoor pursuits on public land areas; obtaining public lands for state and community parks; photographs; mineral and oil and gas leasing on acquired lands and on the Outer Continental Shelf. Contact: Office of Public Affairs, Bureau of Land Management, Department of the Interior, Room 5625, Washington, DC 20240/202-343-5717.

Land Management Library

The collection at the Bureau of Land Management Library consists of the following areas: engineering, including cadastral engineering surveying; forest resources management; lands and land reserve studies; legislation and public land laws; range management; watershed management; minerals management; mineral, oil, gas and geothermal leasing; history, development, administration, conservation and use of public lands; and management and utilization of the Outer Continental Shelf. Contact: Bureau of Land Management Library, Department of the Interior, Denver Service Center, Building 50, Denver Federal Center, Denver, CO 80225/303-234-4578.

Land Resource Planning

Studies are conducted to translate earth-science information into formats and languages for use by land and resource planners, and the general public. Topics covered include: environmental impact, geological hazards, and land use and land cover. Contact: Land Information and Analysis Office, Publications Section, Geological Survey, Department of the Interior, 708 National Center, Reston, VA 22092/703-860-6981.

Land Resources Management

The Water and Power Resources Service is responsible for recreation, land acquisition, appraisal and relocation, land management and land disposal, archeologic and historic resources, and fish and wildlife enhancement. Contact: Land Resources and Management, Division of Operations and Maintenance Policy and Planning, Water and Power Resources Service, Department of the Interior, Room 7426, Washington, DC 20240/202-343-5204.

Loans and Loan Guarantees

The programs described below are those which offer financial assistance through the lending of federal monies for a specific period of time or programs in which the federal government makes an arrangement to idemnify a lender against part or all of any defaults by the borrower.

Indian Education—Assistance to Schools

Objectives: To assure adequate educational opportunities for Indian children attending public schools and tribally operated previously private schools.

Eligibility: Public school districts and previously private schools which have eligible Indian children in attendance and which provide educational services meeting established state standards; and which have established Indian

Education Committees to approve operations of programs beneficial to Indians.

Range of Financial Assistance: $10,000 to $7,000,000.

Contact: Elementary and Secondary Education Division, Office of Indian Education Programs, Bureau of Indian Affairs, Department of the Interior, 18th and C Sts. N.W., Washington, DC 20240/202-343-2175.

Indian Loans—Claims Assistance

Objectives: To enable Indian tribes or identifiable groups of Indians without available funds to obtain expert assistance in the preparation and processing of claims pending before the U.S. Court of Claims.

Eligibility: An Indian organization must have one or more pending claims of a nature and in a stage of prosecution requiring the services of expert witnesses.

Range of Financial Assistance: $500 to $250,000.

Contact: Director, Office of Tribal Planning Service Division, Bureau of Indian Affairs, Department of the Interior, 18th and C Sts. N.W., Room 4650, Washington, DC 20245/202-343-6858.

Indian Loans—Economic Development

Objectives: To provide assistance to Indians, Alaskan Natives, tribes, and Indian organizations in obtaining financing from private and governmental sources which serve other citizens. When otherwise unavailable, financial assistance through the Bureau is provided eligible applicants for any purpose that will promote the economic development of a Federal Indian Reservation.

Eligibility: Indians, Alaskan Natives, tribes, and Indian organizations. Individual applicants must be a member of a federally recognized tribe and not members of an Indian organization which conducts its own credit program. Organizational applicants must have a form of organization satisfactory to the Commissioner of Indian Affairs.

Range of Financial Assistance: $100 to over $1,000,000.

Contact: Director, Office of Planning Service Division, Bureau of Indian Affairs, Department of the Interior, 18th and C Sts. N.W., Room 4650, Washington, DC 20245/202-343-6858.

Irrigation Distribution System Loans

Objectives: To provide fully reimbursable federal loans to organized irrigation districts with lands included within congressionally authorized Reclamation projects to plan, design, and construct irrigation and municipal and industrial water distribution or drainage systems in lieu of federal construction.

Eligibility: Irrigation district must be organized under state law and eligible to contract with the United States; must have water service contract with the Water and Power Resources Service.

Range of Financial Assistance: $3,760,000 to $7,980,000.

Contact: Commissioner, Water and Power Resources Service, Department of the Interior, Washington, DC 20240/202-343-3125.

Irrigation Systems Rehabilitation and Betterment

Objectives: To rehabilitate and improve irrigation facilities on projects governed by Reclamation law.

Eligibility: Any water users organization whose irrigation facilities were constructed by the Water and Power Resources Service and to which the United States holds title, and any water users organization on non-federal projects constructed under the Small Reclamation Projects Act of 1956.

Range of Financial Assistance: $1,900,000 to $8,300,000.

Contact: Commissioner, Water and Power Resources Service, Department of the Interior, Washington, DC 20240/202-343-5471.

Minerals Discovery Loan Program

Objectives: Encourage exploration for specified minerals within the United States, its territories, and possessions. The Government will contribute to the total allowable costs of exploration to a maximum of 75 percent for nine specified mineral commodities, and to a maximum of 50 percent for 27 others. Funds must be spent for the exploration of geologic targets considered to be favorable for the occurrence of deposits of ore of the specified commodities. Loans are paid back by means of royalties on mineral production if a discovery is certified by the Government.

Eligibility: Individuals or private firms that: 1) have sufficient interest in property which can qualify for exploration for one or more of the eligible minerals or mineral products; 2) furnish evidence that funds for exploration are not available from banking institutions or other commercial sources of credit on reasonable terms; 3) certify that the applicant would not ordinarily undertake the proposed exploration under current conditions at his or her sole expense; and 4) have sufficient funds to meet their share of the

cost of the exploration work.

Range of Financial Assistance: up to $25,000.

Contact: Department of the Interior, National Center, MS 913, 12201 Sunrise Valley Dr., Reston, VA 22092/703-860-6561.

Small Reclamation Projects

Objectives: To provide fully reimbursable federal loans and possible grants to public non-federal organizations for rehabilitation and betterment or construction of water resource development projects located in the 17 western-most contiguous states and Hawaii.

Eligibility: Public non-federal organizations, organized under state law and eligible to contract with the federal Government, and who can demonstrate engineering and financial feasibility of project proposal. Private individuals are not eligible.

Range of Financial Assistance: $700,000 to $18,000,000.

Contact: Loan Officer, Water and Power Resources Service, Department of the Interior, Washington, DC 20240/202-343-3125.

Magnetic Declination

Magnetic declination is the angle between the true meridian and the magnetic meridian, and is considered east or west accordingly as magnetic north is east or West of true north. Information related to this and related topics is available from: Branch of Electromagnetism and Geomagnetism, Geological Survey, Department of the Interior, Box 25046, Federal Center, MS 964, Denver, CO 80225/303-234-5505.

Mammals and Nonmigratory Birds

The Division of National Wildlife Refuges protects native wildlife from damage of foreign wildlife, keeps species from becoming endangered, and perpetuates the natural diversity of wildlife species and native habitats on national wildlife refuges. Its area of responsibility includes oxen, elk, sea otters, polar bears, walrus, manatee, nonmigratory birds, reptiles, amphibians, mollusks, and crustaceans. Contact: Division of National Wildlife Refuges, Fish and Wildlife Service, Department of the Interior, Room 2024, Washington, DC 20240/202-343-4305.

Mapping Technology

Information and expertise are available on surveying, mapping, cartography, and photogrammetry. Rare, unpublished, and out-of-print books, papers and journals are also available. Contact: Technical Information Services, Office of Research and Technical Standards, Mineral Mapping Division, Geological Survey, Department of the Interior, National Center, MS 520, Reston, VA 22092/703-860-6275.

Maps and Charts

See "Cartographic Information Center" in this section.

Marine Geology

Information is available on submarine natural resources (oil, gas, and minerals), environmental hazards due to offshore drilling, and the effects of the commercial development of oil and gas deposits on the environment. Contact: Office of Marine Geology, Geologic Division, Geological Survey, Department of the Interior, National Center, Room 3A312, MS 915, Reston, VA 22092/703-860-7241.

Market Studies on Recreation Activities

Surveys are conducted periodically to determine such items as what types of recreation are used, what types would be preferred, and what keeps one from recreation. Contact: Recreation and Resource Development Division, National Park Service, Department of the Interior, 440 G St. N.W., Room 204, Washington, DC 20243/202-272-3730.

Migratory Bird Banding Information

The Office of Migratory Bird Management provides a central repository for all migratory bird banding records in North America. It provides analysis of banding records and production and harvest surveys for use in research and management, and publishes findings of these analyses for public reference. Contact: Office of Migratory Bird Management, Fish and Wildlife Service, Department of the Interior, 1717 H St. N.W., Room 555, Washington, DC 20006/202-254-3207.

Mine Passages

Mine Map Repository describes old passageways in abandoned mines throughout the country. These old mine passages are open to the public. For a free copy, contact: Office of Mineral Information, Bureau of Mines, Department of the Interior, Columbia Plaza, Room 1035, Washington, DC 20241/202-634-1004.

Mineral and Water Resources

The Geological Survey is responsible for appraising water, mineral, and mineral fuel resources throughout the United States. For information on the latest available data, contact: Chief Geologist, Geological Survey, Department of the Interior, National Center, 12201 Sunrise

Valley Dr., MS 911, Reston, VA 22092/703-860-6531.

Mineral Commodity Summaries

Free up-to-date summaries are available on 91 mineral commodities. These data sheets contain information on the domestic industry structure, government programs, tariffs and statistics, and world resource data. Contact: Office of Mineral Information, Bureau of Mines, Department of the Interior, Room 1035, Columbia Plaza, Washington, DC 20241/202-634-1001.

Mineral Industry Location System

This system contains a file of maps and transparent overlays showing mineral deposit locations. Contact: Division of Mineral Availability, Bureau of Mines, Department of the Interior, 2401 E St. N.W., Room 645, Washington, DC 20241/202-634-1026.

Mineral Information Office

The main function of the Bureau of Mines is to 1) collect statistical information on 91 nonfuel mineral commodities (fuel minerals are handled by the Department of Energy); and 2) research health and safety matters in mine and mineral processing, investigate environmental technology and mineral resource technology. For information on free publications and periodicals, contact: Office of Mineral Information, Bureau of Mines, Department of the Interior, Columbia Plaza, Room 1035, Washington, DC 20241/202-634-1001.

Mineral Leasing Program—Outer Continental Shelf

This program develops an Outer Continental Shelf oil and gas leasing schedule which tentatively schedules Outer Continental Shelf sales for a five-year period. The schedule is a planning document which outlines the pre-leasing steps to be accomplished that lead to a lease rate decision for designated areas. The five steps are: 1) call for nominations, and comments in the *Federal Register*; 2) tentative tract selection; 3) environmental impact statements available to the public; 4) proposed notice of sale; 5) final notice of sale and opening of submitted bids. Contact: Division of Offshore Resources, Bureau of Land Management, Department of the Interior, 18th and C Sts. N.W., Washington, DC 20240/202-343-6906.

Mineral Resource Potential

For information and expertise on national and world mineral resources and resource potential, contact: Office of Mineral Resources, Geologic Division, Geological Survey, Department of the Interior, National Center, MS 913, Reston, VA 22092/703-860-6566.

Minerals and Materials Supply and Demand Analysis

The Minerals Availability System (MAS) consists of a computer-based file and a back-up hard copy file which describes the supply availability as well as the technical and economic feasibility of mining and extractions. It includes a mineral reserve classification system describing ore deposits, processing facilities, available transportation, labor requirements, a variety of economic and statistic data on operative mines producing any of the 30 mineral commodities. Contact: Division of Minerals Availability, Bureau of Mines, Department of the Interior, 2401 E St. N.W., Room 645, Washington, DC 20241/202-634-1026

Mineral Trends

Mineral Trends and Forecasts is an annual forecasting system of both statistical and contingency analysis on metals and minerals forming elements, nonmetallic minerals and commercial gases. Free reports are available from: Division of Publications, Bureau of Mines, Department of the Interior, 2401 E St. N.W., Room 725, Washington, DC 20241/202-634-1001.

Mine Reports

Free reports on mining and minerals are available from:

Office of Mineral Information, Bureau of Mines, Department of the Interior, 2401 E St. N.W., Room 1035, Washington, DC 20241/202-634-1001.

Branch of Publications, Distribution, Bureau of Mines, Department of the Interior, 4800 Forbes Ave., Pittsburgh, PA 15213/412-621-4500.

Division of Technical Reports, Bureau of Mines, Department of Interior, 2401 E St. N.W., Washington, DC 20241/202-634-4740

Mines Library

The Bureau of Mines Library is open to the public and answers reference questions by telephone and mail. The information it supplies includes all aspects of mineral production, both domestic and foreign, with economic and statistical emphasis; state and county mineral data; mineral and material supply and demand analysis; mineral-related U.S. Senate and House of Representatives reports; patent gazettes; oil and gas reports and market reports. Contact: Bureau of

Mines Library, Division of Publications, Department of the Interior, 2401 E St. N.W., Room 127, Washington, DC 20241/202-634-1116.

Mines, Publications
The Bureau of Mines publishes a large range of periodicals and reports on both a free and fee basis. For a list of available publications, contact: Division of Publications, Bureau of Mines, Department of the Interior, 4900 La Salle Rd., Avondale, MD 20782/301-436-7912.

Mines Technology Transfer
The following disseminate information on the latest mining technology: 1) *Technology News*—a free newsletter; 2) free seminars, conferences, in-mine demonstration projects, and traveling displays and exhibits; 3) technical assistance for mine operators. Contact: Technology Transfer Group, Division of Minerals, Health and Safety Technology, Bureau of Mines, Department of the Interior, 2401 E St. N.W., Washington, DC 20241/202-634-1225.

Mining and Minerals Research
The results of research are available on such topics as: mining, metallurgy and mineral economics, mineral and materials supply/demand analysis, belium activities, mineral processing, hydrometallurgy, pyrometallurgy, metallic and nonmetallic materials, mining health and safety research, dust control, survival and rescue, methane control, explosives and mining environmental research. Contact: Office of Mineral Information, Bureau of Mines, Department of the Interior, Room 1035, Columbia Plaza, Washington, DC 20241/202-634-1001.

Mining Claims
All unpatented mining claims, mill or tunnel sites, must be recorded. If the unpatented lode or placer claim, or mill, or tunnel site is located on federal lands, it must be recorded with the Bureau of Land Management state office having jurisdiction over the federal lands where the claim is located. Information is also available on how to file an application for a mineral patent. Contact: Locatable Minerals, Division of Minerals Resources, Bureau of Land Management, Department of the Interior, Room 3560, Washington, DC 20240/202-343-8537.

Mining Operations
The Geological Survey acts as an agent for administering the laws and regulations of mining operations for both underground and strip mining. It sets royalty fees for solid mineral and coal sales and classifies public lands as to their value.

Contact: Branch of Mining Operations, Conservation Division, Geological Survey, Department of the Interior, National Center, Room 6A1133, MS 650, Reston, VA 22092/703-860-7506.

Museum
The Department of the Interior maintains a collection that reflects the Department's areas of interest and includes National Park Service photos, Indian artifacts, early types of surveying equipment, aerial charts, maps, model of Hoover Dam, photos of wildlife, and handiwork from trust territories. Contact: Departmental Museum, Department of the Interior, 18th and C Sts. N.W., Room 1240, Washington, DC 20240/202-343-5016 (open 8:00 A.M. to 4:00 P.M. weekdays).

National Cartographic Information Center
The Center operates a national information service which organizes and distributes maps and charts, aerial and satellite photographs, satellite imagery, map data in digital form and geodetic control data. It also has information about aerial photographic and mapping projects planned by federal agencies. Maps and photographs can be purchased from the Center. A special teacher's packet emphasizing topographic mapping is available free. Contact: National Cartographic Information Center, Geological Survey, Department of the Interior, 507 National Center, Room 1-C-107, 12201 Sunrise Valley Dr., Reston, VA 22092/703-860-6045.

National Fish and Wildlife Laboratory
This laboratory is responsible for the North American collection of amphibian, reptile, bird and mammal specimens. It performs studies on the ecological relationships and population dynamics of wildlife, especially those forms affected by land use practices. It also works on determining the ecological effects on marine wildlife and ecosystems of man's activities related to development and exploitation of the marine environment. Contact: National Fish and Wildlife Laboratory, Fish and Wildlife Service, Department of the Interior, National Museum of Natural History, 10th St. and Constitution Ave. N.W., Washington, DC 20560/202-343-5715.

National Park Concessions
For information on obtaining a contract to provide goods or services within the National Park System, contact: Concession Management Division, National Park Service, Department of the Interior, 1100 L St. N.W., Room 3211, Washington, DC 20006/202-523-5322.

National Park Information Center

The Technical Information Center contains information on the National Park properties including 300,000 maps and design drawings, and 25,000 scientific and technical reports. Contact: Technical Information Center, National Park Service, Department of the Interior, Denver Service Center, 755 Parfet St., Denver, CO 80225/303-234-4570.

National Park Service Information

The National Park System contains 76 million acres including: 39 national parks; 92 national monuments; 2 national preserves; 4 national lakeshores; 10 national rivers (includes wild and scenic rivers and riverways); 10 national seashores; 60 national historic sites; 22 national memorials; 11 national military parks; 3 national battlefield parks; 9 national battlefields; 1 national battlefield site; 22 national historic parks; 17 national recreation areas; 4 national parkways; 1 national trail; 10 parks (other); 1 national capital park; 1 White House; 1 National Mall; 1 National Visitors Center. For information on park usage such as camping, swimming, boating, mountain climbing, hiking, fishing, winter activities, wildlife, archeologic and historic area studies, pack trips, or photographs of activities and areas, contact: Office of Public Affairs, National Park Service, Department of the Interior, Room 3043, Washington, DC 20240/202-343-7394.

National Registry of Natural Landmarks

This Registry identifies terrestrial and aquatic communities, landforms, geological features, and habitats of threatened plant and animal species that constitute the Nation's natural history. Official recognition of an area in the National Registry often stimulates its owner to protect the area's nationally significant qualities. Contact: Natural Landmarks Division, National Park Service, Department of the Interior, 440 G St. N.W., Room 202, Washington, DC 20243/202-523-5152.

Natural History Publications

The Scientific Publications Program of the National Park Service publishes a number of books and periodicals dealing with natural history, including: *Urban Ecology Series, Scientific Monographs, Natural Resource Reports, Natural History Theme Studies,* and *Ecological Service Bulletins.* Contact: Scientific Publications Program, Natural History Division, National Park Service, Department of the Interior, 1100 L St. N.W., Room 3317, Washington, DC 20005/202-523-5127.

Natural Resources Library

Information is available on: conservation and development of natural resources, including scientific, engineering, legal, and social aspects of mining and minerals, oil, gas, and energy, land reclamation and management, fish and wildlife management, water resources, parks and outdoor recreation, preservation of scenic and historic sites, Native Americans, geology and mapping. Also available are: computerized literature searches, legal research and a free *Library and Information Services Directory* which lists all field libraries and personnel of over 400 departmental field libraries across the country. Contact: Natural Resources Library, Office of Library and Information Services, Department of the Interior, 18th and C Sts. N.W., Washington, DC 20240/202-343-5821 (reference service: 202-343-5815).

Nuclear Waste Disposal

Information and expertise are available on the safe disposal of nuclear waste. Information is also available on the disposal of hazardous, non-nuclear waste. Contact: Nuclear Waste Disposal Program, Office of Radiohydrology, Water Resources Division, Geological Survey, Department of the Interior, National Center, MS 410, Reston, VA 22093/703-860-6976.

Oil and Gas Lottery

The Department of the Interior runs a lottery to award leases for exploring resources on federally-owned land. For information on the development and implementation of policy procedures, and technology relating to the management of salable, locatable and leasable minerals and other energy resources, contact: Division of Onshore Energy Resources, Bureau of Land Management, Department of the Interior, 18th and C Sts. N.W., Room 3560, Washington, DC 20240/202-343-2718.

Oil Shale

For information on the impact of fish and wildlife when developing oil shale, contact: Ecological Services, Fish and Wildlife Service, Department of the Interior, 1375 K St. N.W., Suite 403, Washington, DC 20240/202-343-5656.

Oil Shale Data Bank

Information is kept on all aspects of oil shale, including: characterization by properties, strength, surrounding rock, mining methods, premining investigation techniques, mine design, health and safety aspects of mining oil shale, energy potential of oil shale, related environmental

information, patents on oil shale development, and technology and current research projects. Contact: Oil Shale Data Bank, Mining Research Center, Minerals and Materials Research and Development, Bureau of Mines, Department of the Interior, P.O. Box 1660, Twin Cities, MN 55111/612-725-4560.

Older Americans Receive Free Discount Passport

Persons over 62 years of age can receive a free Golden Age Passport which acts as a lifetime entrance permit to those parks, monuments and recreation areas administered by the federal government. The passport also provides for a 50 percent discount on federal use fees charged for facilities and services such as camping, boat launching, parking, etc. Apply in person for passports at most federally operated recreation areas, National Park Service regional offices, or at Information Office, Department of the Interior, 18th and C Sts. N.W., Washington, DC 20240/202-343-4747.

Onshore Energy Leases

For information on both competitive and noncompetitive leases for geothermal and oil-shale resource development, contact: Division of Onshore Energy Resources, Bureau of Land Management, Department of the Interior, Room 3560, Washington, DC 20240/202-343-7722.

Outdoor Activities

General information is available on camping, fishing, hiking, and pack trips on the 475 million acres of public land. Assistance is available on recreational resources, cultural resources, visual resources, and natural history resources. Contact: Division of Recreation, Bureau of Land Management, Department of the Interior, 18th and C Sts. N.W., Room 3660, Washington, DC 20240/202-343-9353.

Outdoor Recreation

For information on National Park Service facilities for camping, swimming, boating, mountain climbing, hiking, and fishing, contact: Office of Public Affairs, National Park Service, Department of the Interior, Room 3420, Washington, DC 20240/202-343-7394.

Outdoor Recreation—Technical Assistance

Technical assistance and advice is available to states, political subdivisions, and private interests, including non-profit organizations, with respect to outdoor recreation. Free publications include: *Citizen's Action Manual: A Guide to Recycling Vacant Lots, Land Conservation and Preservation,* and *Private Sector Involvement Workbook.* Contact: Parks and Recreational Technical Services Division, Heritage Conservation and Recreation Service, Department of the Interior, 440 G St. N.W., Room 307, Washington, DC 20243/202-343-6767.

Outer Continental Shelf Bid Statistics

Statistics and other information are available on the number of bids received, the companies involved, the total amount of the bids, and the amount per acre leased. Information on permits to harvest coral can also be obtained. Contact: New Orleans Outer Continental Shelf Office, Bureau of Land Management, Department of the Interior, Hale Boggs Federal Building, 500 Camp St., Suite 841, New Orleans, LA 70130/504-589-6541.

Park and Recreation Technical Assistance

Technical assistance is available to state and local agencies, private, nonprofit organizations, and individuals, and territories, in planning, developing and managing their park and recreation areas so as to help meet the park and recreation needs of the Nation. Contact: Division of Federal and State Liaison, National Park Service, Department of the Interior, Washington, DC 20240/202-523-4190.

Park History

The National Park Service maintains a special library containing archival and artifact collections. The library includes: history of the National Park Service; decorative and useful arts; handicrafts; folk art; historic furnishings; American social history; clothing and dress; military art and science; and the history of agriculture. Contact: Harpers Ferry Center, Division of Reference Services, National Park Service, Department of the Interior, Harpers Ferry, WV 25425/304-535-6371.

Park Index

The *Index to National Park System and Related Areas* describes some 300 national parks, rivers, and trails, and provides information on location and available facilities. Contact: Office of Public Affairs, National Park Service, Department of the Interior, Room 3420, Washington, DC 20240/202-343-7394.

Park Land Acquisitions

The National Park Service buys land for its use with revenues received from off-shore oil leases. Contact: Land Acquisition Division, National

Park Service, Department of the Interior, 1100 L St. N.W., Room 3135, Washington, DC 20005/202-523-5252.

Park Passport

The Golden Eagle Passport ($10) allows holders to enter national parks, monuments and recreation areas free. It admits the permit holder and carload of accompanying people. People over 62 years old can receive a free passport. (See "Older Americans Receive Free Discount Passport" in this section.) Passports may be purchased at most federally operated recreation areas, National Park Service regional offices or at Information Office, Department of the Interior, 18th and C Sts. N.W., Room 1013, Washington, DC 20240/202-343-4747.

Park Photographs

Prints and transparencies can be borrowed free of charge on all aspects of the National Parks, including natural history, geologic features, and living history from prehistoric times to the present. Contact: Photo Library, Office of Public Affairs, National Park Service, Department of the Interior, Room 3043, Washington, DC 20240/202-523-0051.

Park Planning and Environmental Quality

For information on all phases of planning, design and construction of recreation and park areas as well as the environmental impact of activities and alternate transportation projects, contact: Park Planning and Environmental Quality, National Park Service, Department of the Interior, Room 3127, Washington, DC 20240/202-343-6703.

Park Police

The U.S. Park Police are part of the Department of the Interior and most are assigned within the Washington, DC metropolitan area. They have the same police powers as the Washington, DC metropolitan police and act as hosts to park visitors. Contact: National Capital Region, Park Service, Department of the Interior, 1100 Ohio Dr. S.W., Room 177, Washington, DC 20242/202-426-6656.

Park Practices

The Park Practices Program serves as a means of disseminating information to park and recreation professionals and practitioners about tried and proven a) designs for park structures and facilities, b) methods for operation and maintenance, and c) policy discussion on current trends in the field. Publications include:

Trends—a quarterly focusing on park and recreation management; topics include art in the parks, special populations, urban parks, environmental education rivers and trails, and exotic wildlife in parks (subscription, $15/year).

Grist—a bimonthly serving as a field operations manual, including money and labor saving ideas for solving day-to-day maintenance problems (initial subscription includes 2 previous years, $15/year).

Design—a quarterly containing detailed plans for park and recreation structures including plans for a concrete picnic shelter, a bait house, multiple camp sites, visitor centers and concession stands (initial subscription includes copies of all previous designs, $100 for 1st year, $10 renewal).

To order publications, send check or money orders to National Recreation and Park Association, 1601 Kent St., Arlington, VA 22209. For further information, contact: Park Practices Program, Heritage Conservation and Recreation Service, Department of the Interior, 440 G St. N.W., Washington, DC 20243/202-523-5190.

Park Rangers

The Rangers of the National Park Service plan and carry out conservation efforts to protect plant and animal life from fire, disease and visitor use. They plan and conduct programs of public safety, including law enforcement and rescue work. They set up and direct interpretative programs such as slide shows, guided tours, displays and even dramatic presentations to help visitors become aware of the natural, cultural and historic significance of areas. They coordinate environmental education programs aimed at acquainting visitors, especially school children with how man and nature function. Rangers can be historians, archeologists and naturalists. Contact: Ranger Activities and Protection Division, National Park Service, Department of the Interior, Room 3324, Washington, DC 20240/202-343-4874.

Park Service Publications and Information

Information is available on more than 290 areas administered by the National Park Service, including national parks, national recreation areas, national seashores, national monuments, historic sites, statistics on park acreage and attendance, types of park usage—camping, swimming, boating, mountain climbing, hiking, fishing, winter activities—wildlife management in parks, archeologic and historic area studies, pack trips, photos of activities, and areas. For assistance or a listing of available publications, contact: Office of Public Affairs, National Park Service, Department of the Interior, Room 3043, Washington, DC 20240/202-343-7394.

Park Statistics

Monthly and yearly data on National Park usage and attendance including visitor hours and number of over-night stays are available from: Statistical Unit, Branch of Scientists, National Park Service, Department of the Interior, Denver Service Center, 755 Parfet St., Denver, CO 80255/303-234-4529.

Pesticide Surveillance

Over 100 sampling stations monitor the effects of pesticides on various species of wildlife. For information, contact: Division of Fishery Ecology Research, Fish and Wildlife Service, Department of the Interior, 1717 H St. N.W., Room 511, Washington, DC 20240/202-343-5715 (see "Fishery Research Laboratories" in this section).

Photographs, Aerial

An aerial photograph can be purchased for practically any areas of the country. You may even be able to obtain one of your neighborhood. Contact: National Cartographic Information Center, National Mapping Division, Geological Survey, Department of the Interior, 507 National Center, Reston, VA 22092/703-860-6045.

Photographs, Geological

The Geological Survey maintains a collection of some 200,000 photographs of subjects taken during geologic studies of the United States and its territories from 1869 to the present. Prints, copy negatives, duplicate transparencies and enlargements can be purchased from the collection. Contact: Photographic Library, Geological Survey, Department of the Interior, Box 25046, Federal Center, MS 914, Denver, CO 80225/303-234-4004.

Photographs, Land Subjects

Over 10,000 black and white and color slides are available, covering forestry, lands and realty, minerals and range subjects. Contact: Office of Public Affairs, Audio-Visual Support, Bureau of Land Management, Department of the Interior, 1129 20th St. N.W., Room 311, Washington, DC 20240/202-343-5717.

Power Plants

The National Power Plant Team offers technical assistance in assessing the environmental impact of electric power generation and transmission on fish and wildlife. It seeks to improve existing transmission line rights-of-way for wildlife habitat and in selecting routes for transmission line corridors that will minimize the impact on wild life and their habitats. Contact: National Power Plan Team, Office of Biological Services, Fish and Wildlife Service, Department of the Interior, 1451 Green Rd., Ann Arbor, MI 48105/313-994-3331.

Professional Park Services to Foreign Countries

Foreign governments can receive technical help and assistance in establishing and maintaining national parks from: Office of Cooperative Activities, National Park Service, Department of the Interior, Room 3310, Washington, DC 20240/202-343-6741.

Public Lands for Sale and Lease

The Department of the Interior is authorized to sell or lease lands in the public domain to state and local governments for recreation and public purposes and to qualified nonprofit organizations for public and quasi-public purposes, including recreation, education and health. Contact: Division of Lands and Realty, Bureau of Land Management, Department of the Interior, Room 3647, Washington, DC 20240/202-343-8693.

Range Land Management

Information available on grazing on National Resource Lands includes the location of the range, the number of heads of livestock that can run on these public ranges, and the best seasons for grazing. Contact: Division of Range Land Management, Bureau of Land Management, Department of the Interior, Room 2525, Washington, DC 20240/202-653-9193.

Recreation Information Clearinghouse

The Heritage Conservation and Recreation Service (HCRS) Information Exchange is designed to assist practitioners, government agencies, nonprofit organizations, and individuals involved in recreation, cultural, and natural preservation. A free newsletter, *Technical Assistance Notifications,* announces the availability of studies, handbooks, audiovisuals, films, surveys, case studies, publications and training manuals. All services are free. Contact: National Park Service, Department of the Interior, 440 G St. N.W., Room 307, Washington, DC 20243/202-272-3761.

Recreation Planning

The Division of Nationwide Recreation Planning provides technical assistance to federal, state, and local agencies and to the private sector in finding solutions to recreational problems. This division achieves and coordinates statewide

Comprehensive Outdoor Recreation Plans. Two major studies are produced by this office:

Nationwide Outdoor Recreation Action Program (annual)—describes what policy the federal government should have on outdoor recreation.

Nationwide Outdoor Recreation Assessment (every 5 years)—presents the state of the nation's recreational needs and facilities report; it includes survey materials with summary and detailed reports.

Contact: Recreation and Resource Development Division, National Park Service, Department of the Interior, 440 G St., N.W., Room 204, Washington, DC 20243/202-343-4317.

Regulatory Activities

Listed below are those organizations within the Department of the Interior which are involved with regulating various business activities. With each listing is a description of those industries or situations which are regulated by the office. Regulatory activities generate large amounts of information on the companies and subjects they regulate. Much of the information is available to the public. A regulatory office can also tell you your rights when dealing with a regulated company.

Public Affairs Water and Power Resources Service, Department of the Interior, C St. between 18th and 19th Sts. N.W., Washington, DC 20240/202-343-4662. Manages power resource development and management in 17 Western states.

Information, Office of Water Research and Technology, C St. between 18th and 19th Sts. N.W., Washington, DC 20240/202-343-8445. Supervises the nation's water quality and quantity.

Public Affairs, Office of Surface Mining Reclamation and Enforcement, Department of the Interior, 1951 Constitution Ave. N.W., Washington, DC 20240/202-343-6416. Regulates coal mining operations.

Public Affairs, National Park Service, Department of the Interior, C St. between 18th and 19th Sts. N.W., Washington, DC 20240/202-343-6844. Responsible for conserving the scenery, natural and historic objects and wildlife in the nation's parks.

Public Affairs, National Park Service, Department of the Interior, 440 G St. N.W., Washington, DC 20243/202-343-7394. Regulates the development, conservation, and utilization of the nation's natural, cultural, and recreation resources.

Information Office, Geological Survey, Department of the Interior, National Center, 12201 Sunrise Valley Dr., Reston, VA 22092/703-860-6167. Enforces regulations applicable to oil, gas, and other mining leases, permits, licenses, development contracts and gas storage contracts.

Office of Public Affairs, Fish and Wildlife Service, Department of the Interior, C St. between 18th and 19th Sts. N.W., Washington, DC 20240/202-343-5634. Regulates the development of wildlife resources and their habitat.

Office of Public Affairs, Bureau of Land Management, U.S. Department of the Interior, C St. between 18th and 19th Sts. N.W., Washington, DC 20240/202-343-7205. Manages public lands and administers the resources on these lands.

Office of Public Information, Bureau of Indian Affairs, Department of the Interior, C St. between 18th and 19th Sts. N.W., Washington, DC 20240/202-343-7445. Acts as trustee for Indian land and monies held in trust by the United States.

Resources Information Bank

The Computerized Resources Information Bank provides basic information needed to characterize one or more mineral commodities, a mineral deposit, or several related deposits. The data base contains both text and numeric data. Topics covered include name, location, commodity information, geology, production reserves, potential resources, references, status of exploration and development, mining districts, and 1000 largest mines of the world. Contact: Mineral Resources Data Base, Information System Programs, University of Oklahoma, Energy Resources Center, Box 3030, Norman OK 73076/405-360-1600.

River System, National Wild and Scenic

This system consists of free-flowing streams which have remarkable scenic, recreational, geologic, fish and wildlife, historic and cultural significance. These streams must be long enough (25 miles or more) to provide a recreational experience, have sufficient volume of water, and high or restorable water quality. The rivers included in the system are classified as either wild, scenic, or recreational river areas. For free maps and other information, contact: Rivers and Trails Division, National Park Service, Department of the Interior, 440 G St. N.W., Room 203, Washington, DC 20243/202-272-3566.

Rock Analysis

Information is available on over 190,000 specimens of rocks, plants, soils, and organic fuels. In-

formation includes location data, formation, sample, name, descriptions, source of sample, geologic age of sample, economic geology data, lithologic data, and mineralogic data. Contact: Rock Analysis Storage System, Office of Geochemistry and Geographics, Geologic Division, Geological Survey, Department of the Interior, Denver Federal Center, MS 925, P.O. Box 25046, Denver CO 80225/303-234-2438.

Saline Water Conversion

A free publication, *The A-B-C of Desalting*, is available from: Research, Office of Water Research and Technology, Department of the Interior, Room 4210, Washington, DC 20240,/ 202-343-5345.

Scientific Publications

The Office of Scientific Publications approves all scientific publications, both internal and external to assure scientific quality. Contact: Office of Scientific Publications, Geologic Division, Geological Survey, Department of the Interior, National Center, MS 904, Reston, VA 22092/ 703-860-6575.

Solar Prints For Your Exhibitions

A large file of "Solar Prints" focusing on a particular architectural or geographic theme can be mounted on request. The prints are sold at $15 per print or are available on loan. Contact: National Architectural and Engineering Records, National Park Service, Department of the Interior, 440 G St. N.W., Room 323, Washington, DC 20243/202-272-3527.

Space Photographs

Photographs are available from the following space missions:

Landsat—helps users identify and inventory different environmental phenomena such as distribution and general type of vegetation, regional geologic structures, and extent of surface water.

Skylab—data consists of a wide variety of phenomena on the earth's surface, including multispectral photography.

Gemini—photographs taken by a hand-held 70mm camera.

Apollo 9—three types of filtered black and white and one type of false-color infrared photographs, each showing an area approximately 100 miles by 100 miles.

Contact: User Services, Earth Resources Observation System Data Center, Geological Survey, Department of the Interior, Sioux Falls, SD 57198/605-594-6511, ext. 111.

Sport Fishing on Federal, Military and Indian Waters

Technical assistance is available in the field on the management of waters for sport fishing, including what kind of fish to stock and how to monitor pollution. Contact: Office of Fishery Assistance, Fish and Wildlife Service, Department of the Interior, 1717 H St. N.W., Room 554, Washington, DC 20240/202-632-5166.

State Mineral Information

The following offices maintain information on state mineral industry activity. The state offices can be contacted directly or a state expert can be reached at: State Mineral Information Program Office, Branch of Domestic Data, Bureau of Mines, Department of the Interior, 2401 E St. N.W., Room 879, Washington, DC 20241/202-634-4772.

Streams, Measuring the Quality of

The National Stream Quality Accounting Network (NASQAN) compiles regional and nationwide data on the quality of streams. NASQAN water-quality data measure the quality and quantity of water moving within and from the U.S.; provide a large-scale picture of how stream quality varies from place to place; and detect changes in stream quality. The public can visit the 518 stations throughout the United States by appointment. A list of all stations is available. The types of data collected include: temperature, pH, bacteria indicators, inorganic compounds, biologic nutrients, suspended sediment, floating algae, trace elements, organic carbon and attached organisms. Contact: Quality of Water Branch, Water Resources Division, Geological Survey, Department of the Interior, National Center, 12201 Sunrise Valley Dr., MS 412, Room 5A420, Reston, VA 22092/703-860-6834.

Strip Mining

The Office of Surface Mine Reclamation provides the following:

Technical Assistance—writes rules, solves problems, and provides legal and technical expertise on reclamation and coal mining.

Environmental Assessment—writes environmental impact statements, rules, guidelines, and handbooks on reclamation, air pollution, water quality, impact on fish and wildlife, climate and geology.

Research—applied and basic research to determine short-term impact of mining; provides funding to 31 state mineral institutes for research grants, scholarships and fellowships in mining engineering and related fields.

Technical Training—trains federal inspectors in reclamation assessments.

Contact: Office of Surface Mine Reclamation and Enforcement, Bureau of Mines, Department of the Interior, 1951 Constitution Ave., N.W. Room 15, Washington, DC 20240/202-343-2188.

Submarine Landslides

Investigations are conducted into the natural hazards such as sandwaves, currents, sea-floor erosion and mudflow which may occur on the sea floor because of giant oil platforms. Contact: Office of Marine Geology, Geologic Division, Geological Survey, Department of the Interior, National Center, Room 3A312, MS 915, Reston, VA 22092/703-860-7241.

Surplus Wildlife

Nonprofit organizations can receive surplus wildlife for restocking of wildlife ranges, zoo display, scientific specimens and meat. Contact: Division of Natural Resources, National Park Service, Department of the Interior, 1100 L St. N.W., Room 3317, Washington, DC 20240/202-523-5127.

Technical Preservation Services

The Technical Preservation Service develops and disseminates information on techniques for preserving and maintaining publicly owned historic properties; advises federal agencies on the evaluation, preservation and maintenance of historic properties; evaluates applications for the transfer of surplus federal property for historic monuments; evaluates and certifies rehabilitation of historic structures for tax benefit purposes; evaluates Heritage Conservation and Recreation Service historic preservation grant-in-aid applications, plans and specifications; and insures conformance with the standards for historic preservation projects. A free listing of publications is available. Contact: Technical Preservation Services Division, National Park Service, Department of the Interior, 440 G St. N.W., Room 211, Washington, DC 20243/202-272-3761.

Territories of the U.S.

Among the territories administered by the United States are: American Samoa, Baker, Howland and Jarvis Islands, Canton and Enderburg Islands, Guam, Johnston Island, Kingman Reef, Midway Island, Navarra Island, Northern Mariana Islands, Palmyra Island, Puerto Rico, Virgin Islands and Wake Island. Contact: Office of Territorial and International Affairs, Department of the Interior, Room 4321, Washington, DC 20240/202-343-6971.

The Man and the Biosphere Program

This program plans for the rational use and conservation of the biosphere—that portion of the earth's crust and lower atmosphere which contains life—and for the improvement of the relationship between humans and the environment. This program coordinates diffuse national and international research, conservation and training activities. The U.S. has designated 28 sites as part of an international network of biosphere reserves. These sites are standards for measuring with greater accuracy human impact on the environment and for predicting probable future effects. Contact: National Park Service, Division of Natural History, Department of the Interior, 1100 L St. N.W., Room 4125, Washington, DC 20005/202-523-5051.

Topographic Maps

Free indexes show available topographic maps published for each state and territory. Indexes for areas east of the Mississippi River and Minnesota, Puerto Rico and the Virgin Islands may be requested from: Branch of Distribution, Geological Survey, 1200 South Eads St., Arlington, VA 22202/703-557-2751. Indexes for areas west of the Mississippi River, including Alaska, Hawaii, Louisiana, Guam, and American Samoa, may be requested from: Branch of Distribution, Geological Survey, P.O. Box 25286, Federal Center, Denver, CO 80225/303-234-3832. Residents of Alaska may request indexes directly from: Distribution Section, Geological Survey, New Federal Building, P.O. Box 12, 101 12th Ave., Fairbanks, AK 99701/907-479-7062. The indexes contain lists of special maps, addresses of local map reference libraries, local map dealers, and federal map distribution centers. An order blank and detailed instructions for ordering maps are supplied with each index.

Topography Information

Data files are maintained on all phases of topographic mapping and related subjects such as cartography, geodesy, and photogrammetry. These files are kept mainly for reference and include professional journals, technical instructions, research reports, technical papers, photographs and visual aids. Contact: National Mapping Division, Technical Information Office, Geological Survey, Department of the Interior, 520 National Center, Room 2A-325, Reston, VA 22092/703-860-6275.

Trails, National

There are approximately 452 recreation, scenic and historic trails in the United States. Recrea-

tion trails are usually located near urban areas. Scenic and historic trails are usually long-distance hiking paths with nationally significant scenic and/or historic values. The following publications are available free:

Directory of Sources of Trail Information—lists federal, state and private sources which can provide information on trails.
Trails Guide—describes National Recreation Trails and provides addresses of sources for more information. Contact: Rivers and Trails Division, National Park Service, Department of the Interior, 440 G St., N.W. Room 203, Washington, DC 20243/202-272-3566.

Visit Ghost Towns and Mines

The first ironmaking furnace in the original 13 colonies, replicas of early wooden derricks used for oil drilling in East Texas, Sutter's Mill in Northern California, open-pit iron mines in Minnesota and off-shore oil and gas wells in the Gulf Coast can all be visited by the public. For information on these and other new and old mines, contact: Office of Mineral Information, Bureau of Mines, Department of Interior, Columbia Plaza, Room 1035, Washington, DC 20241/202-634-1001. The following 6 publications describe mining and mining operations of all 50 states. Copies are available from: Superintendent of Documents, Government Printing Office, Washington, DC 20402/202-783-3238.

Mining and Mineral Operations in the New England and Mid-Atlantic States ($2.30).
Mining and Mineral Operations in the South Atlantic States ($2.70).
Mining and Mineral Operations in the North-Central States ($3.25).
Mining and Mineral Operations in the South-Central States ($4.75).
Mining and Mineral Operations in the Rocky Mountain States ($2.40).
Mining and Mineral Operations in the Pacific States ($2.15).

Visitor Information Center

For general information and referrals on the various bureaus within the Department of the Interior, contact: Visitor Information Center, Department of the Interior, Room 2070, Washington, DC 20240/202-434-5278 (open 7:45 A.M. to 4:15 P.M. weekdays).

Volcano Hazards Program

This program monitors active volcanos and publishes maps citing potential volcanos. Contact: Office of Geochemistry and Geophysics, Geologic Division, Geological Survey, Department of the Interior, National Center, Room 3A110, MS 906, Reston, VA 22092/703-860-6584.

Water and Land Resource Accomplishments

An annual report, *Water and Land Resource Accomplishment Report,* describes new projects of the Water and Power Service including statistical data on physical features of the projects, crop yields resulting from projects, financial status of projects, economic impact on the local community, recreation usage and flood control. For a free copy, contact: Division of Operations and Maintenance, Technical Services, Engineering Research Center, Water and Power Resources Service, Department of the Interior, 2D-450, P.O. Box 25007, Denver, CO 80225/303-234-3383.

Water and Power Photographs

A large collection of black and white prints and color slides, dating back to the early 1900s are free to illustrators, nature lovers, etc. Mobile exhibits, slide shows and other audiovisual presentations, are also available. Contact: Public Affairs Service Center, D140, Water and Power Resources Service, Department of the Interior. Denver Federal Center, Engineering and Research Center, P.O. Box 25007, Denver, CO 80225/303-234-6260.

Water and Power Resources Library

The library contains information on water resources development, dams, irrigation, environmental control, agriculture, civil engineering, concrete technology, desalinization, drainage, ground water, electrical engineering, fish and wildlife, flood control, hydroelectric power, geothermal, solar and wind energy, materials technology, hydrology, river regulation and control, snow, ice and permafrost, soil mechanics, water quality, weather control and structural engineering. Contact: Library, Division of Management Support, Denver Federal Building, Engineering and Research Center, P.O. Box 25007, Denver, CO 80225/303-234-3019.

Water Data Exchange, National (NAWDEX)

NAWDEX is a computerized data system that can identify sources of water data and that indexes the types of water data these sources collect. The primary purpose of the system is to facilitate the exchange of data between the organizations that gather water data and the organizations that

need the data. Contact: National Water Data Exchange, Geological Survey, Department of the Interior, 421 National Center, Reston, VA 22092/703-860-6031.

Water Data Storage and Retrieval Systems, National (WATSTORE)

Access of all types of water data is through WATSTORE. These data are organized into five files: 1) Station Header File; 2) Daily Values File; 3) Peak Flow File; 4) Water Quality File; and 5) Ground Water Site Inventory File. Contact: Chief Hydrologist, Geological Survey, Department of the Interior, 437 National Center, Reston, VA 22092/703-860-6879.

Water Policy

Research is conducted in water quality and quantity, soil erosion control, improving water yield, snow management for wildlife and livestock and water quality improvement from nonpoint source. Contact: Soil, Water and Air Branch, Range Land Resources Division, Bureau of Land Management, Department of the Interior, 18th and C Sts. N.W., Washington, DC 20240/202-653-9193.

Water Recreation Activities

A series of free brochures is available with a comprehensive list of dams and reservoirs showing available recreational facilities and principal recreational uses. There are 271 recreation areas, 4.2 million acres of land, 1.7 million acres of water surface, 12,200 miles of shoreline, 580 campgrounds, 700 picnic sites, 25,450 tent and trailer spaces, 215 swimming beaches, 660 boat ramps, and 13,800 boat slips. Available brochures include:

Map No. 1—recreation areas of Idaho, Oregon, and Washington

Map No. 2—recreation areas of Montana, Nebraska, South Dakota, North Dakota, and Wyoming

Map No. 3—recreation areas of Arizona, California, Nevada, and Utah

Map No. 4—recreation areas of Colorado, Kansas, Oklahoma, New Mexico, and Texas.

Contact: Office of Public Affairs, Water and Power Resources Services, Department of the Interior, Room 7642, Washington, DC 20240/202-343-4662.

Water Research and Development

Information is available on saline water conversion; new and improved technologies and systems to convert unusable water to water suitable for industrial, agricultural and home use; the recovery and beneficial use of byproducts and disposal of residuals; the site selection, design, construction and operation of demonstration desalting plants; providing solar energy from hydropower. A free bimonthly newsletter, *Water Research in Action,* describes current research projects. Contact: Research, Office of Water Research and Technology, Department of the Interior, Room 4210, Washington, DC 20240/202-343-4607.

Water Research and Technology

The Department of the Interior conducts research and development activities to solve current and projected water problems, and a research and development program to convert saline water for beneficial uses; trains water scientists and engineers through student participation in ongoing research; and operates a national center to disseminate information about water research results and ongoing research. Contact: Director, Office of Water Research and Technology, Room 4410, Department of the Interior, Washington, DC 20240/202-343-5975.

Water Resource Development

The Water and Power Resource Service conducts research to improve the technology to support its general mission of water resources development and conservation in the Western United States. The focus is on energy research and development; water resource planning and engineering such as new techniques and materials for safer and more economical structures, dam safety, water conservation, environmental impacts and water quality; and atmospheric water resources management. Contact: Bureau of Reclamation, Engineering, Department of the Interior, Room 7611, Washington, DC 20240/202-343-4054.

Water Resources

For information and expertise on topics related to water, as a resource, contact: Water Information Group, Geological Survey, Department of the Interior, 420 National Center, Room 53410, Reston, VA 22092/703-860-6867.

Water Resources in Foreign Countries

For information on activities in foreign countries concerning water resource planning, water treatment and quality alteration, effects and sources of pollution, watershed protection and control of surface water, contact: Division on Foreign Activities, Water and Power Resource Service, Department of the Interior, P.O. Box 25007, Denver Federal Center, Mail Code D 2000, Denver, CO 80225/303-234-3015.

Water Resources Planning for Parks

Information is available on water-related recreation including waterfront projects, public access and recreation at piers and wharves, and fishing, picnicking, and gardening at waterfront areas. Information is also available on the multiple use of water-related projects such as a wastewater treatment facility serving recreational needs at little extra cost; bike trails built along a sewer line; aeroclarifier used as a splash pool and skating rink; and treatment buildings being used as observation and astronomy decks. Contact: Division of Community and Human Resource Development, National Parks Service, Department of the Interior, Room 312, 440 G St. N.W., Washington, DC 20243/202-343-4693.

Water Resources Review

This monthly publication provides a summary of the condition of water resources. Subscriptions are free from: *Water Resources Review*, Geological Survey, Department of the Interior, 419 National Center, 12201 Sunrise Valley Dr., Reston, VA 22092/703-860-6884.

Water Resources Scientific Information Center

The center provides current information on water resources research and development by means of a semimonthly research results abstract bulletin, state-of-the-art reviews, and topical bibliographies. The Center also operates a computerized retrieval program to supply basic research and development information in response to specific inquiries. A listing of publications is available. Contact: Water Resources Scientific Information Center, Office of Water Research and Technology, Department of the Interior, Room 1308, Washington, DC 20240/202-343-7220.

Water, Scientific Publications

Publications are available related to the occurrence distribution and availability of water resources. Topics include hydrologic data; suspended-sediment data; flood-prone data; drainage areas; watersheds; rainfall fall-off relationships; lake data; surface reservoirs data; temperature and chemical analysis of ground and surface water. For a list of available publications, contact: Scientific Publications and Data Management, Water Resources Division, Geological Survey, Department of the Interior, 440 National Center, MS 440, Reston, VA 22092/703-860-6877.

Water Scientists and Engineers

Water scientists and engineers receive training at 54 water research and technology institutes.

For a listing of institutes and information on available research, contact: Research Program Coordinator, Office of Water Research and Technology, Department of the Interior, Room 4413, Washington, DC 20240/202-343-8092.

Wetlands Inventory

Wetlands and deepwater habitats are vital nursery areas for many forms of wildlife, fish and fowl. They also perform important flood protection and pollution control functions. A computerized data bank describes all the national wetlands in terms of their ecologic and physical characteristics, geographic locations and natural resource values. Contact: National Wetlands Inventory, Office of Biological Survey, Fish and Wildlife Service, Department of the Interior, 1730 K St. N.W., Room 818, Washington, DC 20240/202-653-8726.

Wild Horses and Burros
Up for Adoption

The Federal Wild Horses and Burros Act allows people to adopt at no charge excess animals when herds grow too large to be supported by available food supplies. The prospective owners must treat the adopted horses and burros humanely during a one-year trial period before legal title can be obtained. Contact: Wild Horses and Burros, Bureau of Land Management, Department of the Interior, 18th and C Sts. N.W., Room 2042, Washington, DC 20240/202-343-4773.

Wildlife Ecology Research
Information

Through a network of 3 research centers, 3 laboratories, and 54 field stations, research is conducted on: developing techniques for wildlife ecology research; evaluating predator-prey relationships; developing methods for reducing animal damage to crops, livestock, etc.; how to monitor, proprogate, and protect endangered and threatened species; and determining the effects of public use on refuges, parks, and other federal conservation holdings. Contact: Division of Wildlife Ecology Research, Fish and Wildlife Service, Department of the Interior, 1717 H St. N.W., Room 515, Washington, DC 20240/202-653-8763.

Wildlife Management

For information on the management of wildlife and other natural resources in the National Park System, contact: Division of Natural Resources, National Park Service, Department of the Interior, 1100 L St. N.W., Room 3317, Washington, DC 20240/202-523-5127.

Wildlife of North America Library

Books, pamphlets, reprints, periodicals, and topographic maps are available from: Library, Fish and Wildlife Service, Department of the Interior, Patuxent Wildlife Research Center, Laurel, MD 20811/301-776-4880, ext. 235.

Wildlife Refuges

Information and technical assistance are available to Native Americans, military reservations, other state and federal agencies, and private organizations to improve conditions for the management of wildlife resources. There are over 400 federally run wildlife refuges. Information is available describing their location, the different types of recreation, their size and their primary species. Contact: Division of National Wildlife Refuges, Fish and Wildlife Service, Department of the Interior, Room 2024, Washington, DC 20240/202-343-4305.

Wildlife Use of Federal Lands

The Bureau of Land Management seeks to preserve wildlife habitats on public lands, mainly in 11 Western States and Alaska. It tries to insure that threatened or endangered plants and animals and their critical habitats are not jeopardized by Bureau activities. It also maintains lists of endangered plants and animals, including mammals, birds, reptiles, amphibians, fish, snails, clams, crustaceans, insects, butterflies and plants. Contact: Division of Wildlife, Bureau of Land Management, Department of the Interior, Room 2649, Washington, DC 20240/202-343-6188.

Young Adult Conservation Corps

This program provides year-round jobs for unemployed and out-of-school young men and women ages 16 through 23. The work performed is in areas of conservation at national forests, national parks, fish hatcheries, wildlife refuges and other public lands. The program includes both residential camps and nonresidential work projects. Contact: Young Adult Conservation Corps, Department of the Interior, Room 2413, Washington, DC 20240/202-343-4148.

Youth Conservation Corps

Each summer the Department of the Interior employs 15- to 18-year-olds to further develop and maintain the natural resources of the United States. Projects may include clearing streambanks, building trails, planting trees, gathering air and water samples or developing campgrounds. Contact: Youth Conservation Corps, Office of Youth Programs, Department of the Interior, Room 2427, Washington, DC 20240/202-343-8086.

Youth Conservation Programs

Employment and on-the-job training are provided to young people in such areas as brick masonry, carpentry, operation of heavy equipment, painting, cement finishing, plastering, caulking and welding. The programs available are: the Youth Conservation Corps (ages 15 to 18) and the Young Adult Conservation Corps (ages 16 to 23), which work on the improvement of recreation facilities, wildlife, water, and conservation projects. Contact: Youth Conservation Programs, Water and Power Resources Service, Department of the Interior, Washington, DC 20240/202-343-9366.

How Can the Department of the Interior Help You?

To determine how the Department of the Interior can help you, contact: Office of Public Affairs, Department of the Interior, Room 7211, Washington, DC 20240/202-343-3171.

Department of Justice

(Attorney General), Constitution Ave. and 10th St. N.W.,
Washington, DC 20530/202-633-2007

ESTABLISHED: June 22, 1870
BUDGET: $2,347,935,000
EMPLOYEES: 58,396

MISSION: Serves as counsel for the citizens of the Nation; represents them in enforcing the law in the public interest; through its thousands of lawyers, investigators, and agents it plays a key role in protection against criminals and subversion, in insuring healthy competition of business in our free enterprise system, in safeguarding the consumer, and in enforcing drug, immigration, and naturalization laws; plays a significant role in protecting citizens through its efforts for effective law enforcement, crime prevention, crime detection, and prosecution and rehabilitation of offenders; conducts all suits in the Supreme Court in which the United States is concerned; and represents the Government in legal matters generally.

Major Divisions and Offices

Deputy Attorney General

Department of Justice, Constitution Ave. and 10th St. N.W., Washington, DC 20530/202-633-2101.
Budget: $1,322,622,000
Employees: 22,628

1. Office of Justice Assistance, Research and Statistics

Department of Justice, 633 Indiana Ave. N.W., Washington, DC 20531/202-724-7782.
Budget: $486,463,000
Employees: 571
Mission: Coordinates and provides staff support for the Law Enforcement Assistance Administration, the National Institute of Justice and the Bureau of Justice Statistics.

2. Drug Enforcement Administration

Department of Justice, 1405 Eye St. N.W., Washington, DC 20537/202-633-1249.
Budget: $201,717,000
Employees: 4,119

Mission: Enforces the controlled substances laws and regulations, and brings to the civil and criminal justice system of the United States or any other competent jurisdiction, those organizations involved in the growing, manufacturing, or distribution of controlled substances appearing in or destined for the illicit traffic in the United States; and provides leadership role in narcotic and dangerous drug suppression programs at the national and international levels and, as the lead agency in federal drug law enforcement, develops the overall federal drug enforcement strategy, programs, and plans and continually assesses their effectiveness and applicability.

3. Bureau of Prisons

Department of Justice, 320 First St. N.W., Washington, DC 20534/202-724-3198.
Budget: $336,350,000
Employees: 10,518
Mission: Protects society through the care and custody of those persons convicted by the courts to serve a period of time incarcerated in a Federal penal institution.

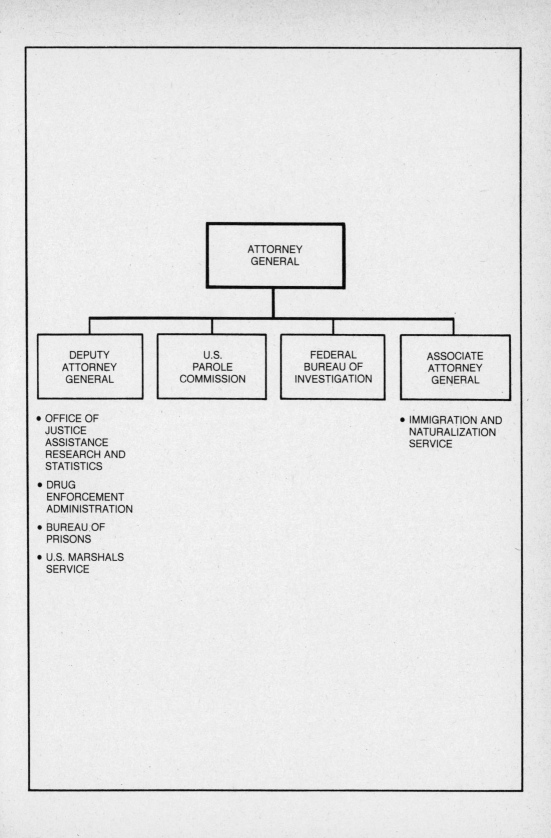

4. *Marshals Service*

Department of Justice, One Tysons Corner Center, McLean, VA 22102/703-285-1131.
Budget: $292,092,000
Employees: 7,220
Mission: Protect witnesses to organized crime whose lives and those of their families are jeopardized by their testimony; provide physical security for U.S. courtrooms and personal protection for federal judges, jurors, and attorneys; perform federal law enforcement functions for the Attorney General; execute all civil and criminal process emanating from the federal courts; disburse appropriate funds to satisfy Government obligations incurred in the administration of justice at the federal level; maintain the custody of federal prisoners from the time of their arrest to their commitment or release; transport federal prisoners pursuant to lawful writs and direction from the Bureau of Prisons; and maintain custody and control of evidence, as well as money and property, seized pursuant to federal statutes.

Parole Commission

Department of Justice, Park Place, 1 N. Park Building, 5550 Friendship Blvd., Bethesda, MD 20015/301-492-5990.
Budget: $5,500,000
Employees: 178
Mission: Grants, denies, or revokes parole for eligible federal offenders; supervises paroled or otherwise released offenders until expiration of their terms; and determines whether or not persons convicted of certain crimes may serve as officials in the field of organized labor or in labor-oriented management positions and whether or not such persons may provide services to, or be employed by, employment benefit plans.

Federal Bureau of Investigation

Department of Justice, 9th St. and Pennsylvania Ave. N.W., Washington, DC 20535/202-324-3000.
Budget: $613,906,000
Employees: 19,913
Mission: Gathers and reports facts, locates witnesses, and compiles evidence in matters in which the federal government is or may be a party of interest; investigates all violations of federal laws except those assigned to some other federal agency, and is the principal investigation arm of the Department of Justice.

Associate Attorney General

Department of Justice, Constitution Ave and 10th St. N.W., Washington, DC 20530/202-633-3752.
Budget: $335,742,000
Employees: 11,172

1. *Immigration and Naturalization Service*

Department of Justice, 425 Eye St. N.W., Washington, DC 20536/202-633-4316.
Budget: $329,492,000
Employees: 10,943
Mission: Administer the immigration and naturalization laws relating to the admission, exclusion, deportation, and naturalization of aliens; inspect aliens to determine their admissibility into the United States; adjudicates requests of aliens for benefits under the law; guards against illegal entry into the United States; investigates, apprehends, and removes aliens in this country in violation of the law; and examines alien applicants wishing to become citizens.

Major Sources of Information

Adjudication
This office assists the criminal justice system leadership—judges, prosecutors, defense counsels and planners—in developing ideas and strategies to improve and reform the system. Programs include: Career Criminal Program, Fundamental Court Improvement Program, Court Delay Reduction Program, Jail Overcrowding Program, Courts Training and Technical Assistance, and Jury Usage and Management Program. Contact: Adjudication Division, Office of Criminal Justice Programs, Department of Justice, 633 Indiana

Ave. N.W., Room 1142, Washington, DC 20531/202-724-7647.

Advanced Criminal Justice Research
Research projects supported by this office investigate the application of advanced analytical techniques to such problems as: estimating the impact of charges in criminal justice policies or procedures; measuring progress or deterioration. Contact: Office of Research and Evaluation Methods, National Institute of Justice, OJARS, Department of Justice, 633 Indiana Ave. N.W.,

Room 1200, Washington, DC 20531/202-724-7631.

Advocacy Institute, Attorney General's

The Institute trains Assistant U.S. Attorneys and all U.S. Department of Justice attorneys in trial advocacy. The courses include separate civil and criminal trial advocacy courses, an appellate advocacy course, and seminars on specialized topics, such as white-collar crime, narcotics, conspiracy, environmental litigation, bankruptcy, land comdemnations, public corruption and fraud, civil rights, witness security and computer fraud. Contact: Attorney General's Advocacy Institute, Executive Office for U.S. Attorneys, Department of Justice, 10th St. and Constitution Ave. N.W., Room 1342, Washington, DC 20530/202-633-4104.

Alien Documentation Identification and Telecommunications Systems (ADIT)

ADIT includes a new alien registration card and an automated file of information on registered aliens. The new card identifies the holder by a color photo, fingerprint, signature, biographic data and some other secure features. Contact: ADIT, Immigration and Naturalization Service, Department of Justice, 425 Eye St. N.W., Room 6118, Washington, DC 20536/202-633-3024.

Antitrust

The mission of this Division is to encourage workable competition throughout the American economy. It brings civil and criminal antitrust cases to promote or maintain competition in particular markets. It participates in proceedings of federal (and sometimes state) regulatory agencies where those proceedings involve important questions of antitrust law or competition policy. It also participates in seminars and speaks before professional organizations, business groups and other organizations as advocates of competition. Contact: Antitrust Division, Department of Justice, 10th St. and Constitution Ave. N.W., Room 3109, Washington, DC 20530/202-633-2401.

Antitrust—Business Reviews

This section reviews proposed business plans at the written request of interested parties and states its present enforcement intentions. The request and response will be announced at the time a business review letter is issued. These letters and the supporting information supplied by the requesting party are available for public inspection. Case studies of investigations can be seen at this office. Examples of favorable reviews include: a joint venture to build and operate a blood plasma fractionization plant; technical assistance agreement between Chrysler and General Motors whereby Chrysler would receive certain emission control and safety technology; and establishment of prepaid legal services plans. Contact: Business Reviews, Legal Procedure Unit, Antitrust Division, Department of Justice, 10th St. and Constitution Ave. N.W., Room 7416, Washington, DC 20530/202-633-2481.

Antitrust Cases—Information

Researchers can visit the Legal Procedures Unit and thumb through the files for information on companies investigated for antitrust violations. Information includes: pleadings in antitrust cases, formal complaints against companies, and depositions and summaries of legal proceedings. For those who wish more complete information, these documents refer them to the courts in which the cases were tried. Contact: Legal Procedure Unit, Antitrust Division, Department of Justice, 10th St. and Constitution Ave. N.W., Room 7416, Washington, DC 20530/202-633-2481.

Antitrust—Consumer Affairs

This office is responsible for litigation arising under the Food, Drug and Cosmetic Act, the Consumer Product Safety Commission Act, and civil penalty cases arising under the Federal Trade Commission (FTC) Act. It enforces federal criminal provisions prohibiting the turning back of odometers and prohibits certain kinds of actions under the Truth in Lending Act. A free pamphlet, *Antitrust Enforcement and the Consumer,* is available. It explains antitrust laws, describes how antitrust violations hurt the consumer and how the public can actively pursue the violator. Contact: Consumer Affairs, Antitrust Division, Department of Justice, 521 12th St. N.W., Room 604, Washington, DC 20530/202-724-6786.

Antitrust—Energy Industry

A special division handles antiturst violations within the energy industry. Contact: Energy Section, Antitrust Division, Department of Energy, 414 11th St. N.W., Room 9317, Washington, DC 20530/202-724-6410.

Antiturst—Foreign Commerce

This office monitors foreign cartel activity for any effect on U.S. trade and commerce, particularly those activities that may present a significant adverse impact on inflation and prices of vital products for the American consumer. It informs American businessmen on the relationship between export promotion and the antitrust laws.

It assists foreign antitrust officials on antitrust laws and enforcement methods, and is involved with the Committee of Experts on Restrictive Business Practices of the Organization for Economic Cooperation and Development (OECD). Contact: Foreign Commerce, Antitrust Division, Department of Justice, 10th St. and Constitution Ave. N.W., Room 7115, Washington, DC 20530/202-633-2464.

Antitrust Guide Concerning Research Joint Ventures

This publication describes ways that corporate cooperation on research can be pursued without violating antitrust laws. The guide is available for $4.50 from the Superintendent of Documents, Government Printing Office, Washington, DC 20402/202-783-3238. For further information on content contact: Antitrust Division, Department of Justice, 10th and Constitution Ave. N.W., Room 3109, Washington, DC 20530/202-633-2401.

Antitrust Issues

The legislative unit prepares statutory reports to the President and to Congress on a variety of competition issues. Examples include reports on activities of the International Energy Agency (IEA), the state of competition in the coal and energy industries and federal government activities that may adversely affect small businesses. Contact: Legislative Unit, Antitrust Division, Department of Justice, 10th St. and Constitution Ave. N.W., Room 3112, Washington, DC 20530/202-633-2497.

Antitrust—Special Industries

For information on antitrust activities concerning businesses involved with telecommunications, securities, and commodity futures, contact: Special Regulated Industries Section, Antitrust Division, Department of Justice, 521 12th St. N.W., Room 504, Washington, DC 20530/202-724-6693.

Antitrust—Transportation

This office has intervened in a variety of regulatory proceedings involving the transportation industry, to act as a procompetitive voice advocating the elimination of unnecessary restraints on entry into markets and the removal of unnecessary restrictions on competitive ratemaking. Examples of its involvement include the Airline Deregulation Act and the U.S. Postal Service's proposed regulations regarding implementation of the private express laws. Contact: Transportation Section, Antitrust Division, Department of Justice, 414 11th St. N.W., Room 8120, Washington, DC 20530/202-724-6349.

Applications for Benefits for Immigrants

The Office of Adjudication renders decisions on the various applications and petitions to bestow benefits to aliens. For example, it decides on preference visas for immigrants or for temporary workers and applications for adjustments of status from temporary nonimmigrant statuses to lawful permanent residents of the United States. Contact: Adjudication, Immigration and Naturalization Service, Department of Justice, 425 Eye St. N.W., Room 7116, Washington, DC 20536/202-633-3228.

Arson

The arson desk coordinates and manages the National Arson Control Assistance Strategy. It combines the investigative and prosecutorial expertise of the federal criminal justice agencies with financial and technical assistance capabilities. The objective of the grant program is to assist state, regional, county, and local efforts in reducing the number of deaths, personal injury and the economic loss related to arson, and to upgrade current knowledge regarding arson incidence and arson control approaches. Contact: Arson Desk, Office of Criminal Justice Programs, Department of Justice, 633 Indiana Ave. N.W., Room 1142C, Washington, DC 20534/202-724-7652.

Block Grant

For information on the Law Enforcement Assistance Administration's block grant program, contact: Criminal Justice Assistance Division, Office of Criminal Justice Programs, LEAA, Department of Justice, 633 Indiana Ave. N.W., Room 1142, Washington, DC 20531/202-724-7647.

Bureau of Prisons Publications

The following publications are available: *Annual Report; Statistical Report; Facilities* (describing prison facilities); and *Development of the Federal Prison System.* Contact: Public Information, Bureau of Prisons, Department of Justice, 320 1st St. N.W., Room 554, Washington, DC 20534/202-724-3198.

Citizenship Education

Citizen education films are available at no charge to civic, patriotic, educational and religious groups. There are also about 15 textbooks on citizenship available, consisting of teachers' manuals and student textbooks at various reading

levels. These books are distributed free to public schools for applicants for citizenship. Contact: Naturalization, Immigration and Naturalization Service, Department of Justice, 425 Eye St. N.W., Room 7246, Washington, DC 20536/202-633-3320.

Civil Rights—Appeals

This office handles all Division cases in the Supreme Court and court of appeals for legislative matters and for in-house legal counsel such as affirmative action, school desegregation remedies and jury selection. Contact: Appellate Section, Civil Rights Division, Department of Justice, 10th St. and Constitution Ave. N.W., Room 5740, Washington, DC 20530/202-633-2195.

Civil Rights—Criminal

Statutes to preserve personal liberties are enforced to prohibit persons from acting under cover of law or in conspiracy with others to interfere with an individual's federal constitutional rights and to prohibit the holdings of individuals in peonage or involuntary servitude. Contact: Criminal Section, Civil Rights Division, Department of Justice, 10th St. and Constitution Ave. N.W., Room 7627, Washington, DC 20530/202-633-4067.

Civil Rights Enforcement

The Civil Rights Division prosecutes actions under several criminal civil rights statutes; coordinates the civil rights enforcement efforts of the Federal agencies whose programs are covered by Title VI of the 1964 Act; and assists federal agencies in identifying and eliminating sexually discriminatory provisions in their policies and programs. Contact: Civil Rights Division, Department of Justice, 10th St. and Constitution Ave. N.W., Room 5643, Washington, DC 20530/202-633-2151.

Civil Rights—Federal

Statutes are enforced that prohibit employment discrimination by state and local governments, that prohibit discriminatory use of federal funds, and provide equal opportunity among federal contractors. *Questions and Answers on the Uniform Guidelines on Employee Selection Procedures* is a free publication that explains government-wide standards for employers to follow in using selection procedures for employment on a nondiscriminatory basis. Contact: Federal Enforcement Section, Civil Rights Division, Department of Justice, 10th St. and Constitution Ave. N.W., Room 4712, Washington, DC 20530/202-633-3831.

Civil Rights—General Litigation

This office enforces: 1) laws and statutes designed to bring about desegregation of public elementary and secondary schools and to ensure nondiscriminatory treatment by all schools, including colleges, that receive federal funds; 2) the Fair Housing Act of 1968 which prohibits discrimination in virtually all residential housing transactions; and 3) Equal Credit Opportunity Act which forbids discrimination in all aspects of credit transactions, including those for commercial and other nonhousing purposes. Contact: General Litigation Section, Civil Rights Division, Department of Justice, 10th St. and Constitution Ave. N.W., Room 7525, Washington, DC 20530/202-633-4716.

Civil Rights—Special Litigation

This office is responsible for protecting rights secured under Title VI of the Civil Rights Act of 1964 requiring nondiscrimination against persons confined in state and local prisons and jails. The Act protects nonstatutory rights to insure adequate treatment and rehabilitation in the setting least restrictive of personal liberty for those persons confined in state or local mental retardation, mental health, juvenile and nursing home facilities. This office enforces part of the Rehabilitation Act of 1973 which prohibits discrimination by recipients of federal funding against qualified handicapped persons in employment and in enjoyment of services and activities. Contact: Special Litigation Section, Civil Rights Division, Department of Justice, 10th St. and Constitution Ave. N.W., Room 7341, Washington, DC 20530/202-633-3414.

Commercial Litigation

This office pursues the Government's affirmative civil claims arising from fraud, bribery, or other official misconduct and the collection of civil fines or other money judgments awarded to the United States. It also handles white collar crime, improved procedures in collection enforcement activity, contract actions, cases arising under grants, subsidies or insurance undertakings by the government, foreclosures, bankruptcies, negotiations, patent and copyright infringement suits, and customs-related cases. Contact: Commercial Litigation Branch, Civil Division, Department of Justice, 10th and Constitution Ave., N.W., Room 3607, Washington, DC 20530/202-633-3306.

Community Relations Service (CRS)

This service helps communities and groups resolve disputes, disagreements, and difficulties

arising from racial discrimination. It employs various techniques of persuasion to defuse tensions and conflicts within communities that arise from racial discrimination. The three fundamental services the CRS provides are technical assistance, conciliation, and mediation. In technical assistance, it identifies and analyzes the roots of community tension and recommends a corrective course of action. In conciliation, the agency informally acts as a third party to disputes to avoid or reduce violence, offer alternatives to involved parties, and influence actions or reactions toward peaceful resolution. In mediation, it acts as a third party intermediary in a more formal sense with sanction from the disputants, assisting them in reaching a settlement of their differences. The Service may enter a community on its own initiative or upon request. Contact: Community Relations Service, Department of Justice, 5500 Friendship Blvd., Suite 330, Chevy Chase, MD 20815/301-492-5929.

Conspiracies

For information on programs for detection and prosecution of criminal conspiracies and activities in the areas of fencing, organized crime, white-collar crime, economic crime and fraud against government, contact: Criminal Conspiracies Division, Office of Criminal Justice Programs, LEAA, Department of Justice, 633 Indiana Ave. N.W., Room 1144, Washington, DC 20531/202-724-7661.

Correctional Assistance

Technical assistance is available to state and local departments of corrections, institutions, jails, probation and parole agencies, and other correctional units to help upgrade and strengthen the practice of corrections. For technical assistance information specifically related to jails, contact: National Institute of Corrections Jail Center, Bureau of Prisons, Department of Justice, 1790 30th St., Suite 140, Boulder, CO 80301/303-497-6700. For general information on technical assistance, contact: National Institute of Corrections, Bureau of Prisons, Department of Justice, 320 1st St. N.W., Washington, DC 20534/202-724-3106.

Corrections

This office supports the operation and improvement of agencies and programs that provide residential and nonresidential services to pretrial detainees, inmates, probationers, parolees and ex-offenders. Some of their programs include: treatment alternatives to street crime; treatment and rehabilitation for addicted prisoners; presentence investigation report; legal services programs; general corrections technical assistance; and major correctional initiatives. Contact: Corrections Division, Office of Criminal Justice Programs, LEAA, Department of Justice, 633 Indiana Ave. N.W., Room 724, Washington, DC 20531/202-724-2959.

Corrections Information Center

The Center provides information in all areas of corrections as well as in specialty areas such as volunteers in corrections, staff development and training and legal matters. Contact: National Institute of Prisons, Department of Justice, 1790 30th St., Suite 130, Boulder, CO 80301/303-444-1101.

Corrections, National Institute of

This office gives technical assistance to state and local correctional programs. Grant funds finance projects in the Institute's priority areas of staff development and training, jails classification systems, offender grievance mechanism, probation and parole programs and clearinghouse activities. Contact: National Institute of Corrections, Bureau of Prisons, Department of Justice, 320 1st St. N.W., Room 200, Washington, DC 20534/202-724-3106.

Crime Control Information

The Enforcement Division finances projects related to the deterrence, detection, investigation and control of crime by state and local law enforcement agencies. Programs include Integrated Criminal Apprehension Program, Managing Criminal Investigations, and Counterterrorism Training. Contact: Enforcement Division, Office of Criminal Justice Programs, LEAA, Department of Justice, 633 Indiana Ave. N.W., Room 1158, Washington, DC 20531/202-724-7659.

Crime in the United States

An annual report called, *Uniform Crime Reports,* contains information on the types of crimes committed (murder, rape, robbery, motor vehicle theft, etc), victim/offender relationships, types of weapons, motives, persons arrested, crime trends, and areas in which crimes were committed. Other published reports include: *Assaults on Federal Officers, Bomb Summary,* and *Law Enforcement Officers Killed Summary.* Contact: Uniform Crime Reporting Section, Federal Bureau of Investigation, Department of Justice, 9th St. and Pennsylvania Ave. N.W., Room 7437, Washington, DC 20535/202-324-2820.

Criminal Behavior

Research programs conducted on crime and criminal behavior include: 1) *Research Agree-*

ments—longterm grants that allow groups of researchers to focus their collective efforts on fundamental questions of crime or behavior, e.g., habitual offender, white collar crime, economic studies in criminal justice, unemployment and crime and community reactions to crime, alcohol and drugs, race relations and crime; and 2) *Visiting Fellowships*—which bring researchers to the Institute to work on independent projects of their own choosing. Contact: Center for the Study of Crime Correlates and Determinants of Criminal Behavior, Office of Research Programs, National Institute of Justice, OJARS, Department of Justice, 633 Indiana Ave. N.W., Room 1200, Washington, DC 20531/202-724-7631.

Criminalistics Laboratory Information System (CLIS)

This computerized data base is currently composed of a general Rifling Characteristics File that is used to identify the manufacturer and type of weapon that may have been used to fire a bullet or cartridge. Contact: Laboratory Division, Federal Bureau of Investigation, Department of Justice, 9th St. and Pennsylvania Ave. N.W., Washington, DC 20535/202-324-4410.

Criminal Justice Bibliographies

The National Crime Justice Reference Service maintains the following bibliographies. When requesting a bibliography, ask for the latest available update.

Affirmative Action-Equal Employment Opportunities in the Criminal Justice System (NCJ 61834)
Alternatives to Institutionalization (NCJ 58518)
Arson (NCJ 58366)
Basic Sources in Criminal Justice (NCJ 49417)
Bibliographies in Criminal Justice (NCJ 62014)
Community Crime Prevention (NCJ 43628)
Crime and Disruption in Schools (NCJ (NCJ 56588)
Crimes Against the Elderly (NCJ 43626)
Criminal Justice and the Elderly (NCJ 55197)
Criminal Justice Evaluation (NCJ 25659)
Criminal Justice Periodicals (NCJ 57168)
Etiology of Criminality: Nonbehavioral Science (NCJ 60117)
Female Offender (NCJ 55637)
Firearm Use in Violent Crime (NCJ 52677)
Halfway Houses (NCJ 46851)
International Policing (NCJ 46190)
Jail-Based Inmate Programs (NCJ 60331)
Jury Reform (NCJ 48232)
Paralegals (NCJ 57986)
Plea Bargaining (NCJ 32329)
Plea Negotiation (NCJ 66559)
Police Consolidation (NCJ 34700)
Police Crisis Intervention (NCJ 48005)
Police Discretion (NCJ 46183)

Police Stress (NCJ 59352)
Prison Industries (NCJ 49701)
Private Security (NCJ 47367)
Publications of the National Institute of Law Enforcement and Criminal Justice (NCJ 49700)
Publications of the National Institute of Law Enforcement and Criminal Justice (NCJ 57987)
Restitution (NCJ 62011)
Speedy Trial (NCJ 48110)
Spouse Abuse (NCJ 54427)
Standards of Care in Adult and Juvenile Correctional Institutions (NCJ 61443)
Strategies for Reintegrating the Ex-Offender (NCJ 61571)
Team Policing (NCJ 35887)
Techniques for Project Evaluation (NCJ 43556)
Terrorism Supplement (NCJ 45005)
Variations on Juvenile Probation (NCJ 62010)
Victim Compensation and Offender Restitution (NCJ 32009)
Victimless Crime (NCJ 43630)
Victim/Witness Assistance (NCJ 49698)
White Collar Crime (NCJ 69331)

Contact: NCJRS Distribution Service, Department of Justice, P.O. Box 6000, Rockville, MD 20850/301-251-5500.

Criminal Justice Programs Evaluations

This office designs and sponsors evaluations of selected criminal justice and crime prevention programs currently in use; innovative local programs; significant changes or reforms in law or policy; institute-sponsored tests of promising experimental approaches; and large-scale demonstration programs supported by LEAA. It also helps state and local agencies develop their own evaluation capabilities. Contact: Office of Program Evaluations, National Institute of Justice, OJARS, Department of Justice, 4340 East-West Highway, Room 338, Bethesda, MD 20014/301-492-9085.

Criminal Justice Reference Service

This office acts as an international clearinghouse and reference center serving both the professional law enforcement community and the general public on subjects such as courts, police, corrections, juvenile justice, human resources, fraud and abuse of government programs, evaluations and statistics. The service maintains a reading room and a reference library which is open to the public. The library holds Categorical Grants Files of the National Institute of Justice, the Bureau of Justice Statistics and the Law Enforcement Assistance Administration. The Selective Notification of Information Service provides monthly announcements of significant publications, audiovisual material and events that relate

to specific areas of interest. Contact: National Criminal Justice Reference Service, National Institute of Justice, Department of Justice, 1600 Research Blvd., Rockville, MD 20850/301-251-5500.

Criminal Justice Research

Research to explore major problems of crime prevention and criminal justice includes: 1) Police Division research which advances police science and strengthens police effectiveness, e.g., lightweight body armor, police response; 2) Adjudication Division research, which focuses on the prosecution, defense and courts components of the criminal justice system, e.g., improving consistency of sentencing in criminal cases, and better techniques for juror management; 3) Corrections Division research projects directed at increasing the knowledge of the custody, treatment, and community supervision of offenders; and 4) Community Crime Prevention Division which focuses on the role of the citizen, the municipality, law enforcement authorities and environmental design factors in preventing crime and crimes of special concerns include organized crime, white-collar crime, and rape. The Unsolicited Research Program invites criminal justice researchers to submit proposals for work on problems of their own choice. Contact: Office of Research Programs, National Institute of Justice, OJARS, Department of Justice, Room 866, Washington, DC 20531/202-724-2965.

Desegregation of Public Education

The Justice Department may go to court to obtain an order to desegregate a public school or public college. The Attorney General acts on the basis of a meritorious written complaint from 1) any parent or group of parents whose minor children are being deprived by a school board of equal protection of the laws; or 2) any individual or parent of an individual who has been denied admission to or is not permitted to continue in attendance at a public college because of race, color, religion, sex, or national origin. The Attorney General must certify that the suit will materially further the orderly process of desegregation. The Department of Justice may not bring suit unless the person complaining is unable to sue either because of financial reasons or because of intimidation. Contact: Chief, General Litigation Section, Civil Rights Division, Department of Justice, Room 7527, Washington, DC 20530/202-633-4713.

Desegregation of Public Facilities

The Attorney General may bring suit for an injunction prohibiting discrimination in operation of public facilities on account of race, color, religion, or national origin when he or she receives, and certifies as meritorious, a written complaint from a person who is unable to bring suit either because of financial reasons or possible intimidation. The Attorney General may intervene in suits of general public importance alleging denial of the equal protection of the laws on account of race, color, religion or national origin and is entitled to the same relief as if he or she had instituted the suit. The Attorney General has the enforcement mission to correct widespread deprivation of civil rights of persons confined in penal and nonpenal institutions. Contact: Chief, Special Litigation Section, Civil Rights Division, Department of Justice, Washington, DC 20530/202-633-3414.

Direct Payments

The program described below provides financial assistance directly to individuals, private firms and other private institutions to encourage or subsidize a particular activity.

Public Safety Officers' Benefits Program

Objectives: To provide a $50,000 death benefit to the eligible survivors of state and local public safety officers whose death is the direct and proximate result of a personal injury sustained in the line of duty on or after September 29, 1976.

Eligibility: Applicants must be an eligible survivor of a state or local public safety officer whose death is the direct and proximate result of a personal injury sustained in the line of duty on or after September 29, 1976. Public safety officers include law enforcement officers and fire fighters both paid and volunteer. Law enforcement officers include, but are not limited to, police, corrections, probation, parole and judicial officers.

Range of Financial Assistance: $50,000.

Contact: Director, Public Safety Officers' Benefits Program, Law Enforcement Assistance Administration, Department of Justice, Washington, DC 20531/202-724-7620.

Disaster Squad

The disaster squad identifies, through fingerprints, the victims of disasters. Its services are available upon the request of local law enforcement and government agencies or transportation companies following a catastrophe where the identification of victims is a problem. The squad also assists in identifying Americans in disaster abroad only at the specific invitation of the country involved. Contact: FBI Disaster Squad, Identification Division, Federal Bureau of Investigation, Department of Justice, 9th St. and Pennsylvania Ave. N.W., Room 11255, Washington, DC 20537/202-324-5401.

Drug Abuse Warning Network (DAWN)

This network identifies and evaluates the scope and magnitude of drug abuse in the United States. More than 900 hospital emergency rooms and medical examiner facilities supply data to the program. DAWN identifies drugs currently being abused; determines existing patterns and profiles of abuse/abuser in Standard Metropolitan Statistical Areas; monitors systemwide abuse trends; detects new abuse entities and polydrug combinations; provides data for the assessment of health hazards and abuse potential of drug substances; and provides data needed for rational control and scheduling of drugs of abuse. Contact: Information Systems Section, Office of Compliance and Regulatory Affairs, Drug Enforcement Bureau, Department of Justice, 1405 Eye St. N.W., Room 519, Washington, DC 20537/202-633-1172.

Drug Education Materials

Drug education films are available free of charge to civic, educational, private and religious groups. Available publications include:

Drugs of Abuse—a 40-page booklet, written especially for law enforcement officers, educators, health and other professionals, containing full color illustrations of drugs controlled under the Controlled Substances Act 1970 (CSA)-1970, administered by the Drug Enforcement Administration (DEA), it also gives concise, factual, accurate scientific descriptions of the drugs, their effects and the consequences of abuse. It contains a chart summarizing scientific data about controlled licit and illicit drugs and a glossary of slang terms. The Controlled Substances Act-1970 is summarized.

Drug Abuse and Misuse—a 21-page pamphlet for the general public describes the effects of commonly-abused drugs. It provides brief description of drugs, their effects, and the consequences of abuse.

Controlled Substances Terms and Symptoms Chart—a 12 × 18-inch poster for school health classes, clinics, law enforcement agencies, on controlled substance effects that lists the CSA schedules for commonly abused drugs and provides other information.

Soozie—An activities book designed for children ages 6–9, which teaches them the consequences of drug abuse in a clever and interesting way emphasizing the theme, "Only sick people need drugs." For use by parents and educators.

Katy's Coloring Book on Drugs and Health—a 16-page coloring book for children ages 5–7. Parents and teachers find this book very useful in developing its major theme, respect for drugs.

Contact: Preventive Programs, Office of Public Affairs, Drug Enforcement Administration, Department of Justice, 1405 Eye St. N.W., Room 715, Washington, DC 20537/202-633-1199.

Drug Enforcement Research

Operational and scientific support are available in the form of: research directly related to the Drug Enforcement Administration law enforcement, intelligence and regulatory functions; drug analysis for prosecution of illicit drug violators; new covert tracking devices; miniature sized agent alert devices; systems studies for voice privacy requirements; and regional communication networks. Contact: Office of Science and Technology, Drug Enforcement Administration, Department of Justice, 1405 Eye St. N.W., Room 208, Washington, DC 20537/202-633-1211.

Drug Enforcement Training

The Drug Enforcement Administration's training program provides basic and advanced training in drug law enforcement skills to the Drug Enforcement Administration and other federal, state, local and foreign officials. There are also training programs for foreign officials. Contact: Enforcement Training Division, Office of Training, Drug Enforcement Administration, Department of Justice, 1405 Eye St. N.W., Room 418, Washington, DC 20537/202-633-1323.

Drug Registration

Information is available about registration under the Controlled Substances Act. Every person who manufacturers, distributes or dispenses any controlled substance or who proposes to engage in the manufacture, distribution or dispensing of any controlled substance must register annually with the Registration Branch of the DEA (Department of Justice, Box 28083, Central Station, Washington, DC 20005). A schedule of controlled substances is available. The Drug Enforcement Administration has more than 540,000 registrants. It monitors and periodically investigates registrants to ensure that they are accountable for the controlled substances handled. Contact: Registration Section, Office of Compliance and Regulatory Affairs, Drug Enforcement Administration, Department of Justice, 666 11th St. N.W., Room 920, Washington, DC 20001/202-724-1016.

Drug Reporting Systems

Three computerized systems are maintained by this office:

Drug Abuse Warning Network (DAWN)—see listing above.

Automated Reporting and Consolidated Order System (ARCOS)—a comprehensive drug-tracking system that enables the Drug Enforcement Administration to monitor the flow of selected drugs from points of import or manufacture to points of sale, export or distribution.

Project Label—a system that represents a listing of all marketed drug products containing controlled substances.

Contact: Office of Compliance and Regulatory Affairs, Drug Enforcement Administration, Department of Justice, 1405 Eye St. N.W., Room 519, Washington, DC 20537/202-633-1172.

Drug Situation Indicators

A retail and wholesale heroin price/purity index is available based upon data from the analysis of drug evidence samples submitted to the Drug Enforcement Administration. Reports are available on drug-related emergency room admissions and deaths from metropolitan areas widely distributed throughout the United States. Heroin-related death and injury data are published on a quarterly basis for 21 of these areas. All legal drug handlers are registered with the Drug Enforcement Administration and are required to report thefts or losses of controlled substances. Stolen supplies of controlled drugs comprise a substantial portion of the supply of certain substances in the illicit drug distribution network. Drug Enforcement Administration uses these data to evaluate trends in the overall heroin situation. Information is also available on heroin-related crimes. Contact: Office of Intelligence, Drug Enforcement Administration, Department of Justice, 1405 Eye St. N.W., Room 1013, Washington, DC 20537/202-633-1071.

Drug Statistics

The following statistical information according to subject are available:

Drug Enforcement Statistical Report—enforcement activity, drug abuse indicators, organization and training data;

Enforcement Activity—domestic drug removals through seizures, through delivery, at posts and borders, immigration and naturalization service illicit drug removals, customs referral drug removals, federal and Drug Enforcement Administration initiated task force arrests and dispositions, domestic arrests and clandestine labs seized, Drug Enforcement Administration foreign cooperative arrests, compliance investigations and regulatory actions;

Drug Abuse Indicators—statistics on heroin, cocaine, stimulants, hallucinogens, depressants;

Organization and Training Data—Drug Enforcement Administration offices and personnel.

Contact: Office of Intelligence Services, Drug Enforcement Administration, Department of Justice, 1405 Eye St. N.W., Room 1221, Washington, DC 20537/202-633-1263.

Drug Training

The National Training Institute provides both basic and advanced training in drug law enforcement and related skills to insure that trained personnel are available to perform the necessary functions of Drug Enforcement Administration. It provides training to forensic chemists, intelligence analysts and to the foreign drug law enforcement community. Contact: National Training Institute, Office of Training, Drug Enforcement Administration, Department of Justice, 1405 Eye St. N.W., Room 418, Washington, DC 20537/202-633-1325.

Emergency Programs Center

This office coordinates Department of Justice activities in three main areas—civil disorder, domestic terrorism, and nuclear incidents (criminal aspects only—extortion, theft, etc.). It also responds to special crises and special security events such as coordinating responsibilities for the Winter Olympics and the Cuban refugees. Contact: Emergency Programs Center, Department of Justice, 10th St. and Constitution Ave. N.W., Room 6101, Washington, DC 20530/202-633-4545.

Equal Opportunity

For information on the Department of Justice's annual affirmative action plan for equal employment opportunity, contact: Equal Opportunity Programs Staff, Justice Management Division, Department of Justice, 10th St. and Constitution Ave. N.W., Room 1230, Washington, DC 20530/202-633-5049.

Fair Housing and Equal Credit Opportunity

Title VIII of the Civil Rights Act of 1968 is designed to insure freedom from discrimination in the sale, rental and financing of housing and other related activities. A private suit alleging discrimination may be filed in the appropriate federal or state court. The Attorney General is authorized to bring civil actions in federal courts when there is reasonable cause to believe that any person or group of persons is engaged in a pattern or practice of discrimination or when there is reasonable cause to believe any group has been denied such rights in a case of general public importance. The Equal Credit Opportunity Act, as amended, is designed to prohibit discrimination in all aspects of credit transactions on a prohibited basis. Persons who believe that they are victims of such discrimination may file complaints with one of the appropriate federal regulatory agencies, or may bring the information to the attention of the Attorney General. The Justice Department is authorized to institute litigation in

federal courts when a matter is referred to the Attorney General by an agency responsible for administrative enforcement of the Act or when there is reasonable cause to believe that one or more creditors are engaged in a pattern or practice in violation of the Act. In addition, an aggrieved person may institute suit in federal court and in such cases, punitive damages in an amount not to exceed $10,000 in addition to actual damages, or in the case of a class action a maximum of the lesser of $500,000 or one percent of the net worth of the creditor, may be granted by the court. Contact: Chief, General Litigation Section, Civil Rights Division, Department of Justice, Washington, DC 20530/202-633-4716.

FBI Academy

The programs at the Academy include: new agents' training; in-service program for field agents; training for mid-level and senior police administrators; National Executive Institute for top police executives; Senior Executive Program for top FBI executives; Executive Development Institute for FBI mid-level managers. Custom designed courses are also available. Contact: Federal Bureau of Investigation (FBI) Academy, Quantico, VA 22135/703-640-6131.

FBI Agent Careers

For information on special agent and nonagent positions, contact the nearest FBI field office, or: Federal Bureau of Investigation, Department of Justice, 9th St. and Pennsylvania Ave. N.W., Washington, DC 20535.

FBI Guided Tours

Guided tours of the Federal Bureau of Investigation Headquarters, the J. Edgar Hoover FBI Building, are offered Mondays through Fridays, excluding holidays, from 9:00 A.M. to 4:00 P.M. The building is located on E St. between 9th and 10th Sts. N.W., in Washington, DC. No appointments are necessary for groups numbering less than 15. Contact: Office of Public Affairs, Federal Bureau of Investigation, Department of Justice, 9th St. and Pennsylvania Ave. N.W., Room 7116, Washington, DC 20535/202-324-5352.

FBI Laboratory

This laboratory is divided into three major sections:

Document Section—conducts scientific examinations of all documents submitted as physical evidence as well as shoe print, tire tread and other sophisticated image examinations. It translates and interprets oral and written foreign language material; performs rhe-

torical/aural analysis; examines evidence in gambling cases and extortionate credit transactions, administers the FBI Polygraph Examination Program, and conducts cryptanalytic examination of secret/enciphered communications;

Scientific Analysis Section—conducts highly specialized examinations involving chemistry, arson, firearms, tool marks, hairs and fibers, blood, metallurgy, mineralogy, number restoration, glass fracture, instrumental analysis and related matters. It has primary responsibility for physical and biologic science research and forensic science training.

Special Projects Section—provides visual aids such as demonstrative evidence, 2-dimensional graphics and 3-dimensional models used in the prosecution of FBI cases. It designs and fabricates special purpose equipment used for special laboratory applications in investigative techniques and visual aids in the field. It handles photographic research, all necessary scientific and technical photography and direct photographic assistance.

Contact: Laboratory Division, Federal Bureau of Investigation, Department of Justice, 9th St. and Pennsylvania Ave. N.W., Room 3090, Washington, DC 20535/202-324-4410.

Federal Prison Industries

UNICOR is the trade name under which the Federal Prison Industries does most of its business. Its mission is to employ and train federal inmates through a diversified program providing products and services exclusively to other federal agencies. Contact: Federal Prison Industries, Department of Justice, 320 1st St. N.W., Room 654, Washington, DC 20534/202-724-3013.

Federal Programs Litigation

This office handles litigation against federal agencies, cabinet officers, and other officials. It handles the enforcement and litigation aimed at remedying statutory or regulatory violations, the defense of employment policies, and personnel actions, and litigation relating to the disposition and availability of government records. Examples of cases include: the injunction to keep *Progressive Magazine* from publishing H-bomb information, the extension of time for the ratification of the Equal Rights Amendment, and declaring California airline regulations unconstitutional in light of federal airline deregulation. Contact: Federal Programs Branch, Civil Division, Department of Justice, 10th St. and Constitution Ave. N.W., Room 3643, Washington, DC 20530/202-633-3354.

Female Offenders

This office monitors programs for female inmates. One major area is the psychiatric unit for

women with problems which has been established
at the Federal Correctional Institution at Lexing-
ton, Kentucky. Contact: Correctional Programs
Division, Bureau of Prisons, Department of Jus-
tice, 320 1st St. N.W., Room 534, Washington,
DC 20534/202-724-3257.

Fingerprint Records to Private Citizens

An individual may obtain a copy of his/her ar-
rest record by submitting a written request di-
rectly to the FBI Identification Division, together
with a set of rolled, inked fingerprint impressions
taken on a fingerprint card which indicates the
individual's name and birth data. There is a $5.00
fee. This office also complies with court-ordered
expungements and purge requests received from
criminal justice agencies. Contact: Identification
Division, Federal Bureau of Investigation, De-
partment of Justice, 9th St. and Pennsylvania
Ave. N.W., Room 11255, Washington, DC
20535/202-324-5401.

Foreign Agent Information

The public can look through the records of for-
eign agents for their initial statements upon regis-
tration and the six-month follow-ups. These
statements provide details on the country, pay-
ments, contracts, missions and everything else
that involves the agent's relationship with the
foreign country. A list of Public Agents is avail-
able for $11.00. Contact: Public Office, Internal
Security Section, Criminal Division, Department
of Justice, 315 9th St. N.W., Room 100, Wash-
ington, DC 20530/202-724-6926.

Foreign Agents Registration

The Internal Security Section administers and
enforces the Foreign Agents Registration Act of
1938. For information on registering as a foreign
agent, contact: Internal Security Section, Crimi-
nal Division, Department of Justice, 315 9th St.
N.W., Room 216, Washington, DC 20530/202-
724-7109.

Foreign Claims Settlement

This office determines claims of U.S. nationals
against foreign governments for losses and inju-
ries sustained by them. Examples include claims
by ex-prisoners of the Vietnam War, by United
States nationals against the People's Republic of
China for losses resulting from nationalization or
other taking of property, and claims against the
GDR for losses arising out of the nationalization
or other taking of property located in the area
commonly referred to as East Germany. Contact:
Foreign Claims Settlement Commission of the
United States, Department of Justice, 1111 20th
St. N.W., Room 400, Washington, DC
20579/202-653-6152.

Foreign Litigation

This office represents the United States before
foreign tribunals in civil cases brought by and
against the United States. It represents the gov-
ernment in domestic cases involving questions of
international and foreign law. Contact: Office of
Foreign Litigation, Commercial Litigation
Branch, Civil Division, Department of Justice,
550 11th St. N.W., Room 1234, Washington, DC
20530/202-724-7455.

Frauds and White Collar Crimes

This section directs and coordinates the federal
effort against white-collar crime. Focuses on
frauds involving government programs and pro-
curement, transnational and multi-district trade,
the security and commodity exchanges, banking
practices, and consumer victimization. Contact:
Fraud Section, Criminal Division, Department of
Justice, 315 9th St. N.W., Room 832, Washing-
ton, DC 20530/202-724-7038.

Freedom of Information Act

This office carries out the Department of Jus-
tice's responsibilities under the Freedom of Infor-
mation Act to encourage agency compliance. It
also advises other departments and agencies on
all questions of policy, interpretation and appli-
cation of the Freedom of Information Act. Con-
tact: Office of Information Law and Policy,
Department of Justice, 10th St. and Constitution
Ave. N.W., Room 6345, Washington, DC
20530/202-633-2674.

Grants

The programs described below are for sums of
money which are given by the federal govern-
ment to initiate and stimulate new or improved
activities, or to sustain on-going services.

Antitrust State Enforcement

Objectives: To establish and improve state anti-
trust enforcement capability.

Eligibility: State attorneys general may apply
for funding under this program.

Range of Financial Assistance: $12,000 to
$385,000.

Contact: Grant Administrator, State Grants
Program, Office of Policy Planning, Antitrust
Division, Department of Justice, Room 7318,
Washington, DC 20530/202-633-3472.

Corrections—Clearinghouse

Objectives: To serve as a clearinghouse and in-
formation center for the collection, preparation,
and dissemination of information on corrections,
including, but not limited to, programs for the
prevention of crime and recidivism, training of
corrections personnel, and rehabilitation and

treatment of criminal and juvenile offenders.

Eligibility: States, general units of local government, public and private agencies, education institutions, organizations, and individuals involved in the development, implementation or operation of correction programs and services.

Range of Financial Assistance: $1,500 to $25,000.

Contact: National Institute of Corrections, Department of Justice, 320 1st St. N.W., Room 200, Washington, DC 20534/202-724-3106.

Corrections—Policy Formulation

Objectives: To formulate and disseminate corrections policy, goals, standards, and recommendations for federal, state, and local correction agencies, organizations, institutions, and personnel.

Eligibility: States, general units of local government, public and private agencies, educational institutions, organizations, and individuals involved in the development, implementation or operation of correction programs and services.

Range of Financial Assistance: $1,500 to $75,000.

Contact: Director, National Institute of Corrections, Department of Justice, 320 1st St. N.W., Room 200, Washington, DC 20534/202-724-3106.

Corrections—Research and Evaluation

Objectives: To conduct, encourage, and coordinate research relating to corrections including the causes, prevention, diagnosis, and treatment of criminal offenders. To conduct evaluation programs which study the effectiveness of new approaches, techniques, systems, programs, and devices employed to improve the corrections system.

Eligibility: States, general units of local government, public and private agencies, education institutions, organizations and individuals involved in the development, implementation or operation of correction programs and services.

Range of Financial Assistance: $1,500 to $200,000.

Contact: Chief, Community Corrections, National Institute of Corrections, Department of Justice, 320 1st St. N.W., Room 200, Washington, DC 20534/202-724-3106.

Corrections—Technical Assistance

Objectives: To encourage and assist federal, state, and local government programs and services, and programs and services of other public and private agencies, institutions and organizations in their efforts to develop and implement improved corrections programs. To assist and serve in a consultant capacity to federal, state, and local courts, departments, and agencies in the development, maintenance, and coordination of programs, facilities, and services, training, treatment, and rehabilitation with respect to criminal and juvenile offenders.

Eligibility: States, general units of local government, public and private agencies, education institutions, organizations, and individuals involved in the development, implementation or operation of correction programs and services.

Range of Financial Assistance: $1,500 to $50,000.

Contact: Program Development Specialist, National Institute of Corrections, Department of Justice, 320 1st St. N.W., Room 970, Washington, DC 20534/202-724-3106.

Corrections—Training and Staff Development

Objectives: To devise and conduct, in various geographic locations, seminars, workshops, and training programs for law enforcement officers, judges and judicial personnel, probation and parole personnel, corrections personnel, welfare workers and other personnel, including lay exoffenders and paraprofessionals, connected with the treatment and rehabilitation of criminal and juvenile offenders. To develop technical training teams to aid in the development of seminars, workshops, and training programs within the several states and with the state and local agencies which work with prisoners, parolees, probationers, and other offenders.

Eligibility: States, general units of local government, as well as public and private agencies, education institutions, organizations, and individuals involved in the development, implementation or operation of correction programs and services.

Range of Financial Assistance: $1,500 to $300,000.

Contact: Chief, Institutions Division, National Institute of Corrections, Department of Justice, 320 1st St. N.W., Room 200, Washington, DC 20534/202-724-3106.

Crime Prevention—Mobilization of Public and Nonpublic Resources

Objectives: To combine government criminal justice and noncriminal justice resources with private business, industry and citizen/community resources in order to carry out comprehensive and coordinated crime prevention activities throughout a local jurisdiction.

Eligibility: Local units of government in medium-sized urban areas (jurisdictions with populations in the range of 150,000 to 500,000).

Range of Financial Assistance: Up to $400,000.

Contact: Office of Community Anti-Crime Programs, Department of Justice, Room 1005,

633 Indiana Ave. N.W., Washington, DC 20531/202-724-6556.

Criminal Justice—Part D Formula Grants

Objectives: To provide financial assistance to states and units of local government in carrying out criminal justice programs.

Eligibility: States which have established State Criminal Justice Councils.

Range of Financial Assistance: $253,000 to $3,776,000.

Contact: Director, Criminal Justice Assistance Division, Office of Criminal Justice Programs, Law Enforcement Assistance Administration, Department of Justice, Washington, DC 20531/202-724-5886.

Justice Research and Development Project Grants

Objectives: To encourage and support research and development to further understanding of the causes of crime and to improve the criminal justice system.

Eligibility: State and local governments, private, profit, nonprofit organizations, institutions of higher education and qualified individuals.

Range of Financial Assistance: Not specified.

Contact: National Institute of Justice, Department of Justice, Washington, DC 20531/202-724-2965.

Juvenile Justice and Delinquency Prevention— Allocation to States

Objectives: To increase the capacity of state and local governments to conduct effective juvenile justice and delinquency prevention programs by providing matching grants to each state and territory; and to develop guidelines for State Plans that meet the requirements set forth in the Juvenile Justice and Delinquency Prevention Act of 1964 as amended, and to assist states in developing such plans.

Eligibility: States that have established operating State Criminal Justice Councils in accordance with the Justice System Improvement Act of 1979.

Range of Financial Assistance: $56,250 to $225,000.

Contact: Office of Juvenile Justice and Delinquency Prevention, Law Enforcement Assistance Administration, Department of Justice, Washington, DC 20531/202-724-7753.

Juvenile Justice and Delinquency Prevention— Special Emphasis and Technical Assistance Programs

Objectives: Develop and implement programs that support effective approaches, techniques and methods for preventing and controlling juvenile delinquency through development and utilization of community-based alternatives to traditional forms of official justice system processing; improvement of the capability of public and private agencies to provide delinquency prevention services to youths and their families; development of new approaches and techniques for reducing school drop-outs, unwarranted suspensions and expulsions; and through support of advocacy by groups and organizations committed to protection and improvement of the legal rights and welfare of youth. Provide technical assistance to federal, state and local governments, courts, public and private agencies, institutions, and individuals, in the planning, establishment, operation or evaluation of juvenile delinquency programs; and assist operating agencies having direct responsibilities for prevention and treatment of juvenile delinquency in the development and promulgation of regulations, guidelines, requirements, criteria, standards, and procedures established through the Office of Juvenile Justice and Delinquency Prevention and the priorities defined for formula grant programs.

Eligibility: Public and private nonprofit agencies, organizations, individuals, state and local units of government, combinations of state or local units.

Range of Financial Assistance: Not specified.

Contact: Office of Juvenile Justice and Delinquency Prevention, Law Enforcement Assistance Administration, Department of Justice, Washington, DC 20531/202-724-7753.

Law Enforce Assistance Administration—Office of Community Anti-Crime Programs

Objectives: To assist community organizations, neighborhood groups and individual citizens in becoming actively involved in activities designed to prevent crime, reduce the fear of crime, and contribute to neighborhood revitalization; in establishing of new community and neighborhood based anti-crime organizations and groups which can mobilize neighborhood residents to conduct crime prevention activities; in strengthening and expanding existing community and neighborhood based anti-crime organizations and assist existing organizations involved in community improvement efforts in developing anti-crime programs; in developing improved understanding and cooperation of crime prevention activities among criminal justice officials and neighborhood residents; in integrating neighborhood anti-crime efforts with appropriate community development activities.

Eligibility: The Office of Community Anti-Crime Programs is authorized to make grants to

incorporated nonprofit community/neighborhood organizations.

Range of Financial Assistance: $20,000 to $175,000.

Contact: Office of Community Anti-Crime Programs, Department of Justice, Room 1000, 633 Indiana Ave. N.W., Washington, DC 20531/202-724-6556.

Law Enforcement Assistance—Educational Development

Objectives: To improve criminal justice curricula, educational materials, to conduct research, educate and train faculty through the development of criminal justice education programs at selected colleges and universities.

Eligibility: Applicant must be an accredited institution of higher education, or combination of such institutions.

Range of Financial Assistance: Not specified.

Contact: Office of Criminal Justice Education and Training, Law Enforcement Assistance Administration, Department of Justice, Washington, DC 20531/202-724-5914.

National Institute for Juvenile Justice and Delinquency Prevention

Objectives: To encourage, coordinate, and conduct research and evaluation of juvenile justice and delinquency prevention activities; to provide a clearinghouse and information center for collecting, publishing, and distributing information on juvenile delinquency; to conduct a national training program; and to establish standards for the administration of juvenile justice.

Eligibility: Public or private agencies, organizations, or individuals.

Range of Financial Assistance: Not specified.

Contact: Director, National Institute for Juvenile Justice and Delinquency Prevention, Law Enforcement Assistance Administration, Department of Justice, Washington, DC 20531/202-724-7772.

National Institute of Justice
Visiting Fellowships

Objectives: To provide opportunities for experienced criminal justice professionals to pursue promising new ideas for improved understanding of crime, delinquency and criminal justice administration by sponsoring research projects of their own creation and design.

Eligibility: Fellowship grants are awarded to individuals.

Range of Financial Assistance: Not specified.

Contact: National Institute of Justice, Department of Justice, Washington, DC 20531/202-724-2965.

Privacy and Security of Criminal Justice Systems

Objectives: To provide assistance to criminal justice agencies in achieving compliance with federal and state privacy and security requirements and to further the administration of criminal justice through assistance in the specific area of computer crime.

Eligibility: State and local units of governments; combinations of state and local units; and not-for-profit corporations.

Range of Financial Assistance: $84,000 to $255,000.

Contact: Privacy and Security Staff, Bureau of Justice Statistics, Department of Justice, Washington, DC 20531/202-724-7759.

Urban Crime Prevention

Objectives: The principal objectives of this initiative are to increase neighborhood participation and problem-solving capacity and to forge a working partnership among neighborhood groups, criminal justice agencies, and other public/private sector institutions in new community crime prevention efforts.

Eligibility: Applicants must be a private nonprofit corporation located in a city with a population of at least 150,000.

Range of Financial Assistance: Up to $500,000.

Contact: Director, Urban Crime Prevention Program, Office of Community Anti-Crime Programs, Department of Justice, Law Enforcement Assistance Administration, 633 Indiana Ave. N.W., Room 1019, Washington, DC 20531/202-724-6242.

Hazardous Waste

This office deals with hazardous waste disposal problems. It investigates hazardous waste sites and is responsible for litigation, both civil and criminal, under the Resource Conservation and Recovery Act. This office is also working on a report concerning the liability for costs of remedial action at uranium mill processing sites. A special publication, *Report of the Interagency Task Force on Compensation and Liability for Releases of Hazardous Substances*, deals with compensation and liability for damages from releases of hazardous substances. Contact: Environmental Enforcement Section, Land and Natural Resources Division, Department of Justice, 10th St. and Constitution Ave. N.W., Room 1254, Washington, DC 20530/202-633-4351.

How to Contact the FBI with Important Information

The front page of most telephone directories lists the telephone number of the nearest Federal Bureau of Investigation field offices, all of which

are open 24 hours a day, including Saturdays, Sundays, and holidays.

Illegal Sales of Narcotics and Drugs
To report the illegal sale of narcotics or dangerous drugs, contact: Enforcement, Drug Enforcement Administration, Department of Justice, 1405 Eye St. N.W., Room 619, Washington, DC 20537/202-633-1151.

Immigrant Outreach Program
The Outreach Program provides training and guidance to voluntary community groups and agencies which assist aliens in applying for benefits under the Immigration and Naturalization laws. Among the topics included are: basic immigration laws, how to process visas abroad, how to become citizens, how to become permanent residents, and deportation hearings. Contact: Outreach Program, Immigration and Naturalization Service, Department of Justice, 425 Eye St. N.W., Room 6244, Washington, DC 20536/202-633-4123.

Immigration and Naturalization Publications
For a descriptive listing of available publications, contact: Public Information Office, Immigration and Naturalization Service, Department of Justice, 425 Eye St. N.W., Room 5034, Washington, DC 20536/202-633-4330.

Immigration Appeals, Board of
The Board is a quasi-judicial body (independent of the Immigration and Naturalization Service (INS) operating under the supervision and control of the Associate Attorney General that establishes guidelines on immigration procedures and policies. Contact: Board of Immigration Appeals, Department of Justice, 5203 Leesburg Pike, Falls Church, VA 22041/701-756-6168.

Immigration Arrivals
The office of inspections covers the inspections of persons arriving at United States ports of entry to determine admissibility, requests for admission to an immigration status according to immigration law, the supervision of refugee and parole programs and the examination of applicants for naturalization. Contact: Inspections, Immigration and Naturalization Service, Department of Justice, 425 Eye St. N.W., Room 7123, Washington, DC 20536/202-633-3019.

Immigration—Inspections
This office has designed the "one-stop" inspection at airports. Under this new procedure, passengers will be inspected for both immigration and customs purposes at the same time. Contact: Inspections, Immigration and Naturalization Service, Department of Justice, 425 Eye St. N.W., Room 7123, Washington, DC 20536/202-633-3019.

Immigration Statistics
For statistics information on immigration-related topics, contact: Statistical Branch, Information Services, Immigration and Naturalization Service, Department of Justice, 425 Eye St. N.W., Room 5020, Washington, DC 20536/202-633-3665.

Improvements in Administration
This office is primarily responsible for developing measures to improve the systems of justice—civil and criminal on both a state and federal level—and for administering the Federal Justice Research Program. It has worked on: a large-scale study of the history and characteristics of selected groups of claims to determine why some were taken to court for resolution while others were resolved by alternative mechanisms; the study of the disposition of certain types of criminal cases by U.S. Attorneys' offices to improve allocation of prosecutorial responsibility between state and federal authority; a long-range study to develop data required for the formulation and evaluation of sentencing guidelines for the federal courts, and the impact of the Speed Trial Act; and development of proposals for improving the handling of scientific information by courts. Contact: Office for Legal Policy, Department of Justice, 10th St. and Constitution Ave. N.W., Room 4234, Washington, DC 20530/202-633-3824.

Indian Claims
This office defends the United States against legal, equitable and moral claims asserted by Indian tribes under the Indian Claims Commission Act of 1946. Contact: Indian Claims Section, Land and Natural Resources Division, Department of Justice, 550 11th St. N.W., Room 648, Washington, DC 20530/202-724-7376.

Indian Resources
This office is concerned with tribal hunting and fishing rights, both on and off the reservations, assertions of state jurisdiction over activities of Indians, and water rights. Contact: Indian Resources Section, Land and Natural Resources Division, Department of Justice, 10th St. and Constitution Ave. N.W., Room 1740, Washington, DC 20530/202-633-4241.

Interpol
Interpol is a world-wide consortium of 126 countries. In each member country a point of

contact and coordination is established for the Interpol function. It coordinates and facilitates requests between foreign police organizations and law enforcement agencies in the United States for information regarding persons, vehicles, and goods that bear on criminal matters within those respective jurisdictions. Interpol exists as a catalyst to provide efficient police communications between the United States and other member countries, and the General Secretariat Headquarters, which is located outside of Paris, France. Investigations can cover criminal history checks, license plate and driver's license checks, International Wanted Circulars, weapons trace, locating suspects. Contact: National Central Bureau, Interpol, Department of Justice, 10th St. and Constitution Ave. N.W., Room 6649, Washington, DC 20530/202-633-2867.

Justice Assistance News

This newsletter is published 10 times per year and offers information primarily on criminal justice projects of the Law Enforcement Assistance Administration, the National Institute of Law Enforcement and Criminal Justice, and the National Criminal Justice Information and Statistical Service. Available for $10.00 per year, from: Superintendent of Documents, Government Printing Office, Washington, DC 20402/202-783-3238.

Justice Development, Testing and Dissemination

This office links research to action. It publicizes successful local projects and publishes *Program Models*, a publication that synthesizes research data, experience and expert opinion. *Program Models* includes: Neighborhood Justice Center, Police Warrant Services, Prevention, Detection and Correction of Corruption in Local Government. Other programs include: *Program Designs*, in managing patrol operations; pre-release centers; neighborhood justice centers; juror usage and management; community response to rape; managing criminal investigations; and *Field Tests*, designed and mounted on experimental projects such as neighborhood justice centers, multi-county sentencing guidelines; and *Training Workshops*. Contact: Office of Development, Testing and Dissemination, National Institute of Justice, Office of Justice Assistance Research and Statistics, Department of Justice, 633 Indiana Ave. N.W., Room 800, Washington, DC 20531/202-272-6001.

Justice Library

Information and reference services are available on topics related to the Department of Justice. Contact: Justice Library, Department of Justice, 10th St. and Pennsylvania Ave. N.W., Room 5400, Washington, DC 20530/202-633-3775.

Justice News

This free monthly newsletter is available from: Office of Public Affairs, Department of Justice, 10th and Constitution Ave. N.W., Room 5114, Washington, DC 20530/202-633-2007.

Justice Statistics

This office collects and disseminates criminal justice statistics and supports the development of information and communications systems at the state and local level for both statistical and operation purposes. It offers grants to states to develop statistical analysis centers, uniform crime reporting systems, etc. Reports available include:

Myths and Realities About Crime
Parole in the United States, 1967 and 1977
Criminal Victimization in the U.S.: A Comparison of 1976 and 1977 Findings (Advance Report)
A Cross-City Comparison of Felony Case Processing
Rape Victimization in 26 Cities
Expenditure and Employment Data for the Criminal Justice System: 1977
State Court Statistics: The Start of the Art
Sourcebook of Criminal Justice Statistics 1978

Contact: Statistical Division, Bureau of Justice Statistics, Department of Justice, 633 Indiana Ave. N.W., Washington, DC 20531/202-724-7774.

Juvenile Justice and Delinquency

This office provides a focal point for programs and policies relating to juvenile delinquency and juvenile justice. It disseminates information on delinquency and juvenile justice programs, coordinates federal delinquency programs, gives formula grants to states and Special Emphasis discretionary funds, and provides technical assistance to governmental and nongovernmental agencies. Contact: Office of Juvenile Justice and Delinquency Prevention, Department of Justice, 633 Indiana Ave. N.W., Room 442, Washington, DC 20531/202-724-7751.

Juvenile Justice, National Institute for

This office conducts research on juvenile justice programs, and develops and evaluates programs, including training programs. The institute collects, synthesizes, and disseminates information. Its publications include:

Youth Crime and Delinquency in America—which includes information on the nature and extent of delin-

quency, justice system operations, and programs.

Foster Parenting—information on selecting and training foster parents; includes an audiovisual list and a bibliography.

Runaway Youth Program Directory—lists selected resources including hotlines, bibliographies, government agencies, general information, and state contracts.

Contact: National Institute for Juvenile Justice and Delinquency Prevention, Office of Juvenile Justice and Delinquency Prevention, Law Enforcement Assistance Administration, Department of Justice, 633 Indiana Ave. N.W., Room 304, Washington, DC 20531/202-724-5893.

Land Acquisition

This office initiates and prosecutes condemnation proceedings in the District Courts for the acquisition of lands necessary for public use. The issues for decision in a condemnation case are usually either the amount of compensation to be paid by the United States for the property acquired or the authority of the United States to condemn the property and the right to possession. Some client agencies and projects for which this Section acquires land for condemnation are the Army Corps of Engineers, National Park Service, Forest Service, Department of Energy, Federal Aviation Administration, Washington Metro Subway System, Government Services Administration, Fish and Wildlife Service, and others. Contact: Land Acquisition Section, Land and Natural Resources Division, Department of Justice, 10th St. and Constitution Ave. N.W., Room 1527, Washington, DC 20530/202-724-6883.

Land and Natural Resource Case Appeals

This office handles appeals from district court decisions. It prepares briefs on the merits, petitions for certiorari, briefs in opposition, jurisdictional statements, miscellaneous cases involving the Supreme Court. It also prepares amicus curiae briefs in state and federal courts of appeals. Contact: Appellate Section, Land and Natural Resources Division, Department of Justice, 10th St. and Constitution Ave. N.W., Room 2339, Washington, DC 20530/202-633-2748.

Land and Natural Resource Litigation

This office handles cases related to environmental land, natural resources and water law not specifically assigned to other sections. Examples include the protection of Alaska National Interest Land; the development of energy resources and its relation to protection of public values in the environment; and cases involving the National Environmental Policy Act. Contact: General

Litigation Section, Land and Natural Resources Division, Department of Justice, 10th St. and Constitution Ave. N.W., Room 2133, Washington, DC 20530/202-633-2704.

Land Appraisal

This office assists in matters relating to establishing the fair market value of real property that is secured by the federal government for public use. Contact: Appraisal Section, Land and Natural Resources Division, Department of Justice, 521 12th St. N.W., Room 336, Washington, DC 20530/202-724-6686.

Law Enforcement Assistance—FBI Crime Laboratory Support

FBI Laboratory facilities are made available to duly constituted municipal, county, state, and federal law enforcement agencies in the United States and its territorial possessions. Submitted evidence is examined and the FBI Laboratory also furnishes the experts necessary to testify in connection with the results of these examinations. These examinations are made with the understanding that the evidence is connected with an official investigation of a criminal matter (for federal agencies both criminal and civil matters) and that the laboratory report will be used only for official purposes related to the investigation or a subsequent prosecution. The FBI Laboratory will not accept cases from other crime laboratories which have the capability of conducting the requested examinations. Contact: Director, Federal Bureau of Investigation, Department of Justice, Washington, DC 20535/202-324-3000.

Law Enforcement Assistance—FBI Field Police Training

Courses available from FBI instructors range from basic recruit training to specialized instruction in such areas as fingerprinting, legal topics, police-community relations, hostage negotiation, white collar crime, organized crime, computer fraud, management techniques, etc. FBI training assistances is available in complete programs of instructions or as supplemental courses to already existing local policy training sessions. Contact: Director, Federal Bureau of Investigation, Department of Justice, Washington, DC 20535/202-324-3000.

Law Enforcement Assistance—FBI Fingerprint Identification

This service provides criminal identification by means of fingerprints, determination of the number of previously reported arrests and convictions; fingerprint identification of victims of major disasters; and processing of submitted evi-

dence for latent fingerprint impressions. Information must be used for official purposes only and is not furnished for public dissemination. Contact: Assistant Director, Identification Division, Federal Bureau of Investigation, Department of Justice, Washington, DC 20537/202-324-5401.

Law Enforcement Assistance—Narcotics and Dangerous Drugs—Training

This program is to acquaint appropriate professional and enforcement personnel with 1) techniques in the conduct of drug investigations; 2) aspects of physical security in legitimate drug distribution; 3) techniques in analysis of drugs for evidential purposes; and 4) pharmacology, sociopsychologic aspects of drug abuse, drug education, and investigative techniques. Contact: Director, National Training Institute, Drug Enforcement Administration, Department of Justice, 1405 Eye St. N.W., Washington, DC 20537/202-633-1323.

Law Enforcement Assistance—Uniform Crime Reports

The FBI collects, analyzes, and publishes certain crime statistics which it receives on a regular and voluntary basis from law enforcement agencies nationwide. These data are published annually in the publication, *Crime in the United States Uniform Crime Reports*, which is supplemented with quarterly releases. The annual publication provides information on 1) crime trends; 2) offenses known to police; 3) age, sex, and race of persons arrested; 4) police disposition of persons arrested; and 5) police employee information. The information is intended to assist heads of law enforcement agencies in administration and operation of their departments and to be available to judges, penologists, sociologists, legislators, students, and others interested in crime and its social aspects. Contact: Director, Federal Bureau of Investigation, Department of Justice, Washington, DC 20535/202-324-3000.

Law Enforcement Films

The following publication identifies free films on law enforcement subjects:

Criminal Justice Audiovisual Materials Directory—a source directory of materials for education, training, and orientation in the field of criminal justices; covers courts, police techniques and training, prevention, prisons and rehabilitation/corrections and public education.

These films and videotape recordings can be borrowed for education and information purposes. Contact: National Criminal Justice Research Service, 1600 Research Blvd., Rockville, MD 20850/301-251-5500.

Law Enforcement Research Publications

This office is responsible for the publication and distribution of Institute research and evaluation findings and programs. It also oversees the operations of the National Criminal Justice Reference Services. It maintains the Law Enforcement Assistance Administration Library, and helps law enforcement agencies to make informed decisions on purchasing equipment. The Law Enforcement Standards Laboratories do research and development on performance standards for equipment. Contact: Reference and Dissemination Division, Office of Development, Testing and Dissemination, National Institute of Justice, Department of Justice, 633 Indiana Ave. N.W., Room 810, Washington, DC 20531/202-272-6001.

Legal Opinions

The legal opinions of the Department of Justice are published by the Office of Legal Counsel and are made available through the Superintendent of Documents, Government Printing Office, Washington, DC 20402/202-783-3238. Contact: Office of Legal Counsel, Department of Justice, 10th St. and Constitution Ave. N.W., Room 5214, Washington, DC 20530/202-633-2041.

Marine Resources

This office handles litigation relating to mineral and biological resources of the adjacent seas and seabed. It is responsible for cases involving the determination of the location of the coastline and other maritime boundaries of the United States, and cases dealing with the rights of the United States in submerged lands, particularly as those rights involve increasingly valuable oil and gas resources. The Office also has the responsibility for litigation concerning the conservation and management generally of the living resources of the adjacent seas, and the more than 70 species of fish in the 200-mile fishing zone. Contact: Marine Resources Section, Land and Natural Resources Division, Department of Justice, 10th St. and Constitution Ave. N.W., Todd Building, Room 639, Washington, DC 20530/202-724-7353.

Missing Persons

The Federal Bureau of Investigation will not look for a missing person but it will post a stop notice in the files of the Identification Division at the request of relatives or law enforcement agencies and will notify the inquirer of any information received regarding the missing person's whereabouts. Contact: Identification Division,

FBI, Department of Justice, 9th St. and Pennsylvania Ave. N.W., Room 11255, Washington, DC 20535/202-324-5401.

Narcotics and Dangerous Drugs

This office provides litigation and litigation support for the prosecution and conviction of high-level offenders and members of criminal organizations involved in the manufacture, shipment or distribution of illicit narcotics and other dangerous drugs. It is involved in all facets of drug enforcement policies, including negotiating with foreign governments, prosecuting foreign nationals involved with illicit drug traffic, evaluating narcotic-related legislation, and providing studies for the government on the subject, etc. Contact: Narcotics and Dangerous Drug Section, Criminal Division, Department of Justice, 315 9th St. N.W., Room 901, Washington, DC 20530/202-724-7045.

National Crime Information Center

This Center is a computerized information system established by the FBI as a service to all criminal justice agencies—local, state and federal. Documented information is available on missing persons, serialized stolen property, wanted persons for whom an arrest is outstanding and criminal histories on individuals arrested and fingerprinted for serious or significant offenses. Contact: National Crime Information Center, Technical Services Division, Federal Bureau of Investigation, Department of Justice, 9th St. and Pennsylvania Ave. N.W., Room 7230, Washington, DC 20535/202-324-2606.

National Institute of Justice

The institute supports research on topics that include: violent crime, community crime prevention, career criminals, sentencing, rehabilitation, deterrence, utilization and deployment of police resources, correlates of crime and the determinants of criminal behavior, pretrial process—consistency, fairness and delay reduction—and performance standards and measures. A Visiting Fellowship Program is open to senior-level criminal justice professionals and researchers. Contact: National Institute of Justice, Office of Justice Assistance Research and Statistics, Department of Justice, 633 Indiana Ave. N.W., Washington, DC 20531/202-724-2942.

National Institute of Justice Library

The Library provides reference services on police, courts, corrections, juvenile justice, community crime prevention, and anything else that relates to the criminal justice field. Contact: National Institute of Justice Library, National Institute of Criminal Justice, Department of Justice, 633 Indiana Ave. N.W., Washington, DC 20531/202-724-5884.

Nazi War Criminals

The Office of Special Investigations detects identifies, and takes appropriate administrative action leading to denaturalization and/or deportation of Nazi war criminals. It provides historic research, investigations and proceedings before both administrative bodies and United States courts. Contact: Office of Special Investigations, Criminal Division, Department of Justice, P.O. Box 28603, Washington, DC 20005/202-633-2502.

New Car Information Disclosure

The Department of Justice enforces jurisdiction over the federal law requiring the disclosure of new automobile information. The following information must be included on the windshield or side window of the vehicle: make, model, identification number, assembly point, name and location of dealer to whom the vehicle was delivered, method of transportation, total suggested retail price for accessories and transportation charges. Contact: Consumer Affairs Section, Antitrust Division, Department of Justice, 521 12th St. N.W., Room 604, Washington, DC 20530/202-724-6711, or U.S. Attorney's Office in each major metropolitan area. Automobile purchasers who suspect tampering with odometers should contact this office or telephone 202-724-6786.

Organized Crime and Racketeering

This office develops and coordinates nationwide enforcement programs to suppress the illicit activities of organized criminal groups, including: narcotics, loan sharking, vice and the illegal infiltration of legitimate businesses, labor unions, and the political process. Attorneys in this section are assigned to Organized Crime Strike Forces operating in major cities. Contact: Organized Crime and Racketeering Section, Criminal Division, Department of Justice, 10th St. and Constitution Ave. N.W., Room 2515, Washington, DC 20530/202-633-3516.

Pardon Attorney

This office receives and reviews all petitions for Executive Clemency; initiates the necessary investigations and prepares the recommendation of the Attorney General to the President in connection with the consideration of all forms of Executive Clemency, including pardon, commutation, reduction of sentence, remission of fine and re-

prieve. Contact: Office of the Pardon Attorney, Department of Justice, 550 Friendship Blvd., Suite 280, Chevy Chase, MD 20815/301-492-5910.

Parole Commission
The Parole Commission is an independent agency in the Department of Justice. Its primary function is to administer a parole system for federal prisoners and develop federal parole policy. The Commission is authorized to: 1) grant or deny parole to any eligible federal prisoner; 2) impose reasonable conditions on the release of any prisoner from custody or discretionary parole or mandatory release by operation of "good-time" laws; 3) revoke parole or mandatory release; and 4) discharge offenders from supervision and terminate the sentence prior to the expiration of the supervision period. Contact: United States Parole Commission, Department of Justice, Park Place, 1 North Park Building, 5500 Friendship Blvd., Bethesda, MD 20015/301-492-5990.

Patent and Copyright Policy
Advice is supplied to the Department of Justice and other agencies on government patent policy. Work is also done on the improper uses of copyrights and patents as a tool of marketing power. Contact: Intellectual Property Section, Antitrust Division, Department of Justice, 521 12th St. N.W., Room 704, Washington, DC 20530/202-724-7966.

Pollution Control
This office supervises the prosecution and defense of civil and criminal cases involving the abatement of pollution and protection of the environment. Much of the caseload includes civil and criminal enforcement actions under the various environmental statutes. The rest is composed of litigation in which regulations, permits, or other determinations by the Environmental Protection Agency and other agencies have been challenged by industry or environmental organization. Contact: Environmental Defense Section, Land and Natural Resources Division, Department of Justice, 10th St. and Constitution Ave. N.W., Room 2644, Washington, DC 20530/292-633-5290.

Premerger Notification
The Hart-Scott-Rodino Antitrust Improvements Act—Premerger Notification Program requires large enterprises merging or entering into acquisition transactions to notify both the Antitrust Division and the Federal Trade Commission. Contact: Premerger Notification Unit, Operations, Antitrust Division, Department of Justice, 10th St. and Constitution Ave. N.W., Room 3218, Washington, DC 20530/202-633-2558.

Prisons Information
General information is available on prisons including statistics such as percentage of population confined to institutions by offense, and history of federal prisons. Free brochures include: *Federal Prison System Education for Tomorrow* which details the education programs in the Federal Bureau of Prisons. Contact: Public Information, Bureau of Prisons, Department of Justice, 320 1st St. N.W., Room 554, Washington, DC 20534/202-724-3198.

Prisons Library
A free publication, *Correctional Bookshelf*, is a bibliography of some of the books and periodicals in the library and covers such areas as: administration and organization, programs for offenders, community corrections, jails, the prison social system, institutions for female offenders, and law and history. Reference and research services are also available. Contact: Bureau of Prisons Library, Bureau of Prisons, Department of Justice, 117 D St. N.W., Washington, DC 20534/202-724-3029.

Privacy and Information Appeals
This office processes administrative appeals from initial denials of data requested under the Freedom of Information and Privacy Acts. It also processes initial requests for records from the Department of Justice. Contact: Office of Privacy and Information Appeals, Department of Justice, 10th St. and Constitution Ave. N.W., Room 6620, Washington, DC 20530/202-633-2870.

Public Safety Officers' Benefits
The Public Safety Officers' Benefits Act pays $50,000 in death benefits to the eligible survivors of a public safety officer who died as the direct result of a personal injury sustained in the line of duty. Contact: Public Safety Officers' Benefits Act, Law Enforcement Assistance Administration, Department of Justice, 633 Indiana Ave. N.W., Room 1158, Washington, DC 20531/202-724-7623.

Race Relations
A special office helps people settle their race-related differences voluntarily rather than in the courts or the streets. Agency professionals enter

troubled communities with no investigative power or authority to dispense funds and try to mediate or arrange a voluntary settlement. For instance, they have: mediated a dispute over Chinook salmon fishing; conciliated a Klan/Southern Christian Leadership Conference (SCLC) clash; helped with general community disputes (public housing, revenue sharing); conciliated problems in education, law enforcement and sentencing disparities. Free publications include:

Guidelines for Effective Human Relations Commissions
School Disruptions: Tips for Educators and Police
School Security: Guidelines for Maintaining Safety in School Desegregation
Viewpoints and Guidelines on Court Appointed Citizens Monitoring Commissions in School Desegregation
Desegregation Without Turmoil—the role of multi-racial community coalitions in preparing for smooth transition
Human Relations: A Guide for Leadership Training in the Public Schools
Police Use of Deadly Force—What Police and the Community Can Do About It

Contact: Community Relations Service, Department of Justice, 550 11th St. N.W., Room 652, Washington, DC 20530/202-724-7386.

Refugees and Parole

This office supervises the refugee and parole programs of Immigration and Naturalization Service including the processing of applicants for conditional entry. It processes humanitarian parole requests which are granted on an individual basis for aliens outside the U.S. Contact: Office of Refugees and Parole, Immigration and Naturalization Service, Department of Justice, 425 Eye St. N.W., Room 7240, Washington, DC 20536.

Regulatory Activities

Listed below are those organizations within the Department of Justice which are involved with regulating various activities. With each listing is a description of those industries or situations which are regulated by the office. Regulatory activities generate large amounts of information on the companies and subjects they regulate. Much of the information is available to the public. A regulatory office can also tell you your rights when dealing with a regulated company.

Antitrust Division, Department of Justice, 10th St. and Constitution Ave. N.W., Washington, DC 20530/202-633-2421. Enforces laws which punish violations of restraints on the monopolization of trade.

Public Affairs, Civil Rights Division, Department of Justice, 10th St. and Constitution Ave. N.W., Washington, DC 20530/202-633-2017. Enforces laws which prohibit discrimination on the basis of race, national origin, religion, or in some instances, sex, age, or handicap, in the areas of voting, education, employment, housing, credit, the use of public facilities and accommodations, and in federally assisted and conducted programs.

Public Affairs, Drug Enforcement Division, Department of Justice, 1405 Eye St. N.W., Washington, DC 20537/202-633-1249. Enforces laws which regulate narcotics and dangerous drugs.

Public Information Immigration and Naturalization Service, Department of Justice, 425 Eye St. N.W., Washington, DC 20536/202-633-4330. Regulates aliens.

Sex Discrimination

A special task force has been established to assist federal departments and agencies in their reviews and revisions of sexually discriminatory language and practices. The task force also identifies statutory and regulatory bias and studies several systemic problems that disproportionately affect women. Publications of the task force include:

The Pension Game: The American Pension System from the Viewpoint of the Average Woman ($2.50)
Interim Report of the Task Force on Sex Discrimination ($5.00)

Both publications are available from: Superintendent of Documents, Government Printing Office, Washington, DC 20402/202-783-3238. Contact: Office of Coordination and Review, Civil Rights Division, Department of Justice, 10th St. and Constitution Ave. N.W., Room 867-A, Washington, DC 20530/202-724-2222.

Solicitor General

The Solicitor General conducts and supervises government litigation in the Supreme Court of the United States. He or she reviews every case litigated by the federal government that a lower court has decided against the United States, to determine whether to appeal and also decides whether the U.S. should file a brief as "amicus curiae" in any appellate court. Contact: Office of the Solicitor General, Department of Justice, 10th St. and Constitution Ave. N.W., Room 5143, Washington, DC 20530/202-633-2201.

Statistical Publications

A large number of statistical reports are available, including:

Criminal Victimization in the United States
The Cost of Negligence
Intimate Victims
Crime and Seasonality
Criminal Victimization of New York State Residents, 1974–77
Criminal Victimization Surveys in 13 American Cities
Public Attitudes About Crime
Public Opinion About Crime
Local Victim Surveys
Compensating Victims of Violent Crime
Crime Against Persons in Urban, Suburban and Rural Areas
Capital Punishment
Profile of Inmates of Local Jails
Characteristics of the Parole Population
Myths and Realities About Crime

For free single copies or for a more complete listing of publications, contact: National Criminal Justice Reference Service, Box 6000, Rockville, MD 20850/301-251-5500.

Statistics—Justice

A variety of statistical services and publications are available. Contact: Statistical Division, Bureau of Justice Statistics, Department of Justice, 633 Indiana Ave. N.W., Room 332, Washington, DC 20531/202-724-7774.

Take a Bite Out of Crime

This free pamphlet is full of tips and ideas on how to discourage burglars, disappoint muggers and make life tougher for criminals. Contact: National Criminal Justice Reference Service, Department of Justice, P.O. Box 6000, Rockville, MD 20850/301-251-5500.

Tax Criminal Litigation

The Criminal Section controls and supervises all cases involving criminal violations of the Internal Revenue Code. Its responsibilities include the control and supervision of criminal proceedings and collaboration in trial and appellate courts. Contact: Criminal Section, Tax Division, Department of Justice, 10th St. and Constitution Ave. N.W., Room 4611, Washington, DC 20530/202-633-2973.

Tax Litigation

Among the types of litigation in which the Tax Division represents the federal government are:

1 Criminal prosecutions involving attempts to evade taxes, willful failure to file returns or to pay taxes, filing false returns and other deceptive documents, and making false statements to revenue officials.
2 Refund suits brought by taxpayers to recover taxes alleged to have been erroneously or illegally assessed and collected.
3 Suits brought by the United States to collect unpaid assessments, to foreclose federal tax liens or to determine the priority of such liens, to obtain judgments against delinquent taxpayers, to enforce Internal Revenue Service administrative summonses, and to establish tax claims in bankruptcy, receivership, and probate proceedings.
4 Proceedings involving mandamus, injunctions and other writs arising in connection with Internal Revenue matters.
5 Suits against Internal Revenue Service employees for damages claimed because of alleged injuries caused in the performance of their official duties.
6 Suits against the Secretary of the Treasury, the Commissioner of Internal Revenue, or similar officials to test the validity of regulations or rulings, including declaratory judgment actions pursuant to Section 7428 of the Internal Revenue Code, challenging initial denial or revocation of an organization's tax-exempt status under Code Section 501 (c) 3.
7 Proceedings against the Tax Division and the Internal Revenue Service for disclosure of information under the Freedom of Information Act or for the alleged improper disclosure of information under the Privacy Act.
8 Intergovernmental immunity suits in which the United States resists attempts to apply a state or local tax to some activity or property of the United States.
9 Suits brought by taxpayers pursuant to Code Section 7429 for a judicial determination as to the reasonableness of the use of jeopardy/termination assessment procedures and the appropriateness of the amount so assessed.
10 Suits brought by individuals to foreclose mortgages or to quiet title to property in which the United States is named as a party defendant because of the existence of a federal tax lien on the property.

Contact: Tax Division, Department of Justice, 10th St. and Constitution Ave. N.W., Room 4143, Washington, DC 20530/202-633-2901.

Tax Refund Litigation

The Civil Trial Section represents the government in refund suits brought by taxpayers to recover taxes alleged to have been erroneously or illegally assessed and collected. Contact: Civil Trial Section, Tax Division, Department of Justice, 414 11th St. N.W., Room 4122, Washington, DC 20530/202-724-6398.

Tax Settlements Review

The Review Section appraises settlement offers in light of litigating potential and policy considerations. It also conducts legal research on pending or proposed legislation on which the Division has been asked to comment. Examples include legislation to revise aspects of the Internal Revenue Code which deal with bankruptcy, insolvency and discharge of indebtedness, privacy legislation, and proposals to allow awards of attorneys' fees against the Government. Contact: Review Section, Tax Division, Department of Justice, 414 11th St. N.W., Room 2113, Washington, DC 20530/202-724-6567.

Ten Most Wanted Fugitives

The selection is based on several items including the fugitive's past criminal record, the threat posed to the community, the seriousness of the crime for which he/she is sought, and whether nationwide publicity is likely to assist in apprehension. Contact: Office of Public Affairs, Federal Bureau of Investigation, Department of Justice, 9th St. and Pennsylvania Ave. N.W., Room 7116, Washington, DC 20535/202-324-5353.

Torts

This office defends the United States, its officers and agents, against suits seeking money damages for negligent and wrongful acts of government employees while acting within the scope of their employment. It also prosecutes affirmative tort claims on behalf of the United States. The docket includes medical malpractice and aircraft accidents, personal injury radiation litigation, and regulatory torts. It has handled claims arising out of the Swine Flu Immunization Program, Teton Dam disaster, and hazards of asbestos manufacture. Contact: Torts Branch, Civil Division, Department of Justice, 521 12th St. N.W., Room 1100, Washington, DC 20530/202-724-6846.

U.S. Attorneys, Executive Office

This office provides general executive assistance and supervision to 95 officers of the U.S. Attorneys. The U.S. Attorney is the chief law enforcement representative of the Attorney General, enforcing federal criminal law and handling most of the civil litigation in which the United States is involved. The Attorneys are involved with white collar crime, official corruption, controlled substances (narcotics), organized crime, and criminal and civil litigation. Contact: Executive Office for U.S. Attorneys, Department of Justice, 10th St. and Constitution Ave. N.W., Room 1619, Washington, DC 20530/202-633-2121.

U.S. Attorney's Publications

The following publications are published by the Executive Office for U.S. Attorneys:

U.S. Attorney's Manual—consists of nine titles—General Appeals, Office of Justice Management, Civil, Lands and Natural Resources Division, Tax, Antitrust, Civil Rights and Criminal. Available for $145 from Superintendent of Documents, Government Printing Office, Washington, DC 20402/202-738-3238.

Bulletin—This biweekly goes to all U.S. Attorneys and contains notes of recent cases and other Department of Justice information.

Contact: Executive Office for U.S. Attorneys Manual Staff, Department of Justice, 10th St. and Constitution Ave. N.W., Room 129-Cab, Washington, DC 20530/202-633-4660.

U.S. Marshals

The U.S. marshals service supports the federal court system and the enforcement of federal law under the direction of the Attorney General. Its activities include the serving of the criminal and civil process; the execution of arrest warrants; the movement and custody of federal prisoners; the protection of witnesses to organized crime; the seizing and disposing of property under court orders; the security of federal court facilities, judges, jurors, and other trial participants; the prevention of civil disturbances, and the restoration of order in riot or mob violence situations; the collection and disbursal of federal funds; and other special law enforcement functions at the direction of the Attorney General. A free publication, *United States Marshals Service Then ... And Now*, is available.

Contact: United States Marshals Service, Department of Justice, 1 Tysons Corner Center, Room 202, McLean, VA 22101/703-285-1131.

U.S. Trustees

The U.S. Trustees are charged with administering bankruptcy cases in their respective regions. There is a trustee for each of 10 regions who has the responsibility for appointing private trustees as well as committees of creditors in order to insulate Bankruptcy Judges from the day-to-day administration of cases. Contact: Executive Office for United States Trustees, Department of Justice, 10th St. and Constitution Ave. N.W., Room 4256, Washington, DC 20530/202-633-5122.

Voting Laws

This office enforces voting laws designed to insure that all qualified citizens have the opportunity to register and vote without discrimination

on account of race, color, membership in a language minority group, or age. It also enforces the Overseas Citizens Voting Rights Act. Contact: Voting Section, Civil Rights Division, Department of Justice, 10th St. and Constitution Ave. N.W., Room 716, Washington, DC 20530/202-724-3095.

White Collar Crime
Hotline
Each FBI field office maintains a hotline for reporting white collar crimes. The office in Washington, DC is: Federal Bureau of Investigation, 1900 Half St. S.W., Washington, DC 20235/202-252-7777.

Wildlife
This office handles wildlife laws, both civil and criminal. It also conducts litigation for the control of illegal trade in wildlife and plants. Contact: Wildlife Section, Land and Natural Resources Division, Department of Justice, 10th St. and Constitution Ave. N.W., Room 2632, Washington, DC 20530/202-633-2716.

How Can the Department of Justice Help You?
To determine how the Department of Justice can help you, contact: Consumer Affairs, Antitrust Division, Department of Justice, 10th St. and Constitution Ave. N.W., Washington, DC 20530/202-724-6786.

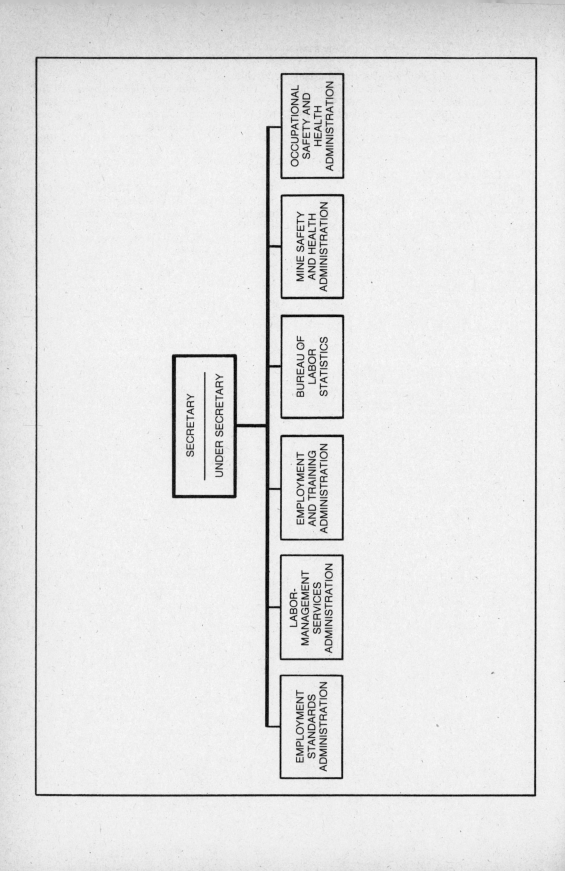

Department of Labor

200 Constitution Ave. N.W., Washington, DC 20210/202-523-6666

ESTABLISHED: March 4, 1913
BUDGET: $28,496,300,000
EMPLOYEES: 23,454

MISSION: Foster, promote, and develop the welfare of the wage earners of the United States, to improve their working conditions, and to advance their opportunities for profitable employment; protect workers' pension rights; sponsor job training programs; help workers find jobs; strengthen free collective bargaining; and keep track of changes in employment, prices, and other national economic measurements.

Major Divisions and Offices

Employment Standards Administration

Department of Labor, 200 Constitution Ave. N.W., Room S2321, Washington, DC 20210/202-523-6191.
Budget: $923,776,000
Employees: 5,271
Mission: Administer and direct employment standards programs dealing with: minimum wage and overtime standards; registration of farm labor contractors; determining prevailing wage rates to be paid on government contracts and subcontracts; nondiscrimination and affirmative action for minorities, women, veterans, and handicapped workers on government contracts and subcontracts; and workers' compensation programs for federal and certain private employers and employees.

Labor-Management Services Administration

Department of Labor, 200 Constitution Ave. N.W., Room S2203, Washington, DC 20210/202-523-6045.
Budget: $53,941,000
Employees: 1,333
Mission: Administer section 7120 of the Civil Service Reform Act; provide assistance to collective bargaining negotiators; keep the Secretary of Labor posted on developments in labor-management disputes of national scope; provide technical assistance to state and local governments in matters concerning public employee labor rela-

tions; and pursue research and policy development in the overall labor-management relations field.

Employment and Training Administration

Department of Labor, 200 Constitution Ave. N.W., Room S2307, Washington, DC 20210/202-523-6050.
Budget: $26,882,625
Employees: 3,486
Mission: Implement the responsibilities assigned to the Department of Labor for conduct of certain work-experience and work training programs; funding and overseeing of programs conducted under the provisions of the Comprehensive Employment and Training Act of 1973, as amended, by state and other authorized sponsors; administration of the Federal-State Employment Security System; and conduct of a continuing program of research, development, and evaluation.

Bureau of Labor Statistics

Department of Labor, 441 G St. N.W., Room 2106, Washington, DC 20212/202-523-1913.
Budget: $103,665,000
Employees: 2,232
Mission: Be the Government's principal factfinding agency in the field of labor economics, partic-

ularly with respect to the collection and analysis of data on labor requirements, labor force, employment, unemployment, hours of work, wages and employee compensation, price, living conditions, labor-management relations, productivity and technological developments, occupational safety and health, structure and growth of the economy, urban conditions and related socio-economic issues, and international aspects of certain of these subjects.

Mine Safety and Health Administration

Department of Labor, 4015 Wilson Blvd., Room 1237-A, Arlington, VA 22203/703-235-1452.
Budget: $144,147,000
Employees: 3,857
Mission: Develop and promulgate mandatory safety and health standards; ensure compliance with such standards; assess civil penalties for violations, investigate accidents; cooperate with and provide assistance to the states in the development of effective state mine safety and health

programs; improve and expand training programs in cooperation with the states and the mining industry, and, in coordination with the Department of Health and Human Services, and the Department of the Interior; and contribute to the improvement and expansion of mine safety and health research and development.

Occupational Safety and Health Administration

Department of Labor, 200 Constitution Ave. N.W., Room S2315, Washington, DC 20210/202-523-9326.
Budget: $187,004,000
Employees: 3,015
Mission: Develop and promulgate occupational safety and health standards; develop and issue regulations; conduct investigations and inspections to determine the status of compliance with safety and health standards and regulations; and issue citations and propose penalties for noncompliance with safety and health standards and regulations.

Data Experts

Labor Statistical Experts

The following experts are available to answer specific questions concerning their areas of expertise. Call directly or write in care of: Department of Labor, Bureau of Labor Statistics, Washington, DC 20212.

Current Employment Analysis
Assistant Commissioner/Vacant/202-523-1530
Absences from work/Janice Hedges/202-523-1821
Current employment and unemployment analysis/John Bregger/202-523-1944
Demographic studies/Paul Flaim/202-523-1821
Discouraged workers/Harvey Hamel/202-523-1371
Earnings data from Current Population Survey/Earl Mellor/202-523-1821
Educational attainment/Anne Young/202-523-1959
Employment and Earnings publications/Gloria Green/202-523-1944
Employment situation—press release/John Bregger/202-523-1944
Family and marital characteristics of labor force/Elizabeth Waldman/202-523-1959
Microdata tapes and analysis/Robert McIntire/202-523-1776

Minorities/Harvey Hamel/202-523-1371
Multiple jobholding/Janice Hedges/202-523-1821
National Commission on Employment and Unemployment Statistics/Harvey Hamel/202-523-1371
Occupational employment and unemployment/Deborah Klein/202-523-1944
Older workers/Philip Rones/202-523-1944
Person-family data/Elizabeth Waldman/202-523-1959
Seasonal adjustment methodology/Robert McIntire/202-523-1776
Students and dropouts/Anne Young/202-523-1959
Veterans/John Stinson/202-523-1944
Women/Elizabeth Waldman/202-523-1959
Work experience/Anne Young/202-523-1959
Work-life estimates/Shirley Smith/202-523-1821
Work schedules (hours of work, shift work, etc.)/Janice Hedges/202-523-1821
Youth/Norman Bowers/202-523-1371
Diane Westcott/202-523-1944

Employment Structure and Trends
Assistant Commissioner/Thomas Piewes/202-523-1695

Earnings—national/Gloria Goings/202-523-1146

Earnings—local area/Richard Green/202-523-1227

Employment and Earnings—periodical/Gloria Goings/202-523-1146

Employment and Wages/Michael Searson/202-523-1339

Employment—local area/Richard Green/202-523-1227

Industry employment statistics/Jerry Storch/202-523-1172

Job vacancy statistics/Lois Plunkert/202-523-9444

Labor turnover-press release/Carol Utter/202-523-1146

Local area unemployment statistics/Martin Ziegler/202-523-1919

Occupational classification/Linda Hardy/202-523-1636

Occupational and Administrative Statistics/Brian MacDonald/202-523-1949

Thomas Shirk/202-523-1684

Real earnings—press release/Mike Buso/202-523-1172

Seasonal adjustment methodology—industry employment/Carol Utter/202-523-1446

State and area demographic data/Paul Hadlock/202-523-1002

State and area unemployment—press release/Richard Rosen/202-523-1002

Unemployment insurance/Sharon Brown/202-523-1807

Economic Growth and Employment Projections

Assistant Commissioner/Ronald Kutscher/202-272-5381

Economic growth—projections/Charles Bowman/202-272-5383

Employment requirements/Richard Oliver/202-272-5278

Energy-related questions/Ronald Kutscher/202-272-5381

Industry occupational employment matrix/George Silvestri/202-272-5279

Occupational outlook/Neal Rosenthal/202-272-5382

Occupational outlook handbook/Michael Pilot/202-272-5282

Occupational projections—National/Michael Pilot/202-272-5282

Occupational Safety and Health Statistics

Acting Assistant Commissioner/William Mead/202-523-9271

Annual survey of occupational injuries and illnesses/William Mead/202-523-9271

Characteristics of injuries and illnesses/Lyle Schauer/202-523-9281

Health studies and special projects/Harvey Hilaski/202-523-9258

Industry estimates and incidence rates/John Inzana/202-523-9275

Recordkeeping and reporting in Section 18(b) States/Lee Cooper/202-523-9286

Recordkeeping interpretations/Stephen Newell/202-523-9275

Recordkeeping requirements under the Occupational Safety and Health Act/Norman Root/202-523-9281

Revision of recordkeeping and recording system/Norman Root/202-523-9281

State participation and state reports/Herbert Schaffer/202-523-9286

Supplementary data system/Norman Root/202-523-9281

Workers' compensation data/Norman Root/202-523-9281

Prices and Living Conditions

Associate Commissioner/John Layng/202-272-5038

Consumer expenditure surveys, 1960–61 and all public use tapes/Ray Gieseman/202-272-5156

Consumer expenditure survey data, 1972–73/George Weeden/202-272-5156

Consumer price indexes/Patrick Jackman/202-272-5160

Estimated retail food prices—monthly/Floyd Rabil/202-272-5173

Export and import price indexes—U.S./Katrina Reut/202-272-5020

Family budgets/John Rogers/202-272-5060

PRODUCER PRICE INDEXES

Current analysis/Craig Howell/202-272-5113

Technical Information/William Thomas/202-272-5113

Energy and chemicals/Kenneth Lavish/202-272-5210

Nonelectric machinery/Alvon Roark/202-272-5115

Electric machinery and transportation equipment/James Sinclair/202-272-5052

Metals/Edward Kazanowski/202-272-5204

Nonmetallic minerals, wood and paper/Susan Snow/202-272-5134

Textiles and leather/Maureen Zoller/202-272-5127

Revision/Thomas Tibbetts/202-272-5110 Methodology/Elliott Rosenberg/202-272-5118

International price indexes/Edward Murphy/202-272-5025

Living conditions studies and consumer expenditure analysis/Eva Jacobs/202-272-5156

Price and index number studies/Robert Gillingham/202-272-5096

Retail prices and indexes of fuels and utilities—

monthly report/Ina K. Ford/202-272-5177

Retail prices—gasoline only/Betty Rice/202-272-5080

Service industry price indexes/Frank Prunella/202-272-5130

Transportation price indexes/John Royse/202-272-5131

Productivity and Technology

Assistant Commissioner/Jerome A. Mark/202-523-9294

Productivity research/John R. Norsworthy/202-523-6010

Productivity and costs—press release/Lawrence J. Fulco/202-523-9261

Productivity trends in selected industries and federal government/Charles W. Ardolini/202-523-9244

Foreign countries—productivity, labor costs, industrial disputes, and other economic indicators/Arthur Neef/202-523-9291

Foreign countries—labor force and unemployment/Constance Sorrentino/202-523-9301

Cost-of-living abroad, prices, earnings and compensation in foreign countries/Patricia Capdevielle/202-523-9301

Technological trends in major industries/Richard W. Riche/202-523-9321

Labor and material requirements for different types of construction/Robert L. Ball/202-523-9321

Wages and Industrial Relations

Assistant Commissioner/George Stelluto/202-523-1382

Agreements-collective bargaining-public file/Jane Green/202-523-1597

Annual earnings and employment patterns (historic data only)/Al Bauman/202-523-1910

Area wage surveys/John Buckley/202-523-1763

Building trades—quarterly union wage rates (no longer current)/Sandra King/202-523-1309

Collective bargaining agreements analysis/Mike Cimini/202-523-1320

Collective bargaining settlements/Douglas LeRoy/202-523-1921

Compensation expenditures and payroll hours

(no longer current)/Patricia Smith/202-523-1313

Current wage developments/George Ruben/202-523-1319

Employee benefit plans—health, insurance, pensions, etc./John Thompson/202-523-9241

Employee earnings and hours frequency distribution (no longer current)/Paul Scheible/202-523-1143

Employment cost index/Judy Finger/202-523-1165

Federal employees—average salary/William Smith/202-523-1570

Hourly earnings index/Beth Levin/202-523-1165

Income distribution/Al Bauman/202-523-1910

Industry wage surveys/Sandra King/202-523-1309

Municipal government wage surveys/Dick Keller/202-523-1570

Professional, administrative, technical, and clerical pay/William Smith/202-523-1570

Payroll hours/Paul Scheible/202-523-1105

Service contracts surveys/Phil Doyle/202-523-1392

Union wage rates and hours—annual and biennial/Sandra King/202-523-1309

Wage chronologies/George Ruben/202-523-1319

Wages—state and local governments/Dick Keller/202-523-1392

Publications

Bureau of Labor Statistics (BLS) *Handbook of Methods*/Constance DiCesare/202-523-1090

Current Wage Developments/Robert Fisher/202-523-1139

Olivia Amiss/202-523-1662

Employment and Earnings/Rosalie Epstein/202-523-1554

Handbook of Labor Statistics/Rosalind Springsteen/202-523-1554

Major Programs/Rosalind Springsteen/202-523-1554

Monthly Labor Review/Robert Fisher/202-523-1139

Occupational Outlook Quarterly/Melvin Fountain/202-272-5298

Major Sources of Information

Agency For International Development Financial Labor Program

The Agency for International Development (AID) finances numerous labor programs for foreign governments such as employment and training, labor statistics, and labor market analysis. A list of these activities and end of term reports are available from: AID Financial Technical Assistance, Bureau of International Labor Affairs, Department of Labor, 200 Constitution Av. N.W.,

Room S5309, Washington, DC 20210/202-523-9905.

Apprenticeship Programs

Apprenticeship is a combination of on-the-job training and related technical instruction in which workers learn the practical and theoretical aspects of the work required for a skilled occupation, craft, or trade. Programs are conducted by employers, often jointly with labor and management. There are apprenticeship programs available for personnel in the Armed Forces, for veterans, and for female inmates in correction institutions. Contact: Bureau of Apprenticeship and Training, Employment and Training Administration, Department of Labor, 601 D St. N.W., Room 5000, Washington, DC 20213/202-376-6585.

Black Lung Benefits

Monthly payments and medical treatment benefits are available to coal miners totally disabled from pneumoconiosis (black lung) arising from their employment in or around coal mines. Payments are also available to surviving dependents. Contact: Division of Coal Mine Workers' Compensation, Employment Standards Administration, Department of Labor, 200 Constitution Ave. N.W., Room C3525, Washington, DC 20210/202-523-6795.

Bureau of Labor Statistics Bulletins Service

These major surveys and research studies include 100 area and industry wage studies each year, and 50 miscellaneous volumes dealing with prices, productivity, economic growth, occupational safety and other subjects including the following:

Bargaining Calendar—a yearly schedule of information on anticipated contract adjustments between labor and management negotiations. Major situations by company and union are identified in which contracts will terminate, deferred wage increases will become due, changes in the Consumer Price Indexes will be reviewed, and contracts will be reopened ($4.25).

Rent or Buy? Evaluating Alternatives in the Shelter Market—describes a method of analyzing the financial costs and benefits of owning a home compared to renting ($2.00).

Directory of National Unions and Employee Associations—a biennial factbook about labor organizations, provides membership figures, names of officers, and other information ($5.50).

Occupational Projections and Training Data—presents both general and detailed information on the relationship between occupational requirements and training needs for over 250 occupations; includes occupational projections to 1985 ($5.50).

Occupational Injuries and Illnesses in the United States by Industry—a detailed annual report with charts and tables showing the job-related injury and illness experience of employees in a wide range of industries ($4.75).

Perspective on U.S. Working Women: A Databook—Sixty-one tables provide a wide array of information on the characteristics of working women in the United States ($5.00).

Available from: Superintendent of Documents, Government Printing Office, Washington, DC 20402/202-783-3238.

Bureau of Labor Statistics—Just Published

This free monthly publication identifies new Bureau of Labor Statistics publications, data tapes and microfiches. Contact: Office of Publications, Bureau of Labor Statistics, Department of Labor, 441 G St. N.W., Room 1539, Washington, DC 20212/202-523-1239.

Bureau of Labor Statistics Monthly Publications Calendar

This free wallet-sized calendar lists due dates for major Bureau of Labor Statistics publications. Contact: Office of Publications, Bureau of Labor Statistics, Department of Labor, 441 G St. N.W., Room 2029, Washington, DC 20212/202-523-1913.

Bureau of Labor Statistics News Releases

A free monthly calendar shows dates of future press releases covering such subjects as labor union and employee association membership, urban family budgets and comparative indexes for selected urban areas, white collar salaries, work stoppages, major collective bargaining settlements, employment cost index, productivity and costs, employment situation, state and metropolitan area unemployment, and earnings of workers and their families. Contact: Division of Information Services, Bureau of Labor Statistics, Department of Labor, 441 G St. N.W., Room 2029, Washington, DC 20212/202-523-1208.

Carcinogen Identification

A list is maintained of chemicals that might be cancer-causing agents. The list is made up of 3 categories: 1) those chemicals which, based on epidemiologic and animal studies, are carcinogenic; 2) those chemicals thought to be carcinogenic based on preliminary studies; and 3) those chemicals that appear suspicious that will be studied. Contact: Office of Carcinogen Identification and Classification, Directorate of Health Standards Programs, Occupational Safety and Health Administration (OSHA), Department of Labor, 200 Constitution Ave. N.W., Room N3718, Washington, DC 20210/202-523-7111.

Career Information Systems Program

This program was launched to improve the quality and dissemination of occupation and education information. This includes descriptions of occupations such as duties, tasks, special tools and equipment needed, working conditions, career advancement, types of employer and occupation requirements. There is also information about the economy, current employment outlook, earnings and fringe benefits, data on training, education and other ways to prepare for an occupation. Contact: Career Information Services Division, Office of Policy, Evaluation and Research, Employment and Training Administration, Department of Labor, 601 D St. N.W., Room 9122, Washington, DC 20213/202-376-7264.

CETA Follow-Up Reports

Surveys are conducted on pre-program and post-program experiences of participants in the Comprehensive Employment and Training Administration (CETA) programs. Contact: Office of Program Evaluation, Policy Evaluation, Education and Training Administration, Department of Labor, 601 D St. N.W., Room 9122, Washington, DC 20213/202-376-8090.

CETA Programs

The Comprehensive Employment Training Administration (CETA) program provides economically disadvantaged persons, who are unemployed or underemployed, training, upgrading, retraining, education, and other services to qualify them for jobs. Contact: Comprehensive Employment and Training Program, Comprehensive Employment Development, Employment and Training Administration, Department of Labor, 601 D St. N.W., Room 5014, Washington, DC 20213/202-376-6254.

CETA Statistics

Data are available on participants of the Comprehensive Employment Training Administration (CETA) Program, including age, ethnic origin, sex, wages pre- and post CETA job, English language ability, number of participants reviewed by program title, total placement rate, positive result rate, average cost per placement, and amount of funds available. Contact: Information Analysis and Systems Development, Office of Management Information Systems, Education and Training Administration, Department of Labor, 601 D St. N.W., Room 4426, Washington, DC 20213/202-376-6478.

Child Labor Laws

Certain provisions of the Fair Labor Standards Act apply to minors employed in nonagricultural occupations. Violators of the child labor laws are subject to civil penalties of up to $1,000 for each violation. Contact: Child Labor Branch, Wage and Hour Division, Employment Standards Administration, Department of Labor, 200 Constitution Ave. N.W., Room S3030, Washington, DC 20210/202-523-7640.

Collective Bargaining Agreement Analysis

Information is available on contract provisions by major industry groups as well as contract clauses illustrating different approaches. Contact: Industrial Relations Division, Office of Wages and Industrial Relations, Division of Developments in Labor-Management Relations, Bureau of Labor Statistics, Department of Labor, 441 G St., N.W., Room 1288, Washington, DC 20212/202-523-1143.

Collective Bargaining Agreements

The public has access to copies of some 5,000 agreements in private industry and government, including all those covering 1,000 employees or more, exclusive of railroads and airlines. Contact: Public File of Collective Bargaining Agreements, Union Contracts Section, Industrial Relations Section, Office of Wages and Industrial Relations, Bureau of Labor Statistics, Department of Labor, 441 G St. N.W., Room 1288, Washington, DC 20212/202-523-1143.

Compensation Trends and Current Wage Developments

Data are available showing amount and nature of changes in wages and related benefits for collective bargaining agreements. Data are identified by individual company and union, with number of workers affected, listed by industry group and location. Contact: Division of Occupational Pay and Employee Benefit Levels, Office of Wages and Industrial Relations, Bureau of Labor Statistics, Department of Labor, 441 G St. N.W., Room 1284, Washington, DC 20212/202-523-1246. For description of the division, call Charles O'Connor, 202-523-1246.

Computerized Placement Systems

These systems include:

Job Bank—a daily printout of all jobs listed with the employment service in a metropolitan or large area and distributed to employment service offices throughout the area.

Automated Matching System—uses computers to identify registered jobs for which a particular applicant is qualified or for all registered qualified applicants.

Contact: Computerized Placement System, Automated Matching System Division, Office of Program Services, Employment Service, Employment Training Administration, Department of Labor, 601 D St. N.W., Room 8025, Washington, DC 20213/202-376-6890.

Construction Industry Labor Information

The Office of Construction Industry Services deals with problems of the construction industry. It collects, analyzes and reports on industry wages and fringe benefits, and on significant industry trends. A free publication, *Handbook of Wages and Benefits for Construction Unions*, summarizes data from about 5,000 collective bargaining agreements in the construction industry. The *Annual Report* covers: industrial relations and outlines the structure of the industry, employment projections, energy-related construction proposals, productivity and safety and health, sponsored research which focuses on inter-industry mobility of construction workers, compilation of federal regulations and laws, and economics of the industry. Contact: Construction Industry Services, Labor-Management Services Administration, Department of Labor, 200 Constitution Ave. N.W., Room N5655, Washington, DC 20210/202-523-8356.

Construction Industry Services

Services are provided: to extend the length of the work year, reduce seasonal and intermittent unemployment in construction and increase productivity; to encourage inter- and intra-governmental coordination of construction planning, contract awards, project starts and scheduling to eliminate potential bottlenecks and reduce inflationary pressures on labor and material prices; to establish and maintain local tripartite coordinating committees of labor, management and government (federal, state and local); to maintain a data bank on construction wages and fringes; to relate training to industry requirements; and, to encourage the modification of industry and Government practices and regulations which raise the cost of public construction. Contact: Director, Office of Construction Industry Services, Department of Labor, 200 Constitution Ave. N.W., Washington, DC 20216/202-523-8356.

Construction Labor Requirements

Data are available on employee hours per unit, per square foot and per dollar volume of construction for on-site labor. Information is also available on employer hour requirements by selected characteristics; relative share of total cost of labor, materials, overhead and profit, and on-site employee hours by occupation. Contact:

Technology Studies Division, Bureau of Labor Statistics, Department of Labor, 200 Constitution Ave. N.W., Room S4325, Washington, DC 20210/202-523-9219.

Consumer Credit Protection (Federal Wage Garnishment Law)

This law provides restrictions on the amount of an employee's wages or salary which may be garnished, and prohibits employers from discharging employees by reason of garnishment for any one indebtedness. Contact: Administrator, Wage and Hour Division, Employment Standards Administration, 200 Constitution Ave. N.W., Room S3502, Department of Labor, Washington, DC 20210/202-523-8305.

Consumer Expenditure and Family Budget Studies

Income and expenditure studies are available in varying detail for the total U.S., regions and selected areas. Selected data are classified by income class, family size and other demographic and economic characteristics of consumer units. Data are also available on hypothetical budgets for self-sufficient urban 4-person family and retired couples at 3 levels of living for 24 individual metropolitan areas, nonmetropolitan averages for 4 regions, and Anchorage, Alaska. Contact: Consumer Expenditure Studies, Living Conditions Studies Division, Bureau of Labor Statistics, Department of Labor, 600 E St. N.W., Room 3306, Washington, DC 20212/202-272-5156.

Consumer Price Index Detailed Report

This monthly publication provides comprehensive data each month on movements in the Consumer Price Indexes by expenditure group, by item and by city. The Consumer Price Index is based on prices of food, clothing, shelter, fuels, transportation fares, charges for doctors, dentists, drugs, and other goods and services that people buy for day-to-day living. Available for $15.00/year from Superintendent of Documents, Government Printing Office, Washington, DC 20402/202-783-3238. For more details on content, contact: Office of Prices and Living Conditions, Bureau of Labor Statistics, Department of Labor, 600 E St. N.W., Washington, DC 20212/202-272-5160.

Consumer Price Index in 24 Hours

This service provides unadjusted and seasonally adjusted data within 24 hours after release via mailgram service. The service is available for $95 per year from: National Technical Information Service, 5285 Port Royal Rd., Springfield, VA 22161/703-487-4630.

..dexes are computed for both urban ...ners and urban consumers, including ..ed workers, the self-employed, the retired, ..id the unemployed, as well as for clerical workers. Both these Computer Price Indexes (CPI) include data for all items and major commodity and service groups and subgroups for the United States and the 5 largest metropolitan areas. Also available are bimonthly indexes for all items. Contact: Consumer Price and Price Indexes Division, Office of Prices and Living Conditions, Bureau of Labor Statistics, Department of Labor, 600 E St. N.W., Room 3306, Washington, DC 20212/202-272-5060.

Continuing Education for Women

Information is available on programs which allow women to study part-time in school or at home in order to get formal educational qualifications. A free publication, *How To Get Credit for What You Know: Alternative Routes to Educational Credit*, lists organizations which offer information on adult education programs and opportunities. Contact: Women's Bureau, Department of Labor, 200 Constitution Ave. N.W., Room S3005, Washington, DC 20210/202-523-6668.

Cost of Living Overseas

U.S. Department of State Indexes of Living Costs Abroad and Quarter Allowances: A Technical Description is a free quarterly publication which provides technical descriptions of the methods of compiling the indexes of living costs abroad, post allowances based on these indexes, and quarter allowances and their use in the government overseas allowance program. Contact: Office of Productivity and Technology, Bureau of Labor Statistics, Department of Labor, 200 Constitution Ave. N.W., Room S4214, Washington, DC 20212/202-523-9291.

Counselor's Guide to Occupational Information

This publication is an annotated listing of federal government publications. It includes information about occupations describing job duties, entry requirements, advancement opportunities, job outlook, earnings, etc. It also includes information on overseas jobs; special programs or jobs for minorities, women, veterans, and young workers; education and financial aid; job search; career education, statistics and bibliographies useful to counselors. Available for $4.50 from: Superintendent of Documents, Government Printing Office, Washington, DC 20402/202-783-3238.

Current Employment Analysis

Detailed analyses are conducted on data from the Current Population Survey from the Bureau of the Census showing employment, unemployment and the number of persons not in the labor force. Studies include: characteristics of special groups in the labor force; changing patterns in work time and leisure; absence from work; employment status of noninstitutional population 16 years and over; hours of work, annual average employment levels for detailed occupational and industry groups; and employed persons by major occupational and industry groups. Contact: Current Employment Analysis, Office of Current Employment Analysis, Division of Employment and Unemployment, Bureau of Labor Statistics, Department of Labor, 441 G St. N.W., Room 2486, Washington, DC 20212/202-523-1944.

Current Wage Development

This monthly publication reports on collective bargaining settlements, wage and benefit data, and compensation and wage trends. Available for $12.00/year from: Superintendent of Documents, Government Printing Office, Washington, DC 20402/202-783-3238. For detailed information on content, contact: Office of Wages and Industrial Relations, Bureau of Labor Statistics, Department of Labor, 441 G St. N.W., Room 1916, Washington, DC 20212/202-523-1319.

Dictionary of Occupational Titles (DOT)

This publication contains 12,099 definitions of jobs in the American economy which represent about 20,000 job titles. It offers a system to classify employees and job applicants according to the work they have done and to match them with available jobs. Available for $12.00 from Superintendent of Documents, Government Printing Office, Washington, DC 20402/202-783-3238. For more detailed information on content, contact: Division of Occupational Analysis, Employment Service, Employment and Training Administration, Department of Labor, Washington, DC 20213/202-376-6292.

Direct Payments

The programs described below are those which provide financial assistance directly to individuals, private firms and other private institutions to encourage or subsidize a particular activity.

Coal Mine Workers' Compensation (Black Lung)

Objectives: To provide benefits to coal miners who have become totally disabled due to coal workers' pneumoconiosis (CWP), and to widows and other surviving dependents of miners who

have died of this disease, or who were totally disabled from the disease at the time of death.

Eligibility: The miner must have worked in the nation's coal mines and become "totally disabled" (as defined in the Act) from CWP. The applicant may be able to work in areas other than coal mines and still be eligible for benefits. Widows and other surviving dependents of coal miners totally disabled from or whose death resulted from CWP are also eligible for benefits. Applicants can reside anywhere in the world at the time they apply.

Range of Financial Assistance: Up to $508.00 monthly.

Contact: Division of Coal Mine Workers' Compensation, Office of Workers' Compensation Programs, Employment Standards Administration, Department of Labor, Washington, DC 20210/202-523-6692.

Longshoremen and Harbor Workers' Compensation

Objectives: To provide compensation for disability or death resulting from injury, including occupational disease, to eligible private employees.

Eligibility: Longshoreworkers, harbor workers, and certain other employees engaged in maritime employment on navigable waters of the United States and the adjoining pier and dock areas, employees engaged in activities on the Outer Continental Shelf, employees of nonappropriated fund instrumentalities, employees of private employers engaged in work outside of the United States under contracts with the United States Government, and others as specified, including survivors of the above. Employees of private concerns in the District of Columbia and their survivors are eligible for benefits under extension of the Act. Puerto Rico and the Virgin Islands are not covered by the Longshoremen's and Harbor Workers' Compensation Act.

Range of Financial Assistance: Not specified.

Contact: Office of Workers' Compensation Programs, Division of Longshoremen and Harbor Workers' Compensation, Department of Labor, Washington, DC 20210/202-523-8721.

Trade Adjustment Assistance—Workers

Objectives: To provide adjustment assistance to workers adversely affected by increase of imports of articles like or directly competitive with articles produced by such workers' firm.

Eligibility: A significant number or proportion of workers in such workers' firm or a subdivision of the firm have become or have been threatened to become totally or partially separated; sales or production, or both, of such firm has decreased

absolutely; and increases of imports like or directly competitive with articles produced by the firm have contributed importantly to such total or partial separation, or threat thereof, and to such decline in sales or production. The petition may be filed with the Secretary of Labor by a group of workers or the group's certified or recognized union or other duly authorized representative. Notice of such filing should be promptly published in the *Federal Register*. Within ten days after publication, the petitioner, or any other person found by the Secretary to have a substantial interest, may request a hearing to present evidence and to be heard. Not later than sixty days after receipt of a petition, the Secretary determines whether the petitioning group meets the requirements and may issue a certification of eligibility to apply for adjustment assistance.

Range of Financial Assistance: Up to 70 percent of the beneficiary's average weekly wage, but such payments may not exceed the national weekly wage in manufacturing.

Contact: Director, Office of Trade Adjustment Assistance, Employment and Training Administration, Department of Labor, 601 D St. N.W., Room 10400, Washington, DC 20213/202-376-6896.

Unemployment Insurance

Objectives: To administer unemployment insurance for eligible workers through federal and state cooperation; to administer payment of worker adjustment assistance.

Eligibility: State unemployment insurance agencies, including Puerto Rico and the Virgin Islands.

Range of Financial Assistance: $754,404 to $120,139,683.

Contact: Administrator, Unemployment Insurance Service, Employment and Training Administration, Department of Labor, 601 D St. N.W., Room 7000, Washington, DC 20213/202-376-7032.

Economic Growth Projections

Information is available showing projections of total gross national product and aggregate components of demand specified by 160 industry groups under alternative assumption for basic economic variables (labor force, unemployment, productivity, etc.) and government policies. Projections are also made of the labor force by age, sex, and race under 3 alternative growth scenarios. Contact: Office of Economic Growth and Employment Projections, Bureau of Labor Statistics, Department of Labor, 600 E St. N.W., Room 7216, Washington, DC 20212/202-272-5381.

Employee Protection

Special protection has been awarded to certain employees who have been adversely affected by legislation. For example, under the Urban Mass Transportation Act fair and equitable arrangements must be established to protect the interests of affected transit employees. These arrangements might include priority employment rights, continuation of pension and other benefits, preservation of collective bargaining rights, paid training programs, etc. Other programs include: Rail Passenger Service Act, Airline Deregulation Act, Redwood Park Expansion Act, Hospital Conservation Act, Social Security Disability Program. Contact: Division of Employee Protections, Office of Labor-Management Relations Services, Labor-Management Services Administration, Department of Labor, 200 Constitution Ave. N.W., Room N5639, Washington, DC 20210/202-523-6495.

Employment and Earnings

This monthly publication provides a comprehensive report of current data on unemployment, employment, hours, earnings, and labor turnover. Available for $31.00 per year from: Superintendent of Documents, Government Printing Office, Washington, DC 20402/202-783-3238. For detailed information on content, contact: Employment Structure and Trends, Bureau of Labor Statistics, Department of Labor, 441 G St. N.W., Room 2089, Washington, DC 20212/202-523-1487.

Employment and Training Programs for Youth

This office sponsors and supports programs to help young people get jobs, and services such as counseling and training to prepare them for jobs. These include:

Summer Youth Employment Program—tries to increase the opportunities for vocational exploration in the private sector.
Youth Employment and Training Program—seeks to enhance the job prospects of low-income youth aged 16–21 who have the most severe problems entering the labor force.
Youth Community Conservation and Improvement Projects—develops the vocational potential of jobless youth by providing them with well-supervised work of tangible community benefit.

Contact: Employment and Training Programs for Youth, Division of Program Planning and Design, Office of Youth Programs, Employment and Training Administration, Department of Labor, 601 D St. N.W., Washington, DC 20213/202-376-7124.

Employment and Training Publications

For information on available publications, contact: Inquiries Unit, Employment and Training Administration, Department of Labor, 601 D St. N.W., Room 10225, Washington, DC 20213/202-376-6730.

Employment and Training Report of the President

This report includes the Department of Labor's annual report on employment and occupation requirements, resources, use of training as well as the Department of Health and Human Services' annual report on facilities utilization, employment and training program coordination. It also describes experimental and development projects that test innovative ways of serving workers with particular job-related needs such as placement, orientation, training, upgrading or counseling. Contact: Reports Group, Office of Planning and Policy Analysis, Employment and Training Administration, Department of Labor, 601 D St. N.W., Room 9424, Washington, DC 20213/202-376-6318.

Employment and Training Research

Research is conducted on such topics as: labor market processes, factors contributing to unemployment and underemployment, strengths and weaknesses that disadvantaged persons bring to the work force, transition from school to work, from job to job, and from work to retirement. A free *Annual Volume* lists, by subject, ongoing and recently completed research. Contact: Office of Research and Development, Office of Policy Evaluation and Research, Employment and Training Administration, Department of Labor, 601 D St. N.W., Room 9100, Washington, DC 20213/202-376-7335.

Employment and Wage Research

Research programs are conducted on such topics as wages and hours, workers' compensation, equal employment opportunities, and older workers and federal contract compliance. Contact: Evaluation and Research Division, Office of Administrative Management, Employment Standards Administration, Department of Labor, 200 Constitution Ave. N.W., Room C3313, Washington, DC 20210/202-523-8493.

Employment Cost Index

Quarterly data measure the change in straight time hourly earnings for the total private non-

farm economy excluding households. Data are available for four broad geographic areas, five major industries, and nine occupational groups for metropolitan and nonmetropolitan areas. Contact: Division of Employment Cost Trends, Office of Wages and Industrial Relations, Bureau of Labor Statistics, Department of Labor, 441 G St. N.W., Room 1913, Washington, DC 20212/202-523-1165.

Employment Projections

Long-term economic projections which include projections of aggregate labor force, potential demand, and industrial output and employment by industry and occupation are available from: Office of Economic Growth, Bureau of Labor Statistics, Department of Labor, 441 G St. N.W., Room 4860, Washington, DC 20212/202-523-1450.

Employment Research and Development

Research and development programs cover various aspects of labor-related subjects including: education, public employment programs, supported employment, training and apprenticeship, upgrading and job restructuring, welfare recipient programs, worker assessment and orientation, supportive services for workers and trainers, worker attitudes, employer practices, labor force, labor demand and economic and social policies. The annual publication, *Research and Development Projects*, summarizes funded projects. Contact: Office of Research and Development, Office of Policy, Development and Research, Employment and Training Administration, Department of Labor, 601 D St. N.W., Room 9100, Washington, DC 20213/202-376-7244.

Employment Security Automated Reporting System

This system provides an assessment of employment services programs. It records information on the number of job applicants, the type of job applications, and the number and type of job openings. It describes how applicants are secured, tested, and placed. The characteristics of individuals placed are also noted. Publications available include: *Summary of Highlights of the Job Service, Programs Serving Migrants and Seasonal Farm Workers*, and *Targeted Jobs Tax Credit*. Contact: Division of Data and Cost Analysis, Office of Program Review, Employment Service, Employment and Training Administration, Department of Labor, 601 D St. N.W., Room 8208, Washington, DC 20213/202-376-6856 and 376-6755.

Employment Service

The Employment Service and affiliated state employment service agencies operate nearly 2500 local offices to serve those seeking employment and those providing it. Local offices in most states are now identified as the Job Service. Services include outreach, interviewing, testing, counseling, and referral. Contact: Employment Service, Employment and Training Administration, Department of Labor, 601 D St. N.W., Room 8000, Washington, DC 20213/202-376-6289.

Employment Standards

The Employment Standards Administration has the authority to correct a wide range of unfair employment practices. It enforces laws and regulations, setting employment standards providing workers' compensation to those injured on their jobs, and requiring federal contractors and subcontractors to provide equal employment opportunity. Contact: Office of Information and Consumer Affairs, Employment Standards Administration, Department of Labor, 200 Constitution Ave. N.W., Room C4331, Washington, DC 20210/202-523-8743.

Employment Structures and Trends

Detailed data are available on employment, wages, hours, earnings, and turnover; monthly estimates of states and local area unemployment; occupational employment for most industries; and employment in major nonagricultural industries. Contact: Office of Employment Structure and Trends, Bureau of Labor Statistics, Department of Labor, 441 G St. N.W., Room 2919, Washington, DC 20212/202-523-1694.

Exemplary Rehabilitation Certificates

Exemplary rehabilitation certificates are awarded by the Secretary of Labor to ex-servicepersons separated from the Armed Forces under conditions other than honorable if it is established that such person has been self-rehabilitated. This Certificate provides tangible evidence of rehabilitation, since discharge, to present to an employer. Certificate does not in any way change the nature of original discharge or alter ex-serviceperson's eligibility for veterans benefits. Contact: Assistant to the Director for Field Operations, Veterans Employment Service, Employment and Training Administration, Department of Labor, Room 8400, 200 Constitution Ave. N.W., Washington, DC 202-376-6550.

Exploring Careers

This career guidebook is designed for young-

sters in their early teens and is designed to help teenagers explore careers. It emphasizes the job as it is experienced by workers, the tasks and the tools. It is an excellent guide for youth service organizations to help with counseling, encouraging teenagers to learn job skills and behaviors, and to familiarize themselves with the work environment. Available for $11.00 from: Superintendent of Documents, Government Printing Office, Washington, DC 20402/202-783-3238. For more detailed information on content, contact: Office of Economic Growth and Employment Projections, Bureau of Labor Statistics, Department of Labor, 600 E St. N.W., Room 7216, Washington, DC 20212/202-272-5285.

Export Price Indexes

Quarterly indexes are available for detailed and aggregate product groups covering machinery and transportation equipment, intermediate manufacturers, chemicals, crude materials, and food. Product categories are based on the Standard International Trade Classification System. Indexes also compare price trends for 34 detailed categories of substitutable products exported by both the U.S. and Germany and 26 detailed categories of substitutable products exported by both the U.S. and Japan. Contact: International Prices Division, Office of Prices and Living Conditions, Bureau of Labor Statistics, Department of Labor, 600 E St. N.W., Room 3302, Washington, DC 20212/202-272-5020.

Fair Labor Standards Act

This act establishes minimum wages, overtime pay, equal pay, recordkeeping and child labor standards affecting more than 50 million full-time and part-time workers. Contact: Office of Information and Consumer Affairs, Employment Standards Administration, Department of Labor, 200 Constitution Ave. N.W., Room C4331, Washington, DC 20210/202-523-8743.

Farm Labor Registration

The Farm Labor Contractor Registration Act requires farm labor contractors and other users of migrant labor to observe certain rules in the employment of migrant workers and to register with the Department of Labor before they begin contracting. Contact: Branch of Farm Labor, Wage and Hour Division, Employment Standards Administration, Department of Labor, 200 Constitution Ave. N.W., Room S3030, Washington, DC 20210/202-523-7605.

Federal Contract Compliance Program

This program investigates cases that involve groups of people or indicate patterns of employment discrimination by federal contractors. The program also investigates individual or group complaints under the handicapped workers and veterans laws. Contact: Enforcement Coordination Division, Office of Federal Contract Compliance Programs, Employment Standards Administration, Department of Labor, 200 Constitution Ave. N.W., Room N5718, Washington, DC 20210/202-523-9912.

Federal Contractors Discrimination

Specialists from field offices review the employment practices of federal contractors to determine whether they fulfill Equal Employment Opportunity (EEO) and Affirmative Action obligations. Contact: Field Liaison Branch, Office of Federal Contract Compliance Programs, Employment Standards Administration, Department of Labor, 200 Constitution Ave. N.W., Room N3422, Washington, DC 20210/202-523-9423.

Federal Employees Workers' Compensation

A free publication, *Federal Injury Compensation*, lists 112 Questions and Answers about the Federal Employees' Compensation Act. For the pamphlet and other information regarding benefits to civilian employees of the United States for disability due to personal injury sustained while in the performance of duty or due to employment-related disease or death, contact: Division of Federal Employees' Compensation, Office of Workers' Compensation Programs, Employment Standards Administration, Department of Labor, 200 Constitution Ave. N.W., Room S3520, Washington, DC 20210/202-523-7493.

Fiduciary Standards

This office grants or denies requests for exemption from Employee Retirement Income Security Act (ERISA) prohibited transactions provisions. Contact: Office of Fiduciary Standards, Pension and Welfare Benefit Programs, Labor Management Services Administration. Department of Labor, 200 Constitution Ave. N.W., Room C4526, Washington, DC 20216/202-523-7461.

Foreign Economic Research

Research is conducted on such topices as: Review of U.S. Competitiveness in World Trade; Demographic and Occupational Characteristics of Workers in Trade-Sensitive Industries; Trade and Employment Effects of Tariff Reductions Agreed to in the Multilateral Trade Negotiations; An Emperical Analysis of the Structure of U.S. Manufacturing Trade 1964–1976; Shortrun Effects of Trade Liberalization; Productive Strate-

gies and Practices of Foreign Multinationals in the U.S.; and Trends in World Trade with Emphasis on the Trade in the Developing Countries. Contact: Foreign Economics Research Staff, Bureau of International Labor Affairs, Department of Labor, 200 Constitution Ave. N.W., Room S5004, Washington, DC 20210/202-523-7597.

Foreign Financial Labor Programs

A number of labor programs are financed by other countries (e.g., Saudi Arabia is financing a vocational training system). A list of such activities and end-of-tour reports are available from: Office of Foreign Financial Programs, Bureau of International Labor Affairs, Department of Labor, 200 Constitution Ave. N.W., Room S5016, Washington, DC 20210/202-523-7631.

Foreign Workers

On the basis of the Immigration and Naturalization Act, employers can request, through local employment offices, foreign workers or foreign individuals who fill a certain void in the labor market. Contact: Alien Labor Certification, Labor Certification Division, Office of Technical Support, Employment Service, Employment and Training Administration, Department of Labor, 601 D St. N.W., Room 8410, Washington, DC 20213/202-376-6295.

Freedom of Information Act

For information regarding Freedom of Information Act activities, contact: Assistant Secretary for Administration and Management, Department of Labor, 200 Constitution Ave. N.W., Room S2514, Washington, DC 20210/202-523-9086.

Grants

The programs described below are for sums of money which are given by the federal government to initiate and stimulate new or improved activities, or to sustain on-going services.

Comprehensive Employment and Training Programs

Objectives: To provide job training and employment opportunities for economically disadvantaged, unemployed, and underemployed persons and to assure that training and other services lead to increased earnings and enhanced self-sufficiency by establishing a flexible decentralized system of federal, state, and local programs.

Eligibility: States, units of local government having a population of 100,000 or more, and U.S. territories.

Range of Financial Assistance: Not specified.

Contact: Employment and Training Administration, Department of Labor, 601 D St. N.W., Washington, DC 20213/202-376-6366.

Employment and Training—Indians and Native Americans

Objectives: To reduce the economic disadvantages among Indians and others of Native American descent and to advance the economic and social development of such people in accordance with their goals and life styles.

Eligibility: Indian tribes, bands, or groups, Alaskan Native villages or groups (as defined in the Alaska Native Claims Settlement Act of 1971 [85 Stat. 688]) and Hawaiian Native communities.

Range of Financial Assistance: $50,000 to $7,500,000.

Contact: Office of Indian and Native American Programs, Employment and Training Administration, Department of Labor, 601 D St. N.W., Room 6414, Washington, DC 20213/202-376-6102.

Employment and Training Research and Development Projects

Objectives: To support employment and training studies to develop policy and programs for achieving the fullest utilization of the nation's human resources; to improve and strengthen the functioning of the nation's employment and training system; to develop new approaches to facilitate employment of the difficult to employ; and to conduct research and development addressing the employment implications of long-term social and economic trends and forces.

Eligibility: State colleges and universities, public, private, junior and community colleges, state and local government organizations including U.S. territories and other organizations and individuals capable of fulfilling the objectives of the programs. There are no formal guidelines or conditions performers must meet other than that they have demonstrated financial responsibility and competence to fulfill the terms of the contract or grant.

Range of Financial Assistance: $1,000 to $1,000,000.

Contact: Director, Office of Research and Development, Department of Labor, Washington, DC 20213/202-376-7335.

Employment Service

Objectives: To place persons in employment by providing a variety of placement-related services to job seekers and to employers seeking qualified

individuals to fill job openings.

Eligibility: State employment security agencies, including Virgin Islands, Puerto Rico, and Guam.

Range of Financial Assistance: $1,151,575 to $42,075,242.

Contact: Director, Office of Plans, Policies and Design, Employment Service, Employment and Training Administration, Department of Labor, Washington, DC 20213/202-376-6650.

Institutional Grant Program

Objectives: To assist academic institutions in developing human resources education programs aimed at professionalizing state and local level employment and training staff, and insuring a future source of skilled planners, evaluators, and administrators.

Eligibility: Accredited institutions of higher education in any of the states of the United States, its territories, or possessions may apply if they grant bachelor's or higher degrees in the social or behavioral sciences, or in any other disciplines relevant to the employment and training area.

Range of Financial Assistance: $130,000 to $200,000.

Contact: Director, Office of Research and Development, Employment and Training Administration, Department of Labor, Washington, DC 20213/202-376-7335.

Job Corps

Objectives: To assist young men and women who need and can benefit from an intensive education and vocation training program operated in a residential group setting in order to become more responsible, employable, and productive citizens.

Eligibility: federal, state, local government agencies including U.S. territories, private profit and nonprofit organizations and Indian tribes and organizations having the capabilities to carry out the objectives of the program.

Range of Financial Assistance: $500,000 to $12,500,000.

Contact: Director, Job Corps, Employment Training Administration (ETA), Department of Labor, 601 D St. N.W., Washington, DC 20213/202-376-6995.

Migrant and Seasonal Farm Workers

Objectives: To provide necessary employment, and training and supportive services to help migrant and seasonal farm workers, their families, and youth find economically viable alternatives to seasonal agricultural labor, and improve the live style of seasonal agricultural workers who re-

main in the agricultural labor market.

Eligibility: 1) Comprehensive Education and Training Act (CETA) prime sponsors whose jurisdictions include significant numbers of individuals meeting the definition of migrant and seasonal farm workers for whom they have committed funds provided under Title II of the Act; or public agencies within the geographic boundaries of CETA prime sponsors who have been designated by such prime sponsors to receive Section 303 funds; 2) private nonprofit organizations authorized by their charters or articles of incorporation to operate Employment and Training programs or such other programs or services as are permitted by Title III, Section 303 of this Act.

Range of Financial Assistance: $100,000 to $3,000,000.

Contact: Office of National Programs, Employment and Training Administration, Department of Labor, 601 D St. N.W., Washington, DC 20213/202-376-6128.

Mine Health and Safety Grants

Objectives: To assist states in developing and enforcing effective mine health and safety laws and regulations, to improve state workmen's compensation and occupational disease laws and programs, and to promote federal-state coordination and cooperation in improving health and safety conditions.

Eligibility: Any mining state of the United States through its mine inspection or safety agency.

Range of Financial Assistance: $24,426 to $1,229,297.

Contact: Chief, State Grants Program Office, Mine Safety and Health Administration, Department of Labor, Ballston Towers No. 3, Arlington, VA 22203/703-235-8264.

Occupational Safety and Health (OSHA)

Objectives: To assure safe and healthful working conditions.

Eligibility: a) Any employer, employee or representative concerned with OS&H problems; b) state agencies which have federally approved occupational safety and health programs; c) labor unions, trade associations, educational institutions and other nonprofit organizations; d) any employee or employee representative of a business engaged in interstate commerce except those under the jurisdiction of other federal agencies; e) anyone concerned about the OS&H program.

Range of Financial Assistance: Not specified.

Contact: Assistant Secretary, Occupational Safety and Health Administration, Department of Labor, Washington, DC 20210/202-523-9361.

Senior Community Service Employment Program

Objectives: To provide, foster, and promote useful part-time work opportunities up to 20 hours per week in community service activities for low income persons ages 55 years old and older, who have poor employment prospects.

Eligibility: The following types of organizations are eligible to receive project grants: 1) states and agencies of a state; 2) national public and private nonprofit agencies and organizations other than political parties; and 3) U.S. territories.

Range of Financial Assistance: Not specified.

Contact: Administrator, Office of National Programs, Employment and Training Administration, Department of Labor, 601 D St. N.W., Washington, DC 20213/202-376-6232.

Special Programs and Activities for the Disadvantaged

Objectives: To provide, foster, and promote training and other employment related services to groups with particular disadvantages in the labor market. To promote and foster new or improved linkages between the network of federal, state, and local employment and training agencies and components of the private sector. To carry out other special federal responsibilities under CETA.

Eligibility: State and local governments, federal agencies, private nonprofit and profit-making organizations, education institutions, and Native American entities.

Range of Financial Assistance: $70,000 to $16,000,000.

Contact: Administrator, Office of National Programs, Employment and Training Administration, Department of Labor, 601 D St. N.W., Washington, DC 20213/202-376-6225.

Youth Incentive Entitlement Pilot Projects

Objectives: The program is designed as a national experiment to 1) test the impact on high school return, retention, and completion of a school-year (part-time) and summer (full-time) job guarantee for all 16–19 year old economically disadvantaged youth residing in a designated area who are in secondary school or who are willing to return to school or enroll in a course leading to a certificate of high school equivalency; 2) to ascertain the longer-term impacts of the entitlement experience on the earnings of program participants subsequent to their completing or otherwise leaving high school.

Eligibility: All CETA Title I prime sponsors (state and local governments, U.S. territories) are eligible to compete for entitlement projects.

Range of Financial Assistance: $700,000 to $38,000,000.

Contact: Employment and Training Administration, Department of Labor, 601 D St. N.W., Washington, DC 20213/202-376-2649.

Handbook of Labor Statistics

This publication is a compilation of the major statistics series published by the Bureau of Labor Statistics. Available for $9.50 from: Office of Publications, Bureau of Labor Statistics, Department, 441 G St. N.W., Room 2029, Washington, DC 20212/202-523-1239.

Handicapped Program

This program tries to provide handicapped persons with equal opportunity for employment and equal pay. The local employment office will provide counseling, aptitude testing and appraisal of employability. Contact: Program for the Handicapped, Division of Applicant Services, Employment and Training Administration, Department of Labor, 601 D St. N.W., Room 8113, Washington, DC 20213/202-376-6908.

Health Careers Guidebook

This publication describes about 100 health-related occupations such as physicians, nurses, medical illustrators, and physical and occupational therapists. Available for $5.25 from: Superintendent of Documents, Government Printing Office, Washington, DC 20402/202-783-3239.

Health Standards

For information on OSHA health standards requirements in general industry, maritime, construction or agriculture, contact: Directorate of Health Standards Program, Occupational Safety and Health Administration (OSHA), Department of Labor, 200 Constitution Ave. N.W., Room N3718, Washington, DC 20210/202-523-7075.

Hours and Earnings

Data are available showing gross hours and earnings of production or nonsupervisory workers in private nonagricultural industries. Contact: Office of Employment Structures and Trends, Bureau of Labor Statistics, Department of Labor, 441 G St. N.W., Room 2919, Washington, DC 20212/202-523-1694.

Immigrant Workers Certification

Aliens who seek to immigrate to the United States for employment shall be excluded from admission unless the Secretary of Labor determines and certifies to the Secretary of State and to the Attorney General that there are not sufficient U.S. workers available for the employment and that the employment of such aliens will not ad-

versely affect the wages and working conditions of U.S. workers similarly employed. Contact: Division of Labor Certification, Employment Service, Employment and Training Administration, Department of Labor, Washington, DC 20213/202-376-6295.

Import Price Indexes

Quarterly indexes are available for detailed and aggregate groups covering food, intermediate manufacturing, machinery, transportation equipment, and crude materials. Product categories are based on Standard International Trade Classification. Contact: International Prices Division, Office of Prices and Living Conditions, Bureau of Labor Statistics, Department of Labor, 600 E St. N.W., Room 3302, Washington, DC 20212/202-272-5025.

Indian Programs

Unemployed, underemployed and disadvantaged Indians and other Native Americans are provided with training, public service employment and a wide range of services to enable them to support themselves and their families. Contact: Indian and Native American Programs, Employment and Training Administration, Department of Labor, 601 D St. N.W., Room 6414, Washington, DC 20213/202-376-7282.

Industrial Prices and Price Indexes

Monthly prices and indexes are available for 3,000 products by commodity line (end use), and stage of production (degree of fabrication and class of buyer). Contact: Industrial Prices and Price Indexes Division, Office of Prices and Living Conditions, Bureau of Labor Statistics, Department of Labor, 600 E St. N.W., Room 5210, Washington, DC 20212/202-272-5110.

Industry Productivity Measurement

Data are available on output per employee hour, output per employee, output, employment and employee hours. Contact: Productivity Trends in Selected Industries, Industry Productivity Studies Division, Office of Productivity and Technology, Bureau of Labor Statistics, Department of Labor, 200 Constitution Ave. N.W., Room S4320, Washington, DC 20210/202-523-9244.

Industry Wages

Data are available showing averages and distribution of straight-time earnings for representative occupations—nationwide, regional and selected areas—by size of establishment and other characteristics depending upon industry. Contact: Division of Occupational Pay and Employee Benefit Levels, Office of Wages and In-

dustrial Relations, Bureau of Labor Statistics, Department of Labor, 441 G St. N.W., Room 1283, Washington, DC 20212/202-523-1309.

Industry Work Experience Program

This program helps young people get needed experience in private business and industry. For further information, contact: Office of Job Corps and Young Adult Conservation Corps, Office of Youth Programs, Employment and Training Administration, Department of Labor, 601 D St. N.W., Room 6020, Washington, DC 20213/202-376-7163.

Information Processing at Bureau of Labor Statistics

This free publication gives a descriptive account of the evolution and application of machines and computers in the processing of Bureau of Labor Statistics. Contact: Office of Publications, Bureau of Labor Statistics, Department of Labor, 441 G St. N.W., Room 1539, Washington, DC 20212/202-523-1239.

Insured Employment Wages

Data are available showing monthly employment, total quarterly wages, taxable wages and employer contributions by state, industry and size of establishment of workmen covered by state employment insurance laws and program of unemployment compensation for federal employees. Contact: Office of Employment and Trends, Bureau of Labor Statistics, Department of Labor, 441 G St. N.W., Room 2919, Washington, DC 20212/202-523-1694.

International Comparisons of Productivity, Labor Costs, Economic Indicators and Unemployment

Comparative statistics are available on such topics as: output per employee hour, hourly compensation, unit labor costs, real gross domestic product per employed person, rates of change in consumer and wholesale prices, nominal and real earnings of wage earners, composition and level of earnings and fringe benefits, living costs and quarters allowances, number of stoppages, workers involved, and time lost from industrial disputes, levels of capital investment, and labor force employment and unemployment data. Contact: Foreign Labor Statistics and Trade Division, Office of Productivity and Technology, Bureau of Labor Statistics, Department of Labor, 200 Constitution Ave. N.W., Room S4214, Washington, DC 20210/202-523-9301.

International Comparisons of Unemployment

This publication adjusts foreign unemployment rates to U.S. concepts. It includes data on

labor force, employment, participation rates, employment population ratios, and unemployment by age and sex for the United States, Canada, Australia, Japan, France, Germany, Great Britain, Italy and Sweden. Available for $3.50 from: Superintendent of Documents, Government Printing Office, Washington, DC 20402/202-783-3238.

International Labor Programs

For general information on programs from the Bureau of International Labor Affairs, contact: Office of Management, Administration and Planning, Bureau of International Labor Affairs, Department of Labor, 200 Constitution Ave. N.W., Room S5303, Washington, DC 20210/202-523-6289.

Job Bank Openings Seminar

This monthly report provides information on job opportunities listed in the preceding month with the public employment service Job Bank System. It includes openings data for all occupational categories. The *Job Bank Frequently Listed Openings* is a monthly publication providing information on "high volume occupations" for which there is a relatively large number of job listings in the preceding month. Information is also provided on the industries requiring new workers, the numbers of openings listed in these high volume occupations, average pay and employee education and experience requirements. Contact: Division of Occupational Analysis, Office of Technical Support, Education and Training Administration, Department of Labor, 601 D St. N.W., Room 8421, Washington, DC 20213/202-376-6578.

Job Corps

This program provides basic education, vocational training, counseling, health care, and similar renewal services to help disadvantaged young men and women 16 through 21 prepare for jobs. Enrollees in Job Corps centers receive room and board, clothing for work, books, supplies, and cash allowances, part of which is paid on leaving the program after satisfactory participation. Training is given in such occupations as: heavy equipment operation, auto repair, carpentry, painting, masonry, nursing and other health care jobs, clerical and office work, and electronic assembly. Basic education includes reading, math, social studies and preparation for the high school equivalency exams. Contact: Office of Job Corps and Young Adult Conservation Corps, Office of Youth Programs, Employment and Training Administration, Department of Labor, 601 D St. N.W., Room 6020, Washington, DC 20213/202-376-7163.

Job Corps Advanced General Education Program

This published program is designed to help prepare adult students with the information, concepts and general knowledge needed to pass the American Council on Education's "Test of General Education Development" (GED) for high school equivalency certification. The program kit consists of 126 booklets and is available for $40 from: Superintendent of Documents, Government Printing Office, Washington, DC 20401/202-783-3238. For more detailed information on the program, contact: Division of Technical Assistance, Office of Job Corps and Young Adult Conservation Corps, Office of Youth Programs, Office of National Programs, Employment and Training Administration, Department of Labor, 601 D St N.W., Room 6114, Washington, DC 20213/202-376-7053.

Job Corps Statistics

Statistics cover new arrivals, terminations, and transfers by Job Corps Centers. Contact: Office of Job Corps and Young Adult Conservation Corps, Office of Youth Programs, Employment and Training Administration, Department of Labor, 601 D St. N.W., Room 6100, Washington, DC 20213/202-376-6995.

Job Discrimination

Veterans and handicapped people who are discriminated against in the job market should file complaints with the nearest state Employment Service/Job Service office. They can also file a complaint with any of the 10 regional Federal Contract Compliance Program offices, or contact: Veterans/Handicapped Worker Policy, Office of Federal Contract Compliance Programs, Employment Standards Administration, Department of Labor, 200 Constitution Ave. N.W., Room 3422, Washington, DC 20210/202-523-9410.

Job Information Service (JIS)

Job Information Service Centers are located within local employment service centers to enable job-ready applicants to conduct their own job exploration through the *Job Bank Book* and other listings of employment information and opportunities. Contact: Division of Applicant Services, Office of Program Services, Employment Service, Employment and Training Administration, Department of Labor, 601 D St. N.W., Room 8118, Washington, DC 20213/202-376-6718.

Job Requirements Studies

Information is available on job requirements for 160 industries. Contact: Office of Economic Growth, Bureau of Labor Statistics, Department

of Labor, 600 E St. N.W., Room 7106, Washington, DC 20212/202-272-5381.

Labor Force Statistics

Data are available on: a) employment and unemployment analysis on the current economic status of workers, based on data from households as well as employment, hours earnings, and labor turnover statistics collected from industrial establishments; b) labor force studies yielding information on such characteristics as educational attainment, work experience and family relationships; c) occupational employment statistics available for a wide variety of occupations, including employment outlook, nature of the work, earnings, working conditions and qualifications; d) national industry/occupational matrices current and projected; e) state and local area labor force employment and unemployment data used to identify areas of high unemployment and for allocations of funds under various federal assistance programs including CETA; and f) long-term projections of labor and employment. Contact: Bureau of Labor Statistics, Office of Employment Structure and Trends, Department of Labor, Washington, DC 20212/202-523-1694.

Labor Force Studies

Special studies are conducted on labor force topics that include: selected characteristics of workers such as marital status and family relationships, work schedules, work experience, multiple job holding, educational attainment, school enrollment and employment status of young workers; status of particular subgroups of the population (women who head families, and women with children), occupational mobility, job tenure or workers, intensity of job search and absence from work; annual, weekly and hourly earnings by detailed demographic groups; work life expectancy for men and women; and labor-market-related economic hardships. Contact: Labor Force Studies Division, Office of Current Employment Analysis, Bureau of Labor Statistics, Department of Labor, 441 G St. N.W., Room 2486, Washington, DC 20212/202-523-1821.

Labor Foreign Service Attaches

There are about 50 labor attaches in foreign service jobs who report on foreign labor developments and relate U.S. labor activities to foreign audiences. Contact: Bureau of International Labor Affairs, Department of Labor, 200 Constitution Ave. N.W., Room S5308, Washington, DC 20210/202-523-6257.

Labor Historian

For historic information, contact: Historian,

Office of Information and Public Affairs, Department of Labor, 200 Constitution Ave. N.W., Room N1501, Washington, DC 20210/202-523-6461.

Labor Library

The Department of Labor Library will provide research services, on-line computer searches, and special bibliographies on labor-related subjects. Contact: Department of Labor Library, 200 Constitution Ave. N.W., Room N2439, Washington, DC 20210/202-523-6988.

Labor-Management Disputes

Information is available about labor-management disputes and collective bargaining situations. A free publication, *Significant Collective-Bargaining Contract Expirations*, lists contract expirations for the coming year. Contact: Industrial Relations Service, Labor-Management Services Administration, Department of Labor, 200 Constitution Ave. N.W., Room N5645, Washington, DC 20210/202-523-6475.

Labor-Management Information

For general information on labor-management topics and for a list of available publications, contact: Information Office, Labor-Management Services Administration, Department of Labor, 200 Constitution Ave. N.W., Room N5637, Washington, DC 20216/202-523-7408.

Labor-Management Policy

This office provides analysis and guidance in the formulation of labor-management relations policy and legislation. It conducts research in the labor-management relations field, including the impact of public and private policies affecting labor-management relations, collective bargaining, job security, and labor-management relations in state and local government. Contact: Office of Labor-Management Policy Development, Labor Management Services Administration, Department of Labor, 200 Constitution Ave. N.W., Room N5677, Washington, DC 20210/202-523-6231.

Labor-Management Relations Services

This office provides assistance to industry, organized labor, state and local governments, and other public and private groups in developing sound labor-management relations and to aid these groups in resolving labor-management problems outside of the collective bargaining process. It also protects the interests of employees affected by projects authorized under the Urban Mass Transportation Act, the Rail Passenger Service Act, Federal Aid Highway Act, the Redwood Park Expansion Act, the Airline Deregula-

tion Act of 1978, and other statutes cited under the Authorization section of the program. Contact: Director, Office of Labor-Management Relations Services, Department of Labor, 200 Constitution Ave. N.W., Washington, DC 20216/202-523-6487.

Labor-Management Training Films

The following films are produced by the Department of Labor; *Scenes From the Workplace*, *Button . . . Button*, and *Out of Conflict . . . Accord*. They are available from: Reference Section, National Audio Visual Center, General Services Administration, Washington, DC 20409/301-763-1896.

Labor Market Information

For information on any local labor market including employment and unemployment information and characteristics of persons in the labor force; intelligence or the characteristics of occupation and jobs; or how and when to find a job, contact: Division of Labor Market Information, Office of Policy and Evaluation and Research, Office of Policy and Planning, Employment and Training Administration, Department of Labor, 601 D St. N.W., Room 9304, Washington, DC 20213/202-376-6263.

Labor Organization and Membership

Information is available on national unions, employee associations and state labor organizations giving names of key officials, number of members and related information, including membership structure and activities, geographic and industrial distributions, trends, size, women members, white-collar members, etc. Contact: Division of Developments in Labor-Management Relations, Office of Wage and Industrial Relations, Bureau of Labor Statistics, Department of Labor, 441 G St. N.W., Room 1288C, Washington, DC 20212/202-523-1858.

Labor Publications

For a listing of publications published by the Department of Labor, contact: Office of Information, Publications and Reports, Department of Labor, 200 Constitution Ave. N.W., Room S1030, Washington, DC 20210/202-523-7323.

Labor Review, Monthly

The research journal, *Monthly Labor Review*, includes analytical articles, 40 pages of current labor statistics, reports on industrial relations, court decisions, book reviews and foreign labor developments. Available for $23.00 per year from: Superintendent of Documents, Government Printing Office, Washington, DC 20402/202-783-3238.

Labor Surplus Areas

The *Area Trends in Empl[oyment and Unem]ployment* is an official list of [areas] as classified by the Depart[ment in] which employers are eligibl[e for] bidding on certain federal [contracts. Contact: Office of] Policy, Evaluation and Research, Office of Policy and Planning, Employment and Training Administration, Department of Labor, 601 D St. N.W., Room 9304, Washington, DC 20213/202-376-6263.

Labor Turnover Statistics

Labor turnover data are available for 248 manufacturing industries, 12 mining industries, and a number of communications-related industries. Contact: Office of Employment and Trends, Bureau of Labor Statistics, Department of Labor, 441 G St. N.W., Room 2919, Washington, DC 20212/202-523-1694.

Local Area Employment and Unemployment

Statistics are available for labor force employment and unemployment for states, metropolitan areas, counties, cities of 25,000 or more population, and certain additional areas. Contact: Local Area Unemployment Statistics Division, Office of Employment Structure and Trends, Bureau of Labor Statistics, Department of Labor, 441 G St. N.W., Room 2081, Washington, DC 20212/202-523-1038.

Longshore and Harbor Workers

The Longshoremen and Harbor Workers' Compensation Act provides compensation benefits to about 1 million workers disabled due to injury or an employment-related occupational disease occurring on the navigable waters of the U.S. or in adjoining shoreside areas. Contact: Division of Longshoremen and Harbor Workers' Compensation, Employment and Standards, Department of Labor, 200 Constitution Ave. N.W., Room C4315, Washington, DC 20210/202-523-8721.

Major Programs of the Bureau of Labor Statistics

This free publication describes the Bureau's principal programs and information sources. Contact: Office of Publications, Bureau of Labor Statistics, Department of Labor, 441 G St. N.W., Room 2029, Washington, DC 20212/202-523-1208.

Matching Personal and Job Characteristics

A chart shows 23 occupational characteristics and requirements which are matched with 281 occupations. The table is designed as an exploratory tool to help compare personal interests, ca-

...ities, abilities and educational qualifications with characteristics usually associated with an occupation. Contact: Division of Occupational Outlook, Office of Growth and Employment Projections, Bureau of Labor Statistics, Department of Labor, 441 G St. N.W., Room 2488, Washington, DC 20212/202-272-5382.

Migrant and Seasonal Farmworker Program

This program provides migrant and other seasonal farmworkers and their families with a wide range of services to help them find alternative job opportunities in year-round employment and to improve their living and working conditions. Services include: educational training, job referral, emergency services, residential support, self-help housing, legal services and transportation and relocation assistance. Contact: Division of Farmworker Programs, Employment and Training Administration, Department of Labor, 601 D St. N.W., Room 6308, Washington, DC 20213/202-376-6128.

Mine Health and Safety Academy, National

The primary purpose of the Academy is to design, develop and conduct instructional programs which will assist in government, industry, and labor efforts to reduce accidents and health hazards in the mineral industries. Courses cover subjects such as mandatory health and safety standards, industrial hygiene, mine emergency procedures, safety management, accident prevention techniques, etc. The Academy also provides safety manuals on such subjects as: electrical hazards, accident investigation, job safety analysis, fire safety, coal mine maps, coal mining, laboratory safety, heat stress in mining, gas detectors, and safety tips for underground coal mining. Contact: Continuing Education Department, National Mine Health and Safety Academy, P.O. Box 1166, Beckley, WV 25801/304-255-0451.

Mine Safety Information

Publications, newsletters, training films and educational materials are available on mine safety and health. Contact: Office of Information, Mine Safety and Health Administration, Department of Labor, 4015 Wilson Blvd., Room 1237A, Arlington, VA 22203/703-235-1452.

Mine Safety Training

Training courses are tailored to the specific conditions of individual mining operations. Course materials include safe mining practices, mine emergency situations, mine rescue techniques, and first aid and equipment operations. Teaching aids include training modules and miner training films. Contact: Training Policy, Plans and Planning Division, Education and Training,

Mine Safety and Health Administration, Department of Labor, 4015 Wilson Blvd., Room 538, Arlington, VA 22203/703-235-1400.

Minimum Wage Exemption

Special certificates allow employers to pay less than the minimum wage to certain groups of workers, e.g., student learners, full-time students and handicapped workers. Contact: Special Minimum Wages Division, Wage and Hour Division, Employment Standards Administration, Department of Labor, 200 Constitution Ave. N.W., Room C4316, Washington, DC 20210/202-523-8727.

Mining Machinery

The office of management research and technology approves new equipment technology, makes assessments and provides technical improvements for safe design of mining machinery, roof control and ventilation systems, mine waste facilities, and instruments used for measuring dust, noise, radiation and other health hazards. Contact: Office of Information, Mine Safety and Health Administration, Department of Labor, 4015 Wilson Blvd., Room 1237A, Arlington, VA 22203/703-235-1452.

Municipal Government Occupational Surveys

Data are available showing averages and distributions of salary rates for professional, administrative, technical, clerical, data processing, skilled maintenance, custodial, protective service, sanitation and social work occupations. Information is also available on selected work practices and supplementary benefits. Contact: Wage Studies, Division of Occupational Pay and Employee Benefit Levels, Office of Wages and Industrial Relations, Bureau of Labor Statistics, Department of Labor, 441 G St. N.W., Room 1283, Washington, DC 20212/202-523-1268.

National Industry Promotion

This office provides for the formulation and promotion of labor standards necessary to safeguard the welfare of apprentices, for bringing together employers and labor to set up programs of apprenticeship, and for providing equal employment opportunities in apprenticeship to minority groups and women. Contact: Office of National Industry Promotion, Bureau of Apprenticeship and Training, Employment and Training Administration, Department of Labor, 601 D St. N.W., Room 5414, Washington, DC 20213/202-376-6217.

National Longitudinal Surveys

These surveys study the relationship of factors influencing the labor force behavior and work ex-

perience of four groups: men age 45 to 59 and 14 to 24, and women 30 to 44 and 14 to 24. The surveys focus on the interaction among economic, sociologic and psychologic variables that permit some members of a given age-education-occupation group to have satisfactory work experience while others do not. Contact: National Longitudinal Surveys, Office of Research and Development, Office of Policy Evaluation and Research, Employment and Training Administration, Department of Labor, 601 D St. N.W., Room 9028, Washington, DC 20213/202-376-7346.

National Occupational Projections

This large matrix shows distribution of employment by occupation and industry for 470 occupations and occupation groups and 200 industries. It includes projections on job openings by occupation and is used to analyze industry and technologic trends, to evaluate national training policies and for market research. Contact: Office of Economic Growth, Bureau of Labor Statistics, Department of Labor, 600 E St. N.W., Room 7216, Washington, DC 20212/202-272-5383.

National-State-Industry-Occupational Matrix System

The distribution of employment is shown in these matrices which include data on 470 occupations in 260 industries. Matrices for over 1500 occupations in 300 industries provide local information for 27 states. Contact: Office of Economic Growth, Bureau of Labor Statistics, Department of Labor, 600 E St. N.W., Room 7905, Washington, DC 20212/202-272-5279.

Occupational Employment Statistics

For statistics on employment by occupation and industry, contact: Occupational Outlook Division, Office of Employment Structure and Trends, Bureau of Labor Statistics, Department of Labor 441 G St. N.W., Room 2913A, Washington, DC 20212/202-523-1221.

Occupational Injuries and Illnesses

Data are available showing incidence rates by industry, including number of fatal and nonfatal cases without lost workdays, and illness by category of illness. Data are also available showing nature of injury or illness, part of body affected, source of injury or illness, event or exposures which produced the injury or illness, and industry and characteristics of injured or ill workers. Contact: Office of Occupational Safety and Health Statistics, Bureau of Labor Statistics, Department of Labor, 200 Constitution Ave. N.W., Room E4311, Washington, DC 20210/202-523-9271.

Occupational Injuries and Illnesses Surveys

Data are available on occupational injuries, fatalities, illnesses, and on lost work time. Contact: Period Surveys Division, Office of Occupational Safety and Health Statistics, Department of Labor, 200 Constitution Ave. N.W., Room C4311, Washington, DC 20210/202-523-9275.

Occupational Outlook Handbook

This publication shows employment outlook, location of jobs, earnings, nature of the work, training, entry requirements, advancement and working conditions for each occupation, and employment outlook, location, principal occupations, earnings, nature of the industry, training, entry requirements, advancement and working conditions for each industry. It covers several hundred occupations and 35 major industries. Available for $9.00. *Occupational Outlook for College Graduates* provides information for more than 100 jobs for which an education beyond high school is necessary or useful. Available for $7.00 from: Superintendent of Documents, Government Printing Office, Washington, DC 20402/202-783-3238. For more detailed information on content, contact: Office of Economic Growth, Bureau of Labor Statistics, Department of Labor, 441 G St. N.W., Room 4860, Washington, DC 20212/202-523-1450.

Occupational Outlook Quarterly

This publication is designed to help high school students and guidance counselors assess career opportunities. It provides information on several hundred occupations and 35 industries. Available for $8.00. *Job Outlook In Brief* is a companion publication that allows you to compare job prospects. Available for $1.75 from: Superintendent of Documents, Government Printing Office, Washington, DC 20402/202-783-3238.

Occupational Projections and Training Data

This publication shows estimated average annual openings and a summary of available statistics on the number of people completing training in each field for each of several hundred white-collar, blue-collar and service jobs. It also discusses long-term employment prospects for college graduates. Available for $5.50 from: Superintendent of Documents, Government Printing Office, Washington, DC 20402/202-783-3238.

Occupational Safety and Health Subscription Service

This service provides all standards, interpretations, regulations and procedures in easy-to-read

loose-leaf form. All changes and additions will be issued for an indefinite period of time. Individual volumes are available at the following rates:

General Industry Standards and Interpretations ($66.00)
Maritime Standards and Interpretations ($8.25)
Construction Standards and Interpretations ($21.00)
Other Regulations and Procedures ($26.00)
Fuel Operations Manual ($21.00)
Industrial Hygiene Field Operation Manual ($31.00)

Available from: Superintendent of Documents, Government Printing Office, Washington, DC 20402/202-783-3238.

Occupational Titles

The *Dictionary of Occupational Titles* lists over 20,000 job definitions that match job requirements to worker skills. It contains occupation classifications for nearly all jobs in the U.S. economy. Available for $13.00 from Superintendent of Documents, Government Printing Office, Washington, DC 20402/202-783-3238. For more detailed information, contact: Division of Occupational Analysis, Office of Technical Support, Employment Service, Employment and Training Administration, Department of Labor, 601 D St. N.W., Room 8430, Washington, DC 20213/202-376-6293.

Occupations in Demand
This monthly publication provides the job seeker with a summary of available jobs in newspaper format. Two extra editions are published in the spring and fall for students and recent graduates. It also includes job search tips. Available for $18.00 per year from Superintendent of Documents, Government Printing Office, Washington, DC 20402/202-783-3238.

Occupations, Selected Characteristics

Selected Characteristics of Occupations Defined in the Dictionary of Occupational Titles (DOT) provides additional information about jobs in the DOT such as physical demands, working conditions and specific vocational preparation. Available for $9.50 from Superintendent of Documents, Government Printing Office, Washington, DC 20402/202-783-3238. For more detailed information on content, contact: Division of Occupational Analysis, Employment Service, Employment and Training Administration, Department of Labor, Washington, DC 20213/202-376-6292.

Older Workers Program

The Senior Community Service Employment Program (SCSEP) employs economically disadvantaged people 55 years or older in part-time community service jobs. Contact: Older Worker Work Group, Office of National Programs for Older Workers, Employment and Training Administration, Department of Labor, 601 D St. N.W., Room 6122, Washington, DC 20213/202-376-6232.

OSHA Area Offices—Reporting

An on-the-job accident should be reported within 48 hours to the nearest OSHA office if five or more employees required hospitalization or if one of them dies. A complaint should also be lodged if a worker loses his or her job for reporting a safety or health hazard. *Hazard Alerts* and *Intelligence Reports* are published as needed. For information and for a listing of area offices, contact: Office of Field Coordination and Experimental Programs, Occupational Safety and Health Administration, Department of Labor, 200 Constitution Ave. N.W., Room N3603, Washington, DC 20210/202-523-7725.

OSHA Analytical Laboratory

Samples taken in the field by OSHA staff undergo chemical analysis at Occupational Safety and Health Administration, Salt Lake City Laboratory, 390 Wakara Way, P.O. Box 8137, Salt Lake City, Utah 84108/801-524-5287.

OSHA Cincinnati Laboratory

This laboratory calibrates and tests the technical monitoring equipment used by the OSHA compliance staff. Contact: OSHA Cincinnati Laboratory, U.S. Post Office Building, Room 108, Fifth and Walnut Sts., Cincinnati, OH 45202/513-684-3721.

OSHA Consumer Affairs

The Division of Consumer Affairs is responsible for: 1) managing two advisory committees—National Advisory Committee on Occupational Safety and Health, and National Advisory Committee on Construction Safety and Health; 2) managing all hearings on proposed standards and public factfinding meetings; and 3) publishing a calendar of events announcing hearings and meetings. Contact: Office of Information and Consumer Affairs, Division of Consumer Affairs, Occupational Safety and Health Administration (OSHA), Department of Labor, 200 Constitution Ave. N.W., Room N3635, Washington, DC 20210/202-523-8024.

OSHA Inspection Data

Data are available on what companies were inspected, when, where, type of complaint, stan-

dards violated (if any), proposed penalties, violations contested, enforcement information, incidents incurred (warrants needed), referrals to health experts, who has been trained, what type of training, etc. Contact: Office of Management Data Systems, Directorate of Administrative Programs, Occupational Safety and Health Administration, Department of Labor, 2100 M St. N.W., Room 156, Washington, DC 20210/202-653-5500.

OSHA News and Information

For general information on OSHA programs and developments, contact: Division of News Media Service, Office of Information and Consumer Affairs, Occupational Safety and Health Administration, Department of Labor, 200 Constitution Ave. N.W., Room N3637, Washington, DC 20210/202-523-8151.

OSHA Onsite Consultation

Free consultation on safety and health programs is available to those employers who cannot afford a private consultant. Through these programs, hazardous work conditions can be identified and corrected by the employer. For a free 12-page book listing the offices in each state which offer the service, contact: OSHA Publications Distribution, Office of Administration Services, Occupational Safety and Health Administration, Department of Labor, 200 Constitution Ave. N.W., Room S1212, Washington, DC 20210/202-523-6138.

OSHA Petitions

Employers or employees can petition OSHA for the development of standards as well as for their modification or revocation. Contact: Office of the Assistant Secretary, Occupational Safety and Health Administration, Department of Labor, 200 Constitution Ave. N.W., Room S2315, Washington, DC 20210/202-523-9362.

OSHA Publications and Training Materials

For a complete listing of materials published by OSHA, contact: OSHA Publications Distribution Office, Occupational Safety and Health Administration, Department of Labor, 200 Constitution Ave. N.W., Room S1212, Washington, DC 20210/202-523-6138.

OSHA Regulatory Analysis

Information and analysis are available on issues surrounding major standards such as those for cotton, dust, benzine, and carcinogens. Contact: Office of Regulatory Analysis, Directorate of Technical Support, Occupational Safety and Health Administration, Department of Labor, 200 Constitution Ave. N.W., Room N3657, Washington, DC 20210/202-523-7056.

OSHA Scientific and Engineering Support

The Directorate of Technical Support provides scientific and engineering support for OSHA's standard-setting and compliance operations. It works on such projects as the health hazards associated with the petro-chemical industry and the hazards of low-level radiation at abandoned radium processing facilities. Contact: Directorate of Technical Support, Occupational Safety and Health Administration, Department of Labor, 200 Constitution Ave. N.W., Room N3651, Washington, DC 20210/202-523-7031.

OSHA Standards for Physical Agents

For information on standards for radiation, noise, heat, vibration and ultra and infra sounds, contact: Office of Physical Agents, Directorate of Health Standards Program, Occupational Safety and Health Administration, Department of Labor, 200 Constitution Ave. N.W., Room N3669, Washington, DC 20210/202-523-7157.

OSHA Statistical Studies

Studies are made on occupational safety and health statistics data from a variety of public and private sources. Data studies determine the areas that OSHA should inspect, and evaluate whether OSHA has had any impact. Available reports include:

Occupational Fatalities Related to Ladders
Occupational Fatalities Related to Scaffolds
Occupational Fatalities Related to Roofs, Ceilings and Floors
Occupational Fatalities Related to Fixed Machinery

Contact: Office of Statistical Studies, Directorate of Technical Support, Occupational Safety and Health Administration, Department of Labor, 200 Constitution Ave. N.W., Room N3662, Washington, DC 20210/202-523-7177.

OSHA Technical Data

Technical data are available on all of OSHA's projects from Technical Data Center, Directorate of Technical Support, Occupational Safety and Health Administration, Department of Labor, 200 Constitution Ave. N.W., Room N2439 Rear, Washington, DC 20210/202-523-9694.

OSHA Technical Laboratory

Technical monitoring equipment used by the OSHA Compliance staff is calibrated and tested at: Occupational Safety and Health Administra-

tion, Cincinnati Laboratory, U.S. Post Office Building, Room 108, Fifth and Walnut Sts., Cincinnati, OH 45202/513-684-3721.

OSHA Training Institute

Courses at the Institute are designed to enable OSHA's compliance safety and health officers to learn how to deal with actual workplace situations. Many courses are also open to non-OSHA employees. Contact: OSHA Training Institute, Occupational Safety and Health Administration, Department of Labor, 1555 Times Dr., Des Plaines, IL 60018/312-297-4810.

Pension and Welfare Studies

Research studies include: Multi-Employer Pension Plans, Study of Pension Plan Costs, Reciprocity and Single Employers Plans, Study of National Health Insurance Proposals on Collective Bargaining, Study on the Provisions and Benefits Provided by Health Plans, Study on Encouraging Growth of Health Plans, Pension Plans and Health Plan Coverage, Women and Pensions, Empirical Study of the Effects of Pensions on Savings and Labor, and Supply Decisions of Older Men. Contact: Office of Policy Planning and Research, Pension and Welfare Benefit Programs, Labor-Management Services Administration, Department of Labor, 200 Constitution Ave. N.W., Room S4220, Washington, DC 20216/202-523-9421.

Pension Plan Publications

The following publications and audiovisual materials are free:

What You Should Know About the Pension and Welfare Law (Also available in Spanish)
How to File a Claim for Your Benefit
Often Asked Questions About the Employee Retirement Income Security Act
Fiduciary Standards Under the Employee Retirement Income Security Act
Coverage Under the Employee Retirement Income Security Act
ERISA Report to Congress 1977
U.S. Department of Labor Program Highlights (ERISA)
Reporting and Disclosure Guide for Employee Benefit Plans
Know Your Pension Plan
ERISA—General Information About the Employee Retirement Income Security Act of 1974
Identification Numbers Under ERISA
Informacion General De ERISA
Eligibilidad para la Participacion en el Plan de Pensiones
Derechos Inalienables a los Beneficios de Pensiones
Contando anos de Servicios en los Planes de Pensiones
Proteccion Contra la Interrupcion en el Servicio

You and ERISA—a 20-minute presentation designed to help plan participants understand their basic rights under ERISA
This Is ERISA—a 20-minute overview of the Act designed for plan administrators and practitioners
The SPD and You—an 11-minute presentation describing the procedures for preparing summary plan descriptions
How to Fill Out the 5500 Annual Report for Small Plans—a 28-minute presentation designed as an aid in helping administrators of small plans complete their annual report as required under ERISA (available only in slide-sound set).

Contact: Information and Publications, Pension and Welfare Benefit Programs, Department of Labor, Labor-Management Services Administration, 200 Constitution Ave. N.W., Room N5471, Washington, DC 20210/202-523-8921.

Pension Plan Reporting and Standards

This office provides expertise and research for interpretations and opinions regarding collective bargaining standards and reporting on disclosure standards. Contact: Office of Reporting and Plan Standards, Pension and Welfare Benefit Programs, Labor and Management Relations, Department of Labor, 200 Constitution Ave. N.W., Room N4461, Washington, DC 20210/202-523-8474.

Pension Plans—Reports

The Employee Retirement Income Security Act (ERISA) is administered by the Labor-Management Services Administration. Every plan covered by ERISA must give each participant a written summary describing in simple language the plan's eligibility requirements, its benefits, and how to file claims for benefits. Each participant must also be given an annual report on the plan's financial activities. A copy of each plan's summary description and annual reports must be filed with the Labor-Management Services Administration. Copies are available from: Disclosure Room, Office of Reports and Disclosure, Pension and Welfare Benefit Programs, Labor Management Services Administration, Department of Labor, 200 Constitution Ave. N.W., Room 4667, Washington, DC 20216/202-523-8771.

Price and Index Number Studies

In-depth research is conducted on various aspects of price measurements such as adjustment for quality change and cost-of-living indexes. Contact: Prices and Index Number Research Division, Office of Prices and Living Conditions, Bureau of Labor Statistics, Department of Labor,

600 E St. N.W., Room 3211, Washington, DC 20212/202-272-5096.

Prices and Living Conditions

Programs provide information on Consumer Prices Indexes, Producer Price Indexes, Export and Import Price Indexes, as well as for retail prices in primary markets, consumer expenditures, income, assets, and liabilities of all U.S. families, and hypothetical budgets at three levels of living in selected areas. Contact: Office of Prices and Living Conditions, Bureau of Labor Statistics, Department of Labor, 600 E St. N.W., Room 3205, Washington, DC 20212/202-272-5038.

Private Pension and Welfare Plans Information

For general information and referrals on topics related to private pension and welfare plans, contact: Office of Communications and Public Services, Pension and Welfare Benefit Programs, Labor-Management Services Administration, Department of Labor, 200 Constitution Ave. N.W., Room N5459, Washington, DC 20216/202-523-8776.

Private Sector CETA Programs

The Comprehensive Employment and Training Administration program has a variety of services through which employers can receive substantial reimbursement for the cost of training workers. Contact: Private Sector Initiatives, Office of Community Employment Programs, Employment and Training Administration, Department of Labor, 601 D St. N.W., Room 5404, Washington, DC 20213/202-376-7633.

Private Sector Initiative Program (PSIP)

This program allows employers to receive tax reductions in the federal income tax liabilities by selecting their employees from specified groups of youth, minorities and other disadvantaged workers. Free publications explaining the program include:

Federal Hiring Incentives—New Ways to Hold Down Taxes and Training Costs
An Instructional Handbook for the Targeted Job Tax Credit Program
Targeted Jobs Tax Credit and WIN Credit

Contact: Division of Public Sector Initiatives, Office of Comprehensive Employment Development, Employment and Training Administration, Department of Labor, 601 D St. N.W., Room 5328, Washington, DC 20213/202-376-7633.

Private Sector Productivity

Quarterly and annual data are available showing percent changes for labor productivity, unit labor cost, real and current dollar compensation per hour and unit labor and nonlabor payments. Contact: Productivity Research Division, Office of Productivity and Technology, Bureau of Labor Statistics, Department of Labor, Washington, DC 20212/202-523-9261.

Producer Prices and Price Indexes

This is a comprehensive monthly report on primary market price movements of both farm and industrial commodities by industry and stage of processing. Available for $20 a year from Superintendent of Documents, Government Printing Office, Washington, DC 20402/202-783-3238. For detailed information on content, contact: Office of Prices and Living Conditions, Bureau of Labor Statistics, Department of Labor, 600 E St. N.W., Room 5210, Washington, DC 20212/202-272-5113.

Productivity and Technology

This office is involved with the following: measuring productivity trends in the economy, major sector, individual industries, and the federal government; providing relevant international comparisons as well as studies of changing labor materials requirements in major types of construction; investigating the nature and the effect of technology change within industries and across industry lines. Contact: Office of Productivity and Technology, Bureau of Labor Statistics, Department of Labor, 200 Constitution Ave. N.W., Room S4325, Washington, DC 20210/202-523-9294.

Productivity Indexes for Selected Industries

This publication provides data on output per employee hour for over 50 industries. Available for $7.50 from: Superintendent of Documents, Government Printing Office, Washington, DC 20402/202-783-3238.

Productivity in Federal Government

Annual indexes show output per employee year, unit labor costs, compensation per employee year, and output and employee years for various functional areas within the federal sector. Contact: Industry Productivity Studies Division, Office of Productivity and Technology, Bureau of Labor Statistics, Department of Labor, 200 Constitution Ave. N.W., Room S4320, Washington, DC 20210/202-523-9244.

Profiles of Occupational Pay

This publication presents a look at pay rela-

tionships within major occupational groups, including profiles of high and low paying metropolitan areas and of high and low paying manufacturing industries. Available for $4.00 from: Office of Publications, Bureau of Labor Statistics, Department of Labor, 441 G St. N.W., Room 2029, Washington, DC 20212/202-523-1239.

Private Sector Initiative Program (PSIP) Clearinghouse

Information services are available on various aspects of the Private Sector Initiative Program (PSIP), including newsletters, bimonthly packets of instructional material, and free publications. Contact: PSIP Clearinghouse, 1015 15th St. N.W., Washington, DC 20005/202-457-0040.

Public Service Employment Programs

Programs of public service employment are funded through block grants and are operated by prime sponsors consisting of all states and cities, counties, and combinations of local units. Contact: Office of Comprehensive Employment Development, Employment and Training Administration, Department of Labor, Room 5402, 601 D St. N.W., Washington, DC 20213/202-376-6366.

Regulatory Activities

Listed below are those organizations within the Department of Labor which are involved with regulating various activities. With each listing is a description of those industries or situations which are regulated by the office. Regulatory activities generate large amounts of information on the companies and subjects they regulate. Much of the information is available to the public. A regulatory office can also tell you your rights when dealing with a regulated company.

Labor-Management Services Administration, Department of Labor, 200 Constitution Ave. N.W., Room 5637, Washington, DC 20210/202-523-7408. Regulates activities of labor unions and private pension and welfare plans.

Office of Information and Consumer Affairs, Employment Standards Administration, Department of Labor, 200 Constitution Ave. N.W., Washington, DC 20210/202-523-8743. Administers minimum wage and overtime standards, farm labor contractors, wage rates paid on government contracts, nondiscrimination and affirmative action on government contracts, and worker compensation programs.

Office of Information, Mine Safety and Health Administration, 4015 Wilson Blvd., Arlington, VA 22203/703-235-1452. Regulates health and safety standards in coal, metal, and other mining.

Office of Information, Occupational Safety and Health Administration, Department of Labor, 3rd St. and Constitution Ave. N.W., Washington, DC 20210/202-523-8148. Regulates safety and health activities at the place of employment for private employers.

Rural Employment and Training Service

Through a network of state employment service offices, a wide range of services is offered to help rural workers find jobs and employers meet their personnel needs. The job bank system gives information about openings in all parts of the state. In some states, Agricultural Labor Information Centers supply farm workers with current information about seasonal farm jobs such as crop location and conditions, job opportunities, approximate date and duration of employment, wages and general working conditions. Contact: Rural Employment and Training Services, Office of National Programs, Office of Farm Worker and Rural Employment Programs, Employment and Training Administration, Department of Labor, 601 D St. N.W., Room 6318, Washington, DC 20213/202-376-6128.

Safety Standards

For information on OSHA safety standards requirements in general industry, maritime, construction or agriculture, contact: Directorate of Safety Standards Program, Occupational Safety and Health Administration, Department of Labor, 200 Constitution Ave. N.W., Room N3605, Washington, DC 20210/202-523-8061.

State and Area Employment Projections

Information is available on current and historic occupational employment estimates, industry and occupation employment projections, and job openings resulting from economic growth and replacement needs for states as a whole and for labor market areas with populations of 50,000 or more. Contact: Office of Economic Growth, Bureau of Labor Statistics, Department of Labor, 600 E St. N.W., Room 7216, Washington, DC 20212/202-272-5283.

Statistical Data Tapes

Bureau of Labor Statistics Data Bank Files and Statistical Routines is a free publication which provides detailed information on available data files. Subject areas include: labor force; industry employment, hours, and earnings—national; industry employment, hours, and earnings—state and area; industry employment and wages (covered by unemployment insurance laws); unemployment and labor force—state and area;

industry labor turnover—national; consumer price index; wholesale price index; industry price index; export and import price index; imports; productivity and cost measures; productivity—industry and federal government; international labor and price trend comparisons; and employment cost index. Contact: Data Tapes, Office of Systems and Standards, Bureau of Labor Statistics, Department of Labor, 441 G St. N.W., Room 2045, Washington, DC 20212/202-523-1975.

Statistical Software Programs

The Bureau of Labor Statistics has developed several statistics programs that are for sale to users who have machine processing capabilities. They include: multiple regression programs, seasonal adjustment programs, and table producing language. Contact: Systems Design Division, Office of Systems and Standards, Bureau of Labor Statistics, Department of Labor, 441 G St. N.W., Room 2045, Washington, DC 20212/202-523-1042.

Status of Women, Commissions on the

This office contains information on all commissions organized to improve the status of women. It also acts as liaison for the Department of Labor with the various federal, state, county, or city commissions on women. Contact: Commissions on the Status of Women, Women's Bureau, Department of Labor, 200 Constitution Ave. N.W., Room S3319, Washington, DC 20210/202-523-6631.

Summer Job Tips

Tips on How to Find a Summer Job, along with *A Guide for Young People on How to Get a Job*, are free from: Employment Service, Employment and Training Administration, Department of Labor, 601 D St. N.W., Room 8000, Washington, DC 20213/202-376-6289.

Summer Youth Employment Program

This program provides jobs for young people from low-income families. Contact: Office of Youth Programs, Education and Training Administration, Department of Labor, 601 D St. N.W., Room 7208, Washington, DC 20210/202-376-7079.

Technical Research

Research is conducted on such topics as occupationally related pulmonary and respiratory diseases, youth employment problems, and job loss through plant shut-downs or extensive lay-offs due to government trade, economic, and regulatory policies. Contact: Office of Technical Sup-

port, Policy Evaluation and Research, Department of Labor, 200 Constitution Ave. N.W., Room S2121, Washington, DC 20210/202-523-6075.

Technological Trends

Analyses are made of major impending changes in products, materials, and production methods in selected industries, their effect on output, productivity, employment, skill levels, training, and occupation requirements. Contact: Division of Technological Studies, Office of Productivity and Technology, Bureau of Labor Statistics, Department of Labor, 200 Constitution Ave. N.W., Room S4325, Washington, DC 20210/202-523-9219.

Testing Division

This office develops tests used by the state employment agencies to screen for specific jobs on behalf of the employer and for counseling purposes. The tests include: General Aptitude Test Batteries; Nonreading Aptitude Test Batteries; Specific Aptitude Test Batteries; Clerical Skills Test; Basic Occupational Literacy Test; Pretesting Orientation Techniques; Jewish Employment and Vocational Service Work Sample Assessment Interest Check List. Contact: Division of Testing, Office of Technical Support, Employment Service, Employment and Training Administration, Department of Labor, 601 D St. N.W., Room 8402, Washington, DC 20213/202-376-7515.

Toxic Substances

For information on toxic and hazardous substances such as air contaminants and asbestos, contact: Office of Toxic Substances, Directorate of Health Standards Programs, Occupational Safety and Health Administration, Department of Labor, 200 Constitution Ave. N.W., Room 3718, Washington, DC 20210/202-523-7148.

Trade and Employment Statistics

Information is available on import values and quantities by Trade Schedule United States Annotated (TUSA) number and Standard Industrial Classification (SIC) codes. Information is also available on the ratio of imports to new supply (domestic shipments plus imports), ratio of exports to product shipments, and employment tabulations by SIC industry and industry group. Contact: Office Productivity and Technology, Bureau of Labor Statistics, Department of Labor, 200 Constitution Ave. N.W., Room S4325, Washington, DC 20210/202-523-9294.

Training International Visitors

Each year over 1,000 international visitors par-

ticipate in customized training programs on such topics as manpower assessment and planning, industrial psychology and industrial economics. Contact: International Visitor Program, Bureau of International Labor Affairs, Department of Labor, 200 Constitution Ave. N.W., Room S5325, Washington, DC 20210/202-523-6284.

Unemployment Compensation, Federal Advisory Council

This advisory body is made up of five employers, five employees, and five members of the general public to study, review and advise the Secretary of unemployment insurance issues. They meet, by law, at least twice a year and issue reports on their meetings. Contact: Federal Advisory Council on Unemployment Compensation, Unemployment Insurance Services, Employment and Training Administration, Department of Labor, 601 D St. N.W., Room 7000, Washington, DC 20213/202-376-7032.

Unemployment Compensation, National Commission on

This office has disbanded, but in 1980 it completed a report covering a comprehensive review of the unemployment compensation system since its creation in 1935. Contact: Unemployment Insurance Service, Employment and Training Administration, Department of Labor, 601 D St. N.W., Room 7376, Washington, DC 20213/202-376-7122.

Unemployment Insurance Laws, Comparison of State

This semi-annual review includes information on eligibility, administration, temporary disability insurance, federal training allowances, benefits, taxes, etc. Contact: Unemployment Insurance Service, Employment and Training Administration, Department of Labor, 601 D St. N.W., Room 7030, Washington, DC 20213/202-376-7120.

Unemployment Insurance Programs

This program provides temporary income as partial compensation to unemployed workers. The programs are administered jointly by the Employment and Training Administration and the individual states. Contact: Unemployment Insurance Programs, Policy and Legislation, Unemployment Insurance Service, Employment and Training Administration, Department of Labor, 601 D St. N.W., Room 7310, Washington, DC 20213/202-376-7123.

Unemployment Insurance Statistics

This monthly report provides data that are collected and reported under the unemployment insurance programs. Data include initial claims, average weekly insured unemployment, weeks compensated, first payments, etc. Additional data may be received from state agencies. Contact: Actuarial Services Division, Office of Research, Legislation and Program Policies, Unemployed Insurance Service, Employment and Training Administration, Department of Labor, 601 D St. N.W., Room 7410, Washington, DC 20213/202-376-7231.

Unemployment Research

The Research Services Division publishes *Unemployment Research Exchange*, which is a semi-annual publication containing a wide variety of research information, including announcements of reports, meetings, and personal actions, research data and information sources, and review of books and studies. A library is maintained containing copies of research studies related to unemployment. A data base is also maintained at the state and national levels for unemployment insurance research management information and reporting. Contact: Division of Research Services, Office of Research, Legislation and Program Policies, Unemployment Insurance Service, Employment and Training Administration, Department of Labor, 601 D St. N.W., Room 7402, Washington, DC 20213/202-376-6162.

Union Constitution Provisions

Analyses are made of selected union constitution provisions showing their prevalence, nature and characteristics. Contact: Industrial Relations Division, Office of Wage and Industrial Relations, Bureau of Labor Statistics, Department of Labor, 441 G St. N.W., Room 1283, Washington, DC 20212/202-523-1320.

Unions, Information on

Reports filed by unions, employers and labor relations consultants are open to the public. Unions must file copies of their constitutions and by-laws, annual financial reports and certain other information. Union officers and employees must report any payments from employers other than regular wages or other regular payments and employers must report making the payments. Employers must report any expenditures made to interfere with or restrain the right of employees to form a union or bargain collectively. Employers must file reports if they make any agreements with labor relations consultants or other independent contractors to persuade employees not to join a union or exercise their collective bargaining rights or any agreements to obtain certain information about employees' union activities. Labor relations consultants must file reports if they make such agreements with employers. For

information on this documentation, contact: Disclosure Room, Reports and Disclosure Division, Office of Labor-Management Standards Enforcement, Labor-Management Services Administration, Department of Labor, 200 Constitution Ave. N.W., Room N5616, Washington, DC 20210/202-523-7393.

Union Wage Rates and Benefits

Data are available showing averages and distributions of union wage rates and hours by industry, trade and region by city, as well as employer contributions to selected funds. Contact: Wage Studies, Division of Occupational Pay and Employee Benefit Levels, Office of Wages and Industrial Relations, Bureau of Labor Statistics, Department of Labor, 441 G. St. N.W., Room 1283, Washington, DC 20212/202-523-1309.

Veterans' Employment Programs

The following programs are aimed at veterans:

Disabled Veterans Outreach Program—staff works with the Veterans Administration, veterans' organizations and other groups primarily to find disabled and Vietnam-era veterans in need of job services.
Reemployment Rights—helps qualified veterans obtain their legal rights to return to their former employer with the position and benefits they would have attained had they not been in military service.
CETA Job Training and Work Experience—veterans who are unemployed and economically disadvantaged are eligible for on-the-job training and public service employment with pay under Comprehensive Employment and Training Administration (CETA) programs.
Job Placements—local employment Service/Job Service offices offer a variety of assistance to veterans, including counseling, aptitude testing, and referrals to training and jobs.

Contact: Assistant Secretary for Veterans' Employment, Employment and Training Administration, Department of Labor, 200 Constitution Ave. N.W., Room 10008, Washington, DC 20210/202-523-9116.

Veterans Preference Indicators

Quantitative indicators tell how well state aid is serving veterans. The assessment of state programs is made on a quarterly basis. Contact: Division of Data and Cost Analysis, Office of Program Review, Employment Service, Employment and Training Administration, Department of Labor, 601 D St. N.W., Room 8208, Washington, DC 20213/202-376-6856.

Veterans' Reemployment Rights

Federal law gives reemployment rights to people who leave their jobs to enter the military service or to train with National Guard or military reserve units. These rights also apply to people who leave their jobs to enter military service but are rejected. Assistance is available to help veterans exercise these rights. Complaints are investigated and problems are referred to the Department of Justice. Contact: Office of Veterans' Reemployment Rights, Labor-Management Services Administration, Department of Labor, 200 Constitution Ave. N.W., Room N5414, Washington, DC 20210/202-523-8611 or 376-6755.

Wage and Hour Enforcement

The Wage and House Division administers and enforces the law with respect to private employment, state and local government, federal employees of the Library of Congress, U.S. Postal Service, Postal Rate Commission and the Tennessee Valley Authority. It has the authority to conduct investigations and gather data on wages, hours and other employment conditions, as well as supervise the payment of back wages. Contact: Division of Fair Labor Standards Policy and Procedure, Office of Fair Labor Standards, Wage and Hour Division, Employment Standards Administration, Department of Labor, 200 Constitution Ave. N.W., Room S3018, Washington, DC 20210/202-523-7474.

Wage Indexes

National and some regional and city wage indexes are available for: selected occupation groups of public employees such as teachers, police, firefighters, federal employees, and refuse collectors; clerical and electronic data processing workers, and industrial workers; and production and nonsupervisory workers' hourly earnings excluding the effects of overtime. Contact: Trends in Employee Compensation Division, Office of Wages and Industrial Relations, Bureau of Labor Statistics, Department of Labor, 441 G St. N.W., Room 4061F, Washington, DC 20212/202-523-1382.

Wages and Industrial Relations Data

This program provides for: a) wages studies made for selected occupations in about 300 areas and about 16 industries annually; b) studies of the level of employee benefits such as various types of leave, holidays, insurance and retirement; c) wage trend studies, summarizing wage changes in major industries; and d) industrial relations studies providing collective bargaining agreement analysis, information on work stoppages, and labor union directors. Contact: Bureau of Labor Statistics, Office of Wages and Industrial Relations, Department of Labor, Washington, DC 20212/202-523-1382.

Wage Surveys

The following occupational wage surveys are conducted: area surveys; industry surveys; national white-collar salary survey; union wage survey; and municipal government workers' survey. These surveys are meant to measure trends in employee compensation. Contact: Office of Wages and Industrial Relations, Bureau of Labor Statistics, Department of Labor, 441 G St. N.W., Room 4057, Washington, DC 20212/202-523-1382.

Where to Find BLS Statistics on Women

The Bureau of Labor Statistics (BLS) publishes a great variety of statistics on women. It covers the labor force status, employment and unemployment, earnings and hours of work, education, membership in labor organizations and the occupational injuries and illnesses of women. It can also generate special data on the labor force and other socioeconomic variables concerning women. This report describes the publications available and how to obtain them. Contact: Bureau of Labor Statistics Regional Offices or Office of Publications, Bureau of Labor Statistics, Department of Labor, 441 G St. N.W., Room 1539, Washington, DC 20212/202-523-1239 or 523-1221.

White-Collar Salary

Data are available showing averages and distribution of salary rates for about 90 professional, administrative, technical and clerical work levels. Contact: Wage Studies, Occupational Wage Structures Division, Office of Wages and Industrial Relations, Bureau of Labor Statistics, Department of Labor, 441 G St. N.W., Room 4077B, Washington, DC 20212/202-523-1246.

Who Are the Unemployed?

This publication presents 31 charts covering characteristics of the unemployed by race, education, family, marital status, and occupation. Available for $2.75 from: Superintendent of Documents, Government Printing Office, Washington, DC 20402/202-783-3238.

Women in the Work Force Statistics

Statistics are compiled on a monthly and annual basis on women in the labor force, e.g., female heads of households, earnings gap, minority women workers, and mature women workers. Contact: Economic Status and Opportunities Branch, Women's Bureau, Department of Labor, 200 Constitution Ave. N.W., Room S3305, Washington, DC 20210/202-523-6635.

Women's Bureau

The Women's Bureau promotes a variety of programs for women to improve their chances for employment, better pay and higher status. Programs include, helping minority women, displaced homemakers, teen-age mothers, American Indian women, women offenders, union women, apprenticeship in nontraditional jobs, and child care facilities. The Bureau also maintains a Resource Center which collects and disseminates information on women's programs throughout the United States. Contact: Information Office, Women's Bureau, Department of Labor, 200 Constitution Ave. N.W., Room S3313, Washington, DC 20210/202-523-6653.

Women Workers—Special Projects

Programs are initiated to help meet the job market needs of special target groups such as minority women, older women, rural women, displaced homemakers and young mothers. Contact: Coordination and Special Projects Division, Women's Bureau, Department of Labor, 200 Constitution Ave. N.W., Room S3319, Washington, DC 20210/202-523-6624.

Worker Adjustment Assistance

This program aids workers who have recently been laid off or forced to go on short work weeks because of foreign trade competition. Workers can receive weekly allowances and a variety of help in preparing for and finding new employment. They may also get grants to look for work outside their home areas and money to pay for moving to new jobs. Petitions for group eligibility may be filed by a group of three or more workers through a union or an authorized representative. Contact: Office of Trade Adjustment Assistance, Employment and Training Administration, Department of Labor, 601 D St. N.W., Room 10400, Washington, DC 20213/202-376-6896.

Work Incentive Program (WIN)

This program provides help in finding jobs to families with dependent children. It provides job information, help in looking for work, and services like child care and medical aid. Contact: Office of Work Incentive Programs, Office of Comprehensive Employment Development, Employment and Training Administration, Department of Labor, 601 D St. N.W., Room 5102, Washington, DC 20213/202-376-6694.

Work Stoppages

Studies are conducted on the number of work stoppages, workers and days idle, work stoppages by industry and area, issues involved, duration of stoppage and method of settlement. Contact: Division of Developments in Labor-Management Relations, Office of Wage and Industrial Relations, Bureau of Labor Statistics, Department of

Labor, 411 G St. N.W., Room 1288, Washington, DC 20212/202-523-1858.

Young Adult Conservation Corps

This program aims to give young people, 16 through 23, experience in particular occupational skills through their work in conservation and other projects carried out at federal and non-federal sites. Contact: Young Adult Conservation Corps, Job Corps, Employment and Training Administration, Department of Labor, 601 D St. N.W., Room 6014, Washington, DC 20213/202-376-3959.

Youth Incentive Entitlement Pilot Projects (YIEPP)

This program is designed to test the effect of guaranteed jobs on the high school return, reten-tion, and completion rates of economically disadvantaged youth. Young people, 16 to 19 years old in selected areas, are guaranteed year-round jobs if they agree to attend high school or work toward a high school equivalency degree. Contact: Division of Program Review and Analysis, Office of Community Youth Employment Programs, Office of Youth Programs, Employment and Training Administration, Department of Labor, 601 D St. N.W., Room 7122, Washington, DC 20213/202-376-6704.

How Can the Department of Labor Help You?

To determine how the Department of Labor can help you, contact: Office of Information, Publications and Reports, Department of Labor, 200 Constitution Ave. N.W., Washington, DC 20210/202-523-7316.

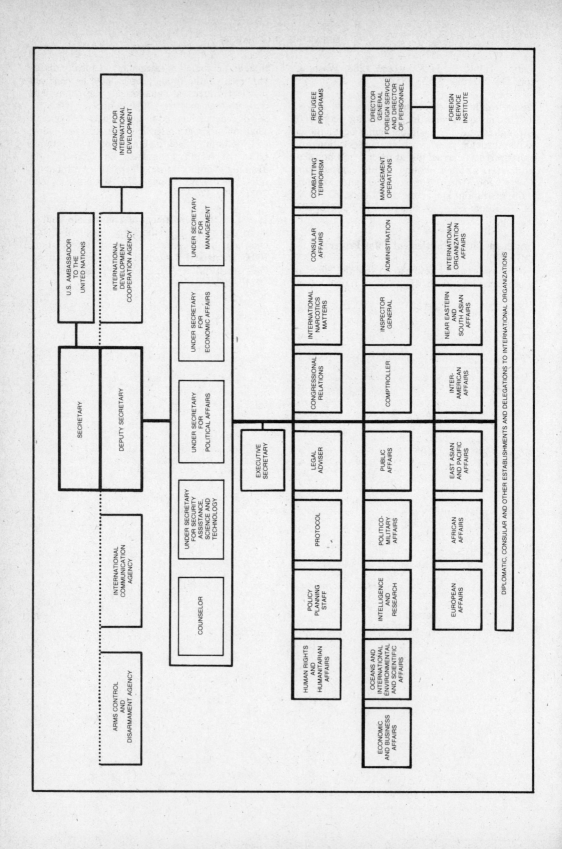

Department of State

2210 C St. N.W., Washington, DC 20520/202-632-6575

ESTABLISHED: January 10, 1781
BUDGET: $2,094,368,000
EMPLOYEES: 23,738

MISSION: Advises the President in the formulation and execution of foreign policy; promotes the long-range security and well-being of the United States; determines and analyzes the facts relating to American overseas interest, makes recommendations on policy and future action, and takes the necessary steps to carry out established policy; engages in continuous consultations with the American public, the Congress, other U.S. departments and agencies, and foreign governments; negotiates treaties and agreements with foreign nations; speaks for the United States in the United Nations and in more than 50 major international organizations in which the United States participates; and represents the United States at more than 800 international conferences annually.

Data Experts

Country Desk Officers

The following experts can provide current political, economic, and other background information on the country which they study. These experts can be reached by telephone or by writing in care of: Country Officers, Department of State, 2201 C St. N.W., Washington, DC 20520.

Afghanistan (Kabul)/Ronald D. Lorton/202-632-9552

Albania/Robert D. Johnson/202-632-1457

Algeria (Algiers)/Donald V. Hester/202-632-0304

Andorra/Keith C. Smith/202-632-2633

Angola (Luanda)/James E. Overly***/202-632-0725

Argentina (Buenos Aires)/Gerald J. Whitman/202-632-9166

Australia (Canberra)/Charles Twining/202-632-9690

Austria (Vienna)/Ralph C. Porter III/202-632-2005

Bahamas (Nassau)/Julien LeBourgeois/202-632-6386

Bahrain (Manama)/David Stockwell/202-632-1794

Baltic States/D. Thomas Longo, Jr./202-632-1739

Bangladesh (Dacca)/Lawrence N. Benedict/202-632-0466

Barbados (Bridgetown)/Therese Kleinkauf/202-632-8451

Belgium (Brussels)/Michael J. Habib/202-632-0498

William H. Dameron III*/202-632-0624

Belize (Belize City)/James F. Mack/202-632-0467

Benin (Cotonou)/Roger L. Hart/202-632-0842

Bermuda (Hamilton)/Michael A. G. Richaud/202-632-2622

William H. Dameron III*/202-632-0624

Bhutan/Donald Paalberg, Jr./202-632-0653

Bolivia (La Paz)/Philip B. Taylor/202-632-3076

Botswana (Gaborone)/Peter S. Maher/202-632-0916

David E. Jensen/202-632-9693

Brazil (Brazilia)/Adolph H. Eisner/202-632-1245

British Honduras/(See Belize)

British Indian Ocean Territory (BIOT)/Maxwell K. Berry/202-632-3040

British Solomon Islands Protectorate/(See Solomon Islands)

Brunei/Joseph C. Snyder III***/202-632-3276

Bulgaria (Sofia)/Robert D. Johnson/202-632-1457

Robert A. Bradtke*/202-632-3191

Burma (Rangoon)/Charles B. Smith, Jr./202-632-3276

Burundi (Bujumbura)/Arlene Render/202-632-3138

Cambodia (Phnom Penh)/Edmund F. McWilliams/202-632-3132

Cameroon (Yaounde)/ Susan M. Mowle/202-632-0996

Canada (Ottawa)/Richard J. Smith/202-632-2170
 Wingate Lloyd**/202-632-3135
 Sidney Friedland/202-632-3189
 Walter B. Lockwood, Jr.*/202-632-3150

Cape Verde (Praia)/Albert L. Glad/202-632-8436

CENTO/Vacant/202-632-3121

Central African Republic (Bangui)/Arlene Render/202-632-3138

Central America (ROCAP)/Penelope Farley/632-9158

Ceylon (Colombo)/(See Sri Lanka)

Chad (N'Djamena)/Margaret K. McMillion/202-632-3066

Chile (Santiago)/Peter Whitney/202-632-2575

China, People's Republic of (Beijing)/Daryl N. Johnson/202-632-1004
 Jerome Ogden*/202-632-2656
 Hong Kong/Jeffrey J. Buczacki/202-632-1436

Colombia (Bogota)/Eileen M. Heaphy/202-632-3023

Comoros/Kenneth C. Brill/202-632-0668

Congo (Brazzaville)/James E. Overly/202-632-0725

Congo (Kinshasa)/(See Zaire, Republic of)

Cook Islands/Harlan Lee/202-632-3546

Costa Rica (San Jose)/John Davis/202-632-3385

Council of Europe/Ward D. Barmon/202-632-0740

CSCE/Roger G. Harrison/202-632-8050
 Alan Parker/202-632-0315

Cuba (Havana)/Patrick Fitzgerald/202-632-1476
 Terrezene Brown/202-632-1658
 Ralph L. Braibanti/202-632-1503

Cyprus (Nicosia)/James A. Williams/202-632-1429
 James E. Tobin/202-632-9336

Czechoslovakia (Prague)/Robert D. Johnson/202-632-1457
 William E. Primosch*/202-632-3747

Dahomey (Cotonou)/(See Benin)

Denmark (Copenhagen)/Dennis C. Goodman/202-632-1774
 William H. Dameron III*/202-632-0624

Diego Garcia/Maxwell K. Berry/202-632-3040

Djibouti, Republic of (Djibouti)/Lars H. Hydle/202-632-3355

Dominica (Roseau)/Therese Kleinfauf/202-632-8451

Dominican Republic (Santo Domingo)/Robert

W. Beckham/202-632-3447

East African Community/Richard Eney/632-9762

Economic and Social Commission for Asia and the Pacific/Joyce Rabens/202-632-1654

Economic Commissions for Africa/Joyce Rabens/202-632-1654

Economic Commission for Europe (ECE)/Alan Parker/202-632-0315
 John Simmons/202-632-0600

Economic Commission for Latin America/Joyce Rabens/202-632-1654

Ecuador (Quito)/Manuel Guerra/202-632-5864

Egypt, Arab Republic of (Cairo)/Charles E. Marthinsen/202-632-2365
 Samuel R. Pearle**/202-632-1169
 David S. Robins***/202-632-2802

El Salvador (San Salvador)/Arlen R. Wilson/202-632-8148

Equatorial Guinea (Malabo)/Susan M. Mowle/202-632-0996

Estonia/D. Thomas Longo, Jr./202-632-1739

Ethiopia (Addis Ababa)/Lars H. Hydle/202-632-3355

European Atomic Energy Commission (Euratom)/Alan Parker/202-632-0315
 Leigh A. Morse/202-632-0533

European Coal and Steel Community (ECSC)/Theodore E. Russell/202-632-1708
 Ward D. Barmon/202-632-0740

European Communities/Theodore E. Russell/202-632-1708

European Economic Community (EEC)/Theodore E. Russell/202-632-1708

European Free Trade Association (EFTA)/ Russell A. LaMantia Jr./202-632-0457

European Launcher Development Organization (ELDO)/Alan Parker/202-632-0315
 Leigh A. Morse/202-632-0533

European Programs

European Space Research Organization (ESRO)/Alan Parker/202-632-0315
 Leigh A. Morse/202-632-0533

Fiji (Suva)/Harlan Lee/202-632-3546

Finland (Helsinki)/William H. Dameron III*/202-632-0624

France (Paris)/Vacant/202-632-1412
 Ruth A. Whiteside/202-632-1726
 Edgar J. Beigel**/202-632-3746

French Antilles/Therese A. Kleinkauf/202-632-8451

French Guiana/(See French Antilles)

French Polynesia/Harlan Lee/202-632-3546

Gabon (Libreville)/Susan M. Mowle/202-632-0996

Gambia, The (Banjul)/John Lewis/202-632-2865

Germany, Federal Republic of (Bonn)/Susan M. Klingman/202-632-2155

Erwin von den Steinen/202-632-0414
Peter G. Schoettle**/202-632-0415
William E. Ryerson (Berlin affairs)/202-632-2310
German Democratic Republic (Berlin)/Bruce W. Clark/202-632-2721
Ghana (Accra)/Albert L. Glad/202-632-8436
Gibraltar/Dennis G. Goodman/202-632-2622
William H. Dameron III*/202-632-0624
Gilbert and Ellice Islands/Harlan Lee/202-632-3546
Great Britain/(See United Kingdom)
Greece (Athens)/Thomas M. Coony/202-632-1563
Paul I. Schlamm/202-632-0330
Greeland/Michael A. G. Michaud/202-632-1774
William H. Dameron III*/202-632-0624
Grenada/Therese Kleinkauf/202-632-8451
Guadeloupe/Therese Kleinkauf/202-632-8541
Guatemala (Guatemala)/James F. Mack/202-632-0467
Guinea (Conakry)/Roger L. Hart/202-632-0842
Guinea-Bissau (Bissau)/Albert L. Glad/202-632-8436
Guyana (Georgetown)/Richard A. McCoy/202-632-3449
Haiti (Port-au-Prince)/Robert W. Beckham/202-632-3447
Honduras (Tegucigalpa)/John R. Davis/202-632-3385
Hong Kong/Jeffrey J. Buczacki/202-632-1436
Horn of Africa/(See Ethiopia and Somalia)
Hungary (Budapest)/Mildred A. Patterson/202-632-1739
Donald E. Gradenstetter*/202-632-3191
Iceland (Reykjavik)/Dennis C. Goodman/202-632-1774
William H. Dameron III*/202-632-0624
India (New Delhi)/John R. Malott/202-632-1289
H. R. Lucius****/202-632-0701
Indonesia (Jakarta)/James S. Landberg/202-632-3276
Vacant*/202-632-3276
Iran (Tehran)/Henry Precht/202-632-0313
Carl Clement/202-632-0448
Mark Johnson*/202-632-0915
Iraq (Baghdad)/Mary Ann Casey/202-632-0695
Ireland (Dublin)/Richard S. Thompson/202-632-1194
William H. Dameron III*/202-632-0624
Israel (Tel Aviv)/John L. Hirsch/202-632-3672
Jock P. Covey/202-632-3672
John P. Spillane*/202-632-3672
John F. Scott**/202-632-3672
Edwin P. Cubbison***/202-632-3672
Italy (Rome)/Lacey A. Wright, Jr./202-632-2453

E. J. Beigel*/202-632-3746
Vittorio A. Brod/202-632-8210
Ivory Coast (Abidjan)/Roger L. Hart/202-632-0842
Jamaica (Kingston)/Julien LeBourgeois/202-632-6386
Japan (Tokyo)/Martha Ann Dewitt****/202-632-3152
Marilyn A. Meyers***/202-632-3152
James H. McNaughton**/202-632-3152
Jordan (Amman)/Ronald E. Neumann/202-632-0791
H. R. Malpass/202-632-4714
Kampuchea/(See Cambodia)
Kenya (Nairobi)/Louis Janowski/202-632-0857
Korea, North and South/David Blakemore**/202-632-7717
Douglas B. Rasmussen/202-632-7717
Douglas B. McNeal/202-632-7717
Blaine D. Porter*/202-632-7717
Kuwait (Kuwait)/Henry S. Sizer/202-632-1334
Laos (Vientiane)/Edmund F. McWilliams/202-632-3132
Latvia/D. Thomas Longo Jr./202-632-1739
Lebanon (Beirut)/David Winn/202-632-1018
Lesotho (Maseru)/Peter S. Maher**/202-632-0916
David E. Jensen/202-632-9693
Liberia (Monrovia)/Anna M. Lehel/202-632-8354
Libya (Tripoli)/Wayne Alan Roy/202-632-9373
Liechtenstein/Ralph C. Porter III/202-632-2005
Lithuania/D. Thomas Longo Jr./202-632-1739
Luxembourg/Michael J. Habib/202-632-0498
William H. Dameron III*/202-632-0624
Macao/David E. Reuther/202-632-2656
Madagascar, Republic of (Antananarivo)/Maxwell K. Berry/202-632-3040
Malagasy Republic/(See Madagascar, Republic of)
Malawi (Lilongwe)/Richard W. Hoover/202-632-8851
Malaysia (Kuala Lumpur)/Joseph C. Snyder III***/202-632-3276
Maldives/Lee O. Coldren/202-632-2351
Mali Republic (Bamako)/John H. Lewis/202-632-2865
Malta (Valletta)/Ruth A. Whiteside/202-632-1726
Martinique/Therese A. Kleinkauf/202-632-8451
Mauritania (Nouakchott)/John Lewis/202-632-2865
Mauritius (Port Louis)/Maxwell K. Berry/202-632-3040
Mexico (Mexico, D.F.)/Everett E. Briggs/202-632-9894
Paul E. Storing*/202-632-9293
Kenneth R. McKune***/202-632-9364

Micronesia/(See Trust Territories of the Pacific Islands)

Monaco/Ruth A. Whiteside/202-632-1726

Mongolia/David E. Reuther/202-632-2656

Morocco (Rabat)/R. Grant Smith/202-632-0279

Mozambique (Maputo)/Alan M. Hardy/202-632-8434

Namibia/Alan M. Hardy/202-632-8434
 David E. Jensen*/202-632-9693

NATO/Stephen J. Ledogar/202-632-1626

Nauru/Harlan Lee/202-632-3546

Nepal (Kathmandu)/Donald Paalberg Jr./202-632-0653

Netherlands (The Hague)/Michael J. Habib/202-632-0498
 William H. Dameron III*/202-632-0624

Netherlands Antilles (Curacao)/Richard McCoy/202-632-6386

New Caledonia and New Hebrides/Harlan Lee/202-632-3546

New Zealand (Wellington)/Charles Twining/202-632-9690

Nicaragua (Managua)/Dan W. Figgins/202-632-2205

Niger (Niamey)/Margaret K. McMillion/202-632-3066

Nigeria (Lagos)/Samuel B. Thomsen***/202-632-3406
 Deborah R. Schwartz/202-632-3469
 H. Marshall Carter/202-632-3468

Northern Rhodesia/(See Zambia)

Norway (Oslo)/Dennis C. Goodman/202-632-1774
 William H. Dameron III*/202-632-0624

OECD/Robert J. Montgomery/202-632-0326

Oman (Muscat)/Henry S. Sizer/202-632-1334

Pacific Islands (General)/Harlan Lee***/202-632-3546

Pakistan (Islamabad)/Teresita Schaffer*/202-632-9823
 Michael Hornblow**/202-632-2441

Panama (Panama)/A. Craig Murphy/202-632-4986
 Richard Wyrough/202-632-4982

Papua New Guinea (Port Moresby)/Harlan Lee/202-632-3546

Paraguay (Asuncion)/Timothy Browth/202-632-1551

Peru (Lima)/John A. Purnell/202-632-3360

Philippines (Manila)/Robert H. Stern/202-632-1669
 Alice Straub/202-632-1221

Poland (Warsaw)/Victor S. Gray Jr./202-632-0575
 Robert A. Bradtke*/202-632-3191

Portugal (Lisbon)/Harry E. Cole Jr./202-632-0719

Portuguese Guinea/(See Guinea-Bissau)

Qatar (Doha)/David Stockwell202-632-1794

Reunion/Ruth A. Whiteside/202-632-1726

Romania (Bucharest)/Frank Tumminia/202-632-3298
 William E. Primosch*/202-632-3747

Rwanda (Kigali)/Arlene Render/202-632-3138

Samoa/(See Western Samoa)

San Marino/Lacy A. Wright, Jr./202-632-2453

Sao Tome and Principe/Susan M. Mowle/202-632-0996

Saudi Arabia (Jidda)/James Gagnon/202-632-0865
 Michael R. Arietti**/202-632-3121

Senegal (Dakar)/John Lewis/202-632-2865

Seychelles (Victoria)/Louis Janowski***/202-632-0857

Sierra Leone (Freetown)/Anna M. Lehel/202-632-8354

Singapore (Singapore)/Joseph C. Snyder III***/202-632-3276

Solomon Islands/Harlan Lee/202-632-3546

Somalia (Mogadishu)/Thomas W. Mears/202-632-0849

South African Republic (Pretoria)/Cameron R. Hume/202-632-3274
 David E. Jensen*/202-632-9693

South Pacific Commission/Harlan Lee/202-632-3546

Southern Rhodesia (Salisbury)/Eugene Schmiel/202-632-8252

South West Africa/(See Namibia)

Spain (Madrid)/Keith C. Smith/202-632-2633

Sri Lanka (Ceylon) (Colombo)/Lee O. Coldren/202-632-2351

Sudan (Khartoum)/Kenneth C. Brill/202-632-0668

United Arab Emirates (Abu Dhabi)/David Stockwell/202-632-1794

USSR (Moscow)/Robert W. Farrand (Bilateral)/202-632-8671
 Gary L. Matthews (Multilateral)/202-632-0821
 James L. Colbert*/202-632-3071
 Edward S. Hurwitz (Exchanges)/202-632-2248

United Kingdom (London)/Michael A. G Michaud/202-632-2622
 William H. Dameron III*/202-632-0624

United Republic of Tanzania (Dar es Salaam)/Maxwell Berry***/202-632-3040

Upper Volta (Ouagadougou)/Margaret K. McMillion/202-632-3066

Uruguay (Montevideo)/Timothy Browtn/202-632-1551

Vatican/Vittorio Brod/202-632-8210

Venezuela (Caracas)/Suzanne Butcher/202-632-3338

Vietnam/Michael Gelner*/202-632-3132

Western European Union (WEU)/Robert F. Hopper/202-632-1134

Western Sahara/John H. Lewis/202-632-2865

Western Samoa (Apia)/Harlan Lee/202-632-3546

Yemen Arab Republic (Sana)/Michael R. Arietti/202-632-3121

Yemen, People's Democratic Republic of/Michael R. Arietta/202-632-3121

Yugoslavia (Belgrade)/Richard M. Miles/202-632-3655

William E. Primosch*/202-632-3747

Zaire, Republic (Kinshasa)/Mary Lee K. Garrison/202-632-2216

Zambia (Lusaka)/Richard W. Hoover/202-632-8851

Zanzibar/(See United Republic of Tanzania)

*denotes Economic Officer
**denotes Politico-Military Officer
***denotes Political/Economic Officer
****denotes Economic/Commercial Officer

Major Sources of Information

African Affairs

Regional profiles of Sub Sahara African countries which includes biographical data, relationship with the United States. Information such as background notes on each country; discussion papers—political, economic, historical and ethnographic data; speeches by country experts; press clips; general information on Africa; and current policy speeches, are available on: Angola, Benin, Botswana, British Indian Ocean Territory, Burundi, Cameroon, Cape Verde, Central African Republic, Chad, Comoros, Congo, Republic of Djibouti, Equatorial Guinea, Ethiopia, Gabon, The Gambia, Ghana, Guinea, Guinea-Bissau, Ivory Coast, Kenya, Lesotho, Liberia, Republic of Madagascar, Malawi, Mali Republic, Mauritania, Mauritus, Mozambique, Namibia, Niger, Nigeria, Rwanda, Sao Tome and Principe, Senegal, Seychelles, Sierra Leone, Somalia, South African Republic, Sudan, Swaziland, Togo, Uganda, United Republic of Tanzania, Upper Volta, Western Sahara, Republic of Zaire, Zambia, Zimbabwe. Contact: Bureau of African Affairs, Public Affairs, Department of State, 2201 C St. N.W., Room 3509, Washington, DC 20520/202-632-0362.

Agriculture

This office is the United States link with four Rome-based United Nations agriculture organizations: Food and Agriculture Organization (FAO), World Food Council, World Food Program, and International Fund for Agricultural Development. Contact: Agriculture Office of Economic and Social Affairs, Bureau of International Organization Affairs, Department of State, 2201 C St. N.W., Room 5331, Washington, DC 20520/202-632-0492.

Arms Control—Nuclear

The office of Non-Proliferation Policy specializes in the arms control and the national security dimension of the nuclear proliferation problem. It pays particular attention to the role of U.S. alliance relationships and security assistance programs within the nonproliferation policy, and formulates the U.S. Department of State policy regarding nonproliferation aspects of other arms control agreements. Contact: Office of Non-Proliferation Policy, PM/NPP, Bureau of Politico-Military Affairs, Department of State, 2201 C St. N.W., Room 7327, Washington, DC 20520/202-632-1835.

Arms Transfer

For information on the transfer, selling, giving or licensing of arms or arms technology to foreign countries, contact: Office of Security Assistance and Sales, Bureau of Politico-Military Affairs, Department of State, 2201 C St. N.W., Room 7418, Washington, DC 20520/202-632-3882.

Art in Embassies

This program borrows art works of all mediums by American artists from museums, corporations and private collections, commercial galleries and artists for a minimum period of two years. Anyone interested in participating in the program by lending art works should contact: Art in Embassies Program, Bureau of Administration, Department of State, 21st and Virginia Ave. N.W., Room B-258, Washington, DC 20520/202-632-1634.

Business Practices

This office is active in government-business dialogues concerning the protection of industrial property, various restrictive business practices, and patent, trademark and copyright protection, as well as various problems relating to licensing agreements. Contact: Office of Business Practices, Bureau of Economics and Business Affairs, Department of State, 2201 C St. N.W., Room 3531A, Washington, DC 20520/202-632-0786.

Certification for Travel Abroad

Foreign governments sometimes require American businesspeople conducting business abroad to receive certification from the American government showing that they represent business entities operating legally within the United States. This certification may be required to register for visa purposes, to obtain work permits, or to license a vehicle. Businesspeople must first obtain from the appropriate official in their states of residence a certificate of incorporation. This office will authenticate that document so that it may be presented to the foreign government. Contact: Authentications, Foreign Affairs Documents and Reference Center, Bureau of Administration, Department of State, 2201 C St. N.W., Room 2815 (2813 for mailing), Washington, DC 20520/202-632-0406.

Citizens Arrested Overseas

The Arrest Unit monitors arrests and trials to see that United States citizens are not abused; acts as a liaison with family and friends in the United States; sends money, messages, etc. (with written consent of arrestee); offers lists of lawyers; will forward money from the United States to detainee; tries to assure that your rights under local laws are observed. The Emergency Medical and Dietary Assistance Program includes: providing vitamin supplements when necessary; granting emergency transfer for emergency medical care; and short-term feeding of two or three meals a day when arrestee is detained without funds to buy his or her own meals. Contact: Arrests Unit, Citizens Emergency Center, Overseas Citizens Service, Bureau of Consular Affairs, Department of State, 2201 C St. N.W., Room 4800, Washington, DC 20520/202-632-5225.

Citizens Emergency Center

Emergency telephone assistance is available to United States citizens abroad in the following areas:

Arrests—(See "Citizens Arrested Overseas")—202-632-5225.

Deaths—202-632-5225; notification of interested parties in the United States of the death abroad of United States citizens. Assistance in the arrangements for disposition of remains.

Financial Assistance—202-632-5225; repatriation of destitute United States nationals, coordination of medical evacuation of nonofficial United States nationals from abroad; transmission of private funds in emergencies to destitute United States nationals abroad when commercial banking facilities are unavailable (all costs must be reimbursed).

Shipping and Seamen—202-632-5225; protection of American vessels and seamen.

Welfare and Whereabouts—202-632-5225; search for nonofficial United States nationals who have not been heard from for an undue length of time and/or about whom there is special concern; transmission of emergency messages to United States nationals abroad.

Contact: Overseas Citizen Services, Bureau of Consular Affairs, Department of State, 2201 C St. N.W., Washington, DC 20520/202-632-3444.

Claims Against Foreign Governments

The Government of the United States, at the discretion of the Secretary of State, will act on behalf of U.S. nationals in attempting to settle claims against foreign governments. Assistance is not available: 1) to non-nationals; 2) in cases where there has not been an exhaustion of all local administrative or judicial remedies with a resulting denial of justice; or 3) where the respondent government is not responsible under international law. If the claim is found to be valid by the U.S. Department of State and the Secretary of State chooses to back the claim, the claimant will be informed as to how the claim should be prepared and documented. The U.S. Department of State, using the documentation prepared by the claimant, would then act on behalf of the claimant in pressing for settlement. Settlements (compensation or restitution) result either from direct negotiation through diplomatic channels or from arbitration, which lead to payment by the foreign government. Contact: Assistant Legal Advisor for International Claims, Office of the Legal Advisor, Department of State, 2201 C St. N.W., Washington, DC 20520/202-632-1365.

Commercial Policy

Information is available on such topics as: policy and agreement on developing country trade, General Agreement on Tariffs and Trade (GATT) coordinator, and multilateral trade negotiations. Contact: General Commercial Policy Division, International Trade Policy, Bureau of Economic and Business Affairs, Department of State, 2201 C St. N.W., Room 3829, Washington, DC 20520/202-632-0687.

Consumer Affairs

This is the main office at the U.S. Department of State for consumer complaints, advice and information. They bring consumer leaders to Washington to get their opinions on consumer issues such as pricing coffee, etc. It also has consumer advisors as delegates during international negotiations. Contact: Consumer Affairs, Bureau

of Economic and Business Affairs, Department of State, 2201 C St. N.W., Room 6822, Washington, DC 20520/202-632-8836.

Consumer Countries—Energy

This office coordinates policies of energy-consuming nations. It also works with the U.S. Department of Energy to coordinate domestic and foreign policy. Contact: Consumer Country Affairs, International Energy Policy, Bureau of Economics and Business Affairs, Department of State, 2201 C St. N.W., Room 3336, Washington, DC 20520/202-632-8097.

Cooperative Science and Technology

This office deals on a bilateral basis with other governments—mainly China, Mexico, USSR, Japan, Brazil, African countries on science and technology, including energy research and development, agriculture, marine science, and space. Contact: Office of Cooperative Science and Technology Programs, Science and Technology Affairs, Bureau of Oceans and International Environmental and Scientific Affairs, Department of State, 2201 C St. N.W., Room 4330, Washington, DC 20520/202-632-2958.

Country Reports on Human Rights

This is an annual report submitted to Congress which lists recipients of United States economic or security assistance, all foreign countries which are United Nations members, and also the amounts of United States bilateral assistance and multilateral development assistance. It provides descriptions of human rights conditions for each country which received such assistance. Bilateral assistance figures are broken down by three basic categories: economic assistance; military assistance; and total economic and military assistance. For additional information contact: Country Reports, Bureau of Human Rights and Humanitarian Affairs, Department of State, 2201 C St. N.W., Room 7802, Washington, DC 20520/202-632-3660.

Decorations and Gifts from Foreign Governments

A list of all decorations and gifts given to federal departments and agencies by foreign governments is published annually in the *Federal Register*. The gifts are described and their value is estimated. If the gifts are not used by the government or are not donated to public institutions, they are sold to the public by the General Services Administration. For information, contact: Office of Protocol, Department of State, 2201 C St. N.W., Room 1238, Washington, DC 20520/202-632-0907.

Development and Humanitarian

This office is the U.S. Department of State's link to organizations established for development and humanitarian programs. Development organizations include: U.N. Development Program; U.N. Industrial Development Organization; U.N. Institute for Training and Research. Humanitarian organizations include: UNICEF: Commission for Social Development; International Year of the Child—1979; International Year of the Disabled Person—1981. Contact: Development and Humanitarian Programs, Bureau of International Organization Affairs, Department of State, 2201 C St. N.W., Room 5327, Washington, DC 20520/202-632-1544.

Digest of U.S. Practices on International Law

This is an annual compendium of U.S. activities, both domestic and international, that have a bearing on international law. Available for $21.00 from the Government Printing Office, Superintendent of Documents, Washington, DC 20402/202-783-3238. For more detailed information on content, contact: Legal Adviser, Department of State, Room 6422, Washington, DC 20520/202-632-2628.

East Asia and Pacific

For information on: Australia, Brunei, Burma, Cambodia, People's Republic of China, Cook Islands, Fiji, French Polynesia, Gilbert and Ellice Islands, Hong Kong, Indonesia, Japan, North Korea, South Korea, Laos, Macao, Malaysia, Mongolia, Nauru, New Caledonia and New Hebrides, New Zealand, Pacific Islands, Papua New Guinea, Phillippines, Singapore, Solomon Islands, Taiwan, Thailand, Tonga, Trust Territory of the Pacific Islands, Vietnam, and Western Samoa, contact: Bureau of East Asian and Pacific Affairs, Public Affairs, Department of State, 2201 C St. N.W., Room 5310, Washington, DC 20520/202-632-2538.

East-West Trade

For policy information on trading with Communist nations, contact: Office of East-West Trade, Bureau of Economic and Business Affairs, Department of State, 2201 C St. N.W., Room 3819, Washington, DC 20520/202-632-0964.

Energy Technology Cooperation

This office is concerned mostly with aspects of non-nuclear advanced forms of energy such as extracting low-grade petroleum and coal, solar power and other alternative energy sources, and energy research and development on a multilateral and a bilateral basis. Some examples include: work with coal liquefaction research and devel-

opment with Japan and Germany, and enhanced oil recovery with Venezuela. The office gives international policy guidance on energy research and development to the U.S. Department of Energy and Interior and to various agencies and it is involved in international energy development programs. Contact: Office of Energy Technology Cooperation, Environment, Health and Natural Resources, Bureau of Oceans and International Environmental and Scientific Affairs, Department of State, 2201 C St. N.W., Room 3536, Washington, DC 20520/202-632-4413.

Environment and Health

Information is available on environmental and health matters within the international community. Priority attention is given to: toxic chemicals, transboundary air pollution (especially acid-rain problem), and global environmental monitoring systems. Health issues are focused on the world's poor, both in rural areas and urban slums; prevention of ill health including malnutrition and infectious diseases. Work is done in conjunction with the World Health Organization, U.N. Children's Fund, U.N. Development Program, Commission on Narcotic Drugs, and U.N. Environment Program. Contact: Office of Environment and Health, Bureau of Oceans and International Environmental and Scientific Affairs, Department of State, 2201 C St. N.W., Room 7820, Washington, DC 20520/202-632-9278.

European Affairs

Background notes, speeches and other information are available on all European countries and Canada, and OECD, European Community and Atlantic Political-Economic Affairs, NATO, and Atlantic Political-Military Affairs, Council of Europe, European Atomic Energy (EURATOM), European Coal and Steel Community (ECSC), European Communities, European Economic Community (EEC), European Free Trade Association (EFTA), European Launcher Develop (ELDO), and European Space Research Organization (ESRO). Contact: Bureau of European Affairs, Department of State, 2201 C St. N.W., Room 5229, Washington, DC 20520/202-632-0850.

Executive-Diplomat Seminars

These seminars provide an opportunity for indepth discussions of economic, commercial and other aspects of U.S. foreign policy between business executives and senior U.S. government officials. The seminar consists of a two-day program, with topics that cover: international finance, multilateral trade negotiations, tax reform, code of conduct, energy, commercial services, technology transfer, organization of the U.S. Department of State, International Resources and Food Policy, Human Rights, Ecology and Environmental Affairs. Contact: Executive-Diplomat Seminar, Office of Public Programs, Bureau of Public Affairs, Department of State, 2201 C St. N.W., Room 5831, Washington, DC 20520/202-632-3888.

Export and Import Control

The office coordinates and reviews replies with the Nuclear Regulatory Commission (NRC) for requests they receive to license nuclear export. They are also concerned with transfer of technology, nuclear-related energy and subsequent arrangements. Contact: Office of Export and Import Control, Nuclear Energy and Energy Technology Affairs, Bureau of Oceans and International Environmental and Scientific Affairs, Department of State, 2201 C St. N.W., Room 4327A, Washington, DC 20520/202-632-4101.

Family Planning

The Office of Population Affairs is involved with contraceptive research efforts to improve the technology available for family planning programs throughout the world. Contact: Population Affairs, Bureau of Oceans and International Environmental and Scientific Affairs, Department of State, 2201 C St. N.W., Room 7825, Washington, DC 20520/202-632-3472.

Film—History of U.S. Foreign Relations

A four-part color film series, 30 minutes each, with accompanying discussion guides, may be bought or borrowed without charge.

Part I—begins with the militia diplomacy of the Revolution and ends with the Monroe Doctrine.
Part II—traces expansion of U.S. interests in other nations and its evolution into a world power prior to the events of World War I.
Part III—shows the process by which the United States was finally obliged to accept the role of a major power in the years between World War I and Pearl Harbor.
Part IV—traces the development of U.S. foreign policy from 1945 to 1975.

Contact: Films Officer, Office of Public Communication, Public Affairs, Department of State, 2201 C St. N.W., Room 4827A, Washington, DC 20250/202-632-8203.

Fisheries

This office works principally with the Inter-

governmental Oceanographic Commission (IOC), part of UNESCO and the International Council for the Exploration of the Seas (ICES). Their interests include: research in the Caribbean on food from the sea; the North Atlantic fisheries resources; and other oceanographic phenomena. Contact: Office of Fisheries Affairs, Oceans and Fisheries Affairs, Bureau of Oceans and International Environmental and Scientific Affairs, Department of State, 2201 C St. N.W., Room 5806, Washington, DC 20520/202-632-2335.

Food and Natural Resources
The main interest of this office is to maintain long-term productivity of renewable and nonrenewable resources including: forest cover (mostly tropical), arid land management, wildlife conservation, water resource management, protection of crop land and commercialization of new crops. The office coordinates these programs with the other United States agencies and their deals with foreign countries. One program, *Global 2000*, shows conditions and trends of global resources, population and environment. Contact: Office of Food and Natural Resources, Bureau of Oceans and International Environmental and Scientific Affairs, Department of State, Room 7819, Washington, DC 20520/202-632-8002.

Food Policy
This office makes sure that foreign policy concerns are considered where food aid programs are prepared, principally at the U.S. Department of Agriculture and the Agency for International Development. Information is available on the Food for Peace Program. This office also follows activities in other international food programs, such as World Food Program and Food Aid Committee which was recently set up by Food Aid Convention. Contact: Office of Food Policy and Programs, Bureau of Economic and Business Affairs, Department of State, Room 3427, 2201 C St. N.W., Washington, DC 20520/202-632-0563.

Foreign Country Information
Background Notes on the Countries of the World is a series of short, factual pamphlets with information on the country's land, people, history, government, political conditions, economy, foreign relations, and U.S. policy. Each *Notes* also includes a factual profile, brief travel notes, a country map, and a reading list. Single copies are $1.50. Write to the Superintendent of Documents, Government Printing Office, Washington, DC 20402/202-783-3238. Single copies of the following publications are free from the Office of

Passport Services, Department of State, Washington, DC 20524/202-783-8170.

Travel to the Soviet Union
Travel to European Community Countries, Excluding the Soviet Union
Travel by Private American Citizens to East Berlin and the German Democratic Republic (GDR)
Travel to Eastern Europe on Official U.S. Government Business or Sponsorship
Travel to Norway, Denmark, Sweden, and Finland
Travel to Syria
Travel to Southern Yemen (Aden)
Travel to Israel, Jerusalem, and Nearby Arab Countries
Travel to Libya
Travel to Morocco
Travel to Italy
Travel to Greece

Foreign Language Training
The Foreign Service Institute is an in-house educational institution for foreign service officers, members of their families and employees of other government agencies. It provides special training in public administration, international relations, economics, area studies, consular studies and 50 foriegn languages. It puts out instructional materials (books and tapes) designed to teach modern foreign languages. Lists of available books and tapes and their prices are available. Tapes are obtained through: National Audio Visual Center, General Services Administration, Order Section/AV, Washington, DC 20409/301-763-1891. Books are available from: Government Printing Office, Superintendent of Documents, Washington, DC 20402/202-783-3238. Additional available publications include: *Foreign Versions, Variations and Diminutives of English Names; Foreign Equivalents of United States Military and Civilian Titles.* This catalog is issued by the Immigration and Naturalization Service. It lists the foreign equivalent names for U.S. military and civilian titles for 45 countries. Available for $3.00 from: Government Printing Office, Superintendent of Documents, Washington, DC 20402/202-783-3238. *Testing Kit—French and Spanish*, contains eight audiocassettes, two-track mono recordings of actual speaking proficiency tests conducted at the Institute. The 140-page manual discusses and describes Foreign Service Institute language testing and techniques. Contact: National Audiovisual Center, National Archives and Records Service, General Services Administration, Order Section AV, Washington, DC 20409/301-763-1896. For more information on the Foreign Service Institute, Contact: Foreign Service Institute, Depart-

ment of State, SA-3, 2201 C St. N.W., Room 604, Washington, DC 20520/703-235-8826.

Foreign Service Officer Careers

Available information includes: description of various careers, eligibility requirements, examination information with sample questions, places where Foreign Service examinations are given, and bibliography about Foreign Service. There are special career opportunities for women and minority group members as mid-level officers and as junior Foreign Service Reserve Officer positions. Contact: Board of Examiners for the Foreign Service, Box 9317, Rosslyn Station, Arlington, VA 22209/703-235-9392.

Free Booklets for Travellers

The following book is available from: Publications Distribution, Bureau of Public Affairs, Department of State, 2201 C St. N.W., Room 5845, Washington, DC 20520/202-632-9859.

Travel Information Your Trip Abroad:—provides basic information from the U.S. Department of State to help prepare for a trip—how to apply for a passport, customs tips, lodging information and how American consular officers can help you in an emergency.

The following publications are available from: Customs Office, P.O. Box 7118, Washington, DC 20044:

Customs Information
Bureau of Consular Affairs: Your Trip Abroad
Visa Requirements of Foreign Governments—lists the entry requirements for U.S. citizens traveling as tourists, and where and how to apply for visas and tourist cards. Available from: Passport Services, Bureau of Consular Affairs, Department of State, 1425 K St. N.W., Room G-62, Washington, DC 20524/202-783-8170. (See "Foreign Country Information" in this section.)

Freedom of Information

For information concerning requests made under the Freedom of Information Act, contact: Information and Privacy Staff, Foreign Affairs Information Management Center, Department of State, Room 1239, Washington, DC 20520/202-632-8459.

Geographic Data

Precise geographical information is available on boundary locations, territorial sovereignty, and terrain. Available publications include:

International Boundary Studies—land boundaries.
Limits in the Seas—sea boundaries listed by title and number.

Status of the World's Nations—Lists independent countries and gives their official long- and short-form name, capital city, population and area. Also lists dependencies and areas of special sovereignty (e.g., islands that belong to other countries).

Contact: Office of the Geographer, Bureau of Intelligence and Research, Department of State, 2201 C St. N.W., Room 8742, Washington, DC 20523/202-632-2021.

Historian

The Office of the Historian provides historical reference services to government officials, scholars, the press, and the general public. This office prepares, selects, compiles, edits and publishes *Foreign Relations of the United States*, a 260 volume set based on the records of government departments and agencies and includes major telegrams, memoranda, diplomatic notes and other basic papers comprising the official record of U.S. foreign policy. The office also conducts policy-related historical reference for the government. When this material is declassified it goes to the National Archives for Public Research. A list is available of major publications of the U.S. Department of State. Contact: Office of the Historian, Bureau of Public Affairs, Department of State, SA-1, Room 3100, Washington, DC 20520/202-632-8888.

Human Rights

For information on human rights activities within the United Nations and other multilateral organizations such as UNESCO, and International Labor Organization (ILO), contact: Office of Human Rights Affairs, Bureau of International Organization Affairs, Department of State, 2201 C St. N.W., Room 1509, Washington, DC 20520/202-632-0520.

Industrial and Strategic Materials

This office is concerned with all minerals and metals, both U.S.-produced or imported, that are used by U.S. industry and the military (over 90 different materials). It follows developments in the domestic and foreign markets and is involved in the negotiations of agreements. Contact: Industrial and Strategic Materials Division, Office of International Commodities, Bureau of Economic and Business Affairs, Department of State, 2201 C St. N.W., Room 3524A, Washington, DC 20520/202-632-1420.

InterAmerican Affairs

Background information as well as policy matters are available on: Argentina, Bahamas, Barbados, Belize, Bolivia, Brazil, Chile, Colombia,

Costa Rica, Cuba, Dominica, Ecuador, El Salvador, French Antilles, Grenada, Guadeloupe, Guatemala, Guyana, Haiti, Honduras, Jamaica, Martinique, Mexico, Netherlands Antilles, Nicaragua, Panama, Paraguay, Peru, Suriname, Trinidad and Tobago, Uruguay and Venezuela. Contact: Bureau of InterAmerican Affairs, Public Affairs, Department of State, 2201 C St. N.W., Room 6913A, Washington, DC 20520/202-632-3048.

International Aviation

This office provides assistance in resolving international operational problems such as overflight and landing clearances. It is the focal point for coordinating U.S. policies on a multilateral basis and for ascertaining whether U.S. aircraft are being discriminated against. Contact: Office of Aviation, Bureau of Economic and Business Affairs, Department of State, 2201 C St. N.W., Room 5830, Washington, DC 20520/202-632-0316.

International Commerce

The Bureau of Economic and Business Affairs deals with international finance and development, trade policy, international resources, including food and energy, transportation and telecommunications. Contact: Bureau of Economic and Business Affairs, Department of State, 2201 C St. N.W., Room 6828, Washington, DC 20520/202-632-0396.

International Communications

This office provides information and reports on bilateral and multilateral agreements and activities of international communications conferences and organizations such as the 1979 World Administrative Radio Conference. Contact: Office of International Telecommunications, Transportation and Telecommunications Affairs, Bureau of Economic and Business Affairs, Department of State, 2201 C St. N.W., Room 5824, Washington, DC 20520/202-632-3405.

International Conferences

For information on intergovernmental multilateral conferences attended by the United States (no bilateral conferences) as accredited delegates, contact: Office of International Conferences, Bureau of International Organization Affairs, Department of State, 2201 C St. N.W., Room 1517, Washington, DC 20520/202-632-1271.

International Conferences, Schedule of

This free quarterly publication provides the names, places and dates of intergovernmental, multilateral conferences attended by the United States as accredited delegates for the next six months. Statistics are also available on such topics as how many people attend conferences and the number of conferences held. Contact: Office of the Budget, Bureau of International Affairs, Department of State, 2201 C St. N.W., Room 1429, Washington, DC 20520/202-632-2738.

International Economic Policy

This office oversees U.S. participation in economic policy making by the whole range of organizations within the United Nations system, mainly the economic and social council of the United Nations. It also maintains a list of "consultative status" organizations at the United Nations. Contact: Office of International Economic Policy, Bureau of International Organization Affairs, Department of State, 2201 C St. N.W., Room 5321, Washington, DC 20520/202-632-1654.

International Environment

This office deals with the foreign policy implications of nuclear and other energy programs, outer space concerns, environmental questions, population problems, technological and scientific relations and various other undertakings such as ocean resources, fisheries and wildlife management. Contact: Bureau of Oceans and International Environmental and Scientific Affairs, Department of State, 2201 C St. N.W., Room 7831, Washington, DC 20520/202-632-1554.

International Finance

The Office of Development Finance is involved in North-South Dialogue in the United Nations concerning rich and poor countries and their prices and commodities; World Bank, African Development Bank, Asian Development Bank, and InterAmerican Bank; following the general foreign aid policy for the U.S. Department of State; and following Export-Import Bank and the issues of negotiations of export credits. Contact: Office of Development Finance, Bureau of Economic and Business Affairs, Department of State, 2201 C St. N.W., Room 2529, Washington, DC 10520/202-632-9426.

International Labor Affairs

For information on foreign policy that has to do with the International Labor Organization, contact: Labor Affairs, Bureau of International Organization Affairs, Department of State, 2201 C St. N.W., Room 5336, Washington, DC 20520/202-6323049.

International Organizations

This office supervises U.S. participation in the

United Nations and in the other international organizations to which the United States belongs. It supports U.S. delegates to over 800 conferences annually. Contact: Bureau of International Organization Affairs, Department of State, 2201 C St. N.W., Room 7513, Washington, DC 20520/202-632-8647.

PMRSA and PM-TMP

This office coordinates and meshes national security interests with diplomatic policy, e.g., Strategic Arms Limitation Talks (SALT) and Cruise missile. Contact: Office of International Security Policy, Bureau of Politico-Military Affairs, Regional Security Policy, Department of State, 2201 C St. N.W., Room 7424, Washington, DC 20520/202-632-1862.

International Trade Policy

This office works on trade agreements and trade relations with developed countries and is concerned with restrictions that other countries put on U.S. exports. Their major areas are: European Economic Community (EEC), mainly agriculture, Canada and non-EEC European countries (Greece, Scandinavia, etc.), Japan, Australia, New Zealand, and South Africa. It also deals with licensing, aircraft agreements, trade and services (Organization for Economic Cooperation and Development), and customs valuation. Contact: Trade Agreements Division, International Trade Policy, Bureau of Economic and Business Affairs, Department of State, 2201 C St. N.W., Room 3822, Washington, DC 20520/202-632-1718.

Law of the Sea

The U.N. Conference on the Law of the Sea deals with international issues such as navigation, overflight, conservation and management of fisheries resources, the protection of the marine environment, the exploitation of oil and gas in the continental shelf, marine scientific research and a system of compulsory dispute settlement. Contact: Office of the Law of the Sea Negotiations, Office of the Deputy Secretary, Department of State, 2201 C St. N.W., Room 4321, Washington, DC 20520/202-632-9098.

Library

The U.S. Department of State Library is open only to those who can enter the State Department Building. It publishes the *International Relations Dictionary*—a dictionary of terms used in foreign affairs. Available for $4.75 from: Government Printing Office, Superintendent of Documents, Washington, DC 20402/202-783-3238. The Library will try to answer mail inquiries.

Contact: Library, Department of State, 2201 C St. N.W., Room 3239, Washington, DC 20520/202-632-0372.

Licenses to Export Military Goods

The Office of Munitions Control issues special export licenses to manufacturers and exporters of commercial arms, amunitions, implements of war and related technical data. A free booklet, *International Traffic and Arms Regulations*, lists goods deemed "munitions" (defines munitions) and includes regulations governing their possible export. Contact: Office of Munitions Control, Bureau of Politico-Military Affairs, Department of State, SA-6, Room 800, Washington, DC 20520/703-235-9755.

Marine Science

This office deals with oil pollution strategies, assesses biologic damages from spills and blowouts, and works on marine environmental quality. Contact: Office of Marine Science and Technology Affairs, Oceans and Fisheries Affairs, Bureau of Oceans and International Environmental and Scientific Affairs, Department of State, Room 5801, Washington, DC 20520/202-632-0853.

Maritime Affairs

This office informs the U.S. maritime industry ship operators, labor unions and others involved with maritime matters on policy regulations. It deals with such issues as bunkering, detained cargo, and foreign discriminatory practices. Contact: Office of Maritime Affairs, Bureau of Economic and Business Affairs, Department of State, 2201 C St. N.W., Room 5826, Washington, DC 20520/202-632-0704.

Monetary Affairs

This office deals with international monetary issues, primarily with the International Monetary Fund. It also follows the financial conditions of foreign countries and to a lesser degree it follows dollar and gold prices for the U.S. Department of State. Contact: Office of Monetary Affairs, Bureau of Economic and Business Affairs, Department of State, 2201 C St. N.W., Room 4830, Washington, DC 20520/202-632-2580.

Near Eastern and South Asia

For information on: Afghanistan, Algeria, Bahrain, Bangladesh, Bhutan, Arab Republic of Egypt, India, Iran, Iraq, Israel, Jordan, Kuwait, Lebanon, Maldives, Morocco, Nepal, Oman, Pakistan, Qatar, Saudi Arabia, Sri Lanka, Syrian Arab Republic, Tunisia, United Arab Emirates, Yemen Arab Republic, People's Democratic Re-

public of Yemen, and Central Treaty Organization (CENTO), contact: Bureau of Near Eastern and South Asian Affairs, Department of State, 2201 C St. N.W., Room 6252A, Washington, DC 20520/202-632-5150.

Nuclear Nonproliferation
For information on U.S. nuclear export laws and agreements, nonproliferation policy, and international organizations concerned with peaceful nuclear development, contact: Office of Nuclear Energy and Energy Technology Affairs Nonproliferation and Export Policy, Bureau of Oceans and International Environmental and Scientific Affairs, Department of State, 2201 C St. N.W., Room 7828, Washington, DC 20520/202-632-7036.

Nuclear Technology
The Office of Nuclear Technology and Safeguards makes sure that the nuclear energy exported is used for peaceful purposes. It also works with the International Nuclear Fuel Cycle Evaluation, a technical study of the need for nuclear energy, of the link between nuclear energy programs and weapons proliferation and of means to minimize proliferation risks without jeopardizing the availability of nuclear energy. Contact: Office of Nuclear Technology and Safeguards, Environment, Health and Natural Resources, Bureau of Oceans and International Environmental and Scientific Affairs, Department of State, 2201 C St. N.W., Room 7828, Washington, DC 20520/202-632-3310.

Oceans and Polar Affairs
For information on U.S. international scientific, environmental, oceanic and marine, arctic and antarctic programs and policies, contact: Office of Oceans and Polar Affairs, Oceans and Fisheries Affairs, Bureau of Oceans and International Environmental and Scientific Affairs, Department of State, 2201 C St. N.W., Room 5801, Washington, DC 20520/202-632-6491.

Organization of American States (OAS)
For documents, reports and other general information on all Organization of American States' activities, contact: Documents and Reference, Permament Mission of the United States of America to the Organization of American States, Bureau of Inter-American Affairs, Department of State, 2201 C St. N.W., Room 6489, Washington, DC 20520/202-632-8650.

Outer Space Treaties
This office works with: NASA on all the international aspects of the peaceful uses of outer space, with other governments and agencies on the civil space activities of the U.S. government which affect them, and with multilateral organizations such as the European Economic Community (EEC), Organizations for Economic Cooperation and Development (OECD), and the North Atlantic Treaty Organization (NATO). Contact: Office of Advanced Technology, Science and Technology Affairs, Bureau of Oceans and International Environmental and Scientific Affairs, Department of State, 2201 C St. N.W., Room 4333, Washington, DC 20520/202-632-2841.

Overseas Citizen Services
This office is responsible for activities relating to the protection and assistance of U.S. citizens abroad. Among its services are aids to U.S. citizens (including U.S. Merchant Seamen) who are arrested (see "Arrests Units" in this section); assistance, in case of death of a citizen abroad such as the provisional conservation of his/her personal estate abroad, and the repatriation to the United States of citizens who are destitute or ill. The Bureau serves as liaison with other government agencies in matters such as payment of benefits to beneficiaries residing abroad, and in determinations of the acquisition or loss of U.S. citizenship by persons outside the United States. It also provides notarial functions and related services to U.S. citizens abroad including coordinating with the U.S. Department of Justice to bring witnesses to U.S. courts. Contact: Overseas Citizen Services, Bureau of Consular Affairs, Department of State, 2201 C St. N.W., Room 4800, Washington, DC 20520/202-632-3816.

Overseas Schools
Individuals with children who plan to live abroad for an extended period may obtain fact sheets on individual U.S. Department of State supported schools. To apply for jobs at these schools, contact: International School Services (ISS), 126 Alexandria, P.O. Box 5910, Princeton, NJ 08540. For other information , contact: Office of Overseas Schools, Bureau of Administration, Department of State, SA6, Room 234, Washington, DC 20520/703-235-9600.

Passport Information
A recorded telephone message provides general information on what is needed when applying for a passport. call: 202-783-8200. U.S. citizens and nationals can apply for passports at all passport agencies as well as those post offices and federal and state courts authorized to accept passport applications. The office also maintains a variety of records, including:

Consular Certificates of Witness to Marriage—records of those persons at whose marriage abroad a consular officer of the United States was present as a witness. It is merely a certificate indicating that a consular officer was present.

Reports of Birth—children born of American parents in a foreign country will have a Report of Birth Abroad on file with this office if their parents have made such reports to the American consul in the country of birth.

Reports of Death—Since 1979 reports of death of Americans abroad are on file with the Passport Services files if the death has been brought to the attention of an American consul.

For more specific information on the issuance of passports, contact: Passport Services, Bureau of Consular Affairs, Department of State, 1425 K St. N.W., Room G-62, Washington, DC 20524/202-783-8170.

Passport Offices—Regional

The following is a listing of local passport offices:

John F. Kennedy Building, Government Center, Room E123, Boston, MA 02203/617-223-2946.

Kluczynski Office Building, 230 S. Dearborn St., Room 380, Chicago, IL 60604/312-353-7155.

New Federal Building, 300 Ala Moana Blvd., Room C-106, P.O. Box 50185, Honolulu, HI 96850/808-546-2130

One Allen Center, 500 Dallas St., Houston, TX 77002/713-226-4581.

Hawthorne Federal Building, 15000 Aviation Blvd., Room 2W16, Los Angeles, CA 92061/213-536-6503.

World Trade Center, 350 S. Figueroa St., Room 183, Los Angeles, CA 90071/213-688-3285.

Federal Office Building, 51 Southwest 1st Ave., Room 804, Miami, FL 33130/305-350-4681.

International Trade Mart, 2 Canal St., Room 400, New Orleans, LA 70130/504-589-6161.

Rockefeller Center, International Building, 630 5th Ave., Room 270, New York, NY 10020/212-541-7710.

Federal Building, 600 Arch St., Room 4426, Philadelphia, PA 19106/215-597-7480.

Federal Building, 450 Golden Gate Ave., Room 1405, San Francisco, CA 94102/415-556-2630.

Federal Building, 915 2nd Ave., Room 906, Seattle, WA 98174/206-442-7945.

One Landmark Square, Broad and Atlantic Sts., Stamford, CT 06901/203-327-9550.

Room G62, 1425 K St. N.W., Washington, DC 20524/202-783-8170.

Political Asylum

For general and specific information on politi-cal asylum in the United States, contact: Office of Human Rights, Bureau of Human Rights and Humanitarian Affairs, Department of State, 2201 C St. N.W., Room 7802, Washington, DC 20520/202-632-2551.

Politico-Military Affairs

This office develops and coordinates guidance on issues that affect U.S. security policy, military assistance programs, and arms control and disarmament matters. Contact: Bureau of Politico-Military Affairs, Department of State, 2201 C St. N.W., Room 7317, Washington, DC 20520/202-632-9022.

Producing Countries—Energy

This office urges producing countries (Organization of Petroleum Exporting Countries) to follow "responsible" production and pricing policies. Contact: Producing Country Affairs, International Energy Policy, Bureau of Economic and Business Affairs, Department of State, 2201 C St. N.W., Room 3331, Washington, DC 20520/202-632-0641.

Protection of Ships from Foreign Seizure

Insurance is available to reimburse a financial loss to owners of vessels registered in the United States for fines paid to secure the release of vessels seized for operation in waters that are not recognized as territorial waters by the United States. Owners of private vessels documented or certificated under the laws of the United States whose boats are seized in waters not recognized as the territorial waters of another state by the United States are eligible. No registration or payment of premiums is required prior to the seizure in order to qualify for reimbursement. Contact: Assistant Legal Adviser for International Claims, Office of the Legal Adviser, Department of State, Washington, DC 20520/202-632-1365.

Publications

The major publications from the U.S. Department of State include:

Department of Bulletin (monthly, $21.00 a year)—lists new publications, provides the public, Congress and government agencies with information on developments in U.S. foreign relations as well as on the work of the Department and Foreign Service; its contents include: major addresses and news conferences of the President and Secretary; statements made before Congressional committees; special features and articles on international affairs; selected press releases issued by the White House, the U.S. Department of State, and the U.S. Mission to the United Nations; and treaties and other agreements to which the United States is or may become a party.

Department of State Newsletter (monthly except August, $18.00 a year)—acquaints officers and employees of State, at home and abroad, with developments of interest which may affect operations or personnel. It includes a one-page subject bibliography.

Diplomatic List and List of Foreign Consular Offices in the U.S. (quarterly, $11.00 a year)—a list of foreign diplomatic representatives in Washington, with addresses.

Employees of Diplomatic Missions (quarterly, $8.00 a year)—a quarterly publication listing names and addresses of employees of foreign diplomatic representatives in Washington.

Key Officers of Foreign Service Posts: Guide for Business Representatives ($5.00 a year)—a pocket-size directory, published three times a year, listing key foreign service officers abroad with whom American business representatives would most likely have contact.

The above publications are available from Government Printing Office, Superintendent of Documents, Washington, DC 20402/202-783-3238. For more detailed information on available publications, contact: Publications Distributions, Office of Opinion Analysis and Plans, Bureau of Public Affairs, Department of State, 2201 C St. N.W., Room 5815A, Washington, DC 20520/202-632-9859.

Public Availability of Diplomatic Archives in Foreign Countries

This publication summarizes the policies and practices in most countries of the world concerning access to unpublished diplomatic records. Contact: Office of the Historian, Bureau of Public Affairs, Department of State, SA1, Room 3100, Washington, DC 20520/202-632-8888.

Public Communications

Publications available from this office include:

Current Policy Paper—speeches by the Secretary and other major policymakers at the U.S. Department of State (free).

Special Reports—analytical papers on major foreign policy issues including human rights, trade and pollution (free).

Copies of Treaties (free).

Program Notes—information books on individual countries including history, geography, and economy (free).

GIST—quick reference aid to understanding U.S. foreign relations (free).

Background Notes—short factual summaries which describe international organizations and the people, history, government, economy and foreign relations of 160 countries ($31.00 for set).

The Trade Debate—includes information on current U.S. policy, vis-à-vis nontariff barriers, commodities, agricultural trade, adjustment to structural problems, and problems of East-West trade with developing countries (free).

A list of films is also available. Contact: Office of Public Communications, Bureau of Public Affairs, Department of State, 2201 C St. N.W., Room 4827A, Washington, DC 20520/202-632-6575.

Public Programs

Among the programs for the public are:

National Conferences—with opinion leaders from nongovernmental organizations, business and labor, media, education, state and local government and other areas of the private sector.

Seminars—which bring together between 10 and 30 nongovernmental specialists with U.S. Department of State officials for discussions on specific areas of foreign policy.

"Scholar-Diplomat" Seminars

Briefings and Policy Discussions (on request) for small groups.

Town Meetings—regional foreign policy conferences across the country.

Speakers Bureau

Contact: Office of Public Programs, Bureau of Public Affairs, Department of State, 2201 C St. N.W., Room 5831, Washington, DC 20520/202-632-1433.

Refugee Affairs

This office coordinates all U.S. Refugee Assistance programs, both foreign and domestic, and oversees all other agency programs involved with refugees. Fact sheets and other publications are available on current refugee problems. Speakers are also available on the subject. Contact: Refugee Affairs, Office of Public Affairs, Department of State, 2201 C St. N.W., Room 7526, Washington, DC 20520/202-632-5203.

Scholar-Diplomat Seminars

These seminars serve as a professional exchange of views and expertise between scholars and U.S. Department of State officials working in similar fields. This is a week-long program where each scholar sits with his or her assigned officer, reads incoming and outgoing messages, uses files and makes suggestions and comments. Meetings with other department officials are also arranged. Seminars are arranged by the Bureau on a periodic basis with major units of the U.S. Department of State which cover geographic and functional areas: Africa, Latin America, Europe, Near East and South Asia; East Asia; Economic

and Business Affairs; International Organization Affairs; Science, Technology and Environment in Foreign Affairs; Population Matters. Contact: Scholar-Diplomat Seminars, Office of Public Programs, Bureau of Public Affairs, Department of State, 2201 C St. N.W., Room 5831, Washington, DC 20520/202-632-3888.

Science and Technology

This office deals with overall management, political issues (not substantive scientific and technological issues), for international organizations in science and technology such as: International Energy Administration, International Atomic Energy Administration; World Meteorological Organization; U.N. Environment Program; U.N. Intergovernmental Committee on Science and Technology Development; International Hydrographic Organization; International Organization for Legal Metrology; and International Bureau of Weights and Measures. Contact: Science and Technology, Bureau of International Organization Affairs, Department of State, 2201 C St. N.W., Room 1429, Washington, DC 20520/202-632-3511.

Speakers

The U.S. Department of State officers are available to speak to institutions and groups throughout the country. Contact: Office of Public Programs, Bureau of Public Affairs, Department of State, 2201 C St. N.W., Room 5825, Washington, DC 20520/202-632-1433.

Special Briefings to Groups

A business, group, or other organization can request a special briefing on almost any topic related to foreign affairs. Contact: Office of Public Communications, Bureau of Public Affairs, Department of State, 2201 C St. N.W., Room 5831, Washington, DC 20520/202-632-2406.

Terrorism Abroad

Assistance is available to help design corporate security programs for businesses in foreign countries. Information is available on the security climate within a given country. *Countering Terrorism* is a free pamphlet providing security suggestions for U.S. business representatives abroad, and describes precautionary measures as well as suggested behavior in case of kidnapping. Additional information is also available from: Executive Committee and Working Group on Terrorism, D/CT, Department of State, 2201 C St. N.W., Room 2238, Washington, DC 20520/202-632-9892. Contact: Foreign Operations, Office of Security, Bureau of Administra-

tion, Department of State, 2201 C St. N.W., Room 3422, Washington, DC 20520/202-632-3122.

Textiles

For information on textile agreements with other countries, contact: Textiles Division, Bureau of Economic and Business Affairs, International Trade Policy, Department of State, 2201 C St. N.W., Room 3333, Washington, DC 20520/202-632-0280.

Tour of the Diplomatic Reception Rooms

These rooms, still used nearly every day for diplomatic receptions, can handle small luncheons or receptions for up to 500 people. The three principal rooms are the John Quincy Adams State Drawing Room, Thomas Jefferson State Reception Room, and the Benjamin Franklin State Dining Room.

Trade Policies

For information on government policies having to do with countervailing codes; government procurement codes; standard problems; escape clause cases; market disruption cases; steel policy; Buy America problems; subsidies codes; and unfair trade practices, contact: Special Trade Activities and Commercial Treaties Division, International Trade Policy, Bureau of Economic and Business Affairs, Department of State, 2201 C St. N.W., Room 3828, Washington, DC 20520/202-632-1327.

Travel Advisories

Advisories on travel to foreign countries include information on civil disturbances, natural disasters, epidemic diseases, strikes, shortages of hotel rooms and anything else that may affect a traveler. Additional publications describe consular services, visa requirements and special features of a particular country. Contact: Overseas Citizens Services, Bureau of Consular Affairs, Department of State, 2201 C St. N.W., Room 4800, Washington, DC 20520/202-632-3732.

Travel Tips for Senior Citizens

Information is available including: health advice, emergency help, general information, customs hints for returning U.S. residents, visa requirements of foreign governments, foreign country information, passports and visas, and clothing. Contact: Bureau of Consular Affairs, Office of Public Affairs, Department of State, 2201 C St. N.W., Room 6811, Washington, DC 20520/202-632-1489.

Treaties

The following publications provide data on U.S. treaties:

Treaties in Force ($7.00)—annual publication that lists by name, date, and date of entry into force, all treaties and other international agreements of the United States for that year. It also indicates where a complete text of the cited treaty can be found.

Treaties and Other International Acts ($145 a year)— published individually and contain the full text on each treaty.

U.S. Treaties and Other International Agreements— successive volumes (29 thus far) of texts of treaties and international agreements other than treaties to which the United States is a party. The price varies according to the volume.

These publications are available from the Government Printing Office, Superintendent of Documents, Washington, DC 20402/202-783-3238. For more detailed information, contact: Treaty Affairs, Office of the Legal Adviser, Department of State, 2201 C St. N.W., Room 5420, Washington, DC 20520/202-632-1074.

Tropical Products

Tropical products include: sugar, coffee, cocoa, cotton, bananas, and jute and other fibers. For information on international commodity agreements and regulations, and some statistical information (not for customs or domestic information), contact: Tropical Products Division, Office of International Commodities, Bureau of Economic and Business Affairs, Department of State, 2201 C St. N.W., Room 3421, Washington, DC 20520/202-632-3059.

UN Documents and Reference

United Nations documents from New York and Geneva are available from: U.N. Documents and Reference, Bureau of International Organization Affairs, Department of State, 2201 C St. N.W., Room 3428, Washington, DC 20520/202-632-7992.

United Nations Educational Scientific and Cultural Organization (UNESCO)

For UNESCO information within the U.S. Department of State, contact: UNESCO Affairs, Bureau of International Organization Affairs, Department of State, 2201 C St. N.W., Room 4806, Washington, DC 20520/202-632-8588.

United Nations Mission

The United States office at the United Nations is: United States Mission to the United Nations, 799 United Nations Plaza, New York, NY 10017/212-826-4497.

Visa Information for Aliens Waiting to Enter the United States

This office provides general or specific information or visas for aliens wishing to enter the United States. Inquiries about the status of specific cases should be directed to the U.S. consul in the country where the application is made. A list is available of American diplomatic and consular offices that issue visas. Contact: Visa Services, Bureau of Consular Affairs, Department of State, SA2, Room 605, Washington, DC 20520/202-632-1972.

Visiting and Living Abroad

The Citizens Consular Services offers help for Americans visiting, living and doing business abroad in a number of ways.

Notary Public Services—includes administering oaths in depositions, affidavits, and other documents, and takes acknowledgement of signatures.

Voting Assistance—includes help in obtaining absentee ballots and election information.

Judicial Assistance—offers help in determining particular foreign laws, transmits letters, authenticates foreign documents, obtains documents abroad for legal purposes, retains lists of English-speaking lawyers, helps in the whereabouts and welfare search in child custody cases, in property claims, and in nationality and expatriation cases.

Passport and Registration Services Abroad—issues U.S. passports and travel documents to United States citizens and nationals abroad and registers U.S. citizens abroad.

Claims Assistance—in the protection of property and other interests owned by U.S. nationals abroad. Answers claims inquiries including those regarding foreign government restitution/compensation. Provides advice on methods of obtaining documents from abroad as property claims evidence. Handles inquiries concerning private trade complaints.

Child Custody Disputes—welfare and whereabouts information about children involved in custody disputes.

Estates—guidance to consular office and heirs concerning estates in foreign countries of U.S. nationals who die abroad when there is no qualified legal representative present. Consular services include handling inquiries on the transfer of estates from the United States to foreign countries.

Federal Benefits Function—assures the receipt of U.S. federal checks abroad.

Other services include providing tax forms and tax information and the protection of a person's

material remains should he or she die while traveling alone overseas. Contact: Citizens Consular Services, Bureau of Consular Affairs, Department of State, 2201 C St. N.W., Room 4800, Washington, DC 20520/202-632-3666.

Women's Programs

For information on women's programs and women's concerns in international organizations, contact: International Women's Program, Bureau of International Organization Affairs, Department of State, 2201 C St. N.W., Room 1511, Washington, DC 20520/202-632-1120.

How Can the Department of State Help You?

To determine how the U.S. Department of State can help you, contact: Public Affairs Bureau, Department of State, 2201 C St. N.W., Room 6800, Washington, DC 20520/202-632-9606.

Department of Transportation

400 7th St. S. W., Washington, DC 20590/202-426-4000

ESTABLISHED; October 15, 1966
BUDGET: $17,952,115,000
EMPLOYEES: 74,855

MISSION: Assures the coordinated, effective administration of the transportation programs of the federal government and develops national transportation policies and programs conducive to the provision of fast, safe, efficient and convenient transportation at the lowest cost consistent therewith.

Major Divisions and Offices

Saint Lawrence Seaway Corporation

Department of Transportation, 800 Independence Ave. S.W., Washington, DC 20591/202-426-3574.
Budget: $1,372,000
Employees: 194
Mission: Responsible for the development, operation, and maintenance of that part of the Seaway between Montreal and Lake Erie, within the territorial limits of the United States.

Urban Mass Transportation Administration

Department of Transportation, 400 7th St. S.W., Washington, DC 20590/202-426-4043.
Budget: $2,169,289,000
Employees: 565
Mission: Assists in the development of improved mass transportation facilities, equipment, techniques, and methods; encourages the planning and establishment of area-wide urban mass transportation systems; and provides assistance to state and local governments in financing such systems.

Federal Railroad Administration

Department of Transportation, 400 7th St. S.W., Washington, DC 20590/202-426-0881.
Budget: $1,541,452,000
Employees: 1,703
Mission: Consolidates government support of rail transportation activities; provides a unified and unifying national rail transportation policy; administers and enforces rail safety laws and regulations; administers financial assistance programs for certain railroads, conducts research and development in support of improved intercity ground transportation and the future requirements for rail transportation; provides revitalization of Northeast Corridor rail passenger service; and operates the Alaska Railroad.

National Highway Traffic Safety Administration

Department of Transportation, 400 7th St. S.W., Washington, DC 20590/202-426-1828.
Budget: $281,728,000
Employees: 874
Mission: Carries out programs relating to the safety performance of motor vehicles and related equipment, motor vehicle drivers, and pedestrians, carries out programs and studies aimed at reducing economic losses in motor vehicle crashes and repairs, through general motor vehicle programs; administers the federal odometer law, and a uniform national maximum speed limit; and promulgates average fuel economy standards for passenger and nonpassenger motor vehicles.

Federal Highway Administration

Department of Transportation, 400 7th St. S.W., Washington, DC 20590/202-426-0630.
Budget: $8,985,557,000
Employees: 4,414
Mission: Coordinates highways with other modes

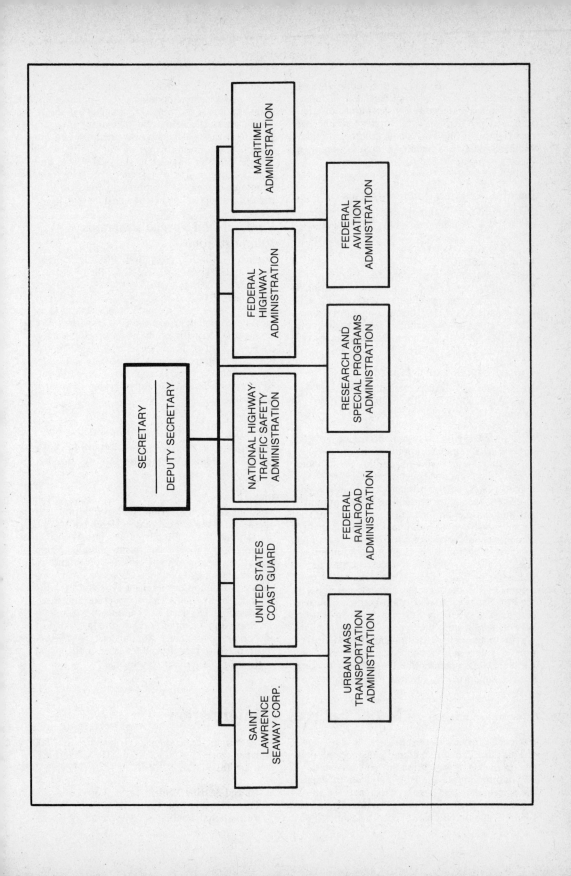

of transportation to achieve the most effective balance of transportation systems and facilities under cohesive federal transportation policies; and be concerned with the total operation and environment of highway system, with particular emphasis on improvement of highway-oriented aspects of highway safety.

Federal Aviation Administration

Department of Transportation, 800 Independence Ave., Washington, DC 20591/202-426-8058.
Budget: $3,244,054,000
Employees: 58,107
Mission: Regulates air commerce to foster aviation safety; promotes civil aviation and a national system of airports; achieves efficient use of navigable airspace; and develops and operates a common system of air traffic control and air navigation for both civilian and military aircraft.

United States Coast Guard

Department of Transportation, 2100 2nd St. S.W., Washington, DC 20593/202-426-2158.
Budget: $1,661,007,000
Employees: 6,845
Mission: Maintains a system of rescue vessels, aircraft and communications facilities to carry out its function of saving life and property in and over the high seas and the navigable waters of the United States; be the primary maritime law enforcement agency for the United States; administers and enforces various safety standards for the design, construction, equipment and maintenance of commercial vessels of the United States and off-shore structures on the Outer Continental Shelf; regulates pilotage services on the Great Lakes; implements the nation's policies for protection of the marine environment; administers the Port Safety and Security Program; establishes and maintains United States aids to navigation system; administers the several statutes regulating the construction, maintenances, and operation of bridges across the navigable waters of the United States; operates the nation's icebreaking vessels, supported by aircraft for ice reconnaissance, to facilitate maritime transportation and aid in prevention of flooding in domestic waters, and supports logistics to U.S. polar installations; administers a licensing and regulatory program governing the construction, ownerships, and operation of deepwater ports on the high seas to transfer oil from tankers to shore; develops and directs a national boating safety program; and maintains a state of readiness to function as a specialized service in the navy in time of war.

Research and Special Programs Administration

Department of Transportation, 400 7th St. S.W., Washington, DC 20590/202-426-4486.
Budget: $26,081,000
Employees: 918
Mission: Serves as a research, analysis, and technical development arm of the U.S. Department of Transportation with emphasis on pipeline safety, transportation of hazardous cargo by all modes of transportation, transportation safety, transportation control, safety, season extension, and related programs designed to fully develop the fourth seacoast.

Maritime Administration

Department of Transportation, 400 7th St. S.W., NASIF Building, Washington, DC 20590/202-426-5806.
Budget: $643,275
Employees: 1,310
Mission: Aids in development, promotion and operation of the United States Merchant Marine and United States Merchant Marine Academy. Organizes and directs emergency merchant ship operations. Administers subsidy programs to ship operators and builders. Constructs or supervises construction of merchant type ships for the federal government. Helps generate increased business for U.S. ships and conducts programs to develop ports, facilities and intermodal transport and domestic shipping. Administers a War Risk Insurance Program. Regulates sales to aliens and transfer to foreign registry of ships.

Major Sources of Information

Accident Prevention—Aviation
This office provides national guidance and policy on accident prevention in general aviation. For information on available publications, tapes, slides, seminars and speakers, contact: Accident Prevention Staff, General Aviation Division, Flight Standards Service, Federal Aviation Administration, Department of Transportation, 800 Independence Ave. S.W., Room 317A, Washington, DC 20591/202-426-8102.

Advanced Marine Vehicle Technology
This office conducts research on the following: 1) recreational boating safety, including opera-

tions research determining the effect of safety programs, development of personal flotation device concepts, and development of regulations; 2) evaluation of new and existing boat designs, including fleet replacement alternatives; and 3) search and rescue, including human factors which determine the limitations of search and rescue. Contact: Advanced Marine Vehicle Technology Branch, Safety and Advanced Technology Division, Office of Research and Development, Coast Guard, Department of Transportation, 2100 2nd St. S.W., Washington, DC 20593/202-472-5770.

Advanced Transportation System

Research is conducted on developing concepts, designs and evaluation of integrated multi-modal transportation systems such as freight systems improvement (worldwide dock-to-dock systems, container innovations, and terminal mechanization), and integrated passenger service (moving rendezvous systems, low density air networks, noncontact suspension systems). Contact: Carrier and Technology Analysis Branch, Transportation System Center, Research and Special Programs Administration, Department of Transportation, Kendall Square, Room 735, Cambridge, MA 02142/617-494-2714.

Aeromedical Standards

This office sets policy, regulations and standards for medical certificates required for a pilot's license. Contact: Aeromedical Standards, Office of Aviation Medicine, Federal Aviation Administration, Department of Transportation, 800 Independence Ave. S.W., Room 320, Washington, DC 20591/202-426-3802.

Aids to Navigation

Each U.S. Coast Guard district can provide a free copy of *Local Notice to Mariners* which includes information on establishments, changes and discontinuances of aids to navigation in the United States, its territories and possessions, reports on channel conditions, obstructions to navigation, danger areas and new charts. The publication, *Aids to Navigation*, explains the significance of the colors of beacons and buoys, of the variety of light and fog signal characteristics, and of the system of electronic aids to navigation. Contact: Marine Information Branch, Short Range Aids to Navigation Division, Office of Navigation, Coast Guard, Department of Transportation, 2100 2nd St. N.W., Room 1414, Washington, DC 20593/202-426-9566.

Air and Marine Systems Technology

Research is conducted on developing future air and marine transportation, i.e., aircraft wake vor-tex avoidance systems to help aircraft avoid landing hazards, wind shear detection systems for airports to improve flight safety, automation of flight service stations to provide improved services to pilots, weapons and explosives sensing devices, harbor and waterway traffic control system assessments, analysis of vessel design and capabilities to carry out specific Coast Guard missions. Laboratories are maintained in airport traffic control, explosives detection, communications, display systems, human performance, ride comfort, flight service station automation. Contact: Office of Air and Marine Systems, Transportation Systems Center, Research and Special Programs Administration, Department of Transportation, Kendall Square, Room 5-31, Cambridge, MA 02142/617-494-2467.

Aircraft Accidents

For information on general aviation accidents and near mid-air collisions, contact: Safety Analysis Division, Office of Aviation Safety, Federal Aviation Administration, Department of Transportation, 800 Independence Ave. S.W., Washington, DC 20591/202-426-8256.

Aircraft Accidents Reports

A central file is maintained showing documentation of all accidents and incidents involving aircraft. Contact: Accident/Incident Analysis Branch, Air Traffic Service, Federal Aviation Administration, Department of Transportation, 800 Independence Ave. S.W., Room 432B, Washington, DC 20591/202-426-3353.

Aircraft Maintenance Data

Available aircraft data include maintenance surveillance, mechanical reliability and malfunctions or defects, mechanical interruptions, and inflight mechanical problems. Contact: Maintenance Analysis Center Section, AFO-581, Federal Aviation Administration, Department of Transportation, Aeronautical Center, P.O. Box 25082, Oklahoma City, OK 73125/405-749-4171.

Aircraft Management Information

The following publications are available upon request:

Inventory of Active Federal Aviation Administration Aircraft Report—provides the type, number, location and mission assignment on all Federal Aviation Administration-owned, loaned, purchased and exclusive air lease aircraft.

Aircraft Management Cost Accounting Information, Selected—cost of operating and maintaining the Federal Aviation Administration fleet, provides workload and financial information to support management

decisions on the allocation and use of aircraft and program resources.

Aircraft Program Data—flight inspection, air space and procedure programs, aircraft maintenance utilization and availability.

Energy Conservation Data—fuel consumption by agency-owned and operated aircraft.

Contact: Fleet Management Branch, Aircraft Programs Division, AFO-700, Office of Flight Operations, Federal Aviation Administration, Department of Transportation, 800 Independence Ave. S.W., Washington, DC 20591/202-426-8260.

Aircraft Noise

Research is conducted on reducing noise levels of new aircraft, sonic boom prohibition on civil aircraft, and retrofitting of older aircraft to reduce noise levels. A free bimonthly report is available on noise monitoring at National and Dulles airports. Contact: Noise Abatement Division, Office of Environment and Energy, Federal Aviation Administration, Department of Transportation, 800 Independence Ave. S.W., Room 838, Washington, DC 20591/202-755-9468.

Airmen and Aircraft Registry

Permanent records are kept on all U.S. civil aircraft and airmen (students, private, commercial and airline transport). Certificates are issued to air carrier personnel involved in international civil aviation. Registration numbers for all civil aircraft are issued and monitored by the Registry. Contact: Airman and Aircraft Registry, Federal Aviation Administration, Department of Transportation, Mike Monroney Aeronautical Center, P.O. Box 25082, Oklahoma City, OK 73125/405-686-4331.

Airport Data

Data bases with information on airports include:

Activity Data—estimated number of general aviation operations, estimated annual air taxi operations, estimated annual military operations, and the number of based general aviation aircraft.

Airport Data—physical characteristics of each airport, heliport, and seaplane base.

Facility Data—physical characteristics of all landing facilities.

Inspections—performance of an on-site airport inspection by Federal Aviation Administration field representatives.

Location/Addresses—geographic location of the landing facilities, latitude, longitude, distance and direction from the airport to its associated city, name and mailing address of the owner or manager.

Contact: Airport Safety Data Group, Office of Airport Programs, Federal Aviation Administration, Department of Transportation, 800 Independence Ave. N.W., Room 623C, Washington, DC 20591/202-426-3554.

Airport Security

This program insures law enforcement presence in airports, approves the security programs proposed by every operating airport, certifies walk-through detection devices, and conducts internal investigations of airport personnel. Contact: Airport Security Program, Civil Aviation Security Service, Federal Aviation Administration, Department of Transportation, 800 Independence Ave. S.W., Room 705, Washington, DC 20591/202-426-8768.

Airport Standards

Information is available on standards required for constructing and operating airports such as size, length, separation between runways, snow and ice control, and crash and fire rescue equipment. Contact: Design and Operational Criteria Division, Office of Airport Standards, Federal Aviation Administration, Department of Transportation, 800 Independence Ave. S.W., Room 614, Washington, DC 20591/202-426-3446.

Air Traffic Control System

This system tracks controlled flights automatically and tags each target with a small block of information written electronically on the radar scope used by air traffic controllers. The data block includes aircraft identity, altitude and ground speed. Contact: Air Traffic Control System Program Division, Air Traffic Service, Federal Aviation Administration, Department of Transportation, 800 Independence Ave. S.W., Room 426, Washington, DC 20591/202-426-3136.

Air Traffic System Errors

A central file is maintained on all system errors chronologically by region. The file consists of reports identifying anything wrong in the air traffic service terminal. Contact: Evaluation and Analysis Staff, Air Traffic Services, Federal Aviation Administration, Department of Transportation, 800 Independence Ave. S.W., Room 432A, Washington, DC 20591/202-426-3353.

Alaska Railroad

This railroad is 478 kilometers of single mainline track from Seward and Whittier to the interior of central Alaska through Anchorage to Fairbanks. It is under mandate from the U.S. Congress to operate within its revenues. Contact:

The Alaska Railroad, Federal Railroad Administration, Department of Transportation, 400 7th St. S.W., Room 8218, Washington, DC 20590/202-472-9047.

Automated Guideway Transit (AGT) Applications

This office coordinates the introduction of people mover systems into the urban environment.

The major objectives include: 1) development and implementation of projects that can demonstrate the applications of AGT systems in urban areas; 2) a "delivery system" for the development of federal and private advanced technology systems that have shown promise in providing improved transit service; and 3) the necessary planning, technical and managerial support to local, state and other departmental offices involved with the implementation of AGT systems in urban applications. Contact: New Systems Applications, Technology Development and Deployment, Urban Mass Transportation Administration, Department of Transportation, 400 7th St. S.W., Room 7410, Washington, DC 20590/202-426-2896.

Automobile Energy Efficiency

For information on the energy efficiency of new passenger cars and approaches to improving it, contact: Office of Automotive Fuel Economy Standards, Rulemaking, National Highway Traffic Safety Administration, Department of Transportation, 400 7th St. S.W., Room 6124, Washington, DC 20590/202-426-0846.

Auto Safety Hotline

The Auto Safety Hotline will tell you if your vehicle has been determined as unsafe and involved in a recall. You can also call the hotline to record a complaint. Computerized literature searches can be made on the files maintained by the Technical Reference Service. However, there is a charge for computer searches. Contact: Office of Defects Investigation, NEF-10, National Highway Traffic Safety Administration, Department of Transportation, 400 7th St. S.W., Room 5326, Washington, DC 20590/800-424-9393 (DC: 202-426-0123).

Aviation Accident Investigations

Pertinent medical data associated with persons involved in aviation accidents are analyzed. Contact: Accident Investigations Biomedical and Behavioral Science Division, Office of Aviation Medicine, Federal Aviation Administration, Department of Transportation, 800 Independence Ave. S.W., Room 320, Washington, DC 20591/202-426-3767.

Aviation Consumer Complaints

Complaints on such subjects as safety, noise, pesticide spraying or broken seat belts are handled by: Community and Consumer Liaison Division, Office of Public Affairs, Federal Aviation Administration, Department of Transportation, 800 Independence Ave. S.W., Room 906A, Washington, DC 20591/202-426-1960.

Aviation Education Programs

A wide range of training and teaching materials are available in elementary, secondary and career levels. For a listing of free publications and films available on a free-loan basis, contact: Aviation Education and Consultative Planning Branch, Federal Aviation Administration, Department of Transportation, 800 Independence Ave. S.W., Room 939, Washington, DC 20591/202-426-8444.

Aviation Equipment Specifications

Information is available on specifications for the manufacturing and installation of such aviation equipment as visual aides associated with landing and taxiing of aircrafts, runway lights, approach lights, beacons, etc. Contact: Engineering and Specifications Division, Office of Airport Standards, Federal Aviation Administration, Department of Transportation, 800 Independence Ave. S.W., Room 614, Washington, DC 20591/202-426-3824.

Aviation Forecasts

The following publications are available:

Federal Aviation Administration Aviation Forecast—this annual publication provides 12-year projections on all aspects of aviation, including total aircraft, total airborne, statute miles of U.S. air carriers, hours flown in general aviation, and fuel consumed.
Terminal Area Forecasts—this annual publication provides 10-year projections on 400 specific airports including in-plane passengers, and operations of air carriers.

Contact: Aviation Forecasts Branch, Office of Aviation Policy, Federal Aviation Administration, Department of Transportation, 800 Independence Ave. S.W., Room 935F, Washington, DC 20591/202-426-3103.

Aviation History

For information on aviation history, contact: Agency Historian, Office of Public Affairs, Federal Aviation Administration, Department of Transportation, 800 Independence Ave. S.W., Room 907A, Washington, DC 20591/202-755-7234.

Aviation Inquiries

For general information concerning subjects covered by the Federal Aviation Administration, contact: Public Inquiry Center, Office of Public Affairs, Federal Aviation Administration, Department of Transportation, 800 Independence Ave. S.W., Room 907E, Washington, DC 20591/202-426-8058.

Aviation Medicine

Aeromedical research is conducted on such topics as: 1) psychology—evaluates spatial disorientation and visual perception in the aviation environment; 2) physiology—performance and health of aircrew and air traffic controllers under diverse environmental conditions; 3) toxicology—toxic hazards such as pesticides used in aerial application, products of combustion and ionizing radiation from air shipment of radioactive cargo in the high altitude environment; and 4) protection and survival—studies of techniques for attenuating or preventing crash injuries, developing concepts and evaluating survival equipment used under adverse environmental conditions, establishing human physical limitations of civil aviation operations and evaluating emergency procedures for downed aircraft. Contact: Biomedical and Behavioral Science Division, Office Of Aviation Administration, Department of Transportation, 800 Independence Ave. S.W., Room 321, Washington, DC 20591/202-426-3767.

Aviation News

This bimonthly publication is a safety magazine for general aviation pilots. Available for $6.10 per year from: U.S. Government Printing Office, Superintendent of Documents, Washington, DC 20402/202-783-3238. For more detailed information on content, contact: *FAA General Aviation News*, General Aviation and Commercial Division, AFO-807, Flight Standards Service, Federal Aviation Administration, Department of Transportation, 800 Independence Ave. S.W., Washington, DC 20591/202-426-3903.

Aviation Policy

Reports and data are generated from some 18 data bases to aid in aviation policy decisions on such topics as the activities of airlines, seat belt configurations, and the number of airports in the United States. Contact: Information Systems Branch, APO-130, Policy Analysis Division, Office of Aviation Policy and Plans, Federal Aviation Administration, Department of Transportation, 800 Independence Ave. S.W., Room 935, Washington, DC 20591/202-426-3374.

Aviation Procedures Periodicals

The following periodicals will keep the reader current on internal directives published by Federal Aviation Administration Headquarters:

Flight Services Handbook—describes the procedures and terms used by personnel providing assistance and communications services ($19.00/subscription).
Data Communications Handbook—describes teletypewriter operating procedures, applicable international teletypewriter procedures and continuous U.S. Service weather schedules ($15.00/subscription).

Contact: Government Printing Office, Superintendent of Documents, Washington, DC 20402/202-783-3238.

Aviation Radio Systems

Work is performed to insure that radio systems have frequencies on which to operate that are compatible with other frequencies. Work is also done in conjunction with international organizations on future plans for radio systems. Contact: Spectrum Management Branch, Systems Research and Development Service, Federal Aviation Administration, Department of Transportation, 800 Independence Ave. S.W., Room 735, Washington, DC 20591/202-426-3628.

Aviation Small Business Procurement

A small business specialist provides Federal Aviation Administration contracting and procurement support for spare parts, modifications and service contracts for the fleet of aircraft and their air navigation and communication gear operated by the Federal Aviation Administration. Contact: Small Business Specialist Procurement Division, AAC-70A, Federal Aviation Administration, Department of Transportation, Mike Monroney Aeronautical Center, P.O. Box 25082, MPB 304, Oklahoma City, OK 73125/405-686-4774.

Aviation Statistics—Accidents

Statistics are maintained on: 1) general aviation accident information; 2) incidents (little damage or minor injury) of both air carrier and general aviation; 3) service difficulty reports; and 4) enforcement data and violations. Contact: Safety Data Branch, Flight Standards, National Field Office, Federal Aviation Administration, Department of Transportation, P.O. Box 25082, AFO 580, Oklahoma City, OK 73125/405-686-4171.

Aviation Statistics—General

Historical and current aviation statistics are available on such topics as: air traffic activities,

number of aircraft, flying hours, pilots and passengers. For a listing of available publications, contact: Information Analysis Branch, Information and Statistics Division, Office of Management Systems, Federal Aviation Administration, Department of Transportation, 800 Independence Ave. S.W., Room 635, Washington, DC 20591/202-426-3791.

Bird Strikes

Information is available on where bird strikes occur. Contact: Airport Safety Data Group, Office of Airport Standards, Federal Aviation Administration, Department of Transportation, 800 Independence Ave. S.W., Room 624, Washington, DC 20591/202-426-3854.

Boating Information

Information and technical assistance is available on boating including the following free publications:

Federal Requirements for Recreational Boats—detailed information on such items as fire extinguishers, personal flotation devices, lighting, safe boating tips, and marine sanitation devices.
Suddenly in Command—basics of how to run the boat, how to use emergency equipment, and what to do in case of trouble.
Marine Communication for the Recreational Boater
Trailer-Boating—A Primer
Visual Distress Signals
Passport to Pleasure Cruising
U.S. Coast Guard Boating Safety Newsletter
Boating Statistics
Cold Water Drowning—A New Lease on Life
First Aid for the Boatman
Hypothermia and Cold Water Survival
This is the Seal of Safety
Emergency Repairs Afloat
Safety Standards for Backyard Boat Builders
Navigational Rules—International—Inland
COLREGS Demarcation Lines, Supplement to Navigational Rules—International—Inland

Contact: Boating Information Branch, Office of Boating Safety, Coast Guard, Department of Transportation, G-BA2, 2100 2nd St. S.W., Washington, DC 20593/202-426-1587.

Boating on the Saint Lawrence River

Boating information is available in the publication, *Pleasure Craft Guide—the Seaway*. Available for $5.00 from: Public Information Office, St. Lawrence Seaway Corp., P.O. Box 520, Massena, NY 13662/315-764-3200.

Boating Safety and Seamanship Courses—Free

The U.S. Coast Guard Auxiliary offers courses in boating safety and seamanship to the public. They are taught by experienced auxiliary members and the only charge for materials. Some courses include: Basic Boating, Sailing and Seamanship, Principles of Sailing, Water and Kids, Young Peoples Boating Course, First Aid and the Boatmen, and Introduction to Sailing. Contact: your local auxiliary flotilla, or Auxiliary and Education Division, Office of Boating Safety, Coast Guard, Department of Transportation, 2100 2nd St. S.W., Room 4304, Washington, DC 20593/202-426-1077.

Bus and Paratransit Technology

This office is involved in two major programs:

Paratransit Integration—attempts to find solutions to transportation analysis, management, and operating problems.
Automated Vehicle Monitoring—an electronic system of monitoring the location and status of transit vehicles operating on city streets.

Contact: Office of Bus and Paratransit Technology, Technology Development and Deployment, Urban Mass Transportation Administration, Department of Transportation, 400 7th St. S.W., Room 7410, Washington, DC 20590/202-426-4035.

Civil Aeromedical Institute (CAMI)

This Institute conducts research to identify human factor causes of aircraft accidents, prevent future accidents and make accidents that do occur more survivable. It also operates a program for the medical certification of airmen, educates pilots and physicians in matters related to aviation safety, and is responsible for developing and producing brochures, slides and training films for distribution to aviation groups and organizations. Contact: Civil Aeromedical Institute, Mike Monroney Aeronautical Center, Federal Aviation Administration, Department of Transportation, P.O. Box 25082, Oklahoma City, OK 73125/405-686-4806.

Civil Aviation Security Service

This office maintains information and expertise on domestic and foreign aircraft hijacking, including bomb threats at airports and on carriers, compliance and enforcements of violations of regulations, prevented attempts, explosives and explosive devices found at airports and aircraft, worldwide criminal incidents involving civil aviation, information on number of people screened, number of weapons found, and weapon detection devices. Contact: Civil Aviation Security Services, (ACS 400) Federal Aviation Administra-

tion, Department of Transportation, 800 Independence Ave. S.W., Room 707, Washington, DC 20591/202-426-8210.

Coast Guard Institute

This Institute trains coast guard personnel in their specialties through a nonresident course program. Most courses are designed to provide training to assist enlisted personnel in preparing for advancement. Contact: Coast Guard Institute, Coast Guard, Aeronautical Center, MPB 237, P. O. Substation 18, Oklahoma City, OK 73169/405-686-4263.

Coast Guard Publications

For a listing of available publications and photographs, contact: Directives, Publications and Printing Branch, Management Analysis, Chief of Staff, Coast Guard, Department of Transportation, 2100 2nd St. S.W., Room 2604, Washington, DC 20593/202-426-2631.

Coast Guard Research

Information is available on research and development in the following areas: Ice Operations (IO); Marine Science Activities (MSA); Marine Environmental Protection (MEP); Port Safety and Security (PSS); Short Range Aids to Navigation (AN); Radionavigation Aids (RA); Search and Rescue (SAR); Telecommunications R&D (GAC); Commercial Vessel Safety (CVS); Recreational Boating Safety (RBS); Energy Technology (ENG); Command, Control, Surveillance Systems; and Advanced Marine Vehicles. Contact: Planning and Evaluation, Office of Research and Development, Coast Guard, Department of Transportation, 2100 2nd St. S.W., Room 5400J, Washington, DC 20593/202-426-1030.

Coast Guard Reservist Magazine

This free, bimonthly magazine features human interest stories and includes news and information of interest to coast guard reservists. Contact: Office of the Reserve, Coast Guard, Department of Transportation, 2100 2nd St. S.W., Room 5101, Washington, DC 20593/202-426-2350.

Coast Guard Training

Coast Guard Reserve Training courses are developed and validated in three areas: 1) correspondence courses; 2) inactive duty training through video and classroom; and 3) active duty schools. Contact: Training Development Branch, Reserve Training Division, Office of the Reserve, Coast Guard, Department of Transportation, 2100 2nd St. S.W., Room 5103, Washington, DC 20593/202-426-1624.

Commuter and Air Taxi

Information is available covering policy, regulations and directives of commuter and air taxi aircraft. A listing is available of air taxi operators and commercial operators of small aircraft. Contact: Commuter and Air Taxi Branch, Air Transportation Division, Office of Flight Operations, Federal Aviation Administration, Department of Transportation, 800 Independence Ave. S.W., Room 306, Washington, DC 20591/202-426-8086.

Consumer Liaison

This office assures the coordination of consumer policy within the U.S. Department of Transportation; insures that consumer considerations are incorporated into the Department's policy; and has established systematic procedures for complaint handling. Free publications include:

Transportation Consumer—a bimonthly newsletter on consumer activities and interest in transportation.
Gasoline—More Miles Per Gallon
Common Sense on Buying a New Car
Rideshare and Save-A-Cost Comparison

Contact: Office of Consumer Liaison, Department of Transportation, 400 7th St. S.W., Room 9402, Washington, DC 20590/202-426-4518.

Cooperative Marine Sciences Program

This program provides optimum utilization of specialized Coast Guard facilities in any area where cooperative efforts may enhance the national marine sciences effort. Space available accommodations of scientists, researchers and students on Coast Guard vessels, aircraft and stations. Joint planning of Coast Guard scientific programs with the programs of others. Accommodation of non-Coast Guard scientific projects on board Coast Guard vessels and iarcraft on a "not to interfere with primary mission" basis. Assignment of Coast Guard vessels and aircraft in support of non-Coast Guard scientific projects as a primary mission of that vessel or aircraft. The only restrictions are the availability of suitable ships and aircraft and the pertinence of the project to the national program. Contact: Marine Science and Ice Operations Division, Coast Guard Headquarters, Department of Transportation, Washington, DC 20593/202-426-1881.

Courtesy Marine Examination

To determine if your vessel meets federal and state safety-related equipment requirements as well as further recommended safety standards, contact a member of the U.S. Coast Guard Aux-

iliary for a free Courtesy Marine Examination or: Boating Information Branch, Office of Boating Safety, Coast Guard, G-BA2, Department of Transportation, 2100 2nd St. S.W., Room 4213, Washington, DC 20593/202-426-9716.

Deepwater Ports
This office has licensing and safety oversight responsibility for deep water port projects. Deep water ports enable off-shore off-loading of all through pipelines into storage. Contact: Office of Economics, Ports Division, Department of Transportation, 400 7th St. S.W., Room 10309, Washington, DC 20590/202-426-4144.

Direct Payments
The programs described below provide financial assistance directly to individuals, private firms and other private institutions to encourage or subsidize a particular activity.

Capital Construction Fund
Objective: To provide for replacement vessels, additional vessels or reconstructed vessels, built and documented under the laws of the United States for operation in the United States foreign, Great Lakes or noncontiguous domestic trades.
Eligibility: An applicant must be a U.S. citizen, own or lease one or more eligible vessels, have a program for the acquisition, construction or re-construction of a qualified vessel and demonstrate the financial capabilities to accomplish the program.
Range of Financial Assistance: Applicant receives tax benefits for depositing assets in accordance with the program.
Contact: Assistant Administrator for Maritime Aids, Maritime Administration, Department of Transportation, 40 7th St. S.W., Room 8126, Washington, DC 20590/202-382-0634.

Construction-Differential Subsidies
Objective: To promote the development and maintenance of the Merchant Marine by granting financial aid to equalize cost of constructing of a new ship in a U.S. shipyard with the cost of constructing the same ship in a foreign shipyard.
Eligibility: U.S. flagship operators or U.S. shipyards for construction of ships to be used in foreign trade. Prospective purchaser must possess the ability, experience, financial resources, and other qualifications necessary for the acquisition, operation, and maintenance of the proposed new ship.
Range of Financial Assistance: $300,000 to $40,000,000.

Contacts: Assistant Administrator for Maritime Aids, Maritime Administration, Department of Transportation, 40 7th St. S.W., Room 8126, Washington, DC 20590.

Operating-Differential Subsidies
Objective: To promote development and maintenance of U.S. Merchant Marine by granting financial aid to equalize cost of operating a competitive foreign flag ship.
Eligibility: Any U.S. citizen who has the ability, experience, financial resources, and other qualifications necessary to enable him to conduct the proposed operation of U.S. flag vessels in an essential service in the foreign commerce of the U.S.
Range of Financial Assistance: $2,400 to $6,390 per day.
Contact: Assistant Administrator for Maritime Aids, Maritime Administration, Department of Transportation, 40 7th St., Room 8626, Washington, DC 20590/202-382-0364.

Driver and Pedestrian Education
Technical and financial assistance is available to states and local communities for programs on driver education, pupil transportation safety, alcohol, safety belts, motorcycle, bicycle and moped safety, and pedestrian safety. Contact: Driver and Pedestrian Education Division, Driver and Pedestrian Programs, Traffic Safety Programs, National Highway Traffic Safety Administration, Department of Transportation, 400 7th St. S.W., Room 5130, Washington, DC 20590/202-426-8681.

Driver and Pedestrian Research
Research is conducted to study the interaction between people and machines. The seven basic areas of concentration are: 1) unsafe driving—why, developing countermeasures, public information, detection; 2) occupant restraints—belts, air bags; 3) alcohol—rehabilitation, public information; 4) pedestrian—bicycle research; 5) motorcycles and mopeds—helmet use; 6) driver licenses—developing uniform standards, working with major abuses, special groups; 7) young drivers—risk taking and driver education. Contact: Office of Driver and Pedestrian Research, Research and Development, National Highway Traffic Safety Administration, Department of Transportation, 400 7th St. S.W., Room 6240, NRD40, Washington, DC 20590/202-426-9591.

Driving Publications and Films
For information on available publications and films for both the consumer and expert, contact:

Office of Public Affairs and Consumer Participation, National Highway Traffic Safety Administration, Department of Transportation, 400 7th St. S.W., Room 5232, Washington, DC 20590/ 202-426-9550.

Driving Records

Each state sends in its suspension and revocation records to a central point in order that other states can make use of the information in granting new licenses. The kind of data included is: name, date of birth, social security number, driver license number, height, weight, eye color, data and reason license was revoked, and date of reinstatement. Not all states participate. Contact: National Driver Register, Traffic Safety Programs, National Highway Traffic Safety Administration, Department of Transportation, 400 7th St. S.W., Room 5206, Washington, DC 20590/ 202-426-4800.

Economic Development—Loans for Public Works and Development Facilities

Objectives: To promote construction and reconstruction of ships in the foreign and domestic commerce of the United States by providing government guarantees of obligations so as to make commercial credit more readily available.
Eligibility: Any U.S. citizen with the ability, experience and financial resources, and other qualifications necessary to the adequate operation and maintenance of the vessel.
Range of Financial Assistance: $106,000 to $126,300,000
Contact: Assistant Administrator for Maritime Aids, Maritime Administration, Department of Transportation, 400 7th St. S.W., Room 8126, Washington, DC 20590/202-382-0364.

Energy and Environment

The Transportation Systems Center provides technological, economic and analytical support for U.S. Department of Transportation programs on energy conservation and environmental impacts in transportation systems. The Center's analyses have been used in the establishment of fuel economy standards. It analyzes and assesses manufacturers' plans in support of the fuel economy standards. It has developed an extensive motor vehicle industry data base with information on the auto industry's capabilities—product plans, production plans, capacity analysis, capital costs, cash flow and financial analyses. It develops plans for the acquisition and development of Environmental Protection Agency-approved chemical agents to be used to disperse oil slicks. It performs complex computer simulations to predict airport noise based on aircraft type, flight path, runway usage and weather conditions. It also performs tradeoff analysis among safety, environmental and economic aspects of motor vehicle energy conservation, and originates the qualification tests for breath measurement instrumentation and for blood-alcohol analysis. Its laboratories specialize in noise measurement, dynamometer, breath and blood alcohol, tire tests, physical density and transit materials. Contact: Office of Energy and Environment, Transportation Systems Center, Research and Special Programs Administration, Department of Transportation, Kendall Square, Room 11-39, Kendall Square, Cambridge, MA 02142/617-494-2028.

Energy Policy

This office is concerned with the energy policy that affects the transportation across the country of energy products such as Alaskan oil and coal. It also deals with energy conservation in such areas as car and van pooling. Contact: Energy Policy Division, Office of Economics, Department of Transportation, 400 7th St. S.W., Room 90400, Washington, DC 20590/202-426-0783.

Environment

This office acts as the environmental contact point for the U.S. Department of Transportation on areas including: the review of environmental impact statements for major projects; resolution of environmental concerns and issues; bicycle-related activities such as studies of their benefits and hazards, and funding for bicycle paths; historic preservation activities; development of regulations for accessibility of mass transportation vehicles for the handicapped and the aged; overseeing highway beautification; art and architecture aesthetic considerations in transportation projects; and air quality. Contact: Office of Environment, Office for Policy and International Affairs, Department of Transportation, 400 7th St. S.W., Room 10228, Washington, DC 20590/202-426-4357.

Environmental Protection Newsletter

This newsletter is an official medium for information Coast Guard personnel of developments and matters of general interest in the marine environmental protection field. It is also distributed to federal and state agencies, schools, industries and individuals interested in marine environment. Contact: Environmental Response Division, Office of Marine Environment and Systems, Coast Guard, Department of Transportation, 2100 2nd St. S.W., Room 1200, Washington, DC 20593/202-426-2010.

Environmental Research

Research is performed on water quality, noise abatement, air quality, vegetation management and corrosion control. Studies are also done on bicycling and pedestrians. Contact: Environmental Division, Office of Research, Federal Highway Administration, Department of Transportation, 400 7th St. S.W., Room 6329, Washington, DC 20590/202-426-0291.

Facility for Accelerated Service Testing (FAST)

This project is used to test various track structures, rail ties, ballast, fasteners, switches, track, stability, safety equipment, vehicle components, loading techniques, maintenance methods and other equipment under heavy conditions. Contact: Analysis and Evaluation Division, Research and Development, Federal Railroad Administration, Department of Transportation, 400 7th St. S.W., Room 8322, RRD-11, Washington, DC 20590/202-755-1877.

Federal Aviation Administration Academy

The Academy is the principal source of aviation technical knowledge. It conducts training for Federal Aviation Administration personnel through resident or correspondence courses and occasional on-site training. Air traffic training is available for specialists who man the Federal Aviation Administration airport traffic control towers, air route traffic control center, and flight service stations. Electronics training is also available for engineers and technicians who install and maintain navigation traffic control and communications facilities. Initial and recurrent training is also conducted for air carrier and general operations inspectors. Air navigation facilities and flight procedures analysis is provided to flight inspection personnel. Contact: AAC-900, P. O. Box 25082, Oklahoma City, OK 73125/405-686-4317.

Fifty-Five Miles Per Hour Enforcement

A clearinghouse and information center is available on enforcement programs in the United States. They receive and process annual certifications of 55 MPH enforcement that are required by law. It oversees expenditures of Federal Highway Safety Funds allocated annually for 55 MPH enforcement. It also develops research programs which assist state enforcement agencies to improve their programs. Contact: Police Traffic Services Branch, Enforcement Division, Traffic Safety Programs, National Highway Traffic Safety Administration, Department of Transportation, 400 7th St. S.W., Room 5118, Washington, DC 20590/202-472-5440.

Flight Procedures

Instrument flight procedures are developed and maintained by: Flight Standards, National Field Office, Federal Aviation Administration, Mike Monroney Aeronautical Center, Department of Transportation, P. O. Box 25082, AFO-500, Oklahoma City, OK 73125/405-686-2305.

Freedom of Information Act

Each major division within the Department of Transportation has a Freedom of Information Act office. For a list of these offices, contact: Freedom of Information Office, Office of Public Affairs, Department of Transportation, 400 7th St. S.W., Room 9421, Washington, DC 20590/202-426-4542.

Gasoline Trends

The publication, *Monthly Motor Gasoline Reported By States*, gives an indication of trends in gasoline sales by month. Contact: Highway Users and Finance Branch, Highway Statistics Division, Office of Highway Planning, Federal Highway Administration, Department of Transportation, 400 7th St. S.W., Room 3300, Washington, DC 20590/202-426-0187.

Grants

The programs described below are for sums of money which are given by the federal government to initiate and stimulate new or improved activities, or sustain on-going services.

Airport Development Aid Program

Objectives: To assist public agencies in the development of a nationwide system of public airports adequate to meet the needs of civil aeronautics.

Eligibility: State, county, municipal, and other public agencies including an Indian tribe or pueblo are eligible for airport development grants if the airport on which the development is required is listed in the National Airport System Plan. Certain units of local governments surrounding airports may be eligible for grants associated with achieving noise compatibility with airports.

Range of Financial Assistance: $2,580 to $32,997,746.

Contact: Grants-in-Aid Division, APP-500, Federal Aviation Administration, Office of Airports Planning and Programming, Department of Transportation, 800 Independence Ave. S.W., Washington, DC 20591/202-426-3831.

Airport Planning Grant Program

Objectives: To assist public agencies in the planning of a nation-wide system of public air-

ports adequate to meet the needs of civil aviation.

Eligibility: State, county, municipal, and other public agencies are eligible for development of airport master plans and Airport Noise Compatibility Plans if their airport or location is shown in the National Airport System Plan.

Range of Financial Assistance: Not specified.

Contact: Grant-in-Aid Division, APP-500, Federal Aviation Administration, Office of Airport Planning and Programming, Department of Transportation, 800 Independence Ave. S.W., Washington, DC 20591/202-426-3831.

Gas Pipeline Safety

Objectives: To develop and maintain state gas pipeline safety programs.

Eligibility: The Department provides federal matching funds to any state agency with a certificate under Section 5(a) of the Act; an agreement under Section 5(b) of the Act, or to any state acting as a Department of Transportation agent on interstate gas pipelines.

Range of Financial Assistance: $6,543 to $443,269.

Contact: Department of Transportation, Materials Transportation Bureau, 400 7th St. S.W., Washington, DC 20590/202-426-3046.

Grants-in-Aid for Railroad Safety—State Participation

Objectives: To promote safety in all areas of railroad operations, to reduce railroad related accidents, to reduce deaths and injuries to persons, and to reduce damage to property caused by accidents involving any carrier of hazardous materials, by providing for state participation in the enforcement and promotion of safety practices.

Eligibility: A state may participate in carrying out investigative and surveillance activities in connection with regulations promulgated by the Federal Railroad Administrator under this act applicable to track and rolling equipment.

Range of Financial Assistance: Up to $22,000 per State Inspector.

Contact: Associate Administrator for Safety, Federal Railroad Administration, Department of Transportation, 400 7th St. S.W., Washington, DC 20590/202-426-0895.

Highway Beautification—Control of Outdoor Advertising and Control of Junkyards

Objectives: To beautify highways and their vicinities.

Eligibility: State highway agencies.

Range of Financial Assistance: $6,750 to $1,125,950.

Contact: Federal Highway Administrator, Federal Highway Administration, Department of Transportation, Washington, DC 20590/202-426-0650.

Highway Educational Grants

Objectives: To assist state and local agencies and the Federal Highway Administration (FHWA) in developing the expertise needed for implementation of their highway programs. The programs are intended to address identified training needs of state and local agencies and FHWA identified national emphasis areas which currently include: highway safety, energy conservation, and civil rights.

Eligibility: Employees of federal, state and local highway/transportation agencies engaged in or to be engaged in federal-aid highway work.

Range of Financial Assistance: $250 to $6,000.

Contact: Director, National Highway Institute, Federal Highway Administration, Department of Transportation, Washington, DC 20590/202-426-3100.

Highway Research, Planning and Construction

Objectives: To assist state highway agencies in constructing and rehabilitating the interstate highway system and building or improving primary, secondary and urban systems roads and streets, to provide aid for their repair following disasters, and to foster safe highway design; and to replace or rehabilitate unsafe bridges. Also provides for the improvement of some highways in Guam, the Virgin Islands, American Samoa, and the Northern Mariana Islands.

Eligibility: State highway agencies. Projects related to forest and public lands highway, certain projects in urban areas, or projects of the state highway systems may be proposed by counties or other political subdivisions or agencies through the state highway agencies.

Range of Financial Assistance: $16,708,000 to $528,132,000.

Contact: Federal Highway Administrator, Federal Highway Administration, Department of Transportation, Washington, DC 20590/202-426-0650.

Local Rail Service Assistance

Objectives: To maintain efficient local rail freight services.

Eligibility: States are eligible for assistance.

Range of Financial Assistance: $100,000 to $3,000,000.

Contact: Office of State Assistance Programs, Federal Railroad Administration, Department of Transportation, 400 7th St. S.W., Room 5406, RFA-30, Washington, DC 20590/202-426-1677.

Mass Transportation Technology

Objectives: 1) In conventional bus and rail transit design, equipment manufacture, or construction, to obtain either substantial reductions in life-cycle costs without sacrificing performance, safety or service capability, or substantial improvements in performance, safety or service capability in a cost-effective manner; 2) to support selected high-risk, high-technology projects promising significant potential increases in productivity through the introduction of automation into transit operations (where these initiatives are beyond the financial or other capabilities of the private sector); and 3) to support national priorities, such as central city revitalization, accessibility for the elderly and handicapped, energy conservation, and environmental protection.

Eligibility: Public bodies or nonprofit institutions only.

Range of Financial Assistance: Not specified.

Contact: Associate Administrator, Office of Technology Development and Deployment, Urban Mass Transportation Administration, Department of Transportation, 400 7th St. S.W., Washington, DC 20590/202-426-4052.

Public Transportation for Rural and Small Urban Areas

Objectives: To improve or continue public transportation service in rural and small urban areas by providing financial assistance for the acquisition, construction and improvement of facilities.

Eligibility: Eligible recipients may include state agencies, local public bodies and agencies thereof, nonprofit organizations and operators of public transportation services in rural and small urban areas. Urbanized areas, as defined by the Bureau of the Census, are not eligible.

Range of Financial Assistance: Not specified.

Contact: Federal Highway Administration Rural and Small Urban Areas, Special Programs Branch, Department of Transportation, 400 7th St. S.W., Room 3301, HHP-11, Washington, DC 20590/202-426-0153.

State and Community Highway Safety

Objectives: To provide a coordinated national highway safety program to reduce traffic accidents, deaths, injuries and property damage.

Eligibility: States, federally recognized Indian tribes, the District of Columbia, American Samoa, Guam, the Virgin Islands and Puerto Rico highway safety programs approved by the Secretary.

Range of Financial Assistance: $973,000 to $15,844,000.

Contact: Office of State Program Assistance, Traffic Safety Programs, National Highway Traffic Safety Administration, Department of Transportation, Washington, DC 20590/202-426-0068.

Urban Mass Transportation Capital and Operating Assistance Formula Grants

Objectives: To assist in financing the acquisition, construction and improvement of facilities and equipment for use by operation or lease or otherwise in mass transportation service, and the payment of operating expenses to improve or to continue such service by operation, lease, contract or otherwise.

Eligibility: Funds will be made available to urbanized areas (as defined by the Bureau of the Census) through designated recipients which must be public entities and legally capable of receiving and dispensing federal funds.

Range of Financial Assistance: Not specified.

Contact: Office of Transit Assistance, Urban Mass Transportation Administration, Department of Transportation, 400 7th St. S.W., Washington, DC 20590/202-472-6976.

Urban Mass Transportation Capital Improvement Grants

Objectives: To assist in financing the acquisition, construction, reconstruction and improvement of facilities and equipment for use, by operation, lease, or otherwise, in mass transportation service in urban areas and in coordinating service with highway and other transportation in such areas.

Eligibility: Public agencies. Private transportation companies may participate through contractual arrangements with a public agency grantee.

Range of Financial Assistance: $1,216 to $800,000,000.

Contact: Office of Transit Assistance, Office of Grants Assistance, Urban Mass Transportation Administration, Department of Transportation, 400 7th St. S.W., Washington, DC 20590/202-472-6976.

Urban Mass Transportation Demonstration Grants

Objectives: To demonstrate new, innovative techniques and methods in an operational environment that will reduce urban transportation problems and improve mass transportation service.

Eligibility: Grants to conduct operational tests must be to a legally constituted public agency.

Range of Financial Assistance: Not specified.

Contact: Director, Office of Service and Methods Demonstrations, Urban Mass Transportation

Administration, Department of Transportation, 400 7th St. S.W., Washington, DC 20590/202-426-4995.

Urban Mass Transportation Grants for University Research and Training

Objectives: To sponsor research studies and training in the problems of transportation in urban areas.

Eligibility: Public and private nonprofit institutions of higher learning, offering baccalaureate or higher degrees.

Range of Financial Assistance: Up to $100,000.

Contact: Office of Policy Research, Office of Policy, Budget, and Program Development, Urban Mass Transportation Administration, Department of Transportation, 400 7th St. S.W., Washington, DC 20590/202-426-0080.

Urban Mass Transportation Managerial Training Grants

Objectives: To provide fellowships for training of managerial, technical and professional personnel employed in the urban mass transportation field.

Eligibility: Public bodies may apply for their employees or those of urban transit companies operating in their areas.

Range of Financial Assistance: $1,091 to $12,000.

Contact: Director, Office of Transportation Management, Urban Mass Transportation Administration, Department of Transportation, 400 7th St. S.W., Washington, DC 20590/202-426-9274.

Urban Mass Transportation Planning Methods Research and Development

Objectives: To develop and demonstrate improved transportation planning methods, both computerized and manual.

Eligibility: State and local governments and nonprofit organizations.

Range of Financial Assistance: Not specified.

Contact: Director, Office of Planning Methods and Support, UPM-20, Urban Mass Transportation Administration, Department of Transportation, 400 7th St. S.W., Washington, DC 20590/202-426-9271.

Urban Mass Transportation Technical Studies Grants

Objectives: To assist in planning, engineering, and designing of urban mass transportation projects, and other technical studies in a program for a unified or officially coordinated urban transportation system.

Eligibility: State and other local public bodies and agencies.

Range of Financial Assistance: $10,000 to $4,500,000.

Contact: Director, Office of Planning Assistance (UPM-10), Office of Planning, Management and Demonstrations, Urban Mass Transportation Administration, Department of Transportation, 400 7th St. S.W., Room 9314, Washington, DC 20590/202-426-2360.

Ground Transportation

Information and expertise is available on: evaluating and improving the safety and productivity of ground transportation; systems, tunneling technology to improve safety and advance the rate of underground construction; signal and control studies to improve safety and operational efficiency; automated guideway transit studies; and track structure research. Contact: Office of Ground Systems, Transportation Systems Center, Research and Special Programs Administration, Department of Transportation, Kendall Square, Room 1040, Cambridge, MA 02142/617-494-2488.

Hazardous Materials

"Special Permits" are required to insure the proper making, packaging, labeling and safe transportation of hazardous materials on U.S. highways. Regulation also requires the safe transportation of migrant workers in interstate commerce. Contact: Regulations Division, Bureau of Motor Carrier Safety, Federal Highway Administration, Department of Transportation, 400 7th St. S.W., Room 3404, Washington, DC 20590/202-426-0033.

Heavy Duty Vehicles

Research is conducted on improving the energy consumption of trucks, heavy equipment and commercial vehicles. Contact: Office of Heavy Duty Vehicle Research, Research and Development, National Highway Traffic Safety Administration, Department of Transportation, 400 7th St. S.W., Room 6221, Washington, DC 20590/202-426-4553.

High Seas Law Enforcement

The U.S. Coast Guard enforces within the territorial waters, contiguous zones and special interest areas of the high seas, federal laws and international agreements, except those related to pollution, traffic control and port and vessel safety. This includes: minimizing fishing gear loss and damage resulting from conflicts based on the simultaneous use of desirable fishing areas by

fishermen, using mobile fishing gear, and other fixed equipment; providing operational assistance enforcement advice and information on offshore activity to other agencies and entities concerned with protecting and preserving ocean resources and national interests; providing fisheries enforcement with random patrols to detect changes in fishing fleet operations, illicit measures of fishing and other illegal activity. Contact: Operational Law Enforcement Division, Office of Operations, Coast Guard, Department of Transportation, 2100 2nd St. S.W., Room 3108, Washington, DC 20593/202-426-1890.

Highway Environment
Information is available on the environment affected by a highway. Areas of concern include archeology, history, architecture, landscape, ecology, geography, and the preservation of historic sites, wetlands and farm lands. Contact: Environmental Quality Division, Office of Environmental Policy, Federal Highway Administration, Department of Transportation, 400 7th St. S.W., Room 3240, Washington, DC 20590/202-426-9764.

Highway Films
For a description of films available on a free loan basis, contact: Publications and Visual Aids Branch, Operations and Services Division, Office of Management Systems, Federal Highway Administration, Department of Transportation, 400 7th St. S.W., Room 6415, Washington, DC 20590/202-426-0473.

Highway Materials Research
Research is focused on the improvement of materials performance and development of new materials in such areas as bridge foundations, embankments, pavements and corrision materials. Contact: Materials Division, Office of Research, Federal Highway Administration, Department of Transportation, Research Station, HRS33, Room 702, Washington, DC 20590/703-285-2051.

Highway Publications
The following publications are free from: Public Information, Federal Highway Administration, Department of Transportation, 400 7th St. S.W., Room 4208, Washington, DC 20590/202-426-0660.

America on the Move
Consumer's Resource Handbook
Cost of Owning and Operating an Automobile
Driver License Administration Requirements and Fees

Federally Coordinated Programs of Highway Research and Development
Highway Joint Development and Multiple Use
Highway Traffic Noise and Future Land Development
Interstate Transfer Provisions
Junkyards and the Highway and Visual Quality
License Plates—1981
National Highway Institute
National Highway Institute—The First 10 Years— 1970–1980.
Ridesharing: A Leadership Role
Ridesharing: How It Can Help Your Company
The Sulfur Breakthrough
Surface Transportation Assistance Act of 1978
U.S. Road Symbol Signs
Your Guide to the Freedom of Information Act

Highway Research and Development
For information on administrative documents pertaining to the Federal Highway Administration's research and development program, contact: Adminstrative Documents, Research and Development, Federal Highway Administration, Department of Transportation, 400 7th St. S.W., Room 214, FHRS, HRD2, Washington, DC 20590/703-285-2037.

Highway Research and Development— Federally Coordinated Program (FCP)
This is a selected group of projects that concentrates on research programs to obtain timely solutions to urgent, national problems. Contact: Research and Development Administrator, Federal Highway Administration, Department of Transportation, 400 7th St. S.W., Room 218, FHRS, HRD1, Washington, DC 20590/703-285-2051.

Highway Research Implementation
"Implementation Packages" are special publications which document the application of highway research and development results to solving or alleviating problems in highway design, construction and maintenance. The *Implementation Catalog* lists selected publications, visual aids, computer programs, and training materials that are available as part of the Federal Highway Administration implementation program. Contact: Federal Highway Administration, Department of Transportation, HDV-20, 400 7th St. S.W., Washington, DC 20590/202-426-9230.

Highway Research Publications
A free listing of publications is available including:

Index to Research and Development Reports

Federally Coordinated Program of Highway Research and Development

Contact: Research and Development Publications, Technical Information Staff Office of Development, Federal Highway Administration, Department of Transportation, 400 7th St. S.W., Room 223, FHRS, Washington, DC 20590/202-285-2104.

Highway Statistics

Statistics are available on such topics as: the number of motor vehicles by state; the amount of fuel consumed by state; the number of drivers licenses issued by age, sex, and state; state finances; and vehicle miles traveled. Contact: Highway Statistics Division, Office of Highway Planning, Federal Highway Administration, Department of Transportation, 400 7th St. S.W., Room 3300, HHP 40, Washington, DC 20590/202-426-0180.

Highway Noise

For information and expertise on how to minimize the impact of highway noise, contact: Office of Environmental Policy, Noise and Air Quality Division, Federal Highway Administration, Department of Transportation, 400 7th St. S.W., Room 3240, Washington, DC 20590/202-426-4836.

Icebreaking

The U.S. Coast Guard is responsible for all icebreaking activities including: a polar icebreaking fleet to support scientific and defense related research in the Arctic and Antarctic regions; the Northslope/DEW Line resupply project which provides logistical support to the Alaskan North Slope oil fields and to isolated northern Alaska defense installations; Operation Deepfreeze which supplies the American Scientific effort in Antarctica, and facilities on the Great Lakes and on the East Coast. Contact: Marine Science and Ice Operations Division, Office of Operations, Coast Guard, Department of Transportation, 2100 2nd St. S.W., Room 3106, Washington, DC 20593/202-426-1881.

Innovations in Public Transportation

This publication describes current research, development and demonstration projects funded by the Urban Mass Transportation Administration. Tables show funding for major program areas. Charts summarize funding and other important information about various individual projects. Contact: Office of Technology Sharing, DTS-151, Transportation Systems Center, Research and Special Programs Administration, Department of Transportation, Kendall Square, Cambridge, MA 02142/614-494-2000.

Intercity Passenger Programs

This includes such projects as the Northeast Corridor, Conrail and the Alaska Railroad. Contact: Public Affairs, Federal Railroad Administration, Department of Transportation, 400 7th St. S.W., Room 5420, Washington, DC 20590/202-426-0881.

Intermodal Studies

Research is conducted on analytical and policy studies that involve more than one mode of transportation including the advisability of standardizing weight limits of states, and the impact of railroad energy consumption. Contact: Economic Studies Division, Office of Assistant Secretary for International Affairs, Office of Economics, Department of Transportation, 400 7th St. S.W., Room 10309, Washington, DC 20590/202-426-4163.

International Airports

Information is available on traffic at U.S. international airports including operations, freight, mail, passengers and financial data. Contact: Analysis and Evaluation Branch, Office of International Aviation Affairs, Federal Aviation Administration, Department of Transportation, 800 Independence Ave. S.W., Room 1026A, Washington, DC 20591/202-426-3231.

International Aviation

This office prepares Department of Transportation's views for consideration in U.S. bilateral aviation negotiations, and the Department's position before the Civil Aeronautics Board in international aviation cases. It also assists in preparing analysis and policy for the U.S. government in discrimination cases that have been brought by foreign governments against U.S. air carriers. Contact: Office of International Policy and Programs, International Aviation Division, Department of Transportation, 400 7th St. S.W., Room 9412, Washington, DC 20590/202-426-2903.

International Cooperation

This office arranges for international cooperation programs that are mutually beneficial or for technical assistance that is reimbursable. Contact: International Cooperation Division, Office of International Policy and Programs, Office of Policy and International Affairs, Department of Transportation, 400 7th St. S.W., Washington, DC 20590/202-426-4398.

International Environment

International environmental coordination and representation to such groups as the United Nations' Intergovernmental Maritime Consultative Organization is handled by: Environmental Coordination Branch, Environmental Response Division, Coast Guard, Department of Transportation, Room 1204, Washington, DC 20593/202-426-9573.

Junkyard and Outdoor Advertising

This office conducts a program that controls junkyards and outdoor advertising along federally aided primary and interstate highway systems. A publication, *Junkyards, the Highway and Visual Quarterly,* is also produced by this office. Contact: Junkyard and Outdoor Advertising Branch, Office of Right of Way, Federal Highway Administration, Department of Transportation, 400 7th St. S.W., Room 4132, Washington, DC 20590/202-245-0021.

Landscape and Roadside Development

Information is available on programs designed to clean up and beautify the highways. Awards are presented to State Highway Departments for cleaning up litter in conjunction with Keep America Beautiful, Inc. "Operation Wildflower" urges state highway departments to plant wildflowers near highways and a cooperative program between citizens, the state and the federal government is trying to promote art on highways. Contact: Landscape Branch, Highway Design Division, Office of Engineering, Federal Highway Administration, Department of Transportation, Room 3118A, 400 7th St. S.W., Washington, DC 20590/202-426-0314.

Loans and Loan Guarantees

The programs described below offer financial assistance through the lending of federal monies for a specific period of time or program in which the federal government makes an arrangement to idemnify a lender against part of all of any defaults by the borrower.

Loan Guarantees for Purchase of Aircraft and Spare Parts

Objectives: To guarantee loans under certain conditions for the purchase of aircraft and spare parts.

Eligibility: Applications of eligible applicants will be approved only if the Administrator of the Federal Aviation Administration finds that 1) the air carrier would not otherwise be able to obtain funds for the purchase of aircraft upon reasonable terms; 2) the aircraft to be purchased are needed to improve the service and efficiency of the air carrier; 3) there is reasonable assurance of the carrier's ability to repay the loan; and 4) the value of the security pledged furnishes reasonable protection to the United States.

Range of Financial Assistance: $1.5 to $99 million.

Contact: Federal Aviation Administration, Office of Aviation Policy and Plans, APO-22D, Department of Transportation, 800 Independence Ave. S.W., Washington, DC 20591/202-426-3420.

Railroad Rehabilitation and Improvement— Guarantee of Obligations

Objectives: To provide financial assistance for the acquisition or rehabilitation and improvement of railroad facilities or equipment.

Eligibility: Applicant is defined to mean any railroad or other person, including state and local government entities, which submits an application to the Administrator for the guarantee of an obligation under which it is an obligor.

Range of Financial Assistance: $5,000,000 to $35,000,000.

Contact: Office of National Freight Assistance Programs, Federal Railroad Administration, Department of Transportation, 400 7th St. S.W., Washington, DC 20590/202-426-9657.

Railroad Rehabilitation and Improvement— Redeemable Preference Shares

Objectives: To provide railroads with financial assistance for the rehabilitation and improvement of equipment and facilities or such other purposes approved by Secretary.

Eligibility: Any common carrier by railroad or express as defined in section 1 (3) of the Interstate Commerce Act (49 U.S.C. 1 (3)) may apply for assistance.

Range of Financial Assistance: $5,000,000 to $100,000,000.

Contact: Office of National Freight Assistance Programs, Federal Railroad Administration, Department of Transportation, 400 7th St. S.W., Washington, DC 20590/202-426-9657.

Urban Mass Transportation Capital Improvement Loans

Objectives: To finance the acquisition, construction, reconstruction and improvement of facilities and equipment for use, by operation, lease, or otherwise, in mass transportation service in urban areas.

Eligibility: Public agencies or private transportation companies through contractual arrangements with a public agency.

Range of Financial Assistance: Not specified.

Contact: Office of Transit Assistance, Office of

Grants Assistance, Urban Mass Transportation Administration, Department of Transportation, 400 7th St. S.W., Washington, DC 20590/202-472-6976.

Marine and Ice Operations

This office collects maritime data for oceanographic, meterological and hydrographic applications, and emphasizes applied oceanography in support of oceanographic instrumentation on icebreakers and other large cutters. It also collects routine and special weather and oceanographic data for other agencies and furnishes vessels to display and rewire the large environmental data buoys off U.S. coasts. Contact: Marine Science and Ice Operations Division, Operations Division, Office of Operations, Coast Guard, Department of Transportation, 2100 2nd St. S.W., Room 3106, Washington, DC 20593/202-426-1881.

Marine Pollution Data

The Pollution Incident Reporting System (PIRS) lists oil spills and hazardous chemical spills within the United States. This computerized data base is designed to provide information on cleanup activities and penalty actions. Information is also available on volume in gallons of oil and other substances spilled, volume in pounds of hazardous and other substances, and incidents by location and month. Contact: Information Analysis Branch, Environmental Response Division, Office of Marine Environment and Systems, Coast Guard, Department of Transportation, 2100 2nd St. S.W., Room 1205, G-WER-4, Washington, DC 20593/202-426-9571.

Marine Safety

The Marine Safety Information System provides computerized information on vessels with safety or pollution violations along with records of inspections and port visits. Contact: Safety Information and Analysis Branch, Prevention and Enforcement Division, Office of Marine Environment and Systems, Coast Guard, Department of Transportation, 2100 2nd St. S.W., Room 1106, Washington, DC 20593/202-426-1450.

Mass Transit for the Handicapped

Research is conducted to support the Urban Mass Transportation Administration's policies such as accessibility for the handicapped. Projects include: 1) Automated Guideway Transit Systems (AGT)—transit system in which automatic vehicles are designed to travel along their own separate guideways; 2) Automated Transit Information System (ATIS)—a computer-aided

system that can automatically respond to consumer questions on bus and other transit services. Contact: Office of Socio-Economic Research and Special Projects, Technology Development and Deployment, Urban Mass Transportation Administration, 400 7th St. S.W., Room 6426, UTD-10, Washington, DC 20590/202-472-5140.

Mass Transportation Planning

The Office of Planning Methods and Support aims to research, develop, demonstrate and disseminate computerized and manual techniques to assist federal, state and local agencies in planning, programming, budgeting and implementation of improvements in their transportation systems. Contact: Office of Planning Methods and Support, Planning Management and Demonstrations, Urban Mass Transportation Administration, Department of Transportation, 400 7th St. S.W., Room 6105, Washington, DC 20590/202-426-9271.

Medical Appeals

For information on appealing medical certification denials, contact: Medical Appeals, Aeromedical Standards Division, Office of Aviation Medicine, Federal Aviation Administration, Department of Transportation, 800 Independence Ave. S.W., Room 319, Washington, DC 20591/202-426-3093.

Merchant Marine Safety Data

Computerized files are available on merchant marine safety including: reported vessel casualties, personnel casualties occurring in commercial vessels, and vessels inspected. The information is also available in published format. Contact: Marine Safety Information and Analysis Staff, Office of Merchant Marine Safety, Coast Guard, Department of Transportation, 2100 2nd St. S.W., Room 1506, Washington, DC 20593/202-426-9561.

Merchant Vessel Documentation

This office administers the laws and regulations on the registration, enrollment and licensing of vessels that are five or more net tons and which are engaged in the coasting trade or fisheries. Vessels engaged in foreign trade must also be registered. Contact: Merchant Vessel Documentation Division, Office of Merchant Marine Safety, Coast Guard, Department of Transportation, 2100 2nd St. S.W., Room 1312, G-MVD/13, Washington, DC 20593/202-426-1494.

Merchant Vessel Inspection

Merchant vessels (including U.S. flag vessels, passenger, freight for hire, dangerous cargo, com-

bustibles and flammables in bulk) are under U.S. Coast Guard regulation from design to construction. Vessels are periodically inspected and records are kept on penalties and violations. Contact: Merchant Vessel Inspection Division, Office of Merchant Marine Safety, Coast Guard, Department of Transportation, 2100 2nd St. S.W., Room 2415, Washington, DC 20593/202-426-1464.

Merchant Vessels of the United States
This publication is issued annually by the U.S. Coast Guard and lists the name, owner, official number, call signs, date and place of construction and home port of merchant vessels. Contact: Superintendent of Documents, Government Printing Office, Washington, DC 20402/202-783-3238.

Merchant Vessel Training
Certain vessels are required to have a specified manning of licensed, qualified crew. The manning of the vessel depends on the route, tonnage, horsepower, and type of trade. The publication, *Rules and Regulations for Licensing and Certification of Merchant Marine Personnel*, includes regulations that are applicable to all persons who want to be licensed, registered or certificated. It also contains rules and regulations concerning shipment and discharge of seamen, allotments of seamen and U.S. shipping commissioners. Contact: Licensing and Evaluation, Merchant Vessel Personnel Division, Office of Merchant Marine Safety, Coast Guard, Department of Transportation, 2100 2nd St. S.W., Room 1400, Washington, DC 20593/202-426-2240.

Merchant Vessel Statistics
Merchant Vessels of the U.S. is an annual publication which lists such information as: names of vessels, home port, names of owners, official number, gross and net tonnage, breadth and length of vessel, and year it was built. Available for $50.00 from Government Printing Office, Superintendent of Documents, Washington, DC 20402/202-783-3238.

Mike Monroney Aeronautical Center
This Center provides much of the Federal Aviation Administration's in-resident flight training. Information is available on airmen and aircraft, human factors research, maintenance and modification of agency aircraft, and flight inspection of airways electronic and communications equipment. Contact: Public Affairs Office, Mike Monroney Aeronautical Center, Federal Aviation Administration, Department of Transportation, P. O. Box 25082, 6500 S. MacArthur, Oklahoma City, OK 73125/405-686-2562.

Minority Business Contracts
The Federal Railroad Administration has created a Minority Business Resource Center to ensure that minority-owned businesses should have the opportunity to participate in railroad projects. The Center maintains a Marketing Assistance Clearinghouse and provides a free newsletter aimed at identifying business opportunities in the railroad programs and at assisting business people through the entire procurement process. Contact: Minority Business Resource Center, Office of the Secretary, Department of Transportation, 400 7th St. S.W., Room PL-413, Washington, DC 20590/202-472-2438.

Motor Carrier Safety Research
Research projects are sponsored to administer the Motor Carrier Safety Regulations and the Hazardous Materials Regulations governing trucks and buses operating in interstate and foreign commerce which includes for-hire and private carriers of property for-hire carriers of passengers, carriers of agricultural commodities, livestock and horticultural products. The field offices contain staffs of hazardous material specialists and safety investigators which assist in the implementation of the U.S. Department of Transportation's Cargo Security Program. They perform periodic and unannounced roadchecks on the vehicle's condition, loading and documentating. Contact: Operations Division, Bureau of Motor Carrier Safety, Federal Highway Administration, Department of Transportation, 400 7th St. S.W., Room 3408, Washington, DC 20590/202-426-1724.

Motor Vehicle Accident Data
Data are collected on drivers, pedestrians, vehicles, collision types, injuries, environmental factors and exposure. The national data collection systems operated by the National Center for Statistics and Analysis include:

National Accident Sampling System (NASS)—investigates and analyzes data on all types of motor vehicle accidents throughout the country; investigations focus on information such as vehicle crash protection, driver characteristics, roadside hazards, and injury security; data are compiled into national totals based on geographic, population and type of raodway.

Fatal Accident Reporting System (FARS)—provides statistical data on fatal accidents.

National Crash Severity Study (NCSS)—seeks to link vehicle damage with injury severity.

National Electronic Injury Surveillance System (NEISS)—extends the Consumer Product Safety Commission Data System to include traffic accident information.

Contact: National Center for Statistics and Analysis, Research and Development, National Highway Traffic Safety Administration, Department of Transportation, 400 7th St. S.W., Room 6125, Washington, DC 20590/202-426-1470.

Motor Vehicle Diagnostic Inspection Program

This report concludes that car owners can achieve greater safety, lower pollution, improved gas mileage and lower repair and maintenance costs for their cars by using diagnostic inspection. These diagnostic inspections involve running a series of tests on a car and giving the consumer a status report on its conditions, complete enough to serve as a prescription for getting proper repairs. Contact: Traffic Safety Program (NPS-30), Office of Vehicles in Use, National Highway Traffic Safety Adminstration, Department of Transportation, 400 7th St. S.W., Room 5208, Washington, DC 20590/202-426-9294.

Motor Vehicle Safety Standards

The Office of Crashworthiness provides information and sets standards for: air bags, seat belts, child restraint safety seats, motorcycle helmets, fuel system integrity, odometers, windshield defrosters, rearview mirrors, tire selection and rims, door locks, school bus rollover protection, seating systems, new pneumatic tires, and more. A publication covering this topic, *Federal Motor Vehicle Safety Standards and Regulation*, is available for $35.00 from: Government Printing Office, Superintendent of Documents, Washington, DC 20402/202-783-3238.

National Airport System Plan

Statistical information and interpretation is available on the National Airport System. Contact: National Planning Division, Office of Airport Planning and Programming, Federal Aviation Administration, Department of Transportation, 800 Independence Ave. S.W., Room 616, Washington, DC 20591/202-426-3844.

National Flight Data Center

Information is available on all civilian airports (and those military airports with joint usage), navigation aids, and procedures for the national air space system. A data base is maintained containing such items as the latitude and longitude of airports, airport runways, records of obstruction to air navigation, flight planning information, bearing and distance information, and records of hazards to air navigation. Contact: National Flight Data Center, Flight Service Division, Air Traffic Service, Federal Aviation Administration, Department of Transportation, 800

Independence Ave. S.W., Room 631, Washington, DC 20591/202-426-8472.

National Highway Institute

This Institute develops and administers training programs for Federal Highway Administration, and state and local highway department employees engaged or to be engaged in federal-aided highway work. It administers graduate and undergraduate awards for study in transportation-related fields and compiles information on available training materials, short courses and visual aids. A listing of available films and publications is also available. Contact: National Highway Institute, Training Facility, Federal Highway Administration, Department of Transportation, 400 7th St. S.W., Room 6404, Washington, DC 20590/202-755-7840.

New Transit Systems

Research is conducted on the following: 1) Advanced Group Rapid Transit; 2) Automated Guideway Transit Supporting Technology; and 3) Accelerating Walkway Program. Contact: Office of New Systems and Automation, Technology Development and Deployment, Urban Mass Transportation Administration, Department of Transportation, 400 7th St. S.W., Room 7411, Washington, DC 20590/202-426-4047.

No-Fault Insurance

For information and expertise on no-fault automobile insurance, contact: Office of Economics, Department of Transportation, 400 7th St. S.W., Room 10301, Washington, DC 20590/202-426-4416.

Northeast Corridor Project

This is a major track upgrading program on AMTRAK's main line from Washington, D.C. to Boston. The upgrading is aimed at producing the best high-speed passenger railroad the United States has ever seen. For current progress, contact: Office of Public Affairs, Federal Railroad Administration, Department of Transportation, 400 7th St. S.W., Room 5420, Washington, DC 20590/202-426-0881.

Odometer Law

It is a federal offense to roll back the odometer in a car. An odometer disclosure statement must be signed when you sell a car stating that the mileage on the odometer is accurate. Contact: Office of the Chief Counsel, National Highway Traffic Safety Administration, Department of Transportation, 400 7th St. S.W., Room 5219, Washington, DC 20590/202-426-1835.

Oil and Chemical Spills Hotline

The National Response Center is the clearinghouse for notification of incidents of oil and hazardous substance spills in U.S. waters. It discovers spills through surveillance systems, provides for timely notification of all those charged with responsibilities, evaluates the situation, initiates immediate containment action and countermeasures, and provides for cleanup and disposal. It also maintains the Hazardous Materials Emergency Response System which collects information on spills. Contact: National Response Center, Marine Environment and Response Division, Office of Marine Environment and Systems, Coast Guard, Department of Transportation, 400 7th St. S.W., Room 7402, Washington, DC 20590/202-426-1192 (Hotline: 800-424-8802).

Paratransit

Paratransit includes a broad range of services that lies between conventional fixed route transit and the private automobile (jitneys, taxis, carpools, etc.). The primary focus is on the use of these alternative travel modes to provide more efficient use of transportation facilities where needed. Testing is also done on specialized services that will provide for the travel needs of transit-dependent people, particularly the elderly, the handicapped and the poor. Contact: Paratransit and Special User Groups, Office of Service and Methods Demonstration, Urban Mass Transportation Administration, Department of Transportation, 400 7th St. S.W., Room 6418, Washington, DC 20590/202-426-4984.

Passenger Vehicle Research

Research is conducted on vehicles under 10,000 lbs and includes cars, pick-up trucks and vans. Studies are made on automotive systems, occupant packaging (inside the car), accident avoidance (tires, braking, towing), structures (fuel tanks, crash performance), technology assessment (advanced technology, diesels, emissions, new materials), economic assessment (cost of new technology, production engineering), experimental vehicles projected for 1985 to 1990, downsizing and fuel economy. Contact: Office of Passenger Vehicle Research, Research and Development, National Highway Traffic Safety Administration, Department of Transportation, 400 7th St. S.W., Room 6226, Washington, DC 20590/202-426-4862.

Pedestrian Safety

For information on the kind of facilities used to improve pedestrian safety, contact: Environmental Design and Surveys Branch, Highway Design Division, Office of Engineering, Federal Highway Administration, Department of Transportation, 400 7th St. S.W., Room 3126, Washington, DC 20590/202-426-0294.

Pilot Schools

A *List of Pilot Schools* is available for $1.20 from: Government Printing Office, Superintendent of Documents, Washington, DC 20402/202-783-3238.

Pollution National Strike Force

Marine pollution control experts, specially trained and equipped, provide technical advice and undertake containment and cleanup activities when needed. Contact: National Strike Force, Pollution Response Branch, Environmental Response Division, Office of Marine Environment and Systems, Coast Guard, Department of Transportation, 2100 2nd St. S.W., Room 1205, Washington, DC 20593/202-426-9568.

Pollution Response

The U.S. Coast Guard is the primary federal agency responsible for cleaning up coastal areas. It conducts aerial and surface surveillance patrols for oil discharge pollution, sets policies for the pollution response program, and maintains the Chemical Hazards Response Information System with the following data bases:

Condensed Guide to Chemical Hazards—first aid information.
Hazardous Chemical Data—physical and chemical properties.
Hazard Assessment Handbook—series of formulas that simulate and have access to pollution or spill incidents.
Response Methods Handbook—techniques for cleaning up spills.
Spill Cleanup Equipment Inventory System—inventory of equipment available for pollution response.

Contact: Pollution Response Branch, Marine Environment Response Division, Office of Marine Environment and Systems, Coast Guard, Department of Transportation, 2100 2nd St. S.W., Room 1205, Washington, DC 20593/202-426-9568.

Pollution Surveillance

Surveillance and monitoring activities to prevent water pollution are conducted by: Commandant, GWPE, Enforcement Branch, Port and Environmental Safety Division, Coast Guard, Department of Transportation, 2100 2nd St.

S.W., Room 1104, Washington, DC 20593/202-755-7917.

Port Facilities

Regulations for pollution prevention and port safety for waterfront facilities are handled by: Port and Environmental Safety Division, Programs Development Branch, Office of Marine Environment and Systems, Coast Guard, Department of Transportation, 2100 2nd St. S.W., Room 1611, Washington, DC 20593/202-755-1354.

Port Safety

Daily checks are made on vessel traffic in the harbor, special transport arrangements, security zone classifications and other special authorizations for port movements. Inspections are also made of commercial vessels for safety of their equipment and cargo stowage, especially when dangerous cargo is listed on the manifest. Contact: Enforcement Branch, Port and Environmental Safety Division, Office of Marine Environment and Systems, Coast Guard, Department of Transportation, 2100 2nd St. S.W., Room 1104, Washington, DC 20593/202-755-7917.

Rail and Construction Technology

This office responds to the need for rehabilitation of existing rail systems. It seeks ways to reduce costs and to improve service on urban rail transportation systems, and ways to reduce the capital requirements and to improve construction methods for new systems and the rehabilitation of existing ones. Contact: Rail and Construction Technology, Technology Development and Deployment, Urban Mass Transportation Administration, Department of Transportation, 400 7th St. S.W., Room 7415, Washington, DC 20590/202-426-0090.

Rail Dynamics Laboratory

This laboratory provides a testing capability to identify improvements for current railroad and transit systems. It is available to governments and to private organizations such as foreign and domestic railroads, car builders, locomotive manufacturing trade associations and universities. Contact: Rail Dynamics Laboratory, Transportation Test Center, Federal Railroad Administration, Department of Transportation, P. O. Box 11449, Pueblo, CO 81001/303-545-5660.

Railroad Accidents

One can obtain access to accident data maintained on a computer data base as well as the following free publications:

Accident-Incident Bulletin (annual)
Railroad Highway Crossing Accident-Incident and Inventory Bulletin (annual)
Summary of Accidents Investigated by the Federal Railway Administration (annual)
Railroad Employee Fatalities Investigated by the Federal Railway Administration (annual)
Railroad Accident Investigation Reports

Contact: Reports and Analysis Division, Safety, RRS-32, Federal Railroad Administration, Department of Transportation, 400 7th St. S.W., Room 7320, Washington, DC 20590/202-426-2762.

Railroad Crossings

States receive federal funds to correct railroad grade crossing hazards. Contact: Program Development Division, Office of Highway Safety, Federal Highway Administration, Department of Transportation, 400 7th St. S.W., Room 3413, Washington, DC 20590/202-246-2131.

Railroad Freight and Operations

Studies are made on the use of freight cars, accounting and financial systems of railroads, coal rates, grain transportation and mergers. Available publications includes: *Carload Waybill Statistics, Waybill Statistics, Waybill Data Base, Waybill/Freight Commodity Statistics*. Contact: Industry Analysis, Office of Policy, Federal Railroad Administration, Department of Transportation, 400 7th St. S.W., Room 5100, Washington, DC 20590/202-472-7260.

Railroad Information

For information on available programs, publications and other activities, contact: Public Affairs, Federal Railroad Administration, Department of Transportation, 400 7th St. S.W., Room 6420, Washington, DC 20590/202-426-0881.

Railroad Research and Development

Information is available on: developments to improve track and track bedstructures; work to reduce the effects of accidents involving tank cars carrying hazardous materials; efforts to gain a better understanding of equipment failures; development of lower cost and more effective grade crossing techniques; and research into human factors in train operation. Contact: Office of Research and Development, Federal Railroad Administration, Department of Transportation, 400 7th St. S.W., Room 8324, Washington, DC 20590/202-426-9601.

Railroad Research Bulletin

This semi-annual publication which lists books and reports on railroad-related matters, is prepared by the Railroad Research Information Service at the Transportation Research Board. Contact: Operations Division, Office of Rail Economics, Policy and Program Development, Federal Railroad Administration, Department of Transportation, 400 7th St. S.W., Room 5100, Washington, DC 20590/202-426-9682.

Railroad Safety

The Office of Safety Programs inspects tracks, equipment, signals and general railroad operations. It investigates accidents and complaints and makes routine investigations. The office has jurisdiction over such areas as locomotives, signals, safety appliances, power brakes, hours of service, transportation of explosives, and human factors in rail operations. A publication, *Safety Report*, lists federal actions to improve railroad safety and includes statistical compilations of accidents; incident reports, federal safety regulations, orders and standards issued by the Federal Railroad Administration; evaluation of the degree of their observance; summary of outstanding problems; analysis and evaluation of research and related activities; a list of completed or pending judicial actions for the enforcement of any safety rules, regulations, orders or standards issued; and recommendations for additional legislation. Contact: Office of Safety Programs, Safety, Federal Railroad Administration, Department of Transportation, 400 7th St. S.W., Room 7330, Washington, DC 20590/202-426-9252.

Rail Transit Safety

The rapid rail and light rail transit safety system consists of the following three elements: 1) Safety Information—Reporting and Analysis System—developing a new rapid rail transit accident/incident reporting system; 2) System Safety—disseminates pertinent information to individuals working in the field of mass transit; 3) Safety Research—research in fire safety, etc. Contact: Office of Safety and Product Qualifications, Technology Development and Deployment, Urban Mass Transportation Administration, Department of Transportation, 400 7th St. S.W., Room 7421, Washington, DC 20590/202-426-9545.

Regulatory Activities

Listed below are those organizations within the U.S. Department of Transportation which are involved with regulating various activities. With each listing is a description of those industries or situations, which are regulated by the office. Regulatory activities generate large amounts of information on the companies and subjects they regulate. Much of the information is available to the public. A regulatory officer can also tell you your rights when dealing with a regulated company.

Public Inquiry Center, Federal Aviation Administration, Department of Transportation, 800 Independence Ave. S.W., Washington, DC 20591/202-426-8058. Regulates civilian and military safety aspects of air commerce.

Public Affairs, Federal Highway Administration, Department of Transportation, 400 7th St. S.W., Washington, DC 20590/202-426-0660. Regulates design, construction, maintenance and use of the nation's highways.

Consumer Affairs, Federal Railroad Administration, Department of Transportation, 400 7th St. S.W., Washington, DC 20590/202-426-0881. Regulates the safety aspects of rail transportation.

Information Services, Materials Transportation Bureau, Research and Special Programs Administration, Department of Transportation, 400 7th St. S.W., Washington, DC 20590/202-426-2301. Regulates hazardous materials transportation and pipeline safety.

Public Affairs, National Highway Traffic Safety Administration, Department of Transportation, 400 7th St. S.W., Washington, DC 20590/202-426-0670. Regulates motor vehicle safety and efficiency.

Public Information, Saint Lawrence Seaway Corporation, Department of Transportation, P. O. Box 520, Massena, NY 13662/315-764-3200. Responsible for operating the U.S. section of the Saint Lawrence Seaway.

Public Affairs, Urban Mass Transportation Administration, Department of Transportation, 400 7th St. S.W., Washington, DC 20590/202-426-4043. Responsible for developing improved mass transportation facilities and equipment.

Public Affairs, Coast Guard, Department of Transportation, 2100 2nd St. S.W., Washington, DC 20593/202-426-1587. Regulates vessels and merchant marine personnel.

Relocation Assistance Near Airports

Assistance is available to airport owners involved with airport development projects to provide uniform and equittable treatment of persons displaced from their homes, business or firm by federal or federally assisted programs. Assistance is also available on environmental impact statements and noise. Contact: Community and Environmental Needs Division, Office of Airport Planning and Programming, Federal Aviation Administration, Department of Transportation, 800 Independence Ave. S.W., Room 617, Washington, DC 20591/202-426-8434.

Rescues at Sea

The Coast Guard resource has the capability to respond effectively to a distress call—about 70,000 calls are made a year. Searches are planned using scientific methods based on experience and statistical foundations. The Guard also maintains a cooperative international and distress response system for open ocean incidents. Contact: Search and Rescue Division, Office of Operation, Coast Guard, Department of Transportation, 2100 2nd St. S.W., Room 3222, Washington, DC 20593/202-426-1948.

Ridesharing Information Center

The Center acts as a clearinghouse for information on ridesharing. They maintain a list of public ridesharing agencies that help in setting up systems and offer the following free publications:

Bi-Monthly Newsletter—information on new programs such as hitchhiking tax incentives, legislation, matching funds, etc.
Rideshare and Save-a-Cost Comparison—a pamphlet for the individual to use in calculating the costs of commuting to work alone, in a carpool or in a van-pool.
Ridesharing: An Easy Way to Save Gas and Money
Community Ridesharing: A Leadership Role
How Ridesharing Can Help Your Company

Contact: Transportation Management and Ride-Sharing Program Branch, Urban Planning and Transportation Division, Federal Highway Administration, Department of Transportation, 400 7th St. S.W., Room 3303, HHP25, Washington, DC 20590/202-426-0210.

Safety Data Management

Hazardous material incident reports are available on gas distribution and transmission and liquid pipeline carriers. Contact: Information Systems Division, Transportation Programs Bureau, Research and Special Programs Administration, Department of Transportation, 400 7th St. S.W., Washington, DC 20590/202-426-4317.

Sailing Correspondence Course

A $4.00 book, *The Skipper's Course*, includes an examination on water safety. Those who pass the exam are awarded a water safety certificate. The book is available from: Government Book Store #15, Majestic Building, 720 N. Main St., Pueblo, CO 81003. For more details on the course, contact: Boating Auxiliary Division, Coast Guard, Department of Transportation, G-BAU, 2100 2nd St. S.W., Washington, DC 20593/202-426-1077.

Saint Lawrence Seaway

The following publications are free:

The St. Lawrence Seaway—general and historic information in French and English; economic and port data, tool schedules for skippers and potential skippers; information in French and English for tourists traveling by automobile.
St. Lawrence Seaway Development Corporation Annual Report
Annual Traffic Report in the St. Lawrence Seaway—calendar year statistics on cargo vessels between Montreal and Lake Erie
Seaway Handbook—operating manual and chart booklet for commercial vessels, rules and regulations and seaway toll schedule.

Contact: Public Information Office, St. Lawrence Seaway Development Corp., P. O. Box 520, Massena, NY 13662/315-764-3200.

Saint Lawrence Seaway
Statistics

For statistical and other data on the St. Lawrence Seaway, contact: Transportation Data, Office of Systems and Economic Analysis, St. Lawrence Seaway Development Corp., Department of Transportation, 800 Independence Ave. S.W., Room 800W, Washington, DC 20591/202-426-2884.

Search and Rescue Data

Information is available on all calls for assistance from the U.S. Coast Guard, including: identification of unit that responded, date and time, how they were notified, nature of call, how far off shore was the vessel, position of vessel, method used by distressed unit to call, cause of distress, ownership of vessel, type of vessel, type of propulsion, size, number of lives lost and saved, property lost or damaged, number of people assisted, description of Coast Guard unit, distance from vessel, time spent searching, total amount of time on the sortie, sea height, wind speed, visibility, kind of assistance offered and mission performance. Contact: Search and Rescue Data Section, Information Systems Staff, Office of Operations, Coast Guard, Department of Transportation, 2100 2nd St. S.W., Room 3222, Washington, DC 20593/202-426-1957.

Shipbuilding

For information on the market for and the cost of shipbuilding, contact: Office of Shipbuilding Costs, Maritime Administration, Department of Transportation, 400 7th St. S.W., Washington, DC 20590/202-426-5813.

Special Transportation Studies

Information is available on socio-economic research applied in the determination of costs, benefits and impacts of alternative transportation investments; analysis of rail patronage performance, financing and operations; short-term forecasting of commodity and passenger flows; consumer and industry impacts of federal policy and regulation related to automobile design, sales and fuel usage; and the analysis of policy issues surrounding funding and development of new systems. Contact: Office of System Research and Analysis, Transportation Systems Center, Research and Special Programs Administration, Department of Transportation, Kendall Sq., Room 7-28, Cambridge, MA 02142/617-494-2563.

Standard Highway Signs

This publication provides detailed drawings of standard highway signs for the promotion of a national uniform highway sign design. It also includes general design guidelines for developing signs that conform with basic standards. Available for $10.00 from: Government Printing Office, Superintendent of Documents, Washington, DC 20402/202-783-3238.

The Car Book

The publication is a free comprehensive guide to car buying. It includes information on crash test results, fuel economy, maintenance, insurance costs, accident fatality rates, safety defects and recalls for foreign and domestic cars. The publication can be obtained by writing: *Car Book*, Pueblo, CO 81009. For further information on content, contact: Office of Public Affairs and Consumer Participation, National Highway Traffic Safety Administration, Department of Transportation, 400 7th St. S.W., Room 5232, Washington, DC 20590/202-426-9550.

Traffic Accident Information

An extensive computerized list of publications related to accidents and highway safety is maintained by: Accident Analysis Branch, Office of Highway Safety, Federal Highway Administration, Department of Transportation, 400 7th St. S.W., Room 3409, Washington, DC 20590/202-755-9035.

Traffic Characteristics

This office collects information on traffic, including speed volume, effect on traffic flow, width of lane, payment, highway capacity and the psychological factors on drivers. Contact: Traffic Characteristics Branch, Traffic Perfor-

mance and Programs Division, Office of Traffic Operations, Federal Highway Administration, Department of Transportation, 400 7th St. S.W., Room 3101, Washington, DC 20590/202-426-1993.

Traffic Information and Records

Information is available on the following: 1) National Project Reporting System—keeps records of their funded projects; description of the program, amount of money and congressional district; 2) Highway Safety Standards Program—keeps information on what the states are doing, such as periodic car inspections and pedestrian safety; and 3) Public Federal Bureau of Investigation data on arrests made on those driving while under the influence of alcohol. Contact: Information and Records Systems Division, State Program Assistance, Traffic Safety Programs, National Highway Traffic Safety Administration, 400 7th St. S.W., Room 5117, Washington, DC 20590/202-426-4932.

Traffic Safety Publications

The following publications are free:

Pedestrian-Bicycle Safety Study
Marijuana, Other Drugs and Their Relation to Highway Safety

For a copy of these or for a complete list of available publications, contact: General Services Division, Office of Management Services Administration, National Highway Traffic Safety Administration, Department of Transportation, 400 7th St. S.W., Room 4423, Washington, DC 20590/202-426-0874.

Traffic Safety Records

All National Highway Traffic Safety Administration records are available for public examination. This includes research reports, accident investigation case reports, defects investigations, consumer letters, compliance reports listing investigations opened, closed and pending, and compliance test reports accepted, an index to consumer advisories, documentary filmed records of research and testing, consumer films, and a bibliography of Technical Reports of the National Highway Traffic Safety Administration. Subject categories include: tires, fuel tank systems, passive restraint systems, bumpers, pedestrians, fuel economy, youth and driving, emergency medical services, crashworthiness of motor vehicles, vision and visibility in highway driving, brakes, bicycle safety, accident risk forecasting, rollover accidents, and heavy duty vehi-

cles. Contact: Technical Reference Branch, Office of Management Services, National Highway Traffic Safety Administration, Department of Transportation, 400 7th St. S.W., Room 5108, Washington, DC 20590/202-426-2768.

Traffic Signs and Markings

Information and expertise is available on the design of traffic control device standards. A free 45-minute slide presentation describes symbol signs and traffic signal meanings. The following publications are available from the Government Printing Office, Superintendent of Documents, Washington, DC 20402/202-783-3238.

Manual on Uniform Traffic Control Devices ($18.00)
Standard Highway Signs Booklet ($10.00)
Road Symbol Signs ($1.25)
Work Zone Traffic Control ($5.00)

Contact: Signs and Markings Branch, Traffic Control System, Office of Traffic Operations, Federal Highway Administration, Department of Transportation, 400 7th St. S.W., Room 3419, Washington, DC 20590/202-426-0411.

Traffic Systems

For information on research focused on the developments to control techniques for the improvement of traffic flow, motorist information systems, or the use of available freeway lanes, contact: Traffic System Division, Office of Research, Federal Highway Administration, Department of Transportation, Fairbank Highway Research Station, HRS-30, Room 207, McLean, VA 22102/703-285-2021.

Traffic Trends

The following publications are free:

Weekly Traffic Trends Press Release—monitors travel trends especially during periods of fuel shortfall;
Monthly Traffic Volume Trends—monitors travel trends over time.

Contact: Planning Services Branch, Highway Statistics Division, Office of Highway Planning, Federal Highway Administration, Department of Transportation, 400 7th St. S.W., Room 3300, Washington, DC 20590/202-426-0160.

Transit Employee Training

Among the projects developed in training transit employees is a set of bus operator training materials in the areas of passenger relations, emergency and accident procedures, and defensive driving. Contact: Human Resources Divi-

sion, Office of Transportation Management, Planning, Management and Demonstration, Urban Mass Transportation Administration, Department of Transportation, 400 7th St. S.W., Room 6432, Washington, DC 20590/202-426-9157.

Transit Marketing

Research is conducted to develop transit marketing techniques and to assist transit operators in understanding and successfully applying these techniques. Work is also done on a Transit Marketing Information Exchange which serves as a clearinghouse for marketing materials. Contact: Marketing Division, Office of Transportation Management, Planning Management and Demonstrations, Urban Mass Transportation Administration, Department of Transportation, 400 7th St. S.W., Room 6432, Washington, DC 20590/202-426-9274.

Transit Pricing

Studies are conducted on ways to increase the number of transit riders so that the transit system is more productive. Contact: Pricing and Policy Division, Office of Services and Methods Demonstration Program, Planning, Management and Demonstrations, Urban Mass Transportation Administration, Department of Transportation, 400 7th St. S.W., Room 6418, Washington, DC 20590/202-426-4984.

Transit Research Information Center

This office acts as a clearinghouse for Urban Mass Transportation Administration research projects. Topics include: energy and environment; financing; conventional transit services, innovations and improvements; fares, pricing and service innovations; international transportation; paratransit systems; political processes and legal affairs; rural and low-density areas; safety and security; bus and paratransit vehicle technology; rapid rail vehicles; and light rail vehicles. Contact: Transit Research Information Center, Planning Management and Demonstrations, Urban Mass Transportation Administration, Department of Transportation, 400 7th St. S.W., Room 6432, Washington, DC 20590/202-426-9157.

Transit Service Innovations

This office is responsible for such items as: innovative use of traffic engineering techniques and transit services; policies aimed at improving conventional fixed-route transit systems; more effective utilization of existing transportation and urban resources; and expediting peak period movement of passengers on surface transit vehi-

cles. Contact: Conventional Transit Service Innovations, Office of Service and Methods Demonstrations, Planning Management and Demonstrations, Urban Mass Transportation Administration, Department of Transportation, 400 7th St. S.W., Room 6418, Washington, DC 20590/202-426-4984.

Transportation and Energy
Technical information is available on energy issues and programs within the U.S. Department of Transportation. A free publication, *Transportation Energy Activities of the U.S. Department of Transportation*, describes available technical assistance, programs, projects, contacts, and conferences. Contact: Office of Technology Sharing, Office of the Secretary of Transportation, Department of Transportation, 400 7th St. S.W., Room 9402, I40, Washington, DC 20590/202-426-4208.

Transportation Economic Analysis
This office provides staff analysis of the economic and institutional aspects of major transportation policy issues as they relate to the public transportation sector, rural and urban passengers and freight. They conduct analysis to support policy development in the areas of 1) transportation energy conservation, 2) contingency planning for responses to energy emergencies, and 3) transportation requirements and capabilities for the movement of energy materials by all modes. They develop contingency plans and are responsible for strategic planning for the national transportation system. They also design, carry out, and coordinate studies and assessments of the effect of federal policies and program options upon the performance of intercity, urban and local transportation systems. Contact: Office of Transportation Economic Analysis, Office of Policy and International Affairs, Department of Transportation, 400 7th St. S.W., Room 10301F, Washington, DC 20590/202-426-1911.

Transportation Facilities
This office tries to reduce barriers and impediments to the flow of people and trade. It works with transportation regulatory agencies in developing a uniform set of symbols for all modes of transportation. Contact: Office of Facilitation, Research and Special Programs Administration, Department of Transportation, 400 7th St. S.W., Room 8114, Washington, DC 20590/202-426-4350.

Transportation Films
For a listing of films available on a free-loan basis, contact: Audiovisual Division, Office of Public Affairs, Department of Transportation, 400 7th St. S.W., Washington, DC 20590/202-426-4333.

Transportation Library
The Library maintains an extensive collection of literature on all aspects of transportation. In addition to reference services, the library offers a free biweekly compilation of current transportation literature. Contact: Library, Department of Transportation, 400 7th St. S.W., Room 2200, Washington, DC 20590/202-426-1792.

Transportation of Hazardous Materials
Two newsletters are available: 1) *Hazardous Material Regulations*; and 2) *Pipeline Safety Regulations*. Information is also available on packaging, labeling and marketing of hazardous and radioactive materials. Contact: Information Services Division, Office of Operations and Enforcement, Research and Special Programs Administration, Department of Transportation, 400 7th St. S.W., Room 8430, Washington, DC 20590/202-426-2301.

Transportation Safety Institute
This Institute fosters and promotes the development and improvement of transportation safety and security management technology and operating procedures. Some 52 courses are offered to government employees and those in industry and international governments in topics which include aviation safety, highway safety, marine safety, materials analysis, motor carrier safety, pipeline safety, railroad safety, transportation of hazardous materials, and transportation security. Contact: Transportation Safety Institute, Department of Transportation, 6500 S. MacArthur Blvd., MPB-60, Oklahoma City, OK 73125/405-686-2153.

Transportation Statistical Information
Statistical information is available on such topics as: air transportation, economics, energy, geographic coding, motor vehicles, freight transportation, motor vehicle population and profiles, domestic and foreign car registration, multimodal freight and multimodal passenger transportation, rail transportation accidents and socioeconomic characteristics. Contact: Transportation Information Management Branch, Code: DTS 423, Kendall Sq., Cambridge, MA 02142/617-494-2582.

Transportation Systems Center
This center performs reserach and analysis on

all modes of transportation—air, highway, rail, marine, urban and pipeline. Contact: Transportation Systems Center, Research and Special Programs Administration, Department of Transportation, Kendall Sq., Cambridge, MA 02142/617-494-2000.

Transportation Systems Engineering

Basic transportation research is conducted in modeling of transportation systems in the environment, non-petroleum-based transportation, technological options for the future, highway transportation with new energy sources, and materials research for new forms of transportation. Contact: Office of Systems Engineering, Research and Special Programs Administration, Department of Transportation, 400 7th St. S.W., Room 8109, Washington, DC 20590/202-426-2900.

Transportation System Management

This office provides information on such transportation techniques and methods as exclusive lanes for high occupancy vehicles, parking policies and staggered work hours. Contact: Transportation System Management Branch, Office of Highway Planning, Federal Highway Administration, Department of Transportation, 400 7th St. S.W., Room 3303, HHP25, Washington, DC 20590/202-426-0210.

Transportation Test Center

This Center conducts comprehensive testing, evaluation and associated development of ground transportation systems. Such test operations include: determining system feasibility, the validity of designs, the expected operational cost and the environmental impact of new developments. The facilities are available for use by government agencies, private industry and international projects. Contact: Transportation Test Center, Federal Railroad Administration, Department of Transportation, P. O. Box 11449, Pueblo, CO 81001/303-545-5660.

Transportation USA

This quarterly publication covers all aspects of transportation, including information on U.S. Department of Transportation events, news, major actions, legislation, and recent publications. Available for 16.00 per year from: Government Printing Office, Superintendent of Documents, Washington, DC 20402/202-783-3238.

University Research

Two publications, *Summary of Awards Program of University Research* and *U.S. Department of Transportation Awards to Academic Institutions*, describe research and development fundings. Subjects covered include suspension systems, guideways and vehicle dynamics, automotive technologies, information processing, vehicle guidance and control; improvement in system efficiencies, innovation in personal and mass transportation, state-wide systems planning, commodity and freight flow, policy evaluation, rural transportation planning, transportation land use and social interactions, system safety, vehicle safety, and environment. Copies of *A Proposal Preparation Manual* are also available. Contact: Office of University Research, Research and Special Programs Administration, Department of Transportation, 400 7th St. S.W., Room 8109, Washington, DC 20590/202-426-0190.

Urban Mass Transportation Evaluation

For information on evaluation studies of Urban Mass Transportation Administration programs assessing the effectiveness of urban transportation performance, contact: Office of Program Evaluation, Policy, Budget and Program Development, Urban Mass Transportation Administration, Department of Transportation, 400 7th St. S.W., Room 9311, Washington, DC 20590/202-426-4059.

Urban Mass Transportation for the Handicapped

For information on research conducted on the transportation of the handicapped, contact: Special Projects, Office of Service and Methods Demonstration, Planning Management and Demonstrations, Urban Mass Transportation Administration, Department of Transportation, 400 7th St. S.W., Room 6418, Washington, DC 20590/202-426-4984.

Urban Mass Transportation Information

The Information Services Division responds to information requests on the Urban Mass Transportation Administration and other mass transit research; collects statistical information on financial and operational aspects of research programs; maintains an index to and abstracts of all research reports; maintains the Urban Mass Transportation Information Service, which is a data base that includes all transportation research information for national access; and maintains the Transit Research Information Center, which is a repository of all Urban Mass Transportation Administration-sponsored reports. Contact: Information Services Division, Office of Transportation Management, Planning Manage-

ment and Demonstrations, Urban Mass Transportation Administration, Department of Transportation, 400 7th St. S.W., Room 6432, Washington, DC 20590/202-426-9157.

Urban Mass Transportation Planning

For information on the Planning Grant Program and special energy planning research studies, contact: Office of Planning Assistance, Planning Management and Demonstration, Urban Mass Transportation Administration, Department of Transportation, 400 7th St. S.W., Room 9314, Washington, DC 20590/202-426-2360.

Urban Mass Transportation Policy

Studies and analyses are conducted to provide data and concepts to help establish long-term goals. Major areas of research include: urban revitalization, joint transit land-use development, paratransit, light rail transit, parking management, transit futures and financing. Contact: Office of Policy Research, Policy, Budget and Program Development, Urban Mass Transportation Administration, Department of Transportation, 400 7th St. S.W., Room 9301, Washington, DC 20590/202-426-0080.

Vehicle Defects

Information is available on safety-related complaints, recall data, defects data, investigations, etc. A publication is also available—*Safety Related Recall Campaigns for Motor Vehicle Equipment Including Tires.* Quarterly issues $3.25, annual $3.75, from: Government Printing Office, Superintendent of Documents, Washington, DC 20402/202-783-3238. For further information on content, contact: Office of Defects Investigation, Enforcement, National Highway Traffic Safety Administration, Department of Transportation, 400 7th St. S.W., Room 5326, Washington, DC 20590/202-426-2843.

Vehicle Maintenance and Fuel Economy

For information on improving the fuel economy through inspection, maintenance and repair programs, contact: Maintenance and Repair Division, Office of Vehicles in Use, Traffic Safety Programs, National Highway Traffic Safety Administration, Department of Transportation, 400 7th St. S.W., Room 5117, Washington, DC 20590/202-426-1597.

Vehicle Research and Test Center

This center combines the engineering test facility with safety research. Contact: Vehicle Research and Test Center, Research and Development, National Highway Traffic Safety Administration, Department of Transportation, P. O. Box 37, East Liberty, OH 43319/513-666-4521.

Vehicle Safety Compliance

This office provides the testing, inspection, and investigation necessary to assure compliance with federal motor vehicle safety standards by foreign and domestic vehicle and equipment manufacturers. Contact: Office of Vehicle Safety Compliance, Enforcement, National Highway Traffic Safety Administration, Department of Transportation, 400 7th St. S.W., Room 6113, Washington, DC 20590/202-426-2832.

Vessel Requirements

This office writes regulations on pollution prevention and port safety for vessels. It has developed a method to "fingerprint" oil spills, by analyzing the oil and comparing it with samples of all vessels known to have traveled the area the days preceding the spill. Contact: Vessel Requirements Branch, Prevention and Enforcement Division, Office of Marine Environment and Systems, Coast Guard, Department of Transportation, 2100 2nd St. S.W., Washington, DC 20593/202-755-9578.

Vessel Traffic

Through electronic surveillance and shore-based centers, attempts are made to reduce vessel congestion, incidents of collision, rammings and groundings. Contact: Vessel Traffic Services Branch, Waterways Management Division, Office of Marine Environment and Systems, Coast Guard, Department of Transportation, 2100 2nd St. S.W., Room 1606, Washington, DC 20593/202-426-1940.

War-Risk Insurance for Ships

The Maritime Administration offers standby war-risk insurance to ships when such coverage is not available from commercial insurance companies. The program covers material and life loss caused by war involving any of the five major powers or by a hostile nuclear detonation. The plan covers about 600 U.S. flagships and 150 ships of coinvenient flags. Contact: Office of Marine Insurance, Maritime Administration, Department Transportation, 400 7th St. S.W., NASIF Building, Washington, DC 20590/202-426-5806.

Waterway Safety

This office deals with navigation safety for ves-

sels, navigation equipment, bridge-to-bridge radio telephone requirements, shipping safety fairways, and traffic separation schemes. It publishes *Rules of the Road: Great Lakes Rules, Rules of the Road: Western River Rules,* and *Navigation Rules—International—Inland.* It also writes the regulations and rules for waterway safety. Contact: Waterway Safety Branch, Waterways Management Division, Office of Marine Environment and Systems, Coast Guard, Dept. of Transportation, 2100 2nd St. S.W., Room 1606, Washington, DC 20593/202-426-4958.

How Can the Department of Transportation Help You?

To determine who the U.S. Department of Transportation can help you, contact: Public Information, Office of Public Affairs, Department of Transportation, 400 7th St. S.W., Room 10413, Washington, DC 20590/202-426-4321.

Department of Treasury

15th St. and Pennsylvania Ave. N.W., Washington, DC 20220/202-566-2041

ESTABLISHED: September 2, 1789
BUDGET: $94,139,158,000
EMPLOYEES: 116,535
MISSION: Formulates and recommends economic, financial, tax, and fiscal policies; serves as financial agent for the U.S. government; law enforcement; and manufactures coins and currency.

Major Divisions and Offices

Under Secretary for Monetary Affairs

Department of Treasury, 15th St. and Pennsylvania Ave. N.W., Room 3312, Washington, DC 20220/202-566-5164.
Budget: $7,236,687,000
Employees: 189

1. Assistant Secretary—Domestic Finance

Department of Treasury, 15th St. and Pennsylvania Ave. N.W., Room 3321, Washington, DC 20220/202-566-2103.
Budget: $7,236,521,000
Employees: 178

2. Office of Revenue Sharing

Department of the Treasury, 2401 E St. N.W., 14 Floor, Washington, DC 20226/202-634-5157.
Budget: $7,236,338,000
Employees: 158
Mission: Returns specified amounts of federally collected funds to eligible units of general-purpose governments under the general revenue sharing program.

Under Secretary

Department of the Treasury, 15th St. and Pennsylvania Ave. N.W., Room 3432, Washington, DC 20220/202-566-5847.
Budget: $23,800,934,000
Employees: 114,851

1. Bureau of Engraving and Printing

Department of the Treasury, 14th and C Sts. S.W., Room 602-11A, Washington, DC 20228/202-447-1380.
Budget: $159,485,000
Employees: 3,189
Mission: Designs, engraves and prints all major items of financial character issued by the U.S. Government; and produces paper currency, Treasury bonds, bills, notes, and certificates; postage, revenue and certain customs stamps.

2. Bureau of the Mint

Department of the Treasury, 501-13th St. N.W., Washington, DC 20220/202-376-0837.
Budget: $61,847,000
Employees: 2,415
Mission: Produces domestic and foreign coins; manufactures and sells proof and uncirculated coin sets and other numismatic items; provides for the custody, processing and movement of bullion.

3. Fiscal Assistant Secretary

Department of the Treasury, 15th St. and Pennsylvania Ave. N.W., Washington, DC 20220/202-566-2112.
Budget: $18,475,836,000
Employees: 5,217

4. Bureau of the Public Debt

Department of the Treasury, 1435 G St. N.W.,

```
                    ┌─────────────────────────┐
                    │       SECRETARY         │
                    │  ─────────────────────  │
                    │   DEPUTY SECRETARY      │
                    └─────────────────────────┘
```

UNDER SECRETARY FOR MONETARY AFFAIRS	UNDER SECRETARY	INTERNAL REVENUE SERVICE	OFFICE OF THE COMPTROLLER OF THE CURRENCY

UNDER SECRETARY FOR MONETARY AFFAIRS

- ASSISTANT SECRETARY– DOMESTIC FINANCE
 - OFFICE OF REVENUE SHARING

UNDER SECRETARY

- BUREAU OF ENGRAVING AND PRINTING
- BUREAU OF THE MINT
- FISCAL ASSISTANT SECRETARY
 - BUREAU OF THE PUBLIC DEBT
 - BUREAU OF GOVERNMENT FINANCIAL OPERATIONS
- ASSISTANT SECRETARY FOR ENFORCEMENT AND OPERATIONS
 - UNITED STATES SECRET SERVICE
 - UNITED STATES CUSTOMS SERVICE
 - BUREAU OF ALCOHOL, TOBACCO AND FIREARMS
 - FEDERAL LAW ENFORCEMENT TRAINING CENTER

Room 310, Washington, DC 20226/202-376-0319.
Budget: $186,082,000
Employees: 2,671
Mission: Prepares U.S. Department of the Treasury circulars offering public debt securities; directs the handling of subscriptions and making of allotments; formulates instructions and regulations pertaining to security issues; and conducts or directs the conduct of transactions in outstanding securities.

5. Bureau of Government Financial Operations

Department of the Treasury, Pennsylvania Ave. and Madison Pl. N.W., Room 618, Washington, DC 20226/202-566-2158.
Budget: $18,289,754,000
Employees: 2,546
Mission: Maintains a system of central accounting and reporting, disclosing the monetary assets and liabilities of the U.S. Treasury and provides for the integration of Treasury cash and funding operations with the financial operations of disbursing and collecting officers and of federal program agencies; provides disbursing services for most civilian agencies of the government; provides technical support for the system of tax payments by business organizations; supervises the government-wide letter-of-credit system for financing federal grant-in-aid programs; monitors all cash held outside the Treasury; handles claims from the public for the redemption of partially destroyed U.S. currency; and administers functions relating to the qualifications of surety companies.

6. Assistant Secretary for Enforcement and Operations

Department of the Treasury, 15th St. and Pennsylvania Ave. N.W., Room 4308, Washington, DC 20220/202-566-2568.
Budget: $886,888,000
Employees: 22,992

7. United States Secret Service

Department of the Treasury, 1800 G St. N.W., Room 805, Washington, DC 20223/202-535-5708.
Budget: $172,100,000
Employees: 3,588
Mission: Detects and arrests any person committing any offense against the laws of the United States and foreign governments; detects and arrests any person violating any of the provisions of

sections 508, 509 and 871 of Title 18 of the United States Code; executes warrants issued under the authority of the United States; carries firearms; protects the person of the president of the United States, the members of his immediate family, the president-elect, the vice president or other officer next in the order of succession to the office of president, the immediate family of the vice president, the vice-president-elect, major presidential and vice-presidential candidates, former presidents and their wives during his lifetime, widows of former presidents until their death or remarriage, and minor children of a former president until they reach age of 16, and visiting heads of a foreign state or foreign government; and performs such other functions and duties as are authorized by law.

8. United States Customs Service

Department of the Treasury, 1301 Constitution Ave. N.W., Washington, DC 20229/202-566-5286.
Budget: $557,684,000
Employees: 15,234
Mission: Properly assesses and collects customs duties, excise taxes, fees, and penalties due on imported merchandise; interdicts and seizes contraband, including narcotics and illegal drugs; processes persons, carriers, cargo, and mail into and out of the United States; administers certain navigation laws; detects and apprehends persons engaged in fraudulent practices designed to circumvent customs and related laws, copyright, patent, and trademark provisions, quotas and marking requirements for imported merchandise.

9. Bureau of Alcohol, Tobacco and Firearms

Department of the Treasury, 1200 Pennsylvania Ave. N.W., Washington, DC 20226/202-566-7777.
Budget: $143,702,000
Employees: 3,916
Mission: Enforces and administers firearms and explosive laws, as well as those covering the production, use, and distribution of alcohol and tobacco products.

10. Federal Law Enforcement Training Center

Department of the Treasury, Glynco, GA 31524/912-267-2100.
Budget: $13,402,000
Employees: 254
Mission: Serves as an interagency training center

serving 36 federal law enforcement agencies representing executive departments; conducts common, recruit, advanced, specialized, and refresher law enforcement training for the special agents and police officers from participating agencies, and provides the necessary facilities, equipment and support for the acocmplishment of that training; and to provide training on a space-available basis to the law enforcement personnel of an additional 15 federal agencies, to qualified civilian personnel from military agencies, and to the training personnel of various state and local law enforcement agencies.

Internal Revenue Service

Department of the Treasury, 1111 Constitution Ave. N.W., Washington, DC 20224/202-566-5000.
Budget: $4,107,478,000
Employees: 77,780
Mission: Administers and enforces the internal revenue laws and related statutes, except those relating to alcohol, tobacco, firearms, and explosives; encourages and achieves the highest possible degree of voluntary compliance with the tax laws and regulations and to conduct itself so as to warrant the highest degree of public confidence in the integrity and efficiency of the Service; advises the public of its rights and responsibilities, communicates requirements of the law to the public; assists taxpayers in complying with the laws and regulations; and takes those enforcement actions necessary for fair, effective and impartial tax administration.

Office of the Comptroller of the Currency

Department of the Treasury, 490 L'Enfant Plaza E S.W., Washington, DC 20219/202-447-1800.
Budget: $109,400,000
Employees: 3,258
Mission: Responsible for the execution of laws relating to national banks, and promulgates rules and regulations governing the operations of approximately 4,450 national and District of Columbia banks.

Data Experts

Customs Commodity Experts

These important specialists can provide information on tariffs, classifications, and other related topics concerning the commodities they cover. Each can be contacted directly by telephone or by writing in care of the Customs Service, Department of the Treasury, 6 World Trade Center, Room 425, New York, NY 10048/212-466-5821.

Autos—Europe/E. Lainoff/212-466-5454
Machines, Pumps/A. Brodbeck/212-466-5460
Machines, Industrial/A. Horowitz/212-466-5463
Machine Tools, Computer Systems/P. Losche/212-466-5466
Food Machines, Printing Machines/H. Rocks/212-466-5470
Agricultural Equipment/W. O'Connell/212-466-5475
T.V., Radios/M. Dicero/212-466-5480
Electronic Components, Transistors/I. Josephs/212-466-5540
Valves, Lighting Equipment/T. Milo/212-466-5494
Transformers, Tape Players, X-ray Equipment, Measuring Instruments/A. Johansen/212-466-5510
Switches, Hair Dryers, Electric Dryers, Electric

Articles NSPF/J. Miller/212-466-5512
Medial Instruments, Tools/M. Schulberg/212-466-5516
Boats, Iron Ore/M. E. Laker/212-466-5520
Steel/P. Ilardi/212-466-5522
Steel Wire/S. Tirrito/212-466-5526
Fasteners (Nuts and Bolts)/J. Fitzgerald/212-466-5528
Generators, Models, Chains/A. Shapiro/212-466-5533
Articles of Metal NSPF/M. Schulberg/212-466-5535
Wood/S. Dym/212-466-5723
Small Appliances, Locks, Needles/S. Dellaventura/212-466-5720
Plastic/D. Masiello/212-466-5715
Musical Instruments/A. Manzella/212-466-5712
Luggage, Handbags/K. Gorman/212-466-5709
Sporting Goods/Y. Tomenga/212-466-5706
Toys, Games/T. McKenna/212-466-5700
Toys, Models, Dolls/D. Ranier/212-466-5699
Weapons, Cutlery/J. Preston/212-2-466-5692
Christmas Decorations/S. Hantman/212-466-5658
Incense, Oriental Foods/T. Brady/212-466-5661
Vegetables, Coffee/M. Ryan/212-466-5667
Aircrafts, Boats/T. Rauch/212-466-5670
Dairy Products/M. Olbrich/212-466-5673

Wood Products/P. Garretto/212-466-5680

Tobacco/R. Conte/212-466-5682

Alcoholic Beverages/W. Springer/212-466-5664

Meats, Fish/W. Mitchell/212-466-5689

Furniture, Works of Art/L. Mushinske/212-466-5768

Printed Matter, Paper Maché, Postage Stamps, Books, Maps/C. Abramowitz/212-466-5765

Shell Articles, Jewelry, Ivory, Rough Diamonds, Rough Semi-Precious Stones/K. Pukel/212-466-5762

Religious Articles, Marble, Granite, Concrete, Abrasives, Cement, Mineral Substances/C. Scavo/212-466-5759

Antiques, Paintings, Prints/P. Tutone/212-466-5756

Leather Dog Equipment, Marine Sponges, Gloves, Leather Horse Equipment, Brooms, Combs, Candles/R. Odom/212-466-5754

Household Utility Items, Pots and Pans, Tableware, Kitchenware/S. Schwartz/212-466-5748

Clocks, Watches, Clock Movements, Ceramic Tiles/L. Piropato/212-466-5741

Household Glassware, Vacuum Containers, Atomizers/A. Arszulowicz/212-466-5738

Porcelain, Earthenware, Asian Ceramicware/G. Kalkines/212-466-5732

Inorganic Chemicals/J. DiMaria/212-466-5753

Chemicals, Pigments, Films, Waxes, Polishes, Cleaners, Paints, Clays, Bristles, Inks, Carbons, Dyeing Compounds, Starch/G. Brownchweig/212-466-5797

Cameras, Optical Equipment/C. O'Carroll/212-466-5780

Chemicals, Nonbenezoid, Petroleum Products, Schedule 4, Part 2/F. Schiazzano/212-466-5791

Chemicals, Pharmaceutical, Plastics, Pesticides/C. Reilly/212-466-5794

Chemicals, Benezoid, Dies, Textiles/W. Winters/212-466-5794

Miscellaneous Textiles and Related Articles/A. Falcone/212-466-5870

Bedding, Furnishings/R. Eyskens/212-466-5872

Nonwoven Fabrics/G. Barth/212-466-5866

Fibers, Yarns, Lace Netting/K. Springer/212-466-5878

Woven Fabrics/N. Klotz/212-466-5881

Casual Footwear/E. Francke/212-466-5887

Athletic Footwear/J. Sheridan/212-466-5889

Leather and Protective Footwear/E. Koplik/212-466-5892

Animals, Animal Products/J. Faraci/212-466-5895

Apparel Accessories/H. Davis/212-466-5919

Woven Wearing Apparel, Men and Boys/V. DeMavio/212-466-5898

Knit Wearing Apparel, Men and Boys/H. Persky/212-466-5901

Knit Wearing Apparel, Girls and Infants/S. Berczuk/212-466-5905

Woven Wearing Apparel, Girls and Infants/R. Swierupski/212-466-5908

Knit Wearing Apparel, Women/M. Crowley/212-466-5913

Woven Wearing Apparel, Women/M. Crowley/212-466-5857

Intimate Apparel, Women/B. Kiefer/212-466-5910

Major Sources of Information

Actuaries, Joint Board for the Enrollment of

This board is responsible for the enrollment of individuals who wish to perform actuarial services under the Act and for the supervision and revocation of the enrollment of such individuals after notice and opportunity for hearings. Contact: Joint Board for the Enrollment of Actuaries, Department of the Treasury, 1325 G St. N.W., Washington, DC 20220/202-376-0767.

Advance Financing

Information and expertise is available to agencies on advance financing of federal grant-in-aid programs under the letter-of-credit procedure whereby recipients draw funds from the U.S. Treasury only as needed for program disbursements. Contact: Office of Banking and Cash Management, Bureau of Government Financial Operations, Department of the Treasury, Pennsylvania Ave. and Madison Pl. N.W., Room 206, Washington, DC 20226/202-566-2586.

Alcohol Fuels Information Director—Gasohol Packet

This free publication provides a brief bibliography as well as lists of alcohol equipment manufacturers, enzyme and yeast suppliers, engineering firms and organizations that can provide the potential alcohol producer with assistance. Contact: Publication Distribution Center, Bureau of Alcohol, Tobacco and Firearms, Department of the Treasury, 3800 S. Four Mile Run Drive, Arlington, VA 22206/703-557-7850.

Alcohol Regulation

For information on the regulation of the pro-

duction and formulation of distilled spirits, wines, and malt beverages, their distinctive liquor bottles, case markings and advertising, contact: Community Classification Branch, Office of Regulatory Enforcement, Bureau of Alcohol, Tobacco and firearms, Department of the Treasury, 1200 Pennsylvania Ave. N.W., Washington, DC 20226/202-566-7715.

Alcohol, Tobacco and Firearms Information

For information concerning any activity in the Bureau of Alcohol, Tobacco and Firearms, contact: Communication Center, Office of Administration, Bureau of Alcohol, Tobacco and Firearms, Department of the Treasury, 1200 Pennsylvania Ave. N.W., Room 1202, Washington, DC 20226/202-566-7777.

Alcohol, Tobacco, Firearms, Explosives Regional Commercial Hotlines

Regional offices provide information and technical assistance on matters ranging from information on the criminal violations of firearms law to how to obtain an experimental distilled spirits plant. The regional commercial hotlines are listed below:

Central Region—513-684-3715
Mid-Atlantic Region—215-597-2238
Midwest Region—312-353-1963
North-Atlantic Region—212-264-1733
Southeast Region—404-455-2675
Southwest Region—214-729-2277
Western Region—415-774-9632

Alcohol, Tobacco and Firearms Bulletin

The quarterly publication informs all permit holders and licensees on current alcohol, tobacco, firearms and explosive matter. It contains regulatory, procedural and administrative information as well as items of general interest. Available for $9.50 a year, contact: Government Printing Office, Superintendent of Documents, Washington, DC 20402/202-783-3238.

Alcohol, Tobacco and Firearms Regulations

A *Semiannual Agenda* is published that identifies significant and nonsignificant regulations under development and review. Its purpose is to give the public adequate notice of regulatory activities. Contact: Research and Regulation Branch, Regulations and Procedures Division, Office of Regulatory Enforcement, Bureau of Alcohol, Tobacco and Firearms, Department of the Treasury, 1200 Pennsylvania Ave. N.W., Room 6215, Washington, DC 20226/202-566-7626.

Alcohol, Tobacco and Firearms Scientific Services

Information is available on the analysis of tobacco products to distinguish between cigarettes and cigars for taxing purposes; the analysis of alcoholic beverages to distinguish between wines, spirits, medicinal purposes and industrial alcohol for different taxes; and the examination of inks for date verification. Contact: Scientific Services, Office of Technical and Scientific Services, Bureau of Alcohol, Tobacco and Firearms, Department of the Treasury, 1401 Research Blvd., Rockville, MD 20850/301-443-1062.

Alcohol, Tobacco and Firearm Statistics

Data are available on the domestic manufacturing and importation of all types of alcohol, tobacco and firearms. The data are broken down monthly by state and include statistics on establishments qualified to manufacture these items and the number of permits issued. Contact: Planning and Budget Branch, Financial Management Division, Office of Administration, Bureau of Alcohol, Tobacco and Firearms, Department of the Treasury, 1200 Pennsylvania Ave. N.W., Room 7011, Washington, DC 20226/202-566-7482.

Automated Import Merchandise Processing System

This system improves merchandise processing by automatically handling routine entries to it by import specialists. Contact: Data Systems, Business System Division, Customs Service, Department of the Treasury, 1301 Constitution Ave. N.W., Room 1218, Washington, DC 20209/202-566-2471.

Balance of Payments

For information on merchandise trade balance and official and private international capital flow, contact: Office of Balance of Payments, International Economic Analysis, Economic Policy, Department of the Treasury, 15th St. and Pennsylvania Ave. N.W., Room 5464, Washington, DC 20220/202-566-5474.

Banking Statistics

Quarterly financial and operating data for all national banks are available from: Statistical Analysis, Banking Research and Economic Analysis, Comptroller of the Currency, Department of the Treasury, 490 L'Enfant Plaza E. S.W., 3rd Floor, Washington, DC 20219/202-447-9550.

Bureau of Engraving and Printing Tours

This free 25-minute tour is very popular with visitors of Washington. It is available on weekdays from 8:00 A.M. to 2:00 P.M and shows

how money is made. Samples are not given. Contact: Bureau of Engraving and Printing, Department of the Treasury, 14th and C Sts. S.W., Washington, DC 20228/202-447-9916.

Capital Markets Legislation

This office is concerned with the development and administration of policy and legislation affecting banks and other financial institutions. Its recent reports include *Interagency Task Force Study on Thrift Institutions.* Contact: Capital Markets Policy, Domestic Finance, 15th St. and Pennsylvania Ave. N.W., Room 3025, Washington, DC 20220/202-566-5337.

Cargo Processing

Research is conducted on the best methods of processing merchandise through Customs. This office also provides a free pamphlet, *Importing A Car,* which explains import requirements for clearing your car or vehicles through U.S. Customs. Contact: Cargo Processing Division, Office of Inspections, Office of Border Operations, Customs Service, Department of the Treasury, 1301 Constitution Ave. N.W., Room 4136, Washington, DC 20229/202-566-5354.

Check Claims

Claims against the United States or U.S. Department of the Treasury for checks that are lost in the mails, or which bear forged endorsements are made at: Check Claims Division, Disbursements and Claims, Bureau of Government Financial Operations, Department of the Treasury, 401 14th St. N.W., Room 520, Washington, DC 20227/202-447-1080.

Coast Guard Reserve

The Reserve trains individuals and units for active duty in time of war or national emergency. Reservists help insure the safety of ports and waterways, enforce maritime law and commercial vessel safety and take part in search and rescue missions. They also augment the active Coast Guard during serious national or manmade disasters such as hurricanes, floods and catastrophic explosions. The Coast Guard Reserve operates under the control of the U.S. Department of Transportation in peacetime and is transferred to the Department of the Navy in time of war. Contact: Office of Reserve, Coast Guard, Department of the Treasury, 2100 2nd St. S.W., Room 5100, Washington, DC 20593/202-426-2337.

Coin Sets

The following coin sets are sold by the U.S. Mint: 1) Regular Proof Coin Sets—proof claims bear the "S" mint mark and are produced only at the San Francisco area office; proof coins have higher relief than regular issue circulating coins; 2) Regular Uncirculated Coin Sets—these coins represent the best coins which can be made with the same coining techniques used for circulating coinage production; each set contains one of each denomination from the Denver and Philadelphia mints. Only coin sets manufactured and issued during the current year will be available from the U.S. Mint. Contact: Customer Affairs, Marketing Division, Bureau of the Mint, Department of the Treasury, 501 13th St. N.W., Room 1021, Washington, DC 20220/202-376-0458.

Combined Annual Wage Reporting

This system has been developed to reduce the reporting burden for employers. Contact local field office for detailed information (see "Local Tax Offices" in this section), or: Returns, Processing and Accounting Division, Internal Revenue Service, Department of the Treasury, 1111 Constitution Ave. N.W., Room 7009, Washington, DC 20224/202-566-6881.

Community Development

Technical assistance is available to banks, neighborhood groups and local governments to develop, implement or expand community or economic development activities. This office attempts to foster urban and rural redevelopment through nonregulatory means by encouraging bankers and community groups to work together. Contact: Community Development Division, Comptroller of the Currency, Department of the Treasury, 490 L'Enfant Plaza E. S.W., 5th Floor, Washington, DC 20219/202-287-4169.

Consumer Bank Examination

This office conducts consumer examiner training schools for outside groups and representatives from trade associations, consumer groups and other federal and state regulatory agencies. They teach examiners what to look for when they examine the bank's activities. They also assist consumer groups in developing their own compliance programs. Contact: Consumer Examinations, Bank Supervision, Comptroller of the Currency, Department of the Treasury, 490 L'Enfant Plaza E. S.W., 5th Floor, Washington, DC 20219/202-447-1600.

Consumer Complaints Against National Bank

Consumer complaints against national banks are handled by regional offices and the head office. A free pamphlet, *Do You Have a Complaint Against a National Bank?,* is designed to help consumers notify the Office of Consumer Complaints about any problems they have with na-

tional banks. The pamphlet begins with an explanation of how to resolve a complaint and includes a summary of some consumer credit protection and civil rights laws. Contact: Consumer Complaint Information System, Consumer, Community and Fair Lending Examinations Division, Comptroller of the Currency, Department of the Treasury, 490 L'Enfant Plaza E. S.W., Washington, DC 20219/202-447-1600.

Consumer Guide

This free guide provides information on a number of Treasury programs: labeling alcoholic beverages, IRS taxpayer assistance, alcohol fuels, drinking and pregnancy, and Customs for travelers. Contact: Treasury Consumer Affairs Guide, Office of Consumer Affairs, Department of the Treasury, 15th St. and Pennsylvania Ave. N.W., Room 2218, Washington, DC 20220/202-566-9626.

Consumer Rights

The following are consumer-related laws monitored by the U.S. Department of the Treasury:

Truth in Lending Act—makes comparison shopping for loans possible, allowing you to save money; among other required disclosures, banks must tell you the Annual Percentage Rate (APR) for the loans they offer.

Fair Credit Billing Act—provides the means to resolve credit card billing errors promptly and fairly; also, under certain circumstances, you may withhold payment of any balance due on defective merchandise or services purchased with your credit card.

Consumer Leasing Act—protects you against incomplete and misleading leasing information; requires full disclosure of consumer lease terms and enables you to shop wisely; the act covers personal property leases, such as automobile leases; it does not cover apartment leases.

Fair Credit Reporting Act—allows you to find out the information credit bureaus have on you and to have wrong information corrected; it also requires banks to tell you where they got information about you if they deny you a loan.

Equal Credit Opportunity Act—prohibits discrimination in any aspect of a credit transaction on the basis of race, color, religion, national origin, sex, marital status, age; or if all or part of your income comes from public assistance, or if you have exercised any right under the Consumer Credit Protection Act (i.e., Truth in Lending); the act does not guarantee that you get credit; banks determine this by considering such factors as income, expenses and debts.

Fair Housing Act—prohibits a bank from denying you a loan to purchase or improve your home, or offering you a loan on less favorable terms, because of your race, color, religion, sex or national origin.

Real Estate Settlement Procedures Act—requires the bank to disclose the nature and costs of real estate settlements; the bank must provide you with a special information booklet which explains your rights and with a good faith estimate of the cost of settlement services.

State Laws—state laws that give you rights and remedies in consumer credit transactions; normally, unless a state law directly conflicts with some federal law, the state law will apply and may give you protection; many states have some form of usury law, which establishes maximum rates of interest that creditors can charge you on loans or credit sales; the maximum interest rates vary from state to state and depend upon what kind of credit transaction is involved.

Copyrights and Trademarks

This office makes rulings to assure that trademark and copyright items are not too closely copied by imported goods entering the country. A free pamphlet, *Trademark Information for Travelers*, is also available. Contact: Entry, Licensing and Restricted Merchandise, Entry Procedures and Penalties Division, Office of Regulation and Rulings, Customs Service, Department of the Treasury, 1301 Constitution Ave. N.W., Room 2417, Washington, DC 20229/202-566-5765.

Corporate Finance and Special Projects

This office deals with special problems related to domestic finance, including programs of financing assistance to private firms, the Chrysler Corporation loan, capital formation and innovation, and the Task Force of the Steel Tripartite Commission. Contact: Office of Corporate Finance and Special Projects, Capital Markets Policy, Domestic Finance, Department of the Treasury, 1435 G. St. N.W., Room 3025, Washington, DC 20220/202-566-5337.

Corporate Tax Statistics

For information on corporation taxes by industry and size, contact: Corporation Statistics, Internal Revenue Service, Department of the Treasury, 1111 Constitution Ave. N.W., Washington, DC 20224/202-376-0102.

Counterfeit and Forgery Statistics

The free *Annual Statistical Summary* provides counterfeit and forgery statistics and trends. Contact: Public Affairs, Secret Service, Department of the Treasury, 1800 G St. N.W., Room 805, Washington, DC 20223/202-535-5708.

Currency Imports/Exports

There is no limitation in terms of total amount of monetary instruments which may be brought

into or taken out of the United States. However, if you transport or cause to be transported more than $5,000 on any occasion into or out of the United States, or if you receive more than that amount you must file a customs report. Contact: Currency Investigation Division, Office of Investigations, Border Operations, Customs Service, Department of the Treasury, 1301 Constitution Ave. N.W., Room 4339, Washington, DC 20229/202-566-6531.

Customs Audit

The Regulatory Audit Division provides the U.S. Customs Service with an external audit capability to verify transactions and claims of importers, carriers and exporters. Contact: Regulatory Audit Division, Office of Border Operations, Customs Service, Department of the Treasury, 1301 Constitution Ave. N.W., Room 2114, Washington, DC 20229/202-566-2812.

Customs Bonded Warehouse

Customs Bonded Warehouses are buildings or other secured areas (duty-free stores) in which dutiable goods may be stored, manipulated, or may undergo manufacturing operations without payment of duty. Contact: Drawbacks and Bonds Branch, Carrier Drawbacks and Bonds Division, Office of Regulations and Rulings, Customs Service, Department of the Treasury, 1301 Constitution Ave. N.W., Room 2414, Washington, DC 20229/202-566-5856.

Customs Bulletin

This weekly publication contains current amendments to Customs Regulations and decisions of U.S. Customs Court and U.S. Court of Customs and Patent Appeals. Available for $65 a year, from: Government Printing Office, Superintendent of Documents, Washington, DC 20402/202-783-3238. For more detailed information on the availability of published rulings and decisions in all areas of customs laws, especially tarrif classification and value rulings, contact: Legal Retrieval Branch, Office of Regulations and Rulings, Customs Service, Department of the Treasury, 1301 Constitution Ave. N.W., Room 2406, Washington, DC 20229/202-566-5095.

Customs Business Liaison

Each regional office of the U.S. Customs Service has a business liaison ombudsman to provide information and technical assistance to importers, brokers, freight forwarders, etc. For a listing of regional offices, contact: Headquarters, Customs Service, Department of the Treasury, 1301 Constitution Ave. N.W., Washington, DC 20229/202-566-8195.

Customs Economic Analysis

This office provides economic information, analysis and policy advice on issues affecting the U.S. Customs Service, i.e., analysis of the potential economic impact of changes in various laws that govern U.S. international commerce; studies on productivity and resource allocation in the U.S. Customs Service; U.S. export trends; and long-term forecasts of international passenger arrivals. Contact: Office of Economic Analysis, Customs Service, Department of the Treasury, 1301 Constitution Ave. N.W., Room 2119, Washington, DC 20229/202-566-8933.

Customs Investigation

U.S. Customs maintains a force of special agents at 66 domestic and 8 foreign offices. They investigate violations of customs and related laws and regulations—fraud, currency reporting violations, cargo theft, neutrality violations, narcotics and bird smuggling. Contact: Office of Investigations, Customs Service, Department of the Treasury, 1301 Constitution Ave. N.W., Room 3124, Washington, DC 20229/202-566-5401.

Customs Regulations

The Legal Precedent Retrieval System is a key word index to U.S. Customs Service regulations and rulings. Microfiche copies of documents are available for sale. Contact: Legal Reference Area, Office of Regulations and Rulings, Customs Service, Department of the Treasury, 1301 Constitution Ave. N.W., Room 2404, Washington, DC 20229/202-566-5095.

Customs Research Branch

This office runs the Customs Laboratory which samples and analyzes a wide range of commodities that is or might be subject to duty, i.e., sugar, oil, textiles, tobacco, alcoholic beverages, and drugs, It will also react to a patent search request by companies who suspect that their patented items might be entering the United States under a different guise. The office maintains the National Commodity Sampling Information System which provides import data and classification change rates for imported merchandise. Contact: Research Branch, Technical Services Division, Customs Service, Department of the Treasury, 1301 Constitution Ave. N.W., Room 7113, Washington, DC 20229/202-566-5853.

Customs Rulings

An exporter, importer, or any other person who has a direct interest may request an administrative ruling on the application of a Customs law to their specific situation. Contact: Customs Rulings on Imports, Office of Regulations and Rulings, Commercial Operations, Customs Service,

Department of the Treasury, 1301 Constitution Ave. N.W., Room 3117, Washington, DC 20229/202-566-8181.

Customs Statistics
Statistics are available on merchandise entries, carriers, cargo, passengers, foreign trade, enforcement, seizures of narcotics and dangerous drugs, seizures of violators of the law, and much more from: Program Information and Analysis Branch, Program Evaluation Division, Office of the Controller, Customs Service, Department of the Treasury, 1301 Constitution Ave. N.W., Room 5134, Washington, DC 20229/202-566-5817.

Customs Today
This free quarterly magazine is the official magazine of the U.S. Customs Service. It contains features and information on such items as statistics on merchandise entries, sources of customs operating funds, customs collections by region and district, and by category, and seizures for violations of laws enforced by Customs. Contact: Customs Today, Public Information Division, Customs Service, Department of the Treasury, 1301 Constitution Ave. N.W., Room 6311, Washington, DC 20228/202-566-5286.

Daily Treasury Statement
This publication provides information on the cash and debt operations of the U.S. Treasury, operating cash balance, deposits and withdrawals of operating cash, public debt transactions, federal tax deposit system activities, tax and loan note accounts by depository category, and income tax refunds issued. Available for $135.00 per year from Government Printing Office, Superintendent of Documents, Washington, DC 20402/202-783-3238.

Debt Management
This office deals with federal debts including public debt securities, nonmarketable public issues, federal agency securities, and government-suponsored agency securities. Contact: Federal Finance, Domestic Finance, Department of the Treasury, 15th St. and Pennsylvania Ave. N.W., Room 3315, Washington, DC 20220/202-566-5806.

Detector Dogs
Detector dogs and handlers are assigned to Customs international mail facilities, airports, cargo docks, terminals, and border ports. They screen mail, cargo, baggage, ships, aircraft and vehicles. They are never used to search people. Customs uses a wide variety of dogs, many of which are recruited from animal shelters. Customs also accepts dogs from individual owners who offer their dogs as a donation. Dogs may be available to the public when they retire (at age 9), if their handlers do not wish to keep them. Contact: Canine Training Center, Inspection and Control Division, Customs Service, Department of the Treasury, RR22, Box 7, Front Royal, VA 22630/703-635-7104.

Developing Nations
This office is involved with the situation in non-OPEC developing countries, including discussions and negotiations between developed and nondeveloped countries, and the operation of multilateral development banks, World Bank, Inter-American Development Bank, Asian Development Bank and the African Development Bank. Contact: Developing Nations, International Affairs, Monetary Affairs, Department of the Treasury, 15th St. and Pennsylvania Ave. N.W., Room 3222, Washington, DC 20220/202-566-8243.

Drawbacks
Drawbacks refer to a partial or entire refund that may be obtained from tax or duty payments on a commodity used in a special way, e.g., imported material used in the manufacture of exported articles. The purpose of drawbacks is to enable a manufacturer to compete in foreign markets. Contact: Drawbacks and Bond Branch, Carrier Drawbacks and Bonds Division, Office of Regulations and Rulings, Customs Service, Department of the Treasury, 1301 Constitution Ave. N.W., Room 2414, Washington, DC 20229/202-566-5856.

Duty Assessment
Every shipment that enters the United States is subject to duty payments. This office makes the final determination of a shipment's value and the rate of duty it is subject to. Contact: Entry Examination and Liquidation Branch, Duty Assessment Division, Office of Border Operations, Customs Service, Department of the Treasury, 1301 Constitution Ave. N.W., Room 4209, Washington, DC 20229/202-566-5307.

Economic Analysis
Briefings on current economic performance and economic outlook are provided to private groups and organizations. Contact: Office of Financial Analysis, Domestic Ecnomics Policy, Economic Policy, Department of the Treasury, 15th St. and Pennsylvania Ave. N.W., Room 4415, Washington, DC 20220/202-566-5914.

Energy-Related Tax Credits
Tax credits are given to those who purchase

energy saving equipment. Contact local field office for detailed information (see "Local Tax Offices" in this section). or: Returns, Processing and Accounting Division, Taxpayer Service, Internal Revenue Service, Department of the Treasury, 1111 Constitution Ave. N.W., Room 7009, Washington, DC 20224/202-566-6881.

Engraved and Lithographed Printings

Black ink engravings produced from intaglio plates in a manner similar to currency and postage stamp production. It includes: small presidential portraits (6" × 8"); Chief Justice portraits (6" × 8"); large presidential portraits (9" × 12"); vignettes of buildings (6" × 8"); and government seals (5-⅜" diameter). For a complete price list, contact: Administrative Services Division, Bureau of Engraving and Printing, Department of the Treasury, 14th and C Sts. S.W., Room 321-15A, Washington, DC 20228/202-477-0195.

ERISA

For information on the tax aspects of the Employee Retirement Income Security Act (ERISA), including determination and notification letter requests and interpretation of appropriate laws and procedures, contact: Employee Plans Division, Employee Plans and Exempt Organizations, Internal Revenue Service, Department of the Treasury, 1111 Constitution Ave. N.W., Room 6526, Washington, DC 20224/202-566-6740.

Estate and Gift Tax

For information on rulings, laws, etc., on estate and gift tax, contact: Estate and Gift Tax Branch, Individual Tax Division, Internal Revenue Service, Department of the Treasury, 1111 Constitution Ave. N.W., Room 5201, Washington, DC 20224/202-566-3549.

Estimates of Income Unreported on Individual Income Tax Returns

This publication presents estimates of total income individuals should have reported to the Internal Revenue Service but did not and the associated tax revenue loss. The estimates include underreporting on individual returns filed and on returns that should have been filed covering legal and selected types of illegal income. Available for $5.50 from: Government Printing Office, Superintendent of Documents, Washington, DC 20402/202-783-3238.

Explosives Data

The *Annual Explosives Incident Report* provides detailed data analysis on explosives inci-

dents, including thefts, discoveries, and explosions. Contact: Explosives Enforcement Branch, Office of Criminal Enforcement, Bureau of Alcohol, Tobacco and Firearms, Department of the Treasury, 1200 Pennsylvania Ave. N.W., Room 3238, Washington, DC 20226/202-566-7395.

Explosives Hotline

This hotline provides direct contact between citizens and the Bureau of Alcohol, Tobacco, and Firearms field offices for stolen or recovered explosives. Two national response teams can be rushed to the scene of major arson or bombing cases anywhere in the United States within 24 hours. Contact: Explosives Enforcement Branch, Office of Criminal Enforcement, Bureau of Alcohol, Tobacco and Firearms, Department of the Treasury, 1200 Pennsylvania Ave. N.W., Room 3234, Washington, DC 20226/800-424-9555 (202-566-7143—call collect from Guam, Alaska, Hawaii, Puerto Rico and Virgin Islands).

Explosives Research

Research is conducted in such areas as explosive detection and past detonation identification. Contact: Research and Development, Bureau of Alcohol, Tobacco and Firearms, Department of the Treasury, 1200 Pennsylvania Ave. N.W., Room 4220, Washington, DC 20226/202-566-4124.

Federal Law Enforcement Training Center

This interagency facility provides basic police and criminal investigator training for officers and agents of the participating federal organizations, as well as advanced and specialized training that is common to two or more organizations. Their programs include: criminal investigation programs and police programs, criminalistic skills, investigative techniques, legal courses, communication skills, ethics, and firearms training. Participating agencies include Forest Service, National Bureau of Standards, National Marine Fisheries, General Service Administration, U.S. Department of Housing and Urban Development, National Park Service and U.S. Customs Service. Contact: Federal Law Enforcement Training Center, Department of the Treasury, Glynco Facility, Brunswick, GA 31524/912-267-2100.

Federal Regulations of Firearms and Ammunition

This clearly written manual covers all aspects of firearm and ammunition regulations. Free from: Publications Distributions Center, Bureau of Alcohol, Tobacco and Firearms, Department

of the Treasury, 3800 S. Four Mile Run Drive, Arlington, VA 22206/703-557-7850

Firearms Enforcement

This office works with state and local agencies in curtailing the flow of firearms to criminal elements. Contact: Firearms Enforcement, Office of Criminal Enforcement, Bureau of Alcohol, Tobacco and Firearms, Department of the Treasury, 1200 Pennsylvania Ave. N.W., Room 3205, Washington, DC 20226/202-566-7457.

Firearm Imports

Information is available on permits required for importing firearms, aummunition and other implements of war. Free publications include: *Federal Laws and Regulations on Firearms and Ammunition* and *Importation of Arms, Ammunition and Implements of War*. Contact: Import Branch, Technical Service Division, Office of Regulatory Enforcement, Bureau of Alcohol, Tobacco and Firearms, Department of the Treasury, 1200 Pennsylvania Ave. N.W., Room 7241, Washington, DC 20226/202-566-7151.

Fiscal Functions

Work is performed on systems development activities for such fiscal functions as electronic funds transfers through which recipients of recurring federal payments can receive credit directly into their bank accounts. Contact: Operation Planning and Research, Bureau of Government Financial Operations, Department of the Treasury, Pennsylvania Ave. and Madison Pl. N.W., Room 437, Washington, DC 20226/202-634-2007.

Foreign Acquisition of Banks

A series of studies have been conducted on the effects of foreign acquisition of U.S. banks, the advantages and difficulties of how they operate in the United States and what changes have been made in their banking policies. Contact: Banking Research and Economic Analysis, Research and Economic Programs, Policy Planning, Comptroller of the Currency, Department of the Treasury, 490 L'Enfant Plaza E. S.W., 5th Floor BRNEA, Washington, DC 20219/202-447-1585.

Foreign Currency

This office develops guidelines for the funding of cooperative production arrangements for the purchase and sale of technology and equipment between agencies of the U.S. government and foreign nations. Contact: Cash Management Operation Staff, Banking and Cash Management, Bureau of Government Financial Operations, Department of the Treasury, Pennsylvania Ave.

and Madison Place, N.W., Room 204, Washington, DC 20226/202-566-8577.

Foreign Exchange and Gold

The Department of the Treasury sells gold at monthly public auction in order to reduce the U.S. trade deficit and to promote the internationally agreed effort to gradually reduce the monetary role of gold. Foreign exchange market developments and operations are also monitored. Contact: Foreign Exchange and Gold Operations, Department of the Treasury, 15th St. and Pennsylvania Ave. N.W., Room 5050, Washington, DC 20220/202-566-2773.

Foreign Mail Shipments

For information on merchandise mailed from abroad to the United States, Contact: Duty Assessment Division, Customs Service, Commercial Operations, Department of the Treasury, 1301 Constitution Ave. N.W., Room 4114, Washington, DC 20229/202-566-8121.

Foreign Portfolio Investment

This office collects and analyzes data related to international portfolio investment and its effects upon the national security, commerce, employment, inflation, general welfare, and foreign policy of the United States. It also reports on foreigners' portfolio investment in the U.S. Contact: Foreign Portfolio Investment Survey Project, Office of the Assistant Secretary for International Affairs, Department of the Treasury, 1625 I St. N.W., Room 225, Washington, DC 20220/202-634-2271.

Foreign Statistics

For information on foreign tax credits and citizens living abroad, contact: Foreign Statistics, Internal Revenue Service, Department of the Treasury, 1201 E St. N.W., Washington, DC 20224/202-376-0177.

Foreign Tax Credits

Information is available on guidelines for circumstances under which a payment to a foreign country may be credited against U.S. income tax liabilities. Contact: T.C.R, Internal Revenue Service, Department of the Treasury, 1111 Constitution Ave. N.W., Room 900, Washington, DC 20224/202-566-6275.

Forensic Sciences

For information on research and development in the reprographic fields such as color copiers and improved photographic films as well as counterfeit analysis, contact: Counterfeit Deterrent Branch, Research and Engineering, Bureau

of Engraving and Printing, Department of the
Treasury, 14th and C Sts. S.W., Room 207-11A,
Washington, DC 20228/202-447-9725.

Freedom of Information Act

For information on using the Freedom of In-
formation Act throughout the Department of
the Treasury, contact: Director, Disclosure,
Operations, Division, IRS, P.O. Box 388, Ben
Franklin Station, Washington, DC 20044/202-
566-4912.

Gasohol Packet

See "Alcohol Fuels Information Directory" in
this section.

Gasohol Permits

Permits are required to operate distilled spirits
plants. General information on the production of
gasohol is also available. Free publications in-
clude: *Alcohol Fuels Information Directory* and
*Alcohol Fuel Plants and Distilled Spirits for Fuel
Use*. For publications contact: ATF Distribution
Center, 3800 S. Four Mile Run Dr., Arlington,
VA 22006/703-557-7850. For general informa-
tion, contact: Special Operations Branch, Office
of Regulatory Enforcement, Bureau of Alcohol,
Tobacco and Firearms, Department of the Trea-
sury, 1200 Pennsylvania Ave. N.W., Room 6216,
Washington, DC 20226/202-566-7591. (See "Al-
cohol, Tobacco, Firearms, Explosion Regional
Hotline," this section.)

Gold Medallions and Hotline

A series of 10 gold medallions, ½ ounce and 1
ounce, is being produced to honor 10 specific
American artists. The artists and publishing
dates are as follows:

Marian Anderson, Grant Wood—1980
Mark Twain, Willa Cather—1981
Louis Armstrong, Frank Lloyd Wright—1982
Robert Frost, Alexander Calder—1983
Helen Hayes, John Steinbeck—1984

The daily price of the medallions will be based on
the previous day's closing spot price of gold on
the New York Commodity Exchange, plus a pre-
mium to cover production and distribution costs.
Prices of the medallions are available on: 800-
368-5510; 800-368-5500 (Alaska, Hawaii, Puerto
Rico, Virgin Islands); 783-3800 (D.C.). For addi-
tional information on medallions, contact: Cus-
tomer Services Branch, Marketing Division,
Bureau of the Mint, Department of the Treasury,
501 13th St. N.W., Room 1021, Washington, DC
20220/202-376-0458.

Government Checks

The Disbursement Division operates 11 dis-
bursing centers which issue checks for over 1,600
federal administrative offices throughout the
United States. It also prepares and distributes
federal tax deposit forms for the Internal Reve-
nue Service. Contact: Disbursement Division,
Disbursements and Claims, Bureau of Govern-
ment Financial Operations, Department of the
Treasury, 1100 Vermont Ave. N.W., Room 316,
Washington, DC 20226/202-634-5970.

Government Loans Abroad

Information is available on all U.S. govern-
ment loans from all government agencies to for-
eign governments and foreign organizations. The
following reports are issued quarterly:

*Active Foreign Credits of the U.S. Government
 Contingent Foreign Liabilities of the U.S. Government
Significant Monies Due to U.S. Government and Unpaid
 90 Days or More by Official Foreign Obligors
Amounts Due and Unpaid 90 Days or More on Foreign
 Credits of the U.S. Government.*

Contact: Office of Data Services, International
Economic Analysis, Economic Policy, Depart-
ment of the Treasury, 15th St. and Pennsylvania
Ave. N.W., Room 5127, Washington, DC
20220/202-566-5473.

Government Securities, Lost, Stolen or Destroyed

For claims on account of lost, stolen, destroyed
or mutilated securities, contact: Correspondence
and Claims Branch, Securities Operations Divi-
sion, Bureau of the Public Debt, Department of
the Treasury, 13th and C Sts. S.W., Room 429,
Washington, DC 20228/202-447-1339.

Grants

The program described below is for sums of
money which are given by the federal govern-
ment to initiate and stimulate new or improved
activities or to sustain on-going services.

*State and Local Government Fiscal Assistance—
General Revenue Sharing*
 Objective: To provide financial assistance to
state governments and general purpose local gov-
ernments. Revenue sharing funds may be used by
a recipient government for any purpose which is
a legal use of its own source revenues pursuant to
authorization of the governing body following
two public hearings held specifically to permit
the public to discuss: 1) possible uses of funds,
and 2) a proposed use (budget) of revenue shar-
ing funds. Notices of hearings are to be published

in local newspapers at least 10 days in advance of each hearing. Recipient governments may spend revenue sharing funds for the state or local contribution to a federal matching grant program, provided that this is acceptable to the federal agency administering the matching grant and does not violate any state or local laws.

Eligibility: State governments (including the District of Columbia but excluding Puerto Rico, territories, and possessions) and general purpose local governments, including the governing bodies of Indian tribes or Alaskan native villages performing substantial governmental functions, and county sheriffs' offices in the State of Louisiana.

Range of Financial Assistance: Average $289,402,174.

Contact: Intergovernmental Relations Division, Office of Revenue Sharing, Department of the Treasury , 2401 E St. N.W., Washington, DC 20226/202-634-5200.

Hearing Impaired Tax Hotline

The Internal Revenue Service offers telephone tax assistance to hearing-impaired taxpayers with teletypewriter equipment. Call 800-428-4732 (all states except Indiana), 800-382-4059 (Indiana), or contact: Taxpayer Services Division, Internal Revenue Service, Department of the Treasury, 1111 Constitution Ave. N.W., Room 7211, Washington, DC 20224/202-488-3100.

Import Quotas

Import quotas are enforced on some 940 items. These importations are monitored to determine the quantity of a commodity imported from a specific country or countries. A free monthly newsletter is available on every commodity subject to import quotas. The U.S. Customs Service administers most, but not all, import quotas. Contact: Quota Section, Office of Operations, Customs Service, Border Operations, Department of the Treasury, 1301 Constitution Ave. N.W., Room 4111, Washington, DC 20229/202-566-8592.

Importing into the U.S.

This free publication provides an explanation of entry procedures, delivery, duty payments, assigned entry numbers and quotas. Available from: Entry, Licensing and Restricted Merchandise, Entry Procedures and Penalties Division, Office of Regulations and Rulings, Customs Service, Department of the Treasury, 1301 Constitution Ave. N.W., Room 2417, Washington, DC 20229/202-566-5765.

Income Tax Statistics

Publications provide a variety of data reported on tax returns. The publications available include:

Individual Income Tax Returns
Small Area Data from Individual Income Tax Returns
Corporation Income Tax Returns
International Income and Taxes, U.S. Corporations and Their Controlled Foreign Corporations
International Income and Taxes, Domestic International Sales Corporations Returns
Sole Proprietorship Returns
Partnership Returns
Fiduciary Income Tax Returns
Estate Tax Returns
Personal Wealth

For information on content and availability of statistical publications, contact: Statistics of Income Branch, Statistics Division, Office of Planning and Research, Internal Revenue Service, Department of the Treasury, 1201 E St. N.W., Room 301, Washington, DC 20224/202-376-0102.

Individual Tax Model

This program provides state tax officials with a tax model to be used in determining their rate structure and possible revenue yields in connection with the "piggybacking" provisions of the. Federal-State Tax Collection Act of 1972. Contact: Director, Statistics Division, Internal Revenue Service, Department of the Treasury, 1201 E St. N.W., Room 401, Washington, DC 20224/202-376-0216.

Individual Tax Statistics

For information on individual tax returns (aggregate data) by county and Standard Metropolitan Statistical Area, contact: Individual Statistics, Internal Revenue Service, Department of the Treasury, 1201 E St. N.W., Washington, DC 20224/202-376-0155.

Ingredient Labeling for Alcoholic Beverages

After January 1, 1983, producers of alcoholic beverages must either list the ingredients on the label or provide an address to which consumers may write and promptly obtain an ingredient list. For a copy of the labeling regulations, contact: Commodity Classification Branch, Bureau of Alcohol, Firearms and Tobacco, Department of the Treasury, 1200 Pennsylvania Ave. N.W., Room 6208, Washington, DC 20226/202-566-7401.

Ink Research and Development

This office studies: developments of inks which can be formulated from commercially available material; the control of the measurable standard

disposal of the residual material in an environmentally acceptable manner; and black-based rotogravure inks devoid of solvents. Contact: Ink Research and Development Branch, Research and Engineering, Bureau of Engraving and Printing, Department of the Treasury, 13th and C Sts. N.W., Room 2013, Washington, DC 20228/202-447-9725.

Internal Revenue Bulletin

This weekly publication reviews rulings, procedures, announcements, orders, settlements, and public laws relating to taxes. For information on content, contact: Technical Publications Branch, Tax Forms and Publications, Technical Office, Internal Revenue Service, Department of the Treasury, 1111 Constitution Ave. N.W., Room 2571, Washington, DC 20224/202-566-3129. Available for $90.00 a year from: Government Printing Office, Superintendent of Documents, Washington, DC 20402/202-783-3238.

International Commodities

The International Affairs Office is involved with international commodity developments such as National Rubber Agreement, Integrated Program for Commodities, including copper, cocoa, coffee, sugar, wheat and grain, Oceans Policy, World Oil Market and International Energy Policy. Contact: Commodities and Natural Resrouces, International Affairs, Monetary Affairs, Department of the Treasury, 15th St. and Pennsylvania Ave. N.W., Room 3222, Washington, DC 20220/202-566-5881.

International Energy Research

This office focuses on the ways in which international flows of energy resources and technologies affect the U.S. Department of the Treasury's responsibilities for economic policy, balance of payments, and monetary affairs. It also studies the economics of nuclear energy and its impact on international trade, Chinese energy policy and its implications for U.S. exports, OPEC investment and the dollar, the effect of changing oil prices on developing countries, and evaluates technology in international transfers for the Internal Revenue Service. Contact: Office of the Director, Deputy Assistant Secretary for Arabian Peninsula Affairs, Main Treasury, Room 4134, 15th St. and Pennsylvania Ave. N.W., Washington, DC 20220/202-566-5063.

International Financial Statistics

The U.S. Department of Treasury manages two international financial statistics collection systems: 1) the *Treasury International Capital Reporting System*—collects monthly, quarterly, and semiannual data on U.S. banks' foreign assets and liabilities; U.S. commercial firms' claims and liabilities to unaffiliated foreigners; banks' and brokers' securities transactions with foreign residents; foreign transactions in U.S. securities and U.S. banks' lending activity abroad (these data provide information on all movements of capital between the United States and foreign countries other than direct investment flows and government transfers); 2) *Treasury Foreign Currency Reporting System*—gathers information from banks and nonbanking business firms in the United States and their majority-owned foreign subsidiaries and branches on the assets, liabilities and exchange contracts bought and sold in eight major foreign currencies and U.S. dollars held or owned by their foreign branches and majority-owned subsidiaries. Contact: Office of Statistical Reports, International Financial Reports, Economic Policy, Department of the Treasury, 711 14th St. N.W., Room 503, Washington, DC 20220/202-376-0697.

International Mail Imports

The U.S. Customs Service processes all mail entering the country from overseas. A free pamphlet, *U.S. Customs International Mail Imports*, provides information on mail that originates outside the United States. It deals with duty, damaged goods, and provides a listing of Customs International Mail Branches. Contact: Special Operations Branch, Duty Assessment Division, Office of Border Operations, Customs Service, Department of the Treasury, 1301 Constitution Ave. N.W., Room 4217, Washington, DC 20229/202-566-2957.

International Monetary Affairs

This office is concerned with international bank lending and the Eurocurrency market, including treatment accorded to U.S. banks by foreign governments, gold market developments, international balance of payments, foreign exchange market developments and operations, international monetary arrangements, and the International Monetary Fund. Contact: International Monetary Affairs, International Affairs, Department of the Treasury, 15th St. and Pennsylvania Ave. N.W., Room 3221, Washington, DC 20220/202-566-5232.

International Monetary Research

This office is involved with the analysis of the trade and monetary consequences of changes in United States and foreign government policies. It makes specific forecasts of various economic variables and monitors current economic research in

the international macroeconomics and monetary areas. Contact: Office of International Monetary Research, International Economic Analysis, Economic Policy, Department of the Treasury, 1435 G St. N.W., Room 10, Washington, DC 20220/202-376-0333.

IRS Braille
See "Tax Information in Braille for Public Libraries" in this section.

IRS Collections and Returns
Statistics are available on IRS tax collections and tax returns including: IRS collections by sources and by area; number of IRS refunds issued; overassessments of tax as the result of examination; number of returns filed by IRS region; number of returns examined and results; results of collection agencies; civil penalties assessed and abated; number of exempt organizations' returns examined by type of organization. Contact: Returns Processing and Accounting Division, Office of Taxpayer Service and Returns Processing, Internal Revenue Service, Department of the Treasury, 1111 Constitution Ave. N.W., Room 7009, Washington, DC 20225/202-566-6881.

IRS Enrolled Agents
Individuals who are not attorneys or certified public accountants must pass the special enrollment examination in order to represent taxpayers before the Internal Revenue Service. Contact: and Practices, Computer Examination Section, Compliance, Internal Revenue Service, Department of the Treasury, 1111 Constitution Ave. N.W., Room 2328, Washington, DC 20224/202-566-4409.

IRS Films
The following films are offered on a free-loan basis from local Internal Revenue Service Field offices (see "Local Tax Office" in this section), or from: Public Affairs Division, Internal Revenue Service, Department of the Treasury, 1111 Constitution Ave. N.W., Washington, DC 20224/202-566-6860.

The American Way of Taxing—highlights the various services available to taxpayers through local IRS offices and traces the history and current administration of the tax system in the United States.
Hey, We're In Business—stresses the IRS free assistance for small business owners in such areas as good records, obligations to employees, and depreciation, for example (English and Spanish editions).
What Happened to My Paycheck?—explains payroll deductions for taxes and the "pipeline" system at the service centers. While designed for high school students, it need not be restricted to that audience.
A Right Good Thing—is designed for showing to groups of elderly people, those 60 years of age or over, and explains tax counseling available free of charge for these taxpayers. It focuses on those tax problems frequently encountered by older persons, such as what qualifies as taxable income, treatment of Social Security benefits, tax consequences of selling a home, and tax benefits for older taxpayers.
The Subject Was Taxes—narrates the history of taxes throughout the ages from about 5000 BC to Colonial times in various early civilizations.
Money Talks—depicts the history of taxes from Colonial times to post World-War II.
A Vital Service—about volunteer income tax assistance.

IRS Hearing Impaired
See "Hearing-Impaired Tax Hotline" in this section.

IRS Manuals
The following Internal Revenue Service manuals are available from: Freedom of Information Reading Room, Internal Revenue Service, Department of the Treasury, 1111 Constitution Ave. N.W., Room 1569, Washington, DC 20224/202-566-3770.

Organization Functions and Staffing of IRS ($2.25)
Policies of the Internal Revenue Service ($1.00)
Disclosures of Official Information Handbook ($2.75)
Prime Issues List ($1.30)
Travel Handbook ($1.50)
General ($2.00)
Income Tax Examination Handbook ($5.25)
Audit Technique Handbook for Internal Revenue Agents ($3.00)
Audit Guidelines Relating to Specialized Industries ($1.00 each): *Insurance, Auto, Textiles, Mining/Timber, Brokers, Railroads, Real Estate, Banking, Public Utilities*
Tax Audit Guidelines—Individual, Partnerships, Estates and Trusts, and Corporations ($2.25)
Tax Audit Guidelines and Techniques for Tax Technicians ($1.75)
Technique Handbook for In-Depth Audit Investigations ($1.75)
Examination Tax Shelter Handbook ($1.00)
Audit Technique Handbook for Estate Tax Examiners ($3.00)
Handbook for Audit Reviews ($.75)
Employment Tax Procedures ($1.25)
Excise Tax Procedures ($1.00)
Handbook for Audit Group Managers ($.75)
Exempt Organizations Audit Procedures ($4.30)
Collection Techniques ($2.50)
Levy and Sale ($1.75)
Federal Tax Liens ($1.25)
Field Collection Techniques ($1.75)

Uncollectible Accounts ($.25)
Offers in Compromise ($2.00)
Legal Reference Guide for Revenue Officers ($2.75)
Insolvencies and Descedents Estates ($1.00)
Interest and Penalty Provisions ($1.00)
Taxpayer Service Handbook ($3.50)
Exempt Organization Handbook ($3.00)
Private Foundations Handbook ($1.50)
Employee Plans Masterfile Handbook ($.50)
Exempt Organization Masterfile Handbook ($1.50)
Employee Plans Audit Guidelines Handbook ($1.00)
Manual System and Appellate Function ($3.70)
Closing Agreement Handbook ($10.30)
Handbook for Special Agents ($5.25)
Rulings, Determination Letters, Opinion Letters, Information Letters, and Closing Agreements Covering Specific Matters ($4.90)

IRS Publications

The following are free from your local Internal Revenue Service Field Office (see Local Tax Office) or from: Public Affairs Division, Internal Revenue Services, Department of the Treasury, 1111 Constitution Ave. N.W., Room 2315, Washington, DC 20224/202-566-4024.

Your Federal Income Tax (#17)
Tax Guide for U.S. Citizens Abroad (#54)
Farmer's Tax Guide (#225)
Tax Guide for Small Business (#334)
Federal Highway Use Tax on Trucks, Truck-Tractors and Buses (#349)
Fuel Tax Credits—Nonhighway Business Equipment, Aircraft, Buses, and Taxicabs (#378)
Federal Estate and Gift Taxes (#448)
Travel, Entertainment, and Gift Expenses (#463)
Exemptions (#501)
Medical and Dental Expenses (#502)
Child and Disabled Dependent Care (#503)
Tax Information for Divorced or Separated Individuals (#504)
Tax Withholding and Estimated Tax (#505).
Income Averaging (#506)
Educational Expenses (#508)
Tax Calendar for 1981 (#509)
Excise Taxes for 1981 (#510)
Credit Sales by Dealers in Personal Property (#512)
Tax Information for Visitors to the United States (#513)
Foreign Tax Credit for U.S. Citizens and Resident Aliens (#514)
Withholding of Tax on Nonresident Aliens and Foreign Corporations (#515)
Tax Information for U.S. Government Civilian Employees Stationed Abroad (#516)
Social Security for Members of the Clergy and Religious Workers (#517)
Foreign Scholars and Educational and Cultural Exchange Visitors (#518)
U.S. Tax Guide for Aliens (#519)

Tax Information for U.S. Scholars (#520)
Moving Expenses (#521)
Disability Payments (#522)
Tax Information on Selling Your Home (#523)
Credit for the Elderly (#524)
Taxable and Nontaxable Income (#525)
Charitable Contributions (#526)
Rental Property (#527)
Miscellaneous Deductions (#529)
Tax Information for Homeowners (#530)
Reporting Income from Tips (#531)
Self-Employment Tax (#533)
Depreciation (#534)
Business Expenses and Operating Losses (#535)
Installment and Deferred-Payment Sales (#537)
Accounting Periods and Methods (#538)
Withholding Taxes and Reporting Requirements (#539)
Tax Information on Partnerships (#541)
Tax Information on Corporations (#542)
Sales and Other Dispositions of Assets (#544)
Interest Expense (#545)
Tax Information on Disasters, Casualty Losses, and Thefts (#547)
Deduction for Bad Debts (#548)
Condemnations of Private Property for Public Use (#549)
Investment Income and Expenses (#550)
Basis of Assets (#551)
Recordkeeping Requirements and a List of Tax Publications (#552)
Highlights of 1980 Tax Changes (#553)
Tax Benefits for Older Americans (#554)
Community Property and the Federal Income Tax (#555)
Examination of Returns, Appeal Rights, and Claims for Refund (#556)
Revision de las declaraciones de impuesto, derecho de apelacion y reclamaciones de devolucion (Examination of Returns, Appeal Rights, and Claims for Refund) (#556S)
How to Apply for and Retain Exempt Status for Your Organization (#557)
Tax Information for Sponsors of Contests and Sporting Events (#558)
Tax Informaton for Survivors, Executors, and Administrators (#559)
Tax Information on Self-Employed Retirement Plans (#560)
Determining the Value of Donated Property (#561)
Mutual Fund Distributions (#564)
Tax Information on U.S. Civil Service Retirement and Disability Retirement (#567)
Tax Guide for U.S. Citizens Employed in U.S. Possessions (#570)
Tax-sheltered Annuity Programs for Employees of Public Schools and Certain Tax-Exempt Organizations (#571)
Investment Credit (#572)
Pension and Annuity Income (#575)
Tax Information for Private Foundations and Founda-

tion Managers (#578)

Como preparar su declaracion de impuesto federal (#579S)

Federal Use Tax on Civil Aircraft (#582)

Recordkeeping for a Small Business (#583)

Disaster and Casualty Loss Workbook (#584)

Voluntary Tax Methods to Help Finance Political Campaigns (#585)

Proceso de cobro (Deudas del impuesto sobre ingreso) (The Collection Process (Income Tax Accounts) (#586S)

Business Use of Your Home (#587)

Tax Information on Condominiums and Cooperative Apartments (#588)

Tax Information on Subchapter S Corporations (#589)

Tax Information on Individual Retirement Arrangements (#590)

Income Tax Benefits for U.S. Citizens Who Go Overseas (#593)

Tax Guide for Commercial Fishermen (#595)

Earned Income Credit (#596)

Information on the United States-Canada Income Tax Treaty (#597)

Tax on Unrelated Business Income of Exempt Organizations (#598)

Certification for Reduced Tax Rates in Tax Treaty Countries (#686)

Comprehensive Tax Guide for U.S. Civil Service Retirement Benefits (#721)

Guides for Qualification of Pension, Profit-Sharing, and Stock Bonus Plans (#778)

Favorable Determination Letter (#794)

Index to Tax Publications (#900)

U.S. Tax Treaties (#901)

Energy Credits for Individuals (#903)

Computing the Interrelated Charitable, Marital, and Orphans' Deductions and Net Gifts (#904)

Tax Information on Unemployment Compensation (#905)

Targeted Jobs and WIN Credits (#906)

Tax Information for Handicapped and Disabled Individuals (#907)

Identification Numbers under ERISA (#1004)

Filing Requirements for Employee Benefit Plans (#1048)

IRS Rulings and Technical Advice

Internal Revenue Service rulings and technical advice memoranda are open to public inspection. Contact: Freedom of Information Reading Room, Taxpayer Services and Returns Processing, Internal Revenue Service, Department of the Treasury, 1111 Constitution Ave. N.W., Room 1569, Washington, DC 20224/202-566-3070.

IRS Training Publications

Information is available on all training publications for Internal Revenue Service agent training, including tax auditing, state and gift taxes, fiduciary income tax, international taxes, excise taxes

and taxpayer service training. Contact: Training Publications, Taxpayer Service Division, 31 Hopkins Plaza, Baltimore, MD 21203/301-962-2590 or order recording 301-962-0808.

Know Your Money

This publication describes: how to detect counterfeit money; how to guard against forgery losses; what to do when you receive a counterfeit bill or coin; how to print reproductions of paper currency, checks, bonds, revenue stamps and securities of the United States and foreign governments legally; what to do when money burns or wears out. Available for $2.00 from: Government Printing Office, Superintendent of Documents, Washington, DC 20402/202-783-3238.

Library

The main library contains holdings which emphasize both general economics and general law. Contact: Department of the Treasury, Room 5030, Treasury Building, Washington, DC 20220/202-566-2777.

Licensing a Small Still

Permits to build alcohol stills are granted by the Bureau of Alcohol, Tobacco and Firearms. Any person wishing to establish an alcohol fuel plant must obtain an Alcohol Fuels Producers Permit. Contact: Research and Regulations Branch, Regulation and Procedures Division, Office of Regulatory Enforcement, Bureau of Alcohol, Tobacco and Firearms, Department of the Treasury, 1200 Pennsylvania Ave. N.W., Room 6237, Washington, DC 20226/202-566-7626.

LIFO—Last-in-First-out

For information on this permissible method of evaluating inventory, used for sheltering income, contact: TCC, Internal Revenue Service, Department of the Treasury, 1111 Constitution Ave. N.W., Room 5038, Washington, DC 20224/202-566-2750.

Local Tax Offices

For a listing of Internal Revenue Service field offices which provide assistance to taxpayers, contact: Office of the Taxpayer Ombudsman, Internal Revenue Service, Department of the Treasury, 1111 Constitution Ave. N.W., Room 3331, Washington, DC 20224/202-566-6475.

Marking of Country of Origin on U.S. Imports

This free pamphlet describes how every article of foreign origin entering the United States must be legally marked with the English name of the country of origin unless an exception from marking is provided for in the law. Contact: Entry Li-

censing and Restricted Merchandise, Entry Procedures and Penalties Division, Office of Regulations and Rulings, Customs Service, Department of the Treasury, 1301 Constitution Ave. N.W., Room 2417, Washington, DC 20229/202-566-5765.

Medals

The U.S. Mint sells medals authorized by Congress, in recognition of distinguished service, careers or feats of outstanding citizens, e.g., Robert F. Kennedy, John Wagner, Hubert H. Humphrey. There are also official medals of all the United States, miniature presidential medals, secretaries of the Treasury, Director of the Mint, great moments in American military history, great naval heros, national historical events, historic buildings, and chief justices of the Supreme Court. Contact: Consumer Affairs Office, Marketing Division, Bureau of the Mint, Department of the Treasury, 501 13th St. N.W., Room 1021, Washington, DC 20220/202-376-0458.

Merchandise Restricted From Entering the U.S.

Rulings are made on questionable items that may or may not enter the country, i.e., pornographic books or movies, narcotics and dangerous drugs, pre-Columbian monumental and architectural sculpture or murals, switchblade knives and vehicles not equipped to comply with U.S. safety or clean air emission standards. Contact: Entry, Licensing and Restricted Merchandise, Entry Procedures and Penalties Division, Office of Regulations and Rulings, Customs, Department of the Treasury, 1301 Constitution Ave. N.W., Room 2417, Washington, DC 20229/202-566-5765.

Mint Publications

The following publications are published by the U.S. Mint and are available from: Government Printing Office, Superintendent of Documents, Washington, DC 20402/202-783-3238.

Domestic and Foreign Coins Manufactured by Mints of the United States 1793–1976—presents a complete historical record of the production of domestic coins by United States Mint institutions from 1793 through 1976. The manufacture of foreign coinage by United States Mints for other governments began in 1876. Coinage statistics reflect the years from 1876 through 1976 ($3.00).

Annual Report of the Director of the Mint—contains report on operations, functions, and legislation pertaining to the Includes a special section—"The World's Monetary Stocks of Gold, Silver, and Coins"—giving information on production, specifications and metallic composition of coinage of about 100 foreign countries. Illustrated ($5.00).

Medals of the United States Mint Issued for Public Sale (Rev. 1972)—historic bronze national medals, illustrated in actual size. Background and biographical data included ($5.25).

Our American Coins (Rev. 1974)—brief introduction to U.S. coins for youngsters aged 6 to 16. Descriptions of current coin designs (60¢).

For additional information on U.S. Mint publications, contact: Consumer Affairs Office, Bureau of the Mint, Department of the Treasury, 501 13th St. N.W., Room 1021, Washington, DC 20220/202-376-0871.

Monthly Statement of U.S. Currency and Coin

This publication identifies such matters as the amount of currency in circulation, currency in circulation by denomination, and comparative totals of money in circulation. Contact: Reconciliation and Special Reporting, Governments Accounts and Reports Division, Bureau of Government Financial Operations, Department of the Treasury, Pennsylvania Ave. and Madison Place, N.W., Washington, DC 20226/202-566-3717.

Monthly Treasury Statement of Receipts and Outlays of the Government

This publication provides totals of budget results and financing, a summary and detail of budget receipts and outlays, means of financing, analysis of change in excess of liabilities, agency securities issued under special financing authorities, and investment of government accounts in federal securities. Available for $135.00 per year from: Government Printing Office, Superintendent of Documents, Washington, DC 20402/202-783-3238.

Municipal Finance

This office reviews developments and proposals in the fiscal management and financial administration of state and local governments; reviews the impact of tax and/or expenditure controls on state and local government finance; watches for current issues that may affect the municipal credit market, e.g., government accounting principles, development of uniform financial disclosure in the sale of state and local securities, and the impact on credit markets of new federal bankruptcy tax laws for municipalties. Contact: Office of Municipal Finance, State and Local Finance, Domestic Finance, Department of the Treasury, 15th St. and Pennsylvania Ave. N.W., Room 5132, Washington, DC 20220/202-566-5681.

Mutilated Currency

Claims are handled from the public for the re-

demption of partially destroyed U.S. currency. Old bills may be exchanged for new ones at local banks. Contact: Currency Operations, Banking and Cash Management, Bureau of Government Financial Operations, Department of the Treasury, 13th and C Sts. S.W., Room 333, Washington, DC 20223/202-447-0278.

National Firearms Act
This act deals with the manufacture, transfer and exportation of firearms. It covers weapons such as machine guns, short-barreled shotguns and silencers. The office issues special tax stamps and numbers for the purchase of automatic weapons. Contact: National Firearms Act, Branch Office of Technical and Scientific Services, Bureau of Alcohol, Tobacco and Firearms, Department of the Treasury, 1200 Pennsylvania Ave. N.W., Room 7240, Washington, DC 20226/202-566-7019.

Ownership of Securities
The Accounts Branch keeps individual ownership accounts of registered government securities and authorizes payment of interest. Contact: Accounts Branch, Securities Operations Division, Bureau of the Public Debt, Department of the Treasury, 13th and C Sts. S.W., Room 634, Washington, DC 20228/202-287-4063.

Passenger Processing
This office deals with anyone entering the United States by air, boat, train, car or foot. They investigate new processes to facilitate the process and to facilitate the protection of law violators. Contact: Passenger Processing Division, Office of Inspection, Office of Border Operations, Customs Service, Department of the Treasury, 1301 Constitution Ave. N.W., Room 4138, Washington, DC 20229/202-566-5607.

Pets and Wildlife, Importing
There are a number of rules and restrictions for importing pets and wildlife. A free publication, *Pets, Wildlife, U.S. Customs*, describes most of the regulations. Contact: Information Division, Customs Service, Department of the Treasury, 1301 Constitution Ave. N.W., Room 6303, Washington, DC 20229/202-566-8408.

Pleasure Boats, Imports
Special rules and regulations are given to boats imported for pleasure. A free pamphlet, *Pleasure Boats*, describes how to import a boat. Contact: Public Affairs Office, Customs Service, Department of the Treasury, 1301 Constitution Ave. N.W., Room 6303, Washington, DC 20229/202-566-8450.

Problem Resolution Program—Taxes
This program is designed to cut through the red tape for taxpayers with persistent problems. Each Internal Revenue Service district office has a problem resolution officer who is independent from the operating division. If your problem is not resolved within five working days, you will be informed of its status. Contact a district office (see "Local Tax Office" in this section) or: Problem Resolution Branch, Taxpayers Service Division, Internal Revenue Service, Department of the Treasury, 1111 Constitution Ave. N.W., Room 3331, Washington, DC 20224/202-566-6475.

Publications and Information on Alcohol, Firearms and Tobacco
The Public Information Office provides assistance and free publications. The publications include:

Think First of Your Unborn Child—Rex Morgan, M.D. tells of the dangers of drinking during pregnancy, Fetal Alcohol Syndrome, in comic book format.
Explosives and Laws and Regulations
State Laws and Published Ordinances
Liquor Laws and Regulations for Retail Dealers

Contact: Public Information Office, Bureau of Alcohol, Tobacco and Firearms, Department of the Treasury, 1200 Pennsylvania Ave. N.W., Room 4402, Washington, DC 20226/202-566-7268.

Publications to Travelers and Importers
The following publications are free from Media and Public Services Branch, Public Information Division, Customs Service, Department of the Treasury, 1301 Constitution Ave. N.W., Room 6311, Washington, DC 20229/202-566-8195.

Customs Hints—Returning U.S. Residents—explains customs privileges and lists prohibited and restricted imports. "Know Before You Go."
Customs Hints for Visitors (Nonresidents)—customs exemptions for foreign visitors arriving in the United States (English language only).
Pets, Wildlife, U.S. Customs—summary of customs requirements for importing cats, dogs, birds and wildlife.
Importing a Car—customs requirements for individuals importing automobiles.
Customs Guide for Private Flyers—outlines principal customs requirements and procedures for private and corporate pilots making business or pleasure flights to and from foreign countries.
Pleasure Boats—information for owners of yachts and pleasure boats on customs procedures for importing

a boat, entry and reporting requirements.

Books, Copyrights, and Customs—information about copyright restrictions or prohibitions applying to importation of books.

A Gift . . . Are You Sure?—information and suggestions about gift parcels sent by persons overseas to friends and relatives in the United States so that they may qualify for entry as bona fide duty free gifts.

Currency Reporting—a flyer advising that if you take into or out of the United States more than $5,000, a report must be filed with customs.

Drawback—a nontechnical leaflet to explain drawback; how to obtain a duty refund on certain exports.

Customs Bonded Warehouses—a leaflet that explains the types of bonded warehouses, their use, and how to establish a bonded warehouse.

Customs Tips for Visitors—a leaflet issued in English, French, Spanish, German, Italian, Hungarian, Polish, Yugoslavian, and Czechoslovakian, Portuguese, Dutch, and Korean languages. Provides foreign visitors basic information on clearing U.S. Customs.

Customs Highlights for Government Personnel (Civilian and Military—explains customs privileges for personnel of the U.S. Government when returning from extended duty abroad with personal and household effects.

Tourist Trademark Information—list of the most popular tourist items prohibited importation because the trademark owners have recorded their marks with the Treasury Department.

International Mail Imports—information about customs procedures and requirements pertaining to parcels mailed from abroad.

GSP and The Traveler—questions and answers regarding duty-free entry of certain articles brought in by travelers from beneficiary developing countries listed under the Generalized System or Preferences (GSP)—annual update lists popular tourist items and the beneficiary countries.

U.S. Import Requirements—general information on U.S. Customs requirements for imported merchandise.

Customs Rulings on Imports—explains how importers may obtain a binding U.S. Customs duty ruling on items before importation.

Exporting to the United States—a 100-page booklet for foreign exporters planning to ship goods to the United States.

Marking of Country of Origin—Customs requirements for marking imported merchandise with name of country of origin.

Import Quota—summary of information on import quotas administered by the United States Customs Service.

Notice to Masters of Vessels—precautions masters or owners of vessels should take to avoid penalties and forfeitures.

Notice to Carriers of Bonded Merchandise—precautions carriers and customhouse brokers should take to safeguard merchandise moving in-bond.

ATA Carnets—an explanation as to the use of Admission Temporary Admission (ATA) carnets which simplify customs formalities for the temporary admission of certain goods.

Foreign Trade Zones—explains the advantages and use of foreign trade zones and customs requirements.

807 Guide—general information for importers/exporters on use of item 807.00 TSUS which permits a reduced duty treatment for the value of components manufactured in the United States and assembled abroad.

Quota Statistics

For statistics on the quota system—what's allowed into the United States, how much, etc.—contact: Data Center Operations, Automatic Data Processing, Office of Data Systems, Customs Service, Dept. of the Treasury, 1301 Constitution Ave. N.W., Room 1130, Washington, DC 20229/202-566-8461.

Regional Offices of National Bank Examiners

The 14 regional offices regulate and examine national banks for their areas. Contact:

First National Bank Region, Three Center Plaza, Suite P-400, Boston, MA 02108/617-223-2274. Maine, Vermont, New Hampshire, Massachusetts, Rhode Island, Connecticut.

Second National Bank Region, 1211 Ave. of the Americas, Suite 4250, New York, NY 10036/212-944-3495. New Jersey, New York, Puerto Rico, Virgin Islands.

Third National Bank Region, Three Parkway, Suite 1800, Philadelphia, PA 19102/215-597-7105. Pennsylvania, Delaware.

Fourth National Bank Region, One Erieview Plaza, Cleveland, OH 44114/216-522-7174. Indiana, Kentucky, Ohio.

Fifth National Bank Region, F&M Center, Suite 21-51, Richmond, VA 23277/804-643-3517. Maryland, North Carolina, Virginia, West Virginia, District of Columbia.

Sixth National Bank Region, Suite 2700, Peachtree Cain Tower, 229 Peachtree St. N.E., Atlanta, GA 30303/404-221-4926. Florida, Georgia, South Carolina.

Seventh National Bank Region, Sears Tower, 233 S. Wacker Dr., Suite 5750, Chicago, IL 60606/312-353-0300. Illinois, Michigan.

Eighth National Bank Region, 165 Madison Ave., Room 800, Memphis, TN 38103/901-521-3376. Alabama, Arkansas, Louisiana, Mississippi, Tennessee.

Ninth National Bank Region, 800 Marquette Ave., 1100 Midwest Plaza, East Building, Minneapolis, MN 55402/612-725-2684. Minnesota, North Dakota, South Dakota, Wisconsin.

Tenth National Bank Region, 911 Main St., Suite 2616, Kansas City, MO 64105/816-374-6431. Iowa, Kansas, Missouri, Nebraska.

Eleventh National Bank Region, 1201 Elm St., Suite 3800, Dallas, TX 75270/214-767-4400. Oklahoma, Texas.

Twelfth National Bank Region, 1405 Curtis St., Suite 3000, Denver, CO 80202/303-837-4883. Arizona, Colorado, New Mexico, Utah, Wyoming.

Thirteenth National Bank Region, 707 S.W. Washington St., Room 900, Portland, OR 87205/503-221-3091. Alaska, Idaho, Montana, Oregon, Washington.

Fourteenth National Bank Region, One Market Plaza, Steuart St. Tower, Suite 2101, San Francisco, CA 94105/415-974-8561. California, Guam, Hawaii, Nevada.

Regulations and Rulings Specialists

If any problem arises regarding the proper interpretation and application of any of the laws administered or enforced by Customs or any of their regulations, legal rulings, decisions, guidelines, etc., a specialist on any specific rule or regulation can be contacted at: Office of Regulations and Rulings, Customs Service, Department of the Treasury, 1301 Constitution Ave. N.W., Room 3117, Washington, DC 20229/202-566-2507.

Regulatory Activities

Listed below are those organizations within the U.S. Department of the Treasury which are involved with regulating various activities. With each listing is a description of those industries or situations which are regulated by the office. Regulatory activities generate large amounts of information on the companies and subjects they regulate. Much of the information is available to the public. A regulatory office can tell you your rights when dealing with a regulated company.

Public Affairs, Bureau of Alcohol, Tobacco and Firearms, Department of the Treasury, 1200 Pennsylvania Ave. N.W., Washington, DC 20226/202-566-7268. Regulates firearms, explosives alcohol, and tobacco.

Communications Division, Comptroller of the Currency, Department of the Currency, Department of the Treasury, 490 L'Enfant Plaza East S.W., Washington, DC 20219/202-447-1800. Regulates national banks.

Freedom of Information Reading Room, Internal Revenue Service, Department of the Treasury, 1111 Constitution Ave. N.W., Room 1569, Washington, DC 20224/202-566-3770. Determines, assesses and collects taxes.

Information Office, Customs Service, Department of the Treasury, 1301 Constitution Ave. N.W., Washington, DC 20229/202-566-8195. Regulates imports into the United States.

Related Federal Regulators on Alcohol, Tobacco and Firearms

The following agencies administer regulations which are related to the Bureau of Alcohol, Tobacco and Firearms:

Federal Aviation Administration—prohibition against carrying of weapons on aircraft or at National Capital Airports (Washington National and Dulles International Airports).

Department of Transportation—transportation of firearms, ammunition and destructive devices.

Internal Revenue Service—manufacturers' and retailers' tax on firearms.

United States Postal Service—Postal Service Manual, firearms, knives, and sharp instruments.

Bureau of Indian Affairs—Indians carrying concealed weapons; sale of arms and ammunition to Indians.

Department of States—international traffic in arms (importation, exportation, registration, licenses, manufacturing); the Office of Munitions Control, U.S. Department of State, regulates the exportation of arms, ammunition, and implements of war, to the exclusion of any regulation by the U.S. Department of Commerce.

Department of Commerce—export of shotguns with barrels eighteen (18) inches or longer.

Department of Interior—National Park Service—use of firearms in national parks prohibited; possession of firearms in national parks restricted.

Department of the Army—promotion of rifle practice; gun clubs. Contact: Research and Regulations Branch, Regulations and Procedures Division, Office of Regulatory Enforcement, Bureau of Alcohol, Tobacco and Firearms, Department of the Treasury, 1200 Pennsylvania Ave. N.W., Room 6237, Washington, DC 20226/202-566-7626.

Retirement Bonds

Individuals who are self-employed or are not covered by any other retirement plan are eligible to purchase individual retirement bonds and take tax deductions for them. Contact: Bureau of the Public Debt, Department of the Treasury, 200 Third St., Parkersburg, WV 26101/304-442-8551.

Revenue Sharing

This office administers the Revenue Sharing Program which disburses federal funds with minimum restrictions on use permitting the local decisionmaking process to determine the programs and activities where the money is most needed. Based upon data furnished by the Bureau of the Census and other agencies, funds are distributed to eligible governments to spend in accordance with law. A free publication, *Revenue Sharing 1981–83*, is also available. Contact: Public Affairs Division, Office of Revenue Sharing,

Domestic Finance, Department of the Treasury, 2401 E St. N.W., Washington, DC 20226/202-634-5248.

Revenue Sharing Demography

General revenue sharing funds are distributed on the basis of a complex allocation formula involving population, per capita income, adjusted taxes and intergovernmental transfers. Contact: Data and Demography Division, Domestic Finance, Department of the Treasury, 2401 E St. N.W., 15th Floor, Washington, DC 20226/202-634-5166.

Revenue Sharing Systems and Operations

This office is responsible for the development of information systems for all of the compliance areas, civil rights, audit and public participation. These systems allow for instance checking of the status of individual cases. Contact: System and Operations Division, Office of Revenue Sharing, Domestic Finance, Department of the Treasury, 2401 E St. N.W., 15th Floor, Washington, DC 20226/202-634-5170.

Secret Service

Under law, uniformed Secret Service agents provide protection for: the president of the United States and his immediate family; the vice president of the United States and his immediate family; the White House and grounds; the official residence of the vice president in Washington; buildings in which the presidential offices are located; foreign diplomatic missions located in the metropolitan area of the District of Columbia and in such other areas in the United States, its territories and possessions as the President may direct. Contact: Public Affairs, Secret Service, Department of the Treasury, 1800 G St. N.W., Room 805, Washington, DC 20223/202-535-5708.

Secret Service

For free copies of illustrated history of the Secret Service, contact: Public Affairs, Secret Service, Department of the Treasury, 1800 G St. N.W., Room 805, Washington, DC 20223/202-535-5708.

Securities Markets

Research is conducted on corporate securities markets and equity capital formation. Reviews are conducted on proposed changes in the restrictions governing the securities activities of commercial banks, including proposed legislation to permit further bank entry into underwriting and dealing in municipal revenue bonds, monitoring structural and regulatory changes in the securities industry including development of the National Market Systems and problems of security firms associated with cyclical conduct of monetary policy. Contact: Office of Securities Markets Policy, Capital Markets Policy, Domestic Finance, Department of the Treasury, 1435 G St. N.W., Room 3025, Washington, DC 20220/202-566-4211.

Selling to the Department of the Treasury

This free booklet provides general information, a listing of procurement offices, a description of the office's functions, and a list of products and services purchased. Contact: Office of Procurement, Office of Administrative Programs, Department of the Treasury, 1331 G St. N.W., Room 900, Washington, DC 20220/202-376-0650.

Special Agents

Special agents of the Secret Service are charged with protection and investigative responsibilities. Their primary duty is protection of the president of the United States. In addition, they also protect: the vice president; immediate families of the president and vice president; president-elect and vice president-elect and their immediate families; a former president and his wife during his lifetime, the widow of a former president until her death or remarriage; minor children of a former president until age 16; major presidential and vice presidential candidates; visiting heads of foreign states or foreign governments. Special agents are also charged with suppressing the counterfeiting of U.S. currency and securities. They investigate and arrest thousands of people each year for forging and cashing government checks, bonds and securities. Contact: Public Affairs, Secret Service, Department of the Treasury, 1800 G St. N.W., Room 805, Washington, DC 20223/202-535-5708.

State and Local Fiscal Research

For information on state and local government fiscal research, including such items as the outlook for the severance tax, contact: Office of State and Local Fiscal Research, State and Local Finance, Domestic Finance, Department of the Treasury, 15th St. and Pennsylvania Ave. N.W., Room 5132, Washington, DC 20220/202-566-5681.

State Laws on Importing Alcoholic Beverages

Each state has its own laws relating to distilled spirits imported for personal use. This free pamphlet lists quotas by state. Contact: Public Infor-

mation, Office of Public Affairs, Bureau of Alcohol, Tobacco and Firearms, Department of the Treasury, 1200 Pennsylvania Ave. N.W., Room 4402, Washington, DC 20226/202-566-7268.

Sureties
For information relating to surety companies, including the examination of applications of companies requesting authority to write bonds and the review of their financial statements to determine underwriting limitations, contact: Audit Staff, Bureau of Government Financial Operations, Department of the Treasury, Pennsylvania Ave. and Madison Pl. N.W., Room 312, Washington, DC 20226/202-634-5010.

Susan B. Anthony Coins
For brochures, lists, posters and other informational material, contact: Marketing Division, Bureau of the Mint, Department of the Treasury, 501 13th St. N.W., Room 1042, Washington, DC 20220/202-376-0209.

Tables of Redemption Values for U.S. Savings Bonds, Series E and Series EE
This semiannual publication is available for $5.50 for two years or $2.20 for a single copy, from: Government Printing Office, Superintendent of Documents, Washington, DC 20402/202-783-3238.

Targeted Job Tax Credit
Employees who hire people from any of the seven categories listed below may claim a tax credit: 1) people referred by vocational rehabilitation agencies; 2) economically disadvantaged youth 18–24 years old; 3) economically disadvantaged Vietnam veterans under 35 years old; 4) recipients of supplemental security income; 5) recipients of general assistance payments for 30 days or more; 6) people 16 to 18 years old participating in a qualified state certified cooperation education program; and 7) economically disadvantaged ex-offenders. Contact: Office of Comprehensive Employment Development, Employment and Training Administration, Department of Labor, 601 D St. N.W., Room 5014, Washington, DC 20213/202-376-7171.

Tax Analysis
This office provides tax reports and research papers on such topics as: manufacturing investment and the balance of payments; tax depreciation and the need for the Reserve Ratio Test; essays in international taxation; taxation of foreign investment in U.S. real estate; taxation of Americans working overseas. Contact: Tax Analysis, Tax Policy, Department of the Treasury, 15th St. and Pennsylvania Ave. N.W., Room 4040, Washington, DC 20220/202-566-5228.

Tax Appeals
The Internal Revenue Service encourages the resolution of tax disputes through an administrative appeals system rather than litigation. Proceedings in the appeals process are informal so that taxpayers can represent themselves. The Appeals Division serves as liaison with field officers on appeal matters and writes the procedures on how to handle cases on appeal. Contact: Procedures and Technical Branch, Appeals Division, Office of Compliance, Internal Revenue Service, U.S. Department of the Treasury, 1111 Constitution Ave. N.W., Room 2313, Washington, DC 20224/202-566-4881.

Tax Counseling for the Elderly
This program provides volunteers from sponsoring organizations who supply free tax assistance and information to individuals aged 60 years and over. Organizations that sponsor such programs may be reimbursed by the Internal Revenue Service for expenses incurred. Contact: Tax Counseling for the Elderly Program, Taxpayer Service Division, Internal Revenue Service, U.S. Department of the Treasury, 1111 Constitution Ave. N.W., Room 7211, Washington, DC 20224/202-566-4904.

Tax Exempt Organizations
The Office of Exempt Organizations determines the qualifications of organizations seeking tax exempt recognition, determines their private foundation status and examines returns to ensure compliance with the law. There are over 800,000 tax-exempt organizations. Contact: Exempt Organizations Division, Employee Plans and Exempt Organizations, Internal Revenue Service, Department of the Treasury, 1111 Constitution Ave., N.W., Room 6411, Washington, DC 20224/202-566-6208.

Tax Help for Foreign Governments
The Internal Revenue Service, in cooperation with the Agency for International Development, assists foreign governments in modernizing their tax administration systems. Visitors from about 130 countries have participated in Internal Revenue Service orientation and observation programs. Contact: Foreign Visitor Tax Administration Advisory Services Division, Internal Revenue Service, Department of the Treasury, 1111 Constitution Ave. N.W., Room 1031, Washington, DC 20224/202-566-4042.

Tax Information in Braille for Public Libraries

For information on this program, contact your local Internal Revenue Service Office, or: Taxpayer Services Division, Internal Revenue Service, Department of the Treasury, 1111 Constitution Ave. N.W., Room 7331, Washington, DC 20224/202-566-6352.

Taxpayer Information and Education

A number of programs are available to inform the public on the tax system. Volunteers are trained to help others in preparing returns. High school courses are sponsored on understanding tax forms. *Understanding Taxes* and *Fundamentals of Tax Preparation* are two courses which come with instructional films, booklets and teacher's guides. Contact: Taxpayer Information and Education Branch, Taxpayer Service Division, Internal Revenue Service, Department of the Treasury, 1111 Constitution Ave. N.W., Room 1311, Washington, DC 20274/202-566-2136.

Taxpayers Overseas

Taxpayers assistance is available to Americans who live abroad. There are tax assistors in major embassies—London, Paris, Bonn, Rome, Ottawa, Mexico City, Caracas, Sao Paulo, Tokyo, Manila, Sydney, Singapore and Johannesburg. Tax assistors also pass through other cities to provide assistance to American taxpayers. Contact nearby embassy or consulate to learn their schedule. Two free publications are available: *Tax Guide for U.S. Citizens Abroad* and *Foreign Tax Credit for U.S. Citizens and Resident Aliens.* Contact: Taxpayer Service Branch, Office of International Operations, Internal Revenue Service, Department of the Treasury, 1325 K St. N.W., Room 900, Washington, DC 20225/202-566-5941.

Taxpayer Usage Studies

Research is conducted on such topics as: What percentage of taxpayers deduct $1.00 for presidential elections, the development of state tax tables, the windfall profits tax, and the cost of living allowance. Contact: Special Studies and Reports Section, Statistics Division, Planning and Research, Internal Revenue Service, Department of the Treasury, 1201 E St. N.W., Room 403, Washington, DC 20224/202-376-0143.

Tax Projections

The Office of Projections and Special Studies makes workload economic and demographic estimates related to tax administration. Contact: Projections and Special Studies Branch, Office of Planning and Research, Internal Revenue Service, Department of the Treasury, 1201 E St. N.W., Room 405, Washington, DC 20224/202-376-0137.

Tax Publications Index

This free index identifies publications according to subject area. Contact: Taxpayer Education Section, Technical Publications, Tax Forms and Publications, internal Revenue Service, Department of the Treasury, 1111 Constitution Ave. N.W., Room 2603, Washington, DC 20224/202-566-4960.

Tax Returns of Nonprofit Organizations

Tax returns are available on over 700,000 nonprofit organizations who file with the Internal Revenue Service. Contact: Freedom of Information Reading Room, Internal Revenue Service, Department of the Treasury, 1111 Constitution Ave. N.W., Room 1569, Washington, DC 20224/202-566-3770.

Technical Assistance with Firearms

Assistance is available to support criminal investigations. Manufacturers can also get help in classifying and marking of newly designed firearms. Contact: Technical Services Division, Office of Technical and Scientific Services, Bureau of Alcohol, Tobacco and Firearms, Department of the Treasury, 1200 Pennsylvania Ave. N.W., Room 7241, Washington, DC 20226/202-566-7666.

Tell the IRS What You Think

If you have a general concern or opinion or view that is broadly related to the federal tax system and you want the federal tax law changed, make your opinion known to: Tax Analysis, Tax Policy, Department of the Treasury, 15th St. and Pennsylvania Ave. N.W., Room 4040, Washington, DC 20220/202-566-5282.

Toll-Free Tax Assistance

Taxpayers anywhere in the United States can call Internal Revenue Service numbers listed in the tax form packages without paying for a long-distance charge. The number can also be found in the white pages of the telephone book under U.S. Government, Internal Revenue Service. Walk-in assistance is also available as well as foreign language assistance in Spanish, French, Portuguese, Chinese, and Vietnamese. For a listing of local offices, contact: Office of the Taxpayer Ombudsman, Internal Revenue Service, Department of the Treasury, 1111 Constitution Ave. N.W., Room 3331, Washington, DC 20224/202-566-6475.

Trade and Investment Policy

This office is involved with multilateral trade negotiations including: East-West trade such as Romanian Trade Agreements, export credits on multilateral levels, bilateral arrangements and investment incentives and disincentives. Contact: Trade and Investment Policy, International Affairs, Monetary Affairs, Department of the Treasury, 15th St. and Pennsylvania Ave. N.W., Room 3208, Washington, DC 20220/202-566-2748.

Trade Research

This office studies issues related to internationalal trade and United States commercial policies including: analysis of the effects on United States trade of various foreign measures to protect domestic industries and their workers from foreign competition, analysis of alternative methods of calculating effective changes in the dollar exchange rate, the cost of import protection to the United States economy, performance of Export/Import Bank programs to foster U.S. exports, and the impact of changes in the dollar exchange rate on direct foreign investment in the United States. Contact: Office of Trade Research, International Economic Analysis, Economic Policy, Department of the Treasury, 1435 G St. N.W., Room 1017, Washington, DC 20220/202-376-0805.

Travel Information at U.S. Customs

The U.S. Customs Service provides an informative Travel Pak containing customs declaration forms and literature describing its regulations, liquor allowances, rules regarding duty-free gifts, prohibitions on bringing food, plant and animal products into the United States, trademark information, and visa requirements. Speakers are also available to address the travel trade. The packs are available through your travel agent or contact: International Travel, Public Affairs, Customs Service, Department of the Treasury, 1301 Constitution Ave. N.W., Room 6316, Washington, DC 20229/202-566-5286.

Treasury Bills

For a general lesson in government Treasury Bills, call 202-287-4091. For information on recently held and upcoming auctions, call 202-287-4100. Treasury Bills are short-term investments of less than one year in minimum denominations of $10,000. Maturity dates are 13, 26 and 52 weeks. For copies of regulations, application forms or additional information on government securities, contact: Securities Operations Division, Bureau of the Public Debt, Department of the Treasury, 1435 G St. N.W., Room 429, Washington, DC 20226/202-287-4113.

Treasury Bulletin

This Treasury publication provides information and data on: treasury financing operations; federal obligations; currency and coin circulation; federal debt; public operation; U.S. savings bonds and notes; ownership of federal securities; market quotations on Treasury securities; average yields of long-term bonds; exchange stabilization fund; international financial statistics; liabilities to foreigners reported by banks; claims on foreigners reported by nonbanking business enterprises; transactions in a long-term securities by foreigners; U.S. dollar position abroad; and financial operation of government agencies. For more information on content, contact: Special Reporting Branch, Division of Government Accounts and Reports, Bureau of Government Finance Operations, Department of the Treasury, 441 G St. N.W., Room 3021, Washington, DC 20226/202-566-4531. Subscriptions are available for $50 from: Government Printing Office, Superintendent of Documents, Washington, DC 20402/202-783-3238.

Treasury Notes and Bonds Hotline

For a general lesson in government notes and bonds, call 202-287-4088. For information on recently held and upcoming auctions, call 202-287-4100. Treasury Notes are medium-term investments of 1 to 10 year maturity dates and Treasury Bonds are long-term investments of 10 to 30 years. For copies of regulations, application forms or additional information on government securities, contact: Securities Operations Division, Bureau of the Public Debt, Department of the Treasury, 1435 G St. N.W., Room 429, Washington, DC 20226/202-287-4113.

Treasury Publications

For a copy of the U.S. Department of the Treasury's Annual Report or for a listing of available publications, contact: Public Affairs, Department of the Treasury, 15th St. and Pennsylvania Ave. N.W., Room 2313, Washington, DC 20220/202-566-2041.

Urban and Regional Economics

This office evaluates local and regional economic trends and their impact on the fiscal condition of state and local governments, and assesses the impacts of specific federal economic policies or local economics. Contact: Office of Urban and Regional Economics, State and Local Finance, Domestic Finance, Department of the

Treasury, 15th St. and Pennsylvania Ave. N.W., Room 3026, Washington, DC 20220/202-566-5347.

Savings Bonds—Lost, Stolen or Destroyed

To apply for relief on account of loss, theft or destruction of U.S. Savings Bonds, contact: Bureau of the Public Debt, Department of the Treasury, 200 Third St., Parkersburg, WV 26201/304-422-8551.

Savings Bonds Statistics

Statistics are available on sales, redemption and retention by state and county from the inception of the program. Some statistical comparisons with other money markets are also published. Contact: Market Analysis Section, Office of Planning and Market Research, Savings Bonds Division, Department of the Treasury, 1111 20th St. N.W., Room 351, Washington, DC 20226/202-634-5360.

Savings Bonds—Volunteer Activities

State and county volunteers are the grassroots "mainstay" of the savings bonds program. A special kit of materials, *A Program for the Nation's Volunteers*, provides speeches, radio and television scripts and other information. Contact: Office of Banking and Volunteer Activities, Savings Bonds Division, Department of the Treasury, 1111 20th St. N.W., Room 310, Washington, DC 20226/202-634-5357.

Savings Bonds, Where to Buy or Redeem

Local banks or Federal Reserve Banks can sell or redeem U.S. Savings Bonds. For general information and a list of Federal Reserve banks, contact: Office of Public Affairs, Savings Bonds Division, Department of the Treasury, 1111 20th St., N.W., Washington, DC 20226/202-634-5377.

Savings Notes

These notes are not longer sold, but for those still hold them and require assistance, contact: Bureau of Public Debt, Department of the Treasury, 200 Third St., Parkersburg, WV 26101/304-422-8551.

Viticulture Areas

Petitions are accepted to establish viticulture areas for wine. Viticulture areas are grape growing regions which have boundaries based on geographic factors such as soil, rainfall and temperature. The name of an approved viticulture area may be cited on labels and in advertising as the wine's place of origin. Augusta, Missouri is the first named viticulture area. Contact: Research and Regulation Branch, Office of Regulation Enforcement, Bureau of Alcohol, Tobacco and Firearms, Department of the Treasury, 1200 Pennsylvania Ave. N.W., Room 6237, Washington, DC 20226/202-566-7626.

Voluntary Disclosure

This office encourages persons and business entities subject to Bureau jurisdiction to voluntarily disclose suspected violators of the Bureau of Alcohol, Tobacco and Firearms (ATF) laws and regulations. Contact: Voluntary Disclosure, Office of Regulatory Enforcement, Bureau of Alcohol, Tobacco and Firearms, Department of the Treasury, 1200 Pennsylvania Ave. N.W., Room 4405, Washington, DC 20226/202-566-7118.

Voluntary Income Tax Assistance (VITA)

This program recruits, trains and supports volunteers who offer free tax assistance to low income, elderly, military, and non-English-speaking taxpayers. The Internal Revenue Service provides free training, materials, and instruction to volunteer organizations. Contact: Taxpayer Information and Education Branch, Taxpayer Services Division, Internal Revenue Service, Department of the Treasury, 1111 Constitution Ave. N.W., Room 1311, Washington, DC 20224/202-566-2136.

How Can the Department of the Treasury Help You?

To determine how the Department of the Treasury can help you, contact: Assistant Secretary for Public Affairs, Department of the Treasury, 15th St. and Pennsylvania Ave. N.W., Washington, DC 20220/202-566-2041.

AGENCIES, BOARDS, COMMISSIONS, COMMITTEES, AND GOVERNMENT CORPORATIONS

ACTION

806 Connecticut Ave. N.W., Washington, DC 20525/202-254-3120

ESTABLISHED: July 1, 1971
BUDGET: $140,492,000
EMPLOYEES: 1,976
MISSION: Administers and coordinates the domestic and international volunteer programs sponsored by the federal government, which are linked by a commitment to a "bottom-up" development program which fosters self-reliance and utilizes available human and economic resources to overcome conditions of poverty; tests new ways of bringing volunteer resources to bear on human, social and economic problems; and identifies and develops the widest possible range of volunteer service opportunities for Americans of all ages and ethnic backgrounds.

Data Experts

Peace Corps County Desk Officers

The following country desk officers can provide information on peace corps activities, as well as general political, social and economic information about the countries they cover. They can be contacted at: Office of Counsel, Planning and Evaluation, Peace Corps, ACTION, 806 Connecticut Ave. N.W., Room 1200, Washington, DC 20525/202-254-7983.

Africa
Senegal, Sierra Leone, Mauritania/Elena Hughes/202-254-3185
Gambia, Liberia/Theresa Joiner/202-254-8003
Upper Volta, Niger, Mali/Jerry Brown/202-254-7004
Ghana, Togo, Benin/Barbara Gardner/202-254-5644
Zaire, Rwanda, Refugee Programs/Kay Kennedy/202-254-8694
Botswana, Lesotho, Swaziland/David Browne/202-251-6046
Kenya, Seychelles, Malawi, Tanzania/Anika McGee/202-254-9696

C.A.R., Cameroon, Gabon/Paul Rowe/202-254-8397

Latin America
Ecuador, Costa Rica/Eugene Rigler/202-254-9653
Brazil, Paraguay, Dominican Republic/Noreen O'Mera/202-254-8876
Honduras, Guatemala/Dexter Katzman/202-254-9773
Belize, Eastern Caribbean, Jamaica/Yvonne Austin/202-254-9649

North Africa, Near East, Asia and the Pacific (NANEAP)
Papua New Guinea, Malaysia, Thailand/Ed Geibel/202-254-8782
Philippines/Melanie Wilson/202-254-8870
Micronesia, Solomon Islands, Kiribati/Lisbeth Thomsen/202-254-8785
Fiji, Tonga, Western Samoa, Tuvalu/Steve Prieto/202-254-8857
Tunisia, Morocco, Yemen/Bill Dant/202-254-8793
Nepal, Oman/Paula Benjelloun/202-254-9832

Major Sources of Information

ACTION/Peace Corps Library

The Library has material on volunteerism, social services, Peace Corps and ACTION documents and information on third world countries. Contact: ACTION/Peace Corps Library, Room M407, 806 Connecticut Ave. N.W., Washington, DC 20525/202-254-3307.

Agriculture Programs

Peace Corps volunteers assist in fields ranging from agronomy to wildlife management. They are involved in projects to increase food production and can teach techniques of water control. Contact: Agriculture Programmer, Office of Programming and Training Coordination, Peace Corps, ACTION, Room 701, 806 Connecticut Ave. N.W., Washington, DC 20525/202-254-7386.

Community Energy Project

This program assists local communities in obtaining the necessary resources and in developing programs that will involve citizens directly in taking energy saving measures. Contact: Community Energy Project, Office of Voluntary Citizen Participation, ACTION, 806 Connecticut Ave. N.W., Washington, DC 20525.

Fishery Programs

Fishery specialists work as warm water fish culture extension agents. They help farmers stock, manage, feed and harvest pond fish, usually carp or talapia. They work in fish harvesting, marketing and conservation, and teach local fishermen how to improve their fishing techniques. Contact: Fisheries Programmer, Office of Programming and Training Coordination, Peace Corps, ACTION, Room 701, 806 Connecticut Ave. N.W., Washington, DC 20525/202-254-7386.

Freedom of Information Requests

For Freedom of Information Act requests, contact: Office of the General Counsel, ACTION, Room 607, 806 Connecticut Ave. N.W., Washington, DC 20525/202-254-3116.

Grants

The programs described below are for sums of money which are given by the federal government to initiate and stimulate new or improved activities or to sustain ongoing services.

Foster Grandparent Program (FGP)

Objectives: To provide part-time volunteer service opportunities for low-income persons age 60 and over and to render supportive person-to-person services in health, education, welfare and related settings to children having special or exceptional needs through development of community-oriented, cost-shared projects.

Eligibility: Grants are made only to public or nonprofit private agencies or organizations, including state and local governments.

Range of Financial Assistance: $89,000 to $1,060,000.

Contact: Chief, Foster Grandparent Program, ACTION, 806 Connecticut Ave. N.W., Washington, DC 20525/202-254-7310.

Mini-Grant Program

Objectives: To provide small amounts of money (not to exceed $5,000 per grant) to local, public and private nonprofit organizations for the purpose of mobilizing, relatively large numbers of part-time, uncompensated volunteers to work on human, social and environmental needs, particularly those related to poverty.

Eligibility: Restricted to state and local government, public or private nonprofit organizations.

Range of Financial Assistance: $800 to $5,000.

Contact: Director, Office of Voluntary Citizen Participation, ACTION, Suite 907, 806 Connecticut Ave. N.W., Washington, DC 20525/202-254-7262.

National Center for Service-Learning

Objectives: To assist secondary and postsecondary educators to begin new, and improve existing local student service-learning programs which provide services to the poverty community.

Eligibility: Any college or high school desiring to create a new service-learning program, or improve an existing program, may apply for services. Any local agency which uses student volunteers, and any state or national organization desiring to assist the development of service-learning programs may also apply.

Range of Financial Assistance: Not specified.

Contact: National Center for Service-Learning, ACTION, 806 Connecticut Ave. N.W., Washington, DC 20525/202-254-8370.

Retired Senior Volunteer Program

Objectives: To establish a recognized role in the community and a meaningful life in retirement by developing a wide variety of community volunteer service opportunities for persons 60 years

of age or over through development of community oriented, cost-shared projects.

Eligibility: Grants are made only to public and private nonprofit organizations including state and local governments.

Range of Financial Assistance: $10,000 to $450,000.

Contact: Director, Older Americans Volunteer Programs, ACTION, 806 Connecticut Ave. N.W., Washington, DC 20525/202-254-7310.

Senior Companion Program

Objectives: To provide volunteer opportunities for low-income older people which enhance their ability to remain active and provide critically needed community services; to play a critical role in providing long-term care by assisting adults, primarily older persons with mental, emotional and physical impairments, to achieve and maintain their fullest potential to be healthy and to manage their lives independently through development of community-oriented, cost-shared projects.

Eligibility: Grants are made only to public or nonprofit private agencies or organizations including state and local governments.

Range of Financial Assistance: $145,000 to $262,000.

Contact: Chief, Senior Companion Program, ACTION, 806 Connecticut Ave. N.W., Washington, DC 20525/202-254-7310.

Special Volunteer Programs

Objectives: To strengthen and supplement efforts to meet a broad range of human, social and environmental needs, particularly those related to poverty, by encouraging and enabling persons from all walks of life and from all age groups to perform constructive volunteer service; to test or demonstrate new or improved volunteer delivery systems or methods; to encourage wider volunteer participation, particularly on a short-term basis; and to identify segments of the poverty community which could benefit from volunteer efforts.

Eligibility: State and local government agencies and private nonprofit organizations are eligible.

Range of Financial Assistance: $15,000 to $200,000.

Contact: Policy Development Division, Office of Policy and Planning, ACTION, 806 Connecticut Ave. N.W., Washington, DC 20525/202-254-8420.

State Office of Voluntary Citizen Participation

Objectives: To provide grants to states to establish and/or strengthen offices of volunteer services to improve opportunities for volunteer efforts concerned with human, social and environmental needs, particularly those related to poverty.

Eligibility: Restricted to Governor's office of each State, the District of Columbia, Puerto Rico, and territories and possesssions of the United States.

Range of Financial Assistance: Up to $100,000.

Contact: Office of Voluntary Citizen Participation, ACTION, Suite 907, 806 Connecticut Ave. N.W., Washington, DC 20525/202-254-7262.

University Year for Action

Objectives: To strengthen and supplement efforts to eliminate poverty and poverty-related human, social and environmental problems by enabling students enrolled in institutions of higher education to perform meaningful and constructive volunteer service in connection with the satisfaction of such students' course work in agencies, institutions and situations where the application of human talent and dedication may assist those persons afflicted with problems of poverty. In addition, it is to encourage other students and faculty members to engage, on a part-time, self-supporting basis, in such volunteer service and work along with volunteers serving to promote participation by their institutions in meeting the needs of the poor in the surrounding community through expansion of service-learning programs and otherwise.

Eligibility: Any institution of higher education or association of such institutions, including state and local governments.

Volunteers in Service to America (VISTA)

Objectives: To supplement efforts of community organizations to eliminate poverty and poverty-related human, social and environmental problems by enabling persons from all walks of life and all age groups to perform meaningful and constructive service as volunteers in situations where the application of human talent and dedication may help the poor to overcome the handicaps of poverty and poverty-related problems and secure opportunities for self-advancement.

Eligibility: Sponsors applying for Volunteers in Service to America (VISTA) volunteers must be nonprofit organizations; they may be public or private and include state and local governments. The project in which they propose to use the volunteers must be designed to assist in the solution of poverty-related problems. Sponsors receiving program grants in excess of $25,000 must be incorporated nonprofit organiztions and capable of managing grant funds and maintaining auditable records of disbursements.

Range of Financial Assistance: Not specified.

Contact: Deputy Director of VISTA, Office of Domestic Operations, ACTION, 806 Connecticut Ave. N.W., Washington, DC 20525/202-254-5195.

Health Programs

Peace Corps volunteers with degrees in health-related fields work on a person-to-person basis, teaching concepts of modern hygiene, preventive health education principles and medical care. Contact: Health Programmer, Office of Programming and Training Coordination, Peace Corps, ACTION, Room 701, 806 Connecticut Ave. N.W., Washington, DC 20525/202-254-7386.

Information Collection and Exchange (ICE)

This program is shared by the Peace Corps and the Office of Voluntary Citizen Participation to gather and disseminate practical technical knowledge acquired by Peace Corps volunteers. Manuals and handbooks, reprints, and resource packets are available on appropriate technology to assist Third World development. *Appropriate Technologies for Development* presents practical information from initial project planning in the community setting to on-going needs for maintenance training and cooperative organizations for field workers without specialized technical training. Titles include:

Freshwater Fish Pond Culture and Management
Small Farm Grain Storage
Programming and Training for Small Farm Grain Storage
Resources for Development—Organizations and Publications
The Photonovel—A Tool for Development
Reforestation in Arid Lands
Self-Help Construction of One-Story Buildings
Teaching Conservation in Developing Nations
Community Health Education in Developing Countries
Health and Sanitation Lessons/Africa
A Glossary of Agricultural Terms
Water Purification, Distribution, and Sewage Disposal
Poultry "New Methods Pay with Poultry"
Lesson Plans for Beekeeping
Pesticide Safety
Disaster Procedures
Small Vegetable Gardens
Cooperatives

Contact: Information Collection and Exchange, Office of Programming and Training Coordination, Room 701, 806 Connecticut Ave. N.W., Washington, DC 20525/202-254-7386.

National Center for Service-Learning

This program offers free job skills development seminars for educators who run programs that involve students in community service. The Center also offers on-site consultation services to high school and college programs, and groups sponsoring conferences or workshops on various aspects of service-learning. The three-times-a-year newsletter, *Synergist*, is a technical assistance journal for educators who work with programs that integrate coursework and community service. It is available for $5.00 from the Superintendent of Documents, Government Printing Office, Washington, DC 20402/202-783-3238. For general information and dates and location of future seminars, contact: National Center for Service-Learning, ACTION, Room 1106, 806 Connecticut Ave. N.W., Washington, DC 20525/202-254-8370.

Newsletters

The following newsletters are free:

Prime Times—contains articles on action projects plus notices of current consumer events and publications; and *Action Update*. Both available from Public Affairs Branch, ACTION/Peace Corps, Room 513, 806 Connecticut Ave. N.W., Washington, DC 20525/202-254-5010.

Peace Corps Times—free bimonthly news of Peace Corps projects, news people and events. Includes technical information. Contact: *Peace Corps Times*, Peace Corps, ACTION, Room M-1200, 806 Connecticut Ave. N.W., Washington, DC 20525/202-254-5010.

Older American Volunteer Programs

ACTION runs three senior volunteer programs that are mutually beneficial to the volunteers and their communities. The following is a brief description of each of the three programs:

Retired Service Volunteer Program (RSVP)—for people over 60 who use their knowledge and talents to provide many needed services their communities could not afford. One of the projects is Fixed Income Consumer Counseling which provides information on such problems as health, energy, food and budget shopping. A variety of practical tips for people on a fixed income are also available through this project.

Foster Grandparents Program—for low-income people over 60 who work with children who have physical, mental, social or emotional health needs. The volunteers serve in institutions for the mentally retarded, correctional facilities, pediatric wards of general hospitals, schools, day care centers, private homes and with handicapped, emotionally disturbed and dependent and neglected children. In return for the service, Foster Grandparents receive a tax-free modest stipend, a transportation allowance, hot meals while in service and an annual physical examination.

Senior Companion Program—offers low-income older Americans the opportunity to assist other elderly people with moderate physical and mental health impairments to maintain or resume independent living. Senior Companions provide peer support, encouragement, outside contact as well as links to appropriate community services. In return for these services, the Senior Companions receive a tax-free stipend, transportation allowance, a daily hot meal, medical insurance and an annual physical examination.

For general information on these programs, Contact: Older American Volunteer Programs, ACTION, Room 1006, 806 Connecticut Ave. N.W., Washington, DC 20525/202-254-7310. (Also, see "Grants" in this section.)

Peace Corps

Peace Corps volunteers provide individual Americans to work with people of developing nations while living as part of their communities. Volunteers go abroad for two years, after being trained to work with agencies of host governments or with private institutions. Among the professions in demand are: foresters, fishery specialists, architects, planners, engineers, health professionals, home economists, teachers. For information, contact: Peace Corps, ACTION, Room M-1200, 806 Connecticut Ave. N.W., Washington, DC 20525/202-254-7970. The following is a listing of local recruiting offices:

New York Service Center

Peace Corps/VISTA Recruiting Office, 26 Federal Plaza, Room 1607, New York NY 10007/212-264-7123.
Peace Corps/VISTA Recruiting Office, Federal Building, Room 317, 100 State St., Rochester, NY 14514
Peace Corps/VISTA Recruiting Office, McCormack P. O. & Courthouse Building, Room 1405, Boston, MA 02109/617-223-7366.
Peace Corps/VISTA Recruiting Office, P. O. Box 4752, San Juan, PR 00905/809-753-4694.

Atlanta Service Center

Peace Corps/VISTA Recruiting Office, 1713 H St. N.W., Washington, DC 20525/202-254-7346.
Peace Corps/VISTA Recruiting Office, 101 Marietta St. N.W., Room 2207, Atlanta, GA 30303/404-221-2932.
Peace Corps/VISTA Recruiting Office, Customs House, 2nd and Chestnut Sts., Room 102-A, Philadelphia, PA 19106/215-597-0744.

Chicago Service Center

Peace Corps/VISTA Recruiting Office, 1 N. Wacker Dr., 2nd Floor, Chicago, IL 60606/312-353-4990.
Peace Corps/VISTA Recruiting Office, 212 E. Washington Ave., Room 305, Madison, WI 53703
Peace Corps/VISTA Recruiting Office, P.V. McNamara Federal Building, Room M-74, 477 Michigan Ave., Detroit, MI 48226/313-226-7928
Peace Corps/VISTA Recruiting Office, Gateway II Building, Room 318, 4th and State Sts., Kansas City, Kansas 66101/816-374-4556.
Peace Corps/VISTA Recruiting Office, Old Federal Building, Room 104, 212 3rd Ave. S., Minneapolis, Minnesota 55401

Dallas Service Center

Peace Corps/VISTA Recruiting Office, P. O. Building, Suite 264, 400 N. Ervay, Dallas, TX 75201/214-767-5435.
Peace Corps/VISTA Recruiting Office, 1845 Sherman St., Room 103, Denver, CO 80203, 303-837-4173.
Peace Corps/VISTA Recruiting Office, 515 Congress Ave., Suite 1414, Austin, TX 78701/512-397-5925.

San Francisco Service Center

Peace Corps/VISTA Recruiting Office, 1375 Sutter St., 2nd Floor, San Francisco, CA 94102/415-556-8400.
Peace Corps/VISTA Recruiting Office, 522 N. Central St., Room 205-A, Phoenix, AZ 85004/602-261-6621.
Peace Corps/VISTA Recruiting Office, 1601 2nd Ave., Seattle, WA 98101/206-442-5490.
Peace Corps/VISTA Recruiting Office, 9911 W. Pico Blvd., Room B-16, Los Angeles, CA 90035/213-824-7742.
Peace Corps/VISTA Recruiting Office, Federal Building, 300 La Moana Blvd., Room 6326, Honolulu, Hawaii 96850/808-546-2178.
Peace Corps/VISTA Recruiting Office, 1220 S.W. Morrison, Room 333, Portland, OR 97205/1-800-426-1022.

Peace Corps Programming and Training

This office provides Peace Corps with in-house technical capabilities to support current and projected program and training initiatives. It provides technical support to overseas posts; is a focal point for Peace Corps training and programming; and serves as a central source of information collection and dissemination. Contact: Office of Programming and Training Coordination, Peace Corps, ACTION, Room 701, 806 Connecticut Ave. N.W., Washington, DC 20525/202-254-8890.

Peace Corps Public Information

For general information on Peace Corps Programs, a list of country desk officers, and contacts in the regional offices, contact: Public Information Specialist, Office of Development Information, Peace Corps, ACTION, Room 1200, 806 Connecticut Ave. N.W., Washington, DC 20525/202-254-7990.

Voluntary Citizen Participation

This program supports volunteer activities and

promotes citizen actions that meet local needs in the United States and abroad. Voluntary Citizen Participation consists of the following programs:

1. State Offices of Voluntary Citizen Participation—provides grants to stimulate citizen initiatives, and promote and coordinate voluntary participation in public and private state organizations through the establishment of state offices.
2. Former Volunteer Services—helps Peace Corps and VISTA volunteers returning from service find career opportunities. The Service publishes *Hotline*, a weekly bulletin of employment and educational opportunities, and *Reconnection*, a bimonthly publication for former volunteers which describes new ACTION programs, also noting the national and community projects that need assistance.
3. Peace Corps Partnership—a form of cultural exchange between U.S. schools, clubs, or other private organizations and overseas communities in need of starting-up funds for a new project. In exchange for the money contributed, the overseas community keeps the group apprised of the work.
4. Domestic Development Service—initiates a comprehensive program to support domestic volunteer efforts throughout the Third World. Some of the programs include the encouragement of applying a

university education to the development of the country, volunteer programs focusing on youth and the elderly, and emphasis on the use of appropriate technology.

Contact: Office of Voluntary Citizen Participation, ACTION, Room 907, 806 Connecticut Ave. N.W., Washington, DC 20525/202-254-8079.

Volunteers in Service to America—VISTA

VISTA volunteers serve in rural and urban communities to help people become their own advocates for the resources and services they need. They work together with rural and urban poor to find solutions to community problems. Contact: VISTA, ACTION, Public Information, Room 303 PAR, 806 Connecticut Ave. N.W., Washington, DC 20525/202-254-7526.

How Can ACTION Help You?

To determine how ACTION can help you, contact: Public Information, ACTION, Room 303 PAR, 806 Connecticut Ave. N.W., Washington, DC 20525/202-254-7526.

Administrative Conference of the United States

2120 L St. N.W., Washington, DC 20037/202-254-7020

ESTABLISHED: 1964
BUDGET: $1,127,000
EMPLOYEES: 20

MISSION: Develops improvements in the legal procedures by which federal agencies administer regulatory, benefit and other government programs; and provides a forum for agency heads, other federal officials, private lawyers, university professors, and other experts in administrative law and government to conduct continuing studies of selected problems involving these administrative procedures.

Major Sources of Information

Conference Reports

The Conference provides copies of its recent recommendations and reports and a selected bibliography on the Administrative Conference of the United States. It also maintains a library where copies of all official conference documents are available for public inspection. For further information, contact: Administrative Conference of the United States, Suite 500, 2120 L St. N.W., Washington, DC 20037/202-254-7020.

Freedom of Information Act Reports

For Freedom of Information Act requests, contact: Freedom of Information, Administrative Conference of the United States, Suite 500, 2021 L St. N.W., Washington, DC 20037/202-254-7020.

How Can the Administrative Conference of the United States Help You?

To determine how this agency may be of help to you, contact: Public Information, Administrative Conference of the U.S., Suite 500, 2120 L St. N.W., Washington, DC 20037/202-254-7020.

American Battle Monuments Commission

5127 Pulaski Building, Washington, DC 20314/202-272-0536

ESTABLISHED: March 4, 1923
BUDGET: $8,225,000
EMPLOYEES: 384

MISSION: Responsible for the design, construction and permanent maintenance of military cemeteries and memorials on foreign soil, as well as for certain memorials on American soil.

Major Sources of Information

American Memorials and Overseas Cemeteries

This free pamphlet outlines the Commission's functions and lists, with brief descriptions and directions, the cemetery memorials and monuments under its care. For further information, contact: American Battle Monuments Commission, 20 Massachusetts Ave. N.W., Room 5127, Washington, DC 20314/202-272-0533.

Freedom of Information Requests

For Freedom of Information Act requests, contact: Freedom of Information, American Battle Monuments Commission, Room 5127, 20 Massachusetts Ave. N.W., Washington, DC 20014/202-272-0533.

How Can the American Battle Monuments Commission Help You?

To determine how this agency can help you, contact: American Battle Monuments Commission, Room 5127, 20 Massachusetts Ave. N.W., Washington, DC 20314/202-272-0533.

Appalachian Regional Commission

1666 Connecticut Ave. N.W., Washington, DC 20235/202-673-7835

ESTABLISHED: 1965
BUDGET: $8,316,000
EMPLOYEES: 12
MISSION: Concerned with the economic, physical and social development of the 13-state Appalachian region, which includes parts of Alabama, Georgia, Kentucky, Maryland, Mississippi, New York, North Carolina, Ohio, Pennsylvania, South Carolina, Tennessee, Virginia, and all of West Virginia.

Major Sources of Information

Appalachian Regional Commission
Library

The Library emphasizes information on the socioeconomic aspects of the 13 Appalachian states. Contact: Library, Appalachian Regional Commission, 6th Floor, 1666 Connecticut Ave. N.W., Washington, DC 20235/202-673-7835.

Freedom of Information
Requests

For Freedom of Information Act Requests, contact: General Counsel, Appalachian Regional Commission, Room 305, 1666 Connecticut Ave. N.W., Washington, DC 20235/202-673-7871.

Grants

The programs described below are for sums of money which are given by the federal government to initiate and stimulate new or improved activities or to sustain on-going services:

Appalachian Child Development

Objectives: To create a state and substate capability for planning child development programs and a program to provide child development services in underserved areas throughout the region and to test innovative projects and programs for replicability.

Eligibility: State interagency committees are eligible for planning grants. Public and private nonprofit organizations are eligible for project grants, if the projects are consistent with the state plan and priorities.

Range of Financial Assistance: $5,312 to $1,433,461.

Contact: Executive Director, Appalachian Re-

gional Commission, 1666 Connecticut Ave. N.W., Washington, DC 20235/202-673-7874.

Appalachian Development Highway System

Objectives: To provide a highway system which, in conjunction with other federally aided highways, will open up areas with development potential within the Appalachian region where commerce and communication have been inhibited by lack of adequate access.

Eligibility: State governments only are eligible for development highways within their Appalachian portions.

Range of Financial Assistance: Not specified.

Contact: Executive Director, Appalachian Regional Commission, 1666 Connecticut Ave. N.W., Washington, DC 20235/202-673-7874.

Appalachian Health Programs

Objectives: To provide a flexible, noncategorical approach to the development of health demonstration projects through community planning on a multicounty basis and implementation of that planning through service.

Eligibility: States, and through the states, health systems agencies, local governments and nonprofit organizations. Construction and operating grants are available only for publicly owned facilities or for facilities owned by public or private nonprofit organizations and not themselves operated for profit.

Range of Financial Assistance: $2,596 to $1,250,000.

Contact: Executive Director, Appalachian Regional Commission, 1666 Connecticut Ave. N.W., Washington, DC 20235/202-673-7874.

Appalachian Housing Project Planning Loan,
Technical Assistance Grant and Site
Development and Off-Site Improvement Grant
State Appalachian Housing Programs

Objectives: To stimulate low- and moderate-income housing construction and rehabilitation, and to assist in developing site and off-site improvements for low- and moderate-income housing in the Appalachian Region.

Eligibility: Private nonprofit organizations, limited dividend organizations, cooperative organizations, or public bodies.

Range of Financial Assistance: $155,000 to $1,692,681.

Contact: Executive Director, Appalachian Regional Commission, 1666 Connecticut Ave. N.W., Washington, DC 20235/202-673-7874.

Appalachian Local Access Roads

Objectives: To provide access to industrial, commercial, educational, recreational, residential and related transportation facilities which directly or indirectly relate to the improvement of the areas determined by the states to have significant development potential.

Eligibility: States and, through the states, public bodies and private groups within Appalachia.

Range of Financial Assistance: $35,000 to $2,000,000.

Contact: Executive Director, Appalachian Region Commission, 1666 Connecticut Ave. N.W., Washington, DC 20235/202-673-7874.

Appalachian Local Development District
Assistance

Objectives: To provide planning and development resources in multi-county areas; to help develop the technical competence essential to sound development assistance; and to meet the objectives stated under the program entitled Appalachian Regional Development.

Eligibility: Multi-county organizations certified by the State.

Range of Financial Assistance: $6,045 to $705,369.

Contact: Executive Director, Appalachian Regional Commission, 1666 Connecticut Ave. N.W., Washington, DC 20235/202-673-7874.

Appalachian Mine Area Restoration

Objectives: To further the economic development of the region by rehabilitating areas presently damaged by deleterious mining practices and by controlling or abating mine drainage pollution.

Eligibilty: States and through the states, public bodies or private nonprofit entities organized under state law to be used for public recreation,

conservation, community facilities or public housing owning strip-mined land in need of restoration are eligible. The states are eligible to apply for assistance to seal and fill voids in abandoned coal mines, plan and execute projects for the extinguishment and control of underground and outcrop mine fires, seal abandoned oil and gas wells, and control or abate mine drainage pollution.

Range of Financial Assistance: $26,250 to $1,910,625.

Contact: Executive Director, Appalachian Regional Commission, 1666 Connecticut Ave. N.W., Washington, DC 20235/202-673-7874.

Appalachian Special Transportation Related
Planning, Research and Demonstration
Program

Objectives: To encourage the preparation of action-oriented plans and programs which reinforce and enhance other transportation, but particularly highway, investments.

Eligibility: State and local governments, and nonprofit agencies.

Range of Financial Assistance: $3,360 to $100,000.

Contact: Executive Director, Appalachian Regional Commission, 1666 Connecticut Ave. N.W., Washington, DC 20235/202-673-7874.

Appalachian State Research, Technical
Assistance, and Demonstration Projects

Objectives: To expand the knowledge of the region to the fullest extent possible by means of state-sponsored research (including investigations, studies, technical assistance and demonstration projects) in order to assist the Commission in accomplishing the objectives of the Act.

Eligibility: Appalachian states alone or in combination with other Appalachian states, local public bodies and state instrumentalities.

Range of Financial Assistance: $2,000 to $550,000.

Contact: Executive Director, Appalachian Regional Commission, 1666 Connecticut Ave. N.W., Washington, DC 20235/202-673-7874.

Appalachian Supplements to Federal Grant-in-
Aid (Community Development)

Objectives: To meet the basic needs of local areas and assist in providing community development opportunities by funding such development facilities as water and sewer systems, sewage treatment plants, recreation centers, industrial sites and other community development facilities. Grants may supplement other federal grants or, when sufficient federal funds are unavailable,

funds may be provided entirely by this program.

Eligibility: States, and through the states, their subdivisions and instrumentalities and private nonprofit agencies.

Range of Financial Assistance: $2,395 to $6,000,000.

Contact: Executive Director, Appalachian Regional Commission, 1666 Connecticut Ave. N.W., Washington, DC 20235/202-673-7874.

Appalachian Vocational and Other Education Facilities and Operations

Objectives: To provide the people of the region with the basic facilities, equipment, and operating funds for training and education necessary to obtain employment at their best capability for available job opportunities, and to meet the objectives stated under the program entitled Appalachian Regional Development.

Eligibility: States, and through the states public educational institutions and private postsecondary institutions. Most of the proposals are for regional vocational-technical centers serving multicounty areas as well as several school districts. Education demonstration projects must be administered through a public body and be areawide in scope.

Range of Financial Assistance: $1,420 to $1,300,000.

Contact: Executive Director, Appalachian Regional Commission, 1666 Connecticut Ave. N.W., Washington, DC 20235/202-673-7874.

Publications

Appalachian Regional Commission Annual Report provides financial statistics, activities and programs over the past year. Other publications provide information on economic development activities in the region. Contact: News and Public Affairs, Appalachian Regional Commission, Room 328, 1666 Connecticut Ave. N.W., Washington, DC 20235/202-673-7968.

How Can the Appalachian Regional Commission Help You?

To determine how this agency can help you, contact: News and Public Affairs, Appalachian Regional Commission, Room 328, 1666 Connecticut Ave. N.W., Washington, DC 20235/202-673-7968.

Board for International Broadcasting

1030 15th St. N.W., Washington, DC 20005/202-254-8040

ESTABLISHED: October 19, 1973
BUDGET: $97,284,000
EMPLOYEES: 9
MISSION: Oversees the operation of Radio Liberty, which broadcasts to the Union of Soviet Socialist Republics and Radio Free Europe, which broadcasts to Poland, Romania, Czechoslovakia, Hungary and Bulgaria.

Major Sources of Information

Freedom of Information Act

For information on Freedom of Information Act requests, contact: Executive Staff, Board for International Broadcasting, Suite 430, 1030 15th St. N.W., Washington, DC 20005/202-254-8040.

Radio Free Europe-Radio Liberty Information and Publications

Information and annual reports detailing the programs provided and the areas covered by Radio Free Europe and Radio Liberty are available. Contact: Public Inquiries, Board for International Broadcasting, Suite 430, 1030 15th St. N.W., Washington, DC 20005/202-254-8040.

How Can the Board for International Broadcasting Help You?

To determine how this agency may be of help to you, contact: Public Inquiries, Board for International Broadcasting, Room 430, 1030 15th St. N.W., Washington, DC 20005/202-254-8040.

Civil Aeronautics Board (CAB)

1825 Connecticut Ave. N.W., Washington, DC 20428/202-376-2683

ESTABLISHED: 1938
BUDGET: $125,443,000
Employees: 743

MISSION: Promotes and regulates the civil air transport industry within the United States and between the United States and foreign countries in the interests of the foreign and domestic commerce of the United States, the Postal Service, and the national defense; grants licenses to provide air transportation service; approves or disapproves proposed rates and fares; and approves or disapproves proposed agreements and corporate relationships involving air carriers. (The Board is scheduled to be abolished by January 1, 1985.)

Major Sources of Information

CAB Library

The Library collection emphasizes air transportation. It also contains CAB documents and reports. Contact: Library, Civil Aeronautics Board, Room 912, 1825 Connecticut Ave. N.W., Washington, DC 20428/202-673-5101.

Direct Payments

The programs described below are those which provide financial assistance directly to individuals, private firms and other private institutions to encourage or subsidize a particular activity:

Air Carrier Payments

Objectives: To fix rates of subsidy compensation for development of air transportation to the extent and quality required for the commerce of the United States, the Postal Service and the national defense.

Eligibility: An air carrier holding a certificate authorizing the transportation of mail by aircraft under the Federal Aviation Act of 1958, as amended, upon the air carrier's application and justification of the need thereof.

Range of Financial Assistance: $308,000 to $19,504,173.

Contact: Director, Bureau of Domestic Aviation, B-60, Civil Aeronautics Board, 1825 Connecticut Ave. N.W., Washington, DC 20428/202-673-5319.

Air Transportation—Consumer Affairs

Objectives: To maintain and improve service provided to the public by domestic and foreign carriers. To provide assistance and information to consumers trying to resolve complaints against airlines, travel agents, tour operators, and freight forwarders. To provide information about specific air travel problems such as lost baggage, oversold flights, scheduling problems and overcharges. To refer people to agencies in their communities that provide help through local Small Claims Courts when informal mediation efforts fail.

Type of Assistance: Investigation of complaints.

Eligibility: All users of air transportation.

Range of Financial Assistance: Not specified.

Contact: Bureau of Consumer Protection, Civil Aeronautics Board, 1825 Connecticut Ave. N.W., Washington, DC 20428/202-673-6047.

Payments for Essential Air Services

Objectives: To provide essential air transportation to eligible communities by subsidizing air service.

Eligibility: Carrier must be found fit by the Board and must be selected to perform the subsidized service.

Range of Financial Assistance: Not specified.

Contact: Director, Bureau of Domestic Aviation, B-60, Civil Aeronautics Board, 1825 Con-

necticut Ave. N.W., Washington, DC 20428/202-673-5319.

Dockets

The Dockets section keeps applications from airlines for new operations, orders, and regulations, petitions and comments on pending cases, etc. It also prepares a *Weekly Summary of Orders and Regulations* ($22.15 annual), which lists serial number, docket or agreement number, brief description and adopted or effective date; and a weekly *Digest of Applications Filed and/or Amendments Thereto* ($42.75). Publications are available at the Distribution Section, Civil Aeronautics Board, B-22b, 1825 Connecticut Ave. N.W., Washington, DC 20428/202-673-5432.

Domestic Origin-Destination Survey of Airline Passenger Traffic

Statistics on passenger travel via the scheduled services of the U.S. certificated route air carriers showing passenger-trip origin and destination with routing by carrier and connecting points. Tabulations include detailed tables by city pair and summary data by city pair and city. Contact: Traffic Section, Civil Aeronautics Board, Room 909, 1825 Connecticut Ave. N.W., Washington, DC 20428/202-673-5924.

Financial Studies and Evaluations

Financial studies and evaluations of the air transport industry are available on the following subjects:

FINANCIAL
Quarterly Financial Review—Trunks
Quarterly Financial Review—Locals
Quarterly Financial Review—Large Charters
Quarterly Financial Review—Small Certificated
Quarterly Financial Review—New Entrants
Quarterly Industry Summary
Atlantic Financial and Traffic Trends
Pacific Financial and Traffic Trends
All-cargo Financial and Traffic Trends
Report on Carriers in a Loss Position
Monthly Financial and Traffic Results—Trunks
Monthly Financial and Traffic Results—Locals
Monthly Financial and Traffic Results—Large Charters
Comparative Financial Review—Trunks
Comparative Financial Review—Locals
Profit Margin Trends—Trunks
Profit Margin Trends—Locals
Comparison of Domestic and International Trunk Trends
Latin American Financial and Traffic Trends
Relation Between Operating and Net Financial Results—Trunks
Relation Between Operating and Net Financial Results—Locals

COST
Aircraft Cost and Performance Report—Calendar Year
Aircraft Cost and Performance Report—Fiscal Year
Domestic Jet Trends
International Jet Trends
Long-Term Trends in Unit Costs
Long-Term Trends in Cost Elements
Subpart K Costs
Small Aircraft Cost Inputs
Recent Trends in Cost Elements
Recent Trends in Unit Costs—Trunks
Recent Trends in Unit Costs—Locals
Growth Patterns in Cost Elements
GENERAL
Basic Data Summaries—Trunks
Basic Data Summaries—Locals
Basic Data Summaries—Large Charters
Fuel Trend Summary
Stock Market Performance—Trunks
Stock Market Performance—Locals
Common Stock Ratios—Trunks
Common Stock Ratios—Locals
Fund Flows
Carrier Lenders
Investments
Income Taxes
Growth Trends—Domestic Trunk Traffic and Business Activity
Seasonally Adjusted Traffic and Capacity
Passenger Yield and Traffic Trends—Trunks
Passenger Yield and Traffic Trends—Locals
Domestic Freight Yield and Traffic Trends
Capacity and Load Factor Trends—Trunks
Capacity and Load Factor Trends—Locals
Inventory and Age of Aircraft
Used Aircraft Sales
Aircraft Utilization Trends
Aircraft Seating Trends
Analysis of Capacity Changes
The Changing Nature of Local Service Operations
New Aircraft Purchases
Section 418 Domestic All-Cargo Results
Airline Employment
Long Term Fuel Trends
Long Term Financial and Traffic Results

Contact: Financial Cost Analysis Division, Office of Economic Analysis, Room 615, 1825 Connecticut Ave. N.W., Washington, DC 20428/202-673-5280.

Freedom of Information Requests

For Freedom of Information Act requests, contact: Office of the Secretary, Civil Aeronautics Board, Room 719, 1825 Connecticut Ave. N.W., Washington, DC 20428/202-673-5068.

International Aviation

The Board passes on applications from foreign

carriers, and is also concerned with their fares and tariffs. Contact: Bureau of International Aviation, Civil Aeronautics Board, Room 816, 1825 Connecticut Ave. N.W., Washington, DC 20428/202-673-5218.

Publications

The following publications are free from Distribution Section, Civil Aeronautics Board, 1825 Connecticut Ave. N.W., Washington, DC 20428/202-673-5432:

CAB Telephone Directory
Air Travelers' Fly-Rights
Bibliography of Important Civil Aeronautics Board Regulatory Actions—1975-1979
Trends in Unit Costs (issued biennially).
Agenda of Significant Regulations (issued semiannually).
CAB Press Releases (issued irregularly).
Commuter Air Carrier Traffic Statistics (issued semiannually).
Fuel Cost and Consumption Report (issued monthly).
List of Publications, Civil Aeronautics Board (issued annually).
List of U.S. Air Carriers (issued semiannually)—lists certificated and charter air carriers and all-cargo carriers.
Report on Airline Service, Fare, Traffic, Load Factors and Market Shares (issued bimonthly).
Schedule Arrival Performance in the Top 200 Markets by Carrier (issued monthly)—summarizes for designated market statistics reported by certificated air carriers; includes total flights scheduled by such carrier, number and percentage of flights actually performed, and number and percentage of performed flights which arrived on schedule or within 15 minutes of the scheduled time.
Seasonally Adjusted Capacity and Traffic-Scheduled Operations: System Trunks and Regional Carriers (issued monthly).
Subsidy for United States Certificated Carriers (issued annually)—board report shows tabulations of subsidy accruing for individual carriers, carrier groups, and the industry for each fiscal year since the formal separation of subsidy and service mail pay (1954) through the current fiscal year plus one projected year; includes a summary of the purpose of subsidy,

the process for determination of subsidy, and details the bases employed in preparing all information in the report.

Public Reference Services

The CAB provides a reference and reading room with Board records and documents available for public inspection. Contact: Public Reference Room, Civil Aeronautics Board, Room 710, 1825 Connecticut Ave. N.W., Washington, DC 20428/202-673-5313.

Schedules and Routes Information

Old and new airline schedules and routes can be seen by the public. Contact: Schedules and Routes Information Unit, Civil Aeronautics Board, Room 709, 1825 Connecticut Ave. N.W., Washington, DC 20428/202-673-5317.

Tariffs

Listings of all the tariffs in effect for the last 30 days for all air carriers operating domestic passenger service can be seen. Contact: Tariff Division, Civil Aeronautics Board, Room 814, 1825 Connecticut Ave. N.W., Washington, DC 20428/202-673-5402.

Travelers' Rights

Civil Aeronautics Board has a Bureau of Consumer Protection that informs, assists and protects consumers in their dealings with the air transportation industry. It also works with state and local consumer organizations to help them resolve airline consumer complaints. *Fly Rights*, a free brochure, provides information to the traveller on air fares, reservations and tickets, delayed and canceled flights, overbooking, baggage, smoking, airline safety and complaining. Contact: Bureau of Consumer Protection, Civil Aeronautics Board, 1825 Connecticut Ave. N.W., Washington, DC 20428/202-673-6047.

How Can the CAB Help You?

To determine how this agency may be of help to you, contact: General Information, Civil Aeronautics Board, Room 706, 1825 Connecticut Ave. N.W., Washington, DC 20428/202-673-5990.

Commission of Fine Arts

708 Jackson Pl. N.W., Washington, DC 20006/202-566-1066

ESTABLISHED: May 17, 1910
BUDGET: $268,000
EMPLOYEES: 7

MISSION: Supplies artistic advice relating to the appearance of Washington, DC; reviews the plans for all public buildings, parks, and other architectural elements in the Capital and for private structures in certain areas of the City.

Major Sources of Information

A Brief History of the Commission of Fine Arts—1910–1976

This publication provides a brief history of the Commission activities, highlighting some of its major accomplishments, including the National Gallery of Art, the Jefferson Memorial, Lafayette Square, the Kennedy Center, and some recent projects. The booklet also includes the legislation related to fine arts and preservation, a list of former and present Commission members, and a list of its publications. Contact: Commission of Fine Arts, 708 Jackson Pl. N.W., Washington, DC 20006/202-566-1066.

How Can the Commission of Fine Arts Help You?

To determine how this agency may be of help to you, contact: Commission of Fine Arts, 708 Jackson Pl. N.W., Washington, DC 20006/202-566-1066.

Commission on Civil Rights

1121 Vermont Ave. N.W., Washington, DC 20425/202-254-6697

ESTABLISHED: 1957
BUDGET: $11,719,000
EMPLOYEES: 285

MISSION: Advances the cause of equal opportunity; holds public hearings and collects and studies information on discrimination or denials of equal protection of the laws because of race, color, religion, sex, age, handicap, national origin, or in the administration of justice; performs factfinding efforts on voting rights, and quality of opportunity in education, employment and housing.

Major Sources of Information

Civil Rights Complaints

For complaints alleging denials of civil rights, contact: Office of Federal Civil Rights Evaluation, Commission on Civil Rights, Room 606, 1121 Vermont Ave. N.W., Washington, DC 20425/202-254-6697.

Clearinghouse Services, Civil Rights and Sex Discrimination Complaints

The objective of the Clearinghouse is to communicate civil rights information to the public with emphasis on how federal programs and policy can be used to advance equal opportunities for persons who are subjected to discrimination because of age or handicap, and for minority citizens and women; to receive and refer complaints alleging denial of civil rights because of color, race, religion, sex, age, handicap or national origin; to receive, investigate and refer complaints alleging denial of voting rights. Contact: Commission on Civil Rights, 1121 Vermont Ave. N.W., Washington, DC 20425/202-254-6506 (TTY phone, 202-376-2683 for deaf/hearing impaired persons).

Freedom of Information Requests

For Freedom of Information Act requests, contact: Solicitor Unit, Commission on Civil Rights, Room 710, 1121 Vermont Ave. N.W., Washington, DC 20425/202-254-3070.

Library

The Robert S. Rankin Civil Rights Library is open to the public. The staff provides free research assistance to the general public. A month-ly list of new acquisitions to the collection may be obtained by request. The collection contains material on voting rights, employment, women and minority issues, aging and handicapped discrimination and civil rights education. Contact: Robert S. Rankin Library, Commission on Civil Rights, Room 709, 1121 Vermont Ave. N.W., Washington, DC 20425/202-254-6636.

Publications

The following publications are free from the Commission on Civil Rights, 621 N. Payne, Alexandria, VA 22314/703-557-1794:

Last Hired, First Fired: Layoffs and Civil Rights—examines the effects of seniority as applied to layoffs of minority and female workers; includes findings and recommendations.

Sex Bias in the U.S. Code—assesses the status of women under federal law through a survey of sex-based references in the United States Code; contains findings and recommendations.

Window Dressing on the Set: Women and Minorities in Television—assesses the portrayal of women and minorities in television network programming and their employment at television stations; contains findings and recommendations.

The Age Discrimination Study—a study of unreasonable discrimination on the basis of age in the administration of programs or activities receiving federal financial assistance; based on hearings in Denver, Miami, San Francisco and Washington, D.C.

Civil Rights Directory—lists private and public individuals and organizations concerned with civil rights at local, state, federal, and national levels.

Civil Rights Brochure—explains functions of the Commission on Civil Rights.

A Guide to Federal Laws and Regulations Prohibiting Sex Discrimination (revised edition)—summarizes federal laws, policies, and regulations banning sex discrimination and tells how to file complaints.

Mortgage Money: Who Gets It?—a case study of discrimination against minorities and women in the granting of home mortgages in Hartford, CT.

Using the Voting Rights Act—explains how the Voting Rights Act of 1965, as amended in 1975, works. Contains lists of areas covered by the new language provisions, as well as text of the amended act.

Getting Uncle Sam to Enforce Your Civil Rights—a handbook describing where and how to file a discrimination complaint with the Federal Government.

Women—Still in Poverty—describes the operation of the welfare system, job training programs, employment discrimination, and child care availability and their effects on women.

Fair Textbooks: A Resource Guide—lists materials aimed at reducing biases in textbooks, organizations, publishers, and their guidelines, state education departments, state statutes, procedures, and guidelines, and conferences. Materials are identified for grade level, subject matter, and racial, ethnic and gender group, as well as indexed by group.

Civil Rights Digest—a quarterly magazine designed to stimulate ideas and interest on various current issues concerning civil rights.

Catalog of Publications

How Can the Commission on Civil Rights Help You?

To determine how this agency can help you, contact: Commission on Civil Rights, Room 606, 1121 Vermont Ave. N.W., Washington, DC 20425/202-254-6697.

Commodity Futures Trading Commission

2033 K. St. N.W., Washington, DC 20581/202-254-7556

ESTABLISHED: 1974
BUDGET: $16,917,000
EMPLOYEES: 550

MISSION: Strengthens the regulation of futures trading, and brings under regulation all agricultural and other commodities, including lumber and metals, which are traded on commodity exchanges; seeks to prevent price manipulation, market corners, and the dissemination of false and misleading commodity and market information affecting commodity prices; protects market users against cheating, fraud, and abusive practices in commodity transactions; and safeguards the handling of traders' margin money and equities by establishing minimum financial requirements for futures commission merchants, and by preventing the misuse of such funds by brokers.

Major Sources of Information

Commodity Futures Consumer Information Hotline

Any individual may ask any question concerning commodity futures trading, to include options trading, or request information concerning these subjects. Answers or information that may legitimately be provided by the Commodity Futures Trading Commission will be provided; otherwise the caller will be advised of the most likely source of the information requested. Contact: Office of Public Information, Commodity Futures Trading Commission, 2033 K. St. N.W., Washington, DC 20581/202-254-8630; or Hotline, 800-424-9838; 800-424-9707 (Alaska and Hawaii only).

Commodity Futures Market Reports

These reports provide traders and members of the public information about the futures markets to assist them in understanding the markets. Contact: Division of Economics and Education, Commodity Futures Trading Commission, 2033 K St. N.W., Washington, DC 20581/202-254-3201.

Commodity Futures Traders' Registration

Companies and individuals involved in futures trading, including futures commission brokers, commodity trading advisors, and commodity pool operators must register with the Commodity Futures Trading Commission. The office will confirm the registration of a firm or an employee and will advise if the CFTC has any prior or pending legal actions against them. Contact: Audit and Registration Section, Division of Trading and Markets, Commodity Futures Trading Commission, Room 741, 2033 K St. N.W., Washington, DC 20581/202-254-9703. For a free Directory of Futures Commission Merchants, Commodity Trading Advisors and Commodity Pool Operators, contact: Commodity Futures Trading Commission, Room 813, 2033 K St. N.W., Washington, DC 20581/202-254-8630.

Commodity Futures Trading Commission Library

The Library collection emphasizes law, economics, business and commodities. It is open to the public for limited hours. Contact: Library, Commodity Futures Trading Commission, 5th Floor, 2033 K St. N.W., Washington, DC 20506/202-254-5901.

Commodity Research

This office conducts or sponsors long-term research on the functioning of future markets. It also develops materials and programs explaining the Commodity Futures Trading Commission and its responsibilities. A list of publications is available. Contact: Research and Education Sec-

tion, Division of Economics and Education, Commodity Futures Trading Commission, Room 528, 2033 K St. N.W., Washington, DC 20581/202-254-3310.

Enforcement

Customer complaints are an important source of information about possible violations and assist the Commodity Futures Trading Commission in its enforcement and regulatory functions. Persons who believe they may have been cheated or defrauded in their trading transactions should advise the Commission so that it may take appropriate action. The Commission also provides a customer reparations forum where monetary awards may be directed to any person who can prove damage received as a result of violation of the Commodity Exchange Act in dealing with persons or companies registered with the Commission. Information on future trading is also available to the general public upon request. Contact: Division of Enforcement, Reparations Unit, Commodity Futures Trading Commission, 2033 K St. N.W., Washington, DC 20581/202-254-9501.

Freedom of Information Requests

For Freedom of Information Act requests, contact: Office of the Secretariat, Commodity Futures Trading Commission, Room 806, 2033 K St. N.W., Washington, DC 20581/202-254-3382.

Monitoring Commodity Economics

This office reviews proposed futures contracts to determine whether their trade would serve a valid economic purpose. It analyzes the economic ramifications of Commodity Futures Trading Commission policies and regulations. It also monitors trading on all contract markets to detect actual or potential manipulations, congestion and price distortion. Contact: Division of Economics and Education, Commodity Futures Trading Commission, Room 524, 2033 K St. N.W., Washington, DC 20581/202-254-3310.

Publications

The following publications are free from: Education Unit, Commodity Futures Trading Commission, Room 528, 2033 K St. N.W., Washington, DC 20581/202-254-7446:

The CFTC (CFTC 100)
Economic Purposes of Future Trading (CFTC 102)
Farmers, Futures, and Grain Prices (CFTC 103)
Reading Commodity Futures Price Tables (CFTC 104)
Glossary of Some Trade Terms (CFTC 105)
CFTC Futures Facts Sheets: no. 1—CFTC Reports and Offices; no. 2—CFTC Publications and General Bibliography; no. 3—Commodities Traded and Exchange Addresses; no. 4—Visual Aids (Films and Slides), no. 5—Reporting Levels and Speculative Limits
Grain Pricing

Trading and Markets

This office regulates all exchanges on which commodity futures are traded. It also approves all futures contracts traded or exchanged. Contact: Division of Trading and Markets, Commodity Futures Trading Commission, Room 640, 2033 K St. N.W., Washington, DC 20581/202-254-8955.

How Can the Commodity Futures Trading Commission Help You?

To determine how the agency can be of help to you, contact: Office of Public Information, Commodity Futures Trading Commission, Room 813, 2033 K St. N.W., Washington, DC 20581/202-254-8360.

Consumer Product Safety Commission

1111 18th St. N.W., Washington, DC 20207/202-634-7700

ESTABLISHED: October 27, 1972
BUDGET: $40,600,000
EMPLOYEES: 880

MISSION: Protects the public against unreasonable risks of injury from consumer products; assists consumers to evaluate the comparative safety of consumer products; develops uniform safety standards; and promotes research and investigation into the causes and prevention of product-related deaths, illnesses, and injuries.

Major Sources of Information

Audiovisuals

For information on the availability of free films and slide shows from the Consumer Product Safety Commission, contact: Film Scheduling Center, Modern Talking Picture Service, 5000 Park St. N., St. Petersburg, FL 33709/813-541-6661.

Consumer Deputy Program

This program trains volunteers to obtain marketplace or household survey information for the Consumer Product Safety Commission. The volunteers look for banned products in retail stores, alert retailers to new regulations, and gain product use information from households. Contact: Office of the Secretary, Consumer Product Safety Commission, Room 300, 1111 18th St. N.W., Washington, DC 20207/202-634-7700.

Consumer Education Programs

This office prepares programs to inform consumers of standards issued by the Consumer Product Safety Commission, and to alert them to newly discovered hazards. Contact: Consumer Education and Awareness Division, Consumer Product Safety Commission, Room 356WTB, 1111 18th St. N.W., Washington, DC 20207/202-634-7700.

Consumer Product Hotline

This hotline provides information to the public about product recalls and also handles complaints about hazardous products and product defects. The hotline can also be used to obtain free pamphlets and fact sheets. Contact: 800-638-8326 (Maryland, 800-492-8363; Alaska, Hawaii, Puerto Rico and Virgin Islands, 800-638-8333).

Freedom of Information Office

For making a Freedom of Information Act request, contact: Freedom of Information, Consumer Product Safety Commission, Room 300, 1111 18th St. N.W., Washington, DC 20207/202-634-7700.

Hazard Identification and Analysis

This clearinghouse collects, investigates, analyzes and disseminates injury data and information relating to the causes and prevention of death, injury and illness associated with consumer products. It maintains thousands of detailed investigative reports of injuries that have been reported by a nationwide network of hospital emergency departments. It also maintains supplies of publications such as hazard analyses, special studies, and data summaries. These reports identify hazards, accident patterns and types of products. Contact: National Injury Information Clearinghouse, Consumer Product Safety Commission, Room 625, 5401 Westbard Ave., Washington, DC 20207/301-492-6424.

Help Write a Standard

Consumers or consumer organizations may offer to develop a proposed mandatory standard. When the Commission is looking for offers to develop a standard for a particular product an announcement is made in the Federal Register.

Contact: Office of the Secretary, Consumer Product Safety Commission, Room 300, 1111 18th St. N.W., Washington, DC 20207/202-634-7700.

Library

The CPSC Library collection stresses product safety and liability, consumer affairs, engineering, economics and law. Contact: CPSC Library, Consumer Product Safety Commission, Room 546, 5401 Westbard Ave., Bethesda, MD 20207/301-492-6544.

Petition the CPSC

Any interested person may petition the Commission to begin proceedings to issue, amend or revoke a consumer product safety rule. Contact: Office of the Secretary, Consumer Product Safety Commission, 1111 18th St. N.W., Washington, DC 20207/202-634-7700.

Publications

Up to 10 copies of the following publications are available free by writing to the U.S. Consumer Product Safety Commission, Washington, DC 20207:

BEDS
Bunk Beds (Fact Sheet No. 7)
BICYCLES
Bicycle Regulations (Technical Fact Sheet No. 5)
Bicycles—Buy Right/Drive Right (illustrated brochure)
Frequently Asked Questions about the Bicycle Regulations (brochure)
CHILDHOOD SAFETY, GENERAL
Because You Care for Kids (booklet)
The Super Sitter (booklet, baby sitter's guide)
CHILDREN'S FURNITURE
Baby Walkers (Fact Sheet No. 66)
Buyers' Guide: It Hurts When They Cry (general information booklet for adults)
Cribs (Fact Sheet No. 43)
High Chairs (Fact Sheet No. 70)
It Hurts When They Cry (poster)
Infant Falls (Fact Sheet No. 20)
Toy Boxes and Toy Chests (Fact Sheet No. 74)
CHRISTMAS SAFETY
Christmas Decorations (Fact Sheet No. 40)
Holiday Safety #7T (teacher's Guide on decorations, toys and other gifts)
Merry Christmas with Safety (illustrated pamphlet)
CONSUMER PRODUCTS, GENERAL
Consumer Product Safety: What's It All About? (guide for teachers of grades 4–6)
The Door to Home Safety (booklet)
Federal Consumer-Oriented Agencies (Fact Sheet No. 52)
Formaldehyde in Consumer Products (alert sheet)
The Home Electrical System (Fact Sheet No. 18)

How-To Manual for Product Safety—People Make It Happen (guidebook for organization community programs on product safety)
Misuse of Consumer Products (Fact Sheet No. 68)
Plastics (Fact Sheet No. 41)
FIREWORKS
Fireworks (Fact Sheet No. 12)
FLAMMABILITY
Flammable Fabrics (Fact Sheet No. 17)
Flammable Liquids (Fact Sheet No. 23)
Flammable Fabrics Curriculum: Student Readings No. 4S
Gasoline Is Made to Explode (illustrated pamphlet)
Guide to Fabric Flammability (illustrated pamphlet)
Hazard Analysis of Space Heaters
Hazards of Flammable Liquids (illustrated pamphlet)
Laundering Procedures for Flame Resistant Fabrics (Fact Sheet No. 24)
Smoke Detectors (Fact Sheet No. 57)
Upholstered Furniture (Fact Sheet No. 53)
What You Should Know About Home Fire Safety (booklet)
What You Should Know About Smoke Detectors (booklet)
HALLOWEEN
Halloween Safety Teacher's Guide No. 9T
HEATERS
Caution! Choosing and Using Your Gas Space Heater (illustrated pamphlet)
Electric Baseboard Heaters (Fact Sheet No. 54)
Furnaces (Fact Sheet No. 79)
Space Heaters (Fact Sheet No. 34)
Wood and Coal Burning Stoves (Fact Sheet No. 92)
HOUSEHOLD PRODUCTS, GENERAL
Electric Irons (Fact Sheet No. 76)
Extension Cords and Wall Outlets (Fact Sheet No. 16)
Hair Dryers and Stylers (Fact Sheet No. 35)
Ladders (Fact Sheet No. 56)
Matches and Lighters (Fact Sheet No. 28)
Television Fire and Shock Hazards (Fact Sheet No. 11)
Wringer Washing Machines (Fact Sheet No. 36)
HOUSEHOLD STRUCTURES
Antennas Can Kill You (antenna alert)
Bathtub and Shower Injuries (Fact Sheet No. 3)
Fireplaces (Fact Sheet No. 91)
Home Insulation (Fact Sheet No. 91)
Questions and Answers on Home Insulation (booklet)
KITCHEN PRODUCTS
Electric Blenders, Mixers, Choppers, Grinders (Fact Sheet No. 50)
Kitchen Ranges (Fact Sheet No. 9)
Pressure Cookers (Fact Sheet No. 64)
MOBILE HOMES
Mobile Homes (Fact Sheet No. 39)
OUTDOOR POWER EQUIPMENT
Chain Saws (Fact Sheet No. 51)
Garden Tractors (Fact Sheet No. 78)
Hazards and Safety Practices for Power Mowing (poster)
Make Your Lawn Easier (and Safer) to Mow (illustrated information sheet)

Power Lawn Mowers (Fact Sheet No. 1)
Power Lawn Mower Safety Kit (teacher's manual)
Power Mower Hazards and Safety Features (poster)
Power Mower Maintenance and Storage Tips (illustrated information sheet)
Safe Mowing is Better Mowing (consumer reference book)
Safety, Sales, and Service—Selling Your Customers on Power Lawn Mower Safety (retail sales training booklet for retailers and technical school students)
PLAYGROUND EQUIPMENT
Hazard Analysis of Playground Equipment
Play Happy, Play Safely (coloring book)
Play Happy, Play Safely: Curriculum Approach (for teachers and leaders of children's groups, ages 3–12)
Play Happy, Play Safely: Playground Guide (general information brochure for adults and teachers)
Play Happy, Play Safely: Playground Handbook (technical information and other resources for adult leaders and teachers)
Play Happy, Play Safely: Little Big Kids (illustrated read-together book for adults and children, ages 3–5)
Play Happy, Play Safely: Medium Big Kids (illustrated read-together book for adults and children, ages 7–9)
Play Happy, Play Safely: Big Big Kids (illustrated read-together book for adults and children, ages 10–12)
Play Happy, Play Safely (pamphlet)
Play Happy, Play Safely (poster)
The Swing That Swung Back (illustrated pamphlet)
POISONS
Alternatives for the Older Consumer and the Handicapped (pamphlet, safety closures)
Carbon Monoxide (Fact Sheet No. 13)
First Aid for Poisoning (card)
Lead Paint Poisoning (Fact Sheet No. 14)
Poison Awareness (discussion leader's guide)
Poison Awareness (resource book for teachers of grades 7–9)
Poison Lookout Checklist and Certificate
What Pharmacists Should Know (pamphlet)
RECREATIONAL AND SPORT EQUIPMENT
Hot Tips for Hot Shots on Skateboarding Safety (illustrated brochure)
Minibikes and Minicycles (Fact Sheet No. 38)
Roller Skates and Ice Skates (Fact Sheet No. 84)
Skateboards (Fact Sheet No. 93)
Sleds, Toboggans, and Snow Discs (Fact Sheet No. 49)
REFUSE BINS
Refuse Bins (Fact Sheet No. 81)
TOYS
Electrically Operated Toys (Fact Sheet No. 61)
For Kids' Sake . . . Think Toy Safety (illustrated pamphlet)
For Kids' Sake . . . Think Toy Safety (coloring book)
For Kids' Sake . . . Think Toy Safety (poster)
Little Leon the Lizard—Classroom Activities Guide for the Teacher (booklet with poster insert)
Little Leon the Lizard—Toy Safety Curriculum (booklet)
Toys (Fact Sheet No. 47)

WORKSHOP PRODUCTS
Electric Home Workshop Tools (Fact Sheet No. 59)
Power Saws (Fact Sheet No. 7)

Public Calendar
Notices of meetings are generally published in the Public Calendar at least seven days before meetings of the Commissioners or Commission staff with persons who are not a part of the agency. The calendar may be obtained free of charge. Contact: Office of the Secretary, Consumer Product Safety Commission, Room 300, 1111 18th St. N.W., Washington, DC 20207/202-634-7700.

Selected Injury Information Resources
The National Electronic Injury Surveillance System (NEISS) is the main source of injury data for the Consumer Product Safety Commission. It is an injury data collection system which provides national estimates of the number and severity of injuries associated with consumer products treated in hospital emergency departments. It also serves as a means of locating injury victims so that further information can be gathered on the nature and probable cause of the accident. Summaries of these data are available in two regular publications: *Tabulation of DATA from NEISS*, annual reports of the involvement of the product(s) in the injury; and *NEISS Data Highlights*, a monthly newsletter. The other sources of information include:

Death Certificates—information is coded into a computer data base with information on place of death, age and sex of victim, dates of injury and death, narrative extracts of the coroner's or medical examiner's description of the accident preceding death, plus codes for manner of death and accident mechanism, for the nature of the injury and location and for as many as four products.
NEISS Data Highlights—a free monthly publication of data tables showing numbers of product-related injuries that were treated in hospital emergency departments during the previous month and during the previous 12 months. The data tables are based on top product categories in CPSC's *Product Hazard Index*.
Consumer Complaint File—contains narrative reports of actual or potential product hazards and of injuries or near injuries from consumer products.
Medical Examiners and Coroners Alert Program (MECAP)—provides CPSC with timely information on product-related deaths and additional facts not recorded on death certificates.

Contact: National Information Clearinghouse, Hazard Identification and Analysis, Consumer Product Safety Commission, Room 625, 5401

Westbard Washington, DC 20207/301- 492-6424.

How Can the Consumer Product Safety Commission Help You?

To determine how this agency can help you, contact: Directorate for Communications, Consumer Product Safety Commission, Washington, DC 20207/800-638-8326 (Maryland, 800-492-8363; Alaska, Hawaii, Puerto Rico and Virgin Islands, 800-638-8333).

Environmental Protection Agency

401 M St. S.W., Washington, DC 20460/202-755-0707

ESTABLISHED: December 2, 1970
BUDGET: $4,686,223,000
EMPLOYEES: 11,015
MISSION: Protects and enhances our environment today and for future generations to the fullest extent possible under the laws enacted by Congress; controls and abates pollution in the areas of air, water, solid waste, noise, radiation and toxic substances.

Data Experts

The following experts can be contacted directly concerning the topics under their responsibility. When writing to any of these experts, state the full name and topic area in the address and send in care of U.S. Environmental Protection Agency. For the rest of the address, refer to the area code in the telephone number and consult the listing at the end of this section.

Air
ADP Coordinator (OAQPS)/Jim Hammerle/919-541-5491
Aerodynamic Downwash Studies/Alan Huber/919-541-5381
Air Pollution Documents and Abstracts/Peter Halpin/919-541-2460
Air Pollution Training/Jean Schueneman/919-541-2410
Airport Impact Analyses/Tom McCurdy/919-541-5291
Air Quality Comparison Between Cities/Bob Faoro/919-541-5351
Air Quality Data Statistical Screening Techniques/Tom Curran/919-541-5351
Air Quality Data Interpretation with Respect to NAAQS/Tom Curran/919-541-5351
Air Quality Design Values for Air Pollution Studies/Bob Faoro/919-541-5351
Air Quality & Emissions Data/Harold Barkhau/919-541-5247
Air Quality Index (PSI)/Bill Hunt/919-541-5351
Air Quality Maintenance Planning/Joe Sableski/919-541-5437
Ambient Monitoring Plans (State)/Alan Hoffman/919-541-5351

Annual Air Quality & Emission Trends Report/Bill Hunt/919-541-5351
AQCR Attainment Status/Lanny Deal/919-541-5365
Area Source (NEDS) Coding and Engineering/Charles Mann/919-541-5395
Arsenic/Jo Cooper/919-541-5355
Arsenic/Smelter/Stan Cuffe/919-541-5295
Asphalt Paving, Emulsified/Frank Kirwan/919-541-5201
Asphalt Roofing/Stan Cuffe/919-541-5295
Assemble and Public SIPS/Bob Schell/919-541-5365
Assurance of Plan Adequacy (SO$_2$)/Roger Powell/919-541-5437
Basic Ordering Agreements/Tom Williams/919-541-5226
Basic Oxygen Furnace/Jack Farmer/919-541-5477
Benzene/Richard Johnson/919-541-5355
Benzene Emission Standards/Robert Walsh/919-541-5374
By-Product Coke Ovens/Stan Cuffe/919-541-5295
Carbon Black/Jack Farmer/919-541-5477
CDHS/AQDHS/EIS/Lloyd Hedgepeth/919-541-5492
Chlor-alkli Plants/Jack Farmer/919-541-5477
Coal Gasification/Stan Cuffe/919-541-5295
Complex Terrain Models/Ed Burt/919-541-5381
Computer Assisted Area Source Emissions System/Jerry Mersch/919-541-5335
Computerized Air Quality Models & Graphics Display/Jerry Mersch/919-541-5335
Continuous Emission Monitoring in

SIPS/Charlie Pratt/919-541-5365
Control Strategy Models/Dave Barrett/919-541-5391
Costs of Control Equipment/Bill Hamilton/919-541-5581
Crushed Stone/Jack Farmer/919-541-5477
Data Anomalies/Jake Summers/919-541-5395
Air Quality/Chuck Mann/919-541-5395
Emissions/Chuck Mann/919-541-5395
Data Auditing/Virginia Ambrose/919-541-5248
Data Availability and Auditing MDAD/Virginia Ambrose/919-541-5248
Data Requests (computerized)/Harold Barkau/919-541-5247
Degreasing/Robert Walsh/919-541-5374
Dispersion Models/Jim Dicke/919-541-5381
Economic Analysis of Stationary Source Control Strategies/Bill Hamilton/919-541-5581
Electric Arc Furnaces/Stan Cuffe/919-541-5295
Emissions Data for Power Plants/Al Wehe/919-541-5345
Emission Density Zoning/John Robson/919-541-5291
Emission Factors, Mobile Source/Charles Masser/919-541-5477
Emission Factors, Organic & Fugitive/James Southerland/919-541-5474
Emission Inventory Techniques Development for Organics/Tom Lahre/919-541-5474
Empirical Kinetic Model Approach (EKMA)/Ned Meyer/919-541-5486
Energy Conservation/Dave Moreau/919-541-5201
Energy Data System/Al Wehe/919-541-5345
Energy Data System, Fuel Regulations/John Crenshaw/919-541-5201
Energy Data System, Operation and Development/Al Wehe/919-541-5345
Energy/Environmental Strategies/Bob Bauman/919-541-5345
Environmental Impact Statements/T. J. Sharpe/919-541-5527
ESECA Plant Conversion/Dick Atherton/919-541-5201
ESECA Policy/John Fink/919-541-5345
Existing Source Emission Regulations/Charles Pratt/919-541-5365
Filters (Hi-Vol), EPA Supplied/Alah Hoffman/919-541-5351
Fine Particulates/John Bachmann/919-541-5501
Flurocarbons/Stan Coerr/919-541-5501
Fuel Analysis/Jack Farmer/919-541-5477
Fuel Combustion Regulations/John Crenshaw/919-541-5201
Fuels Availability/Ray Morrison/919-541-5201

Fugitive Dust
 Policy/Dave Stonfield/919-541-5497
 Technical/Dallas Safriet/919-541-5295
Fugitive Emission Factors/Charles Masser/919-541-5474
Gas Turbines/Jack Farmer/919-541-5477
Grain Elevators/Jack Farmer/919-541-5477
Grants to State Agencies/Donald Smith/919-541-5226
Grey Iron Foundries/Stan Cuffe/919-541-5295
Hazardous and Trace Emissions System (HATREMS)/Jake Summers/919-541-5395
Hydrocarbon/Oxidant Studies/Marty Martinez/919-541-5474
Indoor Air Quality/John Robson/919-541-5291
Industrial Source Impact Studies/Phil Youngblood/919-541-5291
Industrial Source Studies/Stan Cuffe/919-541-5295
Inflation Impact Statements/Bill Hamilton/919-541-5581
Interactive Terminal System/Jerry Slaymaker/919-541-5247
Intermediate Size Boilers/Stan Cuffe/919-541-5295
Internal Combustion Engines/Jack Farmer/919-541-5477
Iron Ore Beneficiation/Stan Cuffe/919-541-5295
Kraft Pulp Mills/111(d)/Stan Cuffe/919-541-5295
Land Use-Based Emission Factors/Tom McCurdy/919-541-5291
Land Use Planning/Jim Weigold/919-541-5204
Lead
Stan Coerr/919-541-5355
Lead Battery Manufacturing/Stan Coerr/919-541-5295
Lignite Combustion (NO*)/Jack Farmer/919-541-5477
Manpower Model/Tom Donaldson/919-541-5226
Mobile Source Models/George Schewe/919-541-5391
Mobile Sources Fuel Economy
 Certification/Bob Larson/313-668-4277
 Classes of Regulated Vehicles/Charles Gray/313-668-4291
 Emissions Standards/Charles Gray/313-668-4291
 Fuel Economy/Dan Hardin/313-668-4222
 General/Charles Gray/313-688-4291
 General Policy/Ernest Rosenberg/202-755-0596
 Health Effects/Stan Blacker/202-426-2514
 Inspection and Maintenance/Bruce Carhart/202-755-0596

Policy Issues/Ernest Rosenberg/202-755-0596

Questions on a Specific Regulation/Bob Maxwell/313-668-4268

Technical Issues/Charles Gray/313-668-4291

Technical Questions/Dan Hardin/313-668-4222

Model Applicators/Dave Barrett/919-541-5391

Modification Litigation/Jack Farmer/919-541-5477

Monitor Siting Guidelines/Alan Hoffman/919-541-5477

Monitor Siting Regulations/Stan Sleva/919-541-5477

Monitoring Strategies/Stan Sleva/919-541-5477

National Air Quality Trends Sites/Alan Hoffman/919-541-5351

National Energy Plan Analyses/Bob Bauman/919-541-5345

NATO/CCMS/Bob Bauman/919-541-5345

NEDS System Development/Andrea Kelsey/919-541-5247

NESHAPS Litigation/Jack Farmer/919-541-5477

New Data Programs Requests (AEROS)/Amos Slaymaker/919-541-5247

New Source Review/Michael Trutna/919-541-5497

Nitrogen Dioxide Air Quality Standard/Bob Kellan/919-541-5501

Nitrogen Oxide Preparation Manual/Joe Sableski/919-541-5437

Nitrosamines/John Bachmann/919-541-5501

Nonmetallic Minerals/Stan Cuffe/919-541-5295

OAQPS Guideline Series/Joe Sableski/919-541-5437

Offset Waiver/Michael Trutna/919-541-5497

Permit Fees/Joe Sableski/919-541-5437

Petroleum Refineries, Storage, Marketing/Robert Walsh/919-541-5374

Petroleum Refinery Opacity/Jack Farmer/919-541-5477

Phase II Service Station Control/Robert Ajax/919-541-5581

Phosphate Fertilizer/111(d)/Stan Cuffe/919-541-5295

Phosophate Rock Processing/Stan Cuffe/919-541-5295

Photochemical Oxidant Air Quality Standard/Mike Jones/919-541-5355

Photochemical Oxidant-Natural Background/Marty Martinez/919-541-5474

Point Source Ambient Monitoring/Bill Cox/919-541-5312

Point Source (NEDS) Coding and Engineering/Arch McQueen/919-541-5395

Pollutant Assessment/John O'Connor/919-541-5355

Polychlorinated Biphenyls/Don Lokey/919-541-5501

Polycyclic Organic Matter/Justice Manning/919-541-5501

Population Exposure Analyses/Neil Frank/919-541-5351

Power Plant Data/Al Wehe/919-541-5345

Power Plant Impact Studies/Dave Layland/919-541-5391

Power Plant Revisions/Stan Cuffe/919-541-5295

Primary Aluminum/111(d)/Stan Cuffe/919-541-5295

Program/File Documentation/Barbara Townsend/919-541-5295

Publications and Reports Requests/Pete Halpin/919-541-2460

Reactive Plume Models/John Summerhays/919-541-5391

Reactivity of Volatile Organics/Robert Walsh/919-541-5374

Refuse Combustion in Steam Generators/Jack Farmer/919-541-5477

Regional Air Pollution Study Inventory/Charles Masser/919-541-5474

Regional Assistance in Economic Analysis/Bill Hamilton/919-541-5581

Regional Consistency/Dan deRoeck/919-541-5437

Regulations Concerning Fuel Combustion/John Crenshaw/919-541-5201

Report to Congress/Willis Beal/919-541-5365

Resuspension of Street Dust
 Policy/Dave Dunbar/919-541-5497
 Technical/Dallas Safriet/919-541-5474

Rollback Models/Whit Joyner/919-541-5596

SAMWG/Stan Sleva/919-541-5447

Secondary Impacts of Land Use Development/Tom McCurdy/919-541-5291

Significant Deterioration (TSP, SO_2)/Roger Powell/919-541-5437

Significant Deterioration (other pollutants)/Dave Dunbar/919-541-5497

Sintering Plants/Stan Cuffe/919-541-5295

Smelter Litigation/Jack Farmer/919-541-5477

Smelters/Robert Schell/919-541-5365

Solvent-Using Industries/Robert Walsh/919-541-5374

Source Classification Codes/Charles Mann/919-541-5395

Source Inventory and Emission Factor Analysis (SIEFA)/John Bosch/919-541-5491

Source Receptor Analysis/Joe Tikvart/919-541-5261

Source Test Data System (SOTDAT)/Arch McQueen/919-541-5396

Sources with Interstate Impacts/Gary

Rust/919-541-5365
Special Monitoring Projects/Marty
 Martinez/919-541-5474
Stack Height Regulations/Dave Sanchez/919-
 541-5497
State Air Quality Reports/Virginia
 Henderson/919-541-5351
State Implementation Plans/Charles Pratt/919-
 541-5365
State Implementation Plans (SIPS) in
 Nonattainment Areas/Michael Trutna/919-
 541-5497
Statistical Oxidant Modeling/Ned Meyer/919-
 541-5596
Sulfates/John Bachmann/919-541-5501
Sulfur Recovery/Jack Farmer/919-541-5477
Sulfuric Acid Mist/111(d)/Jack Farmer/919-
 541-5477
Supplementary Control System,
 Monitoring/Meteorology/Larry Budney/919-
 541-5381
Supplementary Control System,
 Regulations/Robert Schell/919-541-5365
Systems Maintenance (AEROS)/Gary
 Wilder/919-541-5248
Systems Problems (AEROS)/Gary Wilder/919-
 541-5248
Toxic Properties of Organic Chemicals/John
 Bachmann/919-541-5501
TSP Fugitive Dust Field Studies/Dallas
 Safriet/919-541-5475
TSP SIP Preparation Manual/Ted
 Creekmore/919-541-5437
TSP National Assessment/Tom Pace/919-541-
 5596
Training (AEROS)/John Bosch/919-541-5395
Trends in Trace Metals/Bob Faoro/919-541-
 5351
Validation/Evaluation of Dispersion
 Models/Russ Lee/919-541-5381
Variances/Robert Schell/919-541-5365
Vinyl Chloride/Jack Farmer/919-541-5477
Wood Residue as Boiler Fuel/Jack Farmer/919-
 541-5477

Drinking Water
Bottled Water/Ervin Bellack/202-472-5016
Chlorine/Frank Bell/202-472-6820
Community Water Supply/James
 Manwaring/202-426-3983
Fluoridation/Ervin Bellack/202-472-5016
Home Purifiers/Frank Bell/202-472-6820
Publications/Beverly Pannell/202-426-8290
Research/Kathy Conway/202-755-0650
 Jim Simons/513-684-7228
 Gordon Robeck/513-684-7201
Subsurface Emplacement/Tom Belk/202-426-
 3934

Noise
Aircraft Noise/John Schettino/703-557-7550
Budgets/John Degnan/703-557-7600
Control Programs, Federal/John Schettino/703-
 557-7750
Control Programs, State and Local/John
 Ropes/703-557-7695
Health Effects/Rudolph Marrazzo/703-557-
 7305
International Activities/Rudolph
 Marrazzo/703-557-7305
National Noise Assessments/Joseph
 Montgomery/703-557-9307
Product Labeling/Kenneth Feith/703-557-2710
Public Information/William Franklin/703-557-
 9698
Standards and Regulations/Henry Thomas/703-
 557-7743
Surface Transportation Noise/William
 Roper/703-557-6666

Radiation
Criteria and Standards/William Mills/703-557-
 0704
Emergency Procedures/Harry Calley/703-557-
 7395
Environmental Analysis/Floyd Galpin/703-557-
 8217
Health Effects/William Ellett/703-557-9380
Monitoring/Raymond Johnson/703-557-7380
Natural Radiation/Allan Richardson/703-557-
 8927
New Standards/William Mills/703-557-0704
Nonionizing Radiation/David Jones/301-427-
 7604
Nuclear Power Plants/John Russell/703-557-
 7604
Over-all Program/Robertson Augustine/703-
 557-9710
Publications/Lorenz Zelsman/703-557-7715
Relation to Clean Air Act/James Hardin/703-
 557-8610
Technology Assessment/David Smith/703-557-
 8950
Uranium Mill Tailings/Allan Richardson/703-
 557-8927
Wastes, High-Level/Daniel Egan/703-557-8610
Wastes, Other/David Smith/703-557-8950

**Research and Development Environmental
Engineering and Technology**
Adhesives and Sealants/Ron Turner/513-684-
 4481
Advanced Energy Conversion (e.g. Combined
 Cycles, High Temperature Turbines, Fuel
 Cells, MHD)/Bill Cain/513-684-4335
Analytical Procedures—Oil and Hazardous
 Spills/Mike Gruenfeld/201-340-6625

Asbestos Manufacturing/Mary Stinson/201-340-6683

Boiler—Utility/Industrial
By-Product Marketing/Chuck Chatlynne/919-629-2915
Effects/Assessment/Wade Ponder/919-629-2915
Fluidized Bed Combustion/Bruce Henschel/919-629-2825
NO$_x$ Control (by Combustion Modification)/Josh Bowen/919-629-2470
David Mobley/919-629-2915
(by Flue Gas Treatment)/James Abbott/919-629-2925
Particulate Control/Mike Maxwell/919-629-2578
SO$_2$ Control (Nonregenerable)/Dick Stern/919-629-2915
(Regenerable)
Thermal Effects Control/Ted Brna/919-629-2683
Waste Disposal/Julian Jones/919-629-2489
Water Pollution/Julian Jones/919-629-2489

Brick-Kilns/Churck Darvin/513-684-4491

Chemical and Fertilizer Minerals Mining and Beneficiation/Jack Hubbard/513-684-4417

Clay, Ceramics and Refractories Mining/Jack Hubbard/513-684-4417

Clay, Ceramics and Refractories Processing/Manufacturing/Chuck Darvin/513-684-4491

Coal
Mining/John Martin/513-684-4417
Cleaning/Jim Kilgroe/919-629-2851
Storage/John Martin/513-684-4417
Gasification/Bill Rhodes/919-629-2851
In Situ Gasification Underground
Aspects/Ed Bates/513-684-4417
Aboveground Aspects/Bob Thurnau/513-684-4363
Liquefaction/Bill Rhodes/919-629-2851

Combustion Modifications/Josh Bowen/919-629-2470

Compounding and Fabricating Industries (e.g., Furniture, Printed Products)/Ron Turner/513-684-4481

Construction Materials Mining/Jack Hubbard/513-684-4417

Drinking Water
Economic Analysis/Robert Clark/513-684-7209
Field Scale Organics Removal/J. DeMarco/513-684-7209
Inorganic Contaminants/Thomas Sorg/513-684-7228
Microbiological Treatment/Edwin Geldreich/513-684-7232
Organics Investigations/Alan Stevens/513-684-7228
Organics Removal Activities/Oliver Love/513-684-7228
Particulate Contaminants/Gary Logsdon/513-684-7228
Treatment Research/Lawrence Gray/202-426-4567
Gordon Robeck/513-684-7201

Electroplating/George Thompson/513-684-4491

Energy Control Technology/Frank Princiotta/202-755-0205

Energy Management (in conservation)
Energy Recovery/Power Systems/C. C. Lee/513-684-4334
Environmental Issues and Policies/Harry Bostian/513-684-4318
Industrial Processes/Bob Mournighan/513-684-4334

Environmental Assessments of Conventional and Advanced Energy Systems/David Berg/202-426-2683
Lowell Smith/202-755-2737
John Burchard/919-629-2821
David Stephan/513-684-4402

Ferrous Metallurgy/Norm Plaks/919-629-2733

Fertilizer Manufacturing/Dale Denny/919-629-2547

Flue Gas Particulate Control/George Ray/202-755-2737
James Abbott/919-629-2925

Flue Gas Sulfur Oxide Control/Robert Statnick/202-755-0205
Everett Plyler/919-629-2915

Food Products/Ken Dostal/513-684-4227

Fuel Processing, Preparation and Advanced Combustion/Morris Altschuler/202-755-2738
Robert Hangebrauk/919-629-2825
Clyde Dial/513-684-4207

Fugitive Emissions Control (call appropriate industry contact)

Furnaces—Residential/Commercial/Josh Bowen/919-629-2470

Gas Turbines/Internal Combustion Engines/Josh Bowen/919-629-2470

Geothermal Energy/Bob Hartley/513-684-4334

Glass Manufacturing/Chuck Darvin/513-684-4491

Hazardous Material Spills/Frank Freestone/201-340-6632

Indoor Air Quality/Bill Cain/513-684-4335

Industrial Air Pollution Control Technology/David Graham/202-755-9014
A. B. Craig/919-629-2509
Eugene Berkau/513-684-4314

Industrial Pollution Control Technology/Marshall Dick/202-755-0647
A. B. Craig/919-629-2509
Eugene Berkau/513-684-4314

Industrial Laundries/Ron Turner/513-684-4481
Inorganic Chemicals/Mary Stinson/201-340-6683
Iron and Steel Foundries/Norm Plaks/919-629-2733
Lead Storage Battery Industry/Chuck Darvin/513-684-4491
Lime/Limestone Scrubbing (Power Plants) Mike Maxwell/919-629-2578
Machinery and Mechanical Products
 Industries/George Thompson/513-684-4491
 General/Jim Dorsey/919-629-2557
 Organic Analysis/Larry Johnson/919-629-2557
 Inorganic Analysis/Frank Briden/919-629-2557
 Particulate Samples/Bruce Harris/919-629-2557
 Instrumentation/Bill Kuykendal/919-629-2557
Metal Finishing and Fabrication/George Thompson/513-684-4491
Mine Drainage (Treatment)/Roger Wilmoth/513-684-4417
Mining and Other Resource Extraction/Wayne Bloch/202-755-0647
 Ronald Hill/513-684-4410
Municipal Wastewater Research/James Basilico/202-426-4567
 John Convery/513-684-7601
Nitrogen Oxide Control/Robert Statnick/202-755-0205
 Robert Hangebrauck/919-629-2825
Nonferrous Metals/John Burckle/513-684-4491
Nonferrous Metal Mining and Beneficiation/Jack Hubbard/513-684-4417
Oil and Gas Production/Jack Farlow/201-340-6631
Oil Processing
 Petrochemicals/Dale Denny/919-629-2547
 Refineries/Dale Denny/919-629-2547
 Residual Oil/Sam Rakes/919-629-2825
Oil Shale
 Mining and Shale Handling/Disposal/Ed Bates/513-684-4417
 Retorting (Surface and In Situ)/George Huffman/513-684-4478
 Aboveground Air Pollution Control/Bob Thurnau/513-684-4363
 Aboveground Water Pollution Control/Tom Powers/513-684-4363
 In Situ Environmental Impacts/Ed Bates/513-684-4417
Oil Spills/Jack Farlow/201-340-6631
Organic and Specialty Chemicals/Atly Jefcoat/513-684-4481
Paint and Ink Formulating/Ron Turner/513-684-4481

Particle Control
Control Devices
 Electrostatic Precipitators/Lee Parks/919-629-2925
 Fabric Filters/Jim Turner/919-629-2925
 Scrubbers From Specific Sources (call appropriate industry contact)/Dennis Drehmel/919-629-2925
Paving and Roofing Materials Manufacturing/Ron Turner/513-684-4481
Pesticides Manufacturing/Dale Denny/919-629-2547
Petrochemical Manufacturing/Dale Denny/919-629-2547
Petroleum Refineries/Dale Denny/919-629-2547
Photographic Processing/Ron Turner/513-684-4481
Pulp, Paper and Wood/Mike Strutz/513-684-4227
Smelters/John Burckle/513-684-4491
Soaps and Detergents/Ron Turner/513-684-4481
Solid and Hazardous Waste Disposal/N. B. Shomaker/513-684-7871
Solid and Hazardous Waste Processing/Albert Klee/513-684-7881
Solid and Hazardous Waste Research/Gary Foley/202-426-4567
 R. L. Stenberg/513-684-7861
Steel Making/Norm Plaks/919-629-2733
Solar Energy/C. C. Lee/513-684-4481
Surfactants Manufacturing/Ron Turner/513-684-4481
Synthetic Fuel Production
 Coal Gasification
 Surface/Bill Rhodes/919-629-2851
 In Situ Underground Aspects/Ed Bates/513-684-4417
 Aboveground Aspects/Bob Thurnau/513-684-4363
 Coal Liquefaction/Bill Rhodes/919-629-2851
 Non-Coal-Based (e.g., Biomass)/Tom Powers/513-684-4363
Textile Manufacturing/Dale Denny/919-629-2547
Toxic Chemical Incineration
 At Sea/Ron Venezia/919-629-2547
 Hazardous Materials Spills Related/John Brugger/201-340-6634
 Specific Sources (call Appropriate Industry Contact)
Toxic Substances Control Technology/Paul desRossiers/202-755-9014
Transportation—Equipment Producing Industries/Chuck Darvin/513-684-4491
Transportation—Solid Fuels/John Martin/513-684-4417
Uranium Mining/Jack Hubbard/513-684-4417

Waste as Fuel
 Co-Firing and Pollution Control/Bob Olexsey/513-684-4363
 Pollutant Characterization/Harry Freeman/513-684-4363
 Pyrolysis/Wally Liberick/513-684-4363
Wastewater Research
 Urban Systems/John Smith/513-684-7611
 Storm and Combined Sewers/Richard Field/201-340-6674
 Economic Analysis/Richard Smith/513-684-7624
 Technology Development/D. F. Bishop/513-684-7628
 Treatment Process Development/Robert Bunch/513-684-7655

Research and Development Health
Air Pollutant Health Effects/Lester Grant/919-541-2266
Assessment of Reproductive Effects/Peter Voytek/202-755-3968
Cancer Biostatistics/Todd Thorslund/202-245-3039
Cancer Policy/Elizabeth Anderson/202-755-3968
Cancer Toxicology/Robert McGaughy/202-245-3039
 Dharm Singh/202-245-3039
Water Pollutant Health Effects/Lester Grant/919-541-2266

Research and Development Monitoring and Technical Support
Air Quality/Thomas Stanley/202-426-4153
Animal Physiology (Neurophysiology)/John Santolucito/702-736-2969
Aquatic Biology/Stephen Hern/702-736-2969
Atmospheric Visibility/William Malm/702-736-2969
Biological Monitoring/Bruce Wiersma/702-736-2969
Budget, Program Planning (Las Vegas)/Walter Petrie/702-736-2969
Carcinogen Field Studies/John Santolucito/702-736-2969
Chesapeake Bay Program—Quality Assurance/Werner Beckert/702-736-2969
Data Systems/Lance Wallace/202-426-2175
DOE Nuclear Testing Monitoring Programs/Richard Stanley/702-736-2969
Drinking Water/Thomas Stanley/202-426-4153
 John Winter/513-684-7325
Emergency Response/William Lacy/202-426-2387
 Phyllis Daly/202-426-2387
 Robert Holmes/202-426-2387

James Shakelford/202-426-2387
Emergency Response—Air/Thomas Hauser/919-541-2106
 Franz Burman/919-541-2106
 Walter Petrie/702-736-2969
 David McNeils/702-736-2969
Emergency Response—Water/Dwight Ballinger/513-684-7301
 Walter Petrie/702-736-2969
 David McNelis/702-736-2969
Emergency Response—Radiation/Erich Bretthauer/702-736-2969
 Walter Petrie/702-736-2969
Environmental Aerial Photography/Vernard Webb/703-557-3110
Environmental Remote Sensing Systems/John Ecert/702-736-2969
Exposure Monitoring/Lance Wallace/202-426-2175
Geothermal Geology/Hydrology/Donald Gilmore/702-736-2969
Groundwater Impacts from Energy Sources/Leslie McMillion/702-736-2969
Hazardous Wastes/John Koutsandreas/202-426-4478
Hazardous Wastes—Quality Assurance Analytical Methodology/Eugene Whittaker/702-736-2969
Integrated Exposure Assessment Modeling/Joe Behar/702-736-2969
Internal Medicine, Nuclear/Maxwell Kaye/702-736-2969
Laboratory Evaluation Procedures/Earl Whittaker/702-736-2969
Laboratory Practice Guides (Toxics)/Werner Beckert/702-736-2969
Monitoring Systems/David McNelis/702-736-2969
Oil and Hazardous Spill Remote Sensing/Robert Landers/702-736-2969
Pesticides/Charles Plost/202-426-2026
Phytoplankton Biology/William Taylor/702-736-2969
Policy/Charles Brunot/202-426-2027
Public Information (Las Vegas Lab)/Geneva Douglas/702-736-2969
Radiation/James Whitney/202-426-4478
Radiation Exposure Investigations/Maxwell Kaye/702-736-2969
Radiochemical Analytical Methods/Earl Whittaker/702-736-2969
Radiochemical Reference Materials and Methods/Loren Thompson/702-736-2969
Safety Officer (Radiation)/John Coogan/702-736-2969
Satellite and Aircraft Remote Sensing/Gary Shelton/702-736-2969
Technical Publications (Las Vegas

Lab)/Geneva Douglas/702-736-2969
Toxic Substances/Robert Medz/202-426-4727
Toxic Substances Control/Maxwell
Kaye/702-736-2969
Water Quality/Robert Medz/202-426-4727
John Kopp/513-684-7306
Wetlands System Analysis/Victor
Lambou/702-736-2969

**Research and Development Processes and
Effects**
Accounting (RI Lab)/David Hobbs/401-789-
1071
Acid Rain/Charles Powers/503-757-4672
Gary Glass/218-783-9526
Administration (FL Lab)/A. Reynolds/904-
932-5311
Administration (RI Lab)/Claire
Geremia/401-789-1071
Administration (OR Lab)/Charles
Frank/503-757-4651
ADP/Bob Payne/401-789-1071
Robert Browning/919-541-2273
Joan Novak/919-541-4545
Agriculture—Forestry Pollution/Robert
Swank/404-546-3476
Air Ecology/Larry Raniere/503-757-4622
Air Pollution Meteorology/L. E.
Niemeyer/919-541-4541
Air Quality Simulation Modeling/Kenneth
Demerjian/919-541-4545
Bruce Turner/919-541-4565
Climatology/George Holzworth/919-541-
4551
Charles Hosler/919-541-2230
Fluid Modeling/William Snyder/919-541-
2811
Meteorologic Processes/George
Holzworth/919-541-4551
Francis Pooler/919-541-2649
Model Application/Bruce Turner/919-541-
4565
Analytical Chemistry/Peter Rogerson/401-789-
1071
D. Garnas/904-932-5311
Charles Anderson/404-546-3183
Animal Production Wastes/Lynn Shuyler/405-
332-8800
Aquaculture/Bill Duffer/405-332-8800
Aquatic Weeds/G. Walsh/904-932-5311
Asbestos Analysis/Charles Anderson/404-546-
3183
Atmospheric Chemistry and Physics/A. P.
Altshuller/919-541-3795
Basil Dimitriades/919-541-2706
Aerosols—Dynamics & Kinetics/Jack
Durham/919-541-2183
William Wilson/919-541-2551

Gases—Dynamics and Kinetics/Joseph
Bufalini/919-541-2422
Basil Dimitriades/919-541-2706
Modeling—Transformation/Marcia
Dodge/919-541-2374
Kenneth Demerjian/919-541-4545
Biological Monitoring/Don Phelps/401-789-
1071
Carcinogen Research/J. Couch/904-932-5311
Characterization and Measurements Methods
Development
Air Quality/Lon Swaby/202-426-0810
Toxic Substances/Riz Hague/202-426-4256
Water Quality/Bill Sayers/202-426-0146
Chesapeake Bay Program
Eutrophication/T. Phiffer/301-266-0017
Management Studies/D. DeMoss/301-266-
0017
Research/Sam Williams/202-426-2317
Submerged Aquatic Vegetation/T.
Nugent/215-597-7943
Toxic Substances/W. Cook/301-266-0017
Chlorination Research/W. Davis/803-559-0371
Clean Lakes Research/Spence Peterson/503-
757-4716
Community Studies/M. Tagatz/904-932-5311
Complex Effluents/William Horning/513-684-
8601
Computers (FL Lab)/R. Ryder/904-932-5311
Congressional Inquiries (GA Lab)/David
Duttweiler/404-546-3134
Consent Decree/J. Lowe/904-932-5311
Consent Decree Chemicals Testing/Richard
Siefert/218-727-6692
Cooperative Testing—HERL/Robert
Drummond/218-727-6692
Corps of Engineers Coordinator/F. Wilkes/904-
932-5311
Cost-Benefit Analysis/James Falco/404-546-
3585
Criteria Documents/William Brungs/218-727-
6692
Data Processing/David Cline/404-546-3123
Ecological Effects
Air Quality/Hal Bond/202-426-2317
Freshwater/Mel Nolan/202-426-2317
Marine/Sam Williams/202-426-2317
Pesticides/Hal Bond/202-426-2317
Toxic Substances/Ken Hood/202-426-2317
Economics Research/503-757-4716
EEO Coordinator (MN Lab)/Diane Olson/218-
727-6692
EEO Coordinator (RI Lab)/Walt
Galloway/401-789-1071
Effluent Permit (Lab)/Stan Berge/401-789-1071
Energy—Fuel Processes/Dave Tingey/503-737-
4621
Energy-related Pollutants

Atmospheric Transport and Transformation/Dan Golomb/202-426-0264

Health Effects/Gerald Rausa/202-426-3975

Measurement Systems and Information Development/James Stemmie/202-426-3974

Transport, Fate and Effects/Al Galli/202-426-0288

Energy—Terrestrial/Eric Preston/502-757-4636

Exposure Assessment/H. Pritchard/904-932-5311

Extramural Program (MN Lab)/Kenneth Biesinger/218-727-6692

Extramural Research/Mary Malcolm/401-789-1071

Facilities/Robert Trippel/503-757-4680

Field Studies/William Wilson/919-541-2551 Francis Pooler/919-541-2649

Fine Particles/Phillip Cook/218-727-6692

Foreign Research Program/David Duttweiler/405-546-3134

Freedom of Information/Jan Prager/401-789-1071 Robert Ryans/404-546-3306

Freshwater Research/Thomas Maloney/503-757-4605

Great Lakes Research/Bill Sayers/202-426-0146

Groundwater Protection/Jack Kelley/405-332-8800

Groundwater Research/Steve Cordle/202-426-3974

Hazardous Materials/Earl Davey/401-789-1071

Industrial Effluent Survey/Walter Shackelford/404-546-3186

Information Services (OR Lab)/Karen Randolph/503-757-4609

Instrumentation Development/Robert Stevens/919-541-3156

Integrated Pest Management/Darwin Wright/202-426-2407

Irrigated Crop Production/J. P. Law/405-332-8800

Joint/Areawide Industrial Wastes/Marvin Wood/405-332-8800

Laboratory and Facilities Management/Richard Latimer/401-789-1071

Laboratory Safety and Health/William Donaldson/404-546-3430

Land Disposal/Jeff Lee/503-757-4758

Land Treatment/Curtis Harlin/405-332-8800

Large Lakes Research/Wayland Swain/313-675-5000

Library (FL Lab)/A. Lowry/904-932-5311

Library (OR Lab)/Betty McCauley/503-757-4731

Library (RI Lab)/Rose Ann Gamache/401-789-1071

Management & Administration (RTP)
Administration/Gloria Koch/919-541-2331
Management/A. P. Altshuller/919-541-3795 Alfred Ellison/919-541-2191
Program Planning/Charles Hosler/919-541-2230
Technical Information/Charles Hosler/919-541-2230

Marine Biological Systems/Richard Swartz/503-757-4031

Marine Research (General)/Donald Baumgartner/503-757-4722

Marine Transport and Transformation/Robert Brice/503-757-4709

Master Analytical Scheme for Organics in Water/Wayne Garrison/404-546-3453

Mathematical Modeling/T. Davies/803-559-0371 Lee Mulkey/404-546-3581 Lawrence Burns/404-546-3148

Microcosms/Ken Perez/401-789-1071

Microcosm Studies/Steven Hedtke/513-684-8601

Monticello Field Studies/John Arthur/612-295-5145

Multi-element Analysis/Thomas Hoover/404-546-3524

National Crop Loss Assessment Network (Air)/Ray Wilhour/503-757-4634

Nonpoint Source Control Technology/Robert Swank, Jr./404-546-3476

Nonpoint Source Pollution/Jack Gakstatter/503-757-4611

Offshore Drilling (Oils, Gases and Muds)/N. Richards/904-932-5311

Oil and Hazardous Substances/W. Davis/803-559-0371

Oil Spill Assessment/Bob Payne/401-789-1071

Organic Chemical Identification/John McGuire/404-546-3185

OTS Testing and Methods Evaluation/Richard Siefert/218-727-6692

PCB, Structure Activity and ISHOW/Gilman Veith/218-727-6692

Pesticides/Jay Gile/503-757-4644

Pesticides Exposure Assessment/Riz Hague/202-426-4256

Pesticides Programs/John Eaton/218-727-6692

Petrochemical Production Wastes/Tom Short/405-332-8800

Petroleum Refining Wastes/Leon Myers/405-332-8800

Pollutant/Emission Characterization/Jack Wagman/919-541-3009 Ambient Air/William Wilson/919-541-2551 Mobile Sources/Ronald Bradow/919-541-3037 Francis Black/919-541-3037

Stationary Sources/Kenneth Knapp/919-541-3085
James Homolya/919-541-3085
Pollutant Transport and Transformation in Soil and Water/George Baughman/404-546-3145
Program Operations (RI Lab)/Stan Hegre/401-789-1071
Public Health Initiative/H. Pritchard/904-932-5311
Public Technical Information/Robert Ryans/404-546-3306
Quality Assurance/Zell Steever/401-789-1071
Radioisotopes/Eugene Jackin/401-789-1071
Renewable Resources (Water Quality)/Will LaVeille/202-426-2407
Research Program Administration (GA Lab)/Connie Shoemaker/404-546-3122
Rural Land Use Research/George Bailey/404-546-3307
Safety Officer (RI Lab)/Richard Latimer/401-789-1071
Safety Officer (MN Lab)/Fred Freeman/218-727-6692
Sampling and Analytical Techniques/Andrew O'Keefe/919-541-2408
 Carbon Fibers, Asbestos/Jack Wagman/919-541-3009
 Inorganics/Robert Stevens/919-541-3156
 Networks/J. C. Romanovsky/919-541-2887
 Organics/James Mulik/919-541-3064
 Remote Sensing/William Herget/919-541-3034
Screening Committee/N. Cooley/904-932-5311
Statistical Analyst/Robert Andrew/218-727-6692
Subsurface Transport of Pollutants/Bill Dunlap/405-332-8800
Technical Assistance/Jan Prager/401-789-1071
William Brungs/218-727-6692
Technical Information Coordinator, Public Information Office and Health Officer (MN Lab)/Evelyn Hunt/218-727-6692
Terrestrial Research/Norman Glass/503-757-4671
Toxicology/Jack Gentile/401-789-1071
Toxicology (Fresh-water)/Ron Garton/503-757-4735
Toxic Round-Robin (Effects)/S. Schimmel/904-932-5311
Toxics (Terrestrial)/James Gillett/503-757-4624
Toxic Substances Monitoring Programs/William Donaldson/404-546-3430
Toxic Substances Risk Assessment/James Falco/404-546-3585
Transport and Fate of Pollutants
 Air Quality/Deran Pashayan/202-426-2415
 Toxic Substances/Riz Hague/202-426-4256
 Water Quality/Harry Torno/202-426-0810

Water Quality Criteria/Jack Gentile/404-789-1071
D. Hansen/904-932-5311
Water Quality Research/Walter Sanders, III/404-546-3171
Watershed Management/Lee Mulkey/404-546-3581
Wetlands/Hal Kibby/503-757-4713

Solid Waste
Administrative/Personnel/Becky Kennedy/202-755-2783
Agency Guidance/Denise Hawkins/202-755-9173
Agricultural Wastes/Kent Anderson/202-755-9125
Air Emissions from Hazardous Waste Facilities/Howard Beard/202-755-9203
Audiovisual/Graphics/Miles Allen/202-755-9157
Budget/Denise Hawkins/202-755-9157
Co-Disposal/David Sussman/202-755-9140
Congressional Correspondence/Henry Norton/202-755-9120
Data/ADP Systems/Essie Horton/202-755-9150
Disposal Facility Safety/Karen Waag/202-755-9128
Disposal Facility Standards S.004/Tim Fiels/202-755-9206
Economic Impacts (Subtitles C & D)/Michael Shannon/202-755-9190
Economics/Frank Smith/202-755-9140
Environmental Impact Statements/202-245-3006
Equivalence of State Programs/Sam Morekas/202-755-9145
Facility Permits S.3005/Arthur Galzer/202-755-9150
Facility Siting/Public Acceptance/Andrea Edelman/202-755-9187
Federal Procurement Guidelines/John Heffelfinger/202-755-9206
Financial Responsibility S. 3004/Ronn Dexter/202-755-9190
Flammability and Corrosion Tests/Chet Ozmar/202-755-9163
Generator Standards S. 3002/Harry Trask/202-755-9150
Groundwater Monitoring/Larry Graves/202-755-9116
Groundwater Policy/Barry Stoll/202-755-9116
Hazardous Waste Basins/Robert Holloway/202-755-9204
Hazardous Waste Characteristics (Chemical)/Donn Viviani/202-755-9187
Hazardous Waste Characterization S. 3001/Alan Corson/202-755-9187
Hazardous Waste Incineration and Recycling Facilities/Howard Beard/202-755-9203

Hazardous Waste Land Disposal/Kenneth Shuster/202-755-9125

Hazardous Waste Listing S. 3001/Matt Strauss/202-755-9187

Hazardous Waste State Program Relations/Ernest Pappajohn/202-755-9145

Industry—Specific Analyses/Jan Auerbach/202-755-9203

International Activities/Elizabeth Cotsworth/202-755-9173

Landfill (METBASE) Gas/Chris Rhyne/202-755-9125

Legal Issues/Anne Allen/202-755-9173

Legislation/Anne Allen/202-755-9173

Liner Technology/Allen Geswein/202-755-9120

Loadfarming S. 3004/Larry Weiner/202-755-9125

Materials Recovery/Source Separation/Charles Miller/202-755-9140

Notification System S. 3010/Harry Trask/202-755-9150

Open Dump Inventory (data)/Martha Madison/202-755-9145

Pesticide Containers Disposal (FIFRA S. 196)/John Knobe/202-755-9145

Polychlorinated Biphenyls—Site Approvals/Arthur Galzer/202-755-9150

Postclosure/Ronn Dexter/202-755-9190

Press Activities/Emily Sano/202-755-8987

Programs Plans/Tony Diecidue/202-755-9173

Publications/Kathy Walters/202-755-9153

Public Education Grants/Gladys Harris/202-755-9157

Public Information/Carol Lawson/202-755-9160

Public Participation/Gerri Wyer/202-755-9157

Resource Conservation and Recovery Act Financial Assistance/Denise Hawkins/202-755-9173

Resource Conservation and Recovery Act Guidance/Truett DeGeare/202-755-9120

Resource Conservation Committee/Frank Smith/202-755-9140

Resource Recovery Planning and Implementation/Steven Levy/202-755-9140

Resource Recovery Technology Evaluations/Dave Sussman/202-755-9140

S. 3001 Criteria/Matt Strauss/202-755-9187

S. 3011 State Grants/Daniel Derkies/202-755-9145

S. 4004 Sanitary Landfill Criteria/Kenneth Shuster/202-755-9125

S. 4008 State Grants/Penny Hansen/202-755-9145

Sludge Regulations/Emery Lazar/202-755-9125

Special Wastes/Jan Auerbach/202-755-9203

State Authorization (Subtitle C)/Sam Morekas/202-755-9145

State—EPA Agreements/Penny Hansen/202-755-9145

State Planning for Resource Recovery/David Gavrich/202-755-9140

State Planning Guidelines (Subtitle D)/Susah Absher/202-755-9150

State Program Assessment (Subtitle D)/Marthan Madison/202-755-9145

Surface Impoundment Technology/Allen Geswein/202-755-9120

Technical Assistance Panels/John Thompson/202-755-9140

Technology Assessment/Jan Auerbach/202-755-9203

Transporter Standards S. 3003/Carolyn Barley/202-755-9145

Urban Policy Grants/Steven Leiry/202-755-9140

User Changes/George Garland/202-755-9190

Waste Analyses and Tests (Biological)/David Friedman/202-755-9163

Waste Exchange/Rolf Hill/202-755-9145

Waste Oil (EPCA S. 383)/Howard Beard/202-755-9203

State—EPA Agreements/Penny Hansen/202-755-9145

Toxic Substances and Pesticides

Animal Sciences/William Phillips/703-557-7399

Applicator Training Certification/Andrew Caraker/202-755-0357

Association of American Pesticides Control Officials Inc./State FIFRA Issues Evaluation Group Liaison/Philip Gray/202-427-9400

Biological Investigation/Robert Jasper/301-344-2187

Chemical Information/Bruno Vasta/202-755-5687

Congressional Inquiries/Susan Sherman/202-755-8020

Control Action/Cindy Kelly/202-755-0920

Disinfectants/Reto Engler/202-426-2680

Ecological Monitoring/Frederick Kutz/202-755-8060

Economic Analysis/Cost Benefit Evaluation/Arnold Aspelin/703-557-7327

Emergency Exemptions/Patricia Critchlow/202-426-0223

Environmental Hazards/Clayton Bushong/202-426-2610

Epidemiologic Studies/Jack Griffith/703-472-9310

Experimental Use Permits/Herbert Harrison/202-755-4851

Exposure Analysis and Environmental Fate Profiles/Gunter Zweig/703-557-7347

Federal Agency Certification Programs/John MacDonald/202-755-0356

Freedom of Information/Charles Colledge/202-426-8850

Health Effects/Richard Hill/202-755-4363

Health Review/Joseph Nash/202-426-2532

Herbicides and Fungicides/James Akerman/202-426-2690

Indian Certification Programs/Andrew Caraker/202-755-0357

Industrial Assistance/John Ritch/202-755-3852

Insecticides and Rodenticides/Herbert Harrison/202-755-4851

Intergrated Pest Management/Charles Reese/202-472-9327

Labeling and Standards/Jean Frane/202-426-2510

Laboratory Studies/Warren Bontoyan/301-344-2266

Monitoring/Martin Halper/202-755-8060

Nitrosamines/Tom Miller/703-557-7400

Pesticide Applicator Training/William Currie/703-557-7485

Pesticide Classification/Walter Waldrop/202-755-8025

Pesticide Disposal/Raymond Krueger/202-755-8023

Pesticide Incidents/Frank Davido/202-426-2535

Pesticide Policy Questions/Maureen Grimmer/202-755-8036

Plant Studies/Thomas Burkhalter/703-557-2242

Policy Analysis & Management/Lillian Regelson/202-755-4871

Policy Questions (General OPP)/Edwin Johnson/202-755-8033

Premanufacturing Review/Blake Biles/202-426-8815

Program Development and Evaluation/Louis True/202-426-9033

Public Education and Communication/George Beshore/202-472-9400

Rebuttable Presumption Against Registration (RPAR) Procedures/Marcia Williams/703-557-7438

Registration—General Policy/Douglas Campt/202-426-2451

Registration Guidelines/William Preston/703-557-1405

Residue Chemistry/Joseph Cummings/202-426-2610

Science Advisory Panel/H. Wade Fowler/703-557-7560

Science Policy/Richard Hill/202-755-4363

Special Local Needs Registration (24(c))/Herbert Harrison/202-755-4851

Supervisory Policy Development Specialist/Bruno Vasta/202-755-5687

System Support/Elgin Fry/202-426-8862

Tolerances/Jesse Mayes/202-426-8815

Toxicology Data Audits/Diana Reisa/703-557-9733

Water Quality

Areawide Publications/Tammy Phillips/202-755-6993

Asbestos Coordinator/Robert Carton/202-755-0300

Clean Lakes/Bob Johnson/202-426-3400

Clean Water Report to Congress/Peter Wise/202-426-2474

Coastal Zone Management Act/202-245-3054

Construction Cost Indexes/Bob Michel/202-426-4443

Early Warning/Mark Cohen/202-755-2887

Economics of Clean Water/Courtney Riordan/202-426-0803

Enforcement (Water)/Brian Molloy/202-755-8731

Estuaries/Jonathan Amson/202-245-3036

Eutrophication/David Flamer/202-426-2317

Facility Plan Requirements/Mike Cook/202-426-9404

Feedlots/Don Anderson/202-426-2707

Fishkills/Ed Biernacki/202-426-7774

Hazardous & Toxic Substances/A. Torsey/202-245-3036

Land Treatment/Dick Thomas/202-426-8976

Manpower & Training/Ken Hay/202-426-8708

Marine Protection/Al Wastler/202-245-3051

Mine Acid Operations/Bill Telliard/202-426-2727

Mine Acid Research/Carl Schafer/202-755-9014

Minority Business Enterprise/John Pai/202-426-8976

Multi-Purpose Projects/Myron Tiemans/202-755-8056

Municipal Construction Grants/Harold Cahill/202-426-8986

Municipal Wastewater Inventory/Jim Chamblee/202-426-4443

Needs Survey Guidance Facilities Planning/Jim Chamblee/202-426-4443

Ocean/William Geller/202-245-3054

Ocean, Secondary Treatment, BPT, Disinfection/Alan Hais/202-426-8976

Operator Certification/Bob Rose/202-426-8705

Pretreatment Systems/Ron DeCesare/202-426-8945

Publications/Bernita Starks/202-426-1744

Research and Development/Joel Fisher/703-577-7720

Research and Development Publications/Linda Smith/202-755-0648

Salt/Frank Condon/202-426-3975

Sewer System Evaluation/Alan Hais/202-426-8976

Sludge/Al Cassel/202-426-8976

Small Community Wastewater Treatment Systems/Keith Dearth/202-426-9404

State Delegation Agreements/Al Pelmoter/202-

426-8945
State Priority Lists/Mike Cook/202-426-9404
Technical Transfer/Michek Herzner/513-684-7394
Thermal Effluent Guidelines/John Lum/202-426-2586
Toxic Publications/Joni Repasch/202-755-1188
Toxic Spills/Hans Crump/202-245-3045
Training Grants/Ben Gryctko/202-426-3971
Urban Runoff/Dennis Athayde/202-245-3154
Waste Oil/Joe Kaivak/202-755-7000
Waste Oil Nonpoint Sources/Carl Myers/202-755-4911
Water Quality Criteria/Dave Sabock/202-245-3042
Water Quality Management/Merna Hurd/202-755-6928
Water Quality Standards/Dave Sabock/202-245-3030
Wetlands/Bill Davis/202-472-3400

Area Code/Address

201	Edison NJ
202	Washington DC
206	Seattle WA
212	New York NY
214	Dallas TX
215	Philadelphia PA
218	Duluth MN
301	Annapolis MD
303	Denver CO
312	Chicago IL
313	Ann Arbor MI
	Gross Ile MI
401	Narragansett RI
404	Athens GA
	Atlanta GA
405	Ada OK
415	San Francisco CA
503	Corvallis OR
513	Cincinnati OH
612	Monticello MN
617	Boston MA
702	Las Vegas NV
703	Arlington VA
803	Charleston SC
816	Kansas City MO
904	Gulf Breeze FL
919	Durham NC
	Research
	Triangle Park NC

Major Sources of Information

Air Quality Planning and Standards

This office provides guidelines and technical assistance for air quality planning, monitors air pollution trends, sets standards for new-source emissions and hazardous pollutants. Contact: Air Quality Planning and Standards, Office of Air, Noise and Radiation, Environmental Protection Agency, Research Triangle Park, NC 27711/919-541-5315.

Automatic Bidder Mailing List System

A centralized system for organizing and maintaining a list of bidders and offerors identifies program element codes and vendor name sources for recurring types of EPA requirements such as basic research, applied research, development, abatement and control, and enforcement. Contact: Procurement and Contracts Management Division, Environmental Protection Agency, 401 M St. S.W., Room M2003, Washington, DC 20460/202-755-0822.

Chemical Control

This office plans, operates and evaluates the Agency's work in controlling toxic substances other than pesticides. Contact: Chemical Control Division, Office of Toxic Substances, Environmental Protection Agency, Room 509, 401 M St. S.W., Washington, DC 20460/202-462-9000.

Clean Lakes

The clean lakes program grants awards related to the restoration of water quality and the prevention of the deterioration of water quality in lake waters. Contact: Clear Lakes Program, Criteria and Standards Division, Office of Water Program Operations, Environmental Protection Agency, Room M2818, 401 M St. S.W., Washington, DC 20460/202-472-3400.

Common Environmental Terms

This excellent little handbook is an alphabetic dictionary of terms. Contact: Office of Public Awareness, Environmental Protection Agency, 401 M St. S.W., Washington, DC 20460/202-755-0717.

Dredge and Fill Disposal

The dredge and fill disposal program is a system through which the Environmental Protection Agency, the Army Corps of Engineers and the individual states control the disposition of various dredge and fill materials which may, if dispersed in natural water, have deleterious effects on aquatic organisms. Contact: Dredge and Fill Disposal, Office of Water Program Operations, Environmental Protection Agency, Room E1209, 401 M St. S.W., Washington, DC 20460/202-426-8856.

Drinking Water Information

The Environmental Protection Agency maintains an information program on drinking water. It also develops plans to handle water emergencies. Contact: Technical Support Division, Water and Waste Management, Environmental Protection Agency, 5555 Ridge Ave., Cincinnati, OH 45268/513-684-7601.

Drinking Water Programs

This office develops standards, rules and guidelines for maintaining the quality of public drinking water supplies. For further information, contact: Office of Water and Waste Management, Environmental Protection Agency, Room 1101, 401 M St. S.W., Washington, DC 20460/202-426-8347.

Economic Analysis

Analyses of the economic and industrial impacts of pollution control regulations on industries and geographic areas are available. Contact: Economic Analysis Division, Office of Planning and Evaluation, Environmental Protection Agency, Room M3002, 401 M St. S.W., Washington, DC 20460/202-287-0700.

Effluent Guidelines

The Environmental Protection Agency defines limiting levels of pollutants in the waste streams of industrial and municipal point sources. Contact: Effluent Guidelines Division, Water and Waste Management, Environmental Protection Agency, Room E913, 401 M St. S.W., Washington, DC 20460/202-426-2576.

Enforcement

This office directs enforcement activities for the Agency's stationary source, pesticides, toxic substances and solid waste programs. For further information, contact: General Enforcement, Office of Enforcement, Environmental Protection Agency, WSMW Room 1111, 401 M St. S.W., Washington, DC 20460/202-755-2977.

Environmental and Engineering Technology

This office develops and assesses methods to control the environmental and economic effects of energy production, mineral extraction and processing, industrial operations, municipal wastewater treatment, solid waste disposal and drinking water treatment. Contact: Environmental Engineering and Technology, Office of Research and Development, Environmental Protection Agency, Room 635. 401 M St. S.W., Washington, DC 20460/202-755-2600.

Environmental Education Programs

The Environmental Protection Agency develops environmental education programs for both graduate and postgraduate courses and training programs. The areas of study include wastewater, drinking water, air, noise, pesticides and toxicology, solid waste, radiation, energy, environmental science, engineering and technology programs. Also available are Federal Education Programs with potential for providing technical or financial assistance to students in environmental studies. Contact: National Workforce Development Staff, Office of Research and Development, Environmental Protection Agency, Room 3801, 401 M St. S.W., Washington, DC 20460/202-755-2937.

Environmental Events Calendar

This calendar lists conferences, meetings, conventions, workshops, seminars, government actions or other events that deal with the environment. For contributions or information, contact: Environmental Constituency Specialist, Office of Public Awareness, Environmental Protection Agency, Room W313C, 401 M St. S.W., Washington, DC 20460/202-755-0736.

Environmental Impact Statements

This office oversees the review of environmental impact statements, the preparation of Environmental Protection Agency impact statements and environmental problems of federal and federally supported activities. Contact: Office of Environmental Review, Environmental Protection Agency, Room 2119, 401 M St. S.W., Washington, DC 20460/202-755-0777.

Environmental Processes and Effects Research

This office develops scientific and technological methods and data to predict and manage the entry, movement and fate of pollutants in the environment and the effects of pollutants on ecological systems. Contact: Environmental Processes and Effects Research, Office of Research and Development, Environmental Protection Agency, Room 3702, 401 M St. S.W., Washington, DC 20460/202-426-0803.

EPA Journal

This journal provides information on national environmental developments involving the Environmental Protection Agency. It also has feature articles on environmental developments, news briefs, reviews of recent major EPA activities in the pollution control program areas. It is published 10 times per year for the subscription price of $10, and is available from: Office of Public Awareness, Environmental Protection Agency, 401 M St. S.W., Washington, DC 20460/202-755-0736.

Finding Your Way Through EPA

This is a free EPA directory listing the offices of the agency and the people in them. A subject index, the agency organizational chart, a map of EPA's 10 regional offices, and brief descriptions of EPA's major programs are also included. Contact: EPA Printing Management Office, Environmental Protection Agency, Room 215, 401 M St. S.W., Washington, DC 20460/202-755-0890.

Freedom of Information Requests

For Freedom of Information Act requests, contact: Freedom of Information Officer, Environmental Protection Agency, Room W1132, 401 M St. S.W., Washington, DC 20460/202-755-2764.

Grants

The programs described below are for sums of money which are given by the federal government to initiate and stimulate new or improved activities or to sustain on-going service:

Air Pollution Control Manpower Training Grants

Objectives: To develop career-oriented personnel qualified to work in pollution abatement and control. Grants are awarded to assist in planning, implementing and improving environmental training programs; increase the number of adequately trained pollution control and abatement personnel; upgrade the level of training among state and local environmental control personnel; and bring new people into the environmental control field.

Eligibility: Training grants are awarded to nonprofit academic institutions in the United States and territories. Traineeships are awarded to individuals by these grantee educational institutions. Trainees may be employees of state or local governmental air pollution control agencies and others who desire a career in governmental air pollution control work.

Range of Financial Assistance: $6,000 to $80,000.

Contact: Control Programs Development Division, Office of Air Quality Palnning and Standards, Office of Air, Noise, and Radiation, Environmental Protection Agency, Research Triangle Park, NC 27711/919-541-2401.

Air Pollution Control Program Grants

Objectives: To assist state, municipal, intermunicipal and interstate agencies in planning, developing, establishing, improving and maintaining adequate programs for prevention and control of air pollution or implementation of national primary and secondary air quality standards.

Eligibility: Any municipal, intermunicipal, state or interstate agency with legal responsibility for appropriate air pollution planning and control is eligible for grant support provided such organization furnishes funds for the current year in excess of its expenditures for the previous year for its air pollution program. This program is available to each state, territory and possession of the United States, including the District of Columbia.

Range of Financial Assistance: $7,025 to $6,449,000.

Contact: Control Programs Development Division, Office of Air Quality Planning and Standards, Office of Air, Noise, and Radiation, Environmental Protection Agency, Research Triangle Park, NC 27711/919-688-8146, ext.226.

Air Pollution Control Research Grants

Objectives: To support and promote research and development projects relating to the causes, effects, extent, prevention and control of air pollution.

Eligibility: This program is available to each state, territory and possession of the United States, including the District of Columbia, for public, private, state universities and colleges, hospitals, laboratories, state and local health departments, and other public or private nonprofit institutions. Grants may also be awarded to individuals who have demonstrated unusually high scientific ability. Profit-making organizations are not eligible.

Range of Financial Assistance: $5,900 to $440,000.

Contact: Air Pollution Control, Office of Research Program Management, RD-674, Environmental Protection Agency, Washington, DC 20460/202-755-8787.

Construction Grants for Wastewater Treatment Works

Objectives: To assist and serve as an incentive in construction of municipal sewage treatment works which are required to meet state and federal water quality standards.

Eligiblity: Any municipality, intermunicipal agency, state or interstate agency having jurisdiction over waste disposal. This program is available to each state, territory and possession of the United States, including the District of Columbia.

Range of Financial Assistance: $675 to $290,800,000.

Contact: Director, Municipal Construction Division, WH-547, Office of Water Programs Operations, Environmental Protection Agency, Washington, DC 20460/202-426-8986.

Construction Management Assistance Grants

Objectives: To assist and serve as an incentive in the process of delegating to the states a maximum amount of authority for conducting day-to-day matters related to the management of the construction grant program. An overriding goal is to eliminate unnecessary duplicative reviews and functions.

Eligibility: State Water Pollution Control Agency, or other agency designated by the governor in any state, territory and possession of the United States, including the District of Columbia.

Range of Financial Assistance: $3,927,000 to $16,118,000.

Contact: Chief, Program Policy Branch, Municipal Construction Division, WH-547, Office of Water Programs Operations, Environmental Protection Agency, Washington, DC 20460/202-426-8820.

Environmental Protection Consolidated Grants-Program Support

Objectives: To enable states to coordinate and manage environmental approaches to their pollution control activities. Consolidated grants are alternate grant delivery mechanisms. These mechanisms provide for consolidation into one grant instrument those grants awarded separately to states for management of environmental protection activitites including but not limited to air pollution control, water pollution control and solid waste management.

Eligibility: Any state-designated entity eligible to receive and administer funds made available through the applicable statutory authorizations.

Range of Financial Assistance: Not specified.

Contact: Grants Administration Division, PM-216, Environmental Protection Agency, Washington, DC 20460/202-755-2896.

Environmental Protection Consolidated Grants-Special Purpose

Objectives: To provide an alternate grant mechanism which will consolidate into one grant instrument grants awarded separately for specific and definite environmental protection activities.

Eligibility: Any entity eligible to receive and administer funds made available through the applicable statutory authorizations.

Range of Financial Assistance: $39,000 to $740,000.

Contacts: Grants Administration Division, PM-216, Environmental Protection Agency, Washington, DC 20460/202-755-2896.

Environmental Protection—Consolidated Research Grants

Objectives: To support reserach to determine the environmental effects and hence the control requirements associated with energy; to identify, develop and demonstrate necessary pollution control techniques; and to evaluate the economic and social consequences of alternative strategies for pollution control of energy systesms. To support research to explore and develop strategies and mechanisms for those in the economic, social, governmental and environmental systems to use in environmental management.

Eligibility: This program is available to each state, territory, and possession of the United States, including the District of Columbia, for public and private state universities and colleges, hospitals, laboratories, state and local government departments, and other public or private nonprofit institutions and individuals who have demonstrated unusually high scientific ability.

Range of Financial Assistance: $10,000 to $504,283.

Contact: Office of Research and Development, Environmental Protection Agency, Washington, DC 20460/20255-8787.

Pesticides Control Reserach Grants

Objectives: To support and promote the coordination of research projects relating to human and ecological effects from pesticidies, pesticide degradation products, and alternatives to pesticides.

Eligibility: This program is available to each state, territory and possession of the United States, including the District of Columbia, for public or private state colleges and universities, state and local governments, and individuals.

Range of Financial Assistance: $20,000 to $3,000,000.

Contact: Office of Research Program Management, RD-674, Office of Research and Development, Environmental Protection Agency, Washington, DC 20460/202-755-8787.

Pesticides Enforcement Program Grants

Objectives: 1) to assist states in developing and maintaining comprehensive pesticide enforcement programs; 2) sponsor cooperative surveillance, monitoring and analytical procedures, 3) avoid duplication of effort, and 4) encourage regulatory activities within the states.

Eligibility: State agencies having pesticide enforcement responsibilities in each state, territory and possession of the United States, including the District of Columbia, and Indian tribes.

Range of Financial Assistance: $10,000 to $1,258,052.

Contact: Director, Pesticides and Toxic Substances Enforcement Division, EN-342, Environmental Protection Agency, Washington, DC 20460/202-755-0970.

Quiet Communities—States and Local Capacity Building Assistance

Objectives: To promote the development of effective state and local noise control programs, by identifying noise problems and establishing or augmenting a noise control capability in such jurisdictions.

Eligibility: The program is available to states and communities in each state, territory and possession of the United States, the District of Columbia, authorized regional planning agencies, state and local environmental protection or pollution control agencies and other appropriate state, regional and local authorities.

Range of Financial Assistance: $10,000 to $50,000.

Contact: Director, State and Local Programs Division, Office of Noise Abatement and Control, Environmental Protection Agency, Washington, DC 20460/202-557-7600.

Safe Drinking Water Research and Demonstration Grants

Objectives: To conduct research relating to the causes, diagnosis, treatment, control and prevention of physical and mental diseases and other impairments of man resulting directly or indirectly from contaminates in water or to the provision of a dependably safe supply of drinking water. Development and demonstration of any project which will demonstrate a new or improved method, approach or technology for providing a dependably safe supply of drinking water to the public or which will investigate and demonstrate health implications involved in the reclamation, recycling and reuse of waste waters for drinking and/or the preparation of safe and acceptable drinking water.

Eligibility: This program is available to each state, territory and possession of the United States, including the District of Columbia, for public, private state colleges and universities, public agencies, state and local governments, other organizations and individuals. Profit-making organizations are not eligible.

Range of Financial Assistance: $2,256 to $378,243.

Contact: Office of Research Program Management, RD-674, Office of Research and Development, Environmental Protection Agency, Washington, DC 20460/202-755-8787.

Solid and Hazardous Waste Management Program Support Grants

Objectives: To assist state, interstate, regional, county, municipal, and intermunicipal agencies, authorities and organizations in the development and implementation of state and local programs and to support rural and special communities in programs and projects leading to the solution of solid waste management problems and the control of solid waste management systems.

Eligibility: State and substate solid waste agencies, authorities and organizations. State includes the 50 states, the District of Columbia, the Commonwealth of Puerto Rico, the Virgin Islands, Guam, American Samoa, and the Commonwealth of the Northern Mariana Islands.

Range of Financial Assistance: $71,500 to $1,318,200.

Contact: Grants Administration Division, PM-216, Environmental Protection Agency, Washington, DC 20460/202-755-9113.

Solid Waste Disposal Research Grants

Objectives: To support and promote the coordination of research and development in the area of collection, storage, utilization, salvage or final disposal of solid waste.

Eligibility: This program is available to each state, territory and possession of the United States, including the District of Columbia, for public or private agencies, public, private, state universities and colleges, state and local governments, and individuals. Profit-making organizations are not eligible.

Range of Financial Assistance: $9,977 to $216,881.

Contact: Office of Research Program Management, RD-674, Office of Research and Development, Environmental Protection Agency, Washington, DC 20460/202-755-8787.

Solid Waste Management Demonstration Grants

Objectives: To promote the demonstration and application of solid waste management and resource recovery technologies and systems which preserve and enhance the quality of the environment and conserve resources, and to conduct solid waste management and resource recovery studies, investigations and surveys.

Eligibility: State, interestate, municipal, intermunicipal, or other public authorities and agencies; public or private, colleges and universities, and private nonprofit agencies and institutions.

Range of Financial Assistance: Not specified.

Contact: Office of Solid Waste (WH-562), Environmental Protection Agency, Washington, DC 20460/202-755-9160.

Solid Waste Management Training Grants

Objectives: To assist grantees in developing, expanding or carrying out a program for training persons in the management, supervision, design, operation or maintenance of solid waste management systems, technologies, and facilities; for training instructors and supervisory personnel in the field of solid waste management; for the con-

duct of technical and public information and education programs.

Eligibility: State or interstate agency, municipality; public or private colleges and universities.

Range of Financial Assistance: $8,000 to $1,000,000.

Contact: Office of Solid Waste, WH-562, Environmental Protection Agency, Washington, DC 20460/202-755-9160.

State Public Water System Supervision Program Grants

Objectives: To foster development of state program plans and programs to assist in implementing the Safe Drinking Water Act.

Eligibility: State agencies designated by the Governor or Chief Executive Officer of one of the states of the United States, the District of Columbia, the Commonwealth of Puerto Rico, the Northern Mariana Islands, the Virgin Islands, Guam, American Samoa, or the Trust Territory of the Pacific Islands.

Range of Financial Assistance: $98,200 to $1,970,000.

Contact: Office of Drinking Water, Office of Water and Waste Management, Environmental Protection Agency, Washington, DC 20460/202-472-4152.

State Toxic Substances Control Programs

Objectives: To establish and operate program to prevent or eliminate unreasonable risks associated with chemical substances and with respect to which EPA is unable or unlikely to take action under the Toxic Substances Control Act.

Eligibility: States, the District of Columbia, the Commonwealth of Puerto Rico, the Virgin Islands, Guam, the Canal Zone, American Samoa, the Northern Mariana Islands, and other territories and possessions of the United States.

Range of Financial Assistance: $100,000 to $500,000.

Contact: Program Integration Division (TS-793), Office of Program Integration and Information, Office of Toxic Substances, Washington, DC 20460/202-382-3813.

State Underground Water Source Protection Program Grants

Objectives: To foster development and implementation of underground injection control programs under the Safe Drinking Water Act.

Eligibility: State agencies designated by the Governor or Chief Executive Officer of one of the states of the United States, the District of Columbia, the Commonwealth of Puerto Rico, the Northern Mariana Islands, the Virgin Islands, Guam, American Samoa, or the Trust Territory

of the Pacific Islands, which has been listed by the EPA Administrator as a state requiring an Underground Injection Control Program.

Range of Financial Assistance: Not specified.

Contact: Chief, Ground Water Protection Branch, Office of Drinking Water, Office of Water and Waste Management, Environmental Protection Agency, Washington, DC 20460/202-426-3934.

Toxic Substances Research Grants

Objectives: To support and promote coordination of research projects relating to the effects, extent, prevention and control of toxic chemical substances or mixtures.

Eligibility: This program is available to each state, territory and possession of the United States, including the District of Columbia, public or private state universities and colleges, hospitals, laboratories, state and local government departments, other public or private nonprofit institutions and individuals who have demonstrated unusually high scientific ability.

Range of Financial Assistance: $15,370 to $305,000.

Contact: Office of Research Program Management, RD-674, Office of Research and Development, Environmental Protection Agency, Washington, DC 20460/202-755-8787.

Water Pollution Control Fellowships

Objectives: To provide technical and professional training for state and local water pollution control agency personnel; to encourage and promote the specialized training of individuals as practitioners in water pollution abatement and control.

Eligibility: All applicants for fellowships under this part must be 1) citizens of the United States, its territories, or possessions, or lawfully admitted to the United States for permanent residence, and 2) accepted by an accredited educational institution for full or part-time enrollment for academic credit in a study program which directly relates to water pollution abatement and control.

Range of Financial Assistance: $250 to $6,000.

Contact: Liaison Office, Office of Water Program Operations, Environmental Protection Agency, Washington, DC 20460/202-426-3971.

Water Pollution Control—Lake Restoration Demonstration Grants

Objectives: To establish the trophic status of a state's publicly owned fresh water lakes and support and promote the coordination and acceleration of demonstration and evaluation projects relating to the causes, effects, extent, prevention, reduction and elimination of water pollution in

publicly owned freshwater lakes.

Eligiblity: By statute, state agencies only. However, through written interagency agreements, funds may be passed through to city and county governments or other locally and municipally constituted authorities. The program is available to each state, territory and possession of the United States, including the District of Columbia.

Range of Financial Assistance: $11,710 to $3,500,000.

Contact: Criteria and Standards Division, Office of Water Planning and Standards, Office of Water and Waste Management, Environmental Protection Agency, Washington, DC 20460/202-755-0100.

Water Pollution Control—Professional Training Grants

Objectives: To improve training and education for professional and scientific water environmental programs and to increase the number of adequately trained water pollution control and abatement personnel.

Eligibility: This program is available to students in 28 schools, as approved by OMB and EPA, which were active at the termination date of the program which originally was June 1976.

Range of Financial Assistance: Average $7,000.

Contact: Deputy Chief, Manpower Planning and Training Branch, Municipal Operations and Training Division, Office of Water Program Operations, Environmental Protection Agency, Washington, DC 20460/202-755-6928.

Water Pollution Control—Research, Development and Demonstration Grants

Objectives: To support and promote the coordination and acceleration of research, development, and demonstration projects relating to the causes, effects, extent, prevention, reduction and elimination of water pollution.

Eligibility: This program is available to each state, territory and possession of the United States, including the District of Columbia, for public, private, state, and community universities and colleges, hospitals, laboratories, state water pollution control agencies, interstate agencies, state and local governments, other public or private nonprofit agencies, institutions or organizations; grants may also be awarded to individuals who have demonstrated unusually high scientific ability. Grants under certain section of this law may be awarded to profit-making organizations.

Range of Financial Assistance: $5,000 to $7,000,000.

Contact: Office of Research Program Management, RD-674, Office of Research and Development, Environmental Protection Agency, Washington, DC 20460/202-755-8787.

Water Pollution Control—State and Areawide Water Quality Management Planning Agency

Objective: To encourage and facilitate the development of water quality management plans by area-wide agencies in designated areas and by the state in nondesignated planning areas.

Eligibility: This program is available to each state, territory and possession of the United States, including the District of Columbia.

Range of Financial Assistance: $3,000 to $4,200,000.

Contact: Director, Water Planning Division, Office of Water Planning and Standards, Office of Water and Waste Management, Environmental Protection Agency, Washington, DC 20460/202-755-6928.

Water Pollution Control—State and Interstate Program Grants

Objectives: To assist state and interstate agencies in establishing and maintaining adequate measures for prevention and control of water pollution.

Eligibility: State and interestate water pollution control agencies as defined in the Federal Water Pollution Control Act.

Range of Financial Assistance: $8,000 to $2,870,000.

Contact: Director, Water Planning Division, Office of Water Planning and Standards, Office of Water and Waste Management, Environmental Protection Agency, Washington, DC 20460/202-755-6928.

Water Pollution Control—State and Local Manpower Program Development

Objectives: To design and carry out innovative and imaginative training programs which respond to the highest publicly owned treatment works (POTW) related training needs. Operator training projects to be part of a development of state self-sufficiency.

Eligibility: This program is available to each state, territory, and possession of the United States, including the District of Columbia, for state and interstate agencies, or district water pollution control agencies, or private nonprofit education/training institutions.

Range of Financial Assistance: $10,000 to $100,000.

Contact: Director, National Training and Operational Technology Center, Municipal Operations and Training Division, Office of Water Program Operations, Cincinnati, OH 45268/513-684-3444.

Water Pollution Control—Technical Training Grants

Objectives: To improve the training and education for technical personnel in the design, operation, and maintenance of waste treatment works.

Eligibility: This program is available to each state, territory and possession of the United States, including the District of Columbia, for public and private state colleges and universities, and junior or community colleges.

Range of Financial Assistance: $7,000 to $58,000.

Contact: Deputy Chief, Manpower Planning and Division, Branch, Municipal Operations and Training Division, Office of Waste Programs Operations, Environmental Protection Agency, Washington, DC 20460/202-755-6928.

Guideline for Public Reporting of Daily Air Quality-Pollutant Standard Index

This index provides a uniform way to report daily on pollution concentrations, to tell the public about the general health effects associated with these concentrations. It also describes some general precautionary steps that can be taken. Contact: Office of Air Quality Planning and Standards, Environmental Protection Agency, Research Triangle Park, NC 27711/919-541-5351.

Health Research

This office conducts research on how pollutants affect human health. Contact: Health Research, Office of Research and Development, Environmental Protection Agency, Room 3100, 401 M St. S.W., Washington, DC 20460/202-426-2382.

Libraries

The Environmental Protection Agency maintains a headquarters library as well as libraries in each of its regional offices that are open to the public. Contact: Headquarters Library, Environmental Protection Agency, Room M2404, 401 M St. S.W., Washington, DC 20460/202-755-0308.

Loans and Loan Guarantees

The programs below are those which offer financial assistance through the lending of federal monies for a specific period of time or programs in which the federal government makes an arrangement to indemnify a lender against part or all of any defaults by the borrower:

Mailing List

The Environmental Protection Agency maintains mailing lists for technical information as well as general information about each of its major programs. Requests to be added to the lists should be made to:

General Information—Mailing List Manager, Office of Public Awareness, Environmental Protection Agency, A-107, Washington, DC 20460/202-755-0700

Solid Waste—Mailing List Manager, OSW Publications Distribution, Environmental Protection Agency, 26 West St. Clair, Cincinnati, OH 45268/513-684-7931.

Water Quality—Central Mailing List Service, Municipal Construction Division, Environmental Protection Agency, GSA (8FSS), Building 41, Denver Federal Center, Denver, CO 80225

Mailing List Manager, Water Planning Division Library, Environmental Protection Agency, WH-554, Washington, DC 20460/202-755-6928.

Distribution Office, Effluent Guidelines Division, Environmental Protection Agency, WH-552, Washington, DC 20460/202-426-2576.

Drinking Water—Mailing List Manager, Office of Drinking Water, Environmental Protection Agency, WH-550, Washington, DC 20460/202-472-4152.

Toxic Substance—Industry Assistance Office, Office of Toxic Substances, Environmental Protection Agency, TS-799, Washington, DC 20460/202-382-3813.

Pesticides—Mailing List Manager, Operation Division, Office of Pesticides Programs, Environmental Protection Agency, TS-770M, Washington, DC 20460/202-557-7460.

Air—Mailing List Manager, Library Services, Environmental Protection Agency, MD-35, Research Triangle Park, NC 27711/919-541-4577.

Noise—Mailing List Manager, Office of Noise Programs, Environmental Protection Agency, ANR-471, Washington, DC 20460/202-557-7698.

Radiation—Mailing List Manager, Office of Radiation Programs, Environmental Protection Agency, ANR-458, Washington, DC 20460/202-557-7380.

Research and Development—Mailing List Manager, ORD Publications, Environmental Protection Agency, RD-674, Washington, DC 20460/202-755-2600

Monitoring Technical Support

This office develops standard references and methods for environmental measurement and oversees EPA's quality assurance programs. Contact: Monitoring Technology Division, Office of Research and Development, Environmental Protection Agency, Room 3809, 401 M St. S.W., Washington, DC 20460/202-426-2026.

Motion Picture Film List

For a free listing of Environmental Protection Agency films available for loan at no cost, contact: Publications, Printing Management Office, Environmental Protection Agency, Room 230, 401 M St. S.W., Washington, DC 20460/202-755-0890. For audiovisual information, contact: Audiovisual, Office of Public Awareness, Envi-

ronmental Protection Agency, Room W230, 401 M St. S.W., Washington, DC 20460/202-755-0700.

Mobile Source Air Pollution

For information on mobile source air pollution, contact: Mobile Source Enforcement Division, Office of Enforcement, Environmental Protection Agency, Room 3220 WSM, 401 M St. S.W., Washington, D.C. 20460/202-382-2546.

Motor Vehicle and Engine Certificates

This office certifies motor vehicles and engines for compliance with emission standards, plans and oversees vehicle emission control programs. Contact: Mobile Source Air Pollution Control, Office of Air, Noise and Radiation, Environmental Protection Agency, Room 737, 401 M St. S.W., Washington, DC 20460/202-426-2464.

National Enforcement Investigation Center

The Center conducts field investigations and analyses to support any Environmental Protection Agency enforcement actions. For additional information, contact: National Enforcement Investigation Center, Environmental Protection Agency, Denver Federal Center, Building 53, P.O. Box 25227, Denver, CO 80225/303-234-4650, or Office of Program Agency, Room W1115, 401 M St. S.W., Washington, DC 20460/202-755-9722.

National Information Center for Quiet

The Center is a clearinghouse for the collection and dissemination of information on noise abatement and control. Brochures, lists of films and referral information on sources of environmental noise as well as technical information are available from the National Information Center for Quiet, Environmental Protection Agency, 401 M St. S.W., Washington, DC 20460/301-466-2318.

National Pollution Discharge Elimination System Program

This program attempts to regulate numerous point sources which have yet been permitted due to limited agency resources. A general permit allows a number of discharges to be regulated under a single general permit under certain conditions. A list of agencies issuing NPDES permits for wastewater discharges is available. *NPDES Advisory*, a free newsletter, is also available. For further information, contact: Permits Division, Office of Water Enforcement, Environmental Protection Agency, Room M3220, 401 M St. S.W., Washington, DC 20460/202-755-0400.

Noise Abatement Control

This office regulates sources of noise and assists state and local noise control programs. Contact: Noise Abatement Control, Office of Air, Noise and Radiation, Environmental Protection Agency, Room 1108, 401 M St. S.W., Washington, DC 20460/202-557-7777.

Noise Emission Standards

The Environmental Protection Agency establishes noise emission standards for those products that have been identified as major sources of noise. Labeling regulations inform consumers of products' noise generating characteristics or their effectiveness in reducing noise. Contact: Standards and Regulations Division, Office of Noise Abatement and Control, Environmental Protection Agency, Room 1107, 401 M St. S.W., Washington, DC 20460/202-557-7743.

Noise Enforcement

This office directs the Environmental Protection Agency's mobile noise control enforcement standards for automobiles and aircraft. Contact: Noise Enforcement Division, Office of Enforcement, Environmental Protection Agency, Room CM2, Room 712, 401 M St. S.W., Washington, DC 20460/202-557-7470.

Oil and Special Material Control

This office develops programs and standards to control oil and hazardous material spills. Contact: Oil and Special Materials Control Division, Office of Water Program Operations, Environmental Protection Agency, Room M2106, 401 M St. S.W., Washington, DC 20460/202-245-3048.

Pesticide Enforcement

The Pesticide Enforcement Program includes the inspection of pesticide-producing establishments, market surveillance, and the monitoring of experimental use permits. Enforcement may include civil actions, stop sales, criminal prosecutions, and injunctive actions, as well as other methods. Contact: Pesticides and Toxic Substances Enforcement Division, Office of General Enforcement, Environmental Protection Agency, Room M32201, 401 M St. S.W., Washington, DC 20460/202-755-0970.

Pesticide Programs

This office plans and carries out programs to limit the use of pesticides that are harmful to people or to the environment. Contact: Office of Pesticide Programs, Environmental Protection Agency, Room E539, 401 M St. S.W., Washington, DC 20460/202-557-7460.

Pesticide Registration

Pesticide products are registered to prevent harmful products from entering the market and to require labeling products to assure proper use. Products are registered only if they perform their intended functions without unreasonable adverse effects on humans or the environment. Contact: Registration Division, Office of Pesticide Programs, Environmental Protection Agency, Room E347, 401 M St. S.W., Washington, DC 20460/202-557-7460.

Pesticide Research and Monitoring

Research and monitoring activities are designed to provide prompt alerts on environmental and human effects and to develop data on the long-term human health effects of exposure to pesticides. Contact: Hazard Evaluation Division, Office of Pesticide Programs, Environmental Protection Agency, Room 821 CH-2, 401 M St. S.W., Washington, DC 20460/202-557-7351.

Planning and Evaluation

This office monitors and evaluates the progress of Environmental Protection Agency programs. It also reviews new standards and regulations. Contact: Standards and Regulations Division, Office of Planning and Evaluation, Environmental Protection Agency, Room M3006, 401 M St. S.W., Washington, DC 20460/202-557-7743.

President's Youth Awards

This program has been established to recognize the accomplishments of those young people who, by becoming active in their communities, have become true environmentalists. The program also encourages schools, summer camps and groups to organize local environmental protection programs and other efforts to increase environmental awareness. Contact: President's Youth Awards Program, Office of Press Services, Environmental Protection Agency, Room W232A, 401 M St. S.W., Washington, DC 20460/202-755-0344.

Publications ... A Quarterly Guide

This free guide lists most of EPA's general and technical publications for the past year. Children's publications, posters and bumper stickers are also included. Among the topics covered are air pollution, noise, pesticides, solid waste, toxic substances, water pollution, radiation, and environmental health and safety. Contact: Publications, Printing Management Office, Environmental Protection Agency, Room 215, 401 M St. S.W., Washington, DC 20460/202-382-2116.

Public Awareness

The Office of Public Awareness is responsible for providing support to the Agency's community relations, public participation and environmental information programs. It also monitors public attitudes concerning the environment. For information, contact: Office of Public Awareness, Environmental Protection Agency, Room W311, 401 M St. S.W., Washington, DC 20460/202-755-0700.

Public Information Center

This center provides first-line contact for public inquiries including walk-in visits. The Center offers a wide variety of information about the EPA and its programs. It will also refer inquiries to the appropriate technical program or regional office. Contact: The Public Information Center, Environmental Protection Agency, West Tower Lobby, North Gallery, 401 M St. S.W., Washington, DC 20460/202-755-0717.

Public Information Reference Unit

The public may inspect documents supporting agency actions at: Public Information Reference Unit, Environmental Protection Agency, Room 2404, 401 M St. S.W., Washington, DC 20460/202-755-2808.

Public Participation

The Environmental Protection Agency is responsible for encouraging and accommodating citizen participation in agency decisions. Contact: Public Participation, Environmental Protection Agency, Room 2802, 401 M St. S.W., Washington, DC 20460/202-755-2808.

Radiation Programs

Criteria and standards for the protection of protection of people and the environment from all sources of radiation, including ambient standards for the total amount of radiation from all facilities in the uranium fuel cycle are developed in this office. Contact: Office of Radiation Programs, Environmental Protection Agency, Room 1015, CM-2, 401 M St. S.W., Washington, DC 20460/202-0704.

Radiation Surveillance

Radiation surveillance includes an assessment of the overall condition of the radiological quality of the environment. An air monitoring network measures ambient radioactivity. Water analysis and sampling programs are carried out on the measure levels of tritium and other radionuclides near specific radioactive material sources and at drinking water sites. Contact: Surveillance and

Emergency Preparedness. Office of Radiation Programs, Environmental Protection Agency, Room 1014, CM-2, 401 M St. S.W., Washington, DC 20460/703-557-8217.

Research and Development

For general and technical information on research on pollution sources, health effects, prevention and control methods, environmental sciences and monitoring systems, *Office of Research and Development Program Guide* is a free annual publication. Contact: Technical Information Office, Office of Research and Development, Environmental Protection Agency, Room 923, 401 M St. S.W., Washington, DC 20460/202-755-0468.

Selling to the EPA

A free pamphlet with procurement and research and development program information is available from: Procurement and Contracts Management Division, Environmental Protection Agency, Room 2003, 401 M St. S.W., Washington, DC 20460/202-755-0822.

Solid Waste Programs

Federal financial and technical assistance to state and local governments in planning and developing comprehensive solid waste management programs is available. These programs include environmental control on all land disposal of solid wastes, regulation of hazardous waste from point of generation through disposal and resource recovery and activities. (Also, see "Grants.") Contact: Office of Solid Waste, Environmental Protection Agency, Room 2714, 401 M St. S.W., Washington, DC 20460/202-755-9170.

Solid Waste Regulation

Public participation is required in the development of all solid waste regulations, guidelines and programs. Contact: Public Information and Participation, Office of Solid Waste, Environmental Protection Agency, Room M2716, 401 M St. S.W., Washington, DC 20460/202-755-9160.

Speakers

For information on available speakers, contact: Speaker's Bureau, Office of Public Awareness, Environmental Protection Agency, Room W313, 401 M St. S.W., Washington, DC 20460/202-426-4188.

State Drinking Water Programs

The states work to develop water supply enforcement programs and control the under-ground injection of contaminants. States also survey the quality and availability of rural drinking water supplies. The Environmental Protection Agency provides grant assistance and technical guidance to facilitate these programs. Contact: States Program Division, Office of Drinking Water, Environmental Protection Agency, Room E1099, 401 M St. S.W., Washington, DC 20460/202-426-8290.

State Solid Waste Programs

State programs include schedules for upgrading or closing all environmentally unacceptable land disposal sites, "open dumps" certified according to EPA criteria, and a nationwide inventory. Contact: State Programs, Office of Solid Waste, Environmental Protection Agency, Room M2511, 401 M St. S.W., Washington, DC 20460/202-755-9145.

Stationary Sources of Pollution Enforcement

Standards for enforcing stationary sources of air pollution, radiation and solid waste such as sewage plants and industrial mills and factories are formulated in this office. For additional information, contact: Stationary Source Enforcement Division, Office of General Enforcement, Environmental Protection Agency, Room M3202D, 401 M St. S.W., Washington, DC 20460/202-755-0658.

Technical Publications

Many Environmental Protection Agency publications are available free from EPA's technical program offices. Others can be obtained from the Government Printing Office or the National Technical Information Service. For a copy of *Publications: A Quarterly Guide*, which includes both technical and general publications, contact: Publications, Printing Management Office, Environmental Protection Agency, Room M215, 401 M St. S.W., Washington, DC 20460/202-382-2116.

Toll-Free Number

For information on the Environmental Protection Agency's regulation of chlorofluorocarbons (CFCs), contact EPA's regional offices, or Office of Pesticides and Toxic Substances, Environmental Protection Agency, Room E429, 401 M St. S.W., Washington, DC 20460/202-554-1404 (800-424-9065).

Toxic Substances

The Environmental Protection Agency identifies and controls harmful chemicals already in commerce as well as new chemicals prior to their

commercial manufacture. EPA requires industry to provide information about the production, distribution, use, exposure and health and environmental effects of chemicals. It also requires industry to test potentially harmful chemicals for health and environmental effects and to control harmful chemicals that pose an unreasonable risk to health or the environment. Contact: Office of Toxic Substances, Environmental Protection Agency, Room E601, 401 M St. S.W., Washington, DC 20460/202-382-3813.

Toxic Substances Tests

The Environmental Protection Agency requires manufacturers and processors to conduct tests on potentially harmful chemicals. The conducted tests evaluate a chemical's characteristics, such as persistence or acute toxicity, and clarify the health and environmental effects of a chemical, including carcinogenic, mutagenic, behavioral and synergistic effects. Contact: Assessment Division, Office of Toxic Substances, Environmental Protection Agency, Room E715, 401 M St. S.W., Washington, DC 20460/202-382-3813.

Unsolicited Proposals

Unsolicited proposals for projects such as fundamental research that might advance the state of the art, present possible development of solutions to problems, or contribute to knowledge of a specific phenomenon is an important method of EPA business. Contact: Grants Admission Division, Environmental Protection Agency, Room W437, 401 M St. S.W., Washington, DC 20460/202-755-0768.

Visitors' Center

The Center exhibits various Environmental Protection Agency programs against pollution. It also has available publications, posters and other material on the environment and pollution control. Contact: Visitors' Center, Environmental Protection Agency, 401 M St. S.W., Washington, DC 20460/202-382-2010.

Water Data

A water program data system with files on water quality, discharge and program data is available. Contact: Monitoring and Data Support Division, Office of Water Program Operations, Environmental Protection Agency, Room E837, 401 M St. S.W., Washington, DC 20460/202-426-7582.

Water Enforcement

The enforcement program includes discharge permit issuance and compliance activities and enforcement actions to achieve compliance with ocean dumping and oil and harzardous materials discharge regulations. Contact: Enforcement Division, Office of Water Enforcement, Environmental Protection Agency, Room M3201, 401 M St. S.W., Washington, DC 20460/202-755-0440.

Water Planning and Standards

This office oversees planning and standard setting for water quality, develops industrial discharge guidelines, and monitors waterways nation-wide. For further information, contact: Office of Water and Waste Management, Environmental Protection Agency, Room 737A, 401 M St. S.W., Washington, DC 20460/202-755-0753.

Water Program Operations

This office develops national programs, technical policies, regulations and guidelines for water pollution control. For information, contact: Water Program Operations, Office of Water and Waste Management, Environmental Protection Agency, Room 1209, 401 M St. S.W., Washington, DC 20460/202-426-8856.

Water Quality Criteria

The water quality criteria program through which the EPA sets acceptable levels for pollutants in ambient waters which serve to protect aquatic life and the health of organisms, including man, which may contact the water. Contact: Criteria and Standards Division, Office of Water Program Operations, Environmental Protection Agency, Room M2824, 401 M St. S.W., Washington, DC 20460/202-755-0100.

Water Quality Program

Water quality program is primarily concerned with controlling the discharge of pollutants into waterways from industrial and municipal point and nonpoint sources. For general information, contact: Water and Waste Management, Environmental Protection Agency, Room E1035, 401 M St. S.W., Washington, DC 20460/202-755-0753.

How Can the Environmental Protection Agency Help You?

For information on how this agency can be of help to you, contact: Office of Public Awareness, Environmental Protection Agency, Room W311, 401 M St. S.W., Washington, DC 20460/202-755-0700.

Equal Employment Opportunity Commission

2401 E St. N.W., Washington, DC 20506/202-634-6930

ESTABLISHED: July 2, 1965
BUDGET: $119,000,000
EMPLOYEES: 3,779
MISSION: Eliminates discrimination based on race, color, religion, sex, national origin or age in hiring, promotion, firing, wages, testing, training, apprenticeship and all other conditions of employment; promotes voluntary action programs by employers, unions, and community organizations to make equal employment opportunity an actuality; and is responsible for all compliance and enforcement activities relating to equal employment opportunity among federal employees and applicants, including handicap discrimination.

Major Sources of Information

Age Discrimination

The Age Discrimination in Employment Act protects workers aged 40–70 from arbitrary age discrimination in hiring, discharge, pay, promotions, fringe benefits and other aspects of employment. For further information, contact: any Equal Employment Opportunity Commission district or area office, or Public Information Unit, Office of Public Affairs, Equal Employment Opportunity Commission, Room 4202, 2401 E St. N.W., Washington, DC 20506/202-634-6930.

Discrimination Complaints

Applicants to and employees of private employers, state or local governments, and public or private educational institutions are protected by Title VII of the Civil Rights Act of 1964. Also covered are employment agencies, labor unions and apprenticeship programs. Any person who believes he or she has been discriminated against should contact an Equal Employment Opportunity Commission District Office, or Office of Equal Employment Opportunity, Equal Employment Opportunity Commission, Room 909, SKY, 2401 E St. N.W., Washington, DC 20506/202-756-6000.

Equal Work Equal Pay

The Equal Pay Act protects women and men against pay discrimination based on sex. For further information, contact: any Equal Employ-

ment Opportunity Commission district or area office, or Public Information Unit, Office of Public Affairs, Equal Employment Opportunity Commission, Room 4202, 2401 E St. N.W., Washington, DC 20506/202-634-6930.

Field Services

The Equal Employment Opportunity Commission has 22 district offices and 37 smaller area offices to oversee the case-processing system on a regional basis. For a list of these offices and general information, contact: Office of Field Services, Equal Employment Opportunity Commission, Room 4230, 2401 E St. N.W., Washington, DC 20506/202-634-6930.

Freedom of Information Requests

For Freedom of Information Act requests, contact: Office of General Counsel, Employment Opportunity Commission, Room 2254, 2401 E St. N.W., Washington, DC 20506/202-634-6595.

Grants

The program described is for a sum of money given by the federal government to initiate and stimulate new or improved activities or to sustain on-going services:

Employment Discrimination—State and Local Anti-Discrimination Agency Contracts
Objectives: To assist EEOC in the enforcement of Title VII of the Civil Rights Act of 1964, as

amended, by attempting settlement and investigating and resolving charges of employment discrimination based on race, color, religion, sex or national origin.

Eligibility: Official state and local government agencies charged with the administration and enforcement of fair employment practices laws.

Range of Financial Assistance: $35,000 to $1,299,900.

Contact: State and Local Division, Office of Field Services, Equal Employment Opportunity Commission, Room 4233, 2401 E St. N.W., Washington, DC 20506/202-634-6040.

Hiring Statistics

Statistics on the hiring of minority groups, including women, for nine job categories such as clerical workers, service workers, blue collar workers, and professional and technical workers, is available by state, Standard Metropolitan Statistical Area (SMSA), industry and nationwide. Statistics are also available on apprentices, union workers, state and local governments, and individuals with elementary and secondary education as well as those with college and university degrees. For further information, contact: Survey Branch, Office of Program Planning and Evaluation, Equal Employment Opportunity Commission, Room 3201, 2401 E St. N.W., Washington, DC 20506/202-756-6020.

Meeting Schedule

The Equal Employment Opportunity Commission provides recorded information on the agenda, date, and place of the next meeting of the Commission. Contact: Equal Employment Opportunity Commission, 2401 E St. N.W., Washington, DC 20506/202-634-6748.

Publications and Information

For general information and Equal Employment Opportunity Commission publications, contact: Office of Public Affairs, Equal Employment Opportunity Commission, Room 4202, 2401 E St. N.W., Washington, DC 20506/202-634-6930.

Special Projects and Programs

This office develops programs for employers designed to deal with Equal Employment Opportunity Commission laws. Such programs include worker–employer arbitration and development of affirmative action programs. Contact: Office of Special Projects and Programs, Equal Employment Opportunity Commission, Room 808, SKY, 2401 E St. N.W., Washington, DC 20506/703-756-6026.

Systemic Problems

The Systemic Charge Processing System is designed to process broad-based actions against discriminatory employment patterns in order to produce benefits for women and minorities on a large scale, creating employment opportunities to previously excluded people. For further information, contact: Office of Systemic Programs, Equal Employment Opportunity Commission, Room 2224, 2401 E St. N.W., Washington, DC 20506/202-634-6460.

How Can the Equal Employment Opportunity Commission Help You?

For information on how this agency can help you, contact: Office of Public Affairs, Equal Employment Opportunity Commission, Room 4202, 2401 E St. N.W., Washington, DC 20506/202-634-6930.

Export-Import Bank of the United States

811 Vermont Ave. N.W., Washington, DC 20571/202-566-8990

ESTABLISHED: February 2, 1934
BUDGET: $6,129,631,000
EMPLOYEES: 416

MISSION: Facilitates and aids in financing exports of U.S. goods and services; and lends directly or issues guarantees and insurance so that exporters and private banks can extend appropriate financing without taking undue risks.

Major Sources of Information

Agricultural Exports

The Eximbank provides financial support for the export of agricultural commodities, agribusiness facilities and production equipment. The export support programs applicable to agricultural commodities, capital goods and services, include insurance for commodity exports, bank guarantees for commodity exports, risk retention, capital goods export financing, discount loan program, feasibility studies, services policy, cooperative financing facility, agricultural project financing and special conditions and provisions. Contact: Office of Public Affairs, Export-Import Bank of the United States, Room 1167, 811 Vermont Ave. N.W., Washington, DC 20571/202-566-8990.

Bank Credit Programs

This office administers the bank credit programs—the Cooperative Financing Facility, and the Discount Loan Program, and the medium-term commercial bank guarantee program. Contact: Exporter Credits and Guarantees, Export-Import Bank of the United States, Room 901, 811 Vermont Ave. N.W., Washington, DC 20571/202-566-8819.

Briefing Programs

Regular briefing programs are held at the Eximbank headquarters to familiarize banks, exporters and others with the Eximbank's financing programs and policies. These sessions are tailored to the needs of the participants and include: two-day programs for U.S. commercial bankers and one-day briefings for U.S. exporters. For further information, contact: The Briefing Program, Office of Public Affairs, Export-Import Bank of the United States, Room 1167, 811 Vermont Ave. N.W., Washington, DC 20571/202-566-8966.

Claims

This office processes claims filed under the Bank's guarantee and insurance programs. It is also responsible for collections and recoveries on claims paid. Contact: Claims, Exporter Credit Guarantees and Insurance, Export-Import Bank of the United States, Room 969, 811 Vermont Ave. N.W., Washington, DC 20571/202-566-8822.

Conferences on Small Business Exporting

The Eximbank initiates a conference program in coordination with the U.S. Department of Commerce, Small Business Administration, and the Overseas Private Investment Corporation. These conferences—held throughout the United States—are designed to show smaller firms what opportunities are available in foreign trade and what government services can do to help. For further information, contact: 800-424-5201. or Advisory Service for Small Business, Export-Import Bank of the United States, Room 1031, 811 Vermont Ave. N.W., Washington, DC 20571/202-566-8860.

Credit Information

The Credit Information Section maintains over 50,000 credit files on thousands of foreign firms with which Eximbank has had experience and administers the exchange information between Eximbank and other members of the Berne Union—an international association of credit insurers. This information is especially helpful to smaller exporters and to those companies of any

size that are relatively new to foreign markets. Contact: Credit Information, Office of Exporter Credit Guarantees and Insurance, Export-Import Bank of the United States, Room 912, 811 Vermont Ave. N.W., Washington, DC 20571/202-566-4690.

Direct Credits and Financial Guarantees

The Direct Credits and Financial Guarantees Division administers the Bank's long-term export financing programs. It is divided into the four following geographic areas: Africa and Middle East; Asia; Europe and Canada; and Latin America. For additional information, contact: Direct Credits and Financial Guarantees, Export-Import Bank of the United States, Room 1243, 811 Vermont Ave. N.W., Washington, DC 20571/202-566-8187.

Export Credits, Guarantees and Insurance

This office is responsible for the Bank's program to support U.S. export sales with repayment terms of five years or less. Contact: Export Credits, Guarantees and Insurance, Export-Import Bank of the United States, Room 919, 811 Vermont Ave. N.W., Washington, DC 20571/202-566-8806.

Exporter Insurance

This office works in close cooperation with the personnel of the Foreign Credit Insurance Association to provide credit insurance protection for U.S. exporters. Contact: Exporter Insurance, Office of Exporter Credits, Guarantees and Insurance, Export-Import Bank of the United States, Room 919, 811 Vermont Ave. N.W., Washington, DC 20571/202-566-8955.

Feasibility Studies

Eximbank will support U.S. firms undertaking studies of overseas projects. Applications for feasibility studies should be made for the appropriate program. For further information, contact: Office of Public Affairs, Export-Import Bank of the United States, Room 1167, 811 Vermont Ave. N.W., Washington, DC 20571/202-566-8990.

Financing for American Exports—Support for American Jobs

This free pamphlet describes Eximbank's programs, which include short-term, medium-term and long-term programs, small business support, agricultural export programs, contractors' guarantee program, and leasing program. It also provides credit information. Contact: Office of Public Affairs, Export-Import Bank of the Unit-ed States, Room 1167, 811 Vermont Ave. N.W., Washington, DC 20571/202-566-8990.

Freedom of Information Act Requests

For Freedom of Information Act requests, contact: Office of Public Affairs, Export-Import Bank, Room 1167, 811 Vermont Ave. N.W., Washington, DC 20571/202-566-8990.

Government Affairs

This office is responsible for Eximbank's liaison with other U.S. government agencies and interagency bodies, such as the National Advisory Council on International Monetary and Financial Policies. Contact: Government Affairs, Office of Direct Credits and Financial Guarantees, Export-Import Bank of the United States, Room 1238, 811 Vermont Ave. N.W., Washington, DC 20571/202-566-8853.

International Relations

This office is responsible for the Bank's international market development, special projects, liaison with minority and small business exporters, and relations with foreign commercial and economic official representatives posted in the United States. Contact: Office of International Relations, Export-Import Bank of the United States, Room 1203, 811 Vermont Ave. N.W., Washington, DC 20571/202-566-8873.

Library

The Eximbank Library concentrates on economics, finance, export credits, business and statistical information. Contact: Library, Export-Import Bank of the United States, Room 1373, 811 Vermont Ave. N.W., Washington, DC 20571/202-566-8320.

Policy Analysis

The staff conducts the policy planning and research work of the Bank. Duties include monitoring and reporting on the developments in the economy that may affect the Bank's operations and the continuing review and evaluation of the Bank's programs and policies. Contact: Office of Policy Analysis, Export-Import Bank of the United States, Room 1231, 811 Vermont Ave. N.W., Washington, DC 20571/202-566-8861.

Public Affairs

Public Affairs is responsible for the Eximbank's public information and business liaison programs, including press relations, conferences, speaking engagements, export and small business counseling. They are also responsible for Export-Import Bank publications. Contact: Office of

Public Affairs, Export-Import Bank of the United States, Room 1167, 811 Vermont Ave. N.W., Washington, DC 20571/202-566-8990.

Small Business Assistance Hotline

An Eximbank Hotline service has been established to help small business. This counseling service can answer questions that small business exporters may have concerning assistance in financing goods and/or services for sale to foreign countries. Various programs exist to help small exporters. They include the small business advisory service, briefing programs, financial support programs such as export credit insurance and the short-term comprehensive policy, small business short-term comprehensive insurance policy, the commercial bank exporter guarantee program, the small business guarantee program, the cooperative financing facility, the discount loan program, optional coverages such as the "Switch Cover Option" and the small and minority bank pilot project. Contact: Advisory Service for Small Business, Export-Import Bank of the United States, Room 1031, 811 Vermont Ave. N.W., Washington, DC 20571/202-566-8860.

Technical and Scientific Information

Eximbank's engineers review the technical and scientific aspects of each District Credit and Financial Guarantee proposal before the bank. Contact: Engineering, Direct Credits and Financial Guarantees, Export-Import Bank of the United States, Room 1017, 811 Vermont Ave. N.W., Washington, DC 20571/202-566-8802.

How Can the Export-Import Bank of the United States Help You?

To find out how this agency can help you, contact: Office of Public Affairs, Export-Import Bank of the United States, Room 1167, 811 Vermont Ave. N.W., Washington, DC 20571/202-566-8990.

Farm Credit Administration

490 L'Enfant Plaza East S.W., Washington, DC 20578/202-755-2170

ESTABLISHED: December 10, 1971
BUDGET: $12,428,000
EMPLOYEES: 256

MISSION: Responsible for the supervision, examination and coordination of the borrower-owned banks and associations that comprise the cooperative Farm Credit System. These institutions make long-term loans on farm or rural real estate through local federal land bank associations; the federal intermediate credit banks which provide short- and intermediate-term loan funds to production credit associations and other institutions financing farmers, ranchers, rural homeowners, owners of farm-related businesses, and commercial fishermen; and the banks for cooperatives which make loans for all kinds of agricultural and aquatic cooperatives.

Major Sources of Information

Farm Credit System Information

The cooperative Farm Credit System provides credit and closely related services to farmers, ranchers, cooperatives, and to selected farm-related businesses. The system also provides credit for rural homes to producers and associations of producers. Detailed information on the Banks and Associations of the Farm System may be found in the following publications available from the Farm Credit Banks and the Farm Credit Administration:

Federal Land Banks and How They Operate
Production Credit Associations—How They Operate
Banks for Cooperatives—How They Operate

The following films are available through the Federal Land Bank Association or a district Federal Land Bank:

Some Land of My Own—a 17½-minute film on using long-term credit profitably.
Generations of the Land—a 27-minute film portraying the agricultural industry.
An American Farmer—a 22-minute documentary-style film on today's agriculture.

Some Call It Luck—a 19½-minute film on farm financial management.
Farmers Who Bank on Themselves—a 20-minute film on the role of credit in agriculture.

For a complete descriptive listing of all publications and films available on the Farm Credit System, contact: Public Affairs Division, Farm Credit Administration, Room 121, 490 L'Enfant Plaza East S.W., Washington, DC 20578/202-755-2170.

Freedom of Information Requests

For Freedom of Information Act requests, contact: Freedom of Information, Public Affairs Division, Farm Credit Administration, Suite 4000, 490 L'Enfant Plaza East S.W., Washington, DC 20578/202-755-2170.

How Can the Farm Credit Administration Help You?

To determine how this agency can help you, contact: Public Affairs Division, Farm Credit Administration, Room 121, 490 L'Enfant Plaza East S.W., Washington, DC 20578/202-755-2170.

Federal Communications Commission

1919 M St. N.W., Washington, DC 20554/202-632-7000

ESTABLISHED: 1934
BUDGET: $76,873,000
EMPLOYEES: 2,261

MISSION: Regulates interstate and foreign communications by radio, television, wire and cable; is responsible for the orderly development and operation of broadcast services and the provision of rapid, efficient nationwide and worldwide telephone and telegraph services at reasonable rates; and promotes the safety of life and property through radio and the use of radio and television to strengthen the national defense.

Major Sources of Information

Applications, Bulletins and Forms

For requesting applications, bulletins and forms of the Federal Communications Commission, contact: Federal Communications Commission District Offices, or Services and Supply Branch, Federal Communications Commission, Room B-10, 1919 M St. N.W., Washington, DC 20554/202-632-7272.

Broadcast Stations

The Federal Communications Commission allocates spectrum space for AM and FM radio, and VHF and UHF television broadcast services; assigns frequencies and call letters to stations; designates operating power and sign-on and sign-off times. It also issues construction permits and inspects technical equipment. The FCC also requires licensees to serve the programming tastes, needs and desires of their communities. For further information, contact: Broadcast Bureau, Federal Communications Commission, Room 314, 1919 M St. N.W., Washington, DC 20554/202-632-6460.

Broadcast Stations of the World

Lists of foreign broadcast stations include: Part 1—AM stations by country and city; Part 2—AM stations by frequency; Part 3—FM Stations; Part 4—TV stations, $4.25 (do not have prices for the first three Parts). Contact: Superintendent of Documents, Government Printing Office, Washington, DC 20402/202-783-3238.

Cable Television

For general information and/or complaints on cable television, contact: Complaints and Information Branch, Cable Television Bureau, Federal Communications Commission, Room 6330, 2025 M St. N.W., Washington, DC 20554/202-632-9703.

Citizens and Amateur Radio Rules

For information on citizens and amateur radio rules and how these rules are made, contact: Personal Radio Branch, Private Radio Bureau, Federal Communications Commission, Room 6329, 2025 M St. N.W., Washington, DC 20554/202-254-6884.

Comments on FCC Rulemaking

The Federal Communications Commission is interested in any experiences, judgments or insights from the public on issues and questions raised in an inquiry or rulemaking. To submit comments and for further information, contact: Office of Opinions and Review, the Secretary, Federal Communications Commission, Room 404, 1919 M St. N.W., Washington, DC 20554/202-632-6990.

Common Carrier Complaints

Consumer Affairs Division will handle informal written or verbal complaints from the public on interstate and international common carrier matters. It will also provide information services to help you understand common carrier propos-

als and issues and procedural assistance for participating in common carrier proposals and issues. Contact: Consumer Affairs Division, Common Carrier Bureau, Federal Communications Commission, Room 6324, 2025 M St. N.W., Washington, DC 20554/202-632-7553.

Common Carriers

The Federal Communications Commission supervises charges, practices, classifications and regulations on interstate and foreign communication by radio, wire and cable; considers applications for construction of new facilities and discontinuance or reduction of service; acts on applications for interlocking directorates and mergers, and prescribes and reviews the accounting practices of communication carriers. For information, contact: Consumer Affairs Division, Common Carrier Bureau, Federal Communications Commission, Room 6324, 2025 M St. N.W., Washington, DC 20554/202-632-7553.

Common Carrier Tariffs

Common carrier tariffs for interstate and foreign wire and communications are on file. Contact: Tariff Review Branch, Common Carrier Bureau, Federal Communications Commission, Room 5, 1919 M St. N.W., Washington, DC 20554/202-632-5550.

Dockets

Information on the status of Federal Communications Commission hearing proceedings is obtainable. History cards for all docketed cases since 1928 are filed, including FCC action setting the case for hearing and all subsequent actions in the case. Information on petitions or requests for rulemaking and on rulemaking proceedings is also available from history cards. Contact: Dockets Branch, The Secretary, Federal Communications Commission, Room 230, 1919 M St. N.W., Washington, DC 20554/202-632-7535.

Equal Time Complaints

To complain about Equal Time in Political Broadcasting, contact: Complaints and Compliance Division, Federal Communications, Room 322, 1919 M St. N.W., Washington, DC 20554/202-632-7586.

Equipment Authorization

Manufacturers of new equipment using spectrum space must obtain an equipment authorization as a legal prerequisite to marketing. Contact: Equipment Authorization, Office of Science and Technology, Authorization and Standards Division, Federal Communications Commission, P.O. Box 429, Columbia, MD 21045/301-725-1585.

Ex-Parte Presentations

For information concerning ex-parte presentations, contact: Office of the Executive Director, Federal Communications Commission, Room 852, 1919 M St. N.W., Washington, DC 20554/202-632-6390.

Field Operations

The Field Operations Bureau is engaged largely in engineering work. This includes monitoring the radio spectrum to see that station operation meets technical requirements, inspecting stations of all types, conducting operator examinations and issuing permits or licenses to those found qualified, locating and closing unauthorized transmitters, furnishing radio bearings for aircraft or ships in distress, locating sources of interference and suggesting the remedial measures, doing special engineering work for other government agencies, and obtaining and analyzing technical data for Commission use. For additional information, contact: Field Operations Bureau, Federal Communications Commission, Room 734, 1919 M St. N.W., Washington, DC 20554/202-632-6980.

FM/TV Data Base Lists

The Federal Communications Commission Facilities Division maintains an FM and TV engineering data base containing applications, construction permits and licenses for all U.S. stations, including translators and boosters and traditional broadcast stations. Also included are vacant allocations, proposed rulemakings to amend the Table of Assignments and similar information in Canadian and Mexican stations. The two lists printed from these data bases are sorted by frequency (channel), state and city and vice versa. FM lists are printed each month, with weekly updates, TV lists every two months with biweekly updates. TV lists are in two parts: regular TV stations and translators/boosters. Lists are available in the Public Reference Room, Broadcast Bureau, Federal Communications Commission, Room 239, 1919 M St. N.W., Washington, DC 20554/202-632-7566, or can be obtained at the Downtown Copy Center, 1730 K St. N.W., Washington, DC 20006/202-452-1422. Note: These lists are unofficial and may contain inadvertent errors.

Freedom of Information Act Requests

For Freedom of Information Act Requests, contact: Internal Review and Security Division, Federal Communications Commission, Room 411, 1919 M St. N.W., Washington, DC 20554/202-632-7143.

Frequency Allocation
Domestic and international frequency allocation is administered through this office. Contact: Spectrum Management Division, Office of Science and Technology, Federal Communications Commission, Room 7218, 2025 M St. N.W., Washington, DC 20554/202-632-7025.

Frequency Assignments
Nongovernment frequency assignment lists give data about radio stations of different classes, including frequency, power and call signal assignments; location of base stations with geographic coordinates, number of mobile units, etc. They include frequency lists for broadcast, aviation, marine, industrial, land transportation, public safety, and common carrier services. The list is available on microfiche for $200. Part 90—Land mobile frequency list is available by state or a computer printout for $100 per state. Contact: Downtown Copy Center, 1114 21st St. N.W., Washington, DC 20036/202-452-1422, or 452-1419 for the computer printout.

Handicapped Information
The coordinator for handicapped individuals offers a job referral service for the handicapped and provides technical assistance to broadcasters in revising job descriptions of positions of interest to handicapped individuals. Contact: The Consumer Assistance Office, Federal Communications Commission, Room 258, 1919 M St. N.W., Washington, DC 20554/202-632-7000.

Information Bulletins
The Federal Communications Commission publishes a number of information bulletins. The following list of bulletins can be obtained from the Public Information Division, Office of Public Affairs, Federal Communications Commission, Room 258, 1919 M St. N.W., Washington, DC 20554/202-632-7000:

Information Services and Publications
How to Apply for a Broadcast Station
Broadcast Services
The FCC in Brief
Radio Station and Other Lists
A Short History of Electrical Communication
Safety and Special Radio Services
Common Carrier Services
Station Identification and Call Signs
Regulation of Wire and Radio Communication
Frequency Allocation
Educational Television
Memo to All Young People Interested in Radio
Letter to a Schoolboy
Field Operations Bureau
Subscription TV

Public Radio
Cable Television
International Communications in Amateur Radio
Information on System Licensing in the Private Land Mobile Radio Services
What You Should Know About CB

Interference Complaints
For complaints of radio and television interference, contact the nearest Federal Communication Commission Field Operations Office of the Investigations Branch, Field Operations Bureau, Federal Communications Commission, Room 744, 1919 M St. N.W., Washington, DC 20554/202-632-6345.

Legal Assistance
The Federal Communications Bar Association has instituted a Legal Aid Program for indigent individuals and groups. For a list of possible sources of legal assistance, contact: Consumer Assistance Office, Federal Communications Commission, Room 258, 1919 M St. N.W., Washington, DC 20554/202-632-7000.

Library
The Library contains books, periodicals and information on research and technical subjects, economics and the mass media. It also keeps a legislative history of the Communications Act and congressional hearings involving the FCC. Contact: FCC Library, Federal Communications Commission, Room 639, 1919 M St. N.W., Washington, DC 20554/202-632-7100.

License Application Status
To obtain information on the status of citizens and amateur radio, aviation and marine licenses, contact: Licensing Processing Section, Federal Communications Commission, 334 York St., Gettysburg, PA 17325/717-337-1511 (amateur radio); 717-337-1212 (aviation and marine); 717-337-1511 (citizens band and business, including land transportation).

Master Lists of Radio Stations
Master lists of radio stations, radio frequencies, construction permits and applicants are available for public reference. Contact: Public Reference Room, License Division, Broadcast Bureau, Federal Communications Commission, Room 239, 1919 M St. N.W., Washington, DC 20554/202-632-7566.

Network Studies
Detailed studies are available of network behavior with respect to affiliates, advertisers and program suppliers, analyses of syndicated pro-

gram distribution and examinations of the factors influencing the profitability of television stations. The historical evolution of the commercial network broadcast system, the structure and business activities of the parent corporations of the major networks, FCC rules governing commercial television network practices and "network dominance" have also been studied. Contact: Broadcast Bureau, Federal Communications Commission, Room 314, 1919 M St. N.W., Washington, DC 20554/202-632-6460.

Owning Your Own Phone
This free brochure answers basic questions on the purchase of telephone equipment. Contact: Consumer Assistance Office, Federal Communications Commission, Room 258, 1919 M St. N.W., Washington, DC 20554/202-632-7000.

Private Radio Services
There are eight main categories of private radio services that are regulated by the FCC: Stations on Land in the Maritime Services; Stations on Shipboard in the Maritime Services; Aviation Services; Private Land Mobile Radio Services; Private Operational-Fixed Microwave Service; Personal Radio Services; Amateur Radio Service; and Disaster Communications Service. Contact: Private Radio Bureau, Federal Communications Commission, Room 5002, 2025 M St. N.W., Washington, DC 20554/202-632-6940.

Program and Advertising Complaints
To complain about programs and advertising, contact: Complaints and Compliance Division, Federal Communications Commission, Room 322, 1919 M St. N.W., Washington, DC 20554/202-632-7048.

Public Documents
Copies of public documents such as a Notice of Inquiry or a Notice of Proposed Rulemaking can be obtained by contacting the Consumer Assistnace Office, Federal Communications Commission, Room 258, 1919 M St. N.W., Washington, DC 20554/202-632-7000.

Public Participation Workshops
Public participation workshops are designed to allow the public to meet and talk with local broadcasters, members of the community, interest groups, individual consumers, and the FCC staff about communications issues. The workshops also serve to inform the public about the FCC, explain the rulemaking process, and inform the public about how to obtain timely information about FCC proceedings. Contact: Consumer

Assistance Office, Federal Communications Commission, Room 258, 1919 M St. N.W., Washington, DC 20554/202-632-7000.

Public Reference Rooms
These rooms maintain dockets concerning rulemaking and adjudicatory matters, copies of applications for licenses, and grants and reports required to be filed by licensees and cable system operators. All folders in docketed cases are retained for two years after the proceedings have been closed. Also available for inspection are transcripts of nondocket proceedings such as oral arguments and hearings or various types of committee or group meetings. Public documents are available for inspection by the general public in the following rooms:

Broadcast Public Reference Room, Federal Communications Commission, Room 239, 1919 M St. N.W., Washington, DC 20554/202-632-7566.
Cable TV Public Reference Room, Federal Communications Commission, Room 6218, 2025 M St. N.W., Washington, DC 20554/202-632-7076.
Common Carrier Public Reference Room, Federal Communications Commission, Room 8316, 2025 M St. N.W., Washington, DC 20554/202-254-6810.

Industrial, public safety and land transportation service files are available at Private Radio Public Reference Room, Federal Communications Commission, Room 5308, 2025 M St. N.W., Washington, DC 20554/202-632-6375. Aviation and Marine Services files are available at Room 8302, 2025 M St. N.W., Washington, DC 20554/202-632-7175.

Radio Equipment List
The Federal Communications Commission prepares a list of certain type-approved and type-accepted equipment. The list is sold for $30 prepaid or $39 plus postage billed, by Downtown Copy Center, 1114 21st St. N.W., Washington, DC 20037/202-452-1422.

Radio Operator Licenses
The Federal Communication Commission issues seven types of commercial radio operator licenses: Radiotelephone First Class Operator License, Radiotelephone Second Class Operator License, Restricted Radiotelephone Operator Permit, Radiotelegraph First Class Operator License, Radiotelegraph Second Class Operator License, Radiotelegraph Third Class Operator Permit, and Marine Radio Operator Permit. The FCC also issues endorsements on first and second class licenses which extend their authority in cer-

tain areas. They are the Radar Endorsement, Six Months Service Endorsement, and Aircraft Radiotelegraph Endorsement. It also provides examination guides for prospective radio operator licensees. Contact: Radio Operator and Public Service Branch, Federal Communications Commission, Room 728, 1919 M St. N.W., Washington, DC 20554/202-632-7240.

Recorded Listings of New Releases and Texts

For recorded announcements of Federal Communications Commission actions, contact: Press and News Media Division, Federal Communications, Commission, Room 202, 1919 M St. N.W., Washington, DC 20554/202-632-0002.

Regulation of Radio

The Federal Communications Commission considers applications for construction permits and licenses for all classes of nongovernment stations; assignment of frequencies, power and call signs; authorization of communication circuits; modification and renewal of licenses; inspection of transmitting equipment and regulation of its use; control of interference; review of technical operation; licensing of radio operators (commercial and amateur); remedial action when necessary and other implementation of the Communications Act. Contact: Private Radio Bureau, Federal Communications Commission, Room 5002, 2025 M St. N.W., Washington, DC 20554/202-632-6930.

Speakers Bureau

For a list of speakers and lecturers who are authorities in various fields of communications and developing technologies, as well as leaders of the national media reform groups, contact: Consumer Assistance Office, Federal Communications Commission, Room 258, 1919 M St. N.W., Washington, DC 20554/202-632-7000.

Spectrum

Spectrum is the range of frequencies available for broadcasting and other industrial uses such as biomedical telemeting equipment, microwave ovens, and garage door openers. Research into spectrum propagation and innovation is being conducted. Contact: Research and Analysis Division, Office of Science and Technology, Federal Communications Commission, Room 7130B, 2025 M St. N.W., Washington, DC 20554/202-632-1934.

Station Licenses

A station license authorizes a particular station (or group of stations) in a particular radio service to transmit radio signals for a particular purpose. Contact: Licensing Division, Private Radio Bureau, Federal Communications Commission, Room 5202, 2025 M St. N.W., Washington, DC 20554/202-632-7597.

Technical Bulletins and Reports

Reports and technical bulletins on standards, types of equipment approved and on topics such as broadcast satellite systems, new television service, noise, audio devices and other technical subjects are available from: Technical Information Specialist, Office of Science and Technology, Federal Communications Commission, Room 7109, 2025 M St. N.W., Washington, DC 20554/202-632-7033.

Telephone and Telegraph Complaints

For notifying the Federal Communications Commission about problems with the telephone and telegraph systems, contact: Consumer Affairs Division, Federal Communications Division, Room 6324, 2025 M St. N.W., Washington, DC 20554/202-632-7553.

Telephone Directory

The Federal Communications Commission Telephone Directory, which includes a functional listing of offices, is available for $1.54 from the Downtown Copy Center, 1114 21st St. N.W., Washington, DC 20036/202-452-1422. (The directory costs $1.00 if you pick it up in person.)

Transcripts

Transcripts of hearings (including prepared statements and oral records, but not exhibits) may be ordered at the time of the hearing from the Federal Communications Commission official reporter. Contact: International Transcription Services, Inc., 1307 Prince St., Alexandria, VA 22314/703-549-7385.

How Can the Federal Communications Commission Help You?

For information on how this agency can help you, contact: Consumer Assistance and Information Division, Federal Communications Commission, Room 258, 1919 M St. N.W., Washington, DC 20554/202-632-7000.

Federal Deposit Insurance Corporation

550 17th St. N.W., Washington, DC 20429/202-389-4221

ESTABLISHED: June 16, 1933
BUDGET: $121,690,000
EMPLOYEES: 3,691
MISSION: Promotes and preserves public confidence in banks and protects the money supply through provision of insurance coverage for bank deposits.

Major Sources of Information

Bank Liquidation

This office supervises the liquidation of failed insured banks and keeps comprehensive records of each case. Contact: Division of Liquidation, Federal Deposit Insurance Corporation, Room 626 NYAV, 550 17th St. N.W., Washington, DC 20429/202-389-4365.

Community Reinvestment

The Community Reinvestment Act of 1977 requires the Federal Deposit Insurance Corporation to monitor the records of financial institutions in meeting the credit needs of their communities, including low and moderate-income neighborhoods. Contact: Community Reinvestment Specialist, Civil Rights Section, Office of Consumer and Compliance Programs, Federal Deposit Insurance Corporation, Room 5130, 550 17th St. N.W., Washington, DC 20429/202-389-4341.

Compliance Information

General and consumer information is available on the compliance of insured state nonmember banks with consumer laws and on the enforcement of the Truth-in-Lending Act. For more information, contact any insured bank, Federal Deposit Insurance Corporation regional office, or Office of Consumer and Compliance Programs, Federal Deposit Insurance Corporation, Room 5134, 550 17th St. N.W., Washington, DC 20429/202-389-4512. For a tollfree hotline that handles complaints about consumer rights in banking, call 800-424-5488.

Consumer Information

The Federal Deposit Insurance Corporation has a computerized system to: 1) follow the status and handling of consumer complaints and requests for information; 2) produce one-page summaries of census information for use by examiners and other FDIC personnel evaluating bank compliance with the Community Reinvestment Act; 3) summarize the letters of comment on proposed new Truth-in-Lending guidelines; and 4) tabulate a follow-up survey asking complainants if their problems were satisfactorily resolved. Contact: Office of Consumer and Compliance Programs, Bank Supervision Division, Federal Deposit Insurance Corporation, Room 5134, 550 17th St. N.W., Washington, DC 20429/202-389-4767.

Consumer Questions

For questions of interest to bank depositors and customers, contact: Office of Consumer and Compliance Programs, Federal Deposit Insurance Corporation, Room 5120, 550 17th St. N.W., Washington, DC 20429/202-389-4767.

Deposit Data

Deposit data can be generated for all banking offices of a specific bank on a computer printout; all banking offices within a given county, SMSA, or state on a computer printout; and all banking offices in the country on magnetic tape. Nominal fees are charged for these services. A series of books is available—one for each of the 14 FDIC regions which groups each banking office by state, country and SMSA, with total deposits and the percentage thereof in each of the six categories of deposits. There is a $5.00 charge for each book in the series. Contact: Data Requests Section, Management Systems and Financial Statis-

tics Division, Federal Deposit Insurance Corporation, Room 3090, 550 17th St. N.W., Washington, DC 20429/202-389-4701.

Enforcement and Supervision

This office supervises the compliance of an insured bank and can initiate cease-and-desist proceedings if the bank does not correct an unsafe or unsound practice or a violation of a law, rule, regulation or written agreement with the FDIC. Contact: Supervisory Surveillance and Enforcement, Bank Supervision Division, Federal Deposit Insurance Corporation, 550 17th St. N.W., Room 5050, Washington, DC 20429/202-389-4677.

Freedom of Information Act Requests

Freedom of Information Act requests are handled by: Office of the Executive Secretariat, Federal Deposit Insurance Corporation, Room 6108, 550 17th St. N.W., Washington, DC 20429/202-389-4446.

International Banking

An insured state nonmember bank must obtain Federal Deposit Insurance Corporation consent before establishing its first branch in a foreign country or before acquiring any ownership interest in a foreign bank or other financial entity. The FDIC and other banking agencies follow uniform procedures for evaluating and commenting on country risk factors in the international loan portfolios of U.S. banks. Contact: International Banking Unit, Bank Supervision Division, Federal Deposit Insurance Corporation, Room 668 NYAV, 550 17th St. N.W., Washington, DC 20429/202-389-4431.

Library

The Library collection emphasizes banking, statistics, economics and law. Make an appointment before visiting. Contact: Library, Federal Deposit Insurance Corporation, Room 4074, 550 17th St. N.W., Washington, DC 20429/202-389-4314.

Liquidation

The Legal Division is responsible for regulation of enforcement actions and liquidation litigation. To keep the Division up with their more than 5,000 lawsuits connected with liquidation and other closed-bank matters, outside attorneys are hired. Contact: Legal Division, Federal Deposit Insurance Corporation, Room 4025, 550 17th St. N.W., Washington, DC 20429/202-389-4381.

Lost and Stolen Securities Program

The Federal Deposit Insurance Corporation shares enforcement responsibility with the Securities and Exchange Commission for the computer-assisted reporting and inquiry system for lost, stolen, counterfeit and forged securities. All insured banks and brokers, dealers and other securities firms are required to register with the securities Information Center, Inc., P.O. Box 421, Wellesley Hills, MA 02181/617-235-8270, where a central data base records reported thefts and losses. Contact: Intelligence Section, Bank Supervision Division, Federal Deposit Insurance Corporation, Room 780 NYAV, 550 17th St. N.W., Washington, DC 20429/202-389-4415.

Pamphelts in English and Spanish

The following pamphlets are free:

Fair Credit Reporting Act—describes the steps you can take to protect yourself if you have been denied credit, insurance, or employment, or if you believe you've had difficulties because of an inaccurate or an unfair consumer report.

Equal Credit Opportunity and Women—describes the provisions of the Equal Credit Opportunity Act that apply to sex and marital status.

Equal Credit Opportunity and Age—describes the provisions of the Equal Credit Opportunity Act that applies to age discrimination.

Truth in Lending—describes the Truth-in-Lending law enforced to let consumers know exactly what their charges are and to require creditors to state such charges in a uniform way.

Consumer Information
Fair Credit Billing
Community Reinvestment Act

For further information and a publication list, contact: Federal Deposit Insurance Corporation regional offices, or Public Information, Federal Deposit Insurance Corporation, Room 6061, 550 17th St. N.W., Washington, DC 20429/202-389-4221, or call 800-424-5488.

Problem Banks

The Federal Deposit Insurance Corporation divides problem banks into three categories based on the degree of insurance risk:

Serious Problem-Potential Payoff—an advanced serious problem with an estimated 50% or more chance of requiring financial assistance by the FDIC.

Serious Problem—a situation that threatens ultimately to involve the FDIC in a financial outlay unless drastic changes occur.

Other Problem—a situation in which a bank has significant weaknesses but where the FDIC is less vulnerable.

For further information, contact: Problem Banks Section, Supervisory Surveillance and Enforcement, Supervision Division, Federal Deposit Insurance Corporation, Room 5055, 550 17th St. N.W., Washington, DC 20429/202-389-4673.

Publications

The following free publications are available from: Public Information Office, Federal Deposit Insurance Corporation, Room 6061, 550 17th St. N.W., Washington, DC 20429/202-389-4221:

Summary of Deposits—the aggregate results of a midyear survey of deposits of commercial and mutual savings banks are published annually. The data are grouped by state, county, SMSA, and FDIC region in the following types of accounts: 1) Demand, IPC (individual, partnership and corporate); 2) Savings, IPC; 3) Other time, IPC; 4) Public funds, demand; 5) Public funds, time and savings; and 6) all other.

Changes Among Operating Banks and Branches—an annual year-end publication that sets forth the changes in number and classification of operating banks and branches.

Operating Banking Offices—a listing of operating banking offices published annually, which includes cities and states in which the offices are located.

Law, Regulations and Related Acts—information presented in loose-leaf format in two volumes, including the FDI Act and Rules and Regulations issued as prescribed by the Corporation's Board of Directors, and certain other statues and regulations that affect the operations of insured banks. The service includes also Report Bulletins issued at two-month intervals that reflect the text of any statutory or regulatory changes that may have occurred and summarizes congressional and federal agency actions affecting insured banks. The charge for this information is $100 for each service per calendar year. Orders and checks (payable to FDIC) should be sent to the Office of Information, Office of Legislative Affairs, Federal Deposit Insurance Corporation, Room 6061, 550 17th St. N.W., Washington, DC 20429/202-389-4221.

Trust Assets of Insured Commercial Banks—an annual publication of trust department data collected from all insured commercial banks and presented by type of account, asset distribution, and size of trust department. This publication lists also trust assets by type of account (but not asset distribution) for each of the 300 largest trust departments—ranked according to total trust assets. This is a combined effort of the Federal Deposit Insurance Corporation, the Board of Governors of the Federal Reserve System, and the Office of the Comptroller of the Currency.

Your Insured Deposit—a free pamphlet that provides examples of insurance coverage under the Corporation's rules on certain types of accounts commonly held by depositers in insured banks.

Bank Operating Statistics—Federal Deposit Insurance Corporation presentation of year-end data in a geographical framework based on the *Reports of Condition* and *Reports of Income* submitted by all insured commercial banks.

Electronic Funds Transfer Series: EFTS Introduction to Point of Sale Systems; EFTS Introduction to EFT Security, EFTS Introduction to Automated Tellers, EFTS Introduction to the Automated Clearinghouse, EFTS Glossary, EFTS—A Guide to EDP (Electronic Data Processing; and EFT (Electronic Fund Transfer) Security Based on Occupations.

Registration and Reporting

The Federal Deposit Insurance Corporation administers and enforces the registration and reporting of the Securities Exchange Act of 1934 for insured nonmember banks. Banks with more than $1 million in assets and 500 or more holders of any class of equity security are required to file an initial registration statement and periodic reports. A public document room files these registration statements and periodic reports. Contact: Securities and Disclosure Activities, Bank Supervision Division, Federal Deposit Insurance Corporation, Room 790, 1709 New York Ave. N.W., Washington, DC 20429/202-389-4221.

Reports of Condition and Reports of Income

The reports must be requested by name of bank—in writing—addressed to the Division of Management Systems and Financial Statistics. *Reports of Condition* available on quarterly basis; *Reports of Income* available on annual basis through December 1975 and semiannual basis since June 1976. Contact: Data Requests Section, Management Systems and Financial Statistics Division, Federal Deposit Insurance Corporation, Room 3090, 550 17th St. N.W., Washington, DC 20429/202-389-4101.

Reports and Surveys

Mutual savings banks must fill out a *Report of Condition* quarterly, and a *Report of Income* semiannually. There are surveys that monitor money market certificates and automatic transfers from savings accounts and a weekly survey of selected nonmember banks for data in estimating the nonmember bank component of the U.S. money supply. Reports for the disclosure of loans are extended to certain bank employees and stockholders by the employing bank and its correspondent banks. The Federal Deposit Insurance Corporation has a toll-free number to assist banks in filling out the required call reports—800-424-5101. Contact: Compliance Examination Section, Bank Supervisory Division, Federal Deposit Insurance Corporation, Room 5134, 550

17th St. N.W., Washington, DC 20429/202-389-4512.

Research

Research activities include monitoring developments in the financial industry and the economy and assessing the implications of existing and proposed regulations and legislation. Studies include: deposit insurance reform, new or modified types of deposit accounts, the condition of commercial and mutual savings banks in the United States, rising inflation and interest rates, state usury ceilings, prospects for the housing industry, Federal Reserve membership, and the impact of payment of interest on transaction accounts (NOW accounts, automatic transfer accounts, telephone transfer services). A listing of research papers by titles and authors, including journals and magazines in which some of the papers have appeared is available. Contact: Research Division, Federal Deposit Insurance Corporation, Room 3025, 550 17th St. N.W., Washington, DC 20429/202-389-4541.

How Can the Federal Deposit Insurance Corporation Help You?

For information on how this agency can help you, contact: Federal Deposit Insurance Corporation, 550 17th St. N.W., Washington, DC 20429/202-389-4221.

Federal Election Commission

1325 K St. N.W., Washington, DC 20463/202-523-4089

ESTABLISHED: 1971
BUDGET: $9,004,000
EMPLOYEES: 277

MISSION: Seeks to obtain compliance with, and formulate policy with regard to the implementation of the Federal Election Campaign Act of 1971. The Act provides for the financing of presidential elections; disclosure of the financial activities of federal candidates and political committees supporting such candidates; limitations on contributions and expenditures regarding such federal candidates and political committees; and the organization and registration of political committees.

Major Sources of Information

Election Assistance

Information and assistance on procedures for registration and reporting requirements for candidates and committees is available to federal candidates, political committess and the general public. Contact: Public Communications Branch, Information Division, Federal Election Commission, 4th Floor, 1325 K St. N.W., Washington, DC 20463/202-523-4068, or toll-free—800-424-9530.

Federal Campaign Finance Law Complaints

If you believe a candidate or committee has violated a provision of the Federal Campaign Finance Law or Federal Election Commission regulations, you may file a complaint with the Federal Election Commission. For further information, contact: Office of the General Counsel, Federal Election Commission, 7th Floor, 1325 K St. N.W., Washington, DC 20463/202-523-4143.

Federal Election Commission Publications

The National Clearinghouse for Election Administration Information compiles and disseminates election administration information related to federal elections. The reports produced by the Clearinghouse are available to the public at cost. For a list of publications and their prices, contact: National Clearinghouse for Election Administration Information, Federal Election Commission, 4th Floor, 1325 K St. N.W., Washington, DC 20463/202-523-4183, or toll-free—800-424-9530.

Freedom of Information Act Requests

Freedom of Information Act requests should be made to: Information Division, Federal Election Commission, 4th Floor, 1325 K St. N.W., Washington, DC 20463/202-523-40-5.

Free Publications

The Federal Election Commission provides the following free publications:

Federal Election Campaign Laws
FEC Regulations
The FEC Record (monthly newsletter)
Campaign Guide for Congressional Candidates and Their Committees
Campaign Guide for Party Committees
Campaign Guide for Political Committees
Campaign Guide for Presidential Candidates and Their Committees
Bookkeeping and Reporting Manual

Contact: Public Communications Office, Information Division, Federal Election Commission, 4th Floor, 1325 K St. N.W., Washington, DC 20463/202-523-4068.

Glossary of Spanish Election Terms

This is an English to Spanish glossary of over 1,000 election terms. It is on sale for $3.50 by the Superintendent of Documents, Government Printing Office, Washington, DC 20402/202-783-3238.

Journal of Election Administration

This is a free quarterly publication available at the National Clearinghouse, Federal Election Commission, 4th Floor, 1325 K St. N.W., Washington, DC 20463/202-523-4183, or toll-free— 800-424-9530.

Library

The Federal Election Commission Library collection includes basic legal research resources, with an emphasis on political campaign financing, corporate and labor political activity and election campaign reform. It is open to the public. Contact: Library, Federal Election Commission, 4th Floor, 1325 K St. N.W., Washington, DC 20463/202-523-4178.

Public Election Records

The Office of Public Records provides for public inspection of all reports and statements relating to campaign finance since 1972. They include campaign finance reports, statistical summaries of campaign finance reports, computer indexes and class indexes to locate documents, advisory opinion requests and advisory opinions, complet-ed compliance cases, audit reports, press releases, Commission memoranda, agendas of all Commission meetings, and agenda items and minutes. Contact: The Office of Public Records, Public Disclosure Division, Federal Election Commission, 1st Floor, 1325 K St. N.W., Washington, DC 20463/202-523-4181, or toll-free—800-424-9530.

Voting Equipment
Standards

This Clearinghouse is conducting a study on the possible development of voluntary engineering and performance standards for voting systems used in the United States. Contact: Clearinghouse, Federal Election Commission, 4th Floor, 1325 K St. N.W., Washington, DC 20463/202-523-4183, or toll-free—800-424-9530.

How Can the Federal Election Commission Help You?

For information on how this agency can help you, contact: Information Division, Federal Election Commission, 4th Floor, 1325 K St. N.W., Washington, DC 20463/202-523-4068.

Federal Emergency Management Agency

1725 Eye St. N.W., Washington, DC 20472/202-634-6660

ESTABLISHED: April 1, 1979
BUDGET: $260,934
EMPLOYEES: 2,507

MISSION: Provides a single point of accountability for all federal emergency preparedness, mitigation and response activities; enhances the multiple use of emergency preparedness and response resources at the federal, state and local levels of government in preparing for and responding to the full range of emergencies—natural, manmade, and nuclear—and to integrate into a comprehensive framework activities concerned with hazard mitigation, preparedness planning, relief operations and recovery assistance.

Major Sources of Information

Arson Assistance Program

This program provides assistance to state and local agencies to support their arson prevention and control programs. The emphasis is on the development of management systems in the form of arson task forces at the state and local level. Workshops are set up to explain the arson task force concept and to show how task forces are structured and how they function. Contact: Office of Planning and Education, Fire Administration, Federal Emergency Management Agency, Room 610, 2400 M St. N.W., Washington, DC 20472/202-287-0763.

Arson Implementation Kits

These kits provide general models for building various aspects of a local arson program. They provide basic information on applying ideas that have proven successful in fighting arson. The topics covered include: municipal task forces, public education, hotlines, tipsters, juvenile counseling, early warning systems, management of training programs, state task forces, rural arson and federal arson programs. Contact: Office of Planning and Education, Fire Administration, Federal Emergency Management Agency, Room 610, 2400 M St. N.W., Washington, DC 20472/202-287-0763.

Arson Media Guidebook

This guidebook covers "how to" information on preparing media campaigns for arson prevention and control. It includes suggestions on how to write news releases, public service announcements, radio and TV scripts, how to conduct press conferences and how to evaluate media campaigns. Contact: Arson Resource Center, Fire Administration, Federal Emergency Management Agency, 2400 M St. N.W., Washington, DC 20472/202-634-6660.

Arson Resource Center

This Center serves as a national arson reference center providing information to states and localities to help them prevent and control arson. It has information on Arson Task Forces, Arson Investigation and Prosecution Legislation, Preservation of Historic Sights from Arson, Juvenile Firesetters Counseling Programs and Arson Information Management Systems. These free publications are available:

Arson Resource Directory
Arson Resource Exchange Bulletin
Arson Task Force Assistance Program
Arson News Media Guidebook
Interviewing and Counseling Juvenile Firesetters
Fire Insurance: Its Nature and Dynamics
Report on the Information Management System Conference, Airlie, Virginia, May 3–5, 1975
Arson: America's Malignant Crime

Two additional publications, Overview, Report to the Congress ($8.00) and The Federal Role in Arson Prevention and Control ($20.00) are sold through the National Technical Information Ser-

vices, Department of Commerce, 5285 Port Royal Rd., Springfield, VA 22161/703-557-4600. For further information, contact: Arson Resource Center, Office of Planning and Education, Fire Administration, Federal Emergency Management Agency, 2400 M St. N.W., Washington, DC 20472/202-634-6660.

Community Eligibility for Flood Insurance

A community qualifies for the National Flood Insurance Program in two ways—Emergency and Regular. To determine whether a community is eligible for the Emergency or Regular Program, contact: National Flood Insurance Program, 6410 Rockledge Dr., Bethesda, MD 20034/301-897-5900, or the Federal Insurance Administration (FIA) Regional Office or Federal Insurance Administration, Federal Emergency Management Agency, Room 5250 HUD, 1725 Eye St. N.W., Washington, DC 20472/202-634-6660, or call toll-free, 800-424-9080 (Alaska, Hawaii, Puerto Rico and U.S. Virgin Islands).

Crime Insurance

The Federal Crime Insurance Program enables residents and businesses to purchase affordable insurance against burglary and robbery losses in eligible states. Federal crime insurance applications are available from any licensed property insurance agency or broker in an eligible jurisdiction. *Questions and Answers on the Federal Crime Insurance Program* is on sale by the Superintendent of Documents, Government Printing Office, Washington, DC 20402/202-783-3238. For further information, contact: Federal Crime Insurance, Federal Emergency Management Agency, P.O. Box 41033, Washington, DC 20014/652-2637 (Washington, DC); 301-652-2637 (call collect from Maryland); 800-638-8780; 800-638-6830 (Puerto Rico and Virgin Islands).

Disaster Assistance Center

In times of disaster, the Federal Emergency Management Agency establishes one or more Disaster Assistance Centers in the affected area. These centers provide a central location where representatives of federal agencies, state and local governments, and private relief agencies can offer aid to the disaster victims. Contact: Operations Center, Disaster Response and Recovery, Federal Emergency Management Agency, Room 600 LOG, 1725 Eye St. N.W., Washington, DC 20472/202-634-7800 (24 hours).

Earthquake Insurance

The Federal Insurance Administration is conducting a study of the earthquake insurance market, its capacity, the supports that would be needed if insurance capacity were strained, the reasons for apparent consumer apathy, whether there is a need to promote the purchase of insurance more aggressively in light of that apathy, and the role that insurance might play in promoting increased mitigation efforts by individuals and communities. The thrust of the study is to provide information on which policy making decisions can be based. Contact: Federal Insurance Administration, Federal Emergency Management Agency, Room 5152 HUD, 1725 Eye St. N.W., Washington, DC 20472/202-287-0176.

Emergency Management

This is a free quarterly with articles and news on emergency and disaster management. It notes new information sources, publications and conferences. Contact: Office of Public Affairs, Federal Emergency Management Agency, Room 807, 1725 Eye St. N.W., Washington, DC 20472/202-287-0300.

Emergency Management Institute

The Institute offers high-level courses in comprehensive emergency management. It serves as a national academic center for the collection and dissemination of emergency management information. For more information, contact: Emergency Management Institute, Federal Emergency Management Agency, Emmitsburg, MD 21727/301-447-6771.

Fallout Shelters

For information on the development, use, marking and stocking of fallout shelters, contact: Plans and Preparedness, Federal Emergency Management Agency, Room 5241, GSA, 1725 Eye St. N.W., Washington, DC 20472/202-634-6600.

Federal Insurance

The Federal Insurance Administration is responsible for examining the operations and activities of state regulated Fair Act Access to Insurance Requirement (FAIR) plans. FAIR plans are private property insurance pools. They make essential property insurance available in areas where such insurance is unavailable through the standard market because of environmental conditions surrounding the specific properties. Contact: Federal Insurance Administration, Federal Emergency Management Agency, Room 5138, 451 7th St. S.W., Washington, DC 20472/202-287-0840.

Federal Response Coordination

When the President declares a major disaster or an emergency, immediate notification is made to the Governor, appropriate members of Con-

gress, federal agencies, and the public. FEMA then designates the countries or other political subdivisions that are eligible for federal assistance and sends a Federal Coordinating Officer to the scene. His or her responsibilities include an initial appraisal of what kinds of relief are needed and coordination of all federal disaster assistance programs as well as, with their consent, the efforts of private relief organizations. Contact: Office of Federal Response Coordination, Disaster Response and Recovery, Federal Emergency Management Agency, Room 618 LOG, 1725 Eye St. N.W., Washington, DC 20472/202-287-0508.

Fire Education

Assistance is available to communities in planning, implementing and evaluating educational programs to reduce incidents, loss, deaths and injuries from fire. Technical assistance is provided in arson prevention and control, comprehensive community master planning and emergency medical service management. Contact: Office of Planning and Education, U.S. Fire Administration, Federal Emergency Management Agency, Room 6, 2400 M St. N.W., Washington, DC 20472/202-287-0763.

Flood Insurance

The National Flood Insurance Program makes flood insurance available to property owners at a reasonable cost, in return for which communities are required to carry out flood plain management measures to protect lives and reduce property loss. For more insurance information, contact your local insurance agents, or Federal Insurance Administration, Federal Emergency Management Agency, Room 5138, HUD, 1725 Eye St. N.W., Washington, DC 20472/202-287-0840, or toll-free, 800-638-6620; or National Flood Insurance Program, 64 Rockledge Dr., Bethesda, MD 20034/2-301-897-5900.

Freedom of Information Act Requests

Freedom of Information Act requests are handled by the Office of Public Affairs, Federal Emergency Management Agency, Room 804, 1725 Eye St. N.W., Washington, DC 20472/202-287-0300.

Grants

The programs described below are for sums of money which are given by the federal government to initiate and stimulate new or improved activities or to sustain on-going services:

Academy Planning Assistance

Objectives: To assist states in training and education in fire prevention and control.

Eligibility: States, District of Columbia, Commonwealth of Puerto Rico, territories and possessions of the United States are eligible to apply.

Range of Financial Assistance: Average $11,000.

Contact: Director, Federal Emergency Management Agency, Washington, DC 20472/202-634-6660.

Civil Defense—State and Local Maintenance and Services

Objectives: To maintain the civil defense readiness of state and local governments by furnishing matching funds for annual recurring and maintenance costs for state and local civil defense direction and control and alerting and warning systems and for emergency public information services and supplies required to conduct a viable civil defense program.

Eligibility: State (includes U.S. territories) or state and political subdivision (city, county, township, etc.) jointly.

Range of Financial Assistance: $500 to $75,302.

Contact: Director and Control Branch, State and Local Operational System Division, Plans and Preparedness, Federal Emergency Management Agency, Washington, DC 20472/202-287-0486.

Civil Defense—State and Local Management

Objectives: To develop effective civil defense organizations in the states and their political subdivisions in order to plan for and coordinate emergency activities in the event of attack or other than enemy-caused disaster.

Eligibility: States (including U.S. territories and interstate civil defense authorities) are eligible. Local governments participate under the state's application.

Range of Financial Assistance: $343 to $3,287,576.

Contact: Chief, Operations Support Branch, State and Local Operation Systems Division, Plans and Preparedness, Federal Emergency Management Agency, Washington, DC 20472/202-287-3892.

Disaster Assistance

Objectives: To provide assistance to states, local governments, selected private nonprofit facilities, and individuals in alleviating suffering and hardship resulting from emergencies or major disasters declared by the President.

Eligibility: State and local governments in declared emergency or major disaster areas, owners of selected private nonprofit facilities, and individual disaster victims.

Range of Financial Assistance: $21 to $39,202,722.

Contact: Federal Emergency Management Agency, Disaster Response and Recovery, Washington, DC 20472/202-287-0508.

Earthquake and Hurricane Loss Study and Contingency Planning Grants

Objectives: To prepare plans for all levels of government for preparedness capabilities for severe earthquake or hurricanes in certain high-density, high-risk areas.

Eligibilty: State or local governments serving highly populated localities designated as highly vulnerable to earthquakes and/or hurricane disasters are eligible.

Range of Financial Assistance: $100,000 to $150,000.

Contact: Federal Emergency Management Agency, Washington, DC 20472/202-634-6660.

Emergency Management Institute

Objectives: To assist in defraying the expenses of professional training for state and local emergency management defense personnel and training for instructors who conduct courses under contract.

Eligibility: Individuals who need emergency management training and are assigned to an emergency management position in state or local government. Home study courses are a prerequisite for attendance at the staff college.

Range of Financial Assistance: $34 to $355.

Contact: Training and Education, Federal Emergency Management Agency, Washington, DC 20472/202-287-0463.

Public Education Assistance Program

Objectives: To develop or improve states' capacity to provide communities with leadership, information and materials, technical assistance and training in planning, implementing and evaluating public fire education programs that will reduce state and local fire losses.

Eligibility: States, District of Columbia, Commonwealth of Puerto Rico, territories and possessions of the United States are eligible to apply.

Range of Financial Assistance: $5,000 to $15,000.

Contact: Project Manager, Office of Planning and Education, Fire Administration, Federal Emergency Management Agency, Washington, DC 20472/202-287-0760.

State Disaster Preparedness Grants

Objectives: To assist states in developing state and local plans, programs and capabilities for disaster preparedness and prevention.

Eligibility: All states are eligible (including District of Columbia, Puerto Rico, Virgin Islands, Guam, American Samoa, Trust Territory of the Pacific Islands, the Commonwealth of the Northern Marianas and the Canal Zone.

Range of Financial Assistance: $12,500 to $25,000.

Contact: Federal Emergency Management Agency, Washington, DC 20472/202-634-6660.

State Fire Incident Reporting Assistance

Objectives: To assist states in the establishment and operation of a statewide fire incident and casualty reporting system.

Eligibility: States, the District of Columbia, Commonwealth of Puerto Rico, territories and possessions of the United States are eligible to apply.

Range of Financial Assistance: Up to $70,000.

Contact: Associate Administrator, National Fire Data Center, Fire Administration, Federal Emergency Management Agency, Washington, DC 20472/202-287-0760.

Impact of Earthquakes on Financial Institutions

The Federal Emergency Management Agency's Office of Mitigation and Research is currently studying the impact of earthquakes and their predictions (when science perfects this technology) on financial institutions. This study has three related objectives: to determine the viability of the financial system in the aftermath of a truly catastrophic earthquake in a densely populated area; to understand the effects of a credible earthquake prediction on the behavior of the public and its consequent demand on financial institutions; and to examine the feasibility of effective earthquake mitigation through financial institutions. Contact: Mitigation and Research, Federal Emergency Management Agency, Room 1104, 1725 Eye St. N.W., Washington, DC 20472/202-234-6600.

Individual Disaster Assistance

The Federal Emergency Management Agency provides assistance to individuals and private businesses in presidentially declared emergencies and major disasters. Such assistance includes temporary housing, low-interest disaster loans, state grants, unemployment assistance, food stamps, income tax advice and Social Security assistance. Contact: Office of Individual Assistance, Disaster Response and Recovery, Federal Emergency Management Agency, Room 708 LOG, 1725 Eye St. N.W., Washington, DC 20472/202-287-0508.

In Time of Emergency: A Citizen's Handbook on Emergency Management

This free handbook provides information and guidance on what to do to enhance survival in the event of nationwide nuclear attack or in case of major natural disasters. Contact: Office of Public Affairs, Federal Emergency Management Agency, Room 406, 1725 Eye St. N.W., Washington, DC 20472/202-287-0300.

Juvenile Firesetters Program

This training workshop program is geared to train fire education specialists, fire investigators, counselors, law enforcement and juvenile authorities. The program is scheduled through state fire training offices. Contact: Office of Planning and Education, Fire Administration, Federal Emergency Management Agency, 2400 M St. N.W., Washington, DC 20472/202-287-0760.

Map Information Facility

Information is provided on Special Flood Hazard Areas and the National Flood Insurance Program Rating Factors to both lenders and insurance agents/brokers. A toll-free phone service is available to answer questions Monday through Friday between the hours of 9:00 A.M. and 8:00 P.M. Eastern Time. A telex service can also be accessed on a 24-hour-a-day basis. Contact: Map Information Facility, Federal Insurance Administration, Federal Emergency Management Agency, P.O. Box 34604, Bethesda, MD 20034/800-638-3100 (Continental United States, except Maryland); 800-638-2151 (Puerto Rico, Hawaii, Virgin Islands, Alaska); 800-492-2701 (Maryland, except for the D.C. metropolitan area). The number for the TWX is 710-825-0431.

Maps of Flood-prone Areas

The law requires the Federal Emergency Management Agency to notify every flood-prone community nationwide that it has one or more flood-prone areas. FEMA publishes a map called a "Flood Hazard Boundary Map" which shows the flood-prone areas within the community, and a free MIF Users' Guide is also available. For map requests and information contact: The National Flood Insurance Program, Federal Insurance Administration, Federal Emergency Management Agency, P.O. Box 34604, Bethesda, MD 20034/toll-free telephone numbers: 800-638-3100 (Continental United States, except Maryland); 800-638-2151 (Puerto Rico, Hawaii, Virgin Islands, Alaska); 800-492-2701 (Maryland).

Mitigation and Research Efforts

The Applications Program is designed to strengthen the capabilities of public interest groups, voluntary agencies and commercial/industrial groups to help set priorities and participate in mitigation and research efforts. It manages a comprehensive emergency management technical information system and formulates prototype projects in a range of emergency situations. Contact: Office of Applications, Mitigation and Research, Federal Emergency Management Agency, Room 909, 1725 Eye St. N.W., Washington, DC 20472/202-287-0390.

Motion Picture Catalog

This catalog contains a current list of public information films. For information on specialized educational, training, research and historical films, contact: Office of Public Affairs, Federal Emergency Management Agency, Room 406, 1725 Eye St. N.W., Washington, DC 20472/202-287-0300.

National Fire Academy

The Academy trains over 6,000 students a year. Courses include executive development, fire data collection and analysis, fire service technologies, arson investigation and detection, and disaster planning for hazardous materials. Many of the courses will be available to paid and volunteer firefighters through the United States. Contact: National Fire Academy, Fire Administration, Federal Emergency Management Agency, Rural Rt. One, Box 10A, Emmitsburg, MD 21727/301-447-6771.

National Fire Data

The National Fire Data Center collects statistical data and general information on fires, fire research, arson, home and building safety, firefighter safety, health and technology, and fire investigation. Through the state fire incident reporting systems, the fire incident file contains information on over one million fires. For further information, contact: National Fire Data Center, Fire Administration, Federal Emergency Management Agency, Room 405, 2400 M St. N.W., Washington, DC 20472/202-287-0763.

National Fire Incident Reporting System

This office collects and analyzes information on the frequency, causes, spread and extinguishment of fires, and on property losses. The NFIRS Handbook provides detailed information on how to report into the system. The National Fire Incident Reporting System News is published by the Center to promote an exchange of information among state and local users of the National Fire Incident Reporting System. Contact: Data Systems, The National Fire Data Center, Fire Ad-

ministration, Federal Emergency Management Agency, Room 408 USFA, 1725 Eye St. N.W., Washington, DC 20472/202-287-0763.

National Security Programs

National Security Programs are directed at reducing the impact of an enemy attack. Major concerns include protecting key segments of the population from blast and fire, lessening the vulnerability to fallout of persons relocated away from prime target areas, and increasing the protection of critical industries in case of enemy action. The programs also address nuclear peacetime problems. Contact: Office of National Security, Mitigation and Research, Federal Emergency Management Agency, Room 909, 1725 Eye St. N.W., Washington, DC 20472/202-287-0390.

Natural and Technical Hazards

Research on improved ways to lessen the impact of earthborne, waterborne and windborne phenomena. Some of the areas include finding ways to develop improved building codes, standards and practices, wiser siting of new structures and greater awareness of hazards. The program coordinates the National Earthquake Hazards Reduction Program and the National Dam Safety Program. Other research activities include hazardous chemical and toxic materials handling, transportation and disposal. For additional information, contact: Office of Natural and Technical Hazards, Mitigation and Research, Federal Emergency Management Agency, Room 909, 1725 Eye St. N.W., Washington, DC 20472/202-287-0390.

Population Protection

Programs include in-place shelter planning, population relocation planning, shelter identification and emergency information to the public. Contact: Population Protection Division, Plans and Preparedness, Federal Emergency Management Agency, Room 422 GSA, 1725 Eye St. N.W., Washington, DC 20472/202-566-0760.

Protection in the Nuclear Age

This free booklet provides information on understanding the hazards of nuclear attack, warnings, improving fallout protection, shelter living, free hazards, emergency care of the sick and injured and options for relocation. Contact: Population Protection Division, Plans and Preparedness, Federal Emergency Management Agency, Room 4227 GSA, 1725 Eye St. N.W., Washington, DC 20472/202-634-6660. Additional publications include information bulletins entitled *Research Report on Recovery from Nuclear Attack* and *Questions and Answers on Crisis Relocation Planning*.

Public Disaster Assistance

Public assistance in presidentially declared emergencies and major disasters is available to local and state governments in the form of federal grants and loans. Contact: Office of Program Support, Disaster Response Recovery, Federal Emergency Management Agency, Room 608 LOG, 1725 Eye St. N.W., Washington, DC 20472/202-287-0508.

Radioactive Hazards

The Federal Emergency Management Agency helps local governments deal with peacetime emergencies involving radioactive materials—transportation accidents or (to a limited degree) nuclear power reactor accidents. The FEMA provides radiological detection instruments, maintenance for the instruments and training for personnel to detect radiological hazards, and assess their impact on operations. Contact: Radiological Emergency Preparedness, Plans and Preparedness, Federal Emergency Management Agency, Room 4241 GSA, 1725 Eye St. N.W., Washington, DC 20472/202-634-6660.

Regional Offices

There are 10 Federal Emergency Management Agency Regional Offices to facilitate federal disaster assistance to states and local areas. Contact: Regional Coordination, Federal Emergency Management Agency, Room 900, 1725 Eye St. N.W., Washington, DC 20472/202-634-6660. Locations, addresses and telephone numbers of the regional offices are as follows:

FEMA Region I, 150 Causeway St., Room 710, Boston, MA 02114/617-223-4271.

FEMA Region II, 26 Federal Plaza, New York, NY 10007/212-264-8980.

FEMA Region III, Curtis Building—7th Floor, 6th and Walnut Sts., Philadelphia, PA 19106/215-597-9416.

FEMA Region IV, 1375 Peachtree St. N.E., Atlanta, GA 30309/404-881-3641.

FEMA Region V, One N. Dearborn St., Room 540, Chicago, IL 60602/312-353-1500.

FEMA Region VI, Federal Regional Center, Denton, TX 76201/817-387-5811.

FEMA Region VII, Old Federal Office Building, 911 Walnut St., Kansas City, MO 64106/816-758-5912.

FEMA Region VIII, Denver Federal Center, Building 7, Denver, CO 80225/303-234-2553.

FEMA Region IX, 211 Main St., Room 220, San Francisco, CA 94105/415-556-8794.

FEMA Region X, Federal Regional Center, Bothell, WA 98011/206-486-0721.

Reporting Claims for Flood Losses (agents only)

Policyholders should report claims for flood losses to their agents. Agents should call toll-free 800-638-6580, or contact: National Flood Insurance Program, 6410 Rockledge Dr., Bethesda, MD 20034/301-897-5900.

Report on Implementation of Federal Guidelines for Dam Safety

A report on early federal agency progress to implement the Federal Guidelines for Dam Safety has been completed by the Federal Emergency Management Agency. Seventeen individual units and bureaus of the eight major federal departments/agencies with responsibilities for federal dams outline their progress for strengthening dam safety procedures in the report. Contact: Federal Dam Safety Program, Mitigation and Research, Federal Emergency Management Agency, Room 909, 1725 Eye St. N.W., Washington, DC 20472/202-287-0390.

Smoke Detectors

It's Alarming is a free brochure on smoke detectors, plus a list of brochures, films, reports and public education campaigns are available from: Federal Emergency Management Agency, Fire Administration, Washington, DC 20472.

Stockpile Information

The Federal Emergency Management Agency develops national plans necessary for resource management and stabilization of the economy in time of emergency, including policy guidance for stockpiling strategic materials. The office also prepares a stockpile report to the Congress which includes information on strategic and critical materials, and other materials in government inventories; stockpile activities such as procurement, research, legislation, storage and maintenance, and disposal programs; expenditure of stockpile finds by type; and stockpile activities of other agencies. Contact: National Defense Stockpile Policy Division, Plans and Preparedness, Federal Emergency Management Agency, Room 5208 GSA, 1725 Eye St. N.W., Washington, DC 20472/202-566-0280.

Urban Property Insurance and Riot Reinsurance

The Federal Riot Reinsurance Program reinsures the general property insurance business against riots. It is available to insurance companies in states with state-wide plans for fair access to insurance requirements meeting federal criteria in making essential property insurance available. For more information, contact: Urban Property Insurance Operations Division, Federal Insurance Operations, Federal Emergency Management Agency, Room 5248 HUD, 1725 Eye St. N.W., Washington, DC 20472/202-755-6555.

Winter Survival

The Federal Emergency Management Agency has two free leaflets on winter survival: *Winter Storms* discusses the problems and solutions for individuals caught by winter storms on the highway or in their homes; and *Winter Fires* provides winter fire safety tips for the home. Contact: Office of Public Affairs, Federal Emergency Management Agency, Room 804, 1725 Eye St. N.W., Washington, DC 20472/202-287-0300.

How Can the Federal Emergency Management Agency Help You?

For information on how this agency can be of help to you, contact: Office of Public Affairs, Federal Emergency Management Agency, Room 804, 1725 Eye St. N.W., Washington, DC 20472/202-287-0300.

Federal Home Loan Bank Board

1700 G St. N.W., Washington, DC 20552/202-377-6677

ESTABLISHED: July 22, 1932
BUDGET: $258,066,000
EMPLOYEES: 1,480

MISSION: Encourages thrift and economical home ownership; supervises and regulates savings and loan associations, which specialize in lending out money on homes and are the country's major private source of funds to pay for building and buying homes; operates the Federal Savings and Loan Insurance Corporation, which protects savings of the more than 84 million Americans with savings accounts in FSLIC-insured savings and loan associations; directs the Federal Home Loan Bank System, which, like the Federal Reserve System for banks, provides reserve credit and the assurance that member savings and loan associations will continue to be a source of economical financing for homes.

Major Sources of Information

Administration

This office handles contractual and leasing issues regarding the Bank Board building, Equal Employment Opportunity (EEO) complaints and adverse action hearings, compliance with Freedom of Information (FOI), the Sunshine Act, and the Ethics in Government Act, as well as other administrative matters relating to the Bank Board, labor negotiating for the Bank Board, and the tort claims made against the FHLBB. Contact: Administration Division, Office of the General Counsel, Federal Home Loan Bank Board, 3rd Floor, 1700 G St. N.W., Washington, DC 20552/202-377-6462.

Application Evaluation

This office evaluates and processes applications submitted by savings and loan associations. It provides data on application trends, facility applications by district banks, merger applications, etc. Contact: Application Evaluation Division, Office of Industry Development, Federal Home Loan Bank Board, 4th Floor, 1700 G St. N.W., Washington, DC 20552/202-377-6715.

Asset Management

FSLIC will purchase specified assets if it proves to be more economical as part of the default prevention activity. Contact: Asset Management Division, Office of the Federal Savings and Loan Insurance Corporation, Federal Home Loan Bank Board, 4th Floor, 1700 G St. N.W., Washington, DC 20552/202-377-6609.

Business Transactions

This office gives advice primarily with regard to legal issues arising in connection with mergers, holding company acquisitions and conversions to federal mutual charter. It also reviews novel legal issues raised by applications for branch offices, remote service facilities, permission to organize, change in control, insurance of accounts, and Federal Home Loan Bank membership. Contact: Business Organizations and Transactions, Office of the General Counsel, Federal Home Loan Bank Board, 3rd Floor, 1700 G St. N.W., Washington, DC 20552/202-377-6450.

Community Investment

This office has been developing broad-based commitments from both public and private interests to further community investment. The activities have been aimed at helping the savings and loan industry recognize the business opportunities that can stem from community investment. Contact: Office of Community Investment, Federal Home Loan Bank Board, 2nd Floor, 1700 G St. N.W., Washington, DC 20552/202-377-6283.

Compliance

This office conducts investigations of suspected statutory or regulatory violations and unsafe

or unsound practices by federally insured savings and loan associations and brings administrative enforcement actions leading to cease-and-desist orders, removal and suspension orders, or the termination of insurance. Contact: Compliance Division, Office of General Counsel, Federal Home Loan Bank Board, 3rd Floor, 1700 G St. N.W., Washington, DC 20552/202-377-6430.

Debt Management

This office is responsible for raising money through the sale of debt instruments. Contact: Debt Management Division, Office of Finance, Federal Home Loan Bank Board, 5th Floor, 1700 G St., N.W., Washington, DC 20552/202-377-6314.

District Banks

The Federal Home Loan Bank system, through its twelve regional banks, provides a reserve credit facility for member savings institutions. These banks provide funds in the form of advances to members for savings withdrawals, seasonal and expansionary needs, and special purposes such as community development. Contact one of the following regional Federal Home Loan Banks or Office of the District Banks, Federal Home Loan Bank Board, 4th Floor, 1700 G St. N.W., Washington, DC 20552/202-377-6650.

Federal Home Loan Bank of Boston, P.O. Box 2196, Boston, MA 20106 (Connecticut, Maine, Massachusetts, New Hampshire, Rhode Island and Vermont).

Federal Home Loan Bank of New York, One World Trade Center, Floor 103, New York, NY 10048 (New Jersey, New York, Puerto Rico and Virgin Islands).

Federal Home Loan Bank of Pittsburgh, 11 Stanwix St., 4th Floor, Gateway Center, Pittsburgh, PA 15222. (Delaware, Pennsylvania and West Virginia).

Federal Home Loan Bank of Atlanta, P.O. Box 56527, Atlanta, GA 30343. (Alabama, District of Columbia, Florida, Georgia, Maryland, North Carolina, South Carolina and Virginia).

Federal Home Loan Bank of Cincinnati, P.O. Box 598, Cincinnati, OH 45201 (Kentucky, Ohio and Tennessee).

Federal Home Loan Bank of Indianapolis, 2900 Indiana Tower, One Indiana Square, Indianapolis, IN 46204 (Indiana and Michigan).

Federal Home Loan Bank of Chicago, 111 East Wacker Dr., Chicago, IL 60601 (Illinois and Wisconsin).

Federal Home Loan Bank of Des Moines, 907 Walnut St., Des Moines, IA 50309 (Iowa, Minnesota, Missouri, North Dakota and South Dakota).

Federal Home Loan Bank of Little Rock, 1400 Tower Building, Little Rock, AK 7220 (Arkansas, Louisiana, Mississippi, New Mexico and Texas).

Federal Home Loan Bank of Topeka, P.O. Box 176, Topeka, KS 66601 (Colorado, Kansas, Nebraska and Oklahoma).

Federal Home Loan Bank of San Francisco, P.O. Box 7948, San Francisco, CA 94120 (Arizona, Nevada and California).

Federal Home Loan Bank of Seattle, 600 Stewart St., Seattle, WA 98101 (Alaska, Hawaii and Guam, Idaho, Montana, Oregon, Utah, Washington and Wyoming).

Fact Sheets

The Federal Home Loan Bank Board provides Fact Sheets on such subjects as Renegotiable Rate Mortgages, Deposit Insurance Coverage, Electronic Fund Transfer, Community Reinvestment Act, Early Withdrawal Penalties, Mobile Home Loan, Consumer Protection provisions, types of mortgages, availability of fixed rate mortgages, and other related topics. Contact: Information Officer, Office of Public Affairs, Federal Home Loan Bank Board, 2nd Floor, 1700 G St. N.W., Washington, DC 20552/202-377-6933.

Federal Savings and Loan Insurance Corp.

The purpose of the Federal Savings and Loan Insurance Corp. is to provide stability to the savings and loan industry while providing safety to small savers by offering insurance for savings accounts. It is also concerned with helping the industry attract funds for economical home financing. Contact: Office of the Federal Savings and Loan Insurance Corporation, Federal Home Loan Bank Board, 4th Floor, 1700 G St. N.W., Washington, DC 20552/202-377-6612.

Files and Dockets

The Files and Dockets of savings and loan associations are available only through Freedom of Information requests. There are files of over 4,000 active members of the Bank system, including associations insured by FSLIC: files of over 670 service corporations which are owned in part or in whole by various federal savings and loans; plus the files of 191 savings and loan holding companies registered with and regulated by the Bank Board. Contact: Office of the General Counsel, Federal Home Loan Bank Board, 3rd Floor, 1700 G St. N.W., Washington, DC 20552/202-377-6469.

Finance

This office provides analysis and research on forecasting asset growth and in managing liabilities of district banks in an effort to insure that adequate funds are available at a reasonable cost. Contact: Office of Finance, Federal Home Loan

Bank Board, 5th Floor, 1700 G St. N.W., Washington, DC 20552/202-377-6308.

Financial Assistance

After a merger or rehabilitation action of an insured savings and loan institution is consummated, the FSLIC administers the financial assistance agreement until its expiration. Contact: Financial Assistance Division, Office of the Federal Savings and Loan Insurance Corporation, Federal Home Loan Bank Board, 4th Floor, 1700 G St. N.W., Washington, DC 20552/202-377-6624.

Freedom of Information Act Requests

For Freedom of Information Act requests, contact: Administrative Division, Office of the General Counsel, Federal Home Loan Bank Board, 3rd Floor, 1700 G St. N.W., Washington, DC 20552/202-377-6462.

Grants

The grant program encourages the use of funds for contracts and special studies for which historical black colleges and universities could be invited to perform. Contact: Administrative Services Division, Federal Home Loan Bank Board, 4th Floor, 1700 G St. N.W., Washington, DC 20552/202-377-6222.

Housing Finance Review

This quarterly journal presents the results of research in housing finance and includes policy issues on that subject. Contact: *Housing Finance Review*, Office of Policy and Economic Research, Federal Home Loan Bank Board, 5th Floor, 1700 G St. N.W., Washington, DC 20552/202-377-6762.

Industry Development

This office provides analyses and recommendations for action on most applications submitted by the savings and loan industry, and develops and implements proposals to improve the agency's regulatory requirements, policies and procedures. Contact: Office of Industry Development, Federal Home Loan Bank Board, 4th Floor, 1700 G St. N.W., Washington, DC 20552/202-377-6707.

International Activities

This office deals with thrift institutions and mortgage lending either in or relating to foreign countries. For example, it has a program of liaison and technical assistance with the Agency for International Development's (AID) Office of Housing. Projects in Latin America include the continued development of a secondary mortgage market in Bolivia and the continued monitoring of the Inter-American Savings and Loan Bank. It has also conducted a survey of mortgage finance systems of seven Asian countries. It also monitors housing finance developments in the major industrialized countries of the world. There is also a Visiting Research Scholars Program where academic economists work with staff economists on policy and statistical projects. Contact: International Division, Office of Policy and Economic Research, Federal Home Loan Bank Board, 5th Floor, 1700 G St. N.W., Washington, DC 20552/202-377-6775.

Investment

This office is the portfolio manager for the Consolidated Securities Fund, the Federal Home Loan Mortgage Corporation, and the Federal Savings and Loan Insurance Corporation. It is also the money control operations arm for all FHLBB System portfolios. Contact: Investment Division, Office of Finance, Federal Home Loan Bank Board, 5th Floor, 1700 G St. N.W., Washington, DC 20552/202-377-6330.

Legal Assistance

This office provides legal advice and assistance in connection with the Federal Savings and Loan Insurance Corporation's default prevention and financial assistance activities. For more information, contact: Federal Savings and Loan Insurance Corporation Division, Office of the General Counsel, Federal Home Loan Bank Board, 3rd Floor, 1700 G St. N.W., Washington, DC 20552/202-377-6428.

Libraries

The Federal Home Loan Bank Board Research Library includes material in banking, savings and loan associations, economics, finance and related subjects. The Federal Home Loan Bank Board also has a law library that includes banking and savings and loan laws for all the states. Contact: Research Library, Basement, Federal Home Loan Bank Board, 1700 G St. N.W., Washington, DC 20552/202-377-6296, or Law Library, Federal Home Loan Bank Board, Basement, 1700 G St. N.W., Washington, DC 20552/202-377-6470.

Neighborhood Reinvestment

The Federal Home Loan Bank Board has established the Neighborhood Reinvestment Corporation (NRC) to stimulate local partnerships in an effort to reverse the process of neighborhood deterioration. The main focus is the im-

provement of housing and public amenities. Contact: Office of Neighborhood Reinvestment, Federal Home Loan Bank Board, 6th Floor, 1700 G St. N.W., Washington, DC 20552/202-377-6366.

Publications

For a list of Federal Home Loan Bank Board publications, contact: Information Office, Office of Public Affairs, Federal Home Loan Bank Board, 2nd Floor, 1700 G St. N.W., Washington, DC 20552/202-377-6933.

Regulations

This office in cooperation with other Bank Board offices, drafts regulations and policy statements to implement the Bank Board's statutory authority, policies, objectives and directives. Contact: Regulations Division, Office of the General Counsel, Federal Home Loan Bank Board, 3rd Floor, 1700 G St. N.W., Washington, DC 20552/202-377-6440.

Research

This office is responsible for most long-range analytical projects relating to the thrift industry and the savings and mortgage markets. Contact: General Research Division, Office of Policy and Economic Research, Federal Home Loan Bank Board, 5th Floor, 1700 G St. N.W., Washington, DC 20552/202-377-6760.

Research and Analysis

This office is responsible for detailed legal analysis and research of issues of concern to the Bank Board such as questions of constitutional law, tax law issues, issues involving the FHLBB system, and civil rights issues. Contact: Research and Analysis Division, Office of the General Counsel, Federal Home Loan Bank Board, 3rd Floor, 1700 G St. N.W., Washington, DC 20552/202-377-6432.

Securities

This office processes mutual-to-stock and state stock-to-federal stock conversion applications and all debt applications. It also administers and enforces provisions of the Securities Exchange Act relating to securities registration, periodic reporting, proxy solicitation, tender offers and insider trading of stock or registered stock savings and loan institutions. Contact: Securities Division, Office of the General Counsel, Federal Home Loan Bank Board, 3rd Floor, 1700 G St.

N.W., Washington, DC 20552/202-377-6459.

Statistics

This office collects and monitors reports for the savings and loan industry and produces special reports on various aspects of savings and loan operations. The statistics include Balance Sheet Data Commitments, Savings Activity, Net Savings Inflow, Mortgage Loan Activity, Mortgage Loans, Closed Mortgage debt held, and maximum rates of return payable on savings of savings and loan associations. Contact: Statistical Division, Office of Policy and Economic Research, Federal Home Loan Bank Board, 5th Floor, 1700 G St. N.W., Washington, DC 20552/202-377-6780.

Supervision

This office monitors compliance with the Community Reinvestment Act by the savings and loan system. It has established a Community Reinvestment Act rating and monitoring system under which every association with an adverse rating at its most recent examination is logged and thereafter closely surveilled. Contact: Supervisor, Office of Examinations and Supervision, Federal Home Loan Bank Board, 3rd Floor, 1700 G St. N.W., Washington, DC 20552/202-377-6545.

Supervisory Agents List for Consumer Complaints

For a list of supervisory agents and their addresses and phone numbers who handle consumer complaints in each of the 12 districts, contact: Department of Consumer and Civil Rights, Office of Examinations and Supervision, Federal Home Loan Bank Board, 3rd Floor, 1700 G St. N.W., Washington, DC 20552/202-377-6947.

There Ought to be a Law ... There Is

This is a free pamphlet on savings and loan associations with information on consumers' and borrowers' rights. Contact: Consumer Division, Office of Community Investment, Federal Home Loan Bank Board, 2nd Floor, 1700 G St. N.W., Washington, DC 20552/202-377-6209.

How Can the Federal Home Loan Bank Board Help You?

For information on how this agency can help you, contact: Communications Office, Federal Home Loan Bank Board, 1700 G St. N.W., Washington, DC 20552/202-377-6677.

Federal Labor Relations Authority

500 C St. S.W., Washington, DC 20424/202-382-0777

ESTABLISHED: December 28, 1978
BUDGET: $12,132,000
EMPLOYEES: 362

MISSION: Oversees the federal service labor-management relations program; administers the law that protects the right of employees of the federal government to organize, bargain collectively, and participate through labor organizations of their own choosing in decisions that affect them; and ensures compliance with the statutory rights and obligations of federal employees and the labor organizations which represent them in their dealings with federal agencies.

Major Sources of Information

Administrative Law Judges

Administrative law judges hear unfair labor practice cases prosecuted by the General Counsel. Contact: Office of Administrative Law Judges, Federal Labor Relations Authority, 500 C St. S.W., Washington, DC 20402/202-382-0777.

Annual Report of the Federal Labor Relations Authority and the Federal Service Impasses Panel

This report includes information on the activities of the Agency and provides statistics on the monthly intake of the total caseload by region, monthly intake of new representation cases by region, monthly intake of new unfair labor practice cases by region, case closings, and cases under investigation. Contact: Public Information, Office of the Executive Director, Federal Labor Relations Authority, 500 C St. S.W., Washington, DC 20424/202-382-0711.

Dockets

Case dockets and decisions can be seen in the Docket Room, Office of Operations and Technical Assistance, Federal Labor Relations Authority, 500 C St. S.W., Washington, DC 20424/202-382-0876 (call ahead).

Federal Service Impasses Panel

This panel provides assistance in resolving negotiation impasses between agencies and exclusive representatives. A *Subject Matter Index* and a *Table of Cases,* an *Annual Report* and a *Guide to Hearing Procedures of the Federal Services Impasses Panel* are available. For further information, contact: Federal Service Impasses Panel, Federal Labor Relations Authority, 500 C St. S.W., Washington, DC 20424/202-382-0981.

Freedom of Information Act Requests

For Freedom of Information Act Requests, contact: Office of the Solicitor, Federal Labor Relations Authority, 500 C St. S.W., Washington, DC 20424/202-382-0782.

General Counsel

The General Counsel may investigate alleged unfair labor practices, and file and prosecute complaints. For additional information, contact: Office of the General Counsel, Federal Labor Relations Authority, 500 C St. S.W., Washington, DC 20424/202-382-0742.

Library

The Federal Labor Relations Authority Library is a small specialized collection of material dealing with Federal Labor Relations. Contact: Library, Federal Labor Relations Authority, 500 C St. S.W., Washington, DC 20424/202-382-0765.

Federal Maritime Commission

1100 L St. N.W., Washington, DC 20573/202-523-5705

ESTABLISHED: August 12, 1961
BUDGET: $11,591,000
EMPLOYEES: 361
MISSION: Regulates the waterborne foreign and domestic offshore commerce of the United States; assures that U.S. international trade is open to all nations on fair and equitable terms, and protects against unauthorized, concerted activity in the waterborne commerce of the United States; maintains surveillance over steamship conferences and common carriers by water; assures that only the rates on file with the Commission are charged; approves agreements between persons subject to the Shipping Act, 1916; guarantees equal treatment to shippers, carriers and other persons subject to the shipping statutes; and ensures that adequate levels of financial responsibility are maintained for indemnification of passengers and clean-up of oil and hazardous substances spills.

Major Sources of Information

Agreements and Trade Activities

All agreements are reviewed in this bureau which is also responsible for the on-going analysis of trade patterns, conference activities, self-policing contracts, pooling statements and operating reports. The Bureau monitors significant trade activities and forecasts future competitive trade conditions. Contrct: Bureau of Agreements, Federal Maritime Commission, Room 10423, 1100 L St. N.W., Washington, DC 20573/202-523-5787.

Bunker Fuel Surcharges

The Commission monitors world fuel oil prices with the dual objective of responding to the concerns of shippers paying increased rates and the needs of carriers burdened by increasing oil prices. Contact: Bureau of Investigation and Enforcement, Federal Maritime Commission, Room 9309, 1100 L St. N.W., Washington, DC 20573/202-523-5860.

Consumer Affairs

This office handles consumer complaints. It meets with shippers and carriers to resolve complaints, problems and matters of mutual concern. It also monitors consumer-related legislation in the Congress, consumer initiatives by the Administration, and consumer activities in other government agencies. Contact: Office of Consumer Affairs, Federal Maritime Commission, Room 12411A, 1100 L St. N.W., Washington, DC 20573/202-523-5800.

Containerized Bulk Cargo

Information on tariff filing requirements for bulk-type cargoes is available. Contact: Bureau of Tariffs, Federal Maritime Commission, Room 10319-A, 1100 L St. N.W., Washington, DC 20573/202-523-5796.

Currency Adjustment Factors

The Commission instituted a rulemaking proceeding establishing tariff requirements for common carriers publishing currency adjustment factors in the foreign commerce. Contact: Bureau of Tariffs, Federal Maritime Commission, Room 10319A, 1100 L St. N.W., Washington, DC 20573/202-523-5796.

Dockets

All official files and records of Commission proceedings, copies of decisions of the administrative law judges, Commission reports, publications and miscellaneous documents as well as informal and special docket proceedings of the Federal Maritime Commission can be seen in the Docket Room. Federal Maritime Commission,

Room 11409, 1100 L St. N.W., Washington, DC 20573/202-523-5760.

Economic Analysis

This office coordinates activity between the Commission's economists and transportation industry analysts. It also analyzes trade by geographic areas (U.S./North Atlantic/Europe; U.S./East Asia; U.S./South America; U.S. Mainland/Puerto Rico-Virgin Islands: West Coast/Hawaii; West Coast/American Samoa). Contact: Office of Economic Analysis, Bureau of Agreements, Federal Maritime Commission, Room 9211, 1100 L St. N.W., Washington, DC 20573/202-523-5870.

Energy and Environmental Impact

Information on the Commission's environmental and energy impact programs and other energy considerations are available. Contact: Office of Energy and Environmental Impact, Federal Maritime Commission, Room 9102, 1100 L St. N.W., Washington, DC 20543/202-523-5835.

Enforcement

A description of the Commission's achievements in prosecuting claims of illegal rebating and standardizing its monitoring, investigative, settlement and prosecutorial activities is available. Contact: Office of General Counsel, Federal Maritime Commission, Room 12221, 1100 L St. N.W., Washington, DC 20573/202-523-5740.

Formal Complaints

Formal complaints involving alleged violations of shipping laws are received and processed by the Commission. Contact: Office of the Secretary, Federal Maritime Commission, Room 11101, 1100 L St. N.W., Washington, DC 20573/202-523-5725.

Freedom of Information Act

For Freedom of Information Act requests, contact: Office of the Secretary, Federal Maritime Commission, Room 11101, 1100 L St. N.W., Washington, DC 20573/202-523-5725.

Freight Forwarding Licenses

Ocean freight forwarding licenses are issued to individuals, partnerships, corporations and associations. Contact: Office of Freight Forwarders, Bureau of Certification and Licensing, Federal Maritime Commission, Room 10105, 1100 L St. N.W., Washington, DC 20573/202-523-5843.

Intermodal Transportation

Intermodal transportation involves the movement of goods over a route involving two or more modes of transportation. Intermodal tariffs, reflecting rates and charges for intermodal transportation services, are filed with both the Federal Maritime Commission and the Interstate Commerce Commission. Contact: Bureau of Tariffs, Federal Maritime Commission, Room 10319A, 1100 L St. N.W., Washington, DC 20573/202-523-5796.

Library

The Library collection contains nautical information, primarily on maritime law. Contact: Library, Federal Maritime Commission, Room 11139, 1100 L St. N.W., Washington, DC 20573/202-523-5762.

Marine Terminals

Marine terminals operated by private parties or state or local governments are currently subject to the Commission's jurisdiction if they provide services in connection with common carriers by water. Agreements entered into between terminal operators and other persons subject to the Shipping Act (e.g., for the lease of property, dock or berthing space, or for services to be performed for carriers) may require the approval of the Commission under section 15 of the Act. Contact: Bureau of Agreements, Federal Maritime Commission, Room 10415, 1100 L St. N.W., Washington, DC 20573/202-523-5845.

Ocean Commerce Monitoring

The Commission systematically monitors U.S. ocean commerce in an effort to curtail illegal rebating and other malpractices by carriers, shippers, consignees and other persons subject to the Shipping Act. Contact: Bureau of Investigation and Enforcement, Federal maritime Commission, Room 9309, 1100 L St. N.W., Washington, DC 20573/202-523-5860.

Passenger Vessel Certification

This office certifies passenger vessels for liability incurred by casualties or nonperformance of scheduled voyages. Contact: Office of Passenger Vessel Certification, Bureau of Certification and Licensing, Federal Maritime Commission, Room 10107, 1100 L St. N.W., Washington, DC 20573/202-523-5838.

Pooling Agreements

Pooling agreements provide for equitable apportioning of cargo and/or revenues by a number of carriers in a given trade, enabling the participants to benefit from the increased efficiency and economy accruing from the pooling of vessels, equipment and other resources. Various sailing requirements and other features relative to ser-

vice efficiency are often included in pooling agreements. Equal access agreements are designed to ensure that national flag carriers maintain access to cargo whose movement is controlled by the government of the reciprocal trading partner through cargo preference laws, import quotas or other restrictions. Contact: Bureau of Agreements, Federal Maritime Commission, Room 10423, 1100 L St. N.W., Washington, DC 20573/202-523-5787.

Publications

A list of Federal Maritime Commission Publications, orders, notices, rulings and decisions is currently available. Contact: Office of Communications, Federal Maritime Commission, Room 12313, 1100 L St. N.W., Washington, DC 20573/202-523-5707.

Regulatory Policy and Planning

Policy and planning involves responsiveness to new developments and trends in the U.S. ocean commerce and the liner shipping industry. Transportation industry analysis and management analysts work on long-range policy. They also analyze and review current Commission policies to determine their impact on regulated industries and U.S. ocean commerce. Contact: Office of Regulatory Policy and Planning, Federal Maritime Commission, Room 11213, 1100 L St. N.W., Washington, DC 20573/202-523-5746.

Space Charter Agreements

Space charter agreements involve the charter (or cross-charter) of space or slots between or among ocean carriers. Space chartering agreements are designed to ensure that a carrier is assured of vessel accommodation beyond that which would be otherwise available. Contact: Bureau of Agreements, Federal Maritime Commission, Room 10423, 1100 L St. N.W., Washington, DC 20573/202-523-5787.

State-Controlled Carriers

All state-controlled carriers operating in the foreign commerce of the United States are identified and classified. Information regarding the registry, ownership and control of the responses received is documented. Changes of ownership, registry and control of carriers, their entry and exit from conferences, and the opening rates within conferences to which controlled carriers belong are also monitored. *Publishing and Filing Tariffs by Common Carriers in the Foreign Commerce of the United States* is the Commission's order on this subject. For additional information, contact: Foreign Tariffs Division, Bureau of Tariffs, Federal Maritime Commission, Room 10319B, 1100 L St. N.W., Washington, DC 20573/202-523-5796.

Tariffs

Foreign and domestic tariffs filed with the Commission are analyzed by this Bureau. It also monitors trade conditions and audits tariffs periodically. Contact: Bureau of Tariffs, Federal Maritime Commission, Room 10319A, 1100 L St. N.W., Washington, DC 20573/202-523-5796.

Vessel Certification

The Commission certifies vessels under various federal anti-pollution laws to ensure liability for spills of oil and hazardous substances. Contact: Office of Water Pollution Responsibility, Bureau of Certification and Licensing, Federal Maritime Commission, Room 10102, 1100 L St. N.W., Washington, DC 20573/202-523-5820.

Weekly Agenda

The Commission Secretary prepares the Commission agenda for weekly meetings. Contact: Office of the Secretary, Federal Maritime Commission, Room 11101, 1100 L St. N.W., Washington, DC 20573/202-523-5725.

How Can the Federal Maritime Commission Help You?

To determine how the Federal Maritime Commission can help you, contact: Office of the Chairman, Federal Maritime Commission, 1100 L St. N.W., Washington, DC 20573/202-523-5707.

Federal Mediation and Conciliation Service

2100 K St. N.W., Washington, DC 20427/202-653-5290

ESTABLISHED: 1947
BUDGET: $26,246,000
EMPLOYEES: 518

MISSION: Represents the public interest by promoting the development of sound and stable labor-management relationships; prevents or minimizes work stoppages by assisting labor and management to settle their disputes through mediation; advocates collective bargaining, mediation and voluntary arbitration as the preferred processes for settling issues between employers and representatives of employees; develops the art, science and practice of dispute resolution; and fosters constructive joint relationships of labor and management leaders to increase their mutual understanding and solution of common problems.

Major Sources of Information

Arbitration

Arbitration is a preferred method for resolving disputes arising during the term of a contract. Upon request, the Federal Mediation and Conciliation Service will furnish a panel of professional and impartial arbitrators from which the opposing part may select the one most mutually satisfactory to hear and provide a final decision on their dispute. Contact: Office of Arbitration Services, Federal Mediation and Conciliation Service, Room 601, 2100 K St. N.W., Washington, DC 20427/202-653-5280.

Foreign Visitors

The foreign visitor program involves representatives of labor, management and governments from around the world who want to see how mediation and collective bargaining function in the United States. Contact: Office of Information, Federal Mediation and Conciliation Service, Room 718, 2100 K St. N.W., Washington, DC 20427/202-653-5290.

Freedom of Information Act Requests

For Freedom of Information Act requests, contact: Office of General Counsel, Federal Mediation and Conciliation Service, Room 908, 2100 K St. N.W., Washington, DC 20427/202-653-5305.

General Counsel

The General Counsel represents the Federal Mediation and Conciliation Service in legal matters. It also participates as needed as part of the mediation team on unusually complex and technical mediation assignments. Contact: Office of General Counsel, Federal Mediation and Conciliation Service, Room 908, 2100 K St. N.W., Washington, DC 20427/202-653-5305.

Mediation Training and Development

Collective bargaining workshops are conducted in areas such as mediation in the federal sector, mediation in the construction industry, group dynamics and communications skills training, instructional skills training, and labor economics and costing skills. Contact: Mediation Training and Development, Federal Mediation and Conciliation Service, Room 511, 2100 K St. N.W., Washington, DC 20427/202-653-5340.

Private Sector Help

The Service helps employers and unions in selecting arbitrators to adjudicate labor-management disputes by maintaining a large roster of qualified arbitrators. When an employer and a union need an arbitrator, they need only notify the FMCS and it will provide, at no charge, a listing of qualified arbitrators in their area who are available to hear the dispute. Mediators are on call 24 hours a day in major cities. Contact your local or regional Federal Mediation and Conciliation Service or Office of Mediation Services, Federal Mediation and Conciliation Ser-

vice, Room 504, 2100 K St. N.W., Washington, DC 20427/202-653-5240.

Publications

The following publications are available: *FMCS Annual Report* summarizing major negotiations and important developments; pamphlets on mediation in the private, federal, state and local sectors; a pamphlet on arbitration procedures and policies, and a booklet explaining collective bargaining in the health care industry. For these publications and general information, contact: Office of Information, Federal Mediation and Conciliation Service, Room 718, 2100 K St. N.W., Washington, DC 20427/202-653-5290.

Public Employee Bargaining

This office provides mediation services and assistance to federal agencies and labor organizations in the resolution of negotiation disputes. It enters state and local collective bargaining situations only where both parties ask for assistance, and only when there is no state or local agency available to provide the service. Contact: Public Sector Coordinator, Office of Mediation Services,

Federal Mediation and Conciliation Service, Room 515, 2100 K St. N.W., Washington, DC 20427/202-653-5240.

Technical Assistance
Efforts

Technical assistance to improve relations between labor and management when negotiations are not in progress can include efforts such as putting on a training exercise for one or both parties, help in modifying a relationship or forming an industry-wide joint labor-management committee. For further information, contact: Technical Assistance Coordinator, Office of Mediation Services, Federal Mediation and Conciliation Service, Room 400, 2100 K St. N.W., Washington, DC 20427/202-653-5320.

How Can the Federal Mediation and Conciliation Service Help You?

For information on how this agency may be of help to you, contact: Office of Information, Federal Mediation and Conciliation Service, Room 715, 2100 K St. N.W., Washington, DC 20427/202-653-5290.

Federal Reserve System

20th St. and Constitution Ave. N.W., Washington,. DC 20551/202-452-3204

ESTABLISHED: December 23, 1913
BUDGET: $52,853,000
EMPLOYEES: 1,488

MISSION: Administers and makes policy for the nation's credit and monetary affairs; and helps to maintain the banking industry in a sound condition, capable of responding to the nation's domestic and international financial needs and objectives.

Major Sources of Information

Bank Holding Companies

A company that qualifies as a bank holding company must register with the Federal Reserve System and file reports with the System. A registered bank holding company must obtain the approval of the Board of Governors before acquiring more than 5% of the shares of either additional banks or permissible nonbanking companies. Contact: Bank Holding Companies, Bank Supervision and Regulation Division, Federal Reserve System, Room 3170 MAR, 20th St. and Constitution Ave. N.W., Washington, DC 20551/202-452-2638.

Bank Mergers

All proposed bank mergers between insured state-chartered member banks must receive prior approval from the Federal Reserve Board. Contact: Bank Mergers, Bank Supervision and Regulation Division, Federal Reserve System, Room 3148 MAR, 20th St. and Constitution Ave. N.W., Washington, DC 20551/202-452-3408.

Board Meetings

Open Board meetings are announced in the *Federal Register*. Agendas of meetings are also available. Minutes of past meetings as well as cassette recordings ($5.00 each) of these meetings are also available upon request. Contact: Freedom of Information, Office of the Secretary, Federal Reserve System, Room 2234, 20th St. and Constitution Ave. N.W., Washington, DC 20551/202-452-3684.

Buying Treasury Securities at Federal Reserve Banks

This free publication offers detailed information on buying treasury bills, notes and bonds. It also includes directions on how to read United States government security quotes, regulations and rules governing book-entry treasury bills and the addresses and phone numbers of Federal Reserve Banks and Treasury. Contact: Federal Reserve Bank of Richmond, 701 East Byrd St., P.O. Box 17622, Richmond, VA 23261/804-643-1250.

Complaints about Banks

Complaints about a state-chartered bank in connection with any of the federal credit laws are handled by the Federal Reserve Board. The Board will acknowledge your letter and try to respond in full within 15 days. It will refer complaints about other institutions to the appropriate Federal Bank regulatory agency. Contact: Consumer and Community Affairs Division, Federal Reserve System, Room 4458 MAR, 20th St. and Constitution Ave. N.W., Washington, DC 20551/202-452-2631.

Consumer Education Materials

Free publications are available from the Board of Governors and other Federal Reserve Banks. The following is a listing of the Federal Reserve Banks as well as some of the available publications:

Board of Governors of the Federal Reserve System,

Publications Services, Room MP-510, Washington, DC 20551/202-452-3244.

Federal Reserve Bank of Boston, Public Information Department, 30 Pearl St., Boston, MA 02106/617-973-3459

Federal Reserve Bank of New York, Public Information Department, 33 Liberty St., New York, NY 10045/212-791-6134.

Federal Reserve Bank of Philadelphia, Public Information Department, 100 North 6th St., Philadelphia, PA 19105/215-574-6115.

Federal Reserve Bank of Cleveland, Research Department, P.O. Box 6387, Cleveland, OH 44101/216-241-2000.

Federal Reserve Bank of Richmond, Bank and Public Relations Department, P.O. Box 17622, Richmond, VA 23261/804-643-1250.

Federal Reserve Bank of Atlanta, Research Department, Publications Unit, 104 Marietta St. N.W., Atlanta, GA 30303/404-586-8788.

Federal Reserve Bank of Chicago, Public Information Department, 230 South LaSalle St., Chicago, IL 60690/312-322-5112.

Federal Reserve Bank of St. Louis, Bank Relations and Public Information Department, P.O. Box 442, St. Louis, MO 63166/314-444-8321.

Federal Reserve Bank of Minneapolis, Public Information Department, 250 Marquette Ave., Minneapolis, MN 55480/612-340-2443.

Federal Reserve Bank of Kansas City, Public Information Department, 925 Grand Ave., Kansas City, MO 64198/816-881-2798.

Federal Reserve Bank of Dallas, Public Information Department, 400 South Akard St., Dallas, TX 75222/214-651-6267.

Federal Reserve Bank of San Francisco, Public Information Department, 400 Sansome St., San Francisco, CA 94120/415-544-2184.

Publications available from the Board of Governors

Consumer Handbook to Credit Protection Laws—explains how consumer credit laws can help in shopping for credit, applying for it, and keeping a good credit rating.

The Equal Credit Opportunity Act and Age—briefly describes criteria used in determining creditworthiness and provisions of the Act that prevent age from being used against an individual.

The Equal Credit Opportunity Act and Credit Rights in Housing—discusses the Equal Credit Opportunity Act rights of prospective home buyers.

The Equal Credit Opportunity Act and Incidental Creditors—explains the effects of the Equal Credit Opportunity Act on doctors, lawyers, craftsmen and other professionals and small businessmen who grant consumer credit.

Equal Credit Opportunity Act and Women—explains the effects of Equal Credit Opportunity Act on women.

Fair Credit Billing—tells how to deal with billing errors on open-end credit accounts.

How To File a Consumer Complaint—explains how to file a complaint against a bank in connection with federal credit laws.

If You Borrow to Buy Stock—explains margin regulations in nontechnical terms.

If You Use a Credit Card—explains the protection under federal law against lost cards, what to do if goods bought with credit cards are unsatisfactory, and how you can figure out and compare various credit card charges.

What Truth in Leasing Means to You—explains major provisions of Truth in Leasing Act

What Truth in Lending Means to You—explains major provisions of the Truth in Lending Act.

Publications available from the Federal Reserve Bank of Boston

Checkpoints—gives step-by-step instructions on the proper way to write, deposit and cash checks. Also available in Spanish and Portuguese.

Consumer Education Catalog—Lists consumer education material published by the System and local organizations.

Credit Points—discusses the major credit laws enacted in recent years such as Truth in Lending, and describes consumer's rights and protections.

Available from the Federal Reserve Bank of New York

Basic Information on Treasury Bills—describes the procedures to be followed by individual investors purchasing T-Bills.

Basic Information on Treasury Notes and Bonds—describes procedures to be followed by individual investors purchasing T-Notes and Bonds.

Fedpoints 5—Book-Entry Procedure—discusses Treasury program to replace physical securities with computer entries.

Fedpoints 17—Consumer Credit Regulations—explains that although the Federal Reserve is charged with writing most consumer regulations, their administration involves 12 separate federal organizations. Explanations and details of each.

Consumer Credit Terminology Handbook—a collection of consumer credit terms and definitions to assist consumers in everyday credit transactions. English and Spanish.

Available from the Federal Reserve Bank of Philadelphia

Consumer Affairs Pamphlets—Titles: *How the New Equal Credit Opportunity Act Affects You, How to Establish and Use Credit, Fair Debt Collection Practices, The Rule of 78's, Your Credit Rating.*

Your Credit Rating—describes importance of a credit history and consumers' rights when using credit. Tells what to do to correct credit record.

Available from the Federal Reserve Bank of Richmond

Mechanics of Buying Original Issues of United States Treasury Securities—basic steps involved in purchasing Treasury bills, notes and bonds together with an explanation of the financial needs of the U.S. Treasury.

Available from the Federal Reserve Bank of Chicago

The A B C's of Figuring Interest—discusses how the various ways of calculating interest affects the dollar amount paid.

Marketable Securities of the U.S. Government,—provides facts on U.S. Treasury bills, notes and bonds.

Credit Protection Laws

Find out how you can profit from the new credit laws by obtaining a free copy of *Consumer Handbook to Credit Protection Laws.* Contact: Board of Governors of the Federal Reserve System, 20th St. and Constitution Ave. N.W., Washington, DC 20551/202-452-3245.

Electronic Fund Transfers

Complaints about Electronic Fund Transfers that have not been resolved by the financial institution involved are handled by the Federal Reserve Board. A free booklet, *Alice in Debitland*, deals with consumer protections and the Electronic Fund Transfer Act. Contact: Consumer and Community Affairs Division, Federal Reserve System, 4458 MAR, 20th St. and Constitution Ave. N.W., Washington, DC 20551/ 202-452-2631.

Federal Open Market Committee

Open market operations are the principal instrument used by the Federal Reserve to implement national monetary policy. The Federal Open Market Committee is responsible for determining what transactions the Federal Reserve System will conduct in the open market. Through frequent buying and selling of United States Government securities, the securities of federal agencies, or bankers' acceptances, the Manager of the System Open Market Account provides or absorbs bank reserves in keeping with the instructions and directives issued by the Committee. In addition to operations in the domestic securities market, the Federal Open Market Committee authorizes and directs operations in foreign exchange markets for major convertible currencies. For further information, contact: Office of Staff Director for Monetary and Financial Policy, Federal Reserve System, Room 2001, 20th St. and Constitution Ave. N.W., Washington, DC 20551/202-452-3761.

Financial Statistics

Economic and financial information is available including data on banking, capital markets, government finance, flow or funds and savings, business conditions, wages, prices and productivity. The information is published in a variety of reports and studies. Contact: Research and Statistics Division, Federal Reserve System, Room 3048, 20th St. and Constitution Ave. N.W., Washington, DC 20551/202-452-3301.

Freedom of Information Act Requests

For Freedom of Information Act requests, contact: Office of the Secretary, Federal Reserve System, Room 2234, 20th St. and Constitution Ave. N.W., Washington, DC 20551/202-452-3684.

International Banking

The Board of Governors issues licenses for foreign branches and regulates the scope of their activities; charters and regulates international banking subsidiaries; and authorizes overseas investments by banks and bank subsidiaries. Contact: International Finance Division, Federal Reserve System, Room 1242B, 20th St. and Constitution Ave. N.W., Washington, DC 20551/202-452-3614.

International Finance

For information on foreign financial markets, international banking, U.S./international transactions, international development, world payments and economic activity, etc., contact: International Finance Division, Federal Reserve System, Room 1242-B, 20th St. and Constitution Ave. N.W., Washington, DC 20551/202-452-3614.

Library

The research library contains material on banking, finance, economics, and other areas related to the Federal Reserve System. Contact: Library, Federal Reserve Board, Room BC241, 20th St. and Constitution Ave. N.W. (entrance is on C St.), Washington, DC 20551/202-452-3398. The law library concentrates on banking laws. Contact: Law Library, Federal Reserve System, Room B1066, 20th St. and Constitution Ave. N.W., Washington, DC 20551/202-452-3284.

Monetary Control Act of 1980

The Monetary Control Act of 1980 (P.L. 96-221), enacted on March 31, 1980, is designed to

improve the effectiveness of monetary policy by applying new reserve requirements set by the Federal Reserve Board to all depository institutions. Among other key provisions, the Act 1) authorizes the Federal Reserve to collect reports from all depository institutions; 2) extends access to Federal Reserve discount and borrowing privileges and other services to nonmember depository institutions; 3) requires the Federal Reserve Board to set a schedule of fees for Federal Reserve Board services; and 4) provides for the gradual phase-out of deposit interest rate ceilings, coupled with broader powers for thrift institutions. For more detailed information, contact your District Reserve Bank or Public Affairs, Federal Reserve System, Room 2117-B, 20th St. and Constitution Ave. N.W., Washington, DC 20551/202-452-3204.

Monetary Policy

This office is responsible for the development of monetary policy, which includes the coordinated use of open market operations, the regulation of member bank discounting with Federal Reserve Banks and changes in member Bank reserve requirements. Contact: Office for Monetary and Financial Policy, Federal Reserve Bank, Room 2001, 20th St. and Constitution Ave. N.W., Washington, DC 20551/202-452-3761.

Public Information Materials of the Federal Reserve System

This is a free guide to Federal Reserve System materials designed for use by educators, bankers and the public. The contents of the items, which include occasional and periodic publications, audiovisual materials and statistical information, are briefly described and applicable charges, if any, are listed. For copies of this booklet, contact your local Federal Reserve Bank, or Publication Services, Federal Reserve System, Room MP-510, 20th St. and Constitution Ave. N.W., Washington, DC 20551/202-452-3244.

Services Pricing

The following services are covered by a fee schedule:

Currency and coin services of a nongovernmental nature
Check-clearing and collection
Wire transfer
Automated clearinghouse
Settlement
Securities safekeeping
Federal Reserve float
Any new service the Federal Reserve System offers including but not limited to payment services to effectuate electronic funds transfer

For information, contact the nearest Federal Reserve Bank, or its Branch, or Public Affairs, Federal Reserve System, Room 2117-B, 20th St. and Constitution Ave. N.W., Washington, DC 20551/202-452-3204.

Treasury Securities

The Treasury Department raises much of its funds by selling marketable securities to the general public through the 12 Federal Reserve Banks. These banks receive applications from the public for the purchase of securities, allot the securities among bidders, deliver the securities, collect payment from the buyers, redeem the securities later when they mature, and pay interest coupons. For additional information, contact the nearest Federal Reserve Bank or its branch, or Public Affairs, Federal Reserve System, Room 2117-B, 20th St. and Constitution Ave. N.W., Washington, DC 20551/202-452-3204.

Visitors

Individuals or groups who wish to visit the Federal Reserve Board should contact: Office of the Secretary, Federal Reserve System, Room 2234, 20th St. and Constitution Ave. N.W., Washington, DC 20551/202-452-3257.

How Can the Federal Reserve System Help You?

For information on how this agency can be of help to you, contact: Office of Public Affairs, Board of Governors, Federal Reserve System, Room 2117-B, 20th St. and Constitution Ave. N.W., Washington, DC 20551/202-452-3204.

Federal Trade Commission

Pennsylvania Ave. and 6th St. N.W., Washington, DC 20580/202-523-3830

ESTABLISHED: 1914
BUDGET: $71,431,000
EMPLOYEES: 1,665
MISSION: Responsible for the maintenance of strongly competitive enterprise as the keystone of the American economic system; prevents the free enterprise system from being stifled, substantially lessened or fettered by monopoly or restraints on trade, or corrupted by unfair or deceptive trade practices.

Major Sources of Information

Administrative Law Judges

Administrative law judges are officials to whom the Commission delegates the initial fact-finding procedures in adjudicative cases. The judges conduct trials and review evidence in the form of documents and testimony of witnesses. Contact: Administrative Law Judges, Federal Trade Commission, Room 603B, 2120 L St. N.W., Washington, DC 20580/202-254-7730.

Advertising Substantiation

This office monitors national advertisements to make sure their claims are substantiated. Contact: Advertising Practices, Bureau of Consumer Protection, Federal Trade Commission, Room 6124A STAR, 6th St. and Pennsylvania Ave. N.W., Washington, DC 20580/202-724-1499.

Advisory Opinions

The Federal Trade Commission established the advisory opinion procedures to enable business people to learn, before implementing a practice, whether the practice might violate the laws the Federal Trade Commission administers. Contact: Office of General Counsel, Federal Trade Commission, 6th St. and Pennsylvania Ave. N.W., Room 568, Washington, DC 20580/202-523-3613.

Antitrust Compliance

This office is responsible for securing compliance with all final orders the Federal Trade Commission issues to protect and maintain competition. When the orders require companies to divest themselves of certain stock, assets or both, the division oversees the divestitures. It also reviews prospective purchasers of the stock or assets when the Federal Trade Commission approval of the purchases appears necessary to protect free and fair competition. Contact: Compliance, Bureau of Competition, Federal Trade Commission, Room 1010, 1726 M St. N.W., Washington, DC 20580/202-254-6024.

Children's Advertising

This office monitors advertising directed at children to determine whether or not it is deceptive. Contact: Advertising Practices, Federal Trade Commission, Room 6124A STAR, 6th St. and Pennsylvania Ave. N.W., Washington, DC 20580/202-724-1456.

Cigarette Advertising and Labeling

This office reports regularly to Congress on the effects of cigarette labeling, advertising and promotion. It also operates a tobacco testing laboratory to measure tar, nicotine and carbon monoxide content. Contact: Advertising Practices, Federal Trade Commission, Room 6124A STAR, 6th St. and Pennsylvania Ave. N.W., Washington, DC 20580/202-724-1458.

Competition and Antitrust

This office enforces antitrust laws. It encourages voluntary compliance with the law, offers industry guidance and small business counseling. Contact: Bureau of Competition, Federal Trade Commission, Room 372, 6th St. and Pennsylvania Ave. N.W., Washington, DC 20580/202-523-3601.

Compliance With Consumer Protection Orders

This office makes certain that companies which are subject to cease-and-desist orders abide by them. It is also conducting a major enforcement project on the unordered merchandise law. Contact: Compliance, Bureau of Consumer Protection, Federal Trade Commission, Room 1100B, 6th St. and Pennsylvania Ave. N.W., Washington, DC 20580/202-254-6128.

Consumer Bibliography

This free bibliography compiled by the Federal Trade Commission Library includes consumer directors, manuals, law and legislative sources, bibliographies and periodicals as well as Federal Trade Commission publications. Contact: Consumer Education, Bureau of Consumer Protection, Federal Trade Commission, Room 656 BCB, 6th St. and Pennsylvania Ave. N.W., Washington, DC 20580/202-724-1870.

Consumer Complaints

To offer assistance, make suggestions or report violations, contact: Bureau of Consumer Protection, Federal Trade Commission, 6th St. and Pennsylvania Ave. N.W., Washington, DC 20580/202-523-3598.

Consumer Dispute Resolution

This program is working on ways to increase the consumer's ability to resolve disputes with business. The staff is preparing guidelines for voluntary business complaint-handling systems. For further information and suggestions, contact: Product Reliability, Bureau of Consumer Protection, Federal Trade Commission, Room 242, 6th St. and Pennsylvania Ave. N.W., Washington, DC 20580/202-523-1670.

Consumer Leasing

This office enforces the Consumer Leasing Act which requires that certain terms be disclosed to consumers. Contact: Credit Practices, Bureau of Consumer Protection, Federal Trade Commission, Room 500 IND, 6th St. and Pennsylvania Ave. N.W., Washington, DC 20580/202-724-1569.

Credit Billing

This office polices unfair and deceptive credit billing practices, according to the Fair Credit Billing Act. Contact: Credit Practices, Bureau of Consumer Protection, Federal Trade Commission, Room 500 IND, 6th St. and Pennsylvania Ave. N.W., Washington, DC 20580/202-724-1188.

Credit Discrimination Complaints

If you feel that you have been discriminated against by a retail store, department store, small loan and finance company, gasoline credit card, travel and expense credit card, state chartered credit union or government lending program, you have recourse. You can complain to, and even sue the creditor. You can also file a complaint with the Federal Trade Commission. For further information, and/or for a copy of the Equal Credit Opportunity Act, contact: Federal Trade Commission Regional Office, or Equal Credit Opportunity, Federal Trade Commission, Room 500, 633 Indiana Ave. N.W., Washington, DC 20580/202-724-1184.

Creditors' Remedies

This office enforces the Fair Debt Collection Practices Act, which prohibits deception, invasion of privacy, overcharging and other unfair practices by debt collectors. Contact: Credit Practices, Bureau of Consumer Protection, Room 500 IND, 6th St. and Pennsylvania Ave. N.W., Washington, DC 20580/202-724-1100.

Design Defects

This office investigates the failure on the part of companies to tell consumers about design defects and health and safety risks. Most of the investigations involve automobile and appliance defects. Contact: Energy and Product Information, Federal Trade Commission, Room 7001-B STAR, 6th St. and Pennsylvania Ave. N.W., Washington, DC 20580/202-724-0726.

Energy and Product Information

This office attempts to ensure that products designed to save energy are marketed in a fair and nondeceptive manner. It investigates claims for such products as storm windows and doors, solar products, automobile gas-saving devices, electric energy-saving devices, wood-burning products and space heaters. The office also enforces rules requiring the disclosure of energy costs of major appliances, and of octane ratings of gasoline. Contact: Energy Policy and Conservation, Federal Trade Commission, Room 7001-B STAR, 6th St. and Pennsylvania Ave. N.W., Washington, DC 20580/202-724-1968.

Equal Credit Opportunity

This office enforces the Equal Credit Opportunity Act which says that credit may be denied only on the basis of individual credit-worthiness and not on the basis of sex, race, marital status, religion, national origin, age, or whether the applicant receives public assistance. The law also

gives the consumer the right to know the specific reasons for denial. Contact: Credit Practices, Bureau of Consumer Protection, Federal Trade Commission, Room 500 IND, 6th St. and Pennsylvania Ave. N.W., Washington, DC 20580/202-724-1094.

Evaluation

This office is responsible for advice on how resources should be allocated to most effectively remedy consumer losses. Contact: Evaluation, Bureau of Consumer Protection, Federal Trade Commission, Room 478, 6th St. and Pennsylvania Ave. N.W., Washington, DC 20580/202-523-3275.

Fair Credit Reporting

This office enforces the Fair Credit Reporting Act which gives consumers the right to know what information is distributed about them and to challenge and change incorrect information distributed to creditors, insurance companies, and employers. Contact: Credit Practices, Bureau of Consumer Protection, Federal Trade Commission, Room 500 IND, 6th St. and Pennsylvania Ave. N.W., Washington, DC 20580/202-724-1182.

Finance Statistics

This office collects, analyzes and consolidates financial data from a cross-section of U.S. corporations. Aggregated statistics from its surveys are published in quarterly financial reports covering manufacturing, mining, retailing and wholesaling corporations and in the annual line of business report series. The following are some of the special reports available from the Bureau of Economics:

Economic Papers 1966–1969 by Staff of the Bureau of Economics
ECONOMIC REPORTS OF THE FEDERAL TRADE COMMISSION
 Annual Line of Business Report, 1973, Statistical Report
 Competition and Market Share Instability, Staff Report on (1976)
 Competition in Sulfuric Acid Industry, Staff Report on (May 1977)
 Concentration Levels and Trends in the Energy Sector of the U.S. Economy, Staff Report on (1974)
 Conglomerate Merger Performance: An Empirical Analysis of Nine Corporations, Staff Report on (1972)
 Corporate Mergers, 2nd Acquisitions, Staff Report on (1971)
 Dairy Industry, Staff Report on (1973)

Discount Food Pricing in Washington, DC, Staff Report on (1971)
Economic Structure and Behavior in the Natural Gas Production Industry
Effects of Federal Price and Allocation Regulations on the Petroleum Industry, Staff Report on
Federal Energy Land Policy: Efficiency, Revenue, and Competition, Staff Report on (1975)
Food and Gasoline Retailing, Economic Report on the Use of Games of Chance in (1968)
Food Chain Profits, Staff Reports on (1975)
Food Chain Selling Practices in the District of Columbia and San Francisco, Staff Report on (1969)
Grocery Retailing Concentration in Metropolitan Areas, Economic Census Years 1954–72
Health Maintenance Organization and Its Effects on Competition, Staff Report on (July 1977)
Influence of Market Structure on Profit Performance of Food Manufacturing Companies, Staff Report on (1969)
Interfuel Substitutability in the Electric Utility Sector of the U.S. Economy, Staff Report on (1972)
Installment Credit and Retail Sales Practices of District of Columbia Retailers, Staff Report on (1968)
Life Insurance Cost Disclosure, Staff Report on (July 1979)
Prescription Drug Markets—Sales, Promotion and Product Differentiation in Two (February 1977)
Price and Profit Trends in Four Food Manufacturing Industries, Staff Report on (1971)
Quality of Data As a Factor in Analyses of Structure-Performance Relationships, Staff Report on (1971)
Semiconductor Industry, A Survey of Structure, Conduct, and Performance, Staff Report on (January 1977)
Sulfuric Acid Industry, Competition in the, Staff Report on (May 1977)
Television Repair Industry in Louisiana and California, Regulation of the, Staff Report on (A Case Study) (1974)
Uranium Supply Industry, Analysis of the Competitive Structure in the, Staff Report (August 1979)
U.S. Sugar Industry, Staff Economic Report on (1975)
Use of Games of Chance in Food and Gasoline Retailing, the, Staff Report on (1971)
Value of Shipments Data by Product Class for the 1,000 Largest Manufacturing Companies of 1950 (1972)
Weakening the OPEC Cartel: An Analysis and Evaluation of the Policy Options, Staff Report on (1977)
Webb-Pomerence Associations: A Fifty Year Review, Staff Report on (1978)

Contact: Financial Statistics, Bureau of Economics, Federal Trade Commission, Room 700, 600 E St. N.W., Washington, DC 20580/202-376-3150.

Food and Nutrition Advertising

The staff is working on a trade regulation rule on food advertising to regulate the following types of claims: energy and calorie; fat, fatty acid and cholesterol content, and "natural," "organic," "health food," and related terms. For futher information, contact: Advertising Practices, Bureau of Consumer Protection, Federal Trade Commission, Room 6124 STAR, 6th St. and Pennsylvania Ave. N.W., Washington, DC 20580/202-724-1492.

Franchising and Business Opportunities

This office enforces the franchise rule which requires sellers of franchises and business opportunities to furnish prospective buyers with pre-sale disclosure of information about the franchisor, the franchise, business, and the terms of the franchise relationship. Contact: Marketing Abuses, Bureau of Consumer Protection, Federal Trade Commission, Room 272, 6th St. and Pennsylvania Ave. N.W., Washington, DC 20580/ 202-523-3814.

Freedom of Information Act Requests

For Freedom of Information Act requests, contact: Freedom of Information Branch, Office of the Secretary, Federal Trade Commission, Room 120, 6th St. and Pennsylvania Ave. N.W., Washington, DC 20580/202-523-3582.

FTC Meetings

A recorded message provides details of FTC meetings. Call: 202-523-3806.

FTC News

A recorded message offers the latest news at the FTC. Call: 202-523-3540.

FTC Will Tell You What It's Doing

To keep on top of what the Federal Trade Commission is doing, ask to be put on its two mailing lists—one to receive news summaries and one for the agency's calendar of events. They will keep you advised on reports issued and investigations of companies and industries. The releases are free: Contact: Public Information Office, Federal Trade Commission, Room 496, 6th St. and Pennsylvania Ave. N.W., Washington, DC 20580/202-523-3830.

Funeral Industry

The funeral industry program is working on proposals for trade regulation rules requiring certain service and price disclosure. Contact: Product Reliability, Bureau of Consumer Protection, Federal Trade Commission, Room 242, 6th St.

and Pennsylvania Ave. N.W., Washington, DC 20580/202-523-3388.

Housing Problems

This office investigates instances of substantial defects in new houses and builders' failure to remedy those defects. Contact: Marketing Abuses, Bureau of Consumer Protection, Federal Trade Commission, Room 272, 6th St. and Pennsylvania Ave. N.W., Washington, DC 20580/ 202-523-3914.

Industry Analysis

This office conducts economic studies of individual industries and trade practices along with broad cross-industry comparisons. Contact: Industry Analysis, Bureau of Economics, Federal Trade Commission, Room 770D, 2120 L St. N.W., Washington, DC 20580/202-254-7770.

Insurance

The staff is working on health insurance policies that supplement Medicare. It has also issued a report on life insurance cost disclosure. Contact: Product Reliability, Bureau of Consumer Protection, Federal Trade Commission, Room 242, 6th St. and Pennsylvania Ave. N.W., Washington, DC 20580/202-523-3652.

Land Sale Abuses

This office polices abuses in the sale of subdivision lots to consumers. For additional information, contact: Marketing Practices, Bureau of Consumer Protection, Federal Trade Commission, Room 772, 6th St. and Pennsylvania Ave. N.W., Washington, DC 20580/202-523-3861.

Library

The Library emphasizes materials on consumer affairs and antitrust matters. Contact: Library, Federal Trade Commission, Room 630, 6th St. and Pennsylvania Ave. N.W., Washington, DC 20580/202-523-3871.

Mobile Homes

For problems with mobile homes, especially those concerning warranty performance and service or formaldehyde odor, contact: Product Reliability, Bureau of Consumer Protection, Federal Trade Commission, Room 242, 6th St. and Pennsylvania Ave. N.W., Washington, DC 20580/202-523-3827.

New Consumer Problems

To raise a consumer problem not covered by an existing federal Trade Commission program or to suggest consumer issues the Federal Trade

Commission should be pursuing in the next few years, contact: Management Planning, Bureau of Consumer Protection, Federal Trade Commission, Room 204, 6th St. and Pennsylvania Ave. N.W., Washington, DC 20580/202-523-3553.

Occupational Deregulation

The Occupational Deregulation Program investigates governmental and trade association regulation of professionals that has the effect of impeding the operation of the marketplace, such as restraints on advertising. Subjects of interest include eyeglasses, dentists, denturists, real estate brokers, veterinarians, nurse practitioners and nurse midwives. Contact: Professional Services, Bureau of Consumer Protection, Federal Trade Commission, Room 242, 6th St. and Pennsylvania Ave. N.W., Washington, DC 20580/202-523-3658.

Over-the-Counter Drug (OTC) Advertising

This program monitors impressions of the safety and efficacy of over-the-counter drugs and devices created by their advertising claims. (Complaints about deceptive labels should be made to the Food and Drug Administration.) For further information, contact: Advertising Practices, Bureau of Consumer Protection, Federal Trade Commission, 6th St. and Pennsylvania Ave. N.W., Room 6124A STAR, Washington, DC 20580/202-724-1492.

Point-of-Sales Practices

This office monitors deceptive and unfair marketing techniques, used by retailers such as advertising specials that are unavailable, bait-and-switch tactics, and calling a regular price a "sale price." Contact: Marketing Practices, Bureau of Consumer Protection, Federal Trade Commission, Room 272, 6th St. and Pennsylvania Ave. N.W., Washington, DC 20580/202-523-3913.

Product Registration Numbers

For registration numbers required by the Wood Products Labeling Act, the Fur Products Labeling Act and the Textile Fiber Products Identification Act, contact: Office of Energy Information, Bureau of Consumer Protection, Room 7001-B STAR, 6th St. and Pennsylvania Ave. N.W., Washington, DC 20580/202-724-1524.

Publications

For reports, brochures and other public documents, contact: Distribution and Duplication Branch, Federal Trade Commission, Room 720, 6th St. and Pennsylvania Ave. N.W., Washington, DC 20580/202-523-3598. The following is a list of the more popular free publications:

CONSUMER RIGHTS BROCHURES:
Bait and Switch
Care Labeling (washing and drying instructions on clothing)
Credit Shopping Guide (monthly payment table for various rates of interest)
Eyeglasses
Equal Credit Opportunity
Fair Credit Billing (what to do about errors on your bill)
Fair Debt Collection (how not to be harassed if you owe money)
How to Complain and Get Results
Plain Talk About IRAs (Individual Retirement Accounts)
Shopping by Mail
Shopping for Advertised Specials
Three-Day Cooling Off (protection when you buy from a door-to-door seller)
Truth in Leasing
Warranties
Women & Credit Histories (have credit reported in your own name)
Fair Credit Reporting (Federal Deposit Insurance Corporation)
Consumer Credit Handbook (Federal Reserve Board)
FTC INFORMATION:
What's Going on at the FTC? (quarterly description of FTC consumer protection programs with contact person for each)
FTC MANUALS FOR BUSINESSES:
Advertising Consumer Credit and Lease Terms (how to comply with the Truth in Lending Act)
FTC POLICY PLANNING BRIEFING BOOKS (EDITED FOR PUBLIC RELEASE):
State Regulatory Task Force Report (March 1978)
Automobiles (April 1978)
Food and Nutritions (May 1978)
Insurance (June 1978)
Private Health Insurance to Supplement Medicare (July 1978)
Consumer Problems of the Elderly (August 1978)
Housing (November 1978)
Drugs and Medical Devices (December 1978)
Life Insurance Sold to the Poor: Industrial and Other Debt Insurance (January 1979)
Trademarks, Consumer Information, and Barriers to Competition (February 1979)
Tax Policy and Competition (February 1979)
Compliance and Enforcement (March 1979)
Mergers (May 1979)
Customer Information Remedies (June 1979)
Health Services (June 1979)

Public Funding for FTC Participants

Public funds are available for formal participa-

tion in Federal Trade Commission rulemaking proceedings. Contact: Public Participation, Office of General Counsel, Federal Trade Commission, Room 679, 6th St. and Pennsylvania Ave. N.W., Washington, DC 20580/202-357-0258.

Public Records

Dockets for Federal Trade Commission proceedings, hearing transcripts, index of orders, opinions and public records of the FTC are available for public view. Contact: Public Records Section, Office of the Secretary, Federal Trade Commission, Room 136, 6th St. and Pennsylvania Ave. N.W., Washington, DC 20580/202-523-3598.

Regional Office Programs

Many consumer protection programs are run by regional offices. These include the textile, wool and fur labeling programs, packaging and labeling program, the hobby protection program, the nursing home and health spa programs. For specific information on each of these, contact: Regional Operations, Bureau of Consumer Affairs, Federal Trade Commission, Room 200, 6th St. and Pennsylvania Ave. N.W., Washington, DC 20580/202-523-3951.

Requests for Closed Meetings

An individual may request that the Federal Trade Commission close that portion of a meeting that might affect his or her interests. Contact: Office of the General Counsel, Federal Trade Commission, Room 568, 6th St. and Pennsylvania Ave. N.W., Washington, DC 20580/202-523-3613.

Standards and Certification

The Standards and Certification Program investigates consumer and competition problems arising out of the development of industry standards and seals of approval. The staff is also monitoring solar standards in warranties. Contact: Product Reliability, Bureau of Consumer Protection, Federal Trade Commission, Room 242, 6th St. and Pennsylvania Ave. N.W., Washington, DC 20580/202-523-3935.

Trade Regulation Rules and Industry Guides

These guides are issued periodically as "dos and don'ts" to business and industry. The Federal Trade Commission defines practices that violate the law so that businesspeople may know their legal obligations and consumers may recognize those business practices against which legal recourse is available. The following guides are available:

Advertising Allowances and Other Merchandise Payments and Services, Guides for (May 1969 as amended August 1972)

Bait Advertising, Guides Against (November 1959)

Beauty and Barber Equipment Supplies Industry, Guides for the (July 1968)

Debt Collection Deception, Guides Against (June 1965; partial revision, June 1968)

Deceptive Pricing, Guides Against (December 1963)

Dog and Cat Food Industry, Guides for the (February 1969)

Endorsements and Testimonials in Advertising, Guide Concerning Use of (May 1975)

Fallout Shelters, Guides for Advertising (December 1961; amended June 1965)

Feather and Down Products Industry, Guides for the (October 1971)

"Free" in Connection with the Sale of Photographic Film and Film Processing Service, Guides Against Deceptive Use of the Word (May 1968)

"Free," Use of the Word and Similiar Representations, Guides Concerning (November 1971)

Fuel Economy Advertising for New Automobiles (December 1978)

Greeting Card Industry Relating to Discriminatory Practices, Guides for the (October 1968)

Guarantees, Guides Against Deceptive Advertising of (April 1960)

Hosiery Industry, Guides for the

Household Furniture Industry, Guides for the (December 1973)

Jewelry Industry, Guides for the

Ladies' Handbag Industry, Guides for the (June 1969, as amended to August 1969)

Law Book Industry, Guides for the (August 1975)

Luggage and Related Products Industry, Guides for the

Mail Order Insurance Industry, Guides for the (July 1964)

Metallic Watch Band Industry, Guides for the

"Mill" in the Textile Industry, Guide for Avoiding Deceptive Use of Word (June 1965)

Mirror Industry, Guides for the

Nursery Industry, Guides for the

Preventing Unlawful Practices, Application of Guides in Radiation-Monitoring Instruments, Guides for Advertising (May 1963)

Rebuilt, Reconditioned and Other Used Automobile Parts Industry, Guides for the

Shell Homes, Guides for Advertising (April 1962)

Shoe Content Labeling and Advertising, Guides for (October 1972; Interpretation, August 1963)

Tire Advertising and Labeling Guides (July 1966; amended to 1968)

Vocation and Home Study Schools, Private, Guides for (1972)

Wall Paneling Industry, Decorative, Guides for (1971)

Watch Industry, Guides for the (May 1968; amended August 1970)

Wigs and Other Hairpieces, Guides for Labeling, Advertising and Sale of (August 1970)

Contact: Distribution and Duplication Branch, Federal Trade Commission, Room 720, 6th St. and Pennsylvania Ave. N.W., Washington, DC 20580/202-523-3598.

Truth-in-Lending

This office enforces the Truth-in-Lending Act which requires creditors to give consumers written disclosures of credit information before they enter into a credit transaction. Most of the enforcement activity is aimed at advertising, credit insurance and disclosure violations. Contact: Credit Practices, Bureau of Consumer Protection, Federal Trade Commission, Room 500 IND, 6th St. and Pennsylvania Ave. N.W., Washington, DC 20580/202-724-1145.

Warranties

The Warranties Section monitors to ensure that the information in warranties is clear, complete, understandable and timely; that they are not used deceptively; and that companies meet their obligations. Service contracts are also monitored. The Federal Trade Commission is also studying options on warranty advertising and warranty readability. For further information, contact: Public Reliability, Bureau of Consumer Protection, Federal Trade Commission, Room 242, 6th St. and Pennsylvania Ave. N.W., Washington, DC 20580/202-523-1642.

How Can the Federal Trade Commission Help You?

For information on how this agency can be of help to you, contact: Office of Public Information, Federal Trade Commission, 6th St. and Pennsylvania Ave. N.W., Washington, DC 20580/202-523-3830.

General Services Administration

18th and F Sts. N.W., Washington, DC 20405/202-472-1082

ESTABLISHED: July 1, 1949
BUDGET: $2,270,404,000
EMPLOYEES: 37,835

MISSION: Establishes policy and provides the government an economical and efficient system for the management of its property and records, including construction and operation of buildings, procurement and distribution and operation of buildings, procurement and distribution of supplies, utilization and disposal of property, transportation, traffic, and communications management, stockpiling of strategic materials, and the management of the government-wide, automatic data processing resources program.

Major Divisions and Offices

Public Buildings Service

General Services Administration, 18th and F Sts. N.W., Washington, DC 20405/202-566-1100.
Budget: $1,829,152,000
Employees: 18,307
Mission: Responsible for the design, building or leasing, appraisal, operation, protection, and maintenance of most of the federally controlled buildings in the nation, 284 million square feet of space, in about 10,000 federally owned and leased buildings, in addition to the $827 million in construction projects currently underway.

Federal Supply Service

General Services Administration, 1941 Jefferson Davis Highway, Washington, DC 20406/202-557-8667.
Budget: $126,683,000
Employees: 4,417
Mission: Operates a government-wide service and supply system; approximatley $3.5 billion worth of supplies, materials and services are procured yearly.

Federal Property Resources Service

General Services Administration, 1755 Jefferson Davis Highway, Washington, DC 20406/703-535-7210.
Budget: $46,095,000
Employees: 998
Mission: Responsible for the utilization and disposition of government-owned real property, personal property, acquisition and management of the stockpile of critical and strategic materials, and the sale of excess stockpile material.

Automated Data and Telecommunications Service

General Services Administrations, 18th and F Sts. N.W., Washington, DC 20405/202-566-1000.
Budget: $16,623,000
Employees: 321
Mission: Responsible for a comprehensive government-wide program for the management, procurement and utilization of automatic data, and telecommunications equipment services.

National Archives and Records Service

General Services Administration, 18th St. and Pennsylvania Ave. N.W., Washington, DC 20408/202-523-3134.
Budget: $86,651,000
Employees: 2,226
Mission: Performs a variety of functions relating to the preservation, use and disposition of the records of the United States Government; preserves

and makes available for further government use and for private research the nation's records of enduring value, both textual and audiovisual; administers a regional network of storage-type facilities for nonarchival records; operates the presidential library system and a government records management program; maintains custody and control of the Nixon Presidential historical materials; and supervises the publication of legislative, regulatory and other widely used documents related to government records.

Transportation and Public Utilities Service

General Services Administration, 425 Eye St. N.W., Washington, DC 20406/202-357-0241.
Budget: $14,587,000
Employees: 542
Mission: Administers the government-wide transportation management, postaudit of transportation payments, and motor equipment and public utilities management programs.

Major Sources of Information

Annotation

A free newsletter announces grants, recent publications, completed records projects, and items of general interest to editors and records project personnel. Contact: National Historical Publications and Records Commission, National Archives and Records Service, General Services Administration, Room 1111, 711 14th St. N.W., Washington, DC 20408/202-724-1083.

Art-in-Architecture

The General Services Administration commissions murals, sculptures, paintings, photographs and other forms of artwork for display in public buildings. Artists are selected in cooperation with the National Endowment of the Arts. *Art-in-Architecture Program* is a free catalog of this art from 1962 on, which includes information and history on the federal programs for the fine arts. It also includes guidance to artists on the submission of plans for projects, a listing of artists, titles and descriptions of the works, and a pictorial section of color and black-and-white photos. For further information, contact: Art-in-Architecture, Office of Design and Construction, Public Buildings Service, General Services Administration, 3rd Floor, 18th and F Sts. N.W., Washington, DC 20405/202-566-0950.

Audiovisual Free Loan Referrals

Free loan distribution of 16mm motion pictures is often available to the public from commercial distributors and from regional federal agency offices. The National Audiovisual Center keeps informed of all federally sponsored, free loan programs, and refers the user to the closest free loan source. Contact: Information Branch, National Audiovisual Center, National Archives and Records Service, 8700 Edgeworth Dr., Capitol Heights, MD 20409/301-763-1896.

Business Opportunities and Information

The following free booklets are available:

GSA Construction—explains how to bid.
Architect-Engineer Services—outlines bidding procedures on GSA architect-engineer contracts.
Architect-Engineer Selection Procedures—explains selection procedures for contracts.
Landscape Design Services—outlines bidding and contracting steps for landscape design projects.

Contact: the nearest Business Service Center, or Office of Design and Construction, Public Buildings Service, General Services Administration, Room 3341, 18th and F Sts. N.W., Washington, DC 20405/202-566-0574.

Business Relocation Assistance

Services and payments are available to businesses asked by the General Services Administration to move from their locations. It applies to both owners and tenants. *Business Relocation Assistance*, a free pamphlet, describes these services and payments and how to obtain them. For additional information, contact: the General Services Administration regional office in your area, or Leasing Division, Office of Space Management, Public Building Service, Room 2330, 18th and F Sts. N.W., Washington, DC 20405/202-566-0638.

Business Service Centers

These centers provide advice and counsel to businesspersons who are interested in contracting with General Services Administration and other federal agencies and departments. Business counselors are available who can contact a suitable business representative in the government. They also provide detailed information about all types of government contracting opportunities. These centers are also responsible for issuing bid-

ders mailing list applications, furnishing invitations for bids and specifications to prospective bidders, maintaining a current display of bidding opportunities, safeguarding bids, providing bid opening facilities, and furnishing free copies of publications designed to assist business representatives in doing business with the federal government. Contact: Business Service Centers, General Services Administration, Room 6103, 18th and F Sts. N.W., Washington, DC 20405/202-566-0776.

Cartographic Archives

This division contains more than 1,600,000 maps and about 2,250,000 aerial photographs, comprising one of the world's largest collections. Included are records of exploration and scientific surveys, public land surveys and settlement, Indian affairs, hydrography and navigation, conservation and development of the national resources, population, urban development, international affairs and boundary surveys, and military campaigns. *Guide to Cartographic Records in the National Archives*, at $3.25, and *Civil War Maps in the National Archives*, at $1.75, are for sale by the Superintendent of Documents, Government Printing Office, Washington, DC 20402/202-783-3238. For special lists of records and for additional information, contact: Cartographic Archives Division, National Archives and Records Service, General Services Administration, Room 2W, 8th St. and Pennsylvania Ave. N.W., Washington, DC 20408/202-523-3062.

Center for Polar Archives

This center contains primary sources of information on the history of U.S. activities in the Arctic and the Antarctic from the 18th century to the present. These records and papers include correspondence, biographical information, scientific and other observational data, journals, diaries, personal accounts, reports, memoranda, manuscripts, research papers and printed publications, maps and charts, still pictures, aerial photographs, sound recordings and motion pictures, and sketches and paintings. Contact: Center for Polar and Scientific Archives, National Archives and Records, General Services Administration, Room 8E, 8th St. and Pennsylvania Ave. N.W., Washington, DC 20408/202-523-3223.

Circuit Rider Program

Trained counselors provide information on contract opportunities throughout the federal government as well as step-by-step help with contracting procedures on a rotating schedule of vis-

its to towns with no Business Service Centers. Contact the nearest Business Service Center or Business Service Centers Division, General Services Administration, Room 6103, 18th and F Sts. N.W., Washington, DC 20405.

Code of Federal Regulations

This is an annual cumulation of executive agency regulations published in the daily *Federal Register*, combined with regulations issued previously that are still in effect. Divided into 50 titles, each representing a broad subject area, individual volumes of the Code are revised at least once each calendar year and issued on a staggered quarterly basis. It is a comprehensive source for general and permanent federal regulations. Available for $400.00 per year from the Superintendent of Documents, Government Printing Office, Washington, DC 20402/202-783-3238. For further information, contact: Office of the Federal Register, National Archives and Records Service, General Services Administration, Room 8401, 1100 L St. N.W., Washington, DC 20408/202-523-5240.

Commercial Item Descriptions (CID)

This is a series of simplified technical contract support documents used in the acquisition of commercial off-the-shelf and commercial-type products. CIDs are suitable for either advertised or negotiated procurement. Contact: Item Identification, Office of Item Management, Federal Supply Service, General Services Administration, Room 428, 1941 Jefferson Davis Highway, Washington, DC 20406/703-557-1514.

Commodity Managers

A list of commodity managers is available for those who wish to contact a specialist. Contact: Office of Procurement, Federal Supply Service, General Services Administration, Room 809, 1941 Jefferson Davis Highway, Arlington, VA 20406/703-557-8626.

Consumer Information Catalog

This free quarterly catalog lists over 150 free consumer publications and about 100 sales publications popular with the general public. Contact: Office of Consumer Affairs, General Services Administration, Room G-142, 18th and F Sts. N.W., Washington, DC 20405/202-566-1794, or write to: Consumer Information Center, Department B, Pueblo, CO 81009.

Consumer Information Center

The General Services Administration makes consumer information available through the Consumer Information Center. It encourages

agencies to provide expert knowledge through informative brochures. It also offers hundreds of publications on subjects ranging from car repairs to home buying. Most are free or available at a small charge. For general information, contact: Office of Consumer Affairs, General Services Administration, Room G-142, 18th and F Sts. N.W., Washington, DC 20405/202-566-1794, or write to: Consumer Information Center, Department B, Pueblo, CO 81009.

Consumer Information Pamphlets

The following consumer information pamphlets describe the selection, purchase, installation, use and care of appliances, home furnishings, and cars:

Automobile Batteries—1971, 13 pages, GPO 022-000-00067-5, 10.65

Paint and Painting—1977, 24 pages, GPO 022-000-00140-0, $0.85

Fire Extinguishers—1971, 10 pages, GPO 022-000-0068-3, $0.65

Ladders—1972, 18 pages, GPO 022-000-00069-1, $0.70

Room Air Conditioners—1972, 20 pages, GPO 022-000-00074-8, $0.70

Antifreeze/Coolant—1972, 5 pages, GPO 022-000-00075-6, $0.35

Washers and Dryers—1972, 22 pages, GPO 022-000-00079-9, $0.75

Floor Polish and Floor Care—1972, 20 pages, GPO 022-000-00081-1, $0.70

Dishwashers—1972, 20 pages, GPO 022-001-00035-3, 10.70

Automatic Toasters—1972, 8 pages, GPO 022-000-00078-1, $0.45

Carpets and Rugs—1977, 32 pages, GPO 022-000-00080-2, $0.90

Mixers and Blenders—1973, 6 pages, GPO 022-000-00077-2, $0.35

Electric Irons—1973, 6 pages, GPO 022-000-00084-5, $0.35

Electric Percolators—1973, 6 pages, GPO 022-003-00901-9, $0.35

Power Hand Tools—1973, 4 pages, GPO 022-003-00902-7, $0.45

Portable Dehumidifiers—1974, 5 pages, GPO 022-001-00055-8, $0.35

Household Cleaners—1974, 9 pages, GPO 022-001-00059-1, $0.35

Portable Humidifiers—1974, 6 pages, GPO 022-001-00061-2, $0.35

Car Care and Service—1979, 13 pages, GPO 022-000-00090-0, $0.90

Pots and Pans—1975, 14 pages, GPO 022-000-00092-6, $0.35

Everyday Hand Tools—1975, 6 pages, GPO 022-000-00093-4, $0.35

Cuidado y Servicio del Automovil, 1979, gratis

Baterias de Automovil, 1979, gratis

Como Comprar una Aspiradora, 1978, gratis

Como Comprar una Lavadora, 1979, gratis

Como Comprar una Secadora, 1978, gratis

Sugerencias para Conservar Gasolina, 1978, gratis

For free Spanish publications write to Consumer Information Center, Pueblo, CO 81009. They are for sale by the Superintendent of Documents, Government Printing Office, Washington, DC 20402/202-783-3238. For additional information, contact: Consumer Information Center, General Services Administration, Room G142, 18th and F Sts. N.W., Washington, DC 20405/202-566-1794.

Crime Data

Data on crime incidents occurring in buildings controlled by the General Services Administration are compiled and summarized. The information includes thefts of government and personal property, larceny, rape, murder, bombings, demonstrations and vandalism. Contact: Crime Prevention Section, Office of Federal Protective Service, Public Building Service, General Services Administration, Room 2035, 18th and F Sts. N.W., Washington, DC 20405/202-566-1429.

Customer and Industry

This office attempts to resolve customer and vendor problems beyond the capabilities of the regular complaint system. Contact: Office of Customer Relations, General Services Administration, Room 6034, 18th and F Sts. N.W., Washington, DC 20405/202-566-0090.

Decorations and Gifts from Foreign Countries

A list of all decorations and gifts given to federal departments and agencies by foreign governments is published annually in the *Federal Register*. The gifts are described and an estimated value is provided. If the gifts are not used by the government or donated to public institutions, they will be sold by the General Services Administration. For information, contact: Sales Division, Federal Property Resources Service, General Services Administration, Room 803, 1755 Jefferson Davis Highway, Arlington, VA 20405/703-535-7000.

Design Contracts

This office contracts with architect-engineers for such projects as office buildings, courthouses and research centers. Design contracts for air-conditioning systems, elevators, repairs and alterations are also negotiated. For additional design information, contact: Management Division, Public Buildings Service, General Services Ad-

ministration, Room 3046, 18th and F Sts. N.W., Washington, DC 20405/202-566-1646.

Dial-A-Reg

This is a recorded summary highlighting documents appearing in next day's issue of the *Federal Register* (see also "Federal Register "): 202-523-5022 (Washington, DC); 312-663-0884 (Chicago, IL); 213-688-6694 (Los Angeles, CA).

Directory of Archives and Manuscript Repositories in the United States

This is a national directory of 3,200 archives and manuscript repositories throughout the United States, arranged by state and town. A subject index as well as special lists of different types of repositories such as religious institutions, public libraries, and college and university holdings is also included. It is for sale for $25.00. Contact: Directory of Archives and Manuscript Repositories, Publications Sales Branch, Office of Public Programs and Exhibits, National Archives and Records Service, General Services Administration, Room G-6, 8th St. and Pennsylvania Ave. N.W., Washington, DC 20408/202-523-3164. For directory information, contact: Guide Program Staff, National Historical Publications and Records Commission, National Archives and Records Service, General Services Administration, Room 1111, 711 14th St. N.W., Washington, DC 20408/202-724-1630.

Documents from America's Past

Printed facsimiles and reproductions have been made of many historical documents contained in the National Archives. Descriptions of the Charter, short illustrated historical accounts, odd naval prints and watercolors, historical maps, World War I posters and photographs of eminent Americans, are included. *Documents from America's Past* is a free catalog that describes these publications and includes price and ordering information. Contact: Publications Sales Branch, (NEPS), Office of Public Programs and Exhibits, National Archives and Records Service, Room G-6, 8th St. and Pennsylvania Ave. N.W., Washington, DC 20408/202-523-3164.

Doing Business with the Federal Government

A free booklet for large or small companies explaining how the government makes purchases, the role of centralized buying, whom to contact for general information, and the names and needs of agencies with special purchasing requirements. Contracting steps and procedures are outlined. Contact: The nearest Business Service Center, or Business Service Centers Division, General Ser-

vices Administration, Room 6103, 18th and F Sts. N.W., Washington, DC 20405/202-566-0776.

Editing Institute

The Institute for the Editing of Historical Documents provides theoretical and practical training in the fundamentals of modern documentary editing to scholars, archivists, librarians and others. It is an annual two-week event. For further information, contact: National Historical Publications and Records Commission, National Archives and Records Service, General Services Administration, Room 1111, 711 14th St. N.W., Washington, DC 20408/202-724-1083.

Energy Conservation in Federal Buildings

A variety of energy conservation programs are being examined and implemented in building designs and construction. Solar energy systems are being installed to supplant fossil fuel systems for heating and cooling. Publications on these subjects are also available. Contact: Energy Conservation Division, Office of Buildings Management, Public Buildings Service, General Services Administration, Room 4046, 18th and F Sts. N.W., Washington, DC 20405/202-566-1735.

Excess Real Property

This office directs a continuing survey of all federal real properties to determine if they are not being put to their best use. Property no longer needed by a federal agency is generally reported excess to Federal Property Resources Service for disposal and may be transferred from one federal agency to another. If it is not needed by any federal agency, it may then be made available for acquisition by a local public body (state, county or local government), or a tax-supported or nonprofit medical or educational institution. Any property not disposed of in the above ways may be acquired by local public bodies at fair market value or is otherwise offered for sale, generally by advertising for bids. A free brochure, *Disposal of Surplus Real Property*, explains how private business and nonprofit state and local groups can acquire real property (land and buildings) no longer needed by the federal government. Contact: The Business Service Center nearest you, or Office of Real Property, Federal Property Resources Service, Room 900, 1755 Jefferson Davis Highway, Washington, DC 20405/703-535-7210.

Federal Archives and Records Centers

These centers are maintained to store and ser-

vice noncurrent records of federal agencies and historically valuable regional records of the National Archives of the United States. These centers also provide reimbursable microfilming service for federal agencies. For additional information, contact the following Archives branches:

Boston area: 380 Trapelo Rd., Waltham, MA 02154/617-223-2657.

New York area: Building 22—MOT Bayonne, Bayonne, NJ 07002/201-858-7245

Philadelphia area: 5000 Wissahickon Ave., Philadelphia, PA 19144/215-951-5591.

Atlanta area: 1557 St. Joseph Ave., East Point, GA 30344/404-763-7477.

Chicago area: 7358 S. Pulaski Rd., Chicago, IL 60629/312-353-0161.

Kansas City area: 2306 East Bannister Rd., Kansas City, MO 64131/816-926-7271.

Fort Worth area: 4900 Hemphill St. (building address), P.O. Box 6216 (mailing address), Fort Worth, TX 76115/817-334-5515.

Contact the Office of Federal Records Centers, National Archives and Records Service, General Services Administration, Room 1216, 711 14th St. N.W., Washington, DC 20408/202-724-1592.

Federal Compiler Testing Center

This Center checks whether federal standard computer languages are being used correctly and compatibly so that programs written for one computer can be used readily by another. Contact: Federal Compiler Testing Center, Office of Software Development, Automated Data and Telecommunications Service, General Services Administration, Room 1100 SKY, 18th and F Sts. N.W., Washington, DC 20405/703-756-6153.

Federal Conversion Support Center

This office helps agencies when converting to new equipment by examining their software or program of computer instructions, to smooth the transition to more modern machines. Contact: Federal Conversion Support Center, Office of Software Development, Automated Data and Telecommunications Service, General Services Administration, Room 1100 SKY, 18th and F Sts. N.W., Washington, DC 20405/703-756-6156.

Federal Information Centers

The staff at the Federal Information Centers attempt to be a one-stop source of assistance with federal-government-related questions and problems. Call or visit your local Federal Information Center to get help in sorting out the wide range of services and information provided by hundreds of different departments, agencies and programs of the federal government, the numerous laws it administers, and the multitude of publications and periodicals available. Questions most commonly asked are on jobs, retirement benefits, taxes, Social Security, veterans' benefits and immigration. FIC staff specialists in many cities speak other languages in addition to English. For information contact the Federal Information Center nearest you, or Federal Information Center, Office of Consumer Affairs, General Services Administration, Room 6034, 18th and F Sts. N.W., Washington, DC 20405/202-566-1937.

Federal Motor Vehicle Fleet Report

A free annual statistical world-wide report on Federally owned and leased cars, station wagons, ambulances, buses, trucks and truck tractors, and their uses is available from Federal Fleet Management Division, Office of Motor Equipment, Transportation and Public Utilities Service, General Services Administration, Room 2103, 425 Eye St. N.W., Washington, DC 20405/202-275-1021.

Federal Procurement Data Center

The Center is trying to become the government's single source of procurement information. Each agency headquarters submits procurement information to the Center showing the same 27 items of information on a uniform basis for every acquisition over $10,000. The Center is responsible for consolidating the information on the individual agencies into a master procurement file, processing the information, and reporting to the Congress, the executive branch and industry. The Center can identify what agencies are buying (products and services), where they are buying (contractor location or from the General Services Administration), in what volume they are buying, and how they are buying (competition, type of contract, or contract modification). In addition, the system provides information on standard industrial classification (SIC) codes and the parent and subsidiary of each contractor establishment, along with the relationship of each. The data cover all prime contract actions awarded to nonfederal sources for supplies, equipment, construction and services including commercial utilities and communications, commercial rents, and transportation or shipments furnished under government bills of lading and government transportation requests. Acquisitions, including contract changes and modifications of more than $10,000, are reported individually. Acquisitions of $10,000

or less are reported in summary. The following is a summary of reports issued by the Center:

SUMMARY QUARTERLY REPORT OF CONTRACT AC-
TIONS
Actions and Dollars by Executive Department and Agency
Percent of Actions and Dollars by Executive Department and Agency
Total Actions Over $10,000 State
Actions Over $10,000 by Executive Department and Agency—by State
Actions Over $10,000 by State—by Executive Department and Agency

SPECIAL ANALYSIS OF FEDERAL CONTRACT ACTIONS
BY TYPE OF CONTRACTOR—SA-1
Business Concerns by Executive Department and Agency (qtrly)
Educational and Nonprofit Institutions by Executive Department and Agency (qtrly)
Acquisitions Outside U.S. and Possessions by Executive Department and Agency (qtrly)
Directed Contracts for Foreign Governments by Executive Department and Agency (qtrly)
Tariff or Regulated Acquisitions by Executive Department and Agency (qtrly)
By Executive Department and Agency by Type of Contractor (qtrly)

SPECIAL ANALYSIS OF FEDERAL CONTRACT ACTIONS
BY PRODUCT/SERVICE—SA-2
By Type of Effort by Executive Department and Agency Number of Actions (qtrly)
By Type of Effort by Executive Department and Agency Dollars (qtrly)
Research and Development—Summary by R&D Category (qtrly)
Research and Development—Detail by Service Code (qtrly)
Other Services and Construction—Summary by Service Category (qtrly)
Other Services and Construction—Detail by Service Code (qtrly)
Supplies and Equipment—Summary by Federal Supply Classification Group (qtrly)
Supplies and Equipment—Detail by Federal Supply Classification (qtrly)
Total Annual Actions by Product/Service for Each Purchasing Office

SPECIAL ANALYSIS OF MINORITY AND DISADVAN-
TAGED BUSINESS PARTICIPATION IN FEDERAL CON-
TRACT ACTIONS—SA-3
Awards to Minority/Disadvantaged Including 8 (a) by Agency (qtrly)
Awards to Minority/Disadvantaged Including 8 (a) by Agency (yr to date)
Awards to Minority/Disadvantaged Including 8 (a) by State by Agency (qtrly)
Awards to Minority/Disadvantaged Including 8 (a) by State by Agency (yr to date)
Minority/Disadvantaged Businesses Participating in Federal Contracting (annual)

Minority/Disadvantaged Actions by Product/Service by State by Agency (annual)
Minority/Disadvantaged Businesses by Product Service (annual)

SPECIAL ANALYSIS OF SMALL BUSINESS PARTICIPA-
TION IN FEDERAL CONTRACT ACTIONS—SA-4
Small Business Actions by Agency (qtrly)
Small Business Actions by Agency (yr to date)
Small Business Actions by State by Agency (qtrly)
Small Business Actions by State by Agency (yr to date)
Small Business Set-Aside Actions by Agency (qtrly)
Small Business Set-Aside Actions by Agency (yr to date)
Small Business Actions by Product/Service by State by Agency (annual)
Small Business R&D Contract Actions by Agency (qtrly)
Small Business R&D Contract Actions by Agency (yr to date)

SPECIAL ANALYSIS OF LABOR SURPLUS AREA PARTICI-
PATION IN FEDERAL CONTRACT ACTIONS—SA-5
LSA Preference Actions by Agency by State by Product/Service (semi-annual)
LSA Preference Actions by Agency by LSA Preference Category (qtrly)
LSA Preference Actions by Agency by LSA Preference Category (yr to date)

SPECIAL ANALYSIS OF 100 TOP FEDERAL CONTRAC-
TORS—SA-6
Total Dollars and Total Actions of 100 Top Contractors (qtrly)
Total Dollars and Total Actions of 100 Top Contractors by Agency (qtrly)

SPECIAL ANALYSIS OF FEDERAL R&D—SA-7
Total Dollars and Actions of 100 Top R&D Contractors (qtrly)
Total Dollars and Actions of 100 Top R&D Contractors by Agency (qtrly)
Top 100 Private Educational/Nonprofit R&D Contractors (qtrly)
Top 100 Private Educational/Nonprofit R&D Contractors by Agency (qtrly)
R&D Contractors (Nos. and Dollars) by Agency (qtrly)
R&D (No. of Contracts and Dollars) by Product/Service by Agency (qtrly)
R&D (No. of Contracts and Dollars) by Agency by Product/Service by R&D Stage (qtrly)

SPECIAL ANALYSIS OF VARIOUS CONTRACTING OPERA-
TIONS—SA-8
Negotiation Exception Authority by Agency (Dollars and Actions) (qtrly)
Extent of Competition Application by Agency (Dollars and Actions) (qtrly)
Multi-Year Contracting Application by Agency (Dollars and Actions) (qtrly)
Statutory Requirements Application by Agency (Dollars and Actions) (qtrly)
CAS Clause Application by Agency (Dollars and Actions) (qtrly)

Kind of Contract Action by Agency by Purchasing Office (Dollars and Actions) (qtrly)

Contracting Method Application by Type Contractor by Agency (Dollars and Actions) (qtrly)

Type of Contract by Type of Contractor by Agency (Dollars and Actions) (qtrly)

SPECIAL ANALYSIS OF CONSULTING SERVICES—SA-9

Consulting Services (Dollars and Nos. of Contracts) by Agency by Agency Component (qtrly)

Top 100 Consulting Contractors by Agency (Dollars and No. of Contracts) (qtrly)

SPECIAL ANALYSIS OF WOMEN-OWNED BUSINESS—SA-10

Women-Owned Businesses and Their Actions by Agency by State (annual)

SPECIAL ANALYSIS OF UTILIZATION OF GSA FEDERAL SUPPLY SCHEDULES—SA-11

FSS Orders (No. and Dollars) by Agency by Contract (qtrly)

FSS Orders (No. and Dollars) by Product/Service by Agency (qtrly)

SPECIAL ANALYSIS OF GBL/GTR TRAFFIC—SA-12

GBL/GTR Traffic (No. of Actions and Dollars) by Carrier by Agency (qtrly)

GBL/GTR Traffic (No. of Actions and Dollars) by Agency by Carrier (qtrly)

SPECIAL ANALYSIS OF FEDERAL CONTRACTORS AND THEIR CONTRACT ACTIONS—SA-13

Listing of All Federal Contractors and Their Actions (annual)

Listing of All Federal Contractors and Their Actions by Federal Region by State by City (annual)

Listing of Federal Construction Contractors and Their Actions by Federal Region by State by City (annual)

Contact: Federal Procurement Data Center, General Services Administration, 1815 N. Lynn St., Arlington, VA 22209/703-235-2036.

Federal Procurement Regulations (FPR)

The Federal Procurement Regulations contain uniform policies and procedures applicable to procurements by civilian executive agencies of personal property and nonpersonal services, including construction. These regulations are prescribed by the General Services administration and published in one of the daily issues of the *Federal Register.* They are also published in cumulative form in the *Code of Federal Regulations.* Contact: Federal Procurement Regulations Directorate, Office of Acquisition Policy, General Services Administration, Room 1107, 1755 Jefferson Davis Highway, Washington, DC 20405/703-566-1043.

Federal Property Management Regulations (FPMR)

The General Services Administration prescribes policies and procedures and delegates authority for management of government property and records. FPMR issuances are published daily in the *Federal Register* and are accumulated in the *Code of Federal Regulations.* Contact: Office of Supply Requirements and Supplies, Federal Supply Service, General Services Administration, Room 814, 1941 Jefferson Davis Highway, Washington, DC 20406/703-557-8646.

Federal Register

The *Federal Register* is the daily publication of federal agency regulations and other legal documents of the executive branch. It also includes proposed changes in regulated areas. Each proposed change published includes an invitation for any citizen or group to participate in the consideration of the proposed regulation. It is available for $50.00 per year from the Superintendent of Documents, Government Printing Office, Washington, DC 20402/202-783-3238. For more information, contact: Office of the Federal Register, National Archives and Records Service, General Services Administration, Room 8401, 1100 L St. N.W., Washington, DC 20408/202-523-5240.

Federal Register Workshops

Educational workshops on how to use the *Federal Register* are open to the general public and federal agency personnel. They are designed as an introduction for those peopel who need to use *Federal Register* publications. The sessions cover the following areas: the regulatory process, with the focus on the *Federal Register* system and the public's role in the development of regulations; an introduction to the finding aids of the Office of the *Federal Register*; the relationship between the *Federal Register* and the *Code of Federal Regulations;* and the important elements of a typical *Federal Register* document. The workshops are scheduled on a regular basis in Washington, D.C. and occasionally in other cities. *The Federal Register—What It Is and How To Use It* provides the history and organization of the *Federal Register-Code of Federal Regulations* system, and the guidelines for its use. Available for $2.40 at the Superintendent of Documents, Government Printing Office, Washington, DC 20402/202-783-3238. For more information contact: Office of the Federal Register, National Archives and Records Service, General Services Administration, Room 8401, 1100 L St. N.W., Washington, DC 20408/202-523-5235.

Federal Surplus Personal Property Donation Programs

These programs enable certain nonfederal organizations to obtain personal property the federal government no longer needs. Eligible

recipients are public agencies, nonprofit educational and public health activities, and educational activities of special interest to the armed services and public airports. Among the types of personal property that may be available are included hand and machine tools, office machines and supplies, furniture, hardware, motor vehicles, boats, airplanes, and construction equipment. Contact: Office of Personal Property Disposal, Federal Property Resource Service, General Services Administration, Crystal Square 5, Room 802, 1755 Jefferson Davis Highway, Washington, DC 20405/202-535-7012.

Federal Supply Schedules

Schedules are indefinite quantity contracts usually established for a one-year term which permit federal agencies to place orders directly with suppliers. The schedule program provides the agencies with sources for approximately 700,000 products and services such as automotive parts and accessories, tires, batteries, furniture, electric lamps, appliances, photographic and duplicating equipment and supplies, athletic equipment, laboratory equipment and supplies, and audio and video recording equipment and supplies. For information on the supply schedules, contact: Publications Management, Office of Item Management, Federal Supply Service, General Services Administration, Room 718, 1941 Jefferson Davis Highway, Washington, DC 20406/703-557-7954.

Federal Supply Service Publications

This office is responsible for the Federal Supply Schedules, the General Services Administration supply catalogues and the *Index of Federal Specifications and Standards.* Contact: Publications Management Division, Office of Item Management, Federal Supply Service, General Services Administration, Room 718, 1941 Jefferson Davis Highway, Washington, DC 20406/703-557-7950.

Finance

The Office of Finance provides publications on public buildings leased and owned by the federal government as well as a detailed listing of real property owned by the United States and used by the Department of Defense for military functions throughout the world. For more information, contact: Public Buildings, Office of Finance, General Services Administration, Room G104, 18th and F Sts. N.W., Washington, DC 20405/202-523-5472.

Fire Safety

Public Buildings Services has programs on fire safety in public buildings. The following publications on fire safety are for sale by the Superintendent of Documents, Government Printing Office, Washington, DC 20402/202-783-3238.

Firesafety Systems: Richard B. Russell Courthouse and Federal Office Building, Atlanta, GA.—1974, 52 pages, free

Firesafety Systems: Seattle Federal Building—1975, 84 pages, 12.75.

Building Firesafety Criteria—1975, 102 pages, $2.75

Protecting Federal Records Centers and Archives from Fire—Report of the General Services Administration Advisory Committee—1977, 202 pages, 13.75

Fireball Tests of Open-Web Steel Joists—discusses six fireball experiments on open-web steel joists, typical of those found in federal records centers, and their results—1977, 148 pages, $3.50

Ten Minutes of Protection—describes a film of fire tests on light steel roof supports; summarizes report *Fireball Tests of Open-Web Steel Joists,* listed above, 6 pages, free

Conference of Firesafety for Buildings: Airlie House, Airlie, Va.—1973, 377 pages, 15.50

Preliminary Task Group Reports on Firesafety Systems for High-Rise Buildings—reports of the nine task groups: maintenance, construction, fuel load, extinguishing systems, building integrity, life support systems, personnel movement, emergency communications and controls and occupant self-protection systems—1975, 94 pages, $2.50

Fire Tests in Mobile Storage Systems for Archival Storage—technical report on three fire tests on a steel mobile shelving unit containing archival storage materials, including paper records, library books and plastic computer tapes—1978, 86 pages, $2.75

For additional information, contact: Accident and Fire Prevention Division, Public Buildings Service, General Services Administration, Room 4338, 18th and F Sts. N.W., Washington, DC 20405/202-566-1464.

Foreign Language Instruction

The Foreign Service Institute (see also "U.S. Department of State") produces foreign language instruction programs on audiotapes with accompanying texts. Some of the languages included are Arabic, Baluchi, Cantonese, German, Hansa, Hebrew, Igbo, Korean, Portuguese, Swahili, Thai, Urdu and Yoruba. A French and Spanish testing kit is also available. For a complete listing of the courses and for additional information, contact: Order Section, National Audiovisual Center, National Archives and Records Service, General Services Administration, NAC, 8th St. and Pennsylvania Ave. N.W., Washington, DC 20409/202-763-1896.

Fraud Hotline

The General Services Administration has a 24-hour hotline for reporting alleged fraud and abuses. Call toll-free 800-424-5210 or 202-566-1780. For additional information, contact: Office of Inspector General, General Services Administration, Room 5340, 18th and F Sts. N.W., Washington, DC 20405/202-566-0450.

Freedom of Information Act Requests

For Freedom of Information Act requests, contact: Information and Privacy, Office of General Counsel, General Services Administration, Room 3107, 18th and F Sts. N.W., Washington, DC 20405/202-566-1460.

Genealogical and Local History Programs

Short workshops for beginners in genealogical research are held regularly at the National Archives. A two-week intensive summer program for experienced and professional research is given annually. Two free pamphlets—*A Guide to Genealogical Records in the National Archives* and *Genealogical Sources Outside the National Archives* are available. For information on the programs, contact: Genealogical and Local History Programs, Office of Public Programs and Exhibits, National Archives and Records Service, General Services Administration, Room 307, 8th St. and Pennsylvania Ave. N.W., Washington, DC 20408/202-633-6983.

General Services Administration Library

The Library has material on government contracts, procurement, specifications, art, and architecture. Consumer publications are also available. Contact: Library, General Services Administration, Room 1033, 18th and F Sts. N.W., Washington, DC 20405/202-566-0655.

Grants

The programs described below are for sums of money which are given by the federal government to initiate and stimulate new or improved activities or to sustain on-going services:

National Historical Publications and Records Grants

Objectives: To carry out the National Historical Documents Program which will help preserve important historical documents.

Eligibility: Educational and other nonprofit institutions (e.g., universities, colleges, libraries, historical societies, museums, university presses, archives, etc.); state and local governmental agencies.

Range of Financial Assistance: $5,000 to $90,000.

Contact: National Historical Publications and Records Commission, Washington, DC 20408/202-724-1083.

Guide to Record Retention

This publication outlines how long businesses and private citizens should retain various types of records. For sale for $3.00 from the Superintendent of Documents, Government Printing Office, Washington, DC 20402/202-783-3238, or contact: Office of Federal Records Centers, National Archives and Records Service, General Services Administration, Room 1210, 711 14th St. N.W., Washington, DC 20408/202-724-1625.

Guide to Specifications and Standards of the Federal Government

This is a free booklet that describes the purpose, use, types and how to obtain them before bidding on federal contracts for goods and services. It is available at the nearest Business Service Center, or contact: Publications Management Division, Office of Item Management, Federal Supply Service, General Services Administration, Room 718, 1941 Jefferson Davis Highway, Washington, DC 20406/703-557-7950.

Historic Preservation

Historic structures are restored and preserved for continued federal use and public enjoyment. There is a listing of the names and locations of these buildings. A file on many of historic structures analyses and reports with a background history, guidance for designers, and the purpose of the buildings is also available. For further information, contact: Historic Preservation, Office of Design and Preservation, Public Buildings Service, General Services Administration, 3rd Floor, 18th and F Sts. N.W., Washington, DC 20405/202-566-0986.

Historical Documents on Display

The Declaration of Independence, the Constitution of the United States, the Bill of Rights, and many other documents that have figures prominently in American history are on permanent display in the Exhibition Hall of the National Archives and Records Service, General Services Administration, 8th St. and Constitution Ave. N.W., Washington, DC 20408.

Historical Records Program

Technical and financial assistance are available for efforts at all levels of government and by private organizations to preserve and make available for use those records generated in every facet of life that further an understanding and appreciation of American history. In the public sector,

these historical records document significant activities of state, county, municipal and other units of government. In the private sector, historical records include manuscripts, personal and family papers, and corporate archives that are maintained by a variety of repositories as well as materials in special collections relating to particular fields of study, including the arts, business, education, ethnic and minority groups, immigration, labor, politics, the professions, religion, science, urban affairs and women. The program also supports projects to advance the state of the art, to promote cooperative efforts among institutions and organizations, and to improve the knowledge, performance and professional skills of those who work with historical records. Contact: Records Program, National Historical Publications and Records Commission, National Archives and Records Service, General Services Administration, Room 1111, 711 14th St. N.W., Washington, DC 20408/202-724-1616.

How the Government Acquires Land

This is a free brochure that answers questions most frequently asked by owners of real property selected by the General Services Administration for public building construction projects. It explains the agency's policy for determining public needs, selecting sites, arriving at a fair price to pay owners and acquiring the property needed for public use. For further information, contact the General Services Administration regional office in your area or Leasing Division, Office of Space Management, Public Building Service, General Services Administration, Room 2330, 18th and F Sts. N.W., Washington, DC 20405/202-566-0638.

Index of Federal Specifications and Standards

This Index has alphabetical, numerical and federal supply classification (FSC) listings plus useful information and periodic supplements. Sold ($15) by the Superintendent of Documents, Government Printing Office, Washington, DC 20402/202-783-3238, or contact: Office of Item Management, Requirements and Supplies, Federal Supply Service, General Services Administration, Room 718, 1941 Jefferson Davis Highway, Washington, DC 20406/703-557-7950.

Interagency Motor Pools

This is a free booklet providing instructions to federal employees for obtaining vehicles. It lists motor pool locations and rates for types of vehicles at different locations. Contact: Interagency Motor Pools Division, Office of Motor Equipment, Transportation and Public Utilities Service, General Services Administration, Room

2112, 425 Eye St. N.W., Washington, DC 20406/202-275-6118.

International Visitors Program for Archivists

Short-term, individualized, information training for archivists, record managers and related professionals from other countries who are sponsored by their governments and other international institutions can be scheduled. For more information, contact: Academic and Curricular Development, Education Division, Public Programs and Exhibits, National Archives and Records Service, General Services Administration, Room G-11, 8th St. and Pennsylvania Ave. N.W., Washington, DC 20408/202-523-3298.

Jewel Bearing Plant

The William Langer Jewel Bearing Plant, the only plant of its kind in North America, produces jewel bearings for the National Stockpile. It was established to provide a domestic source for jewel bearings and related products in order to eliminate U.S. dependency upon foreign sources of supply. For more information, contact: William Langer Jewel Bearing Plant, Rolla, North Dakota, 701-477-3193, or Office of Stockpile Management, Federal Property Resources Service, General Services Administration, Room 908, 1755 Jefferson Davis Highway, Washington, DC 20405/202-535-7139.

Leasing Space to the Government

The General Services Administration leases general purpose and special purpose space for all federal agencies. Each GSA regional leasing office maintains a current listing, by geographic area, of prospective offerors to which it sends notices or leasing needs when they occur. Property managers or owners interested in offering space to the General Services Administration for lease should write to the regional office indicating the type of space available or an interest in constructing space for lease. *Leasing Space to the Government*, a free pamphlet, explains how property owners can lease space to the General Services Administration. Contact: Leasing Division, Office of Space Management, Public Buildings Service, General Services Administration, Room 2330, 18th and F Sts. N.W., Washington, DC 20405/202-566-0638.

Life Cycle Costing Program

The Life Cycle Costing Program strives for the lower ownership cost rather than the lowest bid price. The emphasis is on quality. It is being applied in the procurement of gas and electric water heaters, gas and electric ranges, window air conditioners, refrigerators, freezers and high-speed

printer ribbons. A free pamphlet, *Life Cycle Costing*, describes how federal agencies can use this buying technique to save money. For more information, contact: Value Engineering Division, Office of Engineering and Technical Management, Federal Supply Service, General Services Administration, Room 510, 1941 Jefferson Davis Highway, Washington, DC 20406/703-557-7567.

List of Areawide Public Utilities Contracts

A free list, by geographic area, updated approximately three times a year, is available from the Office of Public Utilities, Transportation and Public Utilities Service, General Services Administration, Room 3007, 425 Eye St. N.W., Washington, DC 20406/202-275-5089.

Living Buildings Program

This program encourages the use of federal buildings by individuals and organizations for educational, cultural and recreational activities. It offers free or at-cost space ranging from full-scale auditoriums to seminar-sized classrooms. The buildings have been used for a broad range of activities including art exhibits, solar energy workshops, senior citizen meetings, and Hawaiian dancers. For information, contact GSA Regional Buildings Management Offices, or Operations Division, Public Buildings Service, General Services Administration, Room 4326, 18th and F Sts. N.W., Washington, DC 20405/202-566-1563.

Machine Readable Records

The Machine-Readable Archives Division maintains an active liaison with data-producing agencies, monitors research applications for machine-readable files, and takes a leading role in developing methods to process, catalog, and describe such record material. It identifies and evaluates new technological developments that influence the creation, management, appraisal, description and preservation of information in machine-readable form. The Division routinely provides researchers with tape copies or printouts of the records in its custody. The fees for such services are relatively low and are set solely to recover the costs involved in preparing and processing the files for distribution. The Division also functions as a clearinghouse for information on the existence, location and availability of data created by other federal agencies. The *Catalog of Machine-Readable Records in the National Archives of the United States* contains bibliographic and abstract entries for the files in its holdings and in the Center for Machine-Readable Records. *Computer Data Bulletin*, a supplement to the catalog, makes users of machine-readable data aware of recent and upcoming accessions or additions to the Center for Machine-Readable Records that occur in the periods between editions of the complete catalog. For additional information, contact: Machine Readable Archives Division, National Archives and Records, General Services Administration, Room 1100, 711 14th St. N.W., Washington, DC 20408/202-724-1080.

Management Information Systems

This office publishes annually the *Automatic Data Processing Equipment Inventory in the United States Government* which includes federally owned or leased digital computers, computer systems, and peripheral equipment, clossary, charts, and summary and inventory tables (1979) ($9.75), and the *Automatic Data Processing Activities Summary in the United States Government*, which identifies the cost, manpower and utilization of federal computers subject to such reporting, glossary, charts and summary and inventory table (1979) ($1.60). These publications are available from the Superintendent of Documents, Government Printing Office, Washington, DC 20402/202-783-3238. For additional information, contact: Management Information Systems, Automated Data and Telecommunications Service, General Services Administration, Room G-32, 18th and F Sts. N.W., Washington, DC 20405/202-566-1544.

Military Data

Some 50 machine-readable data files originally created by the Department of Defense are now in the holdings of the Machine-Readable Archives Division. While some of the data may have general appeal to sociologists, demographers and health care specialists, the greater part of the collection deals with the Vietnam War. Collected in Vietnam by the military headquarters of General Westmoreland, these data were forwarded to the Pentagon for statistical analysis. These files fall into five general subject areas: government and population and South Vietnam; ground operations; air operations including listings of combat and noncombat air missions in North and South Vietnam; naval operations; and the allied incursion into Cambodia. In addition to the Vietnam War data, NARS has accessioned the "American Soldier," a set of over 200 attitudinal and demographic studies, covering more than 500,000 officers and enlisted Army personnel, conducted by the War Department General Staff during World War II. Machine-readable military personnel files include prisoner-of-war files, casualty files, and some personnel dossiers. They span World War II, the Korean War, and the Vietnam War

and include information on personnel in all four armed services. Contact: Machine-Readable Archives Division, National Archives and Records, General Services Administration, Room 1100, 711 14th St. N.W., Washington, DC 20408/202-724-1080.

National Archives Collection

Records in the National Archives span two centuries and total billions of pages of textual material, 6 million photographs, 5 million maps and charts, 100,000 films and 80,000 sound recordings. These records are arranged not by subject but by the order in which they were arranged by the federal agency, bureau or department that produced them. Diplomatic relations can be traced in the records of the State Department; land and Indian affairs are found in Department of Interior records; the growth of foreign and domestic trade and of navigation is seen in records of the Commerce Department, the Customs Bureau and the Interstate Commerce Commission. Pension and census records, naval history and military affairs can all be studied and examined in the National Archives. *A Guide to the National Archives of the United States* can be bought for $12.30 at the sales desk at the National Archives or from the Superintendent of Documents, Government Printing Office, Washington, DC 20402/202-783-3238. A free *Researchers' Guide to the National Archives* is also available. For general information, contact: Orientation and Consultation Office of the National Archives, National Archives and Records Service, General Services Administration, Room 201, 8th St. and Pennsylvania Ave. N.W., Washington, DC 20408/202-523-3218.

National Archives Conference Papers

This series aims to acquaint scholars with the materials in the National Archives and to provide a forum for the discussion of issues and problems relevant to both researchers and archivists. For a list of these papers and for additional information, contact: Office of Public Programs and Exhibits, National Archives and Records Service, General Services Administration, Room G-8, Washington, DC 20408/202-523-3099.

National Archives Conferences

Conferences designed to introduce selected audiences to National Archives resources and staff are offered on an occasional basis. Announcements are made in scholarly and professional journals. For more information, contact: Academic and Curriculum Development, Education Division, Public Programs and Exhibits, National Archives and Records Service, General Ser-

vices Administration, Room G-11, 8th St. and Pennsylvania Ave. N.W., Washington, DC 20408/202-523-3298.

National Archives Publications

A free *Select List of Publications of the National Archives and Records Service* is available. It lists guides, reference information, papers, inventories by record group, audiovisual records, documentary publications, archives administration publications, records management handbooks, National Archives conference papers, exhibit catalogs, historical publications and holdings from the other Government agencies. Contact: Publications Sales Branch (NEPS), National Archives and Records Service, General Services Administration, Room G-6, 8th St. and Pennsylvania Ave. N.W., Washington, DC 20408/202-523-3164.

National Audiovisual Center

The National Audiovisual Center is the central clearinghouse of all government audiovisual materials. It has more than 13,000 titles in the collection produced by nearly 300 federal agencies. The Archives also contain some great works of American film made by some well-known directors, as well as miles of historical combat footage. The audiovisual programs are available for sale and in some cases can be rented. The media formats include 16mm films, videocassettes, slides, filmstrips and audiotapes. Conversions of any of the Center's 16mm titles to videocassette formats are made upon request. Available free publications include: information lists, catalogs and special brochures covering the following major subject areas: agriculture, alcohol/drug abuse, business/government management, career education, consumer education, dentistry, emergency medical services, fire and law enforcement, flight/meteorology, foreign language instruction, history, industry safety, library/information science, medicine, nursing, science, social issues, social science, space exploration, special education and vocational education. *Quarterly Update*, a comprehensive listing of the newest titles and information about new services is available. *A Reference List of Audiovisual Materials Produced by the United States Government* is a listing of more than 6,000 federally produced audiovisual materials distributed by the NAC. A *Supplement* adds 800 titles to the list. The two publications are available for $5.75 and $3.75, respectively, from the Superintendent of Documents, Government Printing Office, Washington, DC 20402/202-783-3238. For additional information on the National Audiovisual Center, contact: Information Branch, National Audiovisual Center,

National Archives and Records Service, 8700 Edgeworth Dr., Capitol Heights, MD 20409/301-763-1896.

National Furniture Center

This is the centralized facility for procuring furniture for the federal government. Identification of requirements for a product, formulation of its specifications, contracting procedures, quality assurance, contract administration, and delivery are all supervised from this Center. Contact: National Furniture Center, Federal Supply Service, General Services Administration, Room 1010, 1941 Jefferson Davis Highway, Washington, DC 20406/702-557-8636.

National Historical Publications and Records Commission

The Commission's main purpose is the collecting, preserving, editing and publishing of papers and other documents important for an understanding and appreciation of the history of the United States. The following publications are available on request from the Commission:

Annotation—the Commission's quarterly newsletter.
Fact Sheet: The National Historical Publications and Records Commission and Its Work
Fellowships in Historical Editing
The Institute for the Editing of Historical Documents
Publications Catalog
Publications Program Guidelines and Procedures: Applications and Grants
National Historical Publications and Records Commission
Records Program Guidelines and Procedures: Applications and Grants
Suggestions for Records Program Applicants
The State Historical Records Coordinator and the State Historical Records Advisory Board: Suggested Roles and Procedures
Microform Guidelines
SPINDEX and Guide/Data Base: Introductory Materials
Directory of Archives and Manuscript Repositories in the United States ($25)

For more information, contact: National Historical Publications and Records Commission, National Archives and Records Service, General Service Administration, Room 1111, 711 14th St. N.W., Washington, DC 20408/202-724-1083.

National Personnel Records

The records of former federal employees, either in the civil or the military service, are kept in the National Personnel Records Center. These files are available only to federal agencies and to the individuals whose records they are. Contact:

National Personnel Records Center, Office of Federal Records Center, National Archives and Records Service, General Services Administration, 9700 Page Boulevard, St. Louis, MO 63132/314-263-7201.

National Tools Center

The central depot for all tools procedure for the federal government is the National Tools Center. It is responsible for nationwide commodity management, including contracting, inventory management, and engineering. Contact: National Tools Center, Federal Supply Service, General Services Administration, Room 605, 1941 Jefferson Davis Highway, Washington, DC 20406/703-557-8575.

Presidential Libraries

The libraries preserve, describe and provide reference service on presidential papers and collections, prepare documentary and descriptive publications, and exhibit historic documents and museum items. For additional information, contact the individual library of your interest:

Herbert Hoover Presidential Library, South Downey St., West Branch, IA 52358/319-643-5301.
Franklin D. Roosevelt Library, Old Albany Post Rd., Route 9, Hyde Park, NY 12538/914-229-8114.
Harry S Truman Library, Highway 24 at Delaware St., Independence, MO 64050/816-833-1400.
Dwight D. Eisenhower Library, Southeast 4th St., Abilene, KS 67410/913-347-8909.
Lyndon B. Johnson Library, 2313 Red River St., Austin, TX 78705/512-397-5137.
John F. Kennedy Library, Federal Archives and Records Center, 380 Trapelo Rd. Waltham, MA 02154/617-223-7250.

Or contact: the Office of Presidential Libraries, National Archives and Records Service, General Services Administration, Room 104, 8th St. and Pennsylvania Ave. N.W. Washington, DC 20408/202-523-3212.

Procurement and Contracts

This office monitors the procurement practices of the regional and field offices. For more information, contact: Surveys Branch, Office of Contracts, Public Buildings Service, General Services Administration, Room 1300, 18th and F Sts. N.W., Washington, DC 20405/202-566-1383.

Prologue

Prologue, a quarterly, publishes articles on topics of American history and culture since 1969. It also provides timely information about National Archives conferences, publications and acces-

sions, and the latest information on declassified records. It is for sale for $12 per year. Contact: Prologue Branch, Publications Division, Office of Public Programs and Exhibits, National Archives and Records Service, General Services Administration, Room 407, 8th St. and Pennsylvania Ave. N.W., Washington, DC 20408/202-523-3159.

Public Art

This office has information on historic public art, mainly murals and sculptures, up to 1962. It also provides policy advice on the fine arts selection for new projects. Contact: Counselor for Fine Arts, Office of Design and Construction, Public Buildings Service, General Services Administration, Room 3302, 18th and F Sts. N.W., Washington, DC 20405/202-566-1499.

Public Building Contracts

The Office of Contracts reviews all major Public Buildings Service contracts for compliance with rules and regulations before a contract is awarded. Contact: Office of Contracts, Public Buildings Service, General Services Administration, Room 1300, 18th and F Sts. N.W., Washington, DC 20405/202-566-0907.

Public Papers of the Presidents of the United States

This series was a compilation of selected presidential documents issued by the White House Press Office during one calendar year. Since 1976 it has been expanded to include full text of proclamations, Executive Orders, and other presidential directives, announcements of presidential appointments and nominations, and a digest of the President's announced daily public schedule. The series is available in individual volumes from the Superintendent of Documents, U.S. Government Printing Office, Washington, DC 20402/202-783-3238. For additional information, contact: Office of the Federal Register, National Archives and Records Service, Room 8401, 1100 L St. N.W., Washington, DC 20408/202-523-5240.

Publications and Information

For a list of the General Services Administration publications and some publications and general information on the GSA, contact: Office of Information, General Services Administration, Room 6111, 18th and F Sts. N.W., Washington, DC 20405/202-566-1231.

Publications Program

The National Historical Publications and Records Commission makes plans, estimates and recommendations for the compilation of historical works and collections of source materials appropriate for printing or recording. It also encourages and cooperates with various federal, state and local agencies and nongovernmental institutions, societies and individuals in collecting and preserving, editing and publishing the papers of outstanding United States citizens and other documents important for an understanding of U.S. history. A list of all publications financially supported or endorsed is available. Contact: Publications Program Branch, National Historical Publications and Records Commission, National Archives and Records Service, General Services Administration, Room 1111, 711 14th St. N.W., Washington, DC 20408/202-724-1090.

Qualified Products List (QPL)

In some cases only items that have been qualified prior to opening of bids will be considered for procurement. Federal specifications involving QPLs are listed in the *Index Specifications and Standards of the Federal Government.* Contact: Office of Item Management, Requirements and Supplies, Federal Supply Service, General Services Administration, Room 412, 1941 Jefferson Davis Highway, Washington, DC 20406/703-557-8910.

Quality Approved Manufacturer Program

This program allows manufacturers with approved quality control systems to ship material based on their own test results. Assistance is given to contractors in establishing adequate quality control systems and planning and scheduling productions, as well as maintaining a continuing liaison with them to ensure that their quality control systems remain effective. Contact: Office of Quality Assurance and Reliability, Federal Supply Service, General Services Administration, Room 1019, 1941 Jefferson Davis Highway, Washington, DC 20406/703-557-8470.

Renovation and Rehabilitation of Federal Property

This office recycles federal government office machines, furniture, carpet and drapes, vehicles and many other items. Most of the rehabilitation work is done by small businesses, and part of the remaining work goes to workshops for the blind or severely handicapped, and to Federal Prison Industries. A free pamphlet, *Contract Opportunities for Maintenance and Repair of Equipment,* describes how to obtain information on federal contracts for services, maintenance and repairs. For additional information, contact the Business Service Center nearest you, or Property Rehabilitation Division, Office of Personal Property,

Federal Property Resources Service, General Services Administration, Room 804, 1755 Jefferson Davis Highway, Washington, DC 20405/703-535-7210.

Requirement Identification and Assessment Program

This program determines which commonly used goods and services will be obtained and supplied to satisfy the requirements of federal programs. Contact: Requirements and Assessment Division, Federal Supply Service, General Services Administration, Room 210, 1941 Jefferson Davis Highway, Washington, DC 20406/703-557-8600.

Research Rooms

There are two main research rooms as well as research rooms that specialize in still pictures, motion pictures, sound recordings and cartographic records. Three additional rooms, in the Washington area but not in the main buildings, are available for printed archival material, for stock film footage, and for a variety of additional subjects. A beginning researcher must obtain an identification card. A free pamphlet, *A Researcher's Guide to the National Archives*, provides information on the National Archives, research rooms, how to obtain copies of documents and other services. Contact: Orientation and Consultation, Office of the National Archives, National Archives and Records Service, General Services Administration, Room 201, 8th St. and Pennsylvania Ave. N.W., Washington, DC 20408/202-523-3218.

Residential Relocation Assistance

Services and payments are available to owners and tenants of residences who are asked by the General Services Administration to move from their homes. *Residential Relocation Assistance*, a free pamphlet, describes these services and payments and how to obtain them. For additional information, contact: the GSA regional office in your area, or Leasing Division, Office of Space Management, Public Buildings Service, General Services Administration, Room 2330, 18th and F Sts. N.W., Washington, DC 20405/202-566-0638.

Security Education

An eight-week basic training course for new recruits and courses in refresher training are provided for federal protective officers and contract guards. For further information, contact: Training and Education Division, Office of Federal Protective Service Management, Public Buildings Service, General Services Administration, Room G309, 18th and F Sts. N.W., Washington, DC 20405/202-566-0839.

Slip Laws

Slip laws are pamphlet prints of each public and private law enacted by Congress and are issued shortly after becoming law in two series—Public Laws and Private Laws. The Public Laws carry *Statute* page numbers, sidenotes and citations, a guide to legislative history, and related presidential statements, and are available on subscription, $130.00 per session, from the Superintendent of Documents, Government Printing Office, Washington, DC 20402/202-783-3238. For additional information, contact: Office of the Federal Register, National Archives and Records Service, General Services Administration, Room 8401, 1100 L St. N.W., Washington, DC 20408/202-523-5282.

Space Management Research

Space management research studies emphasize efficiency and cost productiveness. A major study on "Systems Furniture" aimed at reducing space consumption has been completed. For additional information, contact: Space Standards and Research Branch, Office of Space Management, Public Buildings Service, General Services Administration, Room 2310, 18th and F Sts. N.W., Washington, DC 20405/202-566-1874.

Speakers

The General Services Administration makes available speakers to trade and educational organizations, small and minority business groups and those groups involved or potentially involved with the General Services Administration. Contact: Office of Public Information, General Services Administration, Room 6111, 18th and F Sts. N.W., Washington, DC 20405/202-566-1231.

Specifications and Standards

Single copies of federal specifications and standards are available at no cost from the Business Service Centers. A complete set can be obtained for $70 from: Specification and Consumer Information Distribution Branch (WFSIS), Washington Navy Yard, Building 197, Washington, DC 20407/703-472-2205.

Stock Film Library

The Library is a depository for the storage and preservation of motion picture stock footage produced or acquired by the Government. The nucleus of the Library's collection is the National Aeronautics and Space Administration's stock film. Other subjects include: agriculture in the

United States and foreign countries, business and industry (chemical plants, factories, oil refineries and mining), education (elementary school through college, teaching methods and community involvement), energy resources (nuclear, petroleum and coal), environmental pollution (air, water, oil spills, junkyards), natural disasters (hurricanes, earthquakes, floods and tornadoes), sociological concerns (drug abuse, medicine, slums, recreation and aging), space program (manned and unmanned missions), technology (computers and satelite communications), and wildlife in its natural habitat. The Library sells edited and unedited film footage. For additional information, contact: Stock Film Library Branch, Audiovisual Archives Division, National Archives and Records Service, General Services Administration, 1411 S. Fern St., Arlington, VA 22202/703-557-1114.

Stockpile Disposal

This Division sells, when authorized by Congress, precious commodities such as silver, gold bullion, diamond and tungsten ore, as well as agricultural materials and other metals and minerals. To be placed on the bidders' list and for general information, contact: Stockpile Disposal Division, Federal Property Resource Service, General Services Administration, Room 903, 1755 Jefferson Davis Highway, Washington, DC 20405/703-535-7225.

Stockpile Transactions and Inventories

Data are available describing the strategic and critical material stockpiled by the United States. Contact: Office of Stockpile Transactions, Federal Property Resources Service, General Services Administration, Room 903, 1755 Jefferson Davis Highway, Washington, DC 20405/703-535-7139.

Surplus Personal Property Donations

Surplus personal property can be transferred for donation to nonfederal public agencies and other specified recipients such as public agencies, nonprofit educational and public health activities, educational activities of special interest to the armed services and public airports. The personal property under this program includes hand and machine tools, office machines and supplies, furniture, hardward, motor vehicles, boats, airplanes, construction equipment and many other items. A free pamphlet, *Federal Surplus Personal Property Donation Programs*, explains eligibility and where and how to apply for additional information. For additional information, contact the regional GSA offices or Donation Division, Office of Personal Property, Federal Property Resources Service, General Services Administra-

tion, Room 802, 1755 Jefferson Davis Highway, Washington, DC 20405/703-535-7015.

Surplus Personal Property Sales

The General Services Administration conducts sales of civil agency personal property which include a wide variety of consumer-type items including automobiles and other motor vehicles, aircraft, hardware, plumbing and heating equipment, paper products, typewriters and other office machines, furniture, medical items, textiles, industrial equipment, and many others. Sales catalogs are mailed to prospective buyers who ask to be put on mailing lists and notices to the public of sales are placed in newspapers, trade journals, public buildings, etc. A free pamphlet, *Buying Government Surplus Personal Property*, outlines basic procedures and rules and describes how to be notified of sale dates and locations. Contact: the nearest Business Service Center or Sales Division, Office of Personal Property, Federal Property Resources Service, General Services Administration, Room 803, 1755 Jefferson Davis Highway, Washington, DC 20405/703-472-1804.

Tax Models

Tax models are used primarily to respond to requests for tabulations of tax return data. Five basic models cover individuals, corporations, sole proprietorships, partnerships, and estates. They consist of computer programs used with special statistics of income files of the most current data. The same file, with all taxpayer identifying information removed, can also be purchased by the public. The public may also purchase a companion file resulting from a special study on the sales of capital assets by individuals. Contact: Machine-Readable Archives Division, National Archives and Records, Washington, DC 20408/202-724-1080.

United States Government Manual

The official handbook of the federal government provides comprehensive information on the agencies of the legislative, judicial and executive branches. It also includes information on quasi-official agencies, international organizations in which the United States participates, and boards, committees, and commissions. The government manual is available for $8.50 at the Superintendent of Documents, Government Printing Office, Washington, DC 20402/202-783-3238. For additional information, contact: Presidential Documents Division, Office of the Federal Register, National Archives and Records Service, General Services Administration, Room 8401, 1100 L St. N.W., Washington, DC 20408/202-523-5230.

United States Statutes At Large

All public and private laws and concurrent resolutions enacted during a session of Congress, reorganization plans, and proposed and ratified amendments to the Constitution, and presidential proclamations are bound annually. They are for sale (prices vary) by the Superintendent of Documents, Government Printing Office, Washington, DC 20402/202-783-3238. For additional information, contact: Office of the *Federal Register*, National Archives and Records Service, General Services Administration, Room 8401, 1100 L St. N.W. Washington, DC 20408/202-523-5282.

Utilization of Excess Personal Property

The General Services Administration prescribes policies and methods to promote the maximum utilization of excess property and for transferring excess property among the federal agencies. The GSA regional offices issue Excess Personal Property Catalogs and Bulletins for reported property whenever the property warrants it. A free pamphlet, *The Utilization of Excess Personal Property*, provides information about the program, how the program operates and a guide to action. Contact regional GSA offices or Utilization Division, Office of Personal Property, Federal Property Resources Service, General Services Administration, Room 802, 1755 Jefferson Davis Highway, Washington, DC 20405/703-535-7048.

Value Management

Value management aims at improving the efficiency and effectiveness of an organization while reducing costs. It encourages contractor innotivation to provide better and cheaper goods and services. It also allows employees to challenge existing procedures and services in its internal operations. The program offers executive seminars for senior management representatives. The following free publications are also available:

Increase Your Profit—Use the Value Incentive Clause— how suppliers of federal goods and services can save the U.S. government money and increase their own profits.
Value Management: A Briefing for Executives—introduces executives to the concept of value management, its merits and pitfalls.
Establishing a Value Management Program—outlines methods of implementing the program.
Value Management Guide—a detailed outline of how to implement the program.

For additional information, contact: Value Engineering Division, Office of Engineering and Technical Management, Federal Supply Service, General Services Administration, Room 510, 1941 Jefferson Davis Highway, Washington, DC 20406/703-557-7567.

Visitor Information

A recorded message provides general information on some of the daily activities at the National Archives. Contact: Public Information, National Archives and Records Service, General Services Administration, Room G-8, 8th St. and Pennsylvania Ave. N.W., Washington, DC 20408/202-523-3000. For additional information, call 202-523-3099.

Watergate Tapes

The Watergate Tapes are now being played at specific hours in the National Archives. To sign up and for additional information, contact: Presidential Library, National Archives and Records Service, General Services Administration, Room 20W, 8th St. and Pennsylvania Ave. N.W., Washington, DC 20408/202-523-3146/3193.

Weekly Compilation of Presidential Documents

This compilation contains the remarks, speeches, news conferences, messages to Congress and other presidential material of a public nature issued by the White House Press Office during the week reported. It is a timely reference for the public policies and activities of the President. For sale at $18.50 from the Superintendent of Documents, Government Printing Office, Washington, DC 20402/202-783-3238. For additional information, contact: Office of Federal Register, National Archives and Records Service, General Services Administration, Room 8401, 1100 L St. N.W., Washington, DC 20408/202-523-5240.

How Can the General Services Administration Help You?

For information on how this agency can help you, contact: Division of Public Affairs, General Services Administration, Washington, DC 20405/202-523-1250.

Inter-American Foundation

1515 Wilson Blvd., Rosslyn, VA 22209/703-841-3811

ESTABLISHED: December 30, 1969
BUDGET: $15,964,000
EMPLOYEES: 67
MISSION: Supports and stimulates social change in Latin America and the Caribbean; provides support through grants and the financing of projects for private, community level, self-help efforts in solving basic social and economic problems.

Major Sources of Information

Fellowships

Each year the Inter-American Foundation awards about 15 fellowships for doctoral dissertation research and postdoctoral study in Latin America and the Caribbean. The purpose is to encourage increased scholarly attention to development issues as they affect poor and disadvantaged groups in the region. Contact: Doctoral and Post-Doctoral Fellowships, Inter-American Foundation, 1515 Wilson Blvd., Rosslyn, VA 22209/703-841-3800.

Film

Here, Nothing is Impossible is a 28-minute film in Spanish, English and bilingual on three self-management projects in Peru. Contact: Office of Planning and Research, Inter-American Foundation, 1515 Wilson Blvd., Rosslyn, VA 22209/703-841-3835.

Freedom of Information Act Requests

For Freedom of Information Act requests, contact: Freedom of Information Officer, Inter-American Foundation, 1515 Wilson Blvd., Rosslyn, VA 22209/703-841-3869.

Planning and Research

This office monitors and evaluates current Foundation projects; conducts evaluation studies in such areas as rural credit, worker-managed enterprises, nonformal education and cultural expression; coordinates the Foundation's fellowship and publication programs. Contact: Office of Planning and Research, Inter-American Foundation, 1515 Wilson Blvd., Rosslyn, VA 22209/ 703-841-3835.

Publications

Free publications include:

Bottom-Up Development in Haiti is a monograph with a special focus on the peasant leadership training programs of the Institut Diocesain d'Education des Adultes.
First Steps—The Foundation's first three years.
In Partnership with People: An Alternative Department Strategy.
They Know How—An Experiment in Foreign Assistance.
Journal of the Inter-American Foundation—free quarterly with news features on IAF projects and events in Latin America and the Caribbean.
IAF Annual Report—provides program and financial information on the IAF. It also lists a summary of grants for the past year, and describes the projects.

Contact: Inter-American Foundation, 1515 Wilson Blvd., Rosslyn, VA 22209/703-841-3835.

How Can the Inter-American Foundation Help You?

To determine how this agency can help you, contact: Office of the President, Inter-American Foundation, 1515 Wilson Blvd., Rosslyn, VA 22209/703-841-3811.

International Communication Agency

1750 Pennsylvania Ave. N.W., Washington, DC 20547/202-724-9103

ESTABLISHED: April 1, 1978

BUDGET: $433,195,000

EMPLOYEES: 8,675

MISSION: Responsibility for the conduct of international communication, education, cultural, and exchange programs designed to build two-way bridges of understanding between the people of the United States and the other peoples of the world; engages in a wide variety of communication activities—from academic and cultural exchanges to international broadcasting to press, film, seminar, library, and cultural center programs abroad—to accomplish its goals of telling the world about the society and policies of the United States and telling Americans about the world; and reports to the President and the Secretary of State, as well as the National Security Council, on worldwide public opinion as it is relevant to the formulation and conduct of U.S. foreign policy.

Major Sources of Information

Advisory Commission on Public Diplomacy

The Commission provides oversight, assessment and advice for the international information, cultural and education exchange programs of the United States. It also advises the President, Congress, the Secretary of State, and the Director of the International Communication Agency on the policies of the ICA. Contact: Advisory Commission on Public Policy, International Communication Agency, 1750 Pennsylvania Ave. N.W., Room 1008, Washington, DC 20547/202-724-9243.

American Participants

The International Communication Agency will pay American experts, who can contribute to foreign societies' understanding of the United States, to travel abroad and participate in seminars, colloquia or symposia. Subjects treated by American participants include economics, international political relations, U.S. social and political processes, arts and humanities, and science and technology. A free booklet, *American Participants*, describing the program is available. Contact: American Participants, Office of Program Coordination and Development, International Communication Agency, 1750 Pennsylvania Ave. N.W., Room 200, Washington, DC 20547/202-724-1900.

American Studies

This office supports, through ideas, funds and materials, American Studies Programs abroad. For additional information, contact: Division of the Study of the United States, Office of Academic Programs, Educational and Cultural Affairs, International Communication Agency, 1776 Pennsylvania Ave. N.W., Room 527, Washington, DC 20547/202-724-0918.

Arts America

The International Communication Agency seeks to encourage private-sector involvement and assists qualified artists and performers in arranging private tours overseas. Its aim is to present a balanced portrayal of the American cultural scene. Some of the past activities have included a major exhibition of American crafts shown in China, a modern dance company in the USSR, Spain, and Portugal, and a jazz ensemble in Nigeria, Senegal and Kenya. Contact: Arts Liaison Advisor, Office of the Associate Director for Programs, International Communication Agency, 1776 Pennsylvania Ave. N.W., Room 220, Washington, DC 20547/202-724-9032.

Board of Foreign Scholarships

The Board supervises United States government-supported education exchanges. It sets poli-

cies and procedures for administration of the program, has final responsibility for approving all grantees and supervises the conduct of the program both in the United States and abroad. The annual report of the Board is available. Contact: Board of Foreign Scholarships Staff, Educational and Cultural Affairs, International Communication Agency, 1776 Pennsylvania Ave. N.W., Room 502, Washington, DC 20547/202-724-9032.

Book Exhibits

The Agency cooperates with the publishing world to stage six book exhibits annually, which are seen in some 120 cities throughout the world. It also cooperates with American publishers participating in exhibits at international book fairs. Contact: Book Programs Division, Office of Cultural Centers and Resources, International Communication Agency, 1717 H St. N.W., Room 737, Washington, DC 20547/703-632-5296.

Booklets

The following booklets are available at no cost:

USICA in Brief
The Fulbright Program
The Advisory Commission on Public Diplomacy
American Participants (experts in many professions traveling abroad for USICA)
Arts America (a program to send American arts abroad)
International Visitor Programs
USICA Career Opportunities
Grants to Private Organizations
Annual Report to Congress

To receive any of these, write to: Office of Congressional and Public Liaison, International Communication Agency, 1776 Pennsylvania Ave. N.W., Room 1016, Washington, DC 20547/202-724-9192.

Book Program

The International Communication Agency promotes the publication of books on United States foreign policy, political and social processes, the economy, science and technology, education, and the arts and humanities. Most of the books are sold through commercial channels in developing countries. The agency provides assistance to foreign publishers who bring out editions of American works by absorbing translation and promotion costs or by buying part of the foreign edition for use in its cultural programs. Contact: Book Programs Division, Educational and Cultural Affairs, International Communication Agency, 1717 H St. N.W., Room 736, Washington, DC 20547/202-632-5296.

Career Counseling

For information on a variety of careers available in the Foreign Service, contact: Career Counseling, Office of Personnel Services, International Communication Agency, 1776 Pennsylvania Ave. N.W., Room 823, Washington, DC 20547/202-724-9436.

Copyright Clearance

The International Communication Agency serves as a copyright office for local publishers seeking rights to American books. It will also put them in touch with American publishers. For additional information, contact: Copyright Clearance Staff, Book Programs Office, Office of Cultural Centers and Resources, Educational and Cultural Affairs, International Communication Agency, 1717 H St. N.W., Room 739, Washington, DC 20547/202-632-5298.

Directory of Resources for Cultural and Educational Exchanges and International Communication

This is a free list of contacts in United States government agencies and non-profit organizations. It includes departments and agencies of the federal government, federal boards, commissions, committees and advisory groups, intergovernmental organizations, and private organizations. Acronyms and symbols are also listed. Contact: Office of Cultural Centers and Resources, Educational and Cultural Affairs, International Communication Agency, 1717 H St. N.W., Room 700, Washington, DC 20547/202-632-6700.

Donated Book Programs

American publishers donate books to developing nations and to certain education specialists overseas. Contact: Book Programs Division, Office of Cultural Centers and Resources, Educational and Cultural Affairs, International Communication Agency, 1717 H St. N.W., Room 700, Washington, DC 20547/202-632-5296.

East-West Center in Hawaii

The Center of Cultural and Technical Interchange Between East and West is a national education institution which studies issues involved in transnational communication, the study of foreign cultures and languages, population dynamics, resource systems, and the impact of technology on the environment. The Center has a cooperative relationship with universities and other institutions throughout Asia, the Pacific area and the United States. Contact: D.C. Liaison, East-West Center, Educational and Cultural Affairs, International Communication Agency,

1750 Pennsylvania Ave. N.W., Room 502, Washington, DC 20547/202-724-9333.

Exhibits

Approximately ten international exhibitions a year are held combining the efforts and resources of the federal government and the private sector. The exhibitions focus on a variety of subjects such as the arts, agriculture, communications, and computers. For additional information, contact: Exhibits Service, International Communication Agency, 1425 K St. N.W., Room 700, Washington, DC 20547/202-523-4246.

Films and Television

The International Communication Agency acquires and produces videotape programs and films for distribution through posts. Almost 100 videotape programs a year are produced in ICA studios; others are acquired from United States broadcast networks. These products are shown by ICA posts to audiences overseas and are sometimes also distributed through foreign media and commercial theatres abroad. It also provides foreign TV stations with newsclips of events in the United States. Another important function involves assisting foreign TV teams in producing programs about the United States for telecast abroad. Contact: Television and News Service, International Communication Agency, 601 D St. N.W., Room 2400, Washington, DC 20547/202-376-7806.

Foreign Press Centers

Two Foreign Press Centers, one in Washington and one in New York, assist journalists from all parts of the world in covering stories in the United States. For example, the Centers make appointments for foreign journalists, assist them with credentials and make the daily State Department press briefings available through closed circuit radio to correspondents who cannot be at the Department. Similar arrangements are made for White House and other major press conferences. Contact: New York Foreign Press Center, International Communication Agency, 18 E. 50th St., New York, NY 10022/212-826-4722, or Washington Foreign Press Center, International Communication Agency, 14th St. N.W., Room 202, Washington, DC 20045/202-724-1640.

Fulbright Program

The Fulbright Program is the United States government's international education exchange program. Scholarships are awarded to American students, teachers and scholars to study, teach, lecture and conduct research abroad and to foreign nationals to engage in similar activities in the United States. Citizens of other countries who would like information about Fulbright exchange opportunities should contact the Fulbright Commission or the American Embassy Public Affairs Officer in their countries. For information in this country, contact: Academic Exchange Programs Division, Office of Academic Programs, International Communication Agency, 1776 Pennsylvania Ave. N.W., Room 523, Washington, DC 20547/202-724-9711.

Grants

The programs described below are for sums of money which are given by the federal government to initiate and stimulate new or improved activities or to sustain on-going services:

Educational Exchange—Graduate Students

Objectives: To improve and strengthen international relations with the United States by promoting better mutual understanding among the peoples of the world through education exchanges.

Eligibility: To individuals with the following qualifications: (a) U.S. citizenship at the time of application; (b) with certain exceptions, B.A. degree or its equivalent before the beginning date of the grant; (c) candidates may not hold a doctoral degree at the time of application; (d) applicants must have received the majority of their high school and their undergraduate college education at education institutions in the United States; (e) language proficiency sufficient to communicate with the people of the host country and to carry out the proposed study; language proficiency is especially important for students wishing to undertake projects in the social sciences and the humanities; and (f) good health.

Range of Financial Assistance: $1,000 to $15,000.

Contact: Institute of International Education, 809 United Nations Plaza, New York, NY 10017/212-883-8200.

Educational Exchange—University Lecturers (Professors) and Research Scholars

Objectives: To improve and strengthen international relations with the United States by promoting mutual understanding among the peoples of the world through education exchanges.

Eligibility: To individuals with the following qualifications: (a) U.S. citizenship at the time of application; (b) for lecturing—college or university teaching experience at the level for which application is made; (c) for research—a doctoral degree or, in some fields, recognized professional standing as demonstrated by faculty rank, publi-

cations, compositions, exhibition record, concerts, etc.

Range of Financial Assistance: $2,000 to $30,000.

Contact: Council for International Exchange of Scholars, 11 Dupont Circle, Suite 300, Washington, DC 20036/202-833-4950.

Private Sector Programs

Objectives: To support the enhancement of American competence in world affairs through greater understanding of other societies—their peoples, values, cultures and aspirations.

Eligibility: Grant requests are considered only for projects undertaken by private nonprofit institutions or organizations.

Range of Financial Assistance: $2,500 to $478,000.

Contact: Office of Private Sector Programs, Associate Directorate for Educational and Cultural Affairs, International Communication Agency, 1776 Pennsylvania Ave. N.W., Washington, DC 20547/202-724-9702.

Hubert H. Humphrey North-South Fellowship Program

This program offers mid-career professionals an opportunity to enhance their capabilities by emphasizing practical experience and developing professional skills. Workshops, seminars, and field trips are provided. Contact: Academic Exchange Programs, Office of Academic Programs, Educational and Cultural Affairs, International Communications Agency, 1776 Pennsylvania Ave. N.W., Room 523, Washington, DC 20547/202-724-9711.

International Visitors Program

Under the International Communication Agency's International Visitors Program, some 2,400 foreign leaders in government, labor, mass media, science, education and other fields come to the United States annually to see American society firsthand and to confer with their counterparts in this country. They are chosen by ICA posts abroad on the basis not only of their present influence, but of their potential influence within their own communities. Most visitors come here individually and follow specially tailored itineraries. Others come in small groups to participate in projects on such topics as energy, food systems, environment, communications, the role of women, etc. Contact: Office of International Visitors Programs, Educational and Cultural Affairs, International Communication Agency, 1776 Pennsylvania Ave. N.W., Room 540, Washington, DC 20547/202-724-9986.

Junior Officer Trainee Program

Candidates enter this program by taking the Foreign Service Officer Examination given each December at many locations in the United States and overseas. For information on the Junior Officer Trainee Program, contact: Training and Development Division, Office of Personnel Services, International Communication Agency, Room 800, 1425 K St. N.W., Washington, DC 20547/202-523-4390.

Library

The agency library maintains a collection on a wide variety of subjects and includes a Russian language section. Permission to use the library must be obtained through the Office of Congressional and Public Liaison, Room 1016, 202-724-9578. For additional information about the library, contact: Library, International Communication Agency, 1750 Pennsylvania Ave. N.W., Room 1005, Washington, DC 20547/202-724-9214.

Library Programs

There are some 200 International Communication Agency libraries in 95 countries. Some collections are general in nature while others are designed exclusively for reference by lawmakers, officials, university students, American studies specialists, etc. Services may include interlibrary loans, preparation of special bibliographies, technical advice and loan of books by mail. For further information, contact: Library Programs, Educational and Cultural Affairs, International Communication Agency, 1717 H St. N.W., Room 736, Washington, DC 20547/202-632-5346.

Overseas Publications Program

With one exception, the International Communication Agency publishes the following magazines for overseas distribution only.

Dialogue—a quarterly journal of opinion and analysis on subjects of current intellectual interest in the United States. Published in eight languages during fiscal year 1979, it contains both reprints and original articles.

Topic—a bimonthly magazine published in French and English for distribution in sub-Saharan Africa. It highlights significant aspects of American life and of U.S.-African relations.

al-Majal—published monthly in Arabic for distribution in North Africa and the Near East. It focuses on various aspects of American society and U.S. foreign policy, especially relations with Arab populations.

America Illustrated—an illustrated monthly journal de-

signed to present a balanced and varied picture of American life. It is published in Russian and sent to the Soviet Union in exchange for *Soviet Life*, a magazine from the USSR which is distributed here.

Problems of Communism—a bimonthly scholarly periodical on communist affairs, published in English, available for $10 per year from the Superintendent of Documents, Government Printing Office, Washington, DC 20402/202-783-3238.

For additional publications, contact: Publications Division, Press and Publications Service, International Communication Agency, 1776 Pennsylvania Ave. N.W., Room 1023, Washington, DC 20547/202-724-9718.

Press

A radioteletype network known as the Wireless File sends five regional transmissions, five days a week, of policy statements and interpretive material to 159 United States International Communication Agency (USICA) posts overseas. Each regional transmission averages 12,000 to 16,000 words in English. There are also Spanish, French and Arabic language versions. Features, by-line articles, reprints from U.S. publications and photographs are regularly mailed to all posts. This material is used for the background information of U.S. Mission personnel abroad, for distribution to foreign opinion leaders, and for media placement abroad. Contact: Press Division, Press and Publications Service, International Communication Agency, 1776 Pennsylvania Ave. N.W., Room 223, Washington, DC 20547/202-724-9755.

Private Sector Programs

These programs provide selective assistance and grant support to nonprofit activities of United States organizations outside the federal government that support the enhancement of United States competence in world affairs. For further information, contact: Office of Private Sector Programs, Educational and Cultural Affairs, International Communication Agency, 1776 Pennsylvania Ave. N.W., Room 616, Washington, DC 20547/202-724-9444.

Research

The research staff is concerned with the attitudes and perceptions of foreign peoples. The researchers try to identify the issues of greatest importance to influential persons in foreign countries, their attitudes and opinions, their views of the United States, and the media and other sources of information they rely on. The research staff reviews foreign social science and literary publications, talks with United Sta[...] turning from abroad and review[...] output. Contact: Office of Resear[...] al Communication Agency, 175[...] Ave. N.W., Room 901, Washington, DC 20547/202-724-9361.

Research Reports

The International Communication Agency's research and media-reaction staffs prepare material for the White House, the Department of State and other departments and agencies of the United States government, and for the Agency's own use in assessing issues. The Agency's research reports are available to interested persons at 46 depository libraries in universities and other institutions throughout the country. For a list of these depositories, write to the Office of Research, International Communication Agency, 1750 Pennsylvania Ave. N.W., Room 901, Washington, DC 20547/202-724-9361.

Student Support Services

Programs aimed at enhancing the academic experiences of foreign students in the United States are developed and available. For additional information, contact: Student Support Services, Office of Academic Programs, Educational and Cultural Affairs, International Communication Agency, 1776 Pennsylvania Ave. N.W., Room 556, Washington, DC 20547/202-724-9716.

VOA Broadcasts

Voice of America programs are broadcast in the following 39 languages: Albanian, Arabic, Armenian, Bengali, Bulgarian, Burmese, Chinese, Czech, Dari, English, Estonian, French, Georgian, Greek, Hausa, Hindi, Hungarian, Indonesian, Khmer, Korean, Lao, Latvian, Lithuanian, Persian, Polish, Portuguese, Romanian, Russian, Serbo-Croatian, Slovak, Slovenian, Spanish, Swahili, Thai, Turkish, Ukranian, Urdu, Uzbek, Vietnamese. They include direct broadcasts (about 850 hours a week) and indirect broadcasts. Indirect broadcast programs are those prepared by VOA and/or ICA posts abroad and put on by local radio stations. The backbone of VOA's programming is news and news analysis. Some of the other programs include:

The Breakfast Show—morning program moves westward through breakfast hours in time zones around the world, bringing listeners interviews, popular music and answers to their questions about the United States.

Press Confence USA—features leading figures in the

news who face a panel of distinguished American and foreign journalists.

Critics' Choice—presents listeners with discussions of and critiques about the arts in America, including literature, theater, painting, dance, cinema, architecture and music.

Studio One—covers, in documentary fashion, many facets of life and culture in the United States. Recent programs highlighted the warmth and wit of American humorist Will Rogers and honored Thomas Edison on the 100th anniversary of his invention of the light bulb.

English broadcast schedules to the Americas, the Middle East, East Asia and Pacific, South Asia, Africa and Europe are available. For additional information, contact: Programs Office, Voice of America, International Communication Agency, 330 Independence Ave. S.W., Room 3316, Washington, DC 20547/202-755-4250.

VOA Facilities

The VOA facilities comprise the Master Control in Washington, DC, three facilities in New York City, one each in Chicago, Los Angeles and Miami, 33 domestic and 68 overseas transmitters plus 15 satellite circuits which beam programs to Europe, the Middle East, East Asia and the Pacific Area. A Table of VOA Relay Stations in the United States and overseas showing location, transmitters, power range and area reached, and a Frequency Schedule are available at no cost. For additional information, contact: Office of Engineering and Technical Operations, Voice of America, International Communications Agency, 25 M St. N.W., Room 200, Washington, DC 20547/202-755-4778.

VOA Public Tours

Regularly scheduled guided tours are available to show visitors how the VOA communicates with people around the world. Visitors watch broadcasts in session, and see excerpts of motion pictures and TV programs. For additional information, contact: Voice of America, International Communication Agency, 300 Independence Ave. S.W., Washington, DC 20547/202-755-4744.

Voluntary Visitors

"Voluntary Visitors" are those foreigners who come to the United States under private auspices but, at the request of an International Communication Agency post abroad, receive assistance in planning their trips in the United States. For further information, contact: Office of International Visitors Programs, Educational and Cultural Affairs, International Communication Agency, 1776 Pennsylvania Ave. N.W., Room 742, Washington, DC 20547/202-724-9649.

How Can the International Communication Agency Help You?

For information on how this agency can help you, contact: Office of Congressional and Public Liaison, International Communication Agency, 1750 Pennsylvania Ave. N.W., Washington, DC 20547/202-724-9103.

Interstate Commerce Commission

12th St. and Constitution Ave. N.W., Washington, DC 20423/202-275-7252

ESTABLISHED: February 4, 1887
BUDGET: $143,856,000
EMPLOYEES: 2,024
MISSION: Regulates interstate surface transportation, including trains, trucks, buses, inland waterways and coastal shipping, and freight forwarders; certifies carriers seeking to provide transportation for the public, rates, adequacy of service, purchases, and mergers; and insures that the carriers it regulates will provide the public with rates and services that are fair and reasonable.

Major Sources of Information

Annual Reports of Carriers

Annual Reports of carriers may be examined in the Public Reference Room, Bureau of Accounts, Interstate Commerce Commission, 12th St. and Constitution Ave. N.W., Room 6124, Washington, DC 20423/202-275-7343.

Applications of Motor Carriers

After an application has been published in the *Federal Register*, an applicant must furnish a copy, for $10, of its application package to any person requesting a copy. A copy of the application can be inspected. Contact the ICC Regional Office of applicant's domicile, or Motor and Rail Docket File, Office of the Secretary, Interstate Commerce Commission, 12th St. and Constitution Ave. N.W., Room 1221, Washington, DC 20423/202-275-7285.

Bi-Weekly Review

This is a free, comprehensive review of significant ICC actions of particular interest to consumers. To be put on the mailing list and for additional information, contact: Communications and Consumer Affairs Office, Interstate Commerce Commission, 12th St. and Constitution Ave. N.W., Room 1211, Washington, DC 20423/202-275-7252.

Calendar of Upcoming Events

A weekly calendar listing Interstate Commerce Commission conferences, scheduled board meetings, and speeches by commissioners is available. To be placed on the mailing list and for additional information, contact: Communications and

Consumer Affairs Office, Interstate Commerce Commission, 12th St. and Constitution Ave. N.W., Room 1211, Washington, DC 20423/202-275-7252.

Classification

A "class rating" is assigned to hundreds of commonly-shipped products based on their transportation characteristics. Motor carrier rates are based, for the most part, on the National Motor Freight Classification set up by the National Classification Board, a carrier organization. If the Board cannot settle a dispute regarding the correct classification, contact: Rates and Informal Cases, Bureau of Traffic, Interstate Commerce Commission, 12th St. and Constitution Ave. N.W., Room 4317, Washington, DC 20423/202-275-7323.

Commission Reports and Orders

Individual Interstate Commerce Commission Reports and Orders are available on the day of issuance from the Public Records Section, Office of the Secretary, Interstate Commerce Commission, 12th St. and Constitution Ave. N.W., Room 2223, Washington, DC 20423/202-275-7591. In addition, printed reports of the Commission are available. Contact: Publications, Public Records Section, Interstate Commerce Commission, 12th St. and Constitution Ave. N.W., Room 2229, Washington, DC 20423/202-275-7279.

Complaint and Performance Data

Summaries of complaint and performance data relating to the operations of the seventeen nation-

wide moving companies are available. The data can assist in informing customers of any moving company what to expect in the average move. Contact: Communications and Consumer Affairs Office, Interstate Commerce Commission, 12th St. and Constitution Ave. N.W., Room 1211, Washington, DC 20423/202-275-7252.

Concurrences and Powers of Attorney

A "concurrence" authorizes one carrier to have another carrier publish its rates or fares. A "power of attorney" authorizes a tariff publishing agent to publish rates for a carrier. For information about filing concurrences and powers of attorney, contact: Section of Tariffs, Bureau of Traffic, Interstate Commerce Commission, 12th St. and Constitution Ave. N.W., Room 6217, Washington, DC 20423/202-275-7261.

Consumer Complaint Hotline

The Interstate Commerce Commission National Complaint Center is available to all callers within the United States (except Alaska and Hawaii). Should any problems arise during or after a move, contact: Office of Communications and Consumer Affairs, Interstate Commerce Commission, 12th St. and Constitution Ave. N.W., Room 1211, Washington, DC 20423/202-275-7252.

Consumer Protection Hotline

A nationwide toll-free consumer hotline operates seven days a week, 24 hours a day. Consumers who require assistance or information regarding interstate railroads, bus lines, moving companies, and trucking companies should contact: Office of Consumer Protection, Interstate Commerce Commission, 12th St. and Constitution Ave. N.W., Room 1211, Washington, DC 20423/202-275-7252.

Decisions

The decisions of the Interstate Commerce Commission are on sale (prices vary) in hardbound volumes in four categories: 1) Finance decisions; 2) Finance decisions (motor carriers); 3) Rate or Traffic decisions; 4) Motor Carrier decisions. Contact: Superintendent of Documents, Government Printing Office, Washington, DC 20402/202-783-3238. For additional information, contact: Office of the Secretary, Interstate Commerce Commission, 12th St. and Constitution Ave. N.W., Room 2215, Washington, DC 20423/202-275-7428.

Entering the Trucking Business

A free booklet designed to inform the consumer of the services and remedies available, as well as the obligations and responsibilities of regulated carriers is available. It addresses some of the basic questions or problems on surface transportation services. It also includes a list of ICC field offices and state commissions regulating motor carriers. Contact: Consumer Assistance Section, Bureau of Operations, Interstate Commerce Commission, 12th St. and Constitution Ave. N.W., Room 7309, Washington, DC 20423/202-275-0860.

Exempt Commodities

Can They Do That? Hot or Exempt is a free booklet listing commodities that are both "exempt" or "not exempt." For additional information, contact the nearest ICC Field Office, or Operations Branch, Bureau of Operations, Interstate Commerce Commission, 12th St. and Constitution Ave. N.W., Room 7221, Washington, DC 20423/202-275-0877.

Freedom of Information Act Requests

For Freedom of Information Act requests, contact: Office of the Managing Director, Interstate Commerce Commission, 12th St. and Constitution Ave. N.W., Room 3387, Washington, DC 20423/202-275-7076.

Fuel Surcharge Hotline

The fuel recovery surcharge attempts to compensate common carriers for increased fuel costs. The adjusted surcharge rate is determined weekly and issued every Tuesday. For additional information on the surcharge, contact: Cost Development Section, Bureau of Accounts, Interstate Commerce Commission, 12th St. and Constitution Ave. N.W., Room 6321, Washington, DC 20423/202-275-7651.

Insurance

All motor common carriers of property and freight forwarders are required to maintain cargo insurance for the protection of the shipping public. The name of the company insuring these carriers is available. Contact: Motor, Water, Forwarder Operations, Bureau of Operations, Interstate Commerce Commission, 12th St. and Constitution Ave. N.W., Room 7217, Washington, DC 20423/202-275-7511.

Legal Assistance

All motor carriers must designate an agent for service of legal process in each state into or through which it may operate. The name of this process agency may be obtained. Contact: Motor, Water, Forwarder Operations Section, Bureau of

Operations, Interstate Commerce Commission, 12th St. and Constitution Ave. N.W., Room 7217, Washington, DC 20423/202-275-7511.

Library
The commission library's collection concentrates on law and transportation. Six times a year it issues a bulletin listing the lastest speeches by ICC members and a directory of legal and transportation oriented articles available in the Library. Contact: Library, Interstate Commerce Commission, 12th St. and Constitution Ave. N.W., Room 3392, Washington, DC 20423/202-275-7328.

Loss and Damage of Cargo Claims
Assistance is available in the form of information and guidance to help work out agreeable settlements on claims for loss and damage of cargo. Two free consumer pamphlets, *Loss and Damage Claims: Can You Collect?* and *Administrative Ruling 120*, provide helpful information and suggestions. For additional information, contact the nearest ICC office or Bureau of Operations, Interstate Commerce Commission, 12th St. and Constitution Ave. N.W., Room 7221, Washington, DC 20423/202-275-0877.

Motor and Rail Dockets
Records of proceedings can be examined by the public. Contact: Motor and Rail Docket File Room, Office of the Secretary, Interstate Commerce Commission, 12th St. and Constitution Ave. N.W., Room 1221, Washington, DC 20423/202-275-7285.

Northeast Railroad Network
Plans and policy are being developed to restructure the Northeast railroad network to provide more efficient and economic service. Contact: Rail Policy Section, Office of Policy and Analysis, Interstate Commerce Commission, 12th St. and Constitution Ave. N.W., Room 7376, Washington, DC 20423/202-275-0826.

Operating Authority
The Interstate Commerce Commission grants two types of authority for motor carriers: temporary and permanent. Temporary authority is granted when there is an immediate and urgent need for the transportation of freight which cannot be met by existing carriers. Permanent authority is granted when there is a continuing need for additional transportation service. A free publication, *Guide to Applying for Permanent Operating Authority*, is available. Contact: Applications Evaluation and Authorities Section, Office of Proceedings, Interstate Commerce Commission,

12th St. and Constitution Ave. N.W., Room 5416, Washington, DC 20423/202-275-7020.

Public Advisories
Public Advisories are a series of free pamphlets designed to address some basic questions and problems related to surface transportation services. The following advisories are available at no cost:

No. 1—*Owner Operator Rights, Responsibilities and Remedies*
No. 2—*Arranging Transportation for Small Shipments: Shipper Rights, Remedies, and Alternatives*
No. 3—*Filing Your Tariff*
No. 4—*Lost or Damaged Household Goods; Prevention and Recovery*
No. 5—*Filing Your Contract and Schedule*
No. 6—*Entering the Trucking Business*
No. 7—*Buying Transportation*

Contact: Communications and Consumer Affairs Office, Interstate Commerce Commission, 12th St. and Constitution Ave. N.W., Room 1211, Washington, DC 20423/202-275-7252.

Publications
The Interstate Commerce Commission issues many publications of both general and consumer interest. It also publishes technical and statistical publications dealing with transportation regulation. For a publication catalog and general information, contact: Communications and Consumer Affairs Office, Interstate Commerce Commission, 12th St. and Constitution Ave. N.W., Room 1211, Washington, DC 20423/202-275-7252.

Public Tariff File
Copies of all tariffs filed by carriers and regulated by the Interstate Commerce Commission can be inspected. Contact: Public Tariff File Branch, Bureau of Traffic, Interstate Commerce Commission, 1015 15th St. N.W., Room 50, Washington, DC 20005/202-275-7462.

Rail and Service Abandonments
A railroad must issue a notice of intent to the public before it files an abandonment application. If there is sufficient public opposition to the abandonment, the ICC will hold formal proceedings. For additional information, contact: Rail Services Planning Section, Office of Policy and Analysis, Interstate Commerce Commission, 12th St. and Constitution Ave. N.W., Room 7376, Washington, DC 20423/202-275-0826, or Finance Section, Office of Proceedings, Interstate Commerce Commission, 12th St. and Constitu-

tion Ave. N.W., Room 5417, Washington, DC 20423/202-275-7245.

Rates and Charges

Carriers must file their proposed tariffs with the Interstate Commerce Commission. In case of a dispute on a tariff matter, contact: Rates and Informal Cases, Bureau of Traffic, Interstate Commerce Commission, 12th St. and Constitution Ave. N.W., Room 4317, Washington, DC 20423/202-275-7358.

Small Business Assistance

Help for small businesses with problems in surface transportation as well as information and assistance to small businesses planning to enter the transportation field is available from: Small Business Assistance Office, Interstate Commerce Commission, 12th St. and Constitution Ave. N.W., Room 3385, Washington, DC 20423/202-275-7597.

Special Permission Authority

Thirty days' notice must be given to the Interstate Commerce Commission and to the public before a rate or fare can be increased or reduced. Information about applying for Special Permission Authority to file tariffs on less than 30 days' notice is available. Contact: Special Permission Branch, Bureau of Traffic, Interstate Commerce Commission, 12th St. and Constitution Ave. N.W., Room 4355, Washington, DC 20423/202-275-7396.

Statistics Reports

The following statistics reports are prepared by the Section of Reports, Bureau of Accounts, Interstate Commerce Commission, 12th St. and Constitution Ave. N.W., Room 6140, Washington, DC 20423:

Selected Statistics of Class III Motor Carriers of Property

A-300-Wage Statistics of Class I Railroads in the United States—Calendar Year—number of employees, service hours, and compensation by occupation: professional, clerical, and general; maintenance of way and structures; maintenance of equipment and stores; etc.

QUARTERLY

Large Class I Motor Carriers of Property Selected Earnings Data—operating revenues, net income revenue tons hauled, operating ratio and rates of return.

Class I Line-Haul Railroads Selected Earnings Data—railway operating revenues, net railway operating income, ordinary income, net income and rate of return.

Large Class I Motor Carriers of Passengers Selected Earnings Data—operating revenues, net income, revenue passengers carried, operating ratio and rate of return.

Large Class I Household Goods Carriers Selected Earnings Data—operating revenues, net income, revenue tons hauled, operating ratio and rate of return.

MONTHLY

M-350-Preliminary Report of Railroad Employment, Class I Line-Haul Railroads—number of employees at middle of month, group totals.

These are available at no cost from the Section of Administrative Services, Interstate Commerce Commission, 12th St. and Constitution Ave. N.W., Room 1325, Washington, DC 20423/202-275-7236.

Summary of Information for Shippers of Household Goods

A free booklet intended to help avoid the common pitfalls of moving is available. It includes information on selecting movers, estimating cost, moving by the pound, money-saving tips, methods of packing, bill of lading, inventory, mover's liability, delivery, storage in transit, filing claims and sources of assistance. For the booklet and any additional information, contact: Communications and Consumer Affairs Office, Interstate Commerce Commission, 12th St. and Constitution Ave. N.W., Room 1211, Washington, DC 20423/202-275-7252.

Suspension Procedures

If a carrier fails to comply with Interstate Commerce Commission rules and regulations and if other measures taken by the ICC have failed to make the carrier comply, the Commission may suspend or revoke the carrier's operating permit. For information about suspension procedures and filing protests and replies, contact: Suspension Board, Bureau of Traffic, Interstate Commerce Commission, 12th St. and Constitution Ave. N.W., Room 4421, Washington, DC 20423/202-275-7701.

Tariff Instructional Manual

This is a step-by-step guide for constructing, publishing and filing a tariff. For a free copy and for additional information, contact: Tariffs Section, Bureau of Traffic, Interstate Commerce Commission, 12th St. and Constitution Ave. N.W., Room 4363A, Washington, DC 20423/202-275-7462.

Transport Statistics in the United States

This is an annual compilation of statistics on all modes of transportation in the United States, and on related industries and services. It details

data on traffic operations, equipment, finances and employment for carriers subject to the Interstate Commerce Act, and comprises the following five parts: 1) Railroads, their lessors and proprietary companies and electric railways; 2) motor carriers; 3) freight forwarders; 4) private car lines; and 5) carriers by water. Available for $5.00 from the Superintendent of Documents, Government Printing Office, Washington, DC 20402/202-783-3238. For additional information, contact: Publications Branch, Bureau of Accounts, Interstate Commerce Commission, 12th St. and Constitution Ave. N.W., Room 6140, Washington, DC 20423/202-275-7356.

How Can the Interstate Commerce Commission Help You?

For information on how this agency can help you, contact: Office of Communications and Consumer Affairs, Interstate Commerce Commission, 12th St. and Constitution Ave. N.W., Washington, DC 20423/202-275-7849.

Merit Systems Protection Board

1120 Vermont Ave. N.W., Washington, DC 20419/202-653-7124

ESTABLISHED: January 16, 1883
BUDGET: $17,591,000
EMPLOYEES: 503
MISSION: Protects the integrity of federal merit systems and the rights of federal employees working in the systems; conducts special studies of the merit system, hears and decides charges of wrongdoing and employee appeals of adverse agency actions, and orders corrective and disciplinary actions against an executive agency or employee when appropriate; and investigates, among other things, prohibited personnel practices and allegations of activities prohibited by civil service law, rule and regulation, and prosecutes officials who violate civil service rules and regulations.

Major Sources of Information

Appeals
This office is responsible for the hearing of appeals by employees from adverse actions taken against them. Employees can appeal as a matter of right and are guaranteed a hearing in all cases appealable to the Board. Contact: Office of Appeals, Merit Systems Protection Board, 1120 Vermont Ave. N.W., Washington, DC 20419/202-653-8888.

Freedom of Information Act Requests
For Freedom of Information Act requests, contact: Office of the Secretary, Merit Systems Protection Board, 1717 H St. N.W., Room 350, Washington, DC 20419/202-653-7200.

Library
This library, open to the public, has a legal collection emphasizing personnel law. For information, contact: Library, Merit Systems Protection Board, 1120 Vermont Ave. N.W., Washington, DC 20419/202-653-7132.

Merit Systems Review and Studies
Through special studies of the federal civil service and other merit systems in the executive branch, and through its review of the rules, regulations and significant actions of the Office of Personnel Management, the Board studies and reports to the President and the Congress on the federal merit systems, making sure that the principles of fairness embodied in the Civil Service

Reform Act are being systematically applied. The office is working on two studies: 1) *A Quantitative Study of the Civil Service Reform Act* appeals decisions rendered by the Field offices; and 2) *Study of Sexual Harassment* which seeks to determine not only the extent of the problem in the federal workplace but also its impact on productivity. Contact: Office of Merit Systems, Review and Studies, Merit Systems Protection Board, 1120 Vermont Ave. N.W., Washington, DC 20419/202-653-7208.

Publications
The following publications are free:

How to File an Appeal with the U.S. Merit Systems Protection Board
Questions and Answers on the Merit Systems Protection Board
Office of Merit Systems Review and Studies Annual Report

Contact: Public Information, Office of Legislative Counsel, Merit Systems Protection Board, 1120 Vermont Ave. N.W., Washington, DC 20419/202-653-7124.

Special Counsel
The Special Counsel receives and investigates charges of:

1. Prohibited personnel practices, including reprisals against whistleblowers

2. Arbitrary or capricious withholding of information that has been designated as available under the Freedom of Information Act
3. Illegal discrimination occurring in the course of any personnel action when found by a court or under any administrative proceeding
4. Prohibited political activity
5. Activities prohibited by any civil service law, rule or regulation.

The Special Counsel has the authority to initiate disciplinary actions before the Board against employees after any investigation conducted by the Special Counsel, or on the basis of an employee's willful refusal or failure to comply with an order of the Board. Contact: Office of the Special Counsel, Merit Systems Protection Board, 1120 Vermont Ave. N.W., Washington, DC 20419/202-653-7107.

How Can the Merit Systems Protection Board Help You?

For information on how this agency can help you, contact: Merit Systems Protection Board, 1120 Vermont Ave. N.W., Washington, DC 20419/202-653-7124.

National Aeronautics and Space Administration

400 Maryland Ave. S.W., Washington, DC 20546/202-755-2320

ESTABLISHED: 1958
BUDGET: $5,266,886,000
EMPLOYEES: 22,613

MISSION: Carries out the policy of Congress that activities in space should be devoted to peaceful purposes for the benefit of all humankind; conducts research for the solution of problems of flight within and outside the Earth's atmosphere and develops, constructs, tests and operates aeronautic and space vehicles; conducts activities required for the exploration of space with manned and unmanned vehicles; arranges for the most effective utilization of the scientific and engineering resources of the United States in conjunction with other nations engaged in aeronautic and space activites for peaceful purposes; and provides for the widest practicable and appropriate dissemination of information concerning NASA's activities and their results.

Major Sources of Information

Aeronautics and Space Technology

This office is responsible for the planning, direction, execution, evaluation, documentation, and dissemination of the results of all NASA research and technology programs that are conducted primarily to demonstrate the feasibility of a concept, structure, component, or system and which may have general application to the nation's aeronautic and space objectives. This office is also responsible for coordinating the agency's total program of supporting research and technology related to carrying out specific flight missions in order to avoid unnecessary duplication, and to insure an integrated and balanced agency research program. This includes technology developments supporting reliable low cost energy systems, as a national priority. Contact: Public Affairs, Aeronautics and Space Technology, National Aeronautics and Space Administration, 600 Independence Ave. S.W., Room B647, Washington, DC 20546/202-755-2497.

Annual Procurement Report

This report presents summary data on all procurement actions, including contracts, purchase orders, grants and agreements for the past fiscal year. Information is based on detailed data compiled on all grants, all contracts with educational institutions, and all other procurements of $10,000 and over. Contact: Office of Procurement, National Aeronautics and Space Administration, 600 Independence Ave. S.W., Room B101, Washington, DC 20546/202-755-2255.

Astronaut Appearances

Astronauts are available to speak to education, civic, scientific, and similar groups. For information, contact: Astronaut Appearances, Public Services Branch, Public Affairs Division, National Aeronautics and Space Administration, 400 Maryland Ave. S.W., Room F6093, Washington, DC 20546/202-755-8364.

Atlas-Centaur Rockets

Lewis Research Center manages the Atlas-Centaur rockets which carry many scientific, planetary and application payloads, including commercial communications satellites, into space. Contact: Lewis Research Center, National Aeronautics and Space Administration, 21000 Brookpark Rd., Cleveland, OH 44135/216-433-4000.

Bid Rooms

Two central "Bid Rooms" are maintained where copies of all open National Aeronautics and Space Administration (NASA) solicitations are available for review by interested firms. Each

NASA installation provides "bid room" services for its own procurements. Contact: NASA Resident Procurement Branch, Office of Procurement, National Aeronautics and Space Administration, 4800 Oak Grove Dr., Pasadena, CA 91103/213-354-5359, or: Office of Small and Disadvantaged Business Utilization, National Aeronautics and Space Administration, 600 Independence Ave. S.W., Room B116, Washington, DC 20546/202-755-2288.

Computer Software Management and Information Center (COSMIC)

The Center collects all the computer programs NASA has developed (and also some of the best programs developed by other government agencies), verifies that they operate properly, and makes them available at reasonable prices. Program documentation is also available for evaluation prior to purchase. A catalog of over 1,600 available computer programs is published, or individual searches for relevant programs will be performed by COSMIC free of charge. *Computer Program Abstracts*, a quarterly, is available for $6.50 per year from the Superintendent of Documents, Government Printing Office, Washington, DC 20402/202-783-3238. For further information, contact: COSMIC, 112 Barrow Hall, University of Georgia, Athens, GA 30602/404-542-3265.

"Dear Colleague" Letters

These are periodic notices which disseminate information to members of the scientific and engineering community. These letters outline general research areas in which unsolicited proposals would be of interest and contain appropriate guidance for preparation and submittal of related proposals. To be placed on the mailing list and for additional information, contact: Technology Transfer Division, Space and Terrestrial Applications, National Aeronautics and Space Administration, 600 Independence Ave. S.W., Room B147, Washington, DC 20546/202-755-2244.

Deep Space Network (DSN)

This is a worldwide deep space tracking and data acquisition network. Contact: Jet Propulsion Laboratory, National Aeronautics and Space Administration, 4800 Oak Grove Dr., Pasadena, CA 91103/213-354-5011.

Delta Launch Vehicle

Goddard Space Flight Center manages the Delta launch vehicle which has launched numerous unmanned NASA satellites as well as many of the satellites of other federal and communications agencies and foreign governments. Contact: Goddard Space Flight Center, National Aeronautics and Space Administration, Greenbelt, MD 20771/301-344-7000.

Education Services

Programs and services provided for the education communities throughout the country include curriculum updating, teacher education courses, institutes, seminars and workshops, educational conferences, youth programs, aerospace education services, educational visits and counseling and career guidance. Contact: Community and Education Services Branch, Public Affairs Division, National Aeronautics and Space Administration, 400 Maryland Ave. S.W., Room F6051, Washington, DC 20546/202-755-3756.

Environmental and Earth Science Education

This is an annotated listing providing teachers of environmental education and earth science with an understanding of NASA's programs and technologies which may help in coping with earth resources and environment problems. It includes publications, films and environment-related TV programs. Contact: Education and Community Services, Public Affairs Division, National Aeronautics and Space Administration, 400 Maryland Ave. S.W., Room 6052, Washington, DC 20546/202-755-3350.

Fast Facts

This is a free monthly newsletter with current news on specific programs. Contact: Office of Public Affairs, Goddard Space Flight Center, National Aeronautics and Space Administration, Greenbelt, MD 20771/301-344-7000.

Films

Films describing research and development programs in space and aeronautics, and the results of the research can be borrowed at no cost for showings to education, civic, industrial, professional, youth and similar groups. Special and general interest films are listed as well as films for classroom use and series on life science, Skylab science, demonstration, rediscovery, living in space, and the Moon. Films on careers in research are also included. For a list of films, film libraries and information, contact: Public Services Branch, Public Affairs Division, National Aeronautics and Space Administration, 400 Maryland Ave. S.W., Room F6052, Washington, DC 20546/202-755-3350. NASA films and filmstrips can be purchased from the National Audiovisual Center, National Archives and Records Service, General Services Administration, Order Section AP, Washington, DC 20409/202-763-1891.

Field Centers

There are ten principal field offices within NASA. Most of these can be toured by the public. For information on center programs, contact the following individual centers, or: Office of Public Affairs Division, National Aeronautics and Space Administration, 400 Maryland Ave. S.W., Room F6027, Washington, DC 20546/202-755-3936.

Ames Research Center

The Center is responsible for NASA's research in the life sciences. It conducts research into the medical problems of manned flight, both within the atmosphere and in space. The Center is developing short take-off and landing (STOL) aircraft for urban-region transportation systems, mounting the first flight to planet Jupiter, and supporting research for NASA's orbiting space station-laboratory facility and for the space shuttle to man and supply the space station. Center scientists are also working toward defining the evolution and characteristics of planetary bodies. They are pursuing an active program of astrophysics studying the sun, pulsars, quasars, and the evolution of the galaxies. Contact: Ames Research Center, National Aeronautics and Space Administration, Moffett Field, CA 94035/415-965-5091.

Dryden Flight Research Center

This Center conducts research on flight and the problems of manned flight within the atmosphere. It includes work on the problems of take-off and landing, low-speed flight, supersonic and hypersonic flight, and re-entry in order to verify predicted characteristics and identify unexpected problems in actual flight. The Center is responsible for the development and operation of instrument systems for the acquisition and dissemination of in-flight information collected from various programs. It has also been designated as a prime recovery site of the initial flights of the space shuttle. Contact: Hugh L. Dryden Flight Research Center, National Aeronautics and Space Administration, P.O. Box 273, Edwards, CA 93523/805-258-8381.

Goddard Space Flight Center

The Goddard Space Flight Center has been assigned the prime responsibility within NASA for the management of applications of satellite projects, unmanned scientific satellite projects, and worldwide NASA tracking and data acquisition operations. It is one of the few installations in the world capable of conducting a full range space-science experimentation program from theory through experimentation, design and construc-

tion, satellite fabrication and testing, tracking, and data acquisition and reduction. The Center's scientific staff is concerned primarily with research into magnetic fields, energetic particles, ionospheres and radio physics, planetary atmospheres, meteorology, interplanetary matter, solar physics, communication, and astronomy. An important area of interest to NASA is Goddard's applications satellite program. From this program arose the LANDSAT, formerly Earth Resources Technology Satellite, a modified version of its forerunners, the NIMBUS experimental weather satellite and the TIROS Operational (weather) System (TOS). Contact: Goddard Space Flight Center, National Aeronautics and Space Administration, Greenbelt, MD 20771/301-344-7000.

Jet Propulsion Laboratory

This Laboratory is a government-owned research and development facility, operated for NASA by the California Institute of Technology. The Laboratory carries out research programs and flight projects for NASA, and conceives and executes advanced development and experimental engineering investigation to further the technology required for the Nation's space program. The primary emphasis of the Laboratory's effort is on the carrying out of lunar, planetary and deep-space unmanned scientific missions. Supporting research and advanced development are conducted in electric propulsion, nuclear power, chemical propulsion, aerothermodynamics, fluid physics and electrophysics, applied mathematics, space power generation, optical and radio astronomy, planetary atmospheres fields and particles, long-range communications, guidance and control, and systems simulation and analysis techniques. This Laboratory is also involved in supporting the energy program in the areas of geothermal studies, low-cost silicon solar arrays, solar cells, a high efficiency-low pollution engine(s) and stirling engine for undersea applications. Contact: Jet Propulsion Laboratory, National Aeronautics and Space Administration, 4800 Oak Grove Dr., Pasadena, CA 91103/213-354-5011.

Johnson Space Center

This Center has as its primary mission the development of spacecraft for manned space flight programs and the conduct of manned flight operations. The Center's mission includes an engineering, development, and operational capability to support the Space Shuttle and the Earth Resources Programs and to generate the knowledge required to advance the technology of manned spacecraft development. Engineering and devel-

opment efforts focus on the conception and implementation of a program of applied research and development in the area of space research, space physics, life systems, and test and evaluation. Space science efforts are devoted to science experiments in flight, lunar research, space environment studies, and further development of the capability to survey the Earth's resources from space. The medical capabilities include experiments in flight, flight crew monitoring, and development of physiologic requirements for spacecraft systems. Contact: Johnson Space Center, National Aeronautics and Space Administration, Houston, TX 77058/713-483-5111.

Kennedy Space Center

The Center has launched Apollo and other space vehicles as NASA's major launch organization for manned and unmanned space missions. In addition, it launches a wide variety of lunar, planetary and interplanetary space vehicles as well as scientific, meteorologic, and communications satellites. The Center is responsible for the design of launch and recovery facilities for the Space Shuttle. Supporting this primary mission are a host of technical and administrative activities. These include design engineering; testing, assembly, and check-out of launch vehicles and spacecraft; launch operations; and purchasing and contracting. Contact: Kennedy Space Center, National Aeronautics and Space Administration, Kennedy Space Center, FL 32899/ 305-867-2468.

Langley Research Center

Langley Research Center conducts scientific investigations on a broad scale in the areas of aeronautics, space technology, electronics and structures, and concentrates on the problems of space travel and reentry, application of new materials, supersonic and hypersonic flight, and other areas to provide the technical background necessary for the accomplishment of NASA aeronautic and space missions. Attention is given to the study of systems and techniques for the recovery of vehicles returning to the Earth's atmosphere from a space mission. Aeronautics research is directed toward improvement in the performance, safety, and utility of airborne flight, supersonic military aircraft, helicopters and low-speed airplanes. The Center designed and built the NASA Tech house to demonstrate new techniques suitable for single family residences including the use of solar energy, water recycling and many other innovative features. Also, an office building is being heated and cooled by solar collectors. Contact: Langley Research Center, National Aeronautics and Space Administration,

Langley Station, Hampton, VA 23365/804-827-2934.

Lewis Research Center

Activities at NASA's Lewis Research Center are directed at advancing technologies for aircraft propulsion, propulsion and power generation for space flight, space communications systems, new terrestrial energy systems and automotive engines. The Center also manages two major launch vehicles, the Atlas-Centaur and Titan-Centaur. Aeronautics activities at Lewis are aimed principally at development of engines which will operate as quietly, cleanly, and efficiently as possible. Propulsive lift concepts are being explored for aircraft which will take-off and land in short distances and will meet a need for short haul transportation. Specific projects include demonstration of a fuel efficient engine; a quiet, clean experimental engine for short-haul aviation; and an experimental, quiet, clean engine for general aviation. Research on propulsion for spacecraft emphasizes electric rocket engine technology, hydrogen-oxygen systems for the Space Shuttle, and other high energy propellants. Lewis scientists are also conducting studies pertinent to space communications particularly at frequencies above 10 gigahertz and at high levels of transmission power. In support of the Department of Energy's Solar Energy Programs, NASA scientists are working on wind energy systems. Initial testing is on a 100 kw wind turbine, with larger sizes to follow. Solar photovoltaic arrays are also being tested and demonstrated. The object of this work is to reduce costs per kilowatt by technical advances, market development and expanded manufacturing. Engineers also are studying alternative fuels for jet aircraft, and are evaluating advanced energy conversion systems which use coal as fuel. Auto propulsion research is another area of experimentation. In addition, basic and applied research is conducted on materials and metallurgy; cryogenic and liquid-metal heat-transfer fluids; pumps and turbines; combustion processes, propellants, tankage injectors, chambers and nozzles; seals, bearings, gears and lubrication; system control dynamics; plasmas and magnetohydrodynamics to simulate various flight conditions, and includes atmospheric wind tunnels and space environment facilities. Contact: Lewis Research Center, National Aeronautics and Space Administration, 21000 Brookpark Rd., Cleveland, OH 44135/216-433-4000, ext. 300.

Marshall Space Flight Center

The primary mission of the Marshall Space Flight Center is to develop and provide launch

vehicle and space transportation systems to meet space program requirements from conception through all phases of design, fabrication, testing and production. More than 50 percent of the Center's efforts is devoted to various aspects of the Space Transportation System; the Center has responsibility for the Space Shuttle's main engines, solid Rocket Boosters and External Tank. MSFC is also charged with representing NASA's interests in the development of the Inertial Upper Stage which will be used in conjunction with the Space Shuttle. The Center has the leading role within NASA for the international Spacelab (being developed by the European Space Agency) and is responsible for the first three Spacelab missions. Among other prospective Shuttle "payloads," the Center is charged with developing the Space Telescope. MSFC is also in the early stages of work on the 25 kw Power Module and Solar Electric Propulsion System projects. Other activities include basic research, advanced research in the general fields of astronautics, product improvement and the advancement of launch vehicle technology. The Center also conducts, for the Department of Energy, the development and application of solar energy for both residential and commercial heating and cooling. For information on this and the latest developments regarding Spacelab missions, contact: Marshall Space Flight Center, National Aeronautics and Space Administration, Huntsville, AL 35812/205-453-0034.

Wallops Flight Center

Wallops Flight Center is responsible for planning and conducting applied research and development. Scientific development, instrumentation, facilities and techniques utilized in rocket-borne experiments, aeronautic and airport terminal area research projects and ecologic studies are emphasized. Wallops Flight Center prepares, assembles, launches, and tracks space vehicles, and acquires and processes resulting scientific data. Its facilities are utilized by scientists and engineers from the laboratories and research centers of NASA, other governmental agencies, colleges and universities, and the worldwide scientific community. Wallops Flight Center personnel assist these scientific research teams with their projects. As necessary, special types of instrumentation and equipment are developed to support these projects. Wallops Flight Center exercises project management responsibilities for GEOS-C, the Experimental Inter-American Meteorological Rocket Network (EXAMETNET). Contact: Wallops Flight Center, National Aeronautics and Space Administration, Wallops Island, VA 23337/824-3411.

Foreign Patent Licensing

There is patent coverage on NASA-owned inventions introduced to various foreign countries to further the interests of United States industry in foreign commerce. Licenses are negotiated individually and may be granted to any applicant, foreign or domestic. *Significant NASA Inventions Available for Licensing in Foreign Countries* includes abstracts of those inventions in which NASA owns the principal or exclusive rights and which have been made available for patent licensing in the countries indicated. The corresponding United States patent number is also listed. Copies of the United States patents may be purchased from Customer Services, Patent and Trademark Office, Department of Commerce, 14th St. and Constitution Ave. N.W., Room 1627, Washington, DC 20231/202-377-4937. For additional information, contact: Patent Matters, Office of General Counsel, National Aeronautics and Space Administration, 400 Maryland Ave. S.W., Room F7037, Washington, DC 20546/202-755-3932.

Freedom of Information Act Requests

For Freedom of Information Act requests, contact: Freedom of Information, Public Information Section, Public Affairs Division, National Aeronautics and Space Administration, 400 Maryland Ave. S.W., Room F6043, Washington, DC 20546/202-755-8341.

Get Away Special (GAS)

The main purpose of the Space Shuttle is to carry large, sophisticated instruments into the Earth's orbit. The "get away special" payloads will be accommodated on a space-available basis. Scheduling of GAS payloads will provide for placing payloads on the most appropriate mission based generally on a first-come, first-served sequence. The GAS payloads are to be self-contained, i.e., they will not be allowed to draw upon any Shuttle services beyond on-off controls which will be operated by an astronaut. This program encourages the use of space by all researchers, private individuals and organizations. A free experimenters' handbook, *Get Away Special, Small Self-Contained Payloads,* is available. For a copy of the handbook and other information, contact: Get Away Special Liaison, Goddard Space Flight Center, Greenbelt, MD 20771/301-344-6760, or: Space Transportation Systems Utilization, Space Transportation Operations, National Aeronautics and Space Administration, 600 Independence Ave. S.W., Room B400, Washington, DC 20546/202-755-2427.

High Energy Astronomy Observatories (HEAO)

These are orbiting observatories for the study of celestial x-ray, gamma ray and cosmic ray sources throughout the universe. Contact: Marshall Space Flight Center, National Aeronautics and Space Administration, Marshall Space Flight Center, AL 35812/205-453-0035.

Historical Photographs

NASA field centers maintain photo files on current projects and those of the recent past. Files covering projects and missions extending back to NASA's creation are also available. Contact NASA's Field Centers or Media Services Branch, Public Affairs Division, National Aeronautics and Space Administration, 400 Maryland Ave. S.W., Room F6035, Washington, DC 20546/202-755-8366.

How to Seek and Win NASA Contracts

This is a free booklet which provides some basic guidelines to NASA solicitations and includes information on how to prepare bids, how to submit technical and cost proposals, and ways to seek business as a subcontractor. For a copy of the booklet and for additional information, contact: Office of Small and Disadvantaged Business Utilization, National Aeronautics and Space Administration, 600 Independence Ave. S.W., Room B116, Washington, DC 20546/202-755-2288.

Industrial Application Centers

To promote technology transfer, NASA operates a network of dissemination centers whose job is to provide information retrieval services and technical assistance to industrial and government clients. These Centers are backed by off-site representatives and technology coordinators at NASA field centers who seek to match NASA expertise and ongoing research and engineering with client problems and interests. Literature searches are available as well as current awareness services tailored to individual needs. A nominal fee is charged for these services. A free pamphlet, *Search Before Research*, describes the Centers and their services.

Aerospace Research Applications Center, 1201 E. 38th St., Indianapolis, IN 46205/317-264-4644.

Kerr Industrial Applications Center, Southeastern Oklahoma State University, Durant, OK 74701/405-924-0121, ext. 413.

NASA Industrial Applications Center, 701 LIS Building, University of Pittsburgh, Pittsburgh, PA 15260/412-624-5211.

NASA Industrial Applications Center, University of Southern California, Denny Research Building, University Park, Los Angeles, CA 90007/213-743-6132.

New England Research Applications Center, Mansfield Professional Park, Storrs, CT 06268/203-486-4533.

North Carolina Science and Technology Research Center, P.O. Box 12235, Research Triangle Park, NC 27709/919-549-0671.

Technology Applications Center (TAC), University of New Mexico, 2500 Central Ave. S.E., Albuquerque, NM 87131/505-277-3622.

Contact the nearest Industrial Applications Center, or Industrial Applications, National Aeronautics and Space Administration, 600 Independence Ave. S.W., Room B145, Washington, DC 20546/202-755-2244.

Inventions and Innovations

Awards are given for scientific or technical contributions significantly valuable to the conduct of space and aeronautics activities, such as innovations and inventions which have been used with proven value. For information, contact: Inventions and Contributions Board, National Aeronautics and Space Administration, 400 Maryland Ave. S.W., Room F6057, Washington, DC 20546/202-755-3481.

Libraries

The library's collection emphasizes aerospace, management, basic science, astronomy, and related fields. For a list of NASA field libraries and additional information, contact: Library, Headquarters Administration Division, National Aeronautics and Space Administration, 600 Independence Ave. S.W., Room BA39, Washington, DC 20546/202-755-2214.

Life Sciences Program

The objectives of the life sciences program in space are to qualify personnel to accomplish more manned space functions for longer time periods, including manning space probes and establishing space colonies; studying the effects of the space environment, primarily weightlessness, on living systems in order to learn more about life processes in general; utilizing space conditions for isolation, purification and synthesis of biologic materials such as antigens, hormones, and antibiotics; and assuring that life sciences technology and hardware developed for space are applied on Earth wherever appropriate. This would include communications and sensing systems to bring medical attention to remote areas, as well as systems technology applicable to public health activ-

ities. Contact: Life Sciences Division, Space Science, National Aeronautics and Space Administration, 400 Maryland Ave. S.W., Room F511, Washington, DC 20547/202-755-6280.

Listing of Special Publications Published by the NASA Technology Transfer Division

This is a listing of documents available for purchase through the National Technical Information Service (NTIS). These include surveys, reports, handbooks, compilations and bibliographies. Contact: Technology Transfer Division, Space and Terrestrial Applications, National Aeronautics and Space Administration, 600 Independence Ave. S.W., Room B147, Washington, DC 20546/202-755-2219.

Manned Space Flight Vehicles

This Center is responsible for design, development and testing of the U.S. manned space flight vehicles, for selection and training of space flight crews, for ground control of manned flights and for many of the medical, engineering and scientific experiments carried on aboard the flights. Contact: Johnson Space Center, National Aeronautics and Space Administration, Houston, TX, 713-483-5111.

Michoud Assembly Facility

The primary mission of this facility is the systems engineering, engineering design, manufacture, fabrication, assembly and related work for the Space Shuttle External Tank. Contact: Michoud Assembly Facility, National Aeronautics and Space Administration, P.O. Box 29300, New Orleans, LA 70189/504-255-2603.

NASA Activities

This monthly publication covers space statements, legislative affairs concerning space, and such general NASA activities as agreements, key awards, radio-television programs, new films, new publications, press releases, personnel changes, calendar events (pertaining to space and aeronautics), the current launch schedule, monthly lists of technical briefs, patents resulting from NASA research, and monetary awards for inventions and contributions. It is sold for $11.55 per year by the Superintendent of Documents, Government Printing Office, Washington, DC 20402/202-783-3238. For additional information, contact: Public Services Branch, Public Affairs Division, National Aeronautics and Space Administration, 400 Maryland Ave. S.W., Room F6052, Washington, DC 20546/202-755-3350.

NASA Facts

Each pamphlet describes a NASA project or specific technology such as Voyager to Saturn, the Viking mission, living in space, and others. For sale (prices vary) at the Superintendent of Documents, Government Printing Office, Washington, DC 20402/202-783-3238. For additional information, contact: Public Services Branch, Public Affairs Division, National Aeronautics and Space Administration, 400 Maryland Ave. S.W., Room F6091, Washington, DC 20546/202-755-8330.

National Sounding Rocket Program

Engineering support provided for this program includes analytic, feasibility and design studies, payload, vehicle and recovery systems, engineering, test and evaluation, and data analysis and reporting. Contact: Wallops Flight Center, National Aeronautics and Space Administration, Wallops Island, VA 23337/804-824-3411.

National Space Science Data Center

This facility is the central repository of the data collected through space flight experiments. This information provided the basis for studies to increase understanding of basic phenomena. Contact: National Space Science Data Center, Goddard Space Flight Center, National Aeronautics and Space Administration, Greenbelt, MD 20771/301-344-7000.

National Space Technology Laboratories

This is NASA's prime static test facility for large liquid propellant rocket engine systems. It is also involved in support of the Shuttle Test program; is conducting research in terrestrial applications; and is in charge of managing the base and providing technical and institutional support to federal and state resident agencies on a reimbursable basis. Contact: National Space Technology Laboratories, National Aeronautics and Space Administration, NSTL Station, MS 39529/601-688-3341.

Origins of NASA Names

This booklet describes how names for NASA programs, spacecraft, launch vehicles and installations were chosen. It also provides a selected list of NASA abbreviations, acronyms, and terms. Sold for $3.65 by the Superintendent of Documents, Government Printing Office, Washington, DC 20402/202-783-3238.

Patents

Detailed information concerning patent policies and procedures as well as available forms for petitioning for waivers of rights to contract in-

ventions, and for making applications for licenses under NASA patents is available. *NASA Patent Abstracts Bibliography*, a semi-annual, contains abstracts of all NASA inventions, and can be purchased from National Technical Information Service, Springfield, VA 22161. Contact: Patent Matters, Office of General Counsel, National Aeronautics and Space Administration, 400 Maryland Ave. S.W., Room F7037, Washington, DC 20546/202-755-3932.

Photographs

NASA black and white, and color photographs are available for purchase from NASA's contract laboratory, Bara Photographs, Inc., P.O. Box 486, Bladensburg, MD 20710. A catalog of photographs is available. Contact: Audiovisual Section, Public Affairs Division, National Aeronautics and Space Administration, 400 Maryland Ave. S.W., Room F6035, Washington, DC 20546/202-755-8366.

Pioneer Spacecraft

Ames Research Center manages the Pioneer program. Six Pioneer spacecraft have been launched into solar orbit with two having provided the first closeup views of Jupiter. Contact: Ames Research Center, National Aeronautics and Space Administration, Mountain View, CA 94035/415-965-5091.

Planetary Atmospheres

Study of the solar system including comparative planetology, orbital and physical data, composition, origins, atmospheres, geophysics and geology of planets is conducted by this office. Contact: Planetary Atmospheres Discipline, Space Science, National Aeronautics and Space Administration, 400 Maryland Ave. S.W., Room 5065, Washington, DC 20546/202-755-3660.

Progress in Aircraft Design Since 1903

This booklet traces the changes in aircraft design and technology from the Wright Flyer to the Supersonic F-15. Photos of 90 aircraft are included. Available for $1.85 from the Superintendent of Documents, Government Printing Office, Washington, DC 20402/202-783-3238.

Publications

A list of NASA publications includes educational and scientific publications, wall display sheets with facts on NASA, and classroom picture sets. Contact: Community and Educational Services Branch, Public Affairs Division, National Aeronautics and Space Administration, 400 Maryland Ave. S.W., Room F6052, Washington, DC 20546/202-755-3350.

Remote Sensing Applications Grants

Through grants to universities, NASA seeks to develop new sources of remote sensing expertise within the states, with the goal of facilitating independent state or local government use of the technology. Contact: University Programs, Technology Transfer Division, Space and Terrestrial Applications, National Aeronautics and Space Administration, 600 Independence Ave. S.W., Room B139, Washington, DC 20546/202-755-7450.

Remote Sensing Technology

NASA conducts a Remote Sensing Applications Program to assist states in the use of Landsat technology for operations problems. Information about Landsat capabilities is available. Contact: Regional Remote Sensing Applications Program, Space and Terrestrial Applications, National Aeronautics and Space Administration, 600 Independence Ave. S.W., Room B139, Washington, DC 20546/202-755-7450.

Report to Educators

This free quarterly is aimed at the community of educators, especially at the elementary and secondary school levels. Contact: Community and Educational Services Branch, Public Affairs Division, National Aeronautics and Space Administration, 400 Maryland Ave. S.W., Room F6052, Washington, DC 20546/202-755-3350.

Research and Technology Operation Plan Summary

This summary is designed to facilitate communications and coordination among concerned technical personnel in government, industry and universities. It describes NASA's Research and Development objectives, identifies the installation of primary interest and provides a point of contact for technical information. Available for $9.25 from the National Technical Information Service, Department of Commerce, Springfield, VA 22151/703-557-4650. For additional information, contact: Office of Procurement, National Aeronautics and Space Administration, 300 7th St. S.W., Room B101, Washington, DC 20546/202-755-3394.

Scientific and Technical Aerospace Reports (STAR)

A semi-monthly list of more than 1,000 citations of articles and publications of interest to the aerospace community is available. The annual subscription cost is $60.00. The semi-annual index is $25 per year. Both are available from the Superintendent of Documents, Government

Printing Office, Washington, DC 20402/202-783-3238. For further information, contact: Scientific and Technical Information Branch, Information Systems Division, National Aeronautics and Space Administration, 300 7th St. S.W., Room 823, Washington, DC 20546/202-755-3582.

Scientific and Technical Information

This office is responsible for collecting, abstracting, announcing and disseminating the reports resulting from the work performed by NASA and its contractors, subcontractors and grantees. It is also responsible for locating, acquiring, and disseminating to the NASA community scientific and technical information originating outside the NASA complex. For further information on available publications, contact: Scientific and Technical Information Facility, Information Systems Division, National Aeronautics and Space Administration, P.O. Box 8758, Baltimore/Washington International Airport, MD 21240.

SEASAT

SEASAT is a satellite system for the observation of dynamic physical ocean processing and air-sea interactions. For additional information, contact: Sea Satellite Program, Oceanic Processes Branch, Space and Terrestrial Applications, National Aeronautics and Space Administration, 600 Independence Ave. S.W., Room B227, Washington, DC 20546/202-755-8576.

Selling to NASA

This is a free brochure which describes NASA, its organization and activities, and provides guidance on doing business with the agency. Contact: Office of Small and Disadvantaged Business Utilization, National Aeronautics and Space Administration, 600 Independence Ave. S.W., Room B116, Washington, DC 20546/202-755-2288.

Shuttle Approach and Landing Tests (ALT)

Low altitude flights designed to verify the aerodynamic and flight control characteristics of the Space Shuttle Orbiter should lead to operational Shuttle flights. Contact: Dryden Flight Research Center, National Aeronautics and Space Administration, P.O. Box 273, Edwards, CA 93523/805-258-8381.

Slidell Computer Complex (SCC)

SCC is primarily responsible for fulfilling the computations requirements of NASA. These include scientific, management, and engineering automated data processing and in static and flight test data reduction evaluation. Contact:

Marshall Space Flight Center, National Aeronautics and Space Administration, Marshall Space Flight Center, AL 35812/205-453-0031.

Solar Flare Hotline

A hotline designed to inform the public of solar flares erupting on the sun is provided jointly by NASA and the National Oceanic and Atmospheric Administration. Information on sunspots, solar flares, geomagnetic storms, and the impact of the sun's behavior on radio transmissions will be provided in daily recorded messages which will include reports on the locations of active regions on the Sun, as well as on experiments being conducted aboard NASA's Solar Maximum Mission Spacecraft during the next 24-hour period. Contact: Solar Maximum Mission's Experiment Operations Facility, Goddard Space Flight Center, National Aeronautics and Space Administration, Greenbelt, MD 20771/301-344-8129.

Source Evaluation Board Manual

This book details the formal source evaluation-selection process for negotiated procurements. For sale by the Superintendent of Documents, Government Printing Office, Washington, DC 20402/202-783-3238. For additional information, contact: Office of Procurement, National Aeronautics and Space Administration, 600 Independence Ave. S.W., Room B136, Washington, DC 20546/202-755-9050.

Space and Terrestrial Applications

This office is responsible for all research and development activities that demonstrate the application of space related technology, systems and other capabilities which can be effectively applied and used in the civil sector for practical benefits to mankind. The R&D activities are grouped in the following areas: weather and climate, pollution monitoring, Earth resources survey, Earth and ocean physics applications, space processing, communications, data management and applications experiments and studies. Contact: Public Affairs, Space and Terrestrial Applications, National Aeronautics and Space Administration, 600 Independence Ave. S.W., Room B168, Washington, DC 20546/202-755-4321.

Space Science

This office is responsible for all NASA activities involving the conduct of scientific investigations in space. These activities include the planning, development and conduct of space missions in physics and astronomy, and lunar and planetary exploration as well as solar terrestrial

interactions and life sciences investigations. Contact: Public Affairs, Space Science, National Aeronautics and Space Administration, 400 Maryland Ave. S.W., Room F6051, Washington, DC 20546/202-755-3680.

Space Shuttle Program (Johnson Space Center)

This Center manages the Space Shuttle Program. Contact: Johnson Space Center, National Aeronautics and Space Administration, Houston, TX 77058/713-471-3210.

Space Tracking and Data Acquisitions

This office is responsible for the development and operation of communications, tracking of launch vehicles and spacecraft, data acquisition, and data processing facilities, systems and services required for support of NASA flight programs. The office is also assigned NASA-wide responsibility for administrative communications management and frequency management. Contact: Public Affairs, Space Tracking and Data Systems, National Aeronautics and Space Administration, 400 Maryland Ave. S.W., Room F6091, Washington, DC 20546/202-755-8331.

Space Transportation Operations

This office operates the Space Transportation System for the benefit of all users. It is responsible for the management, direction and coordination of all civil launch capabilities and Spacelab development, procurement and operations. Contact: Public Affairs, Space Transportation Operations, National Aeronautics and Space Administration, 400 Maryland Ave. S.W., Room F6091, Washington, DC 20546/202-755-8331.

Space Transportation Systems

This office is responsible for NASA activities directly involving manned space flight missions. Its principal mission is to develop a new space transportation system significantly improving man and instrument access to space. The Space Shuttle is the key element of the system that will service a wide variety of users. The Shuttle will provide multipurpose, economic space operations for Earth applications, scientific and technologic payloads. Contact: Public Affairs, Space Transportation Systems, National Aeronautics and Space Administration, 600 Independence Ave. S.W., Room B325, Washington, DC 20546/202-755-3090.

Speakers

Speakers are available to address education, civic, scientific and similar groups. For information, contact: Speakers Bureau, Public Services Branch, Public Affairs Division, National Aeronautics and Space Administration, 400 Maryland Ave. S.W., Room F6093, Washington, DC 20546/202-755-8364.

Spinoff

Spinoff is an annual report describing the many uses of space-developed technology in everyday products and processes and NASA's program to encourage the transfer of such technology to commercial and industrial markets. Sold, for $3.25, by the Superintendent of Documents, Government Printing Office, Washington, DC 20402/202-783-3238.

State Technology Applications Centers

These centers facilitate technology transfer to state and local governments, as well as to private industry. They provide information retrieval services and technical assistance to industrial and government clients. Contact: Technology Transfer Branch, Space and Terrestrial Applications, National Aeronautics and Space Administration, 600 Independence Ave. S.W., Room B147, Washington, DC 20546/202-755-2420.

Tech Briefs

This is a free, indexed, quarterly journal containing articles on innovations and improved products or processes developed for NASA which are thought to have commercial potential. Articles are grouped into nine broad technical categories and special sections are included for books and reports, computer programs and new product ideas. Information on NASA's Patent Licensing Program and additional services are also provided. For additional information, contact: Technology Transfer Division, Space and Terrestrial Applications, National Aeronautics and Space Administration, 600 Independence Ave. S.W., Room 3147, Washington, DC 20546/202-755-2219.

Technologies for the Handicapped and the Aged

This booklet outlines several dozen examples of the technology transferred from advanced aerospace research projects to the needs of the handicapped and the elderly. The six sections of the booklet concentrate on technology applied to the heart, limbs, senses, diagnostic tools, treatment and overall way of life. For additional information, contact: Technology Transfer Division, Office of Space and Terrestrial Applications, National Aeronautics and Space Administration, 600 Independence Ave. S.W., Room B147, Washington, DC 20546/202-755-2219.

Wall Display Sheets

Color display sheets of various sizes describe a

NASA project or a specific technology. Some examples of Wall Display Sheets include:

Saturn V—one of America's largest rocket vehicles

Skylab—America's first manned space station, the launch sequence, living quarters and many scientific experiments

The Spectrum—the Electromagnetic spectrum which includes gamma rays, x-rays, ultraviolet light, visible light, infrared rays and radio waves

America on Mars—picture and text describing the scientific results of the Viking mission in which two dual spacecraft studied Mars.

These wall displays can be bought (prices vary) from the Superintendent of Documents, Government Printing Office, Washington, DC 20402/202-783-3238. For additional information, contact: Public Services Branch, Public Affairs Division, National Aeronautics and Space Administration, 400 Maryland Ave. S.W., Room F6091, Washington, DC 20546/202-755-8330.

How Can the National Aeronautics and Space Administration Help You?

For information on how this agency can help you, contact: Headquarters Information Center, National Aeronautics and Space Administration, Lobby, 600 Independence Ave. S.W., Washington, DC 20546/202-755-2320.

National Capital Planning Commission

1325 G St. N.W., Washington, DC 20576/202-724-0174

ESTABLISHED: 1952
BUDGET: $1,975,000
EMPLOYEES: 52

MISSION: Responsible for the overall coordination of planning and development activities in the National Capital region and is the central planning agency for the federal government in this region. Its area of jurisdiction includes the District of Columbia and all land areas within the boundaries of Montgomery and Prince George's counties in Maryland; and Fairfax, Loudoun, Prince William, and Arlington counties in Virginia.

Major Sources of Information

Commission Activities

Commission responsibilities include review of all proposed zoning regulations, map changes, and amendments to the District of Columbia zoning ordinance in order to insure compatibility of zoning regulations with the federal interests as expressed in the Comprehensive Plan. The Commission also adopts urban renewal area boundaries; prepares, adopts, and modifies urban renewal plans; approves the Permanent System of Highways Plan; makes recommendations on proposed street and alley closings; approves transfers of jurisdiction over properties between federal and district; approves the sale of surplus property and park land, and acquires land for parks and parkways in the National Capital region. Contact: Technical Services and Special Studies Division, National Capital Planning Commission, 1325 G St. N.W., Room 1034, Washington, DC 20576/202-724-0196.

Comprehensive Plan for the National Capital

The Comprehensive Plan is a statement of policies dealing with the growth and development of the National Capital; and consists of both federal and district elements. It provides a framework for policy decisions regarding physical development proposed by federal, state, local and regional agencies. It describes how the Washington area should appear in future years. The plan includes:

BACKGROUND STUDIES
Federal Employment

Federal Building Spaces
Federal Land
ENVIRONMENT
Proposed Element
Implementation Proposals
Planning Report
FOREIGN MISSIONS AND INTERNATIONAL AGENCIES
Adopted element and related modification to the elements
Planning Report and Description of Environmental Impact
REVIEW OF PLANNING POLICIES AND PROPOSALS AFFECTING FEDERAL LAND USE AND EMPLOYMENT IN THE NATIONAL CAPITAL REGION
URBAN DESIGN—TOPOGRAPHIC BOWL—ARLINGTON
Proposed Element
Implementation Proposals
Planning Report
Environmental Assessment

Contact: Planning and Programming Division, National Capital Planning Commission, 1325 G St. N.W., Room 1023, Washington, DC 20576/202-724-0171.

Construction Approval

Federal public buildings in the District of Columbia and District of Columbia buildings in the central area of the District must be approved prior to construction. Contact: Review and Implementation Division, National Capital Planning Commission, 1325 G St. N.W., Room 1014, Washington, DC 20576/202-724-0188.

National Capital Planning Commission Quarterly Review of Commission Proceedings

This quarterly review provides a summary of Commission actions and information related to change, growth and development in the Washington, DC area. An index covering each series of four issues is included at the end of every calendar year. Contact: Office of Public Affairs, National Capital Planning Commission, 1325 G St. N.W., Room 1075, Washington, DC 20576/202-724-0174.

Planning Washington 1924–1976: An Era of Planning for the National Capital and Environs

This free publication provides an administrative and legislative history of the National Capital Planning Commission and its predecessor agencies. It also includes a biographic register with biographic sketches of Commission members and Executive Directors. To get a free copy or additional information, contact: Office of Public Affairs, National Capital Planning Commission, 1325 G St. N.W., Room 1075, Washington, DC 20576/202-724-0174.

Publications

A list of publications is available from the National Capital Planning Commission. It includes the comprehensive plans and plans for specific areas, studies subjects such as urban and landscape design and other related subjects. Contact: Office of Public Affairs, National Capital Planning Commission, 1325 G St. N.W., Room 1075, Washington, DC 20576/202-724-0174.

Reviews

Plans and programs proposed by federal, state, regional and local agencies or jurisdictions in the National Capital Region are reviewed in this office. Each federal or district project is also reviewed. Contact: Review and Implementation Division, National Capital Planning Commission, 1325 G St. N.W., Room 1014, Washington, DC 20576/202-724-0188.

How Can the National Capital Planning Commission Help You?

For information on how this agency can help you, contact: National Capital Planning Commission, 1325 G St. N.W., Washington, DC 20576/202-724-0174.

National Credit Union Administration

1776 G St. N.W., Washington, DC 20456/202-357-1100

ESTABLISHED: March 10, 1970
BUDGET: $1,200,000,000
EMPLOYEES: 752

MISSION: Responsible for chartering, insuring, supervising, and examining federal credit unions (FCUs), and for administering the National Credit Union Share Insurance Fund, and manages the Central Liquidity Facility, a mixed-ownership government corporation whose purpose is to supply emergency loans to member credit unions. (A credit union [CU] is a financial cooperative which aids its members by improving their economic situation through encouraging thrift among its members and providing them with a source of credit for provident purposes at reasonable rates of interest. Federal CUs serve associations, and occupational and residential groups, thus benefiting a broad range of citizens throughout the country.)

Major Sources of Information

Central Liquidity Facility

This office provides credit unions with a source of funds to meet their liquidity needs. The facility also encourages saving and supports consumer borrowing and mortgage lending. Membership is voluntary and is available to both federal and state-chartered credit unions. For further information, contact: Central Liquidity Facility, National Credit Union Administration, 1776 G St. N.W., Room 7361, Washington, DC 20456/202-357-1132.

Chartering

Federal credit unions are chartered by the National Credit Union Administration after their applications are reviewed and approved. For information on charter requirements, new charters, the numbers and percent of operating Federal Credit Union Charters and other related information, contact: Chartering and Insurance Division, National Credit Union Administration, 1766 G St. N.W., Room 6661, Washington, DC 20456/202-357-1060.

Consumer Complaints

Complaints of members who are unable to resolve problems with their federal credit union are investigated. The problems must relate to a possible violation of the Federal Credit Union Act or to consumer protection regulations. Contact the nearest regional office or: Complaints and Unfair Practices Division, Office of Consumer Affairs, National Credit Union Administration, 1776 G St. N.W., Room 6601, Washington, DC 20456/202-357-1080.

Credit Union Information

Information on how to start a federal credit union is available. A list of regional National Credit Union Administration offices and a list of publications are also available. Contact: Public Information, National Credit Union Administration, 1776 G St. N.W., Room 6100, Washington, DC 20456/202-357-1050.

Credit Union Statistics

Current information on the operations of both federal and state credit unions provides the basis for making monthly estimates of current trends and developments at credit unions. Contact: Statistical Division, Office of Policy Analysis, National Credit Union Administration, 1776 G St. N.W., Room 6411D, Washington, DC 20456/202-357-1095.

Credit Union Supervision

Federal credit unions are supervised in the areas of general ledger accounts, liquidity, invest-

ment policy, cash management, data processing and internal control. For additional information, contact: Office of Examination and Insurance, National Credit Union Administration, 1776 G St. N.W., Room 6670, Washington, DC 20456/202-357-1055.

Examiner Training Programs

The National Credit Union Administration provides technical training consisting of on-the-job and formalized classroom programs for all examiner staff. The training is available to federal and state examiners. Contact: Training and Program Coordination, Office of Examination and Insurance, National Credit Union Administration, 1776 G St. N.W., Room 6676, Washington, DC 20456/202-357-1055.

Federal Credit Union Statistics

The following statistics are available on federal credit unions:

ASSETS/LIABILITIES AND EQUITY:

1. Assets of operating federal credit unions (by region and state)
2. Liabilities and equity of operating federal credit unions (by region and state)
3. Assets of operating federal credit unions (by type of membership)
4. Liabilities and equity of operating federal credit unions (by type of membership)
5. Investments of operating federal credit unions (by region and state)
6. Investments of operating federal credit unions (by type of membership)

INCOME AND EXPENSES

7. Gross and net income of operating federal credit unions (by region and state)
8. Gross and net income of operating federal credit unions (by type of membership)
9. Expenses of operating federal credit unions (by region and state)
10. Expenses of operating federal credit unions (by type of membership)

LOANS OUTSTANDING, CURRENT, AND DELINQUENT

11. Number and amount of current and delinquent loans outstanding in federal credit unions as of December 31, 1979 (by region and state)
12. Number and amount of current and delinquent loans outstanding in federal credit unions as of December 31, 1979 (by type of membership)

AVERAGE DIVIDEND RATES

13. Average dividend rate paid on regular share accounts by federal credit unions (by asset size and region and state)
14. Average dividend rate paid on regular share accounts by federal credit unions (by asset size and type of membership)

SAVINGS ACCOUNTS

15. Amount of savings accounts in federal credit unions, December 31, 1979 (by size of account and region and state)
16. Amount of savings accounts in federal credit unions, December 31, 1979 (by size of account and type of membership)
17. Percentage distribution of amount of savings accounts in federal credit unions, December 31, 1979 (by size of account and region and state)
18. Percentage distribution of amount of savings accounts in federal credit unions, December 31, 1979 (by size of account and type of membership)
19. Percentage distribution of number of savings accounts in federal credit unions, December 31, 1979 (by size of account and region and state)
20. Percentage distribution of number of savings accounts in federal credit unions, December 31, 1979 (by size of account and type of membership)
21. Number and amount of savings accounts and percentage distribution in federal credit unions, December 31, 1979 (by size of account and asset size of credit union)

AGE AND ASSET SIZE OF FEDERAL CREDIT UNIONS

22. Federal credit union operations, December 31: 1979 (by age)
23. Federal credit union operations, December 31, 1979 (by asset size)
24. Selected ratios and averages pertaining to federal credit union operations (by asset size)

Contact: Statistical Division, Office of Policy Analysis, National Credit Union Administration, 1776 G St. N.W., Room 6411D, Washington, DC 20456/202-357-1095.

Federally Insured State Credit Unions Statistics

The following statistics are available on federally insured state credit unions:

ASSETS/LIABILITIES AND EQUITY

S-1. Assets of operating federally insured state credit unions (by region and state)
S-2. Liabilities and equity of operating federally insured state credit unions (by region and state)
S-3. Assets of operating federally insured state credit unions (by type of membership)
S-4. Liabilities and equity of operating federally insured state credit unions (by type of membership)
S-5. Investments of operating federally insured state credit unions (by region and state)
S-6. Investments of operating federally insured state credit unions (by type of membership)

INCOME AND EXPENSES

S-7. Gross and net income of operating federally insured state credit unions (by region and state)
S-8. Gross and net income of operating federally insured state credit unions (by type of membership)
S-9. Expenses of operating federally insured state credit unions (by region and state)
S-10. Expenses of operating federally insured state

credit unions (by type of membership)

LOANS OUTSTANDING, CURRENT, AND DELINQUENT

S-11. Number and amount of current and delinquent loans outstanding in federally insured state credit unions as of December 31, 1979 (by region and state)

S-12. Number and amount of current and delinquent loans outstanding in federally insured state credit unions as of December 31, 1979 (by type of membership)

AVERAGE DIVIDEND RATES

S-13. Average dividend rate paid on regular share accounts by federally insured state credit unions (by asset size and region and state)

S-14. Average dividend rate paid on regular share accounts by federally insured state credit unions (by asset size and type of membership)

SAVINGS ACCOUNTS

S-15. Amount of savings accounts in federally insured state credit unions, December 31, 1979 (by size of account and region and state)

S-16. Amount of savings accounts in federally insured state credit unions, December 31, 1979 (by size of account and type of membership)

S-17. Percentage distribution of amount of savings accounts in federally insured state credit unions, December 31, 1979 (by size of account and region and state)

S-18. Percentage distribution of amount of savings accounts in federally insured state credit unions, December 31, 1979 (by size of account and type of membership)

S-19. Percentage distribution of number of savings accounts in federally insured state credit unions, December 31, 1979 (by size of account and region and state)

S-20. Percentage distribution of number of savings accounts in federally insured state credit unions, December 31, 1979 (by size of account and type of membership)

S-21. Number and amount of savings accounts and percentage distribution in federally insured state credit unions, December 31, 1979 (by size of account and asset size of credit union)

AGE AND ASSET SIZE OF FEDERAL CREDIT UNIONS

S-22. Federally insured state credit union operations, December 31, 1979 (by age)

S-23. Federally insured state credit union operations, December 31, 1979 (by asset size)

S-24. Selected ratios and averages pertaining to federally insured state credit union operations (by asset size)

Contact: Statistical Division, Office of Public Analysis, National Credit Union Administration, 1776 G St. N.W., Room 6411, Washington, DC 20456/202-357-1095.

Freedom of Information Act Requests

For Freedom of Information Act requests, contact: Freedom of Information, National Credit Union Administration, 1776 G St. N.W., Room 7690, Washington, DC 20456/202-357-1235.

Insured Funds

The share insurance program helps maintain sound conditions in the credit union industry and protects those insured in the event of failure of an insured credit union due to insolvency or bankruptcy. *Your Insured Funds,* a free brochure, describes the National Credit Union Administration share insurance operation. For additional information, contact: Office of Examination and Insurance, National Credit Union Administration, 1776 G St. N.W., Room 6661, Washington, DC 20456/202-357-1080.

Liquidations

Information on Federal Credit Union Charter cancellations includes type of membership and reason for cancellation, such as poor financial condition, mergers, revocation, etc. Contact: Office of Examination and Insurance, National Credit Union Administration, 1776 G St. N.W., Room 6670, Washington, DC 20456/202-357-1055.

Listing of Federal Credit Unions

A master list of the names and addresses of all federal credit unions is available for public scrutiny. Copies of the list may also be obtained. Contact: Freedom of Information Office, National Credit Union Administration, 1776 G St. N.W., Room 7690, Washington, DC 20456/202-357-1235.

One Hundred Largest Federal and State-Chartered Credit Unions

An annual compilation lists 100 largest federal and state-chartered credit unions with their assets and national ranking as of the current and preceding year-end. Contact: Office of Policy Analysis, National Credit Union Administration, 1776 G St. N.W., Room 6411, Washington, DC 20456/202-357-1090.

Policy Analysis and Research

Policy analysis and research programs include economic analyses of the impact on credit union earnings of various types and levels of savings instruments, the condition of the credit union industry in relation to the changing economic and financial environment, the study of mortgage lending at credit unions, and predicting credit union insolvencies. The following research reports, working papers and technical papers are available:

RESEARCH PUBLICATIONS

Regular Reserves of Federal Credit Unions (269 pp.)
Trends in Chartering and in Operating Credit Unions
(186 pp.)

RESEARCH REPORTS

No. 1—*New Automobiles as Loan Security*
No. 2—*Credit Unions and Tight Money*
No. 3—*Sharing the Benefits of Credit Union Membership: Some Guidelines*
No. 4—*Loan Delinquency in Federal Credit Unions*
No. 5—*The Changing Economy*
No. 6—*Interest Charged on Loans by Credit Unions and Other Lenders*
No. 7—*Credit Unions and the Money "Crunch"*
No. 8—*Credit Union Liquidity and Share Insurance: A New Dimension*
No. 9—*Common Bond—Policy Analysis (1965–1974)*
No.10—*The Future Role of Voluntarism in Credit Unions*

NCUA WORKING PAPERS

No. 1—*Credit Union and EFTS*
No. 2—*Credit Unions and the Lexicon of Intermediation*
No. 3—*Credit Unions' Roles in a Changing Environment*

NCUA TECHNICAL PAPERS

No. 1—*The Problems of Data Communication Standards in EFTS*

For further information, contact: Office of Policy Analysis, National Credit Union Administration, 1776 G St. N.W., Room 6411, Washington, DC 20456/202-357-1090.

Publications

A list of National Credit Union Administration publications, including general, technical and research publications, is available. Contact: Public Information, National Credit Union Administration, 1776 G St. N.W., Room 6100, Washington, DC 20456/202-357-1050.

Truth-in-Lending Enforcement

The Truth-in-Lending Enforcement program includes examination of federal credit unions for compliance with all consumer laws, investigation of membership complaints and education of credit union officials, staff and members. Information on the extent of federal credit union compliance with Truth-in-Lending is available. Contact: Office of Consumer Affairs, National Credit Union Administration, 1776 G St. N.W., Room 6601, Washington, DC 20456/202-357-1080.

How Can the National Credit Union Administration Help You?

For information on how this agency can help you, contact: National Credit Union Administration, Public Information, 1776 G St. N.W., Room 6100, Washington, DC 20456/202-357-1050.

National Foundation on the Arts and the Humanities

National Endowment for Arts

2401 E St. N.W., Washington, DC 20506/202-634-6369
Established: 1965
Budget: $143,040,000
Employees: 285
Mission: Fosters professional excellence of the arts in America, nurtures and sustains them, and helps create a climate in which they may flourish so they may be experienced and enjoyed by the widest possible public.

National Endowment for the Humanities

806 15th St. N.W., Washington, DC 20506/202-724-0386.
Established: 1965
Budget: $130,560,000
Employees: 230
Mission: Promotes and supports the production and dissemination of knowledge in the humanities, especially as it relates to the serious study and discussion of contemporary values and public issues.

Major Sources of Information

Annual Program Announcement

This free booklet details the humanities programs. It provides information on how to apply for grants and includes a calendar of deadlines and a list of deadlines by program. State Humanities Councils are also listed. Contact: Public Affairs Office, National Endowment for the Humanities, National Foundation on the Arts and the Humanities, 806 15th St. N.W., Room 1100, Washington, DC 20506/202-724-0256.

Artists-in-Education

This program awards education grants in various ways. The national, state-based program places professional artists in elementary and secondary schools: professional and technical assistance is available to specific components of the program; and aid to universities with graduate level programs in arts administration awards fellowships to students. Contact: Artists-in-Education, Office for Partnership, National Endowment for the Arts, National Foundation on the Arts and the Humanities, 2401 E St. N.W., Room 1361, Washington, DC 20506/202-634-6028.

Arts and Artifacts Indemnity

Objectives: To provide for indemnification against loss or damage for eligible art works, artifacts and objects 1) when borrowed from abroad on exhibition in the U.S., and 2) from the U.S. for exhibition abroad when there is an exchange exhibition from a foreign country.

Eligibility: federal, state and local government entities, nonprofit agencies, institutions and individuals may apply.

Range of Financial Assistance: $500,000 to $50,000,000.

Contact: Director, Museums Program, National Endowment for the Arts, National Foundation on the Arts and the Humanities, Washington, DC 20506/202-634-6164.

Challenge Grants—Arts

The Challenge Grant Program encourages cultural organizations to achieve financial stability. Grants are awarded only once to institutions who match each government dollar with at least three more dollars raised from other sources. Contact: Challenge Grants, Policy and Planning, National Endowment for the Arts, National Foundation on the Arts and the Humanities, 2401 E St. N.W., Room 1430, Washington, DC 20506/202-632-4783.

Challenge Grants—Humanities

This program helps institutions increase and broaden their bases of individual and corporate support by offering one federal dollar to match at least three non-federal dollars raised by the institution, either from new sources or from increases beyond the regular contributions of traditional

sources. Contact: Challenge Grants Program, Special Programs Division, National Endowment for the Humanities, National Foundation on the Arts and the Humanities, 806 15th St. N.W., Room 905, Washington, DC 20506/202-724-0267.

Culture Post, The

The Culture Post is a bimonthly publication, featuring articles on Arts Endowment projects. It includes information on current and upcoming programs, reports of meetings, recent grant recipients, legislative votes, book reviews, and news on the arts from other federal agencies. It also lists grant application deadlines. Available for $11.00 per year from the Superintendent of Documents, Government Printing Office, Washington, DC 20402/202-783-3238. For additional information, contact: Publications Division, National Foundation on the Arts and Humanities, 2401 E St. N.W., Room 1205, Washington, DC 20506/202-634-6372.

Curriculum Materials

This program supports the development, testing, and dissemination of imaginative materials useful to the teaching of the humanities. Contact: Curriculum Materials Grants, Higher Education/ Regional-National, Education Programs Division, National Endowment for the Humanities, National Foundation on the Arts and the Humanities, 806 15th St. N.W., Room 531, Washington, DC 20506/202-724-0311.

Dance Program

The Endowment is committed to assist American dance. It offers direct support to dance companies and choreographers; it gives grants to strengthen companies' managerial staffs; it promotes and supports dance presentations throughout the country; and it seeks to expose the public to dance. Some of the programs include: a dance touring program for large and small companies and long-term dance engagements; resident professional dance companies; management and administration; choreography fellowships; workshop fellowships; production grants; dance, film, video, and general programs. Contact: Dance Program, National Endowment for the Arts, National Foundation on the Arts and the Humanities, 2401 E St. N.W., Room 1241, Washington, DC 20506/202-634-6383.

Design Arts Program

The Design Arts Program aims to support architects, landscape architects, urban designers and city planners, industrial designers, graphic designers, interior designers, and fashion design-

ers in their individual or collective pursuits. Grants are awarded to assist groups in the planning and design of exemplary cultural facilities and to encourage the commitment of local public and private money to carry out projects; to assist the development and dissemination of design ideas and information about design for the public and design professionals; to enable established professionals and those just entering or returning to a design career to take time from their practice for personal career development; to support professional designers who do research on new design concepts or develop ways of educating the public about design; to encourage communities to introduce exemplary design as an integral part of their planning processes; to provide federal and state agencies with professional guidance for upgrading publications; and to assist professional organizations, nonprofit groups and coalitions which advance the cause of design excellence. *Federal Design Matters*, a new quarterly published by the program, serves as a forum for the exchange of news and ideas about design and designers within and outside the government. An indexed compendium of projects, *By Design*, serves both as an encyclopedia of Endowment-supported efforts in design and as a research and writing tool to suggest and encourage new design projects. This report is sold for $4.75 by the Superintendent of Documents, Government Printing Office, Washington, DC 20402/202-783-3238. For further information, contact: Design Arts Program, National Endowment for the Arts, National Foundation on the Arts and the Humanities, 2401 E St. N.W., Room 1129, Washington, DC 20506/202-634-4276.

Elementary and Secondary Education

This program offers support for projects designed to strengthen the teaching of the humanities in elementary and secondary schools. Eligible projects include the development of curricula and curricular material, extended teacher institutes and demonstration projects that will have regional or national impact on the teaching of the humanities. Contact: Elementary and Secondary Education Grants Program, Education Programs Division, National Endowment for the Humanities, National Foundation on the Arts and the Humanities, 806 15th St. N.W., Room 501, Washington, DC 20506/202-724-0373.

Evaluation Reports

Studies and reports provide guidance and technical assistance to the arts programs and to other funders and managers of arts activities. They also demonstrate and document the impact and effectiveness of support for arts programs. Some of

the studies include: a study to determine the impact of the Endowments Support to Orchestras; a study to determine the effectiveness of fellowship support to composers and librettists; and an evaluation of the Challenge Grant Program's reporting and grant monitoring system. Contact: Research Division, Policy and Planning, National Endowment for the Arts, National Foundation on the Arts and the Humanities, 2401 E St. N.W., Room 1300, Washington, DC 20506/202-634-7103.

Expansion Arts Program

The Expansion Arts Program supports the development of professionally-directed arts organizations which are deeply rooted in and reflective of the culture of minority, low income, blue collar, rural and tribal communities. Grants are given to help state art agencies and regional arts groups; to help sponsor organizations bring together regional; tour events; to community arts projects for instruction and training; to support public presentations that include community workshops; for special summer projects; for city arts/community arts organizations that serve as models for other groups; to neighborhood arts services; and community arts consortia. Contact: Expansion Arts Program, National Endowment for the Arts, National Foundation on the Arts and the Humanities, 2401 E St. N.W., Room 1348, Washington, DC 20506/202-634-6010.

Federal-State Partnership Program

A variety of grants awarded include Basic State Operating Grants to provide funding for state plans for support of the arts; Basic Regional Operating Grants to support arts programming planned and implemented by state arts agencies on a multi-state basis; Priority Grants on a state and regional level; and Governmental Support Services for projects that assist state and community arts agencies. Contact: Office for Partnership, National Endowment for the Arts, National Foundation on the Arts and the Humanities, 2401 E St. N.W., Room 1337, Washington, DC 20506/202-634-6055.

Fellowships—Arts

The program is designed to acquaint participants with the policies and operations of the Endowment and to help give them an overview of arts activities around the country. Fellows are given the opportunity to learn about the Endowment programs by observing policy development, grant-making procedures, and administration. In addition to working as members of the Endowment's staff, fellows attend a series of seminars and meetings with members of the National Council on the Arts, Endowment panelists, artists, journalists, federal officials, and leading arts administrators. Contact: Fellowship Program, Policy and Planning, National Endowment for the Arts, National Foundation for the Arts and the Humanities, 2401 E St. N.W., Room 1323, Washington, DC 20506/202-634-6586.

Fellowships—Humanities

Applications for support of individual study and research should be submitted to the Fellowships Division, with these exceptions which should be submitted to the Research Division:

1. The production of reference works and scholarly tools, such as bibliographies, certain editing projects and translations, dictionaries, atlases, and encyclopedias.
2. Any aspect of archeological scholarship.
3. Projects with large research costs other than salary support and travel, such as computer costs, salaries of assistants and consultants' travel costs, and equipment costs.
4. Studies on an aspect of state, local, or regional culture or history where the applicant is not affiliated with an academic institution. College and university applicants with projects of this type should apply to a Fellowships Division program.

Contact: Fellowships Programs Division, National Endowment for the Humanities, National Foundation on the Arts and the Humanities, Room 301, 806 15th St. N.W., Washington, DC 20506/202-724-0238.

Fellowships at Centers for Advanced Study

This program provides funds to centers for advanced study, research libraries and other equivalent institutions independent of universities to enable them to offer fellowships for study and research in the humanities. Contact: Centers for Advanced Study, Fellowships and Seminars Division, National Endowment for the Humanities, National Foundation on the Arts and the Humanities, 806 15th St. N.W., Room 301, Washington, DC 20506/202-724-0238.

Fellowships for College Teachers

These fellowships are intended for teachers in undergraduate colleges and universities and in two-year colleges, especially teachers with heavy teaching loads and limited means of research. Contact: Fellowships for the Professions, Fellowships and Seminar Division, National Endowment for the Humanities, National Foundation on the Arts and the Humanities, 806 15th St. N.W., Room 301, Washington, DC 20506/202-724-0333.

Fellowships for Independent Study and Research

Fellowships are awarded to scholars and others who have made significant contributions to humanistic thought and knowledge, or to those whose careers show promise of such contributions. Contact: Fellowship for Independent Study and Research, Fellowships and Seminars Division, National Endowment for the Humanities, National Foundation on the Arts and the Humanities, 806 15th St. N.W., Room 301, Washington, DC 20506/202-724-0333.

Fellowships in the Humanities for Journalists

This program provides fellowships for full-time practicing journalists to spend an academic year at the University of Michigan or Stanford University studying the humanistic dimensions of their professional interests. Contact: Fellowships for the Professions, Fellowships and Seminars Division, National Endowment for the Humanities, National Foundation on the Arts and the Humanities, 806 15th St. N.W., Room 301, Washington, DC 20506/202-724-0376.

Folk Arts Program

The Folk Arts Program supports community- or family-based arts that have endured through several generations and that carry with them a sense of community aesthetic. The program funds nonprofit, tax-exempt groups such as community and cultural organizations, tribes, media centers, educational institutions, professional societies and state and local government agencies, as well as persons of demonstrated talent who wish to learn traditional music or crafts from a master folk artist. Contact: Folk Arts Program, National Endowment for the Arts, National Foundation on the Arts and the Humanities, 2401 E St. N.W., Room 1129, Washington, DC 20506/202-634-4282.

Freedom of Information Act Requests—Arts

For Freedom of Information Act requests, contact: Office of the General Counsel, National Endowment for the Arts, National Foundation on the Arts and the Humanities, 2401 E St. N.W., Room 1418, Washington, DC 20506/202-634-6588.

Freedom of Information Act Requests— Humanities

For freedom of Information Act requests, contact: Office of General Counsel, National Endowment for the Humanities, National Foundation on the Arts and the Humanities, 806 15th St. N.W., Room 1000, Washington, DC 20506/202-724-0367.

Frequent Errors in Applications

Endowment staff members have identified the following seven errors they have encountered frequently while processing applications for grants and fellowships in National Endowment for the Humanities programs:

1. The budget does not relate closely to the activities described in the narrative.
2. The application does not provide all the information requested, including complete identification of the personnel for the project and their qualifications for the assignment.
3. The application is marred by inflated rhetoric and ignorance of similar projects elsewhere.
4. Arguments in support of the application are subjective and unconvincing; application assumes that its reader is familiar with or is predisposed to support the application.
5. The plan of work is missing or is too vague; the application shows disorganization of proposed activities and illogical sequencing of specific tasks.
6. The application is distorted by errors in grammar, fact, spelling, and mathematics; the application is sloppy; a clutter of styles, unreadable copies, and missing papers and cited attachments.
7. The application does not give adequate attention to dissemination/distribution of the products of the project.

Contact: Grants Information, Office of Planning and Policy Assessment, National Endowment for the Humanities, National Foundation on the Arts and the Humanities, 806 15th St. N.W., Room 1012, Washington, DC 20506/202-724-0344.

General Research

This program provides support for a wide range of scholarships in the humanities in three major areas: Basic Research, including archeological projects; State and Local and Regional Studies; and Research Conferences. Contact: General Research Program, Research Programs Division, National Endowment for the Humanities, National Foundation on the Arts and the Humanities, 806 15th St. N.W., Room 1120, Washington, DC 20506/202-724-0276.

Gifts and Matching Funds

The National Endowment for the Humanities is authorized to accept gifts which are given to NEH in support of particular projects and to match these gifts with federal funds up to the level of one federal dollar for each gift dollar. For further information, contact: Donations Branch, Grants Office, National Endowment for the Humanities, National Foundation on the Arts and

the Humanities, 806 15th St. N.W., Room 522, Washington, DC 20506/202-724-1919.

Grants

The programs described below are for sums of money which are given by the federal government in order to initiate and stimulate new or improved activities or to sustain various on-going services:

Promotion of the Arts—Artists-in-Education

Objectives: To provide grants for special innovative projects in arts education.

Eligibility: Grants may be made only to nonprofit organizations if donations to such organizations qualify as a charitable deduction under Section 170 (c) of the Internal Revenue Code of 1954. This definition also includes states, local governments, and state art agencies.

Range of Financial Assistance: $2,000 to $80,000.

Contact: Director, Artists-in-Education Program, National Endowment for the Arts, National Foundation on the Arts and the Humanities, 2401 E St. N.W., Washington, DC 20506/202-634-6028.

Promotion of the Arts—Challenge Grants

Objectives: To enable cultural organizations and institutions to increase the levels of continuing support and to increase the range of contributors to the programs of such organizations or institutions; to provide administrative and management improvements for cultural organizations and institutions, particularly in the field of long-range financial planning; to enable cultural organizations and institutions to increase audience participation in and appreciation of programs sponsored by such organizations and institutions; to stimulate greater cooperation among cultural organizations and institutions especially designed to better serve the communities in which such organizations or institutions are located; and to foster greater citizen involvement in planning the cultural development and cultural identity of a community.

Eligibility: Grants may be made only to nonprofit organizations if donations to such organizations qualify as a charitable deduction under Section 170 (c) of the Internal Revenue Code of 1954.

Range of Financial Assistance: $30,000 to $1,500,000.

Contact: Challenge Grants Coordinator, Office of Special Projects, National Endowment for the Arts, National Foundation on the Arts and the Humanities, 2401 E St. N.W., Washington, DC 20506/202-632-4783.

Promotion of the Arts—Dance

Objectives: To assist dancers, choreographers, and dance organizations, and to make the highest quality dance widely available.

Eligibility: Grants may be made to 1) nonprofit organizations, including state and local governments and state arts agencies, if donations to such organizations qualify as charitable deductions under Section 170 (c) of the Internal Revenue Code of 1954, and 2) individuals who possess exceptional talent.

Range of Financial Assistance: $1,000 to $251,400.

Contact: Director, Dance Program, National Endowment for the Arts, National Foundation on the Arts and the Humanities, 2401 E St. N.W., Washington, DC 20506/202-634-6383.

Promotion of the Arts—Design Arts

Objectives: To provide grants for projects, including research, education, and professional and public awareness in architecture, landscape architecture, and urban, interior, fashion, industrial, and environmental design. The program attempts to encourage creativity and to make the public aware of the benefits of good design.

Eligibility: Grants may be made to: 1) nonprofit organizations, including state and local governments and state arts agencies, if donations to such organizations qualify as charitable deductions under Section 170 (c) of the Internal Revenue Code of 1954; and 2) individuals who possess exceptional talent.

Range of Financial Assistance: Up to $20,000.

Contact: Director, Design Arts Program, National Endowment for the Arts, National Foundation on the Arts and the Humanities, 2401 E St. N.W., Washington, DC 20506/202-634-4276.

Promotion of the Arts—Expansion Arts

Objectives: To provide grants to professionally directed, community-based arts organizations involved with urban, suburban, and rural communities. Particular attention is given to these organizations which serve citizens—including ethnic minorities—whose cultural needs are not met by the major arts universities.

Eligibility: Grants may be made only to nonprofit organizations if donations to such organizations qualify as a charitable deduction under Section 170 (c) of the Internal Revenue Code of 1954. This definition includes states, local governments, and state arts agencies.

Range of Financial Assistance: $1,000 to $70,000.

Contact: Director, Expansion Arts Program, National Endowment for the Arts, National Foundation on the Arts and the Humanities,

2401 E St. N.W., Washington, DC 20506/202-634-6010.

Promotion of the Arts—Folk Arts

Objectives: To provide grants to assist, foster, and make available publicly throughout the country, the diverse traditional American folk arts. To encourage projects involving those community or family-based arts that have endured through several generations and that carry with them a sense of community aesthetic.

Eligibility: Grants may be made only to nonprofit organizations if donations to such organizations qualify as a charitable deduction under Section 170 (c) of the Internal Revenue Code of 1954. This definition also includes states, local governments, and state arts agencies. There are no grants to individuals.

Range of Financial Assistance: $1,500 to $40,000.

Contact: Director, Folk Arts Program, National Endowment for the Arts, National Foundation on the Arts and the Humanities, 2401 E St. N.W., Washington, DC 20506/202-634-6020.

Promotion of the Arts—Literature

Objectives: To provide fellowships for creative writers, and to support organizations devoted to development of the literary arts in America.

Eligibility: Grants may be made to: 1) nonprofit organizations, including state and local governments and state arts agencies, if donations to such organizations qualify as charitable deductions under Section 170 (c) of the Internal Revenue Code of 1954; and 2) individuals who possess exceptional talent.

Range of Financial Assistance: $500 to $470,000.

Contact: Director, Literature Program, National Endowment for the Arts, National Foundation on the Arts and the Humanities, 2401 E St. N.W., Washington, DC 20506/202-634-6044.

Promotion of the Arts—Media Arts: Film/Radio/Television

Objectives: To provide grants in support of projects designed to assist individuals and groups to produce films, radio and video of high aesthetic quality, to exhibit and disseminate media arts. The Endowment also assists the American Film Institute which carries out a number of assistance programs for film.

Eligibility: Grants may be made to 1) nonprofit organizations, including state and local governments and state arts agencies, if donations to such organizations qualify as charitable deductions under Section 170 (c) of the Internal Reve-

nue Code of 1954; and 2) individuals who possess exceptional talent.

Range of Financial Assistance: $2,000 to $500,000.

Contact: Director, Media Arts Program, National Endowment for the Arts, National Foundation on the Arts and the Humanities, 2401 E St. N.W., Washington, DC 20506/202-634-6300.

Promotion of the Arts—Museums

Objectives: To provide grants in support of the essential activities of American museums.

Eligibility: Grants may be made to: 1) nonprofit organizations, including state and local governments and state arts agencies, if donations to such organizations qualify as charitable deductions under Section 170 (c) of the Internal Revenue Code of 1954, and 2) individuals (ordinarily U.S. citizens only) who possess exceptional talent.

Range of Financial Assistance: $1,100 to $500,000.

Contact: Director, Museum Program, National Endowment for the Arts, National Foundation on the Arts and the Humanities, 2401 E St. N.W., Washington, DC 20506/202-634-6164.

Promotion of the Arts—Music

Objectives: To support excellence in music performance and creativity and to develop informed audiences for music throughout the country.

Eligibility: Grants may be made to: 1) nonprofit organizations, including state and local governments and state arts agencies, if donations to such organizations qualify as charitable deductions under Section 170 (c) of the Internal Revenue Code of 1954; and 2) individuals who possess exceptional talent.

Range of Financial Assistance: $500 to $600,000.

Contact: Director, Music Program, National Endowment for the Arts, National Foundation on the Arts and the Humanities, 2401 E St. N.W., Washington, DC 20506/202-634-6390.

Promotion of the Arts—National Endowment Fellowship Program

Objectives: To provide a limited number of 13-week fellowships in arts administration and related fields for professionals and students. The internship is located at Endowment headquarters in Washington, D.C. The program is designed to acquaint the participants with the policies, procedures, and operations of the Endowment and to give them an overview of arts activities in this country.

Eligibility: Grants made only to nonprofit, tax-

exempt sponsoring organizations.

Range of Financial Assistance: $3,300 stipend plus round trip travel.

Contact: National Endowment Fellowship Program, National Endowment for the Arts, National Foundation on the Arts and the Humanities, 2401 E St. N.W., Washington, DC 20506/202-634-6380.

Promotion of the Arts—Opera and Musical Theater

Objectives: To support excellence in the performance and creation of professional opera and musical theater throughout the nation.

Eligibility: Grants may be made only to professional nonprofit organizations if donations to such organizations qualify as a charitable deduction under Section 170 (c) of the Internal Revenue Code of 1954. This definition includes states, local governments, and state arts agencies.

Range of Financial Assistance: $2,000 to $700,000.

Contact: Director, Opera/Musical Theater Program, National Endowment for the Arts, National Foundation on the Arts and the Humanities, 2401 E St. N.W., Washington, DC 20506/202-634-6390.

Promotion of the Arts—Inter-Arts

Objectives: To provide grants for a limited number of special projects which do not fit other Endowment program guidelines, or projects which involve two or more art forms or program areas.

Eligibility: Grants may be made only to nonprofit organizations if donations to such organizations qualify as a charitable deduction under Section 170 (c) of the Internal Revenue Code of 1954. This definition also includes states, local governments, and state arts agencies. There are no grants to individuals.

Range of Financial Assistance: $1,080 to $100,000.

Contact: Director of Office of Special Projects, National Endowment for the Arts, National Foundation on the Arts and the Humanities, 2401 E St. N.W., Washington, DC 20506/202-634-6020.

Promotion of the Arts—State Program

Objectives: To assist state and regional public arts agencies in the development of programs for the encouragement of the arts and artists.

Eligibility: Agencies officially designated as the State Arts Agency by the governor in each of the 50 states and six special U.S. jurisdictions, and other specific public arts agencies are eligible.

Range of Financial Assistance: $2,000 to $500,000.

Contact: Directors, State Program, National Endowment for the Arts, National Foundation on the Arts and the Humanities, 2401 E St. N.W., Washington, DC 20506/202-634-6055.

Promotion of the Arts—Theater

Objectives: To provide grants to aid professional theater companies and organizations.

Eligibility: Grants may be made only to nonprofit organizations if donations to such organizations qualify as a charitable deduction under Section 170 (c) of the Internal Revenue Code of 1954. This definition includes states, local governments, and state art agencies.

Range of Financial Assistance: $1,000 to $200,000.

Contact: Director, Theater Program, National Endowment for the Arts, National Foundation on the Arts and the Humanities, 2401 E St. N.W., Washington, DC 20506/202-634-6387.

Promotion of the Arts—Visual Arts

Objectives: To provide grants to assist painters, sculptors, craftsmen, photographers, and printmakers and to support institutions devoted to the development of the visual arts in America.

Eligibility: Grants may be made to 1) nonprofit organizations, including state and local governments and state arts agencies, if donations to such organizations qualify as charitable deductions under Section 170 (c) of the Internal Revenue Code of 1954; and 2) individuals who possess exceptional talent.

Range of Financial Assistance: $1,000 to $50,000.

Contact: Director, Visual Arts Program, National Endowment for the Arts, National Foundation on the Arts and the Humanities, 2401 E St. N.W., Washington, DC 20506/202-634-1566.

Promotion of the Humanities—Basic Research

Objectives: To advance basic research that is interpretative in all fields of the humanities. Collaborative, interdisciplinary scholarship involving the efforts of several individuals at the professional, assistant, and clerical levels is encouraged as well as the use of innovative methodologies. Foreign and domestic archaeology projects are supported in the Program.

Eligibility: U.S. citizens and residents, U.S. nonprofit organizations, and academic institutions including state colleges and universities, public, private, junior and community colleges.

Range of Financial Assistance: $5,000 to $300,000.

Contact: Assistant Director, Basic Research Program, Division of Research Programs, MS 350, National Endowment for the Humanities, National Foundation on the Arts and the Humanities, Washington, DC 20506/202-724-0276.

Promotion of the Humanities—Challenge Grant Program

Objectives: To provide financial assistance to institutions that store, research or disseminate learnings in the humanities; to broaden the base of financial support by "challenging" institutions to raise three private dollars for every federal grant dollar; to help secure financial stability in order to maintain existing services and resources.

Eligibility: Any nonprofit humanities institution, association or organization is eligible to apply; institutions whose scope encompasses activities outside the humanities (e.g., arts, science, medicine) may apply for a challenge grant to cover the costs of only the humanities components, or that percentage of total institutional cost which can be directly identified with these. Local, county, and state governments are eligible to apply on behalf of nonprofit institutions, associations or organizations within their jurisdictions; individuals are not eligible to apply.

Range of Financial Assistance: $2,000 to $1,500,000.

Contact: Challenge Grants Program, MS 800, National Endowment for the Humanities, National Foundation on the Arts and the Humanities, Washington, DC 20506/202-724-0267.

Promotion of the Humanities—Consultant Grants Program

Objectives: The Consultant Grants Program is designed to assist college faculty and administrators in the planning of humanities curricula context improvements by furnishing expert consultants and supporting consequence costs.

Eligibility: Public and private two-year and four-year colleges, universities, technical and professional schools. State- and locally-controlled institutions of higher education are eligible to apply.

Range of Financial Assistance: $500 to $10,000.

Contact: Division of Education Programs, National Endowment for the Humanities, National Foundation on the Arts and the Humanities, Washington, DC 20506/202-724-1978.

Promotion of the Humanities—Division of Public Programs, Libraries Humanities Projects

Objectives: To encourage public interest in libraries' humanities resources and stimulate their use through thematic programs, exhibits, media, publications, and other library activities.

Eligibility: Any library or library-related agency serving the adult public may apply. This includes community libraries, county and regional libraries, library systems, independent nonprofit libraries, state libraries, special libraries, library associations, multi-state library organizations, and library schools. Libraries may submit proposals individually or in cooperation with other community organizations. Academic and school libraries are also eligible if the proposed project serves the general adult public as its primary goal.

Range of Financial Assistance: $5,000 to $400,000.

Contact: Assistant Director for Libraries, Humanities Projects, Division of Public Programs, National Endowment for the Humanities, National Foundation on the Arts and the Humanities, MS 406, Washington, DC 20506/202-724-0760.

Promotion of the Humanities—Education Implementation Grants

Objectives: Implementation Grants are designed to assist in the full-scale development of programs that will strengthen the teaching of the humanities at individual institutions. Such programs will be pervasive and long-range, rather than specific and of limited duration.

Eligibility: Two-year and four-year colleges, universities, professional schools, and technical schools.

Range of Financial Assistance: $75,000 to $300,000.

Contact: Program Officer for Implementation Grants, Division of Education Programs, National Endowment for the Humanities, National Foundation on the Arts and the Humanities, Washington, DC 20506/202-724-0393.

Promotion of the Humanities—Education Pilot Grants

Objectives: Pilot Grants are designed to support programs that will strengthen the humanities curriculum and thus effect general institutional changes. Such programs will be pervasive and long-range, rather than specific and of limited duration. It is primarily this factor that distinguishes such grants from those made in the project category.

Eligibility: Two-year and four-year colleges, universities, professional schools, and technical schools.

Range of Financial Assistance: $22,000 to $50,000.

Contact: Program Officer, Pilot Grants, Division of Education Programs, National Endowment for the Humanities, National Foundation on the Arts and the Humanities, Washington, DC 20506/202-724-0393.

Promotion of the Humanities—Elementary and Secondary Education Program

Objectives: To promote the development and testing of imaginative approaches to precollegiate education in the humanities by supporting demonstration projects that can be completed within a specified period of time. Most projects are planned and implemented by groups of school and/or university faculty, last one to three years, and are concerned with the design of model courses or programs, teacher training institutes, or the development of curricular materials including an emphasis on teacher training. Projects often involve increased collaboration between schools, higher education institutions, and cultural institutions. The division particularly seeks projects that show promise of serving as models for other institutions.

Eligibility: Schools, school systems, higher education institutions, and other nonprofit education, cultural, and professional organizations are eligible.

Range of Financial Assistance: $1,000 to $500,000.

Contact: Assistant Director, Division of Education Programs, National Endowment for the Humanities, National Foundation on the Arts and the Humanities, MS 202, Washington, DC 20506/202-724-0373.

Promotion of the Humanities—Fellowships at Centers for Advanced Study

Objectives: To provide fellowships for study and research in the humanities to independent centers for advanced study, in order to increase the opportunities for the uninterrupted and extended interchange of ideas which these centers make possible on an independent basis, not primarily in a college or university setting.

Eligibility: The program is intended for self-standing centers which are financed and directed independent of institutions of higher education, or predominantly so. Internal university centers are not eligible.

Range of Financial Assistance: $15,400 to $150,000.

Contact: Deputy Director and Humanist Administrator, Division of Fellowships, National Endowment for the Humanities, National Foundation on the Arts and the Humanities, Washington, DC 20506/202-724-0236.

Promotion of the Humanities—Fellowships for College Teachers

Objectives: To provide opportunities for college teachers to pursue full-time independent study and research that will enhance their abilities as teachers and interpreters of the humanities.

Eligibility: Since these fellowships are awarded to individuals, state, and local governments, and U.S. territories are ineligible. Applicants must have completed their professional training before applying.

Range of Financial Assistance: Up to $22,000.

Contact: Division of Fellowships, National Endowment for the Humanities, National Foundation on the Arts and the Humanities, MS 101, Washington, DC 20506/202-724-0333.

Promotion of the Humanities—Fellowships for Independent Study and Research

Objectives: To provide time for uninterrupted study and research to scholars, teachers, and other interpreters of humanities who can make significant contributions to thought and knowledge in the humanities. The fellowships free applicants from the day-to-day responsibilities of teaching and other work for extended periods of uninterrupted, full-time study and research so that fellows may enlarge their contributions and continue to develop their abilities as scholars and interpreters of the humanities.

Eligibility: Applications may come from members of college and university faculties and from others who work in the humanities, from persons with broad interests as well as scholars working in specialties.

Range of Financial Assistance: Up to $22,000.

Contact: Program Officer for Fellowships for Independent Study and Research, Division of Fellowships, National Endowment for the Humanities, National Foundation on the Arts and the Humanities, MS 101, Washington, DC 20506/202-724-0333.

Promotion of the Humanities—Higher Education/Regional and National Grants

Objectives: To promote the development and testing of imaginative approaches to education in the humanities by supporting projects that can be completed within a specified period of time. Most projects are planned and implemented by small groups of faculty, last one or two years, and are concerned with the design of model humanities programs intended for wide-spread use, the development of curriculum materials, and increased collaboration among educational and other cultural institutions. Projects also encourage excellence in teaching and promote serious attention

to the central issues in the humanities by bringing groups of college faculty into residence at institutes for periods ranging from four to eight weeks or, in exceptional circumstances, longer for joint curriculum planning.

Eligibility: Two-year and four-year public and private colleges, universities, and nonprofit educational organizations.

Range of Financial Assistance: $5,000 to $250,000.

Contact: Assistant Director, Higher Education Projects, Education Programs, National Endowment for the Humanities, National Foundation on the Arts and the Humanities, MS 202, Washington, DC 20506/202-724-0311.

Promotion of the Humanities—Media Humanities Projects

Objectives: To encourage and support radio and television production that: 1) advances public understanding and use of the humanities, including such fields as history, jurisprudence, literature, anthropology, philosophy, archaeology; 2) is of the highest professional caliber in terms of scholarship in the humanities and in terms of technical production; and 3) is suitable for national or regional television broadcast and distribution, or for national, regional or local radio broadcast.

Eligibility: State and local governments and nonprofit agencies, institutions, organizations or groups are eligible; each proposal must involve direct collaboration between experienced humanities scholars and producers, screenwriters, directors and actors of top professional stature.

Range of Financial Assistance: $4,000 to $1,500,000.

Contact: Media Humanities Projects, Division of Public Programs, National Endowment for the Humanities, National Foundation on the Arts and the Humanities, MS 403, Washington, DC 20506/202-724-0318.

Promotion of the Humanities—Museums and Historical Organizations Humanities Projects

Objectives: To assist museums and historical organizations in implementing effective and imaginative programs which convey and interpret to the general public knowledge of the cultural legacies of the United States and other nations.

Eligibility: State and local governments and nonprofit museums, historical organizations, historic sites and other institutions capable of implementing public programs in the humanities.

Range of Financial Assistance: Up to $50,000.

Contact: Museums and Historical Organizations Humanities Projects, Division of Public Programs, National Endowment for the Humanities, Washington, DC 20506/202-724-0327.

Promotion of the Humanities—Planning and Assessment Studies Program

Objectives: To aid projects that address national humanistic concerns and that analyze the resources and needs in specific areas of the humanities, develop new sources of information that foster a more critical assessment of the humanities, and design, test, and implement tools for evaluation and policy analysis.

Eligibility: Entities of State and local government, U.S. citizens and residents, U.S. nonprofit organizations, and public and private academic institutions at all educational levels are eligible. Foreign institutions are not eligible and foreign nationals are also ineligible unless affiliated with a U.S. institution or organization, or a resident within the U.S. for three consecutive years prior to the time of application.

Range of Financial Assistance: $3,000 to $100,000.

Contact: Assistant Director, Evaluation and Assessment Studies, Office of Planning and Policy Assessment, National Endowment for the Humanities, National Foundation on the Arts and the Humanities, MS 303, Washington, DC 20506/202-724-0369.

Promotion of the Humanities—Program Development

Objectives: To encourage and support exemplary projects that demonstrate new ways of relating the humanities to new audiences. Projects must draw upon resources and scholars in the fields of the humanities which bring humanities programming to members and affiliates; and projects using previously untested techniques for involving the public in programs examining the cultural, philosophic and historic dimensions of contemporary society.

Eligibility: National membership organizations, state and local governments and nonprofit organizations and institutions.

Range of Financial Assistance: $10,000 to $200,000.

Contact: Program Development, Division of Special Programs, National Endowment for the Humanities, National Foundation on the Arts and the Humanities, MS 401, Washington, DC 20506/202-724-0398.

Promotion of the Humanities—Research Conferences

Objectives: To support conferences, symposia, and workshops, which enable scholars to discuss and advance the current state of research on a

particular topic or to consider means of improving conditions for research.

Eligibility: U.S. citizens and residents, U.S. nonprofit organizations, local governments, and academic institutions are eligible.

Range of Financial Assistance: $5,200 to $10,000.

Contact: Program Officer, Research Conferences Program, Division of Research Programs, MS 350, National Endowment for the Humanities, National Foundation on the Arts and the Humanities, 806 15th St. N.W., Washington, DC 20506/202-276-0277.

Promotion of the Humanities—Research Materials: Publications

Objectives: To insure through grants to publishing entities the dissemination of works of scholarly distinction that without support could not be published.

Eligibility: Nonprofit and commercial presses are eligible.

Range of Financial Assistance: $2,000 to $10,000.

Contact: Assistant Director, Division of Research Programs for Research Materials, MS 350, National Endowment for the Humanities, National Foundation on the Arts and the Humanities, Washington, DC 20506/202-724-1672.

Promotion of the Humanities—Research Materials: Editions

Objectives: To fund, wholly or partially, projects which create editions of materials important for scholarly research in the humanities and as cultural documents.

Eligibility: U.S. citizens and residents, U.S. nonprofit organizations, and academic institutions including state colleges and universities, public, private, junior and community colleges are eligible.

Range of Financial Assistance: $2,500 to $200,000.

Contact: Assistant Director, Division of Research Programs for Research Materials, MS 350, National Endowment for the Humanities, National Foundation on the Arts and the Humanities, Washington, DC 20506/202-724-1672.

Promotion of the Humanities—Research Materials: Tools and Reference Works

Objectives: To fund, wholly or partially, projects which create reference works and resources important for scholarly research as cultural documents.

Eligibility: U.S. citizens and residents, U.S. nonprofit organizations, and academic institutions including state colleges and universities,

public, private, junior and community colleges are eligible.

Range of Financial Assistance: $2,500 to $300,000.

Contact: Assistant Director, Division of Research Programs for Research Materials, MS 350, National Endowment for the Humanities, National Foundation on the Arts and the Humanities, Washington, DC 20506/202-724-1672.

Promotion of the Humanities—Research Materials: Translations

Objectives: To support the translation into English of texts and documents that will make an important contribution to research in the humanities and to greater public awareness of the traditions and achievements of other cultures.

Eligibility: U.S. citizens and residents, U.S. nonprofit organizations, and academic institutions including state colleges and universities, public, private, junior and community colleges are eligible.

Range of Financial Assistance: $2,500 to $30,000.

Contact: Assistant Director, Division of Research Programs for Research Materials, MS 350, National Endowment for the Humanities, National Foundation on the Arts and the Humanities, Washington, DC 20506/202-724-1672.

Promotion of the Humanities—Research Resources

Objectives: To fund, wholly or partially, projects which will improve and facilitate scholarly access to significant resources in order to contribute to greater knowledge and understanding of the humanities.

Eligibility: U.S. citizens and residents, U.S. nonprofit organizations, and academic institutions are eligible. Foreign institutions or organizations are not eligible and foreign nationals are also ineligible unless affiliated with a U.S. institution or organization or a resident within the U.S. for three consecutive years prior to the time of application.

Range of Financial Assistance: $1,500 to $150,000.

Contact: Assistant Director, Research Resources Programs, Division of Research Programs, MS 350, National Endowment for the Humanities, National Foundation on the Arts and the Humanities, Washington, DC 20506/202-724-0341.

Promotion of the Humanities—Science, Technology, and Human Values

Objectives: To support a very limited number of projects which will serve as central references

in the science-values field, or as models of scientist-humanist collaboration.

Eligibility: Entities of state and local government, U.S. citizens and residents, U.S. nonprofit organizations, and academic institutions are eligible. Foreign institutions are not eligible and foreign nationals are also ineligible unless affiliated with a U.S. institution or organization, or a resident within the U.S. for three consecutive years prior to the time of application.

Range of Financial Assistance: $15,000 to $300,000.

Contact: Coordinator, Program of Science, Technology and Human Values, National Endowment for the Humanities, National Foundation on the Arts and the Humanities, MS 104, Washington, DC 20506/202-724-0354.

Promotion of the Humanities—State, Local, and Regional Studies

Objectives: To encourage the production of original narrative work relating to the history and customs of regions and communities in the United States drawing upon various disciplines in the humanities such as economics, history, politics, languages and literature, folklore, archaeology, and art history; to encourage cooperation among scholars and citizens in developing and using the resources of the humanities.

Eligibility: U.S. citizens and residents, U.S. nonprofit organizations, and academic institutions including state colleges and universities, public, private, junior and community colleges are eligible.

Range of Financial Assistance: $5,000 to $100,000.

Contact: Assistant Director, Regional and Local History Program, Division of Research Programs, MS 350, National Endowment for the Humanities, National Foundation on the Arts and the Humanities, Washington, DC 20506/202-724-0276.

Promotion of the Humanities—State Programs

Objectives: To promote local humanities programming through renewable program grants to humanities councils within each of the states for the purpose of regranting funds to local organizations, institutions and groups. Under the provisions of Public Law 94-462, only one entity in each state may receive assistance as the state humanities group to administer this program.

Eligibility: Nonprofit citizen councils in the several states which conform to the requirements of Public Law 94-462. If the states matches the federal grant, the governor may appoint up to half the council, otherwise the governor may appoint two members of the council.

Range of Financial Assistance: $309,000 to $390,000.

Contact: Director, Division of State Programs, National Endowment for the Humanities, National Foundation on the Arts and the Humanities, MS 404, Washington, DC 20506/202-724-0286.

Promotion of the Humanities—Summer Seminars for College Teachers

Objectives: To provide opportunities for teachers at undergraduate private and state colleges and junior and community colleges to work during the summer in their areas of interest under the direction of distinguished scholars at institutions with first-rate libraries.

Eligibility: Scholars at institutions with suitable libraries for advanced study, who are not only recognized in their fields but who are well qualified by virtue of their interest and ability in undergraduate teaching, may submit proposals to the Endowment to become seminar directors.

Range of Financial Assistance: $45,000 to $56,000.

Contact: Program Officer for Summer Seminars, Division of Fellowships, National Endowment for the Humanities, National Foundation on the Arts and the Humanities, MS 101, Washington, DC 20506/202-724-0376.

Promotion of the Humanities—Summer Stipends

Objectives: To provide time for uninterrupted study and research to scholars, teachers, writers, and other interpreters of the humanities, who have produced or demonstrated promise of producing significant contributions to humanistic knowledge.

Eligibility: College, junior college, and university teachers, and other humanists who have completed their professional training and are not degree candidates.

Range of Financial Assistance: All awards are for $2,500.

Contact: Program Officer for Summer Stipends, Division of Fellowships, National Endowment for the Humanities, National Foundation on the Arts and the Humanities, MS 101, Washington, DC 20506/202-724-0376.

Promotion of the Humanities—Youth Grants

Objectives: To support humanities projects initiated and conducted by young persons.

Eligibility: Entities of state and local governments, and individuals who are U.S. citizens, native residents of U.S. territorial possessions, or foreign nationals who have been residents in the U.S. for at least three years immediately preceding the date of the application; and nonprofit

U.S. organizations and academic institutions are eligible.

Range of Financial Assistance: Up to $15,000.

Contact: Director, Office of Youth Programs, MS 103, National Endowment for the Humanities, National Foundation on the Arts and the Humanities, Washington, DC 20506/202-724-0396.

Promotion of the Humanities—Youth Projects

Objectives: To support humanities projects which provide educational opportunities beyond those of in-school programs for large groups of young people under the direction of experienced professionals in the humanities and professionals in youth work. These may be sponsored by education, cultural, scholarly, civic, media or youth organizations.

Eligibility: Entities of state and local governments, and nonprofit U.S. organizations and academic institutions are eligible.

Range of Financial Assistance: $2,500 to $5,000.

Contact: Director, Office of Youth Programs, MS 103, National Endowment for the Humanities, National Foundation on the Arts and the Humanities, Washington, DC 20506/202-724-0396.

Higher Education/Individual Institutions

This program supports the design, testing, implementation and evaluation of curricula to strengthen teaching of the humanities in individual colleges and universities. The program includes three types of grants:

1. Consultant Grants—provide consultant assistance in planning new courses and teaching programs
2. Pilot Grants—enable institutions to test and evaluate new courses and teaching programs on a pilot basis
3. Implementation Grants—introduce a new or make extensive revision in an existing humanities teaching program in the curriculum.

Contact: Higher Education/Individual Institutions, Education Programs Division, National Endowment for the Humanities, National Foundation on the Arts and the Humanities, 806 15th St. N.W., Room 545, Washington, DC 20506/202-724-0393.

Higher Education/Regional-National

This program promotes the development, testing and dissemination of imaginative approaches to the teaching of the humanities at many institutions. Contact: Higher Education/Regional-National Grants Program, Educational Program Division, National Endowment for the Humanities, National Foundation on the Arts and the Humanities, 806 15th St. N.W., Room 529, Washington, DC 20506/202-724-0311.

Humanities

This is a monthly publication that describes current developments at the Humanities Endowment. Each issue includes a calendar of grant deadlines, complete listing of all NEH grants by category, articles by major writers on significant issues in the humanities, features on note-worthy Endowment projects and bibliographic essays on selected books resulting from NEH grants in various humanities disciplines. It is available for $8.00 per year from the Superintendent of Documents, Government Printing Office, Washington, DC 20402/202-783-3238. For additional information, contact: *Humanities* Editor, Public Affairs Office, National Endowment for the Humanities, National Foundation on the Arts and the Humanities, 806 15th St. Room 1100, N.W., Washington, DC 20506/202-724-1840.

Humanities Institutes

These institutes bring together at a host institution faculty from a number of colleges and universities to participate in seminars and joint curriculum planning. Contact: Humanities Institutes Grants, Higher Education/Regional-National Grants, Education Programs Division, National Endowment for the Humanities, National Foundation on the Arts and the Humanities, 806 15th St. N.W., Room 519, Washington, DC 20506/202-724-0311.

Inquiries and Preliminary Proposals

Applicants have found it useful to share an outline or draft of their proposed studies with the program staff. An outline as brief as two or three pages is usually sufficient to describe the study's purpose and need, general methodology planned, duration, and cost. Contact: Planning and Assessment Studies, Office of Planning and Policy Assessment, National Endowment for the Humanities, National Foundation on the Arts and the Humanities, 806 15th St. N.W., Room 1030, Washington, DC 20506/202-724-0369.

Inter-Arts Program

The Inter-Arts Program assists arts projects and organizations which involve two or more art disciplines and have national or regional impact. This includes presenting organizations, artists colonies, service organizations and projects and interdisciplinary arts projects. Contact: Inter-Arts Program, National Endowment for the Arts, National Foundation for the Arts and the

Humanities, 2401 E St. N.W., Room 1251, Washington, DC 20506/202-634-6020.

International Fellows

International Fellows Grants acquaint arts administrators or potential arts administrators with the policies, procedures and operations of the Endowment, and give them an overview of arts activities in the United States. Contact: International Program, Policy and Planning, National Endowment for the Arts, National Foundation on the Arts and the Humanities, 2401 E St. N.W., Room 1303, Washington, DC 20506/202-634-6380.

Libraries Humanities Program

This program aims to explore ways to interest the public in the humanities resources of libraries and to stimulate their use through thematic programs, exhibits, media, publications, and other library activities. Contact: Libraries Humanities Projects Program, Public Programs Division, National Endowment for the Humanities, National Foundation on the Arts and the Humanities, 806 15th St. N.W., Room 1209, Washington, DC 20506/202-724-0760.

Library—Arts

The library reflects the interests of the NEA and has material on public policy and the arts, arts management and endowment matters. Contact: Library, National Endowment for the Arts, National Foundation on the Arts and the Humanities, 2401 E St. N.W., Room 1250, Washington, DC 20506/202-634-7640.

Library—Humanities

The Humanities Library has material on humanities subjects. It is open to the public but an appointment is necessary. Contact: Library, National Endowment for the Humanities, National Foundation on the Arts and the Humanities, 806 15th St. N.W., Room 326, Washington, DC 20506/202-724-0360.

Literature Program

The literature program includes fellowships for creative writers; grants for residences for writers in an attempt to put writers in personal contact with their audiences; support for independent literary publishers (books and magazines); and distribution and promotion of contemporary literature. Contact: Literature Program, National Endowment for the Arts, National Foundation on the Arts and the Humanities, 2401 E St. N.W., Room 1358, Washington, DC 20506/202-634-6044.

Media Arts: Film/Radio/Television

The Media Arts program has four main priorities: Media Arts Centers, Production Grants, Programming in the Arts and Exhibition Assistance. Programming in the Arts concentrates on bringing the performing arts to broadcast (radio and television); and major media centers. Media Arts Centers undertake a variety of projects to make the arts of film, video and radio more widely appreciated and practiced. Funds are also available to assist organizations in exhibiting high quality film and video art not shown commercially; to enable organizations to invite renowned film and videomakers, radio producers and critics for workshops and lectures; to distribute selected short films to commercial theaters; to support single film, video and radio productions by tax-exempt organizations; and to help independent film and video makers complete their projects. Contact: Media Arts: Film/Radio/Television, National Endowment for the Arts, National Foundation on the Arts and the Humanities, 2401 E St. N.W., Room 1221, Washington, DC 20506/202-634-6300.

Media Humanities Projects Program

The Media Humanities Projects Program provides support for innovative television, radio and cable projects. It is solely concerned with project ideas which make substantial use of research and information in the humanities and which focus on subjects and issues that are central to the humanities. Contact: Media Humanities Projects Program, Public Programs Division, National Endowment for the Humanities, National Foundation on the Arts and the Humanities, 806 15th St. Room 1206, N.W., Washington, DC 20506/202-724-0318.

Museum Program

Museum grants are awarded to assist museums in providing general education opportunities that complement the goals of the institution; to promote cooperative endeavors between museums, groups of museums, museums and state or regional arts agencies or similar organizations; to encourage museums to purchase works in all media by living American artists; to enable museums to organize special exhibitions and to borrow exhibitions organized by other museums; to install collections formerly in storage or recently acquired or to more effectively display artifacts already on view; to document permanent collections or to publish catalogues or handbooks on collections; to enable museums to engage outside consultants for such projects as fund-raising, research and public relations activities; to enable

museum staff members to take leaves of absence for independent study, research, travel or other activities that contribute to their professional development; to assist museums and universities in training museum professionals and technicians through college-level programs, internships and apprenticeships; to assist museums in their implementation of conservation treatment for permanent collections, in the development of workshops, training centers, and internship programs to train conservation professionals and in the formation or expansion of regional conservation centers; to identify problems and recommend solutions concerning security; to assist with renovation projects where surveys have been completed; and to support services to the field such as research, publications, workshops, and seminars provided by museums or other organizations such as state or regional arts agencies and national or regional museum associations. Contact: Museum Programs, National Endowment for the Arts, National Foundation on the Arts and the Humanities, 2401 E St. N.W., Room 1118, Washington, DC 20506/202-634-6164.

Museums and Historical Organizations

This program funds activities that convey ideas and stimulate learning through the use of artifacts, documents, objects of arts, specimens or living collections. Museums, historical organizations, historic sites and other similar cultural institutions can develop programs which interpret humanities themes for the broad general public. Contact: Museums and Historical Organizations, Humanities Projects Program, Public Programs Division, National Endowment for the Humanities, National Foundation on the Arts and the Humanities, 806 15th St. N.W., Room 1215, Washington, DC 20506/202-724-0327.

Music Programs

The music program seeks to encourage excellence in all musical forms by granting funds to assist a limited number of solo artists; to provide support to professional ensembles to improve the quality of chamber music performances and to make the art form widely available; to professional orchestras to support innovative projects; to support the activities of a limited number of fully professional choral organizations; to support scholarship aid, development activities and master teacher residences for eligible music schools; to assist organizations that provide career development and performance opportunities for young artists; to provide support to professional ensembles and presenting organizations; to encourage the performance of new music and to increase performance opportunities for the work of American composers; to provide for the creation or completion of musical works; and to enable professional jazz composers and performers to advance their careers, to present jazz performances, educational programs and short-term residences, and to assist individuals and organizations with other projects. Contact: Music Program, National Endowment for the Arts, National Foundation on the Arts and the Humanities, 2401 E St. N.W., Room 1229, Washington, DC 20506/202-634-6390.

Opera-Musical Theater Program

This program enables the Endowment to respond to the needs of and opportunities within all forms of lyrical theater. Grants are awarded to help opera companies improve their artistic quality, reach new audiences and broaden their repertories to include more works by American artists; to assist outstanding projects that can be used as models for future developments in opera; to assist organizations that provide services to the opera field; and to assist unique projects of limited duration. Contact: Opera/Musical Theater, National Endowment for the Arts, National Foundation on the Arts and the Humanities, 2401 E St. N.W., Room 1235, Washington, DC 20506/202-634-7144.

Planning and Assessment Studies

Support is provided for studies and experiments designed to: collect and analyze data, including information about financial material and human resources which help assess the status of and trends in important sectors of the humanities or which explore significant emerging issues concerning the humanities; and develop models, techniques and tools helpful in conducting policy research and analysis, and in evaluating the effectiveness of institutional programs in the humanities. Contact: Office of Planning and Policy Assessment, National Endowment for the Humanities, National Foundation for the Arts and the Humanities, 806 15th St. N.W., Room 1014, Washington, DC 20506/202-724-0344.

Program Development Grants

These grants are the chief means for bringing humanities programming to new groups in the population, such as labor unions, ethnic groups, and national adult membership organizations. Contact: Program Development, Special Projects Division, National Endowment for the Humanities, National Foundation on the Arts and the Humanities, 806 15th St. N.W., Room 900, Washington, DC 20506/202-724-0398.

Research Grants—Arts

Research grants are awarded to assist the National Endowment for the Arts and the National Council on the Arts in planning and policy determination through the preparation of reports and presentations on the needs and conditions of the arts field. The Research Division also aids local and national organizations, public and private, by furnishing data, conclusions, and recommendations from research projects and maintains communication with other organizations engaged in arts-related research. Contact: Research Division, Policy and Planning, National Endowment for the Arts, National Foundation on the Arts and the Humanities, 2401 E St. N.W., Room 1260, Washington, DC 20506/202-634-7103.

Research Grants—Humanities

Applications involving the collaboration of two or more scholars should be submitted to the Research Division. Contact: Research Programs Division, National Endowment for the Humanities, National Foundation on the Arts and the Humanities, 806 15th St. N.W., Room 900, Washington, DC 20506/202-724-0226.

Research Materials

This program grants funds for research tools and reference works, editions, translations, and publications to provide support for the preparation of reference works considered important for advanced research in the humanities. Contact: Research Materials Program, Research Programs Division, National Endowment for the Humanities, National Foundation on the Arts and the Humanities, 806 15th St. N.W., Room 1110, Washington, DC 20506/202-724-1672.

Research Resources

This program helps make sources needed for scholarly research in the humanities more accessible for use. It funds projects to place previously unavailable material in public repositories; to facilitate access by preparing catalogs, inventories, registers, guides, bibliographies, and other finding aids: and to improve the ways in which librarians, archivists and others care for and make available research material. Contact: Research Resources, Research Programs Division, National Endowment for the Humanities, National Foundation on the Arts and the Humanities, 806 15th St. N.W., Room 1109, Washington, DC 20506/202-724-0341.

Science, Technology, and Human Values

This program (jointly administered with the National Science Foundation) supports scholarly work in the disciplines which underlay the science-values field: the history, philosophy, and sociology of science and the emerging fields of the history and philosophy of technology. Contact: Science, Technology and Human Values, Special Programs Division, National Endowment for the Humanities, National Foundation on the Arts and the Humanities, 806 15th St. N.W., Room 800, Washington, DC 20506/202-724-0354.

Special Constituencies

The program for special constituencies aims to make the arts more accessible to handicapped people, older adults, veterans, the gifted and talented, and people in hospitals, nursing homes, mental institutions and prisons. Information and technical assistance to artists, arts organizations, and consumers concerning accessible arts programs and other federal programs which support cultural activities is available. Contact: Special Constituencies, Policy and Planning, National Endowment for the Arts, National Foundation on the Arts and the Humanities, 2401 E St. N.W., Room 1272, Washington, DC 20506/202-634-4284.

Special Projects

Projects funded in the Special Projects category comprise a wide variety of unique, emergency, experimental or other special activities. Contact: Special Projects, Special Programs Division, National Endowment for the Humanities, National Foundation on the Arts and the Humanities, 806 15th St. N.W., Room 900, Washington, DC 20506/202-724-0398.

State Programs

The State Programs provide support for state humanities councils which in turn support humanities projects at the state and local levels. These programs concentrate their efforts to make humanistic projects accessible to the adult, out-of-school public. Contact: State Programs Division, National Endowment for the Humanities, National Foundation on the Arts and the Humanities, 806 15th St. N.W., Room 1214, Washington, DC 20506/202-724-0286.

Summer Seminars

This program provides a sum of money for two months of study and research. Recipients participate in seminars directed by distinguished scholars at institutions with libraries suitable for advanced study. Contact: Summer Seminars, Fellowship and Seminars Division, National Endowment for the Humanities, National Foundation on the Arts and the Humanities, 806 15th St. N.W., Room 301, Washington, DC 20506/202-724-0376.

Summer Stipends

Summer stipends provide a sum of money for two months of summer study and research. Their purpose is to free college and university teachers from the necessities of summer employment and to provide support for travel and other research expenses necessary for concentrated study. Contact: Summer Stipends, Fellowships and Seminars Division, National Endowment for the Humanities, National Foundation on the Arts and the Humanities, 806 15th St. N.W., Room 301, Washington, DC 20506/724-0376.

Theater Projects

Theater grants are awarded to state arts agencies for special projects involving professional theater resources in their areas: to bring high quality professional theater to areas where it has not been available; to assist in the development of a theater company by aiding in artistic development, improving the effectiveness of administration or supporting community service activities; to assist professional theater companies with short seasons; to assist theater for youth; to assist small professional theater companies; to help talented individuals make the transition between professional training and full professional work experience; and to assist organizations that provide services to the theater field. Contact: Theater Program, National Endowment for the Arts, National Foundation on the Arts and the Humanities, 2401 E St. N.W., Room 1208, Washington, DC 20506/202-634-6387.

Visual Arts Program

The Visual Arts Program provides money to artists, craftsmen and photographers. Grants are awarded for art in public places such as parks, plazas, riverfronts, airports, subways, and public buildings; for artists' exploration of the potential offered by public sites; for performing arts groups that wish to engage visual artists for the design of sets, costumes or posters for theater, opera or dance productions; to provide for artists, critics, photographers and craftsmen in residence; to help groups organize or borrow photography exhibitions of contemporary or historic significance and publish exhibition catalogues; to help groups organize or borrow crafts exhibitions of contemporary or historic significance; to make possible the publication of important works of photography; to help organizations commission photographers to document the geography or way of life in a particular city or region; to support workshops and alternative spaces; to enable artists, photographers, craftsmen, and art critics to set aside time, purchase materials, and advance their careers; to encourage craftsmen to find ways of

working together and of testing new ideas and media; to assist organizations, artists' groups and individuals concerned with providing services to artists. Contact: Visual Arts Program, National Endowment for the Arts, National Foundation on the Arts and the Humanities, 2401 E St. N.W., Room 1112, Washington, DC 20506/202-634-1566.

What Are the Humanities?

The Act of Congress that authorized the Endowment defines the humanities as the study of the following: language; linguistics; literature; history; jurisprudence; philosophy; archaeology; comparative religion; ethics; the history, criticism and theory of the arts; those aspects of the social sciences which have humanistic content and employ humanistic methods; and the study and application of the humanities to the human environment. For additional information, contact: Public Affairs Office, National Endowment for the Humanities, National Foundation on the Arts and the Humanities, 806 15th St. N.W., Room 1100, Washington, DC 20506/202-724-0256.

Youthgrants in the Humanities

This program supports humanities projects developed and conducted by young people: educational projects, humanistic research, media presentations; and community programs. Contact: Youthgrants Programs, Special Program Office, National Endowment for the Humanities, National Foundation on the Arts and the Humanities, 806 15th St. N.W., Room 900, Washington, DC 20506/202-724-0396.

Youth Programs

The purpose of Youth Programs is to stimulate the active participation of young people in humanities projects under the direction of experienced professionals. Contact: Youth Programs, Special Programs Division, National Endowment for the Humanities, National Foundation on the Arts and the Humanities, 806 15th St. N.W., Room 900, Washington, DC 20506/202-724-0396.

How Can the National Foundation on the Arts and the Humanities Help You?

For information on how this agency can help you, contact: Information Office, National Endowment for the Arts, National Foundation on the Arts and the Humanities, Washington, DC 20506/202-634-6369, or Public Information Officer, National Endowment for the Humanities, National Foundation on the Arts and the Humanities, Washington, DC 20506/202-724-0331.

National Labor Relations Board

1717 Pennsylvania Ave. N.W., Washington, DC 20570/202-632-4950

ESTABLISHED: 1935
BUDGET: $118,000,000
EMPLOYEES: 2,850

MISSION: Administers the Nation's laws relating to labor relations, and safeguards employees' rights to organize, to determine through elections whether workers want unions as their bargaining representatives, and to prevent and remedy unfair labor practices.

Major Sources of Information

Annual Report

This report details the Board's activities for the previous fiscal year with descriptions of the cases handled. Statistical tables of case information are also included. The Annual Report is sold (price varies) by the Superintendent of Documents, Government Printing Office, Washington, DC 20402/202-783-3238. For additional information, contact: Division of Advice, National Labor Relations Board, 1717 Pennsylvania Ave. N.W., Room 820, Washington, DC 20570/202-254-9128.

Bargaining Units

A bargaining unit is a group of two or more employees who share a community of interest and may reasonably be grouped together for purposes of collective bargaining. The National Labor Relations Board (NLRB) determines units of employees appropriate for collective bargaining purposes. For further information, contact the regional office in the area where the unit of employees is located, or Division of Information, National Labor Relations Board, 1717 Pennsylvania Ave. N.W., Room 710, Washington, DC 20570/202-632-4950.

Case Processing System

This system tracks all the cases from the time they are filed to their final disposition. Monthly reports are available providing detailed data on these cases. To be placed on the mailing list, contact: Division of Information, National Labor Relations Board, 1717 Pennsylvania Ave. N.W., Room 710, Washington, DC 20570. The information is also summarized in the Annual Report. It includes a listing of elections conducted by

company and industry, who conducted the election, number of votes, number of eligible voters, results, and other related election information. For additional information, contact: Statistical Services, National Labor Relations Board, 1375 K St. N.W., Room 604, Washington, DC 20005/202-633-6737.

Election Results

The National Labor Relations Board conducts secret-ballot elections so employees may decide whether or not a union should represent them for bargaining purposes. The following is a brief description of the six types of petitions that can be filed requesting an election:

Certification of Representative (RC)

This petition, which is normally filed by a union, seeks an election to determine whether employees wish to be represented by a union or not. It must be supported by the signature of 30 percent or more of the employees in the bargaining unit being sought.

Decertification (RD)

This petition, which can be filed by an individual, seeks an election to determine whether the authority of a union to act as a bargaining representative of employees should continue. It must be supported by the signature of 30 percent or more of the employees in the bargaining unit represented by the union.

Withdrawal of Union-Shop Authority (UD)

This petition, which can be filed by an individual, seeks an election to determine whether the union's contractual authority to require the pay-

ment of union dues and initiation fees as a condition of employment should be continued. It must be supported by the signatures of 30 percent or more of the employees in the bargaining unit covered by the union-shop agreement.

Employer Petition (RM)

This petition is filed by an employer for an election where one or more unions claim to represent the employer's employees or when the employer has reasonable grounds for believing that the union, which is the current bargaining representative, no longer represents a majority of employees.

Unit Clarification (UC)

This petition seeks to clarify the scope of an existing bargaining unit by, for example, determining whether a new classification is properly a part of that unit. The petition may be filed by either the employer or the union.

Amendment of Certification (AC)

This petition seeks the amendment of an outstanding certification of a union to reflect changed circumstances such as changes in the name or affiliation of the union. This petition may be filed by a union or an employer. Contact the Regional Office in the area where the unit of employees is located. For appeals of the regional director's decisions, contact: Office of Representative Appeals, National Labor Relations Board, 1717 Pennsylvania Ave. N.W., Room 760, Washington, DC 20570/202-254-9118.

Executive Secretary's Management Information System

This system tracks those cases before the Board and includes information on the types of allegations, type of industry, geographic location, formal actions taken and other related information. Summaries of this data are available in the Annual Report. Contact: Office of the Executive Secretary, National Labor Relations Board, 1717 Pennsylvania Ave. N.W., Room 701, Washington, DC 20570/202-254-9430.

Formal Complaints

Formal complaints are issued and prosecuted before the Board by the General Counsel. Contact: Office of the General Counsel, National Labor Relations Board, 1717 Pennsylvania Ave. N.W., Room 1001, Washington, DC 20570/202-254-9150.

Freedom of Information Act Requests

For Freedom of Information Act requests, contact: Office of the Executive Secretary, National Labor Relations Board, 1717 Pennsylvania

Ave. N.W., Room 701, Washington, DC 20570/202-254-9430.

Legal Research System

This system provides indexes of Board decisions, court decisions and related legal information. *Classified Indexes of the National Labor Relations Board Decisions and Related Court Decisions* is available bi-monthly (price varies) from the Superintendent of Documents, Government Printing Office, Washington, DC 20402/202-783-3238. For additional information, contact: Legal Research and Policy Planning, Division of Advice, National Labor Relations Board, 1717 Pennsylvania Ave. N.W., Room 1107, Washington, DC 20570/202-254-9350.

Library

The library is open to the public. The collection emphasizes labor law and labor relations. Contact: Library, National Labor Relations Board, 1717 Pennsylvania Ave. N.W., Room 900, Washington, DC 20570/202-254-9055.

Meetings

National Labor Relations Board meetings are generally open to the public. Notices of these meetings are available upon request. Contact: Division of Information, National Labor Relations Board, 1717 Pennsylvania Ave. N.W., Room 710, Washington, DC 20570/202-632-4950.

Publications

A free list of National Labor Relations Board publications is available. Contact: Division of Information, National Labor Relations Board, 1717 Pennsylvania Ave. N.W., Room 710, Washington, DC 20570/202-632-4950.

Public Information Room

Decisions, appeals and advice papers are available for public inspection. For further information, contact: Records Management, National Labor Relations Board, 1717 Pennsylvania Ave. N.W., Room 218, Washington, DC 20570/202-254-9488.

Regional Offices

Regional offices are the starting points for all cases coming to the National Labor Relations Board. In addition to processing unfair labor practice cases in the initial stages, regional offices investigate representation petitions, determine units of employees appropriate for collective-bargaining purposes, and conduct elections and pass on objections to the conduct of elections. Regional offices are listed in the telephone directory under the United States Government, National Labor Relations Board, or contact: Division of

Operational Management, National Labor Relations Board, 1717 Pennsylvania Ave. N.W., Room 1030, Washington, DC 20570/202-254-9102.

Speakers

Washington and regional personnel participate as speakers or panel members before bar associations, labor organizations, management groups and education, civic and other groups. To request speakers or panelists, contact the nearest regional director, or the Division of Information, National Labor Relations Board, 1717 Pennsylvania Ave. N.W., Room 710, Washington, DC 20570/202-632-4950.

Unfair Labor Practice
Charges

Charges that business firms, labor organizations, or both, have committed unfair labor practices are filed with the National Labor Relations Board by employees, unions and employers. Contact the nearest National Labor Relations Board field office. If the regional directors refuse to issue complaints, contact: Office of Appeals, National Labor Relations Board, 1717 Pennsylvania Ave. N.W., Room 1154, Washington, DC 20570/202-254-9316.

Unfair Labor Practice Hearings

Formal hearings in unfair labor practice cases are conducted by Administrative Law Judges. They make rulings, assign dates for hearings and maintain a calendar of cases to be heard. Contact: Division of Administrative Law Judges, National Labor Relations Board, 1375 K St. N.W., Room 1100, Washington, DC 20005/202-633-0500.

Weekly Summary

Weekly summaries of decisions are available. Contact: Division of Information, National Labor Relations Board, 1717 Pennsylvania Ave. N.W., Room 710, Washington, DC 20570/202-632-4950.

How Can the National Labor Relations Board Help You?

For information on how this agency can help you, contact: Division of Information, National Labor Relations Board, 1717 Pennsylvania Ave. N.W., Washington, DC 20570/202-632-4950.

National Mediation Board

1425 K St. N.W., Washington, DC 20572/202-523-5920

ESTABLISHED: June 21, 1934
BUDGET: $4,956,000
EMPLOYEES: 60
MISSION: Provides the railroad and airline industries with specific mechanisms for the adjustment of labor-management disputes, that is, the facilitation of agreements through collective bargaining, investigation of questions of representation, and the arbitration and establishment of procedures for emergency disputes; and is assisted in its activities by the National Railroad Adjustment Board and other special boards of adjustment, which handle individual and group grievances arising under labor-management agreements.

Major Sources of Information

Clerical Forces and Maintenance of Way Men, Dispatchers

This division has jurisdiction over disputes involving station, tower and telegraph employees, train dispatchers, maintenance of way men, clerical employees, freight handlers, express, station and store employees, signalmen, sleeping car conductors, sleeping car porters and maids, and dining car employees. Contact: Third Division, National Railroad Adjustment Board, National Mediation Board, 10 W. Jackson Blvd., Room 200, Chicago, IL 60604/312-886-7300.

Disputes

The disputes between an employee or a group of employees and a carrier or carriers growing out of grievances or out of the interpretation or application of agreements concerning rates of pay, rules, or working conditions shall be handled in the usual manner up to and including the chief operating officer of the carrier designated to handle such disputes; but, failing to reach an adjustment in this manner, the disputes may be referred by petition of the parties or by either party to the appropriate division of the Adjustment Board with full statement of facts and all supporting data bearing upon the disputes. Contact: Executive Secretary, National Railroad Adjustment Board, National Mediation Board, 10 W. Jackson Blvd., Room 200, Chicago, IL 60604/312-886-7300.

Dockets

Copies of collective bargaining agreements between labor and management of various rail and air carriers and copies of the awards and interpretations issued by the several divisions of the National Railroad Adjustment Board are available for public inspection during office hours. Contact: Executive Secretary, National Mediation Board, 1425 K St. N.W., Room 910, Washington, DC 20572/202-523-5920.

Freedom of Information Act Requests

For Freedom of Information Act requests, contact: Freedom of Information Office, National Mediation Board, 1425 K St. N.W., Room 910, Washington, DC 20572/202-523-5343.

Mediation Publications

A booklet outlining the history and operations of the Board and the act, *Administration of the Railway Labor Act by the National Mediation Board 1934–70*, is available on request. Also available for public distribution are the following documents: *Determination of Craft or Class* (6 volumes); *Interpretations Pursuant to Section 5, Second of the Act* (2 volumes); *Annual Reports of the National Mediation Board including the Report of the National Railroad Adjustment Board; The Railway Labor Act at Fifty*. The National Mediation Board maintains two subscription mailing lists:

Subscription List No. 1—the rate of $140.00 per year will cover all publications issued by the Board. These include: *Certifications and Dismissals; Determinations of Craft or Class; Findings Upon Investigation; Annual Reports of the National Mediation Board; Emergency Board Reports; The Representation Manual;* and all other publications on these topics issued by the Agency.

Subscription List No. 2—the rate of $25.00 per year will cover the following publications: *Annual Reports of the National Mediation Board; Emergency Board Reports;* and *Determinations of Craft or Class* (bound volume).

Upon request, the Executive Secretary may waive payment of the subscription rate, in whole or in part, when it is determined that such reduction or waiver is in the public interest. Contact: Executive Secretary, National Mediation Board, 1425 K St. N.W., Room 910, Washington, DC 20572/202-523-5920.

Shop Craft
Disputes

This division has jurisdiction over disputes involving machinists, boilermakers, blacksmiths, sheet metal workers, electrical workers, carmen, the helpers, and apprentices of all of the foregoing, coach cleaners, powerhouse employees and railroad shop laborers. For additional information, contact: Second Division, National Railroad Adjustment Board, National Mediation Board, 10 W. Jackson Blvd., Room 200, Chicago, IL 60604/312-886-7305.

Train and Yard Service Employees

This division has jurisdiction over disputes between employees or groups of employees and carriers involving train and yard service employees, that is, engineers, firemen, hostlers, and outside hostler helpers, conductors, trainmen and yard service employees. Contact: First Division, National Railroad Adjustment Board, National Mediation Board, 10 W. Jackson Blvd., Room 200, Chicago, IL 60604/312-886-7303.

Water Transportation and Miscellaneous Matters

This division has jurisdiction over disputes involving employees of carriers directly or indirectly engaged in transportation of passengers or property by water, and all other employees of carriers, over which jurisdiction is not given to the first, second and third divisions. Contact: Fourth Division, National Railroad Adjustment Board, National Mediation Board, 10 W. Jackson Blvd., Room 200, Chicago, IL 60604/312-886-7303.

How Can the National Mediation Board Help You?

For information on how this agency can help you, contact: Executive Secretary, National Mediation Board, 1425 K St. N.W., Washington, DC 20572/202-523-5920.

National Science Foundation

1800 G St. N.W., Washington, DC 20550/202-357-9498

ESTABLISHED: 1950
BUDGET: $995,406,000
EMPLOYEES: 1,274
MISSION: Promotes the progress of science through the support of research and education in the sciences, emphasizing basic research, the search for improved understanding of the fundamental laws of nature, upon which our future well-being as a nation is dependent; is involved in applied research directed toward the solution of more immediate problems of our society; its educational programs are aimed at insuring increasing understanding of science at all educational levels and an adequate supply of scientists and engineers to meet our country's needs.

Major Sources of Information

Aeronomy

The atmospheric sciences project supports research on upper and middle atmosphere phenomena of ionization, recombination, chemical reaction, photoemission, and transport; the transport of energy, momentum, and mass in the mesosphere-thermosphere-ionosphere system, including the processes involved and the coupling of this global system to the stratosphere below and magnetosphere above; and the plasma physics of phenomena manifested in the upper atmosphere-ionosphere system, including magnetospheric coupling efforts. Contact: Aeronomy Program, Division of Atmospheric Sciences, Directorate for Astronomical, Atmospheric, Earth and Ocean Sciences, National Science Foundation, 1800 G St. N.W., Room 644, Washington, DC 20550/202-357-7619.

Algebra and Number Theory

The algebra and number theory program supports research on topology and geometry of surfaces describable by algebraic equations and analogous situations in higher dimensions; algebraic sets and their special transformations; structure of groups and other algebraic entities; discrete mathematics and combinatorial theory; and new algebraic techniques to answer questions raised in other areas of mathematics and science. Contact: Algebra and Number Theory Program, Division of Mathematical and Computer Sciences, Directorate for Mathematical and Physical Sciences, National Science Foundation, 1800 G St. N.W., Room 304, Washington, DC 20550/202-357-9764.

Alternative Biological Sources of Materials

The alternative biological sources of materials program supports research to determine which biological sources constitute promising alternatives; develop biologically based processes needed to convert the sources to useful materials; and determine the socioeconomic, technical, and environmental impacts of various proposed biological alternative systems. Topics selected for investigation include biological conversion of lignocellulose to useful chemicals and materials and production of specialty chemicals from underutilized plants. Contact: Alternative Biological Sources of Materials Program, Division of Problem-Focused Research, Directorate for Engineering, National Science Foundation, Room 325, 1800 G St. N.W., Washington, DC 20550/202-357-9782.

Antarctic Bibliography

This is a series of compilations presenting abstracts and indexes of current Antarctic literature published worldwide since 1951. A flyer describing the bibliography and the monthly printout of *Current Antarctic Literature* is also available. Contact: Polar Information Service, Division of Polar Programs, Directorate for Astronomical, Atmospheric, Earth and Ocean Sciences, Nation-

al Science Foundation, 1800 G St. N.W., Room 628, Washington, DC 20550/202-357-7819.

Antarctic Research

Antarctic research is supported in the disciplines of biology and medicine, upper atmosphere physics, geology, glaciology, meteorology, and oceanography. Specific objectives of the program are to understand the function, evolution, and adaptations of land and sea species and ecosystems; the geology and geologic history of the continent and its surrounding ocean basins; the structure and dynamics of the magnetosphere and the ionosphere, which are uniquely measurable at the high geomagnetic latitudes of Antarctica; Antarctica's role in past and present global climate through study of surface and upper air processes, the structure, dynamics, and chemistry of the ice sheet, and oceanic circulation; and the physical and chemical oceanography of antarctic seas. Contact: Division of Polar Programs, Directorate for Astronomical, Atmospheric, Earth and Ocean Sciences, National Science Foundation, 1800 G St. N.W., Room 620, Washington, DC 20550/202-357-7766.

Anthropology

The anthropology program supports research on archaeology and cultural, social, and physical anthropology spanning all topics, geographic areas, and methodologies; systematic research collections; human origins; the interaction of population, culture, and the environment; and improved methods of radiocarbon and other techniques of dating and analysis. Contact: Anthropology Program, Division of Behavioral and Neural Sciences, Directorate for Biological, Behavioral and Social Sciences, National Science Foundation, 1800 G St. N.W., Room 320, Washington, DC 20550/202-357-7804.

Applied Mathematics

The applied mathematics program supports research on mathematical description of problems in physical sciences and engineering (e.g., solid and fluid mechanics, wave propagation, bifurcation, galactic phenomena); mathematical formulation of problems in biomedical sciences (e.g., population dynamics, ecological structures, epidemiology, genetics); methodologies of control optimization, optimal allocation of resources including mathematical economics; and development of numerical methods and programming techniques for use of digital computers and mathematical models. Contact: Applied Mathematics Program, Division of Mathematical and Computer Sciences, Directorate for Mathematical and

Physical Sciences, National Science Foundation, 1800 G St. N.W., Room 304, Washington, DC 20550/202-357-9764.

Arctic Research

Research is supported in the disciplines of geology and geophysics, biology, oceanography, meteorology, glaciology, and upper atmospheric physics. Specific objectives of the program are to gain new knowledge on: mechanisms of energy transfer between the magnetosphere, the ionosphere, and the neutral atmosphere; the role of the Arctic Basin in influencing climate; the interactions of arctic and subarctic seas with the global ocean system; sea-ice occurrence and behavior in coastal waters; the history of climatic changes as revealed in the study of deep ice cores from the Greenland ice sheet; properties and characteristics of permafrost; and the structure, function, and regulation of arctic terrestrial and marine eco-systems. Contact: Division of Polar Programs, Directorate for Astronomical, Atmospheric, Earth and Ocean Sciences, National Science Foundation, Room 620, 1800 G St. N.W., Washington, DC 20550/202-357-7766.

Astronomical Instrumentation and Development

The astronomical instrumentation and development program sponsors the development and construction of state-of-the-art detectors and data-handling equipment; procurement of detection and analysis systems for telescopes at institutions that presently lack such systems; development of interactive picture processing systems; development of very long baseline interferometric instrumentation; and application of new technology and innovative techniques to astronomy. Contact: Astronomical, Atmospheric, Earth and Ocean Sciences, National Science Foundation, 1800 G St. N.W., Room 615, Washington, DC 20550/202-357-7621.

Atmospheric Chemistry

The atmospheric sciences project supports research on the concentration and distribution of gases and aerosols in the atmosphere; chemical reactions among atmospheric species; interactions of atmospheric species with solar radiation; sources and sinks of important trace gases; precipitation chemistry; transport of gases and aerosols between the troposphere and stratosphere; polluted urban air chemistry; and air transport and transportation of energy-related pollutants. Contact: Atmospheric Chemistry Program, Division of Atmospheric Sciences, Directorate for Astronomical, Atmospheric, Earth and Ocean Sciences, National Science Foundation, Room

644, 1800 G St. N.W., Washington, DC 20550/202-357-9657.

Atomic, Molecular, and Plasma Physics

The atomic, molecular and plasma physics program supports research on properties and interactions of particles at the atomic, molecular, and more complex aggregation levels in which the atomic characteristics dominate. Specific interests include: measurement of precisely defined states of atoms and the interaction of these states with other such atoms; formation and properties of highly perturbed electronic configurations in light and heavy atoms; study of the complex states formed during close collisions of heavy atoms; ultraprecise measurements of atomic properties to verify basic theories and find expressions of new physical laws; and general and collision-free plasmas. Contact: Atomic, Molecular and Plasma Physics Program, Division of Physics, Directorate for Mathematical and Physical Sciences, National Science Foundation, 1800 G. St. N.W., Room 341, Washington, DC 20550/202-357-7997.

Automation, Bioengineering, and Sensing Systems

The electrical, computer, and systems engineering programs support applied research in engineering sciences in medicine and biology, including the areas of microminiaturized sensors, pattern analysis, machine intelligence, and cognitive systems engineering. Contact: Automation, Bioengineering and Sensing Systems Program, Division of Electrical, Computer and Systems Engineering, Directorate for Engineering, National Science Foundation, 1800 G St. N.W., Room 1101, Washington, DC 20550/202-357-9618.

Bilateral Cooperative Science Activities

Bilateral Cooperative Science Activities receive support for three types of activities: 1) Cooperative research projects which are jointly designed and jointly conducted by principal investigators from the United States and the foreign country; 2) Research-oriented seminars (or workshops), which are meetings of small groups of scientists from the United States and from the foreign country, to exchange information, review the current status of a specific field of science and plan cooperative research; and 3) Scientific visits for planning cooperative activities or for research. (Visits of six months or longer are eligible for consideration of support of dependent travel.) The United States Cooperative Science Programs include formal bilateral arrangements with Ar-

gentina, Australia, Belgium, Brazil, Bulgaria, Federal Republic of Germany, France, Greece, Hungary, India, Italy, Japan, Republic of Korea, Mexico, New Zealand, Pakistan, Romania, Switzerland, USSR, and Venezuela. Contact: Division of International Programs, Directorate for Scientific, Technological and International Affairs, National Science Foundation, 1800 G St. N.W., Room 1214, Washington, DC 20550/202-357-9552.

Biochemistry

The biochemistry program supports research on chemical composition and structure of proteins, carbohydrates, and nucleic acids, and the identification of the molecular parameters that describe their functions; investigations of the mechanism and regulation of the biosynthesis of proteins, carbohydrates, and nucleic and fatty acids; studies on enzyme structure and function; studies on the biogenesis, topography, and assemblage of membranes and the mutual interactions of their constituent macromolecules; and determination of virus structure, assembly, replication, and expression. Contact: Biochemistry Program, Division of Physiology, Cellular and Molecular Biology, Directorate for Biological, Behavioral and Social Sciences, National Science Foundation, 1800 G St. N.W., Room 329, Washington, DC 20550/202-357-7945.

Biological Instrumentation

The biological instrumentation program supports the purchase of major biological research instruments for use by groups of investigators; and development of biological instruments that are not presently available commercially and that will increase the accuracy and sensitivity of research observations. Contact: Biological Instrumentation, Division of Physiology, Cellular and Molecular Biology, Directorate for Biological, Behavioral and Social Sciences, National Science Foundation, 1800 G St. N.W., Room 325, Washington, DC 20550/202-357-7652.

Biological Oceanography

The ocean sciences project supports research on the distribution, abundance, physiology, and life history of pelagic, coastal, and deep sea marine organisms, and their interactions with the chemical, physical, and biological environments; the structure of pelagic and detritus-based food chains; phytoplankton productivity; interactions between deep sea biological processes and the overall ocean ecosystem; biological specialization of deep sea organisms; and the ecology of the Great Lakes and factors regulating phytoplank-

ton productivity in the Great Lakes. Contact: Biological Oceanography Program, Division of Ocean Sciences, Directorate for Astronomical, Atmospheric, Earth and Ocean Sciences, National Science Foundation, 1800 G St. N.W., Room 611, Washington, DC 20550/202-357-9600.

Biological Research Resources

This program provides operational support for biological research resources including living-organism stock centers, biological field research facilities, and systematic research collections to enhance their use by U.S. scientists. Contact: Biological Research Resources Program, Division of Environmental Biology, Directorate for Biological, Behavioral and Social Sciences, National Science Foundation, Washington, DC 20550/202-357-7475.

Biophysics

The biophysics program supports research on the development and interpretation of data that enhance understanding of the chemical and physical changes that occur in macromolecular compounds (biopolymers) during their functional processes; and determination of molecular structure, dynamics, and interactions and alterations in these molecular properties that occur during the functional state. Contact: Biophysics Program, Division of Physiology, Cellular and Molecular Biology, Directorate for Biological, Behavioral and Social Sciences, National Science Foundation, 1800 G St. N.W., Room 329, Washington, DC 20550/202-357-7777.

Cell Biology

The cell biology program supports research on the biology of prokaryotic and eukaryotic cells *in vivo* and in culture; elucidation of the structure and function of the cytoskeleton, membranes, chromosomes, and other organelles of the cell; investigations of the cell cycle, cell behavior, and cell-cell interactions; and mechanisms and regulation of cell motility. Contact: Cell Biology Program, Division of Physiology, Cellular and Molecular Biology, Directorate for Biological, Behavioral and Social Sciences, National Science Foundation, 1800 G St. N.W., Room 332, Washington, DC 20550/202-357-7474.

Cellular Physiology

The program on cellular physiology supports research on the reception of signals by cells, emphasizing the mechanisms of hormone action, including hormone receptors, hormone-gene interactions, and hormonal effects on metabolism; intracellular messengers and message trans-

duction; basic mechanisms of the immune response; and cellular physiology of muscle. Contact: Cellular Physiology Program, Division of Physiology, Cellular and Molecular Biology, Directorate for Biological, Behavioral, and Social Sciences, National Science Foundation, 1800 G St. N.W., Room 332, Washington, DC 20550/202-357-7975.

Ceramics

The ceramics program supports research on the fundamental properties of ceramic materials, including glass, graphite, refractory oxides, nitrides, and carbides, and other inorganic compounds; deformation and fracture mechanisms of ceramic materials in severe environments; corrosion, erosion and wear; and basic optical phenomena in materials considered for fiber optics, lasers, and solar devices. Contact: Ceramics Program, Division of Materials Research, Directorate for Mathematical and Physical Sciences, National Science Foundation, 1800 G St. N.W., Room 411, Washington, DC 20550/202-357-9789.

Cerro Tololo Inter-American Observatory

The National Science Foundation supports the Cerro Tololo Inter-American Observatory (CTIO) to provide qualified scientists with the telescopes and related facilities required for research in ground-based optical astronomy in the Southern Hemisphere. CTIO has eight telescopes, including the 4-meter (158-inch) near-twin to the Kitt Peak 4-meter telescope. Contact: Cerro Tololo Inter-American Observatory, Casila 63-D, La Serena, Chile, South America, or Cerro Tololo Inter-American Observatory, Division of Astronomical Sciences, Directorate for Astronomical, Atmospheric, Earth and Ocean Sciences, National Science Foundation, 1800 G St. N.W., Room 618, Washington, DC 20550/202-357-9740.

Chemical Analysis

The chemical analysis program supports research on new or improved methods of chemical analysis of all forms of matter and surface and interface species; analytic procedures that couple novel chemistry and advanced instrumentation with computer management; and comprehensive approaches to the analysis of complex materials such as catalysts and airborne particulares. Contact: Chemical Analysis Program, Division of Chemistry, Directorate for Mathematical and Physical Sciences, National Science Foundation, 1800 G St. N.W., Room 340, Washington, DC 20550/202-357-7960.

Chemical and Biochemical Systems

The chemical and process engineering program supports research on the basic aspects of chemical and biochemical processes in a variety of technologic areas undergirding a wide range of process industries, with emphasis on biochemical process fundamentals; food process engineering; polymerization and polymer processing; process synthesis, simulation, optimization, and control; and electrochemical processes. Contact: Chemical and Biochemical Systems Program, Division of Chemical and Process Engineering, Directorate for Engineering and Applied Science, National Science Foundation, 1800 G St. N.W., Room 1126, Washington, DC 20550/-202-357-9606.

Chemical Dynamics

The chemical dynamics program supports research on rates of reactions that are critically important in developing general laws and theories in chemistry; influence of chemical environments, energy sources, and catalysis on rates and products of chemical reactions; transient intermediates produced in reacting systems and their roles in producing chemical changes, correlations and generalizations between molecular structure and reactivity; new techniques and instruments; and fundamental rate data for use in disciplines such as biology and atmospheric sciences. Contact: Chemical Dynamics Program, Chemistry Division, Directorate for Mathematical and Physical Sciences, National Science Foundation, 1800 G St. N.W., Room 340, Washington, DC 20550/202-357-7956.

Chemical Instrumentation

The chemical instrumentation program provides assistance to universities and colleges in acquiring major items of instrumentation essential for the improved conduct of fundamental research in chemistry. Contact: Chemical Instrumentation Program, Division of Chemistry, Directorate for Mathematical and Physical Sciences, National Science Foundation, Room 340, 1800 G St. N.W., Washington, DC 20550/202-357-7960.

Chemical Physics

The chemical physics program supports research on the development of a general chemical theory to aid in the design and interpretation of experimental studies; experimental chemical transformation studies of single collisions of atoms and molecules; and acquisition and interpretation of data on the interaction of radiation with atoms and molecules; and energy transfer within and between individual molecules. Contact: Chemical Physics Program, Division of Chemis-

try, Directorate for Mathematical and Physical Sciences, National Science Foundation, 1800 G St. N.W., Room 340, Washington, DC 20550/202-357-7951.

Classical Mathematical Analysis

The classical analysis program supports research on the properties and behavior of solutions of ordinary and partial differential equations; relationships between analysis and geometry, particularly between solutions of partial differential equations and geometric properties of surfaces and manifolds; functions of one and several complex variables; real analysis; and special functions and approximation theory. Contact: Classical Analysis Program, Division of Mathematical and Computer Sciences, Directorate for Mathematical and Physical Sciences, National Science Foundation, 1800 G St. N.W., Room 304, Washington, DC 20550/202-357-9764.

Climate Dynamics

The atmospheric sciences project supports research on the development of a basis for predicting climate variations and for assessing the impact of these variations on human affairs. The program supports research that will contribute to knowledge of the natural variability of climate and to understanding of the physical processes governing climate. Specific areas of research supported are: modern climate data assembly and analysis; paleoclimatic data assembly and analysis; climate modeling and simulation; and climate impact assessment. Contact: Climate Dynamics, Division of Atmospheric Sciences, Directorate for Astronomical, Atmospheric, Earth and Ocean Sciences, National Science Foundation, 1800 G St. N.W., Room 644, Washington, DC 20550/202-357-9892.

College Faculty Conferences

College Faculty Conferences are designed to improve the science teaching competence of undergraduate faculty in two- and four-year colleges and universities by updating their knowledge of recent advances in scientific research and/or familiarizing them with a core knowledge of specific newly emerging subject fields. Contact: Faculty Oriented Programs, Division of Scientific Personnel Improvement, Directorate for Science and Engineering Education, National Science Foundation, 5225 Wisconsin Ave. N.W., Room W458, Washington, DC 20550/202-282-7795.

College Faculty Short Courses

The short courses program is a cooperative enterprise between the scholars who teach the short

courses and the college teachers who participate with the encouragement of their home institutions. The objective of the program is to provide a series of forums in which scholars who teach the short courses communicate recent advances in their fields to college teachers of undergraduate science. Each course director travels in a circuit to meet classes of participants at several field centers. From year to year there is an attempt to rotate courses to different regions of the country. Contact: Short Courses, Faculty-Oriented Programs, Division of Scientific Personnel Improvement, Directorate for Science and Engineering Education, National Science Foundation, 5225 Wisconsin Ave. N.W., Room W458, Washington, DC 20550/202-282-7795.

Committee Minutes

Summary minutes of open meetings of the National Science Foundation advisory groups may be obtained. Contact: National Science Board, National Science Foundation, 1800 G St. N.W., Room 545, Washington, DC 20550/202-357-7811.

Computer Engineering

The electrical, computer and systems engineering programs support research on the impact of large-scale and very large-scale integration on special purpose hardware and new computer architectures; classes of algorithms and their hardware implementation; types of computer architectures that lend themselves to better algorithms; distributed processing, parallel processing, computer-aided design, fault tolerance, and man-machine interfaces to computers; computer engineering for mechanical systems; and hardware and software computational issues involved in engineering intelligent systems, including knowledge representation and planning systems, transformations between different representations, 3-D object modeling, and very high-level languages. Contact: Computer Engineering Program, Division of Electrical, Computer and Systems Engineering, Directorate for Engineering, National Science Foundation, 1800 G St. N.W., Room 1101, Washington, DC 20550/202-357-9618.

Computer Science Special Projects

The special projects program supports research on general and specialized projects in experimental computer science; computer science research equipment; societal issues in computer science including privacy and security; legal aspects of computing, and social and economic impact; new directions in computer science and applications including computer networks, data bases, and database management; computer-based modeling; and other topics of special interest in computer science. Contact: Special Projects, Computer Science Section, Division of Mathematical and Computer Sciences, Directorate for Mathematical and Physical Sciences, National Science Foundation, Washington, DC 20550/202-357-7375.

Computer Systems Design

The program on computer systems design supports research on the principles of computer systems design relating to the structure of computer systems or the process of systems design. Topics include, but are not limited to: computer system architecture; distributed computer systems; integrated hardware/software systems; performance measurement and evaluation; fault tolerant systems; logic design; computer graphics; man-machine interaction; and Very Large Scale Intergration (VLSI) design methodology. The scope of this program includes experimental implementation where that is an integral part of the research. Contact: Computer Systems Design, Division of Mathematical and Computer Sciences, Directorate for Mathematical and Physical Sciences, National Science Foundation, 1800 G St. N.W., Room 339, Washington, DC 20550/202-357-7349.

Condensed Matter Theory

The Condensed Matter Theory program supports theoretical research on condensed matter, involving studies of phase transitions and critical point behavior, elementary excitations, lattice dynamics, defects, surfaces, electronic and magnetic states, transport and optical properties, and macroscopic quantum properties such as superconductivity and superfluidity. Contact: Condensed Matter Theory Program, Division of Materials Research, Directorate for Mathematical and Physical Sciences, National Science Foundation, Room 404, 1800 G St. N.W., Washington, DC 20550/202-357-9787.

Deep Sea Drilling

The deep sea drilling project involves the acquisition of geologic samples from the floor of the deep ocean basins by means of rotary drilling and coring in the sediments and the underlying crystalline rocks. Portions of the core samples are made available to qualified scientists for individual research projects. *Initial Reports of the Deep Sea Drilling Project*, lithologic and paleontologic descriptions and resulting interpretations published in a total of 53 volumes, are on sale from the Superintendent of Documents, Government Printing Office, Washington, DC 20402/202-

783-3238. For a list of these reports and further information, contact: Deep Sea Drilling Project, Ocean Drilling Programs, Directorate for Astronomical, Atmospheric, Earth and Ocean Sciences, National Science Foundation, 1730 K St. N.W., Room K300, Washington, DC 20550/202-653-9146.

Developmental Biology

The developmental biology program supports studies on the mechanisms involved in determining the growth and form of animals, plants and microorganisms. Areas included are reproduction, embryogenesis, pattern formation, developmental genetics, gene expression, recombinant DNA research, plant regeneration from culture protoplasts and cells, and animal regeneration. Emphasis is on experimental analysis of development. Contact: Developmental Biology Program, Division of Physiology, Cellular and Molecular Biology, Directorate for Biological, Behavioral and Social Sciences, National Science Foundation, 1800 G St. N.W., Room 332, Washington, DC 20550/202-357-7989.

Development in Science Education

The development in science education program provides support for projects designed to originate, develop, and experiment with new ideas having potential for improving science education in the following areas: education of early adolescents in science and mathematics; science education projects at all educational levels designed to overcome barriers to science careers for women, minorities, and the handicapped; science literacy and the relations of science to society; dissemination of results of scientific research and invention to those involved in higher education so they can respond more rapidly to changing conditions; and the application of new technologies to science education in ways that will increase opportunities for improved learning at all levels, including continuing education. Contact: Development in Science Education, Division of Science, Education, Development and Research, Directorate for Science and Engineering Education, National Science Foundation, 5225 Wisconsin Ave. N.W., Room W620, Washington, DC 20550/202-282-7904.

Earthquake Design

The earthquake hazards mitigation program supports research on improved characterization of earthquake and natural hazard loadings necessary for the economical design of structures subject to dynamic loading; new methods of analysis and design of buildings and structures of all types that will take into account nonlinear and inelastic behavior of materials and structures; methods to assess the hazard potential and risk assessments applicable to existing structures and facilities and to improve performance within economically acceptable bounds; observation of damage to facilities following actual earthquakes and incorporation of this information into standard design practice; improved computational capability for dynamic analysis of structures and facilities and improved user access to any computer software developed; model standards and design criteria for design of structures and facilities subjected to earthquake and natural hazard loadings; and behavior of smaller, nonengineered structures and secondary components of buildings to improve analytic procedures and design guidelines. Contact: Design Research, Division of Problem-Focused Research, Directorate for Engineering, National Science Foundation, 1800 G St. N.W., Room 1130, Washington, DC 20550/202-357-9500.

Earthquake Policy

The earthquake hazards mitigation program supports research on alternative social adjustments to earthquakes; social, economic, political, legal, and related factors that facilitate or hinder the adoption of both social and technologic solutions to earthquake hazards; effective techniques for disseminating information on earthquake hazard mitigation to the public and to decision-makers at the local, state, and national levels; and analyses of measures that will reduce possible negative social, economic, and political consequences of earthquake predictions and warnings. Contact: Design Research, Division of Problem-Focused Research, Directorate for Engineering, National Science Foundation, 1800 G St. N.W., Room 1132, Washington, DC 20550/202-357-9780.

Earthquake Siting

The earthquake hazards mitigation program supports research on the nature of earthquake motion at typical construction sites and for representative structures; the physical basis for characterizing the nature of earthquake motions and the dynamic forces generated by such motions and by other natural hazards; capabilities for predicting the magnitude and frequencies of strong ground motions; and methodology for qualitative and quantitative estimates of local or regional risk associated with earthquakes and combined hazards; a comprehensive and unified program to improve geotechnical engineering practices applicable to solid dynamics, foundation design failure and instability, and other aspects of earthquake ground motion; and procedures for integrating

information on natural hazards into land-use planning, urban and coastal zone planning, off-shore engineering, and siting procedures. Contact: Siting Research, Earthquake and Hazards Mitigation Program, Division of Problem-Focused Research, Directorate for Engineering, National Science Foundation, 1800 G St. N.W., Room 1132, Washington, DC 20550/202-357-7737.

EAS Publications

For information on Engineering and Applied Sciences publications, contact: EAS Information Resources, Directorate for Engineering, National Science Foundation, 1800 G St. N.W., Room 419, Washington, DC 20550/202-357-7484.

Ecology

The ecology program supports research on community ecology of land and inland waters, with emphasis on interactions such as competition, herbivory, pollination, predation, other antagonisms and symbioses in natural and agricultural ecosystems, and coevolution within interacting groups; microbial ecology of soils and sediments, especially in relation to decomposition, nutrient cycling, and productivity; mechanisms that influence the distribution and abundance of communities of animals and plants now and in the recent geological past. Contact: Ecology Program, Division of Environmental Biology, Directorate for Biological, Behavioral and Social Sciences, National Science Foundation, 1800 G St. N.W., Room 336, Washington, DC 20550/202-357-9734.

Economics

The economics program supports research on microanalysis of economic aggregates, including national income, the price level, and employment; forces determining the time path of the economy in response to various stimuli; determinants and consequences of market structure; interaction of fiscal and monetary variables in open economies, particularly as these pertain to problems of inflation and unemployment; economic study of renewable and nonrenewable resources; nonmarket decisionmaking; economic history and development; international economics; techniques of quantitative analysis; and empirical validation and assessment of different types of economic models. Contact: Economics Program, Division of Social and Economic Sciences, Directorate for Biological, Behavioral and Social Sciences, National Science Foundation, 1800 G St. N.W., Room 312, Washington, DC 20550/202-357-9675.

Ecosystem Studies

The program on ecosystems supports laboratory, field, and mathematical modeling studies of the processes and components of natural, managed, and mandominated terrestrial, freshwater, and wetland ecosystems; research on new methods of predicting ecosystem change and mathematically analyzing functional interdependencies in complex, highly variable systems; and information on ecosystem management and exploitation. Contact: Ecosystem Studies, Division of Environmental Biology, Directorate for Biological, Behavioral and Social Sciences, National Science Foundation, 1800 G St. N.W., Room 336, Washington, DC 20550/202-357-9596.

Electrical and Optical Communications

The electrical, computer and systems engineering program supports research on systems methodology and devices for optical communications and large-scale computer communications networks, information and coding theories, digital signal processing, and speech and image transmission and processing. Contact: Electrical and Optical Communications Program, Division of Electrical, Computer and Systems Engineering, Directorate for Engineering and Applied Science, National Science Foundation, 1800 G St. N.W., Room 1101, Washington, DC 20550/202-357-9618.

Elementary Particle Physics

The program on elementary particle physics supports research on unknown states of matter and their properties and interactions; data that can be compared with theoretical models and ideas regarding the nature of the submicroscopic world. Support is primarily provided to university groups to conduct experimental research at the major accelerator centers at national laboratories or at specialized university-based or university-affiliated laboratories. Contact: Elementary Particle Physics Program, Division of Physics, Directorate for Mathematical and Physical Sciences, National Science Foundation, 1800 G St. N.W., Room 341, Washington, DC 20550/202-357-9575.

Engineering Energetics

The chemical and process engineering program supports research on plasma chemistry and arc technology with emphasis on plasma polymerization, isotope separations, laser-induced chemical processes, arc-heater reactors, electric circuit breakers, and arc light sources; chemical and physical behavior of combustion of coal, oil, gas, and other materials; characterization of flames,

environmental control, problems associated with substitute fuels, and efficiency of combustion, basic phenomena of energy conversion processes, including magnetohydrodynamics; and nucleonics with emphasis on fundamental investigations and applications of nuclear science, such as reactor dynamics, neutron transport theory and analysis, radiation transport and radiation effects, and fusion-related topics. Contact: Engineering Energetics Program, Division of Chemical and Process Engineering, Directorate for Engineering and Applied Science, National Science Foundation, 1800 G St. N.W., Room 1126, Washington, DC 20550/202-357-9606.

Engineering Reports
Technical reports resulting from grants are available from the National Technical Information Service (NTIS). For information regarding the availability of reports in specific scientific and technical areas, contact: Office of Science Education Communication, Communications Program, National Science Foundation, 1800 G St. N.W., Room 1110, Washington, DC 20550/202-357-7484.

Environment, Energy and Resources Studies
Research in this area centers on issue definition and assistance to policymakers in finding techniques to deal with critical problems and improving methods for assessing effects of alternative governmental actions. Contact: Environment, Energy and Resources Studies, Division of Policy Research and Analysis, Directorate for Scientific, Technological and International Affairs, National Science Foundation, 1800 G St. N.W., Room 1229, Washington, DC 20550/202-357-7829.

Ethics and Values in Science and Technology
This program supports projects in ethical issues in the education and professional conduct of scientists and engineers; issues of obligation and constraint associated with scientific and technologic organizations and institutions; ethical and social issues associated with new developments in science and technology; effects of changing ethical and social values upon the conduct of science and technology; and ethical issues and value assumptions in decision-making processes involving science and technology. Contact: Ethics and Values in Science and Technology, Office of Science and Society, Directorate for Science Education, National Science Foundation, 1800 G St. N.W., Room 1140, Washington, DC 20550/202-357-7461.

Experimental Meteorology
The atmospheric sciences project supports field research on the physics and dynamics of the troposphere, including basic research related to international and inadvertent weather modification, precipitation development within cloud systems, the interaction between wind fields within cloud systems and the precipitation process, the development of mesoscale weather systems, the role of mesoscale elements in large-scale cyclone and anticyclone formation, and intentional and unintentional alterations of cloud processes and the cloud environment. Contact: Experimental Meteorology, Division of Atmospheric Sciences, Directorate for Astronomical, Atmospheric, Earth, and Ocean Sciences, National Science Foundation, 1800 G St. N.W., Room 644, Washington, DC 20550/202-357-9431.

Films
The National Science Foundation produces a limited number of films each year to acquaint the general public and the scientific community with scientific research and its applications. The film topics include astronomy, earth sciences, ecology and environment, education and learning, energy, engineering, ocean sciences, physics, polar research, research applications, weather and climate. A free catalog lists the films available and includes the distributors. Contact: Communications Resource Branch, National Science Foundation, 1800 G St. N.W., Room 531, Washington, DC 20550/202-357-9776.

Fluid Mechanics
The mechanical sciences and engineering program supports research on structure of turbulence, with emphasis on the role of coherent structure; dynamical interaction of vortices; and formation and convection of vortical structures. Contact: Fluid Mechanics Program, Division of Civil and Mechanical Engineering, Directorate for Engineering and Applied Science, National Science Foundation, 1800 G St. N.W., Room 1108, Washington, DC 20550/202-357-9542.

Freedom of Information Act Requests
For information on Freedom of Information Act requests, contact: Public Information Branch, National Science Foundation, 1800 G St. N.W., Room 531, Washington, DC 20550/202-357-9498.

Funding of Science and Technology
This program provides for the collection, analysis and dissemination of information on the characteristics and patterns of funding for re-

search and development and for other scientific and technologic activities. Support is also provided for the development of modeling and simulation techniques to improve the capability to project R&D funding. Contact: R&D Economic Studies Section, Division of Science Resources Studies, Directorate for Scientific, Technological and International Affairs, National Science Foundation, 2000 L St. N.W., Room L602, Washington, DC 20550/202-634-4625.

Galactic and Extragalactic Astronomy

The program for galactic and extragalactic astronomy sponsors theoretical and observational studies of the interstellar medium (including interstellar molecules), the Milky Way galaxy, distant galaxies, and quasars, including infrared studies of extragalactic objects, the use of millimeter wavelengths to map molecular clouds, the chemistry of interstellar space, and observational cosmology. Contact: Galactic and Extragalactic Astronomy Program, Division of Astronomical Sciences, Directorate for Astronomical, Atmospheric, Earth and Ocean Sciences, National Science Foundation, 1800 G St. N.W., Room 618, Washington, DC 20550/202-357-7639.

Genetic Biology

The genetic biology program supports research on the organization, transmission, function and control of hereditary information, including recombinant DNA research; genetic control of assembly of viruses; control of gene expression; packaging and fundamental structure of the genetic material; division of labor between genetic material as it is distributed among cell organelles, nucleus, chloroplasts and mitochondria; and application of molecular mechanisms to plant cell biology and crop research. Contact: Genetic Biology Program, Division of Physiology, Cellular and Molecular Biology, Directorate for Biological, Behavioral and Social Sciences, National Science Foundation, 1800 G St. N.W., Room 329, Washington, DC 20550/202-357-9687.

Geochemistry

The earth sciences project supports experimental and theoretical studies of the origin, migration, and distribution of chemical elements in the solar system. The studies include aqueous and organic geochemistry, mineralogy, crystallography, trace element studies, geochemical cycles, phase equilibria, and kinetic studies of terrestrial, lunar, and meteoritic materials. Contact: Geochemistry Program, Division of Earth Sciences, Directorate for Astronomical, Atmospheric, Earth and Ocean Sciences, National Science Foundation,

1800 G St. N.W., Room 602, Washington, DC 20550/202-357-7498.

Geography and Regional Science

The program or geography and regional science supports research on the explanation and impact of population shifts, migration decisions, industrial location, regional stagnation, and residential choice; effects of public policy, environmental preference, and perceived travel costs on land-use decisions; and geographic diffusion of innovations. Contact: Geography and Regional Science Program, Division of Social and Economic Sciences, Directorate for Biological, Behavioral and Social Sciences, National Science Foundation, 1800 G St. N.W., Room 312, Washington, DC 20550/202-357-7326.

Geology

The earth sciences project supports field and laboratory research on such geologic processes as volcanic eruptions, movement of glaciers and erosion and sedimentation; interpretation of ancient environments and organic evolution; studies of the Earth's strata; and regional field studies on plate tectonics. Contact: Geology Program, Division of Earth Sciences, Directorate for Astronomical, Atmospheric, Earth and Ocean Sciences, National Science Foundation, 1800 G St. N.W., Room 602, Washington, DC 20550/202-357-7915.

Geophysics

The earth sciences project supports research on the physical state and properties of the Earth. Subfields covered are seismology, gravity, geodesy, rock magnetism, terrestrial currents, heat flow, and high pressure phenomena. Contact: Geophysics Program, Division of Earth Science, Directorate for Astronomical, Atmospheric, Earth and Ocean Sciences, National Science Foundation, 1800 G St. N.W., Room 602, Washington, DC 20550/202-357-7721.

Geotechnical Engineering

The civil and environmental engineering program supports research on constitutive relations for soils, rocks, and ice; slope stability, subsidence, and expansion; site exploration and characterization based on probabilistic analysis; and use of centrifuge for physical modeling techniques. Contact: Geotechnical Engineering Program, Division of Civil and Environmental Engineering, Directorate for Engineering and Applied Science, National Science Foundation, Room 1130, 1800 G St. N.W., Washington, DC 20550/202-357-7352.

Global Atmospheric Research (GARP)

The global atmospheric research program is a long-term international project designed to acquire knowledge of the physical processes in the troposphere and stratosphere that are essential for an understanding of (a) the transient behavior of large-scale atmosphere phenomena which would lead to increasing the accuracy of forecasting; and (b) the factors that determine the statistical properties of the general circulation of the atmosphere, which would lead to better understanding of the physical basis of climate. Within the United States, the National Science Foundation is the primary agency for the support of nonfederal research in the program, particularly at universities. For additional information, contact: Global Atmospheric Research Program, Division of Atmospheric Sciences, Directorate for Astronomical, Atmospheric, Earth and Ocean Sciences, National Science Foundation, 1800 G St N.W., Room 644, Washington, DC 20550/202-357-9887.

Graduate Fellowships

The graduate fellowships program provides up to 3 years of support to students who are beginning their graduate science studies (masters or doctoral) at their chosen institutions. While approximately one out of eight individual applicants (or 400 individuals) will receive fellowships, the highest rating 1,200 non-awardees (the upper two-fifths of the applicants) will be accorded "honorable mention," citing them as being highly deserving of support. This citation assists applicants in acquiring other sources of funds and thereby aids their pursuit of graduate study. Contact: Graduate Fellowship Program, Division of Scientific Personnel Improvement, Directorate for Science Education, National Science Foundation, 5225 Wisconsin Ave. N.W., Room W400, Washington, DC 20550/202-282-7154.

Grant Policy Manual

This manual is a compendium of basic grant policies and procedures. It contains comprehensive statements of National Science Foundation policy and sets forth the actual terms and conditions under which awards are made. It is available for $9.00 from the Superintendent of Documents, Government Printing Office, Washington, DC 20402/202-783-3238. For additional information, contact: Policy Office, Division of Grants and Contracts, National Science Foundation, 1800 G St. N.W., Room 201, Washington, DC 20550/202-357-7880.

Grants

The programs described below are for sums of money which are given by the federal government to initiate and stimulate new or improved activities or to sustain on-going services:

Astronomical, Atmospheric, Earth and Ocean Sciences

Objectives: To strengthen and enhance the national scientific enterprise through the expansion of fundamental knowledge and increased understanding of the Earth's natural environment and of the universe. Activities include encouragement and support of basic research in the astronomic, atmospheric, Earth and ocean sciences; and in the Antarctic and Arctic. Major objectives include new knowledge of astronomy and atmospheric sciences over the entire spectrum of physical phenomena; a better understanding of the physical and chemical make-up of the Earth and its geologic history; increased insight into the world's oceans, their composition, structure, behavior, and tectonics; and new knowledge of natural phenomena and processes in the Antarctic and Arctic regions.

Eligibility: Public and private colleges and universities, nonacademic research institutions, private profit organizations, and unaffiliated scientists under special circumstances. Grants are made on a competitive basis.

Range of Financial Assistance: $2,000 to $985,000.

Contact: National Science Foundation, 1800 G St. N.W., Washington, DC 20550/202-357-9715. Astronomy: 202-357-9488; Atmospheric Sciences: 202-357-9874; Earth Sciences: 202-357-7958; Ocean Sciences: 202-357-9639; and Polar Programs: 202-357-7766.

Biological, Behavioral, and Social Sciences

Objectives: To promote the progress of science and thereby insure the continued scientific strength of the Nation; to increase the store of scientific knowledge and enhance understanding of major problems confronting the nation. Most of the research supported is basic in character. The program includes support of research project grants in the following disciplines: physiology, cellular and molecular biology, behavioral and neural sciences, environmental biology, and social and economic science. Support is also provided for research workshops, symposia and conferences, and for the purchase of scientific equipment. In addition, awards are made to improve the quality of doctoral dissertations in behavioral, social, and environmental sciences.

Eligibility: Public and private colleges and uni-

versities, nonprofit, nonacademic research institutions, private profit organizations and unaffiliated scientists under special circumstances. Grants are made on a competitive basis.

Range of Financial Assistance: $800 to $2,000,000.

Contact: Assistant Director, Biological, Behavioral and Social Sciences, National Science Foundation, 1800 G St. N.W., Washington, DC 20550/202-357-9854.

Directorate of Engineering

Objectives: To strengthen the United States engineering and applied science research base and enhance the links between research and applications in meeting national goals. Areas of research include: applied social and behavioral sciences; applied physical, mathematical, and biological sciences; intergovernmental program; small business innovation program, industrial programs, and appropriate technology, problem-focused research (programs currently include earthquake hazards mitigation, alternative biological sources of materials, science and technology to aid the handicapped, and human nutrition); integrated basic research and problem analysis; electrical, computer and systems engineering; chemical and process engineering; and civil and mechanical engineering.

Eligibility: Public and private colleges and universities, nonprofit institutions, state and local governments, and profit-making institutions including small businesses, and agencies. The greatest percentage of support goes to academic institutions. Grants to individuals are occasionally made.

Range of Financial Assistance: $1,000 to $800,000.

Contact: Programs and Resources Officer, Directorate for Engineering, National Science Foundation, 1800 G St. N.W., Washington, DC 20550/202-357-9774.

Industry/University Cooperative Research

Objectives: To encourage more effective communication and cooperation between researchers in universities and researchers in industry in order to strengthen the ties between these two segments of the Nation's scientific and technologic efforts. Grants are made for support of cooperative research projects involving universities and industrial firms. Proposals must be prepared jointly by academic and industrial researchers and must be submitted jointly by their respective organizations. The proposed research should focus on fundamental scientific or engineering questions of a basic or applied nature and should be such that it may be expected to make a long-term contribution toward product and/or process innovation or to provide knowledge as a foundation for new or improved technologies. Technological development and clinical research are not supported.

Eligibility: Universities and colleges and established profit-making industrial firms, including small businesses, are eligible. The cooperating institutions must represent bona fide independent operations, as evidenced by absence of interlocking relationships. Collaboration should involve active participation by scientific or technical personnel at both the university and the industrial organization in aspects of the proposed research.

Range of Financial Assistance: $80,000 to $160,000.

Contact: Director, Industrial Support Section, National Science Foundation, 1800 G St. N.W., Washington, DC 20550/202-357-7527.

Intergovernmental Program

Objectives: To facilitate the integration of scientific and technical resources into the policy formulation, management support, and program operation activities in state and local governments.

Eligibility: Units of state (executive or legislative branch) and local government and their regional or national organizations, special governmental districts, colleges and universities, professional schools, professional societies, nonprofit organizations and institutions, and profit-making organizations including small businesses. Awards may be made also under organizational arrangements that combine two or more of the above.

Range of Financial Assistance: $10,000 to $250,000.

Contact: Director, Intergovernmental Program, Division of Intergovernmental Science and Public Technology, National Science Foundation, Washington, DC 20550/202-357-7560.

Mathematical and Physical Sciences

Objectives: To promote the progress of science and thereby insure the continued scientific strength of the Nation; to increase the store of scientific knowledge and enhance understanding of major problems confronting the Nation. Most of the research supported is basic in character. The program includes support of research project grants in the following disciplines: physics, chemistry, mathematical sciences, materials research, and computer research. Support is also provided for research workshops, symposia and conferences, and for the purchase of scientific equipment. In addition, awards are made to encourage innovative engineering research by scientists re-

cently awarded their Ph.D. degrees.

Eligibility: Public and private colleges and universities, nonprofit, nonacademic research institutions, private profit organizations and unaffiliated scientists under special circumstances. Grants are made on a competitive basis.

Range of Financial Assistance: $10,000 to $4,200,000.

Contact: Assistant Director, Mathematical and Physical Sciences, National Science Foundation, 1800 G St. N.W., Washington, DC 20550/202-357-9742.

Research Initiation in Minority Institutions

Objectives: To help predominantly minority colleges and universities develop greater research capability on their campuses and encourage participating faculty to compete for research funds from all appropriate sources.

Eligibility: Eligible institutions are those higher education institutions whose enrollments are predominantly (more than 50 percent) composed of Black, Native-American, Spanish-speaking, or other ethnic minorities, underrepresented in science. A faculty member of an eligible institution may submit a proposal if he/she is not presently receiving and has not received federal research support as a faculty member at the institution.

Range of Financial Assistance: $20,000 to $100,000.

Contact: Director, Office of Planning and Resources Management, National Science Foundation, 1800 G St. N.W., Washington, DC 20550/202-357-7350.

Science Education Development and Research and Resources Improvement

Objectives: To improve capabilities of academic institutions for science education and research training.

Eligibility: Public and private colleges and universities on behalf of their staff members, and individuals acting independently. State and local school systems and industrial organizations generally have not been direct recipients of Foundation support.

Range of Financial Assistance: $1,000 to $250,000.

Contact: National Science Foundation, 1800 G St. N.W., Washington, DC 20550/202-282-7900.

Scientific Personnel Management

Objectives: To help create a more effective supply of scientific manpower by providing a few highly skilled graduate students with resources to pursue their training at the institutions of their choice; encouraging training for research and teaching at all levels; encouraging research participation and short courses for science faculty; providing research experience to a number of talented high school and college students showing early promise in science; and stimulating more participation in science by women, and by minorities and the handicapped.

Eligibility: Applicants are eligible to apply for support in accordance with requirements and procedures specifically described in individual program announcements.

Range of Financial Assistance: $7,000 to $55,000.

Contact: Division of Scientific Personnel Improvement, National Science Foundation, 1800 G St. N.W., Washington, DC 20550/202-282-7754.

Scientific, Technological, and International Affairs

Objectives: To address a broad range of scientific and technologic issues of concern to policymakers and R&D managers in the public and private sector. Programs are designed to monitor and analyze the Nation's science and technology enterprise and to improve national and international exchange of scientific information. Objectives are pursued through international cooperative scientific activities, information science and technology, policy research and analysis, and science resources studies.

Eligibility: Public and private colleges and universities, nonprofit organizations, profit-making organizations, national scientific societies, individuals, and (for international cooperative scientific activities) government scientific organizations.

Range of Financial Assistance: $1,000 to $2,500,000.

Contact: Assistant Director, Directorate for Scientific Technological and International Affairs, National Science Foundation, 1800 G St. N.W., Washington, DC 20550/202-357-7631.

Two-Year and Four-Year College Research Instrumentation

Objectives: To provide research equipment costing not more than $25,000 to United States colleges and universities having substantial undergraduate programs in sciences, mathematics, and/or engineering but granting fewer than 20 Ph.D. degrees annually in those disciplines.

Eligibility: Eligible institutions are those United States colleges and universities having substantial undergraduate programs in sciences, mathematics and/or engineering but granting fewer than 20 Ph.D. degrees annually in the above disciplines.

Range of Financial Assistance: Up to $25,000.

Contact: Director, Office of Planning and Resources Management, National Science Foundation, 1800 G St. N.W., Washington, DC 20550/202-357-7456.

Grants for Scientific Research

This is a free publication that includes the guidelines and instructions directed specifically to the interests of investigators applying for support of projects in fundamental or basic research and other closely related activities such as foreign travel, conferences, symposia, and research equipment and facilities. Contact: Forms and Publications, National Science Foundation, 1800 G St. N.W., Room 235, Washington, DC 20550/202-357-7861.

Gravitational Physics

The gravitational physics program supports research on aspects of the explosive creation of the universe, its present dynamic evolution, and its ultimate fate; strong gravitational fields of X-ray sources, neutron stars, and black holes, fine details of weak gravitational fields; gravitational radiation; gravitational interaction with quantum mechanics; and particle theory. Contact: Gravitational Physics Program, Division of Physics, Directorate for Mathematical and Physical Sciences, National Science Foundation, Room 341, 1800 G St. N.W., Washington, DC 20550/202-357-7979.

Guide to NSF Programs

This guide provides summary information about National Science Foundation programs for the fiscal year. It contains general guidance for institutions and indiviudals interested in participating in these programs. Program Listings describe the principal characteristics and basic purpose of each activity, eligibility requirement, deadline dates (where applicable), and the address from which more detailed information, brochures or application forms may be obtained. Contact: Public Information Branch, National Science Foundation, 1800 G St. N.W., Room 531, Washington, DC 20550/202-357-9498.

Heat Transfer

The mechanical sciences and engineering program supports research on physical properties and predictive models of multiphase heat transfer phenomena; performance characteristics of high-flux devices; application of high-flux concepts to energy and material conservation; characterization of high-temperature transport mechanisms; and transport phenomena in soils and thermal insulation systems. Contact: Heat Transfer Program, Division of Civil and Mechanical Engineering, Directorate for Engineering and Applied Science, 1800 G St. N.W., Room 1108, Washington, DC 20550/202-357-9542.

History and Philosophy of Science

The history and philosophy of science program supports research on the nature and processes of development of science and technology; the interaction between science and technology; the impact of science and technology on society; the interactions of social and intellectual forces that promote or retard the advance of science; and differences in the nature of theory and evidence in different scientific fields. Contact: History and Philosophy of Science, Division of Social and Economic Sciences, Directorate for Biological, Behavioral and Social Sciences, National Science Foundation, 1800 G St. N.W., Room 312, Washington, DC 20550/202-357-7617.

Human Nutrition

The human nutrition program supports research aimed at increasing the knowledge and understanding of key issues involved in the design and implementation of an effective human nutrition policy for the Nation. The program focuses on determining the effects of cooking, processing, packaging, and storage on the nutrient value of processed food in terms of such factors as: bioavailability of proteins, carbohydrates, vitamins, and minerals; binding of nutrients and toxicants with nondigestible ingredients; digestion, absorption, and metabolism of nutrients; functions of microflora; and the interaction between nutrients and food additives. Contact: Human Nutrition Program, Division of Problem-Focused Research, Directorate for Engineering and Applied Science, National Science Foundation, 1800 G St. N.W., Room 1149, Washington, DC 20550/202-357-9414.

Individual Interdisciplinary Incentive Awards in the Field of Science and Values

Interdisciplinary Incentive Awards are designed to permit scholars and practitioners in the mathematical, physical, biological, social, medical, and engineering sciences and in the humanistic disciplines to pursue specific problem-oriented activities in association with specialists in fields other than their own, in order to enhance their ability to deal with issues in their field of science and values. Contact: Division of Intergovernmental and Public Service, Science and Technology, Scientific Technological and International Affairs, National Science Foundation, 5225 Wisconsin Ave. N.W., Room W666, Washington, DC 20550/202-357-7461.

Individual Sustained Development Awards for Science and Values

These awards are intended (a) to enable persons who have already made substantial contributions in the field of science and values to augment their work through long-term support, and (b) to encourage the establishment of new institutional bases for sustained work in this field. Contact: Division of Intergovernmental and Public Service, Science and Technology, Scientific Technological and Intergovernmental Affairs, National Science Foundation, Room W666, 5225 Wisconsin Ave. N.W., Washington, DC 20550/202-357-7461.

Industry/University Cooperative Research

Grants are awarded for the support of cooperative research projects involving universities and industrial firms. The research focuses on fundamental scientific or engineering questions of a basic or applied nature. Contact: Industry/University Cooperative Research/Projects, Industrial Program, Division of Intergovernmental Science and Public Technology, Directorate of Engineering and Applied Science, National Science Foundation, 1800 G St. N.W., Room 1250, Washington, DC 20550/202-357-7527.

Information Dissemination for Science Education (IDSE)

IDSE supports projects aimed at providing information to decisionmakers in education about instructional and research advances, enabling them to select appropriate materials and methodologies for the students they represent. Special emphasis is placed on disseminating information for junior high schools and middle schools, especially those in urban settings. Contact: Information Dissemination for Science Education, Division of Science Education Resources Improvement, Directorate for Science and Engineering Education, National Science Foundation, 5225 Wisconsin Ave. N.W., Room W424, Washington, DC 20550/202-282-7950.

Information Science and Technology

The National Science Foundation supports basic and applied research in information science to advance understanding of the properties and structure of information and to contribute to the store of scientific knowledge which can be applied in the design of information systems. Proposals for research into problems in the following categories are considered: standards and measures for information science; structural properties of information and language; behavioral aspects of information transfer; "infometrics" (the role of information in the economy); and information technology. Contact: Division of Information Science and Technology, Directorate for Scientific, Technological and International Affairs, National Science Foundation, 1800 G St. N.W., Room 1136, Washington, DC 20550/202-357-9572.

Initiation Awards for New Investigators in Information Science

This program is aimed at strengthening research potential in the area of information science and is directed toward young scientists. Contact: Information Science Program, Division of Information Science and Technology, Directorate for Scientific, Technological and International Affairs, National Science Foundation, 1800 G St. N.W., Room 1136, Washington, DC 20550/202-357-9569.

Innovative Processes and Their Management

Research is supported on the following topics and issues:

1. Issues related to industrial innovation and innovation process decisions in private firms;
2. Studies of how regional, state and local governments identify problems concerned with science and technology, set priorities, use formal or informal evaluative feedback, and deal with problems of accountability in the acquisition and implementation of innovative technology;
3. Analyses of how civilian sector organizations successfully use government-supported research and development, technical information, and hardware.

Contact: Innovation Processes and Their Management Working Group, Division of Policy Research and Analysis, Directorate for Scientific, Technological and International Affairs, National Science Foundation, 1800 G St. N.W., Room 1237, Washington, DC 20550/202-357-9804.

Intelligent Systems

The program on intelligent systems supports research on computer based systems that have some of the characteristics of intelligence. Relevant areas include: pattern recognition, pattern generation, knowledge representation, problem solving, natural language understanding, theorem proving, and areas related to the automatic analysis and handling of complex tasks. Contact: Intelligent Systems Program, Division of Mathematical and Computer Sciences, Directorate for Mathematical and Physical Sciences, National Science Foundation, 1800 G St. N.W., Room 339, Washington, DC 20550/202-357-7345.

Intergovernmental Programs

The objective of the intergovernmental programs is to facilitate the integration of scientific and technical resources into the activities of state and local governments. The program assists state and local governments, and the regional and national organizations that represent them, as they investigate alternative approaches toward strengthening their capacity to use scientific and technical resources. Contact: Division of Intergovernmental and Public Service Science Technology, Directorate for Scientific Technological and Intergovernmental Affairs, National Science Foundation, 1800 G St. N.W., Room 1150, Washington, DC 20550/202-357-7552.

Intermediate Energy Physics

The program on intermediate energy physics supports nuclear structure research studies using beams of high energy particles from accelerators; nuclear structure and fundamental physics research using intermediate energy particle accelerators; and nuclear physics research at the interface between particle and nuclear physics. Contact: Intermediate Energy Physics Program, Division of Physics, Directorate of Mathematical and Physical Sciences, National Science Foundation, 1800 G St. N.W., Room 341, Washington, DC 20550/202-357-7993.

International Economic Policy

This program supports research, modeling, and policy analysis on issues of international economic policy which will affect domestic economic progress and the conduct of foreign relations. Contact: International Economic Policy, Division of Policy Research and Analysis, Directorate for Scientific, Technological and International Affairs, National Science Foundation, 1800 G St. N.W., Room 1229, Washington, DC 20550/202-357-9800.

Kinetics, Catalysis, and Reaction Engineering

The chemical and process engineering programs support research on kinetics and mechanisms of reactions and processes of engineering significance; relationships of morphologic, electronic, and chemical properties to catalytic performance; basic principles for the design and fabrication of catalyst systems; reaction engineering, including modeling of chemical and physical processes and the dynamic and stability aspects of their interactions; development of new techniques applicable to the preceding areas; and photo-chemical processes. Contact: Kinetics, Catalysis and Reaction Engineering, Division of Chemical and Process Engineering, Directorate

for Engineering and Applied Science, National Science Foundation, 1800 G St. N.W., Room 1126, Washington, DC 20550/202-357-9624.

Kitt Peak National Observatory

The National Science Foundation supports the Kitt Peak National Observatory (KPNO) as the Nation's center for research in ground-based optical and infrared astronomy. Large optical telescopes, observing equipment, and research support services are made available to qualified scientists. Research carried out at KPNO encompasses fields ranging from solar physics to cosmology. The observatory's basic programs support the operation of 14 telescopes. Many of the telescopes, including the Mayall 4-meter telescope, are used for daytime infrared observations in addition to a wide variety of nighttime observations. The KPNO facilities and instrumentation are available on a competitive basis to all qualified U.S. scientists. Contact: Kitt Peak National Observatory, P.O. Box 26732, Tucson, AZ 85726, or: Kitt Peak National Observatory, Division of Astronomical Sciences, Directorate for Astronomical, Atmospheric, Earth and Ocean Sciences, National Science Foundation, 1800 G St. N.W., Room 618, Washington, DC 20550/202-357-9740.

Law and Social Sciences

The Law and Social Sciences program supports research on the processes that enhance or diminish the impact of law; causes and consequences of variations and changes in legal institutions; personal, social, and cultural factors affecting the use of law; effects of traditional and alternative means of dispute resolution; decision-making in legal forums and contexts; and conditions and processes that create transformations between formal legal rules and law in action. Contact: Law and Social Sciences Program, Division of Social and Economic Sciences, Directorate for Biological, Behavioral, and Social Sciences, National Science Foundation, 1800 G St. N.W., Room 312, Washington, DC 20550/202-357-9567.

Linguistics

The linguistics program supports research on syntactic, semantic, phonologic, and phonetic properties of individual languages and of language in general; acquisition of language by children; psychologic processes in the production and perception of speech; biologic foundations of language; social influences on and effects of language and dialect variation; and formal and mathematical properties of language models.

Contact: Linguistic Program, Division of Behavioral and Neural Sciences, Directorate for Biological, Behavioral and Social Sciences, National Science Foundation, 1800 G St. N.W., Room 320, Washington, DC 20550/202-357-7696.

Low Temperature Physics

The low temperature physics program supports experimental research on condensed matter that requires low and/or ultra-low temperatures, including the study of phase transitions and critical point behavior in the isotopes of helium, hydrogen, and other materials, the occurrence and nature of superconductivity among these new phases of binary and ternary alloys and compounds, nonequilibrium superconducting properties of weak link and Josephson Junction devices, superfluid properties of the isotopes of helium, and these and related phenomena as they pertain to systems of reduced dimensionality and crystalline perfection. Contact: Low Temperature Physics Program, Division of Materials Research, Directorate for Mathematical and Physical Sciences, National Science Foundation, 1800 G St. N.W., Room 404, Washington, DC 20550/202-357-9787.

Marine Chemistry

The ocean sciences project supports research on the equilibria of chemical species and compounds in seawater and their availability for reacting with other chemical phases in the marine environment; fluxes between seafloor sediments, their interstitial waters, and the overlying seawater; the fate of material deposited on the sea floor; alterations of material moving through the water column and the effects of such alterations on the sedimentary record and nutrient availability; interactions and interdependencies between the chemistry and biology of the marine environment; air-sea exchange phenomena related to the sea as a source or sink for manmade and naturally mobilized chemicals; the role of air transport on the chemical properties of the ocean surface; kinetic and thermodynamic reactions in the marine environment; and physical and chemical properties of seawater. Contact: Marine Chemistry Program, Division of Ocean Sciences, Directorate for Astronomical, Atmospheric, Earth and Ocean Sciences, National Science Foundation, 1800 G St. N.W., Room 611, Washington, DC 20550/202-357-7910.

Materials Research Laboratories

Major interdisciplinary laboratories are designed to complement individual research funding. Their essential activities include the development and operation of central experimental facilities for the joint use of faculty and students in such areas as research of high magnetic fields; the study of all forms of matter with an extremely intense source of continuous, electromagnetic radiation reaching into the far ultraviolet and x-ray regions of the spectrum; and the collection of data on small-angle neutron scattering. Contact: Materials Research Laboratory Section, Division of Materials Research, Directorate for Mathematical and Physical Sciences, National Science Foundation, 1800 G St. N.W., Room 408, Washington, DC 20550/202-357-9791.

Measurement Methods and Data Resources

The measurement methods and date resources program supports survey operations research; methods and models for the quantitative analysis of social data; improvements in the scientific adequacy and accessibility of social statistics data, including those generated by government as well as the academic research community; and development and testing of new social indicators. Contact: Measurement Methods and Data Resources Program, Division of Social and Economic Sciences, Directorate for Biological, Behavioral and Social Sciences, National Science Foundation, 1800 G St. N.W., Room 312, Washington, DC 20550/202-357-7913.

Mechanical Systems

The mechanical sciences and engineering program supports research on kinematics, dynamics, mechanisms and gears; lubrication and surface mechanics; vibrations and acoustics; control theory applied to mechanical systems; computer-aided design and manufacturing; robotics; and optimum design, failure analysis, and reliability. Contact: Mechanical Systems Program, Division of Civil and Mechanical Engineering, Directorate for Engineering, National Science Foundation, 1800 G St. N.W., Room 418, Washington, DC 20550/202-357-9542.

Medal of Science Award

The National Medal of Science is awarded by the President to individuals who in the President's judgment deserve special recognition for their outstanding contributions to knowledge in the physical, biological, mathematical or engineering sciences. Not more than twenty individuals may be awarded the Medal in any one calendar year. For information on the selection committees, Medal recipients, ceremonies and related matters, contact: Medal of Science Award, Office of Planning and Resources Management, National Science Foundation, 1800 G St. N.W.,

Room 545, Washington, DC 20550/202-357-7512.

Memory and Cognitive Processes

The memory and cognitive processes program supports research on complex human cognitive behavior including memory, attention, concept formation, decisionmaking, reading, thinking, and problem-solving and the development of cognitive processes in infants and children. Contact: Memory and Cognitive Processes Program, Division of Behavioral and Neural Sciences, Directorate for Biological, Behavioral and Social Sciences, National Science Foundation, 1800 G St. N.W., Room 320, Washington, DC 20550/202-357-9898.

Metabolic Biology

The metabolic biology program supports research on biochemical processes in animal, plant, and microbial systems by which energy is provided and through which material is assimilated and broken down, including photosynthesis and nitrogen fixation, ion transport across membranes, oxidative phosphorylation, chemiosmotic systems, the elucidation of metabolic pathways, and the role of natural products in plant function. Contact: Metabolic Biology Program, Division of Physiology, Cellular and Molecular Biology, Directorate for Biological, Behavioral and Social Sciences, National Science Foundation, 1800 G St. N.W., Room 325, Washington, DC 20550/202-357-7987.

Metallurgy

The metallurgy program supports research on slags and slag metal reactions; kinetics of gas-metal reactions; metal reactions; shape, property change, and control; predictive property and performance analysis under conditions of variable stress, strain-rate, time, temperature, and environmental conditions; surface corrosion, erosion, abrasion, wear, and hydrogen embrittlement; ion implantation of surface and near-surface structure and resulting property changes; preparation, characterization, property behavior and nature of metastability of amorphous metallic materials; theoretic modeling and computer calculations of multicomponent systems, phase transformations, high temperature metal-hydrogen and metal-sulfur systems, and transition metal/noble metal compounds. Contact: Metallurgy Program, Division of Materials Research, Directorate for Mathematical and Physical Sciences, National Science Foundation, Room 411, 1800 G St. N.W., Washington, DC 20550/202-357-9789.

Meteorology

The atmospheric science program supports studies on how severe storms are initiated, organized, and maintained; the relationship of the electrical budget to the characteristics of cloud and precipitation particles; how tornadoes are initiated; the effects of haze layers and clouds on the radiation balance of the Earth and atmosphere; the role of ice in the formulation of natural clouds and precipitation and how ice crystals and nuclei can be measured; and the major physical processes initiating and maintaining cyclonic storms in middle latitudes and how these developments relate to severe local storms. For additional information, contact: Meteorology Program, Division of Atmospheric Sciences, Directorate for Astronomical, Atmospheric, Earth and Ocean Sciences, National Science Foundation, 1800 G St. N.W., Room 644, Washington, DC 20550/202-357-7624.

Minority Graduate Fellowships

Under this program, support is provided to minority graduate students for study or work toward Masters or Doctoral degrees in science fields that receive National Science Foundation support. For additional information on fellowships, contact: Minority Graduate Fellowship Program, Division of Scientific Personnel Improvement, Directorate for Science and Engineering Education, National Science Foundation, 5225 Wisconsin Ave. N.W., Room W484, Washington, DC 20550/202-282-7154.

Minority Research Initiation

The minority research initiation program provides support for individual full-time minority faculty members who are nationals of the United States and who wish to establish quality research efforts on their campuses, thereby increasing their capability to compete successfully for regular support from the Foundation and other sources. Contact: Minority Research Initiation Program, National Science Foundation, 1800 G St. N.W., Room 418, Washington, DC 20550/202-357-7350.

Minor Miracle: An Informal History of the National Science Foundation

This publication is on sale for $2.75 from the Superintendent of Documents, Government Printing Office, Washington, DC 20402/202-783-3238. For additional information, contact: National Science Foundation Historian, Office of Government and Public Programs, National Science Foundation, 1800 G St. N.W., Room 527, Washington, DC 20550/202-357-9637.

Modern Mathematical Analysis

The modern analysis program supports research on linear and nonlinear functional analysis; harmonic analysis; linear topological spaces; operator theory; topological dynamics; ergodic theory; mathematical physics; and measurement theory. Contact: Modern Analysis Program, Division of Mathematical and Computer Sciences, Directorate for Mathematical and Physical Sciences, National Science Foundation, 1800 G St. N.W., Room 304, Washington, DC 20550/202-357-9764.

Mosaic

This is a bimonthly magazine containing articles of particular interest to the scientific and educational communities serviced by the National Science Foundation. It is sold for $12.00 per year by the Superintendent of Documents, Government Printing Office, Washington, DC 20402/202-783-3238. For information, contact: Communications Resource Branch, National Science Foundation, 1800 G St. N.W., Room 531, Washington, DC 20550/202-357-9776.

National Astronomy and Ionosphere Center

The National Science Foundation supports the National Astronomy and Ionosphere Center (NAIC), a visitor-oriented National Research Center devoted to scientific investigations in atmospheric sciences and radio and radar astronomy. Its principal observing facilities are located 19 kilometers (12 miles) south of the city of Aercibo, Puerto Rico. NAIC provides telescope users with a wide range of research and observing instrumentation, including receivers, transmitters, movable line feeds, and digital data acquisition and processing equipment. The Center has a permanent staff of scientists, engineers, and technicians who are available to assist visiting investigators with their observing programs. The NAIC facilities and instrumentation are available on a competitive basis to qualified scientists from all over the world. For information, contact: National Astronomy and Ionosphere Center, Cornell University, Ithaca, NY 14853, or National Astronomy and Ionosphere Center, Division of Astronomical Sciences, Directorate for Astronomical, Atmospheric, Earth and Ocean Sciences, National Science Foundation, 1800 G St. N.W., Room 618, Washington, DC 20550/202-357-9484.

National Center for Atmospheric Research

NCAR serves as a focal point for research in the atmospheric sciences and offers fellowships as well as facilities and research support to qualified scientists working in the atmospheric sciences. NCAR's major efforts include research in: developing and testing of numerical models of large-scale atmospheric circulation; interaction between the properties of clouds and the Earth's surface heat; improved forecasting of severe weather events; relationship among chemical, physical and dynamic processes in the stratosphere and beyond; phenomena occurring in the lower atmosphere; phenomena due to solar variability; and cause-effect relationships among phenomena occurring on and below the solar surface, in the solar atmosphere, and in space out to the Earth's atmosphere. In addition to conducting its own research programs, NCAR participates in a number of atmospheric research efforts conducted by government agencies, university scientists, and research groups on a national or international scale. Contact: National Center for Atmospheric Research, P.O. Box 3000, Boulder, CO 80307, or Centers and Facilities Program, Division of Atmospheric Sciences, Directorate for Astronomical, Atmospheric, Earth and Ocean Sciences, National Science Foundation, 1800 G St. N.W., Room 644, Washington, DC 20550/202-357-9889.

National Radio Astronomy Observatory

The National Science Foundation supports the National Radio Astronomy Observatory (NRAO), which makes radio astronomy facilities available to qualified scientists. The NRAO staff assists visiting scientists with the large radio antennas, receivers, and other equipment needed to detect, measure, and identify radio waves from astronomical objects. Contact: National Radio Astronomy Observatory, Edgemont Rd., Charlottesville, VA 22901, or National Radio Astronomy Observatory, Division of Astronomical Sciences, Directorate for Astronomical, Atmospheric, Earth, and Ocean Sciences, National Science Foundation, 1800 G St. N.W., Room 618, Washington, DC 20550/202-357-9857.

National Science Board

The National Science Board is the policymaking arm of the National Science Foundation. The policies of the Board on support of science and development of scientific personnel are generally implemented throughout the various programs of the Foundation. The Board issues the following publications, *National Science Board Booklet* and *Criteria for the Selection of Research Projects by the National Science Foundation*, which are available at no cost from: Forms and Publications, National Science Foundation, Washington, DC 20550/202-357-7861. *Science at the Bicentenni-*

al—A Report from the Research Community ($2.95), *Basic Research in the Mission Agencies* ($5.75), and *Science Indicators—1978* ($6.00) are sold by the Superintendent of Documents, Government Printing Office, Washington, DC 20402/202-783-3238. For additional information on the National Science Board, contact: National Science Board, National Science Foundation, 1800 G St. N.W., Room 545, Washington, DC 20550/202-357-7510.

National Scientific Balloon Facility

This facility provides the scientific community with ballooning support for high-altitude experiments, and conducts research and development programs aimed at advancing scientific ballooning technology. It also provides ballooning support to a large number of United States and foreign investigators in order to conduct a broad spectrum of experiments in the fields of cosmic rays, X-rays, infrared astronomy, and particles and fields in the magnetosphere. Support is also provided for the measurement of dynamical atmospheric parameters, trace gases involved in ozone formation and destruction, and condensation nuclei important for aerosol production. Contact: Centers and Facilities Program, Division of Atmospheric Sciences, Directorate for Astronomical, Atmospheric, Earth and Ocean Sciences, National Science Foundation, 1800 G St. N.W., Room 644, Washington, DC 20550/202-357-9695.

NATO Postdoctoral Fellowships

The North Atlantic Treaty Organization sponsors a program of NATO Postdoctoral Fellowships. At the request of the Department of State, the Foundation administers this program for NATO. Contact: Postdoctoral Fellowship Program, Division of Scientific Personnel Improvement, Directorate for Science Education, National Science Foundation, 5225 Wisconsin Ave. N.W., Room W400, Washington, DC 20550/202-282-7154.

Neurobiology

The neurobiology program supports research on the development, function, and other aspects of nervous systems at the molecular, cellular, physiological, and behavioral levels; neuroanatomy; neurochemistry; neuroendocrinology; neurophysiology; and neuropsychology. contact: Neurobiology Program, Division of Behavior and Neural Sciences, Directorate for Biological, Behavioral, and Social Sciences, National Science Foundation, 1800 G St. N.W., Room 320, Washington, DC 20550/202-357-7471.

NSF Bulletin

This publication is issued monthly (except July and August), and disseminates information on National Science Foundation programs, policies and activities, staff changes, meetings, new publications, etc. Contact: Public Information Branch, National Science Foundation, 1800 G St. N.W., Room 531, Washington, DC 20550/202-357-9498.

Nuclear Physics

The program on nuclear physics supports research on the characteristics of the strong force and its quantitative relationship to the properties and dynamics of nuclei; nuclear reactions; universal symmetry and conservation laws and the nature of the weak interaction; and interdisciplinary applications of nuclear physics. Contact: Nuclear Physics Program, Division of Physics, Directorate for Mathematical and Physical Sciences, National Science Foundation, 1800 G St. N.W., Room 341, Washington, DC 20550/202-357-7992.

Ocean Margin Drilling

A major initiative of the ocean margin drilling program will be an extensive investigation of the ocean margins. The passive margins with their thick sediment cover (e.g., the U.S. east coast) represent a major frontier for geologic exploration. Besides its great scientific importance, work on the deeply submerged ocean margins will constitute the first major effort to establish the geologic framework for determining the natural resource potential of these areas. Contact: Ocean Margin Drilling Project, Ocean Drilling Programs, Directorate for Astronomical, Atmospheric, Earth and Ocean Sciences, National Science Foundation, 1800 G St. N.W., Room K300, Washington, DC 20550/202-653-9150. Scientists interested in participating aboard the drilling ship should write to: Chief Scientist, Deep Sea Drilling Project, Scripps Institution of Oceanography, University of California at San Diego, La Jolla, CA 92037. Requests for samples of the core material should be directed to: Curator, Deep Sea Drilling Project, Scripps Institution of Oceanography. Suggestions for scientific planning, including sites to be included on the drilling itinerary, should be addressed to: Manager, Deep Sea Drilling Project, Scripps Institution of Oceanography.

Oceanographic Facilities and Support

The National Science Foundation supports construction, modification, conversion, purchase, and operation of oceanographic facilities that

lend themselves to shared usage. Facilities supported under this program are those required for research in the open oceans and in coastal areas. Examples of such facilities are ships, boats, submersibles, and shipboard gear and instruments for data collection and analysis. Contact: Office of Oceanographic Facilities and Support, Directorate for Astronomical, Atmospheric, Earth and Ocean Sciences, National Science Foundation, 1800 G St. N.W., Room 613, Washington, DC 20550/202-357-7837.

Particulate and Multiphase Processes

The chemical and process engineering program supports research on colloidal, interfacial, and hydrodynamic behavior of dispersed solids (colloids, slurries, and aerosols), liquids (emulsions and mists), and gases (froths and foams), and physics, chemistry, and engineering principles governing such solid-processing operations as generation, size modification, transport, classification, and separation. Contact: Particulate and Multiphase Processes Program, Division of Chemical and Process Engineering, Directorate for Engineering and Applied Science, National Science Foundation, 1800 G St. N.W., Room 1126, Washington, DC 20550/202-357-9606.

Patents and Inventions

Each Foundation grant in support of research is subject to a patent and invention clause. This clause governs, in a manner calculated to protect the public interest and the equities of the grantee, the disposition of inventions made or conceived under the grant. Information on patents or inventions, Institutional Patent Agreements, licenses and rights is available. Contact: Office of the General Counsel, National Science Foundation, 1800 G St. N.W., Room 501, Washington, DC 20550/202-357-9435.

Physical Oceanography

The ocean sciences project supports research on the description, analysis, and modeling of ocean circulation and transport on the global scale and mesoscale; effects of global and mesoscale circulation on energy momentum transport; physical processes of circulation, eddy generation, and turbulent mixing on the continental shelves; mixing processes and circulation in rivers and bays where fresh water and ocean meet; wind-generated tides and surface and internal waves; small-scale (less than a meter) transport processes such as diffusion, conduction and convection, and three-dimensional turbulence; physical properties of seawater; and physical processes of circulation and mixing in lakes. Contact: Phys-

ical Oceanography Program, Division of Ocean Sciences, Directorate for Astronomical, Atmospheric, Earth and Ocean Sciences, National Science Foundation, 1800 G St. N.W., Room 606, Washington, DC 20550/202-357-7906.

Polar Region Books, Maps, and Folios

A listing of books, maps, and folios concerning the Polar regions is available. Contact: Information Section, Division of Polar Programs, Directorate for Astronomical, Atmospheric, Earth and Ocean Sciences, 1800 G St. N.W., Room 627, Washington, DC 20550/202-357-7819.

Policy Research

This office funds policy research, and includes among its research performers small business firms which specialize in areas such as: socio-economic effects of science and technology, innovation processes and their management, environment, energy and resources, international economic policy and technology assessment and risk analysis. Contact: Policy Research and Analysis Division, Directorate for Scientific, Technological and International Affairs, National Science Foundation, 1800 G St. N.W., Room 1233, Washington, DC 20550/202-357-9689.

Political Science

The political science program supports research on local, national, and international governmental institutions; the effects of structural factors on political participation and effectiveness; the impact of economic and social change on political processes; factors influencing bureaucratic decisionmaking and policy formulation; and processes of conflict and political instability. Contact: Political Science Program, Division of Social and Economic Sciences, Directorate for Biological, Behavioral and Social Sciences, National Science Foundation, 1800 G St. N.W., Room 312, Washington, DC 20550/202-357-9406.

Polymers

The polymers program supports research on the fundamental behavior of single macromolecules and aggregates in amorphous or crystalline arrangements; synthesis of new polymers; new methods of polymerization; reactions of polymers; molecular characteristics and their relation to mechanical, optical, and transport properties; macromolecular chain dynamics; polymer surfaces; biocompatibility; environmental, raw material, and energy considerations; and theoretical treatment of macromolecular behavior. Contact: Polymers Program, Division of Materials Re-

search, Directorate for Mathematical and Physical Sciences, National Science Foundation, 1800 G St. N.W., Room 411, Washington, DC 20550/202-357-9789.

Population Biology and Physiological Ecology

The program on population biology and physiological ecology supports research on general principles that describe the physiological adaptations of animals and plants to their microenvironments; evolutionary and ecologic significance of life history characteristics of plants and animals (including behavioral ecology); theoretic models for ecological genetics; adaptive significance of genetic variability; and physiological aspects of genetically determined enzyme variability. Contact: Population Biology and Physiological Ecology Program, Division of Environmental Biology, Directorate for Biological, Behavioral and Social Sciences, National Science Foundation, Washington, DC 20550/202-357-9728.

Postdoctoral Fellowships

This program awards fellowships to scientists who have received their doctorate within the last five years to assist them in strengthening their research capabilities. Contact: Postdoctoral Fellowship Program, Division of Scientific Personnel Improvement, Directorate for Science Education, National Science Foundation, 5225 Wisconsin Ave. N.W., Room W400, Washington, DC 20550/202-282-7154.

Probability and Statistics

The program on probability supports research on the mathematical modeling for situations involving change or incomplete information. Major subfields include Markov processes, probability on Banach spaces, limit theorems, interacting particle systems, and stochastic processes. The program on statistics supports the theoretical development and application of methods suitable for extracting information about real events from relevant numerical measurements. Major subfields include testing, design, inference, robustness, sampling, sequential analysis, and multivariate analysis. Contact: Statistics and Probability Program, Division of Mathematical and Computer Sciences, Directorate for Mathematical and Physical Sciences, National Science Foundation, 1800 G St. N.W., Room 304, Washington, DC 20550/202-357-9764.

Psychobiology

The psychobiology program supports research on environmental, genetic, hormonal, and motivational determinants of behavior; animal learning, conditioning, stimulus control, preferences, and aversions; migration and homing behavior of animals; and animal ingestive, reproductive, social, and communicative behavior. Contact: Psychobiology Program, Division of Behavioral and Neural Sciences, Directorate for Biological, Behavioral and Social Sciences, National Science Foundation, 1800 G St. N.W., Room 320, Washington, DC 20550/202-357-7949.

Publications of the National Science Foundation

This publication is a list of administrative and statistics publications issued by the National Science Foundation. Contact: Forms and Publications, National Science Foundation, 1800 G St. N.W., Room 235, Washington, DC 20550/202-357-7861.

Public Policy and Regulation

The applied social and behavioral science program supports research on more and better information on policy issues of national concern such as unemployment, international trade, regulation, telecommunications, inflation, and the use of scientific and technical information in judicial and administrative decisionmaking. Contact: Public Policy and Regulation Program, Division of Applied Research, Directorate for Engineering, National Science Foundation, 1800 G St. N.W., Room 413, Washington, DC 20550/202-357-7538.

Public Service Delivery and Urban Problems

The applied social and behavioral science program supports research on improved information on the changing character of urban areas and populations in the United States, the changing demands for services, alternative mechanisms for improving governmental responsiveness to service needs and improvements in public management, and the effectiveness and quality of public service delivery. Contact: Public Service Delivery and Urban Problems Program, Division of Social and Economic Science, Directorate for Biological, Behavioral, and Social Sciences, National Science Foundation, 1800 G St. N.W., Room 413, Washington, DC 20550/202-357-7534.

Quantum Electronics, Waves, and Beams

The electrical, computer and systems engineering program supports research on new and improved coherent sources for the infrared, visible, and ultraviolet spectral laser regions; generation of picosecond laser pulses and interaction of short pulses with materials; novel laser spectroscopic methods; nonlinear optics; free-electron laser studies; analysis of propagation through random media; numerical methods for solving scattering problems; nonlinear wave phenomena,

antennas, and waveguides; linear and nonlinear effects in surface acoustic wave structures, acoustic resonators, and other bulk devices; sonar-related studies; generation of plasmas; wave effects on plasmas; and properties of charged particle beams. Contact: Quantum Electronics, Waves and Beams Program, Division of Electrical, Computer and Systems Engineering, Directorate for Engineering and Applied Science, National Science Foundation, 1800 G St. N.W., Room 1101, Washington, DC 20550/202-357-9618.

Radio Spectrum Management

This office coordinates radio spectrum usage for research and frequency assignments for other telecommunications/electronics systems with government agencies. Contact: Radio Spectrum Coordinator, Division of Astronomical Sciences, Directorate for Astronomical, Atmospheric, Earth and Ocean Sciences, National Science Foundation, 1800 G St. N.W., Room 618, Washington, DC 20550/202-357-9696.

Reading Room/Library

A collection of agency policy documents, staff instructions and orders, as well as current indexes, is available to the public for inspection. Contact: Reference and Records Management, Financial and Administrative Management Division, National Science Foundation, 1800 G St. N.W., Room 1242, Washington, DC 20550/202-357-7811.

Regional Instrumentation Facilities

The foundation has established regional instrumentation facilities which will improve the quality and scope of research in the various regions of the United States. These facilities will increase the availability of new and powerful instrumentation to researchers in these regions on a shared basis. Trained staff needed to maintain and operate the equipment is available at each facility. The program will improve geographic distribution of basic research capability and enhance research interactions among university, industry, and government scientists and engineers. A list of regional instrumentation facilities is available upon request. Contact: Regional Instrumentation Facilities Program, Directorate of Mathematical and Physical Sciences, National Science Foundation, 1800 G St. N.W., Room 340, Washington, DC 20550/202-357-7503.

Regulatory Biology

The regulatory biology program supports research on the characteristics and evolution of mechanisms, such as endocrine and neuroendo-

crine systems, that initiate, integrate, and regulate physiologic functions in tissues, organs, and organisms. Contact: Regulatory Biology Program, Division of Physiology, Directorate for Biological, Behavioral and Social Sciences, National Science Foundation, 1800 G St. N.W., Room 332, Washington, DC 20550/202-357-7975.

Reports and Studies

The following reports and studies are available from the Division of Science Resource Studies:

ANALYTIC REPORTS

National Patterns of Science and Technology Resources, 1980 ($3.25), 1981 ($4.75)

Federal Funds for Research and Development, Fiscal Years 1977, 1978, and 1979, Volume XXVII ($2.50)

Fiscal Years, 1978, 1979, and 1980, Volume XVIII ($3.75)

Science and Engineering Personnel: A National Overview ($4.75)

An Analysis of Federal R&D Funding by Function, Fiscal Years 1969–1979 and Fiscal Years 1980–1982 ($2.50 each)

Research and Development in State and Local Governments, Fiscal Year 1977 (free)

Research and Development in Industry, 1977 ($3.50), *1978* (free)

Federal Support to Universities, Colleges and Selected Nonprofit Institutions, Fiscal Year 1977 ($3.50), *Fiscal Year 1978* ($5.50)

Academic Science, 1972–77. R&D Funds, Scientists and Engineers, and Graduate Enrollment and Support ($4.25)

Academic Science, R&D Funds, Fiscal Year 1978, Fiscal Year 1979, Scientists & Engineers, January 1979, January 1980

Graduate Enrollment and Support, Fall 1978, Fall 1980

Employment Patterns of Academic Scientists and Engineers, 1973–78 ($1.75)

R&D Activities of Independent Nonprofit Institutions, 1973 ($1.90)

Characteristics of Experienced Scientists and Engineers in the United States, 1976, 1978

U.S. Scientists and Engineers, 1978

Projections of Supply and Utilization of Science and Engineering Doctorates, 1982 and 1987 ($2.25)

Scientific and Technical Personnel in Private Industry 1977, 1978–1980 ($2.00)

Occupational Mobility of Scientists and Engineers ($1.75)

REVIEWS OF DATA ON SCIENCE RESOURCES (SHORT ANALYTIC STUDIES)

Employment Characteristics of Recent Science and Engineering Graduates: The Effects of Work Experience, Advanced Degrees, and Business Cycles ($1.50)

State and Local Government R&D Expenditures, FY 1977 ($1.25)

Sex and Ethnic Differentials in Employment and Salaries Among Federal Scientists and Engineers ($1.00)

U.S. Industrial R&D Spending Abroad ($.70)

Employment Patterns of Recent Entrants into Science and Engineering ($.80)

A Comparison of National Industrial R&D Estimates with Actual NSF/Census Data ($.80)

Scientific and Technical Personnel in Private Industry, 1969–70 and 1975 ($.80)

Current and Future Utilization of Scientific and Technical Personnel in Energy-Related Activities ($.60)

Scientists and Engineers from Abroad, Trends of the Past Decade, 1966–75 ($.35)

Contact: Editorial and Inquiries Unit, Division of Science Resources Studies, Directorate for Scientific, Technological and International Affairs, National Science Foundation, 2000 L St. N.W., Room L611, Washington, DC 20550/202-634-4622.

Research and Resources Facility for Submicron Structures

This facility, supported through the solid state and micro-structures engineering program and located at Cornell University, provides the equipment and expertise needed to fabricate structures that have features less than a micrometer in length. The facility's resources include a computer-controlled, electron-beam pattern-generating system, as well as thin-film growth, processing, and characterization systems. Contact: Research and Resources Facility for Submicron Structures, Cornell University, Ithaca NY 14853, or Solid State and Microstructures Engineering Program, Division of Electrical, Computer and Systems Engineering, Directorate for Engineering, National Science Foundation, 1800 St. N.W., Room 1101, Washington, DC 20550/202-357-9618.

Research Apprenticeships for Minority High School Students

The research apprenticeships for minority high school students program gives talented minority high school students hands-on experience in science and engineering research. During the summer the students work in research projects with individual scientists. Academic year activities include part-time research at the grantee institution, research at the students' high schools to be presented at local or national science fairs demonstrating the summer science experience to high school peers, or laboratory assistant experience. Contact: Student Oriented Programs, Division of

Scientific Personnel Improvement, Directorate for Science Education, National Science Foundation, 5225 Wisconsin, Ave. N.W., Room W408, Washington, DC 20550/202-282-7150.

Research Program in Ethics and Values

This program considers proposals to support several types of activities, including the following:

1. Research on specific situations in which ethical and value issues have arisen in the conduct of science and technology;
2. Workshops of national scope to examine professional responsibilities associated with scientific and technologic activities;
3. Projects of national scope to enable scientists and engineers to enhance their ability to deal with the ethical and social issues associated with their professional work;
4. Projects of national scope to address the integration of Ethics and Values in Science and Technology (EVIST) issues into the education of scientists and engineers.

Contact: Office of Science and Society, Directorate for Science Education, National Science Foundation, 1800 G St. N.W., Room 1140, Washington, DC 20550/202-357-7461.

Resource Centers for Science and Engineering

This program encourages the participation of students from minority and low-income families in science and engineering by establishing geographically dispersed resource centers to promote professional development and research opportunities. The Centers provide access to established scientists and quality science programs and develop joint educational programs designed to increase the involvement of minority and low-income students in science and science careers. The resource centers also foster the dissemination and interpretation of scientific information to the nonscientific community and encourage academic and nonacademic communities to exchange views about local scientific needs and interests. Contact: Resource Centers for Science Engineering, Division of Science Education Resource Improvement, Directorate for Science Education, National Science Foundation, 5225 Wisconsin Ave. N.W., Room W440, Washington, DC 20550/202-282-7760.

Sacramento Peak Observatory

The National Science Foundation supports the Sacramento Peak Observatory (SPO), a National Research Center devoted to studies in the fields of solar physics, solar-terrestrial relationships,

and related disciplines. SPO makes available to qualified scientists optical solar research support services. All qualified U.S. scientists and, on occasion, foreign visitors, have access to SPO facilities on a competitive basis. Contact: Sacramento Peak Observatory, Sunspot, NM 88349, or Sacramento Peak Observatory, Division of Astronomical Sciences, Directorate for Astronomical, Atmospheric, Earth and Ocean Sciences, National Science Foundation, 1800 G St. N.W., Room 618, Washington, DC 20550/202-357-9484.

Science and Engineering Personnel: A National Overview

This publication presents a review of current employment and supply patterns for United States scientists and engineers, details of the status of doctoral scientists and engineers, and an examination of the dynamics of the science and engineering labor markets. Appendices provide technical notes and statistics tables on science and engineering personnel. The report is sold for $4.25 by the Superintendent of Documents, Government Printing Office, Washington, DC 20402/202-783-3238. For additional information, contact: Editorial and Inquiries Unit, Division of Science Resource Studies, 2000 L St. N.W., Room L611, Washington, DC 20550/202-634-4622.

Science and Technology to Aid the Handicapped

The objectives of the science and technology to aid the handicapped program are to:

1. Improve sensory systems (speech, visual, hearing, and tactile) and locomotion and manipulatory capabilities through research projects that encourage the use of the best scientific and engineering developments;
2. Involve the handicapped community in the development of the program to help insure that the research meets the social and economic needs, as well as the physical needs of the handicapped;
3. Focus the research capabilities of universities, industries, small businesses and nonprofit institutions on new low-cost approaches to bringing scientific and technologic developments to the aid of the handicapped.

Contact: Science and Technology to Aid the Physically Handicapped, Electrical Computer and Systems Engineering, Directorate for Engineering and Applied Science, National Science Foundation, 1800 G St. N.W., Room 1101, Washington, DC 20550/202-357-9618.

Science in Developing Countries

The science in developing countries program is directed toward improvement of the scientific infrastructure of developing countries. Research participation grants support (a) the participation of U.S. scientists or engineers in a research project in an eligible developing country, (b) the participation by scientists or engineers from an eligible developing country in an appropriate U.S.-based research project, or (c) a combination of the two. Conference grants support national, regional and international (a) seminars that are research oriented and focused on the problems of developing countries; (b) workshops concerned with the planning and initiation of cooperative research activities; or (c) colloquia at which U.S. and counterpart scientists or engineers who are involved with state-of-the-art research explore the application of science and technology to development programs. Dissertation improvement grants are for the incremental support of developing-country graduate students who are enrolled at U.S. universities and qualified to undertake a dissertation research project. Contact: Division of International Programs, Directorate for Scientific, Technological and International Affairs, National Science Foundation, 1800 G St. N.W., Room 1212, Washington, DC 20550/202-357-9537.

Scientific and Technical Personnel

This program supports studies to provide the factual information needed to track the training and distribution of scientists and engineers in the United States. Specific areas of interest are the capability of institutions of higher education to produce scientific and technical personnel, the current and future utilization of these personnel, and the changing characteristics of scientists and engineers. Contact: Scientific and Technical Personnel Studies Section, Division of Science Resources Studies, Directorate for Scientific, Technological and International Affairs, National Science Foundation, 2000 L St. N.W., Room L611, Washington, DC 20550/202-634-4691.

Scientific Technological and International Affairs

The largest area of opportunity for small businesses in the National Science Foundation is the applied research area of scientific technology. Principal areas of research interest include: physical sciences; mathematical sciences; biological sciences; electrical, computer and systems engineering; civil and mechanical engineering; economics and social sciences; behavioral sciences, and chemical and process engineering. Typical problem areas funded include: materials research; production research; measurement and advanced instrumentation; deep mineral resources; human

nutrition; industrial processes; alternative biological sources of materials; marine research; and science and technology to aid the handicapped. Contact: Program Manager for Innovation and Small Business, Directorate, National Science Foundation, 1800 G St. N.W., Room 1250, Washington, DC 20550/202-357-7527.

Selected List of Fellowship Opportunities and Aids to Advanced Education for U.S. Citizens and Foreign Nationals

This free pamphlet describes in detail a variety of organizations, companies, foundations, etc. that provide fellowships and other financial aids to graduate and postgraduate students. Contact: Publications Office, Public Information Branch, National Science Foundation, 1800 G St. N.W., Room 531, Washington, DC 20550/202-357-9498.

Sensory Physiology and Perception

The program on sensory physiology and perception supports research on mechanisms and processes at the molecular, cellular, physiologic, and behavioral levels involved in sensory transduction, neural coding, and information processing; neurobiologic and psychophysical correlates of sensory and perceptual phenomena; and development of sensory and perceptual systems. Contact: Sensory Physiology and Perception Program, Division of Behavioral and Neural Sciences, Directorate for Biological, Behavioral and Social Sciences, National Science Foundation, 1800 G St. N.W., Room 320, Washington, DC 20550/202-357-7428.

Small Business Guide and Federal R&D

This guide provides small, technically competent firms and businesses working in the area of research and development with information about business opportunities with the federal government. It also describes criteria businesses must meet in order to participate in federally supported R&D programs and efforts, important changes in federal policy and procedures that could affect small business participation in the federal R&D market, and the level of R&D funding likely to be available in various departments and agencies of the government. Contact: Office of Small Business Research and Development, National Science Foundation, 1800 G St. N.W., Room 511A, Washington, DC 20550/202-357-7464.

Small Business Innovation Research

Small, creative science-and-technology-oriented firms have the chance to perform innovative high-risk research on scientific and technical

problems that could have significant public benefit. Research topics may range from engineering and the physical sciences to the life sciences with emphasis on advanced research concepts. Contact: Industrial Program, Division of Intergovernmental Science and Public Technology, Directorate for Engineering, and Applied Science, National Science Foundation, 1800 G St. N.W., Room 1250, Washington, DC 20550/202-357-7527.

Small Business R&D

The National Science Foundation's Office of Small Business Research and Development exists specifically to provide information and guidance to small research firms that wish to know more about National Science Foundation programs and research opportunities. Contact: Office of Small Business R&D, National Science Foundation, 1800 G St. N.W., Room 511A, Washington, DC 20550/202-357-7464.

Social and Developmental Psychology

The program on social and developmental psychology supports laboratory and field studies on how the behavior of others effects individual behavior, and research on changes in personality, social behavior, and emotional responsiveness that occur throughout the life span. Contact: Social and Developmental Psychology, Division of Behavioral and Neural Sciences, Directorate for Biological, Behavioral and Social Sciences, National Science Foundation, 1800 G St. N.W., Room 320, Washington, DC 20550/202-357-9485.

Socioeconomic Effects of Science and Technology

Research in this area addresses the following issues: the impact on economic performance of private and public investment in science and technology; the effects of government policy instruments on the level and outcome of scientific and technologic activities; the role of science and technology in U.S. private sector international transactions; and the effects of technologic change on individual and social institutions. Contact: Socioeconomic Effects of Science and Technology Working Group, Division of Policy Research and Analysis, Directorate for Scientific, Technological and International Affairs, National Science Foundation, 1800 G St. N.W., Room 1229, Washington, DC 20550/202-357-9800.

Sociology

The sociology program supports research on the processes by which organizations adapt to and produce change in their social context; deci-

sionmaking in organizations and small groups; social factors in population change; social stratification and the development of careers and work roles; the role of communication and influence networks in individual and community decision; effects of social organization on science and knowledge; variation in the social attributes of cities and their effects on competition for resources and population. Contact: Sociology Program, Division of Social and Economic Sciences, National Science Foundation, 1800 G St. N.W., Room 312, Washington, DC 20550/202-357-7802.

Software Engineering

The program on software engineering supports research on the structure and design process of computer software, especially verification, testing, portability, reliability, and human interfacing to numeric and non-numeric software systems. Areas of emphasis include: program validation and testing; software tools; and human factors in software design and use. The program also supports research in computationally oriented numerical analysis, the design and construction of high quality portable software for scientific research, and experimental implementation where that is an integral part of the research. Contact: Software Engineering, Division of Mathematical and Computer Sciences, Directorate for Mathematical and Physical Sciences, 1800 G St. N.W., Room 339, Washington, DC 20550/202-357-7345.

Software Systems Science

The program on software systems science supports research on the conceptual basis for the specification of future software systems and the necessary experimentation with such systems, including: advanced programming languages and optimizing compilers; functional and relational specification; program transforming systems; systems for the verification and proof of correctness of programs; the study of the concurrency of operations; and the discovery of new algorithms and improved measures of effectiveness of known algorithms. Contact: Software Systems Science Program, Division of Mathematical and Computer Sciences, Directorate for Mathematical and Physical Sciences, National Science Foundation, 1800 G St. N.W., Room 339, Washington, DC 20550/202-357-7375.

Solar System Astronomy

The solar system astronomy program sponsors research on the detailed structure and activity of the Sun; planetary surfaces, interiors, atmospheres, and satellites; the nature of small bodies—the asteroids, comets, and meteors—and their relevance to the origin and development of the solar system; and the 1980–81 increase to maximum of the quasi-periodic surface activity of the Sun. Contact: Solar System Astronomy Program, Division of Astronomical Sciences, Directorate for Astronomical, Atmospheric, Earth and Ocean Sciences, National Science Foundation, 1800 G St. N.W., Room 615, Washington, DC 20550/202-357-7620.

Solar-Terrestrial

The atmospheric sciences program supports research on the upper atmosphere (including the magnetosphere), responses to the energy flux from the Sun; mechanism by which the magnetosphere energizes particles from the Sun and the ionosphere and deposits them into the polar upper atmosphere to form the aurora; the nature of electric currents and particles which flow between the atmosphere, ionosphere and magnetosphere; and the effect of variation in the Sun's radiation on weather and climate. Contact: Solar-Terrestrial Program, Division of Atmospheric Sciences, Directorate for Astronomical, Atmospheric, Earth and Ocean Sciences, National Science Foundation, 1800 G St. N.W., Room 644, Washington, DC 20550/202-357-7618.

Solid Mechanics

The mechanical sciences and engineering program supports research on the measurement and prediction of the mechanical strength and behavior of solid materials used in engineering, medicine, agriculture, forestry, and food processing; the effects of environmental and loading stresses on the mechanical strength of solids; fracture mechanics and drainage theory; and creep and fatigue. Contact: Solid Mechanics Program, Division of Civil and Mechanical Engineering, Directorate for Engineering, National Science Foundation, 1800 G St. N.W., Room 1108, Washington, DC 20550/202-357-9542.

Solid State and Microstructures Engineering

The electrical, computer and systems engineering program supports research on the modeling of field effect and bipolar junction devices; noise properties of electronic components; thin-film growth and device fabrication; electron-beam and x-ray lithography; photovoltaic devices; and superconductive electronics. Contact: Solid State and Microstructures Engineering Program, Division of Electrical, Computer and Systems Engineering, Directorate for Engineering, National Science Foundation, 1800 G St. N.W., Room 1101, Washington, DC 20550/202-357-9618.

Solid State Chemistry

The solid state chemistry program supports research on electrical and magnetic properties of anisotropic materials, with emphasis on organometallic compounds; molecular studies of chemisorption of species on surfaces, including heterogeneous catalysis and the chemistry of friction, lubrication and wear; properties and phases of liquid crystals; ionic and superionic conductivity in materials; and solid state chemical synthesis. Contact: Solid State Chemistry Program, Division of Materials Research, Directorate for Mathematical and Physical Sciences, National Science Foundation, 1800 G St. N.W., Room 404, Washington, DC 20550/202-357-9737.

Solid State Physics

The solid state physics program supports experimental research on metals, semiconductors and insulators in the crystalline state, the amorphous state, and intermediate states of disorder, involving studies of phase transitions, critical point phenomena, and electronic, magnetic, and lattice structures and their excitations. Important areas include studies of physical phenomena at surfaces and interfaces; photon, electron, and neutron scattering from solids; transport properties; resonance studies; and nonlinear phenomena. Contact: Solid State Physics Program, Division of Material Research, Directorate for Mathematical and Physical Sciences, National Science Foundation, 1800 G St. N.W., Room 404, Washington, DC 20550/202-357-9737.

Source Book of Projects

This book provides information on the awards made in the past fiscal year by the Division of Science Education Development and Research. It also provides information on awards given in previous years. Contact: Division of Science Education Development and Research, Directorate for Science Education, National Science Foundation, 5225 Wisconsin Ave. N.W., Room W638, Washington, DC 20550/202-282-7900.

Special Science and Technology Indicators

This program supports studies of the dynamics of the science and technology resources complex. A major component of this undertaking involves the development of special indicators, primarily of an output nature. This work, along with that of the other science resources studies programs that deal primarily with inputs, provides the basis for the National Science Board's biennial *Science Indicators* publications, which are prepared by the Division. Also included are modeling and simulation activities designed to lead to a better understanding of the factors that are responsible for the changes in the distribution of human and financial resources for science and technology. Contact: Science Indicators Unit, Division of Science Resources Studies, Directorate for Scientific, Technological and International Affairs, National Science Foundation, 2000 L St. N.W., Room L611, Washington, DC 20550/202-634-4682.

Specimens and Core Samples

Ice cores, ocean bottom sedimentary cores, terrestrial sedimentary cores, dredged rocks, biologic specimens, meteorites, and ocean bottom photographs are available for study. For information on "specimen and core-sample distribution policy," contact: Information Section, Division of Polar Programs, Directorate for Astronomical, Atmospheric, Earth and Ocean Sciences, National Science Foundation, 1800 G St. N.W., Room 627, Washington, DC 20550/202-357-7819.

Stars and Stellar Evolution

The stars and stellar evolution program sponsors research on all aspects of the stellar life cycle, including observation and theoretic studies of the beginning and end points of stellar evolution; physical properties of various classes of stellar objects, including the effects of mass loss, rotation, and magnetic fields on stellar structure; and theoretic and laboratory studies associated with atoms and molecules in space. Contact: Stars and Stellar Evolution Program, Division of Astronomical Sciences, Directorate of Astronomical, Atmospheric, Earth and Ocean Sciences, National Science Foundation, 1800 G St. N.W., Room 615, Washington, DC 20550/202-357-7622.

Stellar Systems and Motions

The stellar systems and motions program supports research on the studies of stars in the immediate vicinity of the Sun through determining their distances and motions with the highest attainable precision; improved coverage of the southern skies; binary and multiple star systems; and application of recently developed optical and radio techniques. Contact: Stellar Systems and Motions Program, Division of Astronomical Sciences, Directorate of Astronomical, Atmospheric, Earth, and Ocean Sciences, National Science Foundation, 1800 G St. N.W., Room 615, Washington, DC 20550/202-357-7620.

Structural Chemistry and Thermodynamics

The structural chemistry and thermodynamics program supports research on equilibrium and

time-dependent macroscopic thermodynamics and statistics mechanics; macroscopic properties of matter; intermolecular interactions in condensed phases; properties of colloidal systems and surfaces; high temperature chemistry; new methods for structure determination; and determination and interpretation of the geometric parameters of chemical species by spectroscopic and diffraction methods. Contact: Structural Chemistry and Thermodynamics, Division of Chemistry, Directorate for Mathematical and Physical Sciences, National Science Foundation, Room 340, 1800 G St. N.W., Washington, DC 20550/202-357-9826.

Structural Mechanics

The civil and environmental engineering program supports research on optimality in structural design and system identification; response to random excitation; structural instability and nonlinear effects; concrete technology, with special emphasis on high strength concrete; and active control of structures. Contact: Structural Mechanics Program, Division of Civil and Environmental Engineering, Directorate for Engineering and Applied Science, National Science Foundation, 1800 G St. N.W., Room 418, Washington, DC 20550/202-357-9545.

Submarine Geology and Geophysics

The Ocean Sciences project supports research on the structure of continental margins, oceanic rise systems, and deep sea sedimentary basins; evolution of the ocean basins; processes controlling the exchange of heat and chemical elements between seawater and oceanic rocks; tectonic and volcanic activity at mid-ocean ridges; chemical and mineralogic variations in marine sediments; deposition, erosion, and distribution of marine sediments; geologic and oceanographic processes controlling sedimentary systems; past oceanic circulation patterns and climates; evolution of microfossil groups; effects of water chemistry and temperature controls on fossil groups and sediment types; and interaction of land and oceanic geologic processes. Contact: Submarine Geology and Geophysics Program, Division of Ocean Sciences, Directorate for Astronomical, Atmospheric, Earth and Ocean Sciences, National Science Foundation, 1800 G St. N.W., Room 606, Washington, DC 20550/202-357-7906.

Synthetic Inorganic and Organometallic Chemistry

The synthetic inorganic and organometallic chemistry program supports research on new organometallic and inorganic compounds possess-ing catalytic behavior; the fixation of small molecules for synthetic catalytic behavior; fuels and biomimetic models; inorganic compounds in chemotherapy and plant and animal nutrition; environmental impacts of heavy ions; and the synthesis of inorganic materials possessing useful electrical and thermal properties. Contact: Synthetic Inorganic and Organometallic Chemistry, Division of Chemistry, Directorate for Mathematical and Physical Sciences, National Science Foundation, 1800 G St. N.W., Room 340, Washington, DC 20550/202-357-7499.

Synthetic Organic and Natural Products Chemistry

The synthetic organic and natural products chemistry program supports research on preparation, characterization, and structural manipulation of organic compounds from plant, animal and human sources and nonbiologic synthetic compounds; development of highly efficient reagents and methods for synthesizing compounds for use in energy storage, medicines, and agricultural chemicals; and design and synthesis of novel theories of structure and bonding. Contact: Synthetic Organic and Natural Products Chemistry Program, Directorate for Mathematical and Physical Sciences, National Science Foundation, 1800 G St. N.W., Room 340, Washington, DC 20550/202-357-7499.

Systemic Biology

The systemic biology program supports research on the identities, relationships, and distributions of living species of plants, animals, and microorganisms; fossil studies of extinct species to determine organic changes throughout the Earth's history; improved methods of gathering, processing, and analyzing the above data; functional morphology; chemosystematics; and paleobiology. Contact: Systemic Biology Program, Division of Environmental Biology, Directorate for Biological, Behavioral and Social Sciences, National Science Foundation, 1800 G St. N.W., Room 336, Washington, DC 20550/202-357-9588.

Systems Theory and Operations Research

The electrical, computer and systems engineering program supports the study of mathematical methods useful in the analysis of complex engineering systems and systems management or operations research, and research related to socioeconomic-technologic systems. Contact: Systems Theory and Operations Research Program, Division of Electrical, Computer and Systems Engineering, Directorate for Engineering

and Applied Science, National Science Foundation, 1800 G St. N.W., Room 1101, Washington, DC 20550/202-357-9618.

Technology Assessment and Risk Analysis

Studies in technology assessment seek to systematically identify and examine the planned and unplanned consequences of technology that are indirect, unanticipated, and delayed. Studies in risk analysis seek to understand better how information about risk is used in the science and technology policy decisionmaking process and how considerations of public and private costs and benefits are balanced in the S&T policy decisionmaking process. Contact: Technology Assessment and Risk Analysis Working Group, Directorate for Scientific, Technological and International Affairs, National Science Foundation, 1800 G St. N.W., Room 1233, Washington, DC 20550/202-357-9828.

Theoretical Computer Science

The program on probability supports research on theories of computation and formal languages; analysis of algorithms; theoretical models for computation; and other theoretical problems concerned with the foundations of computer science. Contact: Theoretical Computer Science Program, Division of Mathematical and Computer Sciences, Directorate for Mathematical and Physical Sciences, National Science Foundation, 1800 G St. N.W., Room 339, Washington, DC 20550/202-357-7349.

Theoretical Physics

The program on theoretical physics supports research on quantitative hypotheses to interpret results of experimental physics and to suggest new directions for research on the properties of physical systems, from nuclei to stars. Emphasis is on particle, nuclear, and atomic theories. Contact: Theoretical Physics Program, Division of Physics, Directorate for Mathematical and Physical Sciences, National Science Foundation, 1800 G St. N.W., Room 341, Washington, DC 20550/202-357-7979.

Thermodynamics and Mass Transfer

The chemical and process engineering program supports research on fluid property and phase-equilibrium relating measured thermodynamic and transport properties to molecular structure and interactions; fluid behavior at extreme conditions of temperature and pressure; diffusion in gases, liquids, liquid mixtures, polymer solutions, and solid polymers; mass transfer in microporous materials; separations processes—traditional and unconventional methods; processes taking place at interfaces, such as surface diffusion, surface rheology, absorption and surface instabilities; the effect of turbulence on mass transport; and predicting and correlating mass transfer rattes. Contact: Thermodynamics and Mass Transfer Program, Division of Chemical and Process Engineering, Directorate for Engineering and Applied Science, National Science Foundation, Room 413, 1800 G St. N.W., Washington, DC 20550/202-357-9606.

Topology, Geometry and Foundations

The program for topology, geometry and foundations supports research on general topology, algebraic topology, manifolds and cell complexes; finite planes, convex sets and related geometric topics, differential geometry and its relations to Lie representation theory, to dynamical systems theory, and to global analysis and analysis on manifolds; and mathematical logic and foundations of set theory, including proof theory, recursion theory, and non-standard models. Contact: Topology, Foundations and Geometry, Division of Mathematical and Computer Sciences, Directorate for Mathematical and Physical Sciences, National Science Foundation, 1800 G St. N.W., Room 304, Washington, DC 20550/202-357-9764.

Two-Year and Four-Year College Instrumentation Program

The National Science Foundation awards grants for the purchase of research equipment to improve the ability of scientists and engineers to conduct research at colleges and universities without large doctoral programs. Contact: Two-Year and Four-Year College Instrumentation Program, National Science Foundation, 1800 G St. N.W., Room 416, Washington, DC 20550/202-357-7456.

Undergraduate Research Participation

The program provides support to colleges, universities, and certain nonprofit research organizations with equivalent expertise to bring talented and promising undergraduate students into full-time scientific and engineering research activities with university science faculty or industrial scientists. Contact: Student Oriented Programs, Division of Scientific Personnel Improvement, Directorate for Science Education, National Science Foundation, 5225 Wisconsin Ave. N.W., Room W410, Washington, DC 20550/202-282-7150.

Undergraduate Science Education

The comprehensive assistance to undergraduate science education program's primary objec-

tives are twofold: to strengthen and improve the quality and effectiveness of undergraduate science instruction in colleges and universities, and to enhance institutional capability for self-assessment and continuous updating of science programs. Contact: Comprehensive Assistance to Undergraduate Science Education, Division of Science Education Resources Improvement, Directorate for Science Education, National Science Foundation, 5225 Wisconsin Ave. N.W., Room W418, Washington, DC 20550/202-282-7736.

University/Industry Cooperative Research Centers

The Centers are based on a one university-multicompany relationship which deals with particular scientific areas such as polymer processing or computer graphics. Companies may be from one or more industry. The Centers usually call upon the services of many disciplines and functions within the universities and invite participation by the local business and financial communities. Contact: University/Industry Research Centers, Industrial Programs, Division of Intergovernmental Science and Public Technology, Directorate of Engineering and Applied Science, National Science Foundation, 1800 G St. N.W., Room 1250, Washington, DC 20550/202-357-7527.

U.S.-China Program

The U.S.-China program for cooperation in the basic sciences is being developed. Contact: U.S.-China Program, Division of International Programs, Directorate for Scientific, Technological and International Affairs, National Science Foundation, 1800 G St. N.W., Room 1214, Washington, DC 20550/202-357-7393.

U.S.-Israel Binational Science Foundation

The areas supported by the U.S.-Israel Binational Science Foundation are agriculture, health sciences, natural sciences, social and behavioral sciences, science services, and technologies of interest to both countries, such as mass transportation, energy, arid zone, and environmental research. Contact: U.S.-Israel Binational Science Foundation, Division of International Programs, Directorate for Scientific, Technological and International Affairs, National Science Foundation, Room 1214, 1800 G St. N.W., Washington, DC 20550/202-357-7613.

Water Resources and Environmental Engineering

The civil and environmental engineering program supports research on erosion and transport of sediment; diffusion, dispersion, and biologic interaction of pollutants; flow-through underground aquifers; the mechanics of jets and plumes; wind/wave interaction; environmental acoustics and aerodynamics; hydrology and water resources; and water and wastewater treatment. Contact: Water Resources and Environmental Engineering Program, Division of Civil and Environmental Engineering, National Science Foundation, 1800 G St. N.W., Room 420, Washington, DC 20550/202-357-9542.

How Can the National Science Foundation Help You?

For information on how this agency can help you, contact: Public Information Branch, National Science Foundation, 1800 G St. N.W., Washington, DC 20550/202-357-9498.

National Transportation Safety Board

800 Independence Ave. S.W., Washington, DC 20594/202-382-6600

ESTABLISHED: April 1, 1975
BUDGET: $16,782,000
EMPLOYEES: 388

MISSION: Seeks to insure that all types of transportation in the United States are conducted safely; investigates accidents, conducts studies, and makes recommendations to government agencies, the transportation industry, and others on safety measures and practices; regulates the procedures for reporting accidents; and promotes the safe transport of hazardous materials by government and private industry.

Major Sources of Information

Accident Briefs

Ten accident reports group civil aviation accident findings by kind of flying, type of aircraft or accident, and accident cause. They include computer-printed accident "briefs" which give the basic accident facts, probable cause, and contributing factors, if any, for all the accidents in each category. Statistics tables analyze the accidents by type, injury and cause. All of the ten reports cover general aviation. They are entitled *Briefs of . . .*

Accidents Involving Midair Collisions
Accidents Involving Alcohol as a Cause/Factor
Accidents Involving Corporate/Executive Aircraft
Fatal Weather Involved Accidents
Accidents Involving Rotorcraft
Accidents Involving Turbine-Powered Aircraft
Accidents Involving Aerial Application
Commuter Air Carrier and On-Demand Air
Taxi Accidents
Accidents Involving Amateur
Home Built Aircraft
Accidents Involving Missing, Later
Recovered Aircraft

Contact: Accident Data Branch, National Transportation Safety Board, 800 Independence Ave. S.W., Room 811C, Washington, DC 20594/202-382-6536.

Accident Data

An automated accident data system compiles statistics information for world-wide use.

Annual Review of Aircraft Accident Data—U.S.
Air Carrier Operations

Statistics data and briefs of accidents compiled from reports of U.S. Air Carrier accidents that occurred during a calendar year. The briefs contain the facts, conditions, circumstances, and probable cause for each accident. The record of individual U.S. Air Carriers, U.S. Certificated Route Air Carriers, and U.S. Supplemental Air Carriers is provided by several types of service. Other statistics data include aircraft hours and miles flown, passengers carried, total and fatal accident rates, causal factors, injuries, and other data related to air accidents.

Annual Review of Aircraft Accident Data—U.S.
General Aviation

Statistics information compiled from reports of U.S. General Aviation accidents that occurred during a calendar year. The publication is sectionalized to provide accident statistics on all aircraft accidents, small fixed-wing aircraft, rotorcraft and glider aircraft. Typical accident data include type of accident, phase of operation, kind of flying, causal factors, aircraft damage and injuries.

These reviews are available at no cost as long as the supply lasts. Contact: Accident Data Branch, Bureau of Technology, National Transportation Safety Board, 800 Independence Ave. S.W., Room 811C, Washington, DC 20594/202-382-6536.

Accident Investigation

The Bureau of Accident Investigation is responsible for all accident investigations conducted by the Board in rail, pipeline, highway, marine and civil aviation transportation. It recommends whether a public hearing or depositions are to be held to determine the facts, conditions, and circumstances of accidents, and prepares a public report on accidents for submission to the Board for adoption, including a recommendation as to the probable cause. It may also participate in the investigation of civil aviation accidents involving U.S. registered, or U.S. manufactured, aircraft which occur in foreign countries. For general information, contact: Bureau of Accident Investigation, National Transportation Safety Board, 800 Independence Ave. S.W., Room 800E, Washington, DC 20594/202-382-6800. For information on:

Civil Aircraft Accidents, contact: Aviation Accident Division, Room 820H, 202-382-6830.

Railroad accidents in which there is a fatality, substantial property damage or passenger train involvement, contact: Railroad Accident Division, Room 820G, 202-382-6840.

Pipeline accidents in which there is a fatality or substantial property damage, contact: Pipeline Accident Division, Room 820C, 202-382-0670.

Major marine casualties, contact: Marine Accident Division, Room 840A, 202-382-6860.

Highway accidents (selected in cooperation with the states), contact: Highway Accident Division, Room 820E, 202-382-6850.

Administrative Law Judges

The Office of Administrative Law Judges conducts formal proceedings involving petitions for review from applicants denied airman and medical certificates by the Federal Aviation Administration and also on appeals from FAA orders suspending or revoking certificates issued to pilots, navigators, mechanics, dispatchers, air traffic controllers, air carriers, and air agencies authorized by the FAA to perform aircraft maintenance and to certify aircraft as airworthy. Administrative Law Judges function as trial judges, issuing subpoenas, administering oaths, holding prehearing conferences, ruling on procedural requests and motions, receiving relevant evidence, and other duties. Nearly all hearings on petitions for review and certain other appeals are held outside the Washington, DC area since the place of hearing must be convenient to all parties. *Initial Decisions of the Administrative Law Judges* are issued irregularly as decisions are released. Single copies of an individual decision are available at no cost. Contact: Office of Administrative Law Judges, National Transportation Safety Board, 800 Independence Ave. S.W., Washington, DC 20594/202-382-6760.

Aircraft Flight Data and Voice Recorders Investigation

Vehicle parts, aircraft flight data and voice recorders are examined by the National Transportation Safety Board. Contact: Laboratory Services, Bureau of Technology, National Transportation Safety Board, 800 Independence Ave. S.W., Room 826C, Washington, DC 20594/202-382-6686.

Certificate or License Appeal

Petitions from applicants denied airman and medical certificates by the Federal Aviation Administration are reviewed. Appeals from FAA orders suspending or revoking certificates issued to pilots, navigators, mechanics, dispatchers, air traffic controllers, air carriers and air agencies authorized by the FAA to perform aircraft maintenance and to certify aircraft as airworthy are also reviewed. Contact: Office of Administrative Law Judges, National Transportation Safety Board, 800 Independence Ave. S.W., Washington, DC 20594/202-382-6760.

Dockets

The Safety Board maintains a Public Docket which contains records of all accident investigations, all safety recommendations, and all safety enforcement proceedings. These records are all available to the public and may be copied, reviewed or duplicated. The accident records include each individual accident investigation conducted by and for the Board. The safety recommendation records include each recommendation issued and all responses from the recipients of such actions. The enforcement cases include all proceedings involving appeals to the Board from actions taken by Department of Transportation against airmen certificates and marine licenses and documents. Contact: Public Inquiries Section, National Transportation Safety Board, 800 Independence Ave. S.W., Room 808G, Washington, DC 20594/202-472-6160. Information on appeal cases of air and marine personnel is also available. Contact: Docket Section, Office of Administrative Law Judges, National Transportation Safety Board, 800 Independence Ave. S.W., Room 822, Washington, DC 20594/202-382-6770.

Freedom of Information Act Requests

For Freedom of Information Act requests, contact: Freedom of Information Office, Office of General Counsel, National Transportation Safety Board, 800 Independence Ave. S.W., Room 818, Washington, DC 20594/202-382-6540.

Listing of Aircraft Accidents/Incidents by Make and Model, U.S. Civil Aviation

This publication includes general aviation and airline accidents identified by make and model. Contact: Accident Data Branch, National Transportation Safety Board, 800 Independence Ave. S.W., Room 825A, Washington, DC 20594/202-382-6536.

Publications

A free list of National Transportation Safety Board publications is available. It lists opinions and orders, initial decisions of the Administrative Law Judges, general subject publications, aviation safety publications and ordering information. Contact: Publications, National Transportation Safety Board, 800 Independence Ave. S.W., Room 805G, Washington, DC 20594/202-382-6742.

Public Data on Aircraft Accidents—Computer Tapes

Computer tapes containing public data on aircraft accidents or data processing programs are available for a fee. For information on how to order tapes, contact: Accident Data Branch, National Transportation Safety Board, 800 Independence Ave. S.W., Room 811C, Washington, DC 20594/202-382-6536.

Public Hearings

The Board may hold a public hearing in which the facts determined in its investigation are presented as evidence and persons involved in the accident testify and are questioned. After all the evidence developed at the accident site, and at the hearing, is analyzed, a report setting forth the facts, conditions and circumstances of the accident is adopted by the Board and released to the public. Contact: Public Inquiries, National Transportation Safety Board, 800 Independence Ave. S.W., Room 805F, Washington, DC 20594/202-382-6735.

Regional Offices

There are twelve National Transportation Safety Board regional offices around the country. For a list of their addresses, contact: Public Inquiries, National Transportation Safety Board, 800 Independence Ave. S.W., Room 805F, Washington, DC 20594/202-382-6735.

Safety Recommendations

Safety recommendations are based on information developed from Board investigative findings and special studies, and are aimed at preventing accidents and correcting unsafe conditions in transportation. Recommendations may be issued at any time, sometimes within a few days after an accident, to initiate quick action to prevent additional accidents. Contact: Safety Recommendations, Bureau of Accident Investigation, National Transportation Safety Board, 800 Independence Ave. S.W., Room 815E, Washington, DC 20594/202-382-6810.

Speakers

Speakers are available to discuss subjects relating to transportation safety or to the Safety Board's organization functions, activities, procedures and regulations. Contact: Public Affairs, National Transportation Safety Board, 800 Independence Ave. S.W., Room 808, Washington, DC 20594/202-382-6600.

Technical Expertise

Specialists investigate accidents within their specific technical areas and participate in public hearings as members of the technical panel. Contact: Bureau of Technology, National Transportation Safety Board, 800 Independence Ave. S.W., Room 824B, Washington, DC 20594/202-382-6610. For specific technical expertise, contact:

Operational Factors Division, Room 826A, 202-382-6661

Hazardous Materials Division, Room 826D, 202-382-6682

Human Factors Division, Room 830F, 202-382-6626

How Can the National Transportation Safety Board Help You?

For information on how this agency can help you, contact: Office of Public Affairs, National Transportation Safety Board, 800 Independence Ave. S.W., Washington, DC 20594/202-382-6600.

Nuclear Regulatory Commission

1717 H St. N.W., Washington DC 20555/301-492-7715

ESTABLISHED: January 19, 1975
BUDGET: $417,350,000
EMPLOYEES: 2,851
MISSION: Licenses and regulates the uses of nuclear energy to protect the environment and public health and safety; licenses persons and companies to build and operate nuclear reactors and to own and use nuclear materials; makes rules and sets standards for these types of licenses; and fully inspects the activities of the persons and companies licensed to insure that they do not violate the safety rules of the Commission.

Major Sources of Information

Abnormal Occurrences—Quarterly Report to Congress

This report identifies an abnormal occurrence as an unscheduled incident or event which the Nuclear Regulatory Commission determines to be significant from the standpoint of public health or safety. This report is available from the Government Printing Office Sales Program, Division of Technical Information and Document Control, Nuclear Regulatory Commission, 1717 H St. N.W., Washington, DC 20555/301-492-9530. For additional information, contact: Management Information, Office of Management and Program Analysis, Nuclear Regulatory Commission, 7735 Old Georgetown Rd. Room 12702 MNBB, Bethesda, MD 20019/301-492-7834.

Advisory Committee on Reactor Safeguards

This statutory body of fifteen scientists and engineers reviews and makes recommendations to the Commission on all applications for construction and operation of nuclear power reactors and related nuclear safety matters. The views of the ACRS are taken into account in a Supplementary Safety Evaluation Report. Contact: Advisory Committee on Reactor Safeguards, Nuclear Regulatory Commission, Room 1010, 1717 H St. N.W., Washington, DC 20555/301-634-3265.

Annual Reports

A variety of annual reports are issued by this office. They include:

Occupational Radiation Exposure at Light Water Cooled Power Reactors ($6.00)—a compilation of occupational radiation exposures at commercial light water cooled nuclear power reactors.

Radioactive Materials Released from Nuclear Power Plants ($9.00)—releases of radioactive materials in airborne and liquid effluents from commercial light water reactors are compiled and reported.

Occupational Radiation Exposure Report ($4.50).

Nuclear Power Plant Operating Experience—includes power generation statistics, plant outages, reportable occurrences, fuel element performance, and occupational radiation exposure for each plant.

Population Dose Commitments Due to Radioactive Releases from Nuclear Power Plants—fifty-year dose commitments from a one-year exposure were calculated from liquid and atmospheric releases for four population groups—infant, child, teenager and adult—residing between 2 and 80 km from each site.

These reports are available through: Distribution, Office of Administration, Nuclear Regulatory Commission, 1717 H St. N.W., MS058 MNBB, Washington, DC 20555/301-492-8585.

Antitrust Review

Prior to or parallel with other reviews, the Nuclear Regulatory Commission conducts a prelicensing antitrust review of each application for a major nuclear facility in order to insure that the proposed facility is in compliance with antitrust laws. Hearings are held when recommended by the U.S. Attorney General, or they may be held on the petition of an interested party. Contact: Antitrust Division, Office of the Executive Legal Director, Nuclear Regulatory Commission, 1717 H St. N.W., Room 11701 MNBB, Washington, DC 20555/301-492-7488.

Atomic Safety and Licensing Appeal Panel

Three-member appeal boards are selected from this panel to review decisions of the licensing board. Contact: Atomic Safety and Licensing Appeal Panel, Nuclear Regulatory Commission, 1717 H St. N.W., Room 529 EWT, Washington, DC 20555/301-492-7662.

Atomic Safety and Licensing Board Panel

This is a three-member board drawn from the safety and licensing panel which conducts public hearings on nuclear power plant applications. Contact: Atomic Safety and Licensing Board Panel, Nuclear Regulatory Commission, 1717 H St. N.W., Room 423 EWT, Washington, DC 20555/301-492-7842.

Construction Permit

A utility or any other company must obtain a Nuclear Regulatory Commission construction permit as the first step in operating a nuclear power reactor or other nuclear facility under NRC license. The process for licensing a nuclear power plant or a fuel reprocessing plant requires extensive technical reviews and public proceedings. Contact: Licensing Division, Office of Nuclear Reactor Regulation, Nuclear Regulatory Commission, 1717 H St. N.W., Room 110 PHIL, Washington, DC 20555/301-492-7425.

Construction Status Report Nuclear Power Plants

This report lists projects and provides information necessary for monitoring their progress. It is available from GPO Sales Program, Division of Technical Information and Document Control, Nuclear Regulatory Commission, 1717 H St. N.W., Washington, DC 20555/301-492-9530. For additional information, contact: Management Information, Office of Management and Program Analysis, Nuclear Regulatory Commission, 1717 H St. N.W., Room 12702 MNBB, Washington, DC 20555/301-492-7834.

Construction Surveillance

Nuclear power plants are inspected by NRC representatives during construction and preoperational testing. This largely involves inspection of the quality assurance program of the licensee. Contact: Reactor Construction Branch, Office of Inspection and Enforcement, Nuclear Regulatory Commission, 1717 H St. N.W., MS 5360 EWT, Washington, DC 20555/301-492-8484.

Consumer Products Containing Nuclear Material

The Nuclear Regulatory Commission issues three types of licenses—exemptions, general and specific—for consumer products containing source materials (uranium and thorium), special nuclear materials (plutonium, uranium-233), and byproduct materials. A regulatory guide describing the statistics sampling procedures for exempt and generally licensed items containing byproduct material is also available. Contact: Material Licensing Branch, Office of Nuclear Material Safety and Safeguards, Nuclear Regulatory Commission, 1717 H St. N.W., Washington, DC 20555/301-427-4228 for industrial products, 301-427-4237 for medical products.

Docket Breakdown

Each nuclear power generating facility is assigned a docket number, and all documents pertaining to that facility are filed by the facility docket number. Each Docket 50 file is further subdivided and filed in categories that pertain either to different aspects of the licensing process or to document types. The types of documents in each category are described in *NRC PDR Docket 50 Breakdown*, a free publication. For further information, contact: Public Document Room, Nuclear Regulatory Commission, 1717 H St. N.W., Lobby, Washington, DC 20555/301-634-3273.

Environmental Review

A Nuclear Regulatory Commission staff evaluation of the potential environmental impact of the proposed nuclear plant and the suitability of the site is conducted in advance of, or in parallel with, the safety review. This evaluation, required by the National Environmental Policy Act, considers the effects of construction and operation of the plant on the local environment and weighs the benefits to be gained against the possible risk to the environment. The review—which takes into account comments by expert federal and state agencies and the public—results in an NRC Final Environmental Statement, and this statement may require changes to the plant design or operational mode. Contact: Environmental Technology Branch, Office of Nuclear Reactor Regulation, Nuclear Regulatory Commission, 1717 H St. N.W., AR 5111, Washington, DC 20555/301-492-4845.

Export-Import Licensing

This office licenses the export of nuclear reactors, and the export and import of uranium and plutonium. Contact: Export/Import and International Safeguards, Office of International Safeguards, Nuclear Regulatory Commission, 1717 H St. N.W., MS 8215 MNBB, Washington, DC 20555/301-492-8155.

Freedom of Information Act Requests

For Freedom of Information Act requests, contact: Division of Rules and Regulations, Of-

fice of Administration, Nuclear Regulatory Commission, 1717 H St. N.W., Room 4210, Washington, DC 20555/301-492-8133.

Fuel and Materials Safety

This office performs independent measurements of radioactivity in nuclear facility effluents to insure that the licensee's measurements are accurate and that discharges are maintained at levels that are as low as reasonably possible. Contact: Division of Fuel Facilities, Materials, and Safeguards Office of Inspection and Enforcement, Nuclear Regulatory Commission, 1717 H St. N.W., Room 3105 EWS, Washington, DC 20555/301-492-8225.

Fuel Cycle and Materials Safety

This office licenses and regulates fuel-cycle facilities and the transport and handling of nuclear materials. Contact: Fuel Cycle and Material Safety Division, Office of Nuclear Materials Safety and Safeguards, Nuclear Regulatory Commission, 1717 H St. N.W., MS 396-55, Washington, DC 20555/301-427-4485.

Handbook of Acronyms and Initialisms

This is a dictionary of acronyms, initialisms, and similar condensed forms used in the nuclear industry. Available for $5.00 from GPO Sales Program, Division of Technical Information and Document Control, Nuclear Regulatory Commission, 1717 H St. N.W., Room 212 LAND, Washington, DC 20555/301-492-9530.

High-Level Waste

The Nuclear Regulatory Commission is developing performance criteria for solidified high-level wastes. These criteria are being developed based on a systems analysis model which considers the potential for accidents during interim storage, transportation, handling, emplacement and post-emplacement. Repository site selection criteria are being developed and will encompass a broad spectrum of concerns including earth science, natural resource, demographic and socioeconomic factors. A study to determine the design and operating requirements for high-level waste repositories will provide a basis for the development of standards and staff review methodologies. Contact: Waste Management Division, Office of Nuclear Materials Safety and Safeguards, Nuclear Regulatory Commission, 1717 H St. N.W., MS 905-55, Washington, DC 20555/301-427-4069.

Inspection and Enforcement

The Nuclear Regulatory Commission conducts periodic inspection of nuclear plants and other licenses. Enforcement powers include issuance of violation notices, imposition of fines and license suspension, modification or revocation. Contact: Office of Inspection and Enforcement, Nuclear Regulatory Commission, 1717 H St. N.W., Room 322 EWT, Washington, DC 20555/301-492-7397.

Inspectors

NRC inspectors check the regulatory compliance of other licensees, including hospital nuclear medicine programs, industrial applications, academic and research activities, and nuclear material processing. Contact: Office of Inspection and Enforcement, Nuclear Regulatory Commission, 1717 H St. N.W., Room 322 EWT, Washington, DC 20555/301-492-7397.

Library

The Nuclear Regulatory Commission Library collection stresses energy, nuclear physics and nuclear chemistry and is open to the public. Contact: Library, Nuclear Regulatory Commission, 7920 Norfolk Ave., MS 160, Bethesda, MD 20555/301-492-8501.

Licensee Event Reports

Monthly licensee event reports (LER), which are entered into the computer, are available on the following topics:

LER monthly report sorted by facility

LER monthly report sorted by component

LER monthly regional report sorted by region, facility and event date

LER monthly report on valves and valve operators sorted by facility

LER monthly report on personnel errors and defective procedures sorted by component and system

LER monthly report on mechanical items sorted by component and system

LER monthly report on electrical items sorted by component and system

LER monthly report on instrumentation and control items sorted by component and system

LER monthly report on civil items sorted by component and system

LER monthly report sorted by system and component

LER monthly report on vibration events sorted by component, system and facility

LER monthly report on construction deficiency reports sorted by facility

LER monthly report on events involving personnel errors sorted by facility type, cause subcode and facility

LER monthly report on events involving personnel errors sorted by component, system and facility

LER monthly report on BWR events sorted by cause, facility and event date

LER monthly report BWR events sorted by cause, facility and event date

LER monthly report on the offsite power system sorted by facility

LER monthly report on water hammer events sorted by facility

LER monthly report on pipe cracks and breaks sorted by facility type, facility and event date

Contact: Management Information, Office of Management and Program Analysis, Nuclear Regulatory Commission, 1717 H St. N.W., Room 12702 MNBB, Washington, DC 20555/301-492-7834.

Licensing

The Nuclear Regulatory Commission reviews and issues licenses for the construction and operation of nuclear power plants and other uses of nuclear materials, including medical, industrial, education and research activities. Contact: Licensing Division, Nuclear Regulatory Commission, 1717 H St. N.W., Room 528A PHIL, Washington, DC 20555/301-492-7672.

Limited Work Authorization (LWA)

In appropriate cases, the Nuclear Regulatory Commission may grant a Limited Work Authorization to an applicant in advance of the final decision on the construction permit so certain work at the reactor site can begin sooner. Contact: Licensing Division, Office of Nuclear Reactor Regulations, Nuclear Regulatory Commission, 1717 H St. N.W., Room 528A PHIL, Washington, DC 20555/301-492-7672.

Loss-of-Fluid Test (LOFT)

LOFT is designed to provide additional data on the performance of an emergency core cooling system in a pressurized water reactor. Contact: Idaho Site Representative, Idaho National Engineering Laboratory, Nuclear Regulatory Commission, 550 2nd St., Idaho Falls, ID 83401/208-583-1951, or LOFT Research Branch, Reactor Safety Research Division, Nuclear Regulatory Commission, 1717 H St. N.W., Room 1204 WILL, Washington, DC 20555/301-427-4260.

Low-Level Waste Program

This program develops a framework of criteria and regulations for long-term management of commercial low-level waste disposal sites to provide the tools for applicants to prepare license applications and to enable the Nuclear Regulatory Commission to make uniform, timely licensing decisions. Contact: Low-Level Waste Licensing Branch, Waste Management Division, Office of Nuclear Material Safety and Safeguards, Nuclear Regulatory Commission, Room 736 WILL, 1717 H St. N.W., Washington, DC 20555/301-427-4450.

Material Licensing

This office licenses the users of radioisotopes in industry, research and medicine in those states which have not assumed this authority under agreements with the Nuclear Regulatory Commission. Contact: Material Safety and Licensing Branch, Office of Nuclear Material Safety and Safeguards, Nuclear Regulatory Commission, 1717 H St. N.W., Room 542 WILL, Washington, DC 20555/301-427-4228 for industrial products, 301-427-4237 for medical products.

Monthly Operating Units Status Reports— Licensed Operating Reactors

This publication provides data on the operation of nuclear units. Available for $120.00 per year from GPO Sales Program, Division of Technical Information and Document Control, Nuclear Regulatory Commission, 1717 H St. N.W., Washington, DC 20555/301-492-9530. For additional information, contact: Management Information, Office of Management and Program Analysis, Nuclear Regulatory Commission, 1717 H St. N.W., Room 12702 MNBB, Washington, DC 20555/301-492-7834.

Non-Docketed Files

Various types of documents are maintained in the files of nondocketed materials. These specific types of documents are listed in Descriptions and Content of Non-Docketed PDR File Categories, available free of charge. Contact: Public Document Room, Nuclear Regulatory Commission, 1717 H St. N.W., Washington, DC 20555/301-634-3273.

Nuclear Regulatory Research

This office develops recommendations and determinations for research to be conducted in the fields of nuclear reactor safety, safeguards for nuclear materials and facilities, the nuclear fuel cycle, and environmental protection, waste management, and risk assessment. Contact: Office of Nuclear Regulatory Research, Nuclear Regulatory Commission, 1717 H St. N.W., Room 1140 WILL, Washington, DC 20555/301-427-4341.

Nuclear Safeguards

This office develops programs for protecting nuclear materials from diversion and nuclear facilities from sabotage. It also licenses and regulates the safeguarding of nuclear facilities and materials. Contact: Safeguards Division, Office of Nuclear Material Safety and Safeguards, Nuclear Regulatory Commission, 1717 H St. N.W., Room 872 WILL, Washington, DC 20555/301-427-4033.

Open and Closed Meetings

The general public is welcome to attend and observe all Commission meetings with ten exceptions. The exceptions include meetings involving: classified documents; internal personnel matters; information that is confidential by statute; trade secrets; accusations of a crime or censure; invasion of personal privacy; investigatory records; regulatory reports of financial institutions; premature disclosure of information which will hinder implementation of agenda action; and adjudicatory matters. An announcement of the time, place, subject matter, whether or not it is open to the public and name and telephone number of the contact is placed in the Public Document Room. If a meeting is to be closed the announcement contains an explanation of the reasons for closing the meeting. Notices of meetings are also published in the *Federal Register*. A transcript or electronic recording is made of all meetings. Transcripts of open meetings are placed in the Public Document Room and are available for public inspection or duplication. Contact: Office of the Secretary, Nuclear Regulatory Commission, 1717 H St. N.W., Room 1135, Washington, DC 20555/301-634-1498. A free *Guide for Open Meetings* is available.

PDR Accession List

The *PDR Accession List* is the primary reference tool for finding documents in the Public Document Room (PDR). The accession list permits users to search for documents by docket number or non-docket file level: date; author/recipient name and affiliation; report number, etc. The accession list does not contain a subject index. The accession list, issued daily, announces the documents that have been made available that day. There is a two- or three-week delay in the public availability of newly generated documents. The docket materials are listed by docket number, then by licensing category (Docket 50 only), and date. Non-docket materials are listed alphabetically by non-docket file category and then by date. Each month a special list is issued that describes all documents received during that month. The monthly accession list is sorted by docket number and by non-docket file category and then filed in individual binders in the reading room. For more information about the format and content of the accession list, consult *How to Use the PDR Accession List,* 4/11/80, copies of which are available free of charge by writing to the PDR, 1717 H St. N.W., Washington, DC 20555/301-634-3273.

Power Reactor Events

This is a free bimonthly summary of selected events that have occurred at nuclear power plants. These events are taken mainly from *Licensee Event Reports* and *NRC Inspection Reports* and are, or have been, under review by the NRC. Contact: Office of Management and Program Analysis, Nuclear Regulatory Commission, 1717 H St. N.W., Room 12074 MNBB, Washington, DC 20555/301-492-7834.

Public Document Room

The Public Document Room maintains facilities for receiving, processing, storing and retrieving documents which the Nuclear Regulatory Commission receives or generates in performing its regulatory functions. Some of these documents include Docket Files which relate mainly to the licensing and inspection of nuclear facilities and to the use, transport and disposal of nuclear materials, and non-docket files, including reports, correspondence, contracts, guides, annual reports, press releases, indexes, bibliographies, notices and handbooks. A free *Public Document Room Users Guide* is available. The staff provides reference services, on-line computer searching, document processing, file maintenance, and microfiching and reproduction services. Guided tours of the Public Document Room and orientation or training sessions for individuals or groups are available upon request. Local Public Document Rooms are located in libraries in cities or towns near proposed and actual nuclear power plant sites across the country. They contain the licensing and regulatory files specific to nearby facilities which are either licensed or under review. For locations of LPDRs, consult the *Local Public Document Room Roster* available for examination and copying in the PDR. For additional information, contact: Public Document Room, Nuclear Regulatory Commision, 1717 H St. N.W., Left Lobby, Washington, DC 20555/301-6343273.

Public Participation

The law requires that a public hearing be held before a decision can be made to grant or deny a permit to build a nuclear power plant. The Atomic Safety and Licensing Board conducting the proceedings may combine the safety and environmental matters or it may consider them in separate public hearings. Notices of these hearings are published in the *Federal Register*, posted in the nearest public document room and published in the local newspapers. Interested parties should petition the licensing board for the right to participate in public hearings. Contact: Atomic Safety and Licensing, Nuclear Regulatory Commission, 1717 H St. N.W., Room 423 EWT, Washington, DC 20555/301-492-7842.

Reactor Operating License

Two or three years before completion of the plant is scheduled, the applicant files an application for an operating license. A process similar to that for the construction permit follows. Contact: Operating Reactors, Licensing Division, Office of Nuclear Reactor Regulations, Nuclear Regulatory Commission, 1717 H St. N.W., Room 340 PHIL, Washington, DC 20555/301-492-7817.

Reactor Operations Inspection

Once licensed, a nuclear facility remains under NRC surveillance and undergoes periodic inspections throughout its operating life. In cases where the NRC finds that substantial additional protection is necessary for the public health and safety, or the common defense and security, the NRC may require "backlifting" of a licensed plant, that is, the addition, elimination, or modification of structures, systems, or components of the plant. Contact: Division of Reactor Enforcement, Nuclear Regulatory Commission, 1717 H St. N.W., Room 360 EWS, Washington, DC 20555/301-492-9696.

Reactor Safety Research

Research in progress for the purpose of establishing site, structural, and environmental information to be used in nuclear facility safety evaluations includes studies in seismology, geology, hydrology, and meteorology. Research in such areas of natural phenomena as earthquakes and tornadoes is also under way. Contact: Division of Accident and Evaluation, Office of Nuclear Regulatory Research, Nuclear Regulatory Commission, 1717 H St. N.W., MS 1130-55, Washington, DC 20555/301-427-4442.

Regulatory and Technical Reports

Listings of regulatory and technical reports are available:
Vol. 3 ('75–'78) $10.00
Vol. 4 ('79) $7.50
Vol. 5 ('80–'81) $6.50. Contact: GPO Sales Program, Division of Technical Information and Document Control, Nuclear Regulatory Commission, 1717 H St. N.W., Washington, DC 20555/301-492-9530.

Regulatory Guides

The Nuclear Regulatory Commission Regulatory Guide Series was developed to describe methods acceptable for implementing specific requirements of the Commission's regulations. The Guides are made available at two stages: 1) Task Draft Guides, available free on subscription; and 2) Active Guides, available through a paid subscription.

The following guides are available:

Division 1—*Power Reactor Guides* ($70.00)
Division 2—*Research and Test Reactor Guides* ($5.00)
Division 3—*Fuels and Materials Facilities Guides* ($18.00)
Division 4—*Environmental and Siting Guides* ($8.50)
Division 5—*Materials and Plant Protection Guides* ($26.00)
Division 6—*Product Guides* ($5.00)
Division 7—*Transportation Guides* ($5.00)
Division 8—*Occupational Health Guides* ($5.00)
Division 9—*Antitrust and Financial Review Guides* ($5.00)
Division 10—*General Guides* ($8.00)
Division 1 through 10 inclusive ($148.00)

Contact: GPO Sales Program, Division of Technical Information and Document Control, Nuclear Regulatory Commission 1717 H St. N.W., Washington, DC 20555/301-492-9530.

Resident Inspectors

Resident inspectors are assigned to inspect operating nuclear power plants and many of those under construction. Resident inspectors will be assisted in their inspections by technical specialists based in the regional offices. These specialist inspections include such areas as environmental monitoring, emergency planning, radiation protection, security and in-service inspection of nuclear components. Contact: Field Coordinator, Division of Reactor Programs, Office of Inspection and Enforcement, Nuclear Regulatory Commission, 1717 H St. N.W., Room 360 EWS, Washington, DC 20555/301-492-9696.

Safeguards Inspection

This office also investigates accidents and incidents at licensed facilities as well as complaints or allegations from licensee employees or members of the public concerning activities of NRC licensees. Contact: Division of Fuel Facilities, Materials and Safeguards, Office of Inspection and Environment, Nuclear Regulatory Commission, 1717 H St. N.W., Room 332A EWW, Washington, DC 20555/301-492-7361.

Safety Review

The Nuclear Regulatory Commission staff conducts an in-depth safety review of the proposed design of the plant. When design features do not meet NRC standards, changes by the applicant are required. The staff then prepares a Safety Evaluation Report which is made public. Contact: Safety Program Evaluation, Office of Nuclear Reactor Regulations, Nuclear Regulatory Commission, 1717 H St. N.W., MS 216 PHIL, Washington, DC 20555/301-492-8342.

Speakers

Speakers are available to address seminars, lectures, and workshops given by civic and education groups. Contact: Office of Public Affairs, Nuclear Regulatory Commission, 1717 H St. N.W., Room 3709 MNBB, Washington, DC 20555/301-492-7121.

Standards

This office coordinates NRC staff participation in standards-related activities of the International Atomic Energy Agency, and serves as a principal point of contact for the Commission with the American National Standards Institute and technical and professional societies on matters concerning nuclear standards: Contact: Office of Research, Nuclear Regulatory Commission, 1717 H St. N.W., MS 1130-55, Washington, DC 20555/301-427-4341.

Standards Development

The Nuclear Regulatory Commission establishes regulations, standards and guidelines governing the various licensed uses of radioactive materials. Contact: Office of Standards Development, Nuclear Regulatory Commission, 1717 H St. N.W., MS 1130-55, Washington, DC 20555/301-427-4341.

State Programs

This office develops effective working relationships with the states regarding the regulation of nuclear materials. Contact: Office of State Programs, Nuclear Regulatory Commission, MS AR5307, 1717 H St. N.W., Washington, DC 20555/301-492-8170.

Subscription Publication

Nuclear Regulatory Commission Issuances (monthly plus quarterly and semiannual indexes), a compilation of adjudications and other issuances of the NRC, including those of the Atomic Safety and Licensing Boards and the Atomic Safety and Licensing Appeal Boards, is available for sale either on subscription or on a single-issue basis from NTIS, Springfield, VA 22161/703-557-4600. Hardbound semiannual issuances and indexes are available from the Superintendent of Documents, Government Printing Office, Washington, DC 20402/202-783-3238.

Technical Information Hotline

A technical information clearinghouse responds to inquiries about the availability of technical information on the licensing and regulation of nuclear technologies and applications. The clearinghouse also answers questions on how to obtain various kinds of information available to the public through the NRC, and provides information on meeting schedules, the hearing status of nuclear power plant licensing cases, and the locations of NRC local public document rooms. Call toll-free 800-638-8282, or 800-492-8106 in Maryland, or Contact: Office of Public Affairs, Nuclear Regulatory Commission, 1717 H St. N.W., Room 3709 MNBB, Washington, DC 20555/301-492-7715.

Three Mile Island

For information and reports on Three Mile Island, including the final version of the environmental impact statement on the cleanup, contact: Three Mile Island Program Office, Office of Nuclear Reactor Regulation, Nuclear Regulatory Commission, 7920 Norfolk Ave., Bethesda, MD 20555/301-492-7761.

Title List of Documents Made Publicly Available

The *Title List* is a monthly publication which contains bibliographic descriptions of and indexes to the documentation received and generated by the Nuclear Regulatory Commission. It includes both docketed and non-docketed materials. First issued in January 1979, the *Title List* supersedes *Power Reactor Docket Information* (PRDI). It is indexed by a Personal-Author Index, Corporate-Source Index, and Report-Number Index. The *Title List* is not cumulative and has no subject index. There is a one- to two-month time lag in the publication of the *Title List*. Consult the preface of any volume for further information on this publication. The *Title List* is available for 55.00 per year. For information on how to order this publication, contact: GPO Sales Program, Division of Technical Information and Document Control, Nuclear Regulatory Commission, 1717 H St. N.W., Washington, DC 20555/301-492-9530.

How Can the Nuclear Regulatory Commission Help You?

For information on how this agency can help you, contact: Office of Public Affairs, Nuclear Regulatory Commission, 1717 H St. N.W., Washington, DC 20555/301-492-7715.

Occupational Safety and Health Review Commission

1825 K St. N.W., Washington, DC 20006/202-634-7943

ESTABLISHED: 1970
BUDGET: $7,550,000
EMPLOYEES: 183

MISSION: Rules on cases forwarded to it by the U.S. Department of Labor when disagreements arise over the results of safety and health inspections performed by the Department's Occupational Safety and Health Administration (OSHA). (Employers have the right to dispute any alleged job safety or health violation found during the inspection by OSHA, the penalties proposed by OSHA, and the time given by OSHA to correct any hazardous situation. Employees and representatives of employees may initiate a case by challenging the propriety of the time OSHA has allowed for correction of any violative condition.)

Major Sources of Information

Amendments to Rules

A citizen may propose an amendment or revocation of the Commission's rules. For additional information, contact: Executive Secretary, Occupational Safety and Health Review Commission, 1825 K St. N.W., Room 401, Washington, DC 20006/202-634-7950.

Certificate of Service

Copies of all papers filed with the Commission or a judge must be served on all other parties to the case. A statement that service has been made must be attached to any papers submitted for filing with the Commission. The statement must show the date and manner of service (mail or personal delivery) and the names of the persons served. Contact: Executive Secretary, Occupational Safety and Health Review Commission, 1825 K St. N.W., Room 401, Washington, DC 20006/202-634-7950.

Commission Speakers

Members and officials participate as speakers and panel members before bar associations, safety councils, labor organizations, management associations, and educational, civic, and other groups. Contact: Information Office, Occupational Safety and Health Review Commission, 1825 K St. N.W., Room 701, Washington, DC 20006/202-634-7943.

Dockets

The Executive Secretary files all dockets. Any person may inspect and copy these and any other document filed in any proceeding. Contact: Executive Secretary, Occupational Safety and Health Review Commission, 1825 K St. N.W., Room 401, Washington, DC 20006/202-634-7950.

Freedom of Information Act Requests

For Freedom of Information Act requests, contact: Information and Publications, Occupational Safety and Health Review Commission, 1825 K St. N.W., Room 701, Washington, DC 20006/202-634-7943.

Publications

For a listing of publications, contact: Office of Information, Occupational Safety and Health Review Commission, 1825 K St. N.W., Room 701, Washington, DC 20006, 202-634-7943.

Public Information

This adjudicatory body has information on its procedures, as well as specific case transcripts, briefs and decisions concerning any company which has employees and is engaged in interstate commerce. Contact: Public Information, Occupational Safety and Health Review Commission, 1825 K St. N.W., Room 701, Washington, DC 20006/202-634-7943.

Review Commission Judges

All cases which require a hearing are assigned to a Review Commission Administrative Law Judge. Ordinarily the hearing is held in, or close to, the community where the alleged violation occurred. Contact: Chief Administrative Law Judge, Occupational Safety and Health Review Commission, 1825 K St. N.W., Room 419, Washington, DC 20006/202-634-7980.

Simplified Proceedings

Procedures for resolving contests can be simplified so that parties before the Commission may save time and expense while preserving fundamental procedural fairness. For additional in-formation, contact the nearest regional Occupational Safety and Health Review Commission, or the Executive Secretary, Occupational Safety and Health Review Commission, 1825 K St. N.W., Room 401, Washington, DC 20006/202-634-7950.

How Can the Occupational Safety and Health Review Commission Help You?

To determine how the Occupational Safety and Health Review Commission can help you, contact: Director of Information and Publications, Occupational Safety and Health Review Commission, 1825 K St. N.W., Washington, DC 20006/202-634-7943.

Office of Personnel Management

1900 E St. N.W., Washington, DC 20415/202-632-5491

ESTABLISHED: January 1, 1979
BUDGET: $24,497,915,000
EMPLOYEES: 6,728
MISSION: Administers a merit system for federal employment, which includes recruiting, examining, training, and promoting people on the basis of their knowledge and skills, regardless of their race, religion, sex, political influence, or other nonmerit factors; insures that the federal government provides an array of personnel services to applicants and employees; and supports government program managers in their personnel management responsibilities and provides benefits to employees directly.

Major Source of Information

Affirmative Employment

Through its affirmative employment efforts, the Office of Personnel Management seeks to eliminate nonmerit considerations such as race, color, religion, sex, national origin, or age from all aspects of federal employment. It also operates selective placement programs for physically and mentally handicapped persons, and programs for other groups including veterans, youths, and women. Contact: Office of Affirmative Employment Programs, Office of Personnel Management, 1900 E St. N.W., Room 7528, Washington, DC 20415/202-632-4420.

Agency Relations

Agency officers work with individual federal agencies to insure that the Office of Personnel Management policies and personnel directions are practical, realistic and supportive. For general information, contact: Agency Relations Group, Office of Personnel Management, 1900 E St. N.W., Room 5305, Washington, DC 20415/202-632-6108. For specific information on:

Economics and general government—202-632-3282
Human resources, veterans and labor—Room 7H28/202-254-6450
National security and international affairs—Room 5468/202-632-4500
Natural resources, energy, and science—Room 5542/202-632-5691

Alcoholic Employees

The Reporter is a monthly newsletter of federal employee health and alcoholism/drug abuse programs. Contact: Workforce Effectiveness and Development Group, Office of Personnel Management, 1900 E St. N.W., Room 7K51, Washington, DC 20415/202-632-5685.

Annuities

Free pamphlets describing annuity benefits under the civil service retirement system are available. Contact: Compensation Group, Office of Personnel Management, 1900 E St. N.W., Room 4A10, Washington, DC 20415/202-632-4581.

College Recruiting Programs

The federal government recruits and hires college students and graduates. A variety of publications are available on that subject: *Trends in Federal Hiring*—a biannual periodical for college placement directors; *Graduate to Government*—the employment picture for college graduates; *Federal Recruiting*—federal agency college recruiting programs; *Beyond the BA*—federal jobs for graduates with advanced degrees or experience. Contact: Staffing Services Group, Office of Personnel Management, 1900 E St. N.W., Room 6355, Washington, DC 20415/202-632-6251.

Compensation

Information is available on government employee pay, leave and hours of work policies; the

Civil Service retirement system; group life insurance; and health benefits programs for federal employees. Contact: Compensation Group, Office of Personnel Management, 1900 E St. N.W., Room 4A10, Washington, DC 20415/202-632-4581.

Complaint and Advisory Service

This service provides information about established appeals and other complaint procedures to facilitate the exchange of information between employee and agency and to respond to inquiries about subjects for which specialized offices have not been established. Contact: Federal Employee Advisory Service, Office of Personnel Management, 1900 E St. N.W., Room 5468, Washington, DC 20415/202-632-4530.

Contracts

For information on contracts, contact the nearest regional office, or Property Management Section, Administrative Services Division, Office of Personnel Management, 1900 E St. N.W., Room 1342, Washington, DC 20415/202-254-6863.

Employee and Annuitant Information Center

Help and information is available for employees and annuitants. Free pamphlets are available: *Information for Annuitants about the Federal Employee Health Benefits Program*, and *Information for Survivor Annuitants*. Contact: Employee and Annuitant Information Service, Retirement Programs, Office of Personnel Management, 1900 E St. N.W., Room 1323B, Washington, DC 20415/202-632-7700.

Employee Benefits

Federal employee benefits include health benefits, life insurance programs for the employees, annuitants and survivors, and civil service retirement programs. *Benefits Program* is a summary of these programs. Contact: Compensation Group, Office of Personnel Management, 1900 E St. N.W., Room 4A10, Washington, DC 20415/202-632-4581.

Ethics

Overall direction of executive branch policies is provided to prevent conflicts of interest on the part of officers and employees of any executive agency. Public financial disclosure is monitored, and rules and regulations pertaining to employee conduct and post-employment conflicts of interest are developed. For information, contact: Office of Government Ethics, Office of Personnel Management, 1900 E St. N.W., Room 436H, Washington, DC 20415/202-632-7642.

Executive Seminar Center

These Centers are residential interagency training facilities to aid government agencies in meeting programmatic and managerial training needs. The programs offered are open to federal, state and local governments. The curriculum includes seminars on: administration of public policy; public program management; national economy and public policy; science, technology and public policy; intergovernmental relations; environmental quality and natural resources; domestic policies and programs; energy policies and programs; and management and executive development. The centers are located as follows:

Executive Seminar Center, c/o U.S. Merchant Marine Academy, Kings Point, NY 11024/516-487-4500, or, 482-8200, ext. 343.

Executive Seminar Center, Broadway and Kentucky Ave., Oak Ridge, TN 37830/615-576-1730.

For additional information, contact: Executive Personnel and Management Training Branch, Executive and Management Training Division, Office of Personnel Management, 1900 E St. N.W., Room 6677, Washington, DC 20415/202-632-6214.

Exemption

For advice on "exemption" questions, contact: Advisory Services, Agency Compliance and Evaluation, Office of Personnel Management, 1900 E St. N.W., Room 5468, Washington, DC 20415/202-632-4530.

Fair Labor Standards

Fair Labor Standards to protect employee rights are enforced by investigating complaints and rendering decisions on: designations of employees as "exempt" or "non-exempt," and payment of the minimum wage, overtime pay, and child labor. Agencies found in violation are ordered to comply with the Fair Labor Standards Act, and to correct such violations, including the making of current and retroactive wage payments to injured employees. Contact: Agency Compliance and Evaluation, Office of Personnel Management, 1900 E St. N.W., Room 5468, Washington, DC 20415/202-632-4532.

Federal Employee Attitudes

A government-wide attitude survey of federal employees was administered to establish a baseline of employee attitudes about their jobs and work environment. Groupings included federal agencies, pay levels, pay systems and supervisory and non-supervisory personnel. *Federal Employee Attitudes*, a report, is available for $3.50, from

the Superintendent of Documents, Government Printing Office, Washington, DC 20402/202-783-3238. For additional information, contact: Office of Planning and Evaluation, Office of Personnel Management, 1900 E St. N.W., Room 3305, Washington, DC 20415/202-254-8920.

Federal Executive Institute (FEI)
This is an interagency executive development center which responds to the training and development needs of federal executives. Courses scheduled in various FEI programs are designed to facilitate executive improvement. Four categories of programs are conducted: the Senior Executive Education Program, the Executive Leadership and Management Program, FEI Alumni Follow-up Conferences, and Special Programs. The *FEI Bulletin* is a free publication with information on nomination and eligibility requirements as well as general information on FEI programs and a calendar for the fiscal year. For additional information, contact: Federal Executive Institute, Office of Personnel Management, Rte. 29, North Charlottesville, VA 22903/804-296-0181, or Office of Administration, Office of Personnel Management, 1900 E St. N.W., Room 6R48, Washington, DC 20415/202-632-5438.

Federal Job Information Center
A network of Federal Job Information Centers, located in major metropolitan areas, provides federal employment information. To obtain the appropriate telephone number, check the white pages under U.S. Government Office, Office of Personnel Management (some directories may still list the U.S. Civil Service Commission). A free directory, *Federal Job Information Centers*, is available. For additional information, contact: Federal Job Information Center, General Information, Office of Personnel Management, 1900 E St. N.W., Room 1416, Washington, DC 20415/202-737-9616.

Federal Managers Guide to Washington
This book gives incoming career and political appointees a detailed look at the workings of government and how policy is made. It includes information on Civil Service Reform and Reorganization, Managing the Organization, making policy, special concerns, benefits, and protocol. It also provides general information on living in the Washington area such as a listing of private and public schools, taxes, transportation, weather, and useful phone numbers. It is sold for $4.00 by the Superintendent of Documents, Government Printing Office, Washington, DC 20402/202-783-3238. Contact: Office of Public

Affairs, Office of Personnel Management, 1900 E St. N.W., Room 5F12, Washington, DC 20415/202-632-5491.

Federal Occupational Health Facilities
A free directory of Federal Occupational Health Facilities is available. Contact: Employee Health Service, Workforce Effectiveness and Development, Office of Personnel Management, 1100 L St. N.W., Room 9327, Washington, DC 20006/202-523-4550.

Federal Personnel Manual
This publication covers all aspects of personnel management and includes letters, bulletins and supplements. It is prepared by the various units within the Office of Personnel Management and is available on a subscription basis ($300) from the Superintendent of Documents, Government Printing Office, Washington, DC 20402/202-783-3238. For additional information, contact: Forms and Publications, Office of Personnel Management, 1900 E St. N.W., Room E453, Washington, DC 20415/202-632-4536.

Federal Productivity Program
The Office of Personnel Management aims at improving the measurement of productivity. *Exemplary Practices in Federal Productivity Program* documents successful efforts to improve productivity. *Managers' Guide for Improving Productivity* and *Measuring Federal Productivity*—a summary report and analysis of productivity data—are two additional publications on the subject. Contact: Office of Productivity Programs, Workforce Effectiveness and Development Group, Office of Personnel Management, 1900 E St. N.W., Room 7625, Washington, DC 20415/202-632-5685.

Federal Salary Schedules
Grades and salary rates are available for General Schedule, Executive Schedule and Senior Executive Schedule employees. Contact: Pay Programs, Compensation Group, Office of Personnel Management, 1900 E St. N.W., Room 3353, Washington, DC 20415/202-632-5570.

FED Facts Pamphlets
The Office of Personnel Management issues pamphlets that cover a variety of subjects related to government employees. They include:

Incentive Awards Program
Political Activity of Federal Employees
The Civil Service Retirement System
Financial Protection for Federal Employees
The Federal Merit Promotion Policy

Serving the Public: The Extra Step
The Federal Wage System
Meeting Your Financial Obligations
Maternity Leave
Employee Appeals from Actions
The Displaced Employee Program
Reductions in Force in Federal Agencies
Reemployment Rights of Federal Employees Who Perform Duty in the Armed Forces
Federal Labor Relations
Pay Under the General Schedule
The Cost of Living Allowance for Federal Employees
The Intergovernmental Mobility Program
How Your GS Job is Classified
Merit System Principles and Prohibited Personnel Practices

Contact: Office of Public Affairs, Office of Personnel Management, 1900 E St. N.W., Room 5F12, Washington, DC 20415/202-632-5491.

Freedom of Information Act Requests

For Freedom of Information Act Requests, contact: Administrative Systems Division, Office of Personnel Management, 1900 E St. N.W., Room 1316, Washington, DC 20415/202-632-4498.

Functional Directory of OPM

For a copy of the Office of Personnel Management directory, contact: Office of Public Affairs, Office of Personnel Management, 1900 E St. N.W., Room 5F12, Washington, DC 20415/202-632-5491.

General Schedule Classification

A variety of publications on government service classifications is available. For example, *Classification Principles and Policies* ($1.35) and *Handbook of Occupational Group and Series of Classes* ($8.90) are sold by the Superintendent of Documents, Government Printing Office, Washington, DC 20402/202-783-3238. Free publications include: *FED Facts on How Your GS Job Is Classified;* and *A Report on Study of Position Classification Accuracy in Executive Branch on Occupation Under the General Schedule.* For additional information, contact: Agency Relations Group, Office of Personnel Management, 1900 E St. N.W., Room 5453, Washington, DC 20415/202-254-8026.

Government Affairs Institute

The Government Affairs Institute offers the following services:

Interagency seminars, conducted on Capitol Hill to provide on-site experience with Congress.

Single-agency or single-program projects, tailored to meet the specific needs of an agency or clusters of agencies with related missions.

Courses offered by the Government Affairs Institute are designed to meet developmental needs of current and future executives and managers. Seminars for support staff personnel are also offered. Contact: Government Affairs Institute, Executive Personnel and Management Development Division, Office of Personnel Management, 1121 Vermont Ave. N.W., Room 1124, Washington, DC 20415/202-632-5662 (send mail to P.O. Box 988, Washington, DC 20044).

Health Benefits

The federal employees health benefits program provides various types of hospital, surgical and medical benefits for federal employees. Various free publications are available on this subject, for example: *Federal Employee Health Benefits Program*—biweekly and monthly health benefits rates; and *Information to Consider in Choosing a Health Plan.* Contact: Medical Unit, Compensation Group, Office of Personnel Management, 1900 E St. N.W., Room 3468, Washington, DC 20415/202-632-5510.

Incentive Awards

The incentive awards program provides cash and honor awards to employees for effecting improvements in government operations or services through their suggestions, inventions and superior performance. Free publications on Incentive Awards include: *Annual Award Ceremony; Federal Incentive Awards Program—Annual Report;* and *Suggest: Your Ideas May Be Worth Money!* For additional information, contact: Incentive Awards Branch, Office of Productivity Programs, Work Force Effectiveness and Development Group, Office of Personnel Management, 1900 E St. N.W., Room 6H34, Washington, DC 20415/202-632-4596.

Index to OPM Information

This annual index with quarterly supplements is available at no cost by written request only. It lists all Office of Personnel Management publications, including information required to be available under the Freedom of Information Act. Contact: Internal Distribution Unit, Office of Personnel Management, 1900 E St. N.W., Room B431, Washington, DC 20415/202-632-4677.

Insurance Programs

Information on regular and optional life insurance programs can be obtained from a free pamphlet, *Federal Employees Group Life Insurance*

Program. Contact: Insurance Programs, Compensation Group, Office of Personnel Management, 1717 H St. N.W., Room 809H, Washington, DC 20415/202-632-4670.

Interagency Training Catalog of Courses

This catalog contains a variety of training programs offered by various federal agencies. These courses are available to federal, state and local government employees. The programs include courses on automated data processing, communications and office skills, general management, labor relations, management sciences, personnel management, and records management. Addresses of Training Centers are also listed. Contact: Office of Training Services, Work Force Effectiveness and Development Group, Office of Personnel Management, 1121 Vermont Ave. N.W., Room 7647, Washington, DC 20415/202-632-6802.

Job Grading System

Job Grading System for Trades and Labor Occupations is available on a subscription basis ($60.00) from the Superintendent of Documents, Government Printing Office, Washington, DC 20402/202-783-3238. For additional information, contact: Trades and Labor Occupations, Standards Development Center, Staffing Service Group, Office of Personnel Management, 1900 E St. N.W., Room 3441, Washington, DC 20415/202-632-4441.

Labor Agreement Information Retrieval System (LAIRS)

This system provides current and historic information about the federal labor relations program. The information takes the form of computer searches, microfiche of full text decisions, published analytic reports, current periodicals and a variety of audiovisual training aids. The file contains negotiated agreements, arbitration awards, and significant federal labor relations decisions. A schedule of fees is provided. LAIRS also publishes labor-management reports, surveys, digests and other related publications. For a list of these and for additional information, contact: Labor Agreement Information Retrieval System, Office of Labor-Management Relations, Office of Personnel Management, 1900 E St. N.W., Room 2340, Washington, DC 20415/202-254-5239.

Labor-Management Relations

Information, guidance and assistance are provided to agencies, unions, and the public on federal labor-management relations. Eligible labor organizations are consulted in the development and revision of government-wide personnel policies. Contact: Office of Labor-Management Relations, Office of Personnel Management, 1900 E St. N.W., Room 7A05, Washington, DC 20415/202-632-4468.

Library

The Office of Personnel Management Library contains a comprehensive collection of materials on personnel management and the federal civil service. It also issues *Personnel Literature*, a monthly with an annual index ($17.00 per year), and *Personnel Bibliographies* (price varies). Both are available from the Superintendent of Documents, Government Printing Office, Washington, DC 20402/202-783-3238. For additional information, contact: Library, Office of Management, Office of Personnel Management, 1900 E St. N.W., Room 5L45, Washington, DC 20415/202-632-4432.

Management

This is a quarterly magazine which provides an explanation of personnel management policy and readings of general interest to government managers. Each issue contains four or five features on timely subjects along with continuing coverage of current legal decisions, legislation, and state and local notes. Personnel and general management developments that affect government management are summarized. Sold for $7.00 per year by the Superintendent of Documents, Government Printing Office, Washington, DC 20402/202-783-3238. For additional information, contact: Office of Public Affairs, Office of Personnel Management, 1900 E St. N.W., Room 5F12, Washington, DC 20415/202-632-5491.

Merit Pay

A merit pay system for supervisors and management officials in grades below Senior Executive Schedules has been developed. *FED Facts on Merit System Principles and Prohibited Personnel Practices* is available at the Office of Public Affairs, Office of Personnel Management, 1900 E St. N.W., Washington, DC 20415. For further information, contact: Compensation Program Development, Compensation Group, Office of Personnel Management, 1900 E St. N.W., Room 2424, Washington, DC 20415/202-653-5990.

Personnel Bibliography Series

These publications are compiled periodically from *Personnel Literature:*

Equal Opportunity in Employment (1979, $3.25)
Federal Civil Service—History, Organization and Activities (1979, $1.50)

The Personnel Management Function (1979, $3.50)
Personnel Policies and Practices (1979, $2.25)
Executive Personnel (1979, $3.25)
Self-Development Aids for Supervisors and Middle Managers (1979, $1.25)
Work Force Effectiveness (1979, $3.50)
The Federal Civil Service—History, Organization and Activities (1980, $2.00)
Personnel Management in State and Local Governments (1980, $2.00)
Executive Personnel (1980, $3.50)
The Personnel Management Function (1980, $3.50)
Labor-Management Relations in the Public Service (1980, $2.00)
Work Force Effectiveness (1980, $4.25)
Personnel Policies and Practices (1980, $2.50)
Equal Opportunity in Employment (1980, $3.50)

They are sold by the Superintendent of Documents, Government Printing Office, Washington, DC 20402/202-783-3238. For further information, contact: Library, Office of Personnel Management, 1900 E St. N.W., Room 5L45, Washington, DC 20415/202-632-4432.

Personnel Investigations

Personnel investigations are used in support of the selection and appointment processes. They serve several purposes: to determine the suitability of applicants under consideration for appointment; to check on applicants or employees under consideration for appointment to positions having either national security or special professional or administrative qualifications requirements, or both; and to enforce civil service regulations. The OPM also makes loyalty determinations of United States citizens employed or under consideration for employment by international organizations of which the United States is a member. Contact: Personnel Investigations Division, Office of Personnel Management, 1717 H St. N.W., Room 913, Washington, DC 20415/202-632-6181.

Personnel Literature

This is a monthly publication that includes about 200 or so personnel management subjects such as performance evaluation, productivity, executives, employee training and development, and labor management relations. It includes federal, state and local governments, foreign governments and private organizations. It is sold for $17.00 per year by the Superintendent of Documents, Government Printing Office, Washington, DC 20402/202-783-3238. For additional information, contact: Library, Office of Personnel Management, 1900 E St. N.W., Room 5L44, Washington, DC 20415/202-632-4432.

Personnel Management

Personnel management responsibilities include the government-wide classification system; administration of government pay systems; development and operation of information systems to support and improve federal personnel management decisionmaking; and independent evaluation of agency personnel management systems. Contact: Management Division, Office of Personnel Management, 1900 E St. N.W., Room 1469. Washington, DC 20415/202-632-6118.

Personnel Records

Basic Personnel Records and Files System is available by subscription ($9.15) from the Superintendent of Documents, Government Printing Office, Washington, DC 20402/202-783-3238. For additional information, contact: Agency Relations Group, Office of Personnel Management, 1900 E St. N.W., Room 5305, Washington, DC 20415/202-632-6108.

Presidential and Vice-Presidential Financial Reporting

Top personnel in the Executive Branch, including the President, Vice President and anyone with a basic rate of pay equal to or above a General Schedule-16 is expected to provide financial statements. All appointees file with the agency in which they are employed. The financial statements of the President and Vice President are available. Contact: Office of Government Ethics, Office of Personnel Management, 1900 E St. N.W., Room 436H, Washington, DC 20415/202-632-7642.

Presidential Management Intern Program

This program provides a two-year internship in the federal service for recipients of graduate degrees in general management with a public sector focus. For additional information, contact: Presidential Management Intern Program Division, Office of Intergovernmental Personnel Programs, Office of Personnel Management, 1900 E St. N.W., Room 2510, Washington, DC 20415/202-254-7316.

Productivity Resource Center

The Productivity Resource Center collects, evaluates and disseminates information and documents on productivity in federal, state and local governments as well as in private industry. It is a repository for timely, available productivity products. Contact: Productivity Resource Center, Work Force Effectiveness and Development Group, Office of Personnel Management, 1900 E St. N.W., Room 7H39, Washington, DC 20415/202-632-6151.

Public Reference Room

Labor-management reports, surveys, and analyses can be seen in the Public Reference Room. An appointment is suggested. Contact: Labor Agreement Information Retrieval Systems, Office of Labor-Management Relations, Office of Personnel Management, 1900 E St. N.W., Room 2340, Washington, DC 20415/202-254-5239.

Retirement Benefits

All claims for benefits under the retirement system must be adjudicated. Benefits are not paid automatically. For information on how to apply for retirement benefits, death benefits and refunds, contact: Special Inquiry Section, Retirement Programs, Compensation Group, Office of Personnel Management, 1900 E St. N.W., Room 4466, Washington, DC 20415/202-254-8866.

Retirement Programs

Information on government retirement programs as well as a variety of free publications on the subject can be obtained. Some of these include: *FED Facts on the Civil Service Retirement System; Your Retirement System*—questions and answers on the federal civil service retirement law; *Information for Annuitants; Retirement Benefits When You Leave the Government Early;* and *Federal Fringe Benefits Facts.* Contact: Retirement Programs, Compensation Group, Office of Personnel Management, 1900 E St. N.W., Room 4417, Washington, DC 20415/202-632-4581.

Senior Executive Service (SES)

SES gives every eligible senior manager the chance to shift top career managers around to meet the senior executive's needs. For additional information, contact: Senior Executive Service Division, Office of Personnel Management, 1900 E St. N.W., Room 6R48, Washington, DC 20415/202-632-4486.

SES Candidate Development Program

This program prepares senior federal managers and other employees at a certain level to enter the Senior Executive Service by providing opportunities to improve upon and/or acquire the management and executive competencies required for the SES. For details about the program, contact: Executive Personnel and Management Development, Office of Personnel Management, 1900 E St. N.W., Room 6671, Washington, DC 20415/202-632-4661.

Speakers

Representatives of the Office of Personnel Management will speak to professional societies, business and labor groups, and other organizations interested in or affected by federal personnel policies and changes. Contact: Office of Public Affairs, Office of Personnel Management, 1900 E St. N.W., Room 5F12, Washington, DC 20415/202-632-4588.

Special Benefits

For information on special civil servant benefits, contact: Program Services, Office of Pay and Benefits Program, Compensation Group, Office of Personnel Management, 1900 E St., N.W., Room 3554, Washington, DC 20415/202-632-5530.

Standards

The Standards Development Center develops standards which are tools for evaluating requirements for most government occupations. It provides the minimum qualification standards to which individual agencies can add more qualifications. Contact: Standards Development Center, Staffing Services Group, Office of Personnel Management, 1900 E St., N.W., Room 3609, Washington, DC 20415/202-632-4516.

Summer Job Announcements

These announcements describe summer employment opportunities with federal agencies. They are available in the Federal Job Information Center, or contact: Federal Job Information Center General Information, Office of Personnel Management, 1900 E St. N.W., Room 1416, Washington, DC 20415/202-737-9616.

Training Information Clearinghouse: A Guide

A free annotated list of print and audiovisual materials for the training of government employees is available. Contact: Office Training, Office of Personnel Management, P.O. Box 7230, Washington, DC 20044/202-653-6132.

Washington Management Institute

The Institute provides executive and managerial training and development services to support government agencies in their efforts to achieve greater efficiency and effectiveness in managing federal programs. For further information, contact: Washington Management Institute, Executive Personnel and Management Development, Office of Personnel Management, 1121 Vermont Ave. N.W., Room 1100, Washington, DC 20415/202-632-5671 (send mail to: P.O. Box 988, Washington, DC 20044).

Work Force Analysis and Statistics

Analyses and statistics are available on the

Federal Civilian Work Force. The publications available are:

Federal Civilian Work Force Statistics Monthly Release—has information on current employment by branch, agency, and area; trends of employment and payroll, and accessions and separations. Narrative analyses and summary tables are given.

Occupations of Federal White-Collar Workers (annual)—provides information on professional, administrative, technical, clerical and a few other positions and distributions of these full-time workers by occupation, grade, average salary, sex, major geographic areas and agency.

Occupations of Federal Blue-Collar Workers.

Pay Structure of the Federal Civil Service.

Report of Federal Civilian Employment by Geographic Area.

Work Years and Personnel Costs.

Equal Employment Opportunity Statistics.

Contact: Work Force Analysis and Statistics,

Agency Compliance and Evaluation, Office of Personnel Management, 1900 E St. N.W., Room 6429, Washington, DC 20415/202-254-6287.

Working for the U.S.A.

This book is available for $1.50 from the Superintendent of Documents, Government Printing Office, Washington, DC 20402/202-783-3238. For additional information, contact: Staffing Services Group, Office of Personnel Management, 1900 E St. N.W., Room 6F08, Washington, DC 20415/202-632-6005.

How Can the Office of Personnel Management Help You?

To determine how the Office of Personnel Management can help you, contact: Office of Public Affairs, Office of Personnel Management, 1900 E St. N.W., Washington, DC 20415/202-632-5491.

Overseas Private Investment Corporation—U.S. International Development Cooperation Agency

1129 20th St. N.W., Washington, DC 20527/202-653-2800

ESTABLISHED: 1970
BUDGET: $55,689,000
EMPLOYEES: 132

MISSION: Assists United States investors in making profitable investments in about 80 developing countries; encourages investment projects that will help the social and economic development of these countries; helps the U.S. balance of payments through the profits they return to this country, as well as the U.S. jobs and exports they create; offers U.S. investors assistance in finding investment opportunities, insurance to protect their investments, and loans and loan guarantees to help finance their projects.

Major Sources of Information

Agribusiness

The Overseas Private Investment Corporation (OPIC) is working closely with the Department of Agriculture, the Agribusiness Council, United States cooperative organizations, and others to facilitate the transfer of agribusiness development know-how to raise the efficiency of food systems in the emerging nations. OPIC provides pre-investment study funding, project financing, and insurance. Contact: Office of Development, Overseas Private Investment Corporation, IDCA, 1129 20th St. N.W., 7th Floor, Washington, DC 20527/202-653-2855.

Contractors' and Exporters' Guarantees

Insurance coverage is available for bid, performance and advance payment guarantees posted by U.S. construction and service contractors and exporters in favor of host government owners. OPIC insures such guarantees, which normally take the form of on-demand letters of credit, against drawings which are not justified by the contractor's or exporter's non-performance. *OPIC Program for Insurance of Contractors' Bid* is a handbook which describes the program. Contact: Insurance Department, Applications Office, Overseas Private Investment Corporation, 1129 20th St. N.W., 7th Floor, Washington, DC 20527/202-653-2962.

Country and Area List

OPIC has agreements with these listed countries to permit the operation of its insurance and finance programs: Afghanistan, Antigua, Argentina, Bangladesh, Barbados, Belize, Benin (Dahomey), Bolivia, Botswana, Brazil, Burundi, Cameroon, Central Africa Empire, Chad, Chile, Colombia, Congo (Brazzaville), Costa Rica, Cyprus, Dominica, Dominican Republic, Ecuador, Egypt, El Salvador, Ethiopia, Fiji, Gabon, Gambia, Ghana, Greece, Grenada, Guatemala, Guinea, Hait, Honduras, India, Indonesia, Iran, Israel, Ivory Coast, Jamaica, Jordan, Kenya, Korea, Lesotho, Liberia, Madagascar, Malawi, Malaysia, Mali, Malta, Mauritania, Mauritius, Morocco, Nepal, Nicaragua, Niger, Nigeria, Oman, Pakistan, Panama, Papua New Guinea, Paraguay, Peru, Philippines, Portugal, Romania, Rwanda, St. Christopher (St. Kitts-Nevis), St. Lucia, St. Vincent, Saudi Arabia, Senegal, Sierra Leone, Singapore, Somali Republic, Sri Lanka (Ceylon), Sudan, Surinam, Swaziland, Syria, Taiwan, Tanzania (excl. Zanzibar), Thailand, Togo, Trinidad-Tobago, Tunisia, Turkey, Uganda, Upper Volta, Venezuela, Western Samoa, Yemen (Sanaa), Yugoslavia, Zaire, Zambia. For current information regarding OPIC services offered in specific countries, including their potential availability in nations not listed, or possible temporary limitations due to administrative or underwriting considerations, contact: Information Officer, Overseas Private Investment Corporation, IDCA, 1129 20th St. N.W., 7th Floor, Washington, DC 20527/202-653-2800.

Direct Payments

The program described below provides financial assistance directly to individuals, private firms or other private institutions to encourage or subsidize a particular activity:

Pre-Investment Assistance

Objectives: To initiate and support through financial participation, the identification, assessment, surveying and promotion of private investment opportunities.

Eligibility: U.S. firms capable of carrying project forward if survey indicates feasibility.

Range of Financial Assistance: $10,000 to $300,000.

Contact: Information Officer, Overseas Private Investment Corporation, Washington, DC 20527/202-653-2800.

Feasibility Surveys

On a selective basis, OPIC will enter into cost-sharing arrangements with a U.S. firm to investigate and study the feasibility of an opportunity (other than oil or gas extraction) which that firm has identified through its own reconnaissance in the host country and which offers the basis for a sound and practical investment. Small businesses are eligible for feasibility survey assistance in all countries where OPIC operates. Contact: Finance Department, Overseas Private Investment Corporation, IDCA, 1129 20th St. N.W., 7th Floor, Washington, DC 20527/202-653-2870.

Financial Program

OPIC implements its finance program through a variety of loan and loan guaranty techniques to provide medium-to-long-term funding to ventures involving substantial equity and management participation by U.S. business. OPIC participation often is in the form of "project financing," which is based primarily on the economic, technical, marketing and financial soundness inherent in the project itself. OPIC participates in financing through loans from its Direct Investment Fund and loan guaranties issued to private U.S. financial institutions making eligible loans. *Finance Handbook* details the finance services of OPIC. Contact: Finance Department, Overseas Private Investment Corporation, IDCA, 1129 20th St. N.W., 7th Floor, Washington, DC 20527/202-653-2870.

Hotline—Small Business Services

OPIC encourages investment by U.S. small- and medium-sized companies interested in the growing market potential of the developing countries. Contact: Small Business Office, Finance Department, Overseas Private Investment Corporation, IDCA, 1129 20th St. N.W., 7th Floor, Washington, DC 20527/202-653-2800. Toll-free 800-424-OPIC (6742).

Information

For answers to specific questions on OPIC programs, for details on special programs for smaller businesses, and for the dates of future investment seminars and missions, contact: Public Information, Overseas Private Investment Corporation, IDCA, 1129 20th St. N.W., 7th Floor, Washington, DC 20527/202-653-2800.

Insurance Programs

OPIC is best known for its insurance of private U.S. foreign investment against the political risks of inconvertibility of currency, loss of investment due to expropriation by the host government, and loss due to war, revolution, or insurrection. Insurance is available not only for conventional equity and debt investments, but also for investments under various arrangements such as licensing, management and technical assistance agreements, service contracts, and the production-sharing arrangements sometimes used in energy or raw materials extraction projects. *The Investment Insurance Handbook* provides detailed information on the OPIC Insurance Program. For additional information, contact: Insurance Department, Overseas Private Investment Corporation, IDCA, 1129 20th St. N.W., 7th Floor, Washington, DC 20527/202-653-2966.

Loans and Loan Guarantees

The programs described below are those which offer financial assistance through the lending of federal monies for a specific period of time or programs in which the federal government makes an arrangement to indemnify a lender against part or all of any defaults by the borrower:

Direct Investment Loans

Objectives: To make loans for projects in developing countries sponsored by or significantly involving U.S. small business or cooperatives.

Eligibility: Privately owned firms or firms of mixed private and public ownership sponsored by or significantly involving U.S. small business or cooperatives.

Range of Financial Assistance: $325,000 to $2,500,000.

Contact: Information Officer, Overseas Private Investment Corporation, Washington, DC 20527/202-653-2800.

Foreign Investment Guaranties

Objectives: To guarantee loans and other investments made by eligible U.S. investors in developing friendly countries and areas.

Eligibility: Guaranteed eligible investor must be a citizen of the United States; corporation, partnership or other association created under the laws of the United States or any state or territory, and substantially beneficially owned by U.S. citizens or a 95% owned foreign subsidiary of such entity.

Range of Financial Assistance: Not specified.

Contact: Information Officer, Overseas Private Investment Corporation, Washington, DC 20527/202-653-2800.

OPIC Mineral and Energy Projects

OPIC offers highly flexible and innovative coverage for investments in mineral exploration and development (including processing where it is an integral part of a development project), and in oil and gas exploration, development and production, under terms and conditions tailored to the special needs and concerns of investors in these kinds of projects. Contact: Energy and Minerals, Insurance Department, Overseas Private Investment Corporation, IDCA, 1129 20th St. N.W., 7th Floor, Washington, DC 20527/202-653-2958.

Overseas Opportunities

OPIC promotes market and investment interest in lower income countries which have promising potential and reasonably favorable economic environments. It undertakes studies of a host country's needs and the opportunities it offers, including specific projects which can be brought to the attention of qualified potential U.S. investors. OPIC sponsors seminars for business executives and conducts meetings with a broad spectrum of the business and financial community. OPIC invites host country promotional agencies, development banks, and investment centers to provide information for dissemination to potential investors. It also sponsors investment missions to developing countries for U.S. business executives. Meetings are arranged with local business people, development bankers, government officials, and others who may be of assistance. Contact: Investment Promotions, Overseas Private Investment Corporation, IDCA, 1129 20th St. N.W., 7th Floor, Washington, DC 20527/202-653-2800.

Policy

It is OPIC policy to be selective in approving applications for overseas business insurance and financial assistance, so that each project will generate mutual advantages to the host country and the United States. In addition to its humanitarian aspects, economic development through private investment usually creates new markets for U.S. exports. Mutual benefit also is derived from private investment activities that find and develop new sources of raw materials. Contact: Investment Missions Director, Overseas Private Investment Corporation, IDCA, 1129 20th St. N.W., 7th Floor, Washington, DC 20527/202-653-2800.

Publications

OPIC publications include:

Annual Report
Insurance Handbook
Finance Handbook
Smaller Business Directory
Small Business Guide
Country List
TOPICS (Newsletter)
Claims History
Guidelines for Broker/Agent Participation

For additional information on OPIC, free copies of these publications are available on request from the Information Officer, Overseas Private Investment Corporation, IDCA, 1129 20th St. N.W., 7th Floor, Washington, DC 20527/202-653-2800.

TOPICS

This is a free newsletter that disseminates information about specific investment opportunities and trends in various countries. Contact: Public Affairs, Overseas Private Investment Corporation, IDCA, 1129 20th St. N.W., 7th Floor, Washington, DC 20527/202-653-2800.

How Can the Overseas Private Investment Corporation Help You?

To determine how the Overseas Private Investment Corporation can help you, contact: Overseas Private Investment Corporation, 1129 20th St. N.W., Washington, DC 20527/202-653-2800.

Panama Canal Commission

425 13th St. N.W., Washington, DC 20004/202-724-0104

ESTABLISHED: September 27, 1979
BUDGET: $463,887,000
EMPLOYEES: 8,410
MISSION: Maintains and operates the Panama Canal and the facilities and appurtenances related thereto; coordinates the operation of the waterway and other activities with the Republic of Panama; and correlates joint actions in harbors and port areas, certain housing and public areas, and some civil protection functions.

Major Sources of Information

Commission Files

Official files of the Board of Directors are maintained in this office. Contact: Office of the Secretary, Panama Canal Commission, 425 13th St. N.W., Suite 312, Washington, DC 20004/202-724-0104.

Commission Functional Charts

The Commission issues an organization chart that details the functions of each office within the Panama Canal Commission. It is an excellent source of information on the Commission. Contact: Office of the Secretary, Panama Canal Commission, 425 13th St. N.W., Suite 312, Washington, DC 20004/202-724-0104.

Construction Services

This branch provides the services necessary for the management of construction. These include contract formation and award, quality and safety assurance, resolution of construction problems, contract modifications, etc. Services of experts such as architects, engineers and technical representatives are also procured. Contact: Construction Management Branch, Bureau of Engineering and Construction, Panama Canal Commission, APO Miami 34011.

Dredging Operations

This division is responsible for maintenance and construction dredging; slide removal, inspection and maintenance of the Atlantic breakwater; operation and maintenance of navigational aids in the channel; the detection, containment, recovery, and disposal of oil pollution in the Canal operating areas and the removal and control of aquatic weeds through the use of chemical and biologic means. Contact: Dredging Division, Engineering and Construction Branch, Panama Canal Commission, APO Miami 34011.

Economic Analysis

A variety of economic analyses is prepared by this office. They include: forecasts of Canal traffic and tolls revenue; development of budget premises; economic studies and surveys; balance of payments analysis; development of cost and price indices; analytic review of outside economic analyses and reports; and compilations of Canal traffic data. Contact: Office of Executive Planning, Panama Canal Commission, APO Miami 34011.

Electrical Operations

This division operates and maintains power plants, substations, transmission lines, distribution systems and communication systems. It also operates the Gatun Spillway and Madden Dam. Contact: Electrical Division, Engineering and Construction Bureau, Panama Canal Commission, APO Miami 34011.

Engineering Plans

This division is responsible for designs, estimates, specifications and all pre-contract functions. It also provides engineering studies and architectural designs and maintains record maps of topography, certain streets, utilities, pipelines,

and town sites. For additional information, contact: Engineering Division, Engineering and Construction Bureau, Panama Canal Commission, APO Miami 34011.

Freedom of Information Act Requests

For Freedom of Information Act requests, contact: Administrative Services Division, Panama Canal Commission, APO Miami 34011.

Information

Specific information on the organization and functions of the Commission, the operation and maintenance of the Panama Canal, schedules, announcements and minutes of Board meetings, contact: Office of the Secretary, Panama Canal Commission, 425 13th St. N.W., Suite 312, Washington, DC 20004/202-724-0104.

Library and Museum

The library provides public and technical services to Commission employees and their families, U.S. personnel in other agencies and other Isthmian residents. The museum deals with the history of the Canal. Contact: Library-Museum, General Services Administration, APO Miami 34011.

Marine Accident Investigations

The Board of Local Inspectors is responsible for the investigation of the circumstances surrounding marine accidents which occur in the Canal operating area, harbors, canal anchorages, and areas adjacent to them, involving Commission personnel and/or equipment. Contact: Board of Local Inspectors, Marine Bureau, Panama Canal Commission, APO Miami 34011.

Marine Locks

This office is responsible for the operation and maintenance of the Atlantic and Pacific Locks and related facilities, handling of all vessels in the Locks, and operating and maintaining the Miraflores Spillway and Miraflores Bridge. Contact: Locks Division, Marine Bureau, Panama Canal Commission, APO Miami 34011.

Marine Salvage Operations

This division coordinates the handling of burning, wrecked or damaged vessels. Contact: Canal Support Division, Marine Bureau, Panama Canal Commission, APO Miami 34011.

Marine Traffic

Maritime traffic through the Canal and in the terminal ports of Balboa and Cristobal is controlled by the Commission. It also administers rules and regulations of navigation and transiting of the Canal, its terminal harbors and their adjacent waters. Contact: Marine Bureau, Panama Canal Commission, APO Miami 34011.

Meteorologic and Hydrographic Data

This office improves and develops forecasting and operation techniques to improve water utilization. It also collects records and stores meteorologic and hydrographic data. Contact: Engineering Division, Engineering and Construction Bureau, Panama Canal Commission, APO Miami 34011.

Ombudsman

The Ombudsman receives individual complaints, grievances, requests and suggestions, and reviews and seeks resolution of administrative problems, inefficiencies and conflicts caused within the U.S. government agencies in Panama as a result of the Panama Canal Treaty. Contact: Office of Ombudsman, Panama Canal Commission, Administration Building, Balboa Heights, Panama, or: Panama Canal Commission, 425 13th St. N.W., Suite 312, Washington, DC 20004/202-724-0104.

Panama Canal Commission

The following office of the Panama Canal Commission is located in Panama: Panama Canal Commission, Administration Building, Balboa Heights, Panama. The Secretary's Office is the U.S. Liaison for the Commission. Contact: Office of the Secretary, Panama Canal Commission, 425 13th St. N.W., Suite 312, Washington, DC 20004/202-724-0104.

Potable Water

The Water and Laboratories Branch purifies and distributes potable water through two systems serving the Pacific and the Atlantic areas. It also operates a general testing and environmental quality laboratory. Contact: Maintenance Division, Engineering and Construction Bureau, Panama Canal Commission, APO Miami 34011.

Procurement

This office is responsible for procuring supplies, materials and equipment required by the Commission. Supplies include machinery, hardware, vehicles and related parts, industrial rubber goods, cranes, towing locomotives, floating equipment, raw materials, electrical steamship and institutional-type goods. Contact: Procurement Division, Panama Canal Commission, 4400

Dauphine St. New Orleans, LA 70146/504-948-5299.

Publications

Official circulars, regulations, tariffs, reports and other publications are issued by this office. Commission records are also managed by this office. Contact: Administrative Services Division, Panama Canal Commission, APO Miami 34011.

Surveys

Topographic and hydrographic surveys are available; precise level benchmarks are maintained; and topographic maps, and hydrographic charts are compiled and produced. Contact: Surveys Branch, Engineering Division, Engineering and Construction Bureau, Panama Canal Commission, APO Miami 34011.

Tolls and Services

This office bills vessels and agencies for tolls and services such as pilotage, towboat and deckhands. Contact: Canal Support Division, Marine Bureau, Panama Canal Commission, APO Miami 34011.

How Can the Panama Canal Commission Help You?

To determine how the Panama Canal Commission can help you, contact: Secretary, Panama Canal Commission, 425 13th St. N.W., Washington, DC 20004/202-724-0104.

Pennsylvania Avenue Development Corporation

425 13th St. N.W., Washington, DC 20004/202-566-1218

ESTABLISHED: October 27, 1972
BUDGET: $39,569,000
EMPLOYEES: 47

MISSION: Has prepared a comprehensive development plan for Pennsylvania Avenue and the adjacent blocks on the north side of the Avenue between the Capitol and the White House; will carry out the plan through a combination of public improvements with stimulation of private investment; and is to ensure development, maintenance, and use of the area compatible with its historic and ceremonial importance.

Major Sources of Information

Building Permits

The District of Columbia government refers building permits for new construction in the Pennsylvania Avenue Development Area to PADC for approval relating to conformity with the plan. Contact: Pennsylvania Avenue Development Corporation, 425 13th St. N.W., Room 1148, Washington, DC 20004/202-566-1218.

Contracts

For information on contracts negotiated by the Corporation and various parties, contact: Contract Specialist, Pennsylvania Avenue Development Corporation, 425 13th St. N.W., Room 1148, Washington, DC 20004/202-566-1218.

Finances

Financial information on land acquisition, public development, construction in progress, real property assets, liabilities, etc. is available. Contact: Financial Manager, Pennsylvania Avenue Development Corporation, 425 13th St. N.W., Room 1148, Washington, DC 20004/202-483-4831.

Freedom of Information Act Requests

For Freedom of Information Act requests, contact: Pennsylvania Avenue Development Corporation, 425 13th St. N.W., Room 1148, Washington, DC 20004/202-523-1340.

Private Development

The Pennsylvania Avenue Development Corporation will buy and assemble some properties in the area and lease them back to private investors/developers for developing according to the Congressionally approved plan. A private investor may also purchase land directly from a landowner and develop it in accordance with the plan. Contact: Finance and Development, Pennsylvania Avenue Development Corporation, 425 13th St. N.W., Room 1248, Washington, DC 20004/202-523-5485.

Publications

The Pennsylvania Avenue Development Corporation publications include a free quarterly newsletter and an annual report, *Historic Preservation* ($2.25), the *Pennsylvania Avenue Plan—1974* ($2.50); supplementary technical documents and economic studies are sold at cost. Contact: Public Information, Pennsylvania Avenue Development Corporation, 425 13th St. N.W., Room 1148, Washington, DC 20004/202-523-1218.

Relocation

The Corporation is working on a program for a supplemental relocation assistance program that includes rental assistance payments beyond those provided by the 1970 Uniform Relocation Act. It also is working with developers in the area in an attempt to relocate as many displaced businesses as possible. For information on these programs, contact: Relocation Office, Pennsylvania Avenue Development Corporation, 425 13th St. N.W., Room 1248, Washington, DC 20004/202-523-3726.

Youth Employment

The Corporation initiated a youth employment program that gives on-the-job training to minority youth in the area of construction management. Contact: Construction, Office of Operations, Pennsylvania Avenue Development Corporation, 425 13th St. N.W., Room 1148, Washington, DC 20004/202-523-3810.

How Can the Pennsylvania Avenue Development Corporation Help You?

To determine how the Pennsylvania Avenue Development Corporation can help you, contact: Public Information Officer, Pennsylvania Avenue Development Corporation, 425 13th St. N.W., Room 1148, Washington, DC 20004/202-566-1218.

Pension Benefit Guaranty Corporation

2020 K St. N.W., Washington, DC 20006/202-254-4817

ESTABLISHED: September 2, 1974
BUDGET: Not specified
EMPLOYEES: 480
MISSION: Guarantees basic pension benefits in covered private plans if they terminate with insufficient assets.

Major Sources of Information

Actuarial Programs

The Pension Benefit Guaranty Corporation's Annual Report includes an actuarial evaluation of expected operations and a projection of the status of funds for a five-year period. Contact: Actuarial Program, Branch Office of Financial Operations, Pension Benefits Guaranty Corporation, 2020 K St. N.W., Room 6103, Washington, DC 20006/202-254-7102.

Filing Reportable Events

The notice of a reportable event must be in writing. It may either be mailed or delivered on weekdays between 9:00 A.M. and 4:00 P.M. Contact: Office of Program Operations, Pension Benefit Guaranty Corporation, 2020 K St. N.W., Room 5300-A, Washington, DC 20006/202-254-4703.

Financial Statements

The Pension Benefit Guaranty Corporation combined financial statements include the assets and liabilities of all defined benefit pension plans for which the Corporation is trustee. It includes those plans which have terminated and are expected to result in PBGC trusteeship. Contact: Office of Financial Operations, Pension Benefit Guaranty Corporation, 2020 K St. N.W., Washington, DC 20006/202-254-7106.

Freedom of Information Act Requests

For Freedom of Information Act requests, contact: Freedom of Information Inquiries, Pension Benefit Guaranty Corporation, 2020 K St. N.W., Room 7100, Washington, DC 20006/202-254-4830.

Individual Retirement Programs

The Pension Benefit Guaranty Corporation provides advice and assistance to individuals on the economic desirability of establishing tax-qualified Individual Retirement Accounts (IRAs) or certain other individual retirement programs and on transforming to such IRAs or other programs from qualified pension plans when an employee receives a lump sum distribution. Contact: Office of Public Affairs, Pension Benefit Guaranty Corporation, 2020 K St. N.W., Room 7100, Washington, DC 20006/202-254-4830.

Legal Issues

In addition to developing legal issues through litigation, the General Counsel issues a great many legal opinions which seek to resolve questions of interpretation that arise under PBGC's regulations. Contact: Office of General Counsel, Pension Benefit Guaranty Corporation, 2020 K St. N.W., Room 7200, Washington, DC 20006/202-254-4864.

Multiemployer Program

Multiemployer plans are maintained under collective bargaining agreements, and they cover employees of two or more unrelated employers. Multiemployer plans that become insolvent may receive financial assistance from PBGC to enable them to pay guaranteed benefits. Contact: Office of Program Operations, Pension Benefit Guaranty Corporation, 2020 K St. N.W., Room 5000, Washington, DC 20006/202-254-4700.

Pension Protection Plans

The Pension Benefit Guaranty Corporation

administers two pension protection programs: 1) a plan termination insurance program covering about 25 million people in about 78,000 single employer pension plans; and 2) a plan insolvency insurance program covering about 8 million people in 2,000 multiemployer pension plans. Contact: Branch of Inquiries, Office of Program Operations, Pension Benefit Guaranty Corporation, 2020 K St. N.W., Room 5314, Washington, DC 20006/202-254-4817.

Premiums

All covered pension plans are required to pay prescribed annual premium rates to the Pension Benefit Guaranty Corporation. For further information, contact: Branch of Inquiries, Office of Program Operations, Pension Benefit Guaranty Corporation, 2020 K St. N.W., Room 5314, Washington, DC 20006/202-254-4817.

Public Records

The following items are available for inspection: Pension Benefit Guaranty Corporation Trusteeship Plans, opinion letters, opinion manuals, pertinent litigation for review, termination case data sheets, case log terminating plans updated quarterly, and a computer listing of termination cases. In addition, on microfilm, annual reports filed by pension plans may be inspected by the public. Contact: Disclosure Room, Pension Benefit Guaranty Corporation, 2020 K St. N.W., Room 7100, Washington, DC 20006/202-254-4827.

Reportable Events

The plan administrator of any pension plan covered by the Pension Benefit Guaranty Corporation's plan termination insurance program must notify the PBGC within thirty days after he or she knows or should have known of the occurrence of certain events. Notification of reportable events allows the PBGC to take appropriate action to protect the benefits of plan participants and beneficiaries, or to prevent unreasonable loss to the plan termination insurance program. Reportable events include: tax disqualification; noncompliance with Title I of ERISA; decrease in benefits; reduction in number of active participants; termination or partial termination of a plan; failure to meet minimum standards; inability to pay benefits when due; distribution to a substantial owner; merger, consolidation or transfer; alternative compliance with reporting and disclosure requirements; bankruptcy, insolvency or similar settlements; liquidation or dissolution; and transaction involving a change of employer. *Reportable Events*, a free booklet, de-

scribes what reportable events should be reported, items of information to be submitted in the notice of a reportable event, and events for which the 30-day reporting requirement has been waived. Contact: Pension Benefit Guaranty Corporation Los Angeles Office, Federal Office Building, 300 N. Los Angeles St., Los Angeles, CA 90012/213-688-6428; or: Branch of Coverage and Inquiries, Office of Program Operations, Pension Benefit Guaranty Corporation, 2020 K St. N.W., Room 5314, Washington, DC 20006/202-254-4817.

Single Employer Program

Whenever a non-multiemployer plan insured by the Pension Benefit Guaranty Corporation terminates, the PBGC reviews the plan to ascertain whether it has sufficient plan assets to pay guaranteed benefits. If plan assets are sufficient, the plan administrator winds up the affairs of the plan. If plan assets are not sufficient to pay guaranteed benefits, the PBGC assumes responsibility for the plan by becoming trustee, administering benefit payments and records, managing plan assets, and making up the financial insufficiency from Corporate insurance funds. In all terminations, plan assets must be allocated as specified by ERISA. Contact: Office of Program Operations, Pension Benefit Guaranty Corporation, Room 5000, 2020 K St. N.W., Washington, DC 20006/202-254-4700.

Statistical History of Claims

A table of total pension liabilities guaranteed by the Pension Benefit Guaranty Corporation includes assets of terminated plans, statutory employer liability (the amount expected to be collected from the plan sponsor), and the resulting net claims. Contact: Office of Financial Operations, Pension Benefit Guaranty Corporation, 2020 K St. N.W., Room 6000, Washington, DC 20006/202-254-7106.

Terminations

When a Plan Administrator notifies the Pension Benefit Guaranty Corporation, the plan's assets and guaranteed benefit liabilities are valued to determine the sufficiency of assets to pay guaranteed benefits. PBGC may also institute termination proceedings when certain events indicate that such action may be necessary. Contact: Office of Program Operations, Pension Benefit Guaranty Corporation, 2020 K St. N.W., Room 5000, Washington, DC 20006/202-254-4700.

Trusteeships

If a terminated plan does not have sufficient

assets to pay guaranteed benefits, the Pension Benefit Guaranty Corporation becomes trustee for the plan and administers the payment of such benefits. Contact: Office of Program Operations, Pension Benefit Guaranty Corporation, 2020 K St. N.W., Room 5000, Washington, DC 20006/202-254-4700.

Your Guaranteed Pension

This publication answers questions most commonly asked by workers and retirees about the Pension Benefit Guaranty Corporation and the specific pension benefits it guarantees. Contact: Coverage and Classification, Office of Program Operations, Pension Benefit Guaranty Corporation, 2020 K St. N.W., Room 5413, Washington, DC 20006/202-254-4817.

How Can the Pension Benefit Guaranty Corporation Help You?

To determine how the Pension Benefit Guaranty Corporation can help you, contact: Pension Benefit Guaranty Corporation, 2020 K St. N.W., Washington, DC 20006/202-254-4817.

Postal Rate Commission

2000 L St. N.W., Washington, DC 20268/202-254-3880

ESTABLISHED: August 12, 1970
BUDGET: Not specified
EMPLOYEES: Not specified

MISSION: Submits recommended decisions to the United States Postal Service on postage rates and fees and mail classifications; issues advisory opinions to the Postal Service on proposed nationwide changes in postal services; initiates studies and submits recommendations for changes in the mail classification schedule; and receives, studies, and issues recommended decisions or public reports to the Postal Service on complaints received from the mailing public regarding postage rates, postal classifications, postal services on a substantially nationwide basis, and the closing or consolidation of small post offices.

Major Sources of Information

Change Requests

The Postal Service can request from the Commission an advisory opinion on changes in the nature of postal services which will generally affect service on a nationwide basis. These formal requests are then published in the *Federal Register*. Contact: Office of the Secretary, Postal Rate Commission, 2000 L St. N.W., Room 500, Washington, DC 20268/202-254-3880.

Complaints

Those parties who believe the Postal Service is charging improper rates or who believe that they are not receiving proper postal service may file and serve a written complaint with the Commission. Contact: Office of the Commission, Postal Rate Commission, 2000 L St. N.W., Room 500, Washington, DC 20268/202-254-3840.

Consumer Information

Consumer information as well as information on public hearings on rate changes is available. Contact: Office of the Commission, Postal Rate Commission, 2000 L St. N.W., Room 500, Washington, DC 20268/202-254-3840.

Freedom of Information Act Requests

Contact: Administrative Officer and Secretary, Postal Rate Commission, 2000 L St. N.W., Room 500, Washington, DC 20268/202-254-3880.

Hearing Calendar

A docket of all proceedings and a hearing calendar of all proceedings which have been set for hearing are available for public inspection. The Section also contains notices, motions, rulings, transcripts of hearings, and mail classifications, all dealing with postal rate levels. For further information, contact: Docket Section, Office of the Secretary, Postal Rate Commission, 2000 L St. N.W., Room 500, Washington, DC 20268/202-254-3800.

Information

For general information on postal rates, changes in postal services and the Postal Rate Service, contact: Information Office, Postal Rate Commission, 2000 L St. N.W., Room 500, Washington, DC 20268/202-254-5614.

Open Commission Meetings

The Commission serves as the legal forum for proposed changes in postal rates, fees, and mail classifications, changes in the nature of services, and the closing or consolidating of small post offices. With some exceptions, the Commission meetings are open to public observation (not participation). Access to the documents considered at these meetings is available. Contact: Office of the Secretary, Postal Rate Commission, 2000 L St. N.W., Room 500, Washington, DC 20268/202-254-3880.

Postal Rate Change

A very detailed flow chart provides all the steps followed in a postal rate case. Contact: Officer of the Commission, Postal Rate Commission, 2000 L St. N.W., Room 500, Washington, DC 20268/202-254-3840.

Rate Classification Records

Records of the Postal Rate Commission hearings on rate classification changes can be examined by the public. Contact: Dockets Section, Postal Rate Commission, 2000 L St. N.W., Room 500, Washington, DC 20268/202-254-3800.

Rules of Practice and Procedure

This free booklet describes in detail the Postal Rate Commission's duties and functions. It includes rules of general applicability; rules applicable to requests for changes in rates and fees, establishing or changing mail classification schedules, and changes in the nature of postal services; rules applicable to rate and service complaints, to filing of testimony by intervenors, and to the filing of periodic reports by the Postal Service; and rules applicable to appeal of postal service determinations to close or consolidate post offices. It also includes a statement of Postal Rate Commission revenue and expenses and a glossary of terms. Contact: Officer of the Commission, Postal Rate Commission, 2000 L St. N.W., Room 500, Washington, DC 20268/202-254-3840.

Rural Post Offices

At the Crossroads is a research study into the history and development of postal delivery and the Postal Service, and includes a review of pertinent Congressional legislation. The tables in the Appendix include general population characteristics, U.S. population since 1790, number of rural places and their percentage of U.S. population, population mobility, rural population, education, age and income characteristics, and number of post offices. For additional information on this or other research papers, contact: Office of Technical Analysis and Planning, Postal Rate Commission, 2000 L St. N.W., Room 500, Washington, DC 20268/202-254-3890.

How Can the Postal Rate Commission Help You?

To determine how the Postal Rate Commission can help you, contact, Secretary, Postal Rate Commission, 2000 L St. N.W., Washington, DC 20268/202-254-3880.

Railroad Retirement Board

844 Rush St., Chicago, IL 60611/312-751-4930

ESTABLISHED: August 29, 1935
BUDGET: $4,458,750
EMPLOYEES: 1,895

MISSION: Administers retirement-survivor and unemployment-sickness bene-
fit programs provided by federal laws for the nation's railroad workers and their
families. Annuities are paid by the Board to rail employees with at least 10
years of service who retire because of age or disability and to their eligible
spouses; annuities are also provided to the surviving spouses and children or
parents of deceased employees. (These retirement-survivor benefit programs are
closely coordinated with social security benefit programs and include Medicare
health insurance coverage. Under the Railroad Unemployment Insurance Act,
biweekly benefits are payable by the Board to workers with qualifying railroad
earnings who become unemployed or sick. About 100 field offices are main-
tained across the country.)

Major Sources of Information

Actuarial Assumptions

The Board makes estimates of the liabilities
created by the Railroad Retirement Act. Five
separate and distinct sets of findings are each
based on a different actuarial and economic mod-
el. Contact: Chief Actuary, Railroad Retirement
Board, 844 Rush St., Room 530, Chicago, IL
60611/312-751-4915.

Annual *Statistical Supplement*

Tables include data on the railroad retirement
and railroad unemployment insurance programs.
The tables are divided into four major sections:
financial statistics; retirement and survivor bene-
fits statistics; unemployment and sickness benefit
statistics; employment, compensation and cover-
age statistics. Contact: Budget and Fiscal Opera-
tions, Railroad Retirement Board, 844 Rush St.,
Room 725, Chicago, IL 60611/312-751-4590.

Appeals

Railroad employees have the right to ask for a
review on a determination denying benefits. If the
review still denies the benefits, the employee has
the right to appeal. Contact: Hearings and Ap-
peal Bureau, Railroad Retirement Board, 844
Rush St., Chicago, IL 60611/312-751-4792.

**Certificate of Service Months and
Compensation (Form BA-6)**

Each year employees in the railroad industry
receive a Certificate of Service Months and Com-
pensation from their employers or from the
Board. This annual statement provides a current
and cumulative record of an employee's railroad
service and compensation. To report erroneous
information on Form BA-6, or for additional in-
formation, contact: Data Processing and Ac-
counts Bureau, Railroad Retirement Board, 844
Rush St., Room 406, Chicago, IL 60611/312-
751-4850.

Direct Payments

The program described below provides finan-
cial assistance directly to individuals, private
firms and other private institutions to encourage
or subsidize a particular activity:

Social Insurance for Railroad Workers

Objectives: To protect against loss of income
for railroad workers and their families resulting
from retirement, death, disability, unemploy-
ment, or sickness of the wage earner.

Eligibility: Under the Railroad Retirement
Act, for employee, spouse and survivor benefits

the employee must have had 10 or more years of railroad service. For survivors to be eligible for benefits, the employee must also have been insured at death. Under the Railroad Unemployment Insurance Act, an employee must have earned at least $1,000 in railroad wages (counting no more than $400 in any month), and, if a new employee, must have worked for a railroad at least five months in a calendar (base) year to be a qualified employee in the applicable benefit year.

Range of Financial Assistance: Up to $995 monthly.

Contact: Information Service, Railroad Retirement Board, 844 Rush St., Chicago, IL 60611/312-751-4777.

Freedom of Information Act Requests

For Freedom of Information Act requests, contact: Secretary of the Board, Railroad Retirement Board, 844 Rush St., Room 814, Chicago, IL 60611/312-751-4920.

Information

Information on the Railroad Retirement Board operations and on the provisions of the laws it administers is available. Publications include: *Railroad Retirement Board Quarterly*, the *Annual Report* and the *Statistical Supplement*. In addition, the Board occasionally conducts informal conferences designed to acquaint covered employers and employees with a detailed understanding of the railroad retirement and railroad unemployment insurance systems. Contact: Liaison Officer, Railroad Retirement Board, 425 13th St. N.W., Room 444, Washington, DC 20004/202-724-0121, or; Railroad Retirement Board, 844 Rush St., Room 536, Chicago, IL 60611/312-751-4930.

Informational Conferences and Labor Contacts

The Board conducts conferences to describe and discuss the benefits available under the Board's retirement-survivor, unemployment-sickness and Medicare programs. Each conference attendee receives an *Informational Conference Handbook* (a comprehensive source of information on all of the Board's programs), and an *Informational Conference Kit* containing pamphlets and other materials highlighting various features of the Board's programs. Contact: Labor Member, Railroad Retirement Board, 844 Rush St., Room 825, Chicago, IL 60611/312-751-4905.

Legislative Developments

The Board provides technical assistance to Congress, the Administration, and railroad management and labor officials on various legislative proposals designed to improve the financing of the railroad retirement system. Contact: Legislative Counsel, Railroad Retirement Board, 425 13th St. N.W., Room 507, Washington, DC 20004/202-724-0787.

Library

The Railroad Retirement Board Library is located at 844 Rush St., Room 800, Chicago, IL 60611/312-751-4926.

Placement Service

The Board operates a free placement service directed primarily toward finding employment for experienced railroad workers who have lost their jobs. The placement service is available to those claiming unemployment benefits. Contact: the nearest Railroad Retirement Board office, or: Unemployment and Sickness Insurance Bureau, Railroad Retirement Board, 844 Rush St., Chicago, IL 60611/312-751-4800.

Retirement Benefits

Railroad retirement benefits include regular employee retirement annuities after 10 years of creditable railroad service, supplemental annuities, spouse annuities, cost-of-living increases in employee and spouse retirement benefits as well as a variety of survivor benefits. *Railroad Retirement and Survivor Benefits* (for railroad workers and their families) describes these benefits and provides practical information on how to claim them. Tax information is also included. Contact the nearest Railroad Retirement Board Office, or: Retirement Claims Bureau, Railroad Retirement Board, 844 Rush St., Room 905, Chicago, IL 60611/312-751-4600.

Service and Earnings Records

The Board maintains a record of all railroad service and earnings after 1936. The information is recorded under the employee's Social Security account number used by the employer to report service and compensation to the Board. Covered businesses include railroads engaged in interstate commerce and certain of their subsidiaries, railroad associations, and national railway labor organizations. Contact: Data Processing and Accounts Bureau, Railroad Retirement Board, 844 Rush St., Chicago, IL 60611/312-751-4850.

Unemployment and Sickness Benefits

The railroad unemployment insurance provides two kinds of cash benefits: unemployment benefits and sickness benefits. *Unemployment and Sickness Benefits for Railroad Workers* is a free booklet which describes benefit qualifica-

tions, amounts of benefits payable and how to claim them. Contact: the nearest Railroad Retirement Board, or Unemployment and Sickness Insurance Bureau, Railroad Retirement Board, 844 Rush St., Room 600, Chicago, IL 60611/312-751-4800.

How Can the Railroad Retirement Board Help You?

To determine how the Railroad Retirement Board can help you, contact: Chief Executive Offices, Railroad Retirement Board, 844 Rush St., Chicago, IL 60611/312-751-4930.

Securities and Exchange Commission

500 N. Capitol St., Washington, DC 20549/202-272-2650

ESTABLISHED: July 2, 1934
BUDGET: $72,865,000
EMPLOYEES: 2,109
MISSION: Provides for the fullest possible disclosure to the investing public and protects the interests of the public and investors against malpractices in the securities and financial markets.

Major Sources of Information

Accounting

The Chief Accountant consults with representatives of the accounting profession regarding the promulgation of new or revised accounting and auditing standards and drafts rules and regulations which prescribe requirements for financial statements. Many of the rules are embodied in a basic accounting regulation entitled *Regulation S-X* adopted by the Commission which, together with a number of opinions issued as *Accounting Series Releases*, governs the form and content of most of the financial statements filed with the Commission. The releases are sold for $7.25, and the *SEC Annual Report on the Accounting Profession and the Commission's Oversight Role* is available for $7.00, both from the Superintendent of Documents, Government Printing Office, Washington, DC 20402/202-783-3238. For additional information, contact: Office of Chief Accountant, Securities and Exchange Commission, 500 N. Capitol St., Room 836, Washington, DC 20549/202-272-2050.

Administrative Proceedings Requirements

All formal administrative proceedings are conducted in accordance with SEC Rules of Practice. Included are requirements for timely notice of the proceeding and for a sufficient specification of the issues or charges involved to enable each of the parties to prepare adequately his or her case. Contact: Office of Administrative Law Judges, Securities and Exchange Commission, 1100 L St. N.W., Room 2101, Washington, DC 20549/202-523-5657.

Annual (10-K) Reports

The Annual Report is the official annual business and financial report which must be filed with the Securities and Exchange Commission by most publicly held companies. It provides comprehensive current information about the company such as principal products, services, markets and methods of distribution, summary of operations, properties, parents and subsidiaries, legal proceedings, increases and decreases in outstanding securities, changes in securities and changes in security for registered securities, defaults upon senior securities, approximate number of equity security holders, executive officers, indemnification of directors and officers, financial statements and exhibits filed, directors and remuneration of directors and officers, options granted to management to purchase securities, and interest of management and others in certain transactions. Contact: Office of Consumer Affairs, Information Services, Office of Reports and Information Services, Securities and Exchange Commission, 1100 L St. N.W., Room 7103, Washington, DC 20549/202-523-5506.

Broker-Dealer Registration

Brokers and dealers engaged in an interstate over-the-counter securities business are required to register with the Securities and Exchange Commission. They must conform their business practices to the standards prescribed in the law and the SEC regulations for the protection of investors. Form BD is the form for registration, licensing or membership as a broker or dealer (a person or company trading securities). It shows: form of organization; if it is a corporation, the date and state of incorporation, and class of equity security; if it is a sole proprietorship, the person's residence and Social Security number; if it

is a successor to a previous broker or dealer, the SEC file number of the predecessor; persons with controlling interests; how the business is financed; the firm's or person's standing with the SEC and other regulatory agencies, including disclosure of having made false statements to the SEC in the past, been convicted in the last 10 years of a related felony, been enjoined in the last 10 years from financial activities, aided anyone in violating related laws or rules, been barred or suspended as a broker-dealer, been the subject of a cease and desist order, been associated with a similar firm that went bankrupt; information about the person or business that maintains the applicant's records and holds funds of the applicant or its customers; details about companies which control or are controlled by the applicant; whether the applicant is an investment adviser; types of business done (such as floor activity, underwriting or mutual fund retailing); descriptions of any nonsecurity business; and information about principals, including positions, securities held, Social Security numbers, education and background. For information, contact: Broker-Dealer Inspections and Compliance Branch, Division of Market Regulation, Securities and Exchange Commission, 500 N. Capitol St., Room 369, Washington, DC 20549/202-272-2383, or: Broker-Dealer Registration Branch, Office of Reports and Information Services, Securities and Exchange Commission, 1100 L St. N.W., Room 7417, Washington, DC 20549/202-523-5543.

Clearing Agencies

Clearing agencies must register with the Securities and Exchange Commission. For information on registration and regulations, contact: Clearing Agency Regulation Branch, Division of Market Regulation, Securities and Exchange Commission, 500 N. Capitol St., Room 360, Washington, DC 20549/202-272-2910.

Complaints and Information

Complaints and inquiries from individual investors and the public are handled by the consumer affairs office. This office represents the interests of individual investors to the Commission. It also insures that investors can get assistance in convenient locations. Contact: Office of Consumer Affairs, Securities and Exchange Commission, 1100 L St. N.W., Room 6327, Washington, DC 20549/202-523-5616.

Consumer Information

In addition to providing information about the activities of certain corporations, Consumer Affairs provides assistance communicating with certain corporations and brokers and dealers. The Office also offers advice on possible remedies to problems, such as grievance procedures available through industry organizations, and issues consumer publications. Contact: Office of Consumer Affairs, Securities and Exchange Commission, 1100 L St. N.W., Room 6327, Washington, DC 20549/202-523-5516.

Corporate Disclosure Documents

Quarterly (10-Q) and annual (10-K) reports, registration statements, proxy material and other reports filed by corporations, mutual funds or broker-dealers with the SEC are available for inspection and can be copied for a fee. Current annual and other periodic reports (including financial statements) filed by companies whose securities are listed on exchanges also are available for inspection in the Commission's New York, Chicago and Los Angeles regional offices as are the registration statements (and subsequent reports) filed by those companies whose securities are traded over-the-counter. Moreover, if the issuer's principal office is located in the area served by the Atlanta, Boston, Denver, Fort Worth or Seattle regional offices, its filings also may be examined at the appropriate regional office. In addition, prospectuses covering recent public offerings of securities registered under the Securities Act may be examined in all regional offices; copies of broker-dealer and investment adviser registrations, as well as Regulation A notifications and offering circulars, may be examined in the regional office in which they were filed. Contact: Public Reference Room Section, Office of Reports and Information Services, Securities and Exchange Commission, 1100 L St. N.W., Room 6101, Washington, DC 20549/202-523-5360.

Corporate Reorganizations

The Commission serves as adviser to United States district courts in connection with proceedings for the reorganization of debtor corporations in which there is a substantial public interest. It participates as a party to these proceedings, either at the request or with the approval of the courts. It renders independent, expert advice and assistance to the courts, which do not maintain their own staffs of expert consultants, in connection with the preparation of plans of reorganization. It also presents its views and recommendations on such matters as the qualifications and independence, the need for appointment of trustees or examiners and their fee allowances to the various parties, including the trustees and their counsel, sales of properties and

other assets, interim distributions to security holders, and other financial or legal matters. The Commission has no independent right of appeal from court rulings. For additional information, contact: Reorganization Branch, Division of Corporate Regulation, Securities and Exchange Commission, 1100 L St. N.W., Room 2436, Washington, DC 20549/202-523-5669.

Corporate Reporting

Companies which seek to have their securities listed and registered for public trading on an exchange must file a registration application with the exchange and the Securities and Exchange Commission. A similar registration form must be filed by companies trading securities over-the-counter if the companies meet the size test referred to. The Commission's rules prescribe the nature and content of these registration statements, including certified financial statements. These data are generally comparable to, but less extensive than, the disclosures required in Securities Act registration statements. Following the registration of their securities, such companies must file annual and other periodic reports to keep current the information contained in the original filing. Copies of any of the reported data may be obtained from the Commission at nominal cost. The law prescribes penalties for filing false statements and reports with the Commission, as well as provision for recovery by investors who suffer losses in the purchase or sale of registered securities in reliance thereon. *Corporate Governance: SEC Staff Report on Corporate Accountability* is an examination of rules relating to shareholder communications and participation in corporate electoral process. Available for $8.00 from the Superintendent of Documents, Government Printing Office, Washington, DC 20402/202-783-3238. Contact: Corporate Accountability, Division of Corporate Finance, Securities and Exchange Commission, 500 N. Capitol St., Room 631, Washington, DC 20549/202-272-2597.

Decisions and Reports

The Securities and Exchange Commission's decisions (as well as initial decisions which have become final and are of precedential significance) are printed in the SEC's *Decisions and Reports*. The latest volume, Volume 45 (July 1, 1972–September 30, 1975), is sold for $16.00 by the Superintendent of Documents, Government Printing Office, Washington, DC 20402/202-783-3238. For additional information, contact: Office of Opinions and Review, Securities and Exchange Commission, 500 N. Capitol St., Room 7215, Washington, DC 20549/202-523-4588.

Directory of Companies Required to File Annual Reports with the SEC

This annual directory lists companies alphabetically and classifies them by industry groups according to the Standard Industrial Classification Manual of the Budget. It is available for $8.50 from the Superintendent of Documents, Government Printing Office, Washington, DC 20402/202-783-3238.

Disclosure

The Securities and Exchange Commission requires a company to make "full disclosure" of all material facts (that is, accurate information about the business it conducts or proposes to conduct) before it offers its securities to the public. Most publicly-held companies have an obligation to keep their shareholders informed of their business operations, financial conditions and management on a periodic basis. Contact: Division of Corporate Finance, Securities and Exchange Commission, 500 N. Capitol St., Room 616, Washington, DC 20549/202-272-2800.

Disclosure Policy

If experience shows that a particular requirement fails to achieve its objective, or if a rule appears unduly burdensome in relation to the benefits resulting from the disclosure provided, the Division of Corporation Finance presents the problem to the Commission for consideration of possible modification of the rule or other requirement. Many suggestions for rule modification follow extensive consultation with industry representatives and others affected. In addition, the Commission normally gives advance public notice of proposals for the adoption of new or amended rules or registration forms and affords opportunity for interested members of the public to comment thereon. The same procedure is followed under the other Acts administered by the Commission. Contact: Disclosure Policy and Proceedings Office, Division of Corporate Finance, Securities and Exchange Commission, 500 N. Capitol St., Room 629, Washington, DC 20549/202-272-2589.

Economic Analysis

The Directorate analyzes rule changes and engages in long-term research and policy planning, builds and maintains diverse computer data bases, designs programs that provide access to data, and develops and tests alternative methodologies. For additional information on the activities of this division, contact: Directorate of Economic and Policy Analysis, Securities and Exchange Commission, 500 N. Capitol St., Room 576, Washington, DC 20549/202-272-2850.

Economic Monitoring

The Directorate assesses the impact of securities market regulations on issuers (in particular, small or high technology issuers), broker-dealers, investors, and the economy in general. One area monitored is the impact of competitively determined Commission rates and changes in regulations which affect the ability of small businesses to raise capital. Contact: Directorate of Economic and Policy Analysis, Securities and Exchange Commission, 500 N. Capitol St., Room 576, Washington, DC 20549/202-272-2850.

Enforcement

If the Securities and Exchange Commission investigations turn up facts which show possible fraud, or other law violations, it may pursue several courses of action:

Civil injunction. The Commission may apply to an appropriate United States District Court for an order enjoining those acts or practices alleged to violate the law or Commission rules.

Criminal prosecution. If fraud or other willful law violation is indicated, the Commission may refer the facts to the Department of Justice with a recommendation for criminal prosecution of the offending persons.

Administrative remedy. The Commission may, after a hearing, issue orders suspending or expelling members from exchanges or the over-the-counter dealers association; denying, suspending or revoking the registrations of brokers-dealers; or censuring individuals for misconduct or barring them (temporarily or permanently) from employment with a registered firm.

Contact: Division of Enforcement, Securities and Exchange Commission, 500 N. Capitol St., Room 414, Washington, DC 20549/202-272-2900.

Exemptions from Registration

The registration requirement applies to securities of domestic and foreign private issuers, as well as to securities of foreign governments or their instrumentalities. There are, however, certain exemptions from the registration requirement. Among these are: 1) private offerings to a limited number of persons or institutions who have access to the kind of information registration would disclose and who do not propose to redistribute the securities; 2) offerings restricted to the residents of the state in which the issuing company is organized and doing business; 3) securities of municipal, state, federal and other governmental instrumentalities, of charitable institutions, of banks, and of carriers subject to the Interstate Commerce Act; 4) offerings not in excess of certain specified amounts made in compli-

ance with regulations of the Commission discussed below; and 5) offerings of "small business investment companies" made in accordance with rules and regulations of the Commission. Anti-fraud provisions apply to all sales of securities involving interstate commerce or the mails, whether or not the securities are exempt from registration. Contact: Exemptive Order, Division of Corporate Finance, Securities and Exchange Commission, 500 N. Capitol St., Room 606, Washington, DC 20549/202-272-2573.

Foreign Companies

Form 6-K is filed by foreign companies selling stock in this country, which do not have to file Form 8-K. It requires that they submit information they have made public abroad. Only information not previously furnished to the SEC and information that is important to investors is required. If the information is available only in a foreign language, it does not have to be translated into English. The documents show the financial condition of the company and its subsidiaries; changes in business; major acquisitions or disposition of assets; changes in management or control; remuneration to directors and officers and any transactions with directors, officers or principal stockholders. Contact: International Corporate Finance, Division of Corporation Finance, Securities and Exchange Commission, 320 1st St. N.W., Room 369, Washington, DC 20549/202-272-3246.

Freedom of Information Act Requests

For Freedom of Information Act requests, contact: Freedom of Information, Office of Reports and Information Services, Securities and Exchange Commission, 1100 L St. N.W., Room 7322, Washington, DC 20549/202-523-5530.

Hearings

Hearings are conducted before a Hearing Officer who is normally an Administrative Law Judge appointed by the Commission; he or she serves independent of the interested Division or Office and rules on the admissibility of evidence and on other issues arising during the course of the hearing. The laws provide that any person or firm aggrieved by a decision order of the Commission may seek review by the appropriate United States court of appeals. The initial decisions of Hearing Officers as well as the Commission's decisions are made public. Ultimately, the Commission's decisions (as well as initial decisions which have become final and are of precedential significance) are printed by the Government Printing Office and published in the Commission's *Decisions and Reports*. Contact: Office of Administra-

tive Law Judges, Securities and Exchange Commission, 1100 L St. N.W., Room 2101, Washington, DC 20549/202-523-5657.

Information for Investors

This is a weekly release with timely SEC news for investors. Contact: Office of Public Affairs, Securities and Exchange Commission, 500 N. Capitol St., Room 181, Washington, DC 20549/202-272-2650.

Insider Trading

The protection provided the investing public through disclosure of financial and related information concerning the securities of registered companies is supplemented by provisions of the law designed to curb misuse of corporate information not available to the general public. To that end, each officer and director of such a company, and each beneficial owner of more than 10 percent of its registered equity securities, must file an initial report with the Commission (and with the exchange on which the stock may be listed) showing his or her holdings of each of the company's equity securities. Thereafter, he or she must file reports for any month during which there was any change in such holdings. In addition, the law provides that profits obtained from purchases and sales (or sales and purchases) of such equity securities within any six-month period may be recovered by the company or by any security holders on its behalf. This recovery right must be asserted in the appropriate United States district court. Such "insiders" are also prohibited from making short sales of their company's equity securities. Contact: Corporate Accountability, Division of Corporate Finance, Securities and Exchange Commission, 500 N. Capitol St., Washington, DC 20549/202-272-2597.

Intermarket Trading System

A study on the Intermarket Trading System is available. The system, based on automated communications links among traders on the floors of the New York and American and five regional stock exchanges, permits participants to execute trades at the best price available on any of the participating markets. Contact: Market Structure and Market Trading Studies Branch, Directorate of Economic and Policy Analysis, Securities and Exchange Commission, 1100 L St. N.W., Room 2241, Washington, DC 20549/202-523-5624.

Investigations

The Securities and Exchange Commission investigates complaints or other indications of possible law violations in securities transactions.

Investigation and enforcement work is also coordinated by the regional offices and the main Division of Enforcement. Contact: Division of Enforcement, Securities and Exchange Commission, 500 N. Capitol St., Room 414, Washington, DC 20549/202-272-2900.

Investment Advisor Regulations

The Commission may recommend prosecution of investment advisors by the Department of Justice for fraudulent misconduct or willful violation of the law or rules of the Commission thereunder. The law contains anti-fraud provisions, and it empowers the Commission to adopt rules defining fraudulent, deceptive or manipulative acts and practices and is designed to prevent such activities. It also requires that investment advisors disclose the nature of their interest in transactions executed for their clients; and, in effect, it prevents the assignment of investment advisory contracts without the client's consent. The law also imposes on investment advisors subject to the registration requirement the duty to maintain books and records in accordance with such rules as may be prescribed by the Commission, and it authorizes the Commission to conduct inspections of such books and records. Contact: Investment Advisor Regulation, Division of Investment Management, Securities and Exchange Commission, 500 N. Capitol St., Room 208, Washington, DC 20549/202-272-2030.

Investment Advisors Registration

Persons or firms who engage for compensation in the business of advising others about their securities transactions must register with the Securities and Exchange Commission, and conform their activities to statutory standards designed to protect the interests of investors. Contact: Investment Advisor Registration, Office of Reports and Information Services, Securities and Exchange Commission, 1100 L St. N.W., Room 7417, Washington, DC 20549/202-523-5543.

Investment Companies Registration

Companies engaged primarily in the business of investing, reinvesting and trading in securities and whose own securities are offered to, sold to, and held by the investing public must register with the Securities and Exchange Commission. A list of registered investment companies, showing their classification, assets, size and location, may be purchased from the Commission in photocopy form. The law requires disclosure of their financial condition and investment policies to afford investors full and complete information about their activities; prohibits such companies from

changing the nature of their business or their investment policies without the approval of the stockholders; bars persons guilty of security frauds from serving as officers and directors; prevents underwriters, investment bankers or brokers from constituting more than a minority of the directors of such companies; requires management contracts (and material changes therein) to be submitted to security holders for their approval; prohibits transactions between such companies and their directors, officers, or affiliated companies or persons, except on approval by the Commission as being fair and involving no overreaching; forbids the issuance of senior securities by such companies except under specified conditions and upon specified terms; and prohibits pyramiding of such companies and cross-ownership of their securities. Form N-8A is the notice of registration which investment companies must file. It tells: name of registrant, form of organization (corporation, partnership, trust, etc.), state and date of organization. If the business has directors, it tells the address of the principal office, names and addresses of directors, officers, advisory board members and investment advisors, and, if it is an open-end company, the underwriters. If the business is unincorporated and has no board of directors, it shows the name and address of the trustee or custodian, sponsor, investment advisors, principal underwriters and the officers and directors of the sponsoring company. If the business is a management company, the form shows whether it is open-end or closed-end, diversified or nondiversified and whether it is an employee securities company. The form must tell whether the registrant sells periodic payment plan certificates and whether it issues its own securities to the public. Companies in which the registrant holds 25 percent or more of the voting securities must be listed, and the last report to security holders is attached. The securities of investment companies are also required to be registered; the companies must file periodic reports and are subject to the Commission's proxy and "insider" trading rules. Contact: Investment Company Regulation, Division of Investment Management, Securities and Exchange Commission, 500 N. Capitol St., Room 530, Washington, DC 20549/202-272-3030.

Legal Interpretations and Advice

The Securities and Exchange Commission renders administrative interpretations of the law and regulations to members of the public, prospective registrants and others, to help them decide legal questions about the application of the law and the regulations to particular situations and to aid them in complying with the law. This advice, for example, might include an informal expression of opinion about whether the offering of a particular security is subject to the registration requirements of the law and, if so, advice as to compliance with the disclosure requirements of the applicable registration form. Contact: Division of Corporate Finance, Securities and Exchange Commission, 500 N. Capitol St., Room 606, Washington, DC 20549/202-272-2573.

Library

The Securities and Exchange Commission Library is open to the public. Advance notice is advisable. Contact: Library, Securities and Exchange Commission, 500 N. Capitol St., Room 150, Washington, DC 20549/202-272-2618.

Lost and Stolen Securities Program

The Securities and Exchange Commission shares enforcement responsibility with the Federal Deposit Insurance Corporation for the computer-assisted reporting and inquiry system for lost, stolen, counterfeit, and forged securities. All insured banks and brokers, dealers and other securities firms are required to register with the Securities Information Center, Inc., P. O. Box 421, Wellesley Hills, MA 02181/617-235-8270, where a central data base records reported thefts and losses. Contact: Division of Market Regulation, Securities and Exchange Commission, 500 N. Capitol St., Room 366, Washington, DC 20549/202-272-2374.

Market Surveillance

The Securities and Exchange Commission regulates securities trading practices in the exchange and the over-the-counter markets. Thus, the Commission has adopted regulations which, among other things, 1) define acts or practices which constitute a "manipulative or deceptive device or contrivance" prohibited by the statute; 2) regulate short selling, stabilizing transactions and similar matters; 3) regulate the hypothecation of customers' securities; and 4) provide safeguards with respect to the financial responsibility of brokers and dealers. Contact: Market Surveillance, Division of Enforcement, Securities and Exchange Commission, 500 N. Capitol St., Room 402, Washington, DC 20549/202-272-2187.

Margin Trading

The Securities and Exchange Commission enforces the statute which sets limits on the amount of credit allowed for the purpose of purchasing or

carrying securities. Contact: Legal Policies and Trading Practices, Division of Market Regulation, Securities and Exchange Commission, 500 N. Capitol St., Room 332, Washington, DC 20549/202-272-2836.

Meetings

Notices of open and closed Commission meetings and the agendas of open meetings are published the preceding week in the *SEC News Digest*. For additional information on these weekly meetings, contact: Office of the Secretary, Securities and Exchange Commission, 500 N. Capitol St., Room 892, Washington, DC 20549/202-272-2600. For minutes of the meetings, contact: Office of Public Affairs, Securities and Exchange Commission, 500 N. Capitol St., Room 181, Washington, DC 20549/202-272-2650.

Monthly *Statistical Review*

This publication provides data on the financial condition of the securities industry, registered securities issues, private placement of corporate securities, quarterly assets of non-insured pension funds and property and liability insurance companies, volume and value of trading of exchange-listed equity securities, quarterly stock transactions of selected nonfinancial institutions, and annual estimated market value of stock outstanding. It is sold for $19.00 per year by the Superintendent of Documents, Government Printing Office, Washington, DC 20402/202-783-3238. For additional information, contact: *Statistical Review*, Directorate of Economic and Policy Analysis, Securities and Exchange Commission, 1100 L St. N.W., Room 2217, Washington, DC 20549/202-523-5629.

National Securities Exchanges Registration

National securities exchanges, those having a substantial securities trading volume, must register with the Commission. The Commission oversees, inspects and evaluates the exchanges. Contact: Office of Self-Regulatory Oversight, Division of Market Regulation, Securities and Exchange Commission, Room 319, 500 N. Capitol St., Washington, DC 20549/202-272-2866.

Official Summary

This is a monthly summary of security transactions and holdings reported by "insiders" (officers, directors, and others) pursuant to provisions of the federal securities laws. It is available from the Superintendent of Documents, Government Printing Office, Washington, DC 20402/202-783-3238. For additional information,

contact: Office of Reports and Information Services, Securities and Exchange Commission, 1100 L St. N.W., Room 7121, Washington, DC 20549/202-523-5520.

Opinions and Reviews

Securities and Exchange Commission opinions and decisions as well as the Annual Report are prepared by this office. For additional information, contact: Office of Opinions and Reviews, Securities and Exchange Commission, 500 N. Capitol St., Room 7215, Washington, DC 20549/202-423-4588.

Ponzi or Pyramid Schemes

Warnings against investing in a Ponzi or pyramid scheme are offered. These schemes are varied but usually promise very high yield, quick return, a "once in a lifetime" opportunity, and the chance to "get in on the ground floor." Several free publications are available on the subject: *How to Avoid Ponzi and Pyramid Schemes; Applicability of Securities Laws to Pyramid Schemes;* and *Warning to Investors About Get-Rich-Quick Schemes.* To notify the Securities and Exchange Commission of a fraudulent scheme and for further information, contact: Office of Consumer Affairs, Securities and Exchange Commission, 1100 L St. N.W,, Room 6327, Washington, DC 20549/202-523-5516.

Proxy Solicitations

In any solicitation of proxies (votes) from holders of registered securities (listed and over-the-counter), whether for the election of directors or for approval of other corporate action, disclosure must be made of all material facts concerning the matters on which such holders are asked to vote. Where a contest for control of the management of a corporation is involved, the rules require disclosure of the names and interests of all "participants" in the proxy contest. The Commission's rules require that proposed proxy material be filed in advance for examination by the Commission for compliance with the disclosure requirements. Contact: Division of Corporation Finance, Securities and Exchange Commission, 500 N. Capitol St., Room 616, Washington, DC 20549/202-272-2800.

Publications

The Securities and Exchange Commission compiles numerous periodic and irregular reports. For a list of these, contact: Office of Consumer Affairs, Securities and Exchange Commission, 1100 L St. N.W., Room 6327, Washington, DC 20549/202-523-5516.

Public Utility Registration

Interstate holding companies engaged through their subsidiaries in the electric utility business or in the retail distribution of natural or manufactured gas are subject to regulation. They must register with the Securities and Exchange Commission and file initial and periodic reports containing detailed data about the organization, financial structure and operations of each such holding company and of its subsidiaries. For further information on public utility registration, contact: Public Utilities Branch, Division of Corporate Regulation, Securities and Exchange Commission, 1100 L St. N.W., Room 2408, Washington, DC 20549/202-523-5672.

Quarterly (10-Q) Reports

The quarterly financial report, filed by most publicly held companies, provides a continuing view of their financial position during the year. The information includes the income statement; balance sheet; description of material changes since the previous quarter; legal processing; changes in securities; default upon senior securities; and other materially important events. Contact: Office of Consumer Affairs and Information Services, Office of Reports and Information Services, Securities and Exchange Commission, 500 N. Capitol St., Room 6326, Washington, DC 20549/202-523-5506.

Regional Offices

For information on Securities and Exchange Commission Regional Offices, contact: Regional Office Operations, Office of the Executive Director, Securities and Exchange Commission, 500 N. Capitol St., Room 846, Washington, DC 20549/202-272-3090.

Revocations

If exchange or association members, registered brokers or dealers, or individuals who may associate with any such firms engage in securities transactions violative of the law, the Securities and Exchange Commission may invoke administrative remedy, i.e., it may, after a hearing, issue orders suspending or expelling members from exchanges or the over-the-counter-dealers association; denying, suspending or revoking the registrations of broker-dealers; or censuring individuals for misconduct or barring them (temporarily or permanently) from employment with a registered firm. Contact: Investment Management Enforcement, Division of Enforcement, Securities and Exchange Commission, 500 N. Capitol St., Room 484, Washington, DC 20549/202-272-2352.

Rules and Regulations

The Securities and Exchange Commission's rules and regulations, *Title 17 of the Code of Federal Regulations* ($8.25), and the *Compilation of the Federal Securities Laws* ($4.25), are sold by the Superintendent of Documents, Government Printing Office, Washington, DC 20402/202-783-3238. For additional information, contact: Office of Reports and Information Services, Securities and Exchange Commission, 1100 L St. N.W., Room 7405, Washington, DC 20549/202-523-5586.

SEC Docket

This is a weekly compilation of the full text of SEC releases, including the full texts of *Accounting Series* releases, corporate reorganization and litigation releases. It is sold for $79.00 per year by the Superintendent of Documents, Government Printing Office, Washington, DC 20402/202-783-3238. For additional information, contact: Office of Reports and Information Services, Securities and Exchange Commission, 1100 L St. N.W., Room 7104, Washington, DC 20549/202-523-5510.

Securities Information Processors

Securities Information Processors must register with the Securities and Exchange Commission. For additional information on regulations and legislation, contact: Office of Financial Responsibility and Securities Processing Regulation, Division of Market Regulation, Securities and Exchange Commission, 500 N. Capitol St., Room 384, Washington, DC 20549/202-272-2902.

Securities Registration

Before the public offering of securities, a registration statement must be filed with the Securities and Exchange Commission by the issuer, setting forth the required information. The securities may be sold when the statement has become effective. The registration provides disclosure of financial and other information on the basis of which investors may appraise the merits of the securities. Investors must be furnished with a prospectus (selling circular) containing salient data set forth in the registration statement to enable them to evaluate the securities. The basic registration form, *Form S-1*, requires, among other things, a description of the company's business; its properties; material transactions between the company and its officers and directors; the plan for distributing the securities and the intended use of the proceeds; capitalization; competition; identification of officers and

directors and their remuneration; and any pending legal proceedings. It is not prepared as a fill-in-the-blank form like a tax return, but, rather, is similar to a brochure, with the information provided in a narrative format. In addition, there are detailed requirements concerning financial statements, including that such statements be audited by an independent certified public accountant. In addition to the information expressly required by the form, the company must also provide any other information that is necessary to make the statements complete and not misleading. If there are sufficient adverse or risk factors concerning the offering and the issuer—such as lack of business operating history, adverse economic conditions in a particular industry, lack of market for the securities offered, dependence upon key personnel, etc.—they must be set forth prominently in the prospectus, usually in the very beginning. Contact: Division of Corporate Finance, Securities and Exchange Commission, 500 N. Capitol St., Room 619, Washington, DC 20549/202-272-2579.

Small Business Policy

This office spearheads small business rulemaking initiatives; reviews and comments upon the impact of various Securities and Exchange Commission rule proposals on smaller issuers; and serves as a liaison with Congressional committees, government agencies, and other groups concerned with small business. *Q & A: Small Business and the SEC* is a free booklet which discusses capital formation and federal securities laws. Contact: Small Business Policy Commission, 500 N. Capitol St., Room 642, Washington, DC 20549/202-272-2644.

Small Issues Registration

In April 1979, the Securities and Exchange Commission adopted, as an experiment, a simplified registration form for use by certain domestic or Canadian corporate issues as an alternative to Form S-1. Form S-18 is available for the registration of securities to be sold to the public for cash not exceeding an aggregate offering price of $5 million, provided such issuers are not subject to the SEC's continuous reporting requirements under the Exchange Act. Form S-18 provides for reduced disclosure requirements and has other attributes which are intended to result in a more timely and less expensive registration process for the smaller issuer who wishes to gain access to the public capital markets. Although many of the requirements for an S-18 registration statement are the same as those for a full registration, Form S-18 allows:

1. The issuer to provide audited financial statements for two fiscal years prepared in accordance with generally accepted accounting principles;
2. Less extensive narrative disclosure, particularly in the areas of the description of business;
3. The choice of filing with either the SEC's Regional Office nearest the place where the company's principal business operations are conducted, or with the SEC's Division of Corporation Finance, in Washington, DC, where all Form S-1 registration statements are filed and reviewed. The primary advantage of regional filing is that Regional Office personnel may be more familiar with local economic conditions, the business community, the financial environment and, in some cases, the background and history of the company and the industry.

For further information, contact: Small Business Policy Office, Division of Corporate Finance, Securities and Exchange Commission, 500 N. Capitol St., Room 642, Washington, DC 20549/202-272-2644.

Statistical Bulletin

This is a weekly publication containing data on odd lot and round lot transactions, block distributions, working capital of U.S. corporations, assets of noninsured pension funds, Rule 144 filings and 8-K reports. The Bulletin is available for $15.00 per year from the Superintendent of Documents, Government Printing Office, Washington, DC 20402/202-783-3238. For additional information, contact: *Statistical Bulletin* Editor, Directorate of Economic and Policy Analysis, Securities and Exchange Commission, 1100 L St. N.W., Room 2217, Washington, DC 20549/202-523-5629.

Tender Offer Solicitations

Commission rules and amendments require disclosure of pertinent information by the person seeking to acquire over 5 percent of the company's securities by direct purchase or by tender offer, as well as by any person soliciting shareholders to accept or reject a tender offer. Thus, as with the proxy rules, public investors who hold stock in the subject corporation may now make informed decisions on takeover bids. Schedule 14-D1 describes tender offers made to companies trading on a stock exchange, or to those worth more than $1 million with 500 or more shareholders. It is filed by the target company and identifies: the securities; principals; past major dealings between the two companies or their directors; source and amount of funds required; purpose of the transactions; persons, such as brokers, retained to help with the transaction;

material financial information; and documents such as the tender offer itself, loan agreements and contracts. Schedule 14-D must be filed by companies that are the subject of tender offers if they make recommendations for or against the offer. It tells why the recommendation was made; describes the security and issuer; describes the background of the company; identifies persons retained as a result of the tender offer; and gives information about any transactions with the other company during the previous 60 days. Contact: Tender Offers and Acquisitions Office, Division of Corporation Finance, Securities and Exchange Commission, 500 N. Capitol St., Room 601, Washington, DC 20549/202-272-3097.

Transfer Agents

Transfer Agents must register with the Securities and Exchange Commission. For information on transfer agents registration and regulation, contact: Transfer Agent Regulation, Division of Market Regulation, Securities and Exchange Commission, 500 N. Capitol St., Room 386, Washington, DC 20549/202-272-2895.

Trust Indentures

Bonds, debentures, notes and similar debt securities offered for public sale which are pursuant to trust indentures must conform to specified statutory standards. Applications for qualification of trust indentures are examined for compliance with the applicable requirements of the law and the Commission's rules. Contact: Trust Indenture, Division of Corporate Finance, Securities and Exchange Commission, 320 1st St. N.W., Room 608, Washington, DC 20549/202-272-2573.

How Can the Securities and Exchange Commission Help You?

To determine how the Securities and Exchange Commission can help you, contact Office of Public Affairs, Securities and Exchange Commission, 500 N. Capitol St., Washington, DC 20549/202-272-2650.

Selective Service System

1023 31st St. N.W., Washington, DC 20435/202-724-0790

ESTABLISHED: 1940
BUDGET: $8,251,000
EMPLOYEES: 78

MISSION: To be prepared to supply to the Armed Forces manpower adequate to insure the security of the United States, with concomitant regard for the maintenance of an effective national economy.

Major Sources of Information

Classification

Classification is a statement of a person's availability for military service. The following are some categories: Conscientious objector, college students, ministers, only-son hardship, occupational deferments, medical specialists, alien or dual national, reservists, veterans and women. Contact: Public Affairs, Selective Service System, 1023 31st St. N.W., Washington, DC 20435/202-724-0790.

Programs

For information on current Selective Service programs contact: Programs, Selective Service System, 1023 31st St. N.W., Washington, DC 20435/202-724-0851.

Recorded Message

The recording provides statistics information on the number of draft registrants for specific periods of time. Call: 202-724-0424. For additional information contact: Public Affairs, Selective Service System, 1023 31st St. N.W., Washington, DC 20435/202-724-0790.

Registrants Processing Manual

The purpose of this manual is to disseminate directives which will govern the operational as-

pects of the Selective Service System at state and local levels. It contains all necessary information for registration, classification, examination, induction, allied subjects and the procedures relating thereto. The subscription service is $21.15 and includes approximately six changes a year for an indeterminate period. It is available from the Superintendent of Documents, Government Printing Office, Washington, DC 20402/202-783-3238. For additional information contact: Public Affairs Officer, Selective Service System, 1023 31st St. N.W., Washington, DC 20435/202-724-0790.

Semiannual Report of the Director of Selective Service

This report provides an overview of the Selective Service program every six months. To receive a copy of the report, or for additional information on the Selective Service, contact: Public Affairs, Selective Service System, 1023 31st St. N.W., Washington, DC 20435/202-724-0790.

How Can the Selective Service Help You?

To determine how this office can help you contact: Public Affairs, Selective Service System, 1023 31st St. N.W., Washington, DC 20435/202-724-0790.

Small Business Administration

1441 L St. N.W., Washington, DC 20416/202-653-6832

ESTABLISHED: 1953
BUDGET: $820,250,000
EMPLOYEES: 4,747

MISSION: Aids, counsels, assists, and protects interests of small business; insures that small business concerns receive a fair proportion of government purchases, contracts, and subcontracts, as well as of the sales of government property; makes loans to small business concerns, state and local development companies, and the victims of floods or other catastrophes, or of certain types of economic injury; licenses, regulates, and makes loans to small business investment companies; improves the management skills of small business owners, potential owners, and managers; conducts studies of the economic environment; and guarantees surety bonds for small contractors.

Major Sources of Information

Access Road Construction Loans

Loans are available to small purchasers of national forest timber for construction of primary access roads, when the building of such roads is part of the timber sales contract. These SBA loans free the borrowers' working capital funds to meet ordinary operating expenses and to purchase stumpage. Contact: Timber and Property Sales, Procurement Assistance, Small Business Administration, 1441 L St. N.W., Room 632, Washington, DC 20416/202-653-6078.

Active Corps of Executives (ACE)

Active executives from all major industries, professional and trade associations, educational institutions, and many professionals volunteer their specialized kinds of expertise to help small business owners solve their problems. Contact: ACE, Management Assistance, Small Business Administration, 1441 L St. N.W., Room 602H, Washington, DC 20416/202-653-6768.

Advocacy Publications

A variety of publications, including topical reports on current governmental activities which affect small business interests, economic research, government policy and general information, is available. Contact: Office of Advocacy, Small Business Administration, 1100 Vermont Ave. N.W., Room 1100, Washington, DC 20416/202-653-6273.

Alternative Financing

For information concerning alternative ways of financing small business activities, contact: Office of Chief Counsel for Advocacy, Small Business Administration, 1441 L St. N.W., Room 1010, Washington, DC 20416/202-653-6533.

Business Eligibility

The Small Business Administration generally defines a small business as one which is independently owned and operated and is not dominant in its field. To be eligible for an SBA loan, a business must meet a size standard set by the agency. Contact: Size Standards Division, Policy, Planning and Budgeting, Small Business Administration, 1414 L St. N.W., Room 500, Washington, DC 20416/202-653-6373.

Business Loan Programs

Business loan proceeds can be used for working capital, purchase of inventory, equipment and supplies, or for building construction and expansion. The Small Business Administration offers two basic types of business loans: 1) loans made by private lenders, usually banks, and guaranteed by SBA; and 2) loans made directly by the agency. A free booklet, *Business Loans from the SBA*, is available describing the business loans, eligibility, credit requirements, terms of loans, and collateral. It also outlines how to apply for a loan. Contact: Office of Business Loans, Small Busi-

ness Administration, 1441 L St., N.W., Room 804D, Washington, DC 20416/202-653-6574.

Business Management Courses

Business management courses in planning, organization, and control of a business are co-sponsored by SBA in cooperation with educational institutions, chambers of commerce, and trade associations. Courses generally take place in the evening and last from six to eight weeks. In addition, conferences covering such subjects as working capital, business forecasting, and marketing are held for established businesses on a regular basis. SBA conducts Pre-Business Workshops, dealing with finance, marketing assistance, types of business organization, and business site selection, for prospective business owners. Clinics focus on particular problems of small firms in specific industrial categories and are held on an as-needed basis. *Small Business Goes to College: College and University Courses in Small Business and Entrepreneurship* traces the development of small business management as a college subject and provides samples of courses offered by some 200 colleges and universities. It should be useful to educators as well as to counselors who seek courses to recommend for their clients' self-development. The booklet is available for $3.25 from the Superintendent of Documents, Government Printing Office, Washington, DC 20402/202-783-3238. For additional information, contact: Office of Management Information and Training, Management Assistance, Small Business Administration, 1522 K St. N.W., Room 626, Washington, DC 20416/202-724-1703.

Call Contract Program

The call contract program uses professional management and technical consultants. In some cases, due to the nature of their products and production capabilities, some small or minority businesses will require highly sophisticated marketing information and production technology to identify and service overseas markets. Such specialized export assistance may be provided at no cost to an eligible client through this program. Since the availability of these counseling services will vary, more specific information is available from the local SBA District Office, or from: the Office of International Trade, Small Business Administration, 1441 L St. N.W., Room 602G, Washington, DC 20416/202-653-6544.

Capital Formation

Information on capital formation and venture capital and a pamphlet, *Small Business, Capital Formation, and the Federal Securities Laws,* which identifies those issues under the federal securities laws that affect smaller enterprises and reduce undue regulatory burdens arising from those laws, are available. Contact: Advocate for Capital Formation and Venture Capital, Office of Advocacy, Small Business Administration, 1441 L St. N.W., Room 1017, Washington, DC 20416/202-653-7584.

Case Assistance by Advocacy

Help is available to a small business that has problems with the activities, regulations or policies of a federal government agency, including the Small Business Administration. Contact an SBA Regional Office, or Office of Interagency Policy Affairs and Business Services Management, Office of the Chief Counsel for Advocacy, Small Business Administration, 1441 L St. N.W., Room 501, Washington, DC 20416/202-653-6579.

Certificates of Competency

The Small Business Administration is authorized to study a firm's capabilities and, if it finds that the firm has the eligibility to carry out the specific government contract, certify to this effect. A responsible concern is one that can meet all contract requirements in a timely manner. When it certifies to the competency of a small firm, the Small Business Administration notifies the government contracting officer that the small business is capable of performing the specific government contract in question. Certificates of competency are issued for manufacturers, purchasers of government property, service concerns or regular dealers. Contact: Certificates of Competency, Industrial Support Services Division, Procurement Assistance, Small Business Administration, 1441 L St. N.W., Room 626, Washington, DC 20416/202-653-6582.

Disaster Loans

Disaster loans cover physical disasters such as injury to small businesses due to hurricane, tornado, flood and riot; displacement; economic injury as a result of hurricane, tornado or flood; economic injury to egg or poultry producers; economic injury as a result of coal mine health and safety, occupational safety and health, air pollution control, emergency energy shortage, water pollution control, and strategic arms; and a few others. Contact: Office of Disaster Loans, Small Business Administration, 1441 L St. N.W., Room 820, Washington, DC 20416/202-653-6879.

Economic Opportunity Loans

Economic opportunity loans make it possible for disadvantaged individuals to own their own

businesses. Prospective and established small businessmen may receive assistance under this program. Contact the nearest SBA office, or Minority Small Business and Capital Ownership Development, Small Business Administration, 1441 L St. N.W., Room 317, Washington, DC 20416/202-653-6407.

Economic Research

Government statistics on small businesses are available. Contact: Office of Economic Research, Office for Advocacy, Small Business Administration, 1100 Vermont Ave. N.W., Room 1100, Washington, DC 20416/202-634-4885.

8-a Contracts

The Small Business Administration, working with procurement officials in other agencies, serves as a prime contractor for federal goods and service purchases, and then subcontracts this federal work to small firms owned by socially and economically disadvantaged persons. SBA also provides management, technical and bonding assistance to firms holding 8-a contracts. Contact: 8-a Contracts, Minority Small Business and Capital Ownership Development, Small Business Administration, 1441 L St. N.W., Room 618, Washington, DC 20416/202-653-6549.

Export Marketing for Smaller Firms

This publication is written specifically for small business owner-managers. It outlines the sequence of steps necessary to determine whether and how to utilize foreign markets as a source of immediate and future profits. It describes the problems facing smaller firms engaged in or seeking to enter international trade and the many types of assistance available to help them cope with problems which may arise. The booklet also provides a step-by-step guide to the appraisal of the sales potential of foreign markets and to an understanding of the requirements of local business practices and procedures in those overseas markets. It is available for $2.20 from the Superintendent of Documents, Government Printing Office, Washington, DC 20402/202-783-3238. For additional information, contact: Office of International Trade, Small Business Administration, 1441 L St. N.W., Room 602G, Washington, DC 20416/202-653-6544.

Freedom of Information Act Requests

For Freedom of Information Act requests, contact: Freedom of Information, Public Communications, Small Business Administration, 1441 L St. N.W., Room 720A, Washington, DC 20416/202-653-6460.

Grants

The program described below is for sums of money which are given by the federal government to initiate or stimulate new or improved activities or to sustain on-going research:

Management and Technical Assistance for Disadvantaged Businessmen

Objectives: To provide management and technical assistance through public or private organizations to existing or potential businessmen who are economically or socially disadvantaged or who are located in areas of high concentration of unemployment; or are participants in activities authorized by sections 7(i) and 8a of the Small Business Act.

Eligibility: Public or private organizations that have the capability of providing the necessary assistance.

Range of Financial Assistance: $15,000 to $306,250.

Contact: Assistant Administrator for Management Assistance, Small Business Administration, 1441 L St. N.W., Room 600, Washington, DC 20416/202-653-6894.

Hotline to Publications

Small Business Administration free publications include management aids, small marketers' aids, and small business bibliographies. The management aids are generally aimed at manufacturing businesses; small marketers' aids at retail and service firms; and small business bibliographies list key reference sources for a variety of business management topics, including books, pamphlets and trade associations. For additional information, contact: Publications, Public Communications, Small Business Administration, 1441 L St. N.W., Room 100, Washington, DC 20416/202-653-6365, or call toll-free 800-433-7212; 800-792-8901 in Texas.

Information

A central source of information on the federal government for small businesses, small business organizations and trade associations is available. Contact: Trade Associations Liaison, Office of Advocacy, Small Business Administration, 1100 Vermont Ave. N.W., Room 1100, Washington, DC 20416/202-653-6273.

International Trade

The Small Business Administration works closely with the Department of Commerce, Eximbank, Overseas Private Investment Corporation, and other governmental and private agencies to provide small business with assistance and information on export opportunities. A free

pamphlet, *Expand Overseas Sales with Commerce Department Help*, describes the kind of assistance available. Contact: Office of International Trade, Management Assistance, Small Business Administration, 1441 L St. N.W., Room 602G, Washington, DC 20416/202-653-6544.

International Trade Counseling and Training

International trade counseling and training is available to managers of small businesses considering entering the overseas marketplace as well as those desiring to expand current export operations. Emphasis is placed on the practical application of successful exporting and importing procedures to small business. Contact: Office of International Trade, Management Assistance, Small Business Administration, 1441 L St. N.W., Room 602G, Washington, DC 20416/202-653-6544.

Library

The library has reference material pertaining to small businesses. Contact: Library, Small Business Administration, 1441 L St. N.W., Room 218, Washington, DC 20416/202-653-6914.

Loan and Loan Guarantees

The programs described below are those which offer financial assistance through the lending of federal monies for a specific period of time or programs in which the federal government makes an arrangement to indemnify a lender against part or all of any defaults by the borrower:

Bond Guarantees for Surety Companies

Objectives: To encourage the commercial surety market to make surety bonds more available to small contractors unable for various reasons to obtain a bond without a guarantee.

Eligibility: Guarantees are limited to those surety companies holding certificates of authority from the Secretary of the Treasury as an acceptable surety for bonds on federal contracts, or those other companies which can meet the requirements of the Small Business Administration.

Range of Financial Assistance: $2,000 to $1,000,000.

Contact: Chief, Surety Bond Guarantee Division, Small Business Administration, 4040 N. Fairfax Dr., Suite 500, Arlington, VA 22203/703-235-2900.

Disaster Assistance to Nonagricultural Businesses (Major Source of Employment)

Objectives: To enable a nonagricultural business that is a major source of employment in a major disaster area and which is no longer in substantial operation as a result of such disaster to resume operations in order to assist in restoring the economic viability of the disaster area.

Eligibility: Must be a major source of employment, a nonagricultural enterprise and be located in a major disaster area.

Range of Financial Assistance: No limit.

Contact: Office of Disaster Loans, Small Business Administration, 1441 L St. N.W., Washington, DC 20416/202-653-6376.

Economic Injury Disaster Loans

Objectives: To assist business concerns suffering economic injury as a result of certain Presidential, SBA, and Department of Agriculture disaster designations.

Eligibility: Must be a small business concern as described in SBA rules and regulations. Must furnish evidence of economic injury claimed.

Range of Financial Assistance: $250,000 to $1,083,200.

Contact: Office of Disaster Loans, Small Business Administration, 1441 L St. N.W., Washington, DC 20416/202-653-6376.

Handicapped Assistance Loans

Objectives: To provide loans and loan guarantees for nonprofit sheltered workshops and other similar organizations to enable them to produce and provide marketable goods and services; and to assist in the establishment, acquisition, or operation of a small business owned by handicapped individuals.

Eligibility: For nonprofit organizations, must be organized under the laws of the state, or of the United States, as a nonprofit organization operating in the interests of handicapped individuals and must employ handicapped individuals for not less than 75 percent of the man-hours required for the direct production of commodities or in the provision of services which it renders. For small business concerns, must be independently owned and operated, not dominant in its field, meet SBA size standards, and be 100 percent owned by handicapped individuals. Handicap must be of such a nature as to limit the individual's engaging in normal competitive business practices without SBA assistance.

Range of Financial Assistance: $500 to $350,000.

Contact: Director, Office of Business Loans, Small Business Administration, 1441 L St. N.W., Washington, DC 20416/202-653-6570.

Physical Disaster Loans

Objectives: To provide loans to restore, as nearly as possible, the victims of physical-type disasters to predisaster condition.

Eligibility: Must have suffered physical property loss as a result of floods, riots or civil disturbances, or other catastrophes which occurred in an area designated as eligible for assistance by the Administration. Individuals, business concerns including agricultural enterprises, churches, private schools, colleges and universities, and hospitals are eligible to apply for assistance.

Range of Financial Assistance: Up to $500,000.

Contact: Office of Disaster Loans, Small Business Administration, 1441 L St. N.W., Washington, DC 20416/202-653-6376.

Small Business Energy Loans

Objectives: To assist small business concerns in financing plant construction, expansion, conversion, or startup; and in the acquisition of equipment facilities, machinery, supplies or materials to enable such concerns to manufacture, design, market, install or service specific energy measures.

Eligibility: Must be a small business concern as described in SBA regulations. Must furnish evidence of being engaged in an eligible energy measure. State and local governments not eligible.

Range of Financial Assistance: Not specified.

Contact: Office of Business Loans, Small Business Administration, 1441 L St. N.W., Washington, DC 20416/202-653-6570.

Small Business Investment Companies

Objectives: To make equity and venture capital available to the small business community with maximum use of private sector participation, and a minimum of government interference in the free market, to provide advisory services and counseling.

Eligibility: Any chartered small business investment company having a combined paid-in capital and paid-in surplus of not less than $500,000, having qualified management, and giving evidence of sound operations.

Range of Financial Assistance: $50,000 to $35,000,000.

Contact: Associate Administrator for Finance and Investment, Small Business Administration, 1441 L St. N.W., Washington, DC 20416/202-653-6879.

Small Business Loans

Objectives: To aid small businesses which are unable to obtain financing in the private credit marketplace, including agricultural enterprises.

Eligibility: A small business which is independently owned and operated and is not dominant in its field. Generally for manufacturers, average employment not in excess of 250; wholesalers, annual sales not over $9,500,000; retail and service concerns, revenues not over $2,000,000, and agricultural enterprises, gross annual sales not over $1,000,000.

Range of Financial Assistance: $1,000 to $500,000.

Contact: Director, Office of Financing, Small Business Administration, 1441 L St. N.W., Washington, DC 20416/202-653-6570.

Small Business Pollution Control Financing Guarantee

Objectives: To help small businesses meet pollution control requirements and remain competitive.

Eligibility: Must be a small business concern as described in SBA regulations. Applicant together with affiliates meets SBA size standards (industry employees limit, or assets, net worth, and annual earnings dollar limits); applicant has minimum five years in business, three of last five years profitable, has evidence from pollution control regulatory authority that pollution control facilities/equipment are acceptable.

Range of Financial Assistance: Up to $5,000,000.

Contact: Chief, Pollution Control Financing Division, Office of Special Guarantees, Small Business Administration, 1815 N. Lynn St., Rosslyn, VA 703-235-2902.

State and Local Development Company Loans

Objectives: To make federal funds available to state and local development companies to provide long-term financing to small business concerns located in their areas. Both state and local development companies are corporations chartered for the purpose of promoting economic growth within specific areas.

Eligibility: A state development company must be incorporated under a special state law with authority to assist small businesses throughout the state. Loans are available to local development companies which are incorporated under general state corporation statute, either on a profit, or nonprofit basis, for the purpose of promoting economic growth in a particular community within the state.

Range of Financial Assistance: $13,000 to $500,000.

Contact: Office of Business Loans, Small Business Administration, 1441 L St. N.W., 8th Floor, Washington, DC 20416/202-653-6570.

Management Assistance Publications

Management assistance publications are available on a variety of subjects concerning specific management problems and various aspects of business operations. Most of these publications

are available from the Small Business Administration free of charge. Others are sold by the Government Printing Office. For a list of these and for additional information, contact: Management Publications and Information Division, Management Assistance, Small Business Administration, 1522 K St. N.W., Washington, DC 20416/202-724-1703, or call toll-free: 800-433-7212; 800-792-8901 in Texas.

Minority Business Development

Regional and district SBA staff members cooperate with local business development organizations and explain to potential minority entrepreneurs how SBA services and programs can help them become successful business owners. Contact your regional and district SBA office, or: Minority Small Business and Capital Ownership Development, Small Business Administration, 1441 L St. N.W., Room 317, Washington, DC 20416/202-653-6407.

Minority Enterprise Small Business Investment Companies (MESBICs)

MESBICs provide venture capital to minority-owned small businesses. Venture capital is provided in the form of equity capital convertible debentures (long-term loans which can be converted into equity capital) or long-term loans. Lists of MESBICs are available at SBA Branch and District Offices. To receive these lists or for additional information on MESBICs, contact: Office of Investment, Small Business Administration, 1441 L St. N.W., 8th Floor, Washington, DC 20416/202-653-6584.

Paperwork

Several free publications deal with paperwork requirements:

Catalog of Federal Paperwork Requirements—a printed inventory of small business reporting requirements identifies, for the first time, by three-digit Standard Industrial Classification, all cleared federal reports and record-keeping requirements.
Guide to Record Retention Requirements for Small Business—a guide to government record retention requirements, which identifies these requirements by industry group.
The Regulatory and Paperwork Maze: A Guide for Small Business—one in a series of reports prepared as part of the Office of Advocacy's Paperwork Measurement and Reduction Project. Contains information on understanding the federal legislative process; the state legislative process; the regulatory process; judicial review; and how to participate in the process. Similar information for association executives and government personnel is contained in *The Regulatory and Paperwork Maze: A Guide for Government Personnel.*

Contact: Office of Advocacy, Small Business Administration, 1100 Vermont Ave. N.W., Room 1100, Washington, DC 20416/202-653-6273.

Pollution Control Financing

Assistance is available to highly qualified small businesses to finance pollution control facilities through the use of federal tax-exempt industrial revenue bonds. A free pamphlet, *Reducing Air Pollution in Industry*, discusses measurement methods, control processes and devices, and financing and taxes. Contact: Pollution Control, Financing Guarantee Division, Investment, Small Business Administration, 4040 N. Fairfax Dr., Room 500 Webb, Arlington, VA 22203/703-235-2902.

Prime Contracts

Government purchasing offices set aside some contracts or portions of contracts for exclusive bidding by small businesses. SBA Procurement Center representatives stationed at major military and civilian procurement installations recommend additional "set asides," refer small businesses to federal contracting officers, assist small concerns with contracting problems, and recommend relaxation of unduly restrictive specifications. Contact: Prime Contracts Division, Procurement Assistance, Small Business Administrative, 1441 L St. N.W., Room 634, Washington, DC 20416/202-653-6826.

Procurement Assistance

Counsel on how to prepare bids and obtain prime contracts and subcontracts, how to get your business name on bidders' lists and related services such as supplying leads on research and development projects and new technology is available. Contact: SBA Regional Offices, or Procurement Assistance, Small Business Administration, 1441 L St. N.W., Room 600, Washington, DC 20416/202-653-6635.

Procurement Automated Source System (PASS)

PASS makes available a master list of small companies capable of performing work on federal contracts and subcontracts. This computerized system lists the names of small companies and their capabilities to assist federal procurement officers and procurement officials at private contractors in assigning federal work to small businesses. Many other federal agencies use PASS. Small businesses interested in participating in PASS can get appropriate forms at any SBA office. For further information, contact: Procurement Automated Source System, Procurement Assistance, Small Business Administration, 1441 L St. N.W., Room 628, Washington, DC 20416/202-653-6938.

Property Sales Assistance

The Small Business Administration works with government agencies which sell surplus real and personal property and natural resources to insure that small businesses have an opportunity to buy a fair share of them. SBA also insures that small firms operating in energy-related industries obtain an equitable portion of federal energy-related mineral lease contracts. Contact: Property Sales Assistance, Procurement Assistance, Small Business Administration, 1441 L St. N.W., Room 636, Washington, DC 20416/202-653-6078.

Publications

This office has a list of free management assistance publications and a list of booklets for sale about starting businesses. Contact: Public Communications, Small Business Administration, 1441 L St. N.W., Room 100, Washington DC 20416/202-653-6365.

R&D Assistance

Small business concerns can obtain the benefits of research and development performed by other federal agencies through the assistance of the Small Business Administration. Also available is *The Science Engineering, Research and Development Directory.* This is the main source of R&D information on contract opportunities. Firms can ask to be listed in the directory. Contact: Technology Assistance Division, Procurement Assistant Division, Small Business Administration, 1441 L St. N.W., Room 628, Washington, DC 20416/202-653-6938.

Science Engineering, Research and Development Directory

An annual directory of small businesses is available to help them obtain federal government contracts for research and development. If requested, Small Business Administration field offices will survey a small R&D firm for inclusion in the directory. Contact: Technology Assistance Division, Procurement Assistance, Small Business Administration, 1441 L St. N.W., Room 628, Washington, DC 20416/202-653-6938.

Service Corps of Retired Executives (SCORE)

Retired business executives volunteer their services to help small businesses solve their problems. Assigned SCORE counselors visit the owners in their places of business to analyze the problems and offer help. Contact: SCORE, Office of Management Counseling Services, Management Assistance, Small Business Administration, 1441 L St. N.W., Room 602H, Washington, DC 20416/202-653-6725.

Small Business Data Base

This describes the development of a comprehensive data base for small business in order to conduct research on the impact of governmental policy on small business, provide a common standard by which to measure small business research, and produce a model by which the growth of small business can be traced. Contact: Office of Economic Research, Office of Advocacy, Small Business Administration, 1100 Vermont Ave. N.W., Room 1100 VTB, Washington, DC 20416/202-634-4885.

Small Business Development Centers

Individual counseling and practical training are available for small business owners. Small Business Development Centers draw from resources of local, state and federal government programs, the private sector and university facilities to provide managerial and technical help, research studies and other types of specialized assistance of value to small businesses. Contact: Office of Small Business Development Centers, Management Assistance, Small Business Administration, 1441 L St. N.W., Room 602, Washington, DC 20416/202-653-6519.

Small Business Economic Research

This office promotes an extramural small business economic research program. Some areas of research interest include fiscal and monetary issues; public finance; managerial economics; industrial organization; market imperfections and competitive disequilibrium; special needs of women and minority business owners; small business data base; and dynamic studies. *Small Business Economic Research Program Announcement* is available. Contact: Office of Economic Research, Office of the Chief Counsel for Advocacy, Small Business Administration, 1100 Vermont Ave. N.W., Room 1100, Washington, DC 20416/202-634-4885.

Small Business Guide to Government

This publication describes the functions of several Small Business Administration offices and programs, small business investment companies (SBICs and MESBICs). It lists small business organizations, state policy liaisons to small business; state Congressional delegations and selected Senate and House Standing Committees. It also explains how small business persons can express their views and gain an input into shaping laws, regulations and policies through United States Representatives and Senators. Contact: Office of Management Assistance, Small Business Administration, 1441 L St. N.W., Room 602, Washington, DC 20416/202-653-6881.

Small Business Institute

Extended personal counseling is offered to small business owners, at no charge. This resource is available through the cooperation of faculty, senior and graduate students and business schools. For additional information, contact: Small Business Institute, Office of Management Counseling Services, Management Assistance, Small Business Administration, 1441 L St. N.W., Room 602-H, Washington, DC 20416/202-653-6668.

Small Business Investment Companies (SBICs)

The Small Business Administration licenses, regulates and provides financial assistance to small business investment companies and licensees. The sole function of these investment companies is to provide venture capital in the form of equity financing, long-term loan funds, and management services to small business concerns. *SBIC: Starting a Small Business Investment Company* is a free booklet which details the organization and regulation of SBICs for the benefit of investors interested in profit-sharing with smaller firms. *Money for Growth—SBIC Financing for Small Business* is a free booklet that describes how to obtain financing from SBICs. *SBIC Industry Review*, an annual, provides summaries and analyses of SBIC data, showing the status and progress of the industry. Contact: Office of Investment, Small Business Administration, 1441 L St. N.W., 8th Floor, Washington, DC 20416/202-653-6584.

Small Business Management Training Films

A list of training films is available on the following topics: advertising/sales promotion; credit and collection; crime prevention; customer relations; financial management; inventory management; foreign trade; marketing; motivation; personnel; planning; recordkeeping; relocation; selling; site selection; time management; and women in business. Contact: Office of Management Information and Training, Small Business Administration, 1522 L St. N.W., Room 626, Washington, DC 20416/202-653-6634.

Starting and Managing Series Publications

This series is designed to help the small entrepreneur start a business. *Starting and Managing a Small Business of Your Own* deals with the subject in general terms. Each of the other volumes deals with one type of business in detail. The general booklet is available for $3.50 from the Superintendent of Documents, Government Printing Office, Washington, DC 20402/202-783-3238. For additional information, contact: Office of Management Information and Training, Man-

agement Assistance, Small Business Administration, 1522 K St. N.W., Room 626, Washington, DC 20416/202-724-1703.

Subcontracting Opportunities

The Small Business Administration develops subcontracting opportunities for small businesses by maintaining close contact with prime contractors and referring qualified small firms to them. Contact: Subcontracting Assistance, Procurement Assistance, Small Business Administration, 1441 L St. N.W., Room 622, Washington, DC 20416/202-653-6661.

Surety Bonds

The Small Business Administration makes the bonding process accessible to small and emerging contractors who, for whatever reasons, find bonding unavailable to them. The bonds may be used for construction, supplies or services provided by either a prime or subcontractor for government or nongovernment work. Contact: Surety Bond Guarantee Division, Office of Special Guarantees, Investment, Small Business Administration, 4040 N. Fairfax Dr., Arlington, VA 22203/703-235-2907.

Technology Assistance

Technology assistants use a variety of resources and data banks to identify appropriate technology and make it available to small firms that have requested assistance in solving a problem, improving a process, or developing a new product. Contact: SBA Regional Offices, or: Technology Assistance Division, Procurement Division, Small Business Administration, 1441 L St. N.W., Room 628, Washington, DC 20416/202-653-6938.

Timber Sales

The federal government regularly sells timber from the federal forests. The Small Business Administration, with other federal agencies, sets aside timber sales for bidding by small concerns when it appears that, under open sales, small businesses would not obtain a fair share at reasonable prices. For further information, contact: Timber and Property Sales, Procurement Assistance, 1441 L St. N.W., Room 632, Washington, DC 20416/202-653-6078.

U.S. Purchasing and Sales Directory

This directory lists the products and services bought by the military departments, with a separate listing for civilian agencies. It includes an explanation of the ways in which SBA can help a business obtain government prime contracts and subcontracts, data on government sales of sur-

plus property, and comprehensive descriptions of the scope of the government market for research and development. Contact: Prime Contracts Division, Procurement Assistance, Small Business Administration, 1441 L St. N.W., Room 632, Washington, DC 20416/202-653-6826.

Women in Business

All of the Small Business Asm. inistration loan, loan guarantee, management assistance, procurement assistance, and advocacy programs are available to women-owned businesses. *Women's Handbook: How SBA Can Help You Go Into Business* is a free booklet with information on the services offered by SBA to women starting new businesses. It also provides general guidelines for women thinking of going into business on their own. There is an assigned Women's Representative in every SBA Regional and District Office. Information and assistance are provided by the Women's Representative in the nearest regional or district office, or contact: Office of Women's Business Enterprise Division, Small Business Administration, 1441 L St. N.W., Room 412, Washington, DC 20416/202-653-8000.

How Can the Small Business Administration Help You?

To determine how the Small Business Administration can help you, contact: Office of Public Affairs, Small Business Administration, 1441 L St. N.W., Washington, DC 20416/202-653-6832.

Tennessee Valley Authority

400 Commerce Ave., Knoxville, TN 37902/615-632-3257

ESTABLISHED: May 13, 1933
BUDGET: $15,169,409
EMPLOYEES: 17,674

MISSION: Conducts a unified program of resource development for the advancement of economic growth in the Tennessee Valley region. Activities include flood control, navigation development, electric power production, fertilizer development, recreation improvement, and forestry and wildlife development. (While its power program is financially self-supporting, other programs are financed primarily by appropriations from Congress.)

Major Sources of Information

Agricultural and Chemical Development

The Office of Agricultural and Chemical Development plans and manages programs for research in and development of new and improved fertilizers and processes for their manufacture, for testing and demonstrating methods of chemical and organic fertilizer use as an aid to soil and water conservation and to the improved use of agricultural and related resources, and for operating and maintaining facilities to serve as a national laboratory for research and development in chemistry and chemical engineering related to fertilizers and munitions essential to national defense. The Office also plans and manages programs for the preservation and enhancement of the Valley's agricultural resources and soil conservation; for demonstration of new and improved agricultural methods, placing emphasis on the Valley's small and limited resource farmers; and for readjustment of agricultural areas affected by TVA operations. Contact: Office of Agricultural and Chemical Development, Tennessee Valley Authority, National Fertilizer Development Center, Muscle Shoals Reservation, Muscle Shoals, AL 35660/205-386-2593.

Air Quality

The TVA is working on a massive air pollution control program. Several methods are being used at different power plants to reduce sulfur dioxide and fly ash emissions to the levels required. In addition to large purchases of medium- and low-sulfur Eastern coal supplies, the program includes flue gas scrubbers to remove sulfur dioxide at some plants, coal-cleaning plants, and new electrostatic precipitators or fabric filter baghouses for increased control of fly ash emissions. *How Clean is Our Air?* is a water quality report which notes that air pollution in four of the region's largest cities—Knoxville, Nashville, Memphis, and Chattanooga—exceeded standards established to protect public health. The report also says that air pollution in 38 nonurban and rural Tennessee Valley counties exceeded standards for particulates, ozone, or sulfur dioxide. Contact: Air Resources Program, Office of Natural Resources, Tennessee Valley Authority, River Oaks Building, Hatch Blvd., Room 100A, Muscle Shoals, AL 35660/202-386-2555.

Aquatic Weeds

The aquatic weed control program centers on new herbicides. Researchers have discovered half a dozen species of aquatic plants that previously had not been found in Tennessee Valley lakes. These native plants may be able to compete successfully with such exotics as watermilfoil and hydrilla, either killing the undesirable weeds directly through some chemical process or squeezing them out. The desirable native plants seem to show self-regulating characteristics, indicating they would not spread unchecked throughout a reservoir. In connection with the weed control program, a remote sensing project was completed covering the region from Decatur, Alabama, to Knoxville, Tennessee. This program provides aerial photographs from which the species, abundance, and distribution of aquatic plants can be

determined. Contact: Fisheries and Aquatic Ecologies, Water Resources Division, Office of Natural Resources, Tennessee Valley Authority, 524 Union Ave., Room 445, Knoxville, TN 37902/615-632-3319.

Atmospheric Fluidized Bed Combustion

Atmospheric fluidized bed combustion burns pulverized coal at high temperatures in a bed of limestone particles. Sulfur dioxide released from the burning coal during combustion reacts with the limestone to form calcium sulfate, which is removed from the bottom of the boiler rather than escaping into the atmosphere. The process holds promise for burning high-sulfur coal—abundant in or near the Tennessee Valley—while still meeting air quality standards. Contact: Fluidized Bed Combustion Projects, Energy Demonstrations and Technology Division, Office of Power, Tennessee Valley Authority, Chestnut Street Tower II, 6th and Chestnut Sts., Room 1020, Chattanooga, TN 37401/615-751-7458.

Board of Directors

The Board of Directors is vested with all the powers of the Corporation. The Board establishes general policies and programs; reviews and appraises progress and results; approves projects and specific items which are of major importance, involve important external relations, or otherwise require Board approval; approves the annual budget; and establishes the basic organization through which programs and policies are executed. Citizens also can and do write the TVA Board of Directors and the General Manager, collectively and individually. Although the Board fully expects the TVA staff to investigate and handle suggestions and complaints courteously and expeditiously, they certainly want to hear if matters have not been satisfactorily resolved. Contact: Board of Directors, Tennessee Valley Authority, 400 Summit Hill Ave., Room #12A7, Knoxville, TN 37902/615-632-2531.

Citizen Action Line

A toll-free line has been established for Tennessee Valley residents who wish to get a question answered quickly or make a complaint. Each complaint is independently investigated. Residents can call to obtain information about camping opportunities, the availability of recreation maps, lake levels, and dozens of other subjects. They can call to express their views on TVA programs, all of which are promptly passed on to the TVA Board and the TVA offices directly involved. Contact: Citizen Action Office, Tennessee Valley Authority, 400 Summit Hill Ave., Room EPB20, Knoxville, TN 37902/615-632-

4100. The lines are open to all seven TVA states—Tennessee, Mississippi, Georgia, Alabama, Kentucky, North Carolina, and Virginia. The toll-free numbers are: 800-362-9250 in Tennessee (outside the Knoxville area); 800-251-9242 (outside Tennessee).

Citizens' Guide to TVA

This is a free brochure which gives an overview of the major TVA offices. It also provides addresses and phone numbers of the district administrators. Contact: Citizen Action Office, Tennessee Valley Authority, 400 Commerce Ave., Room EPB6, Knoxville, TN 37902/615-632-4402.

Coal Energy Research

TVA's energy programs emphasize three of the most promising technologies for better use of coal. These are fuel cells using gas from coal, fluidized bed combustion, and advanced sulfur dioxide control processes for conventional coal-fired boilers. Contact: Energy Demonstrations and Technology Division, Office of Power, Tennessee Valley Authority, Chestnut St. Tower II, 6th and Chestnut Sts., Room 1000, Chattanooga, TN 37401/615-751-4573.

Commercial and Industrial Conservation

The conservation program for businesses, industries and other nonresidential power users offers in-depth energy conservation audits to these power users, with loans available for those businesses and industries who carry out measures recommended in the audits. Contact: Conservation and Energy Management, Energy Conservation and Rates Division, Office of Power, Tennessee Valley Authority, 540 Market St., Chattanooga, TN 37401/615-751-6323.

Community and Industrial Development

For information on community and industrial development, and regional planning, contact: Policy Development, Office of Community Development, Tennessee Valley Authority, Walnut St., Knoxville, TN 37902/615-632-4852.

Community Development

Community-oriented programs are planned and conducted to increase citizen participation in the realization of the Valley's sociologic and economic development. Programs provide technical assistance in community planning and in the accomplishment of orderly and balanced development of industry in the Valley and manages TVA's efforts to mitigate the impact of major TVA projects on communities. Contact: Information Services, Office of Economic and

Community Development, Tennessee Valley Authority, 505 Summer Pl., Knoxville, TN 37902/615-632-6240.

Dams and Steam Plants

The Tennessee Valley Authority has constructed a system of dams and reservoirs to promote navigation on the Tennessee River and its tributaries, and to control destructive flood waters in the Tennessee and Mississippi drainage basins. These dams and reservoirs also produce, distribute, and sell power. A free map showing TVA dams and steam plants and including important facts about each of them is available. Contact: Information, Tennessee Valley Authority, 400 Commerce Ave., Room EBD92, Knoxville, TN 37902/615-632-3257, or Washington Representative, Tennessee Valley Authority, 412 1st St., Room 300, Washington, DC 20444/202-245-0101. There is also a Toll-Free Action Line for Tennessee Valley residents: 800-362-9250 in Tennessee; 800-251-9242 in other Valley states.

District Administrators

These seven district administrators oversee all field activities within their areas and act as liaison between local residents and the TVA Board:

Alabama District, Tennessee Valley Authority, 529 First Federal Building, Florence, AL 35630/205-767-4620.

Appalachian District, Tennessee Valley Authority, 4105 Fort Henri Dr., 207 Heritage Federal Building, Kingsport, TN 37663/615-239-5981.

Central District, Tennessee Valley Authority, 1719 West End Building, Suite 100, Nashville, TN 37203/615-327-0643.

Kentucky District, Tennessee Valley Authority, 115 Hammond Plaza, Hopkinsville, KY 42240/502-885-3398.

Mississippi District, Tennessee Valley Authority, 1014 North Gloster, P. O. Box 1623, Tupelo, MS 38801/601-842-5825.

Southeastern District, Tennessee Valley Authority, 68 Mouse Creek Rd., Cleveland, TN 37311/615-476-9131.

Western District, Tennessee Valley Authority, 1804 Watkins Towers, Suite 100, Box 1788, Jackson, TN 38301/901-668-6088.

Electric Power Supply and Rates

For information on electric power supply and rates, contact: Division of Power Utilization, Office of Power, Tennessee Valley Authority, 540 Market St., Room 840, Chattanooga, TN 37401/615-751-2321.

Energy Publications

TVA provides, at no cost, publications on energy for studies and the public. They contain general information on the Tennessee Valley Authority and specific information on such subjects as dams and steam plants, nuclear power, solar energy, energy alternatives, and energy conservation including buying guides for appliances. Contact: Publications Staff, Tennessee Valley Authority, 400 Commerce Ave., Room E3C66 C-K, Knoxville, TN 37902/615-632-6780.

Engineering Design and Construction

This office participates in the planning, and is responsible for the design and construction, of all power plants, major Agency demonstration facilities, or other permanent structures as determined by program needs (except for some power facilities and Office of Agriculture Chemical Development [OACD] facilities). Outside firms may help provide architectural, engineering, or construction services. It also provides general engineering services, geologic, and other technical data for use in planning, design, and construction of structures and works required in carrying out TVA's objectives. Makes independent and final review of all project planning reports which involve its interests, and prepares all statements of detailed estimate of construction cost included in such reports submitted for consideration by the Board. Contact: Office of Engineering and Design Construction, Tennessee Valley Authority, 400 Commerce Ave., Room W12A9, Knoxville, TN 37902/615-632-2911.

Environmental/Energy Education

Much of TVA's environmental education effort is accomplished through university-based environmental education centers. TVA worked with several universities and colleges across the Valley to develop environmental education teaching aids and programs for schools plus workshops for teachers. In addition, TVA offers teacher workshops and interpretive programs for other groups at its Nolichucky Waterfowl Sanctuary and Environmental Study Area near Greenville, TN. Nolichucky is an old hydroelectric project, retired in 1972. TVA has completed conversion of the old powerhouse into an energy conservation and education center, complete with classrooms and an "indoor trail" which winds along the powerhouse's interior, telling the story of energy production and conservation. An outdoor trail system at Nolichucky was also completed in 1979. Contact: Environmental/Energy Education, Land and Forest Resources Division, Office of Natural Resources, Tennessee Valley Authority, Norris, TN 37828/615-632-6450.

Environmental Quality

The Environmental Quality Staff serves as the focal point for TVA's "environmental con-

science." The staff works at a policymaking level and its responsibilities include administration of the National Environmental Policy Act within TVA, planning and coordinating the agency's environmental programs, and the development of new environmental initiatives. EQS focuses on policy implications of programs and projects which are likely to set precedents or are especially significant. Contact: Environmental Qualify Staff, Office of Natural Resources, Tennessee Valley Authority, Forestry Building, Norris, TN 37828/615-632-2007.

Fertilizer Research and Development

At its National Fertilizer Development Center, TVA operates the world's leading facility for developing new fertilizer technology. Major objectives of this program have been to reduce energy requirements for fertilizer production and increase the efficiency of fertilizer use. Contact: National Fertilizer Development Center, Office of Agriculture and Chemical Development, Tennessee Valley Authority, Muscle Shoals Reservation, Muscle Shoals, AL 35660/205-386-2593.

Fertilizer Technology

Most U.S. fertilizers are made with the aid of TVA technology. TVA patents its new developments and then issues licenses to interested companies for nonexclusive use of the patented developments. New TVA technology is also spread throughout the Nation and the world by technical visitors to the National Fertilizer Development Center. TVA manufactures small tonnages of experimental fertilizers at Muscle Shoals for distribution and testing throughout the United States. This program insures that new fertilizer developments get a fair chance of being accepted by the fertilizer industry and farmers. Contact: Office of Agriculture and Chemical Development, Tennessee Valley Authority, National Fertilizer Development Center, Muscle Shoals Reservation, Muscle Shoals, AL 35660/205-386-2593.

Films

The following TVA films can be borrowed at no charge:

FILMS OF GENERAL INTEREST

Shorelines for Progress—the manmade lakes of TVA have 10,000 miles of shoreline. The film describes how they are being used by industry and for recreation.

TVA and the Nation—describes TVA's resource development programs—including river development, chemical research, and electric power—and their impact on commerce and industry in all parts of the United States.

The Valley of the Tennessee (1944)—The problems and attitudes of the farm population in the mid-1930s are the centerpiece of this story of TVA.

Tennessee River: Conservation and Power (1971)—describes TVA's resource development programs, including flood control, power production, navigation, agricultural and forestry improvements, and their effects on the quality of life in the Tennessee Valley region.

There Is A Valley (1976)—camping, swimming, hiking, boating, fishing, environmental education programs, and much more, are among the wide variety of recreation facilities and opportunities you can enjoy in the valley of the Tennessee. This film shows what you can do and where, along the Tennessee River, its tributaries, and manmade reservoirs which stretch throughout a seven-state region of the Southeast.

CONSTRUCTION FILMS

Power From Paradise—in western Kentucky, TVA completed in 1963 a coal-burning steam plant with the two largest turbogenerators in the world. With colorful photography, the construction story is made interesting to laymen as well as specialists.

Superhighways for Power—TVA's construction of one of the Nation's first EHV (extra-high-voltage) transmission lines, a 500,000-volt line from Johnsonville to Memphis in western Tennessee.

FILMS ON SPECIAL SUBJECTS

Discovery!—filmed to encourage education in conservation sciences in the outdoors, this picture follows a group of elementary school pupils and their teachers as they observe plant and animal life, erosion and reforestation in TVA's Environmental Education Center, Land Between the Lakes.

Shell Mounds in the Tennessee Valley—along the Tennessee River, mounds of shells marked the villages of prehistoric inhabitants. The film describes archaeologic work in a TVA reservoir area prior to impoundment.

Strip Mined Land Can Be Reclaimed—coal is America's most abundant fuel, and strip mining is often the only economically feasible way to extract it. TVA has long advocated legislation that would require mine operators to reclaim strip mined land, and in this film demonstrates what can—and has—been done to restore such land after mining.

SOUND FILMSTRIPS

Story of TVA—a factual account of the operations of TVA in fields of flood control, navigation, fertilizer-munitions research, agriculture, forestry and electric power. Suitable for elementary as well as high schools.

A Quality Environment in the Tennessee Valley—a summary of activities to help protect air and water quality, the land, fish, and wildlife and other environmental values.

Contact: Audio-Visual, Tennessee Valley Authority, Knoxville, TN 37902/615-632-2831.

Flood Damage Prevention

TVA's local flood damage prevention program

is designed to help communities avoid flood damages through a variety of measures, with heavy emphasis on nonstructural remedies such as floodplain zoning, flood proofing, and flood insurance. Contact: Floodplain Management, Community Services Division, Office of Community Development, Tennessee Valley Authority, 400 Commerce Ave., Knoxville, TN 37902/615-632-4451.

Freedom of Information Act Requests

For Freedom of Information Act requests, contact: Public Information, Tennessee Valley Authority, 400 Commerce Ave., Room D92, Knoxville, TN 37902/615-632-3257.

Health and Safety

TVA operates a program of health and safety for employees and others affected by their activities, including the provision of medical services to employees; administration of the hazard control plan and compliance with relevant standards; studies and services related to industrial hygiene; and the radiologic hygiene program at planned and operating nuclear facilities. It conducts independent reviews of TVA's nuclear safety program and insures TVA compliance with agency environmental commitments and standards. Contact: Office of Health and Safety, Tennessee Valley Authority, Florence Industrial Park Building, Room 100, Muscle Shoals, AL 35660/205-386-2575.

Home Insulation Program

The program provides energy conservation surveys in the home without charge, with written recommendations on how consumers can make homes more energy-efficient. Interest-free loans are available through TVA distributors to finance weatherization measures with payback spread out over several years as part of the electric bill. Contact: Conservation and Energy Management, Energy Conservation and Rates Division, Office of Power, Tennessee Valley Authority, 540 Market St., Chattanooga, TN 37401/615-751-6323.

Land Between the Lakes

Land Between the Lakes is a 40-mile-long peninsula located between Kentucky and Barkley Lakes in west Kentucky and Tennessee. In its 16th year of operation, Land Between the Lakes is managed by TVA to provide an outstanding outdoor recreation experience as well as a living laboratory for the study of fundamental conservation and resource use principles. A visitors' center features solar-assisted systems which will provide most of the facility's heating and hot water needs and 30 percent of the cooling. The center also has a windmill that produces power which is stored in batteries used by electric cars operated at Land Between the Lakes. The Center will be used for exhibits on solar energy and other areas of interest, and there is a domed theatre for special presentations. TVA offers recreation programs at Land Between the Lakes for everyone, but tailors many programs to groups with special needs. Contact: Land Between the Lakes, Office of Natural Resources, Tennessee Valley Authority, Golden Pond, Kentucky 42231/502-924-5602.

Load Management

TVA and power distributors are trying out a number of ways to flatten out the peaks in power demand that require the use of oil-fired turbines—its most expensive power production—and purchases of high-cost power from other utilities. One of these load management demonstrations involves remote "cycling" of home hot water heaters and space-conditioning units in homes. TVA is also testing three separate methods of heat storage in the home. This concept puts to work electricity generated at night, when demands are lowest, to produce heat, which is stored for use in the day. Some new and existing homes are being used to test the offpeak storage systems, which include pressurized water, special ceramic brick, and a eutectic salt solution heat storage system. Contact: Load Management, Energy Conservation and Rates Division, Office of Power, Tennessee Valley Authority, 540 Market St., Room 210, Chattanooga, TN 37401/615-751-3591.

Management

Management services provide building, office, land acquisition, computing, and transportation services for the Agency, and law enforcement and the protection of TVA property. Contact: Office of Management Services, Tennessee Valley Authority, 400 Commerce Ave., Room EBC76, Knoxville, TN 37902/615-632-4095.

Maps and Charts

Recreation maps of TVA lakes which indicate detailed routes to shoreline recreation areas are available. Single copies are free on request. Each request should specify the lake(s) of interest. Navigation charts and maps for the major lakes have also been published by TVA. They show water depths, the location of public recreation areas, boat docks, resorts, and roads. Charts for the mainstream lakes of the Tennessee River show navigation channels, buoys, lights, and other navigation aids. Maps for tributary lakes show the numbered signs TVA has installed at strategic locations on shore to aid fishermen and recreation boaters in locating their position. Navigation

maps and charts may be purchased from TVA Maps, Knoxville, TN 37902/615-632-2357, or Chattanooga, TN 37401/615-755-2133, or use the hotline: 800-362-9250 in Tennessee; 800-251-9242 outside Tennessee.

Natural Resources Programs

Programs are aimed at providing the people of the region with the multiple benefits of timber, wildlife, fish, and associated recreation and environmental amenities such as clear air and water, healthy vegetation, stable soil, natural beauty, environmental education, and protection of historic and archaeologic resources. There are also programs for water resources conservation, development, and management; waste treatment and disposal; and biologic vector and aquatic plant control. Contact: External Affairs, Office of Natural Resources, Tennessee Valley Authority, Forestry Building, Norris, TN 37828/615-632-2433.

Nuclear Power Plants

The TVA has the largest nuclear power plant construction program in the country with one nuclear plant (Brown's Ferry) in operation and six others in various stages of construction. For information, contact: Nuclear Power Division, Office of Power, Tennessee Valley Authority, Chestnut St. Tower II, 6th and Chestnut Sts., Room 1750, Chattanooga, TN 37401/615-751-6911.

Older Americans Program

The Older Americans Program has three functions: to serve as a central contact point for agencies involved in aging programs which want information or assistance from TVA, to coordinate existent TVA programs which serve the elderly, and to develop new programs to deal with the problems of the elderly. In areas such as energy conservation education and home gardening programs, the Older Americans Program works with other TVA offices to increase the effects of those programs on the elderly. Through the program, TVA is also funding four programs to enable older persons to develop family-type child care centers in their homes. Another project has been designed to enable older persons to make minor modifications in their homes to develop rental units. TVA is funding health demonstration programs for the elderly in each valley state. Contact: Community Services Division, Office of Community Development, Tennessee Valley Authority, 400 Commerce Ave., Knoxville, TN 37902/615-632-3940.

Power

The Office of Power plans and manages the electrical energy supply program to meet the requirements of the power service area consistent with social, conservation, environmental, economic, safety, and lowest-possible-cost objectives. It promotes and demonstrates the most efficient utilization of electrical energy and plans and manages energy conservation demonstration programs. It plans and manages demonstration applications of new technologies in solar and other energy sources and generation, storage, transmission, and use of energy. Contact: Office of Power, Tennessee Valley Authority, Chestnut St. Tower II, 6th and Chestnut Sts., Chattanooga, TN 37401/615-751-2864.

Power System

The system supplies power at wholesale to 160 municipal electric systems and rural electric cooperatives in Tennessee and parts of six neighboring states. Contact: Power System Operations Division, Office of Power, Tennessee Valley Authority, 633 Chestnut St., Room 1200, Chattanooga, TN 37401/615-751-5969.

Procurement

Procurement services for the Tennessee Valley Authority include procurement, transfer, disposal and shipping of equipment, materials, supplies, fuels and management services. Purchases are principally for construction and operation of electric power plants and transmission systems, construction of dams and locks, and development and experimental production of fertilizers. Items required include electrical generating equipment such as turbogenerators, steam-generating units, nuclear plant equipment, hydraulic turbines and generators, transformers, boilers, piping systems, and switchgear. Coal, coke, and nuclear fuel are bought. Electrical and electronic supplies, equipment and spare parts, and communications equipment are stocked. Supplies procured include structural and milled steel, phosphate rock and chemicals, and items for medical laboratory, and photographic purposes. Contact: Purchasing Division, Office of Management Services, Tennessee Valley Authority, 633 Chestnut St., Room 1000, Chattanooga, TN 37401/615-751-2623.

Publications List

For lists of TVA publications that are available at no cost, or for a small fee, contact: Publications Staff, Tennessee Valley Authority, 400 Commerce Ave., Room E3C66, Knoxville, TN 37902/615-632-6780.

Public Board of Directors Meetings

Public Board of Directors meetings are conducted twice a month. One meeting is held in Knoxville and the other outside of Knoxville to provide local citizens in various towns and cities

in the region a convenient opportunity to see how the Agency conducts business. The sessions also provide private citizens the opportunity to talk directly with the Board. For advance notice of these meetings and for further information, contact: Information, Tennessee Valley Authority, 400 Commerce Ave., Room E3D92 C-K, Knoxville, TN 37902/615-632-2629.

Public Meetings

Public meetings, workshops, and consumer forums are held about specific topics or issues such as large-scale construction projects, electric rates, use of public lands, or proposed modifications in recreation policy for TVA reservoirs. Emphasis is on obtaining citizens' views and opinions and providing information. Contact: Information, Tennessee Valley Authority, 400 Commerce Ave., Room E3D92 C-K, Knoxville, TN 37902/615-632-2629.

Rapid Adjustment Farms

Rapid adjustment farms are experimental. University researchers and extension specialists analyze resources on these selected farms and develop management options from which the farmer can choose. TVA supplies fertilizer and some capital to help make the changes, and specialists work with the farmer over a four-year program period. Contact: Agricultural Development Division, Office of Agricultural and Chemical Development, Tennessee Valley Authority, National Fertilizer Development Center, Muscle Shoals Reservation, Muscle Shoals, AL 35660/205-386-2764.

Rates

The TVA is exploring the feasibility of revising rates to more adequately reflect the cost of service, eliminating declining block rates (where the unit price decreases as usage increases), adopting time-of-day rates where justified by costs, adopting seasonal rates to the extent that costs vary by season, and offering interruptible rates to all commercial and industrial customers. TVA is also considering applying a special additional charge to new electrically-heated or cooled residential dwellings which do not meet established TVA requirements. Contact: Rate Design Branch, Energy Conservation and Rates Division, Office of Power, Tennessee Valley Authority, 540 Market St., Room 604, Chattanooga, TN 37401/615-751-3531.

Recreation Areas

A pamphlet listing and describing recreation areas on the Tennessee Valley Authority lakeshores is available. Included are boat docks, resorts, state parks, U.S. Forest Service camp areas and those county and municipal parks which have docks or camping areas. Contact: Information, Resource Services, Office of Natural Resources, Tennessee Valley Authority, 401 Chestnut St., Room 201, Chattanooga, TN 37402/615-751-3740, or use the hotline: 800-362-9250 in Tennessee; 800-251-9242 outside Tennessee.

Resident Environmental Education

The Youth Station at Land Between the Lakes operates the residential environmental education program. It is open year-round and accommodates kindergarten through college-level groups. Teacher training accounted for about 15 percent of the programs at the center. Land Between the Lakes staff also worked with Murray (Kentucky) State University Center for Environmental Education in providing four additional workshops for area teachers and inservice students. LBL's interpretation efforts provide diverse programs to promote better environmental understanding and aesthetic appreciation. Contact: Environmental/ Energy Education, Land Between the Lakes, Office of Natural Resources, Tennessee Valley Authority, Golden Pond, Kentucky 42231/ 502-924-5602.

Scenic River Study

The Recreation Resources Staff completed an evaluation of the river systems of the Valley. The study identifies streams with recreation and aesthetic values, such as the French Broad River in western North Carolina and eastern Tennessee and the Bear Creek streams in north Alabama. And it addresses one of the major problems to full enjoyment of these resources by Valley residents—a lack of easy access to the rivers. Contact: Recreation Resources Staff, Land and Forest Resources Division, Office of Natural Resources, Tennessee Valley Authority, Norris, TN 37828/615-632-6450.

Small Coal Operator Assistance

The TVA tries to strengthen the position of the small coal operator in the market and to insure more competition and reasonable prices. The assistance program reserves a portion of TVA's coal purchases for small producers. In addition, the program provides mining and reclamation technical assistance activities, some operated by college and university extension programs. For additional information, contact: Small Coal Operator Assistance, Land and Forest Resources Division, Office of Natural Resources, Tennessee

Valley Authority, Norris, TN 37828/615-632-6450.

Solar Energy

The TVA is working on the development of solar and renewable energy resources. For examples of and information on its projects, contact: Solar Applications Branch, Energy Conservation and Rates Division, Office of Power, Tennessee Valley Authority, 540 Market St., Room 403, Chattanooga, TN 37401/615-751-6741.

Spent Fuel Options

The TVA is studying alternative facilities needed to store spent fuel from TVA nuclear plants. Contact: Nuclear Power Division, Office of Power, Tennessee Valley Authority, Chestnut St. Tower II, 6th and Chestnut Sts., Room 1740, Chattanooga, TN 37401/615-751-6901.

Technical Library Services

The TVA has library facilities that are open to the public. For information on its holdings and for the location of additional libraries, contact: Library, Tennessee Valley Authority, 400 Commerce Ave., Room E2B7, Knoxville, TN 37902/615-632-3466.

Uranium Supply

As a backstop against future fuel cost increases and supply shortages, the TVA has a program of acquiring and developing interests in uranium properties in the West. Contact: Fuels Division, Office of Power, Tennessee Valley Authority, W. 9th and Broad Sts., Room 303, Chattanooga, TN 37401/615-751-3257.

Wildlife Management

Information gained from field observation of soil types and geologic formations, dominant plant species, and the nature of the land's water supplies, is combined with management goals for certain types of game animals, such as turkey, deer, squirrels, and others whose habitat preferences are known. The system predicts the effects on wildlife habitat of land management practices, such as timber harvesting. Based on this information, wildlife specialists can map out a program compatible with their management goals. Contact: Land and Forest Resources Division, Office of Natural Resources, Tennessee Valley Authority, Norris, TN 37828/615-632-6450.

Woodland Analysis

WRAP, the Woodland Resource Analysis Program, is a computer-backed land management tool which gives foresters a means of identifying quickly management options based on the desires of the landowner. It helps with decisions concerning how to harvest timber in a manner which would also promote other goals, such as improving wildlife habitat or recreation and scenic values. Contact: Land and Forest Resources Division, Office of Natural Resources, Tennessee Valley Authority, Norris, TN 37828/615-632-6450.

How Can the Tennessee Valley Authority Help You?

To determine how the Tennessee Valley Authority can help you, contact: Public Information Office, Tennessee Valley Authority, 400 Commerce Ave., Knoxville, TN 37902/615-632-3257.

Arms Control and Disarmament Agency

Department of State Building, Washington, DC 20451/202-632-9504

ESTABLISHED: September 26, 1961
BUDGET: $18,630,000
EMPLOYEES: 199

MISSION: Formulates and implements arms control and disarmament policies which will promote the national security of the United States and its relations with other countries; prepares and participates in discussions and negotiations with the Soviet Union and other countries on such issues as strategic arms limitations, mutual force reductions in Central Europe, preventing the spread of nuclear weapons to countries that do not now possess them, a prohibition on chemical weapons, and monitoring the flow of arms trade throughout the world.

Major Sources of Information

Advanced Technology

Advanced technology includes environmental warfare, chemical and biological weapons, nuclear weapons tests, radiological warfare. This office has technical and policy responsibilities for arms control in advanced technology. Contact: Advanced Technology Division, Bureau of Multilateral Affairs, Arms Control and Disarmament Agency, 320 21st St. N.W., Room 5499, Washington, DC 20451/202-632-3422.

Anti-Satellite Talks

ACDA participates in National Security Council studies on anti-satellite talks policy matters. Contact: Strategic Affairs Division, Bureau of Strategic Programs, Arms Control and Disarmament Agency, Room 4498, 320 21st St. N.W., Washington, DC 20451/202-632-1542.

Arms Control and Europe

The task of arms control in Europe is to reduce the danger of war. For information on the various programs, contact: Regional Division, Bureau of Strategic Programs, Arms Control and Disarmament Agency, 320 21st St. N.W., Room 4487, Washington, DC 20451/202-632-8253.

Arms Control Impact Statements

· Arms control impact statements are issued to analyze the possible impact on arms control and disarmament policy and negotiations for these programs: nuclear weapons related programs; research, development or procurement programs totalling more than $250 million; other programs involving technology or weapons system could have significant impact. Detailed information about the program includes an analysis of weapon capabilities, stated military requirements and funding. Contact: Defense Program Impact Division, Bureau of Weapons Evaluation and Control, Arms Control and Disarmament Agency, 320 21st St. N.W., Room 5741, Washington, DC 20451/202-632-1296.

Arms Transfer

The arms transfer policy recognizes the defense needs of U.S. friends and allies, but calls for restraint to reduce the threat of uncontrolled spread of conventional arms. Contact: Arms Transfer Division, Bureau of Weapons Evaluation and Control, Arms Control and Disarmament Agency, 320 21st St. N.W., Room 4734, Washington, DC 20451/202-632-3496.

Chemical Weapons Prohibition

ACDA plays a primary role in the negotiations on a chemical weapons prohibition and in discussions of related issues conducted both in the Committee on Disarmament and in the United Nations. Contact: Advanced Science and Technology Division, Bureau of Multilateral Affairs, Arms Control and Disarmament Agency, 320 21st St. N.W., Room 5499, Washington, DC 20451/202-632-3422.

Congressional Liaison

Congressional liaison matters include briefings, hearings and legislative inquiries relating to arms control treaty approval and ACDA legislation. Contact: Congressional Relations, Office of the General Counsel, Arms Control and Disarmament Agency, 320 21st St. N.W., Room 5534, Washington, DC 20451/102-632-9472.

General Advisory Committee

The General Advisory Committee on Arms Contral and Disarmament advises the President, the Secretary of State, and the Director of the Arms Control and Disarmament Agency on matters affecting arms control, disarmament and world peace. Contact: General Advisory Committee on Arms Control and Disarmament, 320 21st St. N.W., Room 5927, Washington, DC 20451/202-632-5176.

Hubert H. Humphrey Fellowship

The Hubert H. Humphrey Fellowship Program encourages research in arms control studies and assists in the training of young professionals. The program involves one-year Fellowships in support of doctoral dissertation research in the field of arms control and disarmament. Candidates for law degrees (J. D. or higher) are also eligible for the Fellowships. Contact: Office of Public Affairs, Arms Control and Disarmament Agency, 320 21st St. N.W., Room 5840, Washington, DC 20451/202-632-0392.

Information

For information on all aspects of Arms Control and Disarmament including Strategic Arms Limitations Talks (SALT) I and II and for copies of the following publications:

ACDA Annual Report
World Military Expenditures—how much money is spent on military programs, how much on social programs, what percentage of the GNP is spent on arms, etc.
Arms Control and Disarmament Agreement—update of various arms control agreements, list of signators on past agreements.
Documents on Disarmament—significant papers by U.S. and other officials. Also speeches, press releases, pamphlets, etc.

Contact: Public Affairs, Arms Control and Disarmament Agency, 320 21st St. N.W., Room 4936, Washington, DC 20451/202-632-9504.

Inhumane Conventional Weapons

The U.N. Conference on Specific Conventional Weapons is attempting to prohibit or limit the use in armed conflict of weapons considered to be excessively injurious or to have indiscriminate effects. Contact: Advanced Technology Division, Bureau of Multilateral Affairs, Arms Control and Disarmament Agency, 320 21st St. N.W., Room 5499, Washington, DC 20451/202-632-3422.

Library

The Library has a collection of documents, reports and other material on arms control and disarmament. It is open to the public but a library card is necessary. To obtain the library card and for general information, contact: Library, Arms Control and Disarmament Agency, 1700 N. Lynn St., Room 805, Arlington, VA 20451/703-235-9550.

Multilateral Affairs

This office has policy responsibility for arms control negotiations and discussions that are conducted in multilateral forums such as the Committee on Disarmament and the United Nations General Assembly. Contact: International Relations Division, Bureau of Multilateral Affairs, Arms Control and Disarmament Agency, 320 21st St. N.W., Room 5499, Washington, DC 20451/202-632-7909.

Mutual and Balanced Force Reductions

The agreed objective of the Mutual and Balanced Force Reductions negotiations is to contribute to stability in Central Europe with lower levels of forces without diminishing the security of any party. Contact: Regional Division, Bureau of Strategic Programs, Arms Control and Disarmament Agency, 320 21st St. N.W., Room 4487, Washington, DC 20451/202-632-8253.

Non-Proliferation

The further spread of nuclear weapons constitutes a serious threat to international peace and security. ACDA plays a leading role in the initiation and implementation of U.S. non-proliferation policy. Contact: Bureau of Non-Proliferation, Arms Control and Disarmament Agency, 320 21st St. N.W., Room 4930, Washington, DC 20451/202-632-3466.

Nuclear Exports

This office provides advice, assessments and policy recommendations on the international relations aspects of non-proliferation. It is responsible for U.S. bilateral initiatives concerning countries of particular non-proliferation interest; for multi-national initiatives including those on supplier countries policies; for encouraging additional adherence to the Non-Proliferation Treaty

and nuclear-free zone agreements; for non-proliferation aspects of related arms control measures such as testing limitations; for participation in the negotiation of U.S. bilateral nuclear agreements for cooperation; and for work on the development and implementation of U.S. nuclear export policies and procedures. Contact: Nuclear Exports Division, Bureau of Non-Proliferation, Arms Control and Disarmament Agency, 320 21st St. N.W., Room 4678, Washington, DC 20451/202-632-1160.

Nuclear Safeguards

Efforts are made to improve all phases of nuclear safeguards from seeking better safeguards agreements to providing improved measurement instrumentation for use by International Atomic Energy Agency inspectors. Contact: Division of Nuclear Safeguards, Bureau of Non-Proliferation, Arms Control and Disarmament Agency, 320 21st St. N.W., Room 4947, Washington, DC 20451/202-632-5124.

Operational Analysis

This office provides quantitative and qualitative assessments of the military, economic and verification implications of arms control issues and options. It maintains an independent analytical and computer capability across a broad spectrum of disciplines. Unclassified reports include *Nuclear Effects Maps; The Effects of Nuclear War;* and *Analysis of Civil Defense in Nuclear War.* Contact: Office of Operational Analysis, Arms Control and Disarmament Agency, 1700 N. Lynn St., Room 805, Arlington, VA 20451/703-235-2249.

Patents and Documents

All operations in the areas of personnel, patents, contracts, procurement, fiscal and administration are handled by Office of the General Counsel, Arms Control and Procurement Agency, 320 21st St. N.W., Room 5534, Washington, DC 20451/202-632-3582.

Publications

The *Annual Report, Arms Control and Disarmament Agreements, World Military Expenditures and Arms Transfers,* and *Documents on Disarmament* are among the major publications of the U.S. Arms Control and Disarmament Agency. *World Military Expenditures and Arms Transfers* include arms transfer data as well. The objective is to provide an authoritative source of world-wide statistical data that demonstrates the size and relative costs of military programs. *Documents on Disarmament* is a compilation of U.S.

and foreign public statements and documents of significance for arms control, and is issued annually. The Agency also issued the 1980 edition of *Arms Control and Disarmament Agreements: Texts and Histories of Negotiations.* ACDA issued a Special Report on the 1980 Review Conference on the Treaty of the Non-Proliferation of Nuclear Weapons held in Geneva August 11–September 7. The report contained the tests of plenary statements of U.S. Delegates and the plenary statements of some 30 delegations on the SALT II Treaty and the Comprehensive Test Ban negotiations. Contact: Office of Public Affairs, Arms Control and Disarmament Agency, 320 21st St. N.W., Room 4936, Washington, DC 20451/202-632-9504.

Research

ACDA sponsors an external research program that studies these subjects: Strategic Arms Limitations; Nuclear Non-Proliferation; Soviet and Other Area Studies; Conventional Arms Control/Arms Transfer; Nuclear Testing Limitations; Non-Nuclear Weapons of Mass Destruction and Advanced Technology Weapons; Economic Studies; and other arms control studies. For a list of specific studies and for additional information, contact: Office of the General Counsel, Arms Control and Disarmament Agency, 320 21st St. N.W., Room 5534, Washington, DC 20451/202-632-3582.

SALT Treaty

The Strategic Arms Limitations Talks (SALT) between the United States and the Soviet Union seek to limit and reduce the strategic nuclear weapons of both countries. Contact: Strategic Affairs Division, Bureau of International Strategic Programs, Arms Control and Disarmament Agency, 320 21st St. N.W., Room 4484, Washington, DC 20451/202-632-1542.

Social Impacts of Arms and Arms Control

The Weapons Evaluation and Control Bureau is devoting increased attention to the arms control implications of various economic and sociopolitical elements in the Soviet society. Soviet military expenditures and their economic burden are an area of primary interest. Alternative estimating approaches for measuring such expenditures are being studied to assess their respective advantages and disadvantages, uses and misuses. ACDA also participated in a new national effort to reinvigorate Soviet studies, generally by contributing financial support to the National Council for Soviet and East European Research.

Contact: Arms Transfer Division, International Nuclear Affairs, Bureau of Nuclear and Weapons Control, Arms Control and Disarmament Agency, 320 21st St. N.W., Room 4734, Washington, DC 20451/202-632-3759.

Speakers

Office of the Agency will address audiences in all parts of the country. Contact: Public Affairs, Arms Control and Disarmament Agency, 320 21st St. N.W., Room 4936, Washington, DC 20451/202-632-9504.

Technology Transfer

Technologies can play a major role in the creation and support of indigenous arms industries in less developed countries, particularly in the latter's capability to manufacture advanced weapons. These dual-use technologies are the subject of arms control deliberations. Contact: Technology Transfer, Bureau of Weapons Evaluation and Control, Arms Control and Disarmament Agency, 1700 N. Lynn St., Room 4734, Arlington, VA 20451/703-632-1100.

Test Ban Treaty

A treaty imposing a comprehensive ban on nuclear explosions has been on the international arms control agenda since the mid-1950s. ACDA develops and coordinates interagency positions on the test ban. Contact: Advanced Technology Division, Bureau of Multilateral Affairs, Arms Control and Disarmament Agency, 320 21st St. N.W., Room 5499, Washington, DC 20451/202-632-3422.

Theater Nuclear Force

The United States and the Soviet Union are negotiating toward achieving equitable and adequately verifiable limitations on their theater nuclear systems. Contact: Regional Division, Bureau of Strategic Programs, Arms Control and Disarmament Agency, 320 21st St. N.W., Room 4487, Washington, DC 20451/202-632-8253.

World Military Expenditures and Arms Transfers

The statistical data describe the size, trends and distribution of global military expenditures and the world's arms trade. This annual ACDA publication contains data on the amount of resources devoted to military purposes and to select social purposes by 145 individual states as well as by major alliances. Relative economic expenditure comparisons are shown as well as detailed data on international arms transfers. Also included are brief articles on measuring Soviet military expenditures and on conversion rate comparisons. Contact: Arms Transfer Division, International Nuclear Affairs, Nuclear and Weapons Control, Arms Control and Disarmament Agency, 320 21st St. N.W., Room 4734, Washington, DC 20451/202-632-3496.

How Can the Arms Control and Disarmament Agency Help You?

To determine how the U.S. Arms Control and Disarmament Agency can help you, contact: Arms Control and Disarmament Agency, 320 21st St. N.W., Washington, DC 20451/202-632-9504.

International Development Cooperation Agency

320 21st St. N.W., Washington, DC 20523/202-632-9170

ESTABLISHED: October 1, 1979
BUDGET: $2,225,000,000
EMPLOYEES: 6,310
MISSION: Insures that developing goals are taken fully into account in all executive branch decision making on trade, financing and monetary affairs, technology and other economic policy issues affecting the less developed nations; and provides strong direction for U.S. economic policies toward the developing world and a coherent development strategy through the effective use of U.S. bilateral development assistance programs and U.S. participation in multilateral development organizations.

Major Divisions and Offices

Agency for International Development

International Development Cooperation Agency, 320 21st St. N.W., Washington, DC 20523/202-632-9170.
BUDGET: $1,592,000,000
EMPLOYEES: 5,742

MISSION: Carries out assistance programs designed to help the people of certain less developed countries develop their human and economic resources, increase productive capacities, and improve the quality of human life as well as to promote economic or potential stability in friendly countries.

Data Experts

Country Desk Officers

The following experts can provide current economic, political and other background information on the country which they study. These experts can be reached by telephone or by writing in care of: Country Officers, Agency for International Development, 320 21st St. N.W., Washington, DC 20523.

Angola/Earl Yates/202-632-3229
Argentina/Robert Lindsay/202-632-2676
Bahamas/Julien Le Bourgeois/202-632-6386
Bahrain/Richard Burns/202-632-8532
Bangladesh/Nancy Tumavick/202-632-9064
Barbados/Susan Merrill/202-632-2116
Belize/James Mack/202-632-0467
Benin/Bernard Lane/202-632-0593
Bolivia/Neil Billig/202-632-2196
Botswana/Leonard Pompa/202-632-1078

Brazil/William Rhodes/202-632-2718
Burma/William McKinney/202-632-9087
Burundi/Theodore Lewis/202-632-1761
Cameroon/Kurt Shafer/202-632-1761
Cape Verde/Joan Johnson/202-632-9106
Central African Republic/Kurt Shafer/202-632-1761
Chad/Yvonne John/202-632-6951
Chile/Robert Lindsay/202-632-2676
Columbia/Neil Billig/202-632-2196
Comoros/Richard Ency/202-632-9762
Congo (Brazzaville)/Gary Nelson/202-632-1761
Cook Islands/Stephen May/202-632-3546
Costa Rica/Penelope Farley/202-632-9158
Cyprus/Christopher Crowley/202-632-9142
Djibouti/James Warner/202-632-4030
Dominican Republic/Bruno Kosheleff/202-632-2200
Ecuador/Robert Lindsay/202-632-2676

Egypt/Gerald Gower/202-632-9048
El Salvador/John Clary/202-632-4795
Equatorial Guinea /Kurt Shafer/202-632-1761
Ethiopia/Jack Warner/202-632-4030
Fiji/Louis Kuhn/202-632-9844
Gabon/Gary Nelson/202-632-1761
The Gambia/Tom O'Connor/202-632-9107
Ghana/David Walsh/202-632-9101
Guatemala/Marvin Schwartz/202-632-4794
Guinea/Bernard Lane/202-632-0593
Guinea-Bissau/Joan Johnson/202-632-9106
Guyana/Edward Campbell/202-632-3448
Haiti/Bruno Kosheleff/202-632-2200
Honduras/Marvin Schwarts/202-632-4794
India/William Oliver/202-632-0212
Indonesia/Jonathan Sperling/202-632-9842
Israel/Russell Misheloff/202-632-0228
Ivory Coast/Bernard Lane/202-632-0593
Jamaica/Richard Delaney/202-632-3447
Jordan/Dennis Morrissey/202-632-8976
Kenya/Richard Ency/202-632-9762
Kiribati (Gilbert Islands)/Harlen Lee/202-632-3546
Kuwait/Richard Burns/202-632-8532
Lebanon/Tom Miller/202-632-8408
Lesotho/Dominic D'Antonio/202-632-4737
Liberia/Sidney Anderson/202-632-0593
Madagascar/Richard Ency/202-632-9762
Malawi/Robert Wrin/202-632-0560
Malaysia/Louis Kuhn/202-632-9844
Mali/Louise Werlin/202-632-7016
Malta/Christopher Crowley/202-632-9142
Mauritania/Celeste Robertson/202-632-9821
Mauritius/Richard Ency/202-632-9762
Morocco/George E. Lewis/202-632-0488
Mozambique/Earl Yates/202-632-3229
Namibia/Dominic D'Antonio/202-632-4737
Nepal/Howard Thomas/202-632-8226
Niger/Yvonne John/202-632-6951
Nigeria/David Walsh/202-632-9101
Oman/Richard Burns/202-632-2388
Pakistan/Neboysha Brashich/202-632-8226

Panama/William Luken/202-632-9158
Papua New Guinea/Stephen May/202-632-3546
Paraguay/William Rhodes/202-632-2718
Peru/William Rhodes/202-632-2718
Phillipines/Carl Penndorf/202-632-8526
Portugal/Christopher Crowley/202-632-9142
Qatar/Richard Burns/202-632-8532
Rwanda/Theodore Lewis/202-632-1761
Sao Tome and Principe/Theodore Lewis/202-632-1761
Senegal/Frances Johnson/202-632-0995
Seychelles/Dale Pfeiffer/202-632-9762
Sierra Leone/Richard Ency/202-632-9762
Singapore/David Rybak/202-632-9844
Solomon Islands/Harlen Lee/202-632-3546
Somalia/Clara Carr/202-632-4030
Sri Lanka/John Miller/202-632-8226
Sudan/John Gunning/202-632-9714
Suriname/Richard McCoy/202-632-3449
Swaziland/Lucretia Taylor/202-632-4728
Syria/Tom Miller/202-632-8408
Thailand/Edward Ploch/202-632-9086
Togo/Bernard Lane/202-632-0593
Tonga/Harlan Lee/202-632-3546
Tunisia/George E. Lewis/202-632-0488
Turkey/Marx Sterne/202-632-9246
Tuvalu (Ellice Islands)/Harlan Lee/202-632-3546
Uganda/Alfred Ford/202-632-9762
United Arab Emirates/Richard Burns/202-632-8532
Upper Volta/John Bierke/202-632-8251
Uruguay/Robert Lindsay/202-632-2676
Vanatu (New Hebrides)/Harlan Lee/202-632-3546
Venezuela/Suzanna Butcher/202-632-3338
Western Samoa/Harlan Lee/202-632-3546
Yemen Arab Republic/Gary Towery/202-632-9246
Zaire/Gary Nelson/202-632-1761
Zambia/Leonard Pompa/202-632-1078
Zimbabwe/Robert Wrin/202-632-0560

Major Sources of Information

Agriculture, Rural Development and Nutrition

To help alleviate starvation, hunger and malnutrition in developing countries, Agency for International Development (AID) personnel overseas include community and area development officers, nutritionists, general agricultural advisors, agricultural economists and agronomy, livestock, research, irrigation, and other specialized advisors. The program includes the following kinds of activities: increasing small farmer income and productivity; creating rural employment; improving nutritional status; enhancing rural infrastructure and environment; and removing institutional and policy impediments. Contact: Food and Nutrition, Bureau for Development Support, Agency for International Development, International Development Cooperation Agency, 1601 N. Kent St., Room 308, Rosslyn, VA 20523/703-235-9090.

American Schools and Hospitals Abroad

This program assists private U.S.-sponsored, nonprofit schools, libraries and hospitals overseas that serve as study and demonstration centers for

American ideas and practices in education and medicine. A list of schools and hospitals is available. Contact: Office of American Schools and Hospitals Abroad, Bureau of Private and Development Cooperation, Agency for International Development, International Development Cooperation Agency, 1400 Wilson Blvd., Room 260, Rosslyn, VA 20523/703-235-1966.

Army Corps of Engineers Technical Assistance

A government interested in obtaining the U.S. Army Corps of Engineers technical assistance should make initial contact with the U.S. Embassy (the economic/commercial attache) in their country. The Reimbursable Disbursement Programs (RDP) Office has regional development attaches who are assigned for specific regions on a world-wide basis and can be contacted through any diplomatic mission of the United States (embassy or consulate). After consideration by the State Department and AID/RDP, appropriate requests are routed to the Corps. AID provides the initial funds to the Corps for on-site evaluation and studies to define required work. Appropriate officials from the requesting nation can also be invited to the United States. Contact: Office of Trade Development Programs, Bureau for Private and Development Cooperation, Agency for International Development, International Development Cooperation Agency, SA 12, Washington, DC 20523/703-235-1800.

Capital Saving Technology

AID supports projects with the specific objective of broadening the range of technologies in use. This is accomplished by increasing local research and the flow of information on appropriate technologies; promoting local development, adaptation and utilization of technologies appropriate to developing countries; and assisting less developed countries to adapt technologies to their public services (such as health and education), especially those that require low initial capital outlay or have low recurrent cost. Contact: Development Technology, Bureau for Science and Technology, Agency for International Development, International Development Cooperation Agency, Room 215B, Washington, DC 20523/703-235-8898.

Catalog of AID Research

Research literature for development can be obtained through AID Research Development, Report Distribution Center, Agency for International Development, International Development Cooperation Agency, P.O. Box 353, Norfolk, VA 23501. For additional information as well as AID quarterly Research and Development Abstracts, contact: Development Information Center, Agency for International Development, International Development Cooperation Agency, NS, Washington, DC 20523/202-632-8701.

Congressional Presentation

The Agency's requests for authorizations and appropriations are an excellent source for AID programs. For information, contact: Office of Legislative Affairs, Agency for International Development, International Development Cooperation Agency, 320 21st St. N.W., Room 2895, Washington, DC 20523/202-632-8264.

Cooperative Development

AID supports cooperative development projects in almost 50 countries through its relationship with U.S. cooperative development organizations and the increased integration of the programs with other technical assistance resources. Contact: Office of Program and Management Support, Bureau for Private and Development Corporation, Agency for International Development, International Development Cooperation Agency, 1400 Wilson Blvd., Room 201, Rosslyn, VA 20523/703-235-1940.

Credit Unions

AID supports the international programs sponsored by the Credit Union National Association (CUNA) and the World Council of Credit Unions. AID's funds are used to improve and expand the technical assistance capability of CUNA's global projects office; expand CUNA's capability to solve problems common to all less developed countries' credit unions; and expedite the development and implementation of a worldwide credit union strategy which combines financial resources from credit unions in both the developed and developing countries. Contact: Food for Peace and Voluntary Assistance, Agency for International Development, International Development Cooperation Agency, AA-FVA, Washington, DC 20523/202-632-8298.

Development Digest

This is a quarterly journal with articles on AID and non-AID projects, and socioeconomic development and problems in less developed countries. It is sold for $7.90 per year by the Superintendent of Documents, Government Printing Office, Washington, DC 20402/202-783-3238. For additional information, contact: Editor of Development Digest, Office of Policy Development and Program Review, Bureau for Program and Policy Coordination, Agency for Interna-

tional Development, International Development Cooperation Agency, 320 21st St. N.W., Room 3643, Washington, DC 20523/202-632-8772.

Development Information Centers

These centers have an extensive collection of program and technical information concerning development assistance and AID research programs. A project data base is also available. They are open to the public but advance notification is advisable. Contact: Development Information Center, Bureau for Development Support, Agency for International Development, International Development Cooperation Agency, Room 1656, NS, Washington, DC 20523/202-632-8701, or Room 105, SA-18, Washington, DC 20523/703-235-1000.

Economic Support Fund

The Economic Support Fund provides economic assistance to countries and organizations, on such terms and conditions as the President may determine to promote economic or political stability. The Fund can finance balance of payments assistance; infrastructure and other capital projects; and development programs of more direct benefit to the poor. Contact: Office of Economic Affairs, Bureau for Program and Policy Coordination, Agency for International Development, International Development Cooperation Agency, Virginia and 21st St. N.W., Room 3669 NS, Washington, DC 20523/202-632-0833.

Education Human Resources Program

This program focuses on increasing the number of children receiving quality primary education; improving the organization and delivery of nonformal education programs; developing communications technology to reach rural communities with appropriate information; encouraging low-cost decentralized programs responsive to community needs; and, assisting Less Developed Countries (LDC) governments to mobilize and use local resources in support of rural development programs. Contact: Office of Education, Human Resources Development, Bureau for Development Support, Agency for International Development, International Development Cooperation Agency, SA-18, Room 311E, Washington, DC 20523/703-235-9012.

Environment and Natural Resources

The Country Development Strategy Statement is prepared by each AID mission and describes the environmental situation in each country as part of the development strategy. AID also prepares environmental profiles of selected countries to help missions and host countries assess environmental problems and their ability to manage natural resources. Contact: Environmental Affairs, Bureau for Program and Policy Coordination, Agency for International Development, International Development Cooperation Agency, 2201 C St. N.W., Room 2842, Washington, DC 20523/202-632-1036.

Excess Property Program

AID is required to use excess property acquired from other federal agencies in its economic development program wherever practicable in lieu of the procurement of new items. Most of the equipment includes heavy construction equipment, vehicles of all types, heavy machinery, electrical generation equipment, and medical equipment and supplies. This program is not only economical but it also assists eligible recipients (friendly countries, international organizations, and registered private and voluntary organizations) to purchase property with their own resources. For additional information, contact: Government Property Resources Division, Office of Contract Management, Bureau for Program and Management Services, Agency for International Development, International Development Cooperation Agency, Building 54-4, New Cumberland Army Depot, New Cumberland, PA 17070/717-782-2288, or Washington Liaison Branch, Room 830F, SA-18, 703-235-8944.

Famine Prevention

Famine Prevention and Freedom from Hunger program supports institution-building programs for the development of national and regional agricultural research, education and extension capacities in developing countries; builds and strengthens human resource skills for agricultural and rural development; supports international agricultural research and strengthens the capacities of land- and sea-grant and other eligible universities to participate more extensively in aid programs overseas. Contact: Title XII Strengthening Grants and University Relations, Food and Nutrition, Bureau for Development Support, Agency for International Development, International Development Cooperation Agency, Room 309D, ST-RUR, Washington, DC 20523/703-235-8930.

Food for Peace (PL 480)

The Food for Peace program draws upon the abundant production of American farmers to provide food aid for primarily humanitarian and development purposes to poor countries. Food

aid may be provided directly to friendly governments or channeled through private voluntary agencies, the World Food Program (United Nations) and the Food and Agriculture Organization. Food for Peace resources can support a variety of programs such as increasing the availability of farm credit, providing price incentives and improving on-farm storage and distribution facilities (Title I). The law also authorizes donations of food for emergency/disaster relief and for programs to help needy people through maternal health, child feeding activities, and food-for-work and other programs designed to alleviate the causes of the need for food assistance. Contact: Food for Peace, Bureau for Private and Development Cooperation, Agency for International Development, International Development Cooperation Agency, Room 535, SA-14, Washington, DC 20523/703-235-9210.

Foreign Currency Programs

Participant training programs enable participants from one country to train in another more developed country. Contact: Office of International Training, Human Resources Development, Bureau for Development Support, Agency for International Development, International Development Cooperation Agency, 1400 Wilson Blvd., Room 402, Rosslyn, VA 20523/703-235-1853.

Foreign Service Retirement and Disability

AID career foreign service employees may become participants in the Foreign Service Retirement and Disability Fund. For additional information, contact: Office of Personnel Management, Agency for International Development, International Development Cooperation Agency, Room 300, Washington, DC 20523/202-632-9608.

Freedom of Information Act Requests

For Freedom of Information Act requests, contact: Information Office, Office of Public Affairs, Agency for International Development, International Development Cooperation Agency, Room 3316, Washington, DC 20523/202-632-9614.

Health

The aim of the health program is to increase access by less developed country populations to preventive and curative health care, family planning and nutrition services; to increase access to use of safe water and adequate sanitation; to reduce debilitating tropical diseases, malnutrition, diarrheal infections, measles and other preventable diseases; and to increase the capacities of less developed countries to manage their health resources. Health, population and nutrition officers around the world help host governments identify and address health problems. Contact: Office of Health, Human Resources Development, Bureau for Development Support, Agency for International Development, International Development Cooperation Agency, Room 709, SA-18, Washington, DC 20523/703-235-9649.

Housing Guarantee Program

The Housing Guarantee Program helps create and organize financing for housing in developing countries for families earning below the median urban income. Under this program, AID guarantees repayment to private U.S. lenders who finance AID approved housing for low-income families. Some of the programs include upgrading squatter settlements through the provision of sewerage, potable water, electricity, and credit for home improvement and low-cost, expandable core housing units. Contact: Office of Housing, Development Technology, Agency for International Development, International Development Cooperation Agency, PRE-H, 2201 C St. N.W., Room 625, Washington, DC 20523/202-632-9637.

Human Rights

The Administrator of AID is responsible for implementing the statutory and policy guidelines for promoting human rights in its bilateral country programs. In consultation with the Assistant Secretary of State for Human Rights and Humanitarian Affairs, the Administrator determines the eligibility of countries to receive foreign assistance and how programs will be formulated to benefit needy people and promote human rights in countries violating internationally recognized human rights. Proposed assistance to such countries is brought before the Interdepartmental Group of Human Rights and Foreign Economic Assistance, chaired by the Deputy Secretary of State. Contact: Office of the Administrator, Agency for International Development, International Development Cooperation Agency, 320 21st St. N.W., Room 5942, Washington, DC 20523/202-632-9620.

International Disaster Assistance

The United States alone maintains a permanent, comprehensive disaster relief capability to assist other countries. The program tries to assure emergency relief within an international context; in-country coordination through AID mission staffs; early assessment by special teams as needed; experienced AID specialists to assist

at disaster sites; and regional stockpiles which shorten emergency response time. Contact: Office of U.S. Foreign Disaster Assistance, Agency for International Development, International Development Cooperation Agency, Room 1262A, NS, Washington, DC 20523/202-632-8924.

Library of Statistical Publications

In addition to automated data banks, Economic and Social Data Services maintains a library of printed data consisting of statistical publications obtained directly from individual country government offices. The library also includes major statistical yearbooks from international organizations and the series of country economic and financial reports published by the World Bank and the International Monetary Fund. Contact: Economic and Social Data Services, Bureau for Development Support, Agency for International Development, International Development Cooperation Agency, Room 509 SA-14, Washington, DC 20523/703-235-9170.

Macro Economic and Social Data Bank

The Economic and Social Data Services Division provides quantitative indicators of economic and social development in lesser developed countries that are relevant to AID's policy, program and reporting needs. The two types of data bases include macro or country-level data and micro household level data. Contact: Economic and Social Data Services, Bureau for Development Support, Agency for International Development, International Development Cooperation Agency, Room 509, SA-14, Washington, DC 20523/703-235-9170.

Multilateral Development Banks

IDCA advises both the Secretary of the Treasury and the U.S. representatives to the multi-lateral development banks on development programs and policies, and on each development project of the banks. Contact: Chief Economist, International Development Cooperation Agency, 320 21st St. N.W., Room 3669, Washington, DC 20523/202-632-0833.

Policy and Budget

The Office of Policy and Budget Review has a central role in a wide range of areas of economic relations between the United States and the developing world, including U.S. bilateral development assistance programs, U.S. participation in the multilateral development institutions, and the effects of U.S. international trade and financial policies on the economic development prospects of developing countries. IDCA focuses special at-

tention on a few critically important elements of the process of economic development, including agriculture, energy and human resources. Contact: Policy and Budget, International Development Cooperation Agency, 320 21st St. N.W., Room 3758, PPC-PB, Washington, DC 20523/202-632-2088.

Population Planning

The population planning program aims to reduce population growth rates that seriously impede economic and social development; and to provide families with effective options in choosing the number of spacing of their children. The program stresses:

Participation of the local community, including women's groups; training of outreach workers, especially in rural areas; effective techniques of communication about family planning to families and communities; and combination of family planning with other programs such as health and nutrition wherever appropriate;

Supplying contraceptives and other family planning commodities;

Country-specific analysis to encourage LDC adoption of informed, comprehensive population policies;

Experimenting with new ways to increase acceptability and cost effectiveness of delivery systems tailored to the needs and existing services of specific country settings;

Technical assistance to LDCs to establish improved management programs and evaluation systems;

Training and equipping LDC physicians, family planning program managers, nurses, midwives, paramedicals and other auxiliary workers with respect to family planning and reproductive health under programs that emphasize local and regional circumstances;

Developing and improving new means of fertility control, and assessing the safety, effectiveness and acceptability of a variety of contraceptive techniques;

Survey, census and vital registration projects and the data analysis needed to evaluate population trends and the impact of family planning programs;

Supporting studies and analyses of the determinants and consequences of fertility, leading to practical program applications.

Total population data are mid-year estimates based on recent census with interpretations of subsequent fertility and mortality trends. Contact: Office of Population, Human Resources Development, Bureau for Development Support, Agency for International Development, International Development Cooperation Agency, Room 209, ST-POP, SA16, Washington, DC 20523/703-235-8117.

Private and Voluntary Organizations

AID provides grants to private and voluntary organizations to help them with their programs of aid to rural and urban poor people. The grants support programs in agriculture, rural development, health, family planning, education and a variety of grassroots collaborative efforts with local groups. The office has information on voluntary agencies such as what they do, and statements of support, revenue, and expenditures. Contact: Office of Private and Voluntary Cooperation, Bureau for Private and Development Cooperation, Agency for International Development, International Development Cooperation Agency, Room 246, SA8, Washington, DC 20523/703-235-1623.

Procurement

For AID procurement information, contact: Office Management Operations, Bureau of Program and Management Services, Agency for International Development, International Development Cooperation Agency, 320 21st St. N.W., Room 3328, Washington, DC 20523/202-632-8972.

Procurement—Small Business

Information on AID procurement for small and disadvantaged businesses is available. Contact: Office of Small and Disadvantaged Business Utilization, Agency for International Development, International Development Cooperation Agency, Room 637, SA14, Washington, DC 20523/703-235-1822.

Program Data

Data on all foreign assistance programs that involve AID and all other government agencies, including bilateral and multilateral programs are available. Contact: Program Data Services Division, Office of Planning and Budgeting, Bureau for Program and Policy Coordination, Agency for International Development, International Development Cooperation Agency, Room 627, PPCB-PIA, Washington, DC 20523/703-235-9167.

Program Evaluation

Evaluation findings are disseminated through two AID publication series:

AID Program Evaluation Discussion Paper Series; and AID Program Evaluation Report Series.

They cover such topics as livestock in Africa, potable water, use of traditional health systems and labor-intensive rural roads. Contact: Office

of Evaluation, Bureau for Program and Policy Coordination, Agency for International Development, International Development Cooperation Agency, 320 21st St. N.W., Room 3659, Washington, DC 20523/202-632-8992.

Public Affairs

The Public Affairs Office provides information and the annual Development Policy Statement which outlines IDCA's international economic development priorities and agenda for the coming year. Contact: Public Affairs, International Development Cooperative Agency, 320 21st St. N.W., Room 3669, Washington, DC 20523/202-632-9170.

Public Affairs Publications

The following publications are available:

World Development Letter—a biweekly newsletter of trends and developments in assistance in the developing world.

Agenda—comes out 10 times a year. It includes articles on AID programs and features stories on Third World countries and their people.

AID's Challenge—describes the purpose of AID and its programs.

U.S. Overseas Loans and Grants and Assistance From International Organizations: Obligations and Loan Authorizations—special statistical report prepared annually for the use of congressional committees primarily concerned with foreign aid. Presents dollar value of all U.S. economic and military assistance, tabulated by country and itemized by program and fiscal year, from July 1, 1945 to recent fiscal year. Updated annually.

Annual Report on Agriculture Export Activities Carried Out Under Public Law 480—message from the President to Congress and referred to the House of Representatives Committee on Agriculture. Published annually as a House document.

Introduction to the FY 1974 Development Assistance Program Presentation to the Congress—issued annually under various titles.

Foreign Disaster Emergency Relief—Report issued annually showing the scope of and new developments in international disaster relief.

Contact: Office of Public Affairs, Agency for International Development, International Development Cooperation Agency, 320 21st St. N.W., Room 4889B, Washington, DC 20523/202-632-1850.

Reimbursable Development Program

This program uses trade, private investment and exports to support Third World economic

and social development. The program provides two basic services:

technology, technical services and training for U.S. federal and state agencies on a reimbursable basis;
planning assistance, including feasibility studies by U.S. agencies and private firms on a grant basis.

Contact: Office Trade Development Programs, Bureau for Private and Development Cooperation, Agency for International Development, International Development Cooperation Agency, SA12, Washington, DC 20523/703-235-1800.

Sahel Development Program

Sahel occupies an area ⅔ the size of the United States and has a population of 30 million people. It encompasses the eight states of Chad, Mali, Mauritania, Niger, Senegal, Upper Volta, The Gambia, and Cape Verde and is one of the world's poorest regions and faces recurring drought. The program, through a multi-donor approach, promotes self-sustaining development and food self-sufficiency. Contact: Sahel Desk, Bureau for Africa, Agency for International Development, International Development Cooperation Agency, Room 2637, Washington, DC 20523/202-632-3911.

Speakers Program

AID officers will address meetings, brief small groups and serve as resource specialists at conferences. Topics discussed include: Third World economic and social development, agricultural, nutritional and health services, world hunger, disaster relief, and rural and urban development. Contact: Speakers Services Staff, Office of Public Affairs, Agency for International Development, International Development Cooperation Agency, Room 4894, 320 21st St. N.W., Washington, DC 20523/202-632-9170.

Technology Assistance

Selected development activities enable AID to deal with a wide range of development concerns that include projects directed toward assisting developing countries with their national energy problems; projects that lessen the problems of rapid urbanization including employment and income problems; to involve U.S. private voluntary organizations in development; to help mitigate urbanization problems; to selectively finance primary road programs; to facilitate access to U.S. scientific and technical knowledge; and to provide environmental management assistance. Contact: Development Technology, Bureau for

Science and Technology, Agency for International Development, International Development Cooperation Agency, Washington, DC 20523/703-235-8898.

Trade and Development Program

This program provides technology, technical services and training on a reimbursable basis and planning assistance by U.S. agencies and private firms to developing countries. Contact: Trade and Development Program, International Development Cooperation Agency, Room 607 SA12, 320 21st St. N.W., Washington, DC 20523/202-632-0138.

Urban Development

AID projects for urban development include introducing pilot programs to more effectively involve urban areas in development; assisting urban-oriented organizations and government agencies in planning, financing and providing basic social and economic services to the urban poor—i.e., shelter, water, and income earning opportunities; and extending technical assistance to developing countries' programs providing adequate shelter and related services such as water for the urban poor. Contact: Office of Urban Development, Developing Technology, Bureau for Science and Technology, Agency for International Development, International Development Cooperation Agency, 1601 N. Kent St., Room 320, Rosslyn, VA 20523/703-235-8898.

U.S. Investments in Developing Countries

The public affairs office provides information to encourage U.S. private investments in developing nations. It furnishes kits which include Overseas Private Investments Cooperations (OPICs) annual report, a country listing and other helpful investment information. Contact: Public Affairs, Overseas Private Investment Corporation, International Development Cooperation Agency, 7th Floor, 1129 20th St. N.W., Washington, DC 20527/202-632-9170.

Women in Development

"Women-in-development" projects are designed to benefit women only. They help women gain access to resources and to acquire and use new skills. They also take account of women's needs and participation in larger AID programs. The Office promotes, assists and coordinates women in development activities and projects. Agency-wide seminars, debriefings and workshops are held to exchange program and project information and experiences. Rosters of women-in-development specialists are published. This of-

fice also collects, publishes and distributes materials through its Resource Center and provides assistance to individuals and groups working on Agency projects. Some of these materials include mission-produced studies, research reports, project documents, specially commissioned papers and relevant publications. Contact: Office of Women in Development, Bureau for Program and Policy Coordination, Agency for International Development, International Development Cooperation Agency, 320 21st St. N.W., Room 3243, Washington, DC 20523/202-632-3992.

How Can the International Development Cooperation Agency Help You?

To determine how the U.S. International Development Cooperation Agency can help you, contact: International Development Cooperation Agency, 320 21st St. N.W., Washington, DC 20523/202-632-9170.

International Trade Commission

701 E St. N.W., Washington, DC 20436/202-523-0161

ESTABLISHED: September 8, 1916
BUDGET: $15,917,000
EMPLOYEES: 438
MISSION: Furnishes studies, reports and recommendations involving international trade and tariffs to the President, the Congress, and other government agencies, and conducts a variety of investigations, public hearings, and research projects pertaining to the international policies of the United States.

Data Experts

Industry Specialists and Commodity Assignments

The following specialists monitor the imports of various goods as well as their impact on the domestic market. The goods are listed alphabetically with their corresponding analysts. For additional information, contact: Office of Industries, International Trade Commission, 701 E St. N.W., Room 254, Washington, DC 20436/202-523-0146.

Abaca/Cook/202-523-0348
Abrasive/Garil/202-523-0304
ABS Resins/Taylor/202-523-0379
Acetal Resins/Taylor/202-523-0379
Acetates/Conant/202-523-0495
 Michels/202-523-0293
Acetic Acids/Conant/202-523-0495
 Michels/202-523-0293
Acetone/Conant/202-523-0495
 Michels/202-523-0293
Acetoricinoleic Acid Ester/Johnson/202-523-0127
Acid, Oleic/Noreen/202-523-1255
Acid, Stearic/Noreen/202-523-1255
Acid, Inorganic/Emanuel/202-523-0334
Greenblatt/202-523-1212
Acid, Organic/Conant/202-523-0495
 Michels/202-523-0293
Acrylates/Conant/202-523-0495
 Michels/202-523-0293
Acrylic Resins/Taylor/202-523-3709
Acrylonitrile/Conant/202-523-0495
 Michels/202-523-0293
Activated Carbon/Noreen/202-523-1255

Acyclic Plasticizers/Johnson/202-523-0127
Adding Machines/Reynolds/202-523-0230
Addressing Machines/Reynolds/202-523-0230
Adhesives/Noreen/202-523-1255
Adipic Acid Esters/Johnson/202-523-0127
Agar Agar/Noreen/202-523-1255
Agglomerating Machinery/DeMarines/202-523-0259
Agricultural Machinery/Skinner/202-523-0265
Air Conditioners/Haarbye/202-523-0169
Ammonium Nitrate, Fuel-Sensitized/Johnson/202-523-3709
Ammonium Nitrate Fertilizer/Briggs/202-523-1145
Ammonium Nitrate Non-Explosive or Fertilizer grade/Emanuel/202-523-0334
 Greenblatt/202-523-1212
Ammonium Phosphate/Emanuel/202-523-0334
 Greenblatt/202-523-1212
Ammonium Sulfate/Emanuel/202-523-0334
 Greenblatt/202-523-1212
Ammunition/Estes/202-523-0977
Analgesics/Briggs/202-523-1145
Angles, Shapes and Sections (Steel)/Kappler/202-523-0342
Angora/Clayton/202-523-5701
Animals, Live/Ludwick/202-724-1763
Animal Feeds/Roeder/202-724-1170
Animal Oil, Fats and Greases/Reeder/202-724-1754
Anthracite/Vacancy[1]
Anti-Convulsants/Briggs/202-523-1145
Antihistamines/Briggs/202-523-1145

[1]/ Call Foreso, 202-523-1230.

Anti-Infective Agents/Briggs/202-523-1145
Anti-Inflammatory Agents/Briggs/202-523-1145
Antimony/Palmer/202-523-0438
Antimony Compounds/Emanuel/202-523-0334
 Greenblatt/202-523-1212
Antipyretics/Briggs/202-523-1145
Antiques/Katlin/202-724-1748
Arms/Estes/202-724-0977
Aromatic Compounds/Land/202-523-0491
Arsenic/Palmer/202-523-0438
Arsenic Compounds/Emanuel/202-523-0334
 Greenblatt/202-523-1212
Art, Works of/Katlin/202-724-1748
Artificial Flowers/Katlin/202-724-1748
Basketwork, Wickerwork, Related
 Products/Wood/202-724-0095
Bathing Caps/Worrell/202-523-0452
Batteries/Cutchin/202-523-0231
Bauxite (Metal)/Woods/202-523-0438
Bauxite Calcined/Garil/202-523-0304
Bay Rum or Bay Water/Land/202-523-0491
Beads/Wilson/202-724-1731
Beads, Articles of/Wilson/202-724-1731
Beans, Ex Oilseed/McCarty/202-724-1753
Bearings, Ball, and Roller/Kapeluck/202-523-0426
Bedspreads/Borsari/202-523-5703
Beef/Ludwick/202-724-1763
Beer/Lipovsky/202-724-0097
Belting, Industrial/Cook/202-523-0348
Belting of Rubber or Plastics (for
 Machinery)/Thompson/202-523-0496
Belts, Apparel:
 Leather/Worrell/202-523-0452
 Other Men's and Boys'/Vacancy[2]
 Other Women's and Girls'/Martello/202-523-5585
Bentonite/Lukes/202-523-0279
Benzene/Vacancy[3]
Benzenoid Intermediates,
 Miscellaneous/Cappuccilli/202-523-0492
Benzenoid Paints/Johnson/202-523-0127
Benzenoid Plasticizers/Johnson/202-523-0127
Benzenoid Plastics/Taylor/202-523-3709
Benzenoid Varnishes/Johnson/202-523-0127
Benzoic Acid/Cappuccilli/202-523-0492
Bottles, Pails and Dishes of Plastic or
 Rubber/Thompson/202-523-0416
Braids, Hat/Worrell/202-523-0452
Braids, Other/Sweet/202-523-0394
Brake Fluid/Gersic/202-523-0451
Bread and Other Baked Goods/Greer/202-523-0029
Breeder Reactor/Vacancy[4]

[2]/ Call Worrell, 202-523-0452.
[3]/ Call Foreso, 202-523-1230.
[4]/ Call Foreso, 202-523-1230.

Brick, Ceramic/Ruhlman/202-523-0309
Bromine/Emanuel/202-523-0334
 Greenblatt/202-523-1212
Brooms/Leverett/202-724-1725
Brushes/Leverett/202-724-1725
Buckles/Mebane/202-724-1730
Building Boards/Hoffmeier/202-724-1766
Building Components (Wood)/Wood/202-724-0095
Bulbs (Lamps)/Cutchin/202-523-0231
Bunker "C" Fuel Oil/Gersic/202-523-0451
Buses/Elroy/202-523-0258
Butadiene/Foreso/202-523-1230
Butane/Foreso/202-523-1230
Butter/Warren/202-724-0090
Buttons/Mebane/1202-724-1730
Butyl Alcohol/Conant/202-523-0495
 Michels/202-523-0293
Butyl Benzyl Phthalate/Johnson/202-523-0127
Butyl Oleate/Johnson/202-523-0127
Butyl Rubber/Thompson/202-523-0496
Butyl Stearate/Johnson/202-523-0127
Butylene/Foreso/202-523-1230
Cadmium/Palmer/202-523-0438
Card Cases/Seastrum/202-724-1733
Cardiovascular Drugs/Briggs/202-523-1145
Carpets/Borsari/202-523-5703
Carrots/McCarty/202-724-1753
Casein/Noreen/202-523-1255
Cash Registers/Reynolds/202-523-0230
Castile Soap/Land/202-523-0491
Casting Machines/Terry/202-523-0262
Cattle/Ludwick/202-724-1763
Caulks/Johnson/202-523-0127
Caulks Compounds/Johnson/202-523-0127
Caustic Potash/Emanuel/202-523-0334
 Greenblatt/202-523-1212
Caustic Soda/Emanuel/202-523-0334
 Greenblatt/202-523-1212
Cedar Leaf/Land/202-523-0491
Cement, Hydraulic/Garil/202-523-0304
Cements, Dental/Noreen/202-523-1255
Cements of Rubber, Vinyl etc./Noreen/202-523-1255
Centrifuges/Slingerland/202-523-0263
Ceramic Construction Articles/Lukes/202-523-0279
Ceramic Table, Kitchen Articles/McNay/202-523-0445
Cereal Breakfast Foods/Greer/202-724-0074
Cereal Grains/Grant/202-724-0099
Cerium/Kennedy/202-523-0270
Cerium Compounds/Emanuel/202-523-0334
 Greenblatt/202-523-1212
Cesium Compounds/Emanuel/202-523-0334
 Greenblatt/202-523-1212
Chain, of Base Metal/Weible/202-523-0273
Chairs/Leverett/202-724-1725
Chalk (Pigment Grade)/Johnson/202-523-0127

Chalks/Hanlon/202-724-1745
Cleaning Machines (Textile)/Skinner/202-523-0265
Clocks/Wilson/202-724-1731
Closures, Stoppers, Seal Lids, Caps of Rubber or Plastic/Thompson/202-523-0496
Clove (Essential Oil)/Land/202-523-0491
Coal/Vacancy[5]
Coal Tar, Crude/Cappuccilli/202-523-0490
Coal-Tar Pitch/Cappuccilli/202-523-0490
Coating Machines/Skinner/202-523-0265
Cobalt/Kennedy/202-523-0270
Cobalt Compounds/Emanuel/202-523-0334
 Greenblatt/202-523-1212
Cocoa/Greer/202-724-0074
Cocks and Valves/DeMarines/202-523-0259
Coffee/Lipovsky/202-724-0097
Coin Purses/Seastrum/202-724-1733
Coke, Calcinated (Non-Fuel)/Garil/202-523-0304
Coke for Fuel/Vacancy[5]
Columbium/Kennedy/202-523-0270
Combs/Leverett/202-724-1725
Concrete and Products/Garil/202-523-0304
Condensate, Lease/Gersic/202-523-0451
Conductors/Cutchin/202-523-0231
Conduit/Cutchin/202-523-0231
Confectionery/Greer/202-724-0074
Construction Paper/Stahmer/202-724-0091
Containers (of Wood)/Wood/202-724-0095
Containers, of Base Metal/Weible/202-523-0273
Dental Cements/Noreen/202-523-1255
Dermatological Agents/Briggs/202-523-1145
Detergents/Land/202-523-0491
Dextrine/Noreen/202-523-1255
Di(2-ethylhexyl) Adipate/Johnson/202-523-0127
Di(2-ethylhexyl) Phthalate/Johnson/202-523-0127
Diamonds/Garil/202-523-0304
Diatomite/Garil/202-523-0304
Diisobutylene/Foreso/202-523-1230
Diisodecyl Phthalate/Johnson/202-523-0127
Dinnerware of Ceramic/McNay/202-523-0445
Dioctyl Phthalate/Johnson/202-523-0127
Distillate Fuel Oil/Gersic/202-523-0451
Doll Carriages, Strollers and Parts/Seastrum/202-724-1733
Dolls/Estes/202-724-0977
Dolomite, Dead Burned/Ruhlman/202-523-0309
Draperies/Borsari/202-523-5703
Drawing Instruments/ Hagelin/202-724-1746
Dresses/Martello/202-523-5585
Dressing Machines (Textile)/Skinner/202-523-0265
Drink-Preparing Machines/West/202-523-0299

Drugs, Natural/Briggs/202-523-1145
Drugs, Synthetic/Briggs/202-523-1145
Dry-Cleaning Machines/West/202-523-0299
Drying Machines/West/202-523-0299
Dyeing Machines/Skinner/202-523-0265
Dyes/Baker/202-523-0492
Dynamite/Johnson/202-523-0127
Ethanolamines/Conant/202-523-0495
 Michels/202-523-0293
Ethers/Conant/202-523-0495
 Michels/202-523-0293
Ethers, Fatty-Acid, of Polyhydric Alcohols/Land/202-523-0491
Ethyl Alcohol (Ethanol) for Nonbeverage Use/Conant/202-523-0495
 Michels/202-523-0293
Ethylene/Foreso/202-523-1230
Ethylene Dibromide/Conant/202-523-0495
 Michels/202-523-0293
Ethylene Glycol/Conant/202-523-0495
 Michels/202-523-0293
Ethylene Oxide/Conant/202-523-0495
 Michels/202-523-0293
Ethlene-Propylene Rubber/Thompson/202-523-0496
Explosives/Johnson/202-523-0127
Eye Glasses/Cunningham/202-724-0980
Fabric Folding Machines/Skinner/202-523-0265
Fabrics:
 Billiard Cloth/Cook/202-523-0348
 Bolting Cloth/Cook/202-523-0348
 Coated/Cook/202-523-0348
 Elastic/Sweet/202-523-0394
 Impression/Chiriaco/202-523-0109
 Knit/Sweet/202-523-0394
 Narrow/Sweet/202-523-0394
Fatty Substances Derived From Animal, Marine Animal, or Vegetable Sources/Noreen/202-523-1255
Feather Products/Katlin/202-724-1748
Feathers/Newman/202-724-0087
Feeds, Animal/Roeder/202-724-1170
Ferments/Briggs/202-523-1145
Ferricyanide Blue/Johnson/202-523-0127
Ferrites/Lukes/202-523-0279
Ferroalloys/Boszormeni/202-523-0328
Ferrocerium/Mebane/202-724-1730
Ferrocyanide Blue/Johnson/202-523-0127
Fertilizers/Briggs/202-523-1145
Fibers:
 Abaca/Cook/202-523-0348
 Alpaca/Clayton/202-523-5701
 Angora/Clayton/202-523-5701
 Camel Hair/Clayton/202-523-5701
 Cashmere/Clayton/202-523-5701
 Cotton/Taylor/202-523-0365
 Flax/Cook/202-523-0348
 Jute/Cook/202-523-0348
 Manmade/Clayton/202-523-5701

Silk/Chiriaco/202-523-0109
Sisam and Henequen/Cook/202-523-0348
Wool/Clayton/202-523-5701
Fibrin/Norean/202-523-1255
Filberts/Burket/202-724-0088
Film (Photographic)/Durkin/202-724-1729
Film, Plastic/Taylor/202-523-3709
Firewood/Hoffmeier/202-724-1766
Foil, Metal:
 Aluminum/Woods/202-523-0277
 Other/Woods/202-523-0277
Food-Preparing Machines/West/202-523-0299
Footwear/Burns/202-523-0200
Forged-Steel Grinding Balls/Kapeluck/202-523-
 0426
Fork-Lift Trucks/Vacancy[6]
Formaldehyde/Conant/202-523-0495
 Michels/202-523-0293
Freon (Chlorofluoro-carbons)/Conant/202-523-
 0495
 Michels/202-523-0293
Fructose/Noreen/202-523-1255
Fruit, Edible, Ex Citrus/Macomber/202-724-
 1765
Fuel, Jet/Gersic/202-523-0451
Fuel Oil, Bunker "C"/Gersic/202-523-0451
Fuel Oil, Navy Special/Gersic/202-523-0451
Fuel Oil (Nos. 1, 2, 3, 4, 5, 6)/Gersic/ 202-523-
 0451
Fulminates/Johnson/202-523-0127
Fur and Furlike Apparel/Worrell/202-523-0452
Furfural/Conant/202-523-0495
 Michels/202-523-0293
Furnace Black/Johnson/202-523-0127
Furnaces/West/202-523-0299
Furniture/Leverett/202-724-1725
Furskins/Ludwick/202-724-1763
Fuses/Mebane/202-724-1730
Fusion Energy/Vacancy[7]
Glue, of Animal or Vegetable
 Origin/Noreen/202-523-1255
Glue Size/Noreen/202-523-1255
Glue, Vegetable/Noreen/202-523-1255
Glycerine/Conant/202-523-0495
 Michels/202-523-0293
Glycols/Conant/202-523-0495
 Michels/202-523-0293
Gold/Taylor/202-523-0273
Gold Compounds/Emanuel/202-523-0334
Greenblatt/202-523-1212
Golf Equipment/Watkins/202-724-0976
Grain Products, Milled/Grant/202-724-0099
Grains/Grant/202-724-0099
Granite/Garil/202-523-0304
Grapefruit (Essential Oil)/Land/202-523-0491

Graphite/Garil/202-523-0304
Grease, Lubricating/Gersic/202-523-0451
Grinding Machines/DeMarines/202-523-0259
Ground Fish/Lopp/202-724-1759
Gum Cotton/Johnson/202-523-0127
Gums and Resins/Reeder/202-724-1754
Gunpowder/Johnson/202-523-0127
Gut, Articles of/Estes/202-724-0977
Gypsum/Garil/202-523-0304
Gypsum Board/Hoffmeier/202-724-1766
Hafnium/Kennedy/202-523-0270
Hair/Ludwick/202-724-1763
Hair, Articles of/Estes/202-724-0977
Hair Curlers Nonelectric/Leverett/202-724-
 1725
Hose, Industrial/Cook/202-523-0348
Hose, of Plastics or Rubber/Thompson/202-
 523-0496
Hosiery/Martello/202-523-5585
Hydrocarbons/Foreso/202-523-1230
Hydrochloric Acid/Emanuel/202-523-0334
 Greenblatt/202-523-1212
Hydrofluoric Acid/Emanuel/202-523-0334
 Greenblatt/202-523-1212
Hypnotics/Briggs/202-523-1145
Ignition Equipment/Cutchin/202-523-0231
Indium/Kennedy/202-523-0270
Industrial Ceramics/Lukes/202-523-0279
Industrial Diamonds/Garil/202-523-0304
Inedible Gelatin/Noreen/202-523-1255
Infants' Accessories or Apparel/Martello/202-
 523-5585
Ingot Molds/Terry/202-523-0262
Ink Powders/Johnson/202-523-0127
Inks/Johnson/202-523-0127
Inorganic Acids/Emanuel/202-523-0334
 Greenblatt/202-523-1212
Inorganic Compounds and Mixtures/
 Emanuel/202-523-0334
 Greenblatt/202-523-1212
Instruments:
 Controlling/Moller/202-724-1732
 Dental/Cunningham/202-724-0980
 Drawing/Hagelin/202-724-1746
Juices, Vegetable/Lipovsky/202-724-0097
Kaolin/Lukes/202-523-0279
Kerosene/Gersic/202-523-0451
Ketones/Conant/202-523-0495
 Michels/202-523-0293
Key Cases/Seastrum/202-724-1733
Knitting Machines/Skinner/202-523-0265
Labels/Cook/202-523-0348
Lace/Sweet/202-523-0394
Lacemaking Machines/Skinner/202-523-0265
Lacings/Cook/202-523-0348
Lactose/Noreen/202-523-1255
Lacquers/Johnson/202-523-0127
Lakes/Baker/202-523-0492

[6]/ Call Haarbye, 202-523-0169.
[7]/ Call Foreso, 202-523-1230.

Lamb/Ludwick/202-724-1763
Lamp Black/Johnson/202-523-0127
Lamps (Bulbs)/Cutchin/ 202-523-0231
Laundry Machines/West/202-523-0299
Lead/Palmer/202-523-0438
Lead Compounds/Emanuel/202-523-0334
 Greenblatt/202-523-1212
Lead Pigments/Johnson/202-523-0127
Leads/Hanlon/202-724-1745
Lease Condensate/Gersic/202-523-0451
Leather/Ludwick/202-724-1763
Leather Apparel/Worrell/202-523-0452
Lemon (Essential Oil)/Land/202-523-0491
Lenses/Cunningham/202-724-0980
Levulose/Noreen/202-523-1255
Lighting Equipment/Cutchin/202-523-0231
Lignite/Foreso/202-523-1230
Lithium/Emanuel/202-523-0334
 Greenblatt/202-523-1212
Logs, Rough/Hoffmeier/202-724-1766
Lubricating Oil/Gersic/202-523-0451
Luggage/Seastrum/202-724-1733
Machines and Machinery:
 Bookbinding/Slingerland/202-523-0263
 Calculators/Paris/202-523-4585
 Cash Registers/Reynolds/202-523-0230
 Cleaning (Heat Process Equipment)/
 Slingerland/202-523-0263
 Cleaning (Textiles)/Skinner/202-523-0265
 Coating/Skinner/202-523-0265
 Converters/Terry/202-523-0262
 Cordage/Skinner/202-523-0265
 Crushing/DeMarines/202-523-0259
 Cutting/Skinner/202-523-0265
 Data Processing/Reynolds/202-523-0230
 Dry Cleaning/West/202-523-0299
 Drying/West/202-523-0299
 Dyeing/Skinner/202-523-0265
 Earth Moving/DeMarines/202-523-0259
 Embroidery/Skinner/202-523-0265
 Farm (Ex Tractors)/Skinner/202-523-0265
 Food Preparing/West/202-523-0299
 Horticultural/Skinner/202-523-0265
 Mining/DeMarines/202-523-0259
 Office Copying/Reynolds/202-523-0230
 Packaging/Slingerland/202-523-0263
 Vending/Slingerland/202-523-0263
 Weighing/Slingerland/202-523-0263
Magnesite:
 Caustic Calcined/Garil/202-523-0304
 Crude/Garil/202-523-0304
 Dead Burned/Ruhlman/202-523-0309
Magnesium/Kennedy/202-523-0270
Magnesium Compounds/Emanuel/202-523-
 0334
 Greenblatt/202-523-1212
Magnetic Devices/Cutchin/202-523-0231
Malts/Grant/202-724-0099

Manganese/Kennedy/202-523-0270
Manganese Compounds/Emanuel/202-523-0334
 Greenblatt/202-523-1212
Manmade fibers/Clayton/202-523-5701
Mantles/Mebane/202-724-1730
Marble, Breccia and Onyx/Garil/202-523-
 0304
Matches/Mebane/202-724-1730
Mattresses/Leverett/202-724-1725
MBS Resins/Taylor/202-523-3709
Meat, Edible/Ludwick/202-724-1763
Meat, Inedible/Ludwick/202-724-1763
Medical Apparatus/Cunningham/202-724-0980
Melamine/Conant/202-523-0495
 Michels/202-523-0293
Melamine Resins/Taylor/202-523-3709
Menthol/Land/202-523-0491
Mercury/Kennedy/202-0277
Mercury Compounds/Emanuel/202-523-0334
 Greenblatt/202-523-1212
Metal Working Machines/Terry/202-523-0262
Meteorological/Moller/202-724-1732
Methacrylates/Conant/202-523-0495
 Michels/202-523-0293
Methane/Foreso/202-523-1230
Methyl Alcohol (Methanol)/Conant/202-523-
 0495
 Michels/202-523-0293
Molasses/Greer/202-724-0074
Molders' Boxes, Forms and Patterns/Vacancy [8]
Moldings, Wooden/Wood/202-724-0095
Molybdenum/Kennedy/202-523-0277
Molybdenum Compounds/Enamuel/202-523-
 0334
 Greenblatt/202-523-1212
Monofilaments, Manmade/Clayton/202-523-
 5701
Monosodium Glutamate/Land/202-523-0491
Motion Pictures/Durkin/202-724-1729
Motor Oil/Gersic/202-523-0451
Motor Vehicles:
 Buses/McElroy/202-523-0258
 Fork-Lift and Other Self-Propelled Work
 Trucks/Vacancy[8]
 Motorcycles and Armored
 Vehicles/Haarbye/202-523-0169
 Passenger Autos/McElroy/202-523-0258
 Snowmobiles/McElroy/202-523-0258
 Tractors, Ex Truck Tractors/DeMarines/202-
 523-0259
 Trailers and Other Vehicles Not Self-
 Propelled/Vacancy[8]
 Trucks (Including Truck
 Tractors)/McElroy/202-523-0258
Motorcycles/Haarbye/202-523-0169

[8]/ Call Haarbye, 202-523-0169.

Motors:
 Electric/Hogge/202-523-0377
 Nonelectric/Kapeluck/202-523-0426
Mufflers/Vacancy[9]
Mushrooms/McCarty/202-724-1753
Nonmetallic Minerals/Lukes/202-523-0279
Nuclear Energy/Vacancy[10]
Numbering Machines/Reynolds/202-523-0230
Nuts, Edible/Burket/202-724-0088
Oakum/Cook/202-523-0348
Odoriferous or Aromatic Substances/Land/202-523-0491
Office Copying Machines/Reynolds/202-523-0230
Office Machines, Not Enumerated/Reynolds/202-523-0230
Oil, Lubricating/Gersic/202-523-0451
Oilcloth/Cook/202-523-0348
Oils, Essential/Land/202-523-0491
Oilseeds/Reeder/202-724-1754
Oleic Acid/Noreen/202-523-1255
Oleic Acid Ester/Johnson/202-523-0127
Oleyl Alcohols/Noreen/202-523-1255
Onions/McCarty/202-724-1753
Ophthalmic/Cunningham/202-724-0980
Optical Elements/Cunningham/202-724-0980
Optical Goods/Cunningham/202-724-0980
Orange (Essential Oil)/Land/202-523-0491
Organic Acids/Conant/202-523-0495
 Michels/202-523-0293
Organo-metallic compounds/Conant/202-523-0495
 Michels/202-523-0293
Ornamented Fabrics/Sweet/202-523-0394
Ossein/Noreen/202-523-1255
Ovens/West/202-523-0299
Packaging Machines/Slingerland/202-523-0263
Perfumery, Cosmetics and Toilet Preps/Land/202-523-0491
Personal Leather Goods/Seastrum/202-724-1733
Pesticides/Cappuccilli/202-523-0490
Pet Animals (Live)/Ludwick/202-724-1763
Petroleum/Gersic/202-523-0451
Phenol/Cappuccilli/202-523-0492
Phenolic Resins/Taylor/202-523-3709
Phonograph Records/Durkin/202-724-1729
Phonographic Equipment/Durkin/202-724-1729
Phonographs/Graves/202-523-0360
Phosphatic Fertilizers/Briggs/202-523-1145
Phosphoric Acid/Briggs/202-523-1145
Phosphoric Acid Esters/Johnson/202-523-0127
Phosphorus/Emanuel/202-523-0334
 Greenblatt/202-523-1212

Phosphorus Compounds/Emanuel/202-523-0334
 Greenblatt/202-523-1212
Photocells/Hogge/202-523-0377
Photographic Chemicals/Cappuccilli/202-523-0490
Photographic Film:
 Scrap/Durkin/202-724-1729
 Waste/Durkin/202-724-1729
Photographic Gelatin/Noreen/202-523-1255
Photographic Supplies/Durkin/202-724-1729
Photographs/Stahmer/202-724-0091
Phthalic Acid Esters/Johnson/202-523-0127
Phthalic Anhydride/Cappuccilli/202-523-0490
Pig Iron/Boszormenyi/202-523-0328
Pigments, Inorganic/Johnson/202-523-0127
Pigments, Organic/Baker/202-523-0492
Pillow Blocks/DeMarines/202-523-0259
Pillowcases/Borsari/202-523-5703
Pillows/Leverett/202-724-1725
Polyethylene/Taylor/202-523-3709
Polyethylene Terephthalate (PET) Resins/Taylor/202-523-3709
Polymers/Taylor/202-523-3709
Polypropylene/Taylor/202-523-3709
Polysaccharides/Noreen/202-523-1255
Polystyrene Resins/Taylor/202-523-3709
Polyurethane Resins/Taylor/202-523-3709
Polyvinyl Alcohol Resins/Taylor/202-523-3709
Polyvinyl Chloride/Taylor/202-523-3709
Pork/Ludwick/202-724-1763
Postage-Franking Machines/Reynolds/202-523-0230
Potash/Briggs/202-523-1145
Potassic Fertilizers/Briggs/202-523-1145
Potassium and Sodium Salts From Coconut, Palm and Other Oils/Land/202-523-0491
Potassium Chloride/Briggs/202-523-1145
Potassium Compounds/Emanuel/202-523-0334
 Greenblatt/202-523-1212
Potatoes/McCarty/202-724-1753
Pottery/McNay/202-523-0445
Poultry/Newman/202-724-0087
Powder, Smokeless/Johnson/202-523-0127
Precious Stones/Garil/202-523-0304
Printing Ink/Johnson/202-523-0127
Printing Machines/Slingerland/202-523-0263
Printing Machines (Textiles)/Skinner/202-523-0265
Printed Matter/Stahmer/202-724-0091
Projectors (Photographic)/Durkin/202-724-1729
Propane/Foreso/202-523-1230
Propylene Glycol/Conant/202-523-0495
 Michels/202-523-0293
Rainwear/Martello/202-523-5585
Rare-Earth Compounds/Emanuel/202-523-0334
 Greenblatt/202-523-1212

[9]/ Call Martello, 202-523-5585.
[10]/ Call Foreso, 202-523-1230.

Rare-Earth Metals/Kennedy/202-523-0270
Rare Saccharides/Noreen/202-523-1255
Rattan/Wood/202-724-0095
Reconstituted Crude Petroleum/Gersic/202-523-0451
Recording Media/Durkin/202-724-1729
Reeling Machines/Skinner/202-523-0265
Refractories/Ruhlman/202-523-0309
Refrigeration Equipment/Haarbye/202-523-0169
Regulators/Cutchin/202-523-0231
Residual Fuel Oil/Gersic/202-523-0451
Resistors/Graves/202-523-0360
Rhenium/Kennedy/202-523-0270
Rhodium Compounds/Emanuel/202-523-0334
 Greenblatt/202-523-1212
Ribbons:
 Inked/Cook/202-523-0348
 Typewriter/Sweet/202-523-0349
 Other/Sweet/202-523-0349
Rice/Grant/202-724-0099
Ricinoleic Acid Esters/Johnson/202-523-0127
Riding Crops/Leverett/202-724-1725
Rifles/Estes/202-724-0977
Rods, Plastic/Taylor/202-523-3709
Rolling Machines/Slingerland/202-523-263
Rope/Cook/202-523-0348
Rosemary (Essential Oil)/Land/202-523-0491
Rouges/Land/202-523-0491
Rubber, Natural/Thompson/202-523-0496
Rubber, Synthetic/Thompson/202-523-0496
Rugs/Borsari/202-523-5703
 Silk/Chiriaco/202-523-0109
 Wool/Clayton/202-523-5701
Shale Oil/Gersic/202-523-0415
Shawls/Vacancy[11]
Sheep/Ludwick/202-724-1763
Sheet, Plastic/Taylor/202-523-3709
Sheets, Bed/Borsari/202-523-5703
Shell, Articles of/Estes/202-724-0977
Shellac and Other Lacs/Reeder/202-724-1754
Shellfish/Newman/202-724-0087
Shingles, Asphalt/Stahmer/202-724-0091
Shingles and Shakes (Wood)/Hoffmeier/202-724-1766
Shirts:
 Other Men's and Boys'/Vacancy[12]
 Other Women's and Girls'/Martello/202-523-5585
Shotguns/Estes/202-724-0977
Shoe Machinery/Slingerland/202-523-0263
Shoes/Burns/202-523-0200
Shorts:
 Men's and Boys'/Vacancy[12]

Women's and and Girls'/Martello/202-523-5585
Shrimp/Newman/202-724-0087
Siding (Wood)/Wood/202-724-0095
Silica/Garil/202-523-0304
Silicon/Kennedy/202-523-0277
Silicones/Conant/202-523-0495
 Michels/202-523-0293
Sorting Machines/DeMarines/202-523-0259
Sound Signaling Apparatus/Baker/202-523-0361
Soybeans and Soybean Oil/Reeder/202-724-1754
Spacecraft/Vacancy[13]
Spectacles/Cunningham/202-724-0980
Special Classification Provisions/Katlin/202-724-1748
Speed Changers/DeMarines/202-523-0259
Spices/Lipovsky/202-724-0097
Spinning Machines/Skinner/202-523-0265
Sponge, Articles of/Estes/202-724-0977
Sporting Goods/Watkins/202-724-0976
Spraying Machinery/Slingerland/202-523-0263
Stains/Johnson/202-523-0127
Staple, Manmade/Clayton/202-523-5701
Starches/Grant/202-724-0099
Starches, Chemically Treated/Noreen/202-523-1255
Stearic Acid/Noreen/202-523-1255
Stearic Acid Esters/Noreen/202-523-1255
Steatite/Garil/202-523-0304
Steel:
 Angles, Shapes and Sections/Kappler/202-523-0342
 Bars/Kappler/202-523-0342
 Ingots, Blooms and Billets/Boszormeni/202-523-0328
 Pipe and Tube and Fittings/Weible/202-523-0273
 Plate/Williams/202-523-0341
 Rails/Weible/202-523-0273
Swimwear:
 Men's and Boys'/Vacancy[14]
 Women's and Girl's/Martello/202-523-5585
Switchgear/Hogge/202-523-0377
Synthetic Detergents/Land/202-523-0491
Synthetic Iron Oxides and
 Hydroxides/Johnson/202-523-0127
Synthetic Natural Gas (SNG)/Foreso/202-523-1230
Synthetic Rubber/Thompson/202-523-0496
Tablecloths/Borsari/202-523-5703
Talc/Garil/202-523-0304
Tall Oil/Noreen/202-523-1255

[11]/ Call Martello, 202-523-5585.
[12]/ Call Worrell, 202-523-0452.

[13]/ Call Haarbye, 202-523-0169.
[14]/ Call Worrell, 202-523-0452.

Tanning Products and Agents/Baker/202-523-0492
Tantalum/Kennedy/202-523-0270
Tape Players and Combinations/Graves/202-523-0360
Tape Recordings/Durkin/202-724-1729
Tapestries/Borsari/202-523-5703
Taps/DeMarines/202-523-0259
Tar Sands Oil/Gersic/202-523-0451
Tea/Lipovsky/202-724-0097
Telegraph and Telephone Apparatus/Fletcher/202-523-0378
Television Equipment/Fletcher/202-523-0378
Telescopes/Cunningham/202-724-0980
Tellurium Compounds/Emanuel/202-523-0334
 Greenblatt/202-523-1212
Tennis Equipment/Watkins/202-724-0976
Tennis and Tarpaulins/Cook/202-523-0348
Tobacco Machines/Slingerland/202-523-0263
Tobacco Pipes/Witherspoon/202-724-0978
Toilet Preps, Cosmetics and
 Perfumery/Land/202-523-0491
Toilet Soaps/Land/202-523-0491
Toluene/Vacancy[15]
Tomatoes/McCarty/202-724-1753
Toners/Baker/202-523-0492
Topped Crude Petroleum/Gersic/202-523-0451
Tow, Manmade/Clayton/202-523-5701
Towels/Borsari/202-523-5703
Toys/Estes/202-724-0977
Toys, Christmas Decorations, Figurines,
 etc./Taylor/202-523-3709
Tractors (Ex Truck Tractors)/DeMarines/202-523-0259
Trailers, Other Vehicles Not Self-
 Propelled/Vacancy[15]
Transceivers/Fletcher/202-523-0378
Transformers/Hogge/202-523-0377
Travel Goods/Seastrum/202-724-1733
Trichloroethylene/Conant/202-523-0495
 Michels/202-523-0293
Tricks/Estes/202-724-0977
Tricycles/Seastrum/202-724-1733

Trimellitic Acid Esters/Johnson/202-523-0127
Trinitrotoluene/Johnson/202-523-0127
Trousers, Men's/Vacancy[16]
Truck Tractors/McElroy/202-523-0258
Trucks/McElroy/202-523-0258
T-Shirts:
 Men's and Boys'/Vacancy[17]
 Women's and Girls'/Martello/202-523-5585
Vegetable Glue/Noreen/202-523-1255
Vegetables/McCarty/202-724-1753
Veiling/Sweet/202-523-0394
Vending Machines/Slingerland/202-523-0263
Vests, Men's/Vacancy[18]
Veterinary, Instruments/Cunningham/202-724-0980
Video Games/Watkins/202-724-0976
Vinyl Chloride Monomer/Conant/202-0495
 Michels/202-523-0293
Vinyl Resins or Plastics/Taylor/202-523-3709
Visual Signaling Apparatus/Baker/202-523-0361
Vitamins/Briggs/202-523-1145
Walking Sticks/Leverett/202-724-1725
Wall Coverings of Rubber or
 Plastic/Thompson/202-523-0496
Wallets/Seastrum/202-724-1733
Wallpaper/Stahmer/202-724-0091
Waste and Scrap (Metals)/Boszormeni/202-523-0328
Waste or Scrap/Katlin/202-724-1748
Waste, Textile:
 Cotton/Taylor/202-523-0365
 Manmade Fiber/Clayton/202-523-5701
 Silk/Chiriaco/202-523-0109
 Wool/Clayton/202-523-5701
Watches/Wilson/202-724-1731
Wax, Articles of/Estes/202-724-0977
Waxes/Noreen/202-523-1255
Weaving Machines/Skinner/202-523-0265
Weighing Machinery/Slingerland/202-523-0263
Welding Apparatus/Cutchin/202-523-0231

[16]/ Call Haarbye, 202-523-0169.
[17]/ Call Worrell, 202-523-0452.
[18]/ Call Worrell, 202-523-0452.

[15]/ Call Foreso, 202-523-1230.

Major Sources of Information

Automotive Trade Statistics

The compilation and publication of the following two series of data began some years ago in response to congressional and general public interest. Series A relates to all motor vehicles (i.e., passenger automobiles, trucks, buses, and so forth), and is published annually, in the spring; Series B relates to new passenger automobiles only and is published annually, in the fall.

Automotive Trade Statistics, 1964–1978: Fac-

tory Sales, Imports, Exports, Apparent Consumption, and Trade Balances with Canada and All Other Countries.

Automotive Trade Statistics, 1964–1978: Factory Sales, Retail Sales, Imports, Exports, Apparent Consumption, Suggested Retail Prices, and U.S. Bilateral Trade Balances with the Eight Major Producing Countries.

Contact: Machinery and Transportation Equipment Branch, Machinery and Equipment

Division, Office of Industries, International Trade Commission, 701 E St. N.W., Room 364, Washington, DC 20436/202-523-0258

Board Meetings

Board meetings are open to the public and are listed in the *Federal Register*. Agenda of meetings are available. For information, contact: Office of the Secretary, International Trade Commission, 701 E St. N.W., Room 160, Washington, DC 20436/202-523-0161.

Bounties or Grants on Imports

The Commission determines, with respect to any duty-free article on which the Secretary of the Treasury has determined that a bounty or grant is being paid, whether and industry in the United States is being or is likely to be injured, or is prevented from being established, by reason of the importation of such article. Contact: Office of Economic Research, International Trade Commission, 6th and E Sts. N.W., Room 636, Washington, DC 20436/202-523-0075.

East-West Trade Statistics Monitoring System

The Commission maintains a program to monitor trade between the United States and the nonmarket economy countries, and to publish a detailed summary of the data collected under the program not less frequently than once every calendar quarter. Contact: Office of Economics, International Trade Commission, 701 E St. N.W., Room 130, Washington, DC 20436/202-523-1539.

Foreign Service Reports

Foreign Service Reports may be examined. Contact: Foreign Service Reports, Office of Data Systems, International Trade Commission, 701 E St. N.W., Room 308A, Washington, DC 20436/202-523-1791.

Freedom of Information Act Requests

For Freedom of Information Act requests contact: Office of the Secretary, International Trade Commission, 701 E St. N.W., Room 156, Washington, DC 20436/202-523-0471.

Generalized System of Preferences

With respect to articles which may be considered for duty-free treatment when imported from designated developing countries, the Commission advises the President as to the probable economic effect of the removal of duty on the domestic industry and on consumers. Contact: Executive Liaison, International Trade Commission, 701 E St. N.W., Room 71, Washington, DC 20436/202-523-0232.

Harmonized Commodity Code

The U.S. International Trade Commission is contributing technical work to assure the recognition of the needs of the U.S. business community in the development of a Harmonized Code reflecting sound principles of commodity identification and specification and modern producing methods and trading practices. Contact: Office of Tariff Affairs, Valuation and Related Activities, International Trade Commission, 701 E St. N.W., Room 144, Washington, DC 20436/202-523-0370.

Import Relief for Domestic Industries

The Commission conducts investigations upon petition on behalf of an industry by a firm, a group of workers, or other representatives of an industry to determine whether an article is being imported in such increased quantities as to be a substantial cause of serious injury, or the threat thereof, to the domestic industry producing an article like or directly competitive with the imported article. The investigation must be completed not later than six months after receipt of petition. Contact: Investigations, Office of Operations, International Trade Commission, 701 E St. N.W., Room 346, Washington, DC 20436/202-523-0242.

Imports of Benzenoid Chemicals and Products

The data for the annual *Imports of Benzenoid Chemicals and Products* are obtained by analyzing invoices covering most of the general imports of benzenoid chemicals. Contact: Statistical Unit, Energy and Chemicals Division, Office of Industries, International Trade Commission, 701 E St. N.W., Room 112, Washington, DC 20436/202-523-0473.

Imports Sold at Less Than Fair Value (Or Subsidized)

The Commission conducts preliminary investigations to determine whether there is a reasonable indication that an industry in the United States is materially injured or is threatened with material injury, or the establishment of an industry in the United States is materially retarded, by reason of imports. Contact: Investigations, Office of Operations, International Trade Commission, 701 E St. N.W., Room 346, Washington, DC 20436/202-523-0242.

Interference with Agricultural Programs

The Commission conducts investigations at the direction of the President to determine whether any articles are being or are practically certain to be imported into the United States under such conditions and in such quantities as to materially

interfere with programs of the Department of Agriculture for agricultural commodities or products thereof, or to reduce substantially the amount of any product processed in the United States from such commodities or products, and makes findings and recommendations to the President. The President may restrict the imports in question by imposition of either import fees or quotas. Contact: Agriculture, Fisheries and Forest Products Division, Office of Industries, International Trade Commission, 701 E St. N.W., Room 636, Washington, DC 20436/202-724-0068.

Investigations

The Commission investigates and reports on many aspects of foreign trade. They include: the administration and fiscal and industrial effects of the customs laws of this country; the relationship between rates of duty on raw materials and finished or partly finished products; the effects of ad valorem and specific duties and of compound (specific and ad valorem) duties; all questions relative to the arrangement of schedules and classification of articles in the several schedules of the customs law; the operation of customs laws, including their relation to the federal revenues and their effect upon the industries and labor of the country; the tariff relations between the United States and foreign countries, commercial treaties, preferential provisions, and economic alliances; the effect of export bounties and preferential transportation rates; the volume of importations compared with domestic production and consumption; and conditions, causes and effects relating to competition of foreign industries with those of the United States. Contact: Office of Operations, International Trade Commission, 701 E St. N.W., Room 338, Washington, DC 20436/202-532-0301.

Law Library

The Law Library maintains a comprehensive file on documents on legislation affecting U.S. trade. Contact: Law Library, International Trade Commission, 701 E St. N.W., Room 213, Washington, DC 20436/202-523-0333.

Legislation

A list of reports submitted on proposed legislation is available. Contact: Office of Congressional Liaison, International Trade Commission, 701 E St. N.W., Room 314, Washington, DC 20436/202-523-0287.

Library

As the international economic research arm of the Government, it maintains a 72,000-volume library, which subscribes to about 1,200 periodicals. This facility houses not only publications on international trade and U.S. tariff and commercial policy, but also many business and technical journals. Contact: Library Division, Office of Data Systems, International Trade Commission, 701 E St. N.W., Room 313, Washington, DC 20436/202-523-0016.

Monthly Production Reports

The monthly production reports (Series C/P) add timeliness to the Commission's statistics. A report, containing production data for 91 selected synthetic organic chemicals, plastics and resins, and other trend-setting indicator materials, is issued for each month at a date approximately six weeks after the month covered by the report. Contact: Statistical Unit, Energy and Chemicals Division, Office of Industries, International Commission, 701 E St. N.W., Room 110, Washington, DC 20436/202-523-0456.

Multilateral Trade Negotiations (MTN)

A study on MTN assessed the impact on U.S. industry, labor and consumers of the tariff reductions made by the United States and its major trading partners and of the nontariff-measure agreements being negotiated with respect to safeguards, government procurements, subsidies and countervailing duty measures, technical barriers to trade (standards), licensing procedures, customs valuation, and several other more specific agreements such as those on trade in aircraft and dairy products. Contact: Trade Agreements, International Trade Commission, 701 E St. N.W., Room 71, Washington, DC 20436/202-523-0232.

New York City Field Office

This office develops and maintains liaison with numerous agencies and organizations at the New York-New Jersey port, including U.S. Customs Service, the United Nations, consulates, transportation companies, freight forwarders, export/import shippers and manufacturers, and banking representatives. The library contains Commission reports, notices and press releases as well as selected statistical data, legal documents, commodity classification schedules, and other trade-related publications. Contact: New York Field Office, International Trade Commission, 6 World Trade Center, Suite 655, New York, NY 10048/212-264-1072.

Publications

Publications and Investigations of the United State Tariff Commission and United States International Trade Commission is an index of all publications issued by both agencies since their

inception. Publications may be ordered 24 hours a day, seven days a week by calling 202-523-5178, or contact: Docket Room, Office of the Secretary, International Trade Commission, 701 E St. N.W., Room 156, Washington, DC 20436/202-523-0471.

Public Documents

Publications is this collection date back to January 1961 and relate to the Commission's investigation of cases in which U.S. industries sought "import relief." Industries investigated include nonrubber footwear, zippers, mushrooms, stainless steel, wrapper tobacco, nuts, bolts and screws. Case documentation is available. Contact: Docket Room, Office of the Secretary, International Trade Commission, 701 E St. N.W., Room 158, Washington, DC 20436/202-523-0471.

Summaries and Trade and Tariff Information

The Commission periodically publishes a series of summaries of trade and tariff information to provide the Congress, the courts, government agencies, foreign governments, industrial institutions, research and trade organizations, and the general public with information on each of the commodities listed in the Tariff Schedules of the United States. These summaries provide comprehensive coverage of product uses, manufacturing processes, and commercial practices, and include analysis of the numerous factors affecting U.S. and world trade in each commodity area. The overall summary program will run several years, ultimately covering all items of the TSUS. Contact: Office of Tariff Affairs, International Trade Commission, 701 E St. N.W., Room 158, Washington, DC 20436/202-523-0370.

Synthetic Organic Chemicals

The annual report on United States production and sales of synthetic organic chemicals published since 918 includes 15 groups of chemicals; tar and tar crudes; primary products from petroleum and natural gas for chemical conversion; cyclic intermediates; dyes; organic pigments; medicinal chemicals; flavor and perfume materials; plastics and resin materials; rubber processing chemicals; elastomers (synthetic rubber), plasticizers; surface-active agents; pesticides and related products; miscellaneous end-use chemicals and chemical products; and miscellaneous cyclic and acyclic chemicals. Approximately 750 manufacturers report data to the Commission on some 8,000 chemical products; these data form the base for the annual report. Also included in the annual report is a directory of manufacturers for each of the named chemicals and chemical prod-

ucts. Contact: Statistical Unit, Energy and Chemicals Division, Office of Industries, International Trade Commission, 701 E St. N.W., Room 110, Washington, DC 20436/202-523-0472.

Tariff Schedules

The Tariff Schedules of the United States Annotated is published periodically by the Commission. It contains the classifications used for reporting import data by commodity and by supplying countries. The schedules delineate some 11,000 commodity classifications for which import statistics are collected. At appropriate intervals the TSUSA is updated to reflect the effects of legislation, presidential proclamations and executive orders, and other modifications of the *Schedules*. The *Schedules* are sold by the Superintendent of Documents, Government Printing Office, Washington, DC 20402/202-783-3238. For additional information, contact: Special Advisor for Trade Agreements, International Trade Commission, 701 E St. N.W., Room 71, Washington, DC 20436/202-523-0232.

Tariff Summaries

The Commission prepares and publishes, from time to time, a series of summaries of trade and tariff information. These summaries contain descriptions (in terms of the Tariff Schedules of the United States) of the thousands of products imported into the United States, methods of production, and the extent and relative importance of U.S. consumption, production and trade, together with certain basic factors affecting the competitive and economic health of domestic industries. Contact: Special Advisor for Trade Agreements, International Trade Commission, 701 E St. N.W., Room 71, Washington, DC 20436/202-523-0232.

Trade Agreement Programs

Trade agreement programs include: tariff, commodity and statistical information for the Multilateral Trade Negotiations; preparation of tariff concessions in the complete nomenclature of the tariff schedules of the United States; and preparation of legislation to approve and implement many of the trade agreements and other related matters. Contact: Trade Agreements, U.S. International Trade Commission, 701 E St. N.W., Room 71, Washington, DC 20436/202-523-0232.

Trade and Tariff Issues

The Commission advises the President as to the probable economic effect on the domestic industry and consumers of modification of duties and other barriers to trade which may be consid-

ered for inclusion of any proposed trade agreements with foreign countries. In addition, the Commission regularly assists the executive branch of the Government in special issue-oriented studies connected with the trade agreements program, primarily through the Office of the President's Special Representative for Trade Negotiations (STR). Contact: Executive Liaison and Special Advisor for Trade Agreements, International Trade Commission, 701 E St. N.W., Room 71, Washington, DC 202-523-0232.

Trade With Communist Countries

The Commission makes investigations to determine whether increased imports of an article produced in a Communist country are causing market disruption in the United States. If the Commission's determination is in the affirmative, the President may take the same action as in a case involving injury to an industry, except that the action would apply only to imports of the article from the Communist country. Contact: Office of Operations, International Trade Commission, 701 E St. N.W., Room 345, Washington, DC 20436/202-523-0301.

Technical Assistance

The Commission provides technical and factual information and data on international trade matters to industry, the press, businesspersons, unions and consumers. Similarly, it receives opinions and comments on issues and policies relating to international trade. Contact: Public Information, International Trade Commission, 701 E St. N.W., Room 518, Washington, DC 20436/202-523-0161.

Unfair Practices in Import Trade

The Commission, after receipt of a complaint under oath from an interested party or upon its own motion, conducts investigations to determine whether unfair methods of competition or unfair acts are being committed in the importation of articles into the United States or in their domestic sale. The investigations must be completed within one year or 18 months in a more complicated case. Contact: Investigations, Office of Operations, International Trade Commission, 701 E St. N.W., Room 346, Washington, DC 20436/202-523-0242.

Uniform Statistical Data For Imports, Exports and Production

The Commission, in cooperation with executive departments of the government, establishes for statistical purposes an enumeration of articles for use in the collection of import and export statistics and statistics and seeks to establish comparability of such statistics with statistical programs for domestic production and programs for achieving international harmonization of trade statistics. Contact: Office of Data Systems, International Trade Commission, 6th and E Sts. N.W., Room 617, Washington, DC 20436/202-724-1715.

World Petroleum Prices

Factors Affecting World Petroleum Prices to 1985 is a report available from Energy Petroleum Benzenoid Chemical and Rubber and Plastics Branch, Energy and Chemicals Division, International Trade Commission, Room 104, 701 E St. N.W., Washington, DC 20436/202-523-0451.

How Can the International Trade Commission Help You?

To determine how the U.S. International Trade Commission can help you, contact: Secretary, International Trade Commission, 701 E St. N.W., Washington, DC 20436/202-523-0161.

Metric Board

1660 Wilson Blvd., Suite 400, Arlington, VA 22209/703-235-2820

ESTABLISHED: 1975
BUDGET: $2,547,000
EMPLOYEES: 36
MISSION: Develops and implements a planning, coordination and public education program designed to increase through voluntary conversion the use of the metric system in the United States.

Major Sources of Information

Metric Information

Information and publications are available to familiarize the public with the metric system so that conversion will be beneficial and not cause unnecessary interruptions or hardship. Contact: Public Information, Metric Board, 1600 Wilson Blvd., Suite 400, Arlington, VA 22209/703-235-2820.

Metric Research

The office of research develops recommendations based on research projects and the coordination of metric programs among all interested and affected parties. Contact: Research Division, Metric Board, 1600 Wilson Blvd., Suite 400, Arlington, VA 22209/703-235-2583.

How Can the Metric Board Help You?

To determine how the U.S. Metric Board can help you, contact: Public Information, Metric Board, 1600 Wilson Blvd., Suite 400, Arlington, VA 22209/703-235-2820.

Postal Service

475 L'Enfant Plaza West S.W., Washington, DC 20260/202-245-4059

ESTABLISHED: August 12, 1970
BUDGET: $1,676,810,000
EMPLOYEES: 680,380

MISSION: Provides mail processing and delivery services to individuals and businesses within the United States; develops efficient mail handling systems and operates its own planning and engineering programs; and is responsible for protecting the mails from loss or theft, and apprehending those who violate postal laws.

Major Sources of Information

Administrative Support Manual

This manual describes matters of internal administration in the Postal Service. It includes functional statements as well as policies and requirements regarding security, communications (printing directives, forms, records, newsletters), government relations, procedurement and supply, data processing systems, maintenance, and engineering. A subscription is available for $15.00 from the Superintendent of Documents, Government Printing Office, Washington, DC 20204/202-783-3238. For additional information, contact: Administration Group, Postal Service, 475 L'Enfant Plaza West S.W., Room 5821, Washington, DC 20260/202-245-4336.

Aerogramme

An aerogramme is a lightweight stationery item which folds into a mailing envelope and may contain imprinted postage. It is an economical and convenient form of letter mail for corresponding with people in foreign countries except Canada and Mexico (domestic letter rates apply to Canada and Mexico). Aerogrammes are available at any post office. Contact: International Mail Processing, Mail Processing Department, Postal Service, 475 L'Enfant Plaza West S.W., Washington, DC 20260/202-245-4050.

Bulk Mail

There are two types of bulk mail: third and fourth-class mail. Third class mail includes bulk rate regular and bulk rate special. When mailing in bulk, the Postal Service supplies bundle labels, trays, rubber bands, sacks and sack labels, etc.

free of charge. For additional information, contact: Office of Bulk Mail Processing, Postal Service, 475 L'Enfant Plaza West S.W., Washington, DC 20260/202-245-4087.

Business Reply Mail

Mailers who want to encourage responses by paying the postage for those responses may use business reply mail which is returned to the sender from any U.S. post office to any valid address in the United States. Using one permit, the mailer may provide for return of all replies to one location or several. Business reply mail must be prepaid according to a specified format. There is a small annual fee for each permit issued. The mailer guarantees to pay the postage for all replies returned to him or her. The postage per piece is the regular first class rate plus a business reply fee. For additional information, contact: Office of Commercial Marketing, Customer Service Department, Postal Service, 475 L'Enfant Plaza West S.W., Room 5687, Washington, DC 20260/202-245-5731.

Business Reply Mailgram

A Business Reply Mailgram is now available for customers who require a quick turnaround response. The Business Reply Mailgram provides all of the features of a regular Mailgram with the addition of a built-in response device using a Business Reply envelope. Contact: Office of Commercial Marketing, Customer Service Department, Postal Service, 475 L'Enfant Plaza West S.W., Room 5647, Washington, DC 20260/202-245-5731.

Carrier Route Information System

For mailers using the Carrier Route Information System, a monthly update capability is provided for hard copy and computer tape information. Contact: Delivery Services Department, Postal Service, 475 L'Enfant Plaza West S.W., Room 7406, Washington, DC 20260/202-245-5706.

Certificates of Mailing

A certificate of mailing provides evidence of mailing only. The fee paid for certificates of mailing does not insure the article against loss or damage. Certificates of mailing are prepared by the mailer, except those mailers living on rural routes. Individual and firm mailing book certificates must show the name and address of both sender and addressee and the amount of postage paid. Identifying invoice or order numbers may also be placed on the certificate. Contact: a local post office, or: Customer Services Department, Postal Service, 475 L'Enfant Plaza West S.W., Room 5667, Washington, DC 20260/202-245-5734.

Certified Mail

Certified mail service provides a receipt to the sender and a record of delivery at the office of address. No record is kept at the office at which mailed. No insurance coverage is provided. Certification may be used only on first class or priority mail containing matter of no intrinsic value. Contact: a local post office, or: Customer Services Department, Postal Service, 475 L'Enfant Plaza West S.W., Room 5667, Washington, DC 20260/202-245-5734.

Collect-on-Delivery (COD) Mail

COD service is used to collect for unpaid merchandise when it is delivered to the addressee. The amount due you for the merchandise, postage, and COD fee is collected from the addressee and returned by the Postal Service. COD service may be used for merchandise sent by parcel post, first class, or third class. The merchandise must have been ordered by the addressee. Fees charged for this service include insurance protection against loss or damage. COD items may also be sent as registered mail. COD service is limited, however, to items valued at a maximum of $400. This service is not available to foreign countries. Contact: Customer Services, Postal Service, 475 L'Enfant Plaza West S.W., Room 5667, Washington, DC 20260/202-245-5734.

Commemorative Stamp Posters

Usually released three to four weeks in advance of the issue day of the stamps, these post-

ers, 8 × 10-½ inches in size, provide an enlarged illustration of the stamp being issued, and other data of interest to stamp collectors, such as the date and place of issue, name of designer, number of stamps to be printed, and size and color. Each poster also includes complete instructions for those desiring to obtain first-day cancellations of the stamp. The subscription service is available for $16.00 from the Superintendent of Documents, Government Printing Office, Washington, DC 20402/202-783-3238. For additional information, contact: Stamps Division, Customer Services Department, Postal Service, 475 L'Enfant Plaza West S.W., Room 5800, Washington, DC 20260/202-245-4956.

Consumers Directory of Postal Services and Products

This is a pamphlet to help the consumer become familiar with services and products of the Postal Service. It includes information on classes of mail, size standards, the fastest mail services, consumer protection, ZIP code, passport applications, lockbox and caller services, postage meters, and other common postal questions. Contact: Consumer Advocate, Public and Employee Communications Department, Postal Service, 475 L'Enfant Plaza West S.W., Room 5910, Washington, DC 20260/202-245-4550.

Contracts

Information pertaining to specific solicitations or contracts is available. Contact: Office of Contracts, Procurement and Supply Division, Postal Service, 475 L'Enfant Plaza West S.W., Room 1010, Washington, DC 20260/202-245-4814.

Criminal Use of the Mail

The Postal Service investigates violations of postal laws such as theft, mail fraud, prohibited mailings, and organized crime in postal-related matters. Contact: Office of Criminal Investigations, Inspection Service Department, Postal Service, 475 L'Enfant Plaza West S.W., Room 3517, Washington, DC 20260/202-245-5449.

Current Mail Rates, Fees and Services

For information on current mail rates, fees and services, contact: Office of Rates, Postal Service, 475 L'Enfant Plaza West S.W., Room 8620, Washington, DC 20260/202-245-4422.

Customer Service Reps

The U.S. Postal Service has a local program called Customer Service Representatives. CSRs are found in main post offices. Their services include: maintaining contact on how to get the

most for your postage dollar; how to set up a mailroom; resolving mail problems; selling services (express mail, contracts); distribution of *Mailer's Guide. Postal Inspectors Protect Consumers* is a pamphlet which describes common mail fraud schemes. For additional information, contact: Office of Commercial Marketing, Customer Services Department, Postal Service, 475 L'Enfant Plaza West S.W., Room 5647, Washington, DC 20260/202-245-5731.

Design Licenses

Designs of postage stamps issued after January 1, 1978, are copyrighted and may not be reproduced except under license granted by the U.S. Postal Service. Earlier designs are in the public domain and may be reproduced without permission for philatelic, educational, historical and newsworthy purposes. Contact: Patent Counsel, Law Department, Postal Service, 475 L'Enfant Plaza West S.W., Room 9226, Washington, DC 20260/202-245-4062.

Domestic Mail Manual

This manual is designed to assist customers in obtaining maximum benefits from doestic postal services. It includes applicable regulations and information about rates and postage, classes of mail, special services, wrapping and mailing requirements and collection and delivery services. The subscription is available for $17.00 from the Superintendent of Documents, Government Printing Office, Washington, DC 20402/202-783-3238. For additional information, contact: Customer Services Department, Postal Service, 475 L'Enfant Plaza West S.W., Room 5647, Washington, DC 20260/202-245-5731.

Domestic Money Orders

Domestic money orders may be purchased at all post offices, branches and stations, and from rural carriers in the United States and its possessions, except for certain offices in Alaska. The maximum amount for a single money order is $400. There is no limitation on the number of money orders that may be purchased at one time, except when the Postal Service may impose temporary restrictions. Contact: Customer Services Department, Postal Service, 475 L'Enfant Plaza West S.W., Room 5647, Washington, DC 20260/202-245-5731.

Expanded Nine-Digit ZIP Code

This program is aimed at holding down the amount of future rate increases by providing more economical and accurate sortation of mail and should speed up the delivery process. For additional information, contact: Office of ZIP Code Expansion, Research and Technology Group,

Postal Service, 475 L'Enfant Plaza West S.W., Room 6624, Washington, DC 20260/202-245-5024.

Express Mail

Express Mail, the fastest postal service, provides several options for both private and business customers who require overnight delivery of letters and packages. This service comes with a money-back guarantee and shipments are insured against loss or damage at no additional cost. Additional Express Mail services available include Same Day Airport Service and Custom Designed Service. Express Mail is also available to 15 foreign countries. For additional information, contact: a local post office, or: Expedited Mail Services, Customer Services Department, Postal Service, 475 L'Enfant Plaza West S.W., Room 5541, Washington, DC 20260/202-245-4498.

Express Mail Reshipment

Express Mail Reshipment allows Express Mail forwarding of mail addressed to a lockbox. It provides firms a way to assure delivery, within two days, of incoming mail from any location in the country. Contact: Expedited Mail Services, Customer Services Department, Postal Service, 475 L'Enfant Plaza West S.W., Room 5541, Washington, DC 20260/202-245-4498.

First Class Mail

First class mail is used for letters, post cards, postal cards, greeting cards, personal notes, and for sending checks and money orders. First class letter mail may not be opened for postal inspection. First class mail over 12 ounces is called priority mail. All first class mail is given the fastest transportation service available. If first class mailing is not letter size, it should be marked "First Class." Contact: Office of Mail Classification Rates and Classification Department, Postal Service, 475 L'Enfant Plaza West S.W., Room 8430, Washington, DC 20260/202-245-4540.

Forwarding Mail

A *Change of Address Kit,* available from any post office, notifies the post office, correspondents and publishers of the user's new address. First class mail is forwarded free for one year. The post office has information about fees for forwarding other classes of mail, holding mail and temporary changes of address. Contact: Customer Services Department, Postal Service, 475 L'Enfant Plaza West S.W., Room 5710, Washington, DC 20260/202-245-4550.

Fourth Class (Parcel Post) Mail

This service is for packages (which do not contain first class matter) weighing one pound or

more. The post office also has information about special mailing rates for books, catalogs and international mailings. Contact: Office of Mail Classification, Rates and Classification Department, Postal Service, 475 L'Enfant Plaza West S.W., Room 8430, Washington, DC 20260/202-245-4540.

Freedom of Information Act Requests

For Freedom of Information Act requests, contact: Freedom of Information Act Office, Records Control Division, Finance Group, Postal Service, 475 L'Enfant Plaza West S.W., Room 8121, Washington, DC 20260/202-245-4142.

Free Mail for the Handicapped

Matter for the use of the blind or other persons who cannot use or read conventionally printed material because of a physical impairment, and who are certified by competent authority as unable to read normal reading material, may be mailed free of charge. Certain restrictions apply. Please consult your local postmaster. Contact: Customer Services Department, Postal Service, 475 L'Enfant Plaza West S.W., Room 5667, Washington, DC 20260/202-245-5734.

General Delivery

Mail can be delivered through General Delivery service at a specific post office. Generally, General Delivery service is available for a maximum of 30 days. However, in areas where carrier delivery service is not available, extended General Delivery Service can be provided. Contact: the local post office, or: Customer Services Department, Postal Service, 475 L'Enfant Plaza West S.W., Room 5667, Washington, DC 20260/202-245-5734.

Inspection Service

The Inspection Service, headed by the Chief Postal Inspector, is the law enforcement and audit arm of the Postal Service which performs security, investigative, law enforcement and audit functions. It is responsible for investigations of approximately 85 federal statues relating to the Postal Service. Mail fraud, false mail order advertising, and unsatisfactory mail order transactions all come under the Inspection Service's jurisdiction. Some examples include: chain letters, work-at-home schemes; pyramid sales promotions; exaggerated cosmetic, diet, medical, and energy saving products; misused credit cards; coupon redemption; false billing; and franchising schemes. Contact: the local postmaster, or Local Postal Inspector, or Chief Postal Inspector, Inspection Service Department, Postal Service, 475 L'Enfant Plaza West S.W., Room 3509, Washington, DC 20260/202-245-5445.

Insured Mail

Insured mail may be used on third and fourth class mail up to a maximum of $400. Official government mail bearing Postage and Fees Paid endorsement may also be insured. First class mail or priority mail containing third or fourth class matter may be insured provided it bears the endorsement "contains third class (or fourth class) matter" in addition to the first class or priority mail endorsement. Contact: A local post office, or: Customer Services Department, Postal Service, 475 L'Enfant Plaza West S.W., Room 5667, Washington, DC 20260/202-245-5734.

Intelpost Service

The Intelpost Service transmits a black and white copy of any information that can be reduced to a maximum of 8-½" × 14" to other cities (the network is growing) within seconds via satellite. The system transmits, with the confidentiality of international letter mail, anything that can be copied. Contact: Intelpost Service Center, Research and Technology Group, Postal Service, 475 L'Enfant Plaza West S.W., Room 1631, Washington, DC 20260/202-245-4264.

International Mail

Airmail and surface mail can be sent to virtually all countries. There are four types of international mail: Letters and Cards—includes letters, letter packages, aerogrammes, and post cards; Other Articles—includes printed matter, matter for the blind, and small packets; Parcel Post; and Express Mail. A subscription to *International Mail* is available for $9.00 (domestic) and $11.25 (foreign) from the Superintendent of Documents, Government Printing Office, Washington, DC 20402/202-783-3238. Registry services with limited insurance protection are available for letters and cards and other articles to most countries. Insurance is available for parcel post to most countries. Check with your post office for specific information about the country to which you are mailing. Or contact: International Mail Processing, Mail Processing Department, Postal Service, 475 L'Enfant Plaza West S.W., Room 7914, Washington, DC 20260/202-245-4050.

International Money Order

International money orders may be purchased at most of our larger post offices and some of the smaller ones. International money orders may only be sent to countries having an agreement with the United States to exchange this courtesy. With the exception of Great Britain and Ireland, the maximum amount for an international money order is $400. Those two countries have agreed to a separate a.nount of exchange. Contact: Customer Services Department, Postal Service, 475

L'Enfant Plaza West S.W., Room 5667, Washington, DC 20260/202-245-5734.

International Surface Air Lift

International Surface Air Lift service provides fast delivery, at a cost lower than airmail, for publications and printed matter sent overseas at the surface rate. Contact: International Mail Processing, Mail Processing Department, Postal Service, 475 L'Enfant Plaza West S.W., Room 7914, Washington, DC 20260/202-245-4050.

Labor Relations

The Postal Service is the only federal agency whose employment policies are governed by a process of collective bargaining. Labor contract negotiations, affecting all bargaining unit personnel, as well as personnel matters involving employees not covered by collective bargaining agreements, are administered by the Employee and Labor Relations Group. Contact: Special Labor Relations Program, Labor Relations Department, Postal Service, 475 L'Enfant Plaza West S.W., Room 9707, Washington, DC 20260/202-245-4714.

Library

In addition to a working collection of materials in law, the social sciences and technology, the Library contains a unique collection of postal materials; legislative files from the 71st Congress to date, reports, pamphlets, clippings, maps, photographs, general postal histories, periodicals of the national postal employee organizations, Universal Postal Union studies, and the reports of foreign postal administrations. It is open to the public. Contact: Library, Postal Service, 475 L'Enfant Plaza West S.W., Washington, DC 20260/202-245-4021.

Library Rate

Specific items loaned or exchanged between schools, colleges, universities, public libraries, museums, herbaria, nonprofit religious, educationa, scientific, philanthropic, agricultural, labor, veterans, or fraternal organizations or the associations may use special fourth class library rate. Material must be labeled Library Rate. Materials include books, printed music, academic theses, sound recordings and others. Check with your postmaster for a specific list of library rate matter. Contact: Office of Rates, Rates and Classification Department, Postal Service, 475 L'Enfant Plaza West S.W., Room 8620, Washington, DC 20260/202-245-4422.

List Correction and Sequencing Service

The Postal Service provides (for a fee) a series of list correction services. In general, incorrect or nonexistent street addresses will be eliminated on both name and address lists and occupant/resident lists. In addition, for name and address lists, incorrect numbers will be corrected and new addresses furnished for customers who have moved if the customers have left a permanent forwarding order. A list sequencing service is also provided by which addresses on a mailing list are sorted into carrier sequence. Undeliverable addresses will be removed during the sequencing. If the mailing list contains at least 90% of the correct addresses in a five-digit ZIP Code area, missing addresses will be provided and incorrect addresses will be corrected. Otherwise, only a blank card will be inserted to indicate a missing address. For additional information on the various mailing list services available from the Postal Service, please contact your local post master or Customer Service Representative, or: Office of Commercial Marketing. Postal Service, 475 L'Enfant Plaza West S.W., Room 5647, Washington, DC 20260/202-245-5731.

Lockbox-Caller Services

Post office lockbox and caller services are available at many post offices for a fee. Lockbox service provides privacy and allows user to get mail any time the post office lobby is open. Caller (pickup) service is available during the hours post office retail windows are open. This service is for customers who receive a large volume of mail or those who need a box number address when no lockboxes are available. For additional information, contact: Customer Services Department, Postal Service, 475 L'Enfant Plaza West S.W., Room 5667, Washington, DC 20260/202-245-5734.

Mail Classification

For information on current mail classification, contact: Office of Mail Classification, Postal Service, 475 L'Enfant Plaza West S.W., Room 1640, Washington, DC 20260/202-245-4540.

Mailer's Guide

This free guide contains abridged information on such topics as bulk mailing permits, mail classfication items, customer service programs and other facts basic to everyday mailing needs. Contact: Office of Consumer Affairs, Postal Service, 475 L'Enfant Plaza West S.W., Room 5910, Washington, DC 20260/202-245-4550.

Mail Fraud/Mail Order Problems

Help is available for consumers who suspect they have been victims of a fraud or misrepresentation scheme. Some of the schemes include: land

sale frauds, charity rackets, investment swindles, work-at-home schemes and medical quackery. Contact: the nearest postmaster or postal inspector, or: Consumer Advocate, Customer Services Department, Postal Service, 475 L'Enfant Plaza West S.W., Room 5910, Washington, DC 20260/202-245-4550.

Mailgram

Mailgram is an electronic communications service offered by Western Union and the Postal Service. Mailgrams are transmitted over Western Union's communications network to printers located in 141 post offices. Delivery is made by regular carrier the next business day throughout the United States, except for parts of Alaska. Customers can send Mailgrams over Telex terminals, by a direct computer connection with Western Union, by producing a computer magnetic tape, and by telephone. Western Union provides a toll-free telephone network throughout the United States. Contact: Office of Commercial Marketing, Customer Service Department, Postal Service, 475 L'Enfant Plaza West S.W., Room 5647, Washington, DC 20260/202-245-5731.

Memo to Mailers

This free monthly publication advises business mailers of all rate and classification changes as well as other postal news. It is available from *Memo to Mailers,* Post Office Box 1, Linwood, NJ 08221. Contact: Office of Consumer Affairs, Postal Service, 475 L'Enfant Plaza West S.W., Room 5910, Washington, DC 20260/202-245-4550.

Merchandise Return Service

Merchandise return service provides a method whereby a merchandise return permit holder may authorize individuals and organizations to send parcels to the permit holder and have the return postage and fees paid by the permit holder. It is available for first class mail, and third and fourth class mail. A permit to use it is required at each post office where parcels will be returned. A fee will be charged each calendar year for each permit issued, in addition to the fee for each merchandise return service transaction. Contact: a local post office or: Customer Services Department, Postal Service, 475 L'Enfant Plaza West S.W., Room 5667, Washington, DC 20240/202-245-5734.

Metered Mail

Many postal customers prefer to use a postage meter which prints prepaid postage either directly on envelopes or on adhesive strips which are then affixed to pieces. The metered mail imprint, or meter stamp, serves as postage payment, postmark, and cancellation mark. It may be used for all classes of mail and for any amount of postage. Any quantity of mail may be metered, and it does not have to be identical in size and shape. *Application for a Postage Meter License* must be approved before obtaining the necessary license. Contact: Customer Services Department, Postal Service, 475 L'Enfant Plaza West S.W., Room 5667, Washington, DC 20260/202-245-5734.

Military Parcels

PAL (Parcel Airlift Mail) is flown to the overseas destination. You pay the regular parcel post rate to the U.S. exit port, plus a small fee for the air services. SAM (Space Available Mail) is transported by surface means in the United States and flown on a space available basis from the United States to the overseas destination. Contact the local post office or: Customer Services Department, Postal Service, 475 L'Enfant Plaza West S.W., Room 5667, Washington, DC 20260/202-245-5734.

Mint Set of Commemoratives

The U.S. Postal Service Mint Set of Commemorative and Special Sets is available (price varies). Contact: Philatelic Sales Division, Postal Service, 475 L'Enfant Plaza West S.W., Room 5546, Washington, DC 20260/202-245-5394.

National ZIP Code and Post Office Directory

The *ZIP Code Directory* is an up-to-date and comprehensive listing of ZIP Code information by state and post office. It includes instructions for quickly finding a ZIP Code number when an address is known. Proper ZIP Code information is essential for speedy and economic delivery of your mail. The ZIP Code Directory also includes official lists of post offices, named stations, named branches, and community post offices in the United States. The volume includes a wealth of handy information about ZIP Codes, postal abbreviations, and basic postal procedures and is an indispensible aid that is worth its price many times over. For sale for $8.00 by the Superintendent of Documents, Government Printing Office, Washington, DC 20402/202-783-3238. For additional information, contact: Mail Processing Department, Postal Service, 475 L'Enfant Plaza West S.W., Room 7847, Washington, DC 20260/202-245-4139.

Official Mail

Members of Congress are authorized by law to send mail without prepayment of postage. The envelope or wrapper bears a written signature, printed facsimile signature or other required

marking instead of a postage stamp. Mail must relate to the official business, activities and duties of the Congress of the United States. This frank may also be used by the Vice President, Members-elect of Congress, Delegates or Delegates-elect, the Resident Commissioner or Resident Commissioner-elect from Puerto Rico, the Secretary of the Senate, Sergeant at Arms of the Senate, each of the elected officers of the House of Representatives, the Legislative Counsel at the House of Representatives and the Senate, and the Senate Legal Counsel. Penalty mail is official mail sent by officers of the Executive and Judicial branches of the Government: departments, agencies and establishments of the Government, official mail of legislative counsel for the House of Representatives and the Senate; official mail of the Superintendent of Documents, and official correspondence concerning the *Congressional Directory*. The President usually uses regularly printed postage stamps on mail dispatched from his immediate office. Contact: Rates and Classification Law, Postal Service, 475 L'Enfant Plaza West S.W., Room 9127, Washington, DC 20260/202-245-4608.

Operating Statistics

Postal Service operating statistics include information on classes of mail by number of pieces, weight and dollars for first class, priority mail, domestic air, express mail, Mailgrams, second class controlled circulation publications, third and fourth class, international surface and air, franked, penalty and free for the blind services. Special services statistics are also available. Contact: Management Information Systems Department, Postal Service, 475 L'Enfant Plaza West S.W., Room 3012, Washington, DC 20260/202-245-4208.

Packaging Pointers

This pamphlet which describes how to package and address parcels, is available at the local post office, or contact: Office of Consumer Affairs, Postal Service, 475 L'Enfant Plaza West S.W., Room 5910, Washington, DC 20260/202-245-4550.

Passport Applications

Many local post offices accept applications for passports. Contact the nearest post office or: Consumer Advocate, Customer Services Department, Postal Service, 475 L'Enfant Plaza West S.W., Room 5910, Washington, DC 20260/202-245-4550.

Permit Imprints

An *Application to Mail Without Affixing Post-age Stamps* is available in order to use imprints and to pay postage in cash at time of mailing. Contact: a local post office or: Customer Services Department, Postal Service, 475 L'Enfant Plaza West S.W., Room 5667, Washington, DC 20260/202-245-5734.

Plant Loading

When a very large mailing is prepared for one or a few destination points, the postmaster may send a vehicle to the mailer's place of business to pick it up. The mail is loaded, under post office supervision, and usually taken directly to the destination, bypassing all handling at the post office of mailing. Contact: Customer Services Department, Postal Service, 475 L'Enfant Plaza West S.W., Room 5667, Washington, DC 20260/202-245-5734.

Pornography

Unsolicited sexually oriented advertisements can be halted by filling out Form 2201 (at the local post office). A mailer who sends sexually oriented advertisements to any person whose name has been added to the Postal Service reference listing for 30 days, is subject to legal action by the United States government. *Notice for Prohibitory Order Against Sender of Pandering Advertisement in the Mails* can also be filled out to stop any further advertisements considered "erotically arousing or sexually provocative." Contact: the nearest post office or: Office of Consumer Affairs, Customer Service Department, Postal Service, 475 L'Enfant Plaza West S.W., Room 5910, Washington, DC 20260/202-245-4550.

Postal Bulletin

This weekly publication contains current orders, instructions and information relating to the Postal Service, including philatelic airmail, money order, parcel post, etc. The subscription is available for $35.00 per year from the Superintendent of Documents, Government Printing Office, Washington, DC 20402/202-783-3238, or for further information, contact: Office of Communications, Postal Service, 475 L'Enfant Plaza West S.W., Room 10746, Washington, DC 20260/202-245-4059.

Postal Career Executive Service

The postal career executive program aims at developing qualified managers and supervisors. The program tries to develop executives through training, educational and work experiences. Contact: Postal Career Executive Service, Employee Relations Department, Postal Service, 475 L'Enfant Plaza West S.W., Room 10531, Washington, DC 20260/202-245-4702.

Postal Life: The Magazine for Postal Employees

This bimonthly periodical contains articles, with illustrations, about new methods, techniques and programs of the U.S. Postal Service. Its purpose is to keep postal employees informed and abreast of developments in the U.S. Postal Service. The subscription is available for $9.00 from the Superintendent of Documents, Government Printing Office, Washington, DC 20402/202-783-3238. For additional information, contact Communications Services, Postal Service, 475 L'Enfant Plaza West S.W., Room 10923, Washington, DC 20260/202-245-4235.

Postal Problem

A *Consumer Service Card,* available from letter carriers and at post offices, should be filled out when there is problem with the mail service. It provides a quick way for Postal Service customers to register a compliant, make a suggestion, ask a question, or make certain that a complaint gets attention. Contact: Consumer Advocate, Postal Service, 475 L'Enfant Plaza West S.W., Room 5910, Washington, DC 20260/202-245-4550.

Postal Publications and Handbooks

A Postal Service publications list is available which includes titles of publications and their supply source. Contact: Publications, Public and Employee Communications Department, Postal Service, 475 L'Enfant Plaza West S.W., Room 10907, Washington, DC 20260/202-245-4235.

Postal Service Employment

The *Employee and Labor Relations Manual* sets forth the personnel policies and regulations governing employment with the Postal Service. Topics covered include organization management, job evaluation, employment and placement, pay administration, employee benefits, employee relations, training, safety and health, and labor relations. The subscription is available for $42.00 per year from the Superintendent of Documents, Government Printing Office, Washington, DC 20402/202-783-3238. For additional information, contact: Employee and Labor Relations Group, Postal Service, 475 L'Enfant Plaza West S.W., Room 9915, Washington, DC 20260/202-245-4721.

Precanceled Stamps

Precanceling means the canceling of postage stamps, stamped envelopes or postal cards in advance of mailing. The use of precanceled postage reduces the time and costs of mail handling. Precanceled mail, sorted and tied in packages by the mailer, requires less processing time in the post office and is therefore dispatched more quickly. Contact: a local post office, or: Office of Customer Services, Postal Service, 475 L'Enfant Plaza West S.W., Room 5667, Washington, DC 20240/202-245-5734.

Presorting

For each advance in level of presorting by the mailer, more handlings are bypassed at the post office, saving time in processing the mail. Presorted mail can be bundled and labeled, or trayed, or sacked depending on your preference and the post office's recommendation. To assist you, the Postal Service normally provides consultation service, mailroom employee training, and certain supplies (trays, labels, rubber bands, etc.) at no cost. Presorted mailings that meet certain requirements are charged reduced postage. Call your postmaster or Customer Service Representative for more details, or contact: Customer Services Department, Postal Service, 475 L'Enfant Plaza West S.W., Room 5667, Washington, DC 20260/202-245-5734.

Priority Mail

Priority mail is first class mail weighing more than 12 ounces. It is used when fast transportation and expeditious handling are desired. For complete information contact: Office of Mail Classification, Rates and Classification Department, Postal Service, 475 L'Enfant Plaza West S.W., Room 8430, Washington, DC 20260/202-245-4540.

Procurement

The Postal Service purchases both goods and services. Goods include mail-processing and mail-handling equipment; material transport and delivery service equipment; customer service equipment; office support requirements such as furniture, machines, equipment and supplies, and custodial, protective, building and vehicle maintenance equipment. Services bought are building protection and maintenance and vehicle maintenance and repair. Details on Postal Service procurement are contained in *Selling to the Postal Service,* a free publication. *Postal Contracting Manual* establishes uniform policies and procedures relating to the procurement of facilities, equipment, supplies and mail transportation services and is available for $88.00 per year from the Superintendent of Documents, Government Printing Office, Washington, DC 20402/202-783-3238. For publication and additional information, contact: Office of Contracts, Procurement and Supply Department, Postal Service, 475 L'Enfant Plaza West S.W., Room 1010, Washington, DC 20260/202-245-4814.

Registered Mail

Registry buys security. It is the safest way to send valuables through the mail system. The full value of the mailing must be declared when mailed for security and insurance purposes. Included in the registration fee is insurance protection up to $25,000. Only mail prepaid at the first class or priority mail rates may be registered. Contact: a local post office, or: Customer Services Department, Postal Service, 475 L'Enfant Plaza West S.W., Room 5667, Washington, DC 20260/202-245-5734.

Research and Development

The research and development program within the Postal Service is directed toward the investigation of new concepts for mail handling by utilizing the latest technologies available in systems and equipment to improve service, reduce costs, improve employee working conditions and to process the mail. For additional information, contact: Research and Development Laboratories, Postal Service, 11711 Parklawn Dr., Room 30, Rockville, MD 20260.

Return Receipts

A return receipt is your proof of delivery. It is available on mail insured for more than $15 value, and on certified, registered, COD and Express Mail. The return receipt identifies the article number, who signed for it and the date it was delivered. For an additional fee you may obtain a receipt showing the exact address of delivery. You may also request restricted delivery service by which delivery is to the addressee only, or to an individual authorized in writing to receive mail of the addressee. Contact a local post office, or: Customer Services Department, Postal Service, 475 L'Enfant Plaza West S.W., Room 5667, Washington, DC 20260/202-245-5734.

Rural or Highway Contract Route

General distribution of third class mail to each boxholder on a rural or highway contract route, or for each family on a rural route, or for all boxholders at a post office that does not have city or village carrier service, may have the mail addressed omitting the names of individuals and box or route numbers if the mailer uses this form of address: "Postal Customer," or, to be more specific: "Rural (or Highway Contract Route) Boxholder, City (or Town), State." A postmaster, on request, will furnish mailers with the number of families and boxes served on each route. Contact: Rural Delivery Division, Delivery Services Department, Postal Service, 475 L'Enfant Plaza West S.W., Room 7112, Washington, DC 20260/202-245-5619.

Second Class Mail

Second class mail is generally used by newspaper and other periodical publishers who meet certain Postal Service requirements. There is also a rate for mailing individual copies of magazines and newspapers. Contact the nearest post office for additional information, or contact: Office of Mail Classification, Rates and Classification Department, Postal Service, 475 L'Enfant Plaza West S.W., Room 8430, Washington, DC 20260/202-245-4540.

Service Standards

Service standards have been established for each area of the country. Contact the postmaster or Customer Service Representative for the specific standards in any local area, or: Office of Consumer Affairs, Customer Services Department, Postal Service, 475 L'Enfant Plaza West S.W., Room 5910, Washington, DC 20260/202-245-4550.

Size Standards

Information is available on nonstandard size mail and minimum size standards. *The Mailer's Guide* and *A Consumer's Directory of Postal Services and Products* provide details on size standards. Contact: Office of Mail Classification, Rates and Classification Department, Postal Service, 475 L'Enfant Plaza West S.W., Room 8430, Washington, DC 20260/202-245-4540.

Small Post Office Closings

For information on small post office closings or consolidations, contact: Delivery Services Department, Postal Service, 475 L'Enfant Plaza West S.W., Room 7347, Washington, DC 20260/202-245-4315.

Souvenir Pages

A souvenir page is prepared for each new stamp issue. Each page bears an official first day cancellation of the actual stamp or stamps. Because souvenir pages are prepared in limited quantities, current issues are available on subscription. A minimum deposit of $20.00 is required to open an account. Contact: Souvenir Page Subscription, Philatelic Automatic Distribution Service, Postal Service, 475 L'Enfant Plaza West S.W., Room 5630, Washington, DC 20260/202-245-5778.

Speakers

Postal Service speakers are available to address the public on postal matters and services. To schedule speakers and to coordinate Postal Service participation in meetings of national organizations and associations, contact: Public and

Employee Communications Department, Postal Service, 475 L'Enfant Plaza West S.W., Room 10736, Washington, DC 20260/202-245-4034.

Special Delivery

Special delivery may be purchased on all classes of mail except Express Mail, to provide prompt delivery. It provides for delivery during prescribed hours which extend beyond the hours for delivery of ordinary mail. Special delivery mail is also delivered on Sundays and holidays at larger post offices. This service is available to all addresses served by city carriers and to addresses within a one-mile radius of other delivery post offices. Contact: Expedited Mail Services, Customer Services Department, Postal Service, 475 L'Enfant Plaza West S.W., Room 5541, Washington, DC 20260/202-245-4498.

Special Fourth Class Mail

Books of 24 pages or more, at least 22 of which are printed, consisting entirely of reading matter, may be sent at the special fourth class rate. Each of the following categories may be sent at this Special Fourth Class rate: 16mm films or 'narrower width films which must be positive prints; printed music in bound or sheet form; printed objective test materials; sound recordings; manuscripts; educational reference charts; and medical information. Contact: Office of Mail Classification, Postal Service, 475 L'Enfant Plaza West S.W., Room 8430, Washington, DC 20260/202-245-4540.

Special Handling

Special handling service is available for third and fourth class mail only, including insured and COD mail. It provides for preferential handling in dispatch and transport, but does not provide special delivery. The special handling fee must be paid on parcels that require special care such as baby poultry, bees, etc. Special handling does not mean special care of fragile items. Anything breakable should be packed with adequate cushioning and marked "Fragile." Contact: Customer Services Department, Postal Service, 475 L'Enfant Plaza West S.W., Room 5667, Washington, DC 20260/202-245-5734.

Stamp Collection and Philatelic Services

The Postal Service has certain philatelic products available for purchase, in most post offices, which are useful for those with an interest in starting a collection. These include: *Stamps and Stories* ($3.50)—a comprehensive guide to stamp collecting and all U.S. stamp issues; starter collecting kits; and an annual mint set of all the commemoratives issued in a given calendar year.

For the individual already collecting, the Postal Service offers all current issues of stamps, products and postal stationery through its mail order service at face value plus a small handling charge. The following free publications are available:

Philatelic Catalog—Bimonthly, free publication which lists commemorative stamps, souvenir mint sets, and souvenir cards.
Introduction to Stamp Collecting—how to begin a stamp collection; equipment guide; condition and color guide; and glossary of terms.

Contact: Philatelic Marketing Division, Postal Service, 475 L'Enfant Plaza West S.W., Room 5630, Washington, DC 20260/202-245-5778.

Stamp Design Selection

Suggestions for commemorative postage stamps meeting specific standards outlined by the Citizens' Stamp Advisory Committee should be presented in writing to the Postmaster General, Washington, DC 20260. For additional information, contact: Public Affairs Division, Postal Service, 475 L'Enfant Plaza West S.W., Room 10916, Washington, DC 20260/202-245-5199.

Stamps and Stamped Paper

Yearly announcements for the stamps and stamped paper to be issued for the upcoming year are available. The date, subject and city of issuance is provided. Contact: Stamp Development Branch, Postal Service, 475 L'Enfant Plaza West S.W., Room 5800, Washington, DC 20260/202-245-4956.

Stamps by Mail

Postage stamps may be obtained through the mail by using a specially printed envelope available through your post office. This service is for those mailers who cannot get to a post office easily. A check or money order may be used to pay for the stamps. The stamp envelope, with check inside, is presented to the carrier on his or her regular rounds or dropped in any collection box. It must be addressed to the local postmaster using the local ZIP Code. The order is filled and returned to the customer within three days. There is a small handling fee required in addition to the cost of the order. For additional information, contact: Customer Services Department, Postal Service, 475 L'Enfant Plaza West S.W., Room 5667, Washington, DC 20260/202-245-5734.

Third Class Mail

Third class mail, sometimes called advertising mail, may be used by anyone but is used most often by large mailers. This class includes printed

materials and merchandise parcels which weigh less than 16 ounces. There are two rate structures for this class, a single-piece rate and a bulk rate, as well as a Third Class Carrier Route Presort. Many community organizations and businesses find it economical to use this service. Also, individuals may use third class for mailing lightweight parcels. The post office has information on which category of third class mail is best suited to your needs. For further information, contact: Office of Mail Classification, Rates and Classification Department, 475 L'Enfant Plaza West S.W., Room 8430, Washington, DC 20260/202-245-4540.

Trayed Mail

Metered and permit imprint letter mail can be placed in trays furnished by the post office. This means handling in the mailer's own mailroom, and better protection from possible damage in transit. Trayed mail bypasses handlings at the post office. For more details on the use of letter mail trays, consult your postmaster or customer service representative, or contact: Customer Services Department, Postal Service, 475 L'Enfant Plaza West S.W., Room 5667, Washington, DC 20260/202-245-5734.

United States Postage Stamps
Basic Manual

This is an excellent reference source for all stamp collectors, particularly those requiring extensive and authoritative information on U.S. stamps. This official U.S. Postal Service guidebook includes an illustration of every U.S. postage and special service stamp issued from July 1, 1874 through June 20, 1970. Accompanying each illustration is a description of the design, history and dimensions of the stamp. Tables containing detailed statistics of postage stamps issued for 1933 to the present are appendixed. Listed below are five transmittal letters that update this basic manual ($3.20):

United States Postage Stamps, Transmittal Letter 2— updates the basic manual with information about new stamps issued from May 1970 to December 1971 ($1.50).
United States Postage Stamps, Transmittal Letter 3— updates the basic manual with information about

new stamps from February 1972 to December 1973 ($1.30).
United States Postage Stamps, Transmittal Letter 4— adds new material for stamps issued during 1974 ($1.30).
United States Postage Stamps, Transmittal Letter 5—includes new information for stamps issued during 1975 ($1.25).
United States Postage Stamps, Transmittal Letter 6—includes new information for stamps issued during 1976 and 1977 ($2.50).

Sold by the Superintendent of Documents, Governing Printing Office, Washington, DC 20402. For additional information on stamps, contact: Stamps Division, Customer Services Department, Postal Service, 485 L'Enfant Plaza West S.W., Room 5667, Washington, DC 20260/202-245-5734.

ZIP Code

The ZIP Code helps process the mail quickly and efficiently. Because of population density, transportation patterns, and other reasons, key geographic areas are designated as mail-processing centers for mail movement between post offices within their area. The first three digits of any ZIP Code number represent a particular sectional center area or a large metropolis. The last two digits identify a local delivery area. For additional information, contact: Mail Processing Department, Postal Service, 475 L'Enfant Plaza West S.W., Room 7847, Washington, DC 20260/202-245-4139.

Zone Charts

Parcel post postage is computed by weight and by distance zones. The official Zone chart available at any post office shows the complete zone structure from that office. Contact: In-Plant Processing Office, Mail Processing Department, Postal Service, 475 L'Enfant Plaza West S.W., Room 7837, Washington, DC 20260/202-245-4083.

How Can the Postal Service Help You?

To determine how the U.S. Postal Service can help you, contact: Public and Communications Department, Postal Service, Washington, DC 20260/202-245-4059.

Veterans Administration

810 Vermont Ave. N.W., Washington, DC 20420/202-389-2073

ESTABLISHED: July 21, 1930
BUDGET: $21,171,227,000
EMPLOYEES: 230,538

MISSION: Administers a system of benefits for veterans and dependents. These benefits include compensation payments for disabilities or death related to military service; pension based on financial need for totally disabled veterans or certain survivors for disabilities or death not related to military service; education and rehabilitation; home loan guaranty; burial, including cemeteries, markers, flags, etc.; and a comprehensive medical program involving a widespread system of nursing homes, clinics, and more than 170 medical centers.

Major Sources of Information

Academic Affairs

The Veterans Administration conducts the largest coordinated health professions education and training effort of its kind in the United States. Its purpose is to assure high quality veterans' health care and to develop sufficient numbers of all categories of professional and other health personnel. Contact: Academic Affairs, Department of Medicine and Surgery, Veterans Administration, 810 Vermont Ave. N.W., Room 87513, Washington, DC 20420/202-389-3178.

Affiliated Education Programs

The Veterans Administration has over 2,000 training relationships between VA health care facilities and schools of medicine, dentistry, nursing, pharmacy, social work, and other allied health professions and occupations at the graduate and undergraduate levels. Contact: Affiliated Education Program, Academic Affairs, Department of Medicine and Surgety, Veterans Administration, 810 Vermont Ave. N.W., Room 870, Washington, DC 20420/202-389-3829.

Alcohol and Drug Treatment

The Veterans Administration's Alcohol Dependence Treatment Programs emphasize relatively short hospitalization during which comprehensive health and vocational assessment are accomplished by patient and hospital staff. The outpatient clinic continues the veteran's rehabilitation during which treatment such as group therapy, family therapy and vocational services are provided. Close collaboration with Alcoholics Anonymous is central to all programs. Contact: Alcohol and Drug Dependence, Mental Health and Behavioral Science and Service, Department of Medicine and Surgery, Veterans Administration, 8 Vermont Ave. N.W., Room 116A3, Washington, DC 20420/202-389-5193.

Appellate Review

Claimants not satisfied with determinations made by Veterans Administration field offices may file a written notice of disagreement with the office taking the action. If, after various other steps followed, the claimant is still dissatisfied, the case may be sent to the Board of Veteran Appeals for review and final decisions. *Rules of Practice, Board of Veterans Appeals* and an index to appellate decisions (in microfiche only) may be obtained without charge. Contact: Board of Veterans Appeals, Veterans Administration, 811 Vermont Ave. N.W., Room 845, Washington, DC 20420/202-389-3001.

Assistance Centers

Assistance centers provide all incoming veterans on their first visit with information about and assistance in applying for various federal benefits. Contact: Veterans Assistance Service, Department of Veterans Benefits, Veterans Administration, 810 Vermont Ave. N.W., Room 344, Washington, DC 20420/202-389-2567.

Building Management

The major functions of the Veterans Administration building management service include environmental sanitation, a laundry/linen program, and interior design. Interior design receives special attention as an integral part of effective medical center operations because of the potential therapeutic effects. The mission of the VA interior designers is to eliminate drab and disheartening environments, with emphasis this year on the admissions/outpatient and clinical support areas of VA medical centers. Contact: Building Management Service, Department of Medicine and Surgery, Veterans Administration, 4040 North Fairfax Dr., Room 640, Arlington, VA 22032/202-235-3010.

Burial Expenses

Some burial expenses for veterans (including an interment allowance) are reimbursable. Contact: Department of Memorial Affairs, Veterans Administration, Room 275K, 810 Vermont Ave. N.W., Washington, DC 20420/202-389-5202.

Burial Flags

An American flag may be obtained to drape the casket of a veteran, after which it may be given to next of kin or close friend or associate of the deceased. Contact the nearest Veterans Administration office, or most local post offices, or: the Department of Memorial Affairs, Veterans Administration, 941 N. Capitol St. S.E., Room 9320, Washington, DC 20420/202-275-1480.

Burial in National Cemeteries

Burial is available to any deceased veteran of wartime or peacetime service at all national cemeteries having available grave space except Arlington. Members of the Reserve and the Army and Air National Guard who die while performing or as a result of performing active duty for training may also be eligible. Burial is also available to the eligible veteran's wife, husband, widow, widower, minor children and, under certain conditions, to unmarried adult children. A free list of Veterans Administration National Cemeteries showing those with and without available grave space and information on procedures and eligibility for burial in a National Cemetery may be obtained. Contact: Cemetery Service, Department of Memorial Affairs, Veterans Administration, 941 N. Capitol St. S.E., Room 9500, Washington, DC 20420/202-275-1486.

Canteen Service

The Veterans Canteen Service (VCS) operates retail stores and provides food and other service activities at each VA medical center for the comfort and well-being of the patients and members. Canteen retail stores offer patients a wide selection of products for their convenience, entertainment, recreation, hygiene and grooming, and leisure use. Food service facilities provide meals and refreshment snacks for patients' families, employees, volunteers and visitors. Contact: Veterans Canteen Service, Department of Medicine and Surgery, Veterans Administration, 7th Floor, 806 15th St. N.W., Washington, DC 20420/202-275-1800.

Central Purchasing

The Veterans Administration has a central purchasing office. It buys medical supplies, textiles, food, paper products, prosthetics, and orthopedic aids, and laundry equipment. Contact: Marketing Center, Veterans Administration, P.O. Box 76, Hines, IL 60141/312-681-6782.

Chaplain Service

Chaplain service provides spiritual and religious ministry for patients in all VA medical centers and for the staff in the medical centers and in Central office. The VA chaplains function as an integral part of the health care team, representing all major faith groups and denominations. Workshops were conducted during the year on death and dying, aging, how to deal with the alcoholic and his or her family, involvement with the medical staff and their needs, and a new area of concern for the chaplain service—the orthopedic patient. Contact: Chaplain Service, Department of Medicine and Surgery, Veterans Administration, 810 Vermont Ave. N.W., Room 916, Washington, DC 20420/202-389-5137.

Civilian Health and Medical Program

This is a medical benefits program through which the Veterans Administration helps pay for medical services and supplies obtained from civilian sources by eligible dependents and survivors of veterans. A handbook for beneficiaries and health benefits services for dependents and survivors describes the benefits and how to claim them. For the handbook and further information, contact: Public Information, Department of Medicine and Surgery, Veterans Administration, 810 Vermont Ave. N.W., Room 815F, Washington, DC 20420/202-389-3552.

Clinics and Clinical Support

Special efforts by Veterans Administration medical services are made in hyptertension, sickle cell anemia, dialysis, rheumatology-immunology, cardiology, pulmonary disease and intensive

care. Contact: Professional Services, Department of Medicine and Surgery, Veterans Administration, 810 Vermont Ave. N.W., Room 944G, Washington, DC 20420/202-389-3560.

Compensation and Pension Service
The Compensation and Pension Service has responsibility for: claims for disability compensation and pension; for automobile allowances and special adaptive equipment; claims for specially adapted housing; special clothing allowance; emergency officer's retirement pay; eligiblity determinations based on military service for other VA benefits and services or those of other government agencies; survivor's claims for death compensation, dependency and indemnity compensation, death pension, burial and plot allowance claims; claims for accrued benefits; forfeiture determinations; claims for adjusted compensation in death cases; and claims for reimbursement for headstone or marker. Contact: Compensation and Pension Service, Department of Veterans Benefits, Veterans Administration, 810 Vermont Ave. N.W., Room 400, Washington, DC 20420/202-389-2264.

Construction
Contracts are available to private firms for design, construction and building technology research. New facilities are built and old ones are improved to provide quality medical care for veterans. Design and construction contracts are also given for the National Cemetery System. Contact: Construction, Veterans Administration, 811 Vermont Ave N.W., Room 449, Washington, DC 20420/202-389-3397.

Continuing Education
The Veterans Administration conducts systemwide continuing education programs to bring the latest in scientific, medical and management knowledge to Department of Medicine and Surgery (DM&S) employees. These programs, include workshops, seminars and individual training, and all forms of audiovisual, print and transmission media. They have three major purposes: 1) instructional design and educational development for all DM&S education activites: 2) executive development and management training; and 3) coordination and funding support of the following activities: Regional Medical Education Centers, the Rehabilitation Engineering Education Program, Cooperative Health Manpower Education Programs, the Engineering Training Center, the Dental Training Center, and continuing education activities at VA health care facilities. Contact: Continuing Education and Staff Development Service, Academic Affairs, Veterans Administration, 810 Vermont Ave. N.W., Room 875-F, Washington, DC 20420/202-389-2581.

Could You Use a Multimillion Dollar Customer and Let's Do Business
There are two free bulletins that list management consultant contract opportunities. Contact: Publications Service, Veterans Administration, 810 Vermont Ave. N.W., Room C2, Washington, DC 20420/202-389-3056.

Dietetics
Veterans Administration dieticians are responsible for direct and special nutritional needs of veteran patients. Contact: Dietetic Service, Department of Medicine and Surgery, Veterans Administration, 810 Vermont Ave. N.W., Room 927, Washington, DC 20420/202-389-3376.

Direct Payments
The programs described below are those which provide financial assistance directly to individuals, private firms and other private institutions to encourage or subsidize a particular activity:

Automobiles and Adaptive Equipment for Certain Disabled Veterans and Members of the Armed Forces
Objectives: To provide financial assistance to certain disabled veterans toward the purchase price of an automobile or other conveyance, not to exceed $3,800, and an additional amount for adaptive equipment deemed necessary to insure the eligible person will be able to operate or make use of the automobile or other conveyance.
Eligibility: Veterans with honorable service having a service-connected disability due to loss or permanent loss of use of one or both feet, one or both hands, or a permanent impairment of vision of both eyes to a prescribed degree. Service personnel on active duty also qualify under the same criteria as veterans.
Range of Financial Assistance: Up to $3,800.
Contact: The local Veterans Administration office in your state, Veterans Administration, Washington, DC 20420/202-389-2356.

Burial Allowance for Veterans
Objectives: To provide a monetary allowance not to exceed $300 toward the funeral and burial expenses plus $150 for plot or interment expenses if not buried in a National Cemetery. If death is service-connected, $1,100 or the amount authorized to be paid in the case of a federal employee whose death occurs as a result of an injury sus-

tained in the performance of duty, is payable for funeral and burial expenses. In addition to the statutory burial allowance, the cost of transporting the remains from place of death to site of burial is paid by the VA if death occurs in a VA facility. The cost of transporting the remains from place of death to the national cemetery in which space is available nearest the veteran's last place of residence may also be paid if death was due to service-connected disability, or at the time of death the veteran was in receipt of disability compensation, and burial is in a national cemetery and the cost of transportation is not fully reimbursable under other provisions. A headstone, marker or the cost of a nongovernment headstone or marker not in excess of the average actual cost of headstones and markers furnished by the VA may be authorized. Also to provide a flag for the burial of a deceased veteran.

Eligibility: The person who bore the veteran's burial expense or the undertaker, if unpaid, is eligible for reimbursement of the burial expense. The next of kin, friend or associate of the deceased veteran is eligible for the flag.

Range of Financial Assistance: Up to $1,100.

Contact: Veterans Administration, Washington, DC 20420/202-389-2356.

Compensation for Service-Connected Deaths for Veterans' Dependents

Objectives: To compensate surviving widows, widowers, children and dependent parents for the death of any veteran who died before January 1, 1957 because of a service-connected disability.

Eligibility: A surviving unmarried widow, widower, child, or children, and dependent parent or parents of the deceased veteran who must have died before January 1, 1957 because of a service-connected disability.

Range of Financial Assistance: Starting at $87 monthly.

Contact: The local Veterans Administration office in your state or Veterans Administration, Washington, DC 20420/202-389-2356.

Dependents' Educational Assistance

Objectives: To provide partial support to those seeking to advance their education who are qualifying spouses, surviving spouses, or children of deceased or disabled veterans, or of service personnel who have been listed for a total of more than 90 days as missing in action, or as prisoners of war.

Eligibility: Spouse, surviving spouses, and children between age 18 and 26 of veterans who died from service-connected disabilities, of living veterans whose service-connected disabilities are considered permanently and totally disabling, of

those who died from any cause while such disabilities were in existence, of service persons who have been listed for a total of more than 90 days as missing in action, or of prisoners of war.

Range of Financial Assistance: Not to exceed $2,500 in any one regular academic year.

Contact: The local Veterans Administration office in your state or Veterans Administration, Central Office, Washington, DC 20420/202-389-2356.

Pension for Non-Service-Connected Disability for Veterans

Objectives: To assist wartime veterans in need whose non-service-connected disabilities are permanent and total and prevent them from following a substantially gainful occupation.

Eligiblity: Those who have had 90 days or more of honorable active wartime service in the Armed Forces or if less than 90 days wartime service were released or discharged from such service becasue of a service-connected disability, who are permanently and totally disabled for reasons not necessarily due to service, and wartime veterans 65 years of age or older or became unemployable after age 65 are considered permanently and totally disabled. Income restrictions are prescribed.

Range of Financial Assistance: Starting at $325 monthly.

Contact: The local Veterans Administration office in your state or Veterans Administration, Washington, DC 20420/202-389-2356.

Pension to Veterans Widows or Widowers and Children

Objectives: To provide a partial means of support for needy widows or widowers, and children of deceased wartime veterans whose deaths were not due to service.

Eligibility: Unmarried widows, widowers, and children of deceased veterans who had at least 90 days of honorable active wartime service or, if less than 90 days during wartime, were discharged for a service-connected disability and who have a limited income. A child must be unmarried and 18 or under (23 if in school) or unmarried 18 or over if disabled before 18 and continues to be disabled.

Range of Financial Assistance: Starting at $218 per month.

Contact: The local Veterans Administration office in your state or Veterans Administration, Washington, DC 20420/202-389-2356.

Post-Vietnam Era Veterans' Educational Assistance Program

Objectives: To provide educational assistance

to persons first entering the Armed Forces after December 31, 1976, to assist young persons in obtaining an education they might otherwise not be able to afford, to promote and assist the all volunteer military persons to serve in the Armed Forces.

Eligibility: The participant must have served honorably on active duty for more than 180 days beginning on or after January 1, 1977, or have been discharged after such date because of a service-connected disability. Also eligible are participants who serve for more than 180 days and who continue on active duty and have completed their first period of obligated service (or six years of active duty, whichever comes first).

Range of Financial Assistance: Up to $8,100.

Contact: The local Veterans Administration office in your state of Veterans Administration, Central Office, Washington, DC 20420/202-389-2356.

Rehabilitative Research (Prosthetics)

Objectives: To develop new and improved prosthetic devices, sensory aids, mobility aids, automotive adaptive equipment, and related appliances for the primary benefit of disabled veterans. Through comprehensive educational and informational programs, the results of such research are made available for the benefit of the disabled throughout the world.

Eligibility: Any institution, state or local health agency, research organization, university, or rehabilitation center is eligible for contract.

Range of Financial Assistance: $6,000 to $280,000.

Contact: Director, Rehabilitation Engineering Research and Development Service, Veterans Administration, Central Office, Washington, DC 20420/202-389-5177.

Specially Adapted Housing for Disabled Veterans

Objectives: To assist certain totally disabled veterans in acquiring suitable housing units, with special fixtures and facilities made necessary by the nature of the veterans' disabilities.

Eligibility: Veterans with permanent, total and compensable disabilities based on service after April 20, 1898, due to a) loss of use of both lower extremities, such as to preclude locomotion without the aid of braces, canes, crutches or a wheelchair, or b) which includes 1) blindness in both eyes, having only light perception, plus 2) loss or loss of use of one lower extremity, together with 1) residuals of organic disease or injury, for 2) the loss or loss of use of one upper extremity which so affects the functions of balance or propulsion as to preclude locomotion without the aid of braces, crutches, canes or a wheelchair.

Range of Financial Assistance: Up to $30,000.

Contact: The local Veterans Administration Office in your state or Veterans Administration, Washington, DC 20420/202-389-2356.

Veterans Community Nursing Home Care

Objectives: To provide service-connected veterans with nursing home care and to aid the non-service-connected veteran in making the transition from a hospital to a community care facility by providing up to six months nursing care at VA expenses.

Eligibility: A nursing home which 1) must be inspected by VA personnel for compliance with VA standards established for skilled or intermediate care facilities, or 2) is accredited by the Joint Commission on Accreditation of Hospitals.

Range of Financial Assistance: Not specified.

Contact: Assistant Chief Medical Director for Extended Care, Department of Medicine and Surgery, Veterans Administration, Washington, DC 20420/202-389-3692.

Veterans Compensation for Service-Connected Disability

Objectives: To compensate veterans for disability due to military service according to the average impairment in earning capacity such disability would cause in civilian occupations.

Eligibility: Persons who have suffered disabilities due to service in the armed forces of the United States.

Range of Financial Assistance: Up to $2,536 per month.

Contact: The local Veterans Administration office in your state or Veterans Administration, Washington, DC 20420/202-389-2356.

Veterans Dependency and Indemnity Compensation for Service-Connected Death

Objectives: To compensate surviving widows, or widowers, children and parents for the death of any veteran who died on or after January 1, 1957 because of a service-connected disability.

Eligibility: A surviving unmarried widow, or widower, a child or children, and parent or parents of the deceased veteran who died on or after January 1, 1957, because of a service-connected disability. Dependency and Indemnity Compensation (DIC) payments may be authorized for surviving spouse and children of certain veterans who were totally service-connected disabled at the time of death and whose deaths were not the result of their service-connected disability.

Range of Financial Assistance: Up to $895 monthly.

Contact: The local Veterans Administration

office in your state or Veterans Administration, Washington, DC 20420/202-389-2356.

Veterans Educational Assistance (GI Bill)

Objectives: To make service in the Armed Forces more attractive by extending benefits of a higher education to qualified young persons who might not otherwise be able to afford such an education; and to restore lost educational opportunities to those whose education was interrupted by active duty after January 31, 1955 and before January 1, 1977.

Eligibility: The veteran must have served honorably on active duty for more than 180 days, any part of which occurred after January 31, 1955 and before January 1, 1977. A veteran with less than 180 days' service may be eligible if he or she was released because of a service-connected disability. A service person who has served on active duty for more than 180 days any part of which was before January 11 1977, and who continues on active duty is also eligible. Upon completion of 18 continuous months of active duty, the maximum of 45 months of educational assistance will be granted, if the veteran is released under condition that satisfy his or her active duty obligation, otherwise assistance will be provided for at the rate of 1½ months for each month of service. An initial period of active duty for training under section 511(d), title 10, U.S. Code, served on or after February 1, 1955 when subsequently followed by one year of active duty, may be included in computing active duty time for determining entitlement. Also eligible for benefits are those persons who enter into service under the Delayed Entry Program between January 1, 1977 and January 1, 1978, and who contracted for this program with the Armed Forces prior to January 1, 1977.

Range of Financial Assistance: Not to exceed $2,500 in any one regular academic year.

Contact: The local Veterans Administration office in your state or Veterans Administration, Washington, DC 20420/202-389-2356.

Vocational Rehabilitation for Disabled Veterans

Objectives: To train veterans for the purpose of restoring employability, to the extent consistent with the degree of a service-connected disability.

Eligibility: Veterans of World War II and later service who, as a result of a service-connected compensable disability, are determined to be in need of vocational rehabilitation to overcome their handicap.

Range of Financial Assistance: Full cost of tuition, books, fees and supplies, plus monthly full-time allowances.

Contact: The local Veterans Administration office in your state or Veterans Administration, Central Office, Washington, DC 20420/202-389-2356.

Domiciliary

A Veterans Administration domiciliary is a health care facility providing a program of planned living in a sheltered environment and necessary ambulatory medical treatment to veterans who are unable because of their disabilities to earn a living but who are not in need of nursing service, constant medical supervision or hospitalization. Contact: Patient Treatment Service, Department of Medicine and Surgery, Veterans Administration, 810 Vermont Ave. N.W., Room 855, Washington, DC 20420/202-389-3692.

Driver Training for the Handicapped

The Veterans Admiminstration operates driver training centers staffed with trained therapist/instructors and equipped with specially adapted automobiles and vans. Contact: Rehabilitation Medicine Service, Department of Medicine and Surgery, 810 Vermont Ave. N.W., Room 915F, Washington, DC 20420/202-389-2341.

Education and Rehabilitation

The Education and Rehabilitation Service administers programs for vocational rehabilitation of disabled veterans, readjustment educational benefits for beterans of post-Korean conflict service, and educational assistance for spouses, surviving spouses and children of veterans who are permanently and totally disabled or die from disability incurred or aggravated in active service in the Armed Forces, or are prisoners of war or are missing in action. Special restorative training is also available to eligible children. Contact: Education and Rehabilitation Service, Department of Veterans Affairs, Veterans Administration, 810 Vermont Ave. N.W., Room 444C, Washington, DC 20420/202-389-5154.

Employment Assistance

The Veterans Administration works with the Department of Labor (DOL) to provide job and job training service to veterans. The VA cooperates in the Disabled Veterans Outreach Program and the Comprehensive Employment and Training Act program by providing names and addresses and by providing veterans' benefits training. VA also provides lists of names and addresses of on-the-job training employers to be used by State Employment Security Administrations (SESAs) in developing job opportunities. Also, Veterans' Employment Representatives are

stationed in some U.S. Veterans' Assistance Centers. Contact: Veterans Assistance Service, Department of Veterans Benefits, Veterans Administration, 810 Vermont Ave. N.W., Room 344, Washington, DC 20420/202-389-2567.

Exchange of Medical Information

The Exchange of Medical Information program supports pilot projects which have as their principal objective the strengthening of those Veterans Administration facilities located remote from urban medical teaching centers. Contact: Academic Affairs, Department of Medicine and Surgery, Veterans Administration, 810 Vermont Ave. N.W., Room 860, Washington, DC 20420/202-389-5093.

Exhibits

A variety of exhibits are available for display at Veterans Administration facilities, veterans' organizations, conventions, educational institutions and professional, medical and scientific meetings. Contact: Audio Visual Service, Veterans Administration, 810 Vermont Ave. N.W., Room C76, Washington, DC 20420/202-389-2715.

Extended Care

The Veterans Administration's extended care concentrates on furnishing an adequate number of nonhospital beds either in VA or non-VA facilities, expanding alternatives to institutional care (e.g., home health services), and designing and improving treatment programs particularly suited to the needs of an aging veteran population. Contact: Extended Care, Department of Medicine and Surgery, Veterans Administration, 810 Vermont Ave. N.W., Room 865, Washington, DC 20420/202-389-3781.

Federal Benefits for Veterans and Dependents

This pamphlet includes the addresses and phone numbers of all Veterans Administration installations. It is available for $2.00 from the Superintendent of Documents, Government Printing Office, Washington, DC 20402/202-783-3238. For additional information, contact: Public Affairs, Department of Veterans Affairs, Veterans Administration, 810 Vermont Ave. N.W., Room 311, Washington, DC 20420/202-389-5210.

Fee-Basis Medical and Pharmacy Program

This program allows authorized veterans to receive medical services from individuals or organizations. The Veterans Administration compensates participating members for services performed, and pays the veteran for travel expenses incurred for the visit. Contact: Benefits Delivery Systems Support Service, Data Management And Telecommunications, Veterans Administration, 810 Vermont Ave. N.W., Room 268, Washington, DC 20420/202-389-5265.

Fiduciary and Field Examinations

This office supervises the payment of benefits to fiduciaries on behalf of adult beneficiaries who are incompetent or under some other legal disability. It also supervises the payments of benefits to minor beneficiaries. Contact: Fiduciary and Field Examination, Veterans Assistance Service, Veterans Benefits, Veterans Administration, 810 Vermont Ave. N.W., Room 344A, Washington, DC 20420/202-389-3643.

Film Catalog

The audiovisual activity maintains the VA's centralized motion picture film library consisting of 780 titles and 3,659 prints for use in medical and scientific research, and in orientation, training, information and rehabilitation programs. In addition to VA use, the films are available to other federal and state agencies, veterans' organizations, educational institutions, and professional and scientific groups. *Veterans Administration Film Catalog* is sold for $5.00 by the Superintendent of Documents, Government Printing Office, Washington, DC 20402/202-783-3238. For additional information, contact: Central Office, Film Library, Veterans Administration, 810 Vermont Ave. N.W., Room B75, Washington, DC 20420/202-389-2780.

Foreign Training

Veterans, in-service students and dependents may pursue training at approved foreign schools. A free pamphlet with information on the program, listing those foreign schools which offer at least one course approved for training is available. Contact: the nearest regional VA office, or Education and Rehabilitation Service, Department of Veterans Benefits, Veterans Administration, 810 Vermont Ave. N.W., Room 444C, Washington, DC 20420/202-389-5154.

Freedom of Information Act Requests

For Freedom of Information Act requests, contact: General Counsel, Veterans Administration, 810 Vermont Ave. N.W., Room 1036, Washington, DC 20420/202-389-3294.

Graduate and Undergraduate Medical and Dental Education

The Veterans Administration health care facilities participate in specialty and subspecialty pro-

grams for physicians and dentists. Contact: Academic Affairs, Department of Medicine and Surgery, Veterans Administration, 810 Vermont Ave. N.W., Room 860, Washington, DC 20420/202-389-5093.

Grants

The programs described below are for sums of money which are given by the federal government to initiate and stimulate new or improved activities or to sustain on-going services:

Exchange of Medical Information

Objectives: To strengthen VA hospitals not affiliated with medical schools or remotely located from medical teaching centers to foster the cooperation and consultation among all members of medical professions, within or outside the Veterans Administration.

Eligibility: Medical schools, hospitals, research centers and other institutions, members of the medical profession, and Veterans Administration health care facilities.

Range of Financial Assistance: $14,639 to $751,785.

Contact: Special Assistant to ACMD for Academic Affairs, Veterans Administration, Central Office, 810 Vermont Ave. N.W., Washington, DC 20420/202-389-2621.

Grants to States for Construction of State Home Facilities

Objectives: To assist states to construct state home facilities for furnishing domiciliary or nursing home care to veterans, and to expand, remodel or alter existing buildings for furnishing domiciliary, nursing home or hospital care to veterans in state homes.

Eligibility: Any state may apply after assuring that the assisted facility will be operated by the state; and will be used primarily for veterans.

Range of Financial Assistance: $8,000 to $5,000,000.

Contact: Assistant Chief Medical Director for Extended Care, Veterans Administration, Central Office, Washington, DC 20420/202-389-3781.

State Cemetery Grants

Objectives: To assist states in the establishment, expansion and improvement of veterans' cemeteries.

Eligibility: Any state may apply.

Range of Financial Assistance: Not specified.

Contact: Director, State Cemetery Grants, Department of Memorial Affairs, Veterans Administration, 810 Vermont Ave. N.W., Washington, DC 20420/202-389-2313.

Veterans State Domiciliary Care

Objectives: To provide financial assistance to states furnishing domiciliary care to veterans in State Veterans' Homes which meet the standards prescribed by the VA Administrator.

Eligibility: Applicant in any state which operates a designated facility to furnish domiciliary care primarily for veterans.

Range of Financial Assistance: $34,117, to $1,106,600.

Contact: Assistance Chief Medical Director for Extended Care, Veterans Administration, Washington, DC 20420/202-389-3781.

Veterans State Nursing Home Care

Objectives: To provide financial assistance to states furnishing nursing home care to veterans in state veterans' homes meet the standards prescribed by the VA administrator.

Eligibility: Applicant is any state which operates a designed facility to furnish nursing home care primarily for veterans.

Range of Financial Assistance: $61,635 to $1,757,658.

Contact: Assistant Chief Medical Director for Extended Care, Veterans Administration, Washington, DC 20420/202-389-3781.

Veterans State Hospital Care

Objectives: To provide financial assistance to states furnishing hospital care to veterans in state veterans' homes which meet the standards prescribed by the VA Administrator.

Eligibility: Applicant is any state which operates a state home for veterans and intends to furnish hospital care primarily for veterans.

Range of Financial Assistance: $14,272 to $1,686,096.

Contact: Assistant Chief Medical Director for Extended Care, Veterans Administration, Washington, DC 20420/202-389-3781.

Headstone or Grave Marker

A headstone or grave marker is available without charge for any deceased veteran of wartime or peacetime service and can be shipped to the consignee designated. Contact: Monument Service, Department of Memorial Affairs, Veterans Administration, 941 N. Capitol St. S.E., Room 9320, Washington, DC 20420/202-275-1480.

Health Services Research and Development

Health services research deals with such issues as cost, effectiveness, efficiency, humaneness and quality of care. Contact: Health Services, Research and Development Service, Research and Development, Department of Medicine and Surgery, Veterans Administration, 810 Vermont

Ave. N.W., Room 648, Washington, DC 20420/202-389-2666.

Hotline

Veterans Affairs Hotline (Toll-free 800-892-7650) provides information and help with problems involving GI loans, educational benefits, insurance, disability compensation, medical and dental care, employment, etc. The Veterans Administration also maintains many local offices and medical facilities. Look in your local phone book under "U.S. Government."

Human Goals

The Office of Human Goals has responsibility for coordinating and advising on all agency civil rights and equal opportunity matters. The Office coordinates the Federal Women's and Hispanic Employment Programs, processes discrimination complaints, develops and monitors the National Equal Employment Opportunity (EEO) Plan of Action, develops policy and standards for EEO program review, and plans and conducts EEO training. Contact: Equal Opportunity Staff, Veterans Administration, 1425 K St. N.W., Room 900, Washington, DC 20420/202-389-2012.

Insurance

Veterans Administration life insurance operations are for the benefit of service members, veterans and their beneficiaries. Insurance activities include: complete maintenance of all individual insurance accounts (policies); authorization of policy loans, cash surrenders, and matured endowments; exchange and conversion of policy plans; development of insurance death claims and the authorization of payment to the beneficiary; development of disability insurance claims to support waiver of premium or disability insurance award payments in behalf of the insured; allotments from pay for members of the military departments; payroll deductions for employees of large commercial employers; establishing relationship of individual death or disability to extra hazard of military service for assessment to proper funding accounts; any other transaction which may have a bearing upon the total responsibility for the insurance program. Contact: Department of Veterans Benefits, Veterans Administration, 810 Vermont Ave. N.W., Room 311, Washington, DC 20420/202-389-5210.

Library

The library contains two collections. The medical collection is in the fields of medicine, surgery, dentistry, pharmacy, physical medicine, rehabilitation, nursing, dietetics, social service and hospital administration. Medical periodicals are regularly received. The general reference collection is such fields as veterans affairs, personnel administration, data processing, public administration, accounting, insurance and statistics. General periodicals are regularly received. The collection includes microfilm and microfiche. It is open to the public. Contact: Library, Veterans Administration, 810 Vermont Ave. N.W., Room 976, Washington, DC 20420/202-389-3085.

Loan Guaranty

The aim of loan guarantees is to provide credit assistance on more liberal terms than is generally available to nonveterans. Assistance is provided chiefly through substituting the Government's guaranty on loans made by private lenders in lieu of the downpayments, shorter terms, and other requirements generally required in conventional home mortgage transactions. Where private capital is not available in nonurban areas, direct loans may be made. In addition, a system of direct financial grants is operated to help certain permanently disabled veterans to acquire specially adapted housing. The major activities include appraising properties to establish their values; supervising the construction of new residential properties; passing on the ability of a veteran to repay a loan and the credit risk; servicing and liquidating defaulted loans; and disposing of real estate acquired as the consequence of defaulted loans. There are also substantial operations involved in managing and realizing loan assets. A counseling service is conducted to aid potential minority homebuyers both in obtaining housing credit and in discharging their obligations as homeowners and mortgagors. *Guaranteed and Direct Loans for Veterans* is a free pamphlet that answers the most commonly asked questions in connection with the guaranty or insurance loans and the making of direct loans. Contact: Loan Guaranty Service, Department of Veterans Benefits, Veterans Administration, 810 Vermont Ave. N.W., Room 367, Washington, DC 20420/202-389-2332.

Loans and Loan Guarantees

The programs described below are those which offer financial assistance through the lending of federal monies for a specific period of time or programs in which the federal government makes an arrangement to indemnify a lender against part or all of any defaults by the borrower.

Veterans Housing—Direct Loans and Advances

Objectives: To provide direct housing credit assistance to veterans, service personnel, and certain unmarried widows and widowers of veterans and spouses of service personnel living in rural

areas and small cities and towns (not near large metropolitan areas) where private capital is not generally available for VA guaranteed or insured loans.

Eligibility: a) Veterans who served on active duty on or after September 16, 1940 and were discharged or released under conditions other than dishonorable. Veterans of World War II, the Korean Conflict or the Vietnam era must have served on active duty 90 days or more. All other veterans must have served a minimum of 181 days on active duty; b) any veteran in the above classes with less service but discharged with a service-connected disability; c) unmarried widows and widowers of otherwise eligible veterans who died in service or whose deaths were attributable to service-connected disabilities; d) service personnel who have served at least 181 days in active duty status; e) the spouse of any member of the Armed Forces serving on active duty who is listed as missing in action, or is a prisoner of war, and has been so listed for a total of more than 90 days.

Range of Financial Assistance: Up to $33,000.

Contact: Veterans Administration, Washington, DC 20420/202-389-2356.

Veterans Housing—Direct Loans for Disabled Veterans

Objectives: To provide certain totally disabled veterans with direct housing credit, to supplement grants authorized to assist the veterans in acquiring suitable housing units, with special features or movable facilities made necessary by the nature of their disabilities.

Eligibility: Veterans who served on active duty on or after September 16, 1940 with permanent, total and compensable disabilities due to a) loss or loss of use of both lower extremities, such as to preclude locomotion without braces, canes, crutches or a wheelchair, or b) which includes 1) blindness in both eyes, having only light perception, plus 2) loss or loss of use of one lower extremity, or c) loss or loss of use of one lower extremity, together with 1) residuals of organic disease or injury, or 2) the loss or loss of use of one upper extremity which so affects the functions of balance or propulsion as to preclude locomotion without the aid of braces, crutches, canes or a wheelchair.

Range of Financial Assistance: Up to $33,000.

Contact: Veterans Administration, Washington, DC 20420/202-389-2356.

Veterans Housing—Guaranteed and Insured Loans

Objectives: To assist veterans, certain service personnel and certain unmarried widows or widowers of veterans, in obtaining credit for the purchase, construction or improvement of homes on more liberal terms than are generally available to nonveterans.

Eligibility: a) Veterans who served on active duty on or after September 16, 1940 and were discharged or released under conditions other than dishonorable. Veterans of World War II, the Korean Conflict or the Vietnam era must have served on active duty 90 days or more. All other veterans must have served a minimum of 181 days on active duty; b) any veteran in the above classes with less service but discharged with a service-connected disability; c) unmarried widows and widowers of otherwise eligible veterans who died in service or whose deaths were attributable to service-connected disabilities: d) service personnel who have served at least 181 days in active duty status; e) spouses of members of the Armed Forces serving on active duty, listed as missing in action, or as prisoners of war and who have been so listed 90 days or more.

Range of Financial Assistance: $30,000 to $58,000.

Contact: Veterans Administration, Washington, DC 20420/202-389-2356.

Veterans Housing—Mobile Home Loan

Objectives: To assist veterans, service persons and certain unmarried widows or widowers of veterans in obtaining credit for the purchase of a mobile home on more liberal terms than are available to nonveterans.

Eligibility: a) Veterans who served on active duty on or after September 16, 1940 and were discharged or released under conditions other than dishonorable. Veterans of World War II, the Korean Conflict and the Vietnam era must have served on active duty 90 days or more. All other veterans must have served a minimum of 181 days on active duty; b) any veteran in the above classes with less service but discharged with a service-connected disability; c) unmarried widows and widowers of otherwise eligible veterans who died in service or whose deaths were attributable to service-connected disabilities; d) service personnel who have served at least 181 days in active duty status; e) the spouse of any member of the Armed Forces serving on active duty who is listed missing in action, or as a prisoner of war, and has been so listed for a total of more than 90 days.

Range of Financial Assistance: $12,500 to $21,354.

Contact: Veterans Administration, Washington, DC 20420/202-389-2356.

Medical Center

A Veterans Administration medical center provides eligible beneficiaries with medical and

other health care services equivalent to those provided by private sector institutions, augmented in many instances by services to meet the special requirements of veterans. For additional information, contact: Operations, Department of Medicine and Surgery, Veterans Administration, 810 Vermont Ave. N.W., Room 814, Washington, DC 20420/202-389-5383.

Medical, Dental and Hospital Benefits

Medical, dental and hospital benefits for veterans include hospitalization in VA hospitals, nursing home car, domiciliary care, outpatient medical care, home health services, outpatient dental treatment, prosthetic applicances, aids for the blind, and alcohol and drug dependence treatment. Contact: the nearest regional VA office, or: Public Information Department of Medicine and Surgery, Veterans Administration, 810 Vermont Ave. N.W., Room 815F, Washington, DC 20420/202-389-3552.

Medical Library Network (VALNET)

Computerized bibliographic data bases provide agency health care professionals with current information for use in caring for the veteran patient. There is also a continuous development of catalogs listing the holdings and location of print and nonprint materials held by the network libraries. The materials listed are available for sharing throughout the VA and to outside organizations. Contact: Library, Academic Affairs, Department of Medicine and Surgery, Veterans Administration, 810 Vermont Ave. N.W., Room 975, Washington, DC 20420/202-389-2781.

Medical Media

Audiovisual aids include color transparencies, charts, and drafts, videotape, and motion picture footage. Scientific exhibits are produced and displayed at national meetings. Contact: Medical Media, Learning Resources Service, Academic Affairs, Department of Medicine and Surgery, Veterans Administration, 810 Vermont Ave. N.W., Room 875B, Washington, DC 20420/202-389-3812.

Medical Research

Medical Research program has clinician-investigators at Veterans Administration medical centers studying problems arising during the care of veteran patients. Nonclinical scientists in VA medical centers work in close collaboration with clinicians and support their research efforts. Alcoholism, schizophrenia, delayed stress disorders in Vietnam era veterans, and loss of limbs and spinal cord injury are high priority problems in veteran patients. Chronic obstructive lung disease, coronary artery disease, diabetes and aging are major unsolved problems for veteran and nonveteran patients alike. Contact: Medical Research Service, Research and Development, Department of Medicine and Surgery, Veterans Administration, 810 Vermont Ave. N.W., Room 744E, Washington, DC 20420/202-389-5041.

Medical Statistics

The demographic and medical characteristics of VA patients are derived from the Patient Treatment File and the Annual Patient Census. Information includes age, service-connected and VA pensioners, diagnoses, duration of stay and disposition status. Contact: Health Service Information System, Department of Medicine and Surgery, Veterans Administration, 810 Vermont Ave. N.W., Room 726, Washington, DC 20420/202-389-3774.

Medicine and Law

Copies of the series of the six educational video tape cassettes, entitled *Current Problems in Medicine and the Law* produced by DM&S have been distributed to each VA health care facility. As a supplement to these tapes, study guides are available for distribution. The study guides and the tapes, augmented by directed discussion, provide a highly effective method of giving health care providers timely information on the impact of law on the practice of medicine. Contact: Department of Medicine and Surgery, Veterans Administration, 810 Vermont Ave. N.W., Washington, DC 20420/202-389-2221.

Memorial Affairs

The Department of Memorial Affairs administers the National Cemetery system, which provides cemeterial services to veterans and other eligibles. These services also include providing headstones and markers for graves of eligibles in national and private cemeteries and monetary aid to States for establishment, expansion and improvement of veterans' cemeteries. Contact: Department of Memorial Affairs, Veterans Administration, 810 Vermont Ave. N.W., Room 275K, Washington, DC 20420/202-389-5202.

Memorial Markers and Memorial Plots

A memorial headstone or marker may be furnished on application of a close relative recognized as the next of kin to commemorate any eligible veteran (also includes a person who died in the active military, naval or air service) whose remains have not been recovered or identified, or were buried at sea through no choice of the next of kin. The memorial may be erected in a private cemetery in a plot provided by the applicant or in a memorial section of a national cemetery. Contact: Monument Service, Department of Memori-

al Affairs, Veterans Adminstration, 941 N. Capitol St. S.E., Room 9320, Washington, DC 20420/202-275-1480.

Mental Health

Mental health services are provided in the Veterans Administration through the use of professional trained personnel in a multi-disciplinary approach to treatment. Mental hygiene clinics serve as the basic units in the delivery of ambulatory mental health care. Contact: Mental Health and Behavioral Sciences Service, Department of Medicine and Surgery, Veterans Administration, 810 Vermont Ave. N.W., Room 963, Washington, DC 20420/202-389-3416.

Mobile Home Loans

The Veterans Administration may guarantee loans made by private lenders to eligible veterans for the purchase of new or used mobile homes with or without a lot. Contact: nearest regional office, or Loan Guaranty Service, Department of Veterans Affairs, Veterans Administration, 810 Vermont Ave. N.W., Room 367, Washington, DC 20420/202-389-2332.

Multi-Level Care Program

The purpose of the multi-level care is to match patients' variable medical needs with different levels of health care resources. Contact: Resource Allocation Staff, Planning and Program Development, Department of Medicine and Surgery, Veterans Administration, Webb Building, 4040 N. Fairfax Dr., Arlington, VA 22203/703-235-3024.

Outreach

The Veterans Administration conducts an outreach program to inform veterans of the benefits and services to which they may be entitled. This outreach program places a high priority on reaching certain categories of veterans, including the educationally disadvantaged, minority groups, the disabled, the unemployed, the aging and the incarcerated. Toll-free numbers appear in telephone directories, and newspapers, radio and television. Congressmen also provide toll-free numbers. For additional information, contact: Outreach Services, Mental Health and Behavioral Sciences Service, Department of Medicine and Surgery, Veterans Administration, 810 Vermont Ave. N.W., Room 962, Washington, DC 20420/202-389-3317.

Patient Satisfaction Survey

This survey is structured not only to provide system-wide information but also to provide individual facilities with extensive feedback about their performance, including comparisons with similar patients in similar facilities. These consumer surveys serve as a management tool useful for local allocation of resources and for taking corrective actions where consumer expectations are not being met. Contact: Information, Department of Medicine and Surgery, Veterans Administration, 810 Vermont Ave. N.W., Room 815F, Washington, DC 20420/202-389-3552.

Pointers for the Veteran Homeowner

This is a guide for veterans whose home mortgage is guaranteed or insured under the GI Bill. Contact: The regional VA office, or: Publication Service, Veterans Administration, 810 Vermont, N.W., Room C2, Washington, DC 20420/202-389-3056.

Presidential Memorial Certificate

The certificate expresses the country's grateful recognition of the person's service in the Armed Forces and bears the signature of the President. For information, contact: the VA regional office, or: Department of Memorial Affairs, Veterans Administration, 810 Vermont Ave. N.W., Room 275A, Washington, DC 20420/202-389-5211.

Publications Index

This is an index to all Veterans Administration publications including bulletins, catalogs, guides, handbooks, manuals, pamphlets, schedules, training programs and VA specifications. Contact: Information and Regulation Staff, Veterans Administration, 1425 K St. N.W., Room 950, Washington, DC 20420/202-389-3616.

Records and Dockets

Some Veterans Administration records can be seen and copied by the public. Contact: Reading Room, Veterans Administration, 810 Vermont Ave. N.W., Room 132, Washington, DC 20420/202-389-3085.

Recreation

The Veterans Administration recreational programs attempt to improve the quality of patients' lives and to facilitate their reentry into the community. A film designed to show how disabled veterans can successfully participate in a multitude of recreation activities has been developed. Contact: Recreation Service, Department of Medicine and Surgery, Veterans Administration, 810 Vermont Ave. N.W., Room 951, Washington, DC 20420/202-389-5389.

Rehabilitative Engineering

Research and development in devices to assist and support physically disabled veterans includes

prosthetics research, spinal cord monitoring, sensory aids program, and workshops on maxillofacial prosthetics among others. Contact: Rehabilitative Engineering Research and Development Service, Department of Medicine and Surgery, Veterans Administration, 810 Vermont Ave. N.W., Room 642, Washington, DC 20420/202-389-5177.

Reports and Statistics

Reports and statistics are issued on a recurring and nonrecurring basis. Among the reports are the following:

Veteran Population
County Veteran Population, Research Monograph
Educational and Income Characteristics of Veterans
School Enrollment of Vietnam Era Veterans
Veterans Benefits Under Current Educational Programs, Information Bulletin
Selected Compensation and Pension Data, by State of Residence
Active Compensation, Pension and Retirement Cases by Period of Service
Service-Connected Disability Compensation Information Approved Recurring Reports Bulletin, 12-A1
Directory of Veterans Administration Facilities
Veterans Administration Facilities
T.38 Physicians, Dentists and Nurses Report
VA Loan Guaranty Highlights
VA Summary of Medical Programs
Data on Vietnam Era Veterans
Trend Data, 1954–1978
Annual Report of the Administrator of Veterans Affairs
Geographic Distribution of VA Expenditures
Statistical Summary of VA Activities
America's Wars
DVB Field Station Summary
DM&S Field Station Summary

For a description and/or a complete list of these, contact: Reports and Statistics Service, Controller, Veterans Administration, 810 Vermont Ave. N.W., Room 518, Washington, DC 20420/202-389-2423.

Social Work

Social work focuses on the social problems of the chronically ill, the disabled and the long-term care patient. Contact: Social Work Service, Professional Services, Department of Medicine and Surgery, Veterans Administration, 1625 Eye St. N.W., Room 218, Washington, DC 20420/202-389-2613.

Specially Adapted Housing

Veterans who have a service-connected disability may be eligible to receive a Veterans Administration grant toward the cost of a specially adapted housing unit. A free pamphlet, *Questions and Answers on Specially Adapted Housing for Veterans*, is available. Contact the nearest regional VA office, or: Department of Veterans Benefits, Veterans Administration, 810 Vermont Ave. N.W., Room 367, Washington, DC 20420/202-389-2332.

State Cemetery Grants

Veterans Administration makes grants to states for the establishment, expansion and improvement of state veterans' cemeteries. Contact: State Cemetery Grants, Department of Memorial Affairs, Veterans Administration, 810 Vermont Ave. N.W., Room 275H, Washington, DC 20420/202-389-2313.

Statistical Reporting

The Automated Management Information System (AMIS) is an agency-wide system designed to meet the VA statistical reporting needs. Contact: Management Information, Controller, Veterans Administration, 810 Vermont Ave. N.W., Room 522, Washington, DC 20420/202-389-3745.

Statistical Tables

Tables include statistics on veteran population (number, state, age, period of service), health care and extended care, hospital care, inpatient and ambulatory care, VA and non-VA facilities, pharmacy activity, construction, guardianship and veterans assistance, compensation and pension, national cemetery system, compensation pension, educational assistance, housing assistance, insurance, personnel, employment of minority groups and women, and appeals. These statistical tables appear in the VA annual report. For further information, contact: Reports and Statistical Service, Controller, Veterans Administration, 810 Vermont Ave. N.W., Room 518, Washington, DC 20420/202-389-2423.

Toll-Free Benefits Information

VA benefits information is available all across the country from a Veterans Benefit Counselor. Other sources that provide information about veterans benefits are service organizations and state and local office of Veterans Affairs. See the listing of VA facilities in the white pages of the telephone directory, or call: Information, Veterans Administration, 810 Vermont Ave. N.W., Room 906, Washington, DC 20420/202-389-2741.

Veterans Benefits for Older Americans

Veterans benefits and services available to older Americans include medical care, disability

compensation, disability pension, insurance, death pension, dependency and indemnity compensation, reimbursement of burial expenses, burial in a national cemetery, a burial flag, and a headstone or grave marker. Contact the nearest regional VA office, or: Department of Veterans Benefits, Veterans Administration, 810 Vermont Ave. N.W., Room 311, Washington, DC 20420/202-389-5210.

Veterans Benefits, Inside . . . Outside

This is a brief publication on VA benefits for veterans in prison and parolees. Prisoners may get information from prison officials or VA representatives who visit their institutions. The publication is available from the VA regional offices, or from: Publications Service, Veterans Administration, 810 Vermont Ave. N.W., Room C2, Washington, DC 20420/202-389-3056.

Vocational Rehabilitation

Helps the service-disabled veteran select, prepare for and secure work. Service and benefits include: educational and vocational counseling; education or training to qualify for a skilled position or profession; tutorial assistance, reader service, or other special help in training; medical and dental treatment, prosthetic aids, special equipment, and special restorative services, as necessary to enter and stay in training; and job placement and job adjustment help after completing training. Contact: Education and Rehabilitation Service, Department of Veterans Affairs, Veterans Administration, 810 Vermont Ave. N.W., Room 444C, Washington, DC 20420/202-389-5154.

Voluntary Service

The Veterans Administration encourages and trains medical volunteers. Contact: Voluntary Service, Department of Medicine and Surgery, Veterans Administration, Room 215, 1625 Eye St. N.W., Washington, DC 20420/202-389-5301.

Work-Study Program

Veterans enrolled full time in college degree, vocational or professional programs may "earn money while they learn" under the VA work-study program. Contact: Veterans Services Division of the nearest VA regional office, or: Education and Rehabilitation Service, Department of Veterans Benefits, Veterans Administration, 810 Vermont Ave. N.W., Room 444C, Washington, DC 20420/202-389-5154.

How Can the Veterans Administration Help You?

To determine how the Veterans Administration can help you, contact: Office of Management Services, Veterans Administration, 810 Vermont Ave. N.W., Washington, DC 20420/202-389-2073.

EXECUTIVE BRANCH

Executive Office of the President

1600 Pennsylvania Ave. N.W., Washington, DC 20500/202456-1414

ESTABLISHED: July 1, 1939
BUDGET: $101,241,000
EMPLOYEES: 1,897

MISSION: The Constitution povides that "the executive power shall be vested in a President of the United States of America. He shall hold his office during the Term of four years—together with the Vice President, chosen for the same Term." The President is the administrative head of the executive branch of the Government, which includes numerous agencies as well as 13 executive departments. The Cabinet functions at the pleasure of the President. Its purpose is to advise the President upon any subject on which he requests information. The Cabinet is composed of the 13 executive departments, and certain other executive branch officials to whom the President accords Cabinet rank.

Major Divisions and Offices

Central Intelligence Agency

Executive Office of the President, Washington, DC 20505/703-351-1100.
Budget: (classified)
Employees: (classified)
Mission: Advises the National Security Council in matters concerning such intelligence activities of the government departments and agencies as relate to national security; correlates and evaluates intelligence relating to the national security, and provides for the appropriate dissemination of such intelligence within the government.

Performs for the benefit of the existing intelligence agencies such as additional services of common concern the National Security Council determines can be more efficiently accomplished centrally;

Collects foreign intelligence, including information not otherwise obtainable, and develops, conducts, or provides support for technical and other programs which collect national foreign intelligence. (The collection of information within the United States is coordinated with the FBI);

Produces and disseminates foreign intelligence relating to the national security, including foreign political, economic, scientific, technical, military, geographic and sociological intelligence, to meet the needs of the President, the National Security Council, and other elements of the U.S. Government;

Collects, produces, and disseminates intelligence on foreign aspects of narcotics production and trafficking;

Conducts counterintelligence activities outside the United States and coordinates counterintelligence activities conducted outside the United States by other agencies within the intelligence community;

Without assuming or performing any internal security funtions, conducts counterintelligence activities within the United States, but only in coordination with the FBI;

Produces and disseminates counterintelligence studies and reports.

Council of Economic Advisors

Old Executive Office Building, Executive Office of the President, Washington, DC 20506/202-395-5084.
Budget: $2,102,000
Employees: 36
Mission: Analyzes the national economy and its various segments; advises the President on economic developments; appraises the economic programs and policies of the federal government; recommends to the President policies for economic growth and stability; and assists in the preparation of the economic reports of the President to the Congress.

National Security Council

Executive Office Building, Executive Office of the President, Washington, DC 20506/202-395-3440.
Budget: $3,658,000
Employees: 64
Mission: Advises the President with respect to the litigation of domestic, foreign and military policies relating to national security.

Office of Administration

Executive Office Building, Executive Office of the President, Washington, DC 20500/202-395-4980.
Budget: $8,105,000
Employees: 139
Mission: Provides administrative support services to all units within the Executive Office of the President, except those services which are in direct support of the President.

Office of Federal Procurement Policy

Office of Management and Budget, Executive Office Building, Washington, DC 20503/202-395-5802.
Budget: $3,000,000
Employees: 45
Mission: Responsible for improving the economy, efficiency and effectiveness of the procurement process by providing overall direction of procurement policies, regulations, procedures and forms.

Office of Management and Budget

Executive Office Building, Executive Office of the President, Washington, DC 20503/202-395-4840.
Budget: $36,899,000
Employees: 616
Mission: Assists the President in his program to develop and maintain effective government by reviewing the organizational structure and management procedures of the executive branch to insure that they are capable of producing the intended results; assists in developing interagency cooperation; assists the President in the preparation of the budget and the formulation of the fiscal program of the Government; supervises and controls the administration of the budget; assists the President by clearing and coordinating departmental advice in proposed legislation and by making recommendations as to Presidential action in legislative enactments, in accordance with past practice; assists in the development of regulating reform proposals and in programs for paperwork reduction, especially reporting burden of the public; assists in the consideration, clearance and preparation of proposed Executive orders and proclamation; plans and develops information system to provide the President with program performance data; and keeps the President informed of the program of activities by agencies of the government with respect to work proposed, work actually initiated, and work completed, together with the relative timing of work between the several agencies of the Government all to the end that the work programs of the several agencies of the executive branch of the government maybe coordinated and that the moneys appropriated by the Congress may be expended in the most economical manner.

Office of Policy Development

Executive Office of the President, 1600 Pennsylvania Ave. N.W., Washington, DC 20500/202-456-2562
Budget: $2,722,000
Employees: 64
Mission: Formulates and coordinates policy recommendations to the President; assesses national needs and coordinates the establishment of national priorities; recommends integrated sets of policy choices; provides a rapid response to presidential needs for policy advice on pressing domestic issues; and maintains a continuous review of on-going programs from a policy development standpoint.

Office of Science and Technology Policy

Executive Office of the President, Executive Office Building, Washington, DC 20500/202-456-7116.
Budget: $2,712,000
Employees: 24
Mission: Serves as a source of scientific, engineering and technological analysis and judgement for the President with respect to major policies, plans and programs of the federal government.

Office of the United States Trade Representative

Executive Office of the President, 600 17th St. N.W., Washington, DC 20506/202-395-4647.
Budget: $8,418,000
Employees: 116
Mission: Responsible for the direction of all trade negotiations of the United States and for the formulation of trade policy for the United States.

The White House Office

Executive Office of the President, 1600 Pennsylvania Ave., N.W., Washington, DC 20500/202-456-1414.
Budget: $18,973,000
Employees: 351

Mission: Serves the President in the performance of the many detailed activities incident to his immediate office; and facilitates and maintains communication with the Congress, the individual members of the Congress, the heads of the executive departments and agencies, the press and other information media, and the general public.

Major Sources of Information

Additional Key Executive Offices

Office of the Counselor to the President/202-456-2235
Office of the Chief of Staff/202-456-6797
Office of Consumer Affairs/202-456-7483
Office of the Deputy Chief/202-456-6475
Office of the Press Secretary/202-456-2100
Office of Legislative Affairs/202-456-2230
Office of Public Liaison/202-456-2270
Political Affairs Office/202-456-7620
Presidential Personnel Office/202-456-2335
Office of Intergovernmental Affairs/202-456-7007
Office of the Counsel to the President/202-456-2632
Intelligence Overnight Board/202-456-2352
Council on Environmental Quality/202-395-5700

Correspondence to these offices should be directed in care of: Executive Office of the President, 1600 Pennsylvania Ave. N.W., Washington, DC 20500.

Atlases and Maps

The following maps and atlases are sold by the Superintendent of Documents, Government Printing Office, Washington, DC 20402/202-783-3238. General multicolored reference maps of most foreign countries which identify major roads, population density, major industries, the location of natural resources or other specific features of the given country. These special maps, guides and atlases are also available. For more information contact: Central Intelligence Agency. Executive of the President, Washington, DC 20505/703-351-7676.

China Map, Pinyin Edition.

This is a one-page multi-colored map which incorporates the new Pinyin (phonetic alphabet) spelling of names that became effective on January 1, 1979. The gazetteer on the reverse side of the map includes both the Pinyin and Wade-Giles renditions of geographic names. Most linear, spot location and name data were computer generated and plotted by the CIA's Cartographic Automated Mapping Program and World Data Bank II.

Leningrad Street Guide.

This guide provides a pocket-size book which shows transportation features, dom (plat) numbers, and points of interest on maps of Greater Leningrad, 1:35,000 scale, Central Leningrad, 1:15,000 scale, and the Pushkin area, 1:15,000, south of Leningrad. Each map page includes overlap with the adjoining pages for ease or orientation from page to page. A complete index and glossary are included at the back of the guide.

Moscow Guide.

A pocket-size map guide depicting Greater Moscow at a scale of 1:35,000 and Central Moscow at 1:15,000. Streets, railroads, Metro stations, dom (plat) numbers and points of interest are shown at both scales. A map of Metro lines and a complete index and glossary are included for easy reference.

Indian Ocean Atlas.

Issued by the Central Intelligence Agency, this colorful publication goes beyond the scope of a conventional atlas by providing a wide variety of economic, historical and cultural data in addition to the usual geographic information. In the interest of simplicity and clarity, it employs a number of innovative graphic techniques as well as standard regional and thematic maps, charts and photographs. It is designed as an introduction and general reference aid for those interested in the natural environment, resources, shipping and political relationships of the Indian Ocean and its islands.

Atlas of Issues in the Middle East.

Hostility among ethnic, religious and traditional groups constantly threatens the Middle East, and at times erupts into open warefare. The issues in the Middle East that set peoples and nations against one another are numerous, complex, and diverse. Some are recent, but the origins of others may be traced thousands of years into the past. This atlas, by maps, charts, photographs and brief texts, highlights the critical issues and provides basic geographic, sociological and economic perspectives of the area.

People's Republic of China, Administrative Atlas.

Publication measures 10 × 14 in.

Polar Regions Atlas.

This atlas describes the developments taking place in the polar regions, both Arctic and Antarctic. It covers discovery and exploration, climate, physical features, natural resources, transportation and other informmation relating to the regions.

U.S.S.R. Agriculture Atlas.

This Central Intelligence Agency book, complete with comprehensive statistics, examines Soviet agriculture, its role in their economy, and the policies that govern it. Sources include studies by Russian agronomists and geographers, as well as official government reports. The book deals with Soviet technology, irrigation and drainage systems, land use, and erosion control. It analyzes the Russian system of farming and discusses the status of the country's top agricultural produts, including corn, rice and oats. It also compares the Soviet system with ours.

Maps of the World's Nations:

Publications measure 10 × 14 in.

Vol. 1, Western Hemisphere. Shows the boundaries and principal cities, rivers and roads of each of the Western Hemisphere's nations on individual color maps.
Vol. 2, Africa. Provides a one-page color map of each of Africa's nations, showing major cities, roads and bodies of water. Includes a diagram illustrating the size of each country in relation to the United States and a brief summary of basic geographic data.

Catalog of Federal Domestic Assistance.

Designed to assist in identifying the types of federal domestic assistance available, describing eligiblity requirements for the particular assistance being sought, and providing guidance on how to apply for specific types of assistance. Also intended to improve corrdination and communication between the federal government and state and local governments.

Subscription service includes supplementary material for an indterminate period. It is available for $20.00 from the Superintendent of Documents, Government Printing Office, Washington, DC 20402/202-703-3238. For additional information contact: Office of Management and Budget, Executive Office of the President, Executive Office Building, Washington, DC 20402/202-395-7250.

Consumer Complaint Referral Center

If you need to know which organization can help you with your consumer complaint, contact: Office of Consumer Affairs, 1009 Premiere Building, Washington, DC 20201/202-634-4329.

Consumer Newsletter

The *Consumer Action Update* is published twice monthly to inform American consumers of current and pending legislation and regulation and is available *free* from Office of Consumer Affairs, 1009 Premiere Building, Washington, DC 20201/202-634-4140.

Guide to Publications of the Executive Office of the President

A free quarterly listing the publications issued by the agencies of the Executive Office of the President and available to the public. Publications of different agencies are also listed. Contact: Publications Management and Records Branch, Office of Administration, Executive Office of the President, New Executive Office Building, Room G-236, Washington, DC 20500/202-395-7332.

Legislative Information

To find out if and when the President signed a piece of legislation into law, contact: *Executive Clerks Office,* The White House, Washington, DC 20500/202-456-2226, or contact: Office of Legislative Affairs, Executive Office of the President, 1600 Pennsylvania Ave. N.W., Washington, DC 20500/202-456-2230.

Middle East Maps

These two maps are available for $3.50 each:

The Middle East—a single-sheet colored reference map, 1:4,500,000 scale, showing status of international boundaries, cities by population category, railroads, roads, airfields, terrain features and bathmyetry. 39 × 36 in.
Middle East Area: Oilfields and Facilities—focusing on an issue of high international interest and concern, this map shows oilfields, pipelines, tanker terminals and refineries against a terrain background. The map is multi-colored and a scale of 1:4,500,000. 39 × 36 in.

Contact: Government Printing Office, Superintendent of Documents, Washington, DC 20402/202-783-3238. For additional information contact: Central Intelligence Agency, Executive Office of the President, Washington, DC 20505/703-351-7676.

Mrs. Reagan's Daily Schedule, see page 845.

Mrs. Reagan's Daily Schedule, see page 845.

Office of the Vice President

For information on the office of the Vice President, contact: Press Secretary, Office of the Vice

President, Executive Office, Office of the President, Exeutive Office Building, Washington, DC 20501/202-456-7123.

President Reagan's Daily Schedule, see below.

Public Papers of the Presidents
The following four volumes are part of a series containing documents from specified periods of the Presidency. They include in chronological order the inaugural addresses, statements, executive orders, announcements, nominations, public letters, press conferences, and so on. In addition, weekly digests contain the President's daily public schedule, lists of nominations submitted to the Senate, checklists of White House press releases, and lists of acts approved by the President.

Gerald R. Ford: Book I—January 1 to April 9, 1976 ($18.00)
Gerald R. Ford: Book II—April 9 to July 9, 1976 ($18.00)
Gerald R. Ford: Book III—July 10, 1976 to January 20, 1977 ($18.00)
Jimmy Carter: Book II—June 30 to December 31, 1978 ($23.00)

For additional information and a list of other volumes in the series contact: Superintendent of Documents, Government Printing Office, Washington, DC 20402/202-783-3238.

Publications/CIA
For copies of the General Report of the President or the Trade Agreements Program, contact: Office of the Trade Representatives, Executive Office of the President, 1800 G St. N.W., Washington, DC 20506/202-395-5123.

Publications/Council of Economic Advisors
Reports issued by the Council are available to the public through the Superintendent of Documents, Government Printing Office, Washington, DC 20402/202-783-3238.

Economic Report of the President, Together with the Annual Report of the Council of Economic Advisers Report on Indexing Federal Programs

For additional information contact: Council of Economic Advisors, Old Executive Office Building, Washington, DC 20506/202-395-5108.

Publications/National Security
For any publications available to the public contact: National Security Council, Executive Office of the President, Old Executive Office Building, Washington, DC 20506/202-395-4974.

Publications/OMB
This office issues numerous publications related to the budget and the government's fiscal program. For a history of these contact: Office of Management and Budget, Executive Office of the President, Old Executive Office Building, Washington, DC 20503/202-395-7097.

Publications/President
For publications issued by this office contact: Office of Policy Development, Executive Office of the President, 1600 Pennsylvania Ave. N.W., Washington, DC 20500/202-456-6402.

President Reagan's Daily Schedule
A recorded message provides the daily schedule of the President. Call: 202-456-2343 or contact: Director of Scheduling, Office of the Deputy Chief of Staff, Executive Office of the President, 1600 Pennsylvania Ave. N.W., Washington, DC 20500/202-456-7560.

Mrs. Reagan's Daily Schedule
A recorded message provides the daily schedule of the First Lady. Call 202-456-6269. For additional information contact: Scheduling Director, Staff for the First Lady, Office of the Deputy Chief of Staff, Executive Office of the President, 1600 Pennsylvania, N.W., Washington, DC 20500/202-456-7910.

Science and Technology Policy Publications
Scientific engineering and technological analyses are issued regarding major policies, plans and programs of the federal government. Contact: Publications, Office of Science and Technology Policy, Executive Office of the President, New Executive Office Building, Washington, DC 20500/202-395-3840.

Unclassified CIA Publications
Unclassified CIA reports and maps are made available to the public. The reports detail foreign government structures, trade patterns, economic conditions and industries. For additional information and lists of CIA publications, contact: Central Intelligence Agency, Executive Office of the President, Washington, DC 20505/703-351-7676.

White House Publications
For information on White House publications contact: Office of the President, 1600 Pennsylvania Ave. N.W., Washington, DC 20500/202-395-7332.

Women Scientists in Industry and Government, How Much Progress in the 1970's?
Document sales is available at: National Tech-

nical Scientific Service (NTIS), Department of Commerce, 5285 Port Royal Rd., Springfield, VA 22161/703-487-4650. For additional information contact: Office of Science and Technology Policy, Executive Office Building, Washington, DC 20500/202-395-3840.

World Data Bank II

This cartographic data base, produced by the Central Intelligence Agency, represents natural and manmade features of the world in a digital format. Also available is the (ALC) program that performs a wide variety of cartographic functions and can be used in conjunction with World Data Bank II. Both the World Data Bank II and the Cartographic Automatic Mapping Program can be obtained from the *National Technical Information Service*, Department of Commerce, 5285 Port Royal Rd., Springfield, VA 22161/703-487-4650.

National Basic World Intelligence Factbook

This is a compilation of basic data on political entities world-wide and is coordinated and pub-

lished January and July. It is available for $8.50 from the Superintendent of Documents, Government Printing Office, Washington, DC 20402/202-783-3238. For additional information contact: Central Intelligence Agency, Executive Office of the President, Washington, DC 20505/703-351-7676.

World Oil Market in the Year Ahead

This report analyzes the outlook for the world oil market in the near future and briefly examines longer-term trends. This report is available for $4.50 from the Superintendent of Documents, Government Printing Office, Washington, DC 20402/202-783-3238. For additional information contact: Public Affairs, Central Intelligence Agency, Executive Office of the President, Washington, DC 20505/703-351-7676.

How Can the Executive Office of the President Help You?

To determine how this office can help you contact: The White House, 1600 Pennsylvania Ave. N.W., Washington, DC 20500/202-456-1414.

JUDICIAL BRANCH

Judicial Branch
(No Central Office)

ESTABLISHED: September 24, 1789
BUDGET: $623,769,000
EMPLOYEES: 14,117

MISSION: The judicial power of the United States shall be vested in one supreme court, and in such inferior courts created by the Congress of the United States.

Major Divisions and Offices

Supreme Court of the United States

Supreme Court Building, 1 First St. N.E., Washington, DC 20543/202-252-3000.
Budget: $12,921,000
Employees: 325
Mission: The judicial power extends to all cases, in law and equity, arising under the Constitution, the laws of the United States, and Treaties made, or which shall be made under their authority; to all cases affecting ambassadors; other public ministers and counsels; to all cases of admiralty and maritime jurisdiction; to controversies to which the United States shall be a party; to controversies between two or more states; between a state and citizens of another state; between citizens of different states, between citizens of the same state claiming lands under grants of different states; between a state, or the citizens; the Supreme Court has appelate jurisdiction, both as the law and fact.

Courts of Appeals and District Courts

c/o Administration Office of the United States Courts, Washington, DC 20544/202-633-6097
Budget: $567,425,000
Employees: 12,385
Mission: District courts are the trial courts with general federal jurisdiction. Each state has at least one district court. Courts of appeals are intermediate appellate courts created to relieve the Supreme Court of considering all appeals in cases originally decided by the federal trial courts.

United States Court of Claims

717 Madison Place N.W., Washington, DC 20005/202-633-7257

Budget: $5,469,000
Employees: 114
Mission: Renders judgment upon any claim against the United States founded upon the Constitution, upon any act of Congress, upon any regulation of an executive Department, upon any expressed or implied contracts with the United States, and for liquidated or unliquidated damages in cases not sounding in tort.

United States Court of International Trade

1 Federal Plaza, New York, NY 10007/212-264-2814
Budget: $5,091,000
Employees: 112
Mission: Exclusive jurisdiction of civil actions arising under the tariff laws including those involving the appraised value of imported merchandise; classification and rate and amount of duties chargeable; exclusion of merchandise from entry of delivery under any provisions of customs laws; liquidation or reliquidation of an entry, or a modification thereof; refusal to pay a claim for drawback; or refusal to reliquidate on entry.

United States Court of Customs and Patent Appeals

717 Madison Place N.W., Washington, DC 20439/202-633-6550
Budget: $1,719,000
Employees: 36
Mission: Jurisdiction is nationwide and includes: Appeals from the U.S. Customs Court, appeals from the U.S. Patent and Trademark Office, appeals from the U.S. International Trade Commis-

sion, appeals from the Secretary of Commerce under the Educational, Scientific, and Cultural Materials Importation Act, appeals from the Secretary of Agriculture under the Plant Variety Protection Act, and petition for extraordinary writs under the All Writs Act.

Administrative Office of the United States Courts

811 Vermont Ave. N.W., Washington, DC 20544/202-633-6096.
Budget: $15,847,000
Emloyees: 490
Mission: Supervises all administrative matter re-

lating to the offices of clerks and other clerical and administrative personnel of the courts.

United States Tax Court

4000 2nd St. N.W., Washington, DC 20217/202-376-2754
Budget: $9,751,000
Employees: 221
Mission: Tries and adjudicates controversies involving the existence of deficiencies or overpayments in income, estate, gift, and personal holding company surtaxes in cases where deficiencies have been determined by the Commission of the Internal Revenue.

Major Sources of Information

Annual Report of the Director of Administrative Office of the United States Courts

This report provides detailed text and tables on the business of all the federal courts (except the U.S. Court of Military Appeals and the U.S. Tax Courts). It is available for $8.00 from the Superintendent of Documents, Government Printing Office, Washington, DC 20402. For additional information contact: Administrative Office of the United States Courts, 811 Vermont Ave. N.W., Washington, DC 20544/202-633-6097.

Bankruptcy

The Administrative Office maintains general supervision for the bankruptcy courts. Information on filing fees, preparation and audit of bankruptcy forms, and interpretations of Bankruptcy Act or rules is available. Contact: Bankruptcy Division, Administrative Office of the U.S. Courts, 811 Vermont Ave. N.W., Room 1050, Washington, DC 20544/202-633-6234.

Bench Book

The *Bench Book for United States District Court Judges* is a reference source containing material derived from statutes, and suggestions, recommendations, and reference material useful to judges in the conduct of judicial proceedings. The Bench Book is prepared by the Center under the guidance of experienced district judges and is distributed only to federal judges and magistrates. Contact: Inter-Judicial Affairs and Information Service Division, Federal Judicial Center, 1520 H St. N.W., Washington, DC 20005/202-633-6365.

Constitution of the United States of America: Analysis and Interpretation

This publication provides the text of the Con-

stitution and its amendments preface annotations of those Supreme Court decisions which have a bearing on the say the Constitution is interpreted. It is available for $28.60 from the Superintendent of Documents, Government Printing Office, Washington, DC 20402/202-783-3238. For additional information contact: Supreme Court of the United States, Supreme Court Building, 1 1st St. N.E., Washington, DC 20543/202-252-3000.

Court Reports and Statistics

Reports and statistics are available on bankruptcy, appeal, criminal, civil and trial cases filed, terminated and pending in each district court. An annual wiretap report, speedy trial and court management statistics are also available. For additional information contact: Statistical Analysis and Reports Division, Administrative Office of the United States Courts, 811 Vermont Ave. N.W., Room 671, Washington, DC 20544/202-633-6094.

District Court Publications

Rules of Civil Procedure for the United States District Courts, With Forms—contains the Rules of Civil Procedure for U.S. District Courts as promulgated and amended by the Supreme Court to October 1, 1977, together with the forms adopted by the Court ($2.00).

Rules of Criminal Procedure for the United States District Courts, With Forms—contains the Rules of Criminal Procedure for the U.S. District Courts, together with forms as amended to October 1, 1979 ($3.00).

Federal Rules of Evidence—sets forth Rules of Evidence for use in proceedings in the courts of the U.S. and before U.S. magistrates ($1.75).

Federal Rules of Appellate Procedure—contains the

Federal Rules of Appellate Procedure as promulgated and amended by the U.S. Supreme Court to October 1, 1979, together with the forms adopted by the Court ($2.00).

These publications are sold by the Superintendent of Documents, Government Printing Office, Washington, DC 20402/202-783-3238.

Federal Defenders

The Criminal Justice Act provides for the establishment of Federal Public Defender and Federal Community Defender Organizations by the District Courts in districts where at least 200 persons annually require the appointment of counsel. Defender organizations provide annual reports of their activities to the administrative office. Contact: Administrative Office of the United States Courts, 811 Vermont Ave. N.W., Washington, DC 20544/202-633-6097.

Federal Judicial Center

The Center is the research, development and training arm of the federal judicial system. It also provides continuing education on a wide range of subjects for federal judicial personnel. For additional information contact: Federal Judicial Center, 1520 H St. N.W., Washington, DC 20005/202-633-6011.

Federal Judicial Center Information Service

The collection contains material on all areas of federal judicial administration. The subjects cover court management, civil and criminal procedure, constitutional law and probabilities. For information contact: Federal Judicial Center, 1520 H St. N.W., Washington, DC 20005/202-633-6011.

Federal Magistrates

The Administrative office supervises the administration of the offices of the U.S. magistrates. Statistical and other information on these offices is provided annually to Congress. For additional information contact: Magistrates Division, Administrative Office of the U.S. Courts, 811 Vermont Ave. N.W., Washington, DC 20544/202-633-6097.

Foreign Visitor Service

The Center assembles materials, conducts briefings and makes appropriate arrangements for official visitors from abroad (judges, legislators, legal officers and others). Contact: Inter-Judicial Affairs and Information Services Division, Federal Judicial Center, 1520 H St. N.W., Washington, DC 20005/202-633-6365.

Handbook for Federal Judges' Secretaries

This handbook contains suggestions for office procedures. It describes the organization and process of the federal courts. Contact: Inter-Judicial Affairs and Information Services Division, Federal Judicial Center, 1520 H St. N.W., Washington, DC 20005/202-633-6365.

Judicial Panel on Multidistrict Litigation

This panel consists of seven federal judges, authorized to temporarily transfer to a single district, for coordinated or consolidated pretrial proceedings, civil actions pending in different districts which involve one or more common questions of fact. Contact: Clerk of the Panel, Judicial Panel on Multidistrict Litigation, 1100 Vermont Ave. N.W., Washington, DC 20002/202-653-6090.

Library of the Supreme Court of the United States

The library maintains a complete working collection of American, English and Canadian statutes; records and briefs dating back to 1832; a collection of federal tax laws; legislative histories of selected federal acts and other historical and constitutional documents. The library is open to public use. Contact: Supreme Court of the United States Library, 1 1st St. N.E., Washington, DC 20543/202-252-3177.

Probation Officer

The Administrative Office supervises the accounts and practices of federal probation offices. *Federal Probation* is a quarterly journal of correctional philosophy and practice. For additional information contact: Probation Division, Administrative Office of the United States Courts, 811 Vermont Ave. N.W., Room 669, Washington, DC 20544/202-633-6226.

Publications—Federal Judicial Center

Federal Judicial Center publications report the results of research and analysis done by or for the Center, as well as the products of the Center's seminars and workshops. They include research reports and staff papers, manuals and handbooks, and catalogs and other related material. For a publications catalog and for further information contact: Federal Judicial Center, 1520 H St. N.W., Washinton, DC 20005/202-633-6365.

Regional Depositories

There are over 20 regional depositories of Supreme Court records. For further information on their locations contact: Clerk's Office, Supreme Court of the United States, 1 1st St. N.E., Washington, DC 20543/202-252-3029.

Supreme Court Document Copies

Supreme Court documents may be copied either at the Library, Supreme Court of the United States, 1 1st St. N.E., Washington, DC 20543/202-252-3177, or, to obtain copies of Supreme Court documents in the mail, contact: Photoduplication Service, Library of Congress, Washington, DC 20540/202-287-5640.

Supreme Court Information

Information from the Clerk's Office includes the status of pending cases, docket sheet information about briefs filed, and information about admissions to the Supreme Court bar. The office also distributes court opinions. Contact: Clerk's Office, Supreme Court, 1 1st St. N.E., Washington, DC 20543/202-252-3029.

Supreme Court Publications

Daily Journal of the Supreme Court of the United States—a journal of the action taking place in the Supreme Court each day. The subscription is $49.00 a term of Court.

Individual Slip Opinions—all the Court's opinions as announced from the bench. These are issued irregularly and are available for $140.00 a term of Court.

Preliminary Prints (advance parts)—official United States Reports containing all the opinions with syllabi, names of counsel, indices, tables of cases, and other editorial additions. These are issued irregularly and are available for $50.00 a term of Court.

For additional information contact: Information, Supreme Court of the United States, Supreme Court Building, 1 1st St. N.E., Washington, DC 20543/202-252-3211.

Temporary Court of Appeals

The court has exclusive jurisdiction of all appeals from the district courts of the United States in cases and controversies arising under the economic stabilization laws, and consists of eight district and circuit judges designated by the Chief Justice. For additional information contact: Clerk, Temporary Emergency Court of Appeals, United States Courthouse, Washington, DC 20001/202-426-7666.

Territorial Courts

Congress has established district courts in the Commonwealth of Puerto Rico, and in the Territories of Guam, the Virgin Islands, the former Canal Zone and the Northern Mariana Islands.

For additional information contact: Administrative Office of the United States Courts, United States Supreme Court Building, Washington, DC 20544/202-633-6097.

The Third Branch

The Third Branch is a monthly bulletin for the federal courts. It reports to the federal judicial community and other interested parties on the work of the Judicial Conference and its committees, policies and projects of the Center and the Administrative Office, innovations undertaken in various courts, and legislative developments. *The Third Branch* also provides a monthly update of changes in federal judicial personnel. For further information contact: Center Information Services Office, Federal Judicial Center, 1520 H St. N.W., Washington, DC 20005/202-633-6365.

U.S. Court of Military Appeals

The Court, consisting of three civilian judges appointed by the President, is called upon to exercise jurisdiction as to questions of law in all cases:

Affecting a general or flag office or extending to death;

Certified to the Court by the Judge Advocates General of the armed services, and by the General Counsel of the Department of Transportation, acting for the Coast Guard;

Petitioned by accused who have received a sentence of a year or more confinement and/or a punitive discharge.

For additional information contact: Clerk, Court of Military Appeals, 450 E St. N.W., Washington, DC 20442/202-693-7100.

U.S. Tax Court Reports

Each monthly issue is a consolidation of the decisions for a month. The yearly subscription, at $26.00, is available from the Superintendent of Documents, Government Printing Office, Washington, DC 20402/202-783-3238. For additional information contact: United States Tax Court, 400 2nd St. N.W., Washington, DC 20217/202-376-2754.

How Can The Judicial Branch Help You?

To determine how this branch of government can help you contact: Public Information, Supreme Court of the United States, 1 1st St. N.E., Washington, DC 20543/202-252-3211.

LEGISLATIVE BRANCH

Congress

(No Central Office)

ESTABLISHED: September 17, 1787
BUDGET: $1,293,501,000
EMPLOYEES: 38,133
MISSION: All legislative powers are vested in the Congress of the United States, which consists of the Senate and House of Representatives.

The Senate

The Capitol, Washington, DC 20510/202-224-2115

BUDGET: $217,287,000
EMPLOYEES: 7,000
MISSION: The Senate is composed of 100 members, 2 from each State, who are elected to serve for a term of six years. One-third of the Senate is elected every two years.

Senate Special Committee on Aging

G-233 Dirksen Senate Office Building, Washington, DC 20510/202-244-5364.
Jurisdiction: Problems and opportunities of older people, including: health, income, employment, housing and care. The Committee must make annual reports to the Senate describing its studies and giving recommendations. (The Committee has no subcommittees.)

Senate Committee on Agriculture, Nutrition and Forestry

322 Russell Senate Office Building, Washington, DC 00510/202-224-2035.
Jurisdiction: Agriculture, livestock, meat, agricultural products, animal industry and diseases, pests and pesticides, forests and forestry, home economics, soils, farm credit and from security, rural affairs, human nutrition and school nutrition programs, food stamp programs and foods from fresh water, food and hunger.
Subcommittee:

Agricultural Credit and Rural Electrification
Agricultural Production, Marketing and Stabilization of prices

Agricultural Research and General Legislation
Rural Development, Oversight and Investigations
Foreign Agricultural Policy
Nutrition/202-224-6901.
Soil and Water Conservation

The subcommittees can be reached at 202-234-2035 unless otherwise stated.

Senate Committee on Appropriations

S-128 Capitol, Washington, DC 20510/202-224-3471.
Jurisdiction: The federal government's revenue, decision of appropriations, new spending and appropriations other than budgetary matters which are handled by the Budget Committee
Subcommittees:

Agriculture, Rural Development, and Related Agencies/202-224-7240
Defense/202-244-7255
District of Columbia/202-244-2731
Foreign Operations/202-244-7274
HUD—Independent Agencies/202-224-7253
Interior and Related Agencies/202-224-7262
Labor, Health and Human Services, Education and Related Agencies/202-224-7283

855

Legislative Branch/202-224-7228
Energy and Water Development/202-224-7260
Military Construction/202-224-7271
State, Justice, Commerce, the Judiciary/202-224-7244
Transportation/202-224-0330
Treasury, Postal Service, General Government/202-224-2726.

Senate Committee on the Armed Services

212 Russell Senate Office Building, Washington, DC 20510/202-224-3871.
Jurisdiction: U. S. defense, including the Department of the Navy and the Department of the Air Force. Subjects studied include pay, promotion, retirement and other benefits, military research and development, weaponry, the Panama Canal and Selective Service System, national security aspects of nuclear energy, and naval petroleum reserves, except those in Alaska.
Subcommittees:

Military Construction/202-224-8631
Manpower and Personnel/202-224-9348
Tactical Warfare/202-224-8636
Strategic and Theatre Nuclear Forces/202-224-8635
Preparedness/202-224-8639

Senate Committee on Banking, Housing and Urban Affairs

5300 Dirksen Senate Office Building, Washington, DC 20510/202-224-7391
Jurisdiction: Banks, banking and financial institutions, financial aid to commerce and industry, deposit insurance, public and private housing, federal monetary policy, currency, notes, control of prices of commodities, rents and services, urban development and mass transit, economic stabilization, exports, nursing home construction, government contract renegotiations.
Subcommittees:

Housing and Urban Affairs/202-224-5404
Financial Institutions/202-224-7391
Rural Housing and Development/202-224-7391
Consumer Affairs/202-224-7391
Securities/202-224-7391
International Finance and Monetary Policy/202-224-0891
Economic Policy/202-224-7391

Senate Committee on the Budget

Room 203, Carroll Arms Building, 301 1st St. N.E., Washington, DC 20510/202-224-0642
Jurisdiction: Budget matters, effects of proposed legislation on the budget, tax expenditures and policies and the functions and duties of the Con

gressional Budget Office. (The Committee has no subcommittees.)

Senate Committee on Commerce, Science and Transportation

5202 Dirksen Senate Office Building, Washington, DC 20510/202-224-5115
Jurisdiction: Interestate commerce, transportation, regulation of interestate common carriers, merchant marine and navigation, the Coast Guard, inland waterways, communications, regulation of consumer products, standards and measurement, high safety, science, engineering and technology, nonmilitary aeronautical and space sciences, marine fisheries, coastal zone management, oceans, weather and atmospheric activities and sports.
Subcommittees:

Aviation/202-224-4852
Communications/202-224-8144
Consumer/202-224-5768
Merchant Marine/202-224-4766
Science, Technology and Space/202-224-8172
Surface Transportation/202-224-4852
Business, Trade and Tourism/202-224-2670

Senate Committee on Energy and Natural Resources

3104 Dirksen Senate Office Building, Washington, DC 20510/202-224-4971
Jurisdiction: Energy policy, regulation and conservation, solar energy, nonmilitary nuclear energy, naval oil reserves in Alaska, oil and gas, energy aspects of deepwater ports, hydroelectric power, coal, public lands and forests, national parks and wilderness, mining and minerals and territorial possessions of this country.
Subcommittees:

Energy, Conservation and Supply/202-224-0613
Energy Research and Development/202-224-4431
Energy and Mineral Resources/202-224-4236
Energy Regulation/202-224-5205
Public Lands and Reserved Water/202-224-5161
Water Power/202-224-2366

Senate Committee on Environment and Public Works

4204 Dirksen Senate Office Building, Washington, DC 20510/20224-6176
Jurisdiction: Environmental policy, research and development, ocean dumping, fisheries and wildlife, solid waste, water resources, flood control, water, air and noise pollution, public works, bridges and dams, highways and buildings in

Washington, DC.
Subcommittees:

Environmental Pollution
Water Resources
Transportation
Regional and Community Development
Nuclear Regulation
Toxic Substances and Environmental Oversight
The subcommittees can be reached at: 202-224-6167.

Senate Select Committee on Ethics

113 Carroll Arms Hotel, 1st and C St. N.E., Washington, DC 20510/202-224-2981
Jurisdiction: Improper conduct, violations of the law or violations of Senate rules by Senate members. The committee recommends disciplinary action, proposes new regulations and reports violations to federal and state authorities.

Senate Committee on Finance

2227 Dirksen Senate Office Building, Washington, DC 20510/202-224-4515
Jurisdiction: Social security, certain health programs, the deposit of public money, customs and duties, tariffs, revenue sharing.
Subcommittees:

Health
International Trade
Taxation and Debt Management
Social Security and Income Maintenance Programs
Energy and Agricultural Taxation
Economic Growth, Employment and Revenue Sharing
Estate and Gift Taxation
Oversight of the Internal Revenue Service Code
Pension Plans and Employee Fringe Benefits
Savings, Pensions and Investment Policy

The Subcommittees can be reached at: 202-224-4515.

Senate Committee on Foreign Relations

4229 Dirksen Senate Office Building, Washington, DC 20510/202-224-4651
Jurisdiction: Foreign policy and relations, treaties, U.S. boundaries, U.S. citizens abroad, foreign assistance, the United Nations, declarations of war and interventions abroad, diplomatic service, oceans, international activities of the Red Cross, international aspects of nuclear energy, foreign loans, international commerce, the World Bank, the International Monetary Fund, national security.
Subcommittees:

African Affiars/202-224-5481
Arms Control, Oceans and International Operations and Environment/202-224-4651
East Asian and Pacific Affairs/202-224-5481
European Affairs/202-224-5481
International Economic Policy/202-224-4192
Near East and South Asian Affairs/202-224-5481
Western Hemisphere Affairs/202-224-3866

Senate Committee on Governmental Affairs

3306 Dirksen Senate Office Building, Washington, DC 20510/202-224-4751
Jurisdiction: Some federal budget matters, organization of the federal executive branch, intergovernmental relations, government relations, municipal affairs of Washington, DC, federal civil service, postal service, census, the Archives, nuclear export policy and congressional organization.
Subcommittees:

Permanent Subcommittee on Investigations/202-224-3721
Intergovernment Relations/202-224-4718
Governmental Efficiency and the District of Columbia/202-224-4161
Federal Expenditures, Research and Rules/202-224-0211
Energy, Nuclear Proliferation, and Government Processes/202-224-9516
Civil Services, Post Office, and General Services/202-224-2254
Oversight of Government Management/202-224-5538
Congressional Operations and Oversight/202-224-3643

Senate Select Committee on Indian Affairs

6317 Dirksen Senate Office Building, Washington, DC 20510/202-224-2251

Senate Select Committee on Intelligence

Room G.308, Dirksen Senate Office Building, Washington, DC 20510/202-224-1700
Jurisdiction: Intelligence activities and programs, oversight over U.S. intelligence activities to ensure they conform with the U.S. Constitution and laws, the Central Intelligence Agency, Federal Bureau of Investigation, Defense Intelligence Agency, National Security Agency and appropriations for intelligence agencies and activities.
Subcommittees:

Legislation and the Rights of Americans
Budget

Collection and Foreign Operations
Analysis and Production

The subcommittees can be reached at: 202-224-1700.

Senate Committee on the Judiciary

2226 Dirksen Senate Office Building, Washington, DC 20510/202-224-5225
Jurisdiction: Judicial proceedings, constitutional amendments, federal courts and judges, local courts, U. S. statutes, national penitentiaries, monopolies, holidays, bankruptcy, muntiny, espionage and counterfeiting, boundary lines, civil liberties, patents, copyrights and trademarks, immigration and naturalization, appointment of representatives, claims against the United States, interstate compacts and government information.
Subcommittees:

Agency Administration/202-224-7703
Constitution/202-224-8191
Criminal Law/202-224-5617
Immigration and Refugee Policy/202-224-7878
Juvenile Justice/202-224-8171
Separation of Powers/202-224-6791
Regulatory Reform/202-224-3980
Courts/202-224-1674
Security and Terrorism/202-224-6136

Senate Committee on Labor and Human Resources

4230 Dirksen Senate Office Building, Washington, DC 20510/202-224-5375
Jurisdiction: Education, health, public welfare, labor, including wages and hours, child labor, arbitration, convict labor, foreign laborers, equal employment, handicapped persons, occupational safety and health, private pension plans, aging, student loans, agricultural colleges, Gallaudet College, Howard University and Saint Elizabeth's Hospital and domestic activities of the Red Cross.
Subcommittees:

Labor/202-224-5546
The Handicapped/202-224-6265
Education/202-224-2962
Employment and Productivity/202-224-6306
Aging, Family and Human Services/202-224-3491

Alcoholism and Drug Abuse/202-224-5630
Investigations and General Oversight/202-224-8789

Senate Committee on Rules and Administration

305 Russell Senate Office Building, Washington, DC 20510/202-224-6352
Jurisdiction: Meetings of Congress, attendance and qualifications of members, administration of the congressional offices, federal elections, corrupt practices, the U.S. Capitol, Library of Congress, the Smithsonian Institution, Botanic Gardens and the Government Printing Office. (The Committee has no subcommittees.)

Senate Select Committee on Small Business

424 Russell Senate Office Building, Washington, DC 20510/202-224-5175
Jurisdiction: Research and investigation into the problems of small businesses, and how Congress can help them.
Subcommittees:

Advisory and the Future of Small Business
Capital Formation and Retention
Export Promotion and Market Development
Government Procurement
Government Regulation and Paperwork
Innovation and Technology
Productivity and Competition
Urban and Rural Economic Development

The subcommittees can be reached at 202-224-5175.

Senate Committee on Veterans' Affairs

410 Russell Senate Office Building, Washington, DC 20510/202-224-9126
Jurisdiction: Veterans' rehabilitation, hospitals, medical care and treatment, national cemeteries, life insurance for the Armed Forces, petitions of war. (The Committee has no subcommittees.)

Senate Commission on Art and Antiquities

Capitol Building, Room S-411, Washington, DC 20510/202-224-2955.

Joint Committees and Commissions of the Congress

Joint Economic Committee

G-133 Dirksen Senate Office Building, Washington, DC 20510/202-224-5171.

Joint Committee on the Library

2418 Rayburn House Office Building, Washington, DC 20515/202-225-0392.

Commission on Security and Cooperation in Europe

H2-23 House Office Building, Annex #2, 2nd and D Sts. S.W., Washington, DC 20515/202-225-1901.

Joint Committee on Printing

Room S-151 Capitol Building, Washington, DC 20510/202-224-5241.

Joint Committee on Taxation

1015 Longworth House Office Building, Washington, DC 20515/202-225-3621.

Commission for the West Central Front of the U.S. Capitol

Room SB-15 Capitol Building, Washington, DC 20515.

The House of Representatives

The Capitol, Washington, DC 20515/202-225-7000

BUDGET: $337,378,000
EMPLOYEES: 12,500
MISSION: The House of Representatives comprises 435 representatives, the number representing each state as determined by population but every state is entitled to at least one representative. Members are elected by the people for two-year terms, all terms running for the same period.

House Committee on Agriculture

Room 1301 Longworth House Office Building, Washington, DC 20215/202-225-2171.
Jurisdiction: Agriculture, agricultural chemistry, colleges, economics and research, extension services, production, marketing and price stabilization, the animal industry and animal diseases, crop insurance and soil conservation, dairy industry, plants and seeds, farm credit and security, forestry, nutrition and home economics, livestock and meat inspections, rural electrification and development.
Subcommittees:

Conservation and Credit and Rural Development/202-225-1867
Cotton, Rice and Sugar/202-225-1867
Domestic Marketing, Consumer Relations and Nutrition/202-225-1867
Forests, Family Farms and Energy/202-225-8406
Livestock, Dairy and Poultry/202-225-8405
Research and Foreign Agriculture/202-225-8408
Tobacco and Peanuts/202-225-1867
Wheat, Soybeans and Feedgrains/202-225-2171

House Select Committee on Aging

712 House Office Building, Annex #1, Washington, DC 20515/202-225-9375
Jurisdiction: The Committee does not prepare legislation. Instead, it holds hearings on problems of the elderly, and submits findings to other committees. In addition, it oversees all federal programs that affect the elderly, such as food stamps, Medicare and Medicaid, and Social Security.
Subcommittees:

Health and Long-Term Care/202-255-2381
Housing and Consumer Interests/202-225-4242

Human Services/202-225-4348
Retirement Income and Employment/202-255-4045

House Committee on Appropriations

H-218, Capitol Building, Washington, DC 20515/202-225-2771
Jurisdiction: Appropriations to support the government, recisions of appropriations, new spending authority and unspent balances.
Subcommittees:

Agriculture and Rural Development Agencies/202-225-2638
Defense/202-225-2847
District of Columbia/202-225-5338
Energy and Water Development/202-225-3047
Foreign Aid Operations/202-225-2041
HUD: Independent Agencies/202-225-3241
Commerce; Judiciary; State; Justice/202-225-3351
Interior/202-225-3081
Labor; Health and Human Services and Education/202-225-3508
Legislative/202-225-5338
Military Construction/202-225-3047
Transportation/202-225-2141
Treasury, Postal Service, General Government/202-225-5834

House Committee on Armed Services

2120 Rayburn House Office Building, Washington, DC 20515/202-225-4151.
Jurisdiction: Defense, the Department of Defense, including the Armed Forces, defense facilities, benefits for members of the Armed Forces, the Selective Service, naval petroleum and oil share reserves.

Subcommittees:

Investigations/202-225-4221
Military Installations and Facilities/202-225-6703
Military Personnel and Compensation/202-225-7560,
202-225-7560
Procurement and Military Nuclear Systems/202-225-
7160
Readiness/202-225-7991
Research and Development/202-225-3168, 202-225-
6527
Seapower and Strategic and Critical Materials/202-
225-4421, 202-225-6704

House Committee on Banking, Finance and Urban Affairs

2129 Rayburn House Office Building, Washington, DC 20515/202-225-4247
Jurisdiction: Banks and banking, money and credit, urban development, housing, economic stabilization, defense production, renegotiation, price and rent controls, financial aid to commerce and industry, international financial and monetary organizations.
Subcommittees:

Consumer Affairs and Coinage/202-225-9181
Domestic Monetary Policy/202-225-7315
Economic Stabilization/202-225-7145
Financial Institutions Supervision, Regulation and Insurance/202-225-2924
General Oversight and Renegotiation/202-225-2828
Housing and Community Development/202-225-7054
International Development Institutions and Finance/202-225-2495
International Trade, Investment and Monetary Policy/202-225-1271

House Committee on the Budget

Room 214, House Annex #1, Washington, DC 20515/202-225-7200.
Jurisdiction: The budget and relevant legislation, tax expenditures, policies and programs.
Task Forces:

Economic Policy and Productivity
Enforcement Credit and Multi-Year Budgeting
Energy and Environment
Entitlements, Uncontrollables and Indexing
Human Resources and Block Grants
National Security and Veterans
Tax Policy
Transportation, Research and Development
Reconciliation

The task forces can be reached at 202-225-7200

House Committee on the District of Columbia

1310 Longworth House Office Building, Washington, DC 20515/202-225-4457.
Jurisdiction: Municipal affairs of Washington, DC, including courts, public health, safety and sanitation, taxes, food and drugs, societies, insurance, wills and divorces and Saint Elizabeth's Hospital.
Subcommittees:

Fiscal and Health Affairs/202-225-4457
Government Operations and Metropolitan Affairs/202-225-1615
Judiciary and Education/202-225-1612

House Committee on Education and Labor

Room 2181, Rayburn House Office Building, Washington, DC 20515/202-225-4527.
Jurisdiction: Education and labor, including: convict labor, child labor, foreign laborers, wages and hours, work incentive programs, the Columbia Institution for the Deaf, Dumb and Blind, Howard University and Freedman's Hospital.
Subcommittees:

Elementary, Secondary and Vocational Education/202-225-4368
Employment Opportunities/202-225-1927
Health and Safety/202-225-6876
Human Resources/202-225-1850
Labor-Management Relations/202-225-5768
Labor Standards/202-225-5331
Postsecondary Education/202-225-8881
Select Education/202-225-5954

House Committee on Energy and Commerce

2125 Rayburn House Office Building, Washington, DC 20515/202-225-2927
Jurisdiction: Interstate and foreign commerce, waterways, oil compacts, petroleum and natural gas, railroads, communications, transmission of power, securities and exchanges, consumer affairs, travel and tourism, public health and health facilities, biomedical research and development.
Subcommittees:

Energy, Conservation and Power/202-226-2424
Fossil and Synthetic Fuels/202-226-2500
Health and the Environment/202-225-4952
Oversight and Investigations/202-225-4441
Telecommunications, Consumer Protection and Finance/202-225-9304
Transportation, Commerce and Tourism/202-225-1467

House Committee on Foreign Affairs

2170 Rayburn House Office Building, Washington, DC 20515/202-225-5021.
Jurisdiction: U. S. foreign relations, embassies, national boundaries, foreign loans, international meetings, interventions and declarations of war, diplomatic service, U. S. business abroad, U. S. citizens abroad, the Red Cross, United Nations, international economic policy, export controls, international commodity agreements and education.
Subcommittees:

Africa/202-225-3157
Asian and Pacific Affairs/202-225-3044
Europe and the Middle East/202-225-3345
Inter-American Affairs/202-225-9404
International Economic Policy and Trade/202-225-3246
International Operations/202-225-3424
International Organizations/202-225-5318
International Security and Scientific Affairs/202-225-8926

House Committee on Government Operations

2157 Rayburn House Office Building, Washington, DC 20515/202-225-5051
Jurisdiction: Budget and accounting measures other than appropriations, the economy and government efficiency, federal procurement, executive branch reorganization, intergovernmental relations, revenue sharing, the National Archives, the Freedom of Information Act and the Privacy Act.
Subcommittees:

Commerce, Consumer and Monetary Affairs/202-225-4407
Environment, Energy and Natural Resources/202-225-6427
Government Activities and Transportation/202-225-7920
Government Information and Individual Rights/202-225-3741
Intergovernmental Relations and Human Resources/202-225-2548
Legislation and National Security/202-225-5147
Manpower and Housing/202-225-6751

House Committee on House Administration

H-326 Capitol Building, Washington, DC 20515/202-225-2061.
Jurisdiction: The House contingent fund, House

employees, House buildings and facilities, travel and campaign fundraising of House members, the Library of Congress, Botanic Gardens and Smithsonian Institution, the Congressional Record and federal elections.
Subcommittees:

Accounts/202-225-7884 or 202-225-7885
Contracts and Printing/202-225-2444 or 202-225-4631
Office Systems/202-225-1608
Personnel and Police/202-225-7552

House Permanent Select Committee on Intelligence

H-405 Capitol Building, Washington, DC 20515/202-225-4121.
Jurisdiction: The Committee has oversight and legislative authority over the federal intelligence community including the CIA, the National Security Administration, the Department of Defense's intelligence activities and the counterintelligence activities of the FBI. In addition, it authorizes the annual budget for each intelligence agency.
Subcommittees:

Evaluation and Oversight/202-225-5657
Legislation/202-225-7310
Program and Budget Authorization/202-225-7690

House Committee on Interior and Insular Affairs

1324 Longworth House Office Building, Washington, DC 20515/202-225-2761.
Jurisdiction: Forests and national parks, geological survey, irrigation and reclamation, Indians, United States insular possessions, military parks and battlefields, national cemetaries, mining and minerals, public lands and prehistoric ruins.
Subcommittees:

Energy and the Environment/202-225-8331
Insular Affairs/202-225-9297
Mines and Mining/202-225-1661
Oversight and Investigations/202-225-2196
Public Lands and National Parks/202-225-6044, 202-225-3681
Special Investigations/202-225-2196
Water and Power Resources/202-225-6042

House Committee on the Judiciary

2137 Rayburn House Office Building, Washington, DC 20515/202-225-3951.
Jurisdiction: Judicial proceedings, apportion-

ment, bankruptcy, mutiny, espionage and counterfeiting, civil liberties, constitutional amendments, courts and judges, immigration and naturalization, interestate compacts, claims against the United States, meetings of Congress, penitentiaries, patents, copyrights and trademarks, presidential succession, monopolies, U. S. Statutes, boundaries and subversive activities.
Subcommittees:

Administrative Law and Governmental Relations/202-225-5741
Civil and Constitutional Rights/202-225-1680
Courts, Civil Liberties and the Administration of Justice/202-225-3926
Crime/202-225-1695
Criminal Justice/202-226-2406

House Committee on Merchant Marine and Fisheries

1334 Longworth House Office Building, Washington, DC 20515/202-225-4047.
Jurisdiction: merchant marine, marine affairs, the Coast Guard, lighthouses, fisheries and wildlife, marine common carriers, navigation laws, the Panama Canal, vessel licensing, naval academies and international fishing agreements.
Subcommittees:

Coast Guard and Navigation/202-226-3533
Fisheries and Wildlife Conservation and the Environment/202-226-3522
Merchant Marine/202-226-3500
Oceanography/202-226-3513
Panama Canal and Outer Continental Shelf/202-226-3508

House Select Committee on Narcotics Abuse and Control

H2-234 House Office Building, Annex #2, 2nd and D Sts. S.W., Washington, DC 20515/202-226-3040.
Jurisdiction: Drug abuse in the United States, including supply, law enforcement, international controls, drug abuse in the military, treatment, rehabilitation and prevention. (The committee has no subcommittees.)

House Committee on the Post Office and Civil Service

309 Cannon House Office Building, Washington DC 20515/202-225-4054.
Jurisdiction: The census, federal civil service, postal savings banks, the postal service, Hatch Act, holidays, population and demographics.
Subcommittees:

Census and Population/202-225-6741
Civil Service/202-225-4025
Compensation and Employee Benefits/202-225-6831
Human Resources/202-225-2821
Investigation/202-225-6295
Postal Operations and Services/202-225-9124
Postal Personnel and Modernization/202-225-3718

House Committee on Public Works and Transportation

2165 Rayburn House Office Building, Washington, DC 20515/202-225-4472.
Jurisdiction: Flood control, the U.S. Capitol and Senate and House office buildings, construction and maintenance of roads, construction and maintenance of the Botanic Gardens, Library of Congress and the Smithsonian Institution, U.S. government buildings, pollution of navigable water, public works benefiting navigation, water power, transportation other than railroads, roads and road safety, water transportation, transportation other than railroads, roads and road safety, water transportation and transportation regulatory agencies.
Subcommittees:

Aviation/202-225-9161
Economic Development/202-225-6151
Investigations and Review/202-225-3274
Public Buildings and Grounds/202-225-9161
Surface Transportation/202-225-4472
Water Resources/202-225-0060

House Committee on Rules

H-312 Capitol Building, Washington, DC 20515/202-225-9486.
Jurisdiction: Rules and orders of business of the House, recesses and adjournments of Congress.
Subcommittees:

Legislative Processes/202-225-1037
Rules of the House/202-225-9091

House Committee on Science and Technology

2321 Rayburn House Office Building, Washington, DC 20515/202-225-6371.
Jurisdiction: Astronautical matters, the Bureau of Standards and standardization of weights and measures, the metric system, the National Aeronautics and Space Administration, National Aeronautics and Space Council, National Science

Foundation, outer space, science scholarships and research and development, energy (except nuclear) research and development and the National Weather Service.
Subcommittees:

Energy Development and Applications/202-225-4494
Energy Research and Production/202-225-8056
Investigation and Oversight/202-225-2121
Natural Resources, Agriculture Research and Environment/202-225-1064
Science, Research and Technology/202-225-8844
Space Science and Applications/202-225-7858
Transportation, Aviation and Materials/202-225-9662

House Committee on Small Business

2361 Rayburn House Office Building, Washington, DC 20515/202-225-5821.
Jurisdiction: Assistance, protection and financial aid for small businesses, and federal contracts for small businesses.
Subcommittees:

Antitrust and Restraint of Trade Activities Affecting Small Business/202-225-6020
Energy, Environment and Safety Issues Affecting Small Business/202-225-8944
Export Opportunities and Special Small Business Problems/202-225-9368
SBA and SBIC Authority and Minority Enterprise/202-225-5821
Tax Access, Equity Capital and Business Opportunity/202-225-7797

House Committee on Standards of Official Conduct

2360 Rayburn House Office Building, Washington, DC 20515/202-225-7103.
Jurisdiction: The Code of Official Conduct, fi-

nancial disclosure by House members and employees, and activities designed to influence legislation. (The committee has no subcommittees.)

House Committee on Veterans' Affairs

335 Cannon House Office Building, Washington, DC 20515/202-225-3527.
Jurisdiction: Veterans' matters, including: Compensation, life insurance, pensions, adjustment to civilian life, hospitals and medical treatment and veterans' cemetaries.
Subcommittees:

Compensation, Pension and Insurance/202-225-3569
Education Training and Employment/202-225-9112
Housing and Memorial Affairs/202-225-9164
Hospitals and Health Care/202-225-9154
Oversight and Investigations/202-225-3541

The subcommittees can be reached at: 202-225-3527.

House Committee on Ways and Means

1102 Longworth House Office Building, Washington, DC 20515/202-225-3625.
Jurisdiction: Customs, reciprocal trade agreements, revenue measures, the U.S. debt, deposit of public money, duties, tax exempt organizations and Social Security.
Subcommittees:

Health/202-225-7785
Oversight/202-225-2743, 202-225-5522
Public Assistance and Unemployment Compensation/202-225-1025 or 202-225-1076
Select Revenues Measures/202-225-9710
Social Security/202-225-9263
Trade/202-225-3943

Major Sources of Information

Bibliographical Directory of the American Congress—1774–1971
This collection of reference material contains biographies and data on every person who served in Congress between 1774 and 1971, a total of more than 10,800 individual biographies. It is sold for $33.65 by the Superintendent of Documents, Government Printing Office, Washington, DC 20402/202-783-3238 or contact Joint Committee on Printing, Congress, the Capitol, Room S-151, Washington, DC 20510/202-224-5241.

Calendar of the House of Representatives and History of Legislation
Contains a list of bills in conference, a list of bills through conference, the Union Calendar, the House Calendar, a history of actions on each bill of the current session, a subject index of active legislation, and more. It is a weekly (when Congress is in session) publication available on subscription for $140.00 per session of Congress from the Superintendent of Documents, Government Printing Office, Washington, DC

20402/202-783-3238, or it can be picked up free at the House Document Room, Room H-226, 202-225-3456, or contact: Clerk of the House of Representatives, The Capitol, Room H-105, Washington, DC 20515/202-225-7000.

Capitol Hill Switchboard

The switchboard will provide and/or connect you with all the offices in the Capitol, House and Senate. Call: 202-224-3121.

Chaplain of the House of Representatives

The Chaplain opens each day's House session with a prayer. Contact: Chaplain of the House of Representatives, The Capitol, Room HB-25, Washington, DC 20515/202-225-2509.

Chaplain of the Senate

Each day's Senate session opens with a prayer. For information contact: Chaplain of the Senate, Russell Senate Office Building, Room 220, Washington, DC 20510/202-224-2510.

Clerk of the House

The Clerk of the House presides at the beginning of a Congress until the election of a Speaker. He is a continuing officer whose duties do not terminate with the sine die adjournment of Congress; his duties are largely executive and quasi-judicial in nature; he attests bills, resolutions and subpoenas; is custodian of the seal of the House, and prepares the roll of Representatives-elect. Contact: Clerk of the House, House of Representatives, Room H-105, The Capitol, Washington, DC 20515/202-225-7000.

Committee Calendar

Most committees and subcommittees issue their own calendars. These include information on their publications, staff and committee membership, and the legislation that concerns them. They also include a subject index of their legislative activities. To be connected with the individual committee, contact the Capitol Hill Switchboard, 202-224-3121, or see list of Committees under U.S. Senate and U.S. House of Representatives.

Congressional Directory

This congressional directory includes biographies of members of the House and Senate and the Supreme Court. It also lists congressional committees, members of the press admitted to the House and Senate galleries and other pertinent information. It is available for $10.00 from the Superintendent of Documents, Government Printing Office, Washington, DC 20402/202-783-3238 or contact: Joint Committee on Print-

ing, U.S. Congress, The Capitol, Room S-151, Washington, DC 20510/202-224-5241.

Congressional Pictoral Directory

Available (no price yet) from the Superintendent of Documents, Government Printing Office, Washington, DC 20402/202-783-3238, or contact: Joint Committee on Printing, U.S. Congress, The Capitol, Room S-151, Washington, DC 20510/202-224-5241. This directory contains photographs of the President, Vice President, members of the Senate and House, Officers of the Senate and House, Officials of the Capitol, and a list of the Senate delegations and an alphabetical list of senators and representatives.

Congressional Record

This is published daily when Congress is in session in an edited transcript of the House and Senate proceedings and actions. *The Daily Digest* section summarizes the day's activities and includes the next day's schedule of committee hearings. Friday's edition provides the schedule for the following week. Biweekly indexes are published for the Record. The subscription price is $75.00 per year. The Record is sold by the Superintendent of Documents, Government Printing Office, Washington, DC 20402/202-783-3238. For additional information contact: House Administration Committee, 300 New Jersey Ave. S.E., 419 HOB Annex, Washington, DC 20515/202-225-7882, or Senate Rules and Administration Committee, 1st St. N.E., Russell Senate Office Building, Room 305, Washington, DC 20510/202-224-6352.

Congressional Staff

Telephone numbers of the members of the Senate staff are available. Contact: Sergeant of Arms, S-321 U.S. Capitol, U.S. Senate, The Capitol, Washington, DC 20515/202-224-3207; members of the House Staff telephone numbers are also available. Contact: Clerk of the House, H-105 Capitol Building, Capitol, Washington, DC 20515/202-225-6515.

Congressional Staff Journal

This bimonthly, published by the Committee on House Administration, contains an array of reviews, features, and tips for the staff of the U.S. Congress. Subjects may range from advice on working with the wire services to how to use the House Information System and from summer hours for Washington tourist attractions to court cases having a possible impact on Congress. The *Congressional Staff Journal* is available for $8.00 per year from the Superintendent of Documents, Government Printing Office, Washington, DC

20402/202-783-3238, or contact: Committee on House Administration, Capitol Building, Room H-326, Washington, DC 20515/202-225-2061.

Congressional Telephone Directory

For a free telephone directory of all the members of both the House of Representatives and the Senate, contact: Clerk of the House, H-105 Capitol Building, Washington, DC 20515/202-225-7000.

Constitution, Jefferson's Manual and Rules of the House of Representatives of the United States 96th Congress

Contains the fundamental source material for parliamentary procedure used in the House of Representatives. Includes a list of services to members of the House, such as franking privileges and legislative counsel, and outlines the general order of business for the House. This biennial manual is available for $8.00 from the Superintendent of Documents, Government Printing Office, Washington, DC 20402/ 202-783-3238. For additional information contact: Parliamentarian of the House of Representatives, the Capitol, Room H-209, Washington, DC 20515/202-225-7373.

Daily Digest

For information on the Senate portion of the *Congressional Record*, call 202-224-0241; for the House portion, call 202-224-2658; for information on bills that have been passed, call 202-225-2868.

Document Room

The Document Room maintains current files of legislation including public laws (slip laws). Periodic compilations of public laws on a variety of subject areas are available for $600.00 from the Superintendent of Documents, Government Printing Office, Washington, DC 20402/202-278-3238. Contact: House Document Room, House of Representatives, The Capitol, Room H-226, Washington, DC 20515/202-225-3456, or Senate Document Room, Senate, The Capitol, Room S-325, Washington, DC 20510/202-224-4321.

Enactment of a Law

This booklet, prepared by the Senate, contains a brief explanation of the procedural steps in the legislative process. It is available for $1.30 from the Superintendent of Documents, Government Printing Office, Washington, DC 20402/202-783-3238.

Government Paper Specification Standards No. 9

Issued by the Joint Committee on Printing, Congress of the United States, for the use of government departments and agencies in the procurement of paper stock for printing. These standards consisting of three parts should also be of value and interest to paper manufacturers, printing establishments and others concerned with paper standards and specifications. Part 1 contains detailed standard specifications; part 2 gives the standards to be used in testing; and part 3 consists of the definitive color standards for all mimeograph, duplicator, writing, manifold, bond ledger and index papers (color standards for other classes of paper will be prepared and issued as such standards are developed). Subscription service includes supplementary material for an indeterminate period and is available for $10.00 from the Superintendent of Documents, Government Printing Office, Washington, DC 20402/202-783-3238, or contact: Joint Committee on Printing, The Capitol, Room S-151, Washington, DC 20510/202-224-5241.

Handbook for Small Business: A Survey of Small Business Programs of the Federal Government

The *Handbook* contains information on programs and services offered to the small businessperson by 25 federal departments and agencies that are directly involved with the support and stimulation of independent enterprise. It includes information on government-sponsored loans and financial guarantees, management and technical assistance programs, government purchasing and sales programs, grants, and entering the world trade markets. It outlines the design of federal programs, describes each program, and indicates how and where further information can be obtained. It is available for $5.50 from the Superintendent of Documents, Government Printing Office, Washington, DC 20402/202-783-3238, or contact: Senate Select Committee on Small Business, Russell Senate Office Building, Room 424, Washington, DC 20410/202-224-5175.

Historical Series

The following series is available at the Superintendent of Documents, Government Printing Office, Washington, DC 20402/202-783-3238, or contact: House Committee on Foreign Affairs, Rayburn House Office Building, Room 2170, Washington, DC 20515/202-225-5021.

Historical Series—House Committee on Foreign Affairs

A series of volumes that present previously unpublished transcripts of selected hearings of the House Committee on Foreign Affairs (now the Committee on International Relations). The transcripts cover the period of the later part of

World War II and the early postwar years. They were selected for their relevance to significant foreign policy and international relations developments during that period and cover such major topics as: the development of policy on the future of Palestine, extension of lend-lease, assistance to Greece and Turkey under the Truman Doctrine, the Foreign Assistance Act of 1948, programs of economic and military assistance to Korea and China, and much more.

Volume I—Problems of World War II and Its Aftermath, Part I; Postwar International Organization; Relations in Italy. $3.60

Volume II—Problems of World War II and Its Aftermath, Part 2; The Palestine Question; Problems of Postwar Europe. $4.95

Volume III—Foreign Economic Assistance Programs, Part 1, Foreign Assistance Act of 1948 (Marshall Plan and Related Measures). $3.40

Volume IV—Foreign Economic Assistance Programs, Part 2, Extension of the European Recovery Program. $5.40

Volume V—Military Assistance Programs, Part 1; Mutual Defense Assistance Act of 1949. $4.90

Volume VI—Military Assistance Programs, Part 2; Extension of the Mutual Defense Assistance Act of 1949; Testimony by Gen. Dwight Eisenhower on the Mutual Defense Assistance program; Assistance to Greece and Turkey; Latin American Military Assistance.

Volume VII—United States Policy in the Far East, Part 1; Military Assistance to the Philippines; Military Assistance to China; Economic Assistance to China; Briefing on the Fall of China. $4.55

Volume VIII—United States Policy in the Far East, Part 2; Korea Assistance Acts; Far East Portion of the Mutual Defense Assistance Act of 1950. $4.55

Hearings

Copies of all House and Senate Hearings are available for $7,900.00 per session of Congress from the Superintendent of Documents, Government Printing Office, Washington, DC 20515/202-783-3238.

House Gallery

The House Gallery is open to the public. Free passes are available from any congressional office. Contact: Doorkeeper of the House of Representatives, The Capitol, Room H-154, Washington, DC 20515/202-225-3505.

House Library

The Library is the official depository of House documents. Its primary function is to serve House members and their staffs. U.S. House of Representatives Library, B-18, Cannon House Office Building, Washington, DC 20515/202-225-0462.

House Postmaster

The Postmaster is in charge of postal matters and activities for the Capitol and House offices. Contact: Postmaster of House of Representatives, The Capitol, Longworth House Office Building, Room B-227, Washington, DC 20515/202-225-3856.

House Telephone Directory

Produced three times a year by the Committee on House Administration, the *House Telephone Directory* provides a listing for representatives, a listing for House committees, an alphabetical staff listing, a listing of staffs by representatives, a listing of staffs by committee, listings for senators and Senate committees, a listing for executive branch leaders, a listing for government agencies, and more. The *House of Representatives Telephone Directory* is available for $8.00 per year from the Superintendent of Documents, Government Printing Office, Washington, DC 20402/202-783-3238, or contact: Committee on House Administration, the Capitol, Room H-326, Washington, DC 20515/202-225-2061.

How Our Laws Are Made

Prepared by the House of Representatives, this booklet provides a plain language explanation of how a legislative idea travels the complex passageways of the federal lawmaking process to become a statute. It is available for $3.50 from the Superintendent of Documents, Government Printing Office, Washington, DC 20402/202-783-3238.

Information on Congressional Publications

The best source of information on congressional publications and for a subject bibliography on Congress, contact: Superintendent of Documents, Government Printing Office, Washington, DC 20401/202-275-3030.

Legislative Status System

This is a computerized informative book which provides information by topic, member, bill number, etc., on the legislative status of all the bills and resolutions before the House and Senate. Contact: Legislative Status System, Bill Status Office, House Office Building Annex 2, Room 650, Washington, DC 20515/202-225-1772. By searching a computerized data base, this office provides the answers to such questions as:

Have any bills been introduced covering a given topic?
What is the status of a given bill?
Who sponsored the bill?
What date was it introduced?
What committee and subcommittees have held hearings on a given bill?

List of House Committees

This is a listing of official and unofficial House committees. The members of each committee are included. Contact: Clerk of the House, House of Representatives, The Capitol, Washington, DC 20515/202-225-7000.

Monitoring House Legislation

Both Democrats and Republicans in the House Cloakroom provide a recorded message with daily legislative actuei information: 202-225-7400 (Democrat), 202-225-7430 (Republican). A recorded message with the next day's, as well as future, legislative schedule(s) is given; call: 202-225-1600 (Democrat), 202-225-2020 (Republicant). For additional information or on-going legislative activity, call: 202-225-7330 (Democrat), or 202-225-7350 (Republican).

Monitoring Senate Legislation

Daily legislative action and future scheduling information is available on a tape recording. For the Democratic cloakroom call 202-224-8541. For the Republican cloakroom call 202-224-8601. To monitor the activity of a bill scheduled for actuei on the Senate floor contact: 202-224-4691 for the Democratic view and 202-224-5456 for the Republican.

New Laws

The 96th Congress introduced 12,583 pieces of legislation during its two-year session and passed only 613 laws. For a complete listing of the 613 new laws passed by the 96th Congress, purchase a copy of the December 30, 1980 issue of the *Congressional Record.* Available for $1.00 from ULS. Government Printing Office, Superintendent of Documents, Washington, DC 20402/202-783-3238.

Report of the Clerk of the House

This quarterly report includes the salaries of House members' staffs, committee staffs and House officers and employees. Contact: Clerk of the House of Representatives, The Capitol, Room H-105, Washington, DC 20515/202-275-7000.

Report of The Secretary of the Senate

This biannual report details the salaries of senators' staff, members, committee staff members and officers and employees of the Senate. Contact: Senate Document Room, The Capitol, Room S-325, Washington, DC 20510/202-224-7860.

Sergeant at Arms of the Senate

The Sergeant at Arms of the Senate is elected by and serves as the Executive Officer of that body. He is also the Law Enforcement Office; has statutory power to make arrests; locates absentee senators for a quorum; is a member of Capitol Police Board, serving as chairman each odd year; is a member of the Capitol Guide Board, serving as chairman each odd year; has custody of the Senate gavel; serves subpoenas issued by the Senate or its committees; is responsible for many aspects of ceremonial functions, including the inauguration of the President of the United States; arranges funerals of Senators who die in office and escorts congressional committees to the services; directs and supervises departments and facilities under his jurisdiction; subject to the Presiding Officer, maintains order in the Senate Chamber, prevents admission of any unauthorized person to the senate floor, and prevents quotas of staff members entitled to the floor at one time from being exceeded; escorts the President when he addresses a Joint Session of Congress or attends any function at the Capitol; and escorts members of foreign parliaments into the Senate Chamber when they are to be introduced to the Senate. Contact: Sergeant at Arms, S-321 Senate, The Capitol, Washington, DC 20510/202-224-2341.

Senate Committees

A listing is available of official Senate committees. These include the members of each committee. Contact: Office of the Secretary of the Senate, The Capitol, Room S-221, Washington, DC 20510/202-224-2115.

Senate Gallery

The Senate Gallery is open to the public. Free passes are available from any congressional office. Contact: Sergeant-at-Arms of the Senate, The Capitol, Room S-321, Washington, DC 20510/202-224-2341.

Senate History

The Senate Historical Office collects and disseminates information on Senate history and Senate members, including photographs, unpublished documents and oral history. A free newsletter, *Senate History,* is also available. Contact: Senate Historical Office, Secretary of the Senate, The Capitol, Room S-413, Washington, DC 20510/202-224-6900.

Senate Library

The Senate Library is the official depository of senate documents. Its primary function is service to Senate members and their staffs. To use the library a researcher must have a letter of introduction from a Senator. Contact: Senate Library,

Suite S-332, The Capitol, Washington, DC 20510/202-224-2971.

Senate Manual

This biennial manual includes Jefferson's Manual, standing rules, orders, and laws and resolutions affecting the Senate. A list of senators and members of the Executive Branch is also provided. It is published every two years with each new Congress. The manual is sold for $5.00 by the Superintendent of Documents, Government Printing Office, Washington, DC 20402/202-783-3238. For additional information contact: Senate Committee on Rules and Administration, Russell Senate Office Building, 1st St. N.E., Room 305, Washington, DC 20510/202-224-6352.

Senate Procedure: Precedents and Practices

This is a compilation of procedural rules, laws, rulings and practices. It is available for $12.00 from the Superintendent of Documents, Government Printing Office, Washington, DC 20402/202-783-3238, or contact: Parliamentariae of the Senate, The Capitol, Room S-132, Washington, DC 20510/202-224-6128.

Statement on the Senate's History

This is a series of addresses to the Senate on subjects related to its history and traditions. For a list of citations with dates, subjects, and page numbers, contact: Senate Historical Office, Secretary of the Senate, The Capitol, Room S413, Washington, DC 20510/202-224-6900.

Tours

Free guided tours of the interior of the Capitol building are available to the public. Contact: Capitol Guide Service, Sergeant-at-Arms of the Senate, The Rotunda, The Capitol, Washington, DC 20510/202-225-6827.

Treaties and Nominations

For information on and copies of treaties and nominations submitted to the Senate for ratification, contact: Senate Document Room, The Capitol, Room 325, Washington, DC 20510/202-224-4321.

U.S. Policy and Supporting Positions (The Plum Book)

This book lists some 3,000 political appointment jobs and describes type of appointment, tenure, grade and salary. Available for $6.00 at the Superintendent of Documents, Government Printing Office, Washington, DC 20402/202-783-3238, or contact: House Post Office and Civil Service Committee, House of Representatives, Cannon House Office Building, Room 309, Washington, DC 20515/202-225-4054.

How Can The Legislative Branch Help You?

To determine how this branch of government can help you contact the local office of your congressman or The Capitol Hill Switchboard, Washington, DC 20510/202-224-3121.

Architect of the Capitol

Capitol Building, Washington, DC 20515/202-225-1200

BUDGET: $117,433,000
EMPLOYEES: 1,921

MISSION: Is charged with the structural and mechanical care of the U.S. Capitol Building, and making arrangements with the proper authorities for ceremonies and ceremonials held in the building and on the grounds; is responsible for the care, maintenance and improvement of the Capitol grounds, comprising approximately 190.5 acres; has the structural and mechanical care of the Library of Congress Buildings and the U.S. Supreme Court Building; and is responsible for the operation of the U.S. Senate Restaurant.

Major Sources of Information

Fact Sheets

Fact sheets or the various features and artifacts of the Capitol are available free of charge. They include information on the Statue of Freedom; the tile floor of the Capitol; the history of the old subway transportation system connecting the Capitol and the Russell Office Building; the Rotunda Frieze; the "cornstalk" or "corncob" columns and capitals; the dome; the historic catafalque; Washington's tomb; those who have lain in state in the rotunda; the flags over the east and west central fronts; and the architects and architecture of the Capitol. Contact: Art and Reference Division, Architect of the Capitol, Capitol Building, Room HB28, Washington, DC 20515/202-225-1222.

Raise a Flag Over the Capitol

For the cost of a flag ($5.55 to $13.00) your congressman can have the Architect of the Capitol fly your personal Stars and Stripes over the Capitol Building on the day you specify. This makes an unusual birthday gift because you then receive the flag and a certificate noting the date the flag was flown and for whom. Be sure to state the day to be flown and the recipient. Contact the local office of your congressman or c/o Capitol, Washington, DC 20515/202-224-3121.

The Capitol

A pictorial history of the Capitol and of the Congress, *The Capitol* provides a pictorial and narrative history of the Capitol building and the Congresses that have served there. Included are sections devoted to the Architects of the Capitol, the Speaker of the House, House leadership, pages of the U.S. Congress, the Senate, elected officers of the Senate, a profile of the 96th Congress, women in American politics, and related information. $4.25 Contact: your congressman's office for a free copy or Superintendent of Documents, Government Printing Office, Washington, DC 20402/202-783-3238. For additional information contact: Art and Reference Division, Architect of the Capitol, Capitol Building, Room HP28, Washington, DC 20515/202-783-3238.

How Can the Architect of the Capitol Help You?

To determine how this office can help you contact: Architect of the Capitol, Capitol Building, Washington, DC 20515/202-225-1200.

Botanic Gardens

245 1st St. S.W., Washington, DC 20024/202-225-8333

BUDGET: $1,534,000
EMPLOYEES: 57
MISSION: Collects, cultivates and grows the various vegetable productions of this and other countries for exhibition and display to the public and for study material for students, scientists and garden clubs.

Major Sources of Information

Botanic Garden Conservatory

The Botanic Garden Conservatory can be considered an educational facility, for it makes available for study many rare and interesting specimens from all over the world. Every year botanical specimens are received, both foreign and domestic, for identification. The Garden also furnishes, upon request, information relating to the proper care and methods of growing plants. Contact: Botanic Gardens, 1st and Canal St. S.W., Washington, DC 20024/202-225-8333.

Display Information

The Botanic Garden collects and cultivates the various plants of this and other countries for display to the public and for study by students, scientists and garden clubs. Contact: Botanic Gardens, 1st and Canal Sts. S.W., Washington, DC 20024/202-225-7099.

Horticulture Classes

Horticulture classes are offered free of charge and consist of informal lectures followed by a series of demonstrations. For scheduled lectures and other information, contact: Botanic Garden, 1st and Canal Sts. S.W., Washington, DC 20024/202-225-7099.

Plant and Flower Shows

The Botanic Garden sponsors four annual plant and flower shows in display areas totaling 9,000 square feet. The Easter Show, features spring flowering plants. It is held from Palm Sunday through Easter Sunday. The Summer Terrace Display is held on the patio in front of the Conservatory from late May through September. Hundreds of flowering and foliage plants in hanging baskets highlight this event. Mid-November through Thanksgiving Day features a wide variety of chrysanthemums. Poinsettias dominate the show, held from mid-December through the Christmas holidays. Each year the Garden hosts plant and flower shows sponsored by area garden clubs and plant societies.

Other services sponsored by the U.S. Botanic Garden include group tours which are given during the year by appointment and a series of horticulture classes held from September through May. All services at the Garden are offered free of charge. Contact: Botanic Gardens, 1st & Canal Sts. S.W., Washington, DC 20024/202-225-7099.

Publications

Publications of horticultural interest, schedules of display and horticulture classes and a pamphlet offering a self-guided tour are available. Contact: Botanic Garden, 1st and Canal Sts. S.W., Washington, DC 20024/202-225-7099.

How Can the Botanic Gardens Help You?

To determine how this office can help you contact:. Botanic Gardens, 245 1st St. S.W., Washington, DC 20024/202-225-8333.

General Accounting Office

441 G St. N.W., Washington, DC 20548/202-275-2812

BUDGET: $200,300,000
EMPLOYEES: 5,442

MISSION: Assists the Congress, its committees, and its members in carrying out their legislative and oversight responsibilities, consistent with its role as an independent, nonpolitical agency in the legislative branch; to carry out legal, accounting, auditing and claims settlement functions with respect to federal government programs and operations as assigned by the Congress; and to make recommendations designed to provide for more efficient and effective government operations.

Major Sources of Information

Audit Reference Services Library

The library provides information of GAO interest and has access to data bases, government documents, dissertations, legislative information, research in progress and organizations. *Literature Limelight*, published monthly lists the latest books acquired. The Law Library is located in Room 7056/202-275-2585. Contact: Audit Reference Services Library, General Accounting Office, 441 G St. N.W., Room 6536, Washington, DC 20548/202-275-5180.

Auditing

General Accounting Office has the right of access to, and examination of, any books, documents, papers, or records of the departments and agencies.

The Office has statutory authority to investigate all matters relating to the receipt, disbursement, and application of public funds. Additionally, GAO's audit authority covers wholly and partially owned government corporations and certain nonappropriated fund activities.

It makes expenditure analysis of executive agencies to enable the Congress to determine whether public funds are efficiently and economically administered and expended; and to review and evaluate the results of existing government programs and activities. The scope of the audit work extends to the activities of state and local governments, quasi-governmental bodies, and private organizations in their capacity as recipients under, or administrators for federal aid programs financed by loans, advances, grants and

contributions. It also covers certain activities of those having negotiated contracts with the government. Contact: Accounting and Financial Management, General Accounting Office, 441 G St. N.W., Washington, DC 20548/202-275-5150.

Bid Protest

Disputes between agencies and bidders for government contracts, including grantee award actions are resolved by the GAO. The publication, *Bid Protests at GAO—A Descriptive Guide*, contains information on GAO's procedures for deciding legal questions arising from the award of government contracts.

Blue Book—Accounting Principles and Standards for Federal Agencies

This free book provides guidance for internal auditing in federal agencies. Contact: Information Handling and Support Facilities, General Accounting Office, P.O. Box 6015, Gaithersburg, MD 20877/202-275-5082.

Checklist for Report Writers and Reviewers

This book standardizes the report format and articulates conceptually how a report should be organized. It breaks a GAO report down to its components—cover, transmittal letter, digest, etc.—and poses questions to use in judging how well each was written. The booklet included reminders of GAO reporting polcies, principles taught in Producing Organized Writing and Effective Reviewing (POWER), recurring reporting problems, and technical reporting requirements.

From Auditing to Editing is a guide for teaching report writing. It is sold for $1.45 by the Superintendent of Documents, Government Printing Office, Washington, DC 20402/202-783-3238. Contact: Publishing Services, General Accounting Office, 441 G St. N.W., Washington, DC 20548/202-275-3798.

Claims Settlement and Debt Collections

The GAO settles claims by and against the United States. Claims may involve individuals; business entities; or foreign, state and municipal governments as claimant or debtor. Claims are settled by GAO when the departments and agencies have not been given specific authority to handle their own claims and when they involve 1) doubtful questions of law or fact, 2) appeals of agency actions, 3) certain debts which agencies are unable to collect, and 4) waivers of certain erroneous payments for pay, etc. Contact: Claims Group Accounting and Financial Management, General Accounting Office, 441 G St. N.W., Washington, DC 20548/202-275-5700.

Community and Economic Development

The Community and Economic Development Division coordinates GAO's work in the areas of food, domestic housing and community development, environmental protection, land use planning arrangement and control, transportation systems and policies, and water and water-related programs.

In addition, this division provides GAO audit coverage at the Departments of Agriculture, Commerce, Housing and Urban Development, Interior (except energy and materials activities) and Transportation; the Army Corps of Engineers (civil functions); the Environmental Protection Agency; the Small Business Administration; the Interstate Commerce, Federal Martime and Federal Communications Commissions; the National Railroad Passenger Corporation (Amtrak); the Washington Metropolitan Area Transit Authority; the U.S. Railway Association; the Civil Aeronautics Board; the Commodity Futures Trading Commission; the Federal Emergency Management Agency; and a variety of boards, commissions, and quasi-governmental entities. Contact: Community and Economic Development Division, General Accounting Office, 441 G St. N.W., Washington, DC 20548/202-275-6167.

Comptroller General Decisions

An annual, bound volume of Comptroller general decisions includes about 10% of the total decisions rendered annually. Digests of decisions not included in this volume are issued quarterly

in pamphlet form. Separate pamphlets are issued for Civilian Personnel, General Government Matters, Military Personnel, Procurement, and Transportation; and include decision digests for three-month periods ending in December, March, June and September. They are available on request. The monthly subscription is available for $17.00 per year from the Superintendent of Documents, Government Printing Office, Washington, DC 20402/202-783-3238. Contact: Index-Digest, Information and Legal Reference Services, General Counsel, General Accounting Office, 441 G St. N.W., Room 7510, Washington, DC 20548/202-275-5006.

Congressional Sourcebook

The *Sourcebook* is published in three volumes:

Volume I: Recurring Reports to the Congress—describes executive agency reports issued regularly. $11.00
Volume II: Federal Program Evaluation—includes evaluation reports on federal agencies' programs. $14.00
Volume III: Federal Information Sources and Systems—identifies federal information sources and systems that provide financial and program data. $16.00

Available at the Superintendent of Documents, Government Printing Office, Washington, DC 20402/202-783-3238, or contact: Information, Government Accounting Office, 441 G St. N.W., Washington, DC 20548/202-275-2812.

Congressional Staff Assignments

Each year the Office assigns 50 to 100 staff members directly to committees to help carry out their responsibilities or assist them in using the results of a GAO study. In accordance with the Budget and Accounting Act, GAO provides staff assistance to committees having jurisdiction over revenues, appropriations and expenditures, and often to other committees, as well. However, the agency does not assign staff to individual members. Contact: Congressional Relations, General Accounting Office, 441 G St. N.W., Wasington, DC 20548/202-275-5456.

Congressional Testimony

Congressional testimony by GAO officials rangin in topic from "long-term planning for national science policy" to "taking the profit out of crime" is available. Contact: Information Handling and Support Facilities, General Accounting Office, P.O. Box 6015, Gaithersburg, MD 20877/202-275-6241.

Debarred List

This is a consolidated list of persons or firms currently debarred for violation of various public

contract acts incorporating labor standards provisions. It is a quarterly with interim lists issued semi-monthly. Contact: Information Handling and Support Facilities, General Accounting Office, P.O. Box 6015, Gaithersburg, MD 20877/202-275-6241.

Discrimination Bars

The General Accounting Office offers a free 72-page book that can help companies avoid discrimination problems. The book, *A Compilation of Federal Laws and Executive Orders for Nondiscrimination and Equal Opportunity Programs*, cites 87 laws and orders relating to equal rights, in employment practices as well as in the provision of services. Each citation names the law or order, describes it briefly, identifies what type of discrimination it prohibits and to whom it applies, and which agencies enforce it.

To order the book (stock number HRD-78-138) write or call: Information Handling and Support Facilities, General Accounting Office, P.O. Box 6015, Gaithersburg, MD 20877/202-275-6241.

Energy and Minerals Division

This division provides GAO audit coverage for the Department of Energy, the Nuclear Regulatory Commission, the Tennessee Valley Authority, energy and minerals programs of the Department of Interior, and energy and materials activities located in numerous other federal entities. Contact: Energy and Minerals Divisions, General Accounting Office, 441 G St. N.W., Room Washington, DC 20548/202-275-3567.

Energy Data Verification

GAO conducts verification examinations of energy-related information developed by private business concerns under certain circumstances delineated in the Act. For the purpose of carrying out this authority, the Comptroller General may issue subpoenas, require written answers to interrogations, administer oaths, inspect business premises, and inspect and copy specified books and records. Certain enforcement powers are provided, including for some types of noncompliance the power to assess civil penalties and to collect such penalties through civil action. Contact: Energy and Minerals, Gneral Accounting Office, 441 G St. N.W., Washington, DC 20548/202-275-3567.

Federal Personnel and Compensation

This division provides audit coverage for the office of Personnel Management, Merit Systems Protection Board, Federal Labor Relations Authority, and Selective Service System. The division also examines government-wide personnel activities relating to and affecting the federal work force. Contact: Federal Personnel and Compensation Division, 441 G St. N.W., Washington, DC 20548/202-275-6209.

Field Operations Division

The Field Operations Division, through its regional offices in 15 cities, provides direct audit support throughout the continental United States, Alaska, Puerto Rico and the Virgin Islands for GAO's other operating divisions. Thus, this division plays a major role in most of the audits and work of GAO. About half of GAO's professional staff is assigned to its regional offices. For addresses of the GAO field offices and for further information contact: Field Operation Division, General Accounting Office, 441 G St. N.W., Washington, DC 20548/202-275-5495.

Financial and General Management Studies

The Financial and Financial Management Division is responsible for coordinating GAO's work in the issue areas of automatic data processing, internal audit, accounting and financial reporting, and national productivity.

This division carries out its responsibilities through participation in the Joint Financial Management Improvement Program and its government-wide responsibilities for automatic data processing, accounting systems, internal auditing and fraud prevention, productivity and regulatory accounting and reporting. It provides GAO audit coverage at the Securities and Exchange Commission. It also has primary responsibility for financial statement audits.

In addition, its Claims Group settles and adjudicates claims and demands by or against the United States and reviews, evaluates, and reports on the claim settlement and debt collection activities of government agencies. Contact: Accounting and Financial Management, General Accounting Office, 441 G St. N.W., Washington, DC 20448/202-275-5150.

Fraud Hotline

A hotline is available to contact GAO about potential problems in government programs involving waste, fraud, abuse and illegal actions. Call: 202-633-6987 (DC area), or 800-424-5454, or contact: Fraud Prevention Group, Accounting and Financial Management, General Accounting Office, 441 G St. N.W., Washington, DC 20548/202-275-5824.

Fraud Prevention Group

This task force tries to identify root causes and recurring patterns of illegal activities and to see how they can best be prevented and detected. It also probes agency information or accounting

systems and programs for weaknesses that invite or allow fraud. Contact: Fraud Prevention Group, Accounting and Financial Management, 441 G St. N.W., Room 6126, Washington, DC 20548/202-275-5824.

GAO—An Administrative History 1966–1981
This book, available for $8, describes the role and operations of the GAO, and the changes it has undergone over the past fifteen years. It details activities of GAO offices and divisions, and describes their functions and their accomplishments. Contact: Distribution Section, General Accounting Office, 441 G St. N.W., Room 4427, Washington, DC 20548/202-782-3238.

The General Government Division is responsible for coordinating GAO's work in the issue areas of intergovernmental policies and fiscal relations, law enforcement and crime prevention, tax administration, data collected from nonfederal sources (statistical and paperwork implications), and federal oversight of financial institutions.

This division provides GAO audit coverage for the Departments of Justice and Treasury, the District of Columbia Government, the United States Postal Service, the judicial and legislative branches of the federal government, and various other agencies and commissions. Contact: General Governments Division, General Accounting Office, 441 G St. N.W., Washington, DC 20548/202-275-6059.

Human Resources
The Human Resources Division coordinates GAO's work in the issue areas of consumer and worker protection, administration of nondiscrimination and equal opportunity programs, education, health, income security, and employment and training.

In addition to its leadership in these issue areas, this division provides GAO audit coverage for the Departments of Labor, Health and Human Services, and Education; the Community Services Administration; the Consumer Product Safety Commission; the Federal Trade Commission; the Pension Benefit Guaranty Corporation; the Legal Services Corporation; ACTION; the Railroad Retirement Board; the Equal Employment Opportunity Commission; the Veterans Administration; all federal health programs; and various small commissions and independent agencies. Contact: Human Resources Division, General Accounting Office, 441 G St. N.W., Washington, DC 20548/202-275-5470.

Index and Files
The Index and Files Section is the correspondence control center for all incoming and outgoing correspondence, reports, decisions, and other documents addressed to or signed by officials in the Office of the Comptroller General and the Office of the General Counsel.

A computerized information system provides immediate access to all case-related information processed since September 1978. Additionally, Index and Files retains manual card files going back to 1921. Thus, a researcher can obtain information, by using both the old card system and the new sutomated system, for any case or group of cases processed by Index and Files since 1921. Contact: Index and Files, Information and Legal Reference General Services, General Counsel Accounting Office, 441 G St. N.W., Room 7510, Washington, DC 20548/202-275-5436.

International Affairs
The International Division serves as lead division for the international affairs issue area.

This division provides GAO audit coverage for the Department of State, the Agency for International Development, the International Development Cooperation Agency, the Central Intelligence Agency, the Export-Import Bank of the United States, the International Communication Agency, and the Panama Canal Commission, as well as international activities of numerous other federal entities. International Division personnel staff GAO's overseas offices. Contact: International Division, General Accounting Office, 441 G St. N.W., Washington, DC 20548/202-275-5518.

International Auditor Fellowship Program
GAO has made an effort to share its knowledge and experience with other nations, particularly the developing countries. The most visible effort is the Comptroller General's International Auditor Fellowship Program, established in 1979, through which a small number of auditors from developing countries are selected annually to spend three to six months in academic and on-the-job experience program. Although GAO cannot pay travel and subsistence for the Fellows, it provides the training itself free of charge and assists many participants in obtaining financial aid from the U.S. Agency for International Development and the United Nations Development Program. Contact: International General Accounting Office, 441 G St. N.W., Washington, DC 20548/202-275-5518.

Legal Index-Digest
The Index-Digest Section compiles and maintains the research material related to all legal issuances of the Office of General Counsel. It maintains an in-house research facility by constantly updating the various legal indexes, pre-

pares for printing all legal publications emanating from the Office of General Counsel, and provides research assistance to GAO legal and audit staffs, personnel from other governmental agencies and other interested parties.

This section also produces an annual, bound volume of Comptroller General decisions, and a quarterly pamphlet of decision digests not included in the annual. Contact: Index-Digest Information and Legal Reference Services, General Counsel, General Accounting Office, 441 G St. N.W., Room 7510, Washington, DC 20548/202-275-5006.

Legal Information and Reference Service

The legal information and reference service provides on-going legal support services to the General Counsel, the Comptroller General, the Audit divisions and the public. The service gathers and maintains legal information. Contact: Information and Legal Reference Sercices, General Counsel, Government Accounting Office, 441 G St. N.W., Room 7510, Washington, DC 20548/202-275-5012.

Legislative Branch Audit Site

The Site assets the Congress by doing 15 recurring financial audits of such units as the House Recording Studio and the Senate Restaurant, and offering informal advice and assistance on administrative matters. Contact: Legislative Branch Audit Site, Accounting and Financial Management, General Accounting Office, 2nd and D Sts. N.W., Washington, DC 20515/202-226-2480.

Legislative Digest

The Legislative Digest Section provides legislative analyses and research assistance and compiles and maintains legislative history files for each bill and public law since the 1920s. It also maintains subject indexes, enabling a researcher to find legislation or reports dealing with a particular subject, and some subject files containing materials generated by Congress on a particular subject but which are not associated with a specific bill or law. The section also has a file identifying comments made by GAO on bills where the comment deals with a matter of GAO policy, such as our audit authority or new functions the agency might be asked to perform. Contact: Legislative Digest, Information and Legal Reference Service, General Counsel, General Accounting Office, 441 G St. N.W., Room 7510, Washington, DC 20548/202-275-5560.

Logistics and Communications

The Logistics and Communications Division serves as the lead division within GAO for work in the areas of facilities and material management, military preparedness, federal information (creation, protection, access, disclosure and management), and communications.

Most of this division's work covers the Department of Defense. It also provides GAO audit coverage for portions of the General Services Administration and the Government Printing Office, in addition to its government-wide responsibilities relating to logistics, information and communication. Contact: Logistics and Communications, General Accounting Office, 441 G St. N.W., Washington, DC 20548/202-275-6503.

Periodicals

These periodical subscriptions are available from the Superintendent of Documents, Government Printing Office, Washington, DC 20402/202-783-3238. *GAO Documents.* (Monthly.) A comprehensive record of current GAO publications and documents, including audit reports, staff studies, memoranda, opinions, speeches, testimony and Comptroller General decisions. $24.00 per year.

GAO Review (Quarterly.) Contains articles on accounting generally and particularly on accounting and auditing activities of the General Accounting Office, its officials and staff employees. $6.00 per year. *Gasoline Prices* (Energy Data Report). (Monthly.) $9.50 per year. *General Accounting Office Policy and Procedures Manual for Guidance of Federal Agencies.* Subscription service of each title listed below includes changes for an indeterminate period. Issued in looseleaf form, with index dividers. Punched for three-ring binder. Title 1, *The United States General Accounting Office*, $4.75; Title 2, *Accounting*, $8.00; Title 3, *Audit*, Subscription price, $7.00; Title 4, *Claims-General*; Title 5, *Transportation*, subscription price, $14.00.

Policy and Procedures Manual

The General Accounting Office *Policy and Procedures Manual for Guidance of Federal Agencies* is the official medium through which the Comptroller General promulgates: principles, standards, and related requirements for accounting to be observed by the federal departments and agencies; uniform procedures for use by the federal agencies; and regulations governing the relationships of the General Accounting Office with other federal agencies and with individuals and private concerns doing business with the government.

All decisions of the Comptroller General of general import are published in monthly pamphlets and in annual volumes. Contact: Policy

and Program Planning, General Accounting Office, 441 G St. N.W., Washington, DC 20548/202-275-6190.

Policy and Program Planning

This office sees that the audit work of GAO is planned, coordinated and reported in a consistent and effective manner. It works with the audit divisions to implement GAO's policies and planning guidelines across divisional lines. Contact: Policy and Program Planning, General Accounting Office, 441 G St. N.W., Washington, DC 20548/202-275-6190.

Procurement and Systems Acquisition

The Procurement and Systems Acquisition Division is responsible for coordinating GAO's work in the issue areas of general procurement and the procurement of major systems.

This division monitors the government's entire procurement function and its research and development policies and programs. Most of this division's work is concentrated in the Department of Defense, the National Aeronautics and Space Administration, the defense-related activities of the Department of Energy and the Federal Supply Service of the General Services Administration. Contact: Mission and Systems Acquisition Division, General Accounting Service, 441 G St. N.W., Washington, DC 20548/202-275-3456.

Program Analysis

The Program Analysis Division works in the issue areas of program and budget information for congressional use, economic analysis of alternative program approaches, and science policy.

This division maintains oversight responsibility for several agencies, including the Office of Science and Technology Policy, the National Science Foundation, and the Council on Wage and Price Stability. It is GAO's focal point for work in the areas of economics and science policy, and coordinates GAO activities with the Congressional Budget Office and the Office of Technology Assessment. Contact: Program Analysis, General Accounting Office, 441 G St. N.W., Washington, DC 20548/202-275-4892.

Program Evaluation

The Institute for Program Evaluation performs program evaluation assignments designed to demonstrate new or improved methodologies for program evaluations. The conduct of these evaluations serves to model strategies for similar assignments. The Institute also assumes responsibilities for evaluation methods development. In addition, it provides training in evaluation to all GAO personnel.

The Institute encourages and maintains contacts with evaluation professionals in other federal agencies, universities, professional societies, and state and local governments, and fosters improved communication within the evaluation community. Contact: The Institute for Program Evaluation, General Accounting Office, 441 G St. N.W., Washington, DC 30548/202-275-1854.

Publications

A list of current reports of the Government Accounting Office is available. It includes Comptroller General Reports to Congress and other federal agencies, congressional testimony by GAO officials, speeches by the Comptroller General, and other publications on accounting and auditing procedures, automatic data processing, intergovernmental audit standards and general publications. Contact: Information Officer, General Accounting Office, 441 G St. N.W., Washington, DC 20548/202-275-2812.

Redbook—Guidelines for Financial and Compliance Audits and Federally Assisted Programs

This book indicates which audit standards should be applied, how audits should be planned, and how audit reports and workpapers should be prepared. General procedures for testing compliance with legal and regulatory requirements, studying internal controls, testing account balances, and other audit procedures are also included. Contact: Distribution Section, General Accounting Office, 441 G St. N.W., Room 4427, Washington, DC 20548/202-275-5082.

Regulatory Reports Review

GAO reviews the existing information-gathering practices of independent regulatory agencies. Information report forms designed by these agencies for the collection of information from the public are required to be cleared by GAO before they may be issued. The purposes of the review and clearance functions are to ensure that information is obtained with minimum burden on those businesses required to provide the information, to eliminate duplicate data collection efforts, and to ensure that collected information is tabulated so as to maximize its usefulness. Contact: Regulatory Reports Review, General Accounting Office, 441 G St. N.W., Washington, DC 20548/202-275-6241.

Reports

The Comptroller General sends each month to the Congress, its committees, and its members, a list of GAO reports issued or released during the previous month.

Copies of GAO reports are provided without charge to Members of Congress and congressional committee staff members; officials of federal, state, local and foreign governments; members of the press; college libraries, faculty members, and students; and nonprofit organizations.

Copies are available from the General Accounting Office, 441 G St. N.W., Room 1518, Washington, DC 20548/202-275-6241.

Tax Policy Studies

Tax policy studies include all GAO issue areas that touch or tax law. Contact: Tax Policy Program, Program Analysis Division, General Accounting Office, 441 G St. N.W., Washington, DC 20548/202-275-4892.

Writing Resources

Three levels of courses—introductory, intermediate and advanced—are offered to meet the writing needs of auditors at successive stages in their careers.

The POWER (Producing Organized Writing and Effective Reviewing) course is the heart of the program. POWER is offered to persons in grades GS-12 and up. Its basic principle is that a general-to-specific, or deductive, structure is easiest for readers. POWER applies the deductive principle at the paragraph level first and then extends it to sections and chapters. The course also includes a unit or report review. Contact: Writing Resources Branch, Publishing Services, General Accounting Office, 441 G St. N.W., Washington, DC 20548/202-275-5864.

Yellow Book—Standards for Audit of Governmental Organizations, Programs, Activities and Functions

This booklet contains a body of audit standards, intended for application to audits of all government organizations, programs, activities, and functions—whether they are performed by auditors employed by federal, state, or local governments; independent public accountants; or others qualified to perform parts of the audit work contemplated under these standards. $2.50.

Supplements include: *Auditing Computer-Based Systems: Additional Gao Audit Standards.* This booklet supplements GAO's basic audit standards with additional standards covering audits of computer-based systems. Scope of coverage is same as that for the basic standards. $1.25. *Auditors: Agents for Good Government.* (Audit Standards Supplement No. 2.) An explanation of the scope of governmental auditing and what it can achieve. $1.25. *Examples of Findings from Governmental Audits.* (Audit Standards Supplement No. 4.) Illustrates audit findings developed during reviews of compliance with applicable laws and regulations, efficiency in using resources, and achievement of program results. $2.00. *Questions and Answers on the Standards for Audit of Governmental Organizations, Programs, Activities and Functions.* (Audit Standards Supplement No. 5.) Answers to questions raised by auditors and managers relating to the government and standards (1979 Reprint). Booklet, 25 pp. $1.75. These supplements are available from: Superintendent of Documents, Government Printing Office, Washington, DC 20402/202-783-3238. For additional information contact: Accounting and Financial Management, General Accounting Office, 441 G St. N.W., Washington, DC 20548/202-275-5150.

How Can The General Accounting Office Help You?

To determine how this agency can help you, contact: General Accounting Office, 441 G St. N.W., Washington, DC 20548/202-275-2812.

Government Printing Office

North Capitol and H Sts. N.W., Washington, DC 20401/202-275-2051

BUDGET: $112,337,000
EMPLOYEES: 7,522
MISSION: Executes orders for printing and binding placed by Congress and the departments and establishments of the federal government; furnishes blank paper, ink and similar supplies to all governmental activities on order; and prepares catalogs and distributes and sells government publications.

Major Sources of Information

Bestseller

Lists of publications on specific subjects are available. Contact: Customer Information, Superintendent of Documents, Government Printing Office, North Capitol and H Sts. N.W., Washington, DC 20402/202-783-3238.

Bookdealers

Designated bookdealers and educational bookstores are authorized a 25 percent discount on the selling price of any publication ordered when delivered to the dealer's normal place of business. This rule applies to single as well as multiple copies of a publication, except on items sold at a special quantity price or those specifically designated "no discount allowed." No discounts will be allowed when the publication, pamphlet, periodical or subscription service is mailed to a third party (unless in quantities of 100 or more), or on those periodicals or subscription services which fall into a special pricing category. For additional information contact: Order and Information, Superintendent of Documents, Government Printing Office, North Capitol and H Sts. N.W., Washington, DC 20402/202-783-3238.

Bookstores

The GPO operates bookstores in numerous cities around the country. While the stores carry only a small percentage of the many thousands of titles in the active sales inventory, they do have the ones most in demand and can accept orders for any not carried in a particular store. Single issues of some of the more popular periodicals are available in the stores for over-the-counter sales. Each bookstore has a complete microfiche catalog of all the titles and subscriptions offered for sale. For additional information or for a list of bookstores and their addresses contact: Stores Division, Management and Administration, Government Printing Office, North Capitol and H Sts. N.W., Washington, DC 20402/202-275-2211.

Congressional Information

For information on Congressional publications contact: Superintendent of Documents, Government Printing Office, Washington, DC 20402/202-275-3030.

Consumer Guide to Federal Publications

This is a free pamphlet describing GPO services including deposit accounts, bookstores, subject bibliographies and depository libraries. Contact: Superintendent of Documents, Government Printing Office, Washington, DC 20402/202-783-3238.

Customer Complaints

Complaints are handled by the Customer Service Office, Deputy Public Printer, Government Printing Office, North Capital and H Sts. N.W., Washington, DC 20402/202-275-3050 for publications problems and 202-275-3054 for subscription problems.

Customer Information

For general Government Printing Office Information contact: Customer Information, Superintendent of Documents, Government Printing Office, North Capital and H Sts. N.W., Washington, DC 20402/202-275-3287.

Customer Service

Sometimes the Government Printing Office does not interpret your requests as you desire. Its customer service staff of over 50 employees is available to assist you and make appropriate adjustments. Please be specific about your requested adjustment and they will expedite the necessary actions for you. Superintendent of Documents, Washington, DC 20402/202-783-3238 or contact: Customer Service, Deputy Public Printer, Government Printing Office, North Capitol and H Sts., Washington, DC 20402/202-275-2941.

Deposit Accounts

Over 32,000 customers find the use of a deposit account with the Superintendent of Documents a convenient way to do business. A deposit account can be established by sending a minimum of $50.00 and receiving a unique deposit account number, which can be used to charge future purchases. Special order blanks are provided and monthly statements are mailed to customers with active deposit accounts. Telephone orders will be accepted on any deposit account if sufficient funds are available in the account. Contact: Documents Sales Service, Superintendent of Documents, Government Printing Office, North Capitol and H Sts. N.W., Washington, DC 20402/202-275-2429.

Discounts

Any customer ordering 100 or more copies of a single publication or subscription for delivery to a single destination will be granted a 25 percent discount on the selling price of the publication. Discounts are not available on items sold at a special quantity price, or specifically marked "no discount allowed." For further information contact: Order and Information, Superintendent of Documents, North Capitol and H Sts. N.W., Washington, DC 20402/202-783-3238.

Exhausted GPO Sales Publication Reference File

A useful companion volume to the PRF is the *Exhausted GPO Sales Publications Reference File* (EPRF). The EPRF contains titles of over 25,000 U.S. Government documents formerly sold by the Superintendent of Documents. It provides a ready reference file of historical bibliographic information that will be helpful in identifying older publications. The EPRF is also sold in microfiche but as a single-sales item. Contact: Superintendent of Documents, Government Printing Office, Washington, DC 20402/202-783-3238.

Foreign Orders

International mailing regulations require special handling for which GPO charges an additional 25 percent of the total cost of any order. Remittance is required in advance of shipping by draft on a United States or Canadian bank, by UNESCO coupons, or by International Postal Money Order made payable to the Superintendent of Documents. Foreign customers may also charge their orders to a prepaid deposit account with this Office or to their Master Charge or Visa account. The expiration date of a credit card must be included with your order. These orders are mailed via surface mail unless funds are sent to cover airmail postage. Foreign currency or checks will not be accepted. All orders must be in English. Contact: Order and Information, Superintendent of Documents, Government Printing Office, North Capitol and H Sts. N.W., Washington, DC 20401/202-275-3238.

Government Depository Libraries

Certain governmental publications are deposited for the use of the public in Government Depository Libraries. They are permitted to receive with certain exceptions, one copy of all publications of the U.S. Government. A classified list of the Series C groups of government publications available for selection is furnished to all depository libraries for their use in making the selection. A free list of depository libraries is available by state and congressional district and by state and city. Contact: Library Division (SLOA) Government Printing Office, Alexandria, VA 22304/703-557-9013.

GPO Visits

Tours of the Government Printing Offiice can be arranged. Contact: Customer Service Manager, Deputy Public Printer, Government Printing Office, North Capitol and H Sts. N.W., Washington, DC 20401/202-275-2941.

Government Periodicals and Subscription Services

This is a free quarterly pricelist, partially annotated, available upon request. Contact: Superintendent of Documents, Government Printing Office, Washington, DC 20402/202-783-3238.

How to Do Business With the GPO: A Guide for Contractors

This pamphlet is designed to acquaint commercial contractors with the procurement potential available at the Printing Procurement Department and the Materials Management Service of the Government Printing Office. It lists the printing items and the material and supply items produced commercially. Contact: General Procurement Division, Management and Admin-

istration, North Capitol and H Sts. N.W., Washington, DC 20402/202-275-2470. A list of regional and field printing procurement offices is available.

Just for You

This is an illustrated and annotated catalog of selected publications that cover business and industry, careers, children and families, consumerism, energy conservation, environment and weather, gardening and landscaping, eating and nutrition, health and physical fitness, hobbies and leisure activities, housing, and money management, international topics, military and aviation, national and historical topics, space exploration and recreation. Contact: Superintendent of Documents, Government Printing Office, Washington, DC 20402/202-783-3238.

Microforms

Many GPO publications are now produced in microforms. They are distributed to the Depository Libraries and many are available for sale. Contact: Customer Information, Superintendent of Documents, Government Printing Office, North Capitol and H Sts. N.W., Washington, DC 20402/202-275-3033.

Monthly Catalog of United States Government Publications

Each month the Library and Statutory Distribution Service of the Government Printing Office assembles between 1,500 and 3,000 new publication entries to produce the *Monthly Catalog of U.S. Government Publications*. Entries are arranged by the Superintendent of Documents classification number and contain four indexes: author, title, subject and series report.

Complete bibliographic data are provided for each document, as well as Government Printing Office sales information where applicable. The catalogued entry meets the requirements of Anglo-American Cataloging Rules and Library of Congress Subject Heading practices.

The *Monthly Catalog of U.S. Government Publications* is sold on subscription. In addition to the 12 monthly issues, your subscription includes two indexes and one serials supplement. Because the indexes are arranged by calendar year, all subscriptions to the *Monthly Catalog* are entered to begin with the January issue each year. The subscription is available for $65.00 per year from the Superintendent of Documents, Government Printing Office, Washington, DC 20402/202-783-3238. For additional information contact: Library and Statutory Distribution, Superintendent of Documents, North Capitol and H Sts. N.W., Washington, DC 20402/703-557-2050.

Order Desk

Information regarding the price and availability of sales publications, and orders to be charged to an established Deposit Account, Master Charge or Visa account, may be obtained by contacting: Superintendent of Documents, Government Printing Office, Washington, DC 20402/202-783-3238.

Posters, Charts, Picture Sets and Decals— Subject Bibliography

GPO sells posters, charts, picture sets and decals or a variety of subjects. They include: Wildlife Portrait series; U.S. Air Force Lithograph Series; Marine Fisheries; National Parks; Agriculture; American History; Nutrition; Anti-Paperwork; and Space. A brief subject bibliography is available. Contact: Superintendent of Documents, Government Printing Office, Washington, DC 20402/202-783-3238.

Sale of Surplus Equipment and Material

The Government Printing Office offers a variety of surplus property for sale. This may include printing and binding machinery, industrial trucks and other warehousing equipment, office furniture and machines, and damaged or surplus printing paper. When equipment is being replaced, bids are invited for both trade-in and outright sale, and final disposition is made based on the greatest overall return to the government. All sales are made by competitive sealed bids. Contact: Materials Management Service. Management and Administration, Government Printing Office, North Capitol and H Sts. N.W., Washington, DC 20402/202-275-2701.

Sales Publications Reference File (PRF)

This monthly publication is issued in microfiche only. It is a catalog of all publications currently offered for sale by the Superintendent of Documents. It is, in effect, a "Documents in Print." The PRF is arranged in three sequences: 1) GPO stock numbers; 2) Superintendent of Documents classification numbers; and 3) alphabetical arrangement of subjects, titles, agency series and report numbers, key words and phrases and personal authors.

The complete master file (approximately 170 fiche) is mailed to subscribers six times a year in January, March, May, July, September and November. A monthly supplement of the PRF called *GPO New Sales Publications* (consisting of a single fiche) is included with each mailing of the master file and mailed separately in other months. This supplemental fiche will contain all the new publications that have entered the active sales inventory the preceding month. The sub-

scription is available for $70.00 per year from the Superintendent of Documents, Government Printing Office, Washington, DC 20402/202-783-3238.

Selected U.S. Government Publications
This free catalog highlights GPO publications. Contact: Superintendent of Documents, Government Printing Office, Washington, DC 20402/202-783-3238.

Subject Bibliography
There are 270 subject bibliographies, which touch on nearly every facet of human life. These bibliographies cover over 24,000 different publications, periodicals and subscriptions services for sale by the Superintendent of Documents. For the *Subject Bibliography Index*, a *Subject Bibliography Order Form* and copies of *Price List*, contact: Superintendent of Documents, Government Printing Office, Washington, DC 20402/202-783-3238.

Teletype Service
The Government Printing Office Communications Office is equipped with teletype machines to communicate with its customers including those in other countries of the world. Customers with teletype equipment can reach the Superintendent of Documents by dialing TWX #710 822-9413; answer back USGPO WSH. For further instructions contact the local telegraph office. This service can be used to obtain quotations, make inquiries about the price and availability of publications, and to charge orders to your prepaid Deposit Account. Be sure to include the name, complete mailing address, and Telex number in the message. Also important is the Deposit Account number and order number if appropriate. For further information contact: Director of General Services, 732 North Capitol St. N.W., Room A-648, Washington, DC 20401/202-275-2003.

How Can The Government Printing Office Help You?
To determine how this office can help you contact: Assistant Public Printer, Government Printing Office, North Capitol and H Sts. N.W., Washington, DC 20401/202-275-2951.

Library of Congress

10 1st St. S.E., Washington, DC 20540/202-287-5108

ESTABLISHED: April 24, 1800
BUDGET: $202,380,000
EMPLOYEES: 5,049

MISSION: The Library's first responsibility is service to Congress; one department, the Congressional Research Service, functions exclusively for the legislative branch of the Government; its range of service has come to include the entire governmental establishment in all its branches and the public at large; it has become a national library for the United States.

Major Sources of Information

American Folklife Center

The American Folklife Center coordinates federal, state, local and private programs to support, preserve and present American folklife through such activities as the collection and maintenance of archives, scholarly research, field projects, performances, exhibitions, festivals, workshops, publications and audiovisual presentations. *Folk Life Center News* is a free quarterly newsletter on folklife activities and programs. Contact: American Folklife Center, Library of Congress, 10 1st St. S.E., Washington, DC 20540/202-287-6590.

Archive of Folk Song

The Archive of Folk Song maintains and administers an extensive collection of folk music and lore in published and unpublished form. It is a national repository for folk-related recordings, manuscripts and raw materials. The Archive reading room contains over 3,500 books and periodicals; a sizeable collection of magazines, newsletters, unpublished theses, and dissertations; field notes; and many textual and some musical transcriptions and recordings. Contact: Archive of Folk Song, American Folklife Center, Library of Congress, 10 1st St. S.E., Washington, DC 20540/202-287-5510.

Books for the Blind and Physically Handicapped

Talking books and magazines and braille books and magazines are distributed through 160 regional and subregional libraries to blind and physically handicapped residents of the United States and its territories. Information is available at public libraries throughout the United States and from the headquarters office. Contact: Library of Congress, National Library Service for the Blind and Physically Handicapped, 1291 Taylor St. N.W., Washington, DC 20542/202-287-5100.

Catalogs of Copyright Entries

The catalogs list the material registered during the period covered by each issue. They are sold as individual subscriptions by the Superintendent of Documents, Government Printing Office, Washington, DC 20402/202-783-3238.

Part 1: Nondramatic Literary Works (quarterly) $70.00 per year.
Part 2: Serials and Periodicals (semi-annually) $32.00 per year.
Part 3: Performing Arts (quarterly) $60.00 per year.
Part 4: Motion Pictures and Filmstrips (semi-annually) $9.00 per year.
Part 5: Visual Arts (excluding maps) (semi-annually) $15.00 per year.
Part 6: Maps (semi-annually) $4.00 per year.
Part 7: Sound Recordings (semi-annually). $24.00 per year.
Part 8: Renewals (semi-annually). $10.00 per year.

For additional information contact: Cataloging Division, Copyright Office, Library of Congress, 1st and Independence S.E., Washington, DC 20540/202-287-8040.

Cataloging Data Distribution

Cataloging and bibliographic information in the form of printed catalog cards, book catalogs, magnetic tapes, bibliographies and other techni-

cal publications are distributed to libraries and other institutions. Kits describing the procedure for ordering materials are available from the Library of Congress, Customer Service, Government Printing Office, Washington, DC 20401/ 202-287-6100.

Cataloging-in-Publication

Library of Congress card numbers for new publications are assigned by the Cataloging-in-Publication Office. This program is in cooperation with American publishers to print cataloging information in current books. Contact: Cataloging-in-Publication, Library of Congress, Washington, DC 20540/202-287-6372.

Center for the Book

The Center for the Book works closely with other organizations to explore important issues in the book and educational communities, to encourage reading, and to encourage research about books and about reading. Its goal is to serve as a useful catalyst by bringing together authors, publishers, librarians, booksellers, educators, scholars, and readers to discuss common concerns and work toward the solution of common problems. Four committees reflect its primary concerns: television and the printed word, reading development, the international role of the book and publishing. Contact: The Center for the Book, 10 1st St. S.E., Washington, DC 20540/202-287-5221.

Central Intelligence Agency Reports

The Library of Congress distributes CIA reports that the agency has released to the public. The reports detail foreign government structures, trade patterns, economic conditions and industries. For more information and to order reports, contact: Photoduplication Service, Library of Congress, Washington, DC 20540/202-287-5650. Cost: $.15 per exposure; orders must be prepaid or charged to a standing account at the Library of Congress. The Photoduplication Service can also provide a list of CIA reports available; cost is $5.

Children's Reference Center

The Center's reference librarians and bibliographies serve as consultants in contemporary, rare, and foreign books to scholars, writers, teachers, librarians, illustrators, and others "serving those who serve children." Lists and scholarly bibliographies are prepared. *Children's Literature: A Guide to Reference Sources*—$5.45; first supplement $5.50; second supplement $7.75, are all sold by the Superintendent of Documents, Government Printing Office, Washington, DC 20402/202-783-3238. For additional information

contact: The Children's Center, National Programs, Library of Congress, 10 1st St. S.E., Washington, DC 20540/202-287-5535.

Color Slides

Color slides featuring the Library's buildings and special items from its collections are also available. Inquiries should be directed to the Library of Congress, Photoduplication Service, 10 1st St. S.E., Washington, DC 20540/202-287-5654.

Compendium of Copyright Office Practices

This compendium is an office manual intended as a general guide for the Copyright office. It is a condensed digest of office practices in individual cases representing common fact situations. It is available for $13.00 and includes two semi-annual supplements for an indeterminate period. Available from the Superintendent of Documents, Government Printing Office, Washington, DC 20402/202-2783-3238. For additional information contact: Copyright office, Library of Congress, 1st St. and Independence Ave. S.E., Washington, DC 20540/202-287-6800.

Computer Data Bases

The files listed below may be queried by the public from the computer catalog center or from terminals in the library's reading rooms. Limited searching may be conducted in response to written or telephone inquiries; contact: General Reading Room Division, Library of Congress, Washington, DC 20540/202-287-5522.

BIBL (Bibliographic Information File)

The BIBL file contains references to topical periodical articles, pamphlets, Government Printing Office publications, U.N. documents, and interest/lobby group publications. The Library Services Division of the Congressional Research Service decides which materials to include in the file. Typically, a citation lists the author's name, article title, title of publication, volume, date, date and pagination for periodicals or place of publication, publisher, and date for monographs, as well as annotations and subject headings and terms (descriptors).

NRCM (National Referral Center Master List)

The NRCM file contains data on organizations qualified and willing to provide information on a large number of scientific and technical topics and issues of interest to social scientists. Information provided usually includes: name of organization, mailing address, location, telephone number, areas of interest, holdings (special collections, data bases), publications, and dissemina-

tion services. Researchers should request descriptions of all organizations in the data base related to their field of interest.

LCCC (Library of Congress Computerized Catalog)

The LCCC file contains nearly 3 million records representing books in the library's MARC (Machine-Readable Cataloging) data base, English-language books printed or catalogued since 1968, French-language books since 1975; additional language titles are being added to the file. A bibliographic reference from this file usually includes the author's name, monograph title, place of publication, publisher, date, descriptive annotations, subject headings, Library of Congress and Dewey Decimal System classification numbers, Library of Congress Card Number, and the International Standard Book Number (ISBN). A free LCCC printout of all publications (since 1968) in your interest area may be obtained from the General Reading Room Division, Library of Congress, Washington, DC 20540; some requests may be made on the phone, 202-287-5522.

MUMS (Multiple Use MARC System)

The MUMS file includes the LCCC file as well as maps and serial titles.

CG94, CG95, CG96 (Legislative Information Files for the 94th, 95th and 96th Congresses)

The publication entitled Digest of General Public Bills and Resolutions, popularly known as the Bill Digest, provides the basic content of these files. In addition to information such as bill content, sponsorship, cosponsorship, and action on a bill, including the most recent action by either chamber of Congress, the files provide the unique number assigned to a bill, the public law number, information concerning the existence of identical bills in both chambers, the revised text of a bill, and other information. Access to these files may be obtained through the Bill Status Office; see "Capitol Hill" section of this volume for additional information.

Congressional Research Service

The Library's primary role is to serve as the research and reference arm of Congress. Through the Congressional Research Service, a separate department, the Library furnishes legislators with the information they need to govern effectively. The Service answers more than 300,000 inquiries per year, ranging from a simple question on the population of California to an in-depth study on future energy sources. In addition, the Service prepares bill digests, summaries of major legislation, and other tools to help members and their committees stay abreast of the daily flow of legislation.

The work is performed by a staff of over 800—ranging from civil engineers and oceanographers to labor arbitrators and experts on Soviet rocketry. Their most important charge is to provide objective, unbiased information. Contact: Congressional Research Service, Library of Congress Building, Washington, DC 20540/202-287-7130.

Congressional Serial System

All Senate and House documents and reports since 1980, indexed numerically with each Congress, can be viewed and studied. Contact: Main Reading Room, Library of Congress, 10 1st St. S.E., Washington, DC 20540/202-287-7478.

Copyright

All copyrightable works, whether published or unpublished, are subject to a single system of statute protection which gives the copyright owner the exclusive right to reproduce the copyrighted work in copies or phonorecords and distribute them to the public by sale, rental, lease or lending. Works of authorship include books, periodicals, and other literary works, musical compositions, song lyrics, dramas and dramatico-musical compositions, pantomimes and choreographic works, motion pictures and other audiovisual works, and sound recordings. The Library provides information on copyright registration procedures and copyright card catalogs which cover 16 million works that have been registered since 1870. For general information contact: Copyright Office, Library of Congress, 1st and Independence Ave. S.E., Room 401, Washington, DC 20540/202-287-6800.

CRS Issue Briefs and Reports

Congressional Research Service reports are detailed accounts of issues large and small, foreign and domestic, social and political, etc. An index to these reports is available through your Congressman's office. CRS also publishes and records on cassette tapes hundreds of major issue briefs designed to keep members of Congress informed on timely issues. These briefs, written primarily for the layperson, provide a good deal of background information and are updated daily. Free hard copies may be obtained through your Congressman's office.

Each month, CRS publishes UPDATE, a supplement to the CRS Review. UPDATE includes a list of new and updated issue briefs of current interest. Briefs that are no longer of intense public or congressional interest are listed in the Archived

Issue Brief List. Both are available through your Congressman's office.

Following is a list of issue briefs that were current in late 1980. IB refers to issue brief; MB, mini-brief; and AB, audio brief.

Issue Brief Menu

AGRICULTURE AND FOOD

Agricultural Credit: Expanding Lending Authority of the Farm Credit System [09/30/80] IB80033

Agriculture: Domestic Legislation and Issues [09/24/80] IB75075

Agriculture: Impacts of Air Pollution [09/24/80] IB77052

Agriculture: International Trade and Aid [09/24/80]IB73010

Agriculture: Parity, Parity, Parity [09/24/80]IB77116

Agriculture: Proposed Revisions in Federal Disaster Assistance [09/09/80]IB78076

Agriculture: Significant Legislation of the 96th Congress [09/29/80]MB79269

Agriculture: Soil Conservation and Farmland Productivity [09/25/80]IB80031

Agriculture: U.S. Embargo of Agricultural Exports to U.S.S.R. [08/20/80]IB80025

Agriculture: U.S. Food Power in International Affairs [09/09/80]IB76017

Food Prices [09/25/80]IB79031

BUDGET AND GOVERNMENT SPENDING

Balanced Budget and Spending Limitations Seminar [05/01/79] AB50024

Balanced Budget and Spending Limitations: Proposed Constitutional Amendments [09/24/80] IB79027

The Balanced Budget Proposal: Some Macroeconomic Implications [09/24/80] MB79229

Balanced Budget, Government Expenditures and Taxation: Public Opinion [09/24/81] IB78070

Budget (Federal) for FY80: An Economic Overview [08/25/80] IB79016

Budget: The FY81 Federal Budget [09/22/80] IB80023

CETA and Budget Cuts [07/31/80] MB80212

BUSINESS TRENDS AND CONSUMER AFFAIRS

Antitrust Law: Right of Indirect Purchasers to Sue for Injuries [09/24/80] MB78203

Antitrust Laws: Procedural Reform [09/26/80] IB79028

Oil Industry Profits [08/21/80] MB80215

Products Liability: A Legal Overview [09/24/80] IB77021

CIVIL RIGHTS AND LIBERTIES

Abortion: Legal Control [07/17/80] IB74019

Displaced Homemakers [09/24/80] IB78042

Equal Rights Amendment (Propsed) [09/24/80] IB74122

Free Press and Police Searches: The Stanford Daily Case [08/12/80] IB79029

Free Press: Federal Shield Law [09/24/80] IB74018

Indians: Land Claims By Eastern Tribes [09/26/80] IB77040

Pregnancy as a Discrimination Issue [09/24/80] IB77039

U.S. Population Policy: Some Considerations [09/25/80] IB80075

DEFENSE AND NATIONAL SECURITY

Arms Sales: U.S. Policy [09/24/80sIB[09/24/80] IB77097

Defense Budget—FY80 [09/05/80] IB79040

Defense Budget—FY81 [09/11/80] IB80037

Defense Manpower Costs [09/15/80] IB79078

Fighter Aircraft Program: F-14 [09/09/80] IB79056

Fighter Aircraft Program: F-16 [09/09/80] IB79030

Fighter Aircraft Program: F/A-18 [09/09/80] IB78087

Intelligence Community: Congressional Oversight [09/16/80] IB77079

Intelligence Community: Reform and Reorganization [09/16/80] IB76039

Intelligence Operations: Covert Action [08/07/80] IB80020

Korea: U.S. Troop Withdrawal and the Question of Northeast Asian Stability [09/19/80] IB79053

Military Manpower for Mobilization: The Draft, Registration, and Selective Service [09/09/80] IB79049

Military Manpower and the All-Volunteer Force [09/24/80] IB77032

MX Intercontinental Ballistic Missile Program [10/01/80] IB77080

NATO: Burden Sharing [07/20/79] AB50028

Nuclear Energy: Foreign Policy on Spent Nuclear Fuel [09/29/80] IB79107

Petroleum Imports from the Persian Gulf: Use of U.S. Armed Force to Ensure Supplies [10/01/80] IB79046

Pros and Cons of Military Intervention [01/08/80] AB40033

Rapid Deployment Forces [09/09/80] IB80027

SALT II Acceptance Criteria: A Military Appraisal [09/26/80] IB79005

SALT II Treaty: U.S. and Soviet Interim Observance of its Terms [08/26/80] IB80018

SALT II: Review of Public Opinion Polls [09/24/80] IB79065

SALT II: The Political Context [05/21/79] AB50023

Soviet Defense Economics [07/20/79] AB50027

Terrorism: Informational Requirements [05/01/78] AB50013

Trident Program [10/01/80] IB73001

U.S. Strategic Nuclear Force Options [08/18/80] IB73001

United States/Soviet Military Balance [09/26/80] IB78029

V/STOL Aircraft Development [09/09/80] IB78020

Women in the Armed Forces [11/02/79] AB450031

Women in the Armed Forces [09/17/80] IB79045

ECONOMIC CONDITIONS, GENERAL

Economic Indicators [09/19/80] IB75041

Oil Imports: Policy, Current Events, Domestic Impacts [10/01/80] IB79066

Oil Shipped Through the Strait of Hornmuz [10/01/80] MB80205

Oil Windfall Profits Tax [09/15/80] IB80010

Power Plants: Converting to Coal [07/31/80] IB75046

Solar Energy and Energy Conservation Bank [09/24/80] MB80225

Solar Energy From Space: Satellite Power Stations [09/15/80] IB78012

Solar Power [09/17/80] IB74059

Synthetic Fuels Corporation and Technology [08/29/80] MG79245

Synthetic Fuels: The Model of Synthetic Rubber Production During WW II [09/09/80] IB79075

ENVIRONMENTAL PROTECTION

Acid Precipitation: A Serious and Growing Environmental Problem [09/26/80] IB80022

Acid Rain: A Dialogue [08/25/80] AB50037

Aircraft Noise Abatement [09/09/80] IB79071

Barrier Island Protection [09/24/80] IB80057

Benefit-Cost Analysis and Environmental Decision-making [09/10/80] IB80012

Clean Air Act: An Overview [09/18/80] IB80078

Environmental Protection Agency Programs: Congressional Actions [08/21/80] IB79105

Environmental Protection Agency's FY81 Budget: A Brief Analysis [09/19/80] IB80059

Environmental Protection: Hazardous Wastes [09/09/80] IB79088

Environmental Regulations: Economic Impact [09/30/80] IB79025

High-Voltage Electric Power Transmission Lines: Impact on Public and Environmental Health [09/09/80] MB80222

Mt. St. Helens: An Assessment [09/09/80] IB80066

Municipal Pollution Control: The EPA Construction Grants Program [09/25/80] IB80049

National Environmental Policy Act: An Overview of Current Issues [09/02/80] IB80004

Oil Spill Liability and Compensation [09/10/80] IB78080

Oil Spills in the Marine Environment [09/09/80] IB77014

Pesticides Regulation: An Overview [09/22/80] IB77074

Pollution Control: Taxes, Effluent Charges, and Other Alternatives [09/24/80] IB77009

Resource Conservation and Recovery Act of 1976 [09/09/80] IB79113

Safe Drinking Water [09/24/80] IB78074

Toxic Substances Contamination: Compensation Issues [09/09/80] IB77019

Water Pollution Control: Disposal of Dredge and Fill [09/29/80] IB77026

Water Pollution: Toxic Contaminants [09/09/80] IB77071

Water Quality: Implementing the Clean Water Act [09/09/80] IB79091

FINANCIAL AND FISCAL AFFAIRS

Federal Reserve Membership and Monetary Control [09/08/80] IB79047

General Revenue Sharing: Prospects for Extension in 1980 [08/18/80] IB80015

Inflation and Monetary Policy [06/20/78] IB50010

Money Definitions, Monetary Policy, and Congressional Oversight [09/12/80] IB80017

Regulation Q and Interest on Deposits [09/18/80] IB80056

FOREIGN POLICY AND ASSISTANCE PROGRAMS

Afghanistan: Soviet Invasion and U.S. Response [09/15/80] IB80006

Africa: Soviet/Cuban Role [08/28/80] IB78077

China-U.S. Relations [09/24/80] IB76053

China-U.S.-Soviet Relations [09/24/80] IB79115

Egyptian-Israeli Peace Treaty [09/02/80] IB79076

El Salvador: U.S. Interests and Policy Options [08/26/80] IB80064

Executive Agreements and the Congress [10/01/80] IB74035

Foreign Aid: FY79-80 Foreign Economic and Security Assistance Budgets [09/11/80] IB78055

Genocide Convention [07/18/80] IB74129

The Horn of Africa and the United States [08/26/80] IB78019

Indochinese Refugee Exodus: Causes, Impact, Prospects [09/03/80] IB79079

Iran Confrontation with the United States [09/02/80] IB-9118

Iran: Executive and Congressional Reactions and Roles [09/10/80] IB80001

Iraq: An Overview of Current Issues and Policies [09/26/80] MB80214

Multilateral Development Banks: Can the U.S. Limit Use of its Contributions? [09/09/80] IB79114

Namibia: United Stations Negotiations for Independence/U.S. Interests [09/09/80] IB79114

Nicaragua: Conditions and U.S. Interests [10/01/80] IB80013

Nuclear Exports: The Tarapur Fuel Issue and U.S. Interests in South Asia [09/11/80] IB80067

Palestine and the Palestinians [09/02/80] IB76084

South Africa: Issues for U.S. Policy [08/01/80] IB80032

Taiwan's Future: Implications for the United States [09/24/80] IB79101

Turkey and U.S. Interests [09/19/80] IB79089

U.S.-Soviet Relations After Afghanistan [09/19/80] IB80080

Zimbabwe: U.S. Relations [09/02/80] IB80072

GOVERNMENT AND POLITICS

Balanced Budget Constitutional Convention [02/14/79] AB50020

Civil Service Reform Act: Implementation [09/24/80] IB79094

Congressional Ethics [09/11/80] IB79038

Congressional Pay [09/23/80] IB77048

Congressional Reform [09/23/80] AB50012

Congressional Reform—House (96th Congress)

Crime: Sentencing Reform [09/08/80] IB77108

Criminal Code Reform (Federal) [09/08/80] IB80016

Domestic Violence: Elder Abuse [09/19/80] MB80223

FBI Charter: Proposed Legislation [09/19/80] IB79111

Gun Control [09/09/80] IB74011

Juvenile Delinquency: The Juvenile Justice and Delinquency Prevention Act Reauthorization [09/08/80] IB80043

Law Enforcement Reorganization at the Federal Level [09/22/80] IB77094

Law of the Sea Conference [09/29/78] AB50018

Marihuana Control [09/12/80] IB77119

Narcotics: Control of Illicit Traffic [08/26/80] IB76061

Parental Kidnapping [09/29/78] IB77117

Supreme Court in the Current Session [07/11/80] AB50036

Tort Claims Act: Proposed Amendments [09/23/80] IB79017

NATURAL RESOURCES

Acreage Limitation Controversy: Status Report [09/10/80] IB78002

Alaska National Interest Lands (D-2) Legislation [09/30/80] IB77110

Anadromous Fisheries [09/16/80] IB80054

Coastal Zone Management: Status and Issues [08/29/80] IB79024

Deep Seabed Hard Mineral Resources [08/20/80] IB74024

Fisheries Development [09/19/80] IB79112

Foreign Investment in U.S. Farmland [09/09/80] IB78064

Forest Service's Roadless Area Review and Evaluation (RARE II) [09/19/80] IB79059

Helium Conservation Controversy [09/30/80] IB78060

Outer Continental Shelf Oil and Gas Leasing: Issue of Split Responsibility [09/25/80] IB80051

Sagebrush Rebellion [09/24/80] IB80050

Surface Mining: Federal Regulation [09/09/80] IB74074

Tuna: Fishery in Turmoil [09/23/80] IB79122

U.S.-Canadian East Coast Fishery Treaty and Boundary Agreement [09/09/80] IB79099

Water Resources Development: Administration Reform Efforts [09/09/80] IB78083

Water Resources Development: Cost-Sharing Options for Federal Projects [08/20/80] IB79055

Water Resources: Conservation in Irrigated Agriculture [08/20/80] IB77072

Water Resources: Options for Rural Water Systems [08/20/80] IB78039

Water Resources: Small-scale Hydroelectric Development [09/09/80] IB78035

SCIENCE AND TECHNOLOGY

Aquaculture: Status of Technology and Future Prospects [09/19/80] IB77099

Earth Resources Satellite System [09/19/80] IB78007

Government Patent Policy: The Ownership of Inventions from Federally Funded R&D [09/18/80] IB78057

Industrial Innovation [09/16/80] IB80005

Institute for Scientific and Technological Cooperation [09/09/80] IB79033

Metric System of Weights and Measures: United States Conversion [09/24/80] IB74049

National Defense Stockpile [09/22/80] IB74111

National Materials Policy [09/22/80] IB74094

Passive Restraint Automobile Crash Protection: Air Bags and Automatic Safety Belts [09/24/80] IB80083

Science and Technology in Policy Formation at the Presidential Level: Recent Developments [09/16/80] IB78027

Space Policy and NASA Funding [09/11/80] IB78093

Space Shuttle [09/08/80] IB73019

Technology Transfer: State and Local Government Application of the Results of Federally Funded Research and Development [10/03/80] IB80048

Waste Materials: Recycling and Reuse [09/22/80] IB74112

Weather Modification [09/22/80] IB79109

Women in Science and Technology Careers [09/24/80] IB80065

SOCIAL SERVICES AND INCOME MAINTENANCE

Aid to Families with Dependent Children: Structural Change [09/08/80] IB74013

Child Care: The Federal Role [09/05/80] IB77034

Child Feeding Programs: Budgetary Pressures 09/05/80] IB80053

Employment and Education: Youth Act of 1980 [09/08/80] IB80045

Energy Assistance for Low-Income Households [09/24/80] IB80024

Federal Retirement Programs: Proposals to Change the Cost-of-Living Adjustments (COLA) [09/08/80] IB80052

Food Stamps: 1979 Legislation [09/04/80] IB79034

Holding Down the Food Stamp Budget: 1980 Legislation [09/04/80] IB80079

Pension Plans: Multiemployer Pension Plan Termination Insurance [09/24/80] IB79052

Social Security Benefits for Prisoners [09/03/80] MB80219

Social Security Financing and Taxation [09/29/80] IB80007

Social Security: The Automatic Benefit Increase Provision [09/22/80] IB80073

Social Security's Disability Programs: Amendments of 1980 [09/08/81 IB79084

Trade Adjustment Assistance for Workers: Program Growth and Possible Changes [09/02/80] IB80082

Vesting Regulations for Pension Plans: IRS Proposals [09/02/80] IB80084

Welfare Reform 09/08/80] IB77069

TAXATION
Significant Federal Tax Legislation of the Current Congress [08/28/80] MB80217
Tax Cut Proposals in the 96th Congress [08/22/80] IB79095
Value-Added Tax [09/09/80] IB79120

TRADE AND INTERNATIONAL FINANCE
Automobiles Imported From Japan [09/26/80] IB80030
China-U.S. Trade [08/26/80] IB75085
Debt Problems of Developing Countries [10/01/80] IB79108
The Dollar in International Markets [09/29/80] IB78033
Export Controls [09/09/80] IB75003
Export Trading Companies [09/23/80] IB80044
Foreign Investment in U.S. Industry [09/29/80] IB78091
International Monetary Fund (IMF) Quota Increases [09/09/80] IB80028
Iranian-U.S. Trade and Investment Statistics [09/09/80] MB79273
Japan-U.S. Trade Imbalance [09/25/80] IB78025
Most-Favored-Nation Policy Toward Communistic Countries [09/04/80] IB74139
Steel and the European Community: The Protection Issue [09/09/80] IB80061
Trade Adjustment Assistance [08/18/80] IB77095
U.S. Balance of Payments [04/13/79] AB450022

TRANSPORTATION
Airline Deregulation: An Appraisal [09/29/80] MB79247
Railroad Problems: A Precis [09/09/80] MB79202
Railroads: Regulatory Issues [09/29/80] IB79003
Transportation of Hazardous Materials: Laws, Regulations and Policy [08/22/80] IB76026
Trucking: Economic Regulations [08/27/80] IB76019

URBAN AND RURAL DEVELOPMENT
Rural Development: The Federal Role [09/25/80] IB77113
Urban Affairs: Reauthorization of the Community Development Block Grant Program [08/29/80] IB80042
Urban Affairs: Reauthorization of the Urban Development Action Grant Program [08/06/80] IB80058

Cultural Programs

Chamber music concerts, poetry festivals, lectures and readings are presented in the 500-seat Coolidge Auditorium and in the adjacent Whittall Pavilion during the fall, winter and spring. Recordings of the concerts and many of the programs are offered to radio stations for broadcast across the country. Lectures are often published in pamphlet form.

Through continually changing exhibitions, the Library shows the public what treasures it holds. Prints and photographs, maps and musical scores, rare books and manuscripts are drawn from the collections and displayed in the Library. In addition, many exhibits are sent on tour to libraries and museums across the nation. A free monthly calendar of events is available. Contact: Information, Library of Congress, 10 1st St. S.E., Washington, DC 20540/202-287-5108.

Digest of Public General Bills and Resolutions

The Digest provides summaries of each public bill and resolution and its current status in order of their introduction in Congress. It includes subject, author and specific title. Subscriptions service consists of cumulative issues, including a final issue upon adjournment of Congress. Supplements are issued irregularly. Sold for $75.00 per session of Congress by the Superintendent of Documents, Government Printing Office, Washington, DC 20402/202-783-3238. For additional information contact Congressional Research Service, Library of Congress, Madison Building, S.E., Washington, DC 20540/202-287-6996.

Geography and Maps

The Library's cartographic collection, three and one-half million maps, nearly 40,000 atlases and some 8,000 reference books is the largest and most comprehensive in the world. It includes atlases for the last five centuries which cover individual continents, countries, states, counties and cities as well as the world. Official topographic, geologic, soil mineral and resource maps and nautical and aeronautical charts are available for most countries of the world. Contact: Geography and Map Division, Library of Congress, 1st and Independence Ave. S.E., Washington, DC 20540/202-287-6277.

Greeting Cards and Other Special Items

Greeting cards, notepaper, bookplates, and posters are for sale at the Library's Information Counter and by mail. For an illustrated brochure, write to the Library of Congress, 10 1st St. S.E., Central Services Division, Washington, DC 20540/202-287-5590.

International Division

The Library's international divisions provide reference service on social, economic and political topics overseas.

African-Middle Eastern Division/202-287-7937
 African Section/202-287-5528
 Hebraic Section/202-287-5422
 Near East Section/202-287-5421
Asian Division/202-287-5420

Chinese and Korean Section/202-287-5423
Japanese Section/202-287-5431
Southern Asia/202-287-5600
European Division/202-287-5414
Poland and East Europe/202-287-5413
Czechoslovakia and East Europe/202-287-6175
Finno-Ugrian/202-287-5415
Hispanic Division/202-287-5400

For additional information contact: Area Studies, Library of Congress, 10 1st St. S.E., Washington, DC 20540/202-287-7160.

Law Library

The Law Library contains the world's largest and most comprehensive collection of foreign international and comparative law. Its legal specialists provide information for all known legal systems present and past including common law, civil law, Roman law, canon law, Chinese law, Jewish and Islamic law, and ancient and medieval law. U.S. legislative documents include the *Congressional Record* (and its predecessors), the serial set, an almost complete set of bills and resolutions, current documents, committee prints, reports, hearings, etc. It also has a complete set of U.S. Supreme Court records and briefs and collections of U.S. Courts of Appeals records and briefs. The law library has five major divisions:

American-British Law—United States, Australia, Canada, Great Britain, India, New Zealand, Pakistan, certain other countries of the British Commonwealth and their dependent territories, and Eire: 202-287-5079.
European Law—nations of Europe and their possessions, except Spain and Portugal: 202-287-5090.
Hispanic Law—Spain and Portugal, Latin America, Puerto Rico, the Philippines, and Spanish- and Portuguese-language states of Africa: 202-287-5070.
Far Eastern Law—nations of East and Southeast Asia, including China, Indonesia, Japan, Korea, Thailand, and former British and French possessions in the area: 202-287-5085.
Near Eastern and African Law—Middle Eastern countries, including the Arab States, Turkey, Iran, and Afghanistan, and all African countries, except Spanish- and Portuguese-language states and possessions. 202-287-5073. For additional information contact: Law Library, Library of Congress, 10 1st St. S.E., Washington, DC 20540/202-287-5065.

Legislative Histories and Research

For legislative history information contact: Law Library, Library of Congress, 10 1st St. S.E., Washington, DC 20540/202-287-5065.

Librarians of Congress, 1802–1974

The Library of Congress was created in 1800 by an Act of Congress, and in the intervening 178 years there have been only twelve Librarians of Congress. Among them have been politicians, businessmen, newspapermen, a poet (Archibald MacLeish), lawyers, and even one professional librarian! This book discusses the lives and careers of the first eleven Librarians. It is available for $7.75 from the Superintendent of Documents, Government Printing Office, Washington, DC 20402/202-783-3238. For additional information contact: Information Officer, Library of Congress, 10 1st St. S.E., Washington, DC 20540/202-287-5108.

Manuscripts

The manuscript collection includes personal papers of eminent and important Americans; manuscripts about the history of Latin America; and records of prominent national organizations. Contact: Manuscript Division, Special Collections, Library of Congress, 1st and Independence Ave. S.E., Washington, DC 20540/202-287-5383.

Monthly Checklist of State Publications

This periodical records those documents and publications issued by the various states and received in the Library of Congress. It is available on subscription for $21.90 a year from the Superintendent of Documents, Government Printing Office, Washington, DC 20402/202-783-3238. For additional information contact: Information, Library of Congress, 10 1st St. S.E., Washington, DC 20540/202-287-5108.

Motion Picture and Broadcasting

The film and television collections contain over 75,000 titles, with several thousand titles being added each year through copyright deposit, purchase, gift or exchange. Items selected from copyright deposits include feature films and short works of all sorts, fiction and documentary, exemplifying the range of current film and video production. The collections also include some 300,000 stills. Limited viewing facilities are available for specialized research. For additional information and viewing appointments contact: Motion Picture Broadcasting and Recorded Sound Division, Library of Congress, 1st and Independence Ave. S.E., Room 1053, Washington, DC 20540/202-287-5840.

Music Division

The collections of music and music literature include over 4,000,000 pieces of music and manuscripts, some 300,000 books and pamphlets and about 350,000 sound recordings reflecting the development of music in Western civilization from earliest times to the present. Every type of print-

ed music is represented. Musicians who wish to play music drawn from the Library's collection may use the piano or the violin available in an adjacent soundproof room. For additional information contact: Music Division, Special Collections, Library of Congress, 1st and Independence Ave. S.E., Room G146, Washington, DC 20540/202-287-5504.

National Preservation Program
The Library provides technical information related to the preservation and restoration of library and archival material. New techniques for preservation or restoration are developed and tested in the Restoration Laboratory. Research on longstanding preservation problems is conducted by the Preservation Research and Testing Office. A series of leaflets on various preservation and conservation topics has been prepared by the Preservation Office. Information and publications are available from the Library of Congress, Preservation Office, Research Services, Washington, DC 20540/202-287-5213.

National Referral Center
The National Referral Center is a free referral service which directs those who have questions concerning any subject to organizations that can provide the answer. Its purpose is to direct those who have questions to resources that have the information and are willing to share it with others. Some of these resources exist within the Library itself. The Center file consists of over 13,000 organizations and includes a description of each, its special fields of interest and the type of information service it provides. Most queries are handled within five days. Contact: National Referral Center, Research Services, Library of Congress, 10 1st St. S.E., Washington, DC 20540/202-287-5670.

National Referral Center Publications
The National Referral Center occasionally compiles directories of information resources covering a broad area. These are published by the Library of Congress under the general title *A Directory of Information Resources in the United States* with subtitles as listed below. They may be purchased from the Superintendent of Documents, Government Printing Office, Washington, DC 20402.

Federal Government With a Supplement of Government-Sponsored Information Analysis Centers ($4.25)
Social Sciences ($6.90)
Biological Sciences ($5.00)
Physical Sciences, Engineering ($7.40)

The Center prepares a similar guide entitled *Directory of Federally Supported Information Analysis Centers*, which is sold by the National Technical Information Service, Springfield, VA 22151/703-557-4650.

Under the title *Who Knows?*, the Center issues informal lists of resources that have information on specific topics, such as hazardous materials, population or environmental education. The lists are available free of charge from the center as long as the supply lasts. A list of titles is available. Contact: Publications, National Referral Center, General Reference, Library of Congress, 10 1st St. S.E., Washington, DC 20540/202-287-5683.

National Referral Center Register
The National Referral Center invites organizations that have information in specialized fields to participate as information resources. They may register by letter or on a prepared form, available on request from the center. All applications should include the following information which is necessary for referrals: Contact: National Referral Center, Research Services, Library of Congress, 10 1st St. S.E., 5th Floor, Washington, DC 20540/202-287-5680.

National Union Catalog
The *National Union Catalog* is a register of all the world's books published since 1454 and held in more than 1,100 North American libraries, and other union catalogs which record the location of books in Slavic, Hebraic, Japanese and Chinese languages. It is published in book form so that many libraries have it at hand. Contact: National Union Catalog Publications Project, Processing Services, Library of Congress, 110 2nd St. S.E., Washington, DC 20540/202-287-5983.

Photoduplication Service
Copies of manuscripts, prints, photographs, maps, and book material not subject to copyright and other restrictions are available for a fee. Order forms for photo reproduction and price schedules for this and other copying services are available from the Library of Congress, Photoduplication Service, 10 1st St. S.E., Washington, DC 20540/202-287-5637.

Printed Catalog Cards
Forms for ordering LC printed catalog cards may be obtained from the Cataloging Distribution Service, Library of Congress, Building No. 159, Navy Yard Annex, Washington, DC 20541/202-287-6120.

Prints and Photographs

The collections chronicle American life and society from the invention of photography to the present. Reference librarians will assist researchers doing their own investigations and will furnish names of picture searchers who work for a fee for those who cannot get to the library. Contact: Prints and Photographs Division, Library of Congress, 1st and Independence Ave. S.E., Washington, DC 20540/202-287-6394, Architecture Reference 202-287-6399.

Procurement

Persons seeking to do business with the Library of Congress should contact the Library of Congress, Procurement and Supply Division, Landover Center Annex, 1701 Brightseat Rd., Landover, MD 20785/202-287-8717.

Publications in Print

Library of Congress Publications in Print is a free annual list of publications. As new LC publications are issued, they are announced in the Library's weekly *Information Bulletin* and in the Superintendent of Documents' *Monthly Catalog of United States Government Publications.* The *Annual Report of the Librarian of Congress* contains a list of LC publications issued during the fiscal year covered. Contact: Information, Library of Congress, 10 1st St. S.E., Washington, DC 20540/202-287-5108.

Quarterly Journal of the Library of Congress

Contains articles on the collections, services and programs of the Library. It is written by scholars for the general reader and is heavily illustrated. The subscription is available for $9.00 per year from the Superintendent of Documents, Government Printing Office, Washington, DC 20402/202-783-3238. Contact: Information, Library of Congress, 10 1st St. S.E., Washington, DC 20540/202-287-5108.

Rare Book Division

This division contains about 309,000 volumes and pamphlets. Among the collection are documents of the first fourteen Congresses of the United States; dime novels; incunabula, early American imprints to the year 1801; Adolf Hitler's library; and the Russian Imperial collection. Contact: Rare Book Division, Special Collections, Library of Congress, 1st and Independence Ave. S.E., Washington, DC 20540/202-287-5434.

Reading Rooms

The main reading room is located on the first floor of the main building. It contains material on American history, economics, fiction, language and literature, political science, government doc-

uments and sociology. The general reference section is also housed there. Contact: Main Reading Room, Library of Congress, 10 1st St. S.E., Washington, DC 20540/202-287-7478.

The Thomas Jefferson Reading Room contains material on science, technology, medicine, agriculture, fine arts, military science, education, genealogy, American local history, bibliography and library science, world history, philosophy, religion, geography, anthropology and sports. It keeps bound periodicals and also has a general reference section. Contact: Thomas Jefferson Reading Room, Library of Congress, 110 2nd St. S.E., Washington, DC 20540/202-287-5538.

Reports on High School and Intercollegiate Debate Topics

A free report, prepared by the Library of Congress, contains a compilation of pertinent excerpts, bibliographical references and other materials related to debate topics. These topics are selected by the National University Extension Service Association as the national high school debate topics, and selected annually by the American Speech Association as the national college debate topics. Contact your local Congressman or Information, National Programs, Library of Congress, 10 1st St. S.E., Washington, DC 20540/202-287-5108.

Research Facilities

Full-time scholars and researchers may apply for study desks in semi-private areas. For additional information contact: Research Facilities Section, General Reading Rooms, Research Services, Library of Congress, 10 1st St. S.E., Washington, DC 20540/202-287-5211.

Research Services

Guidance is offered to readers in the identification and use of the material in the Library's collections, and reference service in answer to inquiries is offered to those who have exhausted local, state and regional resources. Persons requiring services which cannot be supplied with names of private researchers who work on a fee basis. Requests for information should be directed to the Library of Congress, Research Services Department, General Reading Rooms Division, Washington, DC 20540/202-287-5543.

Science and Technology

This division offers reference services based on the library's collection of 3 million scientific and technical books and pamphlets and 2.5 million technical reports. Reference librarians assist readers in using the library's book and on-line catalogs and in locating technical reports through abstracting and indexing services housed

in the division's reading room. The division's Reference Section prepares a series of bibliographic guides to selected scientific and technical topics. You can order (at no cost) the *Tracer Bullets* (See *Tracer Bullets* in this section) in your field of interest; they are a handy reference tool. Contact: Science and Technology, Research Services, Library of Congress, 110 2nd St. S.E., Room 5008, Washington, DC 20540/202-287-5639.

Serial and Government Publications

This collection contains over 70,000 titles of periodicals and government serials, microfilms and newspapers, both domestic and foreign. Contact: Serial and Government Publications, General Reference, Library of Congress, 10 1st St. S.E., Washington, DC 20540/202-287-5647.

Sound Recordings

The sound recording collection reflects the entire spectrum of history of sound from wax cylinders to quadraphonic discs, and includes such diverse media as wire recordings, aluminum discs, zinc discs, acetate-covered glass discs, rubber compound discs and translucent plastic discs. The holdings also reflect a century of American life and culture and include a number of collections of unusual historical interest. Included are the Berliner collection, from the company which invented and introduced disc recording, radio news commentaries from 1944 to 1946, eyewitness descriptions of marine combat and House of Representative debates.

For purchase by researchers, the Division's laboratory is prepared to make taped copies of recordings in good physical condition, when not restricted by copyright, performance rights or provisions of gift or transfer. The requester is responsible for any necessary search—by mail or in person—of Copyright Office records to determine the copyright status of specific recordings.

The Division also offers copies of some of its holdings for sale in disc form. These include a number of LP records of folk music, poetry and other literature. A free catalog is available. For additional information contact: Motion Picture, Broadcasting and Recorded Sound Division, Special Collections, Library of Congress, 1st and Independence Ave. S.E., Room G-1053, Washington, DC 20540/202-287-5840.

Surplus Books

The Library of Congress makes its surplus duplicate books available to tax-supported and non-profit educational institutions and bodies on a donation basis. These publications are miscellaneous in character and are not listed or arranged in any way. They are shelved for inspection, and any eligible organization can review these surplus publications. Book dealers and other interested individuals may also review the duplicate collection, provided they are willing to offer library materials in exchange for any publication they select. Contact: Exchange and Gift Division, Acquisitions and Overseas Operations, Library of Congress, 110 2nd St. S.E., Washington, DC 20540/202-287-5243.

Tours

America's Library, an 18-minute slide/sound introduction to the Library of Congress, is shown hourly every day from 8:45 A.M. to 8:45 P.M. in the Orientation Theatre, Ground Floor, Library of Congress Building. Free tours leave from the Orientation Theatre on the hour from 9 A.M. through 4 P.M. Monday through Friday. Group tours must be arranged in advance with the Tour Office. Contact: Tour Office, Library of Congress, 10 1st St. S.E., Washington, DC 20540/202-287-5458.

Tracer Bullets

An informal series of reference guides are issued by the Science and Technology Division under the general title *LC Science Tracer Bullet.* These guides are designed to help a reader begin to locate published material on a subject about which he or she has only general knowledge. New titles in the series are announced in the weekly Library of Congress *Information Bulletin* that is distributed to many libraries. Each *Bullet* is available. Contact Science and Technology Division, Reference Section, Library of Congress, 110 2nd St. S.E., Room 5114, Washington, DC 20540/202-287-5664.

The following titles (Followed by TB number) are available:

Acupuncture (72-1)
Sickle Cell Anemia (72-2)
Endangered Species (Animals) (72-3)
Fresh-Water Ecology (72-4)
Science Policy (72-5)
Biological Effects of Radiation (72-6)
Rose Culture (72-7)
Mars (Planet) (72-8)
Nuclear Medicine (72-9)
Mariculture (Sea Farming) (72-10)
Quasars (72-11)
CATV (Community Antenna TV) (72-12)
Computer Output Microfilm (COM) (72-13)
Algae (72-14)
Dolphins (72-15)
Scientific Careers (72-16)
Sharks (72-17)
Metric System (72-18)
Medical Botany (72-19)

Noise Pollution (72-20)
Manned Undersea Research Stations (73-1)
Steam Engines (73-2)
Venus (73-3)
Artificial Intelligence (73-4)
Optical Illusions (73-5)
Ocean-Atmosphere Interaction (73-6)
Solar Energy (73-7)
Geothermal Energy (73-8)
Telecommunication (73-9)
Edible Wild Plants (73-10)
Technological Forecasting (73-11)
Food Additives (73-12)
Human Evolution (73-13)
Nondestructive Testing (73-14)
Technology Assessment (73-15)
Organic Gardening (73-16)
Wind Power (73-17)
The History of Technology (73-18)
Tidal Power (73-19)
Earthquakes and Earthquake Prediction (74-1)
Drug Abuse (74-2)
Energy Crisis—An Overview (74-3)
Science and Technology in 18th Century America (74-4)
Coal Gasification (74-5)
Organic Fuels (74-6)
Privacy and Security in Computer Systems (74-7)
Ground Effect Machines (Air Cushion Vehicles, etc.) 74-8)
Nuclear Safety (74-9)
Aquaculture (74-10)
Herbs and Herb Gardening (75-1)
Remote Sensing—An Overview (75-2)
Human Bioclimatology (75-3)
Black Holes (Astronomy) (75-4)
Weather Modification (75-5)
Hydrogen As Fuel (75-6)
Science in China (75-7)
Magnetohydrodynamic (MHD) Power Generation (75-8)
Diabetes Mellitus (75-9)
Biorhythms (75-10)
Kinesiology (75-11)
Science Education in America (75-12)
Liquid Crystals (75-13)
Small Scale Water Power (75-14)
Energy Conservation in Building Design (75-15)
Continental Drift (75-16)
Administration and Management of Scientific and Technical Libraries (76-1)
Women in the Sciences (76-2)
Home Food Preservation (76-3)
The History of Psychology (76-4)
Unconventional Sources of Protein (76-5)
Endangered Species (Plants) (76-6)
Airships (76-7)
Fire Retardants (76-8)
Hydroponics (76-9)
Hypertension (76-10)
Industrial Safety and Health (77-1)
Herbal and Folk Medicine (77-2)

Microcomputers (77-3)
Allergy and Asthma (77-4)
Lead Poisoning (77-5)
Science and Society (77-6)
Environmental Education (77-7)
Tidal Energy (77-8)
Cryobiology (77-9)
Ginseng (77-10)
Climate Change (77-11)
Inventions and Inventors (77-12)
Fiber Optics (77-13)
Biographical Sources in the Sciences (77-14)
Recombinant DNA Controversy (78-1)
Beekeeping (78-2)
Astronomy and Astrophysics (78-3)
Dryland Agriculture (78-4)
Thermal Pollution (78-5)
Rockets, Missiles and Propellants (78-6)
Marine Mammal Protection (78-7)
Genetic Engineering (78-8)
Hyperlipoproteinemia (78-9)
Vitamins (78-10)
Science Fair Projects (78-11)
Poisonous Plants and Animals (78-12)
Adhesion and Adhesives (79-1)
Energy Resources in China (79-2)
Brain and Behavior (79-3)
Marine Mineral Resources (79-4)
Sports Medicine (79-5)
Microwaves (79-6)
Cosmology (79-7)
Alcohol Fuels (79-8)
Birth Defects (79-9)
Agent Orange Diozin: TCD_D (79-10)
IN PRESS
Green Revolution (80-1)
Stress: Physiological and Psychological Aspects (80-2)
Automotive Electronics (80-3)
IN PREPARATION
Aging
Terminal Care
Lasers
Low-Level Radiation: Environmental and Biological Effects
Biofeedback
Alcoholism
Technology: The 21st Century
Food Processing

Contact: Science and Technology Division, Reference Section, Library of Congress, 110 2nd St. S.E., Room 5114, Washington, DC 20540/202-287-5664.

How Can the Library of Congress Help You?
To determine how this office can help you contact: Information Office, Library of Congress, 10 1st St. S.E., Washington, DC 20540/202-287-5108.

Office of Technology Assessment

600 Pennsylvania Ave. S.E., Washington, DC 20510/202-224-8996

BUDGET: $11,284,000
EMPLOYEES: 130
MISSION: Helps the Congress anticipate, and plan for, the consequences of uses of technology; provides an independent and objective source of information about the impacts, both beneficial and adverse, of technological applications; and identifies policy alternatives for technology-related issues.

Major Sources of Information

Current Assessment Activities

This booklet provides Members of Congress with brief summaries of OTA's current work projects and their anticipated completion dates. Contact: Publishing Office, Office of Technology Assessment, Congress, 600 Pennsylvania Ave. S.E., Washington, DC 20510/202-224-8996.

Background Papers

OTA Background Papers are documents that contain information believed to be useful to various parties. The information supports formal OTA assessments or is an outcome of internal exploratory planning and evaluation. For information contact: Publishing Office, Office of Technology Assessment, Congress, 600 Pennsylvania Ave. S.E., Washington, DC 20510/202-224-8996.

Priorities

This booklet lists and briefly describes 30 important national and global issues facing the United States that warrant OTA study. Also lists and briefly describes studies currently underway. Contact: Publishing Office, Office of Technology Assessment, Congress, 600 Pennsylvania Ave. S.E., Washington, DC 20510/202-224-8996.

Publications

OTA publishes reports, memoranda and background papers which cover such subjects as energy, food and renewable resources, health, international security and commerce, materials, oceans, telecommunications and information systems and transportation. For further information and a listing of the publications, contact: Publishing Office, Office of Technology Assessment, Congress, 600 Pennsylvania Ave. S.E., Washington, DC 20510/202-224-8996.

Reports

OTA Reports are the principal documentation of formal assessment projects. These projects are approved in advance by the Technology Assessment Board. At the conclusion of a project, the Board has the opportunity to review the report but its release does not necessarily imply endorsement of the results by the Board or its individual members. Contact: Publishing Office, Office of Technology Assessment, Congress, 600 Pennsylvania Ave. S.E., Washington, DC 20510/202-224-8996.

Technical Memoranda

OTA Technical Memoranda are issued on specific subjects analyzed in recent OTA reports or in projects presently in process at OTA. They are issued at the request of Members of Congress. Contact: Publishing Office, Office of Technology Assessment, Congress, 600 Pennsylvania Ave. S.E., Washington, DC 20510/202-224-8996.

How Can the Office of Technology Assessment Help You?

To determine how this office can help you contact: Office of Technology Assessment, 600 Pennsylvania Ave. N.W., Washington, DC 20510/202-224-8996.

Congressional Budget Office

2nd and D Sts. S.W., Washington, DC 20515/202-226-2621

BUDGET: $12,531,000
EMPLOYEES: 218
MISSION: Provides Congress with basic budget data and with analysis of alternative fiscal, budgetary and programmatic policy issues; and responsibility for economic forecasting and fiscal policy analysis, scorekeeping, cost projections and special studies.

Major Sources of Information

Annual Report on the Budget

The Congressional Budget Office is responsible for furnishing the House and Senate Budget Committees by April 1 of each year with a report which includes a discussion of alternative spending and revenue levels and alternative allocations among major programs and functional categories, all in the light of major national needs and the effect on the balanced growth and development of the United States. Contact: Intergovernmental Relations, Congressional Budget Office, 2nd and D Sts. S.W., Room 405, Washington, DC 20515/202-226-2600.

Budget Analysis

CBO provides periodic forecasts and analyses of economic trends and alternative fiscal policies. Contact: Budget Analysis, Congressional Budget Office, 2nd and D Sts. S.W., Room 429, Washington, DC 20515/202-226-2800.

Cost Projections

The Congressional Budget Office is required to develop five-year cost estimates for carrying out any public bill or resolution reported by congressional committees. At the start of each fiscal year, CBO also provides five-year projections on the costs of continuing current federal and taxation policies. Contact: Projections, Congressional Budget Office, 2nd and D Sts. S.W., Room 446, Washington, DC 20515/202-226-2880.

Publications

All papers published by CBO are available to the general public as well as to the members of Congress and their staff. A listing of papers by date of publication and by subject area is also available. Some of the areas covered include Agriculture; The Budget and Budget Projections; Budget Procedures; Defense, the Economy and Fiscal Policy; Education; Employment and Training; Energy; Environment and Natural Resources; Federal Work Force and Government Administration; Foreign Affairs; Health; Housing; Income Assistance; International Economic Relations; Law Enforcement and Justice; State and Local Government; Tax Expenditures; Tax Receipts and Distribution; Transportation; and Urban and Regional Development. Contact: Office of Intergovernmental Relations, Congressional Budget Office, House Office Building Annex 2, 2nd and D Sts. S.W., Washington, DC 20515/202-226-2600.

Scorekeeping

CBO "keeps score" for the Congress by monitoring the results of congressional action on individual authorization, appropriation and revenue bills against the targets or ceilings specified in the concurrent resolutions. Contact: Score-Keeping, Congressional Budget Office, 2nd and D Sts. S.W., Room 437, Washington, DC 20515/202-226-2850.

World Oil Market in the 1980s: Implications for the United States

This is an analysis of oil imports over the coming decade and outlines possible policy response to them. It is available for $4.00 from the Superintendent of Documents, Government Printing

Office, Washington, DC 20402/202-783-3238. For additional information contact: Office of Intergovernmental Relations, Congressional Budget Office, 2nd and D Sts. S.W., Room 405, Washington, DC 20515/202-226-2621.

How Can the Congressional Budget Office Help You?

To determine how this office can help you contact: Congressional Budget Office, 2nd and D Sts. S.W., Washington, DC 20515/202-226-2621.

Copyright Royalty Tribunal

1111 20th St. N.W., Washington, DC 20036/202-653-6175

BUDGET: $490,000
EMPLOYEES: 10
MISSION: Makes determinations concerning the adjustments of copyright royalty rates for records, jukeboxes, and certain cable television transmissions.

Major Sources of Information

Meetings

The Tribunal notifies the public, 30 days in advance, of agency meetings. It publishes a hearing notice in the *Federal Register;* it notifies persons known to have an interest in a particular subject matter, and it uses the trade press to publicize proceedings of the Tribunal. Contact: Copyright Royalty Tribunal, 1111 20th St. N.W., Washington, DC 20036/202-653-5175.

Royalty Payments

In addition to records, jukeboxes and certain cable television transmissions, the Tribunal also establishes, and makes determinations concerning terms and rates of royalty payments for the use by public broadcasting stations of published nondramatic compositions and pictorial, graphic and sculptural works. Cost-of-living adjustments are made to these noncommercial broadcasting rates in August of each year. Contact: Copyright Royalty Tribunal, 1111 20th St. N.W., Room 450, Washington, DC 20036/202-653-5175.

Study in Audio Home Taping

The Tribunal published the results of a survey of consumer practices and attitudes concerning the home taping of audio works. Contact: Copyright Royalty Tribunal, 1111 20th St. N.W., Washington, DC 20036/202-653-5175.

Transcripts of Meetings

Transcripts of Tribunal meetings are available to the public. Contact: Copyright Royalty Tribunal, 1111 20th St. N.W., Washington, DC 20036/202-653-5175.

Use of Certain Copyrighted Works in Connection With New Commercial Broadcasting

This report reviews the necessity for a public broadcasting copyright compulsory license for the performance of nondramatic musical works, the recording of nondramatic performances and displays of musical works, and the use of published pictorial, graphic and sculptural works. Contact: Copyright Royalty Tribunal, 1111 20th St. N.W., Washington, DC 20036/202-653-5175.

How Can the Copyright Royalty Tribunal Help You?

To determine how this agency can help you, contact: Copyright Royalty Tribunal, 1111 20th St. N.W., Room 450, Washington, DC 20036/202-653-5175.

QUASI-OFFICIAL AGENCIES

Legal Services Corporation

733 15th St. N.W., Washington, DC 20005/202-272-4030

ESTABLISHED: July 25, 1974
BUDGET: $321,200,000
EMPLOYEES: 322
MISSION: Provides financial assistance to qualified programs furnishing legal assistance to eligible clients and makes grants to and contracts with individuals, firms, corporations, organizations and state and local governments for the purpose of providing legal assistance to these clients.

Major Sources of Information

Bar Relations

This office works with local and state bar associations and local legal services programs to promote further involvement of private attorneys in the delivery of legal service to the poor. Contact: Office of Bar Relations, Legal Services Corporation, 615 Peachtree St. N.E., Room 911, Atlanta, GA 30308/404-881-3049.

Central Records Room

The records room is open to the people and makes available for inspection all final opinions and orders in the adjudication of cases; statements of policy and interpretations; manual and instruction to the staff. There are regional record rooms as well. Contact: General Counsel's Office, Legal Services Corporation, 733 15th St. N.W., Suite 700, Washington, DC 20005/202-376-4010.

Comptroller

The Comptroller's office has developed a set of fundamental criteria for a local program accounting and financial reporting system. Contact: Comptroller, Legal Services Corporation, 733 15th St. N.W., Washington, DC 20005/202-272-4142.

Delivery Systems Study

This study analyzes new methods of delivering legal services to the poor. The report, delivered to Congress, evaluates each demonstration project performance on the basis, cost of service, quality of service, client satisfaction and impact upon the client community as a whole. Contact: Research Institute on Legal Assistance, Legal Services Corporation, 733 15th St. N.W., Washington, DC 20005/202-272-4100.

Field Services

The legal services program is decentralized. A *Fact Book*, providing the characteristics of field programs, contains graphs and tables of the main programs which include basic field programs; migrant programs; native American programs; state support programs; and national support centers. For a listing and information of the legal services cooperations-funded field programs contact: Office of Field Services, Legal Services Corporation, 733 15th St. N.W., Washington, DC 20005/202-272-4080.

Freedom of Information Act

For Freedom of Information Act requests contact: General Counsel's Office, Legal Services Corporation, 733 15th St. N.W., Washington, DC 20005/202-272-4010.

LSC News

This is a free bimonthly newsletter with news and features on legal services to the poor. Contact: Office of Public Affairs. Legal Services Corporation, 733 15th St. N.W., Washington, DC 20005/202-272-4030.

Meetings

Board, Committee and Council meetings are announced to the public at least seven days in advance. For minutes of the meeting and any other information contact: General Counsel, Legal Ser-

vices Corporation, 735 15th St. N.W., Washington, DC 20005/202-272-4010.

National Clearinghouse on Legal Services

The Clearinghouse distributes a wide variety of materials on particular cases, on the practice of law and other issues affecting legal services programs. It also publishes the monthly *Clearinghouse Review*. Contact: National Clearinghouse on Legal Services, Inc., Research Institute on Legal Assistance, Legal Services Corporation, 500 N. Michigan Ave., Suite 1940, Chicago, IL 60611/312-670-3656.

Research Institute on Legal Assistance

The Institute on legal issues as they relate to the problems of poverty. It also conducts a fellowship program designed to attract lawyers and other scholars with projects of interest to the Institute. Contact: Research Institute on Legal Assistance, Legal Services Corporation, 733 15th St. N.W., Washington, DC 20005/202-272-4100.

Technical Assistance

Technical assistance programs to improve the delivery of legal services include providing experts in such areas as case management, office operations, accounting and personnel. Contact: Office of Program Support, Legal Services Corporation, 733 15th St. N.W., Washington, DC 20005/202-272-4200.

Training

Training is provided for lawyers, paralegals and project direction. Contact: Office of Program Support, Legal Service Corporation, 733 15th St. N.W., Washington, DC 20005/202-272-4200.

How Can the Legal Services Corporation Help You?

To determine how this agency can help you contact: Legal Services Corporation, Public Affairs, 1733 15th St. N.W., Washington, DC 20005/202-272-4030.

National Consumer Cooperative Bank

2001 S St. N.W., Washington, DC 20009/202-673-4300

ESTABLISHED: August 20, 1978
BUDGET: $117,110,000
EMPLOYEES: 169
MISSION: Encourages the development of new and existing consumer and self-help cooperatives in the areas of health care, housing, consumer goods and others.

Major Sources of Information

Coop Bank Notes

This is a free monthly newsletter featuring articles of interest to cooperative enterprises (food, housing, energy, etc.) Contact: Department of Communications and Cooperative Education, National Consumer Cooperative Bank, 2001 S St. N.W., Washington, DC 20009/202-673-4320.

Loans

The Bank provides loans to credit-worthy cooperatives at a market interest rate. Cooperatives that cannot qualify for credit from the Bank may be eligible to receive special financial and technical help from the Office of Self-Help Development and Technical Assistance, National Consumer Cooperative Bank, 2001 S St. N.W., Washington, DC 20009/202-673-4320.

How Can the National Consumer Cooperative Bank Help You?

To determine how this agency can help you contact: Office of the Secretary, National Consumer Cooperative Bank, 2001 S St. N.W., Washington, DC 20009/202-673-4300.

National Railroad Passenger Corporation
(AMTRAK)

400 North Capitol St. N.W., Washington, DC 20001/202-383-3000

ESTABLISHED: 1970
BUDGET: $873,000,000
EMPLOYEES: 23,500
MISSION: Operates as a for-profit corporation to provide a balanced transportation system by improving and developing intercity rail passenger service.

Major Sources of Information

Financial and Operating Statistics

AMTRAK issues detailed financial and operating statistics which include data on ridership revenue cars, locomotive units, turboliners and metroliner, information on operating grants and AMTRAK'S financial position. An Annual Report is also available. For information contact: Corporate Communications, National Railroad Passenger Corporation, 400 North Capitol St. N.W., Washington, DC 20001/202-383-3852.

New Corridor

AMTRAK is studying a new high-speed, high frequency emerging corridor outside the northeast. For information on these potential new corridors contact: Passenger Services, National Railroad Passenger Corporation, 400 North Capitol St. N.W., Washington, DC 20001/202-383-2733.

Passenger Services

For information on AMTRAK passenger service contact: Passenger Service and Communication Group, National Railroad Passenger Corporation, 400 North Capitol St. N.W., Washington, DC 20001/202-383-2733.

How Can AMTRAK Help You?

To determine how this agency can help you contact: Corporate Communications, AMTRAK, 400 North Capital St. N.W., Washington, DC 20001/202-383-3860.

Smithsonian Institution

1000 Jefferson Dr. S.W., Washington, DC 20560/202-357-1300

ESTABLISHED: 1846
BUDGET: $125,221,000
EMPLOYEES: 5,000

MISSION: The Smithsonian Institution is an independent trust establishment, performs fundamental research; publishes the results of studies, explorations, and investigations; preserves for study and reference over 78 million items of scientific, cultural and historical interest; maintains exhibits representative of the arts, American history, technology, aeronautics and space explorations and natural history; participates in the international exchange of learned publications; and engages in programs of education and national and international cooperative research and training, supported by its trust endowments and gifts, grants and contracts, and funds appropriated to it by Congress.

Major Sources of Information

American and Folklife Studies

The Office conducts a graduate program in the material aspects of American civilization for graduate students enrolled in cooperating universities. The Folklife Program is responsible for research, documentation and presentation of American folklife traditions. It prepares publications based on the papers, films, tapes and other materials amassed during previous Festivals of American Folklife and directs the planning, development and presentation of future folklife programs. Contact: Office of American Folklife Studies, Smithsonian Institution, 2306 Massachusetts Ave. N.W., Washington, DC 20560/202-673-4872.

Anacostia Neighborhood Museum

This neighborhood museum serves as a museum exhibition hall and a cultural center. The exhibit, research and educational programs are designed in response to the interest of local residents. Contact: Anacostia Neighborhood Museum, Smithsonian Institution, 2405 Martin Luther King, Jr. Ave. N.E., Washington, DC 20020/202-287-3369.

Antarctic Map Folio Series

Knowledge of Antarctica is summarized in this series which includes books, maps and map folios. For a listing of the items in the series and their prices, contact: Oceanographic Sorting Center, Museum of Natural History, Smithsonian Institute, 10th and Constitution Ave. N.W., Washington, DC 20560/202-287-3302.

Archives

The Smithsonian Archives open to the scholarly community and the general public is the official depository for papers of historic value about the Smithsonian and the fields of science, art, history and the humanities.

The holdings of the Archives are announced by publication of guides which are updated periodically. *Guide to Smithsonian Archives* describes the archival holdings. Contact: Smithsonian Archives, Smithsonian Institution, 900 Jefferson Dr. S.W., Washington, DC 20560/202-357-1420.

Archives Journal

The Archives of American Art publishes a scholarly journal quarterly containing articles and listings of recent acquisitions apprising research community newly available resources. Contact: Archives of American Art, Smithsonian Institution, 8th and F Sts. N.W., Washington, DC 20560/202-357-2781.

Archives of American Art

The Archives of American Art contains the nation's largest collection of documentary mate-

rials reflecting the history of visual arts in the United States. The Archives gathers, preserves and microfilms the papers of artists, craftsmen, collectors, dealers, critics, museums and art societies. These papers consist of manuscripts, letters, notebooks, sketchbooks, business records, clippings, exhibition catalogs, tape-recorded interviews and photographs of artists and their work. The Archives's chief processing and reference center is in the Smithsonian's Fine Arts and Portrait Gallery Building. The Archives's executive office is in New York; regional branch offices, each with a complete set of microfilm duplicating the Archives's collections, are located in Boston, New York, Detroit and San Francisco. Contact: Archives of American Art, Smithsonian Institution, 8th & F Sts. N.W., Washington, DC 20560/202-357-2781; Boston: 87 Mt. Verson St., Boston, MA 02108/617-223-0951; Detroit: 5200 Woodward Ave., Detroit, MI 48202/313-226-7544; New York: 41 E. 65th St., New York, NY 10021/212-826-5722; San Francisco: DeYoung Museum, Golden Gate Park, San Francisco, CA 94118/415-556-2530.

Arts in America: A Bibliography

This four-volume set is a systematic presentation of the literature on the visual and performing arts from the colonial period to the present day. Approximately 25,000 annotated entries, organized into 21 sections, list and describe the resource materials accessible to art historians and curators, students and collectors, librarians and researchers at all levels of interest. Encompassing books, exhibition catalogs, periodical articles, and inventories of pictorial materials, the subject sections cover art of the Native Americans, art of the West, architecture, industrial design and the decorative arts, painting and sculpture, graphic arts and photography, film and theater, dance and music. Special sections of dissertations, serials and periodicals, and visual resources are also included. The four volumes are available for $190,00 from Publications Sales, Smithsonian Institution Press, Smithsonian Institution, 1111 North Capitol St., Washington, DC 20560/202-357-1793. For additional information contact: Smithsonian Archives, Smithsonian Institution, 900 Jefferson Dr. S.W., Washington, DC 20560/202-357-1420.

Astrophysical Observatory

The Harvard-Smithsonian Center for Astrophysics is devoted to research into the basic physical processes which determine the nature and evolution of the Universe Observatory through a variety of efforts grouped programmatically in seven major divisions:

Atomic and Molecular Processes—laboratory astrophysics, shock tube and ultraviolet vacuum spectroscopy, atomic physics and particle physics.

Radio and Geoastronomy—very long baseline interferometric observations of celestial radio sources and laboratory studies of interstellar molecules; kinematics of the earth, optical and laser satellite tracking, geodesy and geophysics and celestial mechanics.

High-Energy Astrophysics—satellite, balloon and ground observations of high-energy sources emitting x-rays and/or gamma rays.

Optical and Infrared Astronomy—satellite, balloon and ground observation of infrared radiation sources, steller and planetary observations and studies of stellar evolution.

Planetary Sciences—studies of the structure and composition of planetary atmospheres; asteroids, meteorites and cosmic dust; comets; extraterrestrial materials; and studies of solar system evolution.

Solar and Stellar Physics—satellite experiments, observational and theoretical studies of solar and stellar processes, and studies of solar activity.

Theoretical Astrophysics—construction of model stellar atmospheres, investigation of massive and high-density stars, studies of galactic evolution, and the physics of interstellar matters.

Data are obtained from laboratory experiments, ground-based observations and space-borne observations and experiments. The Astrophysical Observatory's data collecting efforts are linked by a global communications center located in Cambridge, MA. The Observatory also maintains extensive laboratory, library and computer facilities to support its research. Research results are published in the *Center Preprint Series, Smithsonian Contributions to Astrophysics*, the *SAO Special Reports* series, and other technical and nontechnical bulletins, and distributed to scientific and educational institutions around the world. Contact: Smithsonian Astrophysical Observatory, 60 Garden St., Cambridge, MA 02138/617-495-7461.

Astronomical Phenomena News

The Central Bureau for Astronomical Telegrams and the Minor Planet Center for the International Astronomical Union issue telegrams and postcard circulars describing news of astronomical phenomena requiring prompt world-wide dissemination to the scientific community, such as asteroid and comet discoveries, novae and supernovae observations, and variable start activity. The Minor Planet Center is the principal source for all positional observations of asteroids as well as for establishing their orbits and ephemendes. Contact: Smithsonian Astrophysical Observatory, Smithsonian Institution, 60 Garden St., Cambridge, MA 02138/617-495-4721.

Biological Conservation

The Office of Biological Conservation concentrates on improving public understanding of changes in the natural environment and serves as a monitoring and warning system, sharing and consolidating the available knowledge of scientists at the Smithsonian and other institutions. Contact: Office of Biological Conservation, Museum of Natural History, 10th and Constitution Ave. N.W., Washington, DC 20560/202-357-2670.

Calendar of Events

A free monthly *Calendar of Events* at the Smithsonian Institution is available. Contact: Office of Public Affairs, Smithsonian Institution, 900 Jefferson Dr. S.W., Washington, DC 20560/202-357-2627.

Catalogue of American Portraits

This catalog contains documentation including photographs on almost 70,000 portraits of noted Americans located in public and private collections throughout the country. It includes biographical, historical and art-historical data. Contact: Museum Shop, National Portrait Gallery, Smithsonian Institution, 8 and F Sts. N.W., Washington, DC 20560/202-357-1447.

Center for the Study of Man

This center promotes an interdisciplinary cultural and anthropological research on man. The Center's National Anthropological Film Center which sponsors an effort to record on film the daily life behavior, adaptations and patterns of various peoples in disappearing cultures. Its Research Institute on Immigration and Ethnic Studies researches various recent immigration patterns to the United States. Contact: Center for the Study of Man, National Museum of Natural History and National Museum of Man, 10th and Constitution Ave. N.W., Washington, DC 20560/202-357-2801.

Comics

The Smithsonian Collection of Newspaper Comics is available for $29.95 (cloth) and $14.95 (paper) from Publications sales, Smithsonian Institution Press, Smithsonian Institution, 1111 North Capitol St., Washington, DC 20560/202-357-1793.

Conservation-Analytical Laboratory

The Conservation-Analytical Laboratory provides a focus within the Smithsonian Institution for conservation of the millions of artifacts in the collections. It provides chemical analyses to curators for cataloguing purposes, and to conserva-

tors for establishing the nature of a particular example of deterioration and for determining whether commercial materials proposed for use in prolonged contact with artifacts are truly safe. It treats many hundreds of artifacts each year and, upon request, supports other conservators in the Institution with advice and specialized materials. It collaborates with archeologists, curators, and university and government laboratories in archeometric studies. Contact: Conservation Analytical Laboratory, Smithsonian Institution, 14th St. and Constitution Ave. N.W., Washington, DC 20560/202-357-2444.

Conservation Information

The Conservation Information Program provides data on the preservation of artifacts and specimens which are disseminated to museums, historical societies and other organizations. A series of 80 videotape lectures on the principles of conservation, prepared under the technical direction of the Conservation Analytical Laboratory, is circulating to museums and related organizations. Audiovisual materials on practical aspects of conservation are available. Contact: Conservation Information Program, Office of Museum Programs, Smithsonian Institution, 900 Jefferson Dr. S.W., Washington, DC 20560/202-357-3101.

Contracts and Small Business

Information regarding procurement of supplies; contracts for construction, services, exhibits, research etc.; and property management and utilization services for all Smithsonian Institution organizations may be obtained from Office of Supply Services, Smithsonian Institution, 1000 Jefferson Dr. S.W., Washington, DC 20560/202-287-3238.

Dial-A-Museum

A taped telephone message provides daily announcements on new exhibits and special events. Call 200-357-2020 or contact: Office of Public Affairs, Smithsonian Institution, 900 Jefferson Dr. S.W., Washington, DC 20560/202-357-2627.

Dial-A-Phenomenon

A taped telephone message provides weekly announcements on stars, planets and world-wide occurrences of short-lived natural phenomena. 202-357-2000 or contact: Office of Public Affairs, Smithsonian Institution, 900 Jefferson Dr. S.W., Washington, DC 20560/202-357-2627.

Discovery Room

Discovery Room allows children to touch and examine objects in the Museum of Natural History. Contact: National Museum of Natural His-

tory and National Museum of Man, Smithsonian Institution, 10th and Constitution Ave. N.W., Washington, DC 20560/202-357-2695.

Dwight D. Eisenhower Institute for Historical Research

This institute conducts scholarly studies into the meaning of war, its effect on civilization and on the role of the Armed Forces. Contact: Dwight D. Eisenhower Institute of Historical Research, National Museum of American History, Smithsonian Institution, 12th St. and Constitution Ave. N.W., Washington, DC 20560/202-357-2183.

Elementary and Secondary Education

This office helps make Smithsonian resources for learning available to schools. It coordinates information exchanges between schools and the activities of the Institution's museums, galleries and research centers. Information on the various programs available to schools is published in *Art to 200*, a newsletter for teachers from 4th through 8th grades and *Learning Opportunities*, a free brochure. Contact: Office of Elementary and Secondary Education, Smithsonian Institution, 900 Jefferson Dr. S.W., Washington, DC 20560/202-357-2425.

Environmental Studies

The programs for the Center include scientific and educational research information transfer and ecological education. The scientific program includes studies of esturarine processes, watershed monitoring and research in terrestrial ecology. The education programs include workshops on environmental issues for young persons and adults. Educational Services for schools and other groups are available on request. Contact: Chesapeake Bay Center for Environmental Studies, Smithsonian Institution, RR 4, P. O. Box 28, Edgewater, MD 21037/301-261-4190.

Exhibits Central

This office provides design editorial, production, installation and other specialized exhibition services for a variety of Smithsonian programs. Some of the services include editing exhibition labels, producing motion pictures on exhibition concepts, freeze-dry taxidermy and the application of plastics technology to museum exhibitions. Contact: Office of Exhibits Central, Smithsonian Institution, 900 Jefferson Dr. S.W., Washington, DC 20560/202-357-3118.

Exposition Books

The Smithsonian Exposition Books is publishing books on Smithsonian art and artifacts and on the results of its scholarship and expertise to the general reader. Some of its publications include: *The Smithsonian Experience, The Smithsonian Book of Invention, The American Land, the Magnificent Foragers*, and *A Zoo for All Seasons*. For a list of additional publications and information, contact: Smithsonian Exposition Books, Smithsonian Institution, 475 L'Enfant Plaza, S.W., Washington, DC 20560/202-287-3388.

Famous Aircraft of the National Air and Space Museum

Each volume in this series deals with a different historic airplane in the museum's collection. The books are divided into two main sections. Part I covers the background and history of the aircraft. Part II provides details unique to its restoration by skilled craftsmen of the museum.

Excalibur III: The Story of a P-51 Mustang ($4.95)
Aeronca C-2: The Story of the Flying Bathtub ($4.95)
The P-80 Shooting Star—Evolution of a Jet Fighter ($5.95)

These and other publications are available from Publications Sales, Smithsonian Institution Press, Smithsonian Institution, 1111 North Capitol St., Washington, DC 20560/202-357-1793. For additional information on aircraft, contact: National Air and Space Museum, Smithsonian Institution, 7th St. and Independence Ave. N.W., Washington, DC 20560/202-357-2491.

Fellowships and Grants

The Office administers the Smithsonian predoctoral and postdoctoral fellowship programs, which make grants to visiting scholars and students from the United States and abroad. This program is designed to bring developing scholars to the Smithsonian for periods of directed study, to give more senior scholars the benefit of specialized work with staff researchers, and to provide graduates and undergraduates an opportunity for study visits lasting up to three months. The Office also administers a Special Foreign Currency Program, a nationally competitive grants program for research carried out by U.S. institutions in countries where the United States owns local currencies deemed by the Treasury Department to be in excess of normal U.S. needs. Grants are offered in disciplines in which the Smithsonian has traditional competence and interest: archeology, anthropology and related studies, systematic and environmental biology, astrophysics and earth sciences and museum programs. Contact: Office of Fellowships and Grants, Smithsonian Institution, L'Enfant Plaza,

S.W., AMTRAK Building, Washington, DC 20560/202-287-3271.

Film

The Smithsonian Institution with S. Dillon Ripley is an overview of the Smithsonian. Other films have been produced for particular Smithsonian purposes including one on the National Collection of Fine Arts now called the National Museum of American Arts. Contact Office of Telecommunications Public Service, Museum of Natural History, Smithsonian Institution, 10th and Constitution Ave. S.W., Room C222B, Washington, DC 20560/202-357-2984.

Freer Gallery of Art

The Gallery houses one of the world's most renowned collections of oriental art as well as an important group of ancient Egyptian glass, early Christian manuscripts, and the works of James McNeill Whistler together with other late 19th and early 20th century American painters. Over 10,000 objects in the oriental section represent the arts of the Far East, the Near East, Indochina, and India, including paintings, manuscripts, scrolls, screens, pottery, metalwork, glass, jade, lacquer and sculpture. Members of the staff conduct research on objects in the collection and publish results in scholarly journals and books. They arrange special exhibitions and present lectures in their field of specialization. Annually, a series of six lectures on Far and Near Eastern art is given by distinguished scholars.

Technical Laboratory. The laboratory is one of the outstanding centers in the world for research into the materials and methods of ancient craftsmen. Its staff members study the nature and properties of metals, ceramics, lacquers, papers and pigments in an effort to reconstruct the history of ancient technology and to find out how best to preserve and to protect the objects of art in the collection.

The Gallery publishes two scholarly series:

The Freer Gallery of Art Oriental Studies
The Freer Gallery of Art Occasional Papers and Ars Orientalis

Contact: Freer Gallery of Art, Smithsonian Institution, 12th St. and Jefferson Dr. S.W., Washington, DC 20560/202-357-2104.

Government Sponsored Research on Foreign Affairs

A quarterly report of project information which lists external research projects, reported by sponsoring agencies is available for $5.25 a year from the Superintendent of Documents, Government Printing Office, Washington, DC 20402/202-783-3238. For additional information contact: Smithsonian Science Information Exchange, Smithsonian Institution, 1730 M St. N.W., Suite 300, Washington, DC 20036/202-634-3933.

Grants

The programs described below are for sums of money which are given by the federal government to initiate and stimulate new or improved activities or to sustain on-going services.

Museums—Assistance and Advice:
Objectives: To support the study of museum problems, to encourage training of museum personnel, and to assist research in museum techniques, with emphasis on museum conservation.
Eligibility: Science, history and art museums, as well as museum-related organizations and academic institutions are eligible.
Range of Financial Assistance: $500 to $66,500.
Contact: Program Coordinator, National Museum Act, Office of Museum Programs, Smithsonian Institution, Washington, DC 20560/202-357-2257.

Smithsonian Institution Programs in Basic Research in Collaboration with Smithsonian Institution Staff:
Objectives: To make available to qualified investigators at various levels of educational accomplishment, the facilities, collections, and professional staff of the Smithsonian Institution.
Eligibility: Appointments are available to advanced students and scholars intending to pursue research and study which relates to Smithsonian Institution research and interests of the professional staff.
Range of Financial Assistance: Up to $14,000.
Contact: Director, Office of Fellowships and Grants, Room 3300, 955 L'Enfant Plaza, Smithsonian Institution, Washington, DC 20560/202-287-3271.

Smithsonian Special Foreign Currency Grants for Museum Programs, Scientific and Cultural Research and Related Educational Activities:
Objectives: To support the research activities of American institutions of higher learning through grants in countries where the U.S. Treasury has determined that the United States holds currencies in excess to its needs as a result of commodity sales under Public Law 480. Limited funds are available for travel to professional meetings.
Eligibility: All American institutions of higher

learning are eligible: universities, colleges, museums and research institutions, incorporated in any one of the 50 states or the District of Columbia.

Range of Financial Assistance: $10,000 to $50,000.

Contact: Grants Specialist, Smithsonian Foreign Currency Program, Office of Fellowships and Grants, Smithsonian Institution, Washington, DC 20560/202-287-3271.

Woodrow Wilson International Center for Scholars—Fellowships and Guest Scholar Programs:

Objectives: The theme of the fellowship program is designed to accentuate aspects of Wilson's ideals and concerns for which he is perhaps best known—his search for international peace and his imaginative new approaches in meeting the pressing issues of his day—translated into current terms.

Eligibility: Up to 40 scholars—approximately half from the United States and half from other countries—will be selected to work at the Center. They will be chosen from academic and nonacademic occupations and professions. Limited to established scholars at the postdoctoral level (or equivalent). There will be no higher degree requirements for nonacademic fellows, but professional standing, writings, honors and advanced degrees will be considered.

Range of Financial Assistance: Not specified.

Contact: Director, Woodrow Wilson International Center for Scholars, Smithsonian Institution Building, Washington, DC 20560/202-357-2429.

Handbook of North American Indians

A major project is the *Handbook of North American Indians,* a comprehensive 20-volume encyclopedia written from anthropological, historical and linguistic perspectives. When completed, it will include the work of more than 1,000 author-contributors. Some volumes will be devoted to tribal cultures and histories by geographic region, such as the Northeast, Southwest and the Plains Indians. Other works will be organized around topics such as languages, technologies and the history of Indian-white relations. The first volume deals with the California tribes. The second volume covers Northeast Indians and the third volume is on the Indians of the Southwest. Contact: National Museum of National History and National Museum of Man, Smithsonian Institution, 10th and Constitution Ave. N.W., Washington, DC 20560/202-357-2363.

Hirschhorn Museum and Sculpture Garden

The collection consists of modern American and European sculpture paintings and drawings. It also contains supplementary collections of pre-Columbian sculpture, Benin bronzes, Eskimo carvings and classical antiquities that illustrate some sources of contemporary art. Contact: Hirshhorn Museum and Sculpture Garden, Smithsonian Institution, 8th St. and Independence Ave. S.W., Washington, DC 20560/202-357-3091.

Horticulture

This office is responsible for the development and maintenance of the grounds of the Institution as botanical and horticultural exhibit areas. It coordinates a program of horticultural research, maintains a collection of period garden accessories, documents historic landscape schemes and serves as the Institution's liaison with government organizations for outdoor beautification activities. Contact: Office of Horticulture, Smithsonian Institution, 900 Jefferson Dr. S.W., Washington, DC 20560/202-357-1926.

Insects, National Collection of

The Smithsonian Institution has a large collection of insects, all of which are mounted and classified. For information on the collection, contact: Systematic Entomological Laboratory, Department of Entomology, Smithsonian Institution, Washington, DC 20560/202-357-2078.

International Activities

This office supports Smithsonian programs by advising on foreign affairs affecting Smithsonian museological, cultural and research programs. Contact: Office of International Activities, Smithsonian Institution, 900 Jefferson Dr. S.W., Washington, DC 20560/202-357-2519.

International Center for Scholars

The Center's emphasis is on studies of fundamental political, social and intellectual issues designed to illuminate man's understanding of critical contemporary and emerging problems and to suggest means of resolving such problems. Special programs focus on such areas as: advanced Russian Studies, Latin American, East Asian, and International Security Studies, Latin American, East Asian, and International Security Studies. The chief concerns of the Center, in its annual choice of fellows through open competition, are with the scholarly capabilities and promise of the prospective fellow. The Center also sponsors a large program of meetings. For additional information contact: Woodrow Wilson International Center for Scholars, Smithsonian Institution, 1000 Jefferson Dr. S.W., Washington, DC 20560/202-357-2763.

International Environmental Program

This program is devoted to broad-based ecological studies of tropical and subtropical regions. Contact: Science, Smithsonian Institution, 1000 Jefferson Dr. S.W., Washington, DC 20560/202-357-2903.

International Exchange Service

The Service was established in 1849 to distribute the publications of the Smithsonian Institution to scientific and learned institutions abroad. Staff accepts addressed packages of publications from libraries, scientific societies and educational institutions in the United States for transmission to similar organizations in foreign countries, and in return receives addressed publications from foreign sources for distribution in the United States. Contact: International Exchange Service, Smithsonian Institution, 1111 North Capitol St. N.E., Washington, DC 20560/202-357-2073.

International Handbook of Aerospace Awards and Trophies

This *Handbook* is intended to serve as a reference source for aerospace historians, scholars and libraries with collections in science and technology. All aspects of flight, ballooning, manpowered flight, early air racing events and exceptional contributions to the engineering and administration of aerospace achievements are included. One hundred and twenty organizations world-wide are represented. It is available for $15.00 from Publications Sales, Smithsonian Institution Press, Smithsonian Institution, 1111 North Capitol St., Washington, DC 20560/202-357-1793. For additional information contact: National Air and Space Museum, Smithsonian Institution, 7th St. and Independence Ave. N.W., Washington, DC 20560/202-357-2491.

John F. Kennedy Center for the Performing Arts

Since its opening in 1971, the Center has presented a year-round program of music, dance and drama from the United States and abroad. Facilities include the Concert Hall, the Opera House, the Eisenhower Theater, the Terrace Theater, and a laboratory theater. By special arrangement, the Center also houses the American Film Institute Theater. For additional information contact: John F. Kennedy Center for the Performing Arts, 2700 F St. N.W., Washington, DC 20566/202-872-0466.

Joseph Henry Papers

The Smithsonian is undertaking (with the American Philosophical Society of the National Academy of Sciences) the publication of the papers of Joseph Henry (1797–1878), a major experimental physicist in electricity and magnetism. His papers provide insight into the history of American higher education, the development of federal science policy and American attitudes toward learning and research. Contact: Joseph Henry Papers, Smithsonian Institution, 1000 Jefferson Dr. S.W., Washington, DC 20560/202-357-2787.

Libraries

The Smithsonian Institution libraries system, composed of a central library and 21 bureau and branch libraries, emphasizes multidisciplinary journals, on such topics as ecology, travel exploration and museology, natural history, American ethnology, and cultural, tropical biology, decorative arts and design, astrophysics and the history of science and technology and the history of aeronautics and astronautics. Contact the specialized library or Smithsonian Institution Libraries, Smithsonian Institution, 10th St. and Constitution Ave. N.W., Washington, DC 20560/202-357-2240.

Marine and Estuary Science

The Fort Pierce Bureau sponsors research in marine and estuarine science. Scientists are seeking basic information on life histories, ecology and systematics of vertebrate and invertebrate organisms of the local waters. Contact: Fort Pierce Bureau, Smithsonian Institution, Rt. 1, Box 194-C, Fort Pierce, FL 33450/305-465-6630.

Membership

For information about membership in the Smithsonian Resident Associate Program contact: Resident Associate Program, Smithsonian Institution, 900 Jefferson Dr. S.W., Washington, DC 20560/202-357-3030.

Museum of African Art

This museum is dedicated exclusively to the display and study of the creative traditions of Africa. The collection includes 8,000 objects of African sculpture, artifacts, craftworks, traditional costumes, textiles, drums, musical instruments and jewelry, covering almost every art-producing area of Africa but concentrating on West and Central Africa. The library contains some 10,000 titles on African and Afro-American art, culture and history. Contact: Museum of African Art, Smithsonian Institution, 324 A St. N.E., Washington, DC 20002/202-287-3490.

Museum of Natural History

The museum is responsible for the preservation and conservation of the largest collection of natural history specimens and artifacts in the United States. The permanent exhibitions are devoted to

ecology; the Ice Age; the dynamics of evolution; the rise of Western civilization; meteorites; moon rocks; mammals; birds, human biology; dinosaurs and other extinct animals and plants; sea life; South American, Asian, African and Pacific cultures; gems and minerals; native Americans; and a live insect zoo. (Nearly 60 million specimens of animals, plants, fossils, rocks, gems and human artifacts.) Scientific research of the museum involves basic work in biology, earth sciences, fossils and anthropology. Contact: National Museum of Natural History, 10th and Constitution Ave. N.W., Washington, DC 20008/202-357-2664.

Museum Programs

This Office provides professional guidance and technical assistance to museums on collections and their management, exhibition techniques, educational activities and operational methods. It conducts training programs for museum professionals, produces and distributes information on museum conservation, and conducts evaluation studies of exhibitions and programs to identify areas and means of improvement. The Office cooperates with American and foreign museums and governmental agencies on museum matters, administers the National Museum Act, and oversees the archival, exhibition, conservation, library, registrial and horticultural activities of the Smithsonian. Contact: Office of Museum Programs, Smithsonian Institution, 900 Jefferson Dr. S.W., Washington, DC 20560/202-357-3101.

Museum Shops

There are museum shops in the major Smithsonian museums. The shops sell books, craft products, reproductions of artifacts and educational games and toys. Mail orders are also available, with spring and fall catalogs. For additional information contact: Business Management Office, Treasurer, Smithsonian Institution, 10th and Constitution Ave. N.W., Washington, DC 20560/202-287-3563. Independence Ave. N.W., Washington, DC 20560/202-357-2491.

National Gallery of Art

The National Gallery's collections embrace every major school of western European art from the 13th century to the present. The collections continue to be built by private donation rather than with government funds, which serve solely to operate and maintain the building and its collections. A professor-in-residence position is filled annually by a distinguished scholar in the field of art history; graduate and postgraduate research is conducted under a fellowship program; programs for schoolchildren and the general pub-

lic are conducted daily; and an Extension Service distribution loan program, throughout the world; audio-visual materials, including films, slide lectures, and reproductions may be obtained through the Publications Service; the Gallery makes available quality reproductions, publications about the Gallery's collections, a monthly calendar of events and several brochures including a *Brief Guide to the National Gallery of Art* and *An Invitation to the National Gallery of Art* (the latter in several foreign languages). For general information on the Gallery and its activities, contact the Information Office, National Gallery of Art, Washington, DC 20565/202-842-6355.

National History Library

The Museum maintains the largest natural history reference collection in the United States available to qualified scientists. Contact: Library, Museum of Natural History, Smithsonian Institute, 10th and Constitution Ave. N.W., Washington, DC 20560/202-357-1496.

National Museum of American Arts

This museum is devoted to American painting, sculpture and graphic art from the 18th century to today. A portion of its permanent collection of over 23,000 works is exhibited in its extensive galleries, and the remainder is available for study by scholars. It is also a major center for research in American art. In addition to its research library, the museum possesses a major archive of photographs and slides and has compiled an inventory of American paintings up to 1914. A film on the museum has been made. A monthly calendar of events is available. For additional information contact: National Museum of American Art, Smithsonian Institution, 8th and 9th Sts. N.W., Washington, DC 20560/202-357-1959.

National Museum of American History

The museum is a national center for the study and exposition of the history of American civilization through exhibitions research and publications. The museum interprets aspects of American history and culture from folk art to developments in science and technology. Outstanding features include Whitney's cotton gin, Mope's telegraph, the Pioneer locomotive, Thomas Edison's phonograph and a Model T Ford. *Smithsonian Studies in History and Technology* is the museum's publication series. Educational materials include publications, teacher guides, descriptive leaflets and audiovisual packets. Contact: National Museum of American History, Smithsonian Institution, 12th St. and Constitution Ave. N.W., Washington, DC 20560/202-357-3129.

National Museum of Design—Cooper Hewitt Museum

The Museum is the only one in the U.S. devoted exclusively to the study and exhibition of historical and contemporary design. Its collection consists of more than 300,000 items. It maintains a reference library of about 35,000 volumes relating to design, ornament and architecture and a picture library of about 1.5 million photographs and clippings, as well as a series of archives devoted to color material and industrial design. The Museum is not only a major assemblage of decorative art materials but also a research laboratory serving professionals and students of design. A 12-part series, *The Smithsonian Illustrated Library of Antiques* is being prepared (with the Book-of-the-Month Club) under its direction. Contact: Cooper-Hewitt Museum, Smithsonian Institution, 2 E. 91st St., New York, NY 10028/212-860-6886.

National Portrait Gallery

The National Portrait Gallery was set up "for the exhibition and study of portraiture depicting men and women who have made significant contributions to the history, development, and culture of the people of the United States." Publications include illustrated catalogs for major shows, an illustrated checklist of portraits in the collection, and educational materials designed to be used as teaching guides. Among these are *Fifty American Faces*—a collection of essays are 50 of the Gallery's most significant portraits and the *Collected Papers of Charles Wilson Peale and His Family* in microfiche edition with a letterpress index and guide. *Faces of Freedom* is a 27-minute color film that can be rented. Contact: Publications, National Portrait Gallery, Smithsonian Institution, 8th and G St. N.W., Washington, DC 20560/202-357-2247.

National Zoological Park

The Park's collection is outstanding, and comprises about 2,600 living mammals, birds and reptiles of over 600 species. Research objectives include investigations in animal behavior, ecology, nutrition, reproductive physiology, pathology and clinical medicine. Conservation-oriented studies cover maintenance of wild populations and long-term captive breeding and care of endangered species. Information about activities of the Friends of the National Zoo and their magazine *The Zoogoer,* is available by writing to the Friends at the National Zoological Park, Washington, DC 20008/202-673-4717.

The *Department of Animal Health* is responsible for the health of the collection. Contact: 202-673-4793.

The *Department of Pathology* does research to determine causes of death in zoo animals and to understand disease processes. Contact: 292-673-4869.

The *Office of Zoological Research* studies mammalian behavior, particularly that of primates, birds, rodents, carnivores and ungulates (hoof stock) with special interest in animal communication, alfactuei, social bonds and territorial behavior. The office organizes scientific seminars and sponsors training for students and scholars. Contact: 202-673-4825.

The *Front Royal* facility studies propagation and conservation methods for rare and endangered species. Contact: Conservation and Research Center, National Zoological Park, Front Royal, VA 22630/703-635-4166.

Office of Education and Information organizes education programs to promote understanding of the animal kingdom. It also produces films and publications. Contact: 202-673-4724.

Natural History Education

The Museum has programs for school children and adults. The museum publishes educational materials including booklets, teacher guides and other information. Contact: National Museum of Natural History and Natural Museum of Man, 10th and Constitution Ave. N.W., Washington, DC 20560/202-357-2664.

Naturalist Center

This center provides collections which amateur naturalists can touch, examine and study. Amateurs may bring materials or photographs to the Center for identification. Contact: National Museum of Natural History and National Museum of Man, Smithsonian Institution, 10th and Constitution Ave. N.W., Washington, DC 20560/202-357-2804.

Numismatic Collections

The numismatic collections begin with ancient coins from Asia Minor and trace monetary history into the present. Contact: National Numismatics Collection Historian, National Museum of American History, 12th and Constitution Ave. N.W., Washington, DC 20560/202-357-1798.

Oceanographic Sorting Center

The scientists carry out basic classification of animal and plant materials collected on oceanographic expeditions sponsored by various organizations and federal agencies. These are distributed for further study to scientists around the world concerned with marine pollution and the study of marine organisms. Contact: Oceanographic Sorting Center, Museum of Natural History, Smithsonian Institute, 10th and Constitution Ave. N.W., Washington, DC 20560/202-287-3302.

Performing Arts Division

This division presents a wide variety of music, theater and dance programs for public entertainment. It is responsible for the production of all live performances at the Smithsonian. The concert series includes Jazz Heritage, Three Centuries of Chamber Music, The American Musical Theatre, American Country Music, the American Dance Experience and Gospel Song. Smithsonian Collection of Recordings include the *Smithsonian Collection of Classic Jazz*, a *J. S. Bach Treasury*, the *American Musical Theater Series* and numerous others. The *Discovery Theatre* presents regular programs for children. A calendar of events and a listing of Smithsonian recordings are available. Contact: Division of Performing Arts, Smithsonian Institutes, 2100 L'Enfant Plaza S.W., Amtrak Building, Washington, DC 20560/202-287-3410.

Philatelic Collection

Philatelic materials include a detailed record of U.S. postage stamps as well as philately from other parts of the world. Contact: National Philatelic Collection, National Museum of American History, 12th and Constitution Ave. N.W., Washington, DC 20560/202-357-1796.

Photographs

Color and black and white photographs and slides (including illustrated slide lectures) are available. Subjects include photographs of the Smithsonian's scientific, technological, historical and art collections as well as pictures dating back more than 130 years taken from its photographic archives. Information, order forms and price lists may be obtained from Photographic Services, Smithsonian Institution, 1000 Jefferson Dr. S.W., Washington, DC 20560/202-357-1487.

Psychological Studies

This program evaluates the effectiveness of museum exhibits and presentations and measures visitor reaction to them. Contact: Psychological Studies Program, Office of Museum Programs, Smithsonian Institution, 1000 Jefferson Dr. S.W., Washington, DC 20560/202-357-3101.

Radiation Biology

This laboratory is engaged in the study of basic problems of photobiology at the cellular, subcellular and molecular levels. It conducts research in the measurement of solar energy and in environmental biology, engages in the study and dating of archeological specimens by the carbon-14 method, and studies various biological processes that are controlled by light. The Laboratory encourages both predoctoral and postdoctoral research programs in photobiology. Contact: Radiation Biology Laboratory, Smithsonian Institution, 12441 Parklawn Dr., Rockville, MD 20852/301-443-2306.

Radio Shows

"Radio Smithsonian," a weekly program presenting a sampling of the research, exhibits, and popular musical concerts of the Smithsonian, is broadcast at varying times over approximately 70 stations in 34 states and Canada. "Smithsonian Galaxy," a series of twice-weekly $2\frac{1}{2}$ minute radio features growing out of the Smithsonian's activities in science, history, and the arts is broadcast by approximately 115 stations in the United States and Canada. Contact: Public Information, Smithsonian Institution, 900 Jefferson Dr. S.W., Washington, DC 20560/202-357-2411.

Reading is Fundamental

Reading is Fundamental develops community projects to motivate young people to read by letting them choose and keep books. It supports these programs with publications, training aids and materials such as a film and public service announcement. For additional information contact: Reading is Fundamental, Smithsonian Institution, L'Enfant Plaza S.W., AMTRAK Building, Washington, DC 20560/202-287-3220.

Reference Center

The Museum Reference Center is a major library source of museological information in the U.S. which includes printed works and other materials. Contact: Museum Reference Center, Office of Museum Programs, Smithsonian Institution, 1000 Jefferson Dr., Washington, DC 20560/202-357-3101.

Registrar

The individual museums are responsible for Institution-wide coordination of their information management efforts and for the development of standards for information storage and retrieval systems. Contact: Office of the Registrar, Smithsonian Institution, 900 Jefferson Dr. S.W., Washington, DC 20560/202-357-2555.

Renwick Gallery

The Gallery is a curatorial department of the National Collection of Fine Arts. It exhibits, with accompanying publications, American design, crafts and decorative arts as well as the arts and crafts of other countries. It maintains an active film and lecture program. Contact: The Renwick Gallery, National Museum of American

Arts, Smithsonian Institution, 1661 Pennsylvania Ave. N.W., Washington, DC 20560/202-357-2531.

Research Reports

Smithsonian Research Reports containing news of current research projects, particularly in the sciences, that are being conducted by Smithsonian staff, leaflets concerning various bureaus, and a brief guide to the Smithsonian Institution, are available from the Office of Public Affairs, Smithsonian Institution, 900 Jefferson Dr. S.W., Washington, DC 20560/202-357-2627.

Scholars' Guides to Washington, DC

The Guides are designed to be descriptive and evaluative surveys of research resources. Each work is divided into two parts. Part I examines the holdings of Washington, DC area resource collections: libraries; archives and manuscript deposities; art, film, music and map collections; and data banks. Part II focuses on pertinent activities of Washington-based organizations public and private which are potential sources of information or assistance to researchers. The appendixes include information in press, media, churches and religious organizations, social and recreational clubs, bookstores, etc. The series include scholars' guide to Washington, DC for:

African Studies ($8.95)
Central and East European Studies ($8.95)
Film and Video Collections ($8.95)
Russian/Soviet Studies ($6.95)
East Asian Studies ($8.95)
Latin American and Caribbean Studies ($8.95)

These guides can be ordered from Publication Sales, Smithsonian Institution Press, Smithsonian Institution, 1111 N. Capitol St., Washington, DC 20560/202-357-1793. For further information contact: Woodrow Wilson International Center for Scholars, Smithsonian Institution, Washington, DC 20560/202-357-2429.

Scientific Event Alert Network

This network provides timely notice of short-lived natural phenomena such as volcanic activity, meteor falls and whale beachings, to scientists and others throughout the world. Contact: Scientific Event Alert Network, Museum of Natural History, 10th and Constitution Ave. N.W., Washington, DC 20560/202-357-1511.

Smithsonian Institution Press

The Smithsonian Institution Press publishes books and studies related to the sciences, technology, history, air and space, and the arts at a wide range of prices. It also publishes exhibition catalogs, museum guides and various brochures. A free book catalog and a list of studies are available. Contact: Publications Sales, Smithsonian Institution Press, Smithsonian Institution, 1111 North Capitol St., Washington, DC 20002/202-357-1912.

Smithsonian Magazine

This monthly magazine covers the arts, sciences and history. It is available for $14.00 per year. Contact: Smithsonian Associates, Smithsonian Institution, 900 Jefferson Dr., Washington, DC 20560/202-357-2700.

Smithsonian Medals

The Smithsonian Institution awards six medals for distinguished achievement in areas of Institutional interest. They include:

1. The Charles Lang Freer Medal for contributions of Oriental civilizations as reflected in their arts.
2. The Henry Medal for outstanding service to the Institution.
3. The Hodgkins Medal for important contributions to knowledge of the physical environment bearing upon the welfare of man.
4. The Langley Gold Medal for meritorious investigations in connection with the science of aerodromics with its application to aviation.
5. The Matthew Fontaine Maury Medal for contributions to the science of oceanography.
6. The Smithson Medal in recognition of exceptional contributions to art, science, history, education and technology.

Contact: Public Information, Smithsonian Institution, 1000 Jefferson Dr. S.W., Washington, DC 20560/202-357-2700.

Smithsonian Science Information Exchange (SSIE)

SSIE collects, indexes and disseminates pre-publication information about research projects in progress. Single-page descriptions of projects are collected when they are begun, indexed by topic and administrative parameters, stored by computer, and disseminated in response to requests from users in governments, education and private industry. Brochures describing SSIE's services and prices are available. Contact: Smithsonian Science Information Exchange, Smithsonian Institution, 1730 M St., Suite 300, Washington, DC 20036/202-634-3933.

Speakers Bureau

Curators and historians will speak on subjects

related to portraits in the collection. Contact: Speakers Bureau, National Portrait Gallery, Smithsonian Institution, 8th and F Sts. N.W., Washington, DC 20560/202-357-2920.

Symposia and Seminars

The Office of Smithsonian Symposia and Seminars brings together the Smithsonian's own professional staff, visiting investigators and distinguished figures from many areas of intellectual accomplishment in interdisciplinary symposia, colloquia and seminars. It develops the Institution's international symposia series at which leading scholars and specialists from all over the world examine themes of contemporary concern and significance. Some resulting publications include: *Fitness of Man's Environment* ($12.50); *Man and Beast* ($17.50); and *Kin and Communities* ($17.50). These are available from Publications Sales, Smithsonian Institution Press, Smithsonian Institution, 1111 North Capitol St., Washington, DC 20560/202-357-1793. For additional information on Symposia and Seminars contact: Office of Smithsonian Symposia and Seminars, Smithsonian Institution, 1000 Jefferson Dr. S.W., Washington, DC 20560/202-357-2328.

Telecommunications

This office is responsible for all activities in television, radio, films and similar materials created and produced by or for the Smithsonian for external education and information purposes. Contact: Office of Telecommunications, Smithsonian Institution, 900 Jefferson Dr. S.W., Washington, DC 20560/202-357-2984.

Tours

For tour information contact the appropriate office listed below:

Education and Community Outreach Department, Anacostia Neighborhood Museum, 2405 Martin Luther King, Jr. Ave. S.E., Washington, DC 20020/202-287-3369.

Department of Education, National Collection of Fine Arts, Smithsonian Institution, Washington, DC 20560/202-357-3095.

Curator of Education, National Portrait Gallery, 8th and F Sts. N.W., Washington, DC 20560/202-357-2929.

Friends of the Zoo, National Zoological Park, 3000 Connecticut Ave. N.W., Washington, DC 20008/202-673-4955.

Tour Information, Friends of the Kennedy Center, Washington, DC 20566/202-254-3775.

Education Office, National Gallery of Art, Washington, DC 20565/202-842-6249.

Office of Education, National Museum of Natural His-

tory, 10th St. and Constitution Ave. N.W., Washington, DC 20560/202-357-2810.

Office of Education and Information, National Museum of History and Technology, 14th St. and Constitution Ave. N.W., Washington, DC 20560/202-357-1481; TDD 357-1563.

Office of Education, Hirschhorn Museum and Sculpture Garden, 8th St. and Independence Ave. S.W., Washington, DC 20560/202-357-3235.

Department of Education, Chesapeake Bay Center for Environmental Studies, RR4, Box 28, Edgewater, MD 21037/202-261-4190, ext. 42.

Membership Department, Cooper-Hewitt Museum, 2 E. 91st St., New York, NY 10028/212-860-6868.

Tour Information, Freer Gallery of Art, 12th St. and Independence Ave. S.W., Washington, DC 20560/202-357-2104.

Tour Office, Education Services Division, National Air and Space Museum, 7th St. and Independence Ave. S.W., Washington, DC 20560/202-357-1400.

Department of Education, Museum of African Art, 316 A St. N.E., Washington, DC 20002/202-287-3490, ext. 42.

Traveling Exhibition Service

This service (SITES) provides specially designed exhibits to organizations and institutions across the country and abroad at the lowest possible rental fees. More than 120 exhibitions of painting, sculptures, prints, drawings, decorative arts, history, children's art, natural history, photography, science and technology are circulated every year. Lists of available exhibitions and information for future bookings are available. Contact: Smithsonian Institution Traveling Exhibition Service, Smithsonian Institution, 900 Jefferson Dr. S.W., Washington, DC 20560/202-357-3168.

Tropical Research

The Institute, a research organization devoted to the study and support of tropical biology, education and conservation, focuses broadly on the evolution of patterns of behavior and ecological adaptations. Panama offers its unique zoogeographic characteristics—landbridge to terrestrial life forms of two continents and water barrier to marine life of two oceans. A brochure describing the Institute's activities and illustrating some of the facilities and habitats is available. Contact: Smithsonian Tropical Research Institute, Smithsonian Institution, APO Miami 34002 Balboa 52-5669 or 52-2485 or Box 2072, Balboa, Canal Zone.

Visitor Information

The Smithsonian Visitor Information and Associates' Reception Center, located in the original Smithsonian building, provides a general orienta-

tion and assistance for members and the public relative to the national collections, museum events and programs. Write to the Visitor Information and Associates' Reception Center, 1000 Jefferson Dr. S.W., Washington, DC 20560/202-357-2700.

Volunteer Services

The Smithsonian Institution welcomes volunteers and offers a variety of service opportunities. Persons may serve as tour guides or information volunteers, or may participate in an independent program in which their educational and professional backgrounds are matched with curatorial or research requests from within the Smithsonian. For information, write to the Visitor Information and Associates' Reception Center, 1000 Jefferson Dr. S.W., Washington, DC 20560/202-357-2700; phone for the hearing-impaired is TTY 381-4448. For information about volunteer opportunities at the Kennedy Center, write the Friends of the Kennedy Center, Washington, DC 20566/202-254-3775.

Wilson Quarterly

This is a national journal of ideas and information. It is sold on subscription for $14.00 per year from *The Wilson Quarterly*, P. O. Box 2956, Boulder, CO 80302/212-687-0770. For additional information contact: The Wilson International Center for Scholars, Smithsonian Institution, 1000 Jefferson Dr. S.W., Washington, DC 20560/202-357-2429.

How Can the Smithsonian Institution Help You?

To determine how this agency can help you contact: Office of Public Affairs, Smithsonian Institution, 900 Jefferson Dr. S.W., Washington, DC 20560/202-357-2627.

United States Railway Association

955 L'Enfant Plaza N. S.W., Washington, DC 20595/202-426-4250

ESTABLISHED: 1973
BUDGET: $185,000,000
EMPLOYEES: 250
MISSION: To authorize and direct the maintenance of adequate and efficient rail service in the midwest and northeast regions of the United States.

Major Sources of Information

Documents

The Document Center serves as the official depository of all documents which are involved in the litigation before the Special Court, as well as other courts, in conjunction with the reorganization. It also contains reports and studies dealing with the various issues of rail service. The public is welcome to examine these. Contact: Public Reading Room, Railway Association, 955 L'Enfant Plaza N. S.W., Room 5-500, Washington, DC 20595/202-426-9067.

Publications

USRA prepares reports and studies dealing with rail service. These range from rail planning, light-density lines, productivity, administrative history of the Association, Conrail foreign purchasing policy and practices, trackage rights, employee stock ownership, competitive, Conrail computer service, joint rates and New England freight traffic protection. Contact: Public Affairs, Railway Association, 955 L'Enfant Plaza N. S.W., Washington, DC 20595/202-426-4250.

Meetings

Meetings of the Board of Directors or Committees are open to the public. Notices of the meetings, complete with an agenda, are posted. For additional information contact: Executive Vice President—Law, Railway Association, 955 L'Enfant Plaza N. S.W., Washington, DC 20595/202-755-4052.

How Can the Railway Association Help You?

To determine how this agency can help you contact: Public Affairs Office, Railway Association, 955 L'Enfant Plaza N. S.W., Washington, DC 20595/202-426-4250.

Other Boards, Committees and Commissions

This listing of federal boards, centers, commissions, councils, panels, study groups and task forces is not described elsewhere in the directory. The organizations were established by congressional or presidential action and their functions are not strictly limited to the internal operations of a parent department or agency.

The organizations listed below are not Federal Advisory Committees, as defined by the Federal Advisory Committee Act. A complete listing of these committees can be found in *Federal Advisory Committees—Annual Report to the President.* Available from Superintendent of Documents, Government Printing Office, Washington, D.C. 20402/202-783-3238. For further information on Federal Advisory Committees, contact the Committee Management Secretariat, Office of the Executive Director, National Archives and Records Service, Washington, DC 20408/202-523-5240.

Administrative Committee of the *Federal Register,* National Archives Building, Washington, DC 20408/202-523-5240.

Advisory Board on Child Abuse and Neglect, Office of Human Development Services, Department of Health and Human Services, P. O. Box 1182, Washington, DC 20506/202-245-2840.

Advisory Commission on Intergovernmental Relations, Suite 2000, Vanguard Building, 1111 20th St. N.W., Washington, DC 20575/202-653-5536.

Advisory Council on Historic Preservation, Suite 530, 1522 K St. N.W., Washington, DC 20005/202-254-3974.

Agricultural Policy Advisory, Committee for Trade Negotiations, Department of Agriculture, 14th St. and Independence Ave. S.W., Washington, DC 20250/202-447-4055.

Arthritis Coordinating Committee, National Institutes of Health, Room 9A35, Building 31, Bethesda, MD 20205/301-496-7326.

Board of Foreign Scholarships, Operations Staff, International Communication Agency, Washington, DC 20547/202-724-9011.

Citizens' Stamp Advisory Committee, Stamp Division, United States Postal Service, Room 5536, 475 L'Enfant Plaza W. S.W., Washington, DC 20260/202-245-4956.

Commission on Presidential Scholars, Room 1725, Donohoe Building, 400 6th St. S.W., Washington, DC 20202/202-245-8223.

Committee on Foreign Investment in the United States, Room 5100, Main Treasury Building, Washington, DC 20220/202-566-2386.

Committee for the Implementation of Textile Agreements, Room 3221, 14th St. and Constitution Ave. N.W., Washington, DC 20230/202-377-3737.

Committee for Purchase from the Blind and Other Severely Handicapped, 2009 14th St. N., Suite 610, Arlington, VA 22201/703-557-1145.

Coordinating Council on Juvenile Justice and Delinquency Prevention, Office of Juvenile Justice and Delinquency Prevention, Department of Justice, 633 Indiana Ave. N.W., Washington, DC 20531/202-724-7761.

Delaware River Basin Commission, Office of the United States Commissioner: Department of the Interior Building, Room 5113, 1100 L St. N.W., Washington, DC 20240/202-343-5761. Office of the Executive Director: P. O. Box 7360, W. Trenton, NJ 08628/609-883-9500.

Development Coordination Committee, Room 3491A, 320 21st St. N.W., Washington, DC 20523/202-532-1850.

Export Administration Review Board, Room 1613, Department of Commerce Building, Washington, DC 20230/202-377-3128.

Federal Financial Institutions, Examination Council, Third Floor, Comptroller of the Currency Building, 490 L'Enfant Plaza E., Washington, DC 20219/202-447-1810.

Federal Financing Bank, Room 3054, Main Treasury Building, 15th St. and Pennsylvania Ave. N.W., Washington, DC 20220/202-556-2045.

Federal Financing Bank Advisory Council, Room 3124, Main Treasury Building, 15th St. and Pennsylvania Ave. N.W., Washington, DC 20220/202-566-2248.

Federal Interagency Committee on Education, Department of Education, 313H, Hubert H. Humphrey Building, 200 Independence Ave. S.W., Washington, DC 20201/202-245-7904.

Federal Library Committee, Library of Congress, Washington, DC 20540/202-287-6055.

Federal Mine Safety and Health Review Commission, Sixth Floor, 1730 K St. N.W., Washington, DC 20006/202-653-5633

Franklin Delano Roosevelt Memorial Commission, 3390A House Office Building Annex, No. 2, Washington, DC 20515/202-226-2491.

Great Lakes Basin Commission, 3475 Plymouth Rd., P. O. Box 999, Ann Arbor, MI 48106/313-668-2300.

Harry S. Truman Scholarship Foundation, 712 Jackson Pl. N.W., Washington, DC 20006/202-395-4831.

Indian Arts and Crafts Board, Room 4004, Department of the Interior Building, Washington, DC 20240/202-343-2773.

Intelligence Oversight Board, Old Executive Office Building, Washington, DC 20500/202-456-2352.

Interagency Committee on Handicapped Employees, Equal Employment Opportunity Commission, Room 1009, 2401 E. St. N.W., Attn: OGE Baileys Crossroad, Washington, DC 20506/202-756-6040.

Interagency Information Security Oversight Office, Room 6046, General Services Building, 18th and F Sts. N.W., Washington, DC 20405/202-633-6880.

Interagency Savings Bond Committee, U.S. Savings Bond Division, U.S. Department of the Treasury, Washington, DC 20226/202-634-5347.

Japan-United States Friendship Commission, Room 910, 1875 Connecticut Ave. N.W., Washington, DC 20009/202-673-5295.

Joint Board for the Enrollment of Actuaries, Department of the Treasury, Washington, DC 20220/202-376-0767.

Joint Federal-State Land Use Planning Commission for Alaska, Suite 400, 733 West Fourth Ave., Anchorage, AK 99501/907-279-9565.

Mailers Technical Advisory Committee, United States Postal Service, Washington, DC 20260/202-245-5757.

Marine Mammal Commission, Room 307, 1625 Eye St. N.W., Washington, DC 20006/202-653-6237.

Migratory Bird Conservation Commission, Department of the Interior Building, Washington, DC 20240/202-272-3368.

Mississippi River Commission, United States Army Corps of Engineers, P. O. Box 60, Vicksburg, MS 39180/601-634-5000.

Missouri Basin States Association, Suite 515, 10050 Regency Circle, Omaha, NB 68114/402-397-5714.

National Advisory Council on International Monetary and Financial Policies, Department of the Treasury, Washington, DC 20220/202-566-5227.

National Archives Trust Fund Board, National Archives Building, Washington, DC 20408/202-523-1514.

National Commission for Employment Policy, Room 300, 1522 K St. N.W., Washington, DC 20005/202-724-1545.

National Commission on Libraries and Information Science, Suite 601, 1717 K St. N.W., Washington, DC 20036/202-653-6252.

National Commission on Social Security, 99 Kirkstall Rd., Newton, MA 02160/617-244-4557.

National Foreign Intelligence Board, Community Headquarters, Washington, DC 20505/202-376-5584.

National Historical Publications and Records Commission, National Archives Building, Washington, DC 20408/202-724-1083.

National Park Foundation, National Park Foundation, Washington, DC 20240/202-785-4500.

National Planning Council on the Humanities, 806 15th St. N.W., Washington, DC 20506/202-724-0347.

National Productivity Council, Office of Management and Budget, Executive Office Building, Washington, DC 20503/202-456-6722.

Navajo and Hopi Indian Relocation Commission, 2717 N. Steve Boulevard, Flagstaff, AZ 86001/602-779-3311.

New England Governors Conference, 53 State St., Boston, MA 02109/617-720-4606.

Office of the Federal Inspector for the Alaska Natural Gas Transportation System, Post Office Building, Room 2413, 1200 Pennsylvania Ave. N.W., Washington, DC 20044/202-275-1100.

Pacific Northwest River Basins Commission, 1 Columbia River, P. O. Box 908, Vancouver, WA 98666/206-696-7551.

Permanent Committee for Oliver Wendell Holmes Devise Fund, Library of Congress, Washington, DC 20540/202-287-1094.

President's Commission on Executive Exchange, 744 Jackson Pl. N.W., Washington, DC 20503/202-395-4616.

President's Committee on Employment of the Handicapped, 1111 20th St. N.W., Washington, DC 20210/202-653-5044.

President's Interagency Committee on Export Expansion, Department of Commerce Building, Washington, DC 20230/202-377-1124.

Regional Fishery Management Councils, New England Council—Suntaug Office Park, 5 Broadway, Rt. 1, Saugus, MA 01906/617-231-0422.

Mid-Atlantic Council—Federal Building, Room 2115,

North and New Sts., Dover, DE 19901/302-674-2331.

South Atlantic Council—Suite 306, South Park Building, No. 1 S. Park Circle, Charleston, SC 29407/803-571-4366.

Caribbean Council—Suite 1108, Banco De Ponce Building, Hato Rey, PR 00918/809-753-6910.

Gulf Council—Lincoln Center, Suite 881, 5401 W. Kennedy Blvd., Tampa, FL 33609/813-228-2815.

Pacific Council—526 S.W., Mill St., Portland, OR 97201/503-221-6352.

North Pacific Council—Suite 32, 333 W. 4th Ave., P. O. Box 3136 D.T., Anchorage, AK 99510/907-274-4563.

Western Pacific Council—Room 1608, 1164 Bishop St., Honolulu, HI 96813/808-523-1368.

Susquehanna River Basin Commission, Office of the United States Commissioner: Department of the Interior Building, Room 5113, 1100 L St. N.W., Washington, DC 20230/202-343-4091.

Office of the Executive Director: 1721 N. Front St., Harrisburg, PA 17102/717-238-0422.

Textile Trade Policy Group, Room 300, 600 17th St. N.W., Washington, DC 20506/202-395-4642.

Trade Policy Committee, Room 209, 600 17th St. N.W., Washington, DC 20506/202-395-3204.

United States National Commission for UNESCO, Department of State, Washington, DC 20520/202-632-2762.

United States Regulatory Council, Room 50002, 726 Jackson Pl. N.W., New Executive Office Building, Washington, DC 20503/202-653-7240.

Upper Mississippi River Basin Commission, Room 510, Federal Building, Fort Snelling, Twin Cities, MN 55111/612-725-4690.

Veterans Day National Committee, Room 275, Veterans Administration, 810 Vermont Ave. N.W., (40B), Washington, DC 20420/202-389-5386.

Veteran's Federal Coordinating Committee, Room 118, Winder Building, 17th and Pennsylvania Ave. N.W., Washington, DC 20500/202-456-7160.

Water Resources Council, 2120 L St. N.W., Washington, DC 20037/202-254-6303.

INDEX

Index

Coast Guard (*cont.*)
 research, 476
 Reserve, 506
 sailing correspondence course, 492
 search and rescue data, 492
 training, 476
 vessel information, 497
 waterway safety, 497–98
code of federal regulations, 624
cogeneration, 241
coin sets, 506
collective bargaining agreement analysis, 422
college recruiting programs, federal, 736
colleges and universities. *See* education, higher
coloring books, free, 8, 28–29, 104
commerce:
 advice, free, 39, 143–44, 165
 Antitrust Division, Justice Department,
 393–94, 402, 410, 411
 assistance, 140
 assistance for starting a business, 166
 business conditions digest, 140
 business opportunities, foreign, 746
 business opportunities and information, 623
 business relocation assistance, 623
 business reviews, 393
 business service centers, 623
 business with the federal government, 626
 commercial litigation, 395
 complaints, 143
 corporate social performance, 144
 crime, 143, 144
 and Defense Department, 197, 198
 Department. *See* Commerce Department
 economic information, U.S., 140–41, 144,
 158, 160, 164
 experimental technology, 147
 exporting, 147–52
 foreign, antitrust, 393–94
 foreign, experts on, 138–39
 franchising, 153
 free-trade zones, 153
 general commercial policy, 454
 import/export statistics, 33, 40, 150, 151,
 152, 153
 importing, 143–44, 150, 151, 152
 industrial development grants, 112
 and industrial loans, 116
 industrial mobilization, 158
 information on U.S. firms, 165
 international, 459
 legislation, 166
 military briefings for, 173
 ocean, 16, 607
 Office of Small and Disadvantaged Business
 Utilization, 124
 photographs, 163
 publications and data base, 140

 Regulated Industries, Antitrust Division, 394
 service industries, international, 158
 survey of current business, 140
 transportation and capital equipment, 130
 See also Commerce Department; importing/
 exporting; Interstate Commerce
 Commission
Commerce Department:
 abuses and waste hotline, 139
 Arab boycott, 140
 Assistant Secretary for Science and
 Technology, 128
 business advice, free, 39, 143–44, 166
 business assistance, 140, 141, 159, 160
 business conditions digest, 133
 Business Liaison Office, 143, 144, 145
 business site selection, 141
 business topics, 144
 census. *See* Census Bureau
 Chief Economist Office, 128
 communications and information policy, 143
 complaints from business, 143
 consulting for business, 143–44
 corporate social performance, 144
 crime in business, 144
 data, 143, 144
 data base searches, 162
 description, 127
 district operational assistance, 155
 Economic Analysis Bureau, 34, 40, 128,
 140–41, 144, 153, 160, 164
 economic deterioration, long-term, 157
 Economic Development Administration, 129,
 140, 141, 143–44, 155–56, 157, 159, 160,
 166
 economic dislocation, 157
 economic forecasting, 164
 economic indicators, 144
 economic trends, foreign, 167
 educational materials, 145–46
 experts, 129–39
 export information, 33, 41, 147–52
 films, 152
 fisheries assistance, 155
 fish and fishing information, 154, 159
 flood prevention, 153
 Foreign Trade Reference Room, 40, 42
 franchising, 153
 Freedom of Information requests, 153
 free-trade zones, 153
 government contracts from, 154
 government inventions for licensing, 154
 grants, 154–57
 hotline, 69, 149
 Industrial Economics Bureau, 39, 128–29,
 144, 153
 industrial mobilization, 158
 information on U.S. firms, 165

free *(cont.)*
 law enforcement films, 409
 lead poisoning information, 21
 litter bags, 8
 manure, 6, 108
 maps and brochures, 38
 mariners weather magazine, 160
 market studies, 30–31
 marking of U.S. imports information, 517–18
 medical treatment, 328
 mine reports, 376
 missing persons information, 6
 money programs information, 36
 NASA films, 4
 new product information service, 33
 nutrition information, 7
 organic farming information, 7
 plants and animal diseases information, 124
 posters, 7
 pregnancy information, 26–27
 property, government surplus, 5
 recreation information, 381
 resort guides, 9, 164
 Saint Lawrence Seaway publications, 492
 stains and spot removal information, 124
 stamp collecting guide, 8
 State Department publications, 457, 458
 statistical training, 8
 tax tips, 8
 teaching aids, agricultural, 124
 technical publications, 4, 5
 technology information, 34–35
 toys, 8, 28, 124–25
 travel and recreation aids, 8–10, 125, 164
 travelers and importers information, 519–20
 Treasury Department publications, 522
 U.S. foreign relations film, 456
 veteran benefits information, 17
 visual aids, agricultural, 125
 weather and crop bulletin, 125
 wildlife refuge information, 9
 wine and cheese making information, 10
Freedom of Information Act:
 in Agriculture Department, 108
 appeals, 54, 56
 in Commerce Department, 153
 cost of, 54
 description of, 54
 in Education Department, 210
 in Energy Department, 250
 exemptions, 55
 fee waiver, 54
 FOI Clearinghouse, 55
 FOI Services, Inc., 55
 information about, 55
 and lawyers use of, 54–55
 and Privacy Act requests, 60–61
 problems with, 54

 publications, 55–56
 request letters, 54–55, 56
 rights under, 54
 in Transportation Department, 479
Freer Gallery of Art, 911
free-trade zones, 153
fruit, pick your own, 122
FTC. *See* Trade Commission, Federal
fuel conversion, 250
Fuel Supply Center, 183
fuel surcharge hotline, 648
Fulbright program, 643
funeral industry, 618
Furniture Center, National, 635
furniture for children, 28
Fur Products Labeling Act, 619
fusion energy, 250

G
Gallaudet College, Edward Miner Gallaudet
 Library, 51
gardens, gardening. *See* farms, farming
gas. *See* natural gas
gasohol, 237, 504
 entitlement payments, 250
 hotline, 250
 loans, 109
 permits, 512
 price regulations, 250
gasoline
 mileage, 250
 rationing, 250–51
 trends, 476
gas-saving tips, 18
gas turbines, 251
genealogic services:
 Library of Congress, 17
 National Archives and Records Service, 17
 research workshops, 631
General Accounting Office:
 auditing, 872, 877, 878
 auditor fellowship program, international, 875
 bid protest, 872
 claims settlement and debt collection, 873
 community and economic development, 873
 comptroller general, 873
 congressional staff assignments, 873
 congressional testimony, 873
 debarred list, 873–74
 description, 872
 Energy Division, 874
 Field Operations Division, 874
 financial and general management studies,
 874
 fraud hotline, 874
 history, 875
 hotline, 69
 Human Resources Division, 875

Matthew Lesko is the founder of Washington Researchers, an information service based in Washington, D.C., which through consulting, seminars, and publications helps business clients draw on the vast informational resources of the federal government for their own needs. He lectures widely to business groups, does a regular feature on National Public Radio on finding free help from the government in many different areas, and writes a monthly column for *Good Housekeeping* on money and personal finance. His articles have appeared in *Inc., Boardroom Reports, Industry Week,* and other publications. He is the author of *Getting Yours: The Complete Guide to Government Money* (Viking/Penguin).